P9-EEA-127

ENCYCLOPEDIA OF WOMEN & ISLAMIC CULTURES

VOLUME I

Methodologies, Paradigms and Sources

General Editor: **Suad Joseph** (University of California, Davis)

Associate Editors and their regional responsibilities:

Afsaneh Najmabadi (Harvard University)
Turkey, Iran, India, Bangladesh, Pakistan, Afghanistan, Central Asia and the Muslim
Republics of the ex-Soviet Union.

Julie Peteet (University of Louisville)
Seteney Shami (Social Science Research Council)
Arab Gulf States, the Arab Eastern Mediterranean, North Africa, Mauritania, Israel,
Andalusian Spain and Europe under the Ottoman Empire.

Jacqueline Siapno (University of Melbourne)
China, Mongolia, Philippines, Indonesia, Malaysia, Brunei, Burma, Thailand, Australia,
Vietnam, Cambodia, Singapore, Hong Kong, Taiwan, and the Asian Pacific.

Jane I. Smith (Hartford Seminary)
Western Europe, the Americas, and Sub-Saharan Africa.

Editorial Assistant to Jane I. Smith:

Alice Horner (Independant scholar)
Sub-Saharan Africa.

Copy editing:
Margaret Owen

Indexing:
Marloes Janson

ENCYCLOPEDIA OF WOMEN & ISLAMIC CULTURES

VOLUME I

Methodologies, Paradigms and Sources

General Editor
Suad Joseph

Associate Editors
Afsaneh Najmabadi
Julie Peteet
Seteney Shami
Jacqueline Siapno
Jane I. Smith

BRILL
LEIDEN – BOSTON
2003

ISBN 90 04 11380 0 (Vol. 1)
ISBN 90 04 13247 3 (Set)

This book is printed on acid-free paper.
Cover design: BEELDVORM, Pijnacker

PRINTED IN THE NETHERLANDS

For author's template, see:
http://www.brill.nl
http://www.sjoseph.ucdavis.edu/ewic

Contents

Methodologies, Paradigms and Sources for Studying Women and Islamic Cultures:
Disciplinary Entries

Women and Islamic Cultures: A Bibliography of Books and Articles in
European Languages since 1993
 Compiled by G. J. Roper, C. H. Bleaney, and V. Shepherd

Indices to the Encyclopedia

List of Illustrations

The illustrations can be found between pages 314 and 315.

Literature: 9th to 15th Century (*Marlé Hammond*):
[*See page 44*]
– Miniature from a Persian manuscript in the British Library (Or.8755, f.29v) depicting the legendary poet Mahsatī entertaining a group of male admirers. *By permission of the British Library.*

[*See page 48*]
– Ceramic bowl from the Victoria and Albert Museum in London (no. C 86–1918), featuring a quatrain attributed to Mahsatī. *Photo provided by the V&A Picture Library.*

Safavid Iran: 16th to Mid-18th Century (*Kathryn Babayan*):
[*See page 93*]
– Wall painting of a female entertainer in the reception hall of the Chihil Sutūn palace in Isfahan. *Photo © Sussan Babaie.*

Art and Architecture (*Heghnar Watenpaugh*):
[*See pages 315–320*]
– Image displayed as a billboard in Lara Baladi's *Um El-Donia* project in Cairo in 2001. *Photo: Medina Magazine.*

– Photograph of the Grameen Bank Housing Project, Dhaka, Bangladesh, 1984. *Photo: Aga Khan Trust for Culture.*

– General View of the Yeni Valide Mosque Complex, Istanbul, first half of the seventeenth century. Patron: royal mother Safiye Sultan. *Photo: German Archaeology Institute, Istanbul.*

– Diagram showing the sight lines that enabled the royal female patron of the Mosque Complex of Yeni Valide to see out without being visible herself, Istanbul, first half of the seventeenth century. Prepared by Arzu Ozsavasci. *From: L. Thys-Senocak, Ottoman Women Builders: The Architectural Patronage of Turhan Sultan. Aldershot: Ashgate Press, forthcoming.*

List of Contributors

Abaza, Mona – American University in Cairo
Abou El Fadl, Khaled – University of California, Los Angeles
AbuKhalil, As'ad – California State University, Stanislaus
Afsaruddin, Asma – University of Notre Dame
Allès, Elisabeth – Centre National de la Recherche Scientifique, Paris
Amin, Camron – University of Michigan-Dearborn
Andaya, Barbara – University of Hawaii, Manoa
Arat, Yeşim – Boğaziçi University
Armijo-Hussein, Jacqueline – Stanford University
Babayan, Kathryn – University of Michigan
Babich, Irina – Russian Academy of Sciences
Bassiouney, Reem – Foreign and Commonwealth Office, United Kingdom
Benson, Linda – Oakland University
Bier, Laura – New York University
Bowen, Donna Lee – Brigham Young University
Brodeur, Patrice – Connecticut College
Cesari, Jocelyne – Harvard University
Chakravarti, Uma – Delhi University
Christie, Niall – University of British Columbia
Clancy-Smith, Julia – University of Arizona
Cooke, Miriam – Duke University
Elsadda, Hoda – Cairo University
Fahid, Sima – University of Massachusetts, Amherst
Fargues, Philippe – Institut National d'Etudes Démographiques, Paris
Faroqhi, Suraiya – University of Munich
Fay, Mary Ann – American University, Washington, D.C.
Fuad, Muhammad – Universitas Indonesia
Göçek, Fatma Müge – University of Michigan, Ann Arbor
Green, Monica – Arizona State University
Hammond, Marlé – University of Oxford
Hooker, Virginia – Australian National University, Canberra
Horner, Alice – Independent scholar
Ishii, Masako – National Museum of Ethnology, Osaka, Japan
Jaschok, Maria – Oxford University
Kamp, Marianne – University of Wyoming
Kudsieh, Suha – University of Toronto
Lagrange, Frédéric – Université de Paris IV Sorbonne
Lal, Ruby – Johns Hopkins University
Layoun, Mary – University of Wisconsin, Madison
Lindisfarne, Nancy – Independent scholar
Mahmood, Saba – University of California, Berkeley
Martinez, Patricia – University of Malaya
McDougall, Ann – University of Alberta
Miller, Susan – Harvard University
Mills, Amy – University of Texas, Austin
Minault, Gail – University of Texas, Austin
Moore, Kathleen – University of California, Santa Barbara
Moors, Annelies – University of Amsterdam
Moosa, Ebrahim – Duke University

Mukminova, Roziya – Uzbek Academy of Sciences
Naber, Nadine – University of California, Santa Cruz
Naghibi, Nima – University of Winnipeg
Olmsted, Jennifer – Sonoma State University
Peshkova, Svetlana – Syracuse University
Pollard, Clarissa – University of North Carolina, Wilmington
Ricklefs, Merle – University of Melbourne
Roded, Ruth – Hebrew University, Jerusalem
Sholkamy, Hania – American University in Cairo
Shui, Jingjun – Oxford University
Siapno, Jacqueline – University of Melbourne
Sonbol, Amira – Georgetown University
Sonn, Tamara – College of William and Mary, Williamsburg, VA
Taminian, Lucine – Sarah Lawrence College, Bronxville, NY
Tiwon, Sylvia – University of California, Berkeley
Togan, İsenbike – Middle East Technical University, Ankara, Turkey
Trix, Frances – Wayne State University
Tucker, Judith – Georgetown University
Watenpaugh, Heghnar – Massachusetts Institute of Technology
Yaqub, Nadia – University of North Carolina
Young, Katherine – McGill University

Acknowledgments

A large long-term project such as the *Encyclopedia of Women and Islamic Cultures* always owes its life to more people than can be possibly acknowledged in a formal way or even remembered. From the start of these acknowledgments let me globally thank all those who had part in the production of EWIC, in whatever measure, whose names may not appear here for whatever oversight of mine or limitations of such formal recognitions. The sequence of acknowledgments that follows does not represent an ordering of gratitude. The sequence developed a narrative of its own and I let it stand, rather than wrangle with the impossible task of ranking thank yous.

Encyclopedic knowledge production is staged in the context of relationships between publishers, scholars, funders, and a myriad of staff and other personnel. The EWIC project could not have proceeded without the partnership of the editors, the Brill staff, the research assistants, and the interns. So engaged were they with the work that they became a kind of family to me and to each other.

The publisher of EWIC, Brill, supported the editorial board's imaginative excursion into this genre of knowledge-making. The Brill partnership worked extremely well once the EWIC project was formally established. The editorial board had to negotiate with Brill the fluid evolution of EWIC, explaining and translating what had become of Brill's project in our hands. Given the many changes in Brill editors working with EWIC, no one at Brill had a continuous history with the EWIC project from its inception to its materialization. Each Brill editor, however, came on board with enthusiasm for the project. On almost all counts, they were receptive to our vision and responsive to our changes in EWIC organization and our requests for words, illustration space, staff support, and the like.

In 1994, Peri Bearman, Islamic Studies editor at Brill, invited me to work on an "Encyclopedia of Women in Islam." I am indebted to her for the opportunity to take on the general editorship of what evolved into EWIC. Bearman left Brill before the framework of EWIC was finalized. In 1997, the findings of a market survey undertaken by Albert Hoffstädt were strong enough to breathe oxygen into the idea of the encyclopedia when it seemed as if Brill had lost interest.

Jan-Peter Wissink took over as business unit manger for Islamic Studies at Brill in time to rescue the project, and to him we are most indebted for convincing Brill to move forward with the encyclopedia. Wissink was actively involved with EWIC from 1998 to 2001. His open-mindedness and imaginative play infused the start-up of EWIC with an air of collegiality.

Olaf Köndgen joined Brill as Islamic studies editor in late 2000 and took on the concrete work of moving EWIC forward in its material phases. He attended editorial board meetings, listening as we mulled over mundane details, and met with me numerous times. As EWIC took on a life none of us had anticipated, I often felt like a midwife translating its prenatal communications into common English. Köndgen loyally nursed the project along, including arranging several meetings with Sam Bruinsma, Brill business unit manager for History.

The meetings with Bruinsma and Köndgen were absolutely critical for explaining the evolution and growth of EWIC to Brill. At times, it seemed as if I were a blindly devoted parent explaining to the school principal the magical (if mysterious) meaning behind the child's errant behavior. As EWIC's needs grew, Köndgen was always willing to offer me the space to speak on behalf of EWIC and Bruinsma was always open to considering an idea. Together, they fostered an atmosphere of collaboration that not only allowed EWIC to grow to its present status, but also supported a sense of mutually respectful partnership between editors and their publisher.

The grinding work on the publisher's side is usually done by people whose names never appear on contracts or cover pages. Nor do they usually have the joy of joining in those inspirational moments of discovery in editorial or business meetings. Yet without them, EWIC's work would not have been done. Julie Benschop-Plokker was the main Brill staff member for EWIC from the first editorial board meeting in June 1999, until she took maternity leave at the end of 2000. Isabella Gerritsen took on the main burden of handling the author communications for Volumes II–III in spring 2001 while Benschop-Plokker worked on Volume I. Benschop-Plokker returned and with Gerritsen handled various aspects of invitations, tracking entries, author communications, and record keeping

for Volumes II–VI. They were unstintingly gracious, dedicated, respectful, and attentive to details.

Margaret Owen joined in 2002 as the copy editor for EWIC. To her fell the thankless job of working through the endless small and large details of fine-tuning entries for publication. She was tireless, good spirited when others might have become cranky, and very insightful in anticipating longerterm organizational and editing issues. We are greatly indebted to her for her careful handling of all the entries.

Among the long retinue of care-givers, the successive EWIC research assistants were uniformly outstanding. From 1999 to 2001, they worked at the University of California, Davis, in a tiny office barely big enough for a desk, a bookcase, and a filing cabinet, while I supervised them from Cairo, Egypt. A larger office off campus subsequently accommodated the research assistant and several interns. The research assistant prepared minutes, maintained the editors' web page, prepared binders for the editorial board meetings, sent out templates to potential authors and maintained the database of potential authors, helped track down potential authors for editors, and kept updating our constantly changing entry lists and entry descriptions for Brill as well as for editors. By 2003, we had eight interns engaged in the usual drudgery – filing, templates, database – until we began the Scholars and Scholarship project (to appear in a future EWIC volume), which involved a huge commitment on their part. The research assistants and interns weathered many EWIC storms: computer crashes, the loss of data, the loss of a colleague who left with data that had to be reconstructed, balancing college course work and EWIC work, and the occasional crankiness of one or more of us (including me).

The first research assistant was Lynn Nutile, an undergraduate women's studies student who helped set up the first EWIC office, including spotting and spiriting away discarded furniture from another office. Heather Nelson worked in 1999/2000 as the first paid research assistant dedicated to EWIC. She helped set up the database and the Davis-based administrative structure of EWIC. Javan Howard helped briefly, as did my graduate student, Mimi Saunders. Patricia Ristow took over in 2000/1. At the American University in Cairo, I was assisted by two AUC students, Lisa Raiti, a graduate student who helped orchestrate the January 2001 editorial meeting and typed the minutes, and Khalid Dinnawi who built a temporary website for the editors to make the potential author database available. He also helped with the January 2001 meeting and solved endless computer problems for me.

To Tracy Smith go my deepest thanks. She found me and EWIC on the web in 2001 and volunteered her assistance, but I was able to hire her as the third formal EWIC research assistant. She became the most dedicated of research assistants from fall 2001 to the present. She oversaw the move to the new EWIC office and set it up, developed the EWIC potential author database, organized materials for our editorial board meetings, attending two of them, and typed the minutes from my miserable handwriting. Smith became so immersed in EWIC that she changed the focus of her doctoral research to work on EWIC related issues. From volunteer to research assistant, to my graduate student, to a dear family friend, Tracy Smith was a solid rock for EWIC's work.

Sam Petersen kindly hosted the EWIC website on the cultural studies server at UC Davis until we had our own server. Rajagopalan Venkataramani began working for EWIC in winter 2001 as our computer trouble shooter. He was reliable, dutiful, and most generous with his time, often working late in the evening or early in the morning. He set up the EWIC server and the website and organized our author database for searchability. Jerry Lee succeeded Venkataramani in 2003 in a most productive manner. All of the assistants working directly with the office were utterly essential to EWIC's production.

EWIC has been a many layered production. It was not only a job, but a learning opportunity for all who were associated with it, particularly the undergraduate interns. In 2001/2 Sarah Monaly and Elaine (Ying) Xu worked with me and Heather Nelson on the author database. In winter 2002, Nancy Wan and Monica Garcia began a partnership that would inspire them for over a year and a half of work on EWIC. Wendy Martin joined for winter and spring 2002. Garcia and Wan initially undertook filing and information processing tasks but soon embarked on the Scholars and Scholarship Project. Fatima Naseem Malik joined the project in early fall 2002 and Rhyen Coombs shortly afterwards. They were all astounding in their astute pursuit of the data and in their organization of the materials they found. Four more interns joined us in winter 2003: Marya Osucha, Emily Rostel, Monique Salas, and Michelle Sandhoff. I have been humbled by the energy, devotion, and teamwork of such young scholars.

Administrative support from UC Davis was critical at every point in the development of EWIC. In 1998, JoAnn Cannon (Dean of Humanities, Arts,

and Cultural Studies) initiated inquiries that eventually led to grants of over $25,000 in start-up funds including funding from her own office and those of Barbara Metcalf (Dean of Social Sciences), Cristina Gonzalez (Dean of Graduate Studies), and Kevin Smith (Vice Chancellor for Research). Dean Steven Sheffrin, succeeding Metcalf, and his Assistant Dean, Steve Roth, provided EWIC with an office on campus and then a generous office off campus, an autonomous server for our web page, and other basic assistance. Without this support in funds and facilities, the work of EWIC would have been most difficult.

At UC Davis, I also had the unswerving support of Gayle Bacon (managerial staff officer in the anthropology department) and Nancy McLaughlin (grants officer, later succeeding Bacon) who worked tirelessly for hours on my various EWIC related grants, shepherding them through the bureaucratic maze. Chief among these was a grant from the Ford Foundation; Candy Cayne Clark (who succeeded McLauglin) climbed the learning curve to handle this. Anthropology staff member Barbara Raney helped us set up the off campus office and Peggy Slaven and Royce McClelland contributed at various points. In the UC Davis Office of Sponsored Research Jess Phalen, Mai Hoag, Petrina Ho, Wendy Ernst, and Leanna Sweha all worked on the Ford grant. Jo Peterman and Andrew Wolin (Business Contracts Office) and Ahmad Hakim-Elahi (Office of Research) intervened at an important juncture to unravel contractual knots.

The University of California Humanities Research Institute, Irvine, provided facilities for the first editorial board meeting June 1999. I am indebted to Patricia O'Brien (Director, UCRHI) for her generosity in allowing me to house my work for EWIC during the year of my residency as a fellow of UCHRI in 1998/9. The American University in Cairo kindly provided facilities for the January 2001 EWIC editorial board meeting. AUC also housed my work on EWIC for the two years that I was in residence there. I would especially like to thank President John Gerhart and Provost Tim Sullivan who provided me with support and a visionary engagement far beyond their obligations or the contract between our universities.

The associate editors also had hired assistance and were supported by their academic institutions. Julie Peteet had the assistance of Leslie French, Whitney Gifford, and Maryam Mirriahi who worked with great diligence for her. In addition, Sharon O'Bryan was most helpful. Peteet is particularly grateful for the support of the University of Louisville College of Arts and Sciences.

Seteney Shami would particularly like to thank Laleh Behbehanian and Tina Harris for research and administrative assistance, especially in setting up systems to manage the flow of information and email traffic. Mary Ann Riad, Laura Bier, and Elissa Klein worked diligently to maintain the pace of work and to diversify the pool of invited authors. Maria Todorova and Lucine Taminian were most helpful in suggesting authors. Mohammed Tabishat assisted in translation. Shami also most gratefully acknowledges the Social Science Research Council for accommodating her engagement in the EWIC project, for financial assistance with project funds, and for providing facilities and logistical means for her and her research assistants.

Afsaneh Najmabadi gratefully acknowledges the assistance of Aneesa Sen and Jennifer Snow who worked as student research assistants while she was at Barnard College; and of Havva Gurney, Avi Rubin, Fatima Raja, Parinaz Kermani, Kelly O'Neill, and Loretta Kim who were her student research assistants at Harvard University. Advisory editors who were gracious in their assistance included Yeşim Arat, Barbara Metcalf, Shahrzad Mojab, Carla Petievich, and Nayereh Tohidi. She would also like to thank other colleagues who generously helped her locate authors: Nilufer Isvan, Kamala Visweswaran, Burçak Keskin, and Siobhan Lambert-Hurley. Najmabadi also had local assistants who helped with finding authors and with translations: in Uzbekistan, Nodira Azimova, and in Tehran, Sohrab Mahdavi and Roza Eftekhari. Cory Paulsen, Harvard University history department financial officer, was particularly helpful in processing the EWIC grants. Najmabadi would especially like to thank Barnard College and Harvard University for support during her work as associate editor.

Jane I. Smith would like to acknowledge the support of the Hartford Seminary who allowed her to buy out teaching time in order to carry out her EWIC editorial work. Smith would particularly like to thank Alice Horner, an independent researcher in Washington, D.C., who worked with her as editorial assistant for Sub-Saharan Africa to locate authors. Nancy Schwartz helped greatly with the Sub-Saharan African entries. Nathal Dessing of the International Institute for the Study of Islam in the Modern World, Holland, kindly helped Smith with Western European sources and authors. Sheila McDonough, Nadia Wardeh, and Celine Leduc helped with sources and authors on Canada.

Jacqueline Siapno had the support of the staff

and administration at the Australian National University and the University of Melbourne. She would also like to thank her research assistant, Dina Afrianty.

The editors of EWIC express their gratitude to the international advisory editorial board. They came from all disciplines and all regions of the world. Many contributed entries to EWIC, many helped us find authors for entries, and all lent their good names to this project.

Much of the work and growth of EWIC was made possible by a generous Ford Foundation grant. We are greatly indebted to Steven Lawry, Constance Buchanan, and all the program officers involved. Steven Lawry, Ford Foundation Cairo Office representative, brilliantly managed to solicit the participation of eleven Ford offices. The EWIC grant was among the few to have such an extensive level of participation from other regional offices. Every Ford representative in countries with a significant Muslim population contributed: Steven Lawry (Cairo), Mary McAuley (Moscow), David Chiel (Manila), Gowher Rizvi (New Delhi), Katharine Pearson (Nairobi), Gerry Salole (Johannesburg), Suzanne Siskel (Jakarta), Andrew Watson (Beijing), and Akwasi Aidoo (Lagas). In addition contributions came from the central New York offices: Constance Buchanan and Janice Petrovich (Education, Knowledge and Religion Program) and Mahnaz Ispahani (Human Rights and International Cooperation Program). Lawry took every measure to facilitate and speed the process of funding EWIC, patiently working with our laborious University of California grant process. Constance Buchanan and her assistants, Maxine Gaddis and Irene Korenfield, handled the grant after Lawry moved to the New York City office. The grant supported research assistants, buying out teaching time for editors, computers and supplies, translations, and editorial board meetings. The Ford Foundation facilitated our work, eased the transfers of funding, accommodated our reporting procedures, and was flexible regarding budgeted categories. Without the Ford grant, EWIC surely could not have grown to six volumes. It enabled the editorial board to reach for higher goals and, as a result, we came much closer to materializing our vision.

The acknowledgments must also mention our losses. It is with sadness that we remember the passing of Magda Al-Nowaihi, one of our international advisory editors. She was a focused yet versatile scholar who combined her knowledge of critical theory with philological rigor, and who felt equally at home in both classical and modern Arabic literature, poetry and prose. She seamlessly incorporated issues of women and gender into her teaching, research, and writing. She will be remembered for her insightful analyses of Latifa Zayyat, Assia Djebbar, Salwa Bakr, and Fadwa Tuqan, and her engaging studies of Ibn Kahfaja, Edwar al-Karrat, and Muhammad Barrada. She worked with us, suggesting authors and ideas until her last days.

Most deeply, I express my personal gratitude to EWIC's associate editors: Afsaneh Najmabadi, Julie Peteet, Seteney Shami, Jacqueline Siapno, and Jane I. Smith. I feel deeply privileged to have the honor of working with them. Brilliant, insightful, thoughtful, sensitive, respectful, creative, imaginative, responsible, collegial, supportive – these words only begin to describe them. I glow with the experience of working with scholars of such intellectual stature and personal dignity. As the Introduction documents in detail, we developed a truly collaborative working relationship. I learned from them far more than I can even recognize; I followed them as much as I led; and in the end, we produced an innovative approach to encyclopedic knowledge production that none of us (least of all I) could have accomplished without the others. I thank them for their tireless work; for their provocative challenges; for graciously deferring when I asserted editorial authority; for their respectful cautions when work needed to be done differently or better; and most of all, for their loyal friendship and genuine caring. We together raised this creature that EWIC has become. And more, in the journey, we committed to a passionately human encounter.

EWIC is the product of more people than are listed here. Indeed, it would not be possible to list them all, even if I knew all of them. But listing as many as I could has a purpose beyond just saying thank you. What became most clear to me over the nine years I have worked on EWIC was the power of the personal relationships that conceived, birthed, and nurtured EWIC. These personal relationships drove the passion and purpose of EWIC, kept it alive when it could have died, moved it forward when it could have stalled, enlarged it when it could have remained static. The face to face meetings created relationships of trust and respect that were critical in the shifting terrain of the behemoth EWIC incrementally became: the relationships with Bearman, Wissink, Köndgen, and Bruinsma at Brill; with Brill staff members Benschop-Plokker and Gerritsen; with Lawry and Buchanan at the Ford Foundation; with UC Davis Vice Chancellors Kevin Smith and Barry Klein, Deans Cannon, Metcalf, Gonzalez, and Sheffrin, Assistant Dean Roth; with research assistants,

Nelson, Ristow and Smith; with interns, especially Wan, Garcia, Coombs, and Malik; with the UC Davis grants officers Sweha, Phalen, Ho, Peterman, Wolin and Hakim-Elahi; with departmental staff Bacon, McLaughlin and Clark; and of course, the relationships among the editorial board members, Najmabadi, Peteet, Shami, Siapno, and Smith. The work was always hard. But it would have been much harder without the grace and graciousness of these many people. To them I owe more thanks than I can possibly express.

Finally, as with every article of work I have carried out over the past seventeen years, I must express my gratitude to my daughter Sara Rose Joseph. Without her understanding I could not have carried on. She had to bear with Mama's many departures and distractions. I was at times absent even when I was present. She has endured EWIC through more than half of her life. For that I will be grateful the rest of my life.

SUAD JOSEPH
Davis, California
March 2003

Introduction

The EWIC project

The *Encyclopedia of Women and Islamic Cultures* (EWIC) is an interdisciplinary, transhistorical, and global project. It brings together upwards of 1,000 scholars to write critical essays on women, Muslim and non-Muslim, and Islamic cultures in every region where there have been significant Muslim populations. It aims to cover every topic for which there is significant research, examining these regions from the period just before the rise of Islam to the present. EWIC hopes both to offer the state of the art in the broad sweep of topics to inform the general audience and to take on cutting-edge issues to stimulate new research in new terrains.

Muslims number over one billion people. They account for significant populations in every region of the world, including countries that are predominantly of another faith. Conversely, non-Muslims often account for significant populations in regions in which Islam is the predominant faith. EWIC's scope, therefore, is not women and Islam as a specific religion. Rather it is concerned with women and the civilizations and societies in which Islam has played a historic role. The goal of EWIC is to survey all facets of life (society, economy, politics, religion, the arts, popular culture, sports, health, science, medicine, environment, and so forth) of women in these societies.

The editors were faced with a number of problems. What does it mean to produce an encyclopedia of women and Islamic cultures? How would we title it and would the title convey our vision? Which women would be included and which excluded? Which regions would be emphasized and which would receive less attention? What topics would be covered? How would we organize the topics and entries between volumes and within volumes? How would we decide on the number of words (implying not only research availablity, but importance) to allocate to specific entries? How would we find the appropriate authors and judge whether their submissions merited publication? What were our own limitations as an editorial board to undertake this project? How could we overcome some of these limitations?

This Introduction aims to address these and other questions and to problematize the production of the kind of encyclopedic knowledge that EWIC represents and envisions. The first section of the Introduction offers a basic guide on how to use EWIC by outlining its structure and organization. Section two summarizes the editorial board's vision for EWIC. The third section characterizes the implementation of our vision as represented in our guidelines for authors. Section four discusses our processes of finding authors and the development of the EWIC potential author database. In section five, I document the history of the EWIC project in considerable detail. This section is directed to those who are particularly interested in the evolution and transformations of the project and is offered as a record of the twists and turns of a collaborative feminist project. It may be of less interest to the general reader whom I would encourage to jump to the next section. Section six addresses the problems in the conceptualization of encyclopedic knowledge production through a rendering of the critical decisions the editorial board made over the course of nearly five years of working together. These decisions shaped the final product. By revealing our conversations and concerns over these decisions, we hope to demystify encyclopedic knowledge and make the process of knowledge production itself a central subject of the reading of EWIC. In section seven, I discuss the nature of our editorial process as a collective feminist endeavor. The human stories that are always inscribed in invisible ink in the text of long-term enterprises are the subject of section eight. Section nine discusses future plans for EWIC and section ten reflects on the positioning of the EWIC project at this historical juncture.

1. HOW TO USE EWIC: THE STRUCTURE OF EWIC

A discussion of its structure will help guide the reader in the most efficient uses of EWIC. The first five volumes are organized into two broad sections covering 410 topics. Section I is entirely encompassed within Volume I and is organized into four parts: the Introduction, thematic entries, disciplinary entries, and bibliography. Section I (Volume I) contains 68 topics and is devoted to the examination of the methodologies, paradigms, approaches, and resources available to study women and Islamic cultures in different historical periods and in different disciplines. Section II consists of 341 topics divided among Volumes II through V. These volumes are organized around topical issues. Each

volume is devoted to specific large categories of research, but within each volume the entries are organized alphabetically. Volume VI of EWIC is the cumulative index, compiled from the indexes located in each volume.

EWIC can be read for the knowledge offered by specific entries on specific topics. But we hope that students and scholars will also systematically compare entries on the same topic from different regions or study different topics on the same region for in-depth analysis of a particular area. We encourage readers to critically assess EWIC's limitations: to consider why some topics are covered and others not, and why topics are covered in the manner presented here.

Section I, Volume I: methodologies, paradigms, and sources

Volume I consists of 46 thematic entries on methodologies and sources in specific historical periods and regions; 22 disciplinary entries on paradigms and approaches used by various academic disciplines that have studied women and Islamic cultures; and a bibliography of works published on women and Islamic cultures. Two further pieces of work, produced by undergraduate interns working with me at UC Davis, will appear in future EWIC volumes. The first is a summary survey of Ph.D. dissertations—written on women and Islamic cultures between 1970 and 2002 and the second is a list of Ph.D. dissertations on women and Islamic cultures completed during that period.

Introduction

This Introduction to EWIC, which I have written as general editor, discusses the history, conceptualizations, organization, and objectives of EWIC. It offers an outline of how the editors went about the work of EWIC, the rationale behind important decisions, and the purposes of the different sections. The contradictions between the ways in which encyclopedia projects tend to stabilize concepts and the editors' efforts to complicate and destabilize them are discussed. The Introduction addresses the efforts and limitations of deessentializing, historicizing, and contextualizing. Problems of the "periodization" of scholarship on Islam and implications for the study of women are explored. The rationale for separating methodological pieces and general entries is explained. The Introduction discusses our reasons for organizing the methodological section by periods, regions, and empires, focusing especially on the impact of political projects on the production of knowledge and on

methodologies and sources available for doing research. The problem of the "geography of Islam" and the "social geographies" of the entry topics is addressed in the Introduction as well as in many of the entries. The Introduction challenges the "regionalization" of Islam while explaining the need to organize some of EWIC's work regionally. The Introduction also explains EWIC's effort to avoid the "exceptional women" approach to women's history. In sum, the Introduction attempts to be not only a road map to EWIC, but also an analysis of the challenges and problems of global, interdisciplinary, and transhistorical feminist encyclopedic knowledge production.

Thematic entries

Thematic entries address methodologies, sources available for research, the constraints and limitations presented by methodologies and sources, and the implications of these for differing historical periods, locales, political regimes, and academic disciplines. Section I entries are intended as substantive scholarly articles that set the stage for future research rather than answer all the questions. Authors were asked to identify and evaluate key sources and methods: textual sources, survey methods, statistical tools, fieldwork methods, journals, visual sources, oral histories, and so on used to study women and Islamic cultures in the specific period, place, and discipline assigned. The entries for Section I were solicited before those for Section II. The intent was that Section I entries could be sent to the authors of Section II general entries to inform their writing. Similarly authors of Section I entries were at times sent completed entries by other Section I authors to encourage them to build on each other's work and to model the sort of analysis we were attempting to achieve. In this endeavor, Volume I of EWIC is a most unusual contribution to the field. Rather than the end product of an author's analysis, it offers scholars and students critical tools for their own research by directing them to the sources that exist, to how these sources have been used, and by whom, and how they might be useful. There are two kinds of thematic entry, historical and disciplinary.

Historical thematic entries

The 46 historical entries focus on problems in methodologies and sources that are relevant for research on women and Islamic cultures for each historical period. They are subdivided by region for entries covering contemporaneous periods of time. The logic for regional organization is that

methods and sources change as empires and nation-states emerge. Since the gathering of information of all sorts is directly impacted by the political projects of empires and states, fine tuning EWIC's thematic pieces to assess these differences in methods and sources was deemed by the editors to be important. The entries evaluate the methodological and epistemological problems in the study of women in the period covered and in the specific region covered. They are not reviews of events, the state of Islam, or the conditions of women in those periods and regions; rather they are intended to direct the reader to resources available to carry out research on women and Islamic cultures in specific historical periods and locales.

As such, they offer critical tools for scholars and students interested in further study and research. Authors were asked to be attentive to primary sources and how their use has informed and shaped what is considered to be "known" about women. As some pieces cover large stretches of time, authors were invited to evaluate important changes in methodologies and sources during the period covered and their effect on knowledge of women and Islamic cultures. The majority of the historical thematic entries cover different historical periods in a particular region. Our interest in historicizing the methodological section of EWIC emerged from a recognition that the specific political and social conditions under which knowledge is produced change over time and shape the nature and possible uses of that knowledge. We mean to continually remind ourselves and EWIC's readers of the importance of context, site, situation, and time in understanding not only women and Islamic cultures, but also how we come to know what we know about them.

Disciplinary thematic entries

The 22 disciplinary entries focus on critical evaluations of the methodologies and paradigms used in specific disciplines to study women and Islamic cultures. Authors were invited to evaluate the epistemological assumptions of their disciplines and how these have affected the study of women and Islamic cultures within their disciplines. For example, the entry on anthropology was required to address the epistemological problems of the anthropological ideas of "culture," the methodological problems in doing informant based "fieldwork," and to critically evaluate the assumptions of participant observation. The disciplinary entries do not focus on regions or historical periods, but on disciplinary methodologies and sources

globally. Our interest in addressing disciplinary methodologies came from a recognition that interdisciplinary understanding requires appreciation of the constraints and possibilities for knowledge production built into the training of scholars, discipline by discipline. The overwhelming majority of scholars are trained in specific disciplines, which tend to produce their own genealogies of thought and method. While the boundaries of disciplines always have been porous, and have become increasingly so, we recognize that disciplinary assumptions act both as guiding and blinding lights in the search for understanding.

Bibliography

In the last stages of the production of Volume I, Brill editor Olaf Köndgen proposed the compilation of a bibliography on women and Islamic cultures globally. That bibliography is included in Volume I.

Section II, Volumes II–V

Section II consists of a vast span of topics across disciplines and regions covering every issue on which we could find significant research of relevance to women and Islamic cultures. Three hundred and forty-one topics are covered, grouped into the four volumes of Section II by large categories of research. Section II has two sorts of entries: regionalized entries (212) and overviews (129). Regionalizing a topic meant that, while the topic was covered for each region, associate editors were given the latitude to adapt coverage of that topic in a manner appropriate to their regions. For example, the topic in Volume II on women, gender, and state constitutions might lead to four entries for one associate editor, five for another, or only one for another. The 212 regionalized topics will generate a few thousand entries by the time Volume V is complete. Topics were assigned as overviews when there was too little material or relevance to cover them region by region, or when there was so much that a general introduction to the topic was needed before the regionalized entries.

Volume II. Family, law, and politics

Volume II consists of 66 regionalized topics and 43 overviews, a total of 109 entries on family, law, and politics. Its topics include women, gender and civil society, democracy ideologies, freedom of expression, domestic violence, gay politics, honor, honor crimes, women's rights, human rights, international decades of women, family law, laws on

cultural defense, nation, political parties, political movements, race, rape, women's unions, postcolonial dissent, and sexual abuse. This was one of the smoothest volumes to assemble. In most countries where Islam plays a significant role, family, law, and politics are deeply intertwined. In part, this is a result of the deference in family law to religious law (Muslim, Jewish, and Christian) in many Muslim countries and the deference to Muslim family laws in some non-Muslim countries (such as India). In part the intermeshing of family, law, and politics results from the strength of family systems, which compete with states for the loyalties of their members in many countries. And in part, our grouping together of family, law, and politics resulted from the recognition that all states, in some capacity, generate family policies (and police families) and that law is a prime venue for the mediation of family/state relations. It was also inspired by the recognition that politics is always gendered and that the area of law and family are primary sites for the examination of the politics of gender.

Volume III. Family, body, sexuality, and health

Volume III covers 66 topics, of which 26 are overviews and 40 are regionalized. Like Volume II, these categories of research seemed to want to be bound together. The volume includes such topics as child marriage, premodern childhood, premodern discourses of love, courtship, marriage practices, sex education manuals, religious discourses on sexuality, Islam and the female body, sports and the female body, virginity discourses and practices, disabilities, female genital cutting, HIV, sexually transmitted diseases, reproductive technologies, and science and Islam. The body, as played out in family discourses and practices, as understood in discourses and practices around sexuality, and as conceptualized under regimes of health runs through the topics of Volume III as a thematic continuity.

Volume IV. Economics, education, mobility, and space

Volume IV includes 18 overviews and 70 regionalized topics, a total of 88 topics. The intersections between materialities of various sorts and lived realities and experiences tie these large research categories together. Volume IV takes up questions of women's labor, world markets, traditional professions, environment, premodern education, colonial education, national curricula, migration, diasporic communities, refugees, development discourses, female space, housing, colonial and modern cities, and homelessness.

Volume V. Practices, interpretations, and representations

Volume V consists of 78 topics of which 42 are overviews and 36 are regionalized. Representations and their lived experiences is its unifying theme. How women are represented and interpreted and the practices generating and generated by representations and interpretations are critical for understanding women and Islamic cultures. Particularly important are the representations of women in Islamic religious texts, Islamic sciences, Islamic practices, Islamic discourses. Just as important, there are also representations by women writers and representations of women as women entertainers, women in the media and popular culture, women in the arts; and representation of women's sexualities in poetry, the arts, popular culture, and Islamic texts.

Volume VI. Index

Each EWIC volume has its own index. Volume VI of EWIC is the cumulative index compiled from the indexes of the first five volumes. We asked each author to list 5–10 keywords per 1,000 words of text for the index. These were submitted to the indexer who used them for the basis of the index.

2. THE GUIDING VISION OF EWIC

An encyclopedia represents a particular and a peculiar form of knowledge. Encyclopedias aim to be authorities, often definitive authorities, on their subject matter. In the first instance, an encyclopedia is a positivist enterprise. It presumes that knowledge can be defined, classified, and ordered cleanly and clearly. Encyclopedias tend to stabilize concepts. For the editors of EWIC, these presumptions of encyclopedic knowledge production were problematic. None of the categories rested easily for us. We wanted to destabilize concepts, complicate ideas, document the "fuzziness" of reality. We divided our editorial responsibilities in part by regions of the world. Yet the idea of a "region" (discussed more below) is a troubled, shifting, politically burdened concept. We asked ourselves, what does it mean to divide Islam by regions? We used the "nation-state" as a defining criteria for many of our entries. Yet the nation-state is an unstable unit of analysis. We instructed our authors to bear in mind continually that their entry should be about "women and gender and Islamic cultures." But while the entries were clearly about gender, it was not clear how central the concept of Islam was to all the entries. Indeed, we were troubled by the concept of "women and Islam" and "gender and Islam." We tried to avoid the notion that at the base of

Islam is a core set of beliefs and concepts. Yet we could not entirely escape the recognition that we are products of that notion. We resisted entry titles associated with a crystalized notion of "Islam" such as "segregation" and "seclusion." In general we tried to avoid entries that reinforce the public imagination of Islam. Yet we were not sure we were always successful. Our editorial process entailed a constant tension between creating categories and problematizing them. And while problematizing the very nature of encyclopedia knowledge production was a consuming order of business in editorial discussions, translating our vision to our authors or even to the organization of EWIC was always more difficult than talking about it (see below "Implementing the Vision").

The editorial board of EWIC set out from the first meeting in June 1999 to produce an encyclopedia that had at its core a recognition of the power of the process of knowledge production. All of us had an acute appreciation of the situatedness and historicity of knowledge production. At every step, we reflected and evaluated the choices before us in terms of the impact our decisions would have on the kind of knowledge EWIC would present and represent. Communication among the editors and between the editors and authors became paramount. The editorial board met twice a year and some individual editors met more often (at times at their own expense). We developed a web-page for minutes, decisions, and the author database. We held meetings by email when we could not meet in person. I took extensive notes and wrote detailed minutes from all our meetings to record how we went about our work, what decisions we made, why we made them and the implications of those decisions for the EWIC project. This Introduction is based on those notes.

The editors did not always agree on how to handle specific issues. But we all recognized that the EWIC project was an opportunity, indeed, a rare moment to define a field of knowledge. The excitement of that moment brought with it the burden of responsibility. To whom were we accountable for that responsibility? To our publishers, ourselves, our readers, our subjects, our students, history, truth, all of these? Could the different constituencies be reconciled? These were questions that often hung over us, individually and collectively. At times it seemed as if we were driven by EWIC. Not only did it come to have a life of its own, but it took over our lives. But to the degree that it did, it was because of the passion we had for the project and its possibilities. Our commitment to an encyclopedic project engaged us, as an editorial board, in

intensive conversations on our individual visions for EWIC. By the time of this writing in March 2003, what has emerged over the course of almost five years of working together (and for me, nine years of project development), is a collective vision that belongs to none of us and to all of us.

3. IMPLEMENTING THE VISION: GUIDELINES FOR AUTHORS

The EWIC editors worked closely together to develop a vision for EWIC. Communicating that vision to our authors in order to create a unified project was itself a critical undertaking. Along with the usual instructions concerning house style, authors received a detailed document explaining the EWIC project. Written initially with Volume I authors in mind, the same letter was used for Volumes II–V authors as it outlined the broad vision of EWIC, its different sections, the relationships between authors and editors and the possibility of dialogue among authors.

Section I entries, authors were told, are not meant to be summaries of findings on women and Islamic cultures in various disciplines or historical period and places. Rather they focus on the tools and sources for research on women and Islamic cultures in those disciplines, periods, and places. To ensure that our authors stayed focused on the subject of EWIC in Section II, every entry title and description reminded authors that their entry was about "women and Islamic cultures" in relation to that topic and in that region. Every entry description carried the reminder to contextualize and historicize coverage of the topic.

Authors were asked to highlight debates in such a way that entries would be informative and critical, but not polemical. We encouraged them to minimize the use of jargon specific to theory, field, or discipline, or to define any such terms used, so that entries could be read across disciplines. We invited them to rethink ideas, capture the state of the art, summarize important research, inform and, in the process, avoid attacks and axe-grinding rhetoric. Entries ranged from 2,000 to 10,000 words, with most Volume I entries about 4,000 words, and the rest between 2,000 and 3,000 words. Rarely could we give authors as many words as they needed to cover topics fully.

Each author also received a substantive description of the topic they were invited to cover. Because of our varying visions of EWIC, the field, and the specific entry topic, each topic generated rich, complex discussions. By the time we came to define specific entry topics, the editorial board had created its own language. We could summarize what

we wanted to say in a few words that we all understood. The substantive descriptions sent to authors were brief summaries of these complex discussions. We found, at times, that while the editors read the words with the memory of our rich and nuanced discussions, our descriptions did not always convey the complexity we intended to the authors. Indeed, it would have been nearly impossible to convey to authors, in reasonably sized descriptions, the variegated conversations around a particular topic. In this, the editors felt the privilege of being a small group who could carry on such long-term discussions and the sadness of not being able to fully capture and share that privilege with the authors.

To ameliorate this imbalance, we encouraged each author to communicate with the associate editor assigned to their topic, hoping that the full texture of our discussions of the descriptions might survive some translation and to ensure mutual understanding. Many authors did communicate either before they began to write or early in the process. This allowed us not only to catch the errors in conveying our intent but also to engage in very productive discussions with authors, which led us to refine and retool our entries. In other cases, we failed, either because we did not convey our aim adequately or because the author misinterpreted it. Sometimes, miscommunication as to what we had intended the entry to cover or how we wanted that topic covered was not discovered until the entry was submitted.

Authors were on the whole very forgiving and willing to revise. In a few cases, even when clarification was achieved, authors could not accomplish what we had hoped for a variety of reasons. We rejected a few entries that seemed far enough off the mark to be unrecoverable. Some entries were rejected not necessarily because they were not important or well written, but because they did not meet our needs. Our greatest difficulty with authors, once committed, was that a very large number did not meet their deadlines – a problem of every large editing project. Some delayed so long that their entries could not be included in this volume, resulting in a loss of some critical topics (such as the sociology disciplinary entry). For some authors, their responsibilities as public intellectuals in the aftermath of the tragic events of 11 September 2001 exacted a high toll, leading them to cut back on other obligations. Many were called upon to explain Islam to the global public, and many were particularly called upon to interpret Islam's various positions and histories in relation to women.

In general, when they were not what we had imagined, the entries were themselves so imaginative that they made a valuable contribution to the EWIC project. For some entries there were numerous communications between authors, editors, and at times, the general editor. In almost all cases, the dialogue was productive. The outcome of the EWIC project, then, is not simply the vision of the editors and publisher, but a mix of the visions of editors, publisher, and authors.

4. FINDING AUTHORS

To find authors, we relied, in the first instance, on our own expertise and knowledge of the field. Our editorial board is diversified in terms of regions of specialization (three Arab world scholars, one Iran/Turkey/Central and South Asia scholar, one Southeast Asia scholar, one Americanist, and an Africanist editorial assistant). We also had some disciplinary range (three anthropologists, one historian, one religious studies scholar, and one political scientist/area studies/literary studies scholar). However, our regional and disciplinary range could not possibly cover the range required for seeking all our authors. We asked our 41 international advisory editors, whose expertise spanned the disciplines and regions, to suggest authors for entries as well as to write entries themselves. Even this was not adequate.

Early on, we recognized that the enormity of our commitment to recruit scholars globally would require us to go well beyond any of our circles. We began developing a database of potential authors by placing advertisements in journals, on websites, and at conferences to solicit possible authors. We developed a template for potential authors and created a database searchable by author's name, research interests, and region of research. The database was mostly housed at the University of California, Davis, organized by the EWIC research assistants, and put on the editor's page of the EWIC website at <www.sjoseph.ucdavis.edu/ewic>. Readers interested in contributing to future volumes and editions of EWIC are invited to fill out the potential authors' template at this website or at <www.brill.nl>.

As news spread about the EWIC project, scholars and writers began contacting us to volunteer to write specific entries. To our delight, the database grew within a few years to over 900 potential authors. At times scholars submitted unsolicited entries or suggested writing specific topics that we were not covering or were covering in the context of several different entries. We were very glad to

engage these scholars and keen to figure out how their work might fit into EWIC – if not the print edition, then perhaps the online edition. Many of these scholars contacted us repeatedly. While we were not able to invite all who volunteered to contribute, the database remains a vital resource for future editions of EWIC.

As well as leading scholars, we sought young scholars. Our thinking was that new Ph.D.s and graduate students would have freshly surveyed their fields. We asked senior scholars for recommendations of graduate students and we used our database of Ph.D. dissertations to identify young scholars who could write on specific topics. Where possible, we encouraged co-authoring where it would enhance coverage of material not accessible to one author alone.

The editors had no trouble composing an extensive list of potential entry topics to be covered in EWIC. Often, however, it was not clear whether research had been done on certain topics for some regions. At times, while we found scholars willing to write entries, it was difficult for the scholar to foreground gender. Usually this was because of lack of availability of sources. At other times, authors had to stretch their own expertise concerning a topic to cover gender.

5. THE HISTORY OF THE EWIC PROJECT

The EWIC project is a saga stretched over nine years of development, at least from my first involvement to the publication of the first volume. Over the years, I documented conversations, negotiations, meetings, and exchanges of letters and emails (for which I maintained far more extensive records than are summarized here). This section of the Introduction is intended for those readers particularly interested in the ways in which an intellectual project of encyclopedic proportions is conceived, evolves, and transforms – and in the process shapes the knowledge "product." The documentation of this process was motivated by the belief that knowledge production is embedded in social relations of production, as are other marketable products. My documentation of a portion of this process in the Introduction is intended to reveal the conditionality of knowledge production, the situatedness, and even, at times, the accidentality. At the end of the day, what we know, how we represent it, and what comes to be constituted publically as knowledge, is as much a story about how we produce what we know as it is a story about that which we try to know. The less stalwart may

wish to read forward to the next section on the conceptual problematics of the production of encyclopedic knowledge.

Peri Bearman (Islamic Studies editor at Brill) conceived the idea of an "Encylopedia of Women in Islam." Her initial letter of July 1994 indicated an interest in a 2,500 page (which later changed to 1,500 page), three-volume encyclopedia, with "entries about personalities interspersed with survey articles on women and women's topics from the viewpoint of society, law, literature, mysticism, etc." The encyclopedia would focus on the Arab countries, Turkey, Iran, and Asia and Southeast Asia. Four editors were to be responsible for these four "divisions" and some had been tentatively lined up. I replied, summarizing a few ideas and left for five months, fieldwork in Lebanon. After one more exchange, the project went from my mind until I received a fax from Bearman in October 1995 asking if I were still interested in the project. In December 1995, we met in Davis. I was formally invited to become general editor and we began contract negotiations. The provisional title was "Encyclopedia of Women in the Muslim World" (EWMW). The contract discussions continued, by email, for two years and were almost finalized. But in January 1997, in an effort to reduce the costs of an encyclopedia, Brill floated the idea of producing a journal on the theme of women in the Muslim world, which would later develop into an encyclopedia. I was not enthusiastic about substituting a journal for an encyclopedia or developing an encyclopedia via a journal. The conversations with Brill about EWMW, however, continued. At the end of 1997, Peri Bearman left Brill and interest in the project seemd to have waned, although two Brill acquisition editors maintained contact with me. One of them, Albert Hoffstädt, carried out a market survey to test the waters for scholarly interest in EWMW, which elicited a positive response.

In 1998, Jan-Peter Wissink (business unit manager for Islamic Studies at Brill) contacted me, indicating his interest in moving forward with EWMW. After persuading Brill management to reconsider EWMW, Wissink came to Davis in April 1998 to revive the contract discussions, which were finalized over a few months. I had previously approached my Deans (JoAnn Cannon and Barbara Metcalf), the Vice Chancellor for Research (Kevin Smith), and Graduate Studies Dean (Cristina Gonzalez) at the University of California, Davis, to request start-up funds. Funds were provided as well as an office for EWMW. By the fall of 1998, the contract for the encyclopedia

was in place, and I was ensconced at the University of California Humanities Research Institute (UCHRI) at UC Irvine for the academic year, running a faculty seminar on women and citizenship in Muslim communities.

Academic year 1998/9 was committed to identifying and selecting the associate editors. The original conception of four co-equal editors had been modified initially to one general editor and three associate editors, and later to one general editor and four associate editors. However, as I researched the editorial possibilities, the workload became increasingly clear, and I renegotiated the contract to include one general editor and five associate editors. Discussions with potential editors were fascinating. I was fortunate to be able to consult with many people in the field, finding with each connection enormous enthusiasm for the idea of EWMW. This proved to be a productive learning experience. The highly stimulating conversations and meetings with leading figures produced creative ideas for the vision and structure of the encyclopedia. By spring 1999, the editorial board was in place. I was honored that a distinguished set of scholars had agreed to join me in this intellectual journey: Afsaneh Najmabadi (then at Barnard College and later at Harvard University), Julie Peteet (University of Louisville), Seteney Shami (in transition to a new position at the Social Science Research Council), Jane I. Smith (Hartford Seminary), and Jacqueline Siapno (taking on a new faculty position at the University of Australia and later moving to Melbourne University).

Bearman's original notion of organizing the editorial board division of labor regionally was retained. Afsaneh Najmabadi took responsibility for Turkey, Iran, India, Bangladesh, Pakistan, Afghanistan, Central Asia (to the borders of Mongolia, but not including Mongolia), and the Muslim republics of the former Soviet Union both east and west of the Caspian. Julie Peteet and Seteney Shami together took responsibility for the Arab Gulf states, the Arab Eastern Mediterranean, North Africa, Mauritania, Israel, Andalusian Spain, and Europe under the Ottoman Empire. Jacqueline Siapno took charge of entries covering China, Mongolia, Philippines, Indonesia, Malaysia, Brunei, Burma, Thailand, Australia, Vietnam, Cambodia, Singapore, Hong Kong, Taiwan, the Asian Pacific, and the earlier Malay and Chinese world. Jane I. Smith valiantly agreed to cover Western Europe, sub-Saharan Africa, and the Americas.

On 20 May 1999, I wrote to the newly constituted editorial board a letter inviting them to the first editorial board meeting to be held the following month. In the interests of developing the vision of the work of the editorial board, I proposed:

We would work to develop a collective vision for the EWMW, a philosophy or framework of what we are trying to accomplish through this project. The collective vision would have some basics:

1. We do not all have to agree with an approach to Islam or gender, but we need to be clear on each other's approaches and we need to have an umbrella under which we can all work together.
2. We should all agree there is not one "true" Islam, but many interpretations and views on Islam. This project is not about uncovering or recovery of one true Islam. The project is concerned to contextualize Islam historically and culturally. Therefore, the EWMW is interested in history, art, music, medicine, psychology, social organization, politics, economics, environment, theology, and the like.
3. There is not one Islamic position on gender. The position of women in Islamic communities and in non-Islamic communities in the Muslim world is complex, multiply determined, and has changed over time and place.
4. The EWMW is not just about Islam, but about women in Muslim communities, including Christian and Jewish and women of other religious and ethnic groups who live in predominately Muslim countries and about Muslim women in non-Muslim countries. It is an encyclopedia of women who live in communities where Islam is a significant force. It is not an encyclopedia of Islam per se.
5. The EWMW will try to represent the range of voices within Islamic discourses as well as the range of voices about Islam and its discourses.
6. Time frame for the EWMW will start around the period just prior to the rise of Islam in the 6th century in the Middle East, and in the period just prior to the introduction of Islam in other regions of the world.

The first editorial board meeting was held in June 1999 at the UCHRI in Irvine, California. The first editorial board meeting was attended, in addition to myself, by Jan-Peter Wissink, Julie Plokker (from Wissink's editorial staff), Afsaneh Najmabadi, Julie Peteet, Jane I. Smith, and Jacqueline Siapno. I cannot say that I fully understood what I was doing or what the work ahead would entail. Like a child who jumps into the water to learn how to swim, I dived into the encyclopedia hoping (more than believing) that I would figure it out as I went along. That first meeting was a stunning experience. First was the rapport that the editorial board (who did not all know each other) immediately developed. Second was the efficiency with which we collectively developed a plan of action. Third was the sense of incredible excitement as we embarked on a journey in which we felt we could make a difference in shaping the field.

Several critical decisions were made at the first meeting, based on the notion that we were producing a three-volume, 1,500,000 word (which moved

quickly to 2,000,000 word) encyclopedia to be published in 2003. We chose the tentative title "Encyclopedia of Women and Islamic Cultures" (EWIC). We decided to organize EWIC into two sections. Section I would focus on methodologies and sources and on disciplinary methodologies and paradigms and Section II would include the substantive topics. We outlined a list of topics for Section I, including potential authors, and a long list of potential broad topics for Section II. We also decided that we would solicit entries to Section I before those of Section II in order to make Section I entries available to Section II authors. We divided the 1,500,000 words among the sections and, within Section II, among the regions. We then designed the basic editing process in which every entry was assigned a routing editor (RE). The RE was the associate editor whose task it was to identify potential authors for their entries, communicate with them regarding any questions s/he might have about the entry and be the first reader of the entry when it was submitted. As general editor, I would read all the entries, but only after they had been revised by the author, following the RE comments – unless the RE wanted to bring me into the editing process in the first stage (which did happen with a number of entries). The final decision on acceptance of entries for publication in EWIC rested with me, as did all issues relating to deadlines and deadline extensions. I took upon myself to write exhaustive minutes of our discussions (a pattern I have maintained throughout our work). That meeting did not produce a unified vision for EWIC, or a grand logic, but steps towards a shared vision. We agreed we wanted to capture the flexibility of Islam, the sweeping civilizational stories as well as the quotidian, the dynamics of women and Islamic cultures in their full array across time and place.

In summer 1999, I moved to Cairo, Egypt, where I spent 1999–2001 as the Director of the University of California Education Abroad Program at the American University in Cairo. Jacqueline Siapno, who had been in residence with me at UCHRI, moved to Australia and Seteney Shami, who had been in Cairo, moved to New York. With all these transitions, and our next meeting a year away, we decided to carry on our work with monthly email-meetings for which I developed an agenda in advance. It took me well into the fall of 1999 to write and edit the minutes from our June 1999 meeting, which then formally kicked off our email work.

My research assistant, Heather Nelson, organized the EWIC office at UC Davis, where the edi-

torial work of EWIC continued to be housed. She kept track of our monthly email meetings and sent us minutes. She also began to organize the EWIC web page and the solicitations for a database of potential authors, using the template we had developed for potential authors. In this, she had the help of UC Davis undergraduate interns, Sarah Monaly and Elaine (Ying) Xu, in addition to two of my UC Davis research assistants, graduate student Mimi (Leslie) Saunders and undergraduate Javan Howard, who worked primarily on other projects but helped with database or other programming.

The task for 1999/2000 was to work through the minutes from the June 1999 meeting in order to develop the Section I entries. We did this through extensive email communication and occasional phone calls. We invited a distinguished international advisory board of 42 scholars (the death of one scholar left us with 41) and writers from around the world to help guide our work. The advisory board covers all critical disciplines and every region of the world, and bridges the divide between scholars, activists, artists, and professionals in various fields. Everyone we invited (except one person who was dealing with a family illness) agreed to serve on the advisory board. We warned them that we fully intended them to be a working board with responsibilities delegated to them for writing, soliciting authors, or consulting on entry topics. In the end, some became more involved than others. We were grateful, at every level, to all of them that they lent their good names to this untested project and that they responded as best they could to our requests for help.

Our next editorial board meeting was at the Hartford Seminary in Hartford, Connecticut, in August 2000. That meeting was attended, in addition to myself, by Jane I. Smith, Afsaneh Najmabadi, Julie Peteet, and Seteney Shami. In preparation for this meeting, Julie Peteet and Seteney Shami had met, at their own expense and initiative, to develop a preliminary list of potential topics, working from the June 1999 Irvine list. This expedited our collective work at the Hartford meeting. Initially they had met to develop the topics for the Arab and Ottoman region for which they were responsible. They realized that the topic lists were really the same for all of the regions and offered their lists to the whole editorial board. Had it not been for their initiative, our editorial work would have taken longer. We "finalized" the Section I entry lists and worked further on those for Section II. It is more accurate, however, to say that the entry lists were never fully finalized until they were published. Entry descriptions and parameters

continually changed as we found inconsistencies in our own work, or we found that our wish list of entries could not be fulfilled, or authors renegotiated entry descriptions and parameters.

We decided to begin solicitations for Section I authors immediately. We had to develop the invitational letter and guidelines for authors that included our developing "vision" of EWIC. Optimistically, we set the deadline for all Section I entries as 1 June 2001 (some authors had not submitted their entries even by May 2003). As we had no assistant at that time in Cairo and Brill had no procedure for sending out solicitations, I sent them all by email from Cairo for the first year. Considerable collective efforts were made by the editorial board during much of fall 2000 through spring 2001 to finding authors. In summer 2000, Patricia Ristow became research assistant in the UC Davis office. The editorial board continued the monthly email meetings to refine and define entry lists as well as to help each other suggest and find authors.

The third editorial board meeting was held in Cairo in January 2001. Two AUC students, Khalid Dinnawi and Lisa Raiti, helped organize the meeting. AUC President John Gerhart and Provost Tim Sullivan kindly offered AUC facilities for the meeting and President Gerhart joined the editorial board for lunch, as did Steven Lawry, representative for the Ford Foundation, Cairo. I had submitted a grant application to the Ford Foundation on behalf of EWIC, and this meeting offered an opportunity for EWIC's editorial board and publisher to discuss EWIC with the Ford representative. The meeting was attended, in addition to myself, by Afsaneh Najmabadi, Julie Peteet, Seteney Shami, Jacqueline Siapno, Jan-Peter Wissink, and Olaf Köndgen. Wissink was moving to another post in Brill, and Köndgen was replacing him as the Brill editor for EWIC.

Wissink introduced the idea of putting EWIC online in order to make it an ongoing project. He also encouraged us to not be limited by the 2,000,000 word count. We had, in any case, already effectively extended EWIC to four volumes, by allocating (unauthorized) 2,780,000 words to topical entries. The Cairo meeting also discussed whether to organize EWIC topically or alphabetically. No decision was made and we continued organizing our work topically in order to develop the entry list. We now focused on Section II entries. We needed to develop descriptions for entries, as well as refine our entry list. Authors would need descriptions of their own entries, and of adjacent entries to avoid overlapping. This time too, Julie Peteet and Seteney Shami had met independently to work on the entry list and this again greatly facilitated our collective work. At this meeting, we also agreed that, for a limited number of women, we would have "biography boxes" within entries and we would request index word lists from authors for their entries.

In May 2001 I went to Leiden to meet with Olaf Köndgen, our Brill editor, and Sam Bruinsma, the manager of the business unit in which EWIC was now housed. Routing procedures were developed, including routing sheets to accompany each entry and timetables for entries. The style sheet for authors was completed, and instructions for the Brill staff for handling entries from solicitation to publication. This meeting was extremely helpful as it gave me an understanding of how Brill works, as well as an opportunity to develop a working relationship with Sam Bruinsma. I also met Isabella Gerritsen, who became the in-house Brill staff member dedicated to EWIC. Julie Plokker, now Benschop-Plokker (working as a consultant to Brill, exclusively on EWIC) took over the solicitations for Volume I entries from me, and Isabella Gerritsen took responsibility for the solicitations for Section II entries and for receiving, mailing, and tracking of all the entries, using a systematic author database and tracking procedure. The author database was kept separate from the potential author database for ease of access. The four volumes and 2,500,000 words were confirmed, and we developed the idea that Section I (Volume I) would be published separately, marketed independently of the other volumes.

In summer 2001, I returned to UC Davis. I was fortunate to find Tracy Smith to work as the new EWIC research assistant – a commitment maintained for three years. By July 2001 we had the Ford Foundation grant of $270,000, a turning point for EWIC. Eleven Ford offices worldwide participated in the Ford Foundation grant. Every Ford Foundation office in every region in which there is a significant Muslim population, from Africa to the Middle East to Asia, joined the New York office in funding EWIC, led by the Cairo office To a large extent, it was the Ford grant that made it possible for EWIC to grow.

Our fourth editorial board meeting was held in November 2001 in San Francisco in conjunction with the Middle East Studies Association (MESA) meeting. For the first time an EWIC staff member (Tracy Smith) attended an editorial board meeting, helping us tremendously in administrative and technical aspects of the work. This meeting was attended, in addition to myself, by Olaf Köndgen, Afsaneh Najmabadi, Julie Peteet, Seteney Shami,

Jacqueline Siapno, and Jane I. Smith. It was the only editorial board meeting at which all of the editors were present. The focus was writing entry descriptions for the Section II entries we had finalized. We reviewed the Section II entry list, merging entries when we did not have enough words to allocate. We also fine-tuned Section I entries and brainstormed for authors for unassigned entries. We decided that Jane I. Smith needed an editorial assistant to work with her on sub-Saharan Africa. There was another jump in word count, to 3,000,000 (in addition to the 300,000 allocated for Section I) and it was decided to publish Volume I in fall 2003, with Volumes II–IV coming out in the winter of 2004. We decided to translate the letter of invitation to authors into different languages to increase our range of author recruitment.

In June 2002, we had our fifth editorial board meeting, once again in Hartford, Connecticut. This time the meeting was in conjunction with the Berkshire Conference on the History of Women (the Berkshires), where several editors and authors of EWIC presented the first public panel on EWIC. This editorial board meeting was attended, in addition to myself, by Olaf Köndgen, Afsaneh Najmabadi, Seteney Shami, Jacqueline Siapno, Jane I. Smith and, for the first time, Alice Horner, our editorial assistant on sub-Saharan Africa. This was a watershed meeting. We added a fifth volume to EWIC. By this time, it had become clear to us that while Section I could be published in the fall of 2003, the rest of EWIC would not be ready to be published by winter of 2004. Olaf Köndgen had proposed, in April of 2002, that we publish Volumes II and III in fall 2004 and Volumes IV and V in fall 2005. The editors quickly accepted this proposal as it would give us longer to work more thoroughly and seek out authors for entries. However, this also meant that we had to commit to an organization of Section II before all the entries had been written. We had hoped to allow the way in which EWIC evolved to shape the organization of the volumes. Rather than working from our imagined/wished-for outcomes, we had to agree to an organization when only 6 entries out of 341 entries had been written, only around 40 were in various stages of editing, and another 35 had author acceptances. We finally came to the critical decision to organize Section II topically by volume and alphabetically within volumes. Once this decision was made, we had to decide which entries went into which volumes and give the volumes and entries tentative titles. Up to that point we had been soliciting authors for entries across the board for all 341 topics. Now we had to prioritize solic-

iting authors for the entries that we had placed into Volumes II and III as they had to be completed by the fall of 2003 in order to be published by the fall of 2004.

In August 2002, Sam Bruinsma, Olaf Köndgen, and I met in Mainz, Germany, to discuss EWIC's progress. We developed the idea of publishing a cumulative index of EWIC as a separate volume, Volume VI. We also planned a publicity brochure. Köndgen and I met with Anja Van Hoek of Brill and planned the marketing of EWIC.

Our sixth editorial board meeting was held in November 2002 in Washington, D.C., in conjunction with MESA meetings. This meeting was attended, in addition to myself, by Olaf Köndgen, Afsaneh Najmabadi, Julie Peteet, Seteney Shami, Jane I. Smith, Alice Horner, and Tracy Smith. We completed the assignment of entries to Volumes IV and V, including titles for those volumes and entries. We also had the good news from Köndgen that Brill had given us an additional 700,000 words, enough for another volume, a possible volume VII. The editorial board warmly accepted the additional 700,000 words from Brill, but decided to distribute them among Volumes II–V and not produce a seventh volume. This brought EWIC's total word count to 4,000,000. We also planned the brochure, the index, illustrations, and marketing and discussed the online edition of EWIC.

Also in Washington, D.C., I met with Sam Bruinsma and Olaf Köndgen to explain the editors' decision not to produce a seventh volume. We discussed the online edition, an increase in Brill staff support for EWIC, and the possibility of spin-off volumes. Bruinsma generously authorized additional staff support for EWIC. He welcomed the idea of spin-off volumes and agreed to put an Arabic translation of Volume I online for free if funds could be found for the translation.

November 2002 was the last editorial board meeting and the last meeting with the Brill publishers prior to the publication of Volume I. For all of us, it was another watershed. We had come to provisional closure on the structure of EWIC, on the organization and titles of the volumes, the organization, description, and titles of the entries. We focused our attention on completion of Section I, solicitations for Volumes II and III, and titles of Volumes IV and V entries. As an editorial board, we looked back at four years of collective work with a sense of exhaustion and accomplishment. Yet we saw the enormity of the work ahead. As the general editor, I looked back at eight years of a journey that had started with a letter in July 1994 and realized that I had not had the slightest clue,

when I responded to that letter, of what the ensuing eight years would in fact bring by way of work load, challenge, and excitement.

We talked, as we had at every editorial board meeting for four years, about what the Introduction to EWIC had to cover. I had, at every meeting, taken diligent notes on what the Introduction should address. As each meeting came and went, the burden of responsibility for the Introduction to explain our decisions, our shortcomings, our organization of work, our hopes and dreams for EWIC seemed to grow and grow. The Introduction became almost a nightmare stalking my waking hours. And as I approached writing it, I was filled with both the anxiety of living up to the charge as well as the excitement of finally being able to do it.

It became clear that explaining our editorial process had to entail a history of how the EWIC project started, changed, and took on a life of its own. While I take full responsibility for the shortcomings of this Introduction, the editorial board collectively made decisions and guided me in writing it as a narrative of the unanticipated, a story of decisions based on good judgments and compromised by the limits of knowledge, resources, and time. It describes a project that, while monumental, is incomplete and ongoing. It is an attempt to expose encyclopedic knowledge production to critical scrutiny. We want to let the narrative of the history of EWIC lead to the problematization of our categories of knowledge and open up an exploration of the processes by which information is made into encyclopedic knowledge. By explaining how we organized our work, developed our topics, and worked with our publisher and authors, we hope to make the rationale of EWIC comprehensible, as well as to identify its problems and limitations so that future work by other scholars might address these issues. We hold none of our categories as sacred. Our process was characterized by uncertainty, ambiguity and, at times, arbitrariness. Knowledge is itself a negotiated process and we engaged in extensive and seemingly endless negotiations with each other, with Brill, and with our authors to produce it. Through this Introduction, we hope to document a feminist process, a collective process, an imperfect and incomplete process, a process filled with problems and problematics punctuated by decisions that were not always consistent but that were always carried out with a genuine commitment to intellectual integrity and reverence for the power of knowledge.

The 1998 contract had called for three volumes, 1,500,000 words (with a possibility to increase to 2,000,000 words), to be published all together in the fall of 2003. It had also budgeted three editorial board meetings. By the end of 2002, the editorial board had met collectively six times (in addition to several side meetings between individual members), we had increased the number of volumes to six, increased our word count to 4,000,000 and had decided to stagger publication over a three-year period. This expansion was largely the result of the perfectionism, which fed on itself, continually pushed for by the editorial board. We could indulge this perfectionism in part because of the Ford Foundation grant, and also because Brill indulged us by accommodating us with more words, more staff support, and more time to publish. The history of EWIC started as a germ of an idea by Peri Bearman and developed into a story of over a thousand people, stepping into and out of its life, each one giving something for the duration of their stay. EWIC has left its marks in lives of each of us on the editorial board and we have each given something of ourselves to EWIC. EWIC's story is the story of all those who have joined the journey – interns, research assistants, authors, advisory editors, staff, and editors. And its history will be transformed into something else again in the hands of its readers who will make of it something of their own choosing. So this is a history of EWIC, but it is also the beginning of a story.

6. Editorial decisions and rationale of the organization of the EWIC project

The title

As with most of our decisions, discussions about the title, which lasted for about a year, were extensive and the outcome was based on compromise. I had already rejected Brill's original title, "Encyclopedia of Women in Islam," on the grounds that it privileged Islam and set a very narrow path for what I had in mind. I had used a working title, "Encyclopedia of Women in the Muslim World" (EWMW) to move discussions forward, knowing the title would need revisions. One editor was keen to use Marshall Hodgson's term "Islamicate." Others were not enthusiastic.

We chose the title *Encyclopedia of Women and Islamic Cultures* because it conveys an approach to a civilizational history. By using the term "Islamic cultures" we meant to veer away from the notion

that EWIC would focus mainly on Islam or religious texts (although it does cover them) and to direct attention to the broad panoply of issues that are embraced within the arms of culture. By using the term in the plural, we meant to signal the global and historical reach of the project. This is an encyclopedia about women, but about women within specific cultural and historical milieus. We take Islam more as a point of departure than as a subject. Islam is not only a religion, but a social, cultural, economic, and political phenomenon, critical to the civilizational development of many regions of the world. We approached Islam as religion in its textual manifestations and religious practices. And we approached it by documenting the lived realities and experiences of women and Islamic cultures concerning issues as far ranging as abortion, crafts, recreation, local governance, women's movements, and literary production. We hope that by investigating the concrete, the specific, the local – as well as the commonalities and generalities – the collective product of EWIC will offer a view of the complexities, diversities, pluralities, specificities, contradictions, and historical transformations in the civilizational experiences of Islamic cultures as they pertain to women.

Women and gender

Although the term "gender" does not appear in the title, EWIC is about gender, that is to say, the cultural construction of the meanings of "woman" and "femininity," which is always in relationship to "man" and "masculinity." In focusing on women, we did not mean women or woman as natural categories. The categories of woman and women are socially constructed, as are the categories of man and men, femininity and masculinity. We encouraged authors, as we encourage readers, to problematize the category of woman as we would problematize other social or scientific categories, such as youth, household, family.

Our author guidelines asked every author to address "women and gender" and Islamic cultures. We wanted authors to disaggregate "women" from "gender," terms that are too often conflated. Gender affects the division of labor, the organization of the market, the tenets of religion, the structure of politics, the demographics of health, and so forth. Gender contributes to the organization of the state, of the environment, of the economy. In putting gender alongside women in our guidelines to authors, we meant to signal them as points of departure.

However, we did not provide extensive entries about masculinities and femininities. We did not focus on these topics because there is so much to be done that this subject merits its own encyclopedia. We did cover representations of sexualities extensively. In part this was encouraged by the wonderful materials on sexualities in Southeast Asia where the subject is not considered to be as sensitive as it is in the Middle East. The richness of the Southeast Asia materials on the varieties of sexualities, as well as our own interests in the rich literatures on representations of sexualities, generated many entry topics.

The question remains, however, why produce an encyclopedia of women and Islamic cultures? Does such an undertaking imply religious or cultural continuities? Does it implicitly stabilize Islam? Does it presume an Islamic position on women? Indeed not, for the editors. Yet such presumptions abound in the popular and even scholarly literature on women and on Islam and have endured despite the vast increase in scholarship demonstrating the contrary. EWIC is an effort to deconstruct the homogenization of women in frequent representations of Islamic cultures. It attempts to disrupt the equation of women with Islam or the use of woman as a marker of Islam. By articulating the range of experiences by class, ethnicity, nation, region, and historical period and through the analyses of many topics, EWIC documents the complexities of Islamic cultures and the diversity of meanings and experiences of woman and women.

In addition, by focusing on women, EWIC attempts to disentangle the frequent conflation of man and society. This enterprise has been undertaken by women's studies scholars for many regions and cultures of the world. Research on women in the Middle East and other Islamic cultures began in the 1970s at the same time as second-wave feminism influenced new scholarship throughout the West. But scholarship on women and Islamic cultures was slow to consolidate itself as a disciplinary field. It has spread through disciplinary and area studies venues and has grown exponentially in the past two decades, but EWIC offers the first systematic effort to conceptualize an interdisciplinary, transhistorical, and transnational field of study of women and Islamic cultures.

De-essentializing Islam

While this is an encyclopedia of women and Islamic cultures, we were concerned to de-essentialize and decenter Islam. It has been a political

project of many Western academics and power holders to view the "other" through the lens of culture while viewing themselves through the lens of politics and economics. In that political project, nothing more signifies a culture than religion and no subject is more equated with religion than is woman. In so far as Islam became a signifier of culture and the subject of woman bore the burden of representing Islam, then Islam was sedimented as a set of core concepts and Islamic positions on woman hardened into essentialized truths.

EWIC is an effort to destabilize those notions. EWIC veers away from a privileged focus on religious texts and religious interpretations of women and Islamic cultures. We wanted to challenge the notion that everything carried out in Islamic cultures or by Muslim peoples must be viewed through the lens of Islam just as we accept that everything in Christian cultures or carried out by Christian peoples need not be viewed through the lens of Christianity. That a work of art or a political act is carried out by a Muslim makes it no more Islamic than a work of art or a political act carried out by a Christian makes it Christian.

To de-essentialize Islam, we needed to contextualize, historicize, and regionalize the experiences of women and Islamic cultures. We designed entries that situated issues of relevance to women within specific historical periods, political regimes, and localities. We took a historical approach to Section I, organizing entries by historical periods corresponding with major regimes, empires, or sociopolitical configurations within each region. As the production of knowledge is conditioned by the sociopolitical environments in which it is produced, this historical approach allowed us to identify critical changes in methodologies, resources, and paradigms. To further capture the time flows, we asked authors of every entry in Section II to situate their topics in the historical context and to examine the changes over time relevant to their topics. In decentering and de-essentializing Islam, we paid attention to political, economic, social, and cultural factors that influenced women and Islamic cultures. We were all too aware that de-essentializing and decentering Islam is an ongoing process and that we could be only partially successful.

At times we focused on Islamic textual analysis, at times on cultural practices, and at times on both. For example, our Section II coverage of ablution includes an overview entry on Islam and ablution and regionalized entries on Islam and ablution practices. On the whole, our concern was more with cultural and civilizational patterns than with the textual or doctrinal issues.

Geographies of Islamic cultures: decentering the Middle East

The majority of the world's Muslims are not in the Middle East. Nor are the majority of Muslims Arab. The largest Muslim country in the world is in Southeast Asia – Indonesia. One fourth of the world's Muslims are in Southeast Asia and there are more Asian Muslims than Arab. In addition, not all the Middle East is Muslim. Nor is all the Middle East Arab. Yet, in popular literature, and even at times in scholarly literature, there is an erroneous elision between Islam and the Middle East, Muslim and Arab, and the Middle East and Arab. Iranians and Turks, who are Middle Eastern but not Arab, are at times incorrectly identified as Arab. There is often, even in scholarly works, the assumption that authoritative sources on Islam must come from the Middle East. Implicitly or explicitly, Islam in other areas of the world is often viewed as syncretic, as not "pure" Islam. As a result, the peoples as well as the scholars of Islamic cultures from South, Central, East and Southeast Asia, sub-Saharan Africa, Europe, or the Americas are de-authorized as representative of or spokespersons for Islam or Islamic cultures.

Reworking the geography of Islamic cultures to avoid favoring the Middle East was a constant part of our process. We had to remind each other when we had slipped into privileging the Middle East, despite our best efforts. We challenged the notion of "core Islamic lands," the focus on Islam as only a religious issue, and the Middle East as an arena of Islamic orthodoxy. Unchallenged, these common biases relegate the rest of the world, especially East and Southeast Asia where the largest Muslim nations are found, to Islamic heterodoxy. While those who write about Islam often ignore East and Southeast Asia, we found that many, including noted feminists, who write about Southeast Asia often ignore Islam. We anticipated that entries coming from different regions would in fact have very different conceptualizations of Islam and women and Islamic cultures, given their varying histories, cultures, and experiences. The matrilineal experience of Southeast Asia, for example, offers a very different context for women and Islamic cultures from that of the highly patrilineal experience of the Middle East.

With ultimately 6 editors, 41 international advisory editors and around 1,000 authors from all over the world, EWIC has extended its efforts worldwide in its attempts to decenter the common Middle East and Arab focus of research dealing with women and Islamic cultures. This was hard work as some of the authors were unreachable by

email. We questioned whether we were discriminating against potential authors by relying so heavily on email for author solicitations. It was so important to us to reach scholars globally that we resorted to sending letters with traveling friends and colleagues to reach certain potential authors, telephoning and faxing around the world, and sending word of mouth invitations through networks when we could. In some cases, we wanted specific authors so much that two or three editors, the Brill staff, and my research assistants all worked together to pursue avenues to reach a particular person (thank goodness for Google!). In one case, two editors, the Brill staff, my research assistant and I worked for over six months to reach one potential author to cover a topic for which we felt she was best suited. At times, it was like sleuthing, following all leads to ascertain the whereabouts of a specific scholar. We paid for phone calls out of our own pockets, made calls in the wee hours of the morning to overcome time differences, and begged friends and colleagues to help us find a targeted person.

We often tried to find non-Middle Eastern specialists for entries that might typically be associated with the Middle East, such as the thematic entry on Orientalism or the disciplinary entry on political science. We specifically designed some entries to be written across regions to break the stereotyping of Middle East orthodoxy and to challenge the notion that Islam outside the Middle East is heterodox. We also tried to solicit activists, community organizers, NGO workers, journalists, and professionals in the field. They were often very difficult to recruit as writing for an encyclopedia was not a high priority to them in the face of the immediate challenges of their work. We certainly could not argue the relative merits of taking time to write an entry for EWIC as opposed to working in the field, on behalf of women's health issues, women's human rights, women prisoners, and the like. Nevertheless, where we could we made every effort to seek them out.

Inequalities in knowledge production

Decentering the Middle East was often made difficult not just by the limitations of our networks and knowledge of who was available to write entries, and not just by the limitations of disciplinary and geographic training of potential authors. Rather, what gave us considerable pause was that highly competent scholars in many parts of the world are often hindered by lack of access to sources, libraries, and information. Many have neither funds to travel, hire assistants, release time from teaching or other responsibilities, nor access to the technology and equipment often taken for granted by scholars in Western universities. As a result, many outstanding scholars around the world are able to do brilliant analyses of their own localities, but often are unable to cover areas outside their region or area of expertise. Such comparative or synthetic work requires access to scholarly communities and data that is often unavailable to them. The unevenness in resources sadly produces an unevenness in scholarship and we found that regional scholars at times could not write the entries we had devised. Committed to overcoming the domination of knowledge production by metropolitan market places, we tried as much as we could to reach and support authors whose work was relevant to EWIC. At times we revised entry descriptions to accommodate scholars; we put some scholars in touch with other scholars; we sent them overviews or other entries to read; we encouraged co-authoring. No doubt, though, we failed more than we succeeded in overcoming the discrepancies and inequalities in knowledge production that seem to march with troops of empires. And, no doubt, some of the gaps and absences in EWIC are attributable to the unfortunate reality that knowledge production itself reflects and reproduces political, economic, and cultural hierarchies.

Translation

In our global reach for authors, we tried as much as possible to find authors who could write in English to avoid the complications of translation. Yet we wanted very much to have the best authorities we could on various topics. We were fortunate to have a modest amount ($50,000) within the Ford Foundation grant to dedicate to translation and a small contribution for translation from Brill (10,000 NG). This was divided equally among the regions, with the Americas receiving less. We used some funds to translate the letter of invitation to authors into Persian, Arabic, Turkish, Indonesian, Russian, and French. By any measure, this amount was too little to make a significant difference. It contributed symbolically rather than materially to the breadth of work we could cover. Since our funds for translation were minimal, and we could not in advance know what languages we might be translating from, we did not establish a uniform mechanism for translation.

Dividing methodological and substantive entries: Section I

To separate methodological from substantive entries was among the earliest and perhaps most critical and innovative decisions we made. Section

I (Volume I) emerged from the recognition that what we know and can know about women and Islamic cultures is very much shaped by the methods we use and the sources that are available to us. Approaches to knowledge-making change over time. Therefore the ways in which women and Islamic cultures are represented in specific historical periods is shaped by the world-views and knowledge-making tools of each era. To understand women and Islamic cultures in a specific era is to read back through their technologies of knowledge-making. In soliciting entries on the methodologies and sources for studying women and Islamic cultures in different eras in different regions, we hoped to stimulate conversations with and among scholars, junior and senior, who do research on women and Islamic cultures. We hoped to open new frontiers of research by critically evaluating sources and methodologies for doing research.

Section I was designed to focus on the methods and sources available for research, their constraints and limitations, and their implications for scholarship on women and Islamic cultures. We wanted authors to evaluate the tools of research (the methods and sources used to study women and Islamic cultures in a particular region in a particular period) with the idea of laying out the challenges and problems for the advancement of scholarship. We encouraged authors to set the agenda for future research rather than to provide definitive analyses. The historical entries of Section I aim to evaluate the methodological and epistemological problems in the study of women and Islamic cultures in the period and region covered in the entry. The disciplinary entries provide a critical analysis of the methods and paradigms used in specific disciplines and how these have affected the study of women and Islamic cultures within each discipline.

We were aware, in the historical entries, of the problems of periodization. We followed standard historically recognized periodization, yet understood that periodization itself presumes or imposes certain boundaries around knowledge-making. To ameliorate the limitations of periodization, we invited our authors to redesign the coverage of their entries if they deemed it appropriate to their region.

In many ways Section I presented the most demanding challenges to us and our authors. Attempting to cover the critical methodologies and approaches of all the research available on all the critical topics in every major historical period in all the major world regions within a limited number of words was daunting. We had to collapse regions or countries. At times we had to "bank" entries for future editions when we could not find persons to do them or to do them in a timely fashion. The disciplinary entries presented other challenges. We found at times authors offered a clear sense of their discipline, but did not foreground their disciplines' approach to women and Islamic cultures as much as we would have liked. At times authors focused the disciplinary entry primarily on work done within that discipline in the region with which the author was most familiar. Given the porousness of the fields, disciplinary entries sometimes overlapped in the scholarship they covered.

While we could give authors general guidelines about disciplinary entries, we had to defer to the authors' greater knowledge of their own disciplines. How does one name and analyze the key approaches and paradigms in any given discipline in relation to the study of women and Islamic cultures? As any history of any discipline will reveal, there are many ways to name and write about the methodologies and paradigms of a field. Another problematic question was at what point in the history of the discipline should the author begin coverage? Given the different histories of each discipline and their different records in covering women and Islamic cultures, we asked each author make the judgment appropriate to their field.

Mary Ann Fay, covering the discipline of history, for example, starts with the work of Nadia Abbott. Historians tend to be chronological rather than theoretical, she contended. A chronological discussion of the discipline might look different from a theoretical discussion, yet periodization itself implies a theoretical stance (or a political perspective).

For some disciplinary entries, the question of periodization became critical – that is, the methodologies, approaches, and paradigms used within a discipline to study women and Islamic cultures change over time. Miriam Cooke, covering Western feminist scholarship on women and Islamic cultures, chooses to begin in 1928 as a critical point at which there was considerable activity within Western women's studies concerning colonialist projects. She then jumps to 1978 with the publication of Edward Said's *Orientalism* and the creation of meta-narratives. She argues that the 1985 U.N. Sponsored World Conference on Women in Nairobi was a watershed in the creation of transnational feminist networks across north-south divides, whereas in 1975 the north's interest in the body and sexuality and the south's interest in development and political repression created a

division. Another watershed in Western women's studies emerged in 1990, she suggests, as the end of the cold war triggered the refiguring of Islam as an alternative to American imperialism.

Overviews and regionalized entries: Section II

Section II is devoted to making available to general readers the latest research on key topics of relevance to women and Islamic cultures. Here we were concerned that authors write in a style accessible to the general reader. We wanted to avoid beating dead horses and escape the polemics that often characterize heated debates. We hoped Section II would attract a wide audience including students, policy-makers, planners, activists, professionals, and general readers.

The overviews in Section II are intended to give a general picture of a topic, while the regionalized entries are tailored to fit the understanding of those topics in specific parts of the world. This division between overviews and regionalized entries gave the editors flexibility to cover entry topics in a manner appropriate to the broad range of regions EWIC spans. However, problems arose with this approach.

Overview entries were assigned when there was not enough material on a subject to merit extensive coverage or when there was so much material that an overview was needed to lay out the key issues. To avoid potential overlap between overview and regionalized entries we often asked overview authors to focus on discourses and regionalized authors to focus on practices, knowing full well that discourses and practices cannot be fully disentangled. Most overviews were intended to offer a broad sweep, often cross-regional, at times transhistorical. In this we often needed to ask our authors to stretch beyond their own expertise to cover the parameters of the topic as we had envisioned it. For some authors this proved to be an inviting challenging but for others there were neither the time nor resources to cover the sweep of the entry as defined. In these cases we were grateful for what could be covered and looked forward to the online edition for revisions, updates, and more entries to cover what could not be covered in this edition.

Some authors correctly pointed out to us that overviews were almost impossible to write. We were concerned that in our tediously methodical approach we should not reinscribe old scholarly paradigms bound by disciplinary or theoretical terms. We tried to work against such a possibility through the entry descriptions (almost always inadequate in conveying our discussions of the top-

ics) we wrote for the authors. Even so, we found ourselves caught in the very traps we worked so hard to avoid. This was especially evident in the overviews. The overview solicited on modesty discourses and Islamic cultures, for example, verged on "Orientalism," the author, Lila Abu-Lughod, pointed out to us, because the entry description called for a global coverage of Islamic modesty discourses. Even though we had regionalized entries on modesty discourses immediately after the overview, the overview in the end was itself written regionally because of the historical, epistemological, and political problems in conceptualizing an overview on the subject. In the end we believed it was best to trust our authors and give them leeway to address the issues. They were the experts.

Regionalized entries presented other problems. In the process of regionalizing a topic, the topic itself was transformed. We regionalized entries on performing arts. But as we knew and came to recognize even more profoundly, performing arts evoke politics. Dance can be an avenue for studying politics in Southeast Asia, for example. In Egypt, the theater is highly politicized. Western movies represent women and Islam through politically and culturally skewed lenses. By regionalizing topics, we found the topics shifted and therefore the decision to regionalize a topic affected the kind of knowledge the entry would present. We were aware of this as we developed entries and tried to balance overviews with regionalized entries.

In addition, regionalized entries raised questions about the geographies of Islam. It is not clear how one organizes Islam by regions. The tremendous historical flows in peoples, products, and ideas, and the changes in regional boundaries over time made this regionalization a continual problem. How Islam spread (by conquest, migration, trade, fraternal networks, dissident movements) had different outcomes for women's issues locally and affected whether and how some of the entries could be written. How entries were divided by regions therefore changed constantly. Sometimes certain countries were combined, sometimes others were combined, sometimes entries were regionalized country by country. Even the latter regionalization was problematical as the state is not a natural boundary for many subjects of study. Yet given the regional training of scholars, it was incredibly difficult to find authors who were willing to write other than regionally. There was a constant tension between the shifting grounds of regionalization and the desire for comparative work in our solicitation of entries. Finally there

was the problem of word count limits. In the best of all possible worlds, we could not have enough words to regionalize all the entries. And even the entries we did regionalize could not be allocated enough words to cover them as concretely as we would have liked.

Organizing the editors' work by regions

In the first incarnation of the work developed between Peri Bearman and me, the associate editors were to be chosen, to some degree, on the basis of regional representation. The regional division of labor developed at times more from practical than theoretical or cultural considerations. We could not have an associate editor for every possible way in which the geography of Islamic cultures could be conceived. In the end, we had five associate editors. We could have used ten. In all the iterations, the division of labor among the editors was to be largely by regions of the world.

As EWIC's ambition was global, it was imperative that the editorial board could cover, as much as possible, the critical regions in which Islam has been a major presence. Therefore, while organizing EWIC to challenge the regionalization of Islam, the editorial board found it useful to organize its work by world regions, although the disciplinary and theoretical expertise of the editorial board was also taken into account. At times, the editorial board wondered about the wisdom of the early decision to organize our division of labor regionally. Indeed, being critical of the historical context for the founding of regional or area studies, I was concerned about it as well. But we could find no effective way around a regional division of labor, although we could not and did not wish to work on this basis mechanically. We organized the work by regions not because we accepted an epistemological reality of the regions, but because communities of scholars are organized regionally. Most scholars have been trained in regional contexts, even as we train the next generation of scholars more globally and even as our own work is transnational. Organizing our work regionally reflected the extant organization of knowledge production, even though we did not accept the sanctity of regional geographies.

Despite the ways in which the regional division of labor was helpful, it seemed, at times, an irrational and impossible obstacle. Our regional divisions at times confounded histories and cultures. For example, Shami and Peteet were responsible for the Ottoman Empire, while Najmabadi took modern day Turkey and Iran. Shami and Peteet were in charge of the Balkans, but Smith handled Western Europe. Where or how were we to draw the historical or geographical line between these "regions" when we needed to cover issues such as modesty discourses, sexualities, family systems and the like? Yet we found that our regionally based knowledge was critical in many of our decisions about entries and authors.

The geography of entries

As we developed entries, we found each had its own geography. The geography of entries did not necessarily conform to the regional division of labor among the associate editors. We had to ask what geography made sense for each entry. Political economy entries have different geographies from law entries, for example. Some topics had geographies fixed by space, such as personal status laws that are intrinsically linked to the nation-state. Other topics, such as pastoralism, are not fixed by space and transcend nation-states. Colonialism had to be dealt with broadly, according to the projects of colonizing empires. Sometimes it made sense to include Turkey, for example, with Eastern Europe and sometimes Turkey was covered with the Arab states. Therefore countries or regions were combined differently depending on the entry. This meant the regions collapsed or shifted depending on the entry.

The geography of entries shifted historically. Covering a topic for the Middle East versus covering that topic for the Ottoman Empire meant the inclusion of different regions, making some entries incomparable, in certain ways. What we meant by Central Asia shifted with historical periods. How we covered the Caucasus and the new Muslim republics in the post-Soviet period presented other problems. Here we found the geography of the entries complicated by the inadequacy of the literature available to us. And what the Middle East has come to mean in the aftermath of the tragic destruction of the World Trade Center in New York City and the attack on the Pentagon in Washington, D.C. on 11 September 2001 offered other urgencies. This problem had its advantages: we could use the complex and shifting geographies of entries to de-essentialize Islam and decenter the Middle East.

The different geographies of entries complicated the search for authors. Authors, understandably, tended to want to write about the regions they knew best. But the editors often had a larger vision in mind that required us to ask them to write beyond their geographical knowledge. This be-

came particularly problematic in the writing of the Section I disciplinary entries. Finding authors who could write about the methodological approaches of a particular discipline towards women and Islamic cultures across the global reach of a discipline was difficult if not impossible. Whether the disciplinary entry was women's studies or political science, it was difficult to cover the geographical range we had ascribed to the entries if the author's expertise did not include the geographical range we needed. Many authors would have been delighted to do the work to stretch their coverage, but often we did not have the time to give them or enough words allotted for them to do the kind of coverage they and we would have liked. The shifting geographies of the entries reminded us of the arbitrariness of many of the categories under which we solicited entries. The changing geography of entries challenged the fixity of boundaries. Most especially, the geography of entries exposed the limitations of the geographical context of the nation-state as a unit of analysis.

Disciplinarity and interdisciplinarity

EWIC is an interdisciplinary project. Yet most of our authors are trained in specific disciplines. In searching for associate editors, I tried to cover as many disciplines as possible. But given the complex array of criteria in searching for associate editors, our disciplinary spread did not reach as far as we might have wished. However, all the editors are highly interdisciplinary in their approaches and their range is extended by the international advisory board, where practically every field and every region of the world are represented.

As a result of the broad disciplinary reach of EWIC, we were prepared to solicit and accept entries that would employ different writing styles, different notions of problematics, different notions of women and Islamic cultures, different methodologies, and different approaches to the topics. Even within disciplines there are different regimes of knowledge production. Historians, for example, classically write descriptively and chronologically. Yet new historians write with more problem orientation and analytically. Other historians find the "world history" movement within history more conducive to their approach than the classical "world civilizations" approach.

De-essentializing cultures

In putting "Women and Islamic Cultures" in the title, we specified the plural to note diversity among the different cultures in which Islam has

been a critical force. But in using the term cultures we meant a civilizational approach. We did not intend to let stand an essentialized notion of culture or to elicit descriptions that listed cultural traits. The question of culture and cultures in a transhistorical and global project such as EWIC presented us with a problem: how to encourage authors to address cultural differences without stabilizing and reifying the particular culture they were writing about. No culture is a bounded whole untouched by time and other spaces. We were concerned to demonstrate the dynamism of cultures and contextualize their institutions and processes. We took as a point of departure that cultures exist and have behavioral consequences and yet are always porous and changing. Asserting these points as principles is easy. But describing cultures without essentializing them is not. Edward Said's *Orientalism* inspired a much needed challenge to cultural relativism, yet left us with the problem of how to talk about cultural differences without essentializing, and of how to talk about cultural differences without reducing them to simplistic differences of economy, politics, religion, or worldviews. Here all we could do was to offer authors guidelines, or, more to the point, "alert" lines – "Do not essentialize" – and leave it to the authors to muddle through these muddy waters as best they could.

"Women" and feminism

By taking women and gender as our subject we did not and could not presume specific feminist approaches to the study of women and gender. EWIC authors represent a broad range of approaches, many of which could be considered feminist. But they certainly do not fall into any specific set of theoretical or political stances within feminism. Some of the authors may not describe themselves as feminists at all. Furthermore, we did not and could not presume to provide guidelines as to what behavior of the subjects would be considered feminist. That some entries might discuss women as politically active, for example, does not presuppose that activism is feminist. The complexities of feminism and the meaning of agency had to be left to the author's discretion.

EWIC and women's studies

The field of women and gender studies is over 30 years old in the United States and Europe. Theoretical developments in women and gender studies have been stunning on many fronts and have pushed the boundaries of many disciplines, even

reshaping the basic paradigms of some disciplines, especially history, anthropology, sociology, and literary studies. However, the impact of women and gender studies on the field of Middle East studies has been much less than the impact of women and gender studies on Latin American studies, European studies, or American studies. The field of women and gender studies has had little impact on the ways in which political scientists, economists, and historians do Iranian politics, Algerian economics, or Turkish history, for example. More specifically, one can say the field of women and gender studies has had little impact on how Turks write Turkish history, or how Iranians write about Iranian politics, or how Algerians analyze Algerian economics.

The disciplines of anthropology and literary studies have been more impacted by women and gender studies and this is reflected in the anthropological and literary work on the Middle East. On the other hand, the field of Islamic studies has been minimally moved by the paradigmatic shifts generated by women and gender studies, although here one must take note of the very important work being done, within Islamic studies, by Islamic feminists. South Asian studies appear to have taken up the implications of women and gender studies, perhaps because of the school of subaltern studies. East and Southeast Asian studies have considerable and interesting work on gender and sexuality, but this is not systematically connected with the study of women and Islamic cultures as such. A similar point can be made about the study of Islam in Eastern Europe and sub-Saharan Africa.

These considerations raised for us the question of why Middle East studies in particular, and some other regions as well, has been so insular in regard to women and gender studies. It led us to ask about the impact of that insularity on what we could achieve in the production of the kind of encyclopedic knowledge represented by EWIC. We considered whether the insularity came about as a result of the way in which women's studies compartmentalized itself. Women's studies in the Middle East has carried out very concrete studies, rich and contextual, but often did not draw out the implications of those studies for the discipline as a whole. In the 1970s, the emerging field of women and gender studies challenged disciplinary paradigms leading to paradigmatic shifts in the United States and Europe. Middle East studies, however, in general, has been doing business as usual – waiting out women and gender studies, waiting for it to pass. In the early 1970s, many articles appeared in the United States and Europe asking why we needed a

feminist anthropology, or a feminist economics, or a feminist history. These articles were critical to generating debates within disciplinary frameworks, and indeed, challenging fundamental disciplinary tenants. By 2002, those kinds of debates had subsided, which may be why we did not ask the authors of disciplinary entries to consider why we need feminist political science in the study of women and Islamic cultures, for example. But in retrospect, that might have been a useful exercise.

An interesting case in point is the Association for Middle East Women's Studies (AMEWS), which I founded in 1985 at the New Orleans meeting of MESA. AMEWS (with a membership of about 300) is the main organization for scholars based in the United States, Europe, and the Middle East who do research on women and the Middle East. AMEWS meets largely in conjunction with MESA and organizes panels and special sessions at MESA. It has published a newsletter for 17 years. The newsletter was transformed in the early 1990s into the highly successful *Review of Middle East Studies*.

I attempted to found AMEWS at the 1984 meeting of MESA in San Francisco. Interestingly, there was opposition from some leading scholars that year. Their opposition came from the fear that AMEWS would lead to the ghettoization of women and gender studies within the field of Middle East studies. They opposed the founding of a journal as well, on the grounds that scholars, particularly young scholars, needed to publish in their disciplinary journals. Some of those fears have turned out to be unfounded. Indeed, since the founding of AMEWS in 1985, the number of papers and panels offered at MESA annual meetings on women has grown so much that it is no longer possible to attend them all. The concern over the creation of a journal has been overcome as well, as now not only has Brill established the journal Hawwa, but AMEWS is also in the process of founding the *Journal of Middle East Women's Studies* (JMEWS).

Nevertheless, editors of EWIC have questioned whether feminist research, by AMEWS scholars or others, has actually lead to paradigmatic shifts within Middle East studies. There is no doubt that feminist research and feminist organizations have open spaces for women and gender studies within Middle East studies, have facilitated networks, have encouraged younger scholars, even mentored younger scholars. But has feminist research turned Middle East studies around? Has feminist research forced or precipitated the kind of disciplinary crisis in Middle East studies that women and gender

studies precipitated in anthropology, history, and literature in the 1970s and thereafter?

EWIC editors similarly considered whether paradigmatic disciplinary shifts had occurred as a result of feminist research institutions (such as the Institute for Women's Studies in the Arab World at the Lebanese American University in Lebanon, which was the first such institution in the Arab world, or CAWTAR, the Center of Arab Women for Training and Research based in Tunisia); feminist research groups (such as the Women and Memory Forum in Egypt or the Bahithat group in Lebanon); feminist publications (such as Women Living Under Islamic Laws); feminist organizations, even feminist religious organizations (such as Sisters in Islam); or feminist non-governmental organizations (NGOs) (such as the Gender Linking Project in Lebanon, SIGI – Sisterhood is Global Institute); or governmental organizations (GNGOs) (such as the general Federation of Iraqi Women, the General Federation of Jordanian Women, the National Council on Women in Egypt, the Higher Council for Women in Bahrain). In some places, critical international organizations like the United Nations Development Program (UNDP) or other United Nations organizations such as UNIFEM or UNESCO, the Ford Foundation, and Oxfam have forced the issue of gender by requiring their regional representatives to do gender mainstreaming or to take on projects that place gender center stage. There is no question but that these organizations have had a considerable impact in opening spaces for women, for activists, even changing laws in many countries. But have they led to different methodologies, paradigms, and approaches to the study of women and Islamic cultures or is the study of women and Islamic cultures still marginalized in most disciplines and fields? This is a critical question to be assessed.

Scholars and Scholarship Project

The discussion among the editors concerning the impact of women and gender studies on the field of Middle East studies and the ongoing marginalization of feminist scholars and the study of women encouraged me to begin a project to identify how many doctoral dissertations have been written on women and Islamic cultures over the last quarter of a century, where and when they were done, and the subsequent careers of the scholars who wrote them. Towards this end, I recruited a group of undergraduate interns to work with me on what we came to call the "Scholars and Scholarship Project."

MESA carried out a state of Middle East Studies review in 1991. In 2002, the Social Science Research Council also carried out a review of Middle East Studies in North America, Russia, Japan, and France, studying how Middle East studies is carried out in these regions. But neither focused specifically on women's studies and the impact of women's studies on the study of women and Islamic cultures.

All but one of the interns had enrolled in classes with me and had responded to an invitation I made offering the possibility of working on EWIC. Initially the responsibility of the first three interns who volunteered was support work on the database, filing, and finding information. As I began to think about changes in the field, the problems in finding authors for certain topics and our interest in recruiting graduate student authors, it occurred to me that it would be useful to list all the relevant doctoral dissertations. The idea was to compose as complete a list as possible with author, title, university, topic, date of completion, and abstract of each thesis. From this we would try to identify the kind of research carried out and changes over time, the universities where research was being most supported, the disciplines, and the gender of the researcher. We thought to track these scholars through their careers and see who entered academic positions, who obtained tenure and promotion through the professorial ranks, and whether their research topic/university/gender appeared to make a difference in terms of their securing a position and career mobility. Of course, the initial idea was rather ambitious for the time and resources available.

I proposed the idea to the three undergraduate interns (Nancy Wan, Monica Garcia, and Wendy Martin) in the winter of 2002. They were uniformly enthusiastic about the idea. Wendy Martin could not continue, but Fatima Naseem Malik and Rhyen Coombs joined the project in fall 2002. By winter 2003 Michelle Sandhoff, Monique Salas, Emily Rostel, and Marya Osucha had joined our work. The interns began by identifying the key databases from which they could gather information, finding that the MESA database and the University of Michigan Ph.D. dissertation databases were the most accessible. They tried the EURAMESA website for European theses, but could not access the database. We decided that we should try to cover all the theses we could access from 1970 to 2002, on the assumption that the increase in work on women and Islamic cultures had occurred during that time frame. We met regularly, usually every two weeks, and then every week as the deadline neared. The interns always

produced copies of their weekly work for each other and discussed their findings. The plan had been that they would provide me with summaries that I would use in my Introduction to EWIC. However, as their work progressed and their energy and enthusiasm grew, it became clear that this project was no longer one of background research for my Introduction. The project had truly become theirs. I proposed that they write up their own analysis of the data, which I would consider publishing as an Appendix to the Introduction, if it were sound. They jumped to it. I presented a brief summary of the project to the editorial board at the June and November 2002 board meetings. The interest of the editors was such that it became clear to me that the interns' whole project merited publication and would be a service to the field. I approached Olaf Köndgen, our Brill editor, with the idea of publishing not only their analyses, but the whole list of Ph.D. theses that they had gathered. He agreed that this would indeed enhance EWIC and offer a service. Their analysis and the list of Ph.D dissertations that they found will be included in a future volume of EWIC.

History

EWIC editorial board members and authors presented a roundtable discussion on the "Making of EWIC" at the 2002 Berkshire Conference on the History of Women in Hartford, Connecticut. We were asked how much attention we were paying to history and why we were not organizing all of EWIC chronologically. We were keen to historicize all our entries. But it would have been nearly impossible to organize the 341 entries of Section II into historical periods given the limitations of words, time, and finances. In addition it was highly questionable as to whether it would have been possible to have one set of periodizations for the whole of EWIC. If we organized each topic chronologically, the periodization would have to have been different for different regions of the world. Indeed, the very meaning and definitions of entry topics would have had to change to make sense. EWIC authors present in the audience at the Berkshire roundtable suggested that they were concerned to invent new chronologies or to go beyond chronologies. Given the fact that we did not have unlimited words and space to allocate, we settled on urging our authors always to put every entry into historical context. Many of the entries, however, were differentiated by time periods. At times we have used the term "modern" to designate time periods. In this usage, "modern" does not mean "Western." For example, "modern" educational

systems, does not mean Western educational systems. Rather, it means the contemporary period of time.

Voice

Voice and representation have been critical in feminist studies for the past several decades. This is a particular problem for the production of encyclopedic knowledge. How do authors of encyclopedia entries with limited words available to them write so that the voices of the women covered are heard or represented? In discussions of various systems of inequality (social, economic, political, and religious), for example, a critical question is, do the women see themselves as oppressed? Do they see themselves as powerful? In discussing issues of health, do the women see themselves as healthy? In discussing issues of sexuality, do the women see themselves as they are sexually represented? The questions go on endlessly. As Hoda Elsadda notes in her disciplinary entry on oral history, the questions of voice invoke the problematics of power. What is voice, whose voice, what power inequality is entailed in the idea of giving voice (who gets to give voice and to whom do they give it), what is the connection between experience and voice, how does voice imply truth, and what are the politics of truth making implied in discourses of voice, are all critical questions. Here again, the best we could do was to alert the authors to pay attention to issues of voice as much as possible.

EWIC in the political environment

We found some challenges to EWIC from those who wondered who we were and why we were doing this project. Some scholars wanted to make sure that Muslim women were involved in the project, as indeed they are – from associate editors to international advisory editors, to authors. Some people felt that only Muslims or Muslim women could write about women and Islamic cultures. While the editors did not find that argument compelling, we were clear on soliciting a broad array of local authors from around the world. In the aftermath of the tragic events of 11 September 2001, some authors wondered what the project was about and why their contributions were being solicited. The heightened political tensions made the EWIC project even more critical for the editors.

Not a biographical dictionary

We have been asked by numerous scholars about biographical entries on specific women. Indeed, some had the expectation that an encyclopedia of women and Islamic cultures would be a biograph-

ical dictionary (as it was to some degree in the initial Peri Bearman letter of invitation to me). However, the editors decided early on that to have biographical entries would lead to a focus on "exceptional women" doing unusual things. We wanted to avoid this "individuals and history" kind of approach that distorts and misrepresents the lived lives of the majority of women. We were concerned, not only with ordinary women, but also with themes, social forces, cultural patterns, historical trajectories. We encouraged authors to name key persons relevant to their topics and provide three to four sentences on key persons within their entries. Persons deserving more coverage appear in "biography boxes" within the relevant entry. The decision to have no biographical entries was made after great consideration and with reluctant agreement on the part of the publisher. The editors, while all agreed on this approach, were at times tempted to cover one person or another. And indeed, certain persons must be covered. But the temptation was more a reflection of the history of our training rather than the commitment to our principles, to which, on the whole, we remained true.

Growing pains

I initially contracted with Brill to produce a three-volume encyclopedia of 1,500,000 words to be published in 2003. We slated Section I for 300,000 words and Section II for 1,200,000 words. We assumed that Volume I would include all of Section I and part of Section II, with the rest of Section II for Volumes II and III. The initial costing had accidently allowed for the possibility of growing to 2,000,000 words – an accident we soon realized was far too little. At every step of the way, the editors fought with the word count. There never seemed to be enough words to allocate to entries and cover all the topics. As our entry list grew, we had so few words to allocate most Section II entries that they seemed nonsensical – at one point it seemed as if we were doomed to allocate only 200–400 words to most entries in Section II. Editors hoarded words like precious jewels. Only Jane I. Smith was willing to relinquish some words when it became clear that finding research and authors on women and Islamic cultures in the Caribbean and South America was difficult.

By 2000, we assumed we would use the 2,000,000 words. But by our January 2001 editorial board meeting in Cairo, we were asking Brill for more words. Jan-Peter Wissink told us not to worry if we needed a 20–30 percent increase in words, but there would be no way to double or triple the word count. At that meeting we broached the possibility of moving into four volumes. A few months later, May 2001, in Leiden, Sam Bruinsma and Olaf Köndgen confirmed EWIC could move to four volumes and we decided that we would do Section I as a separate volume to be marketed separately. We added 500,000 words, upping our word count to 2,500,000. By our November 2001 editorial board meeting in San Francisco, we were concerned about meeting our publications deadline. EWIC had continued to grow, but our publications plans had not changed. Olaf Köndgen gave us the good news that we could increase the word count to 3,000,000 words (in addition to the 300,000 words for Section I) and reported that Brill had decided to budget Volumes II–IV for winter of 2004 publication, with Volume I to be published in the fall of 2003.

By April 2002, another shift occurred. It was clear Volumes II–IV would not be ready for winter 2004 publication, and Köndgen proposed publishing Volumes II and III in fall 2004 and IV and V in fall 2005. Soon the 3,000,000 words did not seem enough. At our June 2002, Hartford, Connecticut, editorial board meeting we were planning for five volumes. In September 2002 I met with Sam Bruinsma and Olaf Köndgen in Mainz, Germany. We agreed at that point to publish the cumulative index separately as Volume VI, in addition to publishing an index with each volume. In fall 2002, I was back begging Brill for more words – I optimistically asked for 1,000,000 more words. In November 2002 at our editorial board meeting in Washington, D.C., Olaf Köndgen announced that we could have 700,000 more words. We could then proceed to have seven volumes, with Volumes VI and VII published in 2006. All of us greeted the additional words with gratitude. At this point, however, our perfectionism was coming back to haunt us. We worried about the endless expansionism we had succumbed to. The idea of seven volumes both intrigued and alarmed us. A couple of us argued for a seventh volume that would pull all the entries on family together – indeed, there are enough entries on family to create a volume. Reality and another compromise won out. Rather than creating a seventh volume, the editors took the more efficient route of distributing the 700,000 words among Volumes II–V. I suggested, however, to Sam Bruinsma and Olaf Köndgen, the alternative of publishing spin-off volumes, such as a volume on family, by pooling entries from various volumes. In the end, each of the regions (as defined by the regional division of labor of the associate editors) was allocated a little over 900,000 words

for Section II entries, with about 300,000 for Section I. The associate editors were free to allocate their word budget as they saw fit.

Pooling/merging/expanding/contracting entries

Despite the constant incremental increases in word count, none of us ever felt there were enough words to cover all the topics adequately. As a result, we decided to "pool" or "merge" some entries, and this reduced the word count allocated to a topic by expanding the coverage under a specific entry. For example, we initially had separate entries on women, gender and desertification; rainforests and deforestation; and climate change. These three were pooled into one entry on women, gender, and environmental change and degradation. We had originally separate entries on women, gender, and eco-feminism; and women, gender, and ecological movements. These became one entry on women, gender, and environmental organizations and ecological movements. The entry on women, gender, and water and pollution was originally four entries: women, gender, and pollution; women, gender, and water; women, gender, and sanitation and environment; and women, gender, and health and environment. The entry on folk dance and songs was originally two entries, one on folk dance and one on folk songs. The original entry list, which was extensive, was archived for possible use later in an online edition of EWIC.

At other times, entries contracted in their regional reach. We found, for example, that the best research materials available on some topics, such as birth rituals, came from one or two specific countries in a specific region. Rather than attempting to stretch the entry to cover a whole region where the data was inadequate, we agreed that authors should focus on those countries where the data were rich. This was particularly true for entries on South America where we found few authors and inadequate data. The Section I entry on sources and methods for research on women and Islamic cultures in the Americas by Nadine Naber, for example, could only cover North America because of the difficulty in finding appropriate data on Central and South America.

Topical volumes, alphabetized entries

The organization of Section II was not finalized until June 2002, when we agreed that entries would be organized topically by volumes and alphabetically within each volume, a compromise between those editors who wanted all of EWIC organized alphabetically and those who wanted it organized topically, by categories of research.

From 1999 to 2002, we focused on developing the entry topics (the lemmata lists) without deciding how they would be organized by volumes. Since we initially thought EWIC would consist of three volumes, we proceeded with all the topics at once. We decided to develop the entry list topically because we are trained to think topically and as a way to ensure a broad coverage of the relevant issues. Since the development of the entries had proceeded topically, several editors felt that a topical orgainzation would most accurately reflect the work that we did. Others felt that topical organization would highlight the unevenness of our topic development.

We decided to try to organize the entries into volumes by topics as a trial. Some volumes seemed to naturally fall together, especially Volume II on family, law, and politics. Others remained more problematical, for example Volume IV on economics, education, mobility, and space, and needed special care in the devising appropriate subtitles. Each decision concerning where to put entries, what to group together and whether to organize topically at all required numerous discussions, negotiations, persuasions, and compromises. I cannot say that we were fully content with the organization of volumes by topics, since it would inevitably highlight the absence of certain topic development. But it seemed the most productive of the possibilities. We saw the possibilities of certain volumes being used as a whole for teaching purposes. Several of us imagined we might assign one whole volume to be read by a graduate seminar, for example. We saw organizing volumes topically as a way of juxtaposing critical issues in relationship to each other, which might suggest new ways of thinking about a field and thus encourage further research. This organization would expedite the reader's access to related entries. It offered possibilities for spin-off volumes, which could meet both instructional and research needs. This worked particularly well for Volumes II (Family, Law, and Politics) and V (Practices, Interpretations, and Representations). For example, we hoped the linking of issues related to the body, sexualities, and religious practices in Volume V would provoke interest in new ways of thinking about the relationships of these as bodily or embodied practices.

Once committed to organizing the volumes by topics, we had to decide on whether to organize each volume by topics or alphabetically. The decision to list entries alphabetically was again a compromise with a purpose. The key argument here was that most readers expect alphabetical arrangment of encyclopedias for ease of access. This deci-

sion forced us to be succinct in titles and stimulated us to create titles in a such a way that entries could be grouped and so expedite access to topics. Again, nothing was straightforward. For example, in Volume II, family is a key topic. Several of the entries were entered under family, but most of the topics related to family could stand on their own, for example "divorce," "adoption," "domestic violence," because we assumed that readers would look for them alphabetically. In the end, the compromise between complete alphabetization and complete topicality proved to be productive. The volumes, on the whole, held together and almost organized themselves.

Bibliographic references

One of the services that an encyclopedia offers is reference to other works. At the same time, a large project like EWIC could not have exhaustive bibliographies for each entry. We decided to include a short bibliography of critical texts at the end of each entry. Each author was asked to submit a bibliography of up to 20 percent of the text limit of their entry. That way, each entry could stand on its own and offer the reader further suggestions.

The authors

In the end, much as we had worked to think through the framework of EWIC, as exciting as our discussions had been, hard as we tried to translate our vision to our authors, the entries are the products and work of their authors. Our authors' often approaches differed from what we intended and we had either to ask for revisions or renegotiate the entry descriptions. On few occasions were entries rejected. Generally, we not only had to trust our authors with this child we were raising, but we respected the fact that they knew their topics better than we did and that the best we could do was to foster-parent, with the occasional co-parenting of topics for which a specific associate editor had a specific expertise.

The gaps

There are many gaps in EWIC. For example, we were not able to find an author for the scheduled disciplinary entry on Islamic archeology. The commissioned disciplinary entry on sociology did not materialize at the last minute. Some gaps are there because we did not conceptualize certain topics as extensively as other editors might have done. Sometimes we lacked words to cover all the topics we wanted (for example, the field of education). Some topics remained undeveloped simply through lack of time. Other gaps came regrettably late, when authors who had agreed to write entries failed to deliver in time for production. These gaps are particularly frustrating, since other authors could have been commissioned to write the entry, but no time was left to do so.

Some lacunae came about because research had yet to be carried out on specific topics in some regions, or the work that had been carried out was not known or available to us. We were particularly concerned to seek out scholarship that would challenge the notions that women were not active in certain fields, that women did not exist as writers, or that women did not contribute to certain economies or polities. Where we failed to tap the scholarship that does exist, we hope the online editions of EWIC will access them. Where the scholarship does not yet exist, we hope that EWIC will stimulate its production.

Some gaps developed as a result of changes in editorial decisions. For example, at one point we had thought that it would be important to cover women and gender among the non-Muslim minorities in predominantly Muslim countries. Authors for entries on key minorities in Iran, Turkey, Afghanistan, South Asia, and the Caucasus had already been solicited when we revisited this question as an editorial board. The board was divided on the issue and it was left to me to make the decision. I was persuaded by the argument that it would be impossible to cover all the minorities globally, much as we would have liked to. The Arab region, Indonesia, and African countries have so many minorities that it became clear to us that covering women and gender and ethnic/religious minorities in Muslim countries would require a whole volume of the encyclopedia by itself or a volume that could be undertaken for the online edition of EWIC. However, since some entries had already been solicited, we decided to proceed with these and not solicit others.

Another missing topic over which I fretted perhaps more than my editorial colleagues was the coverage of diasporic non-Muslims from predominantly Muslim countries. In particular, I thought the coverage of Christian Arabs in Europe, the Americas, sub-Saharan Africa, and Southeast Asia, would be very important. The argument of my editorial colleagues that we could not cover all diasporic non-Muslims from all predominantly Muslim countries won the day.

Funding EWIC

In all the work of EWIC since July of 2001, we were assisted by a very generous grant from the Ford Foundation. The Ford grant was utterly

critical to the work of EWIC. Indeed, EWIC would likely not have grown to six volumes had we not had the funding for research assistance, teaching buy-outs, travel moneys, translation funds, supplies and equipment that the Ford grant offered us. The University of California, Davis, provided start-up funds, staff support, and office space and furniture from the formal beginning of EWIC in 1998. UC Davis Dean Steven Sheffrin also funded a server to host the EWIC web work (as well as my other research projects). This, of course, was in addition to the considerable investment of Brill in EWIC by way of financial and staff support.

7. THE EDITORS AND THE COLLECTIVE FEMINIST PROJECT

EWIC has truly been a collective and collaborative project, with the editors working closely with the publisher, with each other, with advisory editors, with authors, and research assistants and interns to invent an approach to encyclopedic knowledge production that is new. To signal the feminist collective enterprise that EWIC engaged us in, we decided to put all our names, rather than just the general editor's name, on the EWIC cover.

From the beginning the editors shared a commitment to the idea of a collective feminist vision of working together. What that vision was, however, differed from editor to editor. By design we came from different disciplines, different cultural and historical backgrounds, different scholarly paradigms, different training and life experiences. All the editors were rather strong personalities with clear notions of what worked and did not work in research. Yet we all had a capacity to listen, hear each other out, and respect different views on subjects close to our hearts. While all of us had to compromise on specifics on occasion, it was rather surprising how much agreement emerged on the most important principles of organization and orientation of EWIC.

The organization of our work together changed as EWIC evolved. We had a certain division of labor among us contractually, but nothing was mechanical or written in stone. We adjusted, changed, and refined the organization of our work and our work relations as the material reality of EWIC took shape. As this history of EWIC documents, we met frequently. These editorial board meetings were probably the most critical part of our work. They created synergy, we were able to provoke each other's thinking creatively, and the warmth and collegiality inspired and energized us. In addition, the meetings taught us to listen to profound and subtle differences among our approaches that we were then able to deploy in productive turns in EWIC's development. The face to face discussions, the engaged dialogues, the collective thinking through of problems could not be accomplished as effectively in any other way. We were better able to work through problems, and we were more efficient in realizing when we could not work through a problem and had either to compromise or let it go. Perhaps the most important contribution of the meetings, however, was the development of a common vision and language among us for the EWIC work. While from the beginning we shared approaches and ideas to a considerable degree, we by no means shared a common vision of EWIC. That vision grew out of our encounters. The side meetings among editors also greatly facilitated our work. In addition, we were in constant email contact, often daily, and often many times in a day. We telephoned each other when it was necessary.

All of us on the editorial board have an acute sense of history. As a result, all of us were meticulous in documenting our conversations and keeping a record of the work we did. Prior to every meeting, I produced a binder for each editor containing minutes from previous meetings, all the documents needed for the current meeting, author database information, and an agenda for the current work. My copious minutes usually filled two to three large notebooks. Making sense of my increasingly miserable handwriting was difficult not only for my research assistants, but for me; and trying to pull coherence out of my scribbles of the intense debates that engaged us often took me months after a meeting had transpired. These became the working documents for the organization of EWIC, for decisions, entry lists, web page, and discussions with authors and with Brill. The minutes were distributed by email and put up on the editor's page of the EWIC website.

Reviewing all these documents, I found that we on the editorial board were often our own worst critics. We continually found fault with the way we organized, with what we were trying to accomplish and how we were trying to accomplish it, the limits of our knowledge, time, talents, resources, and energy. Our meetings were taken up as much by discussions of the impossible as the possible. Negotiating, persuading, compromising, and working as best we could with what we could agree to were very much a part of the editorial process. As much as possible, we made decisions collectively. At times, I took it upon myself or was asked to

make the critical decisions. I sometimes felt more like a cheerleader than a scholarly leader. We took turns keeping each other's spirits and energies going.

Afsaneh Najmabadi's reiterated insistence on a historical approach led us to devise Section I as a historical account of methodologies and sources. Najmabadi continually challenged our decisions, including her own, for their arbitrariness. So committed was she to regional representation of authors that she hired an assistant specifically to seek out Central Asian authors. Quick to read, quick to respond, she often found our problems a step before others of us stumbled over them. Constantly reminding us not to privilege the Middle East, Najmabadi helped us steer entries to authors we might not otherwise have sought out.

Julie Peteet and Seteney Shami worked together to cover the Arab and Ottoman region and were the only editors to share an area. Again and again they brought to us the work they had done for their region as prototypes of work we needed to do for the rest of EWIC. Their critical organization, interrogation, and compilation of entries saved us endless hours of board meeting time. Indeed, we probably could not have met our schedule without the initiative that they took to formulate the work ahead of meetings. Each with their interdisciplinary range brought critical awareness of the imperfection of our process, the tentativeness of our categories of analysis, and yet the necessity to move forward. Particularly they reminded us of the problems that the regional organization of our work brought with it. They continually set on the table the need to challenge the regionalization of Islam and the problematical shifting geographies of entries.

Jacqueline Siapno repeatedly challenged the idea of East and Southeast Asia as lands of Islamic heterodoxy and the Middle East as the land of Islamic orthodoxy. She reminded us of the incredible range of what Islam is and the ways it plays out for women around the world. She helped problematize the so called "core" and "peripheral" Muslim countries. Her contributions brought into relief the ways in which the core was, at times, more heterodox than the periphery. Siapno brought to our deliberations the complex narratives of Islam assimilated into cultures with matrilineal histories and dynamics and societies in which discourses of gender, sexualities, politics, literature, and arts create and move in public spaces in ways fascinatingly different from the core Muslim countries. Siapno traveled from Melbourne, Australia to Hartford,

Connecticut for a two-day editorial board meeting, even though she was ill.

Jane I. Smith brought an understanding of religious studies and kept reminding us how our entry topics, despite our best efforts, were designed for Muslim majority countries. They just did not work well in the Americas, Western Europe, or Sub-Saharan Africa. Her work drew attention to the poverty of our knowledge of women and Islamic cultures in those regions. This is a particularly glaring gap in that Islam is the fastest growing religion in the United States and most of that growth does not come from the Middle Eastern diaspora. She further complicated our work by demonstrating the centrality of Islam to Western Europe, and yet how submerged Islam remains as a topic in those regions. Her work in seeking out the research was heroic. She was so concerned to cover areas that she knew little about that she gave over her honorarium to enable Alice Horner to cover Sub-Saharan Africa. Horner jumped into the work smoothly and generously volunteered for work that was beyond the call of duty, such as researching maps to be used in EWIC, writing entry descriptions, and helping in organizing meetings.

I mention specific contributions of specific editors not to imply that the other editors did not have the same point of view or did not contribute on precisely those points, but as a shorthand for celebrating the synergistic contributions of individuals to collective enterprises. At every intervention of any one editor, others were energized – even though they may have had the same thought or have made a similar intervention earlier or at a previous meeting. That synergy was an essential counterweight to the sinking feeling we often had when, working alone, we wondered if we had been insane to agree to such a project. The vision, the ambition, the sense of mission, the commitment to knowledge, the challenge of the ideas, the investment in women and gender issues, the recognition of the power of ideas in history and the privilege of each other's intellectual partnership kept us going.

All of the editors self-exploited to get the job done. They used their institutional research funds to hire assistants or to travel to meetings. At times they paid from their own pockets for EWIC work. And they regularly lost sleep over EWIC work. The work was sometimes overwhelming for all of us: the organizational work of maintaining the time line; managing the grants; overseeing interns and research assistants (often at a distance); lobbying for space; negotiating with administrators, publishers, authors, and editors; dealing with setting

up and moving offices; facing computer problems with the web page and getting proper IT support; keeping the archives and history and database – all of these I found a swell of responsibilities that sometimes left my stomach in knots and woke me up in the middle of the night. Trying to hold firmly to the intellectual project through the sheer weight of the administrative details was a challenge.

8. THE HUMAN STORIES

In a long-term, global project such as EWIC, there is always the human dimension that rarely surfaces in the published product. Working together over nearly five years, the members of the editorial board came to know each other far more deeply than previously. Most of us had not known each other, no one knew everyone, and none of us knew any of the others very well. It was a most remarkable experience to develop our working relations, which were respectful and supportive, and forged life-time friendships.

Similarly, we came to know many people as a result of our work – our international advisory editors, our authors, our publishers, our research assistants and staff. Over this period of time, we have borne witness in each other's lives to marriages, divorces, illnesses and deaths of family members, births, and, sadly, the deaths of a few authors and international advisory editor Magda Al-Nowaihi. Memories are etched in the ink of EWIC's print – the editor who married and shared the celebratory story; the editors who changed jobs, residences, and shifted life gears; the authors who completed entries for us, even while under bombardment and occupation; the author who asked to be released from responsibility for an entry because her husband was dying; the author who could not complete an entry because a father had died; the author who respectfully asked for an extension because of surgery and another because of a child's serious illness; the editor whose husband died; the editor who lived through a revolutionary uprising, was at risk of her life until she could take refuge in an American embassy – and then stepped right back into her work as an editor; the advisory editor who continued to offer us suggestions on potential authors even as she was dying from cancer. As one editor observed at one of our meetings: "What women are willing to do for feminism." While EWIC's work went on, I cannot think of EWIC's story without remembering witnessing these human stories and being humbled by the honor of the witnessing.

9. THE FUTURE OF THE EWIC PROJECT

As the first encyclopedia to undertake the ambitious project of women and Islamic cultures, EWIC became a living organism. From its much more modest beginning, it expanded into a 4,000,000 word, six-volume encyclopedia to be published in a staggered fashion starting with Volume I, fall 2003. Volumes II and II will be published fall 2004 and Volumes IV, V, and VI will appear fall 2005. Its 410 entry topics, given the regional divisions of the topics, have generated several thousand entries.

With research on women and Islamic cultures burgeoning, EWIC expects to go online. The online edition will allow for ongoing updating of entries, revisions, the adding of new entries and access to archived entries – that is, it will be possible to access old and new versions of entries side by side. The plan to go online with EWIC relieved some of the pressure on the editors when we could not find authors for some entries or when authors did not complete their entries in a timely fashion. Knowing that we would have another opportunity to solicit authors for unfilled entries, to update entries, to develop new entries as new research emerged made it a bit easier to let go of entries for the time being. We encourage authors to contact us if they are interested in contributing to the online edition as the possibilities for entries will be nearly endless (see address and email below).

Brill and the editors are committed to making EWIC accessible to as large an audience as possible. Brill and the EWIC editorial board hope to raise funds to translate Volume I into Arabic. Once the translation into Arabic is complete, Brill plans to make this available on their website, free of charge.

10. THE EWIC PROJECT AT THIS HISTORICAL JUNCTURE

The *Encyclopedia of Women and Islamic Cultures* is a project whose time has come. The literature in the many fields encompassed by EWIC is rapidly expanding. Research on women and Islamic cultures is theoretically and empirically at the frontiers of many disciplines. At the same time the idea of the "Muslim woman" or the "woman and Islam" has come to have a political and historical salience, particularly in Western media and scholarship, which is frequently fabricated for these women, often out of whole cloth that is not of their weaving. EWIC comes at a time when there is chronic confusion over who is a Muslim, there is incessant stereotyping of Muslims, and ongoing

conflation of Muslims with Arabs and of Islam with the Middle East, a time when the political stakes in relation to Islamic cultures have risen globally, heightened by misrepresentation and misunderstanding. EWIC comes at a time when women are often the litmus test of what constitutes "modernity." Women are seen as the signifier par excellence of a culture, of a nation, of a civilization. And the gauntlet has been flung down: Islam must prove itself modern in relation to women.

These and other misguided queries make the work of EWIC urgent in many respects. Yet EWIC is not a response to these cultural confusions. Though knowledge is always embedded historically, culturally, and politically, EWIC must stand the test of scholarship and not the tastes of the time. The goal of EWIC is to capture knowledge in the frame of history, to historicize knowledge in the context of place, and to place knowledge at the service of those who may be enriched by understanding its processes of production.

Much more work needs to be done on these vital topics. Our own limitations as editors often glared at us as we recognized we often did not know how to find appropriate authors, how best to define entries for certain regions, how to deal with the limitations of space within EWIC that hampered our effusive desire to give more words to entries than EWIC (or our generous publisher who kept adding words to our word count) could afford and our endless desire to add more entries than the volumes could hold. At times, even the most enthusiastic of our uniformly enthusiastic team found energy waning as EWIC grew. There were tensions and contradictions in our decisions that we could not resolve. We went in one direction on some editorial decisions and in other directions on others. We made what we thought were the best decisions given the circumstances, data, resources, and time available to us. From the beginning, we knew that EWIC had to be conceptualized as an ongoing research project. We knew we could not possibly capture all the knowledge that was available. The field was constantly changing before our eyes. Scholarship is not a perfect product of perfect minds. EWIC is an incomplete and imperfect project. It always will be. And that is why it will go on.

EWIC is the first effort to summarize the state of the art of the field of women and Islamic cultures on a global, transhistorical, and interdisciplinary basis. EWIC's vision has been as much to lay out a research agenda for the future and future generations of scholars as it has been to lay out what is already known about women and Islamic cultures. We hope that EWIC will promote new work, particularly that it will encourage young scholars to take up the challenges implicit and explicit in the development of the EWIC project.

Conceiving of EWIC as an ongoing project, we recognized that it could, would, and should go on even without those of us who worked so hard to conceptualize it. Five different editors from Brill have worked on EWIC at different points, three have given substantial time commitments. The editorial board may also change. This, in fact, is a rich and wonderful aspect of encyclopedic knowledge production – it relies on no one and everyone at the same time. Each of us who have worked with EWIC has done so with tremendous passion and commitment and we welcome others joining this marvelous adventure.

I believe we can say that we have held true to the vision and dream of EWIC – to inspire its readers to participate in this powerful moment in the field of women's studies. We welcome readers to take what is offered in this most unusual collection of what is known and to move forward towards breaking new ground in the naming, framing, analyzing, and understanding of what is known and what can be known about women and Islamic cultures. Towards that end, we encourage writers with ideas for entry topics or who may want to rework existing entries to contact us through Brill. We invite you to take up the challenge of the production of encyclopedic knowledge, a new EWIC.

<div align="right">

Suad Joseph
Davis, California
March 2003

</div>

Brill EWIC email-address: ewic@brill.nl
Brill postal address: PO Box 9000, 2300 PA, Leiden, The Netherlands
UC Davis EWIC website:
 http://www.sjoseph.ucdavis.edu/ewic

Methodologies, Paradigms and Sources for Studying Women and Islamic Cultures

Thematic Entries

Rise of Islam: 6th to 9th Century

Religious and literary texts provide the most useful information for studying the life of women at the time Islam was founded as a religion and civilization, roughly the sixth to ninth centuries C.E. Because of the scarcity of sources, the concrete realities of women's lives during this early period of Islamic history have yet to be fully studied, which is one reason for the often contradictory conclusions scholars reach regarding the impact of Islam on women and gender. The debate concerning women and Islam is itself quite modern, arising from colonialism and the efforts of modernizing governments under Western tutelage to introduce the modernity they embraced as nation-state culture and ideology. Was the resistance to modernity by Muslim societies due to Islam? Was it Islam that dictated the patriarchal order under which Muslim women lived? What particular issues and laws hindered the progress of Muslim women, and is the answer to be found in secular laws and human rights?

As scholars formulated, addressed, and answered these questions, their hypotheses pointed to socioeconomic changes accompanying the establishment of Islam by which tribal society was moving from a communal system of ownership to a merchant economy. The resultant transformations in social institutions were particularly significant for the status of women and gender relations. Some saw Islam as continuing traditions that pre-existed in Arabia and pointed to the impact of Judeo-Christian culture and Persian traditions that had infiltrated into Arabia before the founding of Islam. Other hypotheses gave greater weight to the impact of Persian and Byzantine culture on Islam following the period of Islamic expansion into the former territories of the Persian and Byzantine Empires.

Conclusions ranged from an unwavering belief among Muslims that Islam greatly improved the condition of women, to critics who saw Islam as extending patriarchal strains already established in Arabia. Others held that Islam made a clean break with the past when Arabian societies were matriarchal and women enjoyed relative powers and freedoms and produced a Muslim order in which women fell under the obedience and control of fathers, husbands, and other male family members. All the divergent paradigms set religion as the predominant determining factor in shaping gender relations and the culture that Muslim women inhabited. All focused on Arabia as a take-off point for understanding the life of Muslim women from the inception of Islam onwards. While this essay focuses on the early years of Islam in Arabia in particular, it must be pointed out that the history of the world into which Islam expanded constitutes an essential part of the Islamic culture that was brought into being (Ahmed 1992, 3). The material life of women before the rise of Islam is discussed first, followed by the changes that occurred in the period immediately following the rise of Islam and those after the Islamic expansions.

WOMEN IN PRE-ISLAMIC ARABIA

The term Jāhiliyya (ignorance) is used by Muslims to describe Arabia before the coming of Islam: people were ignorant of God, his Prophet Muḥammad, and the Qurʾān. Arabia is made up of wide expanses of desert, infertile mountain ranges with fertile valleys fed by mountain floods. Beduins moved from valley to valley herding their cattle, mostly camels suited to desert life, sheep, and goats. Herding formed their most important economic activity, followed by agriculture in oases and fertile valleys, particularly harvest of date palms. Trade was another activity that grew in importance during the century preceding the rise of Islam. As to religion in Arabia, most Arabs were animists who worshipped idols, Mecca being the center of this idolatry. There were Jewish tribes settled particularly around Medina (Yathrib before the Prophet's emigration there in 622 C.E.). Christianity was also known in Arabia, although it was not widespread.

The predominant social structure in pre-Islamic Arabia was the tribe. This was made up of related clans whose relationship was based on absolute loyalty to the tribe, upon which it depended for protection against attacks from other tribes, a constant threat. Arabian society was patriarchal, a result of man's primary function as protector even though women rode into battle and showed

great courage. Ideally, tribesmen and women were expected to have *marū'a*, a term that encompasses the notions of chivalry, courage, generosity, strength of body and character, and loyalty. The ideal image of a man is exemplified by the mythical pre-Islamic hero, 'Antar; he was tall, powerfully built, strong of character, his loyalty and courage unquestioned. The ideal woman was not dissimilar (Richmond 1978, Abū Ḥadīd 1970). 'Amrū b. Kulthūm describes one such women as "tilting with the knights, her face glowing with determination, riding her horse" (al-Siyūfī 1990, 22–3), corroborating stories of women riding into battle, attacking tribal enemies, or protecting their own tribesmen against attack (al-Siyūfī 1990, 19). Since clans lived closely together and the members were highly dependent on one another, it was impossible to separate the sexes. Thus a moral discourse was necessitated to allow for "free" mixing between the women and men of the tribes. A pre-Islamic Arabian woman was therefore admired for her beauty and femininity but also her chastity (*'iffa*). Tribal honor depended on this chastity; she was to remain untouched and chaste (*'afīfa*) until her marriage. While some have seen free mixing of the sexes as an indication that pre-Islamic society was not patriarchal, in fact sexual "purity" and fidelity was required and expected of a woman even if she was the object of love poetry. Ḥakam al-Wādī's poetry to his beloved on her wedding night describes her as the noblest and purest of her race (Ibn 'Abd Rabbih 1987, 61), and Jamīl's declaration to Buthayna that had she agreed to his immoral suggestions he would have killed her, are examples of the moral code expected of women that was to be brought later into Islam (al-Jāḥiẓ 1980, 16).

Seclusion of women was not an issue in pre-Islamic Arabia any more than it was to be in early Islam because within tribal confines it was not possible. But seclusion did exist when it came to the presence of strange men from other tribes. Clan honor, which was fundamental to loyalty, required that it be observed on every level, including gender relations. This loyalty was expected of tribal members under all conditions, even in captivity. A woman captive was admired for taking her life (Sabbagh 1975, 150) and was expected to take the first opportunity to make her escape. Umm Salāma of the Kināna was lauded for escaping her captor and returning to her tribe even after being married to him for eleven happy years and bearing him many children (al-Qāsimī 1981,

24–5). The first female infanticide (*wa'd al-banāt*) was committed by a leader of the Kinda whose daughter refused to leave her captor. He continued to kill ten more female children as they were born to him rather than risk future dishonor (Sabbagh 1975, 151). The connection between infanticide and tribal honor continues as honor crimes among Arab tribes today, a remnant of pre-Islamic practices that were absolutely proscribed by Islam.

Generally speaking, marriage was contracted in accordance with the larger needs of the tribe; each tribe had its own patterns depending on the need to form alliances within the tribe and with other tribes. Cousin marriage could be encouraged or forbidden as was the case in the *'uthri* tribe. Arabs seemed to know something about the ill-effects of cousin marriage; as one pre-Islamic poet put it: "I bypassed my paternal cousin who is my beloved, for fear of being disgraced by my posterity" (Sabbagh 1975, 139). An emissary was considered necessary for transacting a marriage; this emissary vouched for the bridegroom and showed he had tribal support (al-Qāsimī 1981, 18). Tribal honor required that members married only those who were their equal. Inter-tribal power relations based on tribal alliances made this a necessity. Therefore marriage could not be left to the feelings of either the man or the woman, although such marriages did take place. Arab marriages, before and after Islam, were based on comparableness (*kafā'a*) in religion, ethnicity, nobility, and freedom. The opinion of women, however, was required for marriage, particularly when the girl concerned was an adult (*rashīda*) (Abū Ḥadīd 1979, 6). Al-Khansa's refusal of suitors acceptable to her father was not questioned given her reputation as a wise intellectual and healer (al-Qāsimī 1981, 12). Majority and personal ability continued to form the basis of tradition (*'urf*) in regard to gender relations in Islamic society.

WOMEN IN EARLY ISLAM
The position enjoyed by women underwent significant changes during the early period of Islam, these changes probably differing according to particular tribes. Mecca, where Islam originated, was experiencing structural changes brought about with the increased activity in trade and the rise of the Quraysh as the most powerful tribe in Mecca. Pre-eminent in Arabia, the merchant elite of the Quraysh gained monopoly control over the northern trade with Syria. As a moneyed economy began to replace the communal "equitable" sys-

tem that usually defined tribalism, differences in gender and class created serious social problems. One view of Islamic gender laws is that they were meant to correct the inequalities and severe conditions faced by the weak, young, poor, orphans, and women due to the repression and greed of the new Meccan aristocracy. In Medina, where Islam first developed as an *umma* (community), women seemed to have greater power. While marriage in Mecca was moving toward a patrilineal and patriarchal form, it was still matriarchal in Medina. How far the changes went however, is not clear; we can more accurately talk about trends. Matrilocality seemed to have been the rule at least until the time of the Prophet Muḥammad's birth since he and his mother, Amīna, continued to live with her tribe, his father ʿAbdallāh visiting her there from time to time. It was only after she died that Muḥammad moved to live with his paternal grandfather (his father having died before Muḥammad's birth).

The new order proposed by Islam during this period of transition, when merchant capital was becoming the established system of exchange, represented a continuation of the tribal structure but within a framework that integrated the new transformations. As is usual during periods of conjunction, certain traditions remained as part of the culture and were incorporated into laws set up by the new order. Islam's treatment of marriage is consistent with the social organization being built by the Prophet and followed later on by his successors. Solidarity and loyalty to the *umma* were to be central to the new order. Qurʾānic laws pertaining to gender were thus focused around the questions of property and distribution of wealth. Clan structures continued to be a foundation of power for the new *umma*. Connections between the rules of Islam regarding inheritance, marriage, and property illustrate this central interest. Qurʾānic marriage rules were directed to assuring the purity of ʿaṣab and of *nasab* on which inheritance depended. "Those related through the womb are worthier one of the other" (8:4–7). The importance of *nasab* (kinship or lineage) went beyond the family, nuclear or extended, as we understand it today. Rather, the laws conceptualized degrees of relationship encircling the ʿaṣab, or the main "nerve" as the basis for *nasab*, and that included uncles, aunts, and cousins of varying degrees, all of whom had rights to inherit (Mālik b. Anas 1990, 76). The Qurʾān also admonished that an inheritance be left to companions, slaves, wards, and followers: "To those, also, to whom your right hand was pledged" (4:33). Here we see the importance of the extended clan with its dependents. Thus the Qurʾān defined the rules of marriage according to consanguinity and ʿaṣab, setting out the degrees according to which certain members of a family are forbidden in marriage to each other while others are allowed. Mothers, brothers, sisters, uncles, aunts, fathers and grandparents were all forbidden. But cousins were not. Given the closeness within which people of the same clan lived, rules were set to keep the peace and limit breaches of sexual conduct. Forbidden degrees included: "your wives' mothers; your step-daughters under your guardianship, born of your wives to whom ye have gone, no prohibition if ye have not gone in; [those who have been] wives of your sons proceeding from your loins; and two sisters in wedlock at one and the same time, except for what is past; for Allah is Oft-Forgiving, Most Merciful" (4:23).

The moral code prescribed by Islam, which demanded control of sexuality through prescribed dress, actions, and limited mixing between the sexes, was meant to ensure that there would be no confusion about paternity. A child was to be recognized as belonging to the father according to *fiqh* (al-ʿAsqalānī 1987, ix, 33), which was the case in most of Arabia during the Jāhiliyya except in cases of adoption or *mulāʿana* where a father forswore the paternity of the child, who then became known by his mother's name. *Mulāʿana*, accepted by the Qurʾān, can be looked at as a concession to pre-Islamic matrilineal practices. The ʿidda, a three-month waiting period during which a divorced wife cannot take another husband and is supported by her ex-husband until the absence of pregnancy is assured, is another pre-Islamic mechanism taken into Islam to ensure paternity.

Marriage types forbidden by Islam included a wife taking more than one husband and men taking as many wives as they wished. Islam limited the number of wives a husband could have to four. The polygamy verse of the Qurʾān (4:3) speaks of two, three, or four wives, and *fiqh* has established four as the permissible number of wives a man can have at any one time. A conditional clause states that if a man cannot treat his wives equally, then he can have only one wife. The Qurʾān in fact acknowledges that such equal treatment is virtually impossible. The verse has been controversial. The Prophet himself did not divorce the excess number of his wives beyond four and it is not clear that his ṣaḥāba (Companions) followed

this rule. As with temporary marriage, *mut'a*, forbidden by Islam's second caliph, 'Umar b. al-Khaṭṭāb, establishing four as the number of legal wives was probably instituted after the Prophet's death as a general rule, even though the verse itself concerned the welfare of female orphans living under the guardianship of men to whom they were eligible as sexual partners or wives. The verse admonishes such men to look elsewhere for wives or to turn their eyes toward slave women taken in captivity.

Before Islam, men divorced their wives as many times as they wished. Islam limited the number of times a man could divorce his wife to two, after which she would have to be married to another man before he could take her back. One reading of the Qur'ān is that it allows the power to divorce to either husband or wife: "In whoever's hand is the binding contract" (2:237) although *fiqh* has generally interpreted this to be a male prerogative. A wife is guaranteed support during the *'idda* as well as alimony and rules are set up concerning her divorce (2:11, 43, 229–41). The Qur'ān requires that men respect the wives whom they divorce or who wish to be divorced from them (33:49). Sex is dealt with directly in the Qur'ān: men are expected to respect their wives in their demands for sexual intercourse, are admonished to enjoy their wives, but not to take sex lightly, or approach their wives if they are not ready (2:222–3).

Like their pre-Islamic sisters, Muslim women fought beside their men against the *kuffar* (non-believers), they assisted them, brought them water, removed the wounded from the fields and nursed them. Ṣafiyya bt. 'Abd al-Muṭṭalib, for example, fought at Badr and was wounded at Uḥud where she saved the life of the Prophet Muḥammad by taking a spear meant for him (Suwayyid 1990, 28–33). Another, Nusayba bt. Ka'b al-Anṣāriyya, a famous Companion of the Prophet, fought in the very early *ghazwa*s (raids) launched by the *muhājirun* (migrants who left Mecca to Medina with the Prophet) and was one of the female leaders who gave their *bay'a* (oath of allegiance) to the Prophet at 'Aqaba and fought at the battle of Badr and in the Ridda wars (Suwayyid 1990, 60–6). Ibn Sa'd's biographical entries include many important women companions of the Prophet. The Prophet's wife Khadīja bt. Khuwaylid is described as "a woman of substantial honor and wealth, in commerce that traded with Syria, its value reaching the usual

value of the goods of Quraysh. She hired men and speculated in value of goods [and men?] (*tadfa' al-mal mudāraba*)" (Ibn Sa'd n.d., 16). The presence of women in the marketplace and their interest in trade was part of normal life in Arabia and until today it is the women who herd cattle and make woollen cloth for tents and clothing and for sale in the marketplace. Women were important to agricultural labor in Arabia as they were throughout the world and certainly in the areas into which Islam was to expand, from North Africa into India. The lines regarding agriculture in the Qur'ān do not refer to either gender specifically but use the generic male. *Ḥadīth* literature makes clear the involvement of women in agriculture as labor and as investment: "'Abd al-Ḥamid b. Muḥammad informed us . . . of al-Zubayr that Jābir told us that his aunt was divorced and she wished to go to her palm-trees but met a man who forbade her from going. She went to the Prophet who told her to go and harvest the dates off her palm trees; perhaps she would pay *ṣadaqa* and do good" (*Sunan al-Nasā'ī*, Bāb al-ṭalāq, *ḥadīth* 3494).

The Qur'ān also gives equal importance to the work of women. "Do not covet those things by which God has preferred some of you more over others; to the men is a share of what they earned [*iktasbu*] and to the women a share of what they earned [*iktasabna*]; and ask God for his blessing, for God is all-knowing" (4:32). While the Qur'ān explicitly forbids certain acts, it does not link these acts to any particular type of work women performed. Thus, recurring themes include buying, selling, bartering, signing contracts, sowing, harvesting, and so on, with no indication of what work women can perform. *Ḥadīth* literature does mention particular types of *kasb* forbidden to women as it does for men; here the interest was in a work ethic and establishing a moral code for earning a living since all jobs had to be moral and acceptable to God. A *ḥadīth* confirms this premise: "'Abd al-Ṣammād b. al-Faḍl related to us . . . that the Prophet of God forbade earnings from selling a dog, earnings from blood-letting, earnings from prostitution, and earnings from bull stud fees" (*Masnad Aḥmad, baqi masnad al-nukatharīn, ḥadīth* 8039). Prostitution was consistently forbidden for women, although the terms used were that they should not be forced into prostitution. This throws an interesting light on the helpless condition of women pre-Islam: "Do not force your young women [*fatayatukum*] to

become prostitutes when they would rather be chaste, in order that you make a profit and enjoy your lives" (24:33).

MEDIEVAL CULTURE AND THE SOCIAL DISCOURSES ON WOMEN

The Qur'ān outlines ideals of womanhood framed in moral, religious, and spiritual terms. Medieval literature in contrast gives very physical standards for ideal womanhood. Theory, discourse, and practice seem to be at variance when the history of women is studied. While *fiqh* literature gives the impression that women were secluded, the concrete evidence of women's lives from the medieval period onwards shows the continued role that women played in the productive and social life of their communities throughout the Islamic world.

Men were encouraged to marry pious in preference to physically attractive women (2:221). Strict moral codes controlling sexual relations were laid out for men and women in similar terms: "Say to the believing men that they should lower their gaze and guard their modesty," is followed by "And say to the believing women that they should lower their gaze and guard their modesty" (14:30–1). While making men and women equally responsible for their salvation in the eyes of God, medieval *fiqh* elaborated an official Islamic ideal that considered women the weaker sex in need of protection. Even though both sexes are essentially equal in the eyes of God, women are expected to look up to their husbands because they are economically and biologically different. Men are given precedence (*wa-li-al-rijāl ʿalayhin daraja*) (2:228) due to their greater financial and protective obligations. This allows for a gender hierarchization. (4:34)

Fiqh elaborates on gender in other more innovative ways in answer to the new cultures and traditions that formed medieval Islamic civilization. Here slaves are of particular relevance. While the Qur'ān does not forbid slavery, it condemns it and the traditions of the Prophet and his Companions set the example of using one's wealth to buy and free slaves. The Qur'ān confines sexual relations to marriage: "This day good things have been allowed to you and the food of those who have been given the Book is made lawful to you and your food lawful to them, and the chaste from among believing women and the chaste from among those who have been given the Book before you [are lawful to you] when you have pro-

vided them their dowries, taking them in marriage, not by fornication, nor taking them for lovers in secret; and whoever denies faith, his work is useless, and he shall be one of the losers on the Day of Judgment" (5:5). Medieval *fiqh* expanded the interpretation of legal sexual relations to mean legitimate relationships, that is, marriage or concubinage with slave-women. Rather than seeing *zinā'* as sexual intercourse outside of marriage, as is clearly stated in the Qur'ān, which proscribes equally severe penalties for *zinā'* committed by either sex (24:3), intercourse with slave women was seen by the *fuqahā'* as outside of the parameters of *zinā'*. While the Qur'ān speaks about slave women only in the sense of being eligible as wives, medieval *fiqh* spends a great deal of time discussing the rules regarding slave women and their treatment by their owners. The amount of medieval literature devoted to them is impressive, and from it we can see the complexity of the position that women held following the expansion of Islam into areas where owning and enjoying slave women was part of normal life.

The confining and patriarchal approach to gender in medieval *fiqh* should have been expected given the growth of the Islamic *umma* into an empire with multiple traditions and growing institutions. Whereas Arabia was largely desert where clans and their members were identifiable and tribal honor acted as a cement to the social fabric, the urban centers of medieval Islam were crowded, with strangers interacting together and a very active merchant economy. Veiling and seclusion for the upper and middle classes already existed in Middle Eastern cities before Islam, and the practice continued. Seclusion was probably reinforced by the patriarchal structures that required the separation of the sexes. This is in contrast to the situation in Arabia where mixing existed and hence the two genders appreciated each other more. The fabrication of *ḥadīth*s on gender, which was largely practiced during the early ʿAbbāsid period may have been the result of the separation of sexes and the ensuing lack of understanding and suspicions. Such *ḥadīth*s referred back to the Prophet or his Companions but were probably later fabrications based on popular anecdotes. A saying attributed to ʿAlī b. Abī Ṭālib is illustrative: "The evil characteristics of the man are the best characteristics of the woman, stinginess, conceit, and cowardice. If a woman is stingy she conserves hers and her

husband's funds. When she is conceited she declines to speak to everyone in a mild suspicious manner. And if she is a coward she will keep away from everything, will not leave her house and avoid slanderous circumstance for fear of her husband" (al-Ghazālī 1990, 36). Even though the Qur'ān has no concept of "original sin," sin was laid on the shoulders of women by medieval *fiqh*: "Women are an ʿawra [weakness, nakedness, genitals] . . . when she goes out she is accompanied by the devil", hence she must be secluded to protect men from her (al-Jabrī 1983, 92–3). One of the severest medieval critics of women is the Ḥanbali jurist Ibn al-Jawzī, who exemplifies the medieval *fiqh* discourse on gender, who quoted the Prophet as answering the question "What is best for women?" with "That they see not men and men not see them" (al-Jabrī 1983, 39–40). He advises women never to leave their homes, for even if they intended no evil "people would still not be safe from them." If a woman is forced to go after taking her husband's permission, "she should wear worn clothes . . . make sure that her voice is not heard, and that she walks at the side of the road and not in the middle of it" (al-Jabrī 1983, 4). That is in clear contrast with the early Islamic period when the Prophet's women Companions (*ṣaḥābiyyāt*) attended prayers in the mosque, gave the Prophet their *bayʿa*, fought in battle by his side, and voiced their opinions loud and clear.

Medieval discourse, however, must be seen as the efforts of *fuqahāʾ* to establish a moral code rather than as a representation of the actual life that women of that period lived. The lack of archival records from the Umayyad and ʿAbbāsid periods makes it hard to study the concrete realities of women's lives, but records dating from later periods as well as *ṭabaqāt* and other forms of literature from the early centuries of Islam show us that women lived an active productive life, which clearly belies the image of seclusion painted by the *fuqahāʾ*. Even though Muslim communities today delegate religious issues almost exclusively to men, women have played an important theological role as transmitters and interpreters of *ḥadīth*. According to Ibn Saʿd the Prophet had 529 *ṣaḥābiyyāt* among whom 94 were transmitters of *ḥadīth*. Their number began to fall with the establishment of the *madrasa* system with official posts given to male *fuqahāʾ* (Roded 1994, 45–6). Recent research has also shown them to have been active as *muftis* rendering opinions about Islamic law and as teachers of Islam. Women studied

theology and were granted *ijāza*s certifying their abilities by their teachers. Some became important authorities as sources on Islamic jurisprudence. Medicine was another area in which women excelled all the way back to the period of the Prophet. There were famous women doctors in Arabia, Syria, Iraq, and Egypt during the medieval period. Examples include Kharqa' al-ʿAmiriyya who lived in Arabia during the Umayyad period, and Habāba who lived in Basra and died there about 727. Specializations of women doctors included war surgery, ophthalmology, obstetrics, and gynecology (al-Saʿdī and Abū Bakr 1999). Women's work extended to the marketplace where they brought goods they produced or grew to sell. They also acted as *waqf* executors, sometimes setting up the *awqāf* themselves and at other times assigned to the job by the *qāḍī*. Rich archival sources from the Mamluk and Ottoman periods give a glimpse of active women participating in all aspects of public life, buying and selling, and coming to court to litigate their rights in regard to property, marriage, and child custody. The image of seclusion painted by medieval *fiqh* is more representative of how it was thought women should live than a representation of the actual life that women did live.

BIBLIOGRAPHY
M. F. Abū Ḥadīd, *Abu al-Fawāris ʿAntara b. Shaddād*, Cairo 1970.
Leila Ahmed, *Women and gender in Islam*, New Haven, Conn. 1992.
Ibn Ḥajar al-ʿAsqalānī, *Fatḥ al-bārī bi sharḥ al-Bukhārī*, ix, Cairo 1987.
Abū Ḥāmid al-Ghazālī, *Ādāb al-nikāḥ wa-kasr al-shahwatayn*, Susa, Tunisia 1990[?].
Muḥammad Ibn Saʿd, *al-Ṭabaqāt al-kubrā*, viii, *Fī al-nisāʾ*, Beirut n.d.
ʿAbd al-Mutaʿāl Muḥammad al-Jabrī, *al-Marʾa fī al-taṣawwur al-Islāmī*, Cairo 1975, 1983⁶, 92–3.
Abū ʿUthmān al-Jāḥiz, *The epistle on singing girls of Jāḥiz*, ed., trans., and commentary by A. F. L. Beeston, Warminster, U.K. 1980, 16.
Imām Mālik b. Anas, *al-Muwaṭṭaʾ*, Mohammedia, Morocco 1990, 76.
Masnad Aḥmad, baqi masnad al-nukatharīn, ḥadīth 8039, *Mawsūʿat al-ḥadīth al-sharīf*, CD-Rom, Sakh Software 1995.
Ẓāfir al-Qāsimī, *al-Ḥaya al-ijtimāʿiyya ʿind al-ʿArab*, Beirut 1981, 12.
Ibn ʿAbd Rabbih, *al-ʿIqd al-farīd*, 3 vols., Beirut 1987.
D. Richmond, *ʿAntar and ʿAbla. A Bedouin romance*, London 1978.
R. Roded, *Women in Islamic biographical collections. From Ibn Saʿd to Who's Who*, Boulder, Colo. 1994, 45–6.
Hudā al-Saʿdī and Umayma Abū Bakr, *al-Nisāʾ wa miḥnat al-ṭibb fī al-mujtamaʿāt al-islāmiyya*, Cairo 1999.
L. Sabbagh, *al-Marʾa fī al-tārīkh al-ʿArabi. Fī tārīkh al-ʿArab qablu al-Islām*, Damascus 1975, 150.

'Isām al-Siyūfī, *al-Mar'a fī al-adab al-jāhilī*, Beirut 1991, 22–3.
Sunan al-Nisā'ī, Bāb al-Ṭalāq, *ḥadīth* 3494, *Mawsū'at al-ḥadīth al-sharīf*, CD-Rom, Sakh Software 1995.
A. Suwayyid, *Niṣ'shahirāt min tārikhana*, Beirut 1990.

AMIRA SONBOL

Andalusian Literature: 9th to 15th Century

Andalusian literature is a term that refers to all types of literary forms written or composed in the areas where Muslims ruled in the Iberian Peninsula, also known as al-Andalus, during the Middle Ages. Muslims entered Spain in 93/711, and left in 898/1492 after they were defeated by Ferdinand and Isabella. Muslim chronicles mention, altogether, a considerable number of literate Andalusian women who apparently were well known for their poetry, wit, and knowledge. Examples of such chronicles are: Ibn Bassām (d. circa 542/1147), *al-Dhakhīra fī maḥāsin ahl al-Jazīra*; Ibn Bashkuwāl (495–579/1101–1183), *Kitāb al-ṣila*; al-Ḍabbī (d. 599 or 600/1202 or 3), *Bughyat al-multamis fī rijāl ahl al-Andalus*; Ibn Saʿīd (ca. 609–84/1213–86), *al-Mughrib fī ḥulā al-Maghrib*; and Ibn al-Khaṭīb (d. 776/ 1374), *al-Iḥāṭa fī akhbār gharnaṭa*.

Although the names of many women appear in the Islamic chronicles in al-Andalus, there are problems associated with the information they provide about them. Thus, in spite of the availability of several Andalusian sources that mention women's poetry, few details are known about many of those female poets. The majority of what is preserved in the chronicles does not provide sufficient information about their total corpus, or about the full range of their topoi. For example, Andalusian chronicles mention only six lines that were composed by al-Ghassāniyya al-Bajjāniyya (fifth/eleventh or sixth/twelfth century), praising the Amir Khayrān al-ʿĀmirī, who was the ruler of Murcia and Almeria. Similarly, six lines composed by Maryam bt. Yaʿqūb al-Anṣārī (n.d.) are preserved in praise of al-Muḥammad, the Cordoban caliph. Another example is the case of ʿĀʾisha bt. Aḥmad al-Qurṭubiyya (d. ca. 400/ 1009). Andalusian chronicles cite seven lines composed by her in praise of al-Manṣūr b. Abī ʿĀmir. In addition, two more lines by her are cited when she refuses, according to the chronicles, the marriage proposal of one of the poets.

Andalusian chroniclers tend to mention female poets in a context where the focus is not the woman herself, but rather her family, or her lineage, especially when she hails from a noble family. Many incidents relate to the caliph, or the ruler, whom the female poet is praising, or who is addressing her. Also, the chronicles seem to favor situations centered on poetry taunting, especially those that challenge the addressee and test her ability to improvise poetry on the spot. In addition, the chronicles like to cite women's verses that are nested within a love story, or a love triangle. As for slave girls, the chronicles are full of incidents that detail their ability to entertain the court, and the rulers, with their wit and their humor.

For instance, Wallāda bt. al-Mustakfī (ca. 410/ 1010–480 or 484/1087 or 1095) was a princess born to a noble Cordoban family whose lineage goes back to the Umayyad dynasty in the eastern part of the Middle East. Her father, al-Mustakfī al-Amawī, was once in charge of Cordoba. He was known for his bad temper and his boisterous behavior, and, during his rule, corruption prevailed. He was killed around 415/ 1024. However, he was interested in the education of his daughter, Wallāda, who was probably his only child.

When Wallāda grew up, her house became a literary salon open to the poets and literary figures of the time. She was described as beautiful, witty, bright, and humorous. Ibn Bassām, in *al-Dhakhīra*, states that she had an "easy veil," which could be understood as meaning that she was careless about the veil, or that she covered her hair but not her face. Ibn Bassām and al-Maqqarrī praise her company as well as her good manners. They seem to defend her reputation although they add that she had a strong temper and that she was reckless. It seems that she did not refrain from attacking people she did not like, or those with whom she was no longer friendly such as Ibn Zaydūn, another famous Cordoban poet (ca. 394–463/1003–70).

Andalusian chronicles agree that Wallāda bt. al-Mustakfī was one of the most important female poets who lived in Cordoba. However, only a few lines are attributed to her, mostly in relation to Ibn Zaydūn. The chronicles go into details about their love story and their falling out, but the sources do not agree on why the two lovers argued; some state that Wallāda became jealous of a slave girl, others that they quarreled over Ibn Zaydūn's critique of her poetry. The chronicles dwell on Wallāda's reputation, on whether or not she was virtuous, given that she held literary

salons and invited male poets to them. The focus of the chroniclers is Wallāda's love life and her reputation, but not her poetry; hence only a few of her verses are preserved. On the other hand, the chronicles cite many poems composed by Ibn Zaydūn. In fact, enough poems of his are cited to be collected later on as a *dīwān* (collection of poems). Critics and Muslim chroniclers refer to Wallāda as a person who influenced and inspired the majority of Ibn Zaydūn's love poems rather than as a poet in her own right. Consequently, no serious scholarly attention has been given to her. The traditional assumption is that because she was Ibn Zaydūn's beloved, *al-wāshūn* (envious people) interfered and caused the couple to separate. Ibn Zaydūn wrote poems to her asking to renew what they once shared but, according to the chroniclers, she did not reply.

Another female poet whose verses are preserved in relation to a love story is Ḥafṣa bt. al-Ḥājj (530/1135–586/1190). Ḥafṣa was in love with Abū Jaʿfar, a poet who lived in Granada. The chronicles detail the love triangle between Ḥafṣa, Abū Jaʿfar, and Abū Saʿīd, the ruler of Granada who rivaled Abū Jaʿfar in his love for Ḥafṣa. However, after the death of Abū Jaʿfar, few things are known about Ḥafṣa, except that she appeared in Morocco after several years, where she died.

Of slave girls, all those mentioned in Andalusian chronicles were associated with royal courts, or were owned by Andalusian caliphs, or rulers. It was typical at that time to train talented slave girls in music, poetry, and other types of arts. If a slave girl was beautiful, talented and witty, her price was usually high, and she could fetch a considerable amount of money when sold. This practice of owning articulate and talented slave girls was prevalent in al-Andalus as well as in the Muslim courts in the East, such as Baghdad, Cairo, Damascus, and elsewhere. The training of talented slave girls was undertaken to entertain the royal courts and the rulers, not to establish or encourage the literary talents of the slave girls per se. For example, the slave girl Ghāyat al-Munā was asked to improvise by finishing the second verse to the line, "Ask Ghāyat al-Munā/'Who dressed my body with emaciation?'" She replied, "And I see myself in deep love/that Love will say it is I." Nothing beyond this single verse is mentioned of her poetry.

Iʿtimād al-Rumaykiyya provides another example of a talented slave girl whose poetry was not well preserved. Only half a verse of hers survives because it played an important role in a royal love

story. The half verse gained her the admiration and the love of al-Muʿtamid (b. ca. 431/1039), the ruler of Seville. The chronicles tell how al-Muʿtamid challenged his vizier to finish the following verse: "The wind made a garment from the water." But the vizier was lost for words. Iʿtimād, who was washing clothes in the river where both men were standing, replied, "What a battle shield it would have made if frozen." At that point, al-Muʿtamid turned, saw her, and was infatuated by her. Eventually, he brought her to his palace, and finally married her.

More lines of the poetry of their daughter, Buthayna bt. al-Muʿtamid b. ʿAbbād, are mentioned in the chronicles, probably because they too are part of an interesting love story. When Buthayna fell into slavery after her father was deposed and banished, her captor tried to lay his claim upon her. But she refused and insisted on being married before he could satisfy that claim. When he found out that she was the daughter of a king, he proposed. So Buthayna sent a letter in verse to her mother asking for her approval and her blessing.

The verses of female poets are also cited in Andalusian chronicles in courtly gatherings where jovial and entertaining exchanges of poetry prevailed. The few verses preserved from Nazhūn bt. al-Qilāʿī seem to fall into this category. Her verses are cited in response to the comments and taunting of other poets about her poetry such as the several lines cited in her reply to the attacks of Abū Bakr al-Makhzūmī.

Andalusian chronicles present a number of problems for researchers including the fact that the information mentioned can sometimes be rather vague or contradictory. For example, Rāḍiyya (d. 423/1031), the freed slave girl of ʿAbd al-Raḥmān al-Nāṣir, is said to "have some books," but it is not clear whether she wrote the books or owned them. While Umm al-Hanāʾ (lived ca. 500/1106) is said to have written a book on the theme of graves and another one about prayers, neither of these books seems to have survived.

The literature of the period was mainly written in standard Arabic, which was the language of the court and was also used by Muslim Arabs, Mozarabs (Spanish Christians living in Muslim areas in al-Andalus), and Jews in their daily activities. The material available concerning Andalusian Jewish women who composed poetry or lyrics is even scarcer than that concerning Andalusian Muslim women. Nevertheless, Muslim chronicles mention Qasmūna bt. Ismāʿīl al-Yahūdī (lived ca. 400/1009), who apparently excelled in composing

poetry and *muwashshaḥāt*. She is mentioned in relation to her father who appears to have been a poet himself. Some Hebrew sources assume that her father was Samuel ha-Nagid, but Muslim chronicles do not provide the full name of her father or her lineage. Only two of her *qiṭʿas* (short pieces of poetry) have been preserved in Andalusian chronicles; each *qiṭʿa* comprises two verses only. In the first *qiṭʿa*, Qasmūna compares her feeling of loneliness to that of a deer separated from its beloved. She ends the verse by asking herself to be patient, and to wait and see what fate holds for her. In the second *qiṭʿa*, Qasmūna complains that she cannot find any suitors despite her beauty. She adds that she is afraid that she may spend the rest of her life alone. According to the chronicles, her father hears her verses and decides to marry her off. Both *qiṭʿas* are written in classical Arabic. As for her *muwashshaḥāt*, none of them seem to have been preserved. The chronicles are silent as to whether or not she continued to compose poetry after she married.

Literature in al-Andalus was also composed using languages other than standard Arabic. The Andalusian period ushered in the golden age of Hebrew literature. A manuscript found among the Geniza collection mentions an Andalusian Jewish woman who may have written poetry in Hebrew. A few verses are inscribed in the manuscript, which states that the wife of Dunash b. Labrat, without mentioning her full name, said them. However, some critics are not convinced that she composed, or wrote, the verses herself. In medieval times, only Jewish men and not Jewish women were encouraged to learn and read Hebrew. Even if a Jewish woman knew a little Hebrew, it is questionable whether she would have had enough knowledge to compose in the language. Thus most critics believe that the lines ascribed to the wife of Dunash were composed by a scribe.

It is also unlikely that Dunash (ca. mid-fourth/ mid-tenth century) himself wrote the poem using the voice of his wife as a rhetorical device, since the style of the few verses appears to be different from that of Dunash. Dunash is better known for devising a way of adopting Arabic prosody to Hebrew, a method that spearheaded the development of secular Hebrew poetry, and for his connections with Ḥasdai b. Shaprut, his patron and a famous Jewish courtier in al-Andalus, than for his poetry, especially when compared with the more sophisticated Hebrew poetry that appeared later in Spain.

So far there is no evidence of Spanish compositions written by women in al-Andalus, at least not within the areas that were controlled by Muslims. However, in the areas under the rule of Spanish Christians, which were adjacent to the Muslim Andalusian cities, Doña Leonor López de Córdoba (763–ca. 818/1361–after 1414) is known for having written *Memorias*. Leonor was a noblewoman whose father was a cousin of Pedro I, the king of Castille, and one of Pedro's chief soldiers. Due to familial political conspiracies, Leonor was imprisoned in Seville for nine years. In *Memorias*, Leonor describes her ordeal, her imprisonment, and her struggle even after she was set free. Even in this case, some critics argue that it is not known if Leonor wrote the book by herself, or if she dictated it to someone else.

Even if a poem or literary work were discovered to have been composed in al-Andalus entirely in Spanish, the chances are that critics would claim it as European literature, rather than Muslim, Arabic, or Middle Eastern. The linguistic divide of Andalusian literature into Arabic, Hebrew, and Spanish often contradicted the diverse and multicultural civilization that developed in al-Andalus. This situation changed more recently, however, as researchers became interested in the *muwashshaḥ*, *kharja* and *zajal*. These are the Andalusian lyrics that have defied the established linguistic boundaries, and provided challenges to scholars, many as yet unresolved.

MUWASHSHAḤ AND KHARJA

Andalusian literature produced many innovative literary styles previously unknown in the Muslim East or in the Iberian Peninsula. Examples of such new literary forms are the *muwashshaḥ* and the *zajal*; both are forms of lyrical, strophic poetry using vernacular dialects rather than standard languages. The interest in examining these two strophic forms is fairly recent, even though the corpus of the poems, or songs, was known to have existed since medieval times. Because they were written in vernacular dialects their importance was overlooked, especially in the case of Romance-Arabic lyrics. Another reason that they were neglected by medieval critics is that they deviate in meter and rhyme from the *qaṣīda* (ode), which is composed entirely in standard Arabic and is considered the epitome of what gifted poets strive for when they are composing poetry.

The typical *qaṣīda* is tripartite; it begins with a *nasīb* (love prelude), followed by a *raḥīl* (departure), and ends with a *madīḥ* (panegyric) addressed to the poet's patron. Although the *muwashshaḥ* and *zajal* focus on the theme of *ghazal*

(love) and *madīḥ*, they do not conform to the structure of the *qaṣīda*. Moreover, the *qaṣīda* is monorhymic and monorhythmic, whereas the *muwashshaḥ* and *zajal* are polyrhymic and polyrhythmic lyrics.

The term *muwashshaḥīt* (sing. *muwashshaḥ*, an object that is embroidered) has been applied to the whole corpus, including the Hebrew verses. The common Hebrew term for them is *shir ezor* (girdle poem). They seem to have appeared in al-Andalus in the middle of the tenth century. Strophic Arabic lyrics are, in general, not as common as *qaṣīda*s or as *qiṭʿa*s. The origin of the *muwashshaḥāt* has been debated in scholarly circles not only because of the rarity of this genre in Arabic but also because the bulk of the *muwashshaḥāt* is composed in either standard Arabic or Hebrew with the exception of the last stanza, the *kharja* (exit), which is composed in vernacular Arabic Romance, or Mozarabic dialect.

The study of the two forms of vernacular strophic poetry has been complicated by many issues, such as their linguistic nature, the debate about their origins, the feminine voice that speaks in the *kharja*, which is the closing section, or refrain, of a *muwashshaḥ*, and the courtly love clichés that they deploy. Since these issues overlap, it is important to provide a brief overview of all of them.

The most important concern for those who have researched these two new literary forms seems to be the theories concerning the origins of the Arabic and Hebrew *muwashshaḥāt*. The mystery of their origins continues to be controversial among scholars to the extent that they are divided into two opposing camps. The first camp is the European one, which attributes the roots of *muwashshaḥāt* to the Iberian Peninsula and to France. The second camp is the Arabic, or the eastern one, which holds that *muwashshḥāt* originated in al-Andalus, in a Muslim milieu, and probably had roots in earlier lyrics that were sung in the Middle East. In order to understand the reasons for such fierce debates over the origins of *muwashshaḥāt*, it is important to understand the historical background in which they were composed; their relationship to Arabic literature as well as to European lyrics; and the issues at stake when scholars study *muwashshaḥāt*, such as the discipline, or the national literature they are affiliated with.

In *al-Dhakhīra fī maḥāsin ahl al-Jazīra*, Ibn Bassām attributes the invention of *muwashshaḥāt* to an unknown Andalusian poet by the name of Muḥammad b. Maḥmūd al-Qabrī, referred to by Ibn Khaldūn as Muqaddam b. Muʿāfā al-Qabrī.

The early Arabic *muwashshaḥāt*, however, were not included in the *dīwān*s (collections) of the poets. This omission might indicate the unrecognized status of *muwashshaḥāt* as a genre in Arabic literary circles. In Hebrew, where there is not a strong or a strict tradition of *qaṣīda*s, poets did include their *muwashshaḥāt* in their *dīwān*s.

Another new kind of poetry was *zajal*. This poetry resembled the *muwashshaḥ* in its polyrhymic scheme, but it was written only in Arabic dialect and not in standard Arabic. The most well known *zajjāl* in al-Andalus was Ibn Quzmān (ca. 473–556/1080–1160) who wrote using the dialect of Cordoba. His collection of *zajal*s is known as *Dīwān Ibn Quzmān*. The introduction of his collection is written in standard Arabic, but in his poems, or *zajal*s, he confines himself to the use of dialect.

In addition to the debate over the language of *muwashshaḥāt*, the meter employed in composing them poses another problem. The difference between the *qaṣīda* and the *muwashshaḥ* is that the former requires the use of one of the classical meters to form lines that are made up of two hemistiches with a caesura in between. The *muwashshaḥ*, on the other hand, uses diverse, asymmetrical, and syncopated meters. The origin of how, why, and when the *muwashshaḥ* deviated from the *qaṣīda* form has been investigated by many scholars. Some of them attribute the peculiarity of *muwashshaḥāt* to the closing lines of the *kharja*, which has been debated more than any other part of the *muwashshaḥ*. Among the contested issues are its antiquity, whether or not the *kharja* was the foundation for composing the *muwashshaḥ*, and its metrical style.

Another characteristic of the *muwashshaḥāt* that has caused great debate is the fact that the *kharja* is often put in the mouth of another person, usually a woman. In *Dār al-ṭirāz fī ʿamal al-muwashshaḥāt*, Ibn Sanāʾ al-Mulk (d. ca. 609/1212) wrote that women, as well as men, sang *kharja*s. This feature opened the debate as to whether or not *kharja*s were the oldest remnants of the *chansons de femme*, composed before the tenth century. Some scholars postulate that parts of these survived in *kharja*s, while others link the *kharja*s to *cantigas de amigo*, or to *cantigas d'amore*, songs of love, and to *Frauenlieder*, women's songs.

Since Ibn Sanāʾ was referring to North African *kharja*s, some scholars argue that it is difficult to ascertain, beyond any doubt, that this same pattern applied to Andalusian *kharja*s. For example, Guiseppe Tavani, who examined *chansons de*

femme, sees those songs as the works of male troubadours. The argument is that the trope of using female *personae* in dramatic lyrics is an old poetic practice used by dramatists, poets, and narrators. Also, the practice of adopting someone else's voice is an old literary device that was known as *prosopopeia* in classical rhetoric. The use of a feminine voice appears to date from ancient times in Western literature; it did not start with the Middle Ages.

In association with the study of the *muwashshah* and the *kharja*, researchers found clichés that fall within the range of the traditions associated with courtly love. The roots of courtly love according to the European camp go back to Ovid's *Ars Amatoria* (43 B.C.E.–17 or 18 C.E.), and Andreas Capellanus who wrote *De Arte Honeste Amandi* (fifth/twelfth century), better known as *De Amore*. The tradition of courtly love manifested itself in the *chansons de geste*, and troubadour songs that came from Provence in southern France. Scholars have speculated why, if the tradition goes back to Ovid, it enjoyed such a popular revival in the early Middle Ages. The only explanation some scholars offer is that it was new to that area; it was a novelty imported from a nearby culture such as al-Andalus. Muslims were in Spain at the same time courtly love became popular in Provence.

Despite the geographical proximity of Spain and Provence and the presence of Muslims in Spain, the scholars who supported the European or Latin theory contended that the different communities in Spain did not mix and did not influence one another. When Samuel Stern discussed the *kharja* in 1948 (Stern 1974, v), the debate was resumed. But Stern himself denied that the *kharja* or the *muwashshah* influenced the songs of troubadours. Nevertheless, some scholars argue in favor of the Arabist theory. The support for their arguments comes from the songs composed by William of Aquitaine and Guillaume IX and the similarities their songs bear to *kharja*s and *muwashshahāt*. A. R. Nykl (1946) argues that the songs Guillaume composed before he joined the Crusades are more primitive than the well-developed ones composed after he returned from his trips. Nykl attributes this difference to Guillaume's contact with Muslims and their songs. Nykl adds that if Mozarabs, Christians residing in Muslim Iberia, imitated Muslims in their dress, warfare, and other habits, the sphere of songs and poetry should not be excluded from Islamic influence.

The roots of courtly love tradition in Arabic literature go back to the school of ʿudhrī (Platonic) poets, which flourished during the reign of the Ummayad dynasty (79–132/661–750). Later on, in the court of the ʿAbbāsid Caliph Harūn al-Rashīd, the poet Ibn al-Aḥnaf (late second–third/ninth century) wrote a *dīwān* about the moods of love, its disappointments, and fulfillments. He pointed to certain *courtois* values, such as love being a virtue. He portrayed the lover in his poems as totally submissive to the wishes of the beloved. He also referred to the spies, or ill-wishers, *wāshūn*, who get between the lover and his beloved. Also in the eighth century, Ibn Dawūd al-Iṣfahānī wrote *Kitāb al-zahra*, which focused on the theme of love. In this book, Ibn Dawūd seems to be influenced by Platonic philosophy. In al-Andalus, Ibn Ḥazm wrote *Ṭawq al-ḥamāma* (fourth/eleventh century) in which he dealt with the theme of love, using prose and poetry.

As Susan Einbinder and Tova Rosen point out, the study of *muwashshahāt* is still plagued by the need to identify manuscript sources and to establish critical texts. These issues are fundamental to the study of this genre in particular since deciphering the *kharja*s remains conjectural and no one is sure whether certain words are Arabic or Spanish. Another problem is that opinions as to the type of music and instruments, and the manner in which *muwashshahāt* were sung are built, to a large extent, on speculation. The manuscripts do not include any musical notation, nor do they give any clear indication on how *muwashshahāt* were performed. Another question raised by the *muwashshahāt* is whether they moved from popular circles to court circles, or vice versa. The scholarly debate continues until now.

BIBLIOGRAPHY

J. A. Abu-Haidar, *Hispano-Arabic literature and the early provençal lyrics*, Richmond, Surrey 2001.
María L. Avila, Las mujeres "Sabias" en al-Andalus, in María Jesús Viguera (ed.), *La mujer en al-Andalus*, Madrid 1989, 139–84.
L. F. Compton, *Andalusian lyrical poetry and old Spanish love songs*, New York 1976.
Federico Corriente, *Poesía dialectal árabe y romance en Alandalús. Cejeles y xarajat de muwassahat*, Madrid 1997.
al-Ḍabbī, *Bughyat al-multamis fī rijāl ahl al-Andalus*, Cairo 1967.
P. Dronke, *Medieval Latin and the rise of European love-lyric*, Oxford 1965.
D. Earnshaw, *The female voice in medieval romance*, New York 1988.
S. Einbinder, The current debate on the muwashshah, in *Prooftexts* (Baltimore) 9:2 (1989), 161–76.
Margit Frenk Alatorre, *La canción sefardí y la tradición hispánica*, Monterrey, Spain 1972.

——, *Las jarchas mozárabes y los comienzos de la lírica románica*, Mexico 1975.

Ibn al-Abbār, *al-Takmila li-kitāb al-ṣila*, Cairo 1966.

Ibn Bassām, *al-Dhakhīra fī maḥāsin ahl al-Jazīra*, Beirut 1979.

Ibn Khaldūn, *al-Muqadimma*, Cairo 1904.

Ibn al-Khaṭīb, *al-Iḥāṭa fī Akhbār gharnāṭa*, Cairo 1974.

——, *Jaysh al-tawshiḥ*, Tunis 1967.

Ibn Quzman, *Todo Ben Quzman*, ed. Emilio García Gómez, Madrid 1972.

Ibn Saʿīd, *al-Mughrib fī ḥulā al-Maghrib*, Cairo 1964.

Ibn Sanāʾ al-Mulk, *Dār al-ṭirāz fī ʿamal al-muwashshaḥāt*, Damascus 1977.

Sayyid Ghāzī, *Dīwān al-muwashshaḥāt al-Andalusiyya*, Alexandria 1979.

W. Jackson, *Reinmar's women. A study of the woman's song*, Amsterdam 1981.

Frede Jensen, *Earliest Portuguese lyrics*, Denmark 1978.

A. Jones and R. Hitchcock (eds.), *Studies on the muwaššaḥ and the kharja*, Oxford 1991.

Pilar Bravo Lledo, El discurso de la mujer en el medievo Hispano, in María del Mar Graña Cid (ed.), *Las sabias mujeres. Educación, saber y autoría (siglos III–XVII)*, Madrid 1994, 155–60.

al-Maqqarrī, *Nafḥ al-ṭīb min ghuṣn al-Andalus al-raṭīb*, Beirut 1968.

al-Marrākushī, *al-Muʿjib fī talkhīṣ akhbār ahl al-Maghrib*, Cairo 1963.

M. R. Menocal, *The Arabic role in medieval literary history*, Philadelphia 1987.

J. Monroe, *The muwashshaḥāt*, Oxford 1965.

A. R. Nykl, *Hispano-Arabic poetry*, Baltimore 1946.

Muḥammad al-Mustanṣir al-Raysūnī, *al-Shiʿr al-nasawī fī al-Andalus*, Beirut 1978.

Julián Ribera, *Historia de la música árabe medieval y su influencia en la española*, Madrid 1927.

T. Rosen, *The Hebrew girdle poem in the Middle Ages* [in Hebrew], Haifa 1985.

——, On tongues being bound and let loose. Women in medieval Hebrew literature, in *Prooftexts* (Baltimore) 8:1 (1988), 67–87.

——, The muwashshaḥ, in M. R. Menocal, R. P. Scheindlin, and M. Sells (eds.), *The literature of al-Andalus*, New York 2000, 165–89.

R. P. Scheindlin, *Wine, women, and death. Medieval Hebrew poems on the good life*, Philadelphia 1986.

Joseph M. Solá-Solé, *Corpus de poesia mozárabe*, Barcelona 1973.

Leo Spitzer, *Sobre antigua poesia Española*, Buenos Aires 1962.

S. M. Stern, *Hispano-Arabic strophic poetry*, ed. L. P. Harvey, Oxford 1974.

Giuseppe Tavani, *A poesía lírica galego-portuguesa*, Vigo 1986.

O. Zwartjes, *Love songs from al-Andalus. History, structure, and meaning of the kharja*, Leiden 1997.

SUHA KUDSIEH

Crusade Literature: 9th to 15th Century

This article examines both contemporary sources and (in particular) modern works on the Crusades to the Middle East, highlighting both the material available for study and the current state of scholarship of women and Islamic cultures during the period.

It should be noted that this article is concerned only with the Crusades to the Levant, and does not deal with the literature for the *Reconquista* in Spain or crusades elsewhere. It is divided into two sections, the first devoted to Muslim women, and the second to non-Muslim women.

MUSLIM WOMEN

Current scholarship on Muslim women during the Crusades is patchy. There are no studies devoted specifically to the topic, and what attention they do receive often forms part of either wider studies of Muslim women throughout history or the Muslim response to the Crusades. Probably the main reason for this uneven coverage is the fact that the sources themselves contain very little information regarding women during the period. Few Muslim sources concern themselves specifically with women and in those sources in which they do appear, they are generally notable political figures or people viewed as being important or unusual by the author. It might be argued that some of the Muslim sources are actually of more use for study of Frankish (European) than Muslim women.

Some studies do exist of particular female figures during the crusading period. The figure who has received the most attention is Shajar (or Shajarat) al-Durr (d. 655/1257). Originally a Turkish slave, Shajar al-Durr was the concubine, and later the wife, of the ʿAyyūbid Sulṭān al-Ṣāliḥ Ayyūb (d. 647/1249). Al-Ṣāliḥ was fighting the French Crusaders of Louis IX when he died, leaving Egypt in a critical position. However Shajar al-Durr, in collusion with two amirs, concealed her husband's death and so sustained the fight against the Crusaders until the sultan's son, al-Muʿaẓẓam Tūrān-Shāh, arrived to take up the reins of government. The Crusaders were defeated in 648/1250, with Louis being taken prisoner. The new sultan was murdered by Mamluks shortly afterwards, and Shajar al-Durr herself was elected as the new ruler, an event almost without precedent in Islam. She reigned as sultana

for three months before being ousted in favor of the Mamluk Aybak al-Turkumānī, whom she later married. She continued to rule through her husband for the next seven years. When Aybak threatened her position by contracting a marriage with a Mosuli princess, Shajar al-Durr had him murdered. However, Aybak was soon avenged. Shajar al-Durr was arrested and imprisoned in the Citadel in Cairo, then beaten to death. Her corpse was deposited outside the Citadel walls. Shajar al-Durr has been the subject of numerous studies in English, French, German, and Arabic, which have made use, to varying extents, of both European and Middle Eastern sources. An excellent examination of most of these studies is by David J. Duncan in his article, "Scholarly Views of Shajarat al-Durr. A Need for Consensus," which provides a good starting point for further research on this figure. One important article on Shajar al-Durr, which due to a later date of publication is not covered by Duncan's study, is Amalia Levanoni's "Ṣaǧar ad-Durr. A Case of Female Sultanate in Medieval Islam."

Shajar al-Durr is not the only recorded case of a Muslim woman asserting herself in the crusading period. A more subtle figure who is only now beginning to be studied in depth is Ḍayfa Khātūn (d. 640/1243), the regent of Aleppo, who ruled on the behalf of her son, the Ayyūbid al-Nāṣir Yūsuf (d. 658/1260), from 634/1236 to 640/1243. A recent study of Ḍayfa Khātūn is "Ḍayfa Khātūn, Regent Queen and Architectural Patron," by Yasser Tabbaa. Anne-Marie Eddé has also examined Ḍayfa Khātūn in the context of her larger work on Aleppo, *La principauté ayyoubide d'Alep* (579/1183–658/1260).

Another work dealing with important women in Muslim history is *Nufūdh al-nisṭāʾ fi al-dawla al-Islāmiyya fi al-ʿIrāq wa Miṣr*, by Wafāʾ Muḥammad ʿAlī. Written mostly using Arabic sources from later medieval literature, the first half of this work deals with several women involved with the ʿAbbāsid caliphate, while the second concerns itself with a number of important female figures from the Fāṭimid caliphate. The book ends with a study of Shajar al-Durr. As far as the period of the Crusades is concerned, in addition to Shajar al-Durr, the work is also useful for its examination of Raṣad, the mother of the Fāṭimid Caliph

al-Mustanṣir (d. 487/1094), and "the ladies of the castle," (the daughters of the Fāṭimid Caliph al-Ḥāfiẓ, d. 544/1149). Raṣad, herself of Sudanese origin, was involved in the increase of the number of Sudanese soldiers in the Fāṭimid forces, which eventually led to internal strife between the Sudanese and Turkish army troops. The daughters of al-Ḥāfiẓ were instrumental in the rise and eventual downfall of the *wazīr* al-Ṣāliḥ Ṭalāʾiʿ ibn Ruzzīk (d. 556/1161). Thus these figures were important in the internal history of Egypt both immediately before and during the Crusades.

In his article, "Becoming Visible. Medieval Islamic Women in Historiography and History," Gavin Hambly has found women in a number of roles during the period, not only as rulers (officially recognized or otherwise), but also as teachers and architectural patrons. Studies of women as patrons of architecture and other good causes may also be found in articles by several scholars, including Marina Tolmacheva, "Female Piety and Patronage in the Medieval 'ḥajj,'" Doris Behrens-Abouseif, "The Lost Minaret of Shajarat ad-Durr at Her Complex in the Cemetery of Sayyida Nafīsa," and the article by Yasser Tabbaa cited above. Intersecting both temporally and geographically with some of these studies are the examinations of women in Mamluk Egypt (648/1250 to 923/1517) made by several scholars. Huda Lutfi, "Manners and Customs of Fourteenth-Century Cairene Women," pays particular attention to the breaking of prescribed gender boundaries by women in fourteenth-century Cairo. Carl Petry, "Class Solidarity versus Gender Gain," is concerned with women's position and conduct with regard to property. Jonathan Berkey, "Women and Islamic Education in the Mamluk Period," examines women's involvement in the education system during the period. In addition to historical, biographical, and religious texts, a number of the studies of women as patrons and owners of property make use of an important and relatively new resource for study of the period, namely collections of land-tenure documents from archives in the Middle East, many of which have only recently become widely available to scholars. Much work remains to be carried out on these documents, which contain information pertinent to a wide variety of aspects of the history of the period, including the study of women. Many of the documents remain unedited and untranslated.

One of the best known sources for the early Crusades is the *Kitāb al-iʿtibār*, or memoirs, of the Shayzari Amīr Usāma ibn Munqidh (d. 584/1188). Both Muslim and non-Muslim women have a significant presence in Usāma's work. Indeed, he devotes a section of his work to "some accounts of women's deeds" (Usāma 2000, 148–60). The Muslim women include warriors, prisoners, and Usāma's own mother, grandmother, aunt, and sister. Usāma's memoirs have been examined by a number of scholars, including Carole Hillenbrand, Hadiah Dajani-Shakeel, Robert Irwin, Wadiʿ Z. Haddad, and Niall Christie (see bibliography). However, the specific topic of his presentation of women would benefit from further study.

Another source of information on Muslim women and the Crusades is the biographical dictionaries written both during and shortly after the period. These dictionaries are particularly common during the Mamluk period. While in the majority of cases they are concerned with men, biographies of women may also be found in these works. It is unfortunate that the parts of the *Bughyat al-ṭalab fī taʾrīkh Ḥalab* of Ibn al-ʿAdīm (d. 660/1262) that deal with women have been lost, for he presents some of the most detailed information on the personalities of his period. However, there is a volume of the *Taʾrīkh madīnat Dimashq* of Ibn ʿAsākir (d. 571/1176) that deals specifically with women, including contemporaries of the author. This work has been edited as a separate volume by Sukayna al-Shihābī, with the subtitle of *Tarājim al-nisāʾ*. Women also appear in many of the other later biographical dictionaries, either spread throughout the works or in sections devoted specifically to them. Biographies of women are particularly numerous in *Al-durar al-kāmina fī aʿyān al-miʾat al-thāmina* by Ibn Ḥajar al-ʿAsqalānī (d. 852/1449) and *Al-ḍawʾ al-lāmiʿ fī aʿyān al-qarn al-tāsiʿ* by al-Sakhāwī (d. 902/1497). A useful analysis of the Muslim biographical dictionaries and women throughout history is Ruth Roded, *Women in Islamic Biographical Collections*. Using the biographical literature, this study also highlights a number of important female figures from the crusading period, many of whom have not yet been the subjects of significant study.

The issue of Muslim women in captivity has been studied by Hadiah Dajani-Shakeel, in "Some Aspects of Muslim-Frankish Christian Relations in the Shām Region in the Twelfth Century," and Yvonne Friedman, in "Women in Captivity and Their Ransom During the Crusader Period." These scholars have paid most attention to Usāma's memoirs, but have also used a number of other sources, including the Frankish historian William of Tyre (d. 582/1186) and the *Arabian Nights* (or *The Thousand and One Nights*). Using a wider range of sources, Benjamin Z. Kedar has also given some

consideration to Muslim captives and slaves in general as part of his wider study of Muslims under Frankish rule, "The Subjected Muslims of the Frankish Levant." This study also touches on Muslim women in other situations, most particularly with regard to Frankish legal practice. Women as captives have also been the subject of study by Laura Brady, in her unpublished M.A. thesis, "Essential and Despised. Images of Women in the First and Second Crusades, 1095–1148." Written using mainly Frankish primary sources, this thesis also examines Muslim women in other roles, including being emotional influences on their menfolk and (from one incident mentioned by William of Tyre) sorceresses. Brady also considers depictions of them as romantic heroines who advise or aid the cause of the Crusaders, taken from the *Ecclesiastical History* of the French monk Odericus Vitalis (d. ca. 536–7/1142).

The *Arabian Nights*, in which women play a variety of roles, is not the only literary work from the crusading period that is useful for the study of women. Muslim women may also be found in other works, both Levantine and Western, written at the time, on which further research might be carried out. Women, and warrior-women in particular, are also to be found in popular Muslim folk epics, including the *Sīrat Baybars* and the *Sīrat Dhāt al-Himma*. These texts have been studied by Carole Hillenbrand in *The Crusades. Islamic Perspectives*, and Remke Kruk, in "The Bold and the Beautiful. Women and 'fitna' in the 'Sīrat Dhāt al-Himma.' The Story of Nūrā" and Other Articles. Women also appear in a number of poems written during the early crusading period (490/1096 to 564/1169), including works by Ibn al-Khayyāṭ (d. 513–23/1120s) and an anonymous poet cited by the historian Ibn Taghrī Birdī (d. 874/1470). In most cases these women are fearful, abused victims of Frankish aggression, mentioned in order to provoke the listeners into action against the Crusaders. These poems have been the subject of studies by several scholars, including Carole Hillenbrand, in both the work cited above and "The First Crusade. The Muslim Perspective," Hadiah Dajani-Shakeel, in "Jihād in Twelfth-Century Arabic Poetry. A Moral and Religious Force to Counter the Crusades," and Niall Christie, in his unpublished Ph.D. thesis, "Levantine Attitudes towards the Franks During the Early Crusades (490/1096–564/1169)."

On the other side, Muslim women are found in a number of guises in Western literary works, particularly the *chansons de geste*. A recent study of Muslim women in French literature from the period is Jacqueline de Weever, *Sheba's Daughters*.

Whitening and Demonising the Saracen Woman in Medieval French Epic. Although the literary texts are works of fiction, and not always directly concerned with the Crusades themselves, they do often contain historical elements and shed light on popular attitudes towards the period, so they are worthy of further study.

NON-MUSLIM WOMEN

Several scholars have conducted work on non-Muslim women in the Crusades. A general study, using both Muslim and Christian sources and addressing a number of different aspects of the subject, is *Soldiers of the Faith. Crusaders and Moslems at War*, by Ronald Finacune. Another work devoted more specifically to women and the Crusades is *La Femme au temps des croisades*, by Régine Pernoud. Pernoud's work concentrates almost entirely on Frankish noblewomen, although she does occasionally give consideration to women from other social groups, faiths, and cultures. She deals in particular detail with a number of important members of the nobility, including the queens Melisende (d. 556/1161), Eleanor of Aquitaine (d. 600/1204), and Isabella de Courtenay (d. 601/1205), using a mixture of Muslim and Christian sources. Bernard Hamilton has also carried out work on the queens of the first Kingdom of Jerusalem in an article entitled "Women in the Crusader States. The Queens of Jerusalem (1100–1190)," working primarily from a variety of Christian sources. A number of scholars have also conducted work on women in connection with specific individuals or expeditions.

Eleanor of Aquitaine is an important figure in both crusading history and the history of the medieval world in general, and has been the subject of study by a number of scholars. As far as the history of the Crusades is concerned, her most important involvement was in the years 542/1147 to 543/1149, when she accompanied her husband, Louis VII of France (d. 576/1180), to the Levant. Eleanor struck up a rapport with Raymond, the Prince of Antioch (d. 544/1149), who wanted the crusading army to attack Aleppo and Edessa. However, Louis preferred to head for Jerusalem. Eleanor sided with Raymond against her husband, and was said by some chroniclers to have committed adultery with him. Such allegations were expanded upon by later medieval writers, but are discounted by many of her modern biographers. Whatever the truth of the matter, the argument led to the estrangement of the royal couple and the eventual annulment of their marriage in 546/1152. Recent studies of Eleanor's life include *Eleanor of*

Aquitaine by Alison Weir and *Eleonore von Aquitanien*, by Ursula Vones-Liebenstein.

In his article, "Eleanor of Castile and the Crusading Movement," Bernard Hamilton has carried out work on another important female figure. Eleanor of Castile (d. 689/1290) was the wife of Lord Edward of England (later Edward I, d. 706/1307) whom she accompanied on his expedition to the East (669/1271–670/1272). A ninth/fifteenth-century Arabic chancery manual, the *Ṣubḥ al-Aʿshā* by al-Qalqashandī (d. 821/1418), provides another interesting source of information about at least one other member of the Latin nobility. The manual includes the text of a treaty made between the Mamluk Sulṭān al-Ẓāhir Baybars (d. 676/1277) and the Lady of Beirut, Isabella of Ibelin (d. ca. 680–1/1282). A translation and analysis of the text has been made by P. M. Holt.

With regard to specific expeditions, the First Crusade and women have been examined by Walter Porges in his article "The Clergy, the Poor, and Non-Combatants on the First Crusade." A more recent analysis is that of James Brundage, entitled "Prostitution, Miscegenation and Sexual Purity in the First Crusade." The literature concerning the Peasants' Crusade and the First Crusade describes women serving in various non-combatant roles in support of the men, including food- and water-bearers, and also comforting them and exhorting them to fight harder. They are also described as praying for God's favor while the men were fighting. However, the majority of references to women on the First Crusade are concerned with their role as sexual temptations for the men. The chroniclers note that prostitutes accompanied the armies, and brothels were set up in the camps. Sexual purity and misconduct seem to have been a particular concern of the contemporary sources, and were frequently regarded as the causes of setbacks. A full analysis of this theme has been made by Brundage, working from a number of sources, of which the most important are Guibert of Nogent (d. 517–8/1124), Baudry of Dol, Robert the Monk, Fulcher of Chartres (b. ca. 449–51/1058–9), and Albert of Aachen (sixth/twelfth century).

Although it deals to a degree with depictions of Muslim women, the main emphasis of Laura Brady's thesis is on depictions of Frankish women during the First and Second Crusades. Brady has studied women in a variety of roles, including the wives left behind, warriors, captives and hostages, camp followers, settlers, emotional supports, and temptresses. Supplementing Brundage's work, she pays particular attention to the ascription by many contemporary writers of defeat in battle to impurity, usually as a result of temptation by women. She also examines the position of marriage as a means by which diplomatic and political alliances might be secured. In addition, she considers depictions of lands and cities in the Levant as women needing the succor and protection of the Crusaders.

With regard to the Third Crusade, as Helen Nicholson has noted in her article "Women on the Third Crusade," three Muslim sources in particular describe women fighting in the Crusade, namely Bahāʾ al-Dīn ibn Shaddād (d. 632/1234), ʿImād al-Dīn al-Iṣfahānī (d. 597/1201), and Ibn al-Athīr (d. 630/1233). They also refer to women in other roles, including those of prisoner, noblewoman, prostitute, and mother. A number of Western sources confirm the presence of women acting in various capacities on the Crusade, though not as fighters. Indeed the question of whether or not women actually fought in the Crusade is one which is debated among modern scholars. These sources include Ambroise (fl. ca. 592–3/1196), Roger of Howden (d. ca. 597–8/1201) and the anonymous author of the *Itinerarium Peregrinorum et Gesta Regis Ricardi* and his continuator, who was probably a canon of Holy Trinity, London, named Richard de Templo.

The involvement of women in the Fifth Crusade has been the subject of study by James Powell. In his article, "The Roles Of Women in the Fifth Crusade," Powell looks in particular at Genoese women and their importance as financial contributors to the Crusade. His sources include the Frankish Bishop Jacques de Vitry (d. ca. 637–8/1240) and commercial and legal documents from the period. Powell also pays some attention to other roles undertaken by women on the Fifth Crusade, not only as companions to their husbands, but also as millers, market overseers, guards, and nurses.

As noted earlier, Usāma ibn Munqidh's memoirs contain references to a number of Frankish women. The best-known examples are the women who feature in his comments on Frankish sexual practices, but they also include Frankish women taking part in Frankish festivals, fighting with Muslims, and suffering under the ministrations of Frankish doctors. Usāma's accounts of Frankish customs and practices, of which these form a part, have been discussed in a number of works, including Carole Hillenbrand's *The Crusades. Islamic Perspectives* and Niall Christie's thesis. Robert Irwin has also given detailed consideration to Usāma's work, most particularly in his article "Usamah ibn Munqidh. An Arab-Syrian Gentle-Man at the Time of the Crusades Reconsidered."

Another important source of information about non-Muslim women during the period of the Crusades, specifically with reference to Jewish women, is the collection known as the Cairo Geniza, which consists of letters, contracts, and other materials written mostly by members of Jewish communities in the Middle East. A number of the documents address concerns within the Jewish communities with regard to women. S. D. Goitein has examined various issues related to women in a number of works, including not only his magnum opus, *A Mediterranean Society*, but also *Letters of Medieval Jewish Traders* and the articles "Contemporary Letters on the Capture of Jerusalem by the Crusaders" and "The Sexual Mores of the Common People." The last of these also pays some attention to Muslim and Christian women. Another study that includes some information on Jewish women during the period is Joshua Prawer, *The History of the Jews in the Latin Kingdom of Jerusalem*.

As with Muslim women, the issue of non-Muslim women prisoners has been studied by Yvonne Friedman. These include both Frankish and Jewish captives. Friedman's sources include those referred to earlier with regard to Muslim women prisoners, and Bahā' al-Dīn, Ambroise, Guibert of Nogent, Walter the Chancellor, and modern scholarship on the Cairo Geniza documents.

Non-Muslim warrior women may also be found in Muslim folk epics. Once again, one turns here to the *Sīrat Dhāt al-Himma* and the scholarship of Remke Kruk. In the article cited earlier, Kruk deals in particular detail with a Byzantine warrior princess named Nūrā. As noted, these fictional works are valuable for their insight into popular attitudes at the time, even though they do not directly deal with the history of the period. With regard to other literary works, Frankish women also appear in the poetry of Ibn al-Qaysarānī (d. 548/1154), who is fascinated in particular by their beauty. Detailed studies of this aspect of Ibn al-Qaysarānī's poetry may be found in the works of Carole Hillenbrand and Niall Christie cited previously.

Finally, an important female source for the period of the First Crusade is the Byzantine Princess Anna Comnena (d. between 542/1148 and 548-9/1154). Her biography of her father Alexius I (d. 512/1118), known as the *Alexiad*, is vital both for its value as a source of historical information, and also as being the only work from the period written by a woman. Book-length studies of Anna include *Anna Comnena, a Study*, by Georgina Buckler and *Anna Comnena*, by Rae Dalven. Most recently, various aspects of her life and work have been examined in an excellent volume of papers

edited by Thalia Gouma-Peterson, entitled *Anna Komnene and her Times*.

BIBLIOGRAPHY

PRIMARY SOURCES
For bibliography on other primary sources referred to, but not listed here, see the modern works listed below.
Anna Comnena, *The Alexiad of Anna Comnena*, trans. E. R. A. Sewter, Baltimore 1969.
S. D. Goitein (trans.), *Letters of medieval Jewish traders*, Princeton 1973.
Ibn 'Asākir, *Ta'rīkh madīnat Dimashq. Tarājim al-nisā'*, ed. S. al-Shihābī, Damascus 1982.
Ibn al-Khayyāṭ, *Dīwān Ibn al-Khayyāṭ*, ed. Kh. Mardam Bey, Damascus 1958.
Ibn Taghrī Birdī, *Al-nujūm al-zāhira fī mulūk Miṣr wa-al-Qāhira*, v, ed. M. 'A. al-Q. Ḥātim, Cairo 1963.
Usāma ibn Munqidh, *An Arab-Syrian gentleman and warrior in the period of the Crusades. Memoirs of Usāmah ibn-Munqidh*, trans. P. K. Hitti, New York 2000.

SECONDARY SOURCES
W. M. 'Alī, *Nufūdh al-nisā' fī al-dawla al-Islāmiyya fī al-'Irāq wa-Miṣr*, Cairo 1986.
D. Behrens-Abouseif, The lost minaret of Shajarat ad-Durr at her complex in the cemetery of Sayyida Nafīsa, in *Mitteilungen des Deutschen Archäologischen Instituts Abteilung Kairo* 39 (1983), 1–16.
J. P. Berkey, Women and Islamic education in the Mamluk period, in N. R. Keddie and B. Baron (eds.), *Women in Middle Eastern history. Shifting boundaries in sex and gender*, New Haven, Conn. 1991, 143–57.
L. Brady, Essential and despised. Images of women in the First and Second Crusades, 1095–1148, unpublished M.A. thesis, University of Windsor, Canada 1992.
J. A. Brundage, Prostitution, miscegenation and sexual purity in the First Crusade, in P. W. Edbury (ed.), *Crusade and settlement. Papers read at the First Conference of the Society for the Study of the Crusades and the Latin East and presented to R. C. Smail*, Cardiff 1985, 57–65.
G. G. Buckler, *Anna Comnena, a study*, London 1929.
N. Christie, Levantine attitudes towards the Franks during the early Crusades (490/1096–564/1169), unpublished Ph.D. thesis, University of St. Andrews, Scotland 1999.
H. Dajani-Shakeel, Jihād in twelfth-century Arabic poetry. A moral and religious force to counter the Crusades, in *Muslim World* 66 (1976), 96–113.
——, Some aspects of Muslim-Frankish Christian relations in the Shām region in the twelfth century, in Y. Y. Haddad and W. Z. Haddad (eds.), *Christian-Muslim encounters*, Gainesville, Fla. 1995, 193–209.
R. Dalven, *Anna Comnena*, New York 1972.
J. De Weever, *Sheba's daughters. Whitening and demonizing the Saracen woman in medieval French epic*, New York 1998.
D. J. Duncan, Scholarly views of Shajarat al-Durr. A need for consensus, in *Arab Studies Quarterly* 22 (2000), 51–69.
A.-M. Eddé, *La principauté ayyoubide d'Alep (579/1183–658/1260)*, Stuttgart 1999.
R. C. Finacune, *Soldiers of the faith. Crusaders and Moslems at war*, London 1983.
Y. Friedman, Women in captivity and their ransom during the Crusader period, in M. Goodich, S. Menache, and S. Schein (eds.), *Cross-cultural convergences in the*

Crusader period. Essays presented to Aryeh Grabois on his sixty-fifth birthday, New York 1995, 75–87.

S. D. Goitein, Contemporary letters on the capture of Jerusalem by the Crusaders, in *Journal of Jewish Studies* 3 (1952), 162–77.

——, *A Mediterranean society*, 6 vols., Berkeley 1967–93.

——, The sexual mores of the common people in A. L. al-Sayyid Marsot (ed.), *Society and the sexes in medieval Islam*, Malibu 1979, 43–61.

T. Gouma-Peterson (ed.), *Anna Komnene and her times*, New York 2000.

W. Z. Haddad, The Crusaders through Muslim eyes, in *Muslim World* 73 (1983), 234–52.

G. R. G. Hambly, Becoming visible. Medieval Islamic women in historiography and history, in G. R. G. Hambly (ed.), *Women in the medieval Islamic world. Power, patronage and piety*, New York 1998, 3–27.

B. Hamilton, Women in the Crusader states. The queens of Jerusalem (1100–1190), in D. Baker (ed.), *Medieval women*, Oxford 1978, 143–73.

——, Eleanor of Castile and the crusading movement, in *Mediterranean Historical Review* 10 (1995), 92–103.

C. Hillenbrand, *The Crusades. Islamic perspectives*, Edinburgh 1999.

——, The First Crusade. The Muslim perspective, in J. Phillips (ed.), *The first Crusade. Origins and impact*, Manchester, U.K. 1997, 130–41.

P. M. Holt, Baybar's treaty with the Lady of Beirut in 667/1269, in P. W. Edbury (ed.), *Crusade and settlement. Papers read at the first conference of the Society for the Study of the Crusades and the Latin East and presented to R. C. Smail*, Cardiff 1985, 242–5.

R. Irwin, Usamah ibn Munqidh. An Arab-Syrian gentleman at the time of the Crusades reconsidered, in J. France and W. G. Zajac (eds.), *The Crusades and their sources. Essays presented to Bernard Hamilton*, Aldershot, Hampshire 1998, 71–87.

B. Z. Kedar, The subjected Muslims of the Frankish Levant, in J. M. Powell (ed.), *Muslims under Latin rule 1100–1300*, Princeton, N.J. 1990, 135–74.

R. Kruk, The Bold and the beautiful. Women and "fitna" in the "Sīrat dhāt al-Himma." The story of Nūrā, in G. R. G. Hambly (ed.), *Women in the medieval Islamic world. Power, patronage and piety*, New York 1998, 99–116.

A. Levanoni, Šağar ad-Durr. A case of female sultanate in medieval Islam, in U. Vermeulen and J. van Steenbergen (eds.), *Egypt and Syria in the Fatimid, Ayyubid and Mamluk eras*, iii, Leuven 2001, 209–18.

H. Lutfi, Manners and customs of fourteenth-century Cairene women. Female anarchy versus male shar'i order in Muslim prescriptive treatises, in N. R. Keddie and B. Baron (eds.), *Women in Middle Eastern history. Shifting boundaries in sex and gender*, New Haven, Conn. 1991, 99–121.

H. Nicholson, Women on the Third Crusade, in *Journal of Medieval History* 23 (1997), 335–49.

R. Pernoud, *La femme au temps des croisades*, Paris 1990.

C. F. Petry, Class solidarity versus gender gain. Women as custodians of property in later medieval Egypt, in N. R. Keddie and B. Baron (eds.), *Women in Middle Eastern history. Shifting boundaries in sex and gender*, New Haven, Conn. 1991, 122–42.

W. Porges, The clergy, the poor, and non-combatants on the First Crusade, in *Speculum* 21 (1946), 1–23.

J. M. Powell, The roles of women in the Fifth Crusade, in B. Z. Kedar (ed.), *The horns of Ḥaṭṭīn. Proceedings of the second conference of the Society for the Study of the Crusades and the Latin East*, Jerusalem 1992, 294–301.

J. Prawer, *The history of the Jews in the Latin kingdom of Jerusalem*, Oxford 1988.

R. Roded, *Women in Islamic biographical collections. From Ibn Sa'd to Who's Who*, Boulder, Colo. 1994.

Y. Tabbaa, Ḍayfa Khātūn, regent queen and architectural patron, in D. Fairchild Ruggles (ed.), *Women, patronage and self-representation in Islamic societies*, Albany, N.Y. 2000, 17–34.

M. Tolmacheva, Female piety and patronage in the medieval "ḥajj," in G. R. G. Hambly (ed.), *Women in the medieval Islamic world. Power, patronage, and piety*, New York 1998, 161–79.

U. Vones-Liebenstein, *Eleonore von Aquitanien. Herrscherin zwischen zwei Reichen*, Zürich 2000.

A. Weir, *Eleanor of Aquitaine. A life*, New York 2000.

The following important collection of papers was published shortly after the writing of this article:

S. B. Edgington and S. Lambert (eds.), *Gendering the Crusades*, Cardiff 2001.

NIALL CHRISTIE

Turkic Dynasties: 9th to 15th Century

Turks came to the central Islamic lands at different times. First (ninth–tenth centuries) they came as captives; upon arrival they were converted to Islam and came to be known as *mamlūk*s; they were a population consisting mostly of males. Later (eleventh–twelfth centuries) they came in groups, first making incursions into, and later settling in these regions. Towards the end of the eleventh century they had established themselves as Seljuks; later they would be known as Ottomans. They were the most successful and among the longest lasting of the many principalities established in Asia Minor in the thirteenth century. In the thirteenth–fourteenth centuries Qipchaqs, a Turkic people, crossed the Black Sea to Egypt and constituted the ruling class, the Qipchaq Mamluks. In other words, the Turks who came to the central Islamic lands did not present la uniform political picture, except that they arrived – after the *mamlūk* wave – mostly as Muslims and with their families.

PROBLEMS AND METHODS

The tenth-century conversion took place independently in three different regions; it is thus not possible to speak of Muslim Turkish women as a monolithic or homogeneous category either in historical times or in the present. In the context of the tenth century, we face two issues: conversion and way of life (sedentary and nomadic). These two issues also dominated later historical developments; as a result scholars of the past and present attempt to distinguish between these issues and to categorize the situation of women among sedentary and nomadic groups.

The traditional tendency has been to regard nomadic women (whether Muslim or non-Muslim) as the more liberated; as a result the boundary between Muslim and non-Muslim women is lifted. It appears that their being nomadic was emphasized more than their being Muslims. Sedentary Muslim women, on the other hand, are evaluated more by their religion than their way of life. This widespread outlook, which finds support in historical travel accounts, tends to be generalized and is used as a tool for examining history. Ronald Jennings, for example, shows that Central Anatolian women (seventeenth century) used the courts frequently and confidently, and that they seem to have exercised control over their own property and inheritance. But he states that "the position of women in Turkish-Islamic society has not been studied in the sixteenth and seventeenth centuries and indeed has received no severe attention for any period before the fall of the Ottoman Empire." He raises the question of whether "any antique Turkish customs had influenced the legal position of women in Kayseri" (Jennings 1975, 114). By "antique Turkish" he seems to be alluding to the prevalent notion of, in his own words, "pre-Islamic Turkish women who lived in an egalitarian world and continued even to do so until the sixteenth century when the Ottoman Empire was conquered by Arabic Islamism." As Jennings points out, we do not have any evidence that this notion is based on historical facts. The second question he raises is whether this phenomenon "if it existed at all, was merely a part of nomadism which disappeared in the conversion from nomadic to settled society." While granting that there were changes over time in the status of women in the Ottoman Empire, the question of "antique Turkish" or nomadic heritage and influences harbors a monolithic view of pre-Islamic or nomadic Turkish women.

As Islamization in Central Asia was an ongoing process until the seventeenth-eighteenth centuries it is not possible to distinguish easily between non-Muslim and Muslim women. However, the prevalent tendency in studying women is to distinguish between the pre-Islamic and Islamic periods, and treat the pre-Islamic period, that is periods such as the Early Türk and the Uighur, as a time favorable to the position of women. At this stage two points gain importance. First, with the transformation of views of Islam and Muslim women brought about by the recent work of Leila Ahmad, Elizabeth Fernea, and Judith Tucker, we have come to accept the historicity and specificity of women's position in Islamic history. Second, at present, when the contextuality of historical phenomena is gaining importance and replacing linear perceptions, there is no more need for a division into Islamic and pre-Islamic periods.

When conversion and Islamization was understood in a linear way, some scholars emphasized the freer ways of pre-Islamic women and others the legal status of Muslim women. In other words,

each group emphasized only those aspects that were seen as favorable from their own perspective. Another way was to use a combination of these two, that is an eclectic approach to Turkish women, by trying to see a continuation of the "freer ways" in the Islamic period. This approach tries to see the best of the two worlds.

Conversion and Islamization, on the other hand, can also be understood in a DeWeesian way by seeing the process as an overlapping of different cultural layers. In that case we can observe in the layers what was discarded and what was retained and which old and new layers coexisted at various times. Whether this coexistence was a harmonious one, or one of conflict, and what kind of tensions and ways developed for conflict resolution can be observed, are all topics for future research. In this DeWeesian approach it is not so important to define and to classify historical phenomena; what is important is the way they were perceived.

This kind of approach will be very helpful in analyzing and understanding certain issues related to public life, such as participation in the political decision-making process and in non-segregated gatherings, drinking of alcoholic beverages, and participation at funerals. It will also be helpful in studying the tension between the customary law ('urf, yasa) and Sharī'a. Instead of trying to determine the "degree of Islam" among the women of a certain society, research can try to understand how the Muslim women in question perceived a given situation. In this instance one cannot help but think of Elizabeth Fernea's phrase "words of God and words of men" (Fernea and Bezirgan 1994, xix); that is to say words of God were perceived differently according to the cultural constructs of gender even by those who were Turkish-speaking and Muslim, depending on geography and lifestyle. Such differences of perception present yet another area for future research.

Current scholarship, on the other hand, has examined these issues through either study of marriage patterns or the tension between religious and state law. Studying marriage from the angle of politics of reproduction, Leslie Peirce showed that Ottoman sultans preferred concubines over their legal Muslim and Christian wives as mothers of their offspring. Abdülkadir İnan presented the story of Baghdād Khātūn from the fourteenth-century Ilkhanate in Iran as an illustrative case of the tension between the Sharī'a and customary law ('urf, töre, yasa) that affected many Muslim Turkish women. Abū Sa'īd, the Ilkhān, asked for Baghdād Khātūn, basing his request on yasa, according to which a khan could acquire any woman, married or unmarried. Baghdād Khātūn's father refused this request on the basis of Sharī'a. There are hints that she was connected to the ruling family through her mother's side (İnan 1969–91, 274–80, Hambly 1999, 11).

As a result, we can say that future research needs to be directed to certain issues in the realms of continuity and change, and tensions within this change. We need to distinguish between structural differences and their reflection in values, while at the same time preserving a sense of the common cultural, ideological, and historical traits. It is only on the basis of such distinctions that we will be able to understand the dynamics and the complexities of these societies with their later evolution into discrete political formations different from one another. For instance, in the course of history Anatolia became part of a centralized political culture under the Ottoman Empire, whereas Central Asia experienced constant political change under a flexible structure based on the model of Inner Asian khanates – a structure using consent rather than coercion. In terms of social formations, on the other hand, social groups – and therefore women – in the Ottoman Empire experienced greater changes over time than Central Asian women. In Central Asia it was the stability of the social group that provided the coherence and continuity in a society with a flexible political formation.

TOOLS OF ANALYSIS

What were these issues of structural differences? First we can speak of status that is social, economic, and/or political on the micro level. This is one of the areas where we find a great many studies on women in Anatolia like those by Ronald Jennings, Suraiya Faroqhi, Leslie Peirce, Madeline Zilfi, and others. However, comparative studies on women's history taking into consideration macro level political structure, such as society at the state level and tribal groups, are still lacking. Both Anatolian and Central Asian women were under the impact of larger political movements. They had to travel over large distances when taking part in migrations and armies of conquest. In such cases they had to leave their kinfolk and their networks behind and had to adapt their lifestyle to that of their men. At other more peaceful times they played a more pronounced role within their neighborhood and kinship networks, notably those of lineage or tribe.

Here it is maintained that when state is the supreme ideology, women's position is subordinated to that high order, as in the heyday of the Ottoman order. In the absence of a centralized

state, on the other hand, women retained their hold on the ideological sphere. As a result, mechanisms that guaranteed the continuation of women's lives were to be found in Anatolia in the household unit. This functioned within the larger network of associations and solidarity groups that were basically non-kin but existed, however, under the auspices of the centralized state. The so-called *Bācīyān-ı Rūm* (Sisters of Rum) seem to have been members of such an association or group. Contemporaneous sources speak of these women's groups as stationed within the market and as textile producers and weavers. In Central Asia, on the other hand, mechanisms that guaranteed the continuation of women's lives were a function of the larger kin group, the lineage, or the lineage-based tribal group. Therefore a focus on the political structure at the macro level and on the social structure – woven around economic activities – at the micro level is needed so that the role of women can then be evaluated within the context of mechanisms that provided guarantees of property and means of survival.

In terms of women's history in Anatolia and Central Asia we have a situation where the linguistic, cultural, and also religious affiliations on the macro level can be considered constant. However, these two societies differed to a large degree in terms of their political structures as well as in terms of the social networks in which women functioned. On the micro level this situation is reflected by the guarantees accorded by these systems to women. The guarantees of property and of survival in general are seen as playing a decisive role in distinguishing a state organization in the Ottoman case and a khanate in the case of Central Asia. The Ottoman state was able to enforce the principles of religious law in relation to women's property and inheritance, and preserve the related court records as evidence of these guarantees (Jennings 1975). In Central Asia, in a situation of constant change such a system was neither possible nor feasible. Women's property and inheritance rights were guarded by the larger kin groups again through the medium of religious courts and the principles of Sharīʿa, without any official records. Private records were kept, however. Moreover, in both Anatolia and Central Asia we observe differences across gender and age groups, and all of these relationships were hierarchical (Togan forthcoming).

The mother-son relationship, however, was a relationship that functioned across gender. It cannot be placed directly within gender hierarchy. Ottoman sultans did not marry free Muslim women but cohabited with concubines who could not resort to their families when in need of help. In this way the Ottomans disregarded the matriline and strengthened the patriline. As future members of the imperial harem these women were educated in the culture of the patriline, the Ottoman dynastic family. Within these constraints the mother-son relationship was the only emotional relationship across gender. It worked against the principles of gender hierarchy but in accordance with seniority. Unlike Chinese women who experienced "three obediences": subordination to the father, husband, and son, Ottoman mothers retained their authority vis-à-vis their sons. While their authority was established by giving birth to a son, Central Asian women also acquired authority with age. In other words, in Central Asia principles of seniority overruled those of gender hierarchy. As a preference for seniority implied also the suppression of sexuality to a certain degree, only queen mothers who were above and beyond sexuality could exercise power. In studies such as Leslie Peirce's *The Imperial Harem*, and in historical sources such as Bābur's *Bāburnāma*, there are many examples of this perception.

Besides status, marriage patterns represent another issue that needs to be studied in future research. Among the Central Asian and Anatolian Turkish dynasties we observe reciprocity, hypergamy, and hypogamy. Reciprocity in marriage patterns implies exchange of women, in fact of daughters. It entails partners who are more or less equal so, for example, dynasties like the Qarakhanids in Central Asia entered into marriage relationships on an equal footing by exchanging brides. Reciprocity also implies a need for strengthening alliances. But when dynasties were just emerging and in need of alliances with stronger partners, they acted like wife-taking clans and took wives from more prestigious dynasties. This practice by which a family or clan of higher status benefits those of lower status and thus acquires dependants is called hypergamy for the men of lower status while it is hypogamy for the women they marry. Early Ottoman rulers and Tīmūr in Central Asia practiced hypergamy. When a certain dynasty had already extended its branches and wanted to strengthen its trunk, that is to consolidate, it started to act as a wife giver. When rules of exogamy applied, marriages of dynastic women were in the form of hypogamy, whether the specific time period was at the rise of a dynasty or after consolidation. This practice meant that women of higher status married men of a rising dynasty; later daughters of a consolidated dynasty

married men lower in rank, dynastic or bureau-cratic. When consolidation was complete, a change from exogamous to endogamous marriage patterns can also be observed. The Timurids of the fifteenth century present a good example of such a change. Tīmūr's own wives were from more prestigious families. Later he became a wife-giver; and at a stage when the Timurids did not need alliances, marriages were conducted within the family, that is, endogamy gained precedence over exogamy.

Concubinage was another form of exogamy, where neither reciprocity nor hypogamy was the issue; concubinage was hypergamy for the slave women. Concubinage and polygamy relate to the domination of men based on power or wealth or both. In rare cases, or within a limited under-standing, these systems of concubinage and polygamy could work for the benefit of the women concerned. Yet all these issues need to be examined within each specific region and period, that is, in a micro and macro context. For this purpose the scant evidence (such as the letters of Hürrem Sulṭān) left by sultans who came from concubine backgrounds need to be examined, reading between the lines, to have a glimpse of their perception.

SOURCES

Studies on Central Asian women are very scarce and historical sources vary. Although there are no special studies by women or on women in histori-cal sources, there is a fair amount of information scattered in different places, such as myths, legends, epic literature, hagiographical texts, books of advice or mirrors for princes, historical narratives, mem-oirs, travelogues, and some *waqf* documents.

In all Central Asian regions, myths of conver-sion contributed to the development of cultural nodes, while in Anatolia myths or legends about the incoming Sufi masters and saints led to a sim-ilar development. Women played a significant role in most of these stories. These early myths and leg-ends later turned into hagiographies embodying characteristics of earlier oral literature that consti-tute rich sources for gender history. It is very diffi-cult to classify these accounts in terms of their genre, such as epos or hagiography, and then talk about their nature as sources for the history of women; neither were these sources written by women. But the context in which they were writ-ten provides clues about women. First of all, the fact that women are mentioned and appear in these accounts as leading figures is in itself a sym-bol of the mentality that was current. With the

reinforcement of patriarchy they would later dis-appear from these kinds of sources. Second, the fact that they appear as ancestresses of nations and of religious orders is another sign of the soci-etal attitude toward, and perception of, women. It is not at issue whether these accounts reflect the reality or not. It is more important that they reflect the mentality of Muslims for whom it was important to have a woman as a founder of their identity. As later developments in history show, the assignment of a place to women in the ideo-logical sphere cannot be dismissed as women hav-ing a place in ideology only, and not in reality. After the sixteenth century when we start to wit-ness a reinforcement of patriarchy on many fronts, women start to disappear from the ideological sphere too. Their presence in myths, epic litera-ture, hagiography, and historiography represents the legitimation of the women's position accord-ing to ʿurf, yasa, within an Islamic community. This trend is reflected in the historiography of the times. It is a trend that would fade away later in the nineteenth century. These women, such as Ālā Nūr Khānum for the Qarakhanids, Alan Ghoʾa for Muslim Mongols such as the Ilkhāns, the Chaghataids, the rulers of the Golden Horde – the latter two became Turkic speaking during the course of the time – or Fāṭima in the Naqshbandi hagiography in Central Asia, or Kadıncık Ana in the hagiography of the Bektāshiyya in Anatolia, dominate the literature of this period. It is a liter-ature written by men but taking women into account. Ālā Nūr Khānum appears in the conver-sion story, Alan Ghoʾa is the ancestress of the Mongols and of the later Muslim Turco-Mongols, Kadıncık Ana is found in the beginning of the Bektāshiyya, and Fāṭima gives legitimacy to Naqshbandiyya branches in the Kāshghar area. A similar role is given to Kanıkey in the Kyrghyz epic *Manas*, which also goes back to the Qara-khanid times or at least to the fourteenth–fifteenth centuries.

Epic literature, such as *Manas* from Central Asia or *Dede Korkut* from Anatolia, that is available in written form constitutes a source not only for the history of women but also for gender history. It represents vivid illustrations of interaction across and within gender. The researcher who uses these epics needs to determine the historical context in which they were put into writing. For instance, for *Dede Korkut* it is important to understand that the text as we have it was produced in the fifteenth century, whereas the earliest *Manas* text is from nineteenth-century Tsarist Russia.

A similar precaution is needed for hagiogra-

phical literature and early Ottoman historical narratives of ʿĀşıkpāşāzāde and Neşrī discussed in Togan (forthcoming).

Contextualization of a given source is also important for the advice or the so-called mirrors for princes literature. Among these the *Qutadghu Bilig* of twelfth-century Central Asia displays contradictions in terms of seclusion. The work, written under the Qarakhanids, reflects the contradictions inherent in the adaptation of nomadic women to a sedentary setting (see Togan forthcoming). In contrast, the *Siyāsatnāma*, written at about the same time among the Seljukids in Iran, presents a straightforward view. Women's place is secure indoors; there is also advice against their intruding in politics and appearing in public life. As is evident from these examples, the women of 800–1400 lived in varied environments; we cannot evaluate their standing in a uniform way, nor can we assess it on the basis of the genre of the written works, where contextualization is needed of the author, the work, and the society in which the work was created.

Another commonly used source is travelogues, written mostly by Muslim men. There are also some travelogues by non-Muslim (European or East Asian) men. It is difficult to discern the difference in religious background in the works of these men. They all tell us about women as they appear to them. We learn about the social standing of women or about their attire and appearance, about the ways they interact with others, notably with men. In his tenth-century account, Ibn Faḍlān travels from Baghdad to Khwārezm and to the Bulghār – the present Volga-Ural region. Ibn Faḍlān uses value judgments but he is not harsh on the women he sees in these regions. The fourteenth-century traveller Ibn Baṭṭūṭa, on the other hand, uses quite neutral terminology in his evaluations. As Tolmacheva states, "Ibn Baṭṭūṭa had received training as a legal scholar in the Mālikī school of Islamic law and served as a judge on several occasions. It is all the more significant then, that very few of his remarks are openly critical or disparaging of women or of society's permissiveness in regard to their social manner or mobility in public space" (Tolmacheva 1993, 120).

The Spanish ambassador Clavijo speaks of the women at Tīmūr's court with great admiration and respect. He describes their clothing, make-up, and ceremonies. We see these women taking part in feasts carried out in mixed company, serving wine and *kumiss*, the alcoholic drink made from mare's milk. Clavijo tells us further that upon the invitation of the chief wife of Tīmūr, he was shown around into all her tents (Clavijo 1928, 268). From this we know that as late as the beginning of the fifteenth century there was no segregation into *ḥaram* and *salām* in the Central Asian court.

The Taoist priest Ch'ang-Ch'un, on the other hand, describes women and their different headdresses in Samarkand, two centuries before Clavijo's visit. In the course of a long passage, he says: "The hair is always worn hanging down. Some cover it in a bag of floss-silk which may be either plain or coloured; others wear a bag of cloth or plain silk. Those who cover their heads with cotton or silk look just like Buddhist nuns" (Waley 1931, 106). Here we see that historical travel literature does not exhibit or reflect the prejudices of modern times; authors have their own prejudices pertaining to their own times. In terms of methodology, contextualization of sources is of primary importance.

The sources mentioned above are written, and issues can be studied from these sources in a positivist way. The researcher looks for direct or indirect information on women, and analyzes and interprets them accordingly. In this case we usually deal with "notable" women who have been found worth mentioning. Tombs and tomb complexes of such notable women and, if available, *waqf* documents or inscriptions on these tombs complement the written sources.

A second avenue is that of non-written sources, such as headdress, attire, textiles, motifs worn by women, handicrafts produced by women, women's visual depiction on tiles, miniature painting, inscriptions on tombstones, material painting, and non-monumental architecture. A systematic study of these sources will contribute to a reconstruction of the lives of ordinary women.

A third way would be to use all the sources mentioned so far plus others to reconstruct the perceptions and mentality of the times. As Elif Şafak, a young scholar, has shown, this can take the form of reconstruction of mentality related to what is regarded as feminine and beautiful rather than of women themselves. A wide variety of sources are available to help understand and analyze the theme of love, personal or divine, and comprehend attributes of the lover and the beloved and of divine beauty (Şafak forthcoming).

However, what is missing in all these accounts about women are the women themselves. It is very difficult to go beyond the level of appearances and to understand how women perceived certain situations or how they felt. Only after the sixteenth century do we have literature by women, such as

Mihrī Khātūn (d. ca. 1512) in Turkey and Gulbadan Begum (d. 1603) and Zīb al-Nisā' (d. 1707) in India. Timurid histories (fourteenth-fifteenth centuries) and the *Bāburnāma* are other sources of that nature.

At about the same time, that is from the end of the sixteenth to the middle of the seventeenth century, works of history began to be cleansed of aspects of oral literature. With this movement women were also excluded from works of history. One illustrative example comes from the two works by Shāh Maḥmūd Churās (d. ca. 1696), an accomplished writer of Eastern Turkestan. *Anīs al-Ṭālibīn* is a hagiographical work in which anecdotes concerning rulers, saints, women, and common folk are presented within aspects of oral literature. His second work, *Tārīkh*, consists of political history devoid of women. By the second half of the seventeenth century patriarchy had reasserted itself in Anatolia and in the western and eastern halves of Central Asia, even in the Volga-Ural region.

The disappearance of women from works of history caused by reinforcement of patriarchy (Togan 1999, 163–95) can be seen as early as the middle of the fifteenth century, although then it was not a widespread phenomenon. By the nineteenth century, however, patriarchy reached its climax, a development that was reversed in the twentieth century. These fluctuations over time are related to changes in the political sphere. Yet until the nineteenth century there were no revolutionary changes.

This new period of patriarchy was our heritage when we started to write women back into history starting in the 1980s. Future research into medieval and early modern sources will provide us with a greater variety of role models than at present.

BIBLIOGRAPHY

PRIMARY SOURCES
S. al-D. A. al-Aflākī al-ʿĀrifī, *Manākib al-ʿārifīn*, ed. Tahsin Yazıcı, 2 vols. Ankara 1976.
R. R. Arat (ed.), *Kutadgu bilig*, Istanbul 1947.
Babur, Emperor of Hindustan, *Vekâyi. Babur'un Hâtıratı*, trans. R. R. Arat, 2 vols., Ankara 1987.
A. N. Çiftçioğlu, *Âsikpasaoılu Ahmet Âsikî. Tevârîh-i Âl-i Osman*, in A. N. Çiftçioğlu (ed.), *Osmanlı tarihleri*, vol.1, Istanbul, 1949, 79–318.
Shāh Maḥmūd Churās, Anīs al-Ṭālibīn, Bodleian Library, MS India Institute Pers. 45 [Bodleian Library No. 2494].
——, *Khronika*, ed. O. F. Akimushkin, Moscow 1976.
R. G. Clavijo, *Embassy to Tamerlane 1403–1406*, trans. G. L. Strange, London 1928.
A. Eflâkî, *Âriflerin menkıbeleri*, trans. T. Yazıcı, 2 vols., Istanbul 1973.
O. Ş. Gökyay, *Dede Korkut Hikâyeleri*, Istanbul 1976.

A. Gölpınarlı, *Vilâyet-nâme*, Istanbul 1990.
Gülbeden, *Hümayunnâme*, trans. A. Yelgar, Ankara 1987.
Y. K. Ḥājib, *Wisdom of royal glory. A Turco-Islamic mirror of princes*, trans. R. Dankoff, Chicago 1983.
Manas, trans. Walter May, Moscow 1995.
M. Neşrī, *Kitâb-ı cihân-nümâ*, Ankara 1995.
Niẓām al-Mulk, *The book of government. Or, rules for kings*, trans. H. Darke, London 1960.
——, *Siyasetnāme*, Ankara 1999.
W. Radloff, *Manas Destanı*, trans. E. Gürsoy-Naskali, Ankara 1995.
V. V. Radlov, *Manas*, in V. V. Radlov (ed.), *Proben der Volksliteratur der nördlichen türkischen Stämme. V. Theil. Dialect der Kara-Kirgisen*, St. Petersburg 1985, 1–68.
F. Sümer et al. (ed. and trans.), *The book of Dede Korkut*, Austin, Tex. 1972.
W. M. Thackston (ed.), *Zahiruddin Muhammed Babur Mirza. Baburname*, 3 vols., Cambridge, Mass. 1993.
A. Z. V. Togan, *Ibn Faḍlān's Reisebericht*, Leipzig 1939.
M. A. Tolmacheva, Ibn Battuta on women's travel in the Dar al-Islam, in B. Frederick and S. H. Mcleod (eds.), *Women and the journey. The female travel experience*, Washington, D.C. 1993, 119–40.
A. Waley (trans.), *The travels of an alchemist. The journey of the Taoist Chʻang-Chʻun from China to the Hindukush at the summons of Chingiz Khan*, London 1931.

SECONDARY SOURCES
L. Ahmed, *Women and gender in Islam. Historical roots of a modern debate*, London 1992.
N. Araz, *Anadolu'nun Kadın Erenleri*, Istanbul 2001.
M. Bayram, *Bacıyan-ı Rum*, Konya 1990.
L. Benson, A much-married woman. Marriage and divorce in Xinjiang: 1850–1950, Paper presented at the Association of Asian Studies Annual Conference, Washington, D.C., 2–5 April 1992.
E. Bilgin (E. Şafak), Destructuring women in Islam within the context of Bektashi and Mawlavi thought, M.A. thesis, Middle East Technical University 1996.
D. DeWeese, *Islamization and native religion in the Golden Horde*, University Park, Pa. 1994.
E. Esin, Katun, in *Erdem* 7 (1991), 471–503.
S. Faroqhi, *Men of modest substance. Houseowners and house property in seventeenth-century Ankara and Kayseri*, Cambridge 1987.
W. E. Fernea and B. Q. Bezirgan, *Middle Eastern Muslim women speak*, Austin, Tex. 1977, repr. 1994.
G. R. Hambly (ed.), *Women in the medieval Islamic world. Power, patronage, and piety*, New York 1999.
A. İnan, Türk mitolojisinde ve halk edebiyatında kadın, in A. İnan, *Makaleler ve incelemeler*, 2 vols., Ankara 1969–91, 274–80.
R. C. Jennings, Women in early seventeenth-century Ottoman judicial records. Court of Anatolia Kayseri, in *Journal of the Economic and Social History of the Orient* 28 (1975), 53–114.
A. K. S. Lambton, *Continuity and change in medieval Persia*, New York 1988.
Melek Hanım, *Haremden mahrem hatıralar*, trans. I. Yergun, Istanbul 1996.
J. Millward, A Uyghur Muslim in Qianlong's court. The meanings of the fragrant concubine, in *Journal of Asian Studies* 53 (1994), 427–51.
H. Özdemir, *Adile sultan divanı*, Ankara 1996.
L. Peirce, *Imperial harem*, Oxford 1993.
E. Şafak, Venerated mothers, emancipated daughters, condemned sisters. The crossroads of marginality and

femininity in Turkish modernization maps of belonging (forthcoming).

P. P. Soucek, Timurid women. A cultural perspective, in G. Hambly (ed.), *Women in the medieval Islamic world. Power, patronage, and piety*, New York 1999.

İ. Togan, In search and approach to the history of women in Central Asia, in K. A. Erturk (ed.), *Rethinking Central Asia*, Reading, U.K. 1999, 163–95.

——, Islam. Early expansion and women (overview), in *EWIC*, v, Brill (forthcoming).

J. E. Tucker, *Women in nineteenth-century Egypt*, Cambridge 1985.

Ç. Uluçay, *Osmanlı sultanlarına aşk mektupları*, Ankara 1950.

M. Zilfi, *Women in the Ottoman Empire. Middle Eastern women in the early modern era*, Leiden 1997.

İSENBIKE TOGAN

Islamic Biographical Dictionaries: 9th to 10th Century

These collections comprise significant proportions and numbers of entries devoted to women as well as material on gender interspersed in the men's biographies. The types of women included in these collections reflect the cultural and political milieus in which their authors functioned. The earliest extant works were compiled exclusively by men more than two centuries after the advent of the Islamic community, at the high point of the far-reaching ʿAbbāsid Empire centered in the new imperial capital of Baghdad. They were composed at a time when scholars were collecting, evaluating, and classifying the bedrock material of Islam – the story of the life of the Prophet, his sayings and deeds, legal compendia, and exegesis of the Qurʾān. These scholars seem to have treated the material that came down to them about the early golden age of Islamic history quite gingerly. As a result, it is often difficult to separate gender relations in the urban centers of the affluent empire in which they lived from those in oasis towns of the Hijaz that they recreated.

The earliest extant Islamic biographical collection is the *Kitāb al-ṭabaqāt al-kabīr* (Book of classes) by Ibn Saʿd (d. 230/845). It deals with classes, or generations, of men and women from the Prophet's epoch to Ibn Sʿad's own time (drawing upon earlier written works that have not survived and oral traditions). Of the 4,250 biographies comprising this work, 629, or 15 percent, are devoted to women, concentrated in a separate section. The women are either Companions of the Prophet or Successors who did not come into direct contact with Muḥammad but with one of his Companions, as opposed to the men who comprise all of the generations up to the author's lifetime.

The male and female Companions of the Prophet Muḥammad have great symbolic and practical importance (for Sunnī Muslims in particular). Female Companions (ṣaḥabiyyāt) represent a large contingent of all women whose biographies were recorded through the generations, and to some extent the focus on the lives of the ṣaḥabiyyāt served as a model for subsequent biographers. The most privileged of these were the kin of Muḥammad and the early converts. Although male kinship and patrilineal genealogy were of primary importance, Arab society at the time of the Prophet is portrayed in the biographies as semimatrilineal, that is, female kinship and maternal lineage are frequently cited. The first believer was Muḥammad's first wife Khadīja, but not all of his female relatives are reckoned among the early converts. The original adherents to Islam – not all of whom were relatives of the Prophet – were ranked according to the timing of their conversion, but unlike male Companions, women's religious commitment was not principally linked to fighting in the early military campaigns. Thus, the proportion and number of women in the biography of the Prophet and other works that focus on the military exploits of the early Muslims is far lower than that in the biographical collections. Another impetus for the interest in biographies of the first generation of Muslim women was the attempt to elucidate the many verses of the Qurʾān that refer to women. Some women were even linked to exegesis of Qurʾānic passages that are not gender specific.

Another important, although not exclusive, rationale for including women in the biographical collection is their quantitative and qualitative role as transmitters of oral information, in particular ḥadīth traditions of the sayings and deeds of the Prophet. Already in the classical period, specialized ḥadīth dictionaries of male and female transmitters were produced concurrently with the compilations of sound traditions. One of the earliest formal collections of trustworthy traditions arranged according to the original authority – the *Musnad* of Ibn Ḥanbal (164/780–241/855), a contemporary of Ibn Saʿd in Baghdad – included traditions related in the first instance by 125 women out of 700 Companions, about 18 percent. When the organization by primary source was superseded by collections of traditions classified by subject, specialized indices of transmitters became even more important. The earliest of these were composed by Bukhārī (d. 256/870), author of the most prominent compilation of reliable ḥadīths classified by subject (*Al-jāmiʿ al-ṣaḥīḥ*), and his pupil Ibn Abī Ḥātim al-Rāzī (d. 327/938), who ranked the transmitters by credibility. Both of these handbooks of traditionists originally had separate sections devoted to female transmitters. Ibn Ḥibbān (d. 354/965), a ḥadīth scholar of

Nishapur, an important intellectual and commercial center at the time, produced a dictionary of reliable transmitters that was organized by generations. His book underscores the far smaller number of female traditionists of the first generation deemed trustworthy (222 compared to nearly 1,000 recorded in other sources as relating information from and about the Prophet). Gender was not a criterion for classical *ḥadīth* scholars, however, when they weighed the reliability of traditionists, since the proportion of women deemed trustworthy by Ibn Ḥibbān (16.5 percent) does not differ significantly from their percentage among the Companions in general. Nevertheless, female transmitters were regarded as different enough to be placed in separate sections. On the other hand, the format of Ibn Ḥibbān's handbook accentuates the dramatic drop in the number and proportion of female *ḥadīth* transmitters in the second and third generations (1.9 percent, 90 women among the Successors and only 12 in the third generation). This phenomenon is reflected in Ibn Saʿd's *Kitāb al-ṭabaqāt al-kabīr* as well.

Many biographies of women contain legal or customary precedents that are not elaborated in the Qurʾān. Most of these are gender related, such as ritual purity, marriage and divorce, burial arrangements, and women's apparel. Some of the traditions on what early Muslim women wore or avoided wearing clearly relate to modest dress. In *Marriage in Early Islam* (1939), Gertrude Stern concluded that the term *ḥijāb* had a well-defined meaning by the ninth century. This would reinforce the prevalent thesis that seclusion of some women as well as the legal dress code requiring the covering of the entire body save the face, hands, and feet were products of Byzantine, Sassanid, and imperial influences. Although this may be true, neither Ibn Saʿd nor subsequent classical biographers are concerned with the finer legal points of what women are prohibited from doing or permitted to do within the context of the *ḥijāb*. Some information reported in these biographies supports the idea of seclusion, but other parts imply that women had a greater degree of freedom. The silence of the biographers and their ambivalent attitude towards this issue may be a product of their mechanical transmission of information about the golden age of Islam even if it was incomprehensible and dissonant to them. Their approach to this subject may also reflect a tension between earlier practice and the social reality of their own time. It may be a function of a retroactive assumption that the early Muslim women obviously maintained rules of seclusion and dress developed at a later date, and

any information that seems to contradict this belief clearly derives from the period before the "*ḥijāb* verse" was revealed. In the context of legal or customary precedents, it is worthy of note that on occasion women may be linked to the origin of rules on issues that are not gender specific such as theft, emancipated slaves, and charity. Citation of women as legal and normative models in the biographical collections of Ibn Saʿd and others coincided with the classical age of the development of Islamic law. This suggests that gender analysis of the early legal compendia would complement and amplify findings from the biographies.

The female Companions of the Prophet and their Successors who were involved in miraculous events or are noted for their piety and devotion to Islam are important not only as role models for Muslim women but also as the first mystics and Sufis in Islam. Although the Sufi movement developed in the eighth and ninth centuries, long after the time of the Prophet, it was only natural that Ibn Saʿd, Ibn Ḥibbān, and biographers of the great mystics would include Companions as the first devout Muslims. The earliest extant dictionary of female Sufis, compiled by al-Sulamī (325/937–412/1021) another native of Nishapur around the turn of the eleventh century, comprised some 80 women (excluding Companions), compared to about 100 men in his *Book of Sufi Classes*. Although tales of mystic women rarely cite dates, many can be dated by external evidence to the golden age of Sufism in the eighth and ninth centuries.

Some information in the classical biographies of women relates to material benefits and political implications. The biographers of female Companions of the Prophet report in detail the cases of women who received shares of the spoils of war. Portions from the bounty of the Khaybar oasis were eventually transformed into stipends from the treasury of the Islamic state that were dispensed at least until the ʿAbbāsid period. Allocation of state funds to women or to male descendants of female Companions is worthy of further investigation. Women in the biographical material are rarely portrayed as directly involved in political affairs. Political messages encoded in the biographies of women, however, relate to the relative merits of early Islamic protagonists, derogatory references to the Umayyads (whose dynasty, centered in Damascus, was overthrown by the ʿAbbāsids in 747), positive depictions of al-ʿAbbās and in particular his wife Umm al-Faḍl, and hints at ʿAbbāsid-ʿAlid relations.

Classical biographical collections are a rich source for gender research that has yet to be fully

mined. The biographies have the advantage of concentrating information on women in easily accessible format, but this material is devoid of the context found in other sources from the period such as the biography of the Prophet, *ḥadīth* compilations, legal compendia, Qur'ānic exegesis, and historical chronicles. The concerns of the religious and scholarly establishment inform the content of the biographical collections to a great extent, accounting for the absence of information on many important types of women and aspects of women's lives. Moreover, women's voices are mediated by the male compilers. The perennial problem of texts written during the 'Abbāsid period that relate to the ideal formative age of Islam plagues these works as well. The dramatic drop in the number and proportion of women recorded after the first generation of Muslims limits comparisons of gender relations during the 'Abbāsid period itself to the image of women at the dawn of Islam constructed at that time. The large number and proportion of women from the golden age of Sufism memorialized in the tenth century, however, highlights the significant role of women in the formative stage of religious movements. These alternative, idealized images that emerged in reaction to the scholarship, the legalism, the affluence, and perhaps the political discord that increasingly characterized Islamic society may recapitulate the normative lives of the female Companions of the Prophet in an ideal past syndrome.

BIBLIOGRAPHY

Muḥammad Ibn Ḥibbān, *Kitāb al-thiqāt*, ed. M. 'A. Khān, 8 vols., Hyderabad 1973–82.
Muḥammad Ibn al-Ḥusayn al-Sulamī, *Early Sufi women. Dhikr al-niswa al-mutaʿabbidāt as-Sufiyyāt*, ed. and trans. R. E. Cornell, Louisville, Ky. 1999.
Muḥammad Ibn Saʿd, *Kitāb al-ṭabaqāt al-kabīr*, ed. I. al-ʿAbbās, 9 vols., Beirut 1960–68.
Ruth Roded, *Women in Islamic biographical collections: From Ibn Saʿd to Who's Who*, Boulder, Colo. 1994.
G. Stern, *Marriage in early Islam*, London 1939.

RUTH RODED

Islamic Biographical Dictionaries: 11th to 15th Century

Biographical dictionaries are valuable repositories of historical and cultural information about different groups of individuals from different eras. They contain references to those individuals who distinguished themselves in some way, on account of their personal accomplishments and aptitudes and/or their ascription to specific social classes or occupational categories. Happily for us, many of these works contain a special section devoted to remarkable women of earlier as well as of their contemporary periods. Critical scrutiny of these reports helps us identify the individual traits and accomplishments that conferred recognition on these women. Careful comparison of entries on individual women in biographical dictionaries from different periods also aids us in plotting how varying social and historical circumstances, undergirded particularly by shifting attitudes towards women's public roles, were reflected in recounting the lives of exceptional women.

In the period under discussion here, a number of important biographical works were written. The best known among them are: *Ta'rīkh madīnat Dimashq: Tarājim al-nisā'* by 'Alī b. al-Ḥasan Ibn 'Asākir (d. 571/1176); *Ṣifat al-ṣafwa* by 'Abd al-Raḥmān b. 'Alī Ibn al-Jawzī (d. 597/1201); *Tadhkirat al-awliyā'* by Farīd al-Dīn 'Aṭṭār (d. 628/1230); *Wafayāt al-a'yān wa-anbā' abnā' al-zamān* by Aḥmad b. Muḥammad Ibn Khallikān (d. 681/1282); *Siyar a'lām al-nubalā'* by Muḥammad Shams al-Dīn al-Dhahabī (d. 748/1347); and *al-Wāfī bi-al-wafayāt* by Khalil b. Aybak al-Ṣafadī (d. 764/1362). Although the next biographical dictionary stretches somewhat our *terminus ad quem*, I am also including the enormously influential *al-Iṣāba fī tamyīz al-aṣaḥāba* of Ibn Ḥajar al-'Asqalānī (d. 852/1449) in this period, for reasons that will become apparent.

Each of these biographical works has a section on women, a large percentage of whom are the *ṣaḥabiyyāt*, the women Companions who were the contemporaries of the Prophet Muḥammad. Often these entries are verbatim transcripts of entries from the earlier, better-known biographical dictionaries of the third/ninth and fourth/tenth centuries such as *al-Ṭabaqāt al-kubrā* by Muḥammad Ibn Saʿd (d. 230/845); sometimes they are slightly reworked entries from these earlier works. The major biographical works of the period also contain sections on notable women from succeeding generations, sometimes up to the period contemporary with the compiler, as is the case with *al-Wāfī bi-al-wafayāt* of al-Ṣafadī.

The majority of women whose names occur in these compilations fall into four principal categories: relatives and contemporaries of the Prophet; transmitters of *ḥadīth*; mystic women and women of learning in general; and women of literary and cultural accomplishments. In the first three categories, the *ṣaḥabiyyāt* predominate. More than half of the entries on women in al-Dhahabī's *Siyar a'lām al-nubalā'*, which spans the first seven centuries of Islam, and al-Ṣafadī's *al-Wāfī bi-al-wafayāt*, for instance, refer to the female Companions.

The inclusion of the female Companions in the first category by virtue of their kinship and/or contemporaneity to Muḥammad is practically automatic. But within this category, the female Companions, like the male, are "ranked" according to their *sābiqa*, a term which refers to their priority in conversion and service to Islam. Those who had converted the earliest and had rendered exceptional services to Islam were generally grouped together as comprising the first tier of women Companions; not unexpectedly, this group is overwhelmingly composed of the wives and female relatives of the Prophet who would have been in a position to hear his call to Islam the earliest. The next distinguishing characteristic of these prominent women is their role as transmitters of *ḥadīth*. Since *ḥadīth* is the second most important source of law after the Qur'ān, early male and female transmitters of the Prophet's sayings are held in high esteem. As dubious prophetic statements also gained circulation, it further became necessary for religious scholars to scrutinize the lives of the *ḥadīth* transmitters in order to establish their probity, since the reliability of a *ḥadīth* to a large measure depended on the reliability and moral reputation of the individual narrator. The largest proportion of women *ḥadīth* transmitters is drawn from the *ṣaḥabiyyāt*; to a lesser extent, they are drawn as well from the next generation, called

the *tābi'ūn*, or Successors. In the volume on women in his *Ta'rīkh madīnat Dimashq*, Ibn 'Asākir pays a fair amount of attention to the second generation of women, in addition to the *ṣaḥabiyyāt*, since his work is concerned with the Umayyad period when the *tābi'ūn* lived. In most other biographical works, however, the number of women Successors represented drops quite sharply, as does the number of women from succeeding generations.

The next most important category of women is that of pious, mystic women, who became renowned both for their personal piety and their learning. In Ibn al-Jawzī's *Ṣifat al-ṣafwa*, which is a collection of hagiographies of mystic men and women, 14 percent of the 240 women mentioned are *ṣaḥabiyyāt*. The rest of the women are from the succeeding centuries up to the late fifth/eleventh century. Ibn al-Jawzī's work is noteworthy for its inclusion of a relatively large number of women, especially when compared with the work of his predecessor 'Abd al-Karīm al-Qushayrī (d. 465/1072), which included none, or with the work of his Persian contemporary Farīd al-Dīn 'Aṭṭār (d. 628/1230), which included the name of only one woman, the celebrated Rābi'a al-'Adawiyya (d. 185/801).

The fourth category of women, those who were known more for their literary accomplishments and dynamic personalities than for conventional religious piety, is dealt with by biographers such as Ibn 'Asākir and al-Ṣafadī. One such figure mentioned by both is Sukayna bt. al-Ḥusayn (d. 117/735), who married several times, presided over literary salons that were attended by men and women, and earned both admiration and dismay for her biting wit. Female poets and singers, usually slaves, who performed at the caliphal courts, also find mention in these works; one example is Sallāma al-Qāṣṣ from the early second/eighth century, who was regarded as the most gifted singer of her time and favored by the Umayyad Caliph Yazīd b. 'Abd al-Mālik (d. 105/724).

Various theories have been formulated to explain the dwindling biographical entries on women who lived after the second/eighth century, taking into account such factors as: socioecological transformations as a consequence of the rise of urban, agrarian-based societies that transplanted the earlier nomadic ones; changes in the economic infrastructure resulting from the growth in landed property; and the rise of institutionalized learning, which led to the formation of formal, occupational classes and organized professional guilds that typically excluded women.

To these factors must be added the infiltration of certain non-Islamo-Arab values that impacted negatively on women's lives. The period 1100–1400 spans the Seljuk through the Mamluk eras with their distinctive social ethos, crafted from Persianate-Turkic values and sensibilities that were often at odds with classical Islamic values. Persianate sensibilities had of course already permeated particularly high Islamicate society starting in the 'Abbāsid period, as evidenced in contemporary writings. There were serious consequences to this development. Traditional Islamic and Islamo-Arab values that had remained in ascendancy through much of the second/eighth century began to be subtly and not-so-subtly transformed by the third/ninth century, so that by the beginning of the fifth/eleventh century, we can assert that some of these crucial values had been greatly undermined and transformed (Marlow 1997, *passim*). Among these Islamic values was egalitarianism, particularly religious egalitarianism, which predicated the equality of humans on individual piety and learning. The biographical literature in particular shows that women in the first two centuries benefited from this pietistic attitude, which ameliorated to a considerable extent the effects of gender on the moral valuation of an individual. But the infiltration of Persian and Hellenic notions of social hierarchy by roughly the end of the second/eighth century led to the valuation of an individual, that is the male, primarily according to his lineage, class affiliation, and occupational prestige; female relatives would derive their social status from that of the male.

Other sociohistorical trends had enormous repercussions on the lives of women. After the third/ninth century, women's public roles diminished considerably but by no means became nonexistent. Recent scholarship indicates that after the fourth/tenth century, as religious scholarship became increasingly the domain of men, women became progressively marginalized as participants in the production and consumption of religious learning of all kinds. As a corollary to the modesty and circumspect public behavior enjoined equally on men and women by the Qur'ān, the notion of seclusion for women began to be foregrounded in the 'Abbāsid period, probably due to the influence of the Persianate practice of seclusion, which signaled high-born status for women. Throughout the first and second centuries of Islam, as Muslims settled in lands formerly ruled by the Persians and the Byzantine Greeks, they also adopted the customs of female seclusion and veiling practiced by the elite among these people to indicate their aspiration to rise in social status (Ahmed 1992, 64ff.).

This development stands in sharp contrast to the accounts of the lives of the first generation of Muslim women who are depicted as active in the public sphere, particularly in the dissemination of religious knowledge, service on the battlefield as combatants and non-combatants, and as citizens of the new Muslim polity.

This situation affected how biographical entries were recorded in different periods of time particularly in regard to the first generation of Muslim women, who, along with their male contemporaries, now enjoyed the hallowed position of *salaf*, the pious forebears of Muslims everywhere. The male and female *salaf* were regarded as the moral and spiritual predecessors of later generations of Muslims, whose example the pious claimed to follow meticulously. Divergences in behavior from the reported lifestyles of the Companions of the Prophet thus potentially had grave moral repercussions for the scrupulous Muslim.

It is not surprising that the behavior of the female forebears as recorded in the earlier biographical collections would appear to be problematic for some of the later biographers. Particularly in the Seljuk and Mamluk periods, the ideal, virtuous Muslim woman was expected, at least by theologians and other custodians of moral propriety, to remain largely cloistered at home. This is clearly apparent from manuals composed by a number of jurists and theologians on the topic of legal ordinances for women (*ahkām al-nisāʾ*) in this period which prescribed socially desirable feminine behavior. These works should not be taken as reflective of actual social practices and realities but rather as a masculine "wish-list" of desirable qualities in the proper and decorous Muslim lady of the late Middle Ages. These works were, furthermore, primarily compendia of prescriptive counsel directed at women, the major thrust of which was intended to impress upon them not only the desirability but the necessity of staying at home to fulfil the requirements of religious duty and familial obligations, as defined by them.

It is interesting to note that in these works the *ṣaḥābiyyāt* are not customarily invoked as exemplars for their latter-day co-religionists. The reason for that is not hard to discern: the Muslim women of the first generation were anything but cloistered beings residing in splendid seclusion in their homes. According to the fulsome descriptions we have of many of them, some were stalwart combatants in battle, others took part in relief and humanitarian service on the battlefield and in the Prophet's mosque, and still others assumed leadership roles in religious worship. What were the Mamluk biographers to make of this phenomenon? The unedited life of the female *salaf* may after all convey potentially "seditious" impressions to Mamluk women about the range of social and religious activities to which to claim entitlement.

Thus we find that Ibn Ḥajar, for instance, sets out with editorial intrepidity to bring early historical reality more into line with late medieval constructions of virtuous feminine identity. We will look at some length at the specific entry on a particularly "problematic" woman, Umm ʿUmāra, whose independent ways and very public, "masculine" activities, as reported by the earlier biographer Ibn Saʿd, had to be doctored by Ibn Ḥajar in order to conform to Mamluk sensibilities. This he does by forefronting the account about another Companion, Umm Kabsha, which contains details that contradict the conclusions to be drawn from studying the life of Umm ʿUmāra.

Umm ʿUmāra, also known as Nusayba bt. Kaʿb, was a celebrated figure from the Banū Najjār. Ibn Saʿd devotes considerable space to a highly laudatory recounting of her exploits, relating four variant accounts of her valiant defense of the Prophet during Uḥud that emanate from different sources. According to Ibn Saʿd, Umm ʿUmāra gave her allegiance to the Prophet on the night of ʿAqaba (622 C.E., and eventually witnessed several key events of early Islam: she was present at Uḥud, al-Ḥudaybiyya, Khaybar, Ḥunayn, and al-Yamāma. Ibn Saʿd tells us that the valiant Umm ʿUmāra had headed for Uḥud with the intention of quenching the thirst of the combatants but soon found herself engaging in fighting against the enemy. As the tide of the battle began to turn against the Muslims, she remained by the side of the Prophet and began to fight herself, defending Muḥammad with a sword and a bow and arrow, until she was grievously injured. She is said to have sustained twelve wounds to her body, inflicted either by a spear or a sword. The Prophet himself commented on Umm ʿUmāra's valor thus, "Indeed the position of Nusayba bt. Kaʿb today is higher than the position of such-and-such person." She is also said to have lost a hand at al-Yamāma during the battle fought against the false prophet Musaylima from the Banū Ḥanīfa after the fall of Mecca in 9/630. Ibn Saʿd also mentions that she heard and transmitted several *ḥadīth*s from Muḥammad.

The second woman, Umm Kabsha, is described by Ibn Saʿd simply as a "woman from [the tribe of] Quḍāʿa." She is said to have accepted Islam and related a *ḥadīth* from the Prophet. Her entry

particularly catches our eye because she is said to have requested permission from the Prophet to go to battle with him and been refused. She then implored, "O Messenger of God, I will take care of the wounded and tend to the sick." But the Prophet told her, "Stay behind, so that people may not say that Muḥammad fights alongside women" (Ibn Saʿd 1997, 8:237–8). Ibn Saʿd does not mention which specific battle forms the backdrop for this account.

Ibn Ḥajar provides many of the basic details recounted by Ibn Saʿd in his entry on Umm ʿUmāra but with different emphasis on different details. His entry is only about a quarter the length of Ibn Saʿd's entry (Ibn Ḥajar n.d., 8:262). Given Ibn Ḥajar's special interest in ḥadīth and its transmitters, it is not surprising to see that he highlights the report relating Umm ʿUmāra's transmission of ḥadīth from Muḥammad. Like Ibn Saʿd, he then goes on to document Umm ʿUmāra's participation in the early major battles. Compared to the four breathtaking reports related by Ibn Saʿd concerning Umm ʿUmāra's prowess on the battlefield and particularly her brave defense of the Prophet, Ibn Ḥajar provides a single, rather lame account of the same. The prophetic praise earned by Umm ʿUmāra – to the effect that, as reported by Ibn Saʿd, Muḥammad declared her to have the highest status of all Muslims on the day of Uḥud – is not repeated by Ibn Ḥajar. In his rather insipid report, we already sense Ibn Ḥajar's ambivalence towards women's presence on the battlefield, the traditional locus of virile heroism.

It is in the entry on Umm Kabsha that we finally see a resolution in Ibn Ḥajar's biographical work with regard to what has clearly become a touchy subject (Ibn Ḥajar n.d., 8:270). Ibn Ḥajar relates that Umm Kabsha asked Muḥammad's permission to go out with such and such an army; again, as we can see, there is no reference to a specific foray in this report. The Prophet responds with a categorical, "No." Umm Kabsha then pleads with him and explicitly states that she does not wish to fight but only to tend to the wounded and provide water. In Ibn Saʿd's account, she is not quoted as saying that she would not fight. The Prophet then replies, "I would have given you permission were it not for the fact that it would become an established precedent (sunna), and thus it would be said that such and such a female had gone out [sc. to battle]. So remain behind" (Ibn Ḥajar n.d., 8:270).

Ibn Ḥajar then points out that the content of this single report is at odds with another report which relates that another female Companion, Umm Sinān al-Aslamī, had been granted permission to go to the battlefield. The only way to reconcile these two reports with their contradictory implications is to maintain, according to Ibn Ḥajar, that the ḥadīth concerning Umm Kabsha abrogates (nāsikh) the ḥadīth concerning Umm Sinān. According to him, the Umm Kabsha report is the later one and refers to an incident that occurred after the conquest of Mecca (al-fatḥ) in 9/630. Since the Umm Sinān report has Khaybar as the backdrop and another report refers to the battle of Uḥud, both of which were earlier, the later report, according to Ibn Ḥajar, must be considered to have superseded the earlier two. How Ibn Ḥajar comes to know the historical context of the Umm Kabsha report is not explained. Ibn Saʿd, as mentioned before, does not indicate a precise chronology for this report. Choosing the period after the conquest of Mecca as the historical locus for this report makes possible the implication that women's participation in battles before the fall of Mecca was unobjectionable because everyone, male and female, was obligated to defend Islam under the dire circumstances in which the small community of Muslims found itself. After the fall of Mecca, such participation could be dispensed with as Islam became the predominant religion in the Arabian peninsula and then a world civilization. By picking the post-fatḥ period to locate the Umm Kabsha report, Ibn Ḥajar is underscoring that specific historical exigencies in the early period had made women's participation in certain battles necessary, perhaps even desirable; once these exigencies were over, such participation was no longer not only not desirable but objectionable. The fact that Umm Kabsha is cited in Ibn Ḥajar's version as specifically disavowing armed combat and only desiring to aid the wounded and the thirsty is also very significant. Ibn Ḥajar leaves no doubt in the reader's mind that it was not potentially a combatant's role that was being denied to Umm Kabsha, but rather her physical presence itself on the battlefield, for even the most humanitarian of purposes.

Ibn Ḥajar does not at this point bring up, or perhaps conveniently does not remember, the case of Umm ʿUmāra, who is said to have lost a hand at al-Yamāma, a battle that was fought after the fatḥ in 12/633–4 (although both he and Ibn Saʿd mention this historical detail about Umm ʿUmāra in their entries). One could well argue that the conduct of a well-known ṣaḥābiyya who had fought in a clearly identified battle after the fall of Mecca should have more of a bearing on Ibn Ḥajar's discussion of this sensitive issue than the case of Umm

Kabsha, especially since the historical details of the latter are fuzzy at best. The Umm Kabsha episode, therefore, cannot provide a firm basis from which to derive categorical conclusions about the chronology involved, and this would also affect its status as an abrogating report. Ibn Ḥajar, however, appears to have clearly made up his mind regarding the latter-day propriety of feminine presence on the battlefield, and by extension, in the public sphere in general, and, therefore, produces only the Umm Kabsha episode as a proof-text in defense of this position.

This anxiety about female conduct in the public realm, as reflected in some of the later biographical works, reflects concern about the larger historical and political contexts. The Seljuk and Mamluk periods were times of social and political turmoil in the Islamic world. The depredations of the Crusaders and then of the Mongols had caused much material and psychological havoc. As has been generally noticed, in times of such upheaval, there is a tendency to regulate the domestic sphere and restrict women's conduct in the public sphere as a way to stave off further changes in men's public lives and ensure social stability. Political threat from without undoubtedly had further deleterious effect on women's public activities. Male scholars of all sorts from these periods seem to have participated in a collaborative venture to create a first-century genealogy for the practices of female seclusion and to encourage female abandonment of attempts to engage in socially responsible activities.

As is often true about historical records, it is sometimes not so much the written word as the unwritten sub-text that speaks volumes about the historical reality of a given period. Comparison of biographical works from the early and later periods helps us graph the fluctuations in women's lives and status through the generations and to decode the ideological underpinnings of later rewritings of some of these accounts. For this reason, among others, they remain an indispensable part of the sources at our disposal for the credible reconstruction of the lives of women, particularly from the early period.

BIBLIOGRAPHY

PRIMARY SOURCES
Farīd al-Dīn ʿAṭṭār, Tadhkirat al-awliyāʾ, ed. R. A. Nicholson, London 1905.
Muḥammad Shams al-Dīn b. Aḥmad al-Dhahabī, Siyar aʿlām al-nubalāʾ, ed. Shuʿayb al-Arnaʾūṭ et al., Beirut 1981–8.
ʿAlī b. al-Ḥasan Ibn ʿAsākir, Taʾrīkh madīnat Dimashq. Tarājim al-nisāʾ, ed. Sukayna al-Shihābī, Damascus 1982.
Aḥmad b. ʿAlī Ibn Ḥajar al-ʿAsqalānī, al-Iṣāba fī tamyīz al-ṣaḥāba, Beirut n.d.
Aḥmad Ibn Ḥanbal, Aḥkām al-nisāʾ, ed.ʿAbd al-Qādir Aḥmad ʿAṭāʾ, Cairo 1980.
ʿAbd al-Raḥmān b. ʿAlī Ibn al-Jawzī, Aḥkām al-nisāʾ, ed. Aḥmad Shūḥān, Dīr al-Zūr, Syria 1411/1991.
Aḥmad b. Muḥammad Ibn Khallikān, Wafayāt al-aʿyān wa-anbāʾ abnāʾ al-zamān, ed. Isḥsān ʿAbbās, Beirut 1968–72.
Muḥammad Ibn Saʿd, al-Ṭabaqāt al-kubrā, ed. Muḥammad ʿAbd al-Qādir ʿAṭāʾ, Beirut 1418/1997.
Khalīl b. Aybak al-Ṣafadī, Al-Wāfī bi-al-wafayāt, ed. Hellmut Ritter et al., Istanbul 1931–83.

SECONDARY SOURCES
A. Abd al-Raziq, La femme au temps des Mamlouks en Egypte, Cairo 1973.
A. Afsaruddin, Reconstituting women's lives. Gender and the poetics of narrative in medieval biographical collections, in Muslim World (2002), 461–80.
L. Ahmed, Women and gender in Islam. Historical roots of a modern debate, New Haven, Conn. 1992.
M. Chapoutot-Remadi, Femmes dans la ville mamluke, in Journal of the Economic and Social History of the Orient 38 (1995), 145–64.
L. Marlow, Hierarchy and egalitarianism in Islamic thought, Cambridge 1997.
R. Roded, Women in Islamic biographical collections. From Ibn Saʿd to Who's Who, London 1994.

ASMA AFSARUDDIN

Legal and Jurisprudential Literature:
9th to 15th Century

Islamic law, like most human legal institutions and traditions, was sustained and developed predominantly by patriarchal institutions from its inception, and continues to be so until the present. This did not just mean that most of the interpreters of Islamic law throughout its history were men, but also that the prevailing modes of Islamic legal interpretations and determinations were designed to preserve and promote male privileges over women. Women were made to fit narrowly defined functional categories where they were expected to negotiate their sociopolitical roles within limited parameters set for them by men. Most often, according to these functional categories, women were cast in primarily supporting roles for men where they were expected to serve the needs and desires of men as mothers, wives, or daughters. While men were empowered with far greater negotiative ability, which enabled them to play a wide array of sociopolitical roles, the capacity of women to redefine or reinvent their position within and outside the context of the family was portrayed as a serious source of moral danger.

The Islamic juristic tradition is replete with warnings about what is called the *fitna* (the seductions, and guiles) of women, and the dangers of this *fitna* to men. The constructed archetypes of women as seductresses, and as one of the main causes for the moral downfall of men, were utilized to maintain women within limited functional categories and to seriously constrain their negotiative abilities. This is well exemplified by traditions attributed to the Prophet that claim that most of those consigned to hell will be women, or men seduced and corrupted by women. This is also well represented by various misogynist traditions that restrict the ability of women to travel without being in the company of a male chaperone, or that emphasize the strict duty of wives and daughters to obey their husbands and fathers, or that even make a woman's ultimate salvation contingent upon the pleasure of her husband. Typically, such traditions proclaim that a wife will not enter heaven unless her husband is pleased with her, or that the angels curse women who upset or cause their husbands distress (Abou El Fadl 2001). Other misogynist traditions call upon women to avoid venturing

outside their homes except for dire necessities, or attempt to exclude women from public spaces such as mosques, gravesites, or common roads. In these traditions, women are told to remain in the spot farthest to the back in a mosque, or to walk on the farthest edge of public ways instead of down the middle of the road. Similarly, there are traditions that question the ability of women to assume positions of leadership and public responsibility, and that warn against putting women in charge outside their households. In this same genre, some traditions proclaim that a woman's body and voice are *'awra* (a private part that ought to be kept hidden from view), and therefore women ought not be seen or heard in public. These traditions have played a powerful role in justifying the seclusion of women, and in reserving the public space as a nearly exclusive male dominion (Abou El Fadl 2001b).

The dominance of patriarchy is a sociological reality that Islamic law shares with most other legal systems. Nevertheless, the actual extent or the hegemonic reach of this patriarchy remains seriously under-explored and poorly understood. Although the role of men in the development of Islamic law is well documented, the various roles played by women in the different places and periods of the legal system remain the subject of speculative and presumptuous scholarship. Moreover, the various texts that embody the Islamic juristic tradition are a rich but insufficiently exploited source for understanding the construction and reformulation of gender roles in the various periods of Islamic history. There is abundant evidence that the story of patriarchy in Islamic law was not a linear or straightforward one, and that despite the powerful patriarchal forces attempting to exclude and limit women, Islamic law remained one of the major fields where gender roles were strongly negotiated and contested. Both as the subjects and recipients and as the authors and makers of legal determinations, Muslim women played a dynamic negotiative role that is inconsistent with the prevailing stereotypes of the submissive position of women in Islamic legal history.

There is a wide range of textual sources that could be utilized in the process of understanding the varied roles played by women in the develop-

ment of Islamic jurisprudence. Such sources include, among others, historical texts, biographies, Qur'ānic commentaries, theological texts, works on Islamic positive law, legal *responsa*, court and administrative documents and records, fables and literary works, books on sexuality, and a genre of works, usually written by men, on the nature and social roles of women. The material issue in all these sources is not limited to the identity and gender of the authors of these works, and it is also not limited to what such works explicitly claim about women, their nature, their socioreligious roles and presence, and anticipated functions. Rather, what these texts omit, conceal, or obfuscate when it comes to dealing with women is at least as material as what is explicitly stated. It is important to take note of the articulated assertions made by the texts about the moral and sociohistorical position and roles of women, but it is even more important to investigate the unspoken and often hidden assumptions that inform these works, as well as the realities that such texts might be refusing to acknowledge or to come to terms with. But it is also necessary to recognize that Muslim jurists functioned within a highly technical and specialized culture that often responded to its own legalistic imperatives, and not just to sociopolitical realities. In many instances, the specialized technical language of the Muslim juristic culture acted to express or conceal the gender dynamics found in society, but often such language was the product of the self-perpetuating normative categories and binding precedents of the legal culture itself. Discerning the particular dynamic taking place in a set of juristic determinations requires researchers to understand the varied historical contexts of Islamic law, including the context of the juristic culture itself, as well as to investigate the detailed micro-level discourses of the technical language employed by Muslim jurists. This long and involved analytical process of understanding the relationship between Islamic law and women for the most part remains unaccomplished because, to a large extent, this field has remained highly politicized. In the colonial era, Orientalist scholarship sought to emphasize the inadequacies and failures of the traditions of the colonized by searching for evidence of the oppression and subjugation of women in Islam. In the postcolonial period, much of the field was co-opted by Muslim apologists who sought to prove that Islam liberated women, or by social theorists and feminist writers who, while entrenched in powerful theoretical paradigms, prejudged the source materials,

and attempted to construct it into ill-fitting frameworks. Much of this work failed to engage the particulars and details of the juristic discourses, or demonstrated a lack of facility and competence in dealing with the original sources.

Quite apart from the ideological commitments that have tended to plague modern scholarly approaches, one of the most intriguing aspects of Islamic legal history is the rather large number of women authorities who are reported as playing a major role in the early development of the legal system (al-Jawziyya 1996). Authorities such as the Prophet's wives, Umm Salāma and 'Ā'isha are reported to have played a foundational role in early legal adjudications, and were often the center of legal controversies implicating the position of women in society. For example, in various early traditions 'Ā'isha is often portrayed in the role of conscientious objector to legal determinations that are demeaning to women (Abou El Fadl 2001b). Among the equally intriguing but also woefully under-explored sources of information about early gender dynamics in the development of Islamic law are reports on the occasions for the revelation of various Qur'ānic prescriptions (known as the *asbāb al-nuzūl* literature). A substantial number of historical reports indicate that many Qur'ānic verses were revealed in response to ongoing gender tensions and dynamics prevalent within early Muslim society. Reportedly, for instance, the Qur'ān restricted the wide discretion men enjoyed in pre-Islamic society to terminate marriages by limiting the number of times men may divorce their wives, and by condemning the abusive and often vindictive practice of refusing to divorce a woman in order to prevent her from remarrying (al-Suyūṭī 1980, 44–8). Furthermore, there is evidence of widespread male resistance and even protest regarding the Qur'ānic allowance to women of a share in inheritance. According to a number of reports, at the time of the Prophet women demanded a share of inheritance and were granted this right over widespread male opposition in Medina. In addition, in response to specific historical incidents, the Qur'ān limited the access of men to their wives' property and money (al-Suyūṭī 1980, 64–5). These various reports do not convey a simplistic or streamlined narrative of either the vindication or suppression of women's rights in early Islam. Rather, what is apparent in these sources is evidence of a complex and nuanced negotiative gender dynamic that defies the anachronistic and often essentialist scholarship done thus far on women and the early development of Islamic jurisprudence.

Substantially the same dynamic is evidenced in the formative period of Islamic jurisprudence, particularly as to the evolving and competing doctrines of the many different schools of law. For example, one notices that the early schools of Medina and Mecca tended to be more restrictive toward women than their Syrian and Kufan counterparts. In addition, the views of some early authorities such as Ibn 'Umar and Ibn al-'Abbās tended to be considerably more conservative towards gender roles than, for instance, Ibn Mas'ūd. This indicates that Islamic law responded to and interacted with a very diverse set of sociohistorical conditions and cultural settings, and that these conditions and settings had a considerable impact upon the legal determinations pertaining to women. In some of the extinct schools of Islamic law, we find legal determinations that, compared with what eventually prevailed and became established as orthodoxy, are quite surprising. For instance, the extinct Jarīrī and Abū Thawrī schools held that women may lead men in prayer (Ibn Rushd 1999, 123). Furthermore, early heterodox movements, such as the factions of the Khawārij, whom the mainstream scholars often considered heretical (*ahl ahwā'* or *ahl bid'a*), had a notable number of women commanders and leaders, and perhaps as a result, such movements maintained that women may qualify for the *imāma* or the caliphate (al-Jāḥiz 1968, 2:8, 216, Kaḥḥāla n.d., 1:141). It is of course a subject of profound interest to attempt to understand if the atypical positions these schools adopted toward women contributed in any way to their ultimate demise and extinction.

Beyond the issue of the extinction of schools and its relationship to gender, there is a wealth of legal material documenting the continuing existence of major gender-related controversies in the later periods of Islamic history. This material is most often found in the fatwa literature and books of *fiqh* (normative jurisprudence). For example, in the fatwa literature of Ibn Taymiyya and others, there are reports of widespread debates on whether women may set prenuptial conditions in their marriage contracts that enable them to have a full and co-equal power to divorce their husbands if they so desire. This fatwa literature clearly indicates the existence of recurrent and vibrant sociological and legal debates over the ability of women to negotiate their status and rights within a marital relationship. Many of the debates, for instance, focused on the ability of women to use the marital contract as a means of setting conditions that guarantee various rights,

such as access to education, travel, and financial security (for instance, see al-Wansharīsī 1981, iii:6–10, 16–22, 52–5, 108–9, 142–4, 278–9, 384–8, 414–19; iv:366–77, 394–403). In jurisprudential works, there are numerous debates on matters such as the power of a woman to buy her freedom from an undesirable marriage by returning the *mahr* (dowry) to her husband – an institution known as *khul'* – and on more public policy oriented issues such as whether a woman may qualify as a *qāḍī* (judge) or as a *muḥtasib* (market inspector) (al-Farrā' 1983, 31–2, Ibn Rushd 1999, 768–9). Some of the most significant symbolic debates are over the extent to which wives owe their husbands a duty of obedience and the extent to which women possess an unqualified right of access to mosques and schools (al-Akbarī 2001, 1:281–2). Evidence that such juristic debates often represented discrete and complex sociopolitical dynamics is, for instance, found in the *responsa* literature of the Mālikī jurist al-Wansharīsī (d. 914/1508). Al-Wansharīsī reports on a major legal dispute regarding the legal status of a mosque in Andalusia that was commonly frequented by what he describes as heterodox groups and unveiled women. The dispute, al-Wansharīsī reports, focused on whether these unveiled women ought to be banned from frequenting the mosque, or if the mosque should be torn down (al-Wansharīsī 1981, vii:218). These examples serve to emphasize the fact that a careful examination of the detailed micro-level juristic discourses and debates, especially when correlated and placed within their multi-layered and varied sociocultural contexts, can yield a more thorough and vigorous historical view of the dynamics between gender and law in Islamic societies.

Among the richest sources of information are court documents on matters related to personal, criminal, and commercial laws, and texts of wills and trusts that have survived from various historical periods and geographic locations. Some contemporary scholars have started to plow through the voluminous court documents that survived from the Ottoman era, especially from Egypt and Syria. Court documents from the pre-Ottoman era are less accessible, but archeological finds in the Muslim world have not advanced to the point that would allow researchers to assess adequately the availability of actual legal documents, such as judicial decisions and instruments creating trusts or wills. Thus far, researchers have tended to rely on reports of court adjudications, or copies of legal instruments preserved in juristic treatises.

Until recently, most scholars adhered to what can only be described as the historical myth that Islamic law was largely theoretical, impractical, and unenforceable. This typically Orientalist mindset seriously contributed to a lack of interest in the micro-discourses of Islamic law, and also to the failure to seek out and study original legal documents from the pre-Ottoman era. This unfortunate fact has in turn limited our ability to understand the means by which women negotiated their positions or empowered themselves in male dominated judicial systems. Furthermore, although there is ample evidence that women from wealthy families often played a critical role in creating academic endowments for the study of Sharīʿa, we have only a very elementary understanding of the implications of such a practice for gender dynamics in Islamic history (for instance, see Kaḥḥāla n.d. 1:89).

It is well established that women played a significant role in the development of early Islamic jurisprudence, not only as the subjects of law, but also as the transmitters and makers of law. However, the continuing role of women as the authors and interpreters of the divine law is poorly understood. Biographical and other historical sources document the names of literally hundreds of women transmitters and narrators of Prophetic traditions (rāwiyāt al-ḥadīth) who lived particularly between the twelfth and fifteenth centuries. It appears that certain families from Damascus, Cairo, and Baghdad made a virtual tradition of training female transmitters and narrators, and that these female scholars regularly trained and certified male and female jurists and therefore played a major contributing role in the preservation and transmission of Islamic traditions. However, in addition to the preservation and transmission of traditions, a careful reading of biographical dictionaries reveals a large number of women who are described as jurists (faqīhāt), and who are asserted to have attained a level of competence that qualified them to issue fatwas. The stories of these women jurists are enormously diverse, and they suggest venues of research that might lead to the reconstruction of the understanding of gender relations in Islamic legal history. The scope and historical continuity of the stories are quite remarkable, and they range from earlier figures such as Hujayma bt. Ḥuyay al-Awṭābiyya (d. 81/701), who was described as one of the most notable jurists of Damascus, who is said to have taught numerous men, and who enjoyed the confidence of the Caliph ʿAbd al-Malik b. Marwān (r. 65/685–6/705), and used

to meet with him regularly when they would sit together in the back of the Damascus mosque (al-Ziriklī 1997, 8:77); or the Ḥanafī jurist, Khadīja bt. Muḥammad al-Jūzjānī (d. 372/983) (Kaḥḥāla, n.d., 1:341); to later figures such as Amat al-Raḥīm bt. Muḥammad b. Aḥmad al-Qasṭalānī (d. 715/1315) (Kaḥḥāla, n.d., 1:86); the Ḥanbalī jurist Khadīja bt. al-Qayyim al-Baghdādiyya (d. 699/1299); the Shafiʿī jurist Bāyy Khātūn bt. Ibrāhīm al-Ḥalabiyya (d. 942/1535), (Kaḥḥāla, n.d., 1:109, 339); and the Ḥanafī jurist Khadīja bt. Muḥammad al-Bataylūni (d. 930/1523) (Ibn al-ʿImād n.d., 8:172). Some women jurists attained the designation sitt al-fuqahāʾ, an honorific title connoting mastery of jurisprudence. Furthermore, biographical dictionaries report on women jurists who issued influential responsa such as the prominent Shafiʿī jurist Amīnā bt. al-Ḥusayn al-Maḥāmilī (d. 377/987) (Ibn al-ʿImād n.d., 3:88); Umm ʿĪsā bt. Ibrāhīm al-Ḥarbī (d. 328/940) (Ibn Kathīr 1996, 11:234); and others, like Zayn al-ʿArab bt. ʿAbd Raḥmān b. ʿUmar b. al-Ḥusayn (d. 704/1304), who occupied a prestigious teaching chair in Mecca (al-ʿAsqalānī, 1997, 2:69); or the Tunisian Sayyida bt. ʿAbd al-Ghanī al-ʿAbdarī (d. 647/1249), who taught law and regularly attended the council meetings of influential jurists (al-Ṣafadi/1991, 16:65); and the Shafiʿī Zaynab bt. Makkī al-Ḥarrānī (d. 688/1289), who taught in Damascus and was a center of attraction for law students from all over the Arabic-speaking Muslim world (al-Ṣafadi 1991, 15:67, Ibn al-ʿImad, n.d. 5:404). Similarly, it is reported that students thronged to the Cairo jurist Hājar bt. Muḥammad b. ʿAlī b. Abī al-Ṭāʿa (d. 874/1469), who is said to have adopted the practice of older women of her age of not veiling or wearing a head cover (al-Sakhāwī n.d., 12:131). Some women jurists are remembered primarily for taking part in what can be described as culturally meaningful events; for instance, Bint ʿAlī al-Minshār (d. 1031/1621), among other things, is remembered for inheriting and preserving a magnificent library of legal sources numbering about four thousand volumes (Kaḥḥāla n.d., 3:332). Amīnā Khatūn al-Majlisiyya (d. 1080/1669) was noted partly because her husband, a distinguished jurist in his own right, would often consult with her about the meaning of technical terms in law books (Kaḥḥāla n.d., 1:9). Meanwhile, the Shirāzī Ḥabībatu Allāh bt. al-Ṣaffī bt. al-Ḥusaynī al-Ayyjī (d. 895/1489), who studied and lived in Mecca, is remembered for her generosity, strong personality, and imposing presence. Reportedly, her husband secretly

took a young second wife, but when Ḥabība found out about his mischief, he rushed to divorce his new bride rather than confront Ḥabība's wrath (al-Sakhawī n.d., 12:19).

It is fair to say that considering the wealth of historical and legal sources that are yet to be studied, edited, or published, our understanding of gender dynamics and of the way that these dynamics influenced the development of Islamic jurisprudence is still in its nascent stages. One of the most startling facts, for instance, is that despite reports that some women jurists wrote as much as a 60-volume treatise on Islamic law (Kaḥḥāla n.d., 2:45) very few, if any, of these manuscripts authored by female legal scholars have been published. It is somewhat ironic that Islamic jurisprudence, including the issue of gender and its interplay with law, has been a victim of its own importance. It is exactly because Islamic law continues to be a symbolic construct that invokes strong sentiments that its details, micro-level discourse, and technical particulars have been largely sidestepped in modern scholarship. In other words, it is exactly because Islamic law continues to play a central ideological role until today that much of the work done in this field continues to search for a linear and one-dimensional narrative of vindication or condemnation of women's rights without sufficient regard for the complex processes of gender dynamics represented, and at times concealed and obfuscated, by the technical linguistic practice of Muslim jurists. But it is this technical linguistic practice that was the primary vehicle for negotiating, constructing, and inventing the meaning and role of gender in Islamic jurisprudence. Engaging the full range of sources that documented and pre-served the linguistic practice of jurists will enable researchers to start reconstructing and understanding the layered subtleties of the conception and roles of womanhood in the development of Islamic law.

BIBLIOGRAPHY

Abū Mawāhib al-Ḥusayn al-Akbarī, Ru'ūs al-masā'il al-khilafiyya, ed. Khālid al-Khashlān, Riyadh 2001.

Khaled Abou El Fadl, And God knows the soldiers. The authoritarian and authoritative in Islamic discourses. Lanham, Md. 2001a.

——, Speaking in God's name. Islamic law, authority and women, Oxford 2001b.

Shihāb al-Dīn Aḥmad b. Ḥajar al-ʿAsqalāni, al-Durar al-kāmina fī aʿyān al-miʾa al-thāmina, ed. ʿAbd al-Wārith Muḥammad ʿAlī, Beirut 1997.

Abū Yaʿlā Muḥammad b. al-Ḥusayn al-Farrāʿ, al-Aḥkām al-sulṭāniyya, ed. Muḥammad al-Fiqʾ, Beirut 1983.

Muḥammad b. Aḥmad Ibn Rushd, Bidāyat al-mujtahid wa-nihāyat al-muqtaṣid, Beirut 1999.

Taqi al-Dīn Ibn Taymiyya, Majmʿū al-fatāwā, ed. Muḥammad bin Qāsim, Riyadh n.d.

Abū al-Falāḥ b. al-ʿImād, Shadharāt al-dhahab fī akhbār man dhahab, Beirut n.d.

Abū ʿUthmān ʿAmr al-Jāḥiẓ, al-Bayān wa al-tabyīn, Cairo 1968.

Shams al-Dīn Abī ʿAbd Allāh Ibn Qayyim al-Jawziyya, Aʿlām al-muwaqqiʿīn ʿann Rabb al-ʿĀlamīn, ed. Muḥammad ʿAbd al-Salām Ibrāhīm, Beirut 1996.

ʿUmar Riḍā Kaḥḥāla, Aʿlām al-nisāʾ, Beirut n.d.

Abū al-Fidāʿ Ismāʿīl b. Kathīr, al-Bidāya wa-al-nihāya, Beirut 1996.

Ṣalaḥ al-Dīn bt. Aybak al-Ṣafadī, Kitāb al-wāfī bi-al-wafayāt, ed. W. al-Qāḍī, Stuttgart 1991.

Shams al-Dīn Muḥammad al-Sakhāwī, al-Dawʾ al-lāmiʿ li-ahl al-qarn al-tāsiʿ, Beirut n.d.

Jalāl al-Dīn al-Suyūṭī, Lubab al-nuqūl fī asbāb al-nuzūl, Beirut 1980, 44–8.

Aḥmad b. Yaḥyā al-Wansharīsī, al-Miʿyār al-muʿrib, ed. M. Ḥajjī, Beirut 1981.

Khayr al-Dīn al-Ziriklī, al-Aʿlām, Beirut 1997[12].

KHALED ABOU EL FADL

Literature: 9th to 15th Century

Women's literature thrived in many localities during this period of Islamic history, but it did not usually present itself as women's literature as such, in a package neatly segregated from men's literature; instead its specimens tended to be embedded in larger collectively-written texts generally ascribed to male authors, either by attribution, or, in the case of anonymous works, by default. Therefore, the sources one would consult for women's literature tend to be the same as those one would consult for men's, and the question for the student or researcher of women's texts is not "What did women write?" but rather "How did women contribute to what was written?" The answers to this question are as varied as the richness and diversity of the empire at that time would suggest; for this period of Islamic history, falling between the ʿAbbāsid overthrow of the Umayyads in 132/750 and the Ottoman conquest of Constantinople in 857/1453, is characterized by political decentralization and ethnic, linguistic, and cultural pluralism. The gradual weakening of the central authority in Baghdad led to the emergence of more localized seats of power, many of them vying with each other in their patronage of the arts. The resultant aesthetic cross-fertilization caused literature to blossom, such that the period witnessed the development of Arabic prose and the seeds of its fiction, the rise of Persian poetry, the golden age of Hebrew literature, and the emergence of Romance vernacular verse. This period also produced the multi-voiced and multilingual *muwashshah*, the picaresque *maqāma*, and the fantastical *Thousand and One Nights*. On the Arabic front, the transition from an oral to a textual culture was well underway, as knowledge and folklore found newer and faster means for dissemination. The importance of the more accessible and "popular" literature remained, however, and its influence may be felt in literary texts' exploitations of vernacular rhythms. At the beginning of the period, Arabic figures as the dominant vehicle for Islamic literary culture, even though, paradoxically, it was often non-Arabs drawing on their native literary traditions who were producing literary texts. But during the middle of the period, that is under the Samanids (204/819–395/1005) and the Ghaznavids (366/977–582/1186), Persian becomes a favorite language of the courts. It is sources written

in these two languages upon which this essay will focus, but with the underlying assumption that sources of women's literature exist in other languages current in the Islamic empire at this time. Of particular interest in this regard is a Turkish romance entitled *Jamshīd wa-Khurshīd*, a work listed in *Kashf al-ẓunūn* which is attributed to a Cappadocian poet named Janī Khātūn and which Ḥājjī Khalīfa had seen in the handwriting of someone who died in 815/ca. 1412 (Khalfa 1835–58, ii, 609).

Traditionally, verbal craft in Arabic has been divided into *naẓm* (verse) and *nathr* (prose or plain speech). While women from this time period spoke, wrote, composed, and extemporized in each category, their poetry was better preserved or anthologized and is thus better remembered today. Although some women do appear to have had careers as scribes, scholars, and secretaries, very few book-length works from this time period have been identified as female-authored and even fewer survive today. Short epistolary pieces abound but are scattered throughout a great range of sources. (Examples may be found in Ṣafwat 1937, iii, 374 and 527–9, iv, 393–4 and 402–3). Hence women's compositions from the era are predominantly poetic. Furthermore, those textual phenomena (namely, vocal citations) that may be considered women's contributions to prose genres, from popular romantic epics to highly ornate and stylized epistles, are often versified. Indeed, Arabic and Persian literary genres often inextricably link prose and verse forms, and the dimensions and implications of this admixture, which is known as "prosimetrum," have begun to garner the attention of scholars of Middle Eastern literatures (Harris and Reichl 1937, 225–348). Prosimetrum bears heavily on issues of female authorship in particular, and literary constructions of gender and sexuality in general, because for the most part women contribute to prose forms as quoted speakers of verse whose poems are narrated by predominantly male narrators, compilers, and editors. Historically, women throughout the empire during this time period had considerable power to compose texts, but they had less power to frame these texts for posterity in their own names, or so it would seem, given the dearth of book-length manuscripts attributed to women. To my knowledge it is not until the late fifteenth century that one finds a

female Arabic prose and prose/verse writer, in the figure of the religious Damascene scholar 'Ā'isha al-Bā'ūniyya (d. 922/1516) who has several extant works to her name. In this regard the historical picture looks quite different from the fantastical one. Perhaps no figure has as much power to frame, narrate, cut, and paste as the legendary Shahrazād. By contrast, actual women's voices are often encased in so many diegetic levels that one is tempted to read them as masculine authorial fictions, as the words that a succession of men would have women say. Although women's poems and sayings of the Jāhiliyya and early Islam are customarily framed by a chain of transmitters, or *isnād*, their words are often memorized and recited for their own sake as literary units. In subsequent eras, the frame, whether it be in the form of an *isnād* or not, undergoes a gradual epistemological shift, especially in the context of secular *adab*, transforming from a record of attestation to a narrative device. As a result, the 'Abbāsid or Andalusian woman's text often presents itself as a "voice" in a narrative pastiche, a direct quotation casually overheard by a witness or eavesdropper to an occasion in an anecdotal setting which may itself form a story within a story. Hence it is not unreasonable to suggest that women's extant verse and verse-prose compositions from this period, whatever their method of preservation, should normally be read as part of a dialogic continuum and not treated in isolation.

What follows is a discussion of sources of women's literature, categorized by method of preservation, and considered in light of frame and prosody. *Texts* includes sources that relay women's words, usually poems or poetic fragments, as units of literature in their own right, with brief interpolations of commentary or narrative. This category is comprised of single-author *dīwān*s, collective anthologies, and certain biographical compendia. The second category, *Contexts*, looks at *adab* compilations, popular romance and song. Here, women's voices are intimately intertwined with men's, and accepting their words verbatim often requires us to reconfigure our concept of authorship; otherwise, one is tempted to read feminine quotations as masculine hearsay. The final category, *Signs*, deals with epigraphic sources, or texts that are framed by material objects rather than other texts. This category, which roots women's voices tangibly in history like no other, has enormous interdisciplinary potential.

TEXTS

Generally speaking, women from this time period are not particularly well-represented in canonical medieval poetry anthologies. The standard Arabic anthologies, to the extent that they do include women's poetry, heavily privilege the "ancients" (*mutaqaddimāt*) over the "moderns" (*muhdathāt*). In his anthology devoted to "modern" poets *Tabaqāt al-shuʿarāʾ*, Ibn al-Muʿtazz (d. 296/908) highlights the work of a smattering of women poets associated with 'Abbāsid court culture (1956, 421–7). The staple Persian anthologies, such as 'Awfī's *Lubāb al-albāb* (617/1220) and Dawlatshah's *Tadhkirat al-shuʿarāʾ* (892/1487), do cite a few key female poets, but women are under-represented there as well. Nevertheless, these resources should not be overlooked, since they provide a formal poetic framework, or textually aesthetic context, for women's poetry. Moreover, they yield important clues as to the niches that women may have carved out for themselves in the literary marketplace. For example, Jajarmī's Persian anthology *Mu'nis al-ahrār fī daqā'iq al-ashʿār* (741/1342) relays three dozen quatrains by the eleventh- or twelfth-century poet Mahsatī, 22 of which appear in their own independent chapter (1350/1971, ii, 1151–5). These 22 poems are of the *shahrāshūb* genre, a type of poem in which a tradesman is either praised or mocked. Their arrangement in an independent chapter suggests both that Mahsatī was a premier poet of the genre and that, conversely, the genre held a special place in Mahsatī's corpus. Finally, when perusing anthologies, it is important to consult the less canonical collections. Peripheral anthologies, especially those that focus on specific geographical locations or marginal literary forms, sometimes contain gems of women's literature that go largely unnoticed by scholars who rely too heavily on a corps set of texts. For example, a collection of Andalusian *muwashshahāt*, the *ʿUddat al-jalīs* of Ibn Bishrī, contains a full-length piece attributed to the twelfth-century Granadan Nazhūn[1] (1992, 360–1), an attribution which tends to escape her biographical notices, both classical and modern.

In addition to the general anthologies, there exists a sub-category of gender-specific collections dating as far back as the early 'Abbāsid era. Two key 'Abbāsid monographs on women's verbal craft in Arabic, *Balāghāt al-nisāʾ* by Ibn Abī Ṭayfūr (d. 280/893) and *Ashʿār al-nisāʾ* by al-Kātib al-Marzubānī (d. 384/994), focus on women of the Jāhiliyya and early Islam, leaving us with little or no impression of women's poetry and prose of their day. What they do offer us is insight into the status of specific genres of women's writing within their community. Ibn Ṭayfūr organizes his book along a moral continuum: he begins with the

sacred (*ḥadīth* and other utterances of female fig-
ures associated with the Prophet Muḥammad),
moves on to the profane (such as wise sayings or
ḥikma, dialogues with the Caliph Muʿāwiyya and
elegiac poetry) and ends with the downright
obscene (*mujūn*). Al-Marzubānī organizes his
poetry anthology by the tribe of the poet, reflecting
ʿAbbāsid scholarly interest in genealogies. Both of
these works feature detailed *isnād*s for specific
entries, and in them one finds that certain names
recur frequently, perhaps suggesting a kind of
"women's studies" specialization on the part of
individual transmitters. Sadly, only a small fraction
of al-Marzubānī's anthology survives. Two other
classical Arabic monographs that are devoted to
women writers or poets who lived during this time
period and that are available in published form are
Al-Imāʾ al-shawāʿir by Abū al-Faraj al-Iṣbahānī
(d. 356/967) and *Nuzhat al-julasāʾ fī ashʿār al-nisāʾ*
by Jalāl al-Dīn al-Suyūṭī (d. 911/1505). Neither of
these is as substantial as either *Balāghāt al-nisāʾ* or
Ashʿār al-nisāʾ, in that their entries are brief and
presented out of context, but they are the only two
extant anthologies devoted to women's poetry
originating after the pre- and early Islamic periods.
Unfortunately, two other important works on
women poets, *Ashʿār al-jawārī* by the Shiʿi poet al-
Mufajjaʿ (d. ca. 320/ 932) and the multi-volumed
al-Nisāʾ al-shawāʿir by Ibn al-Ṭarāḥ (d. ca. 694/
1295), appear to have been lost.

It is tempting to view the preponderance of pre-
and early Islamic women's writing in early ʿAbbāsid
anthologies as a result of two key epistemological
factors: 1) the cultural importance and scholarly
emphasis on the founding years of Islam, which
made all linguistic and historical pursuits relating
to the period meritorious almost by definition and
2) the favorable position of women speakers,
poets, and storytellers in oral traditions, specifi-
cally that of pre-Islamic Arabia. In other words,
the cultural centrality of the Book (the Qurʾān) in
the early Islamic era ensured the oral transmission
and ultimate written preservation of women's
words at a specific moment in Arab history when
"high" literary culture was primarily oral while the
gradual rise of the book (i.e. written culture with
all its accoutrements and specialist training) corre-
sponded with, and may have contributed to, a
diminishment of women's access to the literary
marketplace in the subsequent era.

In Arabic, the benefit of an individual female
poet's *dīwān* originating in this time period is,
unfortunately, rare; for personal anthologies
would help us to find patterns of themes and tropes
characterizing a woman's corpus, to gauge her for-

mal development and to compare her *œuvre* to that
of her contemporaries, predecessors, and scions.
Although al-Nadīm lists some 15 women's *dīwān*s,
they were, for the most part, very short; the longest
were those of Hārūn al-Rashīd's sister ʿUlayya bt.
al-Mahdī, ʿInān, an associate of Abū Nuwās, and
Faḍl, a slave of al-Mutawakkil, which he measures
at 20 leaves each (1970, ii, 361–2). Occasionally,
biographical dictionaries contain a sizeable por-
tion of a poet's corpus in an entry, and it may be
worth perusing such sources for these types of
entries, especially since certain non-canonical
sources have eluded scholars collating biographi-
cal material on women. One poet of considerable
standing who has often been overlooked is the
thirteenth-century itinerant panegyrist Sāra al-
Ḥalabiyya.[2] A substantial body of her work,
including a sample of her prose, is included in a
biographical dictionary of prominent inhabitants
of Fez, namely Aḥmad Ibn al-Qāḍī al-Miknāsī's
*Jadhwat al-iqtibās fī man ḥalla min al-aʿlām
madīnat Fās* (1973–4, ii, 522–9).

Mahsatī, sometimes known as Mahsatī Ganjawī, is
a Persian poet of legendary status who probably
lived during the eleventh or twelfth century. Her
precise dates are unknown, but various classical
writers place her in the courts of Maḥmūd of
Ghazna (388/998–421/1030) and the Seljuk Sultan
Sanjar (511/1118–552/1157). It may be that her
association with the former derives from a con-
fusion between his historical figure and that of
Sanjar's governor in Azerbaijan, Sultan Maḥmūd
b. Muḥammad b. Malik-Shāh (Rypka 1968, 199).
Her birthplace is variously recorded as Ganja,
Nishapour, Badakhshan, and Khojand (Ishaque
1949, 12); hence modern-day Azerbaijan, Iran,
Afghanistan, and Tajikistan can all lay claim to her.
The story of her love affair with fellow poet Amīr
Aḥmad, son of a preacher from Ganja, is the subject
of a romance in which prose narrative is interwoven
with poetic verse. Her fictional biography, as it is
inscribed in this romance, follows a rags-to-riches
trajectory: orphaned as a young child, Mahsatī
was forced to find her keep in a *kharābāt*, which is a tav-
ern or a house of ill repute, but due to her refine-
ment, musical training, and talents, she quickly
became a frequent guest and admired entertainer of
the ruling elites. Regardless of the veracity of her life
story, she ranks among the pioneers of the Persian
quatrain or *rubāʿī* (de Blois 1994, 409). She is
known, in particular, for her mastery of the
shahrāshūb, a type of poem in which a tradesman,
such as a butcher, a smith, or a carpenter, is either
praised or mocked, often through elaborate puns
and sexual innuendos. She has a reputation for
bawdiness (de Bruijn *EI*[2]), but her penchant for sex-
ually explicit imagery does not seem to have
detracted from her respectability. Indeed, in his
Ilāhī-nāma, the Sufi mystic Farīd al-Dīn ʿAṭṭār refers
to Mahsatī as "the scribe" (*dabīr*) endowed with
"pure essence" (218). (See the illustration section
following page 314.)

There are published *dīwān*s of two women poets of Persian from this period. Mahsatī's has been collated from a variety of sources, including general anthologies, histories, and legends, and is available in more than one edition. There is conflicting information about whether or not a version of her *dīwān* circulated as a manuscript in premodern times. (De Bruijn *EI²*, Ishaque 1949, 11n.) The size of Mahsatī's corpus compares very favorably to that of her Arabic-writing female contemporaries, but an even more astounding legacy comes down to us from the fourteenth-century Jahān Khātūn.[3] Her *dīwān* may turn out to be the richest and most significant source of women's literature in the Islamic world from this period. The first published edition, which was collated from three manuscripts, contains four *qaṣīda*s, over 1,400 short lyric poems (*ghazaliyyāt*), a strophic poem (*al-tarjī-band*), an elegy (*marthiyya*), and a number of poetic fragments (*muqaṭṭaʿāt*). The sense of wholeness that accompanies such an extensive anthology with its wealth of integral (as opposed to excerpted) verse forms puts her corpus on an analytical par with the celebrated male poets of her age. Although E. G. Brown mentioned in *A Literary History of Persia* (1902–24) that he possessed a manuscript of her poetry (iii, 233n), the edited anthology was not published until the late 1990s, and the fact that scholars overlooked her work for so many decades gives one reason to pause. On the one hand it reminds us that the marginalization of women in literary canons is not a premodern phenomenon but rather a gradual process of exclusion and neglect that continues to this day. On the other hand, however, it gives one hope that other gems of Islamic women's literature are waiting to be recuperated.

Last but not least, works about women that are not specific to poets or writers sometimes contain poems and excerpts from women's text. This is due to the fact that they tend to deal with elite and educated segments of the female population such as noblewomen, the slaves and clients of nobles and dignitaries, scholars, and mystics. These works include *Nisāʾ al-khulafāʾ* by Ibn al-Sāʿī (d. 674/1275 or 1276), *Al-Mustaẓrif fī akhbār al-jawārī* by Jalāl al-Dīn al-Suyūṭī (d. 911/1505) and *Dhikr al-niswa al-mutaʿabbidāt al-Ṣūfiyyāt* by al-Sulamī (d. 412/1021), which Rkia Cornell has cross-referenced with the section on women in Ibn al-Jawzī's biographical dictionary *Ṣifat al-ṣafwa* (263–327). Ultimately, they are too numerous to be listed here. Readers may wish to consult Ṣalāḥ al-Dīn al-Munajjid's article on classical books about women, both extant and lost, entitled "Mā

ullifa 'an al-nisā'" (1941). It is still useful but needs to be updated. It is important to bear in mind when consulting these and other sources of women's literature that obscenities are often censored in published editions and that it may therefore be necessary to consult alternative editions and/or manuscripts. It is perhaps appropriate to end this section with reference to a rare tome compiled by a woman: now apparently lost, it is a book about Andalusian *qiyān* (singing slave girls) attributed to an author named Fatḥūna bt. Jaʿfar al-Mursiyya, which she is said to have composed in imitation of Abū al-Faraj al-Iṣbahānī (Al-Tāzī 1992, 119–20).

CON-TEXTS

This category covers those sources in which what may be identified as a woman's text is embedded in another text and framed in such a way as to cast doubt on the authorial authenticity of the woman's text in question. One is more apt to consider it as a narrative voice, created by a third-person narrator/author if we take the source to be fictional, or by a third-person reporter/witness if we take it to be factual. In this category, even when woman's speech is understood to represent what was actually said or written, it loses its originative force and comes across as a subsidiary text: hence the woman speaker is rarely identified as an author or even as a contributing author to the frame text. Here, a male, or potentially female, narrator or editor always exerts some control over woman's text, but not always to the same degree, and sometimes woman's text may influence the way man – or woman – frames it.

In this category one finds first and foremost *adab*. The term applies to a wide variety of predominantly secular works meant to edify, enlighten, and entertain. They are often constructed around exemplary, historical or legendary anecdotes, or *akhbār*, cited to illustrate a point. An *isnād* often serves to frame the *akhbār*, but the narratological transitions between anecdotes and the thematic connections amongst them also function as hermeneutic structures that frame women's words and their meanings. To attempt to inventory all the *adab* works that include potentially authorial women's citations would be cumbersome, suffice it to highlight just a few. One branch of *adab* that is particularly rich with women's words, witticisms, and verses is that which Bray dubs the "palace tradition" (1999, 75–6). It refers to sources that relay anecdotes about the noblewomen, *jawārī*, and courtesans who occupied or frequented ʿAbbāsid (and, in Iberia, Umayyad) palaces, as well as those of subsequent regimes. These sources

include *Kitāb al-aghānī* by Abū al-Faraj al-Iṣbahānī (d. 356/967), *Al-ʿIqd al-farīd* by Ibn ʿAbd Rabbih (d. 328/940) and *Nafḥ al-ṭīb min ghuṣn al-Andalus al-raṭīb* by al-Maqqarī (d. 1041/1631), but there are countless others. The question is not so much what *adab* to read but how to read it. Incidentally, like the poetry anthologies of their day, these sources often privilege women's writing of preceding eras, but they are still rich with quotations of the latter-born. Another fecund branch of *adab* includes epistles composed on a variety of topics by the likes of al-Jāḥiẓ (d. 255/869). In epistles such as *al-Qiyān*, *al-Bayān wa-al-tabyīn*, and *Kitāb al-ḥayawān*, as well as many lesser known works, al-Jāḥiẓ cites women with great frequency. One work which is attributed to him pseudonymously is *al-Maḥāsin wa-al-aḍdād*. The work features a series of vignettes about women, and the way in which it is organized, with passages focusing on the *nādiba* (mourner), the *mājina* (dissolute), the *aʿrābiyya* (woman from Arabia), the *mutakallima* (speaker or theologian), the *nāshiza* (sex-withholding wife), etc., lends insight into how women and their words were socially classified, potentially with regard to how non-Arab women were gradually assimilated into an Arabic-speaking society and the linguistic and literary influences that permeated cultural exchanges. These anecdotes, in other words, provide us with scenes of cultural interface that help us to tease out the threads interweaving, in most cases, the Persian- and Arabic-speaking literary milieus. Bray discusses the work in connection with an article exploring the generic status of "bleeding poetry," that is poems composed by both men and women dedicated to an important figure on the occasion of his or her bloodletting (*faṣd*) (1999, 75–92). This type of poetry, especially insofar as it is associated with women, brings up at least two potentially provocative points of comparison between tropes that recur in Islamic literature across temporal and geographical boundaries. First, one finds an interesting opposition between the bleeding poems, which are basically short panegyrics offered to a "bled" – and hence "cured" – patron, and pre-Islamic elegies of blood vengeance, in which the spilt blood of the slain kinsman is likened to the menses and therefore synonymous with a state of pollution that can only be cleansed through retaliation. (Stetkevych 1993, 161–205) The second point of comparison occurs in the thematic syncretism between Arabic and Persian blood imagery. Mahsatī's erotic poems are rife with allusions to blood, and she occasionally addresses or refers to the phlebotomist or *faṣṣād* (Ishaque 1949, 16 and 28).

Indeed, blood provides rich and multifaceted metaphors for literature in general, and for Arabic and Persian poetry in particular, and examples of women writers' usage of blood imagery may give us insight into the mechanisms by which women transform objectifying tropes into sources of subjective agency.

In assessing the authoritative power of woman's word within a given text, it may be useful to consider its didactic or aesthetic purposes, since the contexts of content and form impact directly on matters of authorial intent. When an author subjects the quotations of others to his or her own moral or aesthetic framework, those quotations assume a degree of fictitiousness. The Persian-language *Ilāhī-nāma* by Farīd al-Dīn ʿAṭṭār (d. circa 616/1220), for example, contains brief stories about two legendary women, Mahsatī and the mystic Rābiʿa al-ʿAdawiyya (d. ca. 135/732) (1976, 115, 153, 218–19). At times the women speak in the first person, but the citations do not seem to be meant as authentic attributions, for the words put into their mouths conform to the rhyme and meter of ʿAṭṭār's *mathnawī*. However, to the extent that the lines may reflect the aesthetic and philosophical viewpoints of their speakers, they in some way conform to their legendary authority and should, perhaps, at least be considered as echoes of authorial presences. Since the stories terminate with bits of mystical wisdom, it is not hard to see how a legendary Sufi figure such as Rābiʿa would emerge as an authority in a text like the *Ilāhī-nāma*. Still, formalistic and didactic considerations cast doubt on the authenticity of the citations and compromise the book's value as an accurate source of women's literary history.

In some cases, however, women's words seem to shape their frames, rather than being shaped by them. Consider the example of a satirical poem by Nazhūn, which appears, in more or less identical forms but in different contexts, in *Al-Mughrib fī ḥulā al-Maghrib* by Ibn Saʿīd al-Maghribī (or al-Andalusī, d. 685/1286), *Al-Iḥāṭa fī akhbār Gharnāṭa* by Lisān al-Dīn b. al-Khaṭīb (d. 776/1374), and al-Maqqarī's *Nafḥ al-ṭīb*. In the first two sources, the poem surfaces in biographical entries on the object of Nazhūn's satire, a male poet and satirist himself. There is a difference, however, in the editorial designs of the sources' compilers; for whereas the thirteenth-century Ibn Saʿīd cites Nazhūn's poem for its slander against the satirized party's hometown of Almodóvar, as is evidenced by an introductory anecdote depicting the town as a dangerous backwater (1953, i, 222–3), the fourteenth-century Ibn al-Khaṭīb cites the poem for its

slander of the satirized party himself, as is demonstrated by the editor's own defamation of his character, which opens his biographical entry (1955, i, 432–3). In the third source, al-Maqqarī cites the poem, as well as the occasion on which it was uttered, as an example of the ferocity with which Andalusian satirists verbally assaulted one another (1968, i, 190–3). In this instance, Nazhūn's text behaves as a formal unit somewhat independently of its framework. When others appropriate her words for their own purposes, they are, in effect, offering interpretations of her text, rather than manipulating or distorting it.

Beyond *adab*, the contextual category includes the popular genres of romance and song. Here women's voices are cited with great frequency and often by anonymous, and thus theoretically unsexed, authors. One Persian-language romance that is constructed in part on the verses of a female poet is the story of *Amīr Aḥmad u Mahsatī*. It recounts the star-crossed amorous adventures of Mahsatī and another poet, Aḥmad b. al-Khaṭīb. While the romance is sometimes ascribed to Jawharī of Bukhara, the version found in a manuscript at the British Library which dates from 867/1462 is unattributed. In it the two protagonists and various other characters recite quatrains to each other, at times conversationally, and their verses are interspersed with omniscient narration and dialogue. Obvious questions arise as to the authenticity of both the events recounted and the poetry cited, since history and legend, fact and fiction, are deftly interwoven. How does one interested in the historical limits and bounds of female authorship approach such a text? How cynically should one read Mahsatī's words? In a prosimetrical case such as this, where it would seem that the constituent poetry, or at least a key portion of it, historically precedes the narration, it is helpful to give equal weight to prose and verse when considering the plot and structure of the fictionalized account; for sometimes the quoted figure seems to direct the narrator/scribe through the course of the narrative. For example, the romance features a trip to the bazaar, where Mahsatī and Amīr Aḥmad address various tradesmen, and the episode acts as a showcase for the *shahrāshūb* (Anon. 867/1462, 91b–95a). Thus one can see how Mahsatī's celebrated compositions in a certain genre give shape to a predominantly fictitious account of her life.

Another popular genre in which women's voices are routinely cited is the song/poem known as the *muwashshaḥ*. This form, with compositions in Arabic and Hebrew, originated in Andalusia by the eleventh century and differs from the paradigmatically dominant Arabic *qaṣīda* in two key ways: first, it is divided into stanzas with varying meters and rhymes, unlike the *qaṣīda*, which maintains the same meter and rhyme throughout; and second, it tends to exploit vernacular language, either Arabic or Romance, especially in the final refrain, known as the *kharja* or "exit" which is often written in a grammatically, if not musically, "feminine" voice and introduced as a direct quote with a phrase such as "he said" or "she said." Much ink has been spilled over the *kharja*, its colloquial and uninhibited expressions of sexual desire, and its association with women and ephebes. Some scholars have adopted the view that many *kharja*s, especially romance *kharja*s, were pre-existing songs, coopted by the *muwashshaḥ* composers, while others argue that they were constructed by those composers as a conceit. The *kharja*s contain some of the earliest specimens of Romance lyric, and they have therefore piqued the interest of scholars of European literatures, some of whom, most notably Theodor Frings, found in them evidence that medieval European courtly love poetry evolved out of a kind of primordial female emotiveness (Monroe 1974, 16). But few have analyzed the "femininity" of the *kharja* in the context of a gender dynamic running throughout the form as a whole. Is the *muwashshaḥ* an inherently masculine paradigm, as has been said of the polythematic *qaṣīda*? (al-Sajdi 2000, 121–46). Must a woman's voice be confined to the exit? If so, how does one account for the aforementioned *muwashshaḥ* attributed to Nazhūn? Up till now, discussions about women's potential involvement in the authorship of the *muwashshaḥ* have been limited to its final refrain. This would seem to place them in a subordinate position vis-à-vis the poem's author who would appropriate their words to his own devices. Hence a woman's authorship of the entire lyric would seem to be by definition subversive, unless of course the feminine voice is more integral to the entire form than its scholarly relegation to the *kharja* would have one believe. Nazhūn's biographers do not mention her involvement with this strophic genre, and the attribution may be incorrect, but questions provoked by the historical fact of female authorship of the *muwashshaḥ* remain; for other women, such as the eleventh-century Andalusian poet Umm al-Kirām, are known to have been *muwashshaḥ* composers.

SIGNS

Throughout the previous category, women's voices are often buried under many layers of male narratives. Indeed, it sometimes seems that textual

excavations are required to locate those sites in Islamic literature where women contributed, as authors, to hybrid textual forms, be they anecdotal compilations, episodic and prosimetrical romances, or multi-voiced lyrics. These texts come down to us framed in other texts. But what of those texts that are framed by objects, materials into which their words are inscribed, carved, and stitched? Literary histories cite numerous examples of women's verses punctuating all kinds of objects from fruit to garments and vessels. The Cordoban princess and poet Wallāda bt. al-Mustakfī[4] (d. 484/1091), for instance, famously wore a robe embroidered with provocative verses. While most of these objects may have receded into oblivion, the few that do remain may be immensely helpful in situating women writers in their historical, social, political, cultural, and material contexts. Two significant examples of artefacts bearing on women's literature from this period are (1) a ceramic bowl at the Victoria and Albert Museum in London whose exterior is decorated with a quatrain ascribed to Mahsatī (see the illustration section following page 314) and (2) the tombstone of Maymūna al-Hudhaliyya (RCEA 9, no. 3306), which features a poem written in the voice of the deceased, and is currently located at the Archaeological Museum in the Citadel, on the Maltese island of Gozo. While the texts themselves are brief and may be of limited value to students and researchers of literary styles and forms, they have an enormous amount to teach us about outlets for women's poetry, its historical settings and circumstantial occasions. In this way they root women's words in time and place much more firmly than the scribes and copyists of manuscripts.

In a seminal article entitled "Mahsati Ganjavi et les potiers de Rey," Firouz Bagherzadeh sorts through textual, archaeological, art-historical, and religio-political evidence in order to determine the probable source of a quatrain appearing on the outside of the aforementioned ceramic bowl. Bagherzadeh notes that the poem is attributed both to Mahsatī and to the Seljuk panegyrist Anwarī (d. ca. 586/1190) and sets out to determine which attribution is correct. By considering information about the bowl's provenance and its Haft-rang variety, the author is able to pinpoint the date (1155–1223 C.E.) and the location (ʿIrāq-i ʿAjam) of its origin. Then, by contemplating the geopolitical and social history of the region, Bagherzadeh is able to deduce that Mahsatī is more likely to have been the quatrain's composer than Anwarī. The latter, a committed Sunni, would not have been a popular choice of poets in ʿIrāq-i ʿAjam during that period of intense sectarianism due to the predomi-

nantly Shiʿi sympathies of the inhabitants of the region (Bagherzadeh 1992, 166). Moreover, Mahsatī's reputed poetic dalliance with tradesmen and artisans suggests that she would have been a favorite for the Haft-rang master ceramists (1992, 173). In sum, this unlikely source of women's literature helps to authenticate an attribution, and this is no small feat in the case of a poet whose career has been overshadowed by her legend. The bowl also underscores Mahsatī's importance as a poet for the mercantile classes and not merely for the ruling elite.

At about the same time that the bowl was created in ʿIrāq ʿAjam, or, to be more precise, in 569/1174, a woman named Maymūna bt. al-Ḥasan b. ʿAlī al-Hudhalī died in the Mediterranean, perhaps on the Maltese island of Gozo, where her gravestone is said to have been found in a field by the road from Xewkija to Sannat (Grassi 1989, 35). This woman whose name is etched in stone lies in authorial obscurity today. Nevertheless, a brief poem of self-mourning written in her voice lives on in a marble stele that apparently once marked her grave. The poem, along with the rest of the funerary inscription, was preserved in stone and hence theoretically free from the distortions and mistakes inflicted on texts passed down by imperfect copyists and scribes, but it was subjected instead to the erosive forces of nature and time. Variations of the text thus exist as a result of divergent readings of its single source. The renowned nineteenth-century scholar Michele Amari remarked that few epigraphs, in Arabic or in any other language, yielded as many interpretations as Maymūna's tombstone (Grassi 1989, 219), also known as "Majmūna's tombstone" or the "Sciara inscription." While the poem itself may not have been written by the deceased woman, the fact that it was written in her voice is significant; for it demonstrates that women had access to semantic authority even in the remote corners of the Islamic world and even beyond its geopolitical boundaries. Indeed, the Christian Normans captured Malta in 483/1090, more than eight decades before Maymūna's death, and many Muslims remained and prospered there until Frederick II expelled them in 647/1249.

On the outside, texts are always framed, either by an object or by another text. How one handles that frame influences their meanings and our interpretation of them. Sometimes a frame seems permanent and unbendable, as in the case of a gravestone. At other times a frame seems logically constructed around resemblances and identities, as in the case of collective poetry anthologies and

individual *dīwān*s. But the vast majority of frames, such as those that occur in *adab*, contain and circumscribe with a great measure of malleability. In order to assess the strength of women's words within these frames, thereby broaching the subject of women as agents of collective authorship, one needs, first and foremost, to deconstruct the frame. In the vast majority of cases, this will be, at least in part, a narratological endeavor, since women's words are most often narrated by men. On the inside, in the middle of the frame, lies the core of woman's word; since this is usually a poem, one must work with poetics. Do woman's devices ever trump man's frame? Or, narrated by man, does woman herself figure as his trope? If we open up texts of masculine or anonymous transmission and edition to the possibility of feminine co-authorship, even if only in a fraction of cases, then we lend historical agency to female personages, both real and imaginary, who would otherwise remain trapped in a realm of symbolism and allegory.

NOTES

1. Nazhūn bt. al-Qilā'ī, a twelfth-century Andalusian poet known for her satire (*hijā'*) and obscenity (*mujūn*), has poems and poetic fragments scattered throughout biographical dictionaries and *adab* compilations. In addition, Ibn Bishrī attributes a full-length *muwashshah* to her. Her precise dates and social circumstances are unclear, but anecdotal evidence places her in the company of the pioneering vernacular poet Ibn Quzmān (d. 555/1160), and she is said to have been the daughter of a judge (di Giacomo 1947, 17n).

2. Sāra al-Ḥalabiyya is a thirteenth-century poet who found patronage in the Ḥafṣid and Mārīnid courts of the Islamic west. Many of her panegyrics are dedicated to the 'Azafī family of Ceuta. Her eastern origins are evident both in her *nisba* ("the Aleppan") and in her verse, where she often expresses longing for the east.

3. Jahān Khātūn, a fourteenth-century poet from Shiraz, has the most extensive extant textual legacy of any woman from the period. Despite the enormity of her corpus, citations of her work in canonical Persian sources seem to be somewhat limited; nevertheless her rounds of flyte with 'Ubayd-i Zākānī (d. ca. 772/1371) are celebrated. She married Amīn al-Dīn Jahramī, a minister to the Injuid ruler Shāh Shaykh Abū Isḥāq.

4. Wallāda bt. al-Mustakfī (d. 484/1091) was the daughter of an Umayyad caliph of Cordoba. She led an independent life, remaining unveiled and unmarried, and hosted literary gatherings. She is quite famous for having had a tortuous affair with the canonical male poet Ibn Zaydūn (d. 463/1071) and slightly infamous for having had a romantic liaison with the female poet Muhja al-Qurṭubiyya. Wallāda's compositions, mostly love poems and satires, are playful and provocative.

BIBLIOGRAPHY

PRIMARY SOURCES
Anon., *Amīr Aḥmad u Mahsatī*, in *Three romances*, Or. 8755, British Library, London, 867/1462, 22b–108a.

F. D. 'Aṭṭār, *The Ilāhī-nāma or Book of God*, trans. J. A. Boyle, Manchester 1976.
Ibn Bishrī, *'Uddat al-jalīs. An anthology of Andalusian Arabic muwashshahāt*, ed. A. Jones, Cambridge 1992.
Ibn al-Jawzī, *Ṣifat al-ṣafwa*, ed. I. Ramaḍān and S. al-Laḥḥām, 4 vols., Beirut 1989.
Ibn al-Khaṭīb, *al-Iḥāṭa fī akhbār Gharnāṭa*, i, ed. M. 'A. 'Unān, Cairo 1955.
Ibn al-Mu'tāzz, *Ṭabaqāt al-shu'arā'*, ed. 'A.-S. A. Farrāḥ, Cairo 1956.
Ibn al-Qāḍī al-Miknāsī, *Jadhwat al-iqtibās fī man ḥalla min al-a'lām madīnat Fās*, 2 vols., Rabat 1973–4.
Ibn al-Sā'ī, *Nisā' al-khulafā'. Jihāt al-a'imma al-khulafā' min al-ḥarā'ir wa-al-imā'*, ed. M. Jawād, Cairo 1960.
Ibn Sa'īd, *al-Mughrib fī ḥulā al-Maghrib*, ed. Sh. Ḍayf, 2 vols., Cairo 1953.
Ibn Ṭayfūr, *Balāghāt al-nisā'*, Beirut 1987.
al-Iṣbahānī, *al-Imā' al-shawā'ir*, ed. N. Ḥ. al-Qaysī and Y. A. al-Sāmirrā'ī, Beirut 1984.
Jahān Malak Khātūn, *Dīwān-i Kāmil*, ed. K. Rād and K. A. Nazād, Tehran 1374/1995 or 1996.
al-Jāḥiẓ, *al-Maḥāsin wa-al-aḍdād*, ed. Y. Farḥāt, Beirut 1997.
Jajarmī, *Mu'nis al-aḥrār fī daqā'iq al-ash'ār*, ed. M. Ṣ. Ṭabībī, ii, Tehran 1350/1971.
Mahsatī, *Dīwān*, ed. Ṭ. Shihāb, Tehran 1957.
al-Maqqarī, *Nafḥ al-ṭīb min ghuṣn al-Andalus al-raṭib*, ed. I. 'Abbās, 8 vols., Beirut 1968.
al-Marzubānī, *Ash'ār al-nisā'*, eds. S. M. al-'Ānī and H. Nājī, Baghdad 1976.
as-Sulamī, *Early Sufi women. Dhikr an-niswa al-muta'abbidāt aṣ-Ṣūfiyyāt*, ed. and trans. R. E. Cornell, Louisville, Ky. 1999.
al-Suyūṭī, *al-Mustazrif min akhbār al-jawārī*, ed. Ṣ.-D. al-Munajjid, n.p. 1963.
——, *Nuzhat al-julasā' min ash'ār al-nisā'*, ed. 'A.-L. 'Āshūr, Cairo 1986.

SECONDARY SOURCES
H. Ḥ. 'Abd al-Wahhāb, *Shahīrāt al-Tūnisiyyāt*, Tunis 1934, 1966².
M. Abu-Rub, La poésie galante des femmes poétesses, in *La poésie galante andalouse*, Paris 1990, 233–80.
F. A. al-'Alāwī, *'Ā'isha al-Bā'ūniyya al-Dimashqiyya. Ashhar a'lām Dimashq awākhir 'ahd al-Mamālīk. Dirāsa wa-nuṣūṣ*, Damascus 1994.
M. Amari, *Le epigrafi arabiche di Sicilia*, Palermo 1881, repr. 1971.
W. M. 'A. al-Aṭruqjī, *al-Mar'a fī adab al-'aṣr al-'Abbāsī*, Baghdad 1981.
F. Bagherzadeh, Mahsati Ganjavi et les potiers de Rey, in J. Bacqué-Grammont and R. Dor (eds.), *Varia turcica XIX. Mélanges offerts à Louis Bazin*, Paris 1992, 161–76.
F. de Blois, no. 235, in *Persian literature. A bio-bibliographical survey 5.2. Poetry ca. A.D. 1100 to 1225*, London 1994, 409.
J. A. Bray, Third- and fourth-century bleeding poetry, in *Arabic and Middle Eastern Literatures* 2:1 (1999), 75–92.
E. G. Browne, *A literary history of Persia*, 4 vols., Cambridge 1902–24.
J. T. P. de Bruijn, Mahsatī, *EI²*.
P. Dawlat Abādī, *Manẓūr kharadmand. Jahān Malak Khātūn wa-Ḥāfiz*, Tehran 1374/1995.
L. Di Giacomo, Une poétesse andalouse du temps des Almohades. Ḥafṣa Bint al-Ḥājj ar-Rukūnīya, in *Hespéris* 34 (1947), 9–101.

S. al-Dīwahjī, Wallāda bt. al-Mustakfī, in S. al-Dīwahjī, 'Aqā'il Quraysh, Mosul 1955, 99–109.

Epitaphe no. 3306, in Répertoire chronologique d'épigraphie arabe 9 (1937), 73–4.

F. Fresnel, Lettre à M. le Dr. C. Vassallo, in Journal asiatique, series 4:10 (1847), 437–43.

S. 'A.-W. Furayyiḥ, al-Jawārī wa-al-shi'r fī al-'aṣr al-'Abbāsī, Kuwait 2002.

T. Garulo, Una poetisa oriental en al-Andalus. Sāra al-Ḥalabiyya, in al-Qantara 6 (1985), 153–77.

——, Dīwān de las poetisas de al-Andalus, Madrid 1986.

V. Grassi, L'épigrafia araba nella isole Maltesi, in Studi Magrebini 21 (1989), 9–92.

B. Gruendler, Lightning and memory in poetic fragments from the Muslim west. Ḥafṣah bint al-Ḥājj (d. 1191) and Sārah al-Ḥalabiyyah (d.c. 1300), in A. Neuwirth and A. Pflitsch (eds.), Crisis and memory. Dimensions of their relationship in Islam and adjacent cultures, Beirut 2001, 435–52.

M. Hammond, He said 'she said'. Narrations of women's verse in classical Arabic literature: a case study. Nazhūn's hijā' of Abū Bakr al-Makhzūmī, in Middle Eastern Literatures 6:1 (2003), 3–18.

J. Harris and K. Reichl (eds.), Prosimetrum. Cross-cultural perspectives on narrative in prose and verse, Cambridge 1997.

Sh. Ḥasanayn, Mahsatī wa-nishāṭuhā al-adabī, in Nisā' shahīrāt fī al-siyāsa wa-al-adab fī al-'aṣr al-Saljūqī, Cairo 1989, 67–104.

C. Huart, La poétesse Fadhl. Scène de moeurs sous les khalifes abbasides, in Journal asiatique 7:17 (1881), 5–43.

M. Ishaque, Mahsatī of Ganja, in Indo-Iranica 3:4 (1949), 11–28.

——, Four eminent poetesses of Iran, Calcutta 1950 (useful appendix 45–95).

H. Khalfa, Lexicon bibliographicum, ed. G. Fluegel, 7 vols., Leipzig 1835–58.

M. Y. Khulayyif, al-Shi'r al-nisā'ī fī adabinā al-qadīm, Cairo 1991.

F. Meier, Die schöne Mahsatī, i, Wiesbaden 1963.

J. T. Monroe, Introduction, in Hispano-Arabic poetry. A student anthology, Berkeley 1974, 3–71.

'A. Muhannā, Mu'jam al-nisā' al-shā'irāt fī al-Jāhiliyya wa-al-Islām, Beirut 1990.

Ṣ. al-D. al-Munajjid, Mā ullifa 'an al-nisa', in Majallat majma' al-'ilmī al-'Arabī 16 (1941), 212–19.

al-Nadīm, The fihrist. A tenth-century survey of Muslim culture, ed. and trans. B. Dodge, New York 1970.

F. Nawzād (ed.), Mahsatī-nāma, Tehran 1999.

M. al-Raysūnī, al-Shi'r al-niswī fī al-Andalus, Beirut 1978.

E. Rossi, Le lapidi sepolcrali arabo-musulmane di Malta, in Revista degli studi orientali 12 (1930), 428–44.

J. Rypka et al., History of Iranian literature, Dordrecht 1968.

A. Z. Ṣafwat (ed.), Jamharat rasā'il al-'Arab, 4 vols., Cairo 1937.

D. al-Sajdi, Trespassing the male domain. The qaṣīdah of Laylā al-Akhyaliyyah, Journal of Arabic Literature 31:2 (2000), 121–46.

A. Salīmī, Zanān sukhanvār, Tehran 1957.

A. Schimmel, A nineteenth century anthology of poetesses, in M. Israel and N. K. Wagle (eds.), Islamic society and culture. Essays in honour of Professor Aziz Ahmad, New Delhi 1983.

M. al-Shak'a, Shā'irāt al-Andalus, in M. al-Shak'a, Ṣuwar min al-adab al-Andalusī, Beirut 1971, 85–217.

S. P. Stetkevych, The mute immortals speak. Pre-Islamic poetry and the poetics of ritual, Ithaca, N.Y. 1993.

'A.-H. al-Tāzī, al-Mar'a fī tārīkh al-Gharb al-Islāmī, Casablanca 1992.

M. J. Viguera, Aṣluhu lil-ma'ālī. On the social status of Andalusī women, in S. K. Jayyusi (ed.), The legacy of Muslim Spain, Leiden 1992.

MARLÉ HAMMOND

The Spread of Islam in Southeast Asia: 15th to Mid-18th Century

By the beginning of the fifteenth century, gravestones and other sources show that Islamic states had been established in several areas of island and peninsular Southeast Asia. In north Sumatra there had been Islamic states since the early thirteenth century, Muslims had been found in East Java in the fourteenth century, and the Malay peninsula had seen the creation of several sultanates.

In Samudra there is the gravestone of one 'Abd Allāh bin Muḥammad bin 'Abd al-Qādir, who died in 809/1406. He was a descendant of the penultimate 'Abbāsid caliph, confirming that by the early fifteenth century north Sumatra was already part of the international world of Islamic travelers.

The sequence of gravestones from the Malay peninsula shows the continuing presence of Islamic states there. Malacca was founded as the greatest Malay-run entrepôt state of Southeast Asia around 1400. Its first ruler, Parameswara, was a Hindu-Buddhist, but he seems to have converted to Islam very late in his reign (?1390–1413/14), when he took the name Sultan Iskandar Syah. His immediate successors were Muslims, but there seems to have been a brief Hindu-Buddhist reaction under the fourth king, Parameswara Dewa Syah (r. 1445–6). He was deposed and replaced by his half-brother, sultan Muzaffar Syah (r. 1446–50), after which time Islam was firmly established as the religion of the elite of Malacca, which became a major center for Islamic trade and scholarship in the region. Malacca is believed to have sponsored the Islamization of other areas of the Malay peninsula. The grave of the first sultan of Pahang, Muḥammad Shāh, is dated 880/1475. At Johor there is the grave of an unnamed grandmother of a sayyid named al-Marḥūm Manṣūr, dated 857/1453.

A particularly interesting gravestone is found at Pengkalan Kempas in Negeri Sembilan on the Malay peninsula. This marks the grave of one Ahmat Majana or Majanu. What is remarkable is that the inscription is in two parts. One is in Malay in Arabic script, the other in Malay using pre-Islamic Kawi characters. The grave is dated in the Indian-derived Śaka era 1389/1467–8 C.E. This is the only such example of a dual inscription found in the Malay peninsula, suggesting that at this time that area of the peninsula was in a state of cultural transition.

The Muslim Chinese voyager Ma Huan visited Malacca in 1413–15, 1421–2, and 1431–3. His reports confirm that both the ruler and his subjects were Muslims. His report on Java (which he visited in 1416) is, however, a source of confusion. Already in the fourteenth century there were elite Javanese being buried as Muslims at the court of Majapahit, as is evidenced by gravestones at Trawulan and Tralaya in East Java, but Ma Huan says that there were only three kinds of people in Java: Muslims from the west, Chinese, of whom many were Muslims, and the local Javanese savages who worshiped devils. Did he not recognize Javanese Muslims on the north coast of Java, or were Javanese converts to Islam making cultural choices so great that he mistook them for either Muslims from the west or Chinese Muslims? Or was it the case that Islam had spread less on the coast than in the interior of East Java at this time?

Certainly the series of Islamic gravestones at Trawulan and Tralaya, which document the presence of elite Javanese Muslims from the fourteenth century, continues into the fifteenth century, as the Hindu-Buddhist court was entering a time of trouble and decline. Graves there are dated Śaka 1329/1407 C.E., Śaka 1340/1418 C.E., Śaka 1349/1427 C.E., Śaka 1389/1467 C.E., Śaka 1397/1475 C.E., and Śaka 1533/1611 C.E. One of these stones uses the Islamic date 874 A.H./1469–70 and the name Zainuddin, but of course this could well have been an ethnic Javanese.

At Gresik, also in East Java, there is the gravestone of one Malik Ibrāhīm, dated 822/1419. He had been born in Persia and was probably a trader who died in Gresik, and his gravestone (like several early stones from north Sumatra) was made in Cambay, in Gujerat. Locally, however, he is remembered as one of the early proselytizers of Islam in Java, collectively known as the *wali sanga* (the nine saints). There is no reliable historical evidence to confirm that Malik Ibrāhīm was such a person, and indeed all of the legends about the *wali sanga* are subject to local variations, conflict among

sources, and an absence of contemporary documentation to support them.

Returning to north Sumatra, where the first evidence of Islamization is found beginning in the early thirteenth century, further gravestones confirm the presence of sultanates there through the fifteenth century. The first sultan of the newly expanding state of Aceh, 'Alī Mughāyat Shāh, is dated 936/1530.

Islam was also present in north Borneo/Kalimantan by this time. Two early gravestones in Malay using the Arabic script come from Brunei. One is dated 835/1432, but the name is illegible. The other is the grave of one Sharīf Hūd and is dated 905/1499.

It is certain that other areas of Southeast Asia had encountered Muslims, and no doubt local conversions had taken place before the end of the fifteenth century, but in the absence of local evidence such as gravestones or early mosques, we know nothing reliable about these developments. And these gravestones themselves are hardly satisfactory forms of evidence. They tell as that a Muslim was buried in a particular location at a particular time, and often that a sultanate existed there, but they cannot tell us such things as how many people other than the ruler were Muslims, how deeply Islam had influenced local beliefs and customs, whether the process of conversion was peaceful or had brought conflict, and so on.

We are fortunate that a particularly valuable early European source – lost for centuries but rediscovered in Paris in 1937 – sheds light on Southeast Asia, including the process of Islamization. This is the *Suma Oriental* of the Lisbon apothecary Tomé Pires, who was in Southeast Asia in the years 1512–15, immediately after the Portuguese conquest of Malacca in 1511. He was of course a person of his times, and the cultural distance between this Christian Portuguese observer and local Muslims was considerable. But Pires seems to have been a remarkably astute observer and candid recorder of what he saw, which was a very great deal at a truly remarkable time. No major error or misrepresentation has ever been ascribed to his account of Southeast Asia in his time, so the *Suma Oriental* remains an invaluable account of the state of Islamization (as well as of many other things, of course) in the early sixteenth century, although of course it is to be used as critically as any other source.

Pires wrote of Malacca's role as a major center of Islam and a promoter of Islamization in surrounding states. He informs us that most of the kings of Sumatra along the Straits of Malacca were Muslims by his time, from Aceh in the north to Palembang in the south, but that most of the states up the west coast were still "heathen." The king of Aceh he described as "a Moor, a knightly man among his neighbors." At Pasai in north Sumatra were found traders from throughout the Islamic world: Bengalis, Turks, Arabs, Persians, Gujeratis (Gujerat itself was undergoing Islamization at this time, and many of the Gujeratis in Sumatra were Hindus), other Indians, Malays, Javanese, and (non-Muslim) Siamese.

Pires describes the process by which, according to his information, Islam had come to be established in Pasai:

> Pasai used to have heathen kings, and it must be a hundred and sixty years since the said kings were worn out by the cunning of the merchant Moors there in the kingdom of Pase, and the said Moors held the sea coast and they made a Moorish king of the Bengali caste, and from that time until now the kings of Pasai have always been Moors; except that up till now they have been unable to convert the people of the interior; and yet . . . those who are not yet Moors are being made so every day, and no heathen among them is held in any esteem unless he is a merchant.

Pires's account thus suggests that Islamization in Sumatra, still actively going on at that time, had been driven very largely by the interests of the international Islamic trading community. His picture of Java in this period suggests a different pattern there.

According to Pires, west Java, the Sundanese-speaking region, was still Hindu: "The kingdom of Sunda does not allow Moors in it, except for a few, because it is feared that with their cunning they may do what has been done in Java."

The king of the Javanese-speaking heartland in central and east Java was still a Hindu-Buddhist "heathen" in Pires's time, and he was at war with the Muslims along the north coast. Despite that conflict, Pires importantly describes a process of cultural emulation among these north coastal Islamic communities:

> These Moorish *pates* [rulers] . . . are great lords, and when they speak of courtesy and civility they say that there is everything at court, and riches. And they speak of *Gusti Pate*'s [the leading figure at the Majapahit court] affairs with great respect.

The conversion process that he observed on Java's coast was unlike what he reports for Sumatra. In Java, foreigners who were already Muslims, had settled there and established Islamic communities, were becoming Javanized:

> At the time when there were heathens along the sea coast of Java, many merchants used to come, Parsees,

Arabs, Gujeratis, Bengalese, Malays and other nationalities, there being many Moors among them. They began to trade in the country and to grow rich. They succeeded in way of making mosques, and mollahs came from outside, so that they came in such growing numbers that the sons of these said Moors were already Javanese and rich. . . . In some places the heathen Javanese lords themselves turned Mohammedan, and these mollahs and the merchant Moors took possession of these places. Others had a way of fortifying the places where they lived, and they took people of their own who sailed in their junks, and they killed the Javanese lords and made themselves lords. . . . These lord *pates* are not Javanese of long standing in the country, but they are descended from Chinese, from Parsees and Kling [Indians] and from the nations we have already mentioned. However, brought up among the bragging Javanese, and still more on account of the riches they have inherited from their ancestors, these men made themselves more important in Javanese nobility and state than those of the hinterland.

Pires wrote, too, of a process of religious toleration and interaction in Java, noting the following about pre-Islamic ascetics found there:

There are about fifty thousand of these in Java. There are three or four orders of them. Some of them do not eat rice or drink wine; they are all virgins, they do not know women. . . . And these men are also worshipped by the Moors, and they believe in them greatly; they give them alms; they rejoice when such men come to their houses. . . . I have sometimes seen ten or twelve of these in Java.

Pires reported that the coast of Java had been Islamized as far east as Surabaya, but from there to the east the population was still Hindu-Buddhist and widow-burning was practiced when lords died. This area was near to Bali, which resisted Islamization, and continued to have close cultural and political interaction with Balinese Hindu states until the late eighteenth century.

East of Java, Madura was still "heathen" in Pires's day. Most of the island of Kalimantan was also not yet Islamized, but Pires reported that the chief lord (i.e. of Brunei) was a recently converted Muslim. Bali, Lombok, and Sumbawa were not yet Islamized. But in the "spice islands" of Maluku (Banda, Seram, Ambon, Ternate, Tidore, and others), Islamic states were being created. In Tidore, for instance, he reported (on the basis of hearsay, for Pires did not personally visit this area so far as is known) that in a population of about 2,000, the king and 200 others were Muslims. The Makasarese and Bugis of south Sulawesi – later regarded as fierce Muslim warriors – were not yet Muslims in his time.

Two Javanese-language manuscripts were brought back to the Netherlands by the first Dutch expedition to Indonesia of 1595–7, so they are indubitably of sixteenth-century origin. No more is

known of their provenance, but their paleography suggests a north coast origin. These sources are very important for demonstrating (1) that Islamic learning was seriously studied in north Java at this time; (2) that Sufism was then a major mode of Islamic thought and practice (indeed, we may safely assume that it was the predominant mode); and (3) that this mysticism was flexible enough to accommodate pre-existing Javanese concepts. Both works have been edited by Drewes, one with the title *Een Javaanse primbon uit de zestiende eeuw* and the other as *The Admonitions of Seh Bari*. The theology of both works is orthodox and indeed their teachings might have been found in any Islamic society of the time. It is notable nevertheless that we find common Islamic concepts expressed with Javanese rather than Arabic terminology. Whereas Arabic is used for terms such as the Qur'ān, the Devil (Setan, Iblis), angels (*malaekat*), or desire (*napsu* from Arabic *nafs*), we also encounter Javanese terms such as *pangeran* for God, *sambahyang* for prayer (as well as Arabic-derived *salat*), *atapa* for asceticism, *swarga* or *syarga* for heaven, *suksma* for the immaterial, innermost soul, and so on.

The evidence considered thus far is useful in establishing a rough chronology of the spread of Islam in the fifteenth and sixteenth centuries. In the case of the two surviving Javanese manuscripts, we gain invaluable insights into the content of Islamic teachings in Java in the sixteenth century, which may be taken to confirm the vital role played by Sufism in the spread of Islam in this period. Tomé Pires provides much more detail about social, economic, political, and cultural forces at work at this time, but of course one must recognize his cultural distance from the societies he described. Unfortunately, there is little more which can be said with great confidence. The early Islamization of the Malay-Indonesian area has inspired much interesting speculation and not a little controversy, but the evidence is so limited in nature and volume that much remains obscure.

Once we move into the seventeenth century, however, we begin to have a somewhat clearer picture. In particular, sources are sufficient to demonstrate that two areas of Indonesia – Aceh and Central Java – were the locations for major religious activities.

Aceh produced a vast amount of religiously inspired literature in Malay, associated particularly with four of the greatest writers of Indonesian literature. The first of these was Hamzah Pansuri, who died in Mecca in 1527. He was followed by two other native Sumatrans, Syamsuddin of Pasai

(d. 1630) and Abdurrauf of Singkil (ca. 1615–93) and the most prolific of these four, the Gujerati Nūr al-Dīn al-Ranīrī, who lived in Aceh from 1637 to 1644. During the reign of Aceh's greatest king, Sultan Iskandar Muda (r. 1607–36), Islamic literature enjoyed royal patronage. The king was initiated into the Naqshabandiyya order by Syamsuddin, who also wielded considerable political influence. Syamsuddin, Abdurrauf, and al-Ranīrī all adopted the mystical doctrine of seven stages of emanation, but after he arrived in Aceh, al-Ranīrī launched a violent campaign against the supposedly heretical versions of the others. In the reign of Sultan Iskandar Thāni (r. 1636–41) it was al-Ranīrī who had royal support. In 1644, however, he lost the favour of Iskandar Thāni's successor, the queen Tāj ul-ʿĀlam (r. 1641–75), and returned to India. Abdurrauf was then the major writer in the Acehnese court. He wrote works of Shāfiʿī jurisprudence as well as mysticism, and the first Malay-language commentary on the entire Qurʾān, to which Riddell tentatively ascribes a date of around 1675.

The works of literature produced by these writers associated with the court of Aceh had great influence throughout the Malay-Indonesian area, and some are found in translations into Javanese and other Indonesian languages. Probably the most famous is al-Ranīrī's *Bustān al-ṣālaṭīn*. This is an encyclopedic work of seven books covering the creation, the major figures of the Islamic tradition, the campaigns of the Prophet Muḥammad and sciences such as physiognomy and medicine.

Another famous work, the authorship of which is not known, is the *Tāj al-ṣālaṭīn* or *Mahkota segala raja-raja* (Crown of all kings), adapted from Persian sources in 1602–3. This was probably written at the court of Aceh, although that is not known with certainty. It provides orthodox teachings on humankind and God and extensive teachings on statecraft. Hamzah Pansuri's works include the earliest known example of the Malay *syair* form of poetry, with its a-a-a-a rhyming pattern.

It needs to be remembered that classical Malay literature did not consist solely of works of Islamic inspiration. Malay authors were heirs to the pre-Islamic culture of the region, and the classical corpus includes works such as *Hikayat Sri Rama*, based on the *Rāmāyana* and the *Hikayat Pandawa Jaya* based on the *Mahābhārata*.

In Java, too, the early seventeenth century saw major advances in Islamization. Although the evidence is frustratingly fragmentary, before the early seventeenth century it seems that the progress of Islamization had encountered some resistance. Evidently the idea that one could be both a Muslim

and a Javanese was not universally accepted. It is noteworthy that one Javanese manuscript of uncertain date and provenance, but certainly from some time and place undergoing a transition to Islam, draws a clear distinction between the religion of Islam and the religion of Java. (This work is edited by Drewes under the title *An Early Javanese Code of Muslim Ethics*.) In particular, it seems that the dynasty of Mataram, which by the early seventeenth century was on the road to hegemony in Java after a series of wars, had not yet fully accommodated itself to the new faith. Indicative of this is that the Indian-derived Śaka calendar was still used for court purposes.

In 1613, the greatest of the Mataram kings came to the throne. This was the man conventionally known as Sultan Agung (the great sultan), although he used other titles for most of his reign (1613–46). His early years were dedicated principally to the military conquest of competitor states in central and east Java, a brutal and costly process that culminated in the successful siege and surrender of Surabaya in 1625. By this time, the Dutch East India Company (VOC) had taken over the west Javanese port of Jayakerta – today's Jakarta, the capital of Indonesia – and renamed it Batavia. Agung was clearly concerned at this intrusion into the island that he intended to dominate entirely himself. So in 1628 and 1629 Agung sent Mataram armies to besiege the fortified Dutch headquarters. The first siege seriously threatened the VOC, but Batavia survived in the end. The second was a complete disaster for the Javanese, the VOC having discovered and destroyed stockpiles in west Java needed by the Javanese attackers.

In the wake of this disaster before the walls of Batavia, Sultan Agung's authority was challenged by a series of local uprisings against him, all of which he put down militarily. The most threatening of these was a rebellion of several (the VOC reported 27) villages in the interior, near the court. This seems to have been led by wandering religious leaders centered on the holy grave site of Tembayat, where the apostle (*wali*) of south-central Java, Sunan Bayat, is buried. Of the life of Bayat nothing is known other than local legends, but certainly up to the present his grave site remains a place of pilgrimage and great spiritual power.

Having subdued the rebellion militarily, in 1633 Sultan Agung made a pilgrimage to the Tembayat gravesite, evidently to domesticate the supernatural forces that had opposed him. According to Javanese legends (known only in later copies), he communed with the spirit of Sunan Bayat, who taught him secret mystical sciences.

The extraordinary role played by a later queen has preserved literary sources that shed light on Agung's pilgrimage to Tembayat and the reconciliation of the Javanese court and Islam that it seems to have represented. The lady in question was Ratu Pakubuwana (d. 1732), the queen of king Pakubuwana I (r. 1704–19), mother of Amangkurat IV (r. 1719–26) and grandmother of Pakubuwana II (r. 1726–49). As part of an Islamizing push in the court early in the reign of her grandson (discussed below), she resurrected supernaturally powerful literary works from the time of Sultan Agung. These now survive in her eighteenth-century versions and a few other fragments, which enable us to make reasonable suggestions about the importance of Sultan Agung's pilgrimage to Tembayat.

There is no doubt about the fact of a pilgrimage by Agung to Tembayat. The VOC received reports that year that the king had gone to Tembayat "in order to make sacrifices there." At Tembayat itself there is still to be seen a ceremonial gateway erected by Agung and inscribed with the date Śaka 1555 *masa 4*, roughly equivalent to the months October-November in the year 1633 C.E. It was during this year that the luni-solar Śaka calendar was abandoned by the court for the lunar Islamic year, but with the numerical sequence of the previous dating preserved, to produce the unique *Anno Javanico*.

Also in 1555 A.J./1633–4 C.E., Agung reconciled his line with that of his erstwhile enemies at Surabaya, by bringing the senior surviving prince of that court, Pangeran (prince) Pekik, to Mataram and joining the families through marriages. To judge from opening comments in Ratu Pakubuwana's later version, Pekik brought with him to Mataram the Javanese work *Carita Sultan Iskandar*, a highly romanticized account based ultimately on the traditions concerning Alexander the Great (Dhū'l-Qarnayn) in Qur'ān 18:82–98. The opening of the 1729 version says that the story was originally composed in Malay but then translated into Javanese upon the order of the Pangeran (Pekik) of Surabaya, who then brought it to Mataram.

A second work was also composed at this time. This is the longer courtly version of the Javanese *Serat Yusuf*, again a romanticized account, this time of the story of Joseph in Egypt found in Qur'ān 12. In more recent times the shorter, more popular, version of this text has been recited in Java on ritual occasions, at rites of passage, in fulfillment of vows, and in the annual village cleansing ceremonies. A fragment of this work published by the Indonesian Department of Education and Culture in 1981, from an original that is not now locatable, is dated Jumadilawal 1555 A.J., equivalent to November 1633, the period noted in the inscription on Agung's gateway at Tembayat. It also says that it was written in the village of Karang, which is the name of a village adjacent to Tembayat. So the Javanese story of Yusuf, at least in its longer version, seems to have been written at the time and place of Sultan Agung's pilgrimage to Tembayat. A century later, Ratu Pakubuwana also produced a new version of this, as she had of *Iskandar*.

A third work, too, appears to have derived from this pilgrimage. At the end of the 1981 text of *Yusuf* mentioned above is found the opening passage of another work entitled *Kitab Usulbiyah*. So this work, too, seems to have existed in 1555/1633. This fragment ends with a passage that makes clear that this was a work of supernatural power:

> [This book's] blessing power
> is as if one were to go on the *hajj*,
> the same as giving food
> to a wretched person,
> the same as a person reciting the Qur'ān.
> Its blessing power is the same as a person fighting Holy
> War:
> his body will not be destroyed
> and he will be admitted to Heaven exalted. . . .
> To all who read this . . .
> will be disclosed
> the secret mystical science,
> all of their sins abolished
> and by the Immaterial [God] given great blessedness,
> forgiven by the Immaterial.

A full text of this work was also produced by Ratu Pakubuwana in the eighteenth century, and that version also makes it clear that this was a work of supernatural power. The story of *Usulbiyah* is an apparently original Javanese tale of the major figures of Islam, the story being set indubitably in a Javanese environment and culminating in an encounter in which Jesus (Ngisa) concedes the superiority of Muḥammad.

A fourth work produced by Ratu Pakubuwana in 1729–30 is called *Suluk Garwa Kancana* and seems also to derive from the time of Sultan Agung. It says at the start that it is "from Susunan Ratu," a not entirely clear reference, but very probably meaning that it was from Sultan Agung. It is a poem setting out a doctrine of Javanese kingship in entirely Islamic ascetic and mystical terms. The king is admonished,

> Let the scriptures serve as your subjects.
> Let piety serve as your bow;
> Let *dhikr* serve as your quiver,
> and the Qur'ān as your arrows . . .

Let there be destroyed
desire and sensual pleasures,
may comforts be defeated. . . .
When you are consecrated as king,
don your royal garb:
let *khak* [reality] serve as your crown,
with *tarekat* [the mystic way] as its crest.
Struggle constantly,
sarengat [the law] serving as your lower garment.

It seems that this may represent Sultan Agung's political philosophy, a marrying of Islamic mysticism and the martial traditions of Javanese kingship. It may even be the lessons in kingship that he is said to have received from the spirit of Sunan Bayat in 1633.

Agung's reconciliation of Javanese and Islamic identities in courtly culture took place at a time when Islamization was advancing elsewhere in the archipelago. Developments in Aceh have been described above. In Banten in west Java, the long-ruling King Pangeran Ratu (r. 1596–1651) read works of Sufi literature and corresponded with Islamic thinkers as far away as Arabia. Nūr al-Dīn al-Ranīrī was among his correspondents. In 1638 he became the first ruler in Java who is known definitely to have adopted the title of sultan (although it is ascribed in Javanese traditions to Islamic rulers from the late fifteenth century), for which he sought approval from the Grand Sharīf of Mecca. He thus became Sultan Abulmafakhir Mahmud Abdulkadir. Shortly thereafter, Agung also sent a mission to Mecca, which came back with approval for him to adopt the title sultan, which he did in 1641, when he became Sultan Abdul Muhamad Maulana Matarani. He was the first ruler of Mataram to use the title of sultan and the last to do so for over a century.

The advance of Islam in the Javanese court in Sultan Agung's time does not, however, appear to have carried on under his son and successor Amangkurat I (r. 1646–77). He stands in Javanese tradition as the quintessential Javanese tyrant. He was responsible for the murder of many senior figures in the state, including his father-in-law, the elderly Pangeran Pekik of Surabaya. In 1648, the VOC ambassador Rijklof van Goens wrote of Amangkurat I's "strange manner of government, . . . whereby the old are murdered in order to make place for the young," not realizing that this was as disapproved of by Javanese as by European observers. In 1648–9 the king ordered a slaughter of religious leaders. According to van Goens (who did not witness the event himself), Amangkurat I assembled the leading religious figures of the kingdom before the court with their families. Upon his signal, within half an hour,

2,000 "priests" were killed and, in all, between five and six thousand men, women and children. Eventually Amangkurat I's tyranny precipitated the greatest rebellion of the seventeenth century, which began in 1670 and toppled the court in 1677. In desperation, the king's son and successor turned to the VOC for aid in regaining his kingdom.

From the 1670s until the late 1720s, there emerged a general pattern in which the Mataram dynasty allied with the VOC in order to defend itself against a series of rebellions. This compromised both the dynasty's claim to be a legitimate Javanese monarchy and its Islamic identity. Its enemies tended to emphasize their own Islamic credentials and to denounce the dynasty for its dependence upon the *kafir*s of the company. The VOC forces themselves, in fact, consisted only in very small part of European Christians. The company always had local allies and its own locally recruited forces included Ambonese Christians and Balinese Hindus, but also Muslim Ambonese and other Muslims, such fighters being described in Javanese sources as *kumpeni selam* (Muslim VOC). Nevertheless it was led by European Christians and understood by its enemies as a mainly *kafir* force.

The civil wars, with their attendant VOC military interventions, finally came to an end in the 1720s. It seems that a powerful clique within the court decided then that it was imperative to reconcile the Mataram dynasty and the powers (including the supernatural powers) of Islam. The leading figure in this was Ratu Pakubuwana. She was a powerful figure in the court at least since the time of her husband's usurpation of 1704, when he became Pakubuwana I. She was a leader among the literati of the court, having produced in 1715 the oldest surviving Javanese version of *Serat Menak*, a highly mythlogized account of the Prophet's uncle Amir Hamza, perhaps adapted from a prior version in Malay. She was a pious Sufi, knowledgeable in the occult powers of the Javanese court, a major political player and the grandmother of almost the entire royal elite by the end of her life.

Ratu Pakubuwana's opportunity came with the accession to the throne of her grandson Pakubuwana II in 1726. By this time she was already in her late sixties and completely blind, but she remained a formidable influence in the court. Her grandson was just sixteen years old and malleable, ideal material for her and her supporters to work on.

Ratu Pakubuwana revived the supernaturally powerful works from the reign of Sultan Agung described above – *Iskandar, Yusuf, Usulbiyah*, and

Suluk Garwa Kancana – and produced them in new versions in 1729–30, i.e. in the year 1654 A.J., as the centennial of Agung's pilgrimage to Tembayat in 1555 A.J. approached. There is no doubt of the supernatural intention of this act, for the manuscripts of 1729–30 make this purpose explicit, as they also make clear the special spiritual standing and powers of Ratu Pakubuwana. Her version of *Usulbiyah* says that the book was produced because Ratu Pakubuwana, "who has received the love of the Most Holy, who has already received the intercession of the Prophet Emissary," was

> striving to make perfect the reign
> of her royal grandson.
> For her sun, indeed,
> rests upon the mountain-tops,
> for she is already old
> and is nearing perfection.

This manuscript also specifically equates *Usulbiyah* with the Qur'ān and claims that it contains the very words of God. In reviving *Garwa Kancana,* the old queen was admonishing Pakubuwana II to live the life of an ascetic Sufi monarch. After Ratu Pakubuwana's death in January 1732 at around the age of 75, others carried on the Islamizing thrust within court circles.

The reign of Pakubuwana II saw developments that reflected a stronger sense of Islamic identity in the court, greater piety in public life, and greater resistance to the influence and presence of the VOC. When local Chinese (at least some of whom were Muslims) went to war against the Dutch Company in 1741, many Javanese joined them. In July 1741, on the orders of Pakubuwana II, the VOC garrison at the court (then at Kartasura) was attacked, besieged, and eventually forced to surrender. The Europeans were forcibly converted to Islam and were scattered amongst Javanese lords as their subjects, and the fortress was broken up.

In mid-1741, Pakubuwana II was the conquering lord of holy war, the destroyer of the *kafir*. But by this time the tide of war on the north coast of Java had turned, the VOC had gained the initiative, and Pakubuwana II realized what a dangerous thing he had done in attacking the company. So he began to seek reconciliation with the Europeans, who were naturally suspicious of a monarch who had taken their garrison at the court and converted their men to Islam. Perversely, the king was more successful in persuading those anti-VOC fighters who had thought him to be on their side that he was, in fact, an inconstant ally at best and an apostate at worst. They turned against him and in June 1742 the rebel armies conquered Kartasura and put the king to

flight. As he wandered and meditated in the wilderness around Mount Lawu, he seems to have gained more spiritual support from the indigenous spirit Sunan Lawu than from the failed Sufism of his previous years. But nevertheless by this time Islam had been clearly established as the religious element in the Javanese sense of identity.

In the Philippines, there is evidence of the presence of local Muslims from the fourteenth century, and in 1417 three Muslim rulers of Sulu sent a mission to China. So by 1500 there were Islamic states in the southern Philippines, although we know little about them. In the 1570s, a wealthy Spaniard named Figueroa was sent to the south to make treaties (or, in their absence, war) with Muslim rulers of Jolo (Sulu) and Magindanao. Desultory contacts followed between the Spanish headquarters in Manila and southern Muslims. The aim of the Spaniards was, inter alia, to reduce Muslim slave raids on the central Visayan islands then being Christianized. But in 1602 Magindanao raided even as far north as the Tagalog-speaking areas of southern Luzon, taking Spaniards as well as Filipinos captive.

One of the Spaniards taken in a raid of 1603 was the Jesuit Father Melchor Hurtado, who was taken to the headquarters of the ruler Sirongan. There he was treated honorably and found himself in learned theological debates with his captor. Clearly by this time Magindanao Islam was well-established under sophisticated leadership. The historian H. de la Costa observed that the Magindanao lords had "almost arrived at the idea of feudal kingship" (1967).

In 1609, the Spanish inflicted a significant defeat on Magindanao attackers and then, when the Magindanaos turned to attack the Islamic state of Brunei, they were resoundingly defeated. Losses appear to have been great, and for some time the southern Muslim lords were little heard of. Not until 1613 did they again raid the Visayas and not until 1634 was there a major raid. By that time, when the southern Muslims again emerge into Spanish historical records, Magindanao had become a unified Sultanate under Sultan Kudrat. The details of this political evolution in the early seventeenth century are, however, not known.

Spanish warfare against the Muslims of Magindanao and Sulu and slave raids by the latter continued, with the Spaniards unable to quell the "Moros." By around 1719 Sulu, too, had developed into a unified sultanate. Both Magindanao and Sulu boasted the paraphernalia of more developed Islamic states, with kings, law courts, and at least elementary bureaucracies.

The most remarkable figure of the eighteenth century was Sultan Alimuddin of Sulu (r. 1735–48, 1764–74). His mother was reportedly a Bugis from south Sulawesi. He was a reformer who had traveled through much of Southeast Asia, spoke Malay and Arabic, revised Sulu's laws, regularized the military forces of the state and had at least parts of the Qur'ān translated into the Sulu language. In 1737, he signed a treaty with the Spanish. He became friendly with Jesuits and, after a political conflict of 1748, he left Sulu, went to the Spanish at Zamboanga and there converted to Catholicism, styling himself Fernando I of Jolo. But the Spanish began to suspect that his conversion and submission were false, mere ploys to attack the Zamboanga garrison from within, so they arrested him and sent him to Manila, where he was released by conquering British forces in 1762. Sulu-Spanish warfare recommenced.

By the mid-eighteenth century Islam in the southern Philippines was more firmly established than it had been at the start of the Spanish presence in the archipelago. Although the southern Muslims were divided from one another by ethnic distinctions, they were clearly part of the larger world of Islamic Southeast Asia.

The sources for this period – both indigenous and foreigners' records – often tell us less than we wish to know about local social and cultural dynamics. Undoubtedly more can be done to explore the place and role of women in these Islamizing societies, but there seems little prospect of a truly comprehensive analysis. The eighteenth-century Javanese Queen Ratu Pakubuwana is an outstanding figure, but there are few such characters evident in the sources and even about Ratu Pakubuwana there is much more we would wish to know.

Women often figure in court chronicles. Dutch sources mention local women traders, concubines, aristocrats, and prostitutes. But one is left with a powerful sense of how little is recorded of the lives of indigenous women in this period. Only in the nineteenth century do the records for Islamized Southeast Asia begin to hold out the prospect of more satisfactory analysis of women within those societies. That scholarly work has hardly begun.

BIBLIOGRAPHY

Martin van Bruinessen, *Tarekat Naqsyabandiyah di Indonesia. Survei historis, geografis, dan sosiologis*, Bandung 1992.
——, The origins and development of the Naqshabandi order in Indonesia, in *Der Islam*, 67:1 (1990), 150–79.
H. de la Costa, *The Jesuits in the Philippines, 1581–1768*, Cambridge, Mass. 1967.
G. W. J. Drewes (ed. and trans.), *Een Javaanse primbon uit de zestiende eeuw*, Leiden 1954.
——, *The admonitions of Seh Bari*, The Hague 1969.
——, *An early Javanese code of Muslim ethics*, The Hague 1978.
Cesar Adib Majul, *Muslims in the Philippines*, Quezon City 1973³.
Tomé Pires, *The Suma Oriental of Tomé Pires*, ed. and trans. Armando Cortesão, 2 vols., London 1944.
M. C. Ricklefs, *War, culture, and economy in Java, 1677–1726. Asian and European imperialism in the early Kartasura period*, Sydney 1993.
——, *The seen and unseen worlds in Java, 1726–1749. History, literature and Islam in the court of Pakubuwana II*, St. Leonards, N.S.W. 1998.
——, *A history of modern Indonesia since c. 1200*, Basingstoke, U.K. 2001³.
——, *Mystic synthesis in Java. A history of Islamization from the fourteenth to the early nineteenth centuries*, Eastbridge (forthcoming).
Peter Riddell, Earliest Quranic exegetical activity in the Malay-speaking states, in *Archipel* 38 (1989), 107–24.

M. C. RICKLEFS

The Spread of Islam in China: 7th to Mid-17th Century

TANG DYNASTY (618–907 C.E.)

From the earliest days of Islam there have been Muslims living in China; Persian and Arab sea traders had been sailing to China's southeast coast for centuries before the birth of the Prophet Muḥammad. This maritime Silk Route, like its overland counterpart, has a long history dating back to the early centuries of the Common Era. Traders taking the sea route arrived in Canton (present-day Guangzhou), the only port open to foreigners at the time, where they lived in separate districts. The Chinese capital city of Chang'an (present-day Xi'an) was the final destination of most of those coming overland.

In Canton, Muslim traders lived together with other foreigners in the relative isolation of districts known as "fanfang" (foreign quarters). Some of the traders settled permanently in these communities while others continued to travel back and forth from Western Asia. Within these districts, which had to be located outside the city walls, the foreign residents were allowed a certain degree of self-governance. They selected a member of their community to represent them in dealings with the Chinese authorities, but were still subject to the laws of the Chinese imperial state. Chang'an, the capital of China during the Tang dynasty (618–907 C.E.), attracted a large number of foreign residents from across Asia, including Arabs, Turks, Uighurs, Persians, Sogdians, Indians, Japanese, and Koreans, as well as Nestorian Christians, Mazdeans, Jews, Manicheans, Zoroastrians, and Muslims. These groups were allowed to establish houses of worship, and their populations included people from a wide variety of occupations. Among the foreign residents were large numbers of foreign envoys who had led tribute missions to the Chinese capital. Chang'an became the largest and most cosmopolitan city in the world, with a population of over one million.

Very little is known about the daily lives of these early Muslim residents. Chinese historical sources document the development of diplomatic relations between the imperial court and Islamic states in Central and Western Asia. No sources survive that describe the development of the first Muslim communities. Consequently, even the simplest questions regarding the role of women in these communities are almost impossible to answer. For example, we do not know whether or not there were women among these early travelers and residents.

One of the only clues regarding the identity of wives of early Muslim residents in China can be found in various imperial decrees over the years that concern marriage between foreign residents and Chinese women. At different times during this period, foreign residents were allowed to marry Chinese women, forbidden to marry Chinese women, or allowed to take Chinese women as concubines, but forbidden to take them with them when they returned home. Governments rarely make the effort to officially proscribe certain actions unless they are relatively common, so we can surmise that intermarriage between Muslim residents and local women was a common practice. Any children born of these unions were almost assuredly raised as Muslim. Sons could marry Chinese women and raise their children as Muslim, whereas daughters would be expected to marry other foreign Muslims or Chinese who had converted to Islam. One scholar has theorized that one of the reasons that the Jewish population of China remained at a relatively low level over several centuries, compared to the Muslim population, which grew significantly during this time, was that the early Jewish settlers in China allowed their daughters to marry outside their faith (Leslie 1986, 138).

Several proscriptions against the ownership of slaves and the adoption of children were included among laws concerning the families and households of foreigners. The Muslim practice of freeing slaves who converted to Islam appears to have been at odds with Chinese ideas of slavery. The prohibition against adoption was most likely directed against the widespread Muslim practice of adopting abandoned Chinese babies and raising them as full family members. The abandonment or sale of children during periods of hardship has been a socially acceptable practice throughout Chinese history. Despite these early prohibitions, the adoption of non-Muslim babies by Chinese Muslims has continued to be widely practiced throughout China down to modern times.

Although the historical sources of the period mention foreign men almost exclusively, with little if any information provided about women,

literary and artistic sources offer numerous depictions of foreign women in China. Foreign women became renowned as singers, dancers, and entertainers, and are depicted in a wide range of artistic and literary media. One of the strongest influences of foreign women was on the fashions of elite Chinese women, apparently much to the chagrin of at least some of the Chinese men. In an exquisitely illustrated article on this phenomenon, "'Our Women are Acting Like Foreigners' Wives!': Western Influences on Tang Dynasty Women's Fashion," Suzanne Cahill quotes Yuan Zhen (779–831) lamenting the influence of foreigners: "Ever since foreign horsemen began raising dust and dirt, Fur and fleece, rank and rancid, have filled Xiangyang [Chang'an] and Luoyang. Our women are acting like foreigners' wives, studying foreign makeup; Entertainers present foreign sounds, servants to foreign music!" (Cahill 1999, 109–10).

Unfortunately, although there were clearly a huge number of foreign women resident in Chang'an, and other major Chinese cities during this time, it is not clear how many of them may have been Muslim.

THE SONG AND YUAN (MONGOL) DYNASTIES 960–1368

During the Song period foreign trade was restricted to the maritime route and thus several additional ports were opened up to foreign trade along the southeast coast. As a result, significant populations of Muslims came to settle in Quanzhou (Zaytūn in the Arabic sources), Hangzhou, Ningbo, and Hainan Island. Although the rise of Chinggis Qan (Ghengiz Khan) in Mongolia proved to be disastrous to much of the Middle Eastern Islamic world, his policies in China facilitated the spread and development of Islam throughout the Chinese Empire. At the end of each of his massive military expeditions across Central Asia, Chinggis forcibly relocated tens of thousands of Muslim artisans, craftsmen, engineers, clerks, scholars, and ordinary workers to Mongolia. He also took the sons of many of the local rulers of areas he had conquered back with him as hostages. These young men were taken into his personal retinue and raised as part of his family. Many of them went on to serve as loyal officials under Mongol rule throughout Asia, and in China after it was conquered and the Yuan dynasty established in 1274. There are Muslim communities spread out through every region of China today, and many of them are able to trace direct descent from the Muslim officials posted

there by the Mongol emperors during the Yuan dynasty.

As their empire spread, the Mongols recruited increasing numbers of Muslims together with other foreigners to assist in the development of local government administrations, tax systems, communication networks, and in the construction of entire cities including a new capital, now known as Beijing. These Muslims proved useful to the Mongol leadership in a myriad of fields including finance, astronomy, medicine, cartography, ballistics and military engineering, hydraulic engineering, linguistics, and architecture.

During this period tens of thousands of Muslims settled in China. Some of the more senior officials may have brought their families with them, though it was most likely still the case that the majority of Muslims were men who settled in China and married Chinese women. The few non-Chinese sources that mention Muslims in China during this period are unfortunately lacking in details about Muslim women. For example, although Marco Polo makes frequent reference to the "Saracens" he encountered in his travels throughout China while he served the Mongol rulers (1275–95) he does not mention any Muslim women. In addition, Ibn Baṭṭūṭa also encountered a wide range of Muslims in his extensive travels, reportedly as far as China, but he too makes no mention of Muslim women. This may well reflect the reluctance of Muslim households to allow female members of the family to interact with male guests, or the reluctance of men to write about female members of Muslim households they visited.

THE MING DYNASTY (1368–1644)

The final overthrow of the "barbarian" Mongol Yuan dynasty and the establishment of the Han Chinese Ming dynasty was accompanied by a period of intense effort to restore traditional Chinese thought and social customs throughout the empire, thereby "making right all under heaven." After a century of Mongol rule in China during which large numbers of foreigners held important positions of power and influence throughout the empire, the founding emperor of the Ming dynasty, Zhu Yuanzhang, was determined to remove the most obvious identifying markers of their presence. Although foreign residents were not killed or expelled, they became subject to a series of laws that were passed to reinforce the dominance of Han Chinese social customs and practices. These laws included laws requiring all those residing in China to adopt Chinese names,

speak Chinese, wear Chinese clothing, and follow Chinese cultural practices. Despite the fact that there were Muslim families who had by then been living in China for several generations, and in some cases several centuries, they were still considered "foreigners" by the Chinese state.

Widow remarriage, a widely accepted practice among both the Mongols and Muslims was targeted by the new administration as an example of the immorality of the "barbarians" and strongly discouraged. Traditional Confucian ideals concerning marriage emphasize that a widow remain loyal to her husband after his death, and continue to serve her in-laws.

In an even stronger effort to facilitate the assimilation of foreign residents, the dynasty's first legal code included a law requiring all male Mongols and foreigners who had accompanied them to China to find Chinese women willing to marry them: "They are not permitted to marry within their own kind. Violators shall be punished by eight blows of the heavy stick and both men and women shall be enslaved by the state" (Farmer 1995, 82).

RESEARCH CHALLENGES

Despite immense progress made in the fields of the history of women in China and the history of women in the Islamic world, I am unaware of any research by Chinese or Western scholars that focuses on the role of women in Muslim societies during the early period of Islam in China. Further complicating the dearth of historical sources dealing with the daily lives of Muslims is the fact that the biographical sources of important Muslim men during this period usually do not mention the names of wives or daughters. In the few cases in which names are mentioned, especially from the Ming period onward, they are invariably Chinese language names, which are usually indistinguishable from non-Muslim names. Despite these challenges it is possible to discover in biographical sources a few individual cases.

One such example is a reference to Safaliq, the granddaughter of Mahmud Yalavach from the early Yuan period. Originally from Khwarazm, Yalavach was one of the earliest Muslims to serve the Mongols. His sons, including Safaliq's father, 'Ali Beg, also served the Mongols. His granddaughter, however, is one of the few Muslim women during this time period to have been identified and singled out for her exemplary behavior. Her Chinese biographer notes how in addition to being a woman of exceptional intelligence and ability, she also played an active role in assisting her husband, Temur Buqa, in his duties as an official under the Mongol Yuan dynasty. Following his early death, Safaliq is noted for single-handedly raising her children under extremely difficult circumstances, refusing offers of charity, and never remarrying. She had four sons (no mention is made of daughters) all of whom served as officials under the Yuan. After her death, local Chinese officials chose to honor her loyalty to her husband by erecting a tablet to honor her memory (Rachewiltz 1993).

Safaliq's refusal to remarry is a notable aspect of this biography. As a member of a prominent Muslim family who held positions of power and influence across China and Central Asia (her uncle Masud Beg is credited with establishing a large *madrasa* in Bukhara in the 1270s) she would have been raised in a traditionally Muslim household. As widow remarriage is not stigmatized in most traditional Muslim societies, whether her decision not to remarry was a reflection of her desire to uphold the traditional values of the Chinese community in which she lived, or a reflection of personal preference, is not known but as a result of her actions, her life has been officially recognized and documented by Chinese scholars.

A second example from the same time period is A-lu (Arqun?), mother of Mai-shu-ding (Majd al-Dīn?), a Muslim official who also served under the Mongols. His father, A-he-ma (Aḥmad) died at the age of 32 when Mai-shu-ding was still quite young. His biography credits his mother with raising him, and with his subsequent success as an official. According to this source she was able to raise him to follow the ideal, "to be loyal in one's affairs, to have a strict self-discipline, and to treat the people with benevolence." Given that this phrase appears in quotation marks in the Chinese original, and the punctuation is not standard, although the ideals expressed are typically Chinese, the Chinese Muslim author of the biography may well have been referring to a Persian or Arabic saying from the *ḥadīth*. The biography goes on to note that she lived to the old age of 80 and was given a posthumous honorary title (Bai Shouyi 1985).

One final example is found in the early Ming period, and is the biography of Ding Yue'e (1320?-50?). She is honored by having her biography placed first in the section on "Exemplary Women" in the official history of the Ming Dynasty (Tang 1985-91, 7691). The first collection of exemplary women was written by Liu Xiang (79-8 B.C.E.) and documented women whose lives (and often deaths) upheld certain traditional Confucian values. The most common

ideals documented in these accounts concern filial piety, widows' refusal to remarry, and women's efforts to safeguard their chastity and family honor by committing suicide to avoid the possibility of rape.

Although Ding was a woman of extraordinary intellectual abilities, she was most likely honored in the biographical collection for leading a group of women in a collective act of suicide in response to an attack by bandits. According to the biography, as bandits approached the city, Ding, holding a baby girl in her arms, led nine other women to a body of water in which they all drowned themselves. Her dying words were reported to have been, "As someone from a refined scholarly family, how could I allow myself to be violated by bandits." As a result of this one act, her life is commemorated and we are able learn something about other aspects of the life of this Muslim woman. Although neither her mother's nor her sisters' names are mentioned, we learn that her family was originally from Central Asia, and that her father's name was Zhi-ma-lu-ding (Jamal al-Dīn). She displayed exceptional intelligence from an early age and was allowed to sit in on her brothers' lessons. She subsequently acquired a comprehensive understanding of the Chinese classics as well as an understanding of "the cardinal principles of righteousness." She was highly respected for both her personal and exemplary intellectual qualities, and a group of women studied under her.

Ding Yue'e is also credited with educating one of her younger brothers, Ding He'nian (1335–1424). He went on to become a well-known scholar of the period, first mastering the Confucian classics, and then becoming an accomplished poet and follower of Buddhism. His biography provides an extraordinary glimpse into the highly fluid nature of identity, culture, and religious practices among some Muslims in China at this time. He is remembered and noted by Han Chinese scholars for being a "barbarian" who became "civilized" by achieving complete fluency in all manners of Chinese language and culture. Born into a large and prominent extended Muslim family, Ding gradually adopted a wide range of traditional Chinese practices. In 1379 he even went so far as to return to his home town, Wuchang (present-day Wuhan in central China), in order to locate the original unmarked burial site of his mother. As she had been given a traditional Muslim burial, he was determined to have her remains disinterred, placed in a proper coffin,

reburied with a tablet placed over her grave, and sacrifices of meat and wine offered to her. His actions demonstrate a conscious effort to repudiate the religion of his birth and accept traditional Chinese customs. And yet, 45 years later as his own death approached, Ding arranged for a proper Muslim burial for himself at the Muslim cemetery in Hangzhou. In a period of dynamic cultural and religious intermingling and confrontation, these biographies reveal some of the complexities and difficult challenges facing scholars who seek to understand the nature of the lives of Muslim women and men living in China at this time.

There are very few scholars anywhere in the world focusing their research on the early history of Islam in China, and to the best of my knowledge there is no one concentrating on women during this period. Although the biographies of Muslim men during this period are fairly well documented by Chinese scholars, and occasionally mentioned by medieval Arab and Persian historians, there is no systematic collection of biographies of women. In the case of Ding Yue'e and her brother, the Chinese sources specifically mention that he was Muslim, and yet she is described ambiguously as someone of Central Asian origin.

These few examples leave open the possibility of more productive research in the future; they also indicate the difficulties faced by researchers trying to locate Muslim women in the sources for the early history of Islam in China. One possible avenue to be explored is the gravestones that have survived in Muslim cemeteries throughout China.

The inscriptions are often bilingual (Chinese and Arabic or Persian) and usually include some traditional Islamic inscription. In addition to positively identifying the deceased as Muslim, the gravestones in China usually include the names of all the immediate relatives, including female family members, such as mothers, daughters, and granddaughters.

BIBLIOGRAPHY

Bai Shouyi (ed.), *Records of notable Hui. The Yuan period* [in Chinese], Yinchuan 1985.
S. E. Cahill, "Our women are acting like foreigners' wives!" Western influences on Tang dynasty women's fashion, in V. Steele and J. S. Major, *China chic. East meets West*, New Haven, Conn. 1999.
Y. Chen, *Western and Central Asians in China under the Mongols. Their transformation into China*, Los Angeles 1966.
R. E. Dunn, *The adventures of Ibn Battuta. A Muslim*

traveller of the fourteenth century, London 1986.

E. L. Farmer, *Zhu Yuanzhang and early Ming legislation. The reordering of Chinese society following the era of Mongol rule*, Leiden 1995.

L. C. Goodrich (ed.), *Dictionary of Ming biography, 1368–1644*, New York 1976.

D. D. Leslie, *Islam in traditional China. A short history to 1800*, Canberra 1986.

I. de Rachewiltz et al. (eds.), *In the service of the Khan. Eminent personalities of the early Mongol-Yüan period*, Wiesbaden 1993.

Tang Gang, *History of the Ming dynasty* [in Chinese], Shanghai 1985–91.

JACQUELINE ARMIJO-HUSSEIN

Mughal India: 15th to Mid-18th Century

HISTORIOGRAPHY SO FAR

The caricature of the harem. Mainstream Mughal historiography continues to this day to be engaged in a fairly traditional manner with the political and economic bases of Mughal power. Issues of social and cultural history, not to mention questions of women and gender relations, have yet to find a significant place in this writing. Ironically, while there is no sustained investigation of the details of domestic arrangements and familial affairs under the Mughals, we live with a widely accepted caricature of a mysterious, unchanging, and fantastical harem, which is supposed to represent the sum total of Mughal private life from the beginning to the end of this remote and magnificent imperial formation (Lal 1988, Findly 1993, Nath 1994).

Consider the one sentence on the harem that appears in the volume *Mughal India*, published in the prestigious New Cambridge History of India series: "Ideally, the harem provided a respite, a retreat for the nobleman and his closest male relatives – a retreat of grace, beauty, and order designed to refresh the males of the household" (Richards 1993, 62). Or take R. Nath's description of the harem in *Private Life of the Mughals* (1994), and note the emptying of all sense of social life in the sketching of Jahangir's "private life." This Mughal emperor was "a sensuous person and he excessively indulged both in wine and women," writes Nath. "By a routine estimate, he had nearly 300 young and beautiful women attached to his bed, an incomprehensible figure in the modern age. This shows his over-indulgence in sex and his excessive engagement in the harem" (Nath 1994, 13, 15, 17).

This received image of a sexualized, secluded feminine domain, centrally premised upon a crude pleasure principle of bodily gratification that was supposed to regulate the everyday lives of imperial men and women, has been powerful in blinding historians to the density and variation of domestic life as projected in the contemporary records. The received image of the Mughal harem, with hedonism invariably constituting its essence, is an apposite entry point for the present piece.

Sources. In thinking of the reasons for the particular emphases that Mughal history writing has come to acquire, the problem of the inadequacy of source materials is often advanced as being critical. "How will you write a history of the domestic life of the Mughals? There are no sources for it," a leading historian of Mughal India commented when I began my research towards a history of early Mughal domestic life. In spite of this historiographical ultimatum, however, alternative histories can be written – indeed must be written. I hope this will be one of the points established by this study.

The problem is not one of sources at all; it is about the politics of history writing. For the sources exist for very different kinds of histories, as long as the relevant questions are asked. I suggest a number of ways in which another history may be brought into view, a gendered or more self-consciously political history that cannot simply be hived off as "supplementary." Indeed, such an account will necessarily reopen other questions of central importance to Mughal history (Lal 2003, book in progress).

Postcolonial historiography. Mughal historiography is rooted in a tradition of writing about military and political power, in this instance, the emergence of the Mughal Empire and its decline. British colonial rulers (and writers) were enamored of the Great Mughals, whom they saw as their immediate predecessors. Postcolonial Indian historiography has continued to be fascinated by the Mughal achievement, seeing in it evidence of India's historical greatness, autonomous development, and even secularism. For all that, mainstream Mughal historians continue to be occupied with the political-administrative-institutional and economic bases of imperial power (Sarkar 1932–50, Ali 1966, Qureshi 1973, Richards 1975, Chandra 1979, Alam 1986). Closely allied to these are studies focused on agrarian conditions, economic change, trade relations, and the attendant class struggles (Moreland 1929, Habib 1963, Hasan 1973). There has been considerable writing in the area of what might be called a socioeconomic history, both in the context of agrarian relations and in that of trade and trading networks (Raychaudhuri 1962, Pearson 1976, Das Gupta 1979, Arasaratnam 1986).

Apart from the close and detailed investigation of politico-military, administrative, revenue, and agrarian matters, the Mughal court has also been

studied selectively as a site mainly for factions and party politics. In most of the histories of the Mughal court and "political" institutions (the emperor, wars, and the administrative and military machinery) two common features may be discerned. First, the premise for investigation is that these institutions are seats exclusively of high politics. Second, the histories show these institutional sites as fully developed from the moment of their birth, fixed, and uncomplicated in form. All one notices is a change of individuals, factions, and perhaps physical location. Many of these histories begin with Akbar, the third Mughal (whose imperium and power was truly impressive), and a time when the institutions of the Great Mughals had come to be quite securely established. This presentation of Mughal splendor – of a fully formed, majestic Mughal Empire – as an unchanging entity for all time hardly speaks to the making of institutions and their changing character. Quite close to this genre are some other Mughal histories in which scholars have made a concerted effort to study the evolution of political culture built around forms of ritual sovereignty, literary pursuits, art, and architectural splendor. A certain amount of ceremonial as it related to the political, and notions of marriage aimed primarily at political aggrandizement or consolidation, may be located in these writings (Roychoudbury 1941, 1951, Sharma 1962, Rizvi 1975, Richards, 1978, Ziegler 1978, Brand and Lowry 1985, 1985–6).

Social history. What happens to the history of Mughal social life in this context? There is very little that historians have had to say about social conditions and cultural relations, let alone questions of gender – a marked difference, one might add, from the ways in which scholars have engaged with the history of India in colonial and postcolonial times (Sangari and Vaid 1989, Chatterjee 1993, Sinha 1995). The task of studying gender relations at the Mughal court, and rethinking political, social, and cultural milieus in light of new questions that one might ask about everyday life, social relations, domestic ideology, or (to take a small but more concrete instance) the nature of Mughal family, has only just begun (Lal book in progress).

In the received literature, the social history of the Mughals takes two main forms. The first is a statement that appears under the generic title "social conditions and life of the people," but amounts to little more than a journalistic listing of items of daily use, festivities, and pastimes, including something called "the position of women" and "women's education." These are described in such general, commonsensical terms that they give the reader a history that seems to be valid for all times. One cannot but note the ahistoricity of compilations of this kind (Chopra 1963, Srivastava 1964, Majumdar 1974). In such general accounts, as also in books on the Mughal harem, one finds little to suggest that royal women were a critical factor in the making of the Mughal world – except, of course, in the most reduced sense, that women helped to reproduce the Mughal population.

A second strand in Mughal social history is best described as belonging to the genre of biographies of women worthies. Historical studies here focus upon the visibility of imperial women and their power. Since writing of this kind has come to be seen as sufficient to its subject (women), there has been little attempt to challenge long-held assumptions about the activities, relationships, and character of Mughal women and men. Thus while these studies open a neglected area of investigation, they exclude the possibility of querying or even raising new questions about the accepted boundaries of family and household, public and private spheres, gender relations, and political power (Misra 1967, Nath 1990, Findly 1993).

Rekha Misra's early book, *Women in Mughal India* (1967), is a study of aristocratic Mughal women covering the reigns of the Great Mughals: it gives details of their political activities, commercial engagements, education and artistic talents, construction and supervision of buildings, charities, organization of marriages, and so on. Misra wrote about women made visible in imperial records and in the narratives of European travelers. The author presents her study in the form of biographical sketches of the royal women, unsurprisingly ending up replicating the sources. Twenty-three years later this was still the dominant trend in writings on Mughal women. In 1990, Renuka Nath continued to write in the biographical mode for elite women, merely adding a few more characters to Misra's list. The title of her book, *Notable Mughal and Hindu Women in the 16th and 17th Centuries* provides a good indication of its contents. In 1993, the same year that Leslie Peirce's extraordinary book on the Ottoman imperial harem came out, Ellison Banks Findly produced another biography in the same mold as her biographer predecessors. The subject here is Nūr Jahān, the "Empress of Mughal India" as Findly calls her. What is striking is that some of these works were produced in the 1990s, a time of lively, engaged debates concerning feminist historiography and the agency of women, both elite and subaltern.

The most useful of these social histories have aimed at bringing women to life, chiefly through simple biographical sketches. In general, however, such histories seem to exist in a separate sphere, all their own. At best they become ancillary histories: women also ran (or, worse, women also existed). Many of these historians appear to work with the belief that women's histories are not a constitutive element of the larger domain of Mughal history.

There have of course been significant exceptions (Raychaudhuri 1953, 1969). More obviously related to the structure of the imperial household is the recent work of Stephen Blake (1993) on the Mughal imperial capital, Shāhjahānābād, in the years 1639–1739, where he makes the case that the Mughal state was a patrimonial-bureaucratic structure, in which the emperor and his household were of overwhelming importance. Historians John Richards, Burton Stein, Noboru Karashima, and Georg Berkemer have accepted Blake's formulations, albeit with slight modifications (Kulke 1997). The work of these scholars demonstrates that the Mughal monarchy was a personalized one, much dependent on the household, the persona of the emperor, and personal service (Richards 1984). Following this line of enquiry, Rosalind O'Hanlon has recently examined the construction of an imperial masculinity under Akbar, as a previously neglected part of the strategy of governance under the third Mughal monarch, thus drawing attention to a crucial gender dimension in the investigation of imperial politics and identity (O'Hanlon unpublished).

This welcome attention to the changing images of power, the willful construction of imperial "charisma," and the related details of spatial arrangements, marital affairs, and bodily regulation, still tends to remain excessively emperor-centered. In spite of their proposition that the imperial household was the crucial domain after which images of other realms of the empire were to be built, neither Blake nor O'Hanlon pays much attention to the activities and relationships – or even the identity – of the other inhabitants of the domestic world. Thus we find no discussion of how the denizens of the "inner apartments" adopted and negotiated the prescriptive norms and values, and of how these were modified in the process of negotiation. Even the king appears in these accounts as an abstract category, produced in the light of inherited ethical-moral texts. When the figure of the monarch is represented in this way, it is not surprising that the king's intimate circle, the invisible members of the Mughal domestic world – who struggled to fashion themselves, and surely contributed to the emergence of new attitudes, values, and behavior – form no part of the investigations.

Many of the histories encountered here have been written as if they are no more than a preamble to "modern" India. They are conditioned by questions of empire formation in relation to colonial and postcolonial history. Mughal historians have concentrated on grand themes such as the rise and fall of the Mughal Empire (the latter supposedly marking the beginning of British colonial rule and of "modern" India?), long distance trade (potentialities of capitalist development in Mughal India), the administrative system of the Mughals, and "religious policy" under different Mughal rulers (was not Mughal India already secular?).

ALTERNATIVE HISTORIOGRAPHY

How then does one construct an alternative history of the Mughals? It has been claimed, as I noted earlier, that part of the reason for not writing alternative histories lies in the inadequacy of available source material. However, the term "inadequacy" requires some unpacking. Are sources so scarce as to not allow us even the chance of raising new kinds of questions? There are also other questions we need to ask about this proposition of "inadequacy." For example, how have the most important Mughal sources become available to us? In other words, what happens to their content and context in the process of collating, editing, and translating? Surely these procedures affect the way in which a source is archived (made into a source) and read (Lal 2003).

But more importantly there is the need for raising different kinds of questions, and attempts to study Mughal history in terms other than those narrowly concerned with the political-institutional-military-agrarian bases of early modern polities. One area that obviously requires close attention is that of familial relations, personal life, domesticity, and reproductive duties. Such an investigation will certainly open up the diversity of conditions and world-views, struggles and aspirations, that mark not only different periods of history but every individual period of history too. One point to be borne in mind throughout such investigations is that Mughal history cannot be seen either as nothing but the precursor of British rule in India, or as a pale (or less developed) form of modern institutions and practices.

The usual sources. Let us begin by considering what the records are that make up the accepted archive for the early Mughal kings. For Bābur

(1487–1530), his autobiography, the *Bāburnāma* (Thackston 1993, 1996, A. Beveridge 1997), and the *Tārīkh-i Rashīdī* by Muḥammad Ḥaydar Dughlat (Ross and Elias 1895), an account composed by his cousin in 1545–6, remain the most popular texts for scholars.

For Humāyūn (1508–56), the following histories have been used most extensively. *The Qānūn-i Humāyūni* (also called *Humāyūn-nāma*) was composed in 1534 under Humāyūn's patronage by one of his officials, Khvāndamīr (BM, Add. 30,774, Elliot and Dowson 1867–7, Prasad 1939, Hosain 1940). The latter was the grandson of the famous historian Mīrkhvānd, the author of *Rawzat al-ṣafā*. Khvāndamīr's memoir is, as he tells us, an eyewitness account of the rules and ordinances of Humāyūn's reign, accompanied by descriptions of court festivities, and of buildings erected by the padshah. The *Tazkirāt al-Vāqiʿāt* (also called *Humāyūn Shāhi*, and *Tārīkh-i Humāyūn*) was put together in 1587 by Jawhar Aftābchī, Humāyūn's ewer-bearer (Stewart 1832, 1971). This contemporary and rather candid account by a servant has been one of the major source books for the reconstruction of the life and times of the second Mughal, although it has been far from adequately explored in several respects.

Next in the corpus of materials is the *Tazkira-i Humāyūn va Akbar* by Bāyazīd Bayāt, which was completed in 1590/1 (H. Beveridge 1898, Saxena 1925–6, 1930, Hosain 1941). It is a history of the reigns of Humāyūn and Akbar from 1542 to 1591. The author was a native of Tabriz and later joined the army of Humāyūn. These two later biographies owe their origins to the time when materials were being collected for an official history during Akbar's reign. It was in this same context that Gulbadan Bānū Begum, the aunt of the emperor, wrote her account – *Ahvāl-i Humāyūn Bādshāh* – about which I shall say more a little later on (BL, Or. 166, A. Beveridge 1892, 1902, 1994).

Akbar commissioned the first official history of the Mughal court. The *Akbarnāma* (completed in 1596), a history of Akbar's life and times, and its official and equally voluminous counterpart, the *Āʾīn-i Akbarī* (an administrative and statistical report on Akbar's government in all its branches), written by a close friend and minister of the emperor, Abū al-Fazl ʿAllāmī, have remained the most important sources for all histories of his reign (Maulawi 1873–86, H. Beveridge 1993, Blochmann 1872–7, 1977, Jarrett, 1977). Apart from the imperial history, ʿAbd al-Qādir Badāʾūni's three-volume *Muntakhab al-Tawārīkh* and Niẓām al-Dīn Aḥmad's *Tabaqāt-i Akbarī*, written by another member of Akbar's court, has also been very important (Ranking et al. 1986).

A feature of Mughal historiography until now is that a canonical position has been ascribed to particular sources. The scholars' choice of certain sources as basic and central has, of course, in turn, colored their own history writing. Relying heavily on texts like the *Akbarnāmā*, historians have often uncritically reproduced the primary sources themselves, and therefore duplicated one or another chronicler's assessments of the empire, and imperial relations. Thus a particular focus in Mughal historiography has privileged certain kinds of sources; and the substantial nature of those privileged sources has, in turn, tended to perpetuate only certain kinds of histories.

One has to ask why it is that the *Akbarnāmā* and the *Āʾīn-i Akbarī* immediately capture the historian's attention when we turn to a reconstruction of the history of Akbar? Why is it that the unfinished and anonymous *Tārīkh-i Khāndān-i Tīmūriyya* (composed early in the reign of Akbar, it is a history of Tīmūr and his Mughal successors, down to the twenty-second year of Akbar's reign), or *Haft Iqlīm* (a succinct work in connection with Agra, composed by an independent author, not connected with the Mughal court in 1598), to take two examples, do not figure in our minds in the same way (Khuda Baksh 1920, Marshall 1967)? Part of the answer surely is that the *Akbarnāma* and the *Āʾīn-i Akbarī* have been singled out because of their historical "accuracy" and "objectivity," but perhaps most of all because they are the official compendia that deal most directly with political-administrative matters (Mukhia 1976, Qureshi 1978, 1987). Other chronicles do not stand on their own in the same way; they simply become adjuncts to these authoritative documents. Several of the other texts mentioned above are well known but little used. There is no doubt that many different dimensions of Mughal history could be more fully explored through an examination of a wider range of known, but in all sorts of ways, neglected sources (Subrahmanyam 1992).

Other sources. Indeed, there are other kinds of sources and descriptions available, apart from the "minor" texts mentioned above, that would repay closer examination. Among these are several volumes of European travelers' accounts from the sixteenth to the eighteenth centuries, a major source of information for historians of Mughal India, containing unusual and valuable details on several aspects of Mughal social life and hierarchy, particularly notable for their depiction of social

visions and contests in ways rather different from those of the imperial chroniclers. What stands out in the European writings is the sketchiness of knowledge and reference to domestic life and social behavior, as well as their ambivalence and fairly considerable difference of interpretation in regard to these matters (Lal book in progress). Even in the case of some of the later authors (especially Francisco Pelsaert of Antwerp, 1618–25, François Bernier, a French physician, 1656–68, and Nicolao Manucci, a Venetian, 1653–1708) whose accounts of Mughal domestic life are far more detailed, and extravagant, than the earlier commentaries, it is striking to observe the diverse tones in writing (Irvine 1907, Moreland and Geyl 1925, Constable 1968). Yet, historians writing on the harem, for example, have used the most exaggerated travel narratives as transparent representations of literal truth (Misra 1967, Lal 1988).

Then there is the great fund of Mughal miniature paintings, as well as Mughal buildings and architectural sites that survive in Fatehpur-Sikri, Agra, Lahore, and Delhi. These too are not hidden or unrecognized. Akbar and his successors had the existing royal biographies, and other important volumes of histories and legends, illustrated, so that miniature paintings form a striking and important part of many of the historians' most prized sources, now dispersed in museums and libraries the world over. However, these other sources – visual materials, the anecdotal and poetic accounts of women and servants and so on, the monuments and artifacts that survive – have been rendered peripheral by existing historiography, either because it treats them as belonging to a separate, specialized discipline (such as art history), or because they are thought to address trivial matters.

Consider only one of these, Gulbadan Bānū Begum's *Ahvāl-i Humāyūn Bādshāh*, and what it tells us about the lively and changing domestic lives of the early Mughals, as they battled, struggled, dreamed of progeny and empire, and survived to live another day. This is a well known memoir but one that has been rendered peripheral in Mughal historiography, a quintessential "small voice" – "drowned in the noise of statist commands" (Guha 1996).

The memoir was composed in 1587 during the rule of Akbar. Gulbadan Bānū Begum was the daughter of Bābur, sister of Humāyūn, and aunt of Akbar. She was born in 1523 in Kabul, and traveled to India at the age of six-and-a-half (1529), after Bābur had made some substantial conquests in that region. Gulbadan Bānū Begum was witness

to the processes and mechanisms of a monarchy in the making, seeing it through many vicissitudes from the inception of the Mughal kingdom in the early conquests of Bābur to its established splendor in Akbar's reign. She came to write about all this at the behest of her nephew, Akbar, whose efforts to consolidate and institutionalize Mughal power included the command that a comprehensive and authoritative official history be written of its early stages and of his reign.

The *Ahvāl-i Humāyūn Bādshāh* is an unusual memoir, both for its detail about the domestic life of the peripatetic kings, Bābur and Humāyūn, as well for its non-conformity to the available genres of writing, most of which were panegyric accounts of monarchs. Gulbadan moved away from this kind of writing to produce an account of far more "modest" incidents in the lives of Bābur and Humāyūn. Her account of the everyday lives of this royal family in peripatetic circumstances is a unique piece of writing; it provides extensive information about Mughal marriages, relationships of kith and kin, women and children, and the crucial moments that project the patriarchal rendering of relationships such as gifts, acknowledgment of alliances enhancing familial solidarities, and so on.

Add to these the impressive detail provided of the celebrations and feasts held by the senior women on different occasions, and we have a lost world of courtly life in camp conjured up by the Begum in a way that is unparalleled in the chronicles of the time or indeed of the later Mughals. In Gulbadan's memoir, we hear of forbidden feelings, hierarchical familial relationships, and acts contrary to the logic of imperial power. In this way, we are confronted with the flesh and blood character of the great historical figures as well as the limitations and inventiveness of their domestic lives.

Let me cite a short episode recounted by the Begum in which she writes about the varied roles and activities of the women of the Mughal household. This narrative relates to the period when Humāyūn was on the run owing to the challenge of the Afghan ruler Sher Shāh. Humāyūn's movements through various parts of Hindustān and Central Asia at this time were complicated by the struggle for power with his own stepbrothers. In this conflict, Mirzā Kāmrān and Mirzā 'Askarī, his two stepbrothers, were often accomplices.

At one point during this struggle, Mirzā Kāmrān suggested to Mirzā 'Askarī that they should work together to take Qandahār from Mirzā Hindāl, the third stepbrother of Humāyūn. On hearing

of what was transpiring, Humāyūn approached Khānzādeh Begum, his paternal aunt (sister of Bābur), and requested her to go to Qandahār to advise Mirzā Hindāl and Mirzā Kāmrān that since the threat of the Uzbeks and Turkmens (rival clansmen) was great, it was in their best interests to be friends among themselves. Khānzādeh Begum traveled from Jūn to Qandahār, and Mirzā Kāmrān arrived there from Kabul. Mīrzā Kāmrān urged Khānzādeh Begum to have the *khuṭba* (the decree for the proclamation of a new kingship) read in his name. As regards the matter of *khuṭba*, he also wrote to Hindāl's mother (and his step-mother) Dildār Begum, who suggested he ask Khānzādeh Begum, their elder kinswoman, "the truth about the *khuṭba* [*ḥaqīqat-i khuṭba*]." When Kāmrān finally spoke with Khānzādeh Begum, she advised him thus: "as his Majesty Firdaws-makānī [Bābur] decided and gave his throne to the Emperor Humāyūn, and as you, all of you, have recited the *khuṭba* in his name till now, so now regard him as your superior and remain in obedience to him" (Or. 166, A. Beveridge 1994).

This extract, which could be set by the side of many others, reveals a harem far different from that commonly presented, even in recent academic accounts. It concerns a woman in the sixteenth century playing a key role in the reading of the *khuṭba*. This fragment from Gulbadan's memoir is enough to indicate the kinds of questions that the text provokes about the imbrication of the Mughal domestic world in the everyday life of the courts and kings, or equally, the imbrication of courts and kings in the everyday life of the domestic world.

Gulbadan's memoir opens some fascinating arenas for us. It also helps us read other Mughal chronicles very differently, for these too turn out to be richer in meaning and content than the historians have made them out to be. When we go to them with new questions, we discover that the canonical, mainstream sources long used by Mughal historians themselves yield information on many of these matters: unusual and unexpected evidence on the rough and tumble of social life, on everyday struggles, fears, and pleasures, on the construction of new subjectivities and new historical conditions. Thus the historian discovers that there is a distinct possibility of writing "other" histories – precisely in the way in which feminist historiography, subaltern studies, and other such interventions have shown in other contexts – on the basis not only of one princess's memoir, but also of the questions that it challenges us to take to other Mughal sources.

It is interesting in this context to refer once more to Abū al-Fazl's grand compendium, the *Akbarnāma,* the place where we find detailed reference to a women's *ḥajj* (pilgrimage) led by Gulbadan Begum herself. The *ḥajj* is remarkable precisely because it is a women's *ḥajj*, initiated by a woman, and to a large extent organized by women; it tells us something about the process of the consolidation of a Muslim empire in South Asia. The women's *ḥajj* seems to be one of the major pietistic activities that Akbar supported and perhaps saw as reinforcing the Islamic face of the empire. We never hear of such an incident again in the reigns of Akbar's well established successors. Is this because they were already so well established? Or because the royal women, now better "incarcerated," had far less opportunity to take exceptional initiatives and set off on such a pilgrimage?

While the *Akbarnāma* provides considerable detail about the *ḥajj*, historians have paid little or no attention to it (Richards 1993, Pearson 1996). A changed approach and closer attention to questions of gender and power enables us to raise questions about a Mughal "becoming" that Mughal historians have all too often skirted. This relates both to the coming into being of an empire, and to the simultaneous institution of an archive. It makes it possible for us to see how one of the most vaunted Mughal sources (the *Akbarnāma*) came into being, rendering its own "sources" peripheral as it did so. Gulbadan Banu Begum's memoir opens up the question of the *making* of sources, even as it raises questions about the assigned limits of Mughal history.

What a fresh approach to the canonical sources, and a closer attention to neglected sources, suggests very clearly indeed is the fact of the fluidity and contestation that went into the founding of this new polity – not only its new power and grandeur, but also its new regulations and accommodations, its traditions, and its hierarchies. Historians wishing to extend the frontiers of Mughal history cannot but ask for a greater appreciation of this fluidity, even as they seek to reconstruct the history of everyday lives and associations, emotions and attitudes, as an integral part of the history of the empire.

BIBLIOGRAPHY

PRIMARY SOURCES
(Manuscripts, Persian editions, and translations)
Gulbadan Bānū Begum, *Aḥvāl-i Humāyūn Bādshāh,* British Library Ms. Or. 166.
A. S. Beveridge (trans.), *The history of Humayun. Humayun Nama,* Delhi 1902, repr. 1994.

Āʾīn-i Akbarī

H. Blochmann (ed.), *The Āʾīn I Akbarī by Abu'l Fazl Allam*, 3 vols., Calcutta 1872–7, vol. 1 trans. 1873, repr. Delhi 1997.

H. S. Jarrett, (trans.), *The Āʾīn I Akbarī by Abu'l Fazl Allam*, vols. 2 and 3, 1891, 1894, repr. Delhi 1997.

Akbarnāma

H. Beveridge (trans.), *The Akbarnāma of Abu-l-Fazl*, vols. 1–3, 1902–39, repr. Delhi 1993.

A. Maulawi (ed.), *Akbarnāmah*, 3 vols., Calcutta 1873–86.

Bāburnāma

A. S. Beveridge (trans.), *Bābur-nāma (Memoirs of Babur)*, 2 vols., Delhi 1927, repr. 1997.

W. M. Thackston (trans.), *Bâburnâma. Chagatay Turkish text with Abdul-Rahim Khankhanan's Persian translation/Zahiruddin Muhammad Babur Mirza*, 3 vols., Cambridge, Mass 1993.

—— (trans., ed., and annotated), *The Baburnama. Memoirs of Babur, prince and emperor*, Washington, D.C. 1996.

Histories of Humāyūn

Sadasukh Lal Baini Prasad (ed. and trans.), Qānūn-i Humāyūni of Khwāndamīr, British Museum, Add. 30, 774.

H. M. Hidayat (ed.), *The Qānūn-i Humāyūni of Khwāndamīr*, Bibliotheca Indica, 260, no. 1488, New Series, Calcutta 1940.

——, *Tazkira-i Humāyūn wa Akbar of Bāyazīd Biyāt*, Bibliotheca Indica, 264, no.1546, New Series, Calcutta 1941.

Niẓām al-Dīn Aḥmad, *The Ṭabaqāt-i Akbarī of Khwājah Niẓāmmudin Aḥmad*, vols. 1–3, trans. D. B. and B. Prasad, Delhi 1936, repr. 1992.

ʿAbd al-Qādir ibn al-Badāʾūnī, *Muntakhab al-tawārīkh*, 3 vols., ed. and trans. G. S. A. Ranking, W. H. Low, and Sir W. Haig, vols. 1–3, Delhi 1884–1925, repr. 1986.

H. Beveridge, The memoirs of Bayazid (Bajazet) Biyat, in *Journal of the Asiatic Society of Bengal* 4 (1898), 296–316.

Descriptive list of the photographic reproductions of illustrations from three Persian manuscripts [of the Badshah-namah of Abd al-Hamid Lahauri, the Shahnamah of Firdausi, and the Timur-namah of Abd Allah Hatifi] in the Oriental Public Library at Bankipore, India. Prepared by Wali-ud-din Khuda Bakhsh, British Library, Shelfmark 14773.1.3.

H. M. Elliot and J. Dowson, *The history of India as told by its own historians*, vols. 1–3. London 1867–77.

——, Humayun-Nama of Khondamir, in H. M. Elliot and J. Dowson (eds.), *The history of India as told by its own historians*, vol. 5, London 1873, 116–26.

Mirzā Ḥaydar, *The tarikh-i Rashidī of Muhammad Haidar Dughlát. A history of the Moguls of Central Asia*, ed. N. Elias and trans. R. Denison, London 1895.

Jawhar, *The Tezkereh al-Vakiāt. Or, private memoirs of the Moghul Emperor Humāyūn, written in the Persian language by Jouher (a confidential domestic of His Majesty)*, trans. Major C. Stewart, Lucknow 1832.

B. Prasad, A note on the buildings of Humayun, in *Journal of the Royal Asiatic Society of Bengal* 5 (1939), 459–61.

B. P. Saxena, Baizid Biyat and his work "Mukhtasar" in *Journal of Indian History* 4:1–3 (1925–6), 43–60.

——, Memoirs of Baizid, in *Allahabad University Studies* 6:1 (1930), 71–148.

Tarikh-i Khandan-i Timuriyya, Ms. Khuda Baksh Oriental Public Library, Patna.

SECONDARY SOURCES

M. Alam, *The crisis of empire in Mughal North India. Awadh and the Punjab*, 1707–48, Delhi 1986.

M. Ali, *The Mughal nobility under Aurangzeb*, London 1966.

S. Arasaratnam, *Merchants companies and commerce on the Coromandel coast, 1650–1740*, Delhi 1986.

F. Bernier, *Travels in the Mogol Empire AD 1656–1668 by Francois Bernier*, trans. I. Brock, rev. A. Constable, Delhi 1968.

A. S. Beveridge, Life and writings of Gulbadan Begam (Lady Rosebody), in *Calcutta Review* 106 (1892), 345–71.

S. Blake, *Shahjahanabad. The sovereign city in Mughal India 1639–1739*, Cambridge 1993.

M. Brand and G. D. Lowry (eds.), *Fatehpur Sikri*, Bombay 1985.

——, *Akbar's India. Art from the Mughal city of victory*, London 1985–6.

S. Chandra, *Parties and politics at the Mughal court*, New Delhi 1979.

P. Chatterjee, *The nation and its fragments. Colonial and postcolonial histories*, Princeton, N.J. 1993.

P. N. Chopra, *Some aspects of society and culture during the Mughal Age (1526–1707)*, Jaipur 1963.

E. B. Findly, *Nur Jahan, empress of Mughal India*, New York 1993.

A. D. Gupta, *Indian merchants and the decline of Surat: c. 1700–1750*, Wiesbaden 1979.

I. Habib, *The agrarian system of Mughal India, 1556–1707*, Bombay 1963.

S. N. Hasan, *Thoughts on agrarian relations in Mughal India*, New Delhi 1973.

H. Kulke (ed.), *The state in India 1000–1700*, Delhi 1997.

K. S. Lal, *The Mughal harem*, New Delhi 1988.

R. Lal, The "domestic world" of the Mughals in the reigns of Babur, Humayun, and Akbar, 1500–1605, D.Phil. thesis, University of Oxford 2000.

——, Rethinking Mughal India. The challenge of a princess' memoir, in *Economic and Political Weekly* 38 (4 January 2003), 53–65.

——, Historicizing the ḥaram. Early Mughal domestic life, book in progress.

R. C. Majumdar (ed.), *The Mughul Empire*, Bombay 1974.

N. Manucci, *Storia do Mogor, or Mogul India 1653–1708 by Niccolao Manucci, Venetian*, 4 vols., trans W. Irvine, London 1907–8.

D. N. Marshall, Mughals in India. A bibliographical survey, London 1967.

R. Misra, *Women in Mughal India 1526–1748*, Delhi 1967.

W. H. Moreland, The agrarian system of Moslem India, Cambridge 1929.

H. Mukhia, *Historians and historiography during the reign of Akbar*, New Delhi 1976.

Renuka Nath, *Notable Mughal and Hindu women in the 16th and 17th centuries A.D.*, New Delhi 1990.

R. Nath, *Private life of the Mughals of India 1526–1803*, Jaipur 1994.

R. O'Hanlon, Kingdom, household and body. Gender and the construction of imperial service under Akbar, unpublished paper.

M. Pearson, *Merchants and rulers in Gujarat*, Berkeley 1976.

——. *Pilgrimage to Mecca. The Indian experience 1500–1800*, Princeton, N.J. 1996.

L. P. Peirce, *The imperial harem. Women and sovereignty in the Ottoman Empire*, New York 1993.

F. Pelsaert, *Jahangir's India. The remonstrantie of Francisco Pelsaert*, trans. W. H. Moreland and P. Geyl, Cambridge 1925.

I. H. Qureshi, *The administration of the Mughul Empire*, Patna 1973.

G. Ranajit, The small voice of history, in S. Amin and D. Chakrabarty (eds.), *Subaltern Studies IX. Writings on South Asian History and Society*, Delhi 1996, 1–12.

T. Raychaudhuri, *Jan Company in Coromandel, 1605–1690. A study in the interrelations of European commerce and traditional economies*, The Hague 1962.

J. F. Richards, *Mughal administration in Golconda*, Oxford 1975.

——, The formulation of imperial authority under Akbar and Jahangir in kingship and authority, in J. F. Richards (ed.), *Kingship and authority in South Asia*, Madison, Wis. 1978, 252–85.

——, Norms of comportment among imperial Mughal officers, in B. D. Metcalf (ed.), *Moral conduct and authority. The place of adab in South Asian Islam*, Berkeley 1984, 225–89.

——, *The Mughal Empire*, Cambridge 1993.

S. A. A. Rizvi, *Religious and intellectual history of the Muslims in Akbar's reign*, Delhi 1975.

M. S. Roychoudbury, *The Din-I-Ilahi. Or, the religion of Akbar*, Calcutta 1941.

——, *The state and religion in Mughal India*, Calcutta 1951.

K. Sangari and S. V. Sangari (eds.), *Recasting women. Essays in Indian colonial history*, Delhi 1989.

J. Sarkar, Fall of the Mughal Empire, Calcutta 1932–50.

——, *Mughal administration*, Calcutta 1935.

S. R. Sharma, *Mughal government and administration*, Bombay 1951.

——, *Religious policy of the Mughal emperors*, Bombay 1962.

M. Sinha, *Colonial masculinity. The "manly Englishman" and the "effeminate Bengali" in the late nineteenth century*, Manchester, U.K. 1995.

A. Srivastava, *The history of India (1000 A.D.–1707 A.D.)*, Agra 1964.

S. Subrahmanyam, The Mughal state. Structure or process. Reflections on recent western historiography, in *Indian Economic and Social History Review* 29:3 (1992), 291–321.

N. P. Ziegler, Some notes on Rajput loyalties during the Mughal period, in J. F. Richards (ed.), *Kingship and authority in South Asia*, Madison, Wis. 1978, 215–51.

RUBY LAL

Ottoman Empire: 15th to Mid-18th Century

The historical sources on the formation and expansion of the Ottoman state contain fragments of knowledge on the lives of women. European travelers' accounts provide interesting but superficial observations on Muslim women they encountered in public. For details about the everyday lives of these women, the European male narrators often relied on translators, usually non-Muslim subjects of the empire. Ottoman historical chronicles, which narrated all significant events around the Ottoman rulers, mention a few prominent royal women such as wives, concubines, or daughters in so far as they affected historical events. Research on the legal transactions of the empire recorded in the thousands of volumes of Islamic court proceedings has revealed the most significant insight into the everyday lives of Ottoman Muslim and non-Muslim women. This entry first presents a brief historical background on this period and then critically examines the sources that provide information on Ottoman women.

HISTORICAL BACKGROUND

The 1400–1700 period marked the formative years of the Ottoman state and its culmination as an empire. The Ottoman state initially emerged in the Western Anatolian town of Söğüt around 1299 when Osman, the leader of a small frontier Seljukid principality, declared his independence from the Seljuk sultanate of Konya. In 1326, the Ottomans captured the city of Bursa from the Byzantine Empire and declared it their second capital. By 1400, Ottoman rule had expanded to encompass much of Anatolia and the Byzantine territories of Macedonia and Bulgaria. In 1402, the Ottoman capital was moved to Edirne (Adrianopolis) in Europe and from there the Ottomans challenged the last great bastion of the Byzantine Empire, its capital Constantinople.

The Ottomans entered a brief period of stagnation when a force from the steppes, led by Timur the Lame (Tamerlane), fought and defeated the Ottoman ruler Bayezid I in 1402. The ensuing decade witnessed a fight among Bayezid's four sons for the throne, with Mehmed I (1412–20) emerging triumphant. By 1440, the Ottoman state had reconsolidated its territories under Murad II; it was during the reign of his son Mehmed II (1451–81) that the Byzantine Empire was defeated and Constantinople captured to become the last and final capital of the Ottoman state. Ottoman territories were then greatly expanded by Selim I (1512–20) who completed the conquests of eastern Anatolia, northern Iraq, Syria, Palestine, Egypt, and the Hijaz. But it was under his son, Sulṭān Süleyman I (1520–66), that the Ottoman Empire reached its greatest expansion over Asia and Europe.

The reigns of the successors Selim II (1566–74), Murad III (1574–95), and Mehmed III (1595–1603) led to seventeenth-century social unrest as a consequence of fiscal and agricultural crises. This period also marked frequent changes of tenure among the Ottoman rulers as nine different sultans assumed the throne throughout the seventeenth century; these were Ahmed I (1603–17), Mustafa I (1617–18, 1622–3), Osman II (1618–22), Murad IV (1623–40), İbrahim (1640–8), Mehmed IV (1648–87), Süleyman II (1687–91), Ahmed II (1691–5), and Mustafa II (1695–1703). Even though there were modest Ottoman successes during this time, such as the restoration of order in the empire by Murad IV and its expansion eastward to capture Baghdad in 1638, ambitious campaigns such as the first siege of Vienna in 1683 culminated in an Ottoman defeat by European forces. While this defeat initiated a long period of peace, it also effectively ended the Ottoman wars of conquest; in 1699, when the Ottomans had to sign the Treaty of Karlowitz, they had only Macedonia and the Balkans left under their control in Europe.

This historical account of events of the Ottoman Empire reflects the dominant narrative in Ottoman historiography, which was centered on the reigns of each Ottoman ruler. Women come into this narrative as they wield power upon the Ottoman ruler either through kinship, as his mother or daughters, or through sexual intimacy, first primarily as wives and later as concubines who bear him heirs. European travel accounts replicate this dominant narrative and, in the case of women, supplement it with descriptions of what they see, often the secluded, veiled Muslim women in public places, and what they hear, often fragmentary knowledge of Muslim women

gleaned from the non-Muslim subjects of the empire.

CHALLENGES TO THE ANALYTICAL STUDY OF OTTOMAN WOMEN

Theoretical and methodological problems surround the study of Ottoman women during this period. The theoretical emphasis on the public domain marginalizes Ottoman women who often do not participate in the public domain as their European counterparts do. This problem quickly becomes compounded by methodology: the historical data where women are absent are assumed to fully represent social reality during this time. Most accounts of this period therefore naturalize the conception that male-dominated public institutions constitute Ottoman social reality and that women – who have different participation patterns – do not contribute to this reality.

Problems generated by this gender difference in public participation are compounded by the lack of adequate research tools with which to locate Ottoman women in society and to articulate their contributions beyond biological reproduction. For instance, ordinary Ottoman women's labor in the guilds or in agriculture does not become as visible as men's because it often does not reach the marketplace. In addition, very few documents remain from a domain where Ottoman women were very active, namely that of social reproduction, comprising the formation and sustenance of networks of kin, friendship, alliances, and marriage. As a consequence, state-centered, male-dominated historical accounts of the public domain where elite women were absent become uncritically accepted and interpreted and thereby reified as the dominant historical narrative. Only a systematic and critical re-analysis of these historical sources, and a subsequent reinterpretation, reveal the variation and complexity in women's lives in the Ottoman Empire.

EUROPEAN TRAVEL ACCOUNTS OF OTTOMAN WOMEN

European travelers came to the Ottoman Empire often as representatives of European rulers on special missions or were on their way to other destinations in the East and happened to travel through Ottoman lands. These travelers, as well as foreign ambassadors who resided at the capital for varying periods, members of their retinue, merchants, renegades or captives, left behind travel accounts. Often fact, hearsay, and fantasy intersected to produce accounts of women. While the European accounts penned during the fifteenth and sixteenth centuries, a time of increasing Ottoman grandeur, were rather favorable, a transformation occurred with the Enlightenment. The Ottoman Empire, once depicted as a powerful enemy of Europe, was represented as the embodiment of tyranny, and the seclusion of elite women played a significant role in accounting for its moral degeneration. Non-elite women's economic and social participation went largely unnoticed in the traveler's accounts.

One dominant theme that colored all European travel accounts during this period was that of religious differences. This led to the portrayal of the Ottomans as "the other," emphasizing those qualities that separated the Ottomans from Europe to the detriment of their many similarities. Since European descriptions almost always contained inherent comparisons between Europe and others, where the latter inescapably became categorized as "different," it was inevitable that this difference centered around the most visible variation, that between Christianity and Islam. Ottoman society was, in terms of dominant culture and character, predominantly Islamic and the religiously prescribed public-private separation limited the public visibility of Ottoman women, both elite and non-elite, in urban areas. This relative public absence led European travelers to compare Ottoman Muslim women with the publicly visible Christian women in their own societies, almost always to the detriment of the former. Myths about Ottoman women's victimization and oppression ensued.

Hence two interrelated inaccuracies ran throughout the European travel accounts of Ottoman women. One derived from culture in that the travelers often employed their own frames of reference, the position of women of comparable status within their own societies; they defined Ottoman women in terms of what European women were not. The image of Ottoman women was thus not objectively based, but rather socially constructed on the negation of the European case. The other related inaccuracy in the European conception was contextual: the inaccessibility of Ottoman women led these travelers to depict what they could not observe as inactive and therefore insignificant. This categorization further enhanced the perception that Ottoman women were very different from European women. This difference was compounded as male European travelers could not question their constructed image of Ottoman women with or against objective reality and therefore resorted to providing hearsay that affirmed

their constructions. It was no accident that European travelers were most interested in seclusion. Their informants probably came from among the non-Muslim minority women to whom Europeans had more access through their husbands, who were often translators for European travelers.

A number of European accounts illustrate these arguments. Ogier Ghiselin de Busbecq, the imperial ambassador of King Ferdinand at Istanbul during 1544–62 and one of the first to visit Anatolia since its occupation by the Ottoman Turks, notes in his memoirs, for instance, that

> the Turks set greater store than any nation on the chastity of their wives. Hence they keep them shut up at home, and so hide them so they hardly see the light of day. If they are obliged to go out, they send them forth so covered and wrapped up that they seem to passers by to be mere ghosts and spectres.... Concubines may be either purchased or acquired in war, and when they are tired of them there is nothing to prevent them sending them to the slave market and selling them (1927, 117).

Two other accounts by men in the retinues of European ambassadors, Guillaume Postel who was in Istanbul in 1535 and Salomon Schweigger in 1577–81, provide similar information. Postel (1560), for instance, who probably did not himself observe any Ottoman Muslim women, nevertheless states that these women liked their hair black and often connected their eyebrows as a sign of beauty. Schweigger (1608) notes that it was not very common for Ottoman men to have more than one woman as wives for two reasons: the good influence of Christians and Jews of the empire, and the peace and quiet achieved by limiting the number of spouses in the household. Schweigger also points out that even though the whole world was afraid of the Turk, the Turk, in turn, was afraid of his wife who was the absolute ruler in the household.

Nicolas de Nicholay (1585), who was sent by the French king to Istanbul in 1551, comments on how Ottoman Muslim women enjoyed going to public baths; he adds that the women often used this opportunity to escape their husbands and have affairs with other men. Hans Dernschwam (1923), who was in Istanbul in 1553 as a part of the retinue of a Hungarian commander, commented that Ottoman Muslim women did not often go to mosques, but prayed at home instead. Philippe du Fresne-Canaye (1897), who joined the retinue of the French ambassador in Istanbul in 1573, provides detailed descriptions of the type and textures of the clothes the Ottoman Muslim women wore, both in public and at home.

Luigi da Zara Bassano (1963), who was in Istanbul in 1537–40, published, upon his return to Rome, a book on the costumes of the Ottoman Turks, including women. He too notes the grooming habits of Ottoman women: they loved black hair so much that regardless of the original color of their hair, they dyed it black using henna. Bassano also could not resist commenting on women who attended public baths; the women at these public baths, he commented, often had sexual affairs with other women – he personally was aware of such a relationship between a Greek and a Muslim woman. Nicolas de Nicholay also mentions the frequency of same-sex relationships between Ottoman women. In the minds of these European travelers, the Ottoman seclusion of women seems inevitably to lead to adultery and what they considered sexual deviance.

Another dominant theme was the large number of women present in the households Ottoman Muslim men. Both Bassano and Dernschwam comment on the roles played by these women; they often helped with household duties, but, most importantly, served the male head of the household. Both note with fascination that the male, if bored, could just sell these women at the market. In producing this interesting information, both narrators seem to engage in a European male fantasy of having a relationship with a woman without any responsibilities. The mention of responsibility led to another European misconception: Dernschwam pointed out that Ottoman Muslim wives had no organizational skills and often sat home idle. Their female slaves who did all the housework produced, in turn, messy and disorganized households. He also notes that even though most women in the households were able to remain chaste, those wives left behind when their husbands went to war for extended periods often resorted to prostitution. These women could not even be adequately punished upon the return of their husbands because they were unrecognizable with their faces veiled. It was once again the fact that Muslim women were kept under constant lock and key, Dernshwam concluded, that accounted for the moral decadence in Istanbul.

European travelers' discussions of Ottoman Muslim women's marital patterns likewise contain derisive elements. Bassano notes that an Ottoman Muslim woman could not marry a Christian, while Ottoman Muslim men faced no such restrictions. As for divorce, the Ottoman Muslim women could divorce her husband if she did not like the house she had been given, if the marriage had not been consummated, if the hus-

band had unnatural tastes, or if he forced his wife to drink wine against her will. All of these accounts focus on highlighting the differences between the lives of Ottoman and European women; the comparisons inherent in all the accounts hinder the description of Ottoman women's experiences in their own terms. An exception is the account by Thomas Dallam who came to Istanbul in 1599–1600 to perform on and maintain the organ Queen Elizabeth had presented to Mehmed III (1595–1603); he caught a glimpse of the beautiful women in the sultan's household when he was at the palace, and described them as he saw them.

In summary, these travel accounts reveal the European male obsession with seclusion. In their attempts to come to terms with it, almost all these observers cannot help mentioning how seclusion leads to a range of immoral behavior ranging from adultery and sexual perversion to slovenly housekeeping practices. These themes become amplified in later centuries to constitute the gaze that was later described as Orientalism. One should note, however, that there were also a few European women travelers who visited the Ottoman Empire and personally observed their Ottoman counterparts. The most significant of these, Lady Mary Wortley Montagu, wife of the British ambassador, was in Istanbul during the early eighteenth century and thus falls outside the purview of this entry.

OTTOMAN ROYAL WOMEN, DURING THE FIFTEENTH TO SEVENTEENTH CENTURIES

Another source of information on Ottoman women during this period is the historical chronicles. These are often limited to scant coverage of royal women. They reveal, for instance, that at the beginning of the period under examination, the mothers and wives of the early Ottoman rulers were daughters of either the leaders of other Muslim states in the region or of prominent Byzantine notables. With the expansion of the Ottoman state at the expense of these Muslim states and the Byzantine Empire, the opportunities to marry such elite women decreased. This fact, combined with the practice developed by the Ottoman dynasty, led Ottoman rulers to gradually stop marrying daughters of neighboring empires. Instead, they started to choose as their partners the slaves who were often presented to them as gifts.

As the Ottoman state turned into a Muslim empire, more information survived on the Muslim wives of the Ottoman rulers as well as on those few who were the mothers of succeeding sultans. An early example is Nilüfer Hatun, one of the wives of the Ottoman ruler Orhan, who was the daughter of the Byzantine lord of Yarhisar. In the fourteenth century, Murat I married several Byzantine princesses including a daughter of the Cantacuzenus family who gave birth to Bayezid I, who in turn married Christian princesses including a daughter of the Byzantine Emperor John V Palaeologus. Until the mid-fifteenth century, the Ottoman rulers took both legal wives and slave concubines. This trend started to change to the advantage of concubines as the rulers' power grew and they disdained forming intimate connections with neighboring dynasties. After the end of the fifteenth century, the daughters of Ottoman rulers were likewise no longer married into foreign dynasties, but instead were given away in marriage either to cousins, or, more often, to prominent state officials in an attempt to guarantee their loyalty to the Ottoman state.

Prominent among the Ottoman rulers' concubines was Hürrem Sultan, known to Europeans as Roxalena, daughter of a Ruthenian priest, who was sold by the Tatars to the Grand Vizier İbrahim Pasha who in turn presented her to the Ottoman ruler Süleyman II. Unlike his other concubines, Hürrem had Süleyman II marry her. She then became involved in the issue of succession during her lifetime to ensure, without success, the rise of her sons to the Ottoman throne. Hürrem also wrote poetry, and sometimes replied in verse to Süleyman's love poems. It was again Süleyman who presented to his son the concubine Nurbanu Sultan, originally called Cecilia, who was an illegitimate daughter of the distinguished Venetian house of Vernier-Baffo. Nurbanu became prominent as the sultan's mother and was instrumental in having the Ottomans sign a peace treaty with Venice in 1573. Another influential woman was Kösem Sultan, the mother of Murad IV, who had been originally presented to the Ottoman ruler Ahmed I by the governor of Bosnia. Kösem was murdered in 1651 through the machinations of Turhan Sultan, who was originally a Russian slave presented to the palace by the Crimean Tatars; Turhan had Kösem killed to guarantee the succession of her son to the Ottoman throne.

What united these women was their seclusion in the Ottoman ruler's household. The practice of seclusion of women within the household was indeed an important aspect of life in the Ottoman Empire, though one often misunderstood by European travelers. The social and political life of

the Ottoman elite took place entirely within private spaces, with men and women separated, while poor men and women lived and worked side by side in public spaces. Hence in the context of the Ottoman Empire, an individual's seclusion demonstrated both social and political status, and in no way was seclusion solely a female experience. In fact, the sultan's power was demonstrated through his seclusion within the harem where women were able to gain political and social power according to their proximity to him. One should note the dramatic difference between this historically contextualized description of seclusion in the household from the one constructed by European travel accounts in the preceding section.

The harem of an Ottoman household, which was common only among the wealthy, did not simply consist of a male head and his wives, but included children, widowed sisters or mothers, and female servants as well; the term harem, derived from the Arabic root ḥ-r-m, meant, among other things, sacred, and was a term of respect referring to religious purity. Even though the harem was generally seen in Europe as a sexualized place of female oppression where women lacked power and men were forbidden, it was actually a patriarchal support system and the center of family and social life. Family politics rather than sex was the main force behind the harem, and men and women both occupied the space.

The royal harem, *harem-i hümayun*, the harem of the Ottoman ruler, though similar in idea, was a much more complex and extremely organized system of administration and hierarchy. It contained the combined households of the Ottoman sultan's mother, his favorites, as well his daughters and their mothers. The harem became more prominent in Ottoman society as the rulers gradually replaced marriage with slave concubinage. This practice emphasized the patriarchal nature of power in that slave concubines had no recognized lineage and derived power from their husbands to whom they were usually devoted and loyal. This condition was quite different from that of the wives whose vested interests in their own family's affairs could potentially interfere with their loyalty to their husbands. The practice of slave concubinage was also probably influenced by the use of slaves throughout the Ottoman administrative structure: Christian youths were systematically converted to Islam and made to join the sultan's military forces as well as the highest administrative offices. Slave concubines were often young

girls of extraordinary beauty who were initially sent to the Ottoman ruler as gifts from high-level officials who either acquired them during their conquests, or bought them from the slave markets after they had been kidnapped, or sold by their impoverished parents. Since the enslavement of Muslims was forbidden, these slave concubines often came from non-Islamic areas. Many Georgian and Circassian families encouraged their daughters to enter concubinage, as it promised a life of luxury and comfort.

The organizational structure of the harem where every individual carried out well-defined tasks exactly reflected the structure surrounding the Ottoman ruler himself. All slaves that entered the royal harem were termed *odalık*, or women of the court, and often became general servants in the harem. The ruler's mother selected among these women only those of extraordinary beauty and talent as potential concubines; these selected few were then trained to be presented to the ruler. They learned to dance, recite poetry, play musical instruments, and master the erotic arts. Only the most gifted were presented to the Ottoman ruler as his personal maids in waiting, *gedikli*. Even though these slave concubines initially had no legitimate claim to power, they acquired titles such as *sultan kadın* or *haseki* as they acquired the Ottoman ruler's favor and especially if they bore him an heir. Care was taken that no one woman bore the ruler more than one son. When a woman became the mother of the next Ottoman ruler, she acquired the title *valide sultan*. All too often, as it occurred in all families, the *valide sultan* and the *haseki* vied for power.

INCREASED POWER OF THE ROYAL HAREM, SIXTEENTH AND SEVENTEENTH CENTURIES

Even though the unprecedented political power of the Ottoman imperial harem from the mid-fifteenth to the mid-seventeenth centuries was viewed widely by both the European travel accounts and the Ottoman historical chronicles as illegitimate and corrupting, a recent study (Peirce 1993) has demonstrated that female power was a logical, indeed an intended consequence of the change in the Ottoman structure of succession and rule. Initially, Ottoman succession was determined by a struggle among all contending heirs where the one who proved the most worthy successor assumed power. During their father's life, the male heirs were sent to train at Anatolian governorships and their mothers accompanied them

to supervise their sons, and organize and oversee their households. When the ruler died, all rushed to the capital and whoever assumed the throne executed all his brothers as well as all their sons to guarantee the cessation of further struggles. During the seventeenth century, this practice was gradually revised so that the senior brother assumed the throne and imprisoned his brothers and their households at the capital. Not only did this political transformation in Ottoman succession reduce the governing experiences of the heirs, it also increased the influence of their mothers and wives upon them.

As future Ottoman rulers detached themselves from world affairs and no longer led their armies in battle, they spent most of their time in the company of women in the palace. Thus the power of royal women grew. The mothers of the rulers became custodians of sovereign power, trained their sons in its use, and exercised it directly as regents when necessary. Through managing the large households of their sons they had acquired the requisite administrative skills. These royal women headed domestic factions, negotiated treaties with foreign powers, acted as regents for their sons, and engaged in the patronage of the arts and charity.

OTTOMAN ROYAL WOMEN AS PATRONS OF ART AND ARCHITECTURE

Royal women played central roles in the public culture of sovereignty, namely royal ceremonial, monumental building, and patronage of artistic production from the inception of the Ottoman state. Among the earlier royal women, Nilüfer Hatun donated funds for the construction of a bridge, as well as a dervish monastery (zaviye) and mescit near Bursa. Women of prominent Ottoman families followed suit and built palaces and public buildings such as mosques, madrasas, hospitals, and caravanserais with waqfs to endow their projects. By providing public spaces for the people of their state, the royal women not only demonstrated their political and social status but also expressed religious commitment and drew attention to significant locations in the empire. Architectural patronage was viewed as an important pious act that would earn patrons rewards in heaven.

In the later centuries, a social pattern started to develop among the female patrons. Among the women in the sultan's household, the sultan's mothers predominated in building activities.

Aside from Hürrem Sultan, Süleyman's wife, who was in her childbearing years when she became an architectural patron, royal women generally finished with childbearing and rearing, thus acquiring seniority in the harem, before they commenced on their building activities. Hürrem was the first royal female to patronize works in the capital as opposed to provincial towns. Her most significant architectural contribution was the Haseki Hürrem Külliye comprised of various religious and social structures including, originally, a mosque, a madrasa, a Qur'ān school (mekteb), and a soup kitchen (imaret). In later years, she added a double bathhouse (hamam) and a hospital devoted entirely to women in a part of the city called avratpazarı where women could trade in goods and where there was once a market in female slaves.

Another prominent royal patron was her daughter Mihrimah Sultan who also built various mosques and charitable foundations in the capital as well as in the former Ottoman capital of Edirne. Her mosque at the entrance to Edirne, designed by the most prominent Ottoman architect, Sinan, comprised, in addition to the mosque, a double hamam, an imaret, and a madrasa, as well as extensive courtyards and gardens. The royal women's structures were often more innovative than the typically monumental, but conservative, works commissioned by men. Among the later valide sultans, Safiye Sultan, the mother of Mehmed III, initiated the building of the Yeni Valide Mosque. After the removal of her son from the throne, it was the mother of his successor Sultan Ahmed I, Kösem Maypeyker Sultan, who finished the project.

Ottoman royal women often figured in chronicles through their connections to the rulers. When the prominence of these women increased during the sixteenth and seventeenth centuries, the allusions to this change in both Ottoman chronicles and European travel accounts were very negative: impotent inept rulers and moral decadence spawned by the harem system were often blamed. Yet this change was actually a consequence of the political transformation in the Ottoman rule of succession: as the heirs were not sent off to the provinces for training but were kept at the capital in palaces under the tutelage of their mothers, the prominence of the latter increased. These royal women became significant patrons of art and architecture. Still, they formed a very small elite group in Ottoman state and society. Other historical sources capture the location and roles of

non-elite Ottoman Muslim and non-Muslim women.

OTTOMAN NON-ELITE MUSLIM WOMEN

Two historical sources regulated the lives of non-elite Ottoman Muslim women: the prescriptions of Islamic law derived from the Qur'ān, the Sharī'a, and their interpretations by jurists in reaching judgments on court cases that were duly inscribed in the Ottoman religious court records (kadı or şer'iye sicilleri). Analysis of these judgments reveals that the Ottomans elevated their traditions as well as local practices into a code of laws termed kanun that were independent of the Sharī'a. By the beginning of the sixteenth century, the kanun rulings in the Ottoman Empire had become a set of laws as significant as Islamic law.

The Qur'ān gave the ideal prescription of women's position in society as opposed to their real location. The failure to recognize this ideal/real distinction worked especially to the detriment of Ottoman Muslim women portrayed in European travel accounts, which assumed Qur'ānic prescriptions translated directly into a societal description. In reality, however, Muslim jurists employed a variety of resources to address the issue of translation of Islamic prescription into practice; they drew upon their own inherited legal tradition, their observations of their own society, and their own ability to reason and judge (Tucker 1998). The existence, in addition, of well articulated Ottoman kanuns provided the jurists a large legal space within which to reach a decision.

In reaching a judgment, the jurists contextualized the case by taking into account the individual's particular composite of social and civic circumstances. Ottoman females were viewed juridically as persons, and, as such, were able to inherit, own, and administer both personal and real property. Since the practice of female seclusion could make women unavailable in court, they were often assigned male guardians who were made legally responsible for them. Still, even though Ottoman law established the public accountability of the male for the female, it was also careful to set limits to it (Peirce 1999).

Research on the wealth of information contained in Islamic court records by scholars such as Ronald Jennings (1975), Haim Gerber (1980), and recently by Judith Tucker (1986, 2001), Suraiya Faroqhi (1987), Gülru Necipoğlu (1991), Julie Marcus (1992), and Leslie Peirce (1993) has highlighted the spectrum of women's circum-

stances. These scholars have been able to expand the available information on Ottoman women of all classes and religious-ethnic affiliation beyond the narrow confines of European travel accounts, Ottoman historical chronicles, and prescriptive legal knowledge. In doing so, they have uncovered the once denied agency of Ottoman women.

The Islamic court records have some limitations as a historical source. The major limitation is that of selectivity: only those cases the litigants brought to court appear in the records; those social and economic interactions settled informally among people are never recorded. In addition, since Islamic courts were established in urban areas, they often favor the court cases of urban women over rural women who may have chosen not to make the trip to the urban center. Only in exceptional cases did rural peasant women leave their villages to sue or be sued in urban courts. Care should be taken not to overestimate this urban bias, however, since there was a higher percentage of people living in urban areas of the Ottoman Empire in Anatolia and the Balkans in the fifteenth and sixteenth centuries than there was in Europe.

The general portrayal of the lives of non-elite Ottoman women in the Islamic court records contradicts their representation in European travel accounts, which mistook women's public absence for decadence. During this period Ottoman women appear in court cases as strong, active participants. The prominence of court cases with women representing themselves further reveals that the Islamic prescription of female seclusion was rarely adhered to in provincial towns. This was no doubt necessitated by the cycle of seasons when men and women had to harvest and thresh together. Another significant factor was the long absences of Muslim men in Ottoman campaigns, which forced women to engage in agricultural work and animal husbandry, as well as domestic labor.

In addition to agriculture, women were also active in another prominent aspect of the Ottoman economy: textile production and trade. Women engaged in embroidery, cloth spinning, dying, and weaving, which in turn allowed them a significant amount of power and financial independence. Produced by women working independently in their homes, embroidery became a significant skill acquired by young girls throughout the empire. As these girls became more skilled, they could, when they matured, set up small informal schools to teach younger girls. This practice of gathering together enabled

women to develop social networks. Court records also indicate that women throughout Anatolia held on to the wealth they accumulated as they owned mills, bakeries, ovens, grocery shops, and other workplaces.

The wealth of information in Islamic court records on the lives of non-elite Ottoman Muslim women can be further documented through specific case studies. For instance, Ronald Jennings (1980, 1975) studied approximately two thousand court cases in which women were involved as litigants in 1600–25 at the provincial Ottoman town of Kayseri. These women brought cases to court for the settlement of estates, property transfers, and disputes arising from marriage and divorce. The records reveal women to be active participants in society as they often managed their own assets, participated in commercial transactions, and appeared in court to pursue their grievances. Since women could not hold government office, and rarely took part in economic activities in shops, crafts, or guilds in the city, their economic participation was largely concentrated in land-holding and money-lending.

Haim Gerber's study (1980) of approximately one hundred Bursa court registers during the 1600–1700 period demonstrates that women used the courts even more actively than women in Kayseri. They sold, bought, and leased both urban and rural real estate; they owned many shops, workshops, and agricultural land. Some were involved in credit transactions, took loans and lent credit on a semi-professional basis; others spun and wove silk, made silk cords, and sold these in the marketplace. Women's increased participation in Bursa may have been due to the city's close proximity to the imperial capital, with its large population of more than half a million subjects that provided opportunities for commercial transactions.

Suraiya Faroqhi's various studies (1995, 1987, 1980) provide additional information on Ottoman women residing in these and other Anatolian towns. She states, for instance, that about 50 percent of all silk-spinning implements were owned or operated by women in Bursa in 1678. When looms were located in houses, women also worked as weavers. Even though women rarely owned shops and often were not guild members, they were nevertheless permitted to sell their wares in whatever markets they pleased without paying taxes by customary privilege. These Bursa women even established their own market, just like the one in Istanbul. Ottoman women's inheritance registers recorded and partitioned in court in accordance with Islamic law are also examined by Faroqhi (2002); they too indicate that women possessed large amounts of cash and commercial and personal property. Their commercial property included windmills, olive and fruit trees, vineyards and farms; they also engaged in money-lending. Difference in personal choices among women emerged in the composition of their personal property as some owned large amounts of clothing and jewelry and others did not. Faroqhi's analyses also provide finer details of Ottoman women's lives such as the observation that among slaves, women were less likely than men to receive their freedom through formal promises on the part of their owner.

Faroqhi (2002) notes another factor that accounts for the strong presence of women in Anatolia especially in agriculture: Ottoman legal intervention. From the late sixteenth century on, the Ottoman state modified the rules governing the tenure of state-owned lands through *kanun*s to allow a limited number of women access to farmsteads and fields, probably because of the long absences of men at military campaigns. A few women appear to have held state-owned agricultural lands and defended their rights to them in court. Following in the footsteps of the royal women, and in accordance with Islamic principles of charity, these women used their accumulated wealth to establish *waqf*s and served as administrators on the foundation board. As endowers, their ability to appoint for life their favorite heirs to serve on the board alongside them undoubtedly served as an added incentive to establish these foundations.

OTTOMAN NON-ELITE NON-MUSLIM WOMEN

The Muslim character assumed by the Ottoman state in its later stages as well the primarily Muslim population of the area today have led many scholars to naturalize the lives of Ottoman Muslim women and take these as a proxy for the social behavior of substantive populations of non-Muslim women who lived in the Ottoman Empire. As has been noted earlier, the Ottoman state was multiethnic and multireligious from its inception and assumed a predominantly Muslim character only toward its demise. The analysis of Islamic court records reveals significant information on non-Muslim Ottoman women who brought their cases to the Islamic courts and who were then accorded treatment in many ways similar to that accorded to their Muslim counterparts (Göçek and Baer 1997).

The Ottoman rulers employed a multi-tiered court system for their subjects where Muslim, Christian, and Jewish courts operated concurrently. Even though the courts were divided between those Islamic courts intended for use by Muslim subjects and those for the Christians, Greek Orthodox, Armenians, and Jews, the Islamic courts within the dominant society were used by non-Muslims as well as Muslims. Non-Muslims seemed to bring their cases to the Islamic court because of the relatively unfair shares given to them according to their own communal laws of inheritance. According to the Islamic law of inheritance, for instance, women were guaranteed shares not allowed in Jewish law. Also, Jewish women could not divorce their husbands according to Jewish law whereas Muslim women could do so according to Islamic law. Christian women, in turn, most often came to the Islamic court for the purposes of marriage and conversion to Islam. In addition, since Muslim judicial authorities had direct access to the force of the sultan's governing authority behind them, they were often viewed as a final arbiter with much more weight to bear in their decisions than the non-Muslim communal courts. It can also be hypothesized that in cases outside the imperial capital, non-Muslim women would have less immediate access to their communal courts and were therefore more inclined to seek Islamic rather than communal justice.

The wealth of non-Muslim women and the property they held in Islamic court records was very similar to that of their Muslim counterparts. Still, the Islamic court language privileged the societal status of men and Muslims over women and non-Muslims. In the texts, Muslim women were referred to as lady (*hatun*), whereas non-Muslim women were often defined through their husband's occupational standing. More specifically, while a Muslim woman was referred to in an inheritance register as "one who had been living or dwelling in a certain neighborhood (*sakine*)," followed by the name of the woman prefaced by the honorific title of a lady whom "God drew back to Himself (*vefat eden*)," a non-Muslim woman's inheritance read as "one who had settled in a place (*mütemekkin*)," succeeded by the name of the woman without any honorific titles, who "perished in unbelief (*halike olan*)." Hence a systematic difference existed in the way Islamic court language referred to a Muslim woman as opposed to a non-Muslim one, which reflected the socially imposed gender and religious differences in Ottoman society at large.

CONCLUSION

In summary, then, elements of legal, physical and communal space converge to construct the boundaries of Ottoman women's experience during the fifteenth to the end of the seventeenth centuries. The observations by European travelers of Ottoman women fell short of their actual participation in society, and Ottoman historical chronicles often highlighted the activities of royal women. Islamic legal prescriptions that regulated Ottoman women's lives and the court cases that structured them reveal, in turn, that even though all Ottoman women actively could, and did, obtain great levels of fiscal capital, the wealth of both the Muslim and non-Muslim Ottoman women did not necessarily translate into power. It was the location of women within the Ottoman social structure that determined the parameters of their power in society. Spatial constraints often interacted with legal codification, communal barriers, and location within the power structure to determine the social boundaries of Ottoman women's experience during the time period analyzed here.

BIBLIOGRAPHY

G. Baer, Women and waqf. An analysis of the Istanbul *tahrir* of 1546, in *Asian and African Studies* 17 (1983), 9–27.

L. da Zara Bassano, *Costumi et i modi particolari della vita de' Turchi*, Munich 1963.

Ü. Bates, Women as patrons of architecture in Turkey, in L. Beck and N. Keddie (eds.), *Women in the Muslim world*, Cambridge, Mass. 1978, 229–44.

O. Ghiselin de Busbecq, *Turkish letters*, trans. E. S. Forster, London 1927.

T. Dallam, *The diary of Master Thomas Dallam, 1599–1600*, ed. M. H. Hauser, London 1893.

H. Dernschwam, *Tagebuch einer Reise nach Konstantinopel und Kleinasien (1553–1555) nach der Urschrift in Fugger-Archiv*, Munich 1923.

S. Faroqhi, Land transfer, land disputes and *askeri* holdings in Ankara, 1592–1600, in R. Mantran (ed.), *Mémorial Ömer Lütfi Barkan*, Paris 1980, 87–99.

——, *Men of modest substance. House owners and house property in seventeenth-century Ankara and Kayseri*, London 1987.

——, The fieldglass and the magnifying lens. Studies of Ottoman crafts and craftsmen, in *Journal of the Economic and Social History of the Orient* 20:1 (1991), 29–57.

——, *Making a living in the Ottoman lands 1480 to 1820*, Istanbul 1995.

——, *Stories of Ottoman men and women. Establishing status, establishing control*, Istanbul 2002.

P. du Fresne-Canaye, *Le voyage du Levant*, ed. M. H. Houser, Paris 1897.

A. Galland, *Journal d'Antoine Galland pendant son séjour à Constantinople (1672–1673)*, ed. C. Schefer, 2 vols., Paris 1881.

H. Gerber, Social and economic position of women in an Ottoman city, Bursa, 1600–1700, in *International Journal of Middle East Studies* 12 (1980), 231–44.

F. M. Göçek and M. D. Baer, Social boundaries of Ottoman women's experience in eighteenth-century Galata court records, in M. Zilfi (ed.), *Women in the Ottoman Empire. Middle Eastern women in the early modern era*, Leiden 1997, 48–65.

F. M. Göçek and S. Balaghi (eds.), *Reconstructing gender in the Middle East. Power, identity and tradition*, New York 1994.

G. Goodwin, *The private world of Ottoman women*, London 1997.

R. C. Jennings, Women in the early seventeenth-century Ottoman judicial records. The sharia court of Anatolian Kayseri, in *Journal of the Economic and Social History of the Orient* 28 (1975), 53–114.

——, The legal position of women in Kayseri, a large Ottoman city, 1590–1630, *International Journal of Women's Studies* 3 (1980), 559–82.

——, Divorce in the Ottoman city of Cyprus, 1580–1640, in *Studia Islamica* 78 (1993), 155–67.

C. Kafadar, *Between two worlds*, Berkeley 1997.

A. Marcus, Men, women and property. Dealers in real estate in 18th-century Aleppo, in *Journal of the Economic and Social History of the Orient* 26 (1983) 137–63.

J. Marcus, *A world of difference. Islam and gender hierarchy in Turkey*, London 1992.

M. Meriwether and J. Tucker (eds.), *Social history of women and gender in the modern Middle East*, Boulder, Colo. 1999.

G. Necipoğlu, *Architecture, ceremonial, and power. The Topkapı palace in the 15th and 16th centuries*, Cambridge, Mass. 1991.

N. de Nicolay, *The navigations, peregrinations and voyages made into Turkie*, London 1585.

L. Peirce, Shifting boundaries. Images of Ottoman royal women in the 16th and 17th centuries, in *Critical Matrix* 4 (1988), 43–81.

——, *The imperial harem. Women and sovereignty in the Ottoman Empire*, New York 1993.

——, Seniority, sexuality and social order. The vocabulary of gender in early modern Ottoman society, in M. Zilfi (ed.), *Women in the Ottoman Empire. Middle Eastern women in the early modern era*, Leiden 1997, 170–96.

——, "The law shall not languish." Social class and public conduct in sixteenth-century Ottoman legal discourse, in A. Afsaruddin (ed.), *Hermeneutics and honor. Negotiating female "public" space in Islamicate societies*, Cambridge, Mass. 1999, 140–58.

——, Gender and sexual propriety in Ottoman royal women's patronage, in D. Fairchild Ruggles (ed.), *Women, patronage, and self-representation in Islamic societies*, Albany, N.Y. 2000.

G. Postel, *De la republique des Turcs: & là ou l'occasion s'offrera, des meurs et loy de tous Muhamedistes*, Poitiers 1560.

H. Reindl-Kiel, A woman *timar* holder in Ankara province during the second half of the 16th century, in *Journal of the Economic and Social History of the Orient* 40:2 (1997), 207–38.

R. Roded, Gendering Ottoman history, in K. Çiçek (ed. in chief), *The great Ottoman-Turkish civilisation*, ii, *Economy and society*, Ankara 2000, 677–85.

H. Sahillioğlu, Slaves in the economic and social life of Bursa in the late 15th and early 16th centuries, in *Turcica* 17 (1985), 43–112.

S. Schweigger, *Reyssbeschreibung aus Deutschland nach Constantinopel a. Jerusalem*, Nuremberg 1608.

Y. Seng, Standing at the courts of justice. Women at the law courts of early 16th century Üsküdar, Istanbul, in M. Lazarus-Black and S. Hirsch (eds.), *Contested states. Law, hegemony, and resistance*, New York 1994, 184–206.

L. Thys-Senocak, The Yeni Valide mosque complex of Eminonu, Istanbul (1597–1665). Gender and vision in Ottoman architecture, in D. Fairchild Ruggles (ed.), *Women, patronage, and self-representation in Islamic societies*, Albany, N.Y. 2000.

J. Tucker, *In the house of the law. Gender and Islamic law in Ottoman Syria and Palestine*, Boulder, Colo. 1998.

S. Yerasimos, *Les voyageurs dans l'empire Ottoman (XIVe–XVIe siecles). Bibliographie, itinéraires et inventaire des lieux habités*, Ankara 1991.

F. Zarinebaf-Shahr, Women, law, and imperial justice in Ottoman Istanbul in the late 17th century, in A. Sonbol (ed.), *Women, the family, and divorce laws in Islamic history*, Syracuse, N.Y. 1996, 81–95.

D. Ze'evi, *An Ottoman century. The district of Jerusalem in the 1600s*, Albany, N.Y. 1996.

M. Zilfi (ed.), *Women in the Ottoman Empire. Middle Eastern women in the early modern era*, Leiden 1997.

FATMA MÜGE GÖÇEK

Central Asia: 15th to Mid-18th Century

The history of Central Asia from 1400 to the 1850s had an uneven development. Periods of economic growth gave way to periods of economic decline, and were accompanied by corresponding changes in the spheres of science and culture. Thus, scholars call the turn of the fifteenth century – the time of Tīmūr and the Timurids – an epoch of renaissance, rich with historical works, poetry, architectural monuments, and works of art.

Having disintegrated into separate semi-independent principalities toward the end of the fifteenth century, the Timurid state in Central Asia was then united under the rule of the Shaybānids. In Shaybānid centers the number of works written in Turkic languages increased, and books were translated from Persian into Turkic (Uzbek). In the second half of the sixteenth century the state, which by that time had again disintegrated, was united by the Shaybānid "collector of lands," ʿAbd Allāh Khān II. Under his rule, significant development in literature and art was noticeable. The development of the economy, culture, and science continued in the three khanates which arose in Central Asia – Bukhara, Khiva and Kokand – and in Afghanistan as well. The history of these states is set forth in historical works and textbooks for universities, schools, lyceums, and colleges.

Various written texts, including medieval documents, historical essays, memoirs written in Persian, Turkic (Uzbek), and Arabic, as well as diaries of travelers, serve as the basic sources for studying the history of these states in the period covered here. General information about them has been published in catalogues and special studies in Russian, Uzbek, Tajik, English, and other languages. Part of the source base has been published: namely texts, excerpts, and translations into various languages.

Manuscript sources are stored in the archives of the institutes of Oriental studies in Tajikistan, Kazakhstan, Turkmenistan, and elsewhere. The greatest number of manuscripts (about 70,000) is stored at the Institute of Oriental Studies of the Academy of Sciences of the Republic of Uzbekistan (AN RUz). Some documentary sources (the archive of the *kushbegi*, several *waqf* documents, inventories of inhabited localities) are stored in the state archive of Uzbekistan. With

official permission, these sources are available to scholars of other countries.

In diverse written sources, alongside the narration of turbulent political, economic, and cultural events in the life of the peoples of the region, we find information about women, though mainly about those who belonged to the privileged strata of society. Until recently, these materials were not treated by scholars as sources of information on the women of that time. Some small articles on the theme have been written in Russian, Uzbek, and French.

DOCUMENTARY SOURCES

Specific data on women are more often found in private legal acts, letters, and other documentary sources. Their composition was connected with the ancient tradition of record keeping in countries of the Muslim East.

In official acts of purchase, mortgages, lease, *waqf*, and other documents connected with purchase and sale, rent, the determination of borders of lands passing into *waqf* holdings, and so forth, not only the names of the women but the immovable property they possessed and their rights, as prescribed by Sharīʿa law, are mentioned.

Besides the individual documents commented on and published as articles in general collections and journals, there are published collections of documents and also brief descriptions of them in catalogues. Of interest for the period under consideration is the publication of the texts of documents written in Persian and concerned with the acquisition of immovable property by the famous Bukhara Shaykhs Hodzha Islam and Hodzha Saʾad Dzhuibar, *From the Archive of the Shaykhs of Dzhuibar* (Moscow 1938). This was translated into Russian (Ivanov 1954). Documents connected with the activity of another famous spiritual leader, ʿUbayd Allāh Hodzha Aḥrār, have been published, including acts of purchase and *waqf* documents (printed, facsimile, and translated into Russian) as well as a collection of his correspondence translated into English (Aḥrār 1974, 2002). The *Catalogue of Khiva Kazi Documents of the Nineteenth and Early Twentieth Centuries* (some of which refer to the eighteenth century), 691 pages long, with the facsimiles of some documents,

includes legal documents (Tashkent-Kyoto 2001). The originals are preserved at the Institute of Oriental Studies AN RUz. For the most part they are written in Uzbek and only partly in Persian. The documents were issued in connection with the completion of different types of transaction in the chancellery office of the *kazi* of Khiva and sealed with his stamp.

The collection of legal documents (in Persian) resulting from the judgment of civil suits in Samarkand is of particular value. The only known copy of the manuscript, "Madjmu'a-yi Vasayik" (Collected articles), is stored at the Institute of Oriental Studies AN RUz. It includes more than 700 resolutions carried out in the chancellery of the *kazi* of Samarkand, mainly in 1588–91. In accordance with their content, the documents were placed in different sections of the manuscript. Less than one-tenth of the collection (text and translation into Russian) was published as *Kazi Documents of the Sixteenth Century* (Tashkent 1937). The edition contains some inaccuracies (see nos. 24, 34, 35, 58). It is a bibliographic rarity. A further 235 documents from the collection were published in Uzbek translation, *Vasikalar Toplami* (Tashkent 1982).

Not one of the known written sources of the region has as much diverse specific material as this collection. It is a most important source for the study of the social and economic history of the Shaybānid state of the 1580s and 1590s, although, based on the content, it could also apply to the earlier and later periods. Some of the manuscript's topics concern the resolution of questions relating to women. Their names are mentioned in connection with the division of inheritance (their share was considerably smaller than that of men); marriage and divorce contracts; and agreements about alimony payments intended for the financial support of a child staying with the mother after the divorce of the parents. Also of interest regarding the rights of women are the contracts composed in the court building in the presence of the mother concerning the entrance of her son into training as an *ustādh*. There are also contracts relating to the training of outside children by women. A monetary payment is indicated for every day of a girl's training. Some contracts reveal the difficult position, deprived of rights, of women from artisanal families with low incomes.

WAQF DOCUMENTS

Waqf documents – *waqf-name* – contain valuable information about women. Their names are mentioned among those of owners of properties bordering establishments converted into *waqf*, and among the names of streets, bridges, and so forth. Some of them were *waqf* founders and, according to the conditions set by them in the *waqf-name*, became *mutavalli*s of *waqf* institutions. One such *waqf* document was drawn up on behalf of the Ishratkhan mausoleum, constructed in 1464 by order of Khabība Sulṭān-begim, representative of the Timurid house. In compliance with the *waqf-name*, she appointed herself *mutavalli* of this *waqf* (for facsimile in Persian and translation into Russian, see Vyatkin 1938).

The role and legal status of the female *mutavalli* in the society of the time is well reflected in the "Waqf-nāme of Hazrati Shaybāni-khān," which was composed on behalf of two Samarkand *medrese*s in the 1520s. The original manuscript is preserved in the Saint Petersburg Department of the Institute of Oriental Studies of the Russian Academy of Sciences, inventory no. B-670 (for a printed text and translation into Russian, see R. G. Mukminova 1966).

Waqf-founder Mihr Sulṭān-hanim, having inherited from her husband Muḥammad Tīmūr, son of the Shaybānī khan, enormous wealth in the form of villages, individual plots of land, trade establishments, and so forth, ordered the establishment of a *waqf* to benefit the *medrese* mentioned above. According to the *waqf* document composed in accordance with her order, she appointed herself *mutavalli* and it remained at her disposal during her lifetime.

MEMOIR LITERATURE

Information about women can be extracted from memoirs. It is spread over the pages of Zahīr al-Dīn Muḥammad Bābur's *Bābur-nāme* (in Uzbek), which has been published many times over in Uzbek, Russian, French, and other languages. The English edition is richly illustrated and filled with maps and diagrams. E. Mano produced a critical text in Arabic script. The book contains data about the wives and daughters of the Timurids, about the mother of Bābur, and about his grandmother Isan Dawlat-begim, who participated in state affairs. During the ceremony of accession to the throne, which usually incorporated the lifting of the future khan on white felt, she was raised together with her husband, Unus.

Bābur gives additional facts concerning Mihr Sulṭān-hanim. In 1528, on the occasion of the ceremony carried out in Agra after the victory of Bābur, envoys of Mihr Sulṭān-hanim and her son

Pulat (Bulat) arrived along with other representatives of the Shaybānid house.

There is also information regarding the quality of women's education. The daughter of the Ferghana ruler ʿUmar-shaykh was trained by a man, Hodzha Muḥammad Darzi. On 18 January 1529, in Kabul, the wife of Bābur, Mahim-begim, wrote a firman composed in the manner of edicts written in Bābur's own hand.

There are many interesting facts in the memoirs of Zayn al-Dīn Vāṣifī. A critical edition of his book *Badāʾiʿ al-vakāʾiʿ* (Amazing events), written in Persian in Arabic script, copied by hand, was published (Boldyrev 1961). The same text, printed in Arabic script, was published in Tehran (1972). The book describes the troubled days in the house of the Timurids and their retainers in connection with the seizure of Herat by the Shaybāni khan and the attempts by Vāṣifī to help the women hide their jewelry. In the course of the description of these events, it reveals the master's cruel treatment of his servants, the complete lawlessness of the slave woman and her husband, and the female singer, Chakari-Changi, who left Herat for Samarkand in a caravan of some 500 people. It mentions a woman in another caravan who left riding a donkey. Vāṣifī also talks about the talent of Rukayat-begim, one of the wives of Timurid Abū Saʿīd, in the field of poetry. She arranged literary disputes where she read her own verses. The poet-historian Kamal al-Dīn Binai, who visited these disputes, said (according to Vāṣifī): "Each time, we left the meetings of Rukayat-begim in shame." Memoirs tell stories of the cunning of women.

Gulbadan-begim, born in Kabul in 1522, the daughter of Bābur and prominent historiographer of the time, wrote the famous *Humāyūn-nāma*, wherein, together with other interesting facts she gives data about women, including those who took part in the reception of Baburid (Mughal) rulers. In her work, Gulbadan-begim managed to depict the position of aristocratic women within contemporary family and society, and also to describe the games they played. Thus, donning male clothing, they participated in *chougan* (polo) and archery.

HISTORICAL WORKS

In historical works, many of which are devoted to the imaginary and real victories of rulers, hunting, feasts and entertainments, one rarely finds information about women. Thus such data present special value. The widely known *Zafar-nāme* of Sharaf al-Dīn ʿAlī Yazdī (in Persian) gives information about the women of the Timurid house.

A copy of the manuscript has been published (Tashkent 1972). The work draws attention to the wives of Amīr Tīmūr, especially to Saray Mulk (Bibi)-hanim, his favorite. She participated actively in decisions regarding the most important matters of state and palace life, the construction of monumental buildings, and the treatment of heirs to the throne.

Ḥasan Rūmlū, in the historical work *Aḥsan al-tavārīkh* (in Persian), writing about the war council in the camp of the Shaybāni khan under the siege of the Iranian Shāh Ismāʿīl Safavī in Merv, describes one of the wives of the Shaybāni khan – Mughal (Asha)-hanim. She played a fatal role in the destruction of her husband and his army. The Persian text and translation into English have been published (Seddon 1931–4, ii, 861).

There is an example of the heroic deeds and punishments of women, in the absence of husbands and sons, by warriors of the political enemy who captured their homes in *Tārīkhī rashīdī* by Mīrzā Muḥammad Ḥaydar. The author also reports the names of the wives and daughters of the ruler of Mughalistan. The Persian text and translation into English was published (1895) and work has been translated into Russian (Urunbaev et al. 1996).

TRAVELERS' ACCOUNTS

The description of the appearance, clothes, and adornments of the women of the house of Tīmūr, as well their participation in ceremonies is narrated by the envoy of the king of Castile to Tīmūr, Ruy Gonzalez de Clavijo, who saw all with the eyes of a foreigner and depicted what seemed common for local writers (Clavijo 1990).

POETRY

The poets of the epoch sang of the beauty, intellect, and nobility of women and their generalized images appear in many of their works. Alisher Navoi, for example, praised the intellectual woman "who was worthy of her husband." His works, the bulk of which were written in Uzbek, have been published many times, in many languages. Chapter 37 of his *Maḥbūb al-kulīb*, written in rhymed prose, was devoted to married life (a copy of the manuscript is in the Bibliothèque nationale in Paris). The poet identifies three categories of women depending on their attitude to family and home. Exposing unfaithful and insidious women who ruined families, he contrasts them with noble women, who "covered their heads with the cloth of chastity."

Women poets – Mahzuna, Uvaisi, Nodira-begim – played a prominent role in the cultural and social life of the state. They left a deep mark on the literature of Central Asia. Their works, saturated with ideas of social equality and the acquisition of freedom for women, are published both separately and in anthologies. The creative activity of these women was spread through the widely known poetic works in Uzbek, Tajik, Russian, and many other languages. By order of Nodirabegim, a caravanserai, trading areas, a *medrese*, mosques, bathhouses, and other buildings were built in Kokand. She participated directly in the government of the Kokand khanate.

MINIATURES

In the Middle Ages images of women were reflected in miniatures. In them we find not only beautiful girls – mistresses of leading figures and dancers – but also student girls taking instruction from their female teachers in *medrese* cells; girls dressed as boys and playing *chougan* with boys; a girl spinning thread. Many miniatures which accompany individual manuscripts are reproduced in editions of these works and also in separate albums. Illustrations of miniatures give the researcher valuable information about the participation of women in social life and official affairs, about the way of life, details of clothing, headgear, and hairstyles.

In sum, analysis of even the fragmentary data we have at our disposal from medieval sources shows basically that although Islam placed prohibitions on the participation of women in social life in precolonial times, women, especially those from the upper strata of society, were nevertheless in some cases able to play a prominent role in the life of the state.

BIBLIOGRAPHY

'Ubayd Allāh ibn Maḥmūd Aḥrār, *Samarkand documents of the fifteenth-sixteenth centuries* [in Russian], ed. O. D. Chekhovich, Moscow 1974.

——, *The letters of Khwāja 'Ubayd Allāh Aḥrār and his associates*, Persian text ed. A. Urunbaev, trans. J.-A. Gross, intro. J.-A. Gross and A. Urunbaev, Leiden 2002.

Navoi Alisher, Beloved of the hearts [in Uzbek], Moscow 1948.

A. N. Boldyrev, *Zayn al-Dīn Vāṣifī's Badā'i' al-vakāi'. Critical text, introduction, and references* [in Russian], Moscow 1961.

Ruy Gonzalez de Clavijo, *Diary of travel to Temur's court in Samarkand (1403–1406)*, Moscow 1990.

Gulbadan-Begim, *Humāyūn-nāma* [in Persian], Tashkent 1959.

Hodzha Islam and Hodzha Sa'ad Dzhuibar, *From the archive of the shaykhs of Dzhuibar* [in Persian], Moscow 1938.

P. P. Ivanov, *The economy of the Dzhuibari shaykhs*, Moscow 1954.

Mīrzā Muḥammad Ḥaydar, *The Tarikh-i Rashidi of Mirza Muhammad Haidar Dughlát. A history of the Moghuls of Central Asia. An English version edited, with commentary, notes, and map by N. Elias. The translation by E. Denison Ross*, London 1895.

——, *Tārīkh-i-Rashīdī. Introduction* [in Russian], trans. A. Urunbaev, R. P. Jalilova, and L. M. Yepifanova, Tashkent 1996.

Madjmu'a-yi vasayik (Collected articles), ms. inventory no.1386, Institute of Oriental Studies AN RUz, Uzbekistan.

R. G. Mukminova, *The social orders of population by Alisher Novoi's Mahbub al-Kulub*, Moscow 1995.

——, *History of agrarian relations in Uzbekistan, 16th century. By waqf-name*, Tashkent 1966.

R. Mukminova, *Le rôle de la femme dans la société de l'Asie centrale sous les Timourides et les Sheybanides*, Tashkent 1997.

T. Phaiziyev, *Timurid queens* [in Uzbek], Tashkent 1999.

C. N. Seddon (ed.), *A chronicle of the early Ṣafawīs, being the Aḥsanu't tawārīkh of Ḥasan-i-Rūmlū*, 2 vols., Baroda 1931–4.

V. L. Vyatkin, Waqf document of Ishratkhan, in *Ishratkhan Mausoleum*, Tashkent 1958, 111–36.

Muḥammad Bābur Ẓahīr al-Dīn, *Bābur-name* [in Uzbek], ed. Eiji Mano, Kyoto 1995.

Azamat Ziyo, The status of women in Amir Tīmūr's state (Life and activities of Saraimulkhonim) [in Uzbek], in *Ozbekiston tarihi* (Tashkent) 1 (2001), 25–34.

ROZIYA MUKMINOVA

Safavid Iran: 16th to Mid-18th Century

Safavid literature is a particular expression of Persianate culture produced by diverse ethnic, linguistic, and religious groups who inhabited eastern Anatolia, the Iranian plateau, and beyond into Central Asia and modern-day Afghanistan. Infused with Indo-Iranian, Semitic, Hellenistic, and Turco-Mongol elements, Persianate sensibilities came to shape a variety of Islamicate identities expressed in emergent early modern empires like the Ottoman (1301–1924), the Mughal (1526–1858), the Uzbek (1500–1785), and the Safavid (1501–1722); each, however, emphasized a particular fusion. As it were, the political boundaries created by these empires were porous: ideas, crafts, and merchandise continued to flow across these frontiers, along with human actors and influences such as poets, calligraphers, pilgrims, merchants, envoys, dervishes, scholars, and even spies. The Safavid literary productions discussed in this article thus necessarily manifest shared cultural symbols that resist imperial categories persistent in contemporary historiography, though they harden in modernizing projects of nationalism and ethnogenesis. Research on Safavid literature should mind these cultural synchronicities and engage in comparative studies in order to illuminate particularities.

Safavid Iran represents a transformative moment in the history of central and eastern Islamdom, stimulating new inclinations that accentuated a particular set of Persianate symbols located in Sufi, ʿAlid and Mazdean circles, and thereby initiating the rendering of a Safavid imperial image in Iranian and Shīʿī (Imāmī) paradigmatic terms. The Safavids began their revolution as a mystical-messianic movement promising the establishment of an earthly utopia, but as they began to consolidate rule they silenced this alternative vision, and favored a more homogeneous and rational language of rule. Temporally, Safavid literature should be contextualized within this historical process, and the revolutionary and formative eras (1447–1591) should be distinguished from the imperial phase (1591–1722). Ultimately, the vitality of the Safavid project enabled it to outlive both phases and to survive a century-long interregnum (Afshār and Zand) until the reconfiguration of a central state in nineteenth-century Qājār Iran (1798–1926). This article will not cover the Afshārid and Zand interregnums.

WOMEN IN SAFAVID SCHOLARSHIP

Modern scholarship on Safavid history has privileged politics and the economy where women appear on the margins. The historiography of women in Safavid Iran must begin to integrate the analytical categories of gender and sexuality, and women should be collectively studied within their textual and historical milieus. Presently, the ways in which constructs of gender and sexuality were (re)shaped by shifting mentalities, which manifested and arranged social, cultural, and political landscapes, remain ambiguous. Safavid historiography on women, a young field of inquiry, invariably attributes women's agency to a Turco-Mongol nomadic culture that regards both sexes more equitably, an assumption often presented uncritically and ahistorically. Moreover, it presumes that the Turco-Mongol episode is not representative of Islamicate practice. Rather, female agency is read as manifesting pagan and tribal customs. So it is the political and social egalitarianism of Central Asian steppe culture that is highlighted in studies of Safavid royal women (Szuppe 1998), of the participation of women in the urban real estate market of Ardabil (Zarrinebaf-Shahr 1998), and of prostitution during the Safavid era as an expression of more relaxed sexual mores (Matthee 2000).

True, early modern empires like the Safavids and Ottomans initially practiced Turco-Mongol conceptions of sovereignty: they all shared power, which was distributed in the form of appanages among the entire dynastic house, both male and female branches. In theory, land belonged to the paramount ruling family as a whole. Like their male kin, Safavid women engaged in politics to preserve the realm and protect their patrimony. Moreover, both male and female Safavid blood was believed to be laced with a divinely bestowed charisma, and in the seventeenth century princesses were blinded along with their brothers for fear of potential claims to the throne, a phenomenon particular to the Safavids and termed "Persian politics," by the reliable French observer of late Safavid Iran, Jean Chardin (1811). In theory, then, all Safavid women, whether descended from patrilineal or matrilineal lines, could rule. Perhaps this particular definition of the family (dūdmān) and of legitimate rule also evoked ancient Iranian notions of divine grace (farr or xvaranah) bestowed upon the dynastic family. Since both

Turco-Mongol and Iranian ideals of sovereignty invested power in the entire ruling family rather than individuals, it is difficult to determine a Central Asian or Iranian heritage for such practices. I tend to understand them as an aspect of cultural reinforcement, where shared conceptions of authority enhanced continuity (Babayan 1998).

What is significant, however, is not the question of tracing origins but of exploring the ways in which gender roles were crafted in Islamicate contexts accordingly and how masculinity and femininity were contingent upon the emphases and locations of these Persianate elements at court. Since much of the extant literature emerges from courtly milieus, we possess a clearer, reliable picture of the women of the Safavid ruling family. Modern scholarship must now begin to explore the multivocal formulations in late medieval and early modern Islamdom of women's roles as members of the royal household in dynastic politics. In order to understand change we ought to look at the ways in which the shift from legitimizing traditions that awarded women an active role in the family affected gender politics within and beyond the court, as the Safavids became more urban and their empire more centralized. In this process of centralization, in the rationalization of power, the Safavids, as the Ottomans and Mughals, came to rely on a legal basis for their dominion, one closely linked to the promise and ability to enforce Islamic law (Sharīʿa). At this time authority was redefined to emphasize aspects of urbanized Islam, more particularly its Imāmī Shīʿī ethos. Once we assimilate women and men, feminine and masculine, into our analyses of Safavid history, we can begin to discern the multiple structures of hierarchy and power. As we shall see, sexuality and the marking of sexual deviance became an inextricable feature of this new patriarchal language of absolutism.

The tensions between peripatetic and urban rhythms of life, cyclical and linear concepts of time, and mystical and rational modes of being are central themes of inquiry in Safavid historiography that would benefit from incorporating women and gender politics in analyses and explications of change. This process calls for a (re)reading of all chronicles – the main body of literature narrating court politics. And here I mean a reading that not only exposes the spaces in which women appear as actors in the sources – which has already been attempted (Hijazi 2002, Szuppe 1998) – but that also illuminates the representations of men's and women's interactions and their mutual compositions. How is sexual difference inscribed in political discourse? And how does gender operate as a discursive category within these courtly texts?

POLITICAL PARTICIPATION OF WOMEN

Sixteenth-century Safavid chroniclers reveal the extent to which political participation for the preservation of rule was understood as a prerogative of both female and male bloodlines, but at the turn of the seventeenth century a trend to discredit female power emerged and is reflected in the chronicles. Parī Khān Khānum (d. 1578), a sixteenth-century princess, who actually ruled between two interregnums that led to the accessions of her brothers (Ismāʿīl II and Muḥammad Khudābandah), became the victim of a rewriting of the Safavid language of authority (Babayan 1998, Golsorkhi 1995). The chronicler Iskandar Bek Munshī (d. 1633) narrates the discontent of her rival brother, Ismāʿīl II, with the Turkmen (Qizilbāsh) generals who had convened at Parī Khān Khānum's residence. He purportedly chides them: "Have friends (yārān) not understood that interference by women in matters of the realm (umūr-i mamlikat) is not worthy of royal honor (lāyiq-i nāmūs-i pādishāhī) and that it is shameful for men to associate with the veiled and chaste of the Safavid royal house?" (Munshī 1971, i, 201). In an attempt to legitimate male supremacy over the Safavid throne, the chronicler of Shāh ʿAbbās I (r. 1587–1629) speaks through Ismāʿīl II to argue not only that women are unworthy of rule, but also that their exercise of political power tarnishes male honor. He projects this attitude anachronistically and invokes an earlier set of traditions in Islamdom to counter Parī Khān Khānum's claim to rule. Such an impulse is not foreign to Islamicate history, for the Seljuk vizier Niẓām al-Mulk (in 1086) offers the very same argument when threatened by another powerful woman at court. He uses prophetic dictums (ḥadīth) to authenticate his position, referring back to the oral traditions about the Prophet and his companions that had been recorded at a moment when Islam had already moved from a tribal Arabian to a sedentary Irano-Semitic setting in which royal women were housed in harems and were legally dependent on their husbands, fathers, or other male legal guardians.

At this time a new political theory was in the process of replacing the Safavid synthesis of Turco-Mongol and Irano-Islamic political systems. According to the chronicler, Iskandar Bek, what distinguished Ismāʿīl II and his male descendants from the Safavid extended family was their reinvigoration of Shiʿism. At the turn of the seventeenth

century, the idea of an eponymous dynastic clan and a sacrosant family was eclipsed by the concept of a fixed patrilineage in which succession was effected through primogeniture. This leads to the question of whether the consolidation of power within patriarchal households was emblematic of centralized rule, which produced a disciplinary discourse of gender and sexuality that, drawing from sacred texts, employed the word to legitimize male supremacy. How did this rhetoric impinge upon the structure of the Safavid family, social networks, and gendered channels of communication at court? Does this rhetoric echo a rationalist interpretation of Shiʿism that attempted to organize and regulate gender relations differently? I would like to use these related questions as a way of entering current historiography on Safavid women and in the process to sketch future trajectories of research and focus attention on related sources that can be deployed productively for gendered explorations.

The sixteenth century is marked by the participation of wives, mothers, sisters, daughters, and aunts of the Safavid family in court politics, in diplomacy, and in the patronage of the arts and sciences. Szuppe (1998) has provided us with an exhaustive study of the participation of Safavid women in all these facets of court life. Now we need to situate these women within court dynamics to more fully appreciate their systemic agency in conjunction with men in the formulation of Safavid imperial ritual and practice. In an attempt at this necessary situating, Rizvi (2000) investigates the ways in which women and men together composed the Safavid imperial image through their patronage of the Shrine of Fāṭima al-Maʿsūma in Qum. She focuses, however, on Safavid women's endowments and their modification of this locus of Shīʿī devotion to include women. Rizvi opens an important avenue for future research, as it is clear that royal women collectively identified with the female holy figure of Fāṭima al-Maʿsūma. And the endowment deed of Shāhzāda Sulṭānim (d. 1561/2) shows there is a concern for the welfare of other women, since she sets aside money for the dowries of young orphan girls. These endowment deeds comprise an important genre to be investigated as a way of exploring the social and cultural values and preoccupations of courtly and elite women (Modarressi 1971).

Images of royal women need to be juxtaposed with their actual individual participation at court, engagement in the epistolary genre (Navāʾī 1989), representation in chronicles by men, transmission of knowledge, and their personal choices with respect to history, patronage, philosophy, religious treatises, poetry, architecture, or visits to sacred shrines. Here Ottoman, Mughal, and Uzbek chronicles are indispensable for their outside perspectives on Safavid women as agents in imperial politics. Only with this process of assembly will we begin to have more nuanced pictures of prominent women like Shāh Begi Begum (d. 1540), Shāhzāda Sulṭānim (d. 1561/2), Parī Khān Khānum (d. 1578), Khayr al-Nisāʾ Begum (d. 1579), and Zubayda Begum (d. 1641/2).

MARRIAGE ALLIANCES AND STATE BUILDING

The tradition of marrying (musāhira) Safavid women to Qizilbāsh (Turkmen) generals, Persian notables, and tributary rulers is another institution that should be read in the context of state building. Some Qizilbāsh were incorporated into the Safavid household through these marriages and women born into the Safavid family were used to construct collateral blood ties with those Qizilbāsh with whom they shared temporal power. How differently or correspondingly do Safavid men and women serve as political pawns in sixteenth-century marriage alliances? What does this tell us about their functions and the perceptions of sexual difference within the family? Answering these questions will allow us to better understand how Safavid reproduction policies and procreation reflect larger imperial strategies. Leslie Peirce (1993) has undertaken a similar inquiry in her study of the Ottoman harem.

Relying on the institution of marriage alliances throughout the sixteenth century, we can map out the political and social vicissitudes at court – the vulnerabilities of the Safavid imperial family and their attempts to fill in fissures in order to assert family supremacy. A shift in family politics emerged, as the Safavids first operated via collateral and vertical membership, whether matrilineal or patrilineal, until the early seventeenth century, when Shāh ʿAbbās I died (1629) and all his grandsons born of daughters were blinded or murdered along with the Safavid princesses – the sisters, cousins and aunts of the new Shāh Ṣafī (r. 1629–42) (Babaie et al. forthcoming). The massacre of all competing cousins leveled the field and propelled slave-mothers into politics. The Safavid household was radically reconfigured, as concubine-mothers, eunuchs, and military slaves came to dominate the court and instate a single male Safavid line. Here again is a common characteristic of state building: as dynasties attempted to consolidate patriarchal power, slavery and concu-

binage became the favored modes of rule and reproduction. Slavery is a ubiquitous feature of Safavid society that calls for a probing into gender and sexual relations. We know very little about domestic slavery and about the status of concubines and female slaves in courtly and elite households.

The organization of slavery within a reformed Safavid household coincided with a new emphasis on rational and legalistic Shi'ism (Babaie et al. forthcoming). In an attempt to investigate these regulatory systems and mechanisms we need to turn to a body of contemporaneous religious texts produced in the vernacular for wider audiences of Safavid denizens. Legal sources of the Safavid era should be consulted to determine whether discussions of slavery reappear in Shī'ī law (Afandī 1996). Attitudes towards slaves and concubines can also be ascertained from local histories, religious manuals on ethics and etiquette (Majlisī 1992), and from Safavid poetry. How, for instance, is the trope of the slave employed in poetry to represent the master and his beloved, whether an idealized male youth (amrad) or a female? A genre of manumission declarations (āzādnāma) ought to be studied to determine the contours of freedom and enslavement in respect to the ownership of body and property (Majmū'a 3846 and 2361).

MALE ROYAL POWER

Along with and partly due to the drastic shift in family structures, patterns of marriage, reproductive systems, and slavery within this urbanized Safavid household in Isfahan (1591–1722) there was a transformation in the representation of male royal power, as the shahs were secluded in the heart of the palace, that is, away from the battlefield – a trend through which they asserted their masculinity and control. Already in the sixteenth century the second Safavid Shāh Tahmāsb (r. 1524–76) began to rewrite Safavid power based on a language of religio-legal legitimacy (Sharī'a). His self-image in his memoir (Tazkira) rejects chivalric and Sufi ideals of masculinity manifested in doing battle, hunting wild beasts, and feasting. Shāh Tahmāsb prefers to fish, although he assiduously informs his audience of his prowess in boar-hunting. Instead it is generosity, wisdom, and piety that he favors as virtues of manliness (mardānagī), a more urbanized brand of masculinity that seems closely tied to world-rejecting Sufism. The narration of his life story draws on a cultural schema of domination and submission in which religion, family, and politics complement and rein-

force one another. He constructs a patriarchal hierarchy of power that visualizes God at the pinnacle, followed by the Prophet Muhammad, the Imām 'Alī, and then the monarch himself. And it is during his reign that anxieties are voiced against deviant gender and sexual practices and articulated in a language of discipline through decrees and manuals of sovereignty. In 1550 Shāh Tahmāsb issued a decree to his imperial functionaries in which he set forth Safavid ethics and etiquette of rule in public gendered spaces (Dānishpazhū 1972). Appropriate and suitable gender roles, public displays of sexualities, and religious tendencies are enunciated, along with the necessity to maintain standardized prices throughout the realm, security of roads, and the welfare and education of orphans. The elite are cautioned against loving seclusion, for that is the custom of desert-dwelling dervishes. Instead, men are called to be productive, both sexually and socially. Men should not become accustomed to vacationing, relaxing, and seeking comfort, activities that, according to the decree, represent the states of the dead and of women.

STATUS OF WOMEN

Although a few studies on the status of women under Shī'ī law in the medieval period have been conducted (Madelung 1979, Ferdows 1983) there is no similar study on women from the Safavid period. How do issues of marriage, divorce, inheritance, temporary marriages (mut'ā), and wet-nursing (rada'a) that had been discussed and adjudicated by medieval Shī'ī religious scholars pre-occupy the Safavids? A genre of Safavid religious production (fiqh) translated from Arabic into Persian, for example, features legal discussions endorsed by prominent medieval Shī'ī scholars on essential practices from pilgrimage to marriage. We need to explore this material to see whether in the process of translation discrete linguistic and rhetorical shifts occur in the definition of marriage (nikā), temporary marriage, or divorce (talāq) ("Fiqh-i Shāhi" in Majmū'a 3029 and "Nihāya" in Majmū'a 3624). How does the religious establishment, backed by the court, interfere with the institution of the family? What was the impact of Safavid Shi'ism on the interactions between the sexes, on the institution of marriage, and more largely on the order and definition of sexuality? What types of gender symmetries and asymmetries are constructed in this process? To ponder the relationship between Shī'ī law and Safavid practice we can read these translations alongside marriage contracts (nikānāma)

and sermons (*khuṭba*) preserved in seventeenth-century collections (*majmūʿa*) (Majmūʿa 3029 and 3624). Although some of these contracts and sermons are formulaic, more than a few are individualized, specifying names of partners, witnesses, dates, and the bride-price (*mahr*).

RELIGIOUS AND DIDACTIC TEXTS

A social history can be produced through an analysis of religious commentaries (*tafsīr*) and the determination of which Qurʾānic verses and *ḥadīth* that deal with female iconography and with gender relations are debated in the Safavid period, adopting modes of inquiry similar to those used by Roy Mottahedeh for the Shuʿūbiyya controversy in the medieval period (1976).

The seventeenth century is an age of conversion to Shiʿism and an important body of literature is penned in Persian for this didactic purpose. One of the most prolific exponents of this production was Muḥammad Bāqir Majlisī Jr., the prominent clergyman and court-appointed Shaykh al-Islām (chief religious dignitary) of Isfahan (d. 1699). In his *Hilyat al-muttaqīn* (1992), a manual on normative Shīʿī manners and ethics written towards the end of the seventeenth century, Majlisī Jr. delineates proper codes of conduct and etiquette concerning matrimony, clothing, praying, traveling, and eating. He encapsulates all aspects of the pious believer's daily life in fourteen chapters. For Majlisī Jr. the best wife was one who bore many children, was chaste, dear to her relatives, humble in front of her husband, made herself up only for him, and obeyed only him. When the husband was intimate with her in sex she should give to him all that he wanted. The worst women were those who dominated their husbands, did not produce children, were vengeful, and would refuse sex. And according to Majlisī Jr., "God did not deem zeal (*ghayra*) proper for women, but reserved it for men" (*Hilyat*, 135). Clear demarcations of the boundaries between the sexes are drawn from the clothes that mark their bodies to the gestures and practices that distinguish them spacially, behaviorally, and sexually. Any transgression of this order is cast as a rebellion against God. Whether such attitudes were successfully engrafted upon the population of Safavid Iran is difficult to access – but it does represent an impulse that under very different historical circumstances in twentieth-century Iran succeeded in fomenting an Islamic revolution that would award political force to render this mentality into law.

Writings on *fiqh* also contain a chapter on Islamic *ḥadd* punishments that deal with fornication (*zinnā*), sodomy (*liwāt*), and tribadism (*musāḥaqa*). Here a set of legal categories of *sexual* behavior is linked to social status that differentiates between male/female, active/passive, adult/child, sane/crazy, free/slave, Muslim/heathen, and married/single. Such classifications communicate sociocultural practices that encode gendered perceptions of honor and morality. How do gender, social status, sexuality, and religion define each other? What are the definitional links between these categories of identity? Can we distinguish a particular Safavid process through which these hierarchical relations are created and maintained? Declarations of repentance (*tawba-nāma*) are another genre that appear in seventeenth-century collections, of which several are individualized for they bear the specific names of repentants. *Tawbanāmas* ought to be read juxtaposed with legal formulations (Majmūʿa 2551, 3029, and 3846). Are these rhetorical confessions that habitually include Islamic prohibitions on adultery, sodomy, consumption of wine, and other proscriptions reinforcing humiliation and shame?

GENDER AND SEX

Literature on the wiles of women (Majmūʿa 1606 and 5014) and erotica (*Risāla-yi Rūḥī Onarjānī*) penned by the literati preserve other male imaginations that enable us to discern a variety of perceptions of gender and sexuality. How do these men represent male and female images in verse and prose in which men predominate as authors, patrons, and protagonists? Does a similar dissonance exist between legal prohibitions voiced by religious scholars and the social and literary acceptability of "illicit" forms of sexual behavior, as observed in medieval Arabic literature by Wright and Rowson (1997)?

In Majlisī Jr.'s chapter on the virtues of marriage and the rejection of celibacy (*rahbāniyya*) he defines heterosexuality as the norm framed around the example of the Prophet sanctified through a report from Imām Jaʿfar – that the conduct of Muḥammad was to love women. Women were to have come to Muḥammad with marital problems, complaining that their husbands refused sexual intercourse with them. The Prophet condemns those men who do not have sex with women – "they are not of my followers." Muḥammad, thus, is represented as drawing the boundaries of male belief on grounds of sexuality – to be a Muslim a man had to have sex with women. The alliance between marriage and sodomy needs further investigation.

From within the same textual milieu Āqā Jamāl

Khwānsārī (d. 1710) writes a social critique of women's vernacular traditions ('Āqā'id al-nisā', Beliefs of women), confirming the general troubles of wives with husbands who were not inclined to them sexually. In this satire the clergyman Āqā Jamāl describes what he terms "superstitious" practices among five Isfahani women. One of the fasts of 'Alī (Ruzā-yi Murtazā 'Alī) entailed the visitation of a minaret in Isfahan (Kawn Birinjī) recommended for women who wanted a husband. I had previously read this as a ritual of fertility (Babayan 1998). Afsaneh Najmabadi offered another reading that now within the context of the politics of matrimony, sodomy, and celibacy makes much more sense. The women performing these rituals in Isfahan seem rather to be voicing their desire for a husband who will have intercourse with them. What was impeding pregnancy was not infertility but the male-preference of their husbands. With the recitation of a verse at the minaret women expressed their desire for a "man of commitment" who had tied a knot around his waist, signifying a virgin man who had not been sodomized (amrad) by an older man during his youth. As Najmabadi suggests, tying a knot (kamar bastan) was perhaps something done to protect young boys from developing a preference for men.

What about female homoeroticism within the context of Safavid Sufi culture? Āqā Jamāl Khwānsārī speaks of the practice of siqa-yi khwāhar khwāndagī, a vow between two women. According to the five Isfahani female experts on vernacular culture, whom our cleric represents, every woman should have such a sister (khwāhar khwānda): "What hope does a woman have if she dies without one?" For then, it is said, she will not go to heaven. The feminization of the Sufi practice tied disciples together in a companionship founded on loyalty and devotion to 'Alī, who is central to Shi'ism and who figures among the Sufis as the model saint, the "perfect individual" (insān-i kāmil).

In this article I have been dealing with sources written by men – a point to keep in mind as scholarship on women in Islamicate societies has been tainted by stock and voyeuristic representations generated by Muslim men whose writings constitute the bulk of our texts. Initially I assumed that Āqā Jamāl Khwānsārī was revealing male anxieties (Babayan 1998) as he portrays these relationships in a language of intimacy and passion that has in twentieth-century English literature been referred to as "romantic friendships." Although the term used to designate these friendships – khwāhar khwānda, or "adopted sister" –

came to imply a tabaq zan, or "lesbian," in modern Persian literary usage, I resisted a homoerotic reading because I could not argue this conclusion on the basis of one early modern representation by a cleric who voiced his own male fantasies and fears.

WOMEN'S WRITING

I was fortunate to come across a pilgrimage narrative (ḥajjnāma) written by a woman who unequivocally expresses her love for her female companion (Safarnāma-yi manzūm-i ḥajj). This late seventeenth-century pilgrim's voice allows for a reading of such female friendships as same-sex desire, at least in her case. She was born into a privileged literary circle of Urdūbādī men of pen, and according to the scribe's introduction to her versified ḥajjnāma she was the widow of Mirzā Khalīl, the raqamnivīs of the divan, who penned royal decrees for the last Safavid Shāhs Sulaymān and Sultān Husayn (1666–1722). It is certainly due to her family's sociopolitical status that the Isfahani widow could perform the ḥajj – an expensive and dangerous venture in her day. It is also thanks to her elite status that she was educated and that her pilgrimage narrative entered the annals of recorded history. We know that women born into families of religious scholars were learned for it is common to allocate a chapter on women in biographies of the 'ulamā', the majority of which state that these women studied with their fathers (Afandi 1980). The Urdūbādī family scribe introduces the pilgrim and includes this travelogue in a collection of letters, decrees, poems, and essays he probably compiled during his tenure in her family library. These types of collections (jung and majmū'a) are numerous and they serve as archives from the Safavid period; here lies an untapped repository for the writing of social and cultural history of Safavid Iran.

Expecting to replenish the void created by her husband's death, the widow sets off from Isfahan, the capital of the Safavid Empire (1591–1722) on her pilgrimage to Mecca. She chooses to narrate her pious journey in verse and the language she employs is mystical. In fact its poetic form of the masnavī is a privileged medium for Sufi expression – one that her favorite medieval poet Nizāmī chose to write in. As she tells her story she reveals another experience of loss that she has been bearing for years in Isfahan as a married woman – a forced separation from another friend who happens to be a woman. It becomes clear in her narrative that their separation had been forced due to rumors that had circulated about these two

women in Isfahan. She describes her companion with similar terms of endearment, using the very same words of friendship (*yār* and *rafīq*) as when she talks about her husband and God. This widow's travelogue reveals a feminine space in Safavid society that was established through a ritual of sisterhood (*khwāhar khwāndagī*), with religious connotations, in which the language of Sufism was uttered to express female love. The freedom allowed by travel, specifically by the experience of pilgrimage, in temporarily rearranging disciplinary spaces allows us to rethink women's places in Islamic societies of the past. How does our traveler situate herself within a male discourse on love, using the very same Sufi tropes of divine love? Why this consistent use of Sufi vocabulary, related to absence and longing, either in the case of the religious experience or of the revisiting of female friendship experienced in the past? The language of mysticism becomes a language for expressing individuality and female experience, and this could lead to some interesting forays into the complex layers that shaped the identity of this Isfahani widow.

Religion seems to have provided options for Safavid women through which they could be heard. Although for the moment we only have one example of a woman writing a *hajjnāma* from the Safavid period, this medium becomes a legitimate genre for women's writing by the Qājār era (*Ja'fariān*, 2000). We have discussed how in the sixteenth century the culture of charity allowed for royal women to publicly mark themselves through the act of gifting to holy shrines. Nuzhat Aḥmadi (2000) has recently published two endowment deeds (*waqf*) established by women in the late seventeenth century, one of which is recorded in the handwriting of Gowhar Shāh a notable living in Isfahan. She endows her property located around Isfahan and Qum to the tombs of Imāms ʿAlī and Ḥusayn. And Gowhar Shāh inserts herself in the text as she states that half of this endowment should be paid for pilgrims, Imāmī Shīʿīs, whether female or male, who did not receive court salaries. Gowhar Shāh sets aside a portion of her endowment in perpetuity for her family, specifying that if among her beneficiaries the male line becomes extinct it should continue with her female descendants. Women had certainly been involved in the recording of earlier endowment deeds where male intermediaries translated their oral speech into writing. And we know that women also took part in documenting the past as scribes (Karīmrezāʾī forthcom-

ing). But when women uttered their words and inscribed them in writing themselves the medium of spirituality, charity, and piety awarded them public exposure. Even then, women like the poet Nihānī who wrote a quatrain and purportedly hung it in the bazaar of Isfahan, announcing that she would marry the person who could match her verse, chose the pen name "hidden" (Shīr Khān Lodi, *Mirʾāt al-khiyāl*; see Szuppe 1998). And it is in Mughal biographies of poets and histories like al-Badāʾūnī's *Muntakhab al-tavārīkh* that these poetesses appear, the majority of whom assume the alias "concealment." Al-Badāʾūnī writes of another "hidden" poetess from the late sixteenth century stating that no man has been able to respond to her couplet: "What manhood is this that cannot cope with a woman?" (494–5).

Safavid historiography is not endowed with "archival" resources such as court records that provide entry into realms of daily life, thus rendering the craft of the historian who is bound by normative or didactic expressions more complex. The historian can nevertheless maintain her integrity when reading and representing such texts as symbolic utterances that expose mentalities of Safavid literate elites. These texts can be interpreted as traces of ritual and practice if analyzed in the spirit of cultural and symbolic anthropology, literary criticism, or new historicism.

VISUAL TEXTS

A variety of Safavid sources and sites of definitional power have been discussed in the situating of chronicles, royal decrees, manuals of sovereignty, and epistles within the imperial sphere. The interplay between religion and politics necessitates a concomitant reading of literature that emanates from the Shīʿī clerical establishment, which deals with the subject of authority, law, ethics, and piety. Visual texts are a rich source that remains unscrutinized in the study of gender and sexuality. Nimet Allam Hamdy (1979) has written an article about the renderings of the female nude in Persian painting, in which he tracks its transfiguration over time from an idealized to a more realist representation, drawn by the famous Safavid painter Reza ʿAbbāsi. Hamdy recognizes traces of European influence in these less abstract depictions of the female body, an interesting point to pursue in terms of early cultural encounters with the West. Although most of these nude female images illustrate scenes from Persian literature like Niẓāmī's *Khusraw va Shīrīn* they do epitomize a genre in single-page paintings that

proliferated during the seventeenth century (Farhad 1987). Sussan Babaie's homoerotic reading (2001) of two drawings by Reza ʿAbbāsi encapsulates the fusion between word and image embodied in Safavid painting, thus opening a new domain for future studies on pictorial and linguistic portrayals of gendered bodies, love, and erotic desire. Once we open up the epistemological and experiential realm and permit for ourselves the apprehension and consideration of visual representations, we will be astonished by the obviousness and past repercussions of our blind spots: how, we will wonder, could we not have noticed the wall painting in the reception hall of the forty-pillared (Chihil Sutūn) palace in Isfahan that portrays a female entertainer smilingly offering her partner a cup of wine while rubbing her groin with the other hand, and all this in the midst of a royal feast held in honor of the Uzbek ruler Valī Muḥammad Khān? (See the illustration section following page 314.)

The task of uncovering women's voices and experiences from the Safavid past is indeed challenging; it involves creative applications of methods of analysis and criticism to a cross section of literary and visual texts where women emplot themselves and are inscribed or veiled by men. In an attempt to imagine women in Safavid society sources such as religious endowments, marriage contracts, manumission declarations, pilgrimage manuals, essays on love and friendship, epics, almanacs, medical treatises, travelogues, dream books, devotional literature, erotica, chronicles, poetry, letters, decrees, minority literature (Judeo-Persian and Armenian), and paintings have to be read within their textual milieus to hear the multiple reverberations that configure gender and sexuality in early modern Iran.

BIBLIOGRAPHY

PRIMARY SOURCES

Chronicles
ʿAbdī Bek Shirāzī Navīdī, Takmilat al-akhbār, Tehran 1990.
Afūshtaʾī Natānzi, Naqāvat al-āsār fī zikr al-akhyār, Tehran 1971.
M. H. Āsif, Rustam al-tavārīkh, ed. M. H. Mushīrī, Tehran 1974.
al-Badāʾūnī, Muntakhab al-tavārīkh, trans. T. Wolseley Haig, Delhi 1899.
Abū Ṭālib Mīr Findiriskī, Tuhfat al-ʿālam, Tehran University Microfilm 4955.
A. Ghaffārī, Tārīkh-i jahān ārā, ed. H. Naraqī, Tehran 1963.
Fazlī Khuzānī, Afzal al-tavārīkh, vol. 2, British Library Or. 4678.

G. Khwāndamīr, Tārīkh-i habīb al-siyar, ed. J. Humāʾī, Tehran 1954.
Iskandar Bek Munshī, Tārīkh-i ʿālam ārā-yi ʿAbbāsi, 2 vols., Tehran 1971.
M. I. Nāṣirī, Dastūr-i shahriyārān, ed. M. Nāṣirī, Tehran 1994.
Q. A. Qumī, Khulāsat al-tavārīkh, 2 vols., ed. I. Ishrāqī, Tehran 1980 and 1984.
H. Rūmlū, Ahsan al-tavārīkh, ed. A. H. Navāʾī, Tehran 1978.
W. Q. Shāmlū, Qisas al-khāqānī, 2 vols., ed. H. S. Nāṣirī, Tehran 1992.

Epistolary Literature and Manuals of Rule
M. T. Dānishpazhū (ed.), Ain-i Shāh Tahmāsb, in Barisiha-yi tārīkhī 7 (1972), 121–42.
Feridun Bey, Mecmūʿa-yi munşeāt-i Feridun Bey, Istanbul 1848–50.
A. H. Navāʾī (ed.), Asnād va-mukātibāt-i tārīkhī, Tehran 1984.
——, Shāh Tahmāsb Safavī: Majmūʿa-yi asnād va-mukātibāt-i tārīkhī, Tehran 1989.
——, Shāh ʿAbbās Safavī: Majmūʿa-yi asnād va-mukātibāt-i tārīkhī, Tehran 1987.

Religious Literature
M. al-ʿĀmilī, Amal al-āmil, ed. A. al-Ḥusayni, 2 vols. Baghdad 1965–6.
Ibn Bazzāz, Safvat al-safā, ed. G. R. Tabātabāʾī Majd, Ardabil 1994.
Fāzil-i Hindī, Manāsik al-hajj, Majlis Library 2761/8.
R. Jaʿfariān, Safaviyya dār ʿarsah-yi dīn, farhang, va siyāsāt, 3 vols., Qum 2000.
Afandī Isfahānī, Riyāz al-ʿulamāʾ wa-hiyāz al-fuzalāʾ, ed. A. al-Ḥusayni, 6 vols., Qum 1980.
——, Azadi-yi Khwājasarāyān, ed. N. Māyil Haravi, Majmūʿahā-yi Fārsī, vol. 4, Mashad 1996, 259–323.
B. Isphahani (trans.), Islamic medical wisdom. The Ṭibb al-aʾimma, London 1991.
H. Kāshifī, Rawzat al-shuhadāʾ, Tehran 1952.
J. Khwānsārī, ʿAqāid al-nisāʾ, ed. M. Katīrāʾī, Tehran 1970.
M. B. Majlisī, Zād al-maʿād, Tehran 1889.
——, Bihār al-anwār, 110 vols., Tehran 1948–68.
——, Jalāʾ al-ʿaynayn, Tehran 1983.
——, Hilyat al-muttaqīn, Qum 1992.
——, Shahr-i ziyārat-i jāmiʿa-i kabīra, Isfahan 1994.
M. T. Majlisī, Ikhtiyārāt al-ayām, British Library, MS Egerton 1002.
Rayāhīn al-shariʿa fī tarjuma-yi dānishmandān-i bānuvān-i shīʿa, Tehran, 1970.

Endowments and Patronage
Z. A. ʿĀbidī, Sariḥ al-milk, Iran Bastan Museum MS. 3598.
N. Ahmadi, Daw Waqfnāma az daw zan: Zubaydah Begum va Gowhaw Shāh, in Mirāth-i Islāmi-yi Īrān 6 (2000), 341–58.
L. Hunarfar, Ganjina-yi āsār-i tārīkhī – yi Isfahān, Isfahan 1965.
S. H. Modarressi, Turbat-i pākān, 2 vols., Qum 1957.
A. H. Sipanta, Tārīkhchah-yi awqāf-i Isfahān, Isfahan 1928.

Biography, Memoir, Travel, Pilgrimage
J. Chardin, Voyages du Chevalier Chardin, en Perse, et autres lieux de l'Orient, ed. L. Langlès, Paris 1811.
Gulbadan Begam, History of Humāyūn (Humāyūn-nāma) by Gulbadan Begam (Princess Rose-Body), trans. A. S. Beveridge, London 1902.

Shahzādah Khānum Muʿtamid al-Dawla Farhād Mīrzā, *Safarnāma-yi Makka*, Majlis Library MS 1225.

Shāh Tahmāsb Safavī, *Tazkira*, ed. D. C. Phillot, Calcutta 1912.

Shīr Khān Lodi, *Mirʾāt al-khiyāl*, Bibliothèque nationale de France, MS Suppl. Persan 323.

Urdūbādī, Widow of Mīrzā Khalīl, *Safarnāma-yi mazʿūm-i hajj*, ed. R. Jaʿfarīyān, Qum 1995.

Regional Histories

M. M. Bafiqi, *Jamīʿ-yi Mufīdī*, ed. Īraj Afshār, Tehran 1961.

M. Bardsīrī, *Tazkira-yi Safaviyya-yi Kirmān*, ed. M. E. Bāstānī-Pārīzī, Tehran 1989.

A. F. Fūmanī, *Tārīkh-i Gīlān*, ed. M. Sutūdah, Tehran 1970.

M. T. Marʿashī, *Tārīkh-i khāndān-i Marʿashī-yi Māzandarān*, ed. M. Sutūdah, Tehran 1985.

N. A. Shūshtarī, *Ihyāʾ al-mulūk*, ed. M. Sutūdah, Tehran 1965.

Poetry and Erotica

Bahāʾ al-Dīn al-ʿĀmilī, *Kashkūl*, Tehran 1987–8.

——, *Dīvān-i kāmil-i Shaykh Bahāʾī*, ed. S. Nafīsī, Tehran 1996.

Muḥtasham Kashānī, *Dīvān-i Mawlānā Muḥtasham*, ed. M. A. Gorgānī, Tehran 1965.

Khatāʾī, *Dīvān. Il canzoniere di Shah Ismaʾil*, ed. T. Gandjei, Naples 1959.

Khākī Khurāsānī, *Dīvān-i Khākī*, ed. A. Ivanov, Bombay 1933.

Rūhī Onarjānī, *Risāla-yi Rūhī Onarjānī*, ed. S. Nafīsi, in *Farhang-i Īrānzamīn*, vol. 2, Tehran 1956, 329–72.

Sāʾib-i Tabrīzī, *Dīvān-i Sāʾib*, Tehran 1966.

Vahshī-yi Bāfiqī, *Dīvān-i Vahshi-yi Bāfiqī*, ed. P. Bābāʾī, Tehran 1996.

Collections (Majmūʿa and Jung)

Jung-i ʿAlī Naqī Khātūnābādī, Tehran University Microfilm 3849.

Jung (compiled by Aḥmad Ghulām, the librarian of Shāh Sulṭān Ḥusayn), Majlis Library 3454.

Jung-i Ḥāsil al-hayāt, Tehran University Microfilm 3525.

Jung-i Ganj, Majlis Library 2506.

Majmūʿa, Tehran University 4602.

Majmūʿa, seven holdings in Malek Library: 1606, 2361, 2551, 3029, 3624, 3846, 5014.

SECONDARY SOURCES

S. Babaie, The sound of the image/The image of the sound. Narrativity in Persian art of the seventeenth century, in O. Grabar and C. Robinson (eds.), *Islamic art and literature*, Princeton, N.J. 2001, 143–61.

S. Babaie, K. Babayan, I. Baghdiantz-McCabe, and M. Farhad, *Slaves of the shah. New elites of Safavid Iran*, I. B. Tauris (forthcoming).

K. Babayan, *Mystics, monarchs and messiahs. Cultural landscapes of early modern Iran*, Harvard Middle Eastern Monographs (forthcoming).

——, The ʿAqāʾid al-nisā. A glimpse at Safavid women in local Isfahani culture, in G. Hambly (ed.), *Women in the medieval Islamic world*, London 1998, 349–81.

C. Elgood, *Safavid medical practice*, London 1970.

M. Farhad, Safavid single page painting, 1629–1666, Ph.D. diss., Harvard University 1987.

A. Ferdows, Women in Shiʿi *fiqh*. Images through *hadith*, in G. Nashat (ed.), *Women and revolution in Iran*, Boulder 1983.

R. Ferrier, Women in Safavid Iran. The evidence of European travelers, in G. Hambly (ed.), *Women in the medieval Islamic world*, New York 1998, 383–405.

S. Golsorkhi, Pari Khan Khanum. A masterful Safavid princess, in *Iranian Studies* 28 (1995), 143–56.

N. A. Hamdy, The development of nude female drawing in Persian Islamic painting, in *Akten des VII. Internationalen Kongresses fur Iranische kunst und archaologie. München 7–10 September 1976*, Berlin 1979, 430–8.

B. Ḥijāzī, *Zāʾifa. Bārīsī-yi jāygāh-i zan-i Īrānī dār ʿasr-i Safavī*, Tehran 2002.

P. Karīmrezāʾī, *Fihrist-i kātibān-i nuskhaha-yi khatti-yi kitābkhāna-yi markazī va-markaz-i asnād-i danishga-i Tehrān*, Tehran University (forthcoming).

W. Madelung, Shiʿi attitudes toward women as reflected in fiqh, in A. L. Sayyid Marsot (ed.), *Society and the sexes in medieval Islam*, Malibu 1979, 69-79.

R. Matthee, Prostitutes, courtesans, and dancing girls. Women entertainers in Safavid Iran, in R. Matthee and B. Baron (eds.), *Iran and beyond*, Costa Mesa 2000.

R. Mottahedeh, The *shuʿūbīyah* controversy and the social history of early Islamic Iran, in *International Journal of Middle East Studies* 7 (1976), 161–82.

A. Najmabadi, *Women with moustaches and men without beards. Gender and sexual anxieties of Iranian modernity*, University of California, Berkeley (forthcoming).

L. P. Peirce, *The imperial harem. Women and sovereignty in the Ottoman Empire*, New York 1993.

K. Rizvi, Gendered patronage. Women and benevolence during the early Safavid empire, in D. F. Ruggles (ed.), *Women, patronage, and self-representation in Islamic societies*, New York 2000, 123-53.

B. Stowasser, *Women in the Qurʾan. Traditions and interpretation*, New York 1994.

M. Szuppe, La participation des femmes de la famille royale à l'exercise du pouvoir en Iran safavide au XVIᵉ siècle, parts I and II in *Studia Iranica* 23:2 (1994) and 24:1 (1995), 61–122.

——, The "jewels of wonder." Learned ladies and princess politicians in the provinces of early Safavid Iran, in G. Hambly (ed.), *Women in the medieval Islamic world*, New York 1998, 325–45.

J. W. Wright, Jr. and E. K. Rowson (eds.), *Homoeroticism in classical Arabic literature*, New York 1997.

F. Zarinebaf-Shahr, Economic activities of Safavid women in the shrine-city of Ardabil, in *Iranian Studies* 31 (1988), 247–61.

KATHRYN BABAYAN

Sub-Saharan Africa: 15th to Early 18th Century

INTRODUCTION

This study might well be subtitled "Looking for the Invisible in the Dark." African historians prefer to work within the chronological period 1500–1800, and even the two-century overlap has failed to attract the attention of those working either in Islamic or women's history. Between the "truly Medieval" and the "emergent Modern" lies one of those historical moments which has too long remained in the shadows of historiographical eras presumed to be more important.

By the early fifteenth century, West African Saharans and the peoples of the sahel-savanna to the south were engaged with Islam. Most of the East African coast, its neighboring islands, and scattered hinterland communities would have referred to themselves as Islamic by culture, if not Muslim by faith. Sources dominated by Arabic accounts originating in North Africa and the Middle East reflect a few first-hand observations, but most are composites of other authors relying in turn on unattributed information gathered haphazardly from Arab merchants. Not surprisingly, given the commercial focus of their interests, they rarely commented on culture, except as it compared favorably (or more often unfavorably) with their own experiences of Islam. Women appear as evaluations of mens' honor and virtue, as elements of domestic organization, and as measures of proper social hierarchy.

The sixteenth-century partial conquest of the coast by the Portuguese, and the nineteenth-century imposition of Arab Omani rule from a new capital in Zanzibar, complicate the task of using any subsequent sources. The Portuguese, frustrated by their own military weakness and inability to access the wealth they observed, presented East African "Moors" as if they were still engaged in Crusades: women were victims of these infidels ("proof" of Islam's oppression) and potential Christian converts. The powerful Omanis, in contrast, strongly influenced how people wished to see and have themselves seen with respect to their social origins, ethnic identity, and religious affiliations. Wealthy, Arab-centered and orthodox, the Omanis became a kind of "internal other" against whom many East Africans wished to define themselves; some of the literature and histories we might otherwise regard as being fully indigenous and relatively transparent are thus, in fact, problematic.

ART AND LITERATURE

Historians accustomed to working with these written texts are uncomfortable moving into the genre of art and literature, but it is here that questions of gender and culture are going to be most fruitfully pursued. In the East African context, Swahili poetry (*utendi*, f. *utenda*) was written in Arabic script beginning in the 1600s. It reflects centuries of interaction with Islam and the Middle East (including Persia and India), while simultaneously building on traditional African oral structures. Working through Swahili, a language that was itself the creation of historical processes, seeking to enrich its oral persona through written expression during the period under consideration, allows us to better penetrate the culture in which we seek women's reality.

Historians of West Africa have exploited oral traditions (epics and stories of origin) to complement the paucity of written records for this era, but not to explore the specific themes of Islamization and women. Saharan stories intended to legitimate a clan's economic or political position take Muslim heritage for granted; they are buttressed by genealogies that omit female family members. Women appear as slaves, concubines, or the "cause" of conflict generating tribal divisions. Here too, a major art-form is poetry composed in the Arabic-Berber dialect Hassanya; relatively little has been recorded, even less plumbed by historians, although it has long been Saharans' preferred manner of remembering and teaching about the past. A whole genre is composed in the context of "love," offering insights into gender relationships that could yet be useful. South of the Sahara, traditions are more often of the poetic, epic genre, rich in metaphor, nuanced in meaning but potentially more revealing of gender relations and women's roles than the external sources interested primarily in male-dominated trade and politics. However, the literacy that accompanied Islam meant that as some of these epics were written for the first time, they acquired an Islamic gloss: patrilineal practices, women's veiling and seclusion, and lawful treatment of slaves and concubines were emphasized. This tendency was accentuated

from the late eighteenth century as reformist movements, *jihāds*, spread across West Africa. Colonial European sources, in turn, frequently attributed the weight of authenticity to these written variations in their own interpretations, further complicating our task of interrogating early oral traditions.

SECONDARY HISTORIES

Contemporary secondary histories of these regions argue that the most significant change occurring prior to the eighteenth century was the strengthening of Islam: as Islam increasingly gained hold of society, women correspondingly lost access to personal and political power. This personifying of Islam simultaneously privileges male voice and obscures female actions of choice. Between 1400 and 1700, West and East African societies were challenged by the destabilizing effects of internal warfare, prolonged droughts, and population fluctuations; they also addressed the transforming impact of international trade (including the slave trades). Islam was absorbed and nurtured in very particular, indeed personal, ways by societies and peoples whose experiences in this context varied widely. Class and gender feature prominently in explaining these differences.

SLAVES AND CONCUBINES

The most visible women are slaves: domestic slaves prepared and served food; female slaves spun cotton in Senegambia (West Africa), and slaves (including women) outnumbered "Moors" on farms and in palm groves around Kilwa and Mombasa (East Africa). But most commented upon are concubines. In West Africa's Ancient Mali, royal concubines in the thirteenth century wore fine clothes and jewels; thousands of them accompanied Mansa Musa on his famous pilgrimage through Egypt. A late fifteenth-century ruler of Kano (Hausaland) announced his commitment to Islam by ordering the catching of girls and women to populate his new harem. And a famous seventeenth-century Swahili *utendi*, "Lament to Greatness," spoke of a declining urban civilization which had once known "harem chambers" ringing with laughter and the talk of slaves. There is nothing intrinsically Islamic about this upper-class concubinage, but there may have been a growing sense that the taking of female slaves should follow Muslim law, the Sharī'a. Mansa Musa was informed by Egyptian scholars that if he "possessed" the beautiful daughters offered to him by his subjects, he must marry them; however, he was permitted only four such wives. Only slaves could be concubines and free women could not be treated as slaves. A fifteenth-century ruler of Songhay (Mali's successor) consulted a North African scholar: slave girls, sold and then married to the purchaser, were frequently already pregnant; quarrels then erupted between the merchants. For the theologian, most important was the fact that the Sharī'a stipulated that sold slave girls should be placed in the care of a trustworthy man until their next menstruation in order to assure that they were not already pregnant (*muwadaʿa*); and it was the responsibility of a good Muslim ruler to enforce this law. The implication here is a recognized responsibility on the part of the father not to sell the mother of his child, *umm al-walīd*. We can also infer from this exchange that female slaves were sometimes married, becoming actual wives; both marriage and concubinage provided immediate social mobility and the potential of freedom, if the Sharī'a was respected. That this was not always the case is revealed in an epic of a Malian ruler who had not treated his slave concubine well. She was forced to raise her son a slave. As a man, he brought civil war to the land in his quest for his rightful power.

The moral of the otherwise traditional story of succession reflects a strong cultural recognition of Islamic values betrayed, a gap between internalizing and implementing the Sharī'a, which may have become especially significant where it involved the treatment of women. One of the first signifiers of a truly converted ruler was the restriction of his wives to four – and invariably the expansion of his slave harem. Early accounts from both East and West Africa reveal a more subtle but equally important aspect of "Islamic" gender relations: foreign merchants established themselves locally by marrying free women to access land and power; they took concubines in order to have children. Whether women were destined to wear silks and jewels was not a function of being free or slave; it mattered more whether they were rural or urban, rich or poor – slaves had more opportunity for social mobility than poor, free women. The role of the concubine was also critical: her children were the progeny of their father; she had no family to claim the child or inheritances on his/her behalf. Local noblewomen may have become increasingly less valued as mothers; frequent descriptions of dark and "black Moors" in East African accounts, as well as observations in later centuries of "black" *bidan* (Saharan nobles) are suggestive of such a trend.

MATRILINY

The significance of these observations is underscored by the fact that these host African societies were matrilineal. Ibn Baṭṭūṭa noted that in the Sahara a man's heirs were the sons of his sister, and women had higher status than men; legitimacy in the oral epics to the south was almost always expressed through female kin relations; and in East Africa, coastal traditions reveal early matrilineal inheritance patterns, while research in the hinterland shows land was inherited through female lineages. It is argued however, that as these societies became more Islamic, they became patrilineal; women lost the powers associated with matrilineality. But even somewhat colored evidence suggests otherwise. Oral traditions recounting the decline of Ancient Ghana reflect continuing matrilineal succession in spite of adoption of Islam by the state. Seventeenth-century Saharan genealogies were rewritten to prove patrilineal descent, but oral histories and poetry continued to betray matrilineal values. One well known East African epic about a struggle over power between a brother and half-brother is centered on the tension between the older African tradition of succession and the newer Islamic one; the latter dominates only belatedly. In one coastal region, the Muslim sultan descended through the African female line for seven generations before a daughter took an Arab husband and it appears that patrilineal succession began.

WOMEN AND POWER

But it is not clear that women were excluded entirely from politics, even over time. In West Africa, marriages continued to cement alliances between Saharan clans, as well as with powerful emirs, through the nineteenth century. Clan histories of origin and migration feature women as causes of conflict but also as the means by which reconciliation later occurs. A late fifteenth-century queen of Hausaland, immortalized in a poem referencing her mortar of "scented Guinea wood" and her pestle of "solid silver," is called both (Muslim) "Amīna" and (African) "Gumsa"; in asking Allah to give her the long life of a frog and the dignity of an eagle, the poet collapses into one cultural identity and definition of power the belief systems of two different but not necessarily competing worlds. Equally telling are the oral epics in which political power remains inextricably tied to occult powers: battles are won with magic and the source of magic is inevitably a powerful woman. Women (or their symbols – food, mortars and pestles) appear as mothers, daughters, sisters and sirens, dynamic catalysts to the men who, like Saharan women, reappear to "accept the responsibility" imposed by such power. Some later manuscript versions, like those of the famous Sonjata, founder of Ancient Mali, attempt to displace the importance accorded to the hero's mother and female kinfolk. In this case, crippled Sonjata's miraculous cure derives from a token taken from his father, rather than his mother; his sister ceases to have a role in his final taking of power. This kind of Islamization of the past is revealing, suggesting (as do traditions that retain a matrilineal social discourse) that societies may not yet have been as reformed in the Islamic patrilineal image as historians have assumed. Sometimes it was necessary for traditional historians to rewrite matrilineal conceptions of origin in order to create contemporary patrilineal identities and facilitate the legitimation of proper Muslim power.

Female rulers and regents, some combining African titles with Arab Muslim names, others being either purely African or Arab, continue to appear through the early eighteenth century in East African chronicles. One tradition celebrates the winning of power from such a queen by a sultan who was himself the son of a humble woman. This woman had been the daughter of a fisherman, serendipitously discovered by royalty in answer to her father's prayers to Allah – a curious legitimation of the throne through a mother, which makes sense only when read through a matrilineal lens. Less abstruse are five seventeenth-century coastal epitaphs commemorating woman rulers – convincing evidence, suggests one scholar, that we may have been mistaken in regarding women as a suppressed class.

PERCEPTIONS OF WOMEN AND ISLAM

We need to dispense with both notions: women as a class, women as suppressed. It was precisely the diversity of classes to which women belonged that shaped their varied adoptions of, and adaptations to, Islam. Suppression reflects a contemporary (mis)valuing of Islam that in turn distorts the way we ask our questions of women's experience. In East African sources we glimpse wealthy wives, royal women, and the female slaves of their households. The poor (free and non-free), the rural, the kin of artisans, petty traders, fisherman, and sailors are invisible except when fate brings them into the realm of the important. Thus, we meet a fisherman's daughter because she became a queen;

the wife of an artisan because she was taken concubine to the sultan – the Pate chronicle remembers her freeman husband seeking revenge; the anonymous women of Malindi and Mombasa because the Portuguese recounted how they resisted or embraced (respectively) conversion to Christianity. West African Arabic sources rarely describe anyone who is neither royal nor slave; and in oral epics, excepting slaves and servants mentioned incidently, women are uniformly identified by their kin roles. They remain undifferentiated except in terms of magical power – significant but still leaving the majority of women invisible.

But we also aggravate these intrinsic problems by rooting questions in modern perceptions – like the notion of Muslim women as an oppressed class. We measure Islam by the practices of seclusion (purdah) and veiling, although these clearly were not signifiers even for the prudish Ibn Baṭṭūṭa. The introduction of purdah is attributed to the same fifteenth-century Kano king who ordered the "catching of women and girls" as concubines and the taking of 1,000 "first-born virgins" as wives – a notable contravention of the Sharī'a, in spite of his purifying reputation. Female seclusion among wealthy Hausa survived into the early twentieth century; yet by the nineteenth century, another Muslim purist bewailed the fact that women in Hausaland no longer knew the basic teachings of their religion, including prayers. Men had "abused" the notion of submission to Allah in demanding their unquestioning obedience in the guise of housework! In East Africa, there is no evidence that Islam brought veiling or seclusion to women. One Portuguese source mentioned that the "Moors" "shut up" their wives, but the many accounts of finely dressed women that observe details like skin color and jewelry belie the predominance of both general veiling and purdah even among wealthy Swahili. The *utendi* "Lament for Greatness" implies the existence of gendered living space ("men's halls," "women's chambers"), as does historical architectural research in the Kano palace, but this is neither synonymous with seclusion nor particular to Islam; its significance in terms of our subject matter has yet to be explored. And as for veiling, one scholar suggests that it was not Islamic but cultural in origin: early Shirazi settlers did not veil but the Arab immigrants seeking social and political ascendancy during the sixteenth and seventeenth centuries did. Veiling was a measure of their social and cultural status vis-à-vis local Swahili and Africans.

RECENT RESEARCH

Recent research raises other issues. One famous seventeenth-century *utenda* appears to be instructions from a mother to her daughter on how to be a good, submissive wife. Once received as evidence of female oppression, it has recently been interpreted by a scholar who understands the literary form (as well as the words) as being a work of irony and sarcasm – an expression of mockery for the power supposed to be in the hands of male spouses and rulers, veiled by literary tradition to all but the intended audience. Not only does this approach open new windows on the accomplishments of women poets, for it appears that upper-class women were generally educated and often adept at *utenda*, it also suggests the existence of a female discourse negotiating the arena of social relationships in ways, and with goals, we have yet to understand. Research in parts of the more rural hinterland shows a continuity of matrilineality: women did not marry down, marriages strengthened female lines, town and village wards were defined and dominated by female lineages, and land remained in their control. Men used their religious roles to establish a kind of parallel system of power, rooted in the mosque, that ultimately came to complement the strength of matrilineality.

The received wisdom that Islam's "penetration" was about male traders and clerics, and Islam's strength was in the hands of sultans and 'ulamā' overlooks the fact that in Africa's matrilineal societies, women were in the position to shape how Islam would be integrated into local culture and politics. As mothers, wives, sisters, daughters and slaves they had many ways to influence society. That matrilineality both competed with and accommodated Islam's patrilineal infrastructure, and that the extra-Islamic power of magic and local cults associated with women remained important to the practice of Islam, should not be surprising. Integrating different belief systems and creating new, sometimes parallel power structures within society and culture was not evidence of "inferior" or "regressive" Islam. More often, the process reflected responses of women to real social change generated by combinations of internal dynamics and external factors. We should not be looking at Islamic culture in Africa as something imposed, measured against signifiers like seclusion and veiling; rather, we should be seeking women's historical experiences, as we have tried to do here, in order to understand just what constituted Islamic culture in any given time and place.

BIBLIOGRAPHY

J. de Vere Allen and T. H. Wilson (eds.), *Paideuma 28. From Zinj to Zanzibar. Studies in history, trade, and society on the eastern coast of Africa (in honour of Jans Kirkman)*, Wiesbaden 1982.

K. M. Askew, Female circles and male lines. Gender dynamics along the Swahili coast, in *Africa Today*, special issue, *Islam in Africa* 46:3–4 (1999), 68–102.

S. Belcher, *Epic traditions of Africa*, Bloomington, Ind. 1995.

I. Berger and E. F. White, *Women in Sub-Saharan Africa*, Bloomington, Ind. 1999.

A. Biersteker, Language, poetry, and power. A reconsideration of Utendi Wa Mwana Kupona, in K. W. Harrow (ed.), *Faces of Islam in African literature*, Portsmouth, N.H. 1991, 59–77.

G. Brooks, *Landlords and strangers. Ecology, society, and trade in West Africa 1000–1630*, Boulder, Colo. 1992.

G. S. P. Freeman-Grenville, *East African coast. Select documents*, London 1962.

——, The coast, 1498–1840, in R. Oliver et al. (eds.), *History of East Africa*, 3 vols. (London 1963–76), i, 129–68.

C. B. Hillard (ed.), *Intellectual traditions of pre-colonial Africa*, New York 1998 (see texts 57, 59, 78, 79, 80 in particular).

J. Knappert, *Four centuries of Swahili verse*, London 1979.

N. Levtzion and J. Hopkins (eds.), *Corpus of early Arabic sources for West African history*, Cambridge 1981.

N. Levtzion and R. Pouwels, *The History of Islam in Africa*, Athens, Ohio 2000 (see especially the introduction and the chapters by Constantine, Dunbar, Pouwels, and Vikor).

H. Nast, The impact of British imperialism on the landscape of female slavery in the Kano Palace, Northern Nigeria, in *Africa* 64:1 (1994), 34–72.

R. Pouwels, *Horn and crescent. Cultural change and traditional Islam on the East African coast (800–1900)*, Cambridge 1987.

T. T. Spear and D. Nurse, *The Swahili. Reconstructing the history and language of an African society*, Philadelphia 1984.

E. ANN McDOUGALL

Colonialism: 18th to Early 20th Century

INTRODUCTION

This essay surveys the impact that European imperialism exerted upon knowledge about women in Islamic cultures from the eighteenth century to the eve of the First World War. The two major colonial powers, Great Britain and France, are its primary focus, although others are considered for comparative purposes. Since more scholarship currently exists on women in the British Empire than for other colonial powers, that empire receives relatively greater attention. It is hoped that this essay will spur future research into colonized peoples and regions not yet extensively studied from the vantage point of gender.

Despite significant differences, the European empires in Africa and Asia emulated each other's policies, institutions, and investigative modalities. The older historiography held that Great Britain favored indirect methods of rule, while France employed direct rule; in reality all empires employed direct and indirect mechanisms of control over time and space. Even French Algeria, administratively attached to France after 1848, utilized both methods simultaneously, depending upon the populations governed. Indirect as opposed to direct rule shaped the nature and degree of knowledge on women. The more interventionist the means of control, the more officials surveyed, counted, and tracked colonized women as part of a larger sociocultural critique. In addition to bureaucrats reporting on colonized subjects, another, more heterogeneous source of data existed: the writings of European settlers, travelers, literati, or adventurers outside of imperial hierarchies but enjoying their protection. The vast archive of textual and visual materials thus produced shaped imperial structures and was also shaped by them. Generally regions where large numbers of Europeans resided permanently – for example, French North Africa – were the most profoundly affected by colonial regimes, which in turn influenced sources of data.

The European empires generated new kinds of information, novel categories of knowing or analysis, and new forms of social control, as well as transforming "traditional" sources of documentation. Among the most important were: missionary archives, ethnographic studies, and administrative, legal, or military documentation, such as modern censuses or public health records. During the age of imperialism, many sources were archived in the colonies as well as imperial centers. State archives in former European possessions still house colonial records, for example in South Asia, where some British collections are still extant today, or in North Africa, where French colonial records remain in place. Indigenous sources, such as Islamic court records, had long predated European domination but were greatly affected by processes that uncoupled Islamic knowledge from the exercise of power. Visual materials, above all photography, introduced by nineteenth-century colonial armies, are very significant, as are accounts authored by native women educated in missionary schools.

Christian missionaries followed imperial armies and European settlers, although in some places, they paved the way for formal imperial rule. In Nigeria during the 1830s, British merchants promoted missionary activity to extend trade into the interior since economic penetration and the Gospel were regarded as mutually reinforcing. Missionaries often introduced print culture along with schools and clinics, keeping detailed records on Asian and African communities with an eye to conversion. Female missionaries were regarded by male officials as especially important since they alone had access to private households. On the other hand, colonial bureaucrats and commercial interests might oppose missionary activity since educating the natives reduced opportunities for labor exploitation and created political demands. Since a complete survey is impossible, the essay's first section examines the interplay between imperial expansion and the production of knowledge on women. This process is analyzed from different sites: British-ruled India, Egypt, and East Africa; French North Africa; and the Dutch East Indies, although the Dutch Empire is employed for comparative purposes since knowledge about native women in Sumatra was generated very late in the period under consideration here. At the risk of oversimplification, the most critical changes for women lay in colonial law, health, and, above all, education. Schooling and health provisions constituted twin realms where European "female impe-

rialism" exerted its greatest impact. The second part of the essay explores documentary sources as well as avenues for future research.

Two key concepts used throughout are "imperialism" and "colonialism." Imperialism refers to those policies and practices allowing one state to impose domination over another state or group of people through organized violence, such as military invasion, and/or economic ascendancy. Imperial regimes often rule over people ethnically, racially, religiously, and/or culturally different or regarded as intrinsically dissimilar from home populations. Because of perceived difference and inferiority, the colonized are invariably subject to laws and treatment not employed in the metropole: extra-judicial proceedings, seizures of property, forced labor, and so forth. Formerly colonialism was understood as a subset of imperialism distinguished by the permanent settlement of large numbers of people from the "mother country" on lands taken by force from subjugated populations. Algeria under French rule from 1830 to 1962 represents the classic colonial state and society. However, often the terms "colonial" and "imperial" are employed interchangeably.

FROM TRADING POST TO FORMAL EMPIRE: AN OVERVIEW OF DOCUMENTATION

From the seventeenth century on, European global ascendancy gradually grew, albeit unevenly, often consciously emulating indigenous Asian or African ruling structures, the clearest example being the English East India Company, which copied Mughal institutions in South Asia. Relative to other regions in Dār al-Islām, the western (i.e., Ottoman and Moroccan Empires) Islamic world's propinquity to expansionist Europe constituted a critical difference since intervention was more direct than elsewhere. Moreover, the politico-military frontiers separating western Islam from Christianity had been the scene of sustained conflict, as well as intense exchanges, for over a millennium and this determined collective mentalités, categories of analysis, and ultimately documentation. In South Asia, however, Muslim sovereigns had ruled for centuries over a non-Muslim majority – diverse communities following various Hindu traditions – but with substantial minorities of Sikhs, Jews, Christians, Parsees, and so on. No more than 20–25 percent of India's vast populace have ever been Muslim whether Sunnī or Shī'ī. When Europeans arrived to trade in the early seventeenth century, the Mughals still ruled from Delhi; as the eighteenth century wore on, the Mughal state became increasingly decentralized due to sectarianism and rebellion, provoked, in large measure, by the growing European presence. Paradoxically, this presence encouraged conversions to Islam, a trend which spurred imperial investigations into Islamic societies in Asia and Africa with a focus upon women.

By about 1600 Portuguese, Dutch, English, and French fleets had arrived in the East Indies searching for pepper and spices. These outposts served as nodes of European influence, although at first the impact was somewhat limited and did not produce much documentation on indigenous societies per se but rather on commercial relations and trading potential. Records of European companies, such as the VOC (Dutch East India Company), located in the Netherlands, or those of European consulates in Mediterranean, Persian Gulf, and Indian Ocean ports contain copious information on exports and imports and on local populations, including women, as producers of commodities sought by European markets – cotton, raw silk, opium, saltpeter, and so forth. Many of the consular and/or commercial records are located today in London and Paris, in repositories such as the Public Record Office or the Quai d'Orsay, although rich collections are also found in university or provincial archives, such as Oxford, Nantes, and Aix-en-Provence. As trading stations gave way to permanent establishments, the notion arose of the civilizing mission, which would exert tremendous influence upon colonial knowledge. This ideology transformed Western attitudes and praxis toward peoples who had formerly been close trading – and, in some cases, marriage – partners.

The three "Cs" of this mission – civilization, commerce, and Christianity – combined in different ways in different empires but triggered multi-layered historical processes that conflated sociocultural changes internal to Europe with asymmetrical global relationships. Promoting the civilizing mission abroad duplicated metropolitan domestic programs aimed at socially "backward" or culturally unassimilated European populations, such as the Bretons, or the "dangerous" working classes born of industrialization. While all European powers manipulated the civilizing mission to justify subjugating peoples worldwide, France, subscribing to universalist principles, vigorously promoted the idea that she alone had a special duty to civilize her colonial subjects. In contrast Great Britain never envisioned transforming imperial subjects into Englishmen and women,

although British policies overseas territories were shot through with contradictions and inconsistencies, as was true of other imperial powers. Finally, imperial exploitation was cloaked not only in the idealized mantle of the civilizing mission but also in a maternalist discourse of the "mother-country" transforming subject peoples into dependent children at best; the Dutch Empire's Ethical Policy, expounded by the late nineteenth century for its colonial populations in Southeast Asia, represents a significant expression of both trends. With the elaboration of the civilizing mission, documentation devoted to African and Asian peoples, above all women, increased dramatically.

INDIGENOUS SOURCES ON WOMEN

To measure changes introduced by these processes, it is necessary to note briefly how women figured in precolonial textual sources. As elsewhere, elite members of society tended to record their deeds more than non-elites. Chronicles of dynasties, such as the seventeenth-century *Akbār-nāma*, narrated the glorious achievements of royal families. In addition, the extensive *ṭabaqāt* literature detailed the lives of exemplary Muslims, male and female, in a highly stylized manner reminiscent of hagiography. Regional or local histories (*tārīkh*), geographies, and travel accounts (*safar-nāma, riḥla*), written in Persian in much of Iran and South Asia, and Arabic or Ottoman Turkish in other regions, also constituted historical sources, although these tended to discuss women when their behavior was seen as untoward. Idealized portraits of women and gender relations are found in advice manuals; medical texts also contain information. Islamic court records generated the largest corpus of written materials by far; from these women's voices emerge. The *sijillāt*, daily legal registers or Sharīʿa court records, and fatwas are particularly important, especially for social history. Women's prominent part in religious endowments is also well documented for precolonial periods. Another type of document is the administrative decree, particularly land grant deeds, which frequently named women as either grantors or beneficiaries. In addition, edicts issued by rulers enjoined their subjects from certain types of actions that can be read "against the grain" by historians to gauge state intervention in women's lives or gender relations. Finally, one of the earliest female-authored pilgrimage accounts in Islam was composed by a Mughal princess, Gulbadan Begum, who performed the *ḥajj* to Arabia in the sixteenth century on a three-year expedition to the holy cities.

THE BRITISH EMPIRE IN SOUTH ASIA: FROM THE BATTLE OF PLASSEY TO THE EVE OF THE FIRST WORLD WAR, CA. 1750–1914

From 1600 on, the English East India Company established factories in Surat, Madras, Bombay, and Calcutta to export Indian cotton, raw silk and silk cloth, saltpeter, indigo, and spices to Europe. However, maritime trade was controlled by heterogeneous communities from Arabia, East Africa, and the vast Indian Ocean system; while there was an old, Muslim merchant presence of disparate ethno-racial origins, many other religious groups participated as well. Until 1757 only 224 English nationals resided on a long-term basis in India; since only males were sent out, the practice of concubinage and/or marriage with local women was frequent. An 1810 advice manual for Englishmen preparing for company service contains a cost-benefit analysis of an Indian *chère amie* (i.e., concubine) who would provide sexual gratification and keep the household. This same source claims that the vast majority of concubines were "Mussulmans." In addition, some company officials "went native," adopting Indian forms of dress, behavior, and lifestyle; many learned Urdu and conducted business in the manner of the Mughal governing class. Some converted to Islam and married local women. During this initial period, indigenous women of ordinary rank were seen as producers and sources of labor, including sexual services, because the company's aim was to export products not found in Europe rather than transform South Asian culture or society. As for elite women, the noted historians of eighteenth-century India, André Wink and C. A. Bayly, have shown that they were central to alliance formation in India. Upper-class or royal women were pivotal to social communication, information networks, and surveillance since they were in constant touch with women of other courts, in addition to overseeing hordes of servants, including marriage brokers and midwives. India Office records housed in London and in South Asia contain invaluable, though underexploited, sources of documentation on women, including wills left behind by East India Company officials who had married into local families.

Over time the company was slowly transformed into a local government. The eighteenth century witnessed a series of wars pitting Britain, France, and Mughal rulers against one another. In 1772 the governor of Bengal, Warren Hastings, assumed full command of the Bombay and Madras factories, laying the groundwork for empire. The 1784

India Act made company officials directly responsible to parliament; a new system of taxation and judicial administration evolved, including courts as well as police and army units under British officers. Transformations in the older system of rural taxation upon which Muslim ruling elites had long depended brought heightened European economic penetration. Novel methods of gathering and deploying information about South Asia – what B. S. Cohn (1996) termed the "survey, enumerative, and surveillance modalities" – were being deployed. One of the most significant was that Hindu and Muslim laws were subject to codification as India's languages and traditions became objects of study. As culture and history became objects of classification, so did women.

The idea of introducing changes into indigenous women's status, however, did not originate entirely with Europeans. Some Mughal leaders had attempted to stamp out Hindu practices regarded as pernicious – especially *sati* (widow burning) and the prejudice against remarriage of widows – or to end practices among Muslims seen as violations of Sharī'a. In the 1820s and 1830s, Sayyid Aḥmad, a Shī'ī leader from northeastern India, campaigned against tribal customs permitting sale of daughters in marriage to the highest bidders. The company first became embroiled in royal women's issues in the Awadh Dynasty (ca. 1722–1868), centered in Lucknow. In Awadh, a Persian Shī'ī successor state to the Mughals, two important processes can be detected. First, because courtesans claimed powerful court positions, Europeans began to portray Lucknow's culture as feminine. The Muslim male elite became associated with female sexual exploitation on the one hand, and depicted as effeminate on the other. The feminization of some Indian males in turn justified more aggressive colonial policies, for example, land annexations and heightened military or administrative control. The themes of the effeminate Bengali male and the oppressed Muslim female were beginning to emerge. Second, Awadh's rulers extended massive loans to the company in the early nineteenth century affording additional opportunities for meddling. The dynasty granted interest income from these loans to pensioners, among them royal women, often secondary wives. When the rulers threatened to withdraw pensions for whatever reason, some women turned to company officials to guarantee rights as pensioners. Before long, company officials acted to "protect" these women, providing another mechanism for intervention as well as nurturing the ideology of passive, victimized Muslim woman. Thus one early source of documentation – petitions composed by royal women – was engendered by the company's growing interference in local society. This foreshadowed the subsequent deeper involvement of British officials in indigenous women's affairs, although the missionaries exerted by far the greatest influence.

Other European sources on South Asia in this period were travel accounts, for example, *Travels in the Mogul Empire, A.D. 1656–68*, by the French traveler, François Bernier, enumerating India's commercial riches. A century later, an East India Company employee, Francis Buchanan, produced several accounts from 1799 on, signaling a rational, quantitative approach. In 1833 Buchanan published a detailed investigation of Chittagong's interior – *A Geographical, Statistical, and Historical Description of the District . . . of Bengal*. Buchanan's works contain information on women, Muslim and otherwise, as agricultural producers and laborers. This survey, and others like it, represented a new encyclopedic approach to imperialism in the genre of Napoleon's multi-volume *Description de l'Egypte*. While women are mentioned as curiosities, they were not yet a sociocultural problem or moral question demanding European intervention. Significantly, Buchanan's study was printed by the Baptist Mission Press.

These writings constitute landmarks in the evolution of thinking on Indian Islam as well as South Asian religions in general. Superimposed upon the Bengali interior, with its fluid folk cosmologies combining Hindu, Muslim, and Buddhist traditions, was the Enlightenment notion of religion as a rigidly bounded, mutually exclusive belief system. By the late eighteenth century, the European canon on India, and particularly her religions, was solidifying. This process was advanced in 1784 by establishment of the Asiatic Society of Bengal whose stated purpose was to study Indian culture, eventually leading to the question of women. The society built the country's first museum in Calcutta in 1840; its substantial ethnographic and archaeological collections ultimately fashioned an imperial vision of Indian history. The extensive proceedings and publications of the dozens of learned associations, like the Asiatic Society, have not been utilized as thoroughly as they might for data on women and gender.

At the same time, Hinduism, a notion without equivalent in Indian languages, was developed. Later legislative acts passed between 1832 and 1850 began to fix the categories of "Muslim" and "Hindu" within a legal armature. These changes

held great consequences for South Asian women. By erecting frontiers around religions, the groundwork was laid for the construction of the "Muslim Woman" or the "Hindu Woman" by the end of the nineteenth century, which would later feed into nationalism and nationalist discourse. At the same time, the portrayal of women by European male literati underwent a transformation. In contrast to earlier portraits, women were increasingly depicted as harem prisoners; the seraglio or *zenana* became the site of oppression, a space of aberrant sexuality, the antithesis of freedom and liberty. Finally, the imagined sexuality of women intensified in Western discourse on the Orient, which was feminized and coded as languid, sensual, and decadent.

A key text on non-Western women was James Mill's 1818 *History of British India*, which posited that female status constituted the most fundamental index of a civilization's maturity. This laid the ground for nineteenth-century European reform efforts on instrumental grounds, that is, for modernizing colonized peoples, mainly through Western education for men and women. Aiding this process were two important notions that shaped historical and ethnographic production on women. First was the notion of a "golden age" in ancient Indian history when women held high social status; subsequent centuries of depravity had eroded female rights within Hindu and Muslim cultures. Colonialism, missionaries, and modern technology would right the wrongs of the Indian past. Second, the idea of a unique, essentialized female nature distinguished by biological differences was advanced. These ideological positions were heartily embraced by the missionaries and would also inspire nineteenth-century reform movements by Hindu and Muslim male elites aimed at native women's uplifting.

THE CREATION OF EDUCATIONAL INSTITUTIONS AND THE ARRIVAL OF MISSIONARIES IN SOUTH ASIA

In 1813 the governor general of India assumed responsibility for educating the natives, exclusively male at first. The next decades witnessed the creation of governmental and private institutions of learning for Hindus and Muslims. At first instruction was in India's own languages but by the mid-nineteenth century, English prevailed in higher education. Primary and secondary instruction remained in local languages considered inferior to English. By the eve of the 1857 revolt, India boasted universities in Calcutta, Madras, and Bombay as well as regional departments of public

instruction; a vast translation effort sought to render scientific and literary texts from European languages into Indian languages. All of these generated considerable documentation on South Asian history, culture, and societies.

The first secular institution for females, Bethune School, was created in 1849 in Calcutta and by 1854 some 626 girls schools enrolled 21,755 students. The principal mediators of cultural and other values, schools in British India were both state-supported and private, mainly missionary-run institutions with government subsidies. This system of mixed institutions of learning was also followed by Belgium in the Congo and by Germany in various African territories. In contrast France favored public (as opposed to private) instruction in the colonies tightly under the control of the minister of education in Paris. In all empires, including the French, female education for colonized girls tended initially to be tied to missionary activity, which represents the single richest source of documentation for this period.

Prior to the Mutiny, the most transformative event for South Asian women was the arrival of missionaries, given permission after 1813 to freely enter British-ruled regions of the subcontinent; previously the East India Company would not allow missionaries in areas under its jurisdiction. The Church Missionary Society (CMS), formed in 1799 in London, was intimately connected to the Evangelical Revival as well as abolition societies. The CMS became one of the largest, best organized, and most influential organizations of this nature and was without parallel in the French Empire. In contrast the Dutch Reformed Church patterned its own missionary organizations for Indonesia along CMS lines. By the 1830s, the CMS set up schools, orphanages, teacher-training for natives, and agricultural institutes. Female missionaries were especially important since European males had little access to families and women. Initially only married women were sent to foreign missions to work alongside husbands, mainly in education. Women missionaries instructed elite women in their households; lower-caste girls attended schools. In 1821 the first English teacher, Mrs. Wilson, was dispatched to Calcutta by the British and Foreign School Society; in Bengal during the 1820s, initial attempts at *zenana* education – home schooling in women's quarters – were organized. At first the curriculum focused upon handicrafts, domestic arts, and Bible study; conversions, aimed principally at Hindu populations, occurred among less privileged groups in society – lower-caste women and widows.

In 1834 the Society for Promoting Female Education (FES) was established in England. An interdenominational organization staffed exclusively by women, the society furnished female teachers and school inspectors to India and China. In 1836 three women were dispatched to Bengal; the FES paid for passage and other expenses as well as sending money, school supplies, and handicraft materials. These societies generated new sources of documentation devoted to women in South Asia: annual reports, school finance, health, and personnel records containing data on indigenous women taught in, or employed by, schools, maps of local regions, and so forth. As significantly, these female-authored accounts eclipsed the hitherto largely male-authored accounts of colonial female subjects. In addition, letters sent home by missionaries with vignettes of daily life in the colonies were often published in European newspapers, journals, or gazettes. Missionary stories appeared in children's literature, another critical, although often overlooked, historical source. Children's books portrayed the missionaries in Asia and Africa as heroic, selfless individuals laboring among the heathens for God and country, thus implicating youth in imperial ventures and ideology. The archives of church societies, including missions, are mainly located at the headquarters of the various churches, often in capital cities; for example, CMS records are in London where the society was founded. In addition, many missionary records devoted to Africa and Asia are available on microfilm.

The advent of missionary societies had a number of key consequences. Partially due to their influence, South Asian religious traditions and customary practices regulating sexuality and gender were less tolerated. On the other hand, their presence increased the demand for female education, forcing the British government to undertake some initiatives, however half-hearted. Missionaries also provided female inspectors for girls schools whereas the government provided only male inspectors until the 1880s. In addition to detailing daily classroom activities, missionaries wrote extensively about social issues, such as caste and marriage customs, intervening in all facets of daily life from hygiene to women's clothing and bodies. The resulting literary production represents a vast, if obviously biased, source on South Asian cultures in general and the politics of female education in particular. Nevertheless the missionaries did not speak with one voice and nor did they blindly follow orders from London or the Indian government. By casting Hinduism in opposition to Islam as much as to Christianity, the missionaries unwittingly laid the ground for political identity based solely upon religious affiliation. Missionaries in other empires – mainly Catholic in French North Africa and Sub-Saharan Africa or Dutch Reformed Church missions in Southeast Asia – frequently exerted similar influences, although differences did exist.

Another process during the late eighteenth and early nineteenth centuries was travel to Europe, which intersected with female education. A few South Asian males from elite families ventured to England for study; returning from Europe, they often advocated modern learning opportunities for girls. Mīrzā Abū Ṭālib Khān, born at Lucknow in 1752/3, served the East India Company before traveling to Europe in 1798, remaining there for three years. Home from London, he wrote a treatise in Persian analyzing English institutions, one of the earliest such accounts by a Muslim scholar and modernizer. Mīrzā Abū Ṭālib Khān also noted the existence in London of thoroughly Anglicized Indian women who had married Englishmen in South Asia and returned with them to Great Britain. It should be noted that Muslim and Hindu male reformers frequently subscribed to the "golden age" argument regarding Indian women as well as an essentialized notion of female nature influenced by European writers. By the end of the century, increasing numbers of Indian subjects, male and female, would pass through the British Isles for various purposes; several Indian women left behind valuable accounts, such as Pandita Ramabai, who studied medicine in London in 1886 or Cornelia Sorabji, who read law at Oxford between 1889 and 1892 and sent letters home to her parents in Bombay.

Western women began to travel to the East in the late eighteenth century. One of the first female writers on India was Eliza Fay (1756–1816) who arrived there around 1779 and published her *Original Letters from India* in 1817; predictably, she described in detail the practice of *sati*, characterizing it as "rules to render the weaker sex subservient to authority." Travel accounts like these, as well as reports and newspaper articles devoted to Indian women, particularly *sati* and purdah, focused European public attention on South Asian cultural practices. With rapid improvements in transportation after the mid-nineteenth century, tens of thousands of Europeans flocked to South Asia and elsewhere in the British Empire. Accounts of their journeys swelled the genre of travel literature, spawning a new sub-genre – highly sensationalized, lurid novels depicting either *sati* or the rape

of European women during the Sepoy rebellion.

Missionary efforts and the English public's greater involvement in Indian affairs triggered extensive social reform legislation, introduced even before 1857, for example, the abolition of slavery in 1843 and an act allowing converts to Christianity to retain inheritance rights after conversion. By far the greatest legal intervention was Regulation XVII proclaimed in 1829, which rendered "the practice of suttee, or of burning or burning alive the widows of Hindus, illegal and punishable by the criminal courts." British parliamentary papers devoted thousands of pages of documentation to the practice, although female victims appear largely as mute objects. The information in parliamentary sources came from local police officers under orders to document cases of *sati* in monthly reports to superiors as well as judicial district records. Building on *sati* legislation, the customary ban on Hindu widows remarrying was revoked – significantly, a year before the Mutiny, in 1856. These laws constituted a seachange from the earlier non-interference in South Asian customs to massive interventions affecting colonized women and men, thereby justifying British rule in the country. At the same time, each legislative act spawned colossal amounts of documentation: parliamentary debates and papers, minutes, reports, and depositions, including letters and petitions by communities affected by proposed legislation. Accounts of debates surrounding judicial or administrative proposals appeared in both the British and Indian press. Many have either been published or are currently housed in the Public Record Office in Kew Gardens; the India Office archive is another rich repository for these materials.

INDIA IN THE POST-MUTINY PERIOD AND KNOWLEDGE ABOUT WOMEN, CA. 1850–1900

While the Mutiny of 1857 is often portrayed as primarily a revolt by Muslim and Hindu soldiers in East India Company service, it was a much wider social movement infused with deep-seated cultural and political antagonisms crossing class, ethnic, and religious lines. By the 1850s British policies and actions were regarded as undermining South Asian traditions, hierarchies, and values. The dominance of the English language and Western education also fueled resentment. As for the revolt's consequences, government was totally reorganized and expanded until the largest bureaucracy in South Asia's long history was assembled. In 1858 Queen Victoria issued a proclamation guaranteeing equal protection of the law and freedom to practice religion and social customs as well as assuring hundreds of Indian princes, Muslim and Hindu, that their rights, dignity, and honor would be respected. Overzealous attempts to end the caste system were reined in. At the same time, momentous legal interventions occurred. In 1862 the India Penal Code was enacted, restricting Islamic jurisprudence principally to family law, a process that occurred in French Algeria and later in British-ruled Egypt. Some legislation has been deemed positive, such as the abolition of female infanticide in 1870; other changes were negative. For instance, as Hindu law was codified, some women, often from lower castes, lost traditional freedoms and rights when Hindu customary laws, originally pertaining only to Brahmin or upper-caste women, were made binding for all castes.

Concurrently economic modernization transformed agriculture, trade, transportation, and industry. The importation of machine-made textiles manufactured in England held disastrous consequences for laboring classes; some former female weavers found new jobs as unskilled agricultural laborers or prostitutes in the burgeoning cities. Related to prostitution, medical regulations increased, as did published materials on public health. Indeed the notion of public health expanded after 1857, a departure from past concerns mainly with the army's fitness. The body of the colonized became increasingly a site for colonial surveillance and management. Imperial medical and public health records, housed largely in repositories in London, constitute yet another fund of potential documentation for women and empire as do the debates over the application of the Contagious Diseases Act (CDA) of 1868, formulated to halt the spread of venereal diseases from Indian prostitutes to soldiers. Repealed in 1886 due to feminist agitation, the two-decade debate over the CDA in the British Isles eventually led British feminists, such as Josephine Butler, to turn full attention to "Indian women's plight." This heralded the full involvement of late nineteenth-century cultural missionaries and maternal feminists in colonized women's affairs, resulting in periodicals such as the *Englishwoman's Review* (1866–1910). While Indian women received by far the greatest coverage in the *Review*'s international section, articles on Muslim women's status in Egypt appeared in the 1880s. Discussions of differing statuses of women in Hindu and Islamic traditions predominated in the *Review* and other publications; however, some European feminists

pointed to Muslim women's divorce and inheritance rights under Islamic law to condemn discriminatory English family law. If South Asian female voices scarcely appear in these publications, the *Women's Penny Paper* occasionally offered space for Indian women's self expression, either through interviews or writings.

After the mid-nineteenth century, European attitudes toward colonized peoples worldwide became marked by a palpable sense of racial superiority. The number of European families residing permanently in South Asia increased, changing the male-female ratios, although European men always outnumbered women, whose arrival brought complex changes. Most did not question the civilizing mission, although some European women – as members of the inferior sex within the superior race – did challenge certain aspects of imperial rule. Female-authored prescriptive literature aimed at European ladies residing in imperial outposts was published from the 1850s on by European and colonial presses. Advice manuals for female readers offered detailed guidance on daily life in the colonies, housekeeping, cooking, servants, travel, and effective missionary work. Flora Annie Steel and Grace Gardiner's 1888 *Complete Indian Housekeeper and Cook* made critical, if metaphorical, connection between colonial household and empire. These guides contain invaluable, although naturally biased, data on indigenous women serving as domestics in European households. At the same time, imperial wives often sought to inculcate Victorian norms of domesticity among their native servants or acquaintances. As the genre burgeoned, the portrait of domestics as sly, dirty, and ignorant crystalized; this would feed into notions of race and hierarchy, justifying increased social distance between Europeans and Indians by 1900. This contrasted with the early days of the East India Company when some Englishmen married Indian women, adopting indigenous customs, languages, and even religious practices. After 1850, the number of memoirs and diaries by European women describing native societies expanded; many, but not all, contain either implicit or explicit racial stereotypes. Similar processes were underway in the Dutch East Indies after the 1890s and elsewhere in the globe at the century's end.

After 1857 missionary activity in South Asia not only increased but also became intimately connected to reform movements in the metropole; henceforth the British public was more aware of, and became more involved in, colonized women's issues. In 1866 the Ladies Association for the Promotion of Female Education among the Heathens was created in London; it urged that female missionaries be allowed full charge of *zenana* education. Finally, in 1887 the CMS permitted unmarried European women to engage in overseas missionary work; by 1901 there were 326 single women in Asia and Africa. During the 1890s, the Zenana Mission Movement sent British female physicians to India to incorporate health education into school curricula. Treatment of cholera, malaria, venereal diseases, and the 1896 plague epidemic inserted colonial medicine and science into the heart of the Indian family, bringing information to light as well as drawing native women into medical training. Missionary publications aimed specifically at women proliferated, such as the *Indian Female Evangelist*, published quarterly under the auspices of the Indian Female Normal School and Instruction Society. The second volume, appearing in 1875, contained original articles devoted to subjects such as "the past and present condition of Indian women." The Church of England Zenana Missionary Society published a magazine beginning in 1881, entitled *India's Women*. A 1894 report from Bhagulpur by an English missionary, Miss Haitz, noted that: "Our average number of schoolchildren has been 302 and instruction has been given in 89 zenanas. About 82 villages have been visited . . . Zenana work has been carried on among Hindus and Mohammedans." These publications and their educational ideology unwittingly conflated the notion of India with that of Indian woman; eventually South Asian women were cast in an entirely new role – mothers of the nation. This would be of fundamental importance for Indian nationalists but ultimately bore bitter fruit for women during Partition. As symbols of the contested nation, women from the two major South Asian religious communities became political targets and objects of violence.

Other British actions inadvertently fostered a collective sense of Muslim solidarity by fusing claims to political power with religious identity, which in turn sparked substantial Hindu animosity. As a minority, the Muslims were entitled to special electoral and educational treatment and were sometimes favored with bureaucratic appointments. An inherent contradiction was that these transformations emphasized achieving radical reform while preserving native traditions; this would eventually exert a determining influence upon the notion of "Indian Muslim womanhood." This ultimately produced a dichotomy between the "traditional woman," mired in superstition and subject to

colonized male whim and tyranny, and the "modern woman," open to Western ideals of bourgeois femininity, domesticity, and motherhood. Increasingly the "traditional Muslim woman" was invoked by colonial officials as the greatest obstacle to modernizing South Asia; a similar argument was raised in British Egypt at the time. Virtually identical polemics emerged in the French Empire in North Africa, and other European empires, by the end of the nineteenth century.

However, officials, missionaries, and reformers seeking to uplift colonized women did not necessarily speak in a monolithic voice. By the 1870s Western-educated Indian men and some women began to agitate for a curriculum offering subjects beyond household management. British administrators were divided, since educating Indian women to be more suitable companions for Western-trained Indian men was seen by some as compromising Indian women's traditional roles in family and household. By the end of the century, advice manuals for women written by Muslim men appeared; these contained moral and practical instructions in household arts and personal ethics and constitute a valuable historical source on changing ideals of womanhood.

Notable among reformers is Nazīr Aḥmad (1830–1912), who composed the earliest advice manuals for South Asian women. Aḥmad conceived of his trilogy, written as three novels in Urdu, as a "syllabus for the instruction of Muslim women." Educated both in classical Islamic studies and English institutions, Aḥmad may have been partially inspired by similar handbooks for European ladies, but the title of his first work suggests another, much older Islamic influence – the mirrors for princes literary genre. Entitled *Mir'āt al-ʿarūs* (The mirror of the bride), the first moral tale was devoted to good housekeeping and ethics. Completed in 1868, it not only won a major literary prize offered by the imperial government but also the approval of women family members. Aḥmad's 1874 masterpiece, *Tawba al-Naṣūḥ* (The repentance of Nasuh), about a young woman's moral redemption, has remained in print since its publication. Significantly, Aḥmad's trilogy was incorporated into Urdu school curricula and syllabi for Muslim girls. A more explicitly Islamic vision for reforming women was *Bihishti Zewar* (Heavenly ornaments) written in the early 1900s by Mawlana Ashraf ʿAlī Thānawī (1864–1943). An instructional guidebook of moral conduct, religious teachings, and daily behavior, Thānawī's work sought to meet the challenge of both the missionaries and westernized, secular Indians.

Rejecting the premise advanced by Bengali Hindu and Muslim male reformers – that women were essentially different from men – Thānawī argued that there were no intellectual or spiritual differences between male and female. All good Muslims must emulate the Prophet Muḥammad as their model, although Thānawī clearly accepted the existence of social and gender hierarchies. Muslim women in India needed moral regeneration because they had been deprived of true religious, that is, Islamic education. These two positions on women, their status, education, and moral reform, would dominate debates among Muslim male reformers from India to Turkey to North and West Africa by 1900.

With the 1891 Age of Consent Law, Indian woman was defined, codified, and thus subjected to imperial moral and sexual regulation; the law was one of the most controversial pieces of legislation enacted by a colonial state. On the face of it, the law seemed potentially beneficial; it raised the age of legally permissible sexual relations for girls from ten to twelve years. By the century's close, anti-British, right-wing Hindu activism arose in opposition to proposed reforms of marriage laws, including age of consent and a proposal to allow divorce. In 1906, Muslims of Bengal founded the All-India Muslim League to counter growing Hindu nationalism. Paradoxically both the successes and failures of British rule stimulated the development of competing Indian nationalisms. By the eve of the First World War, two mass nationalist movements, one Hindu, the other Muslim, coexisted uneasily. As symbols of the nation, increasingly gendered as female, women suffered the traumatic consequences of this in 1947. Despite enormous differences marking religious communities in South Asia's vast, heterogeneous population, colonial categories and stereotypes for Hindu and Muslim women often displayed remarkable congruence. This can be seen in other British possessions elsewhere in the world as well as in other European empires.

EGYPT: BETWEEN FRANCE AND
GREAT BRITAIN, 1798–CA. 1900
In 1798 Napoleon's army conquered Egypt in an ephemeral occupation ending in 1801 due to Ottoman-British intervention. This invasion set the stage for French cultural domination in Egypt, although Great Britain occupied the country in 1882, remaining there in one way or another until the 1956 Suez crisis. In contrast to India, an indigenous government was maintained in place, if much reduced in power, since Egypt was not a

colony but rather a protectorate. British officials in the Nile Valley sought to avert the mistakes made in South Asia by restricting modern education, limiting missionary activity, and avoiding intervention in Islamic family law. Egypt had embarked upon modernization early in the nineteenth century and nationalist sentiment, which counter-balanced British imperialism, was well developed by the 1880s. Another major difference was that Muslims comprised the vast majority of the population, although important indigenous communities of Egyptian Jews and Copts as well as immigrant Syrian Christians existed. Compared to minorities in India, the Copts maintained somewhat different relationships with the British; for example, English missionary societies were allowed into Egypt only after promising to renounce conversion efforts among the Christian Copts.

Egypt's proximity to Europe and the lure of her ancient monuments meant that numerous European expatriates resided there, or traveled through, feeding the insatiable demand for Orientalist art, literature, and photography focused upon exotic "Eastern" women; some examples are Gérard de Nerval (1808–55) who wrote *Voyage en Orient*, first published in serial form in 1846–7; or *Journal of a Visit to Egypt,* published in 1870 by Catharina Fouché, Duchesse d'Otrante (1837–1901). As in India, British administrators embarked upon the systematic acquisition of information that swelled considerably the colonial archive: surveys of many different kinds, police and other types of surveillance, and counting or enumeration. Much of this documentation is, once again, housed at the Public Record Office, although microfilms of some series are available. The enumerative modality played out differently in Egypt as opposed to India where periodic censuses were carried out from the mid-nineteenth century on. The 1881 Indian census engaged nearly a half million volunteers to collect information, supposedly about every person in the country. Due to fears of Muslim unrest, colonial authorities in Egypt did not conduct a census until 1897 and only in 1917 was detailed household information gathered for the first time. (It should be noted that the pre-1882 Egyptian government carried out its own censuses using European methods but counting both sexes.) As for the archeological mode of knowing, so critical to rewriting Egypt's history, another major difference emerged between India and Egypt. French scientists had long claimed a pre-eminent position in digging up and interpreting the country's past as well as in constructing museums.

Unlike in India, the British in the Nile Valley faced a formidable cultural competitor in France, which exerted major influence in art, literature, entertainment, education, and language until well into the twentieth century. French governesses were sought by elite Egyptian families to instruct daughters at home; their memoirs represent a valuable source of information for that class of society. The Jesuit Collège de la sainte famille in Cairo houses a precious, and little used, collection of memoirs and travel accounts, mainly in French. The archive includes the writings of Jehan d'Ivray, a French woman who married an Egyptian in the 1880s and resided in Egypt for four decades.

French social engineers inspired both the discourse of social reform, whether aimed at women or other issues, and actual reform policies in Egypt. Most education for girls in nineteenth-century Egypt was either confessional – French Catholic missionary, Coptic or Jewish – and/or private schools catering to the large resident Mediterranean communities of Italians, Maltese, and Greeks. The Copts founded a girls school in 1853; the Alliance israélite universelle, a French Jewish educational and philanthropic organization, opened institutions around Egypt in the 1890s. At first Muslims did not generally enroll girls in these institutions, although after 1900 some middle-class families sent daughters to Catholic convent schools. Missionary school records constitute a valuable, though underutilized, documentary source on women. For example, the archives of the Sisters of St. Joseph, which maintained girls schools throughout Egypt, are currently housed in the Vatican. In addition, Syrian emigrés resident in Egypt organized primary girls education from the late nineteenth century on and also established a vibrant women's press in Arabic.

During the 1830s the precolonial Egyptian state founded a school to train indigenous midwives, creating an administrative apparatus for health and policing that generated documentation on women and gender. Moreover, a state primary school was founded in 1873, the Suyufiyya, to prepare poor girls for domestic service. These structures were preserved after 1882 so that Britain was, in some respects, a successor state to that of Muḥammad ʿAlī Pasha (r. 1805–48) and his descendants. In contrast to India and the Contagious Disease Act controversy, colonial officials avoided regulating prostitution until around 1905. Somewhat in contrast to India, administrators such as Lord Cromer (1882–1907), did little to further girls education and may have hindered it. Questions regarding women's status under Islamic

law and female education had been raised after mid-century by Egyptian Muslim elites attached to the precolonial state. Partly in consequence, a Muslim feminist movement arose in the first decade of the twentieth century under the leadership of Hudā Sha'rāwī and Nabawiyya Mūsā, both of whom strove to expand girls educational and other opportunities; both women left behind valuable memoirs and other writings. As in India, indigenous male reformers also worked to improve female legal status; the Egyptian Muslim judge, Qāsim Amīn, published *Taḥrīr al-Mar'a (The liberation of woman)* in 1899, calling for legal changes to combat patriarchal oppression. His next publication, *al-Mar'a al-jadīda* (The new woman, 1900), explicitly linked female emancipation with national liberation from Britain. By the late nineteenth century, moral and didactic writings in Arabic by Egyptian and other women appeared, burgeoning into an abundant genre and unparalleled source for understanding women's history and the colonial experience.

Despite considerable differences between British imperialism in India and Egypt, much of the colonial and indigenous nationalist discourse on reforming women in the two countries was similar, although once again, Egypt's cultural inspiration came partially from France. By the turn of the century, Egyptian women assumed a charge not historically theirs – for the moral, physical, and intellectual well-being of their progeny and by extension the nation. Scientific child-rearing, *puériculture*, was taught in Egyptian girls schools patterned after French institutions. *Puériculture* had first appeared in France in 1865 to instruct mothers in raising healthy babies and indoctrinate the laboring classes in bourgeois domesticity. The program was later incorporated into French colonial projects worldwide; by the interwar period, it was taught to women in French West Africa. Despite their foreign origins, some of the ideas informing scientific motherhood found a deep resonance among Muslim thinkers and modernizers throughout the Islamic world from India to Africa. Even in Iran and Turkey, never formally absorbed into European empires, nationalist Muslim elites adopted – and adapted to local cultural understandings – the construction of ideal womanhood contained in scientific motherhood, thenceforth linked to the health and progress of the nation.

BRITISH COLONIALISM IN AFRICA: THE CASE OF THE SWAHILI COAST, CA. 1840–1900

Along the Swahili coast from southern Somalia to northern Mozambique, the first European interference came during the mid-century anti-slavery movement. The English CMS established a station near Mombasa for slaves taken from ships and manumitted by the British. In the 1890s, the CMS center was transformed into an educational institution. At the same time, the British East Africa Company came under the purview of the Foreign Office in 1895, thus ushering in the East Africa Protectorate (EAP). As the port of Mombasa expanded and railroads linked the interior to the port, prostitution developed since male workers, without families, were attracted to Mombasa by cash wages offered by the colonial government. Drought, crop failures, and the 1901 colonial hut tax also pushed women from the interior into coastal prostitution. Documentation on these forces can be found in the Kenya National Archives, particularly in the district quarterly reports and the province annual reports from the first decade of the twentieth century on; CMS records from the mid-nineteenth century on represent another sources of information. However, as Margaret Strobel noted in her 1979 study, *Muslim Women in Mombasa, 1890–1975*, "To write about women on the Swahili coast is to probe the history of the inarticulate and invisible. Evidence written by women themselves is scarce." Nevertheless, divorce and other legal proceedings provide data, although official, male-authored colonial reports tended either to ignore women altogether or focus only on prostitution to the exclusion of other female activities. As elsewhere in the European empires, the British created racial categories, superimposing them upon religious and ethnic differences, which inflamed local conflicts. In addition, by undermining traditional social status and patriarchal hierarchies, the protectorate government dealt a blow to male authority both domestic and public. This was particularly true in terms of divorce, custody, and marriage proceedings as well as inheritance disputes; some women began appealing to local British officials in inheritance matters in an attempt to maximize their rights when Muslim courts proved unsatisfactory. Land Office records, the records of the Chief Native Court, Mombasa, the *East Africa Law Reports*, and the Mombasa Political Record Books in the Kenya National Archives are among the sources for documentation on legal disputes. Another paradoxical trend apparent by the early twentieth century was that under British rule more women began to veil and practice purdah; this was often done by lower-class families seeking to elevate social standing through imitating superiors. The most significant change for women did not occur until the 1930s when formal secular schooling for

females became available; however, this period is outside the purview of the present study.

FRANCE'S EMPIRE IN NORTH AFRICA, CA. 1830–1900

North Africa provides a number of contrasts with the British, Dutch, and other empires. After the loss of most of India to Great Britain, France was a second-rate colonial power, with only small commercial enclaves in the West Indies, Africa, and Asia. Then in 1830 France stumbled into Algeria. The country's pacification demanded nearly 50 years of brutal warfare waged against the Muslim population by the French army. This meant that the military not only directly ruled Algeria for decades but also that the military archives, mainly housed in the Château de Vincennes outside of Paris, represent an important source of historical data. From the 1840s on, Arab Bureau officers described native women, often tribal or rural women. In military records from this period, colonized women appear as ethnographic subjects, often as laborers or producers, endowed with freedom of movement and even political functions; they were not yet deployed as a cultural assault upon Algerian Muslim society. However, as in India, prostitution was a public health concern due to the large French military presence in the country. Apart from references in military correspondence to either organized or freelance trafficking in sexual favors by European women, one of the few published "scientific" inquiries into the colonial sex trade was the physician E. Duchesne's *De la prostitution dans la ville d'Alger depuis la conquête* (1853) which posited the existence of a perverse "Oriental sexuality."

Documentation on women and gender was greatly influenced by the arrival of tens of thousands of impoverished immigrants from the Mediterranean basin in the 1830s. These people, of humble, yet heterogeneous, origins, grew into colonial settlers; some resided in North Africa until 1962, and many displayed an aggressive racism toward indigenous Muslims and Jews virtually without parallel. The literary production of this community is generally infused with a discourse of violence toward native Algerians, although this source has generally been ignored until now by scholars. The French Catholic Church sent missions to Algeria, mainly to tend to the Mediterranean population but also to convert Muslims and Jews. In the Kabylia, where a substantial ethnic, but not religious, Berber minority resided, the colonial regime attempted to divorce Berber Muslims from Arab Muslims through legal and other strategies. Here Catholic missionaries, principally the White Fathers, made some conversions, mainly among orphans or outcasts, by setting up clinics, orphanages, and schools. One of the most singular autobiographies from French Algeria was written by Fadhma Amrouche, a Kabyle village woman. Her *Histoire de ma vie* (Story of my life) details the life of a convert to Christianity, educated by Catholic orders, and living under French colonial rule in Algeria and later Tunisia.

Generally the military and civilian governments of Algeria were hostile to missionary activity, arguing, as in other Muslim colonies, that education and/or attempts at conversion would fan revolt. Thus the church did not establish health and educational institutions comparable with those in India. Finally Alliance israélite universelle reformers from Paris arrived at mid-century to found schools and make Algerian (as well as Moroccan and Tunisian) Jews French. The archives of the White Fathers and other Catholic missions in North Africa, located in Rome and France, as well as those of Protestant missions from the United Kingdom or North America, have hardly been used by historians, although they represent a critical source. Similarly the archives of the Alliance housed in Paris have not been consulted for women and gender issues by historians of colonial Algeria, although several studies are currently underway.

Debates among colonial officials and settlers over Algerian women's status became embroiled in another debate over sexuality and political rights. Polemics concerning native women and their proper education placed them in a contradictory position – as preservers of authentic North African traditions on the one hand, or as beacons of modernity within the household on the other. Each perspective implied radically different educational policies. The deadlock over which of these mutually exclusive social visions should prevail afforded an excuse to neglect female instruction throughout the colonial period. Indeed after 1861 colonial officials successfully lobbied against state-supported instruction, claiming that schools were too costly, and worse, that educated women were accepted by neither society; some even asserted that Western education for Muslim girls produced prostitutes. Arguments against girls education were linked to the sexualization of the Algerian woman by European settlers as well as travelers and photographers. This too contrasts to a degree with British India where the ratio of European to native never approached those in Algeria. Progressively the settlers assumed a novel collective identity encapsulated by the notion of "We Algerians" which held that the Europeans

constituted a cultural race distinct from both the "inferior" Muslims and the degenerate, effeminate, French of the metropole. By 1900 issues of sex and gender dominated the controversy over limited political representation for some colonized males. Deployed as a tool for disenfranchisement, women's supposedly "depraved" status under Islamic law – as interpreted by colonial officials and settlers – proved Muslim assimilation to France was impossible. This explains a new genre of colonial literature – official studies, popular fiction, pseudoscientific tracts devoted to Muslim women – whose real purpose was to deny native Algerians the most basic rights.

In stark contrast, by 1900 Muslim reformers in Egypt and North Africa argued that Islamic law was not immutable; the Tunisian jurist, Ṭāhir al-Ḥaddād, proposed a new reading of women's rights, campaigning for modern female education. Another prominent jurist, the Algerian Kāmil Muḥammad ibn Muṣṭafā, composed in 1903 *Les droits de la femme* (*The rights of woman*), written in the conqueror's language. Its audiences were the French of the metropole and French-educated Muslims, then pressing for political representation.

In contrast to British India and Egypt, or the Dutch East Indies, the construction of French Algeria was as much the forging of a gaze – or spectrum of gazes fixed upon Muslim women's sexuality – as the assembling of coercive mechanisms for knowing and controlling. This produced an enormous corpus of colonial documents, now housed mainly in Aix-en-Provence. That gaze, its discourses and representations, constituted a critical force in the cultural politics of French Algeria. While elements of this existed in other European empires, nowhere was the colonized woman represented in this way, manipulated to this degree, for the political purposes of settler communities. A final difference between British India and French Algeria was that late nineteenth-century French feminists were not as deeply implicated in the imperial project as were British feminists. Nevertheless, the French feminist and suffragist, Hubertine Auclert (1848–1914), resided in Algeria for four years and raised the issue of colonial racism and the oppression of colonized women in many of her writings. Much of her correspondence can be found in Paris in the extensive Bouglé collection located at the Bibliothèque historique de la ville de Paris.

As the British in Egypt attempted to avoid the mistakes made in India, so too the French in Tunisia sought to avoid the errors of Algeria. Like Egypt, Tunisia was a protectorate, conquered in 1881 but never ruled by the French military. In Tunisia the struggle over sexuality and citizenship did not exist due to the country's different status and the different position of European settlers there. Thus the issue of education for indigenous girls or boys was not as highly charged politically. Indeed a novel experiment in modern learning for Muslim girls was launched around 1900 and began to bear fruit by the eve of the First World War. One of the first academic, secular primary schools for colonized girls in the French Empire, the School for Muslim Girls, was organized by both Tunisian Muslims and French liberals. The school, still extant today, not only educated the first female physician in the country but also the spouses of many male Tunisian nationalists. Generally speaking, the vast archives of the French Protectorate for Tunisia represent a rich, but once again underutilized, source for studying women under colonial rule, as do the archives of the precolonial Tunisian state. Some protectorate records, not repatriated to France in 1956, are still housed in the Tunisian national archives in Tunis; vast quantities of colonial documents, shipped to the metropole at independence, are deposited in the archives in Nantes. Finally Catholic missionary records for Tunisia have hardly been studied; once again, the papers of the Sisters of Saint Joseph in the Vatican await their historian.

In precolonial Morocco, one of the first girls schools was opened by the Alliance israélite universelle in Tangiers in 1866; documentation on this school and others like it is readily avaiable in the AIU archives in Paris. Again with Algeria as counter-model, after 1912 the colonial regime in Morocco eschewed, for the most part, introducing overt changes into Islamic personal status law. Indeed the patriarchal authority of the reigning 'Alawī dynasty and of great Arab or Berber lords was reinforced; France wanted Morocco to remain theoretically "traditional," untouched by modernity. Nevertheless colonial divide-and-conquer strategies indirectly politicized Islamic family law by opposing it to Berber customary law. Since the large Berber minority was mistakenly regarded as more amenable to the civilizing mission, French administrators sought to drive a wedge between Arabs and Berbers. Thus the Moroccan Berber woman (as with the Algerian Kabyle woman) was represented as commanding greater respect in her society and displaying greater personal morality than her degraded, eroticized Arab sister. Once again women were deployed as

markers of racial and cultural difference to divide Muslim groups. Of the three French North African countries, the least amount of scholarship on women exists to date for colonial Morocco. Documentation can be found in the Moroccan Protectorate archives in Nantes and the military archives at Vincennes; as is true for Tunisia, colonial records still remain in Morocco, principally in Rabat. The intense study of Berber societies by colonial ethnographers doing fieldwork in Morocco generated a considerable corpus of data that represents an underutilized fund awaiting future researchers. Finally recent oral history projects interviewing Moroccan women participants in nationalist/anti-colonial movements have yielded considerable information, although for periods later than those covered by this essay.

By the eve of the First World War, colonized women throughout the globe were becoming the measure of all things – politico-cultural symbols and objects of reform as well as ideological terrain for debating issues of identity, cultural authenticity, and moral aptitude for Western assimilation.

IMPERIAL SOURCES ON WOMEN: PROBLEMS AND PROSPECTS

Substantially more is known about European women's myriad engagements in overseas empire as settlers, travelers, missionaries, or teachers – particularly for British India – than about colonial female subjects, although this is currently changing as scholarly interest in women, gender, and imperialism expands. For the Islamic world, most attention has been focused upon diverse nationalisms with their ideologies of the female-gendered nation. Various interpretations have been advanced about the consequences for colonized women of the ideological and political construct of Muslim womanhood, tied in turn to motherhood or wifehood, that was clearly articulated by 1900. Some scholars argue that the ideal of the "new Muslim woman" afforded opportunities for improving real women's social positions in their respective societies; others, however, see that ideology, encircled by a double patriarchy, colonial and indigenous, as blocking meaningful change for women. Still others point out that the greatly expanded regulatory reach of the modern state not only brought women, whether colonized or not, ever more firmly under male control but also widened the perceived gap between the feminine "traditional" and feminine "modern." One danger inherent in the nationalist sources is that too much attention has been concentrated upon discourse – what male reformers said or claimed – and not enough about what "facts on the ground" meant for colonized women in their daily lives and multiple encounters with diverse aspects and agents of imperialism. Some of the scholars currently redefining the field are: Janet Afary, Beth Baron, Marilyn Booth, Nikki R. Keddie, Afsaneh Najmabadi, Lisa L. Pollard, Monica Ringer, Mona Russell, A. Holly Shissler, Elizabeth Thompson, and Judith Tucker.

Did the indisputable violence of imperial conquest and settler colonialism "deplete the archive," restrict knowledge about precolonial women, and silence colonized female voices, as some claim? The response to this is probably both affirmative and negative. Abundant, extremely diverse historical data remain to be exploited, however. When used in critical fashion, textual archival sources, such as the vast holding of the English CMS, of the Dutch Reformed Church and missionaries, or of the French Catholic White Fathers and Sisters, offer information about women, families, and societies not generally found elsewhere; for example, details about household management, popular beliefs and practices, child-rearing, or female healers can be gleaned from these documents – even if these activities were recorded to subvert "traditional" customs. In addition, these documents provide evidence not found in government sources since imperial officials at the top of colonial pecking orders often deemed such information unworthy of note – or because, as men, they did not enjoy direct access. Reading against the grain can potentially transform even the most recondite or suspect, even tainted, piece of evidence into a legitimate source for understanding the Europeans as well as the colonial subjects portrayed therein. Colonial censuses are also important sources of information that have scarcely been utilized for women and gender in French colonies. Even less attention has been directed to historical sources on colonized children and youth, such as the records of orphanages or public health organizations, or those of scouting groups, which had chapters for boys and girls, indigenous as well as European, throughout Africa and Asia. Despite inherent limitations – explicit or implicit assumptions and biases – these and other sources offer opportunities for enhanced knowledge about the past, provided that historians continuously acknowledge the problematic nature of the archive of European imperialism generated by those aiming to exploit, dominate, and convert the peoples studied and recorded.

BIBLIOGRAPHY

PRIMARY SOURCES

F. Amrouche, *My life story. The autobiography of a Berber woman*, trans. D. Blair, New Brunswick 1989.

H. Auclert, *Les femmes arabes en Algérie*, Paris 1900.

F. Buchanan, *A journey from Madras through the countries of Mysore, Canara, and Malabar*, London 1808–14.

Church Missionary Society Archive, section II, parts 1–3, *Missions to women*, Wiltshire 1997 and section IV, parts 1–7, *Africa Missions*, Wiltshire 1999.

E. Duchesne, *De la prostitution dans la ville d'Alger depuis la conquête*, Paris 1853.

C. Fouché, *Journal of a visit to Egypt, Constantinople, etc.*, New York 1870.

A. H. Grey-Edwards, *Memoir of the Rev. John Thomas. C.M.S. missionary at Mengnanapuram, Tinnevelly, South India, 1835–1870*, London 1904.

India Office Library, *Catalogue of the Panjabi and Sindhi manuscripts in the India Office Library*, London 1977.

J. Mabro (intro.), *Veiled half-truths. Western travellers' perceptions of Middle Eastern women*, London 1991.

B. D. Metcalf (trans. and commentary), *Perfecting women. Maulana Ashraf ʿAli Thanawi's Bihishti Zewar*, Berkeley 1990.

H. Shaʿrāwī, *Harem years. The memoirs of an Egyptian feminist*, trans., ed., and intro. M. Badran, New York 1987.

S. Tucker, *The rainbow in the north. A short account of the first establishment of Christianity in Rupert's land*, London 1851.

T. Williamson, *The East-India Vade Mecum*, 2 vols., London 1810.

SECONDARY SOURCES

L. Abu-Lughod, *Remaking women. Feminism and modernity in the Middle East*, Princeton, N.J. 1998.

D. Arnold, *Science, technology and medicine in colonial India*, Cambridge 2000.

M. Badran, *Feminists, Islam, and nation. Gender and the making of modern Egypt*, Princeton, N.J. 1995.

S. Bakalti, *La femme tunisienne au temps de la colonisation, 1881–1956*, Paris 1996.

B. Baron, *The women's awakening in Egypt. Culture, society, and the press*, New Haven, Conn. 1994.

C. A. Bayly, *Empire and information. Intelligence gathering and social communication in India, 1780–1870*, Cambridge 1996.

M. Booth, *May her likes be multiplied. Biography and gender politics in Egypt*, Berkeley 2001.

M. Borthwick, *The changing role of women in Bengal, 1849–1905*, Princeton, N.J. 1986.

A. Burton, *Burdens of history. British feminists, Indian women, and imperial culture, 1865–1915*, Chapel Hill 1994.

——, *At the heart of the empire. Indians and the colonial encounter in late-Victorian Britain*, Berkeley 1998.

M. R. Charrad, *Women's rights. The making of postcolonial Tunisia, Algeria, and Morocco*, Berkeley 2001.

P. Chatterjee, *The nation and its fragments. Colonial and post-colonial histories*, Princeton, N.J. 1993.

N. Chaudhuri and M. Strobel (eds.), *Western women and imperialism. Complicity and resistance*, Bloomington, Ind. 1992.

A. Christelow, *Muslim law courts and the French colonial state in Algeria*, Princeton, N.J. 1985.

J. Clancy-Smith, The shaykh and his daughter. Coping in colonial Algeria, in E. Burke III (ed.), *Struggle and survival in the modern Middle East*, Berkeley 1993, 145–63.

——, A visit to a Tunisian harem, in *Journal of Maghrebi Studies* 1–2:1 (1993), 43–9.

——, *Rebel and saint. Muslim notables, populist protest, colonial encounters (Algeria and Tunisia, 1800–1904)*, Berkeley 1994.

——, Gender, work, and handicraft production in colonial North Africa, in M. Meriwether and J. Tucker (eds.), *A social history of women and the family in the Middle East*, Boulder, Colo. 1999, 25–62.

——, Gender in the city. The medina of Tunis, 1850–1881, in D. Anderson and R. Rathbone (eds.), *Africa's urban past*, Oxford 2000, 189–204.

——, Educating the Muslim woman in colonial North Africa, in B. Baron and R. Matthee (eds.), *Iran and beyond. Essays in Middle Eastern history in honor of Nikki R. Keddie*, Los Angeles 2000, 99–118.

——, L'école rue du pacha à Tunis. L'éducation de la femme arabe et "la plus grande France" (1900–1914), in *Clio. Histoire, femmes et société. Le genre de la nation* 12 (2000), 33–55.

J. Clancy-Smith and F. Gouda (eds.), *Domesticating the empire. Race, gender, and family life in French and Dutch colonialism*, Charlottesville, Va. 1998.

B. S. Cohn, *Colonialism and its form of knowledge. The British in India*, Princeton, N.J. 1996.

A. L. Conklin, *A mission to civilize. The republican idea of empire in France and west Africa, 1894–1930*, Stanford, Calif. 1997.

F. Cooper and A. L. Stoler (eds.), *Tensions of empire. Colonial cultures in a bourgeois world*, Berkeley 1997.

K. M. Cuno and M. J. Reimer, The census registers of nineteenth-century Egypt. A new source for social historians, in *British Journal of Middle Eastern Studies* 24:2 (1997), 193–216.

W. Dalrymple, *The White Mughals. Love and betrayal in eighteenth-century India*, New York 2002.

R. M. Eaton, *The rise of Islam and the Bengal frontier, 1204–1760*, Berkeley 1993.

G. Forbes, *Women in modern India*, Cambridge 1994.

F. Gouda, *Dutch culture overseas. Colonial practice in the Netherlands Indies 1900–1942*, Amsterdam 1995.

S. Graham-Brown, *Images of women. The portrayal of women in photography of the Middle East, 1860–1950*, New York 1988.

R. Guha and G. C. Spivak (eds.), *Selected subaltern studies*, Oxford 1988.

G. R. G. Hambly (ed.), *Women in the medieval Islamic world*, New York 1998.

P. M. Holt, A. K. S. Lambton, and B. Lewis (eds.), *The Cambridge history of Islam*, ii, *The further Islamic lands, Islamic society and civilization*, Cambridge 1970.

M. T. Huber and N. C. Lutkehaus (eds.), *Gendered missions. Women and men in missionary discourse and practice*, Ann Arbor 1999.

C. Johnson-Odim and M. Strobel (eds.), *Expanding the boundaries of women's history. Essays on women in the Third World*, Bloomington, Ind. 1992.

M. Kahf, *Western representations of the Muslim woman. From termagant to odalisque*, Austin, Tex. 1999.

H. Kazdaghli (ed.), *Mémoire de femmes. Tunisiennes dans la vie publique, 1920–1960*, Tunis 1993.

N. R. Keddie and Beth Baron (eds.), *Women in Middle Eastern history. Shifting boundaries in sex and gender*, New Haven, Conn. 1991.

R. S. Kipp, *The early years of a Dutch colonial mission*, Ann Arbor 1990.

R. Kumar, *The history of doing. An illustrated account*

of movements for women's rights and feminism in India, 1800–1990, London 1993.

M. Lazreg, *The eloquence of silence. Algerian women in question*, London 1994.

D. Lelyveld, *Aligarh's first generation. Muslim solidarity in British India*, Delhi 1996.

P. M. Lorcin, *Imperial identities. Stereotyping, prejudice and race in colonial Algeria*, London 1995.

L. Mani, *Contentious traditions. The debate on sati in colonial India*, Berkeley 1998.

Y. B. Mathur, *Women's education in India, 1813–1966*, New York 1973.

B. D. Metcalf (ed.), *Moral conduct and authority. The place of adab in South Asian Islam*, Berkeley 1984.

T. R. Metcalf, *Ideologies of the Raj*, Cambridge 1994.

C. Midgley (ed.), *Gender and imperialism*, Manchester, U.K. 1998.

S. G. Miller, Gender and the poetics of emancipation. The Alliance israélite universelle in northern Morocco, 1890–1912, in L. C. Brown and M. S. Gordon (eds.), *Franco-Arab encounters*, Beirut 1996, 229–52.

G. Minault, *Secluded scholars. Women's education and Muslim social reform in colonial India*, Delhi 1998.

R. P. Pierson and N. Chaudhuri (eds.), *Nation, empire, colony. Historicizing gender and race*, Bloomington, Ind. 1998.

G. Prakash (ed.), *After colonialism. Imperial histories and postcolonial displacements*, Princeton, N.J. 1995.

J. D. Ragan, A Fascination for the exotic. Suzanne Voilquin, Ismayl Urbain, Jehan D'Ivray and the Saints-Simonians. French travelers in Egypt on the margins, Ph.D. diss., New York University 2000.

B. N. Ramusack and Sharon Sievers (eds.), *Women in Asia. Restoring women to history*, Bloomington, Ind. 1999.

D. M. Reid, *Whose pharaohs? Archeology, museums, and Egyptian national identity from Napoleon to World War I*, Berkeley 2002.

R. Simon, *Change within tradition among Jewish women in Libya*, Seattle 1992.

M. Sinha, *Colonial masculinity. The "manly Englishman" and the "effeminate Bengali,"* Manchester, U.K. 1995.

A. Sonbol (ed.), *Women, the family, and divorce laws in Islamic history*, Syracuse, N.Y. 1996.

G. C. Spivak, Can the subaltern speak? Speculations on widow-sacrifice, in *Wedge* 7:8 (1985), 120–30 and C. Nelson and L. Grossberg (eds.), *Marxism and the interpretation of culture*, Urbana, Ill. 1988, 271–313.

A. L. Stoler, Sexual affronts and racial frontiers, in *Comparative Studies in Society and History* 34:3 (1992), 514–51.

M. Strobel, *Muslim women in Mombasa, 1890–1975*, New Haven, Conn. 1979.

——, *European women and the second British Empire*, Bloomington, Ind. 1991.

J. E. Tucker, *Women in nineteenth-century Egypt*, Cambridge 1985.

L. S. Vishwanath, Efforts of colonial state to suppress female infanticide. Uses of sacred texts, generation of knowledge, in *Economic and Political Weekly* 33:19 (1998), 1104–12.

A. Wink, *Land and sovereignty in India. Agrarian society and politics under the eighteenth-century Maratha Svarajya*, Cambridge 1986.

L. Wilson, Hinduism. History of study, in S. Young (ed.), *Encyclopedia of women and world religion*, i, New York 1999, 430–2.

JULIA CLANCY-SMITH

Caucasus: Mid-18th to Early 20th Century

The Caucasus is traditionally divided into two zones, North Caucasus and Transcaucasia. Up to 1990, the U.S.S.R. included all of Caucasia. Now North Caucasus is in the Russian Federation and is subdivided into three regions: Northwest (including the republics of Adyghea and Karachay-Cherkessia and Krasnodar Territory), Central (republics of Kabardino-Balkaria and North Ossetia-Alania and Stavropol Territory), and Northeast (republics of Chechnya, Ingushetia, and Daghestan). The Transcaucasian republics (Georgia, Armenia, Azerbaijan) have become independent states.

ISLAM IN CAUCASIAN SOCIETIES

The Islamic identity of Caucasian societies is as follows. East Transcaucasia: Shī'ī Muslims, Ja'farī school; Northeast Caucasus: Sunnī Muslims, Shāfi'ī school; some Shī'ī Muslims live in Southern Daghestan; Northwest and Central Caucasus: Sunnī Muslims, Ḥanafī school.

The status of women in Caucasian society in the eighteenth to early twentieth centuries should be considered in the context of Islamic influence and the level of Islamization among Caucasian peoples. The Caucasus was Islamized gradually from the earliest centuries of Islam. Most of the region was exposed to Islamization except for Georgia (although Muslim Kisti live there), Armenia, Abkhazia, part of Ossetia, and Krasnodar and Stavropol Territories where Christianity prevailed. The Caucasian regions were not Islamized evenly. The strongest and earliest Islamization took place in Azerbaijan, Daghestan, Chechnya, and Ingushetia. The populations of Northwest and Central Caucasus were less influenced. An intense rivalry between Islamic and customary legal traditions in Caucasia existed from the eighteenth to early twentieth centuries.

The status of women in Caucasian customary law and Islamic cultures may be viewed according to different categories: marital, social, and legal. Most Caucasian societies that were exposed to Islamization, namely Kabarda, Chechnya, Ingushetia, and Daghestan, consisted of feudal estates. The main aspects of Caucasian women's status are concerned with the family sphere (*kalym, kebin*, avoidance etiquette, women's status within the clan structures); the social sphere (status of the senior woman, Kabardian *guashe*); and the legal sphere (right of divorce, rights connected with the division of property and inheritance).

The status of women in this period should take into account the period of Ottoman domination of Caucasia; the influence of the Crimean Khanate and Iran (fifteenth to the second half of eighteenth century); the subsequent Russian conquest of the Caucasus (Russo-Caucasian War of 1763–1862); the annexation of North Caucasus (1863) and East Transcaucasia (1878) to Russia; and reforms (administrative, socioeconomical, judicial, and so forth) carried out by the Russian administration.

WRITTEN SOURCES

The written sources from the eighteenth to early twentieth centuries are in Arabic, Old Ottoman, and Russian. The local North Caucasian written languages were still developing in the seventeenth to nineteenth centuries when sources in local languages (Northeast Caucasus and East Transcaucasia) appeared.

UNPUBLISHED (ARCHIVAL) SOURCES

1. *Private archives and mosques*. There are archive materials from private collections and village mosque archives in Daghestan and Azerbaijan. Arabic manuscripts from the sixteenth to twentieth centuries on the history of Northeast Caucasus and East Transcaucasia are kept there. The largest is the manuscript collection (including the Oriental manuscript department) of the Institute of History, Archaeology, and Ethnography of the Daghestan Scientific Center of the Russian Academy of Science (IHAE DSC RAS).

2. *State archives*. These are the Moscow and St. Petersburg archives and the Caucasian archives. The Moscow archives contain the Foreign Affairs Archive; the Russian State Military Historical Archive (collections of the Military Registration Archive of the Main Headquarters); and the State Archive of the Russian Federation. The St. Petersburg archives consist of the St. Petersburg Department of the Archive of Russian Academy of Science and the Central State Archive. The Caucasian archives include the Central State

Historical Archive of Republic of Georgia (CSHA RG, Tbilisi, Georgia); the Central State Historical Archive of the Republic of Azerbaijan (Baku, Azerbaijan); the Central State Archive of the Republic of Daghestan (Makhachkala, Russia); the Central State Archive of the Republic of North Ossetia-Alania (CSA RNOA, Vladikavkaz, Russia); the Central State Archive of the Republic of Kabardino-Balkaria (CSA RKB, Nalchik, Russia); the State Archive of Krasnodar Territory (Krasnodar, Russia); the Republican Archive of Adyghea (Maikop, Russia); the Republican Archive of Karachay-Cherkessia (Cherkessk, Russia); and the State Archive of Stavropol Territory (Stavropol, Russia). The Republican Archive of Chechnya (Grozny) was destroyed in 1990 during the Russian-Chechen war. Many data on the status of women in Chechnya are stored in the CSA RNOA.

All the archives in Caucasus, Moscow, and St. Petersburg provide guidebooks to the main archival holdings that contain file descriptions. These archives were created during Soviet rule in Caucasia (1920s–1980s) and contain information on the Russian administration's activities in Caucasus (sixteenth to early twentieth centuries).

3. *Customary (adat) law and shariat rules registration.* In the nineteenth century in North Caucasus, a codification of customary law regulations was carried out, initially by Imam Shamil (Northeast Caucasus, 1847), then by the Russian administration (Northwest and Central Caucasus). In 1860 the Russian administration had set up an army-administered government in Caucasus with the center in Tiflis (now Tbilisi) (1860–1917).

Judicial materials of the *adat* and Muslim courts contain the descriptions of exercise of both customary law and Sharī'a regulations in respect of women (marriage, divorce, division of property and inheritance, rape, and insults). In Northeast Caucasus and East Transcaucasia (Azerbaijan), the verdicts of the *adat* and Muslim courts were written down only in Arabic. Documents were kept in the mosque libraries and libraries of local rulers. The most important ones were engraved on the walls of public buildings.

In Northwest and Central Caucasus, the resolutions of *adat* and Muslim courts were originally oral. Russian had been an official language there since the late eighteenth century. The resolutions of these courts, and then the courts created by the Russian authorities, were subsequently written in Russian.

Most of this material is stored in the archives of Northwest and Central Caucasus (Nalchik, Vladikavkaz, Krasnodar, Stavropol, Maikop), Transcaucasia (Tbilisi, Baku), Moscow, and St. Petersburg. Very little is published.

4. *Collections related to the study of women's status in Caucasian society.* The most important of these are: CSHA RG: Collection 2, Office of the Head Governor of Transcaucasian Territory; Collection 7, Headquarters of the Chief of Civilian Department in Caucasus. CSA RNOA: Collection 12, Office of the Head of Terskaya Region. CSA RKB: Collection 16, Office of the Commander of Central Caucasian Line; Collection 23, Kabardian Provisional Court; Collection 22, Nalchik Highlander Verbal Court.

PUBLISHED SOURCES

Primary materials consist of newspapers; ethnographical research data on the Caucasus by Russian and foreign researchers; works of Caucasian reformers, scholars; travelogues; and information from Russian officials who were in service in the Caucasus.

Secondary materials include materials of the scientific researches on the Caucasus conducted in the Soviet and post-Soviet periods.

1. *Newspapers.* In the mid-to-late nineteenth to early twentieth centuries, newspapers in the Russian language were started in the main Caucasian centers (Tbilisi, Krasnodar, Vladikavkaz, Derbent). Important titles include: *Kavkaz*, Tbilisi; *Terskiye Vedomosti*, Vladikavkaz; *Severni Kavkaz*, Krasnodar; *Novoye Obozreniye*, Kazbek; and *Terek*, Vladikavkaz. These newspapers are stored in North Caucasian and Azerbaijan republican libraries, the state archives of North Caucasian republics and Azerbaijan, and in the V. I. Lenin Russian State Library (Moscow). Some of the newspaper materials – mainly information on the life of Caucasian peoples – are published as separate books.

2. *Ethnographical research data on Caucasus by Russian and foreign researchers.* Between the eighteenth and early twentieth centuries, aspects of the life of Caucasian peoples were actively studied, including the status of women in Islamic society (M. M. Kovalevskii 1899). Most materials were issued in two collections published in Tbilisi: *Collected Information on Caucasian Highlanders* (Caucasian Highlander Department, 1868–81) and *Collected Information for Describing Caucasian Landscape and Tribes* (Caucasian Education District Department, 1882–1926). In the U.S.S.R., the majority of ethnographic materials of the eighteenth to early twentieth centuries were republished from the 1950s to the 1980s.

3. *Works of Caucasian reformers, scholars, and writers.* Only in Daghestan and Azerbaijan was the influence of Islam so strong that Arabic was used. By the eighteenth century, the main published sources produced by reformers, scholars, and writers were issued in Arabic, for example, *al-Kuduki* (Daghestan, 1652–1717) (copies kept in the Manuscript Collection of the IHAE DSC RAS); *al-Kadari* (1834–1910), in Arabic, Persian, Azeri, Turkish, and Russian (kept in the Manuscript Fund of IHAE DSC RAS and the Institute of Manuscripts and Institute of Literature of Azerbaijan Academy of Science); *Ali Kayayev* (1878–1943), in Arabic, Turkish, and Lakian.

The situation in Northwest and Central Caucasus was different. The North Caucasian reformers had been educated in Russia (St. Petersburg) and had a good command of the written Russian language and used it to write works on the life of Caucasian peoples (Shora Nogmov, Khan-Ghirei, Kazi-Ghirei 1808–63, Adyl-Ghirei 1819–76, Adyl-Ghirei Keshev 1837–73, Lukman Kodzokov, Batyr-Bek Shardanov, Adam Dymov, Kosta Khetagurov). There were numerous publications in Russian-language newspapers and magazines issued in Caucasus and St. Petersburg in the nineteenth century (*Sovremennik, Kavkaz, Voyenni Sbornik, Na Kavkaze, Kubanskiye Voiskovye Vedomosti,* Yekaterinburg; *Etnograficheskoye Obozreniye, Terskiye Vedomosti,* Vladikavkaz). Besides Russian, the Northwest and Central Caucasian reformers used Arabic, Old Ottoman, and local languages.

MATERIAL SOURCES

Archaeological materials
Various religious buildings have survived in Caucasus up to the present, and some of them have a bearing on women. For example, the sanctuaries of the eighteenth to early twentieth centuries in Daghestan and Azerbaijan contain legends about heroic girls and women. The Rutuls (Southern Daghestan and Northern Azerbaijan) have a sanctuary connected with a legend about a deranged girl who at the end of the eighteenth century led a group of pilgrims who had lost their way in the mountains out to the road and then disappeared. The sanctuary (*ujag'abyr*) was erected at the place where her impressed footstep remained miraculously intact.

Museum material
The Caucasian exhibits of Russian ethnographic museums provide important additional information. They make it possible to identify the role of women in the socionormative culture and understand some basic material attributes of their status within the society and family. There are republican museums (local lore, history, and so forth) in the North Caucasian republics and Azerbaijan. The Russian Ethnographic Museum (former State Museum of Ethnography of the U.S.S.R. Peoples) in St. Petersburg holds a large ethnographic collection.

Arabic epigraphical inscriptions
These are found in Daghestan and Azerbaijan as inscriptions on the walls of religious buildings. They include the verdicts of Muslim courts on the walls of old mosques.

Use of sources in current research on women and gender in the Caucasus
The sources in Russian are investigated most fully, the sources in Arabic and Old Ottoman are less well investigated. This is because of the Soviet system of teaching and training of researchers (Eastern languages are not taught in the historical faculties of Russian universities). The private and mosque archives have scarcely been investigated. This kind of source was found in Russia only in the 1990s.

All the sources mentioned here are accessible, though access to private and mosque archives might be difficult. Recommendations are required for visiting them. The Russian archives are in perfect condition. The archives of Transcaucasia are in an unsatisfactory state because of the lack of financial support.

Different kinds of sources should be used to achieve a full picture of the condition of women in the Islamic societies of the Caucasus. In Soviet and Russian research different kinds of sources are rarely compared.

BIBLIOGRAPHY
(All works cited are in Russian.)

PRIMARY SOURCES
T. I. Bittirova (comp.), *Karachay-Balkarian leaders of culture from the end of the nineteenth to the beginning of the twentieth centuries,* 2 vols., Nalchik 1996.
Iogann Blaramberg, *Caucasian manuscripts. Historical and ethnographical descriptions of peoples of the North Caucasus,* Stavropol 1992.
L. A. Chibirova (comp.), *Caucasian periodical material on Ossetia and the Ossetians,* 5 vols., Ckhinvali 1981–91.
H. M. Dumanov and F. H. Dumanova (comps.), *The legal norms of Adygs and Balkaro-Karachains,* Maikop 1997.

V. K. Gardanov (comp)., *Material on Kabardian customary law*, Nalchik 1956.

——, *Adygs, Balkarians, and Karachians in the material of the European authors of the thirteenth to nineteenth centuries*, Nalchik 1974.

Gidatlinsky adat, Makhachkala 1957.

K. K Hetagurov, *Collected works*, 3 vols., Moscow 1951.

Z. I. Jampolskii (comp.), *Travel writing about Azerbaijan*, Baku 1961.

Kabardian folklore, Moscow 1936.

B. A. Kaloev (comp.), *Ossetians from the point of view of foreign travelers (eighteenth to nineteenth centuries)*, Ordzhonikidze 1967.

N. L. Karaulov, Arabic writing on the Caucasus, Armenia, Azerbaijan, in *Collected descriptions of the areas and Caucasian peoples* (Tiflis, now Tbilisi), 24 (1901), 31 (1902), 32 (1903), 33 (1908).

H. O. Khashaev (comp.), *The monuments of Daghestan customary law of the nineteenth to twentieth centuries*, Moscow 1965.

R. H. Khazhhozheva (comp.), *Selected works of the Adyg reformers*, Nalchik 1980.

M. M. Kovalevskii, *Adat of the Dagestan region and Zakatalsky krai*, Tiflis 1899.

——, *Law and tradition in the Caucasus*, 2 vols., Moscow 1890.

V. P. Kurilev (ed.), *Monuments of traditional and everyday life. Culture of the peoples of Central Asia, Kazakhstan, and Caucasus*, Leningrad 1989.

F. I. Leontovich (ed.), *Caucasian adat*, 2 vols., Odessa 1882.

Museum of Azerbaijan history. *Azerbaijan national clothes*, Moscow 1972.

M. I. Naidel (ed.), *Guidebook. The central state archives of Azerbaijan S.S.R.*, Baku 1958.

Nakhichevan manuscripts and documents of the seventeenth to nineteenth centuries, Tbilisi 1936.

M.-S. Saidov (ed.), *Collection of Arabic manuscripts at the institute of history, language, and literature of the RAN Daghestan Science Center*, Moscow 1977.

E. N. Studeneckaja (comp.), *The peoples of the Caucasus. Catalogue of the ethnographical collection of the State Museum of the Peoples of the U.S.S.R.*, Leningrad 1981.

LITERATURE

Arabic documents from 1840s Daghestan, Tbilisi 1971.

Z. M. Buniajtova (comp.), *Review of sources for the history of Azerbaijan*, Baku 1964.

G. G. Gamzatov, M.-S. Saidov, and A. P. Shihcaidov, Arabo-Islamic literary tradition in Daghestan, in G. G. Gamzatov, *Daghestan. The historico-literary process*, Makhachkala 1990.

E. A. Kerimov, *The history of the ethnographical study of Azerbaijan in Russian science (seventeeth to eighteenth centuries)*, Baku 1968.

V. B. Korzun, *Literature of the peoples of the North Caucasus*, Grozny 1966.

M. O. Kosven, *Ethnography and history of Caucasus. Study and materials*, Moscow 1961.

I. U. Krachkovskiy, *Arabic literature in the North Caucasus*, vol. 6 of *Selected works*, Moscow 1960.

L. I. Lavrov, *The ethnographical monuments of the North Caucasus in the tenth to nineteenth centuries. Historico-ethnographical sources*, Moscow 1960.

H. Mamedov, *The Azerbaijan literature of reformers from the end of the nineteenth to the beginning of the twentieth century*, Baku 1978.

T. Nuralieva. *The importance of the collection of nineteenth-century manuscripts for study of Azerbaijan literature*, Baku 1986.

L. P. Semenov, *The Nart monuments of Daghestan in the tenth to seventeenth centuries as historical sources*, Moscow 1984.

R. U. Tuganov (comp.), *The bibliography of Kabardino-Balcaria, Karachay-Cherkessia, and Adyghea from ancient times to 1917*, Nalchik 1997.

IRINA BABICH

History of Islam in China: Mid-18th to Early 20th Century

OVERVIEW

For this period the sources that allow us to recreate the history of Muslim China are generally epigraphic (tombstones or steles in mosques) and local monographs written by officials of the empire. Lineage books, in which the history of each clan or lineage is recorded, provide another very interesting source. Travel narratives written by foreigners such as the fourteenth-century Arab voyager Ibn Baṭṭūṭa, missionaries, or military and diplomatic officers at the end of the nineteenth or the beginning of the twentieth century are equally useful. There are also new editions of old Muslim texts. The absence of any kind of illustration or representation is notable in these texts. The occasional cartoon that appeared in the Chinese press concerning Chinese Muslims rendered them indistinguishable from other Chinese and included no women whatsoever.

But all these sources tell only a part of the story, expressing the point of view of those who controlled or had access to political and cultural expression in China. They were non-Muslim or sometimes Muslim but always male scholars or officials, in short the dominant class. The sources are obviously biased or insufficient for research into the non-privileged classes of Chinese society – particularly Muslim women. This makes on-site anthropological field research indispensable. Even if we are unable to reconstruct the whole past from collective memory, we may at least verify with local women the discourses that are constructed around their existence.

The eighteenth and nineteenth centuries covered in this section were marked by the local anchoring of Islam in Chinese society, especially in peasant life, with the development of local mosques and the conflicts within the Chinese Empire. Another particularly important feature was the building of separate mosques, qingzhensi (temples of purity and truth) for men and women.

In eighteenth-century China, Muslims were not foreign, but fully integrated speakers of local Chinese languages. All Muslims were referred to as "Hui." They were the descendants of Arab and Persian traders who used the land and sea trade routes. The first official contact with Islam occurred in 651 C.E., but most Muslims are the descendants of people who immigrated, some of them forced to do so, during the Mongol dynasty (Yuan), from thirteenth-century Central Asian and Arab civilizations. Scholars such as D. D. Leslie (1986) refer to these citizens as Chinese Muslims. At the end of the sixteenth and the beginning of the seventeenth century, Islam became better established in Chinese society. The expansion of mosques throughout rural China took place principally during the eighteenth and the nineteenth centuries. The Chinese-speaking Muslims, today referred to as Hui, are spread throughout the Chinese territory with a notable concentration in the northwest. Turkish-speaking Muslims of Xinjiang, today referred to as Uyghurs, became part of the Chinese Empire only in the mid-eighteenth century when their pastures, towns, and oases were conquered by the Qing army.

The legal status of Chinese Muslims was the same as that of all the other citizens of the empire. Some exceptions occurred under the Tang and Song dynasties (from the seventh to the thirteenth century) when Arab or Persian traders could not take their Chinese wives out of China and during the Yuan dynasty when Muslims could not practice ritual slaughter. But the situation was different for the Turkish-speaking Muslims who, in the first century after their conquest by the Qing, had to adjust from Sharīʿa to Qing law. After the revolt of the nineteenth century, the Qing law alone was applied (Millward 1998).

WOMEN'S ISLAM

In traditional China all women, including Muslims, were subject to the same imperial laws. They were considered minors with few rights. They could not inherit land and the law allowed the lineage chief complete latitude in determining the distribution of any property. They had to submit to the will of their fathers, husbands, and sons and only obtained power when they were old and could run their own household. The law allowed for one principal wife and numerous concubines. Although polygamy was common in China, only men from well-off families could maintain several wives. The same was true for Muslims.

In historical texts, we have almost no mention of Muslim women. However, Fu Tongxian (1940), a Hui historian, told the story of Yue'e, which he borrowed from the Yuan Annals. The life of this

woman became known because of her disastrous fate. She belonged to a high-class family; she was the daughter of Jamal al-Dīn, an officer of the Yuan dynasty and the sister of a well-known Chinese poet, Ding Henian. She was a woman of great knowledge – she taught Islam to her brother – and was very brave. She lived in Anhui province when the troubles began. To escape from local armed rebels, she tried to organize a hiding place for the women and their daughters, but too late. She threw herself into the river with her own daughter and nine other women. In memory of their courage, these ten women were buried together.

As far as ordinary life is concerned, our knowledge is very limited for this period. From the descendants of the Chinese Muslim refugees in what is now Kazakhstan and Kyrgyzstan we have some information about the mid-nineteenth century. In a small museum in a village of Kazakhstan, we can see that Muslim women wore the same clothes as their Chinese sisters and had their feet bound like them. The military French officer Commandant d'Ollone wrote during his journey (1906–9) to Hezhou (the Chinese Mecca) that the women wore a black silk veil and only went in the streets on horseback. He observed that in other parts of China, the non-Muslim women of high-class families could not generally go out and if they had to, would wear a black veil too. No other women wore anything distinctive (d'Ollone 1911). Missionaries found it difficult to distinguish Muslim women among Chinese women when they tried to make contact in order to convert them. Olive M. Botham (1926) noted of Muslim women: "It seems that in Honan a woman may be as free, well-educated and bigoted as a man; in the northwest they are kept more in the place of women in other Moslem lands; while in many other parts of China their life can scarcely be differentiated from that of the thousands of heathen around."

Despite their dependence and total submission, the women of central China, in the province of Henan in particular, set up their own places of religious worship. Women's mosques were built and managed by a female ahong (imam, in Chinese nü ahong) and a management committee composed entirely of women. The simple places of worship dating from the Yuan dynasty were transformed into real mosques over the course of the centuries. They were constructed in villages as well as cities. Their construction was generally linked to a lineage of the faithful from the same village or region, much like the male mosques. The architecture of these mosques that belong to traditional Islam (laojiao, old teaching) was typically Chinese. The

female ahong led the faithful in prayer and was also a teacher. She often served as a counselor for women and their families and even prepared the bodies of deceased women before their funerals. She learned to read the Qur'ān in Arabic and other religious texts in Persian. Although illiterate in Chinese, she could write it phonetically in the Persian alphabet. Most of the women ahong were born into religious families, but some of them had no religious antecedents and became ahong through dedicated study. She learned with one or more nü ahong. At the beginning of the twentieth century the first phase of knowledge (called halifa in China) was equivalent for young women and men studying Islam. There were special books for women written in Arabic and Persian. The first one, Kitāb al-faṣl (Book of distinction), insists on the importance for women to seek knowledge. After the assimilation of the whole of the curriculum, a student became ahong with the celebration called chuanyi, "wear the cloth" or "wear the dress." In general, the female ahong began her work in the local mosque when her children were adults. The women's mosque was also a place of refuge for women and their children, fleeing war, famine, or repudiation by their husbands. Some elements permit us to suppose that the women's mosques grew out of a desire on the part of newly converted Chinese women to have structures and places of worship similar to that of their Buddhist and Taoist sisters living in the central plain in China (Allès 2000). The development of education in the eighteenth and nineteenth centuries allowed women Muslims to reinforce and extend this type of organization (Jaschok and Shui 2000). In other parts of China, the women prayed at home as in other parts of the Muslim world. The space for women that sometimes exists in a male mosque is a modern feature. In traditional Chinese society the normative way was the strict separation of the sexes.

SPREAD OF ISLAM

By the seventeenth century Islam had spread in China through the Qur'ānic teachings founded by Hu Dengzhou (1522–97), referred to as jingtang jiaoyu (teachings in the room of books) (Aubin 1997). This influence extended throughout the Central China plain to the coast. During the sixteenth and seventeenth centuries Sufism also developed, through teaching and writing, in the entire Central Asian region. The debate between Jesuit and Confucian literati also influenced Muslim scholars such as Wang Daiyu (1570–1650) and Liu Zhi (1660–1730) in Nanjing, or Ma Zhu (1640–

1711) in Yunnan (Murata 2000). Their work gathered together the principals of Islam and Islamic philosophy in the Chinese language. These intellectuals were trained in the classical Chinese curriculum; in addition to their knowledge of Taoïsm and Buddhism, they also knew Persian and Arabic. Their discourses are familiar to us thanks to the regular reissuing of their texts. These works embody the convergence between Islam and Confucianism and are an excellent example of a real adaptation of Islam in the Chinese context.

Muslim religious space is organized in small communities of followers around a mosque. These mosques are directed by an *ahong* who is invited by the followers to guide them in religious affairs; for secular questions, each mosque has a special committee, *waqf* in Arabic, composed only of local members of the mosque. Each is independent from the others. This system, called *laojiao* (*qadīm* in Arabic) is the oldest in China.

In one example in Henan province, local documents attest to the building of mosques in 55 districts and towns between the end of the fourteenth and the mid-seventeenth century. In a village in the north of this province, there was only one mosque in the seventeenth century and five by the end of the nineteenth century; all are still standing. In the city of Zhengzhou seven mosques were built between the eighteenth and nineteenth centuries.

SUFISM

During the sinicization phase of Islam in the east of China, another phase in northwest China centered on Sufism. The best known orders (*tarīqāt*) were the Naqshbandiyya and Qādiriyya. Rather than focusing on the mosque, the Sufis worshipped a line of saints going back to the implantation of Islam in China – a line of saints referred to as *menhuan*. All the religious activities are centered on the tomb of a saint. This type of religious organization did not extend into eastern China. The saint is, of course, a man, but there are also women's tombs. For example, in Xinjiang, there are the tombs of the two girls of Ma Mingxin, the precursor of the Jahriyya (a branch of the Naqshbandiyya) where organized religious activities take place.

DISCRIMINATION

The Hui began to have serious difficulties with the imperial government from the end of the eighteenth century onwards. Discriminatory practices against Muslims appeared amongst the mandarin during the Qing dynasty and amongst the non-Muslim provincial population of the northwest. According to the historian Jonathan Lipman (1997), discrimination arose from the incessant rivalries and violence between brotherhoods during this period. This violence rose to new heights in the middle of the nineteenth century during the Taiping uprising to the south of the empire and the Nian revolt to the east. Muslim uprisings took place in four provinces (Yunnan, Shaanxi, Gansu, Xinjiang). Not all the Hui participated in these revolts; some even joined the Qing camps. Nonetheless these events signal the emergence of the essence of Hui identity, of their position in Chinese society, and of the ways in which that society regarded them. The evolution would only be completed with the development of Han nationalism at the end of the nineteenth and the beginning of the twentieth century (Gladney 1991).

BIBLIOGRAPHY

PRIMARY SOURCES
O. M. Botham, Moslem women in China, in *Muslim World* 16 (1926), 172–5.
Fu Tongxian, *The history of the Muslim religion in China* [in Chinese], Shanghai 1940.
Liu Zhi (1660–1730), *Rites of Arabia* [in Chinese], Tinjin 1988.
Ma Zhu (1640–1711), *Guide to purity and truth* [in Chinese], Ningxia 1988 (first published 1683).
Monograph of Henan [in Chinese], Henan renmin chubanshe, vol. 9, Henan 1994.
Commandant d'Ollone, *Mission d'Ollone, 1906–1909. Recherches sur les musulmans chinois*, Paris 1911.

SECONDARY SOURCES
E. Allès, *Musulmans de Chine. Une anthropologie des Hui du Henan*, Paris 2000.
F. Aubin, L'enseignement dans la Chine islamique pré communiste (du XVIe siècle au milieu du XXe). Entre affirmation identitaire et modernisme, in N. Grandin and M. Gaborieau (eds.), *Madrasa. La transmission du savoir dans le monde musulman*, Paris 1997, 373–88.
D. C. Gladney, *Muslim Chinese. Ethnic nationalism in the People's Republic*, Cambridge, Mass. 1991, 1996².
M. Jaschok and Shui J. J., *The history of women's mosques in Chinese Islam. A mosque of their own*, Curzon 2000.
D. D. Leslie, *Islam in traditional China. A short history to 1800*, Canberra 1986.
J. N. Lipman, *Familiar strangers. A history of Muslims in Northwest China*, Seattle 1997.
J. A. Millward, *Beyond the pass. Economy, ethnicity and empire in Qing Central Asia, 1759–1864*, Stanford, Calif. 1998.
S. Murata, *Chinese gleams of Sufi light*, New York 2000.

ELISABETH ALLÈS

Muslim Communities in China: Mid-18th to Early 20th Century

Inadequacy of sources, the distance of time, the over-writing by an official chronology, all make questions of identity and identification difficult to explore. Only a gender analysis qualified by an analysis of state-minority relations, of ethnicity, and of the history of Islamic indigenization, among other factors, can go some way toward explanations of seemingly contradictory developments, unique to Chinese Muslim women.

INTERPRETATIVE CONTEXTS.
A PARADIGM OF CHINESE MUSLIM
FEMALE VIRTUE: XIANSHU
QIANCHENG

The time under discussion falls into what the Hui historian Bai Shouyi calls "the age of adversity" (fourteenth century to 1911) for Islam in China, following centuries during which Islam enjoyed relative tolerance and self-governance. However, this time of crisis of faith and imminent loss of identity brought forth also the great Islamic intellectual projects of translation of scriptures and of *jingtang jiaoyu*, a system of popular religious education, spawning the first popular mass cultural movement in Chinese Muslim history. Led by *jingshi*, Islamic scholars, the movement was joined by all Muslims. In addition to the teaching of the Islamic scriptures and canons, charitable schools were set up and reforms carried out to enable the teaching of Islam in Chinese, an approach more suitable to Muslim believers' level of religious knowledge and also to social conditions at that time. Both common religious ignorance and the material poverty of people stood in the way of home instruction. *Jingshi* formulated important commentaries on Islamic doctrines and made these accessible to the Muslim masses. In Central China (provinces of Henan, Shanxi, Hebei, Shandong), the education of both males and females became the focus of intellectual and pedagogical endeavor. And women were central to the strategies of enlivening a collective identity based on informed faith and mosque-centered community life.

At a time when Muslims in China confronted an increasingly hostile host society, the most influential Islamic norms governing women were enshrined and codified: *fudao*, women's moral code, embodied in the four virtues of *xianshu qiancheng* (good, virtuous, refined, and pious) and the *jiating daode*, family moral code. Jaschok and Shui (2000) argue that the defining, and most enduring, religious and ethical parameters for ideal Muslim womanhood were formulated most importantly by three great scholars: Wang Daiyu (ca. 1584–1670), Ma Zhu (1640–1710), and Liu Zhi (ca. 1655–1745). They explained Islamic doctrines in terms of accessible Confucian cultural conceptions, theorized about women's position in a proper social order, and formulated ethical criteria and modes of conduct for Muslim women to follow. Thus emerged a hybrid, Confucian/Islamic construct of womanhood that allowed for a cautious surge of women's participation in the religious sphere, enabling a gradual innovation, *bidaerti*, which eventually culminated in the establishment of women's own sites of religious education, *nüxue*, women's religious schools, and spaces of worship and congregation, *qingzhen nüsi*, women's mosques.

To summarize the most salient contributions to what would become a lasting paradigm of essential Chinese Muslim womanhood, Wang Daiyu postulated the religious and social premise for an ideal on which other scholars would build. *Zhengjiao Zhenquan* (Islamic doctrine) appeared in block print in 1643, containing useful information on the Islamic religion and Muslim life. Borrowing from Daoist and Confucian traditions, Wang emphasized the conjugal relationship as the cornerstone of a world based on complementarity, with women firmly ensconced in familial duties. At the same time, all Muslims were exhorted to acquire knowledge to ensure true faith, correct ritual knowledge, proper Muslim conduct in a non-Muslim environment, and immortality in the afterlife. The influential thinker Ma Zhu in his major text, *Qingzhen Zhinan* (The Muslim compass), also embedded Islamic principles in the culture of Confucian social relations. His theorizing of a noble, spiritual nature of men, which he called *yang*, naturally superior to the worldly and debased nature of women, *yin*, added a sacred dimension to Confucian gendered cosmology,

justifying a culturally entrenched superiority of men over women with essentialized and sexualized notions of (God-given) spirituality versus worldliness, purity versus impurity, and rationality versus irrationality. Yet Ma also praised the talents of famous women in Islamic history, encouraging female believers to take heart, to learn in order to improve their base nature and to avoid eternal damnation, the fate of too many ignorant women. When Ma Zhu asserted that "men and women should keep learning until they die" (Ma 1988, 146), it might be contended that he started the development that led to advocacy for women's education.

Although Liu Zhi came to accept in his later writing, *Tianfang Zhisheng Shilu* (Chronicle of a saintly prophet's life), that, indeed, there were women of virtue and outstanding talent who contributed to the spirit and development of Islam, his definition of the core relationship for women, the *yicong*, the relationship of an obedient wife to her husband, which appeared in *Tianfang Dianli* (Islamic rites), remained central to his thinking. The *yicong*, or One Obedience, constituted an Islamic reworking of the Confucian dictum that women must submit to father, husband, and, when widowed, to their son. Yet underlying assumptions about the nature of women as dependent on the husband for spiritual and material life were close to the Confucian construct of women's ideal conduct, *de*, encompassing virtuous behavior, proper speech, proper demeanor, and proper employment in the womanly sphere of her domestic courtyard. Liu, however, disagreed with Confucian privileging of boy children. He emphasized that the female sex of a child was ordained by God. Therefore, he demanded of all parents equal treatment of their children regardless of their sex. Liu also stressed the importance of universal male and female education to facilitate the spiritual health of Muslim society as a whole. Thus, it can be maintained that although Muslim women were defined as unsuited for participation in the societal sphere, they were granted an important place in religious communal life that would prove crucial:

> In secular life, women were left almost no space for development beyond the domestic courtyard. However, they were encouraged to develop in religious life. Religious education of women and men was considered equally important, and women's individual accomplishments were valued and acknowledged. Thus an ideal construct of Muslim womanhood emerged which came to influence the shape of religious education in Central China and in turn shaped women's lives with characteristics that made them uniquely different from Muslim women elsewhere in China (Jaschok and Shui 2000, 55–6).

WOMEN'S OWN RELIGIOUS CULTURE

Hui scholarship places the first of three periods in the history of women's education within the era of external crisis and internal Islamic awakening. The *Jingtang* Religious Educational Period started in the late sixteenth century and lasted until the eighteenth century (it was followed by the second period, the New Educational Period, 1912–49, and the Modern Educational Period, post-1949 to the present). Out of the first *Jingtang* period came major works of translation from Arabic and Persian, the construction of a unique religious linguistic medium, *jingtangyu* (Chinese Muslim historical language of communication that fuses transliterated elements from Arabic, Persian, and Turkish; it is still used today not only in religious education but also in social life), and a corpus of seminal indigenous Islamic scholarship, as well as the creation of a mosque-based religious education, developed by the sixteenth-century educator, Hu Dengzhou (1522–97). These initiatives started in Central China, in Shaanxi Province, moving eastwards, to Shandong, Jiangsu, and Anhui, with Henan Province evolving as the center of Islamic activism and education. From this we can ascertain that women's religious education was first debated, then institutionalized, in China's central provinces. This also explains why it is in Henan Province that the earliest documented facilities for women to receive religious instruction were discovered. (The same region is also today the site of highest concentration of the most evolved women's mosques in China.)

These intellectual, religious, and educational discourses all situated Chinese Muslim women in distinctly gendered worldly and religious spheres so that they became the cornerstone of an indigenized Islamic doctrine, infused with and ultimately reinforced by Confucian cultural conceptions and prescriptions of an ideal social order. As already noted, while in secular life women were left almost no space for commitment beyond a womb and family-centered life-cycle, sharing the fate of non-Muslim women around them, they were encouraged to develop in religious life. Religious education of women was considered to be equally important as that of men, even if subject to different educational texts and pedagogy, and to a mosque-based women's education that would remain stagnant right up to the twentieth century, unlike education received by Muslim men.

Very few historical documents concern themselves with the situation of women's schools, the development of women's mosques, or the lives of Muslim women. But a cautious first reconstruction based on the few extant texts (see below) suggests

that in the mid-seventeenth century, girls' classes for Islamic knowledge were set up on an informal and ad hoc basis. We know of the emergence of *nüxue*, women's schools, in the late eighteenth century, as initially located in private homes and temporary in arrangement, taught by male *ahong* (status tantamount to, but not always identical with, imam) behind curtains (adhering to strict rules of Confucian as well as Islamic sexual segregation). The earliest documented permanent women's school, which came to fulfil the function of a mosque, was set up in Kaifeng, in Henan Province, in 1878. In this Wangjia Hutong Women's Mosque two tablets can be found, inscribed some time between 1875 and 1908. One of them depicts the mosque's history and its succession of female *ahong*; the other is a memorial inscription of *gongdebei*, good deeds, of female Muslims who funded the mosque.

Gradually, as men's direct involvement in women's religious education decreased, instruction came to be carried out instead by wives of *ahong*, called *shiniang* or *shimu*, and in the course of the nineteenth century by the growing number of learned professional religious women, the female *ahong, nü ahong*. Women were also involved in setting up schools, and in contributing to translation and annotation of teaching texts. They donated to women's schools and made provisions in their wills for the financial viability of women's mosques. For instance, in 1878, Zhao Taitai left her property to the Wangjia Hutong Women's Mosque in Kaifeng.

The status and functions of the female *ahong*, unique to Chinese Muslim society, became at times and in certain Muslim communities similar, but never equal, to those of the male *ahong*. Indeed, the qualifications and limitations attached to her religious authority, as compared to that of her male counterpart, would remain highly contested and controversial even in the twenty-first century, with the reputation and influence of an individual female religious leader dependent as much on her personality and learning as on local Islamic tradition and the surrounding culture. In general, an *ahong*'s duty ranged widely, covering responsibility for ritual and ceremonial events, instruction in scriptural knowledge and its application to daily life, teaching of *hailifan*, female students of Islam, counseling, participation in general administrative duties, and representational functions. Interestingly, there is some evidence from the early seventeenth century of women of talent and erudition, *nü junshi*, entering the small elite of learned Islamic scholars.

Taking a comparative perspective, that is, taking into account opportunities for self-improvement available to contemporary non-Muslim Han Chinese women not from an elite stratum of society, it can be argued that in certain respects Muslim women and Islamic precepts justifying women's education were ahead of their time. Education was available for ordinary urban and rural women when only highly privileged Han Chinese women enjoyed education. Women's Qur'ānic schools and increasingly women's mosques provided religious education when female ignorance was still a virtue, and a societal norm.

Through women's experience of their own sites of worship and education, an opportunity was granted to invest a segregated space (its boundaries of both Islamic and Confucian derivation) with a spirit of self-realization, self-determination, and agency. Jaschok and Shui (2000) hold that out of this experience of women's occupation of schools and mosques, orthodox Islamic notions of *jie*, purity, became infused over time with meanings that questioned, sometimes even undermined, their patriarchal origin (in late twentieth-century society positioning women's claim for equal spirituality and equal status side by side with traditional paradigms of ideal wife and motherhood). Through their roles as educators, preachers, ritual guides, and counselors, and in demonstrating their capacity for self-management, women transformed their allotted space into a site of collective self-expression. Schools and mosques opened up for women alternatives to family-centered life. In a society where marriage was a prerequisite to feminine validation, women could acquire a legitimate status that earned them a livelihood and granted them security. Women widowed, reluctant to remarry, unhappy in a son's family, in need of a respectable livelihood, or aspiring to a life of religious devotion, could take advantage of available occupations as preachers, teachers, administrators, cooks, and gate-keepers, opportunities not available to their contemporary non-Muslim neighbors.

In the early twentieth century, a second cultural movement was initiated by male Hui scholars, to modernize Islam through modernizing education. Particular attention was paid to the impact of women's mosques on women's lives and in the republican era (1912–49), scholarly discussions linked women's mosques and women's status. When the Anti-Japanese war (1937–45) and the final civil war between Chinese Communist and Nationalist government forces (1945–9) drove Henanese Muslims to find security elsewhere, they took the tradition of women's mosques with them wherever they settled in China. The presence of a women's mosque became a yardstick of Muslim

women's position, and its growing numbers a telling manifestation of Central Chinese Muslims' influence, right into the 1950s.

To recapitulate: historical imperatives for the Hui Muslim community in China to resort to innovative means in order to preserve and reinvigorate faith in a hostile climate provided women in predominantly Central China with an instrumental role, facilitating their emergence from confined spheres of domestic activity into sites of religious, educational, and social activity. Some of these sites expanded their functions over time and gained in influence over the community (particularly the case in Central Chinese Muslim communities), others contracted (as in Southwest China), and not a few disappeared never to be revived again (in South and North China), with diverse developments depending on local constellations of culture, social structure, religious tradition, and gender relations. The most innovative institutions would culminate, in the late twentieth century, in the emergence of legally registered, economically independent women's mosques in central China, thus beginning to grant unprecedented opportunities to advance and alter existing religious structures, and to incorporate the specific aspirations of women.

Sources, Texts, and Issues

Researching Chinese Muslim women and their religious culture

The difficult position of Islam in the Qing dynasty and the marginality of women in society and organized religion have engendered a dearth of recorded women's history. This has made it important to safeguard surviving material and oral culture as a crucial resource for knowledge and interpretation. Scriptures, ornaments, tablets, buildings, garments, and also the living memory and language of especially older generations of Muslims open up fruitful avenues for an array of methodologies, from ethnography of religious communities and their networks to oral history work and study of material memory. More work is needed on traditional scriptures used in women's Qur'ānic schools and women's mosques, architecture and interiors, prayers and songs, and myths narrated and transmitted from one generation of women to another of gendered origin and belonging.

Traditional teaching materials used in women's mosques, *nüside chuantong jiaocai*, comprised most importantly Islamic teachings that enshrine core gender prescriptions in Persian language texts, referred to as the *nürenjing*, the women's

Qur'ān. But different geographical places had different traditions of transmitting religious understanding and knowledge: through story-telling, *kouchuan jiaocai*; performing Islamic songs, *jingge*, as was the case in Henan; or through lyrics, *shuochangci*, found in Jinan, Shandong Province, which were similar to local operas, *difang quyi*. More thorough research must be done on religious texts, *shouchao jingshu*, hand-copied by female Islamic teachers, *nü jingshi*, and on pedagogical material such as *Xiaoerjin Zhu* (Xiaoerjin is the other Chinese Muslim written historical language that transliterated Chinese into Arabic or Persian letters. Meanings were written in Xiaoerjin under every line in the women's Qur'ān). With the passing away of older generations, we risk losing this knowledge forever. A number of women's mosques have in their possession prized teaching materials in Arabic or Persian used for the education of women *ahong*, but these are scarce. Apart from a handful of horizontal inscribed boards and tablets, important information will have to come from oral transmission.

Worthy of scholarly attention is a collection of over 30 papers brought together in *Zhongguo Huizu Jiaoyushi Lunji* (Critical essays on the history of Muslim education in China), edited by the Shandong Committee of Ethnic Affairs and published by Shandong University Press in 1991. Based on actual fieldwork data, some of the articles touch on issues of education at women's mosques, *nüzi jingtang jiaoyu*, on female Islamic teachers, women's schools, and the development of women's mosques.

Construction of Islamic ideal of womanhood, women's education, and women's lives

Jingxue Xizhuanpu (Genealogy of Islamic education), a book on the history of Chinese Islamic pedagogy, by Zhao Can, was edited and compiled by She Qiling. It was finished between 1662 and 1722 and consists of four hand-written copies. In 1987, Yang Yongchang and Ma Jizu revised and annotated the work, making it accessible to a modern public. It was published by Qinghai Publishers in 1989. The book forms an important source of knowledge of this era, revealing the complexity of Muslim society and mosque education in China during late Ming and early Qing dynasties. It provides an account of the genealogy and pedagogy of influential Islamic teachers, and describes their disciples and their work.

Xi Lai Zong Pu (Our Arabic ancestry), also known as *Tianfang Xianxian Shilue* (Records of Arabian ancient worthies), by Ma Qirong, is

based on legends and fables. One legend relates that 3,000 Muslim soldiers married local Chinese women and turned them into China's earliest Muslim converts. (Li and Luckert's *Mythology and Folklore of the Hui* includes several Hui myths and legends that narrativize gendered Hui Muslim ancestry in China.) The earliest version, believed to be a block-printed publication, came out in 1876.

Although little work has been done on biographies of outstanding female Muslim scholars, a few Chinese-language publications have appeared in the course of the 1990s (Jaschok and Shui 2000, 61).

At the beginning of the twentieth century, Christian churches saw the activism of women's mosques as an important landmark of Islamic activities, referred to in *Zhonghua Gui Zhu* (The Christian occupation of China), edited by Zhonghua Xuxing Weibanhui Diaocha Teweihui. Also, in the first half of the twentieth century, Muslim scholars studied women's mosques, supported the development of women's education and women's mosques, and printed Chinese texts that instructed women as to how to worship. Zhang Hongtao, the Islamic teacher of Zhuolu County Women's Mosque in Hebei, compiled and annotated *Nüzi libai zhengui* (Rules and guidelines on worship for women believers), which was published by Beijing Niujie Qingzhen Shubaoshe in April 1926.

In the early 1950s, under the influence of Maoist sexual egalitarianism and women's liberation, Muslim women intellectuals published books to facilitate the cause of women. For instance, *Tianjing Gulan yu Funüde Diwei he Quanli* (The heavenly Qur'ān and the status and rights of women), by Yousufu et al., brings together materials related to women's issues in Islam in China. The book was published in 1950, by Baiyufang Qingzhen Dasi in Shanghai.

Chinese translations of teaching materials for women's schools during the Qing Dynasty
Sipian Yaodao (Four major doctrines) is a translation of Islamic doctrines. Also known as *Sipian Yaodao Yijie*, the book was translated by Zhang Zhong (1584–1670). Its introduction was written in 1653, but its original date of print is uncertain. The available version is a reprint that appeared in Chengdu, Sichuan Province in 1872; this was followed by another reprint in 1933 by Ma Fuxiang. This version was then incorporated in the *Zhongguo Huizu Dianji Congshu* (Series of Chinese Muslim classics), intended for internal distribution, which offers both the original text and its translation in contemporary Chinese language.

Jiaokuan Jieyao (Islamic doctrines in brief), a book on the rituals and ceremonies of Chinese Islam belief, was written and edited by Ma Boliang around 1678; the block-print came out in 1681. Another surviving version is a block-print produced between 1796 and 1820. The introduction to the 1867 reprint states that the book is for "every Muslim man and woman to understand [issues] instantly", and that "even fools, whether men or women, would not need explanations upon hearing its contents".

Ou Mu Dai (Chinese transliteration of the Arabic word 'umūd, pillars, also translated as *Qingzhen Yuzhu*, Pillars of Islam) is a translation of Islamic rituals and ceremonies from the Arabic. Its Chinese translation was the work of Ding Yunhui, a Muslim woman from Shandong Province. It was published in 1936 by Beiping Qingzhen Shubaoshe, with three introductory notes written by Wang Jingzhai and others. Several Chinese translations now exist of *Ou Mu Dai*, which, until today, constitutes an important part of the teaching in women's Qur'ānic schools.

Primary sources, official memos, and scholarly studies on the status of Islam in Qing China
Official documents, such as imperial edicts and instructions and submissions of local officials, include the following important sources: *Qing Shilu* (Real records of Qing); *Qinding Lanzhou Jilue* (Summary of imperial accounts on Lanzhou); *Qinding Pingding Yunnan Huifei Fanglue* (Summary of imperial accounts on strategies used to put down Hui rebels in Yunnan); and *Xining Junwu Jielue* (Abridged records of military affairs in Xining). Contemporary scholars have compiled these materials into major reference texts: *Zhongguo yisilanjiaoshi gangyao cankao ziliao* (References to key commentaries on the history of Islamic religion in China) and *Huimin Qiyi* (Revolts of Hui people), both edited by Bai Shouyi. The latter publication includes accounts of Muslim life, private notes by Han literati, official papers, semi-official records, and miscellaneous materials. This is a very valuable book with numerous rare first-hand observations.

Gazetteers such as *Xunhua Zhi* (Gazetteer of Xunhua), *Daoguang Lanzhou Fuzhi* (Gazetteer of Lanzhou prefecture in the Daoguang reign), and *Beijing Niujie Zhishu: Gangzhi* (Gazetteer of Niu Street in Beijing), and other local gazetteers, give accounts of the history of Hui people, and of Islamic religion.

Private notes of Qing literati can be found in the following sources: *Wanli Xingcheng Ji* (A journey of tens of thousands of miles), by Qi Yunshi; *Ping Hui Zhi* (Putting down the Hui rebels), by Yang Yuxiu; *Zhengxi Jilue* (Brief notes on expeditions to the West), by Zeng Yuyu; *Sheng Wu Ji* (Sacred military heroes), by Wei Yuan; and *Hui Jiang Zhi* (Gazetteer of the Hui border), edited by Yong Gui and Gu Shiheng.

Contemporary seminal scholarship includes: *Zhongguo Yisilanjiaoshi Cungao* (Extant manuscripts on the history of Islamic religion in China), and *Zhongguo Yisilanjiaoshi Gangyao* (Notes on the history of Islamic religion in China), by Bai Shouyi; *Zhongguo Huijiaoshi* (History of Hui religion in China), by Chen Hanzhang; *Zhongguo Yisilanjiaoshi* (History of Islam in China), jointly written by Li Xinghua, Qin Huibin, Feng Jinyuan, and Sha Qiuzhen; *Huizushi Lungao* (Discussions on the history of Hui ethnicity), by Yang Huaizhong; *Yisilan yu Zhongguo Wenhua* (Islam and Chinese culture), edited by Yang Huaizhong and Yu Zhengui; and *Qingdai Zhongguo Yisilanjiao Lunji* (Selected essays on Chinese Islam in the Qing dynasty), edited by Ningxia Philosophy and Social Sciences Program.

BIBLIOGRAPHY

General Chinese-language references (for other relevant Chinese-language texts, see also discussion in *Sources* above).

Li X. H. and Feng J. Y. (eds.), *Selected reference materials on the history of Islamic belief in China, 1911–1949*, 2 vols., Yinchuan 1985.

Liu Z., *Chronicle of a saintly prophet's life*, 1724, repr. Beijing 1984.

——, *Islamic rites*, 1709, repr. Tianjin 1988.

Ma Z., *The Muslim compass*, 1828, repr. Yinchuan 1988.

Shui J. J., On the genesis and development of women's schools and mosques, in *Huizu Yanjiu* 1 (1996), 51–9.

Shui J. J. and M. Jaschok, *The history of women's mosques in China*, Beijing 2002 (rev. ed. of Jaschok and Shui 2000).

Wang D. Y., *The Islamic doctrine. Allah's words. The Prophet's instructions*, 1643, repr. Yinchuan 1988.

Western-language references

E. Allès, *Musulmans de Chine. Une anthropologie des Hui du Henan*, Paris 2000.

D. Gladney, *Muslim Chinese. Ethnic nationalism in the People's Republic*, Cambridge, Mass. 1991.

——, Islam, in *Journal of Asian Studies* 54:2 (1995), 371–7.

R. Israeli, *Muslims in China. A study in cultural confrontation*, London 1980.

M. Jaschok and Shui J. J., *The history of women's mosques in Chinese Islam. A mosque of their own*, Richmond, U.K. 2000.

D. Ko, Pursuing talent and virtue. Education and women's culture in seventeenth- and eighteenth-century China, in *Late Imperial China* 13:1 (1992), 9–39.

D. D. Leslie, *Islam in traditional China. A short history to 1800*, Canberra 1986.

S. J. Li and K. W. Luckert (eds.), *Mythology and folklore of the Hui*, Albany, N.Y. 1994.

S. Mann, Learned women in the eighteenth century, in C. K. Gilmartin et al. (eds.), *Engendering China. Women, culture and the state*, Cambridge, Mass. 1994, 27–46.

S. Mann, Myths of Asian womanhood, in *Journal of Asian Studies* 59:4 (2001), 835–62.

D. L. Overmyer, Chinese religions. The state of the field, in *Journal of Asian Studies* 54:2 (1995), 314–46.

Shui J. J., In search of sacred women's organizations, in P. C. Hsiung, M. Jaschok, and C. Milwertz (eds.), *Chinese women organizing. Cadres, feminists, Muslims, queers*, Oxford 2001, 101–18.

MARIA JASCHOK AND SHUI JINGJUN

Eastern Turkestan: Mid-18th to Late 20th Century

Eastern Turkestan, a region today encompassed within the Xinjiang-Uighur Autonomous Region of China, is a predominantly Turkic Muslim area inhabited by the Uighur, Kazak, and Kirghiz nationalities, as well as numerically smaller populations of groups such as the Hui (Chinese Muslims), and non-Muslim peoples such as the Han Chinese, Mongols, and Russians. Conquered by the Manchu Qing dynasty (1644–1912) in 1759, and controlled by the Chinese Empire's modern successor republics since 1912, the region and its Muslim women are particularly difficult to study because of the paucity of easily accessible primary sources in local languages, especially in Uighur and Kazak.

Research is further complicated by the fact that many relevant sources are in a variety of languages, particularly in Chinese and Russian, but also in Central Asian languages that have been written in a variety of scripts (for example, Uighur has been written using Arabic, Cyrillic, and Latinized forms), depending on the language policy of the period. English and other Western language sources are more plentiful beginning at the end of the Qing and through 1949, after which time Chinese language sources predominate. Since 1980, there has been an increase in Uighur and Kazak language publications written in the now-restored Arabic script. Many of the latter are also available in Chinese language editions. A limited amount of fieldwork by Western researchers has also been allowed, and the results of this work began appearing in scholarly journals in the late 1990s.

As is the case for other Central Asian Muslims, the peoples of East Turkestan have lived under the rule of more powerful neighboring states since the eighteenth century. Discussion among scholars continues about the applicability of the term "colonialist" for the relationship between imperial China and the area known as Eastern Turkestan, in part because it can be demonstrated that holding this troublesome region was so expensive that the costs often far outweighed the financial advantages an imperialist power would expect to derive from a colony. On the other hand, Chinese rule was clearly not welcomed, and the regularity with which the local Muslim population rebelled against Qing rule strongly suggests a fundamentally colonialist relationship. The issue is further complicated because China itself became a victim of Western imperialism, which, in Chinese historiography, includes China's "semi-colonial" status by 1900. Whether a colony or semi-colony can at the same time also be a colonizer is a question that cannot be resolved here, but the region's historical relationship to China suggests that such was indeed the case.

In the 1750s, the Manchu rulers of China's Qing dynasty undertook the conquest of what they called the Western Regions, securing control of the major trade routes through East Turkestan by 1759. A series of rebellions against the Manchus culminated in the formation of a short-lived Muslim state under Yakub Beg who was defeated by the Qing in 1876. Only after this did the Qing fully incorporate the region into the empire's administrative structure, giving it the name "Xinjiang," or New Dominion, in 1884. The Chinese revolution of 1911 inaugurated a period of rule by Chinese warlords who successfully suppressed local attempts to found Muslim governments. The last of these, the East Turkestan Republic, maintained its independence from 1944 until 1949 when it was merged with the newly established People's Republic of China. Closed to most outsiders from 1949 to 1980, the area now once more known in China as Xinjiang reopened to foreign visitors in 1981. Although the Chinese-dominated regional government has remained wary of non-Chinese researchers, opportunities for fieldwork slowly increased in the 1990s, a trend which should continue in the twenty-first century.

Despite the limitations and challenges for the researcher, the variety of materials available in various countries' archives and libraries, as well as increasing access for researchers in Xinjiang today, promises to make the study of Uighur and other Muslim women living in northwestern China a far more rewarding search than in previous eras. The following survey of sources is organized according to language group, with specific names of collections and their location given where available.

UIGHUR AND KAZAK

Primary sources by or about women, written in local languages, are particularly scarce, in part because of historically high illiteracy rates but also because of the probable destruction of papers and

other documents in the various wars and uprisings that assailed the region during the imperial period and from 1912 to 1949.

A few Uighur language sources may be found in China's First and Second Historical Archives, described below, but few discovered thus far deal specifically with women. Some Uighur language materials from the twentieth century are preserved in the Royal Archives, Stockholm, Sweden, as part of the materials collected by the Swedish Mission Alliance (see Swedish language sources, below). The latter includes issues of journals and newspapers published by the short-lived Muslim government of 1933 and an account of the Red Crescent Society of Kashgar for the same year. A bibliography of the Uighur language works printed by the Swedish mission press is given in Gunnar Jarring's 1991 book, *Prints from Kashghar*.

Original copies of these rare items are also held at the Lund University Library, the Royal Library of Stockholm, and the University Library of Uppsala. Other Uighur language materials, particularly newspapers from the period 1944–9, may be found in the Russian archives in St. Petersburg, although access to these has not been consistently granted to non-Russian scholars.

Since 1978, some Uighur and Kazak literature has been reissued in the Arabic script for sale in Xinjiang, and many of these traditional stories and poems offer a literary approach to the image of women within Uighur society, although the majority of these works are by male authors. Collections of poems, sagas, and folk-tales are another such source. Some traditional literature has been translated into English, particularly in Gunnar Jarring's bilingual *Materials to the Knowledge of Eastern Turki* (1946–51) and more recently in Cuiyi Wei and Karl Luckert, *Uighur Stories from along the Silk Road* (1998). Women appear as heroic, courageous, and capable in many of these popular stories; there is also reference to women leaders and warriors, suggesting a link over time to the ancient Uighur Empire (744–840 C.E.) of central Mongolia.

Among women whose lives have given rise to widely told folk-tales is Iparhan, known in Chinese as Xiang Fei, or the Fragrant Concubine. This eighteenth-century Uighur heroine was given to the Qianlong emperor after his conquest of the region in the 1750s, but in folk-tales she defended her honor, finally committing suicide rather than become an imperial consort. Chinese and American authors, seeking to clarify the circumstances of her life and death, suggest a quite different reality. The most valuable and accessible discussion of the

legends and sources is in James Millward's 1994 article, "A Uyghur Muslim in Qianlong's Court: The Meanings of the Fragrant Concubine."

A modern heroine in the making is Rabiya Kadir. Reputed to be the wealthiest woman in Xinjiang, she became the focus of local and international attention when she was arrested and imprisoned in 1997. The circumstances of her life are a reminder of the sensitivity with which research on Muslim women must be approached since one of the crimes of which she is accused is passing information to a foreigner.

CHINESE AND MANCHU PRIMARY SOURCES

1. The Qing dynastic records, 1644–1912. The Chinese government's efforts since 1949 to collect and catalog historical documents related to the Qing dynasty has resulted in the collection of materials in Manchu and Chinese at the First Historical Archives (Diyi Lishi Dangan Guan) in Beijing, which is now accessible to scholars upon application. All finding aids are in Chinese, and considerable patience is required to find materials specifically related to Xinjiang and Muslim women. Matters pertaining to "frontier" regions such as Xinjiang appear in the records of the Court of Colonial Affairs (Lifanyuan). A useful introduction to these papers, with specific references to documents, appears in Ning Chia, "The Lifanyuan and Inner Asian Rituals in the Early Qing (1644–1795)," and in her unpublished doctoral dissertation, "The Li-fan Yuan in the Early Ching Dynasty." Recent scholarly works in English based on these archive holdings include the names of specific collections related to northwestern China, and while the vast majority deal with government and military matters, some may reward the researcher with items related to women and family issues. For example, see the listing of Xinjiang-related Qing documents given in James Millward, *Beyond the Pass* (1998), and Joanna Waley-Cohen, *Exile in Mid-Qing China* (1991).

Manchu-language materials related to Xinjiang can also be found in the same archives, although the titles of document sets unfortunately do not often make clear the actual content of the files. See, for example, the discussion of Qing archive sources in *Late Imperial China* (December 1985) where Beatrice Bartlett examines the kinds of collections available, including a number specifically related to the Xinjiang region. Researchers periodically have come upon documents related to such matters as Muslim divorce and property cases, but much time-consuming work awaits the scholar searching specifically for information on women.

2. Republican period, 1912–49. The Second Historical Archives (Guoli Dier Lishi Danganguan) located in Nanjing, is the primary repository of documents pertaining to the republican era, and several of the collections include material on Xinjiang, particularly Collection 141, Bureau of Mongolian-Tibetan Affairs (Meng Zang Weiyuanhui) and Collection 105, State Schools in Border Regions (Guoli Bianjiang Xuejiao). In 1994, a description of the archival holdings was published in Chinese, organized under general headings, e.g. names of government bureaus, but excluding specific references to women or minority populations.

A few Uighur-language items, such as school textbooks, for example, are held by the Second Historical Archives, although these are not listed in the official guide. It is possible that the archives hold sources in Kazak or other languages as well, but as with the First Archives in Beijing, a search for such items will require much patience.

3. People's Republic of China, 1949 to the present. After coming to power in 1949, the Chinese government began work on official histories of each minority group in China. The 1980s saw publication of Uighur, Kazak, and other Muslim groups' histories, recast to show the importance of Communist leadership. The role of women is not prominent in any of these accounts, despite rhetoric that women "hold up half the sky." In state-sponsored journals carrying articles on Uighurs and other Muslim minorities, some attention has been paid to women and their past and present status, usually including condemnation of past cultural practices and optimistic portrayals of contemporary women's lives. Examples of such articles can be found in *Minzu Yanjiu* (Minorities research), *Xiyu Yanjiu* (Western regions research) and occasionally in *Xinjiang Xuebao* (Xinjiang university journal). For example, the latter carried an article in 1985 on divorce rates in one southern Xinjiang factory population, concluding that the practice of divorce remained relatively common, with over half of the Uighur men and women at one spinning factory having been married and divorced at least twice. Such articles are relatively rare, however.

The government also published numerous volumes in a series called *Weiwuer Shiliao Jianbin* (Collection of Uighur historical materials). Most of these deal with political history in the twentieth century, providing details not available elsewhere, and some volumes include biographies and memoirs. Although the volumes seen by this author do not include accounts of or by women, this collection is nonetheless of interest for background on local personalities and their families; as the series continues, it may also include items on women other than the wives of prominent political and military figures.

The government also allowed publication of books in both Uighur and Chinese devoted to recent events in Xinjiang history. For example, in 1994, *Xinjiang Sanqu Geming* (The Three Districts revolution) was issued in both languages to commemorate the Ili Rebellion, making public numerous black and white photos from the 1940s. Some of these include Uighur and Kazak women, notably Hatewan, a Kazak woman who served as a government official.

China's concern over its growing population has given rise to books and articles detailing the arguments that support policies to reduce rates of fertility. Books and articles on this topic supply official data of minority family size as well as general population figures. Yearbooks for Xinjiang (*Xinjiang Nianjian*) are published annually by the regional government and are a source of data on rural-urban distribution, education, and income levels. A standard element of these volumes is a section on activities of the Women's Federation (Fulian) detailing programs developed specifically for Xinjiang women. These official sources provide the government's framing of what is of importance with regard to women's issues.

In 1990, the Xinjiang People's Publishing House issued the *Xiyu Yanjiu Shumu* (Bibliography of research on the western regions), which includes a comprehensive list of books in Asian and European languages. Numerous categories are used to organize the entries, and while customs and local culture are included, none specifically mention women. Nonetheless, it is a useful resource because of its broad and inclusive scope.

ENGLISH

There are a variety of sources in English dating from the late nineteenth century ranging from travelers' accounts to missionary records and British and American consular reports. There is also a small amount of secondary source material, scholarly and popular, which includes reference to Muslim women, although much patience is required to glean the limited amount of information in these materials. Many secondary sources in English and European languages are listed in Thomas Hoppe, *Xinjiang: A Provisional Bibliography* (1986).

GOVERNMENT DOCUMENTS AND REPORTS

One of the earliest and most complete accounts of late nineteenth-century Xinjiang in English was written by Sir Douglas Forsyth who undertook a

mission to Xinjiang on behalf of the British government in India and published a two-volume report in 1875, which includes his observations on women and the family. At the end of the nineteenth century, continuing British interest in the region and concern over the Russian presence in Central Asia led the British to request – and receive – permission to establish consulates at Kashgar and Urumqi (then known as Dihua). Consular officials at these posts carefully collected information on many aspects of local society, and as a result British consular files from 1890 to 1949 offer some scattered observations on women's status as well as on a broad range of topics related to health, marriage, divorce, education, and employment, although none of this type of material is extensive. As is true of the other Western and Chinese sources surveyed above, the consular files are marked by a particular perspective, born of British colonial attitudes, but they nonetheless serve as a useful source because they consistently collected information over a long period of time in the same locations.

British consular files, formerly held at the India Office Library and Records, are now held at the British Museum, London, in the Oriental and India Office collection. Most deal with political and military affairs, and information on women is both scattered and scarce. Some of the consuls later published their own accounts: C. P. Skrine, for example, includes some detail on Kashgari women of the 1920s in his 1926 book, *Chinese Central Asia*. Most consuls were accompanied by their wives, some of whom later wrote their own accounts and included descriptions of local women. Examples include Sir George Macartney's wife, Catherine, and Eric Shipton's wife, Diana.

American officials were posted to Xinjiang beginning in the Second World War. O. Edmund Clubb opened the Urumqi office in 1943, and he was followed in succession by Robert Ward and John Hall Paxton. Most of their reports, like United States State Department and OSS files, contain very few references to women, although the Kazak woman leader, Hatewan, is mentioned briefly in some reports. (She and her husband, Alen Wang, shifted allegiance to the CCP after 1949 and remained active in local politics in the 1950s.)

TRAVELERS' ACCOUNTS

While these materials in particular must be used with caution, educated travelers provide yet another perspective. From the 1890s, there are accounts by the Earl of Dunmore (Charles A. M.

Murray) and Henry Lansdell, both of whom record what they describe as *mut'a* marriage in Kashgar, a largely Sunni Muslim area where such a practice would not be expected. Other Victorian travelers who wrote accounts of Eastern Turkestan include H. W. Bellew, Eugene Schuyler, Arminius Vanbery, and R. B. Shaw. Later travelers' accounts offer little useful information but some authors, like Peter Fleming and Ella Maillart, both of whom traveled through Xinjiang in the 1930s, provide photographs that add to the visual record of women's lives between the two world wars. Additional photographs are to be found in missionary records (see below) and in the accounts of early twentieth-century Silk Road explorers like Sven Hedin and Sir Aurel Stein, although in their texts women are virtually invisible.

MISSIONARY ACCOUNTS

In addition to the records of the Swedish Mission Alliance, described below, women missionaries working in the northwestern provinces of Gansu and Xinjiang took a particular interest in Muslim women and included some information in their publications dating from the 1920s and 1930s. The books by Alice Mildred Cable and her colleagues, Evangeline and Francesca French, all of whom served with the China Inland Mission, describe some of the women they encountered and a scattering of details about family life. These three British women had access to women and the women's quarters in ways quite impossible for their male counterparts, and while their accounts are not free of strongly-held cultural and religious values, they clearly admired many of the women with whom they interacted over a period of years in the region. Of particular interest are Mildred Cable and Francesca French, *Through the Jade Gate and Central Asia* (1927) and Mildred Cable, *The Gobi Desert* (1942). The latter includes several black and white photos of women.

FIELDWORK-BASED SCHOLARLY WORKS

Beginning in the 1980s, a few Western scholars received permission to conduct research in Xinjiang. A number of unpublished Ph.D. dissertations are now available. Of particular interest are those by Gardner Bovingdon (Cornell), William Clark (University of Washington), and Jay Dautcher (University of California Berkeley). Recent British fieldwork by Cristina Cesaro (University of Kent) on food and culture, and by Joanne Smith (University of Newcastle) on Uighur identity, has already resulted in publications by both women, e.g. *Inner*

Asia 2 (2000). While none of these researchers focus specifically on women, their works nonetheless provide invaluable insight into contemporary Muslim culture in Xinjiang.

SWEDISH

The Swedish Mission Alliance was the first Christian group to establish a significant mission base in southern Xinjiang, and their records cover the period from 1894 when they opened their first mission at Kashgar to 1938 when the warlord Sheng Shicai ordered their expulsion. The Swedes opened schools for girls and boys, established a small hospital, and also founded a Christian congregation, which at its height counted 400 congregants, mainly converts from among the local Muslim population. The mission had its own printing press and printed not only its own books but also government and bank forms when so requested. (See the bibliography by Gunnar Jarring 1946–51 for a listing of such items.)

Of all the Westerners resident in Xinjiang prior to 1949, the Swedish missionaries were perhaps the best informed on the Kashgar and Yarkand Muslim communities. They spoke Uighur (then called Turki) and developed close relationships with their parishioners and students. An account of this mission and its outreach to Muslims can be read in J. Hultvall, *Mission och revolution i Centralasien*. An English translation appeared under the title of *Mission and Change in Eastern Turkestan*. Another volume that documents the work of the mission is G. Palmaer, ed., *En ny port oppnas. Fran Svenska Missionsforbundets arbete i Ostturkestan aren 1892–1938 och Indien aren 1940–1942*.

The Royal Archives in Stockholm contain materials collected by the Swedish missionaries and many Swedish-language materials related to Uighur life. The collection also includes many rare photographs and even rarer film footage of children at the girls' school in Yarkand.

Swedish scholars, some of whom were former missionaries in the region, have written extensively about Eastern Turkestan. In particular, early dictionaries offer the opportunity to examine vocabulary items related to women in comparison to recent usage. G. Raquette, who once served with the Swedish mission, prepared the first English-Turki (Arabic script) dictionary, published in 1927. Rachel Orde Wingate, also of the mission service, added to linguistic sources through her publications on Eastern Turkestani dialects with Sir Denison Ross in 1931. Miss Wingate also published a volume of Uighur children's stories, which reflect attitudes toward girls and young women.

RUSSIAN

With Russian expansion into Central and East Asia, interest in the peoples of these regions grew, resulting in a number of works that include information on women and the family. A number of important nineteenth-century accounts are listed in the Hoppe bibliography, cited below. Of these, Colonel A. N. Kuropatkin and N. M. Przeval'skiy both traveled extensively in East Turkestan and their careful, detailed accounts include descriptions of Muslim culture from the perspective of educated European observers. Some of their books were translated into English and other European languages.

Russian consular reports may also contain references to Muslim women, although as is the case with the British and American consular papers, mentioned below, these files deal primarily with the political and military affairs of the region. From the 1880s until 1949, first Russia and then the Soviet Union maintained consulates in the region. Offices opened first at Kashgar and Yining; in the twentieth century, additional consulates opened at Urumqi, Altay (Sharasume), and Tacheng (Tarbagatai). Consuls collected issues of local newspapers printed in a number of local languages as well as in Russian, among other materials, and some of these may be available from the Russian archives in St. Petersburg.

Other Russian-language sources related to Uighur and Kazak women include publications from the various Central Asian republics, where many faculty and researchers publish in Russian as well as in local Turkic languages. Access to collections in individual states remains uneven, but research related to Uighur culture has been conducted in both Kyrgystan and Kazakhstan, particularly at the Department of Uighur History, Institute for Oriental Studies, Kazakh Academy of Science, Almaty.

JAPANESE

Japanese scholars have a long-standing interest in the populations of the Silk Road, and there are a number of bibliographies that list some of the many Japanese publications related specifically to Xinjiang. See, for example, T. L. Yuan and H. Watanabe, *Classified Bibliography of Japanese Books and Articles Concerning Sinkiang 1886–1962*. A survey of Japanese scholars active in research on northwest China, which includes a

listing of works by the eminent Central Asian historian Saguchi Toru, is in *Acta Asiatica* 34 (1978).

GERMAN, FRENCH, HUNGARIAN, AND TURKISH

Secondary works in these and other European languages are included in the multilingual bibliography by Thomas Hoppe (1986) and in the bibliography in Chen (1990).

In the 1990s, a number of works were in preparation by Kazaks originally from the Xinjiang region but now resident in Turkey and Germany. These memoirs and autobiographies may also provide new materials on women, but as of this writing no listing of recent works was available.

While the information in these diverse materials is, for the most part, fragmentary and the holdings scattered in archives across the globe, as scholars begin to share their findings from these various repositories, our expanded knowledge of the history and current status of Eastern Turkestani women and their Muslim culture will ultimately allow construction of a more complete account of one of the world's least familiar populations of Muslim women.

BIBLIOGRAPHY

B. Bartlett, Book of revelations. The importance of the Manchu language archival record books for research, in *Late Imperial China*, 6:2 (December 1985), 25–36.

L. Benson, Marriage and divorce in Xinjiang 1850–1950, in *Muslim World*, 83:3–4 (July–October 1993), 227–47.

M. Cable, *The Gobi Desert*, London 1942.

M. Cable and F. French, *Through the Jade Gate and Central Asia*. London, 1927.

Yanqi Chen (ed.), *Bibliography of research on the western regions* [in Chinese], Urumqi, Xinjiang 1991.

Ning Chia, The *Lifanyuan* and Inner Asian rituals in the early Qing (1644–1795), in *Late Imperial China* 14:1 (June 1993), 60–92.

——, The Li-fan Yuan in the early Ch'ing dynasty, Ph.D. diss., Johns Hopkins University 1992.

Earl of Dunmore (Charles A. M. Murray), *The Pamirs*, vols. i and ii, London 1893.

Sir Douglas Forsyth, *Report of a mission to Yarkund in 1873*, Calcutta 1875.

Jiasheng Hong (ed.), *Research materials on the Uighurs* [in Chinese], Urumqi, Xinjiang 1981.

T. Hoppe, *Xinjiang. A provisional bibliography*, Hanover, Germany 1986.

J. Hultvall, *Mission och revolution i Centralasien*, Stockholm 1981.

——, *Mission and change in Eastern Turkestan*, trans. Ruth Lyons, Glasgow 1987.

G. Jarring, *Materials to the knowledge of Eastern Turki*, Lund, Sweden 1946–51.

——, *Prints from Kasghar*, Stockhom 1991.

Colonel A. N. Kuropatkin, *Kashgaria. Eastern or Chinese Turkestan*, trans. W. E. Gowan, Calcutta 1882.

Henry Lansdell, *Chinese Central Asia. A ride to Little Tibet*, New York 1894.

Lady Catherine Macartney, *An English lady in Chinese Turkestan*, London 1931, repr. Hong Kong 1985.

Ella Maillart, *Forbidden journey. From Peking to Kashmir*, trans. Thomas McGreevy, London 1937.

Jianxin Miao, An investigation of the divorce issue in the Kashgar Weaving and Spinning Factory [in Chinese], in *Xinjiang Daxue Xuebao* [Xinjiang university journal] 2 (1985).

J. Millward, A Uyghur Muslim in Qianlong's court. The meanings of the Fragrant Concubine, in *Journal of Asian Studies* 53:2 (May 1994), 427–58.

——, *Beyond the pass*, Stanford, Calif. 1998.

G. Palmaer (ed.), *A new gate is opened. From the work of the Mission Covenant Church of Sweden in Eastern Turkestan 1892–1938 and India 1940–1942* [in Swedish], Stockholm, Sweden 1942.

N. M. Przeval'skiy, *From Kuldja across the Tien Shan to Lob-Nor*, trans. D. Morgan, London 1879.

Gustav Raquette, *English-Turki Dictionary. Kashgar and Yarkand dialects*, Lund, Sweden 1927.

Sir Edward Denison Ross and R. O. Wingate, *Dialogues in the Eastern Turki dialect on subjects of interest to travellers*, London 1934.

Diana Shipton, *The antique land*, London 1950.

C. P. Skrine, *Chinese Central Asia*, New York 1926.

J. Waley-Cohen, *Exile in Mid-Qing China*, New Haven, Conn. 1991.

C. Wei and K. Luckert, *Uighur stories from along the Silk Road*, New York 1998.

T. L. Yuan and H. Watanabe, *Classified bibliography of Japanese books and articles concerning Sinkiang 1886–1962*, Tokyo 1962.

LINDA BENSON

Malay World: 18th to Early 20th Century

DEFINING THE "MALAY WORLD" AND MALAYS

The imprecise but nonetheless convenient phrase "Malay world" refers to a broad area stretching from the east coast of Sumatra across the Malay Peninsula (including the southern provinces of Thailand) to the west and northwest coasts of Borneo. From the beginning of the fifteenth century the cultural and linguistic similarities that linked these communities were strengthened by the rise of the port of Melaka on the peninsula's west coast. Founded by a refugee prince from Palembang (east Sumatra), Melaka soon emerged as the most prosperous port in the region because of its strategic position and the attractive commercial environment fostered by its rulers. Kingdoms on both sides of the Melaka (Malacca) Straits acknowledged Melaka's overlordship and its "Malay" culture was emulated throughout much of the archipelago. When the ruler adopted Islam around 1430, Melaka also became a prestigious exponent of the Muslim faith while preserving many pre-Islamic traditions that came to be subsumed under the Arabic term *adat* or custom.

When Melaka was taken by the Portuguese in 1511 it appeared that its mantle would be inherited by Aceh, a strongly Islamic center in northern Sumatra. By the eighteenth century, however, Aceh had developed its own identity. Leadership of the Malay world was then assumed by the kingdom of Johor, ruled by descendants of the Melaka dynasty who had established their capital on the island of Riau. Captured by the Dutch in 1641 and transferred to the English in 1824, Melaka remained in foreign hands until 1957. Nonetheless, its heritage cast a long shadow, bequeathing a corpus of customs and values, which, despite local variations, were seen to characterize the "Malay world" and to be shared by all Malays.

The great strength of Malay culture was its porous boundaries. For indigenous groups like the *orang asli* or aboriginals of the Malay Peninsula or the tribal groups of Borneo, becoming "Malay" often simply meant adopting Islam and "Malay-like" clothing, hairstyles, and behavior. As elsewhere, however, the imposition of colonial rule in the nineteenth century involved efforts to categorize ethnic and cultural groups more precisely. In the case of Malays this was not easy. In 1913 the admin-istration of British Malaya finally defined a Malay as "any person belonging to the Malayan race" who habitually spoke Malay or "any other Malayan language" and who professed Islam. In the Netherlands East Indies the term "Malay" was used even more loosely. The vagueness of colonial definitions thus allowed for the inclusion of numerous Indonesian Muslims under the Malay rubric. This was particularly evident in British Malaya, where the category "Malay women" could include those whose parents had migrated from Java, central Sumatra, Sulawesi, or other parts of contemporary Indonesia.

THE STUDY OF WOMEN IN THE MALAY WORLD, 1700–1900

Even though the relatively "high status" and economic independence of women is often cited as a regional characteristic, the historical study of gender in Southeast Asia is still in its infancy. In the Malay world two factors help explain this apparent scholarly indifference. First, until recently the dominant historiographical interests in Indonesia and Malaysia have allowed little space for consideration of gender issues. After independence (1945 in Indonesia, 1957 in Malaysia) the great concern was to establish a historical framework in which the modern nation state could be situated, and to free research from the constraints of colonial approaches. Only from the late 1980s did historians seriously begin to consider how the social, economic, and political changes of this period affected male-female relations. However, because an interest in the status of women has grown out of contemporary concerns, notably the impact of development and modernization, this research has focused almost exclusively on the late nineteenth and twentieth centuries.

A second reason for the dearth of scholarship on Malay women prior to the twentieth century relates to the limitations of the historical sources. The most useful European documentation for the eighteenth century is found in travelers' accounts and in the records of the various East India Companies, especially that founded by the Dutch. However, since these records were intended to guide the formulation of commercial policies, they are unconcerned with the position of women as such. Material in Malay would appear to be more

promising, but although Cheah Boon Kheng has identified a number of high-ranking and influential women in court chronicles, no full-scale study has contextualized and analyzed gender relations from a historical perspective. Malay literature also presents problems, despite the dominant theme of romantic love. Since these *hikayat* (stories) are often translations or adaptations of popular tales that reached the region from India or the Islamic heartlands, it is hard to determine the extent to which they reflect the lived experiences of men and women. Understandably, historians are generally wary about reliance on *hikayat* to reconstruct the specifics of male-female interaction.

There has also been little research on Malay women in the nineteenth century, in contrast to the growing body of literature dealing with European females who came to the region as travelers, missionaries, and wives. Although material in European languages and in Malay is much more extensive than in previous times, it has not proved a gold mine for scholars tracking local constructions of gender. European sources may range from travel books and memoirs to newspapers and colonial records, but information helpful for interpreting women's history occurs sporadically and is commonly unearthed while a researcher is exploring some other topic. Even after 1880, often termed the period of "high colonialism," the Dutch and British administrations only addressed the position of Malay women in certain contexts, such as education and public health. Research on nineteenth-century Malay writings is similarly meager. Historians interested in studying women from a Malay viewpoint tend to gravitate to the early twentieth century, when the spread of education, the development of schoolteaching as an acceptable female career path, and the emergence of women's journals allows for a more audible indigenous voice.

The study of Islam in the Malay world, 1700–1900

By contrast, the study of pre-twentieth-century Islam in the Malay world has attracted far greater attention among European historians, although scholarship has been concentrated in the Netherlands and Britain. The involvement of these two countries can be traced to the Anglo-Dutch Treaty of 1824, which divided the Malay world down the Melaka Straits into "Dutch" and "British" spheres of influence. As a result of this agreement, the east coast of Sumatra was eventually incorporated into the Netherlands East Indies while the Malay Peninsula came to be known as "British Malaya." Contemporary Sarawak, Sabah, and Brunei were also drawn under the British umbrella, with the rest of Borneo ultimately falling under Dutch control.

This division had far-reaching academic implications. Because of their rigorous training in "Indology," colonial Dutch civil servants produced an impressive corpus of erudite work on Islam. The University of Leiden, with its concentration on Indonesia, its long-standing interest in the Middle East and India, and its large manuscript collection, provided a fertile environment for literary and philological analyses of Malay texts, including those that dealt with Islamic subjects. Nonetheless, the environment that produced scholars such as G. W. J. Drewes remained essentially Orientalist in the sense that the actual practice of Islam in the Malay areas of Sumatra and Borneo received relatively little attention. A principal center for Islamic study in the nineteenth century, for example, was Johor-Riau, still regarded as an arbiter of Malay culture because of its ancient links to Melaka. The Dutch, however, were far more concerned with Muslim activities in Aceh and Java, which were considered a far greater challenge to the colonial regime.

In British Malaya Islamic-led resistance against the colonial regime was less evident than in the Netherlands East Indies and Islam was never seen as embodying the same kind of threat; in consequence, its study did not assume the same priority. Though a number of British scholar-officials, notably R. J. Wilkinson and R. O. W. Winstedt, were regarded as authorities on Malay culture, they evinced little interest in contemporary Islamic concerns. Despite the colonial understanding that to be a Malay meant to be a Muslim, the British tended to underestimate the depth of Islamic influences in Malay life and to ascribe manifestations of unusual Muslim commitment to Arab or Indian influences.

In the period under question there was little space in the colonial discourse on Malay Islam for anything more than passing references to the position of women. Nor has the situation changed significantly in post-independence Malaysia and Indonesia. The involvement of local researchers has certainly generated a new interest in Islamic history, but contemporary studies have been preoccupied with matters such as the chronology of Islam's arrival or the ways in which Muslim scholars reacted to the advance of the Christian West. As yet historians have not been concerned to address the variety of ways in which females across the Malay world accepted, negotiated, or contested the expectations and demands that Islam introduced.

Specialists in other disciplines, however, have

been more willing to incorporate a historical approach. For example, the anthropologist Wazir Jahan Karim has reached back into premodern times to argue that although Islamic teachings were tempered by indigenous value systems there was always a degree of tension between imported ideas of gender and what she sees as a sexual equilibrium in traditional Malay society. By contrast, Ruzy Hashim's literary analysis of the Melaka text *Sejarah Melayu* (History of the Malays) contends that it was not Islam that endorsed female subservience, but mechanisms of power dedicated to upholding the privileges of kings and their male clients. If the *Sejarah Melayu* is considered in an intertextual context that encompasses Muslim religious law on marriage and divorce, she believes that in critical areas Melaka Malay customs fell short.

Opening up new lines of inquiry

Women and Sufism
In the light of this background, it is pertinent to consider the questions that might be posed by historians interested in the Malay-Muslim-women nexus, and the sources and methodologies that could be tapped. An obvious strategy is to return to the issues that have dominated studies of Malay Islam and reconsider them from a self-consciously female perspective. One of the ongoing discussions in Southeast Asian studies concerns the doctrinal mood that prevailed when Muslim ideas began to spread through the region from the thirteenth century. In 1957 A. H. Johns published a monograph in which he argued that mystical Islam or Sufism was a primary vehicle through which Muslim teachings reached Southeast Asia. Since then a number of other scholars have developed these ideas, pointing to the prevalence of Sufi symbolism in certain Malay texts, like those from seventeenth-century Aceh, and the influence of notions such as the Perfect Man in early formulations of Malay kingship.

Although Sufism's appeal to women has not been considered in these discussions, the mystic environment was highly sympathetic to female devotionalism, despite the occasional misogynist pronouncement by Sufi authorities. For example, by the thirteenth century, when Islam started gathering force in Indonesia, convents specifically for women had been built in Cairo, Aleppo, and Baghdad. The mystical stream of Islam also attracted a large following in Mughal India, and Fāṭima, the daughter of a seventeenth-century emperor, Shāh Jahān, was a member of a Sufi order. Given the influence of Indian Islam during this period, it is highly likely that Sufism brought similar attitudes to Southeast Asia; Merle Ricklefs has shown us, for example, that several high-ranking people in the Surakarta court, including the queen mother, were Sufi devotees. Significantly, the presence of women at the graves of saints was taken for granted in Sufi circles, and this would have melded easily with pre-existing Malay practices where women were always prominent in rituals associated with death. It is notable that the Sufi poetry in Malay produced in seventeenth-century Aceh often employed images which spoke directly to female experiences, and that Malay texts frequently used the metaphor of married love to depict the relationship between Allah and the Sufi devotee. Localized stories of "Grandmother Rubiah," an eighth-century female mystic born in Arabia, occasionally surface in legends collected among Malay communities; in Jambi, on the east coast of Sumatra, popular traditions still depict her as the quintessential teacher of womanly arts such as weaving.

Textual re-evaluation
Further exploration of this topic would, of course, require continuing identification of the Islamic texts that reached Southeast Asia, together with an appraisal of the extent to which religiously-based teachings regarding male-female relations, sexuality, and the position of women were transmitted to Malays. One of the primary difficulties is the fact that we have no way of knowing precisely which treatises and commentaries were available to Malay Muslims, since those that have survived (often by accident) into modern times must represent only a fraction of what once existed. However, while we do not know how extensively his works actually circulated, a name Malays always mentioned with reverence is that of al-Ghazālī (d. 1111 C.E.), whose reputation as a Sufi thinker is unparalleled.

Al-Ghazālī's writings acquired a new currency in the eighteenth century, when there was a revival of interest in his work in India and the Islamic heartlands. It was at this time, for instance, that the Mecca-based Malay scholar, 'Abd al-Samad al-Palimbani, translated an abridged version of al-Ghazālī's most mature work, the *Iḥyā' 'ulūm al-dīn* (The revival of the religious sciences). A full study of the influence of al-Ghazālī in the Malay world would be directly relevant to an understanding of gender constructions among Malay Muslims, for he wrote extensively on religious law as it related to sexuality and male-female relations. From the standpoint of al-Ghazālī and other authorities, there were clear expectations for a Muslim woman of rank because the social status

of a man and his family could be at least partially measured by the behavior of his womenfolk. In al-Ghazālī's view, a respectable woman should spend her time spinning and attending to household matters and to her devotions. If it was necessary for her to venture outside, she should seek her husband's permission and avoid crowded streets and markets, and untoward encounters with men. Indeed, according to the *Iḥyā' 'ulūm al-dīn*, the Prophet once asked his daughter Fāṭima, "What is best for a woman?" To which she replied, "That she should see no man and that no man should see her."

Textual discussion in relation to Malay society could also take another direction, for historians have long recognized that functional literacy was extremely limited among ordinary Malays, especially women. Direct access to Islamic writings and commentaries would therefore have been uncommon, even in cases when Malay translations were available. Popular understanding of Islamic values and doctrine was acquired by listening to locally adapted stories about the Prophet, his relatives, and venerated Muslim teachers rather than by reading religious texts. These stories had a significant role in Qur'ānic exegesis and remained an important means of representing correct conduct in what A. H. Johns has called the "vernacularization" of Islamic learning. It would therefore be revealing to work through Malay versions of well-known Muslim legends and track the kinds of messages they might have relayed to women. This kind of initiative will become more feasible as more Malay texts are available through internet resources like the Malay Concordance Project at the Australian National University.

As an example, one might point to the group of stories that developed around Fāṭima, the most esteemed of the Prophet's three daughters. Malay texts like *Hikayat Siti Fatimah* (The story of Lady Fāṭima) or *Hikayat Nabi Mengajar Anaknya Fatimah* (The Prophet teaches his daughter Fāṭima) depict Fāṭima as an ideal woman and faithful wife whose very piety and modest behavior can make those who follow her example more physically attractive. She rarely leaves her house, and in one episode is reluctant even to open her door to a slave girl because normally only her husband is permitted inside her chamber. Another of the many instances of religiously-endorsed messages relayed to Malay women comes from the *Hikayat Bayan Budiman* (the oldest fragment of which is dated 1600 but which is also mentioned by the eighteenth-century authorities). One episode describes how a prince attempts to seduce a woman whose husband is away on a trading trip. Although

tempted, she is warned by a mynah bird (the repository of wisdom) that she should not succumb because the Qur'ān and the *ḥadīth* lay down that a married woman who commits adultery will be impaled by the angels in hell for a thousand years. Disloyalty to a husband is *derhaka*; in other words, it is like treason to a king. Another seventeenth-century Malay manuscript, the *Hikayat Sultan Ibrahim bin Adham*, is explicitly didactic. In one section the author (possibly a woman) exhorts females to pattern themselves after a particularly faithful wife. "That is how women who love their husbands behave. We women believers should be devoted to our husbands, in the hope that we shall obtain the mercy of Allah the exalted in the hereafter. O my sisters! Emulate what is described in this tale."

The possibility that Muslim women were themselves sponsoring or even writing Malay texts raises another intriguing line of research. While we must beware of imagining that such texts will necessarily reveal gender preoccupations, it would be an interesting intellectual exercise to reconstruct specific historical contexts and try to posit the reasons why one text might have been chosen over another. For instance, we know that seventeenth-century Aceh had witnessed a traumatic conflict when Islamic reformers were highly critical of local adaptations of Muslim doctrine. It is therefore relevant to note, as Peter Riddell has shown, that one of the four women who ruled Aceh in the seventeenth century, Sultana Safiyatr al-Din Syah (1641–75), commissioned the learned scholar 'Abd al-Ra'ūf (d. 1690) to write the *Mir'āt al-ṭullāb*, a work on jurisprudence. By the later seventeenth century four successive female reigns had provided some groups in Aceh with a specific focus around which to voice discontent, and the calls for a return to male rule became more strident. It may be significant that Sultana Inayat Syah (1678–88) appointed 'Abd al-Ra'ūf to write at least two other works, one dealing with the duties of teacher and student and the other a commentary on a collection of *ḥadīth*. In the eighteenth- and early nineteenth-century Malay court, women in Riau and elsewhere were also producing or sponsoring secular texts for entertainment, or as commentaries on court affairs. However, there is little evidence that high-born Malay females were responsible for textual production in the same way as their Javanese counterparts. It is possible that women of means were more active in donating rest houses, maintaining teachers, and supporting *wakaf* (charitable foundations), like those in the port of Riau. Indeed, it seems that the female audience for religious texts

was expanding; it is worth remembering, for example, that the grandmother of Munshi Abdullah, the famed scribe of Stamford Raffles, ran a Qur'ānic school.

Women and the appeal of Islam

In some feminist discussions there is a tendency to see the arrival of the world religions in Southeast Asia as marking the end of a kind of golden age for women. While the picture has certainly been overdrawn, we know that in most areas the adoption of Islam meant that women were excluded from public worship, and that Muslim teachers roundly condemned spirit propitiation, in which females were heavily involved. Historians therefore need to explain Islam's continuing appeal to women, especially when the "Islamization" process extends over many centuries. In this regard it may be useful to look at other Islamic societies such as those in West Africa where women also enjoyed a relative economic independence. The attraction of Christianity in the Philippines, and to a lesser extent in Vietnam, provides other helpful parallels. A broadbrushed comparative approach suggests that in premodern cultures women were often drawn to the world religions by the promise of supernatural protection, which was superior to that provided by indigenous spirits. In societies where infant mortality was high and where every pregnancy held out the possibility of a death sentence, the vocabulary and imagery of Islam was a powerful magnet. Similar expectations applied in other areas of personal life. For instance, the Malay Muslim women who recited the love-charms collected by early ethnographers like W. W. Skeat believed that their beauty would be enhanced and their lovers made faithful by invoking the name of Allah and his prophets. On another level, despite male dominance in Islamic worship, women continued to play important roles in life-passage ceremonies, notably birth, marriage, and death. Though an eighteenth-century manuscript from Melaka, the *Adat Raja-Raja Melayu* (Customs of Malay kings) makes evident the pre-eminence of the *kadi* and *imam*, older court women, notably midwives, remained prominent in royal birth rituals. Furthermore, while Muslim doctrine categorically rejected polytheism, preexisting spirits already revered by women could be "converted" to Islam and become powerful *jin* in their own right, often with the power to cure sickness.

Islam's ongoing appeal may also be attributed to the fact that its social and doctrinal preoccupations played on familiar chords in Malay culture. In this vein an essay by Barbara Watson Andaya suggests that the concept of female seclusion was already deeply embedded in pre-Islamic cultures as a status signifier. Islam's concern to regulate the dealings between men and women within the family, and between kin and non-kin would have been familiar in communities where the fear of improper sexual relations was strong. In fact, as David Banks argues, we have probably underrated the influence of Islam on the family life of Malay peasants. In particular, Islamic legal traditions dealing with marriage, inheritance, and other aspects of social interaction provided clear direction in everyday situations that were highly sensitive to improper conduct between men and women. Some sense of the practical guidance religious teachers may have given in earlier times is apparent in the letters of the famed Raja Ali Haj of Riau (ca. 1809–70), from whom a divorcee sought advice about the length of time she should wait before she remarried. Nor were such authorities averse from addressing sexual matters. Malay translations of Islamic works provided detailed instructions on purification and cleansing after menstruation, and in his own dictionary Raja Ali Haji explained how sexual intercourse (*ayok*) could be made more enjoyable for both men and women, referring his reader to treatises on love-making in both Arabic and Malay.

There is thus ample room for research that tracks the ways in which Islamic beliefs and practices relating to women were both adopted by local societies and adapted to indigenous mores. Despite periodic reformist waves that swept through the Malay-Indonesian archipelago, Islam's ability to meld with existing customs is often striking. At times, Islamic teachings and local practice were in agreement, as in their opposition to adultery; in other matters, such as premarital sex, there was room for compromise. As one Malay text puts it, "It is a great offence for a girl to be pregnant with an unknown father. By religious law she is taken to the mosque on a Friday and forty people spit on her, but according to custom she is free of offence when the child is born." In the Malay Peninsula this type of adaptation was particularly evident in the modern state of Negeri Sembilan, which had been settled by migrants from Minangkabau who traced descent matrilineally while maintaining a reputation as devout Muslims. Though Minangkabau customs in the diaspora underwent some modification, houses and land were still inherited by women and husbands were regarded as guests in their wives' homes. Sustained historical inquiry might also help determine the social adjustments that enabled Malay women to maintain their role in business and marketing, despite the strictures of

Islam. Historians could find it rewarding to use modern anthropological work on villages and household practices as a point of departure from which to reread colonial material. The emergence of middle-class Malay women as entrepreneurs in contemporary Malaysia can only be explained if we appreciate the conceptual space provided for them in earlier Islamic communities.

Women, Islam, and change

One should not, of course, overemphasize the continuities in the lives of Muslims during this period. Although conformity with Islamic prescripts regarding appearance and behavior were more pronounced among those of high rank, throughout the archipelago the adoption of Islam did bring change. Aboriginal women drawn into the Muslim orbit, for example, were expected to signify their new status by changing their hairstyle and clothing to accord with "the Malay manner." The expansion of Islam along the northwest coasts of Borneo required major adjustments in the household economy of Islamizing groups because pork was the major ritual food and the care of pigs was a female occupation. The demand that women cover their breasts was a further burden in societies where the production of textiles was a time-consuming process. The increased trend towards polygamy had a direct impact on the lives of women since a Muslim man of means commonly entered into a second marriage, especially as his first wife grew older.

Such changes were simply components of an expanding gender regime in the Malay world that was promoted and enforced by Malay rulers, and justified and legitimized by reference to Islamic teaching. One obvious example concerns the retreat of women from the public sphere. While kings were undoubtedly the norm, during the seventeenth century four queens had reigned in the strongly Islamic state of Aceh, and in the same period a daughter succeeded her mother in the peninsular state of Patani. Islam, however, was unsympathetic to female rule. As one of the great thinkers of medieval Islam, Niẓām al-Mulk, remarked: "Women cannot be allowed to assume power, for they are wearers of the veil and have not complete intelligence." In 1699, according to the Acehnese chronicles, a fatwa arrived from Mecca that forbade women to govern. From this time on, although outside observers in the Malay world often commented on the formidable position of older women, no woman ruled in her own right.

The various law codes produced during the seventeenth and eighteenth centuries could provide an avenue for exploring the priorities of Malay states. While we must always remember that these do not necessarily represent the realities of women's lives, they do project the ways in which the ideal society was envisaged. As one would expect, laws formulated within the Islamic context placed great emphasis on the maintenance of premarital virginity. They were also extremely hostile towards sexual relations outside marriage (zinā'), regarding both parties as equally blameworthy and imposing theoretical penalties of flogging or stoning. While divorce was quite possible if a woman could prove her husband was at fault, this did not necessarily mean legal equality. In a Perak law code, for instance, a guilty woman would forfeit her property rights; if her husband was at fault she could appeal for a divorce but he would suffer "no disadvantage." According to provisions in some Malay codes, an estranged wife could be forced to return to her husband even if she were unwilling. Nonetheless, one can always track significant departures from textual authorities. According to the laws of Melaka, which were adopted almost unchanged by a number of peninsular states, a rapist should be fined; however, his crime is negated should he marry the girl, an interpolation that is not found in Islamic law. By the same token, the Perak code notes that an adulterous woman should be placed in the stocks at the door of the mosque and her head shaved, but includes a locally-inserted provision that allows her to pay a fine and go free.

Notwithstanding this process of localization, there is good reason to argue that from the late eighteenth century there was a growing impetus towards stricter definitions of male-female behavior in Malay society. As always, however, any research on gender construction should be contextualized in terms of changing moods in Islam itself. For example, although Islamic law did make provision for those whose sexual orientation was ambiguous, the Qur'ān clearly forbids cross-dressing (24:31). The increasing contact between the Malay world and the Islamic heartlands meant a growing impatience with many pre-Islamic practices that had tolerated transvestites as entertainers, spirit mediums, and ritual leaders. The writings of the Mecca-based Malay, 'Abd al-Samad al-Palimbani, directly addressed this issue; in the same breath he condemns both spirit propitiation and men who wear women's clothes, an obvious reference to transvestite groups.

The increasing interest in the application of Islamic law and a greater exposure to Islamic writings received additional stimulus because of a marked rise in the numbers of Arabs in Muslim Southeast

Asia, notably Sayyids from the Ḥaḍramawt. When these newcomers married into local elites, and sometimes even assumed the position of ruler, they brought with them strong views on acceptable ways for men and women to interact. In the eighteenth century the Islamic calendar itself may have provided significant flashpoints for reformist feeling. For example, the advent of a new Muslim century in 1785 witnessed several occasions when Malays rallied to the call of holy war and launched attacks on non-Muslims, both Europeans and Siamese. The militant views of the Wahhābīs, who took Mecca in 1803, initially took root in Minangkabau, but their teachings quickly spread to the Malay Peninsula, albeit in a more modified form.

Because the historiography of the Malay world during the first half of the nineteenth century has been dominated by discussions of political and economic developments, the effects of the new Islamic mood on gender has been almost completely ignored. One of the most thoughtful contemporary recorders was Raja Ali Haji, whose writings make evident the changed environment in Riau. According to his *Tuḥfat al-nafīs*, women were now required to veil, and measures were adopted to prevent any activities that would lead to "loose behavior" between men and women. While the sources are limited, we must assume that when Baginda Umar of Terengganu (1839–76) imposed *syariʿa* law he also introduced practices similar to those that applied in Riau, where he had spent some time. Relationships between men and women in neighboring Kelantan would also have been affected by renewed efforts to eliminate "un-Islamic" customs. Yet official bans like those on local dance dramas, in which women performed and where cross-dressing was tolerated, would have been difficult to enforce in rural areas. Indeed, the *Hikayat Sri Kelantan* acknowledges that in the villages the old ways still prevailed.

In this context, the religious texts or *kitab* produced in the *pondok* or "hut" schools represent a rich but largely untapped source for Islamic discourse on gender. The more famous *pondok* were located in Patani (southern Thailand) and the east coast states of the peninsula, which were demographically more Malay and lay outside direct British control until the early twentieth century. The growing influence of what Marshall Hodgson has termed the "*syariah*-minded" attitudes meant *pondok* teachers were especially concerned with the maintenance of correct moral behavior, and it is hardly surprising that discussions of marriage and relations between men and women are a recurring theme. At the same time, since *kitab* were usually intended to convey Arabic teachings to a Malay audience, their contents may help identify gender issues that were of particular local concern.

Colonialism, Islam, and Malay women

The question of how British and Dutch rule affected the position of Malay women is ripe for reevaluation, especially in the light of work undertaken in other colonized societies. Future research that focuses specifically on gender will almost certainly open up new avenues of inquiry. For example, in Palembang Dutch officials were convinced that late marriages, which they attributed to local customs requiring the payment of a bride-price, caused low birth rates that impeded the development of labor-intensive cash crops. Jeroen Peters has shown that the Dutch invoked Islamic law in an effort to abolish the customary bride-price in favor of the Muslim *mahr*, or bridal gift, the value of which they then sought to restrict. Although the effectiveness of these edicts was always limited, the extension of colonial control into the Sumatran interior was accompanied by the spread of Malay-Islamic ideas that linked high status with female seclusion, and thus curtailed the relative freedom inland women had previously enjoyed.

Across the Straits, where the Pangkor Agreement of 1874 permitted the appointment of British "advisers" to Malay courts, the first colonial officials were more concerned with what they saw as exploitation of debt bondswomen by the Malay aristocracy. However, earlier experiences in the region had taught them that interference in established male-female relationships would certainly provoke angry reaction and the Pangkor Agreement deliberately excluded religious matters from the British purview. Malay rulers, on the other hand, had a very different view of the government's responsibilities, urging the colonial state to assume a more proactive role in a range of socioreligious matters, such as defining a husband's rights and punishing adultery. Yet though John Gullick's meticulous review of colonial sources throws up intriguing questions, the sources he discusses cast no light on the specifics of how women reacted to these elite male initiatives. Confronted by this hiatus, the anthropologist Michael Peletz has adopted a different approach, using colonial accounts of social and political organization in Negeri Sembilan as a basis for discussing how Islamic ideas of gender informed and reshaped older patterns of matrilineal marriage and descent.

One topic that receives some attention in late nineteenth-century colonial records concerns attitudes to female education, a topic that is obviously

critical in understanding the transformations of the twentieth century. When the British attempted to introduce limited vernacular education, they found that Malay parents were unenthusiastic about secular schooling for their daughters. An important advance was made in the state of Selangor where Sultan Sulaiman (1898–1938), a devout Muslim, took an active interest in Malay education. Under his auspices a Malay girls school had been opened in 1895, offering instruction in the Qurʾān, reading and writing, weaving, sewing, knitting, needlework, and cookery. In addition to a financial subsidy, Sulaiman reassured parents that their daughters would not mingle with Malay boys by arranging for the girls to be transported to and from school in a covered bullock cart.

Finally, changing social mores could be explored through the small but growing number of newspapers and journals written in both Jawi (modified Arabic script) and romanized Malay. Articles and letters addressed a range of social issues, including matters relating to women and the family. For instance, the first (albeit short-lived) Chinese-Malay newspaper, the *Bintang Timor* (1894–5) periodically published advice for parents; in one issue a traditional-style poem invoked Western medical reports to argue against the marriage of young girls, contending that any babies they bore would not be healthy. Nonetheless, by 1900 the reading audience for this kind of discussion was still limited. Only with the establishment of *al-Imam*, the first Malay Muslim journal in 1904, and the subsequent expansion of vernacular schooling do we encounter a more sustained debate on matters such as polygamy, marriage, divorce, and female education.

CONCLUSION

As yet, virtually no historical work has focused on women in the Islamic societies of the Malay world prior to the twentieth century. Although there are certainly areas in which the sources are promising, the requisite research tools are formidable and may necessitate more collaborative work than has been customary hitherto. A full investigation of this topic would demand familiarity not merely with Malay culture, but with the shifting religious outlooks in the Islamic heartlands and in neighboring centers such as Minangkabau and Java. Contextualization of the available Malay sources relating to Islam also calls for a knowledge of Arabic and the religious milieu that

produced the texts reaching Southeast Asia. It goes without saying that these specialist skills should be combined with an appreciation of feminist theory and a willingness to exploit comparative data. While many questions will almost certainly remain unanswered, the next generation of scholars will doubtless open up alternative lines of investigation that should supply studies of Malay Islam with a more balanced gender base. In the process, students of contemporary Malay society will be provided with a firmer historical foundation from which to assess continuing changes in the position of Muslim women.

BIBLIOGRAPHY
Raja Ali Haji ibn Ahmad, *Tuhfat al-nafis*, trans. V. Matheson and B. W. Andaya, Kuala Lumpur 1982.
B. W. Andaya, Delineating female space. Seclusion and the state in pre-modern island Southeast Asia, in B. W. Andaya (ed.), *Other pasts. Women, gender and history in early modern Southeast Asia*, Honolulu 2001, 231–53.
D. J. Banks, *Malay kinship*, Philadelphia 1983.
Cheah Boon Kheng, Power behind the throne. The role of queens and court ladies in Malay history, in *Journal of the Malayan Branch of the Royal Asiatic Society* 66:1 (1993), 1–23.
J. M. Gullick, *Malay society in the late nineteenth century. The beginnings of change*, Kuala Lumpur 1987.
R. Hashim, Bringing Tun Kudu out of the shadows. Interdisciplinary approaches to understanding the female presence in the *Sejarah Melayu*, in B. W. Andaya (ed.), *Other pasts. Women, gender and history in early modern Southeast Asia*, Honolulu 2001, 105–24.
A. H. Johns, Malay Sufism as illustrated in an anonymous collection of seventeenth-century tracts, in *Journal of the Malayan Branch of the Royal Asiatic Society* 30:2 (1957), 5–110.
R. Jones, *Hikayat Sultan Ibrahim bin Adham. An edition of an anonymous Malay text with translation and notes*, Berkeley 1985.
W. J. Karim, *Women and culture. Between Malay adat and Islam*, Boulder, Colo. 1992.
M. G. Peletz, *Reason and passion. Representations of gender in a Malay society*, Berkeley 1996.
J. Peters, Kaum Tuo-Kaum Mudo. Sociaal-Religieuze Verandering in Palembang, 1821–1942, Ph.D. diss., University of Leiden 1994.
M. C. Ricklefs, *The seen and unseen worlds in Java 1726–1749. History, literature, and Islam in the court of Pakubuwana II*, Honolulu 1998.
P. Riddell, *Islam and the Malay world*, Curzon (forthcoming).
J. Rigby (ed. and trans.), *The ninety-nine laws of Perak*, Kuala Lumpur 1929.
W. W. Skeat, *Malay magic*, London 1900.
Panuti H.M. Sudjiman, *Adat Raja-Raja Melayu*, Jakarta 1982.

BARBARA WATSON ANDAYA

Ottoman Arab Region: Mid-18th to Early 20th Century

In the course of the last three decades, from the mid-1970s to the present, historians of women and gender in the Arab regions of the Ottoman Empire have made some significant strides in a field that was virtually non-existent prior to 1975. The sources that had been widely used to reconstruct the history of the region, particularly travelers' accounts and European consular records, had long posed obstacles to the development of women and gender history. With a few exceptions, such as the travel accounts authored by women like Lady Lucie Duff Gordon or Mary Eliza Rogers, who interacted extensively with local women, these sources overlooked and distorted the female experience. Much of the more recent research has sought out other sources and followed along the methodological lines of women and gender history elsewhere, although the presence and/or absence of certain kinds of indigenous sources have also shaped both areas of inquiry and approaches. Historians were first motivated to write in the compensatory mode in an attempt to add women to a historical narrative from which they had been sorely absent. This compensatory "herstory" focused on the lives of elite women and, drawing primarily on the records of the Islamic court system, has been able to provide real insights into the world of notable women, particularly in our understanding of the ways they acquired and wielded economic power. Interest in the more "ordinary" woman soon followed, in keeping with a keen general interest in social and economic history in the 1970s and 1980s. Again the records of the Islamic court proved to be critical to any reconstruction of the work lives of ordinary women, although the fact that poor and rural women have only a ghostly presence in much of the court material raised real obstacles. For the waning years of the empire, historians have been able to supplement court material by making some use of oral histories as individuals reflect on the lives of their parents and grandparents. In the 1990s, the influence of postmodernist interest in discourse analysis and modes of social control prompted some historians to turn their attention to the nineteenth-century discourse on the modern and its impact on women and gender. Drawing primarily on prescriptive sources such as newspaper advice columns and textbooks, these studies sought out

the impact of modern forms of power and control. Finally, and throughout the development of the field, there has been sustained interest in tracing female agency in history, an interest most fully developed in research on women's consciousness and women's movements in the later part of the nineteenth century. The availability of women's writings from the period has proved to be critical to the historians' ability to flesh out female identities and contributions in this later period.

WRITING HER STORY

In their engagement with questions of women and gender in the Arab regions of the Ottoman Empire in the eighteenth and nineteenth centuries, historians of the Middle East often have approached the challenge as one of telling herstory, of restoring notable women to their rightful place as important actors on the historical stage. In seeking to highlight and profile women's contributions as movers and shakers, they can draw on a long tradition of recording the ways in which elite women contributed to their communities, a tradition enshrined in a rich biographical literature. Interest in the life stories of early Muslims spawned a more general interest in the biographies of noteworthy Muslims of all eras. The lives of Muslim women from later times, women who were scholars, business women, or members of political elites, were narrated as part of a wider biographical tradition that came to be typified from the ninth century on by the genre of the biographical dictionary. Biographical dictionaries remain a valuable source of information on notable women in general, but unfortunately the key works of the eighteenth and nineteenth centuries in the Arab regions of the Ottoman Empire typically excluded women almost entirely. Al-Murādī's 1791/2 compilation of the biographies of notable people, primarily from the Syrian region, included only one woman out of 753 entries, while al-Jabartī, the famous Egyptian historian, did not include a single woman among the 546 people he profiled in his 1821 dictionary (Roded 1994, chap. 4). We cannot be sure why the biographers came to exclude women; as we shall see below, women did not disappear entirely in this period from the ranks of the educated and influential who were the standard subjects of the collections. Perhaps there were new

literary conventions that discouraged the inclusion of women, some heightened sense of the privacy of women from elite families that did not allow for the discussion of their affairs. In any event, the biographical dictionaries that serve as a source for herstory in earlier periods do not help us in the eighteenth and nineteenth centuries.

Nor have the imperial records of the Ottoman Empire as of yet been much assistance in gaining access to the lives of elite women in the Arab lands. Leslie Peirce's study of the women of the imperial harem for an earlier period does draw on records from the Ottoman central archives, most extensively the prime ministry archives and the Topkapı Palace archives, to trace the ways in which these harem women acquired and wielded economic, social, and even political power. Privy purse records, for example, shed light on the wealth of individual women, while the voluminous official correspondence of the harem tracked the political maneuvers various women engaged in to further their interests and pet policies. Using these records and the accounts of imperial historians, Peirce was able to paint a fairly full picture of the significance of notable imperial women in the sixteenth and seventeenth centuries (Peirce 1993). We do not yet have a comparable study for the eighteenth and nineteenth centuries so we are not able to assess the value of the imperial records for the later time period. But such imperial sources are always limited when it comes to women outside the small circles of imperial power, specifically the harem of the reigning sultan. Non-elite women are mostly absent from the imperial records, of course, but so are the notable women of the Arab lands. The details of women's lives among the local elites of cities and towns like Cairo, Damascus, Aleppo, Baghdad, Jerusalem, and so forth, do not often appear, as far as we know, in such sources despite the fact that the elite household was the fundamental unit of economic, political, and social power during the eighteenth and much of the nineteenth centuries. The imperial archives do hold extensive and as yet untapped material dealing with the relationship between Istanbul and the various Arab lands including imperial orders and their responses as well as the financial details of official salaries and state revenues and expenses. Whether this material will add much to our knowledge of elite women in the future remains to be seen.

In the absence of relevant biographical and imperial sources, historians have looked elsewhere in order to add notable women to the historical record. In an era when politics in the Arab lands was characterized by the dominance of powerful local elites who tended to monopolize official positions and major sources of wealth, much of our information about the activities of notable women and men alike comes from chronicles authored by local intellectuals. The chronicles narrate the turns of community political life as different families and factions developed their holds on local power and their material bases, and the elite household served as seat of both local governance and economic activity. It is thus not surprising that several historians have turned their attention to the affairs of the elite household, as chronicled at the local level, to understand the role that notable women played.

In Egypt in the eighteenth century, for example, political life was organized around factions in Mamluk households, large residential units that housed many retainers sworn to fealty as well as wives, concubines, and servants in the harem. As historians like Jane Hathaway and Mary Ann Fay have recently demonstrated, women came to play an important role in ensuring the prosperity and continuity of the household under these circumstances. The importance of these women as representatives of the household was duly recognized by the French invaders in their dealings with Sitt Nafisa, the wife of the Mamluk Murād Bey, who represented her husband in Cairo during his period of opposition to the French occupation of Egypt (1798–1801) (Hathaway 1997, 122–3). Although some historians have suggested that these women could be viewed as passive "heritable property" that got passed along regardless of their own wishes, such an idea is belied by the very active part they played in the politics of the time. A woman like Nafisa drew on her political experience and vast connections, in the absence of her husband, to maneuver against the French, walking a tightrope of cooperation and resistance.

In Aleppo of the same period we find very similar patterns as women of elite households often shouldered the responsibility for overseeing family fortunes and family reputation. In her study of Aleppine elite families from 1770 to 1840, Margaret Meriwether identified a number of women who had taken on such positions of authority (Meriwether 1999). The endowments (awqāf, sing. waqf) of the 'Uthmāniyya Mosque, the major public work of 'Uthmān Pasha who was a locally-born governor of the city, were managed by a succession of women from his family including his sister, his niece, and his daughter. Linda Schilcher's monograph on Damascene elites of the eighteenth and nineteenth centuries describes similar possibilities for elite women (Schilcher 1985). Some of the women of the 'Azm family, perhaps the most

prominent political family in Damascus for much of the eighteenth and nineteenth centuries, not only managed family fortunes but even founded new branches of the family.

All historians who study elite women in this period remark upon this kind of active role in managing property, particularly Islamic religious endowments or awqāf. Drawing on the records of the Islamic court proceedings, we can document how Mamluk and other elite women in Arab cities and towns ultimately owed their clout to the considerable amounts of property they possessed, amassed through inheritance, marriage gifts, and income-producing properties. In an age when the property of state officials was liable for confiscation if they fell foul of the ruler, many elite families saw the virtue of passing family property to women who did not hold official positions and were therefore not in danger of losing it if they fell out of favor. Families were greatly assisted in these attempts to protect their property by the legal instrument of the waqf. By founding a waqf, an individual could convert his or her private property into a trust, the income of which could be assigned to whomever the founder chose as long as the ultimate purpose was to benefit (even after the passage of many generations) a religious or charitable cause. A significant proportion of property in many cities of the region came to be tied up in waqf deeds, which once established could not, at least in theory, be revoked. Some of these deeds named religious or charitable causes as immediate beneficiaries of waqf income, but many others named family members or other individuals as beneficiaries with the charitable cause as a residual beneficiary when the family line was extinguished. Historians of women and gender in the eighteenth and nineteenth centuries have focused on the waqf as a critical aspect of gendered distribution of property, and the deed (waqfiyya) has proved to be a valuable source of information about the extent and nature of female property holding.

In eighteenth-century Cairo, for example, women founded one quarter of the 496 new awqāf in the city by converting many kinds of property they owned – shops, warehouses, apartments, coffee houses, public baths, and so forth – into awqāf (Fay 1997, 34–5). In nineteenth-century Aleppo, some 30 to 40 percent of the new awqāf were founded by women (Meriwether 1997, 132–3). Clearly, the establishment of these awqāf reflected deep female involvement in the urban real estate market as well as the ability of women to dispose of their property as they wished. Historians have debated, however, the larger impact on gendered

access to property. Were elite women able to employ the waqf institution to consolidate their hold on valuable assets? Or rather, did conversion to waqf gradually dissipate women's hold on property? The latter position was taken by Gabriel Baer in the first study of the question, published in 1983, in which he argued, based on a study of Istanbul, that most waqf property benefited male family members and religious institutions controlled by men (Baer 1983). Men were more likely to select male beneficiaries, and even when female descendants were included, the tendency for families to die out meant that the benefits of the waqf soon were transferred from family members to institutions. In fact, women's activities not withstanding, waqf endowments actually served as a way to shift control of property from women who had inherited it and to turn it over to men, thus vitiating the natural play of Islamic inheritance law that gave women rights to family property. In their research on Cairo and Aleppo respectively, Mary Ann Fay and Margaret Meriwether questioned this conclusion, noting that women often appointed themselves as administrators of waqf property, designated many female beneficiaries, and were commonly named as beneficiaries by men who established awqāf. Over the longer term as well, women seemed to profit from waqf endowments: male and female relatives were often assigned equal shares in the benefits over the generations, a distinct advantage for women over the Islamic (Sunnī) rules of inheritance that assigned them one half the share of parallel male relations, and many women served as administrators of family awqāf of various kinds. Elite women did not endow as many awqāf as did men, nor were they as likely to be administrators of waqf property, but their high level of activity in this important aspect of urban real estate in the period suggests that their rights and abilities to acquire and manage property were well recognized in this period.

How did these women come to wield such power? Why were women entrusted with family fortunes and indeed family futures in a social system with marked patriarchal dimensions? Meriwether, while acknowledging the overarching power of the family's patriarch and the relative weakness of subordinate members of the family (young men and all women by definition), questioned Denise Kandiyoti's argument that seemingly matriarchal figures wielded authority only by internalizing and perpetuating the social order in a "patriarchal bargain" (Meriwether 1999, 103–4, 108). She found Peirce's view, that older women could take advantage of hierarchies of age to

advance themselves in a household, more in accord
with the experience of elite Aleppine women
whose access to power changed dramatically in
rhythm with their life cycle. Nor was it impossible
for younger women to assert themselves. Women
might lay claim to rights they had under Islamic
law to demand their share of an inheritance despite
the opposition of their male relatives, for instance,
or act as guardians of their under-age children, tak-
ing over full management of their property. The
patriarchal system was not, for these elite women,
a monolith; they were able to exploit contradic-
tions within the legal and social underpinnings of
the patriarchal family to advance their own agen-
das. Historians of the period have made consider-
able progress in the documentation of these
maneuvers in a successful effort to restore these
women to their rightful places in social and eco-
nomic history.

INCLUDING THE "ORDINARY" WOMAN

Historians of the Arab region in the eighteenth
and nineteenth centuries have also made some ini-
tial attempts to include "ordinary" women in the
historical narrative. The records of the Islamic
court, which have proven so important for resur-
recting the activity of propertied elite women, have
been put to other uses as well. It was not only
wealthy women who took their affairs to the court
for the purposes of registration or adjudication;
women of limited means also resorted to the court
to buy and sell modest properties, to record
divorces, to make small claims, and to protest
incursions upon their rights. We are fortunate to
have extensive collections of these records for the
period between 1700 and 1900 in the Arab region
of the Ottoman Empire. Most major towns and
cities preserved the records of the local Islamic
court or courts, and many of these records are
extant. In some countries (Egypt and Syria), the
records have been gathered into central state
archives while in others (Palestine) they can still be
found in local court buildings. As in the case of
elite women, the court records have been read, in
the first instance, to document the active role that
ordinary women played in urban economies.
Poorer women, for example, served as the link
between the wealthy consumers of elite harems
and the public world of trade: *dallālāt*, women
who purveyed goods to the secluded denizens of
elite harems, operated as small businesswomen
and pursued debtors in court. Other women ran
small enterprises, often in the food processing sec-

tor, such as bakeries and oil presses (Tucker 1985,
82–5). Although there is ample evidence that both
urban and rural women worked in a variety of
crafts, particularly in textiles, throughout the re-
gion, most accounts of craft activity give us little
hard information about the numbers of women
involved or the conditions under which they
worked. Many craftswomen worked part-time in a
domestic setting, so that their work was camou-
flaged by other household duties. In addition, most
craft guilds did not admit women, so that female
workers were deprived of both the recognition and
the protection such guilds provided. Historians of
gender have still managed to explore, at least in
part, this realm of female labor, primarily through
their use of the records of the Islamic courts in var-
ious towns and cities in the region. There, in the
records of business transactions and inheritance,
we have ample evidence that rural and urban
women did make significant contributions to the
production of silk and cotton cloth, often as spin-
ners using either wheel or distaff. Other more dis-
tinctly urban occupations also drew women into
service work of various kinds, including peddling,
the cooking of prepared food, the operation of
public baths, and musical entertainment. Unlike
their counterparts in elite circles, these working
women did not aspire to a secluded lifestyle: such
occupations required female mobility, and these
women frequently came and went in their neigh-
borhoods and appeared in court to pursue their
interests. It is important to note, however, that the
court records are heavily mediated documents.
The cases, as presented to us by the court scribes,
may reflect the court's interpretation of events or
perhaps a negotiated agreement among parties
reached long before they entered the court room.
Nor can we be sure of the actual implementation of
court decisions. Still, in the absence of other
sources that include any material to speak of about
ordinary women, the court records remain a
unique resource.

As historians have studied the economic activi-
ties of ordinary women in the eighteenth- and nine-
teenth-century court records, they have puzzled
over the implications of certain nineteenth-century
developments. The growing integration of the
region with Western European economies seemed
to have had disparate effects on working women
in both rural and urban areas. Some of the craft
production and service activities that had most
engaged women, such as the production of local
twists and dyes for textile weavers, were virtually
eliminated by European competition. By contrast,

European demand for some products boosted production dramatically: the high demand for raw silk, for example, drove an explosion of production and a shift to factories in the Mount Lebanon area. The use of female labor in many of the nineteenth-century factories in the Arab region had some unexpected outcomes. On the one hand, high rates of female participation in this proto-industrial labor force did not necessarily lead to any discernible long-term increase in female economic activity. After the early factories of Lebanon and Egypt were dismantled as part of the process of economic integration, many women found themselves under- or unemployed with few alternatives. On the other hand, the experience of being wage earners, and often important ones who had contributed significantly to family income, forged a new perspective on women's potential as workers and earners in public space. Their attitudes and understandings of their new roles have been studied only recently as historians make more use of oral history narratives to capture how ideas about gender and work were changing rather fundamentally in this period (Khater 2001, chaps. 2, 3).

Women appeared to be gaining ground in public space in other areas as well. Historians have been studying how public female participation in political life, especially in the context of the emerging nationalist movements of the late nineteenth and early twentieth centuries, was changing during this period. Women did have a history of participation in popular revolts in the eighteenth and early nineteenth centuries, at least in Egypt, the area for which we have the most detailed information in the form of chronicles of political events such as those of Damurdāshī and al-Jabartī. But did the gendering of political action change as the nineteenth century wore on? We have indications that women continued to play an important part in the increasingly organized forms of mass politics that characterized the latter part of the century and the emergence of nationalist movements in the early twentieth century. Press accounts allow us to conclude that Egyptian women, for example, maintained a high profile in the 1919 Revolution: women, veiled and segregated, marched in the massive street demonstrations that drove home the depth of popular opposition to the British presence. Women in Syria held an all-female demonstration in support of nationalism during the visit of the King-Crane Commission in Damascus in the same year. Palestinian women as well began to appear in the anti-Zionist demonstrations in the 1920s (Fleischmann 1999, 111). Such participation seemed to cut across class lines. It was not only lower-class women who swelled the ranks of street demonstrations, but upper-class women as well. The exigencies of the nationalist struggle reworked the rules that had gendered public space even in elite circles. Struggles for independence drew upper-class women out of their homes and legitimized them as political actors. Although they might retain some customary restrictions in the form of covered faces and sexually segregated actions, their right and indeed responsibility to come to the aid of the nation were rarely questioned. Historians agree that this early nationalist period was to be critical for later developments. The proliferation of women's organizations after the First World War focused on expanding women's rights, and systematic campaigns around issues of female higher education, voting rights, and legal reform were the direct legacies of a female activism first mobilized in support of national independence. Overall, the tone of the times was a hopeful one; the disappointments of the later independence period, at least as far as women and gender issues were concerned, were far in the future. Elite women, newly arrived on the stage of public politics, expected their power to expand along with that of their nation.

Historians have had more success in the discussion and documentation of the contributions elite women made to the nationalist movements than those of more "ordinary" women. The biases of the sources are largely at fault here since the memoirs and press reports on which we rely for the history of the political movements of the period have little to say about non-elite participation, whether male or female, aside from occasional references to mass demonstrations, and oral history accounts shed only refracted light on the nineteenth century. There is much about the participation of ordinary women in the politics of the period that we have yet to learn.

CONFRONTING THE MODERN

In the context of the challenges posed by European interventions as well as the transformations in the nature and reach of local state power, various intellectuals and publications of the later nineteenth century began to debate a broad range of other issues concerning women, gender, and the challenge of the modern. Historians have become increasingly interested in a discourse on the "new" or "modern" woman that emerged towards the end of the nineteenth century and came to dominate much of the discussion of women and gender

in the region well into the twentieth century. In brief, this discourse defined the attributes of the "New Woman" who could help her society and nation succeed in the modern world in contradistinction to a "traditional" woman who was mired in customary notions and antiquated practices. The New Woman should be able to run a modern household complete with modern conveniences, socialize and educate her children to be modern citizens, and serve as her husband's partner and confidant. Historians point to magazines that touted the virtues of a range of new consumer products, introducing women to pharmaceuticals, cosmetics, household fixtures, and even bicycles, all of which could assist her in these tasks, and to textbooks that instructed girls in the arts of modern housewifery. All these activities and products were valued primarily because they contributed to the major tasks at hand, the construction of a modern society and nation.

Relying in large part on the magazines and school curricula of the period, historians have debated the extent to which the concept of the new woman opened up new opportunities. To play the roles of mother as tutor, and wife as companion, a woman had to be fairly well educated. But the education of females could no longer be left to the haphazard approaches of early mosque education or individual tutoring at home as in the old system, and thus the cause of women's higher education came to be championed in diverse parts of the region. In Egypt, when Qāsim Amīn called for the education of women in his book *The Liberation of Women* (published in 1899), he couched his demands in the context of the necessity of educating women so that they could raise their children – materially, intellectually, and morally – to be men in the service of the development of the Egyptian nation (Shakry 1998, 131–2). Class considerations also informed notions of appropriate education for females: Egyptian texts of the period addressed the upper and middle classes somewhat differently. Females of the upper-class elite should follow a curriculum that stressed home economics, but also included foreign languages, fine arts, and perhaps the religious sciences, French, or piano lessons. The curriculum for middle-class girls was rather more conservative, focused almost exclusively on new ways of cooking, cleaning, and caring for children (Russell 1997, chap. 5). In all cases, however, the domesticity of the new woman required new forms and levels of education, resulting in the significant expansion of female educational opportunities. The female curriculum at the turn of the century, focused as it was on the development of

the skills of housewifery and maternity, may strike us today as very limited and discriminatory, but historians agree that it served as a Trojan Horse for the longer term prospects for women's education. Once the door was opened for women to be educated for their roles as housewives, the ground was laid for the later (1920s and 1930s onwards) expansion of women's education into most professional arenas.

Some historians argue, however, that the New Woman discourse placed some significant and lasting restrictions on women. In keeping with the postmodernist critique of the discourses and technologies of the modern state, it is possible to make the case that the New Woman was a disciplined subject of the state assigned a highly restricted role. Even in cases when women were brought into seemingly novel arenas, such as was the case with the creation of a school for training women doctors in Egypt under Muḥammad ʿAlī, all was not as liberating as it seemed. The Egyptian state established the School for Midwives, as it was called, in order to train women who could enforce the state's public health programs, geared to the control of epidemic disease and regulation of the population in the interests of improving the numbers and health of the Egyptian military. Female graduates took their places as servants of the state whose duties included delivering babies, registering births, conducting postmortem examinations on women to determine cause of death, overseeing vaccination programs, and enforcing quarantine orders. Women were often recruited to the school by force and their lives were strictly controlled by the state, to the extent of assigning them to posts without any consultation and even arranging their marriages. Khaled Fahmy, who has studied the School for Midwives relying primarily on Egyptian state documents, stresses the paradoxical character of this and other projects of modernity: women were being given new opportunities while at the same time being subjected to ever more powerful forms of state and social control (Fahmy 1998). They were also expanding their own spheres of action while they helped the state limit the freedom of other women to act as they liked when it came to matters of health and procreation.

The double-edged sword of modernity has also been an issue implicit in much of the research on gender and legal discourse in the period. Historians who have studied both court practices and the development of legal doctrine through readings of Islamic legal literature produced in the eighteenth and nineteenth centuries question whether the advent of the modern state spelled progress for

women in the legal sphere. The flexibility and diversity of the traditional Islamic legal system still in operation throughout much of the period allowed women a certain latitude in their dealings with the law. In the matters of marriage, divorce, child custody and guardianship, and a number of other marital and familial rights and duties, women were often able to stake claims and assert rights with the full support of local muftis and judges who appeared able and willing to take individual needs and circumstances into consideration (Tucker 1998). The ways in which the reforms of the modern state, which promoted a less flexible and less accessible legal culture, began to encroach on this system to the detriment of both women's and men's ability to obtain a favorable hearing have recently been explored by a number of historians (see Sonbol 1996).

We thus find that the phenomenon of the New Woman was rather complex. Women, at least those of the middle class, were being empowered – educated and respected – as agents critical to the creation of the modern household, in turn the lynchpin of the modern nation. But they could also be mired in this new form of domesticity, caught in an elaborate regimen of discipline they had internalized that harnessed them to the service of their husbands, children, and nation at the expense of their own leisure, pleasure, and ultimately freedom; at the same time they were also being deprived of some of the traditional legal means of asserting their rights. Still, some of these changes in the prospects for women contributed to a perceived awakening of female consciousness, another major theme in the historiography of women and gender in this period.

A WOMEN'S AWAKENING?

The latter part of the nineteenth century has also been identified as a period in which women themselves began publicly to raise questions, less and less muted as time went by, about the roles of women and men in their societies. The New Woman discourse, focusing as it did on the need to involve women in the building of a modern family, invited reflection on how women could improve themselves. In some of the major urban centers of the region – Cairo and Damascus, for example – women writers began to contribute articles on women's issues to the mainstream periodical press. By the 1890s, a number of women's periodicals, dedicated to "women's issues" and dependent in the main on female contributors, had been founded. The women who wrote for these publications thought of themselves as the vanguard of a

regional women's "awakening," a phrase that recurs with regularity in their articles. Beth Baron, who did a close study of women's periodicals of this period in Egypt, notes that they covered a wide range of topics pertaining to women's issues. While many of the articles dealt exclusively with the domestic – household management and child rearing in particular – others ventured into more contested territory. Women wrote in favor of the expansion of female education, against the practice of child labor, and in favor of legal reform, specifically the imposition of a minimum marriage age to deter child marriage (Baron 1994).

Not all urban centers boasted women's magazines: in smaller cities like Jerusalem a separate women's press did not emerge in this period although women did contribute to journals edited by men. Nor should we overlook the no doubt limited nature of the readership of women's magazines and articles. The editor of a woman's magazine in turn-of-the-century Cairo, for example, one of the larger urban markets, would be pleased with a circulation that topped 1,000. It was a small group of young educated women who were the main readers (and contributors as well) of these publications. But in the homosocial worlds of the elite and the emerging middle class, we must also allow for the presence of many listeners: some illiterate women might have access to the articles in these periodicals by way of their relatives or employers. It is also unwise to measure the impact of these publications in purely numerical terms: the women who used them to explore and communicate ideas were among the most influential in their respective societies in terms of their family connections and their public activities. Still, high rates of illiteracy among women in this period and the fact that the majority of women still lived in rural areas removed from the urban centers that spawned these publications suggest only a limited diffusion of the ideas promoted in them.

The impulse to improve the situation of women, however, did bear some real fruit with the development of various women's associations. Women did not restrict their public interventions to the support of nascent nationalism but also embarked on a range of activities directed at the improvement of the lot of other women, including the less fortunate. Such activities took on a novel organizational form: upper-class women established a number of groups to pool their charitable efforts. The Sisters of Love in Lebanon, established in 1847, supported a girls school and a home for wayward girls. The Orthodox Aid Society for the Poor, established in Palestine in 1903, undertook to provide

trousseau items for needy girls. The Mabarrat Muḥammad 'Alī opened a dispensary for poor women and children in Egypt in 1909. The largely charitable nature of these organizations should not prevent us from recognizing the significant role they played in developing women's consciousness and abilities. Historians have pointed out the extent to which the experience of activism in the service of charity brought these women out of the home and opened their eyes to the depth of their societies' problems. As they organized to help poorer women, middle- and upper-class women also grew more confident in their own abilities and more comfortable in the public eye. They began to examine their own situation in a more systematic fashion through discussions and lectures sponsored by a burgeoning number of literary clubs and societies: by the eve of the First World War, most major urban centers boasted several ladies' societies founded for the purpose of self-education.

In their discussions of the development of women's writings and organizations in the nineteenth and early twentieth centuries, based largely on their readings of women's writing in the press along with selected memoirs, historians have helped revise our ideas about the role that women themselves played in this critical period. The surge in the public need to address gender issues, specifically in regard to the implications of building modern states and societies, prompted a high level of female engagement, in terms of both thought and action. The former notion that the Woman Question was largely the province of male intellectuals of a reformist bent has given way to a more nuanced view that recognizes the various women who wrote and organized in this period. This focus on female agency as key to the dramatic changes of the turn of the century characterizes much of the recent scholarship on women and gender in the period.

CONCLUSION

The very real accomplishments of historians in the field, as discussed above, should not blind us to the many challenges and problems we face. The study of women and gender in the Arab lands of the Ottoman Empire is still new and the record of research rather sparse. There are substantial areas of almost total neglect, at both a regional and a thematic level.

Regionally, certain areas like Egypt – and Palestine, Syria, Algeria, and Tunisia to a lesser extent – have captured the lion's share of attention. There are virtually no studies of women and gender in Iraq and the Gulf countries in the Ottoman period, for example. In part this is a problem of sources: the paucity of written sources for Gulf history prior to the twentieth century works against all kinds of historical research. In part it is a problem of access: the difficulties of doing research in certain countries like Saudi Arabia and Iraq have made it difficult to get to the local sources that are so crucial to working in gender history. Addressing these disparities in regional coverage, insofar as it is possible, should be high on the research agenda.

Thematically, there is still much work to be done. Compensatory history still has an important role to play: we are missing the woman and gender piece in much of the traditional historical narrative of the Arab lands in the Ottoman period. We struggle yet with the reticence of the sources when it comes to the ways in which women participated in the economies and politics of their societies, whether at the apex of power or in more humble quarters and villages. Interrogating local sources in order to divine female forms of power and participation remains a primary task. There are also more focused areas of historical inquiry that remain virtually untouched. The female body, as the subject of medical thought and popular practices in the period, has yet to be systematically examined even though this is an area that has born much interesting fruit in women and gender history in other parts of the world. The construction of gender in the literary canon has been addressed in only the most partial and piecemeal fashion. In addition, prior to the emergence of the modernist discourse in the 1880s, we have virtually no information on critical aspects of women's lives, from patterns of female education to family ties. We do now see the beginnings of serious research into some of these areas, and we can expect some new publications in these sorely neglected fields.

On balance, despite the substantial efforts of the past few decades, the history of women and gender in the Arab region of the Ottoman Empire has not yet received the sort of attention paid to the Arab region in the twentieth century on the one hand, or the heartland of the Ottoman Empire on the other. Given the current upsurge of interest in the history of the Arab region in this formative period as well as in women and gender themes, however, we can look forward to an increase in the tempo of research and publication.

BIBLIOGRAPHY

PRIMARY SOURCES
Q. Amin, *The liberation of women*, trans. S. Peterson, Cairo 1982.
A. Damurdāshī, *Kitāb al-durra al-muṣāna fī akhbār al-kināna*, Cairo 1989.

I. Eberhardt, *The passionate nomad. The diary of Isabelle Eberhardt*, trans. N. de Voogd, London 1987.

L. D. Gordon, *Letters from Egypt (1862–1869)*, London 1969.

A. al-ʿImādī, *al-ʿUqūd al-durriyya*, ed. Ibn ʿĀbidīn, Cairo 1882/3.

ʿA. al-Jabartī, *ʿAjāʾib al-āthār fī al-tarājim wa-al-akhbār*, Cairo 1959–67.

M. al-Mahdī, *al-Fatāwā al-mahdiyya fī al-waqāʾiʿ al-miṣriyya*, Cairo 1883–6.

M. Mishāqa, *Murder, mayhem, pillage and plunder. The history of the Lebanon in the 18th and 19th centuries*, trans. W. M. Thackston, Albany, N.Y. 1988.

M. W. Montagu, *Letters from the Levant during the embassy to Constantinople, 1716–18*, New York 1971.

K. Murādī, *Silk al-durar fī aʿyān al-qarn al-thamin ʿashr*, Cairo 1791/2.

K. al-Ramli, *Kitāb al-fatāwā al-khayriyya li-nafʿ al-bariyya*, Cairo 1856/7.

M. E. Rogers, *Domestic life in Palestine*, New York 1989.

H. Shaʿrāwī, *Harem years. The memoirs of an Egyptian feminist (1879–1924)*, trans. M. Badran, New York 1987.

SECONDARY SOURCES

L. Abu-Lughod (ed.), *Remaking women. Feminism and modernity in the Middle East*, Princeton, N.J. 1998.

L. Ahmed, *Women and gender in Islam. Historical roots of a modern debate*, New Haven, Conn. 1992.

M. Badran, *Feminists, Islam and nation. Gender and the making of modern Egypt*, Princeton, N.J. 1995.

G. Baer, Women and *waqf*. An analysis of the Istanbul *tahrir* of 1546, in *African and Asian Studies* 17 (1983), 9–27.

B. Baron, *The women's awakening in Egypt. Culture, society and the press*, New Haven, Conn. 1994.

L. Beck and N. Keddie (eds.), *Women in the Muslim world*, Cambridge, Mass. 1978.

M. Booth, *May her likes be multiplied. Biography and gender politics in Egypt*, Berkeley 2001.

J. Clancy-Smith, *Rebel and saint. Muslim notables, populist protest, colonial encounters (Algeria and Tunisia, 1800–1904)*, Berkeley 1994.

J. R. I. Cole, Feminism, class, and Islam in turn-of-the-century Egypt, in *International Journal of Middle East Studies* 13 (1981), 394–407.

——, *Modernity and the millennium. The genesis of the Bahaʾi faith in the nineteenth-century Middle East*, New York 1998.

K. Cuno, Joint family households and rural notables in 19th-century Egypt, in *International Journal of Middle East Studies* 27:4 (1995), 485–502.

F. Davis, *The Ottoman lady. A social history from 1718 to 1918*, New York 1986.

B. Doumani, *Rediscovering Palestine. Merchants and peasants in Jabal Nablus, 1700–1900*, Berkeley 1995.

A. Duben and C. Behar, *Istanbul households. Marriage, family, and fertility, 1880–1940*, Cambridge 1991.

K. Fahmy, Women, medicine, and power in nineteenth century Egypt, in L. Abu-Lughod (ed.), *Remaking women. Feminism and modernity in the Middle East*, Princeton, N.J. 1998, 35–72.

M. Fay, Women and *waqf*. Property, power and the domain of gender in eighteenth-century Egypt, in M. Zilfi (ed.), *Women in the Ottoman Empire. Middle Eastern women in the early modern era*, Leiden 1997, 28–47.

——, Women and *waqf*. Toward a reconsideration of women's place in the Mamluk household, in *Inter-national Journal of Middle East Studies* 29:1 (1997), 33–52.

E. Fleischmann, The other "awakening." The emergence of women's movements in the modern Middle East, 1900–1940, in M. Meriwether and J. Tucker (eds.), *A social history of women and gender in the modern Middle East*, Boulder, Colo. 1999, 89–139.

M. Hatem, The politics of sexuality and gender in segregated patriarchal systems. The case of eighteenth- and nineteenth-century Egypt, in *Feminist Studies* 12 (1986), 250–74.

——, ʿAisha Taymur's tears and the critique of the modernist and feminist discourses on nineteenth-century Egypt, in L. Abu-Lughod (ed.), *Remaking women. Feminism and modernity in the Middle East*, Princeton, N.J. 1998, 73–88.

J. Hathaway, *The politics of households in Ottoman Egypt. The rise of the Qazdaglis*, Cambridge 1997.

D. Kandiyoti, Bargaining with patriarchy, in *Gender and Society* 2:3 (1988), 274–90.

N. Keddie and B. Baron (eds.), *Women in Middle Eastern history. Shifting boundaries in sex and gender*, New Haven, Conn. 1991.

A. Khater, *Inventing home. Emigration, gender, and the middle class in Lebanon, 1870–1920*, Berkeley 2001.

D. Khoury, Drawing boundaries and defining spaces. Women and space in Ottoman Iraq, in A. Sonbol (ed.), *Women, the family, and divorce laws in Islamic history*, Syracuse, N.Y. 1996, 173–87.

——, Slippers at the entrance or behind closed doors. Domestic and public spaces for Mosuli women, in M. Zilfi (ed.), *Women in the Ottoman Empire. Middle Eastern women in the early modern era*, Leiden 1997, 105–27.

L. Kuhnke, *Lives at risk. Public health in nineteenth-century Egypt*, Berkeley 1990.

A. Marcus, Men, women, and property. Dealers in real estate in eighteenth-century Aleppo, in *Journal of the Economic and Social History of the Orient* 26 (1983), 137–63.

——, *The Middle East on the eve of modernity. Aleppo in the eighteenth century*, New York 1989.

A. al-Sayyid Marsot, The revolutionary gentlewoman in Egypt, in L. Beck and N. Keddie (eds.), *Women in the Muslim world*, Cambridge, Mass. 1978, 261–76.

M. Meriwether, *The kin who count. Family and society in Ottoman Aleppo*, Austin, Tex. 1999.

——, Women and *waqf* revisited. The case of Aleppo, 1770–1840, in M. Zilfi (ed.), *Women in the Ottoman Empire. Middle Eastern women in the early modern era*, Leiden 1997, 128–52.

M. Meriwether and J. Tucker (eds.), *A social history of women and gender in the modern Middle East*, Boulder, Colo. 1999.

L. Peirce, *The imperial harem. Women and sovereignty in the Ottoman Empire*, New York 1993.

A.-K. Rafeq, Public morality in 18th century Ottoman Damascus, in *Revue du monde musulman et de la Méditerranée* 55/56 (1990), 180–96.

R. Roded, *Women in Islamic biographical collections. From Ibn Saʿd to Who's Who*, Boulder, Colo. 1994.

M. Russell, Creating the New Woman. Consumerism, education, and national identity in Egypt, 1863–1922, Ph.D. diss., Georgetown University 1997.

L. Schilcher, *Families in politics. Damascene factions and estates in the eighteenth and nineteenth centuries*, Stuttgart 1985.

O. Shakry, Schooled mothers and structured play. Child rearing in turn-of-the-century Egypt, in L. Abu-Lughod

(ed.), *Remaking women. Feminism and modernity in the Middle East*, Princeton, N.J. 1998, 126–70.

A. Sonbol (ed.), *Women, the family, and divorce laws in Islamic history*, Syracuse, N.Y. 1996.

J. Tucker, *Women in nineteenth century Egypt*, Cambridge 1985.

——, *In the house of the law. Gender and Islamic law in Ottoman Syria and Palestine*, Berkeley 1998.

—— (ed.), *Arab women. Old boundaries, new frontiers*, Bloomington, Ind. 1993.

M. Zilfi (ed.), *Women in the Ottoman Empire. Middle Eastern women in the early modern era*, Leiden 1997.

JUDITH E. TUCKER

Women in the Ottoman World: Mid-18th to Early 20th Century

This entry concentrates on the – as yet – quite limited categories of women who have formed the focus of historical research. Partly because sources survive in greater or lesser numbers, but for the most part because of the vagaries of topic selection on the part of present-day scholars, we can point to certain "islands" about which something is known, but that are tiny compared to the wide uncharted seas of our ignorance. This has to do with the fact that Ottoman historians have largely approached the subject of women with a concern for their political functions. Thus researchers have been able to demonstrate that the widely visible activities of certain female members of the dynasty, much maligned as meddling by unqualified harem inmates, were in no way illegitimate in the context in which they occurred. Rather these actions formed part of an overall strategy of self-legitimization by the Ottoman ruling family, which made sense in political terms even though the imperial women participating in it were often criticized by misogynous contemporaries (for the sixteenth and seventeenth centuries Peirce 1993, Singer 2002; for the eighteenth century, Artan 1993).

In a provincial context, this concern with political issues in the wider sense of the term has led to the highlighting of women from notable milieus; historians have asked themselves if females had a role to play in the stabilization of such often "upstart" families, and if so, how they went about playing the relevant roles. Many of these studies also focus on issues of property and its disposal by females. For the late nineteenth century, concern has been with the early stages of entry into the professions, which among other things also may be viewed as a strategy of maintaining family prominence at a time when military and administrative careers for the male members were becoming increasingly difficult to achieve. By contrast, women without such more or less overtly political roles have been grievously neglected.

Outlining the project

After a brief overview of the relevant primary sources, the entry discusses the female members of the dynasty as well as women belonging to the milieu of notables (a'yān) and religious scholars, including those who made reputations for themselves as writers. Beginning with the mid-nineteenth century, the focus shifts toward urban women who were still of the elite, but whose families had not necessarily reached the top of the sociopolitical hierarchy. During the last decades before 1900, and in larger numbers between 1900 and 1923, some of these women read journals and newspapers and in certain cases even wrote for the print media. Moreover, a few of them began to work outside the home, especially as teachers or in charitable organizations. Formal education for women thus forms a central theme of late Ottoman women's history.

What limited information on demography we possess also refers mostly to the later nineteenth century. As the result of a spurt in bureaucratization and data gathering, we can make a few statements about marriage as experienced in certain large cities, particularly in Istanbul. Unfortunately our information on the vast majority of the female population, namely peasant women, is still very scanty, concerning mainly a few villages of what was to become Bulgaria. The same thing applies to the urban poor. Articles by Yavuz Selim Karakışla shed some light on poor urban women during the First World War. While our emphasis will be on Muslim women, the large cities of Anatolia and the Balkans were typically multicultural, and thus it is possible to say something about certain categories of Christian and Jewish women as well.

Primary sources

When we try to gauge the wealth of Ottoman princesses, knowledge of the foodstuffs and kitchenware assigned to them by the central palace administration can be very valuable (Artan 2000). For sisters and daughters of sultans, researchers have also focused on the records concerning lifetime tax farms (malikâne), with inscriptions on buildings belonging to pious foundations as a sometimes helpful supplement. The so-called bostancıbaşı defterleri list the occupants of the more important seaside villas on the Bosphorus around 1800; they include those

belonging both to princesses and to wealthy urban women (for the locations of the different manuscripts, see Kayra and Üyepazarcı 1992, 2). In addition, some of the palace ladies have left a larger or smaller number of letters, while a few lists survive of the precious items that princesses were given upon marriage (for published letters see Uluçay 1950 and 1955; on ceyiz defterleri see Delibaş 1988. Most of the documents in question are in the Topkapı Palace archives or, where lifetime tax farms are concerned, in the Başbakanlık Arşivi-Osmanlı Arşivi, both in Istanbul; on the latter, a full published catalogue is available: Anonymous 1998).

Female outside observers can also be of help, especially, for the beginning of the eighteenth century, Lady Mary Montagu and, for the early nineteenth, Julia Pardue. These visitors were able to speak to certain palace ladies, or at least they saw and described their dwellings, which today have almost all disappeared (for travel accounts available in print, see Montagu 1993; for further reading, Melman 1992, 49–50 and passim). For the second half of the nineteenth century, personal memoirs and letters play a more important role than in the eighteenth century: these include the often translated book by the poet and musician Leylâ (Saz), whose memories, written down around 1920, concern the harem of Sultan Abdülmecid experienced by the author as a child (Saz 1991; this is an abridged version of the serial publication of her memoirs in Vakit and İleri, both Istanbul newspapers. The best collection of Ottoman-Turkish newspapers is in the Hakkı Tarik Us Library, Istanbul. However, since the 1999 earthquake, access is not easy). One of the daughters of Sultan Abdülhamid has also left a volume of memoirs, reprinted several times, while the numerous personal letters of Princess Refia Sultan, a daughter of Sultan Abdülmecid, have permitted the writing of a full-fledged biography (Osmanoğlu n.d.; on Refia Sultan see Akyıldız 1998).

With respect to women of the subject class, for the period before the mid-nineteenth century (and possibly even earlier, but there is no research on this matter), the kadı (qāḍī) registers (sicils) of major towns and cities such as Istanbul, Bursa, or Kayseri contain records of court cases and commercial transactions in which women participated, along with occasional estate inventories (where Turkey is concerned, these registers are now for the most part in the National Library, Ankara; see Akgündüz et al., 1988–9. For locations outside of Turkey, see Faroqhi 1999, 76–9).

Such inventories have also survived as individual files, namely when the inheritances of women of notable background were confiscated, at times linked to confiscations involving their menfolk (see the Başbakanlık Arşivi-Osmanlı Arşivi; for a secondary study, see Faroqhi 1992). After about 1750, the newly established vilayet ahkâm defterleri constitute a further resource; here cases are documented that could not be solved in the local courts, and in which both female plaintiffs and defendants occasionally occur (also in the Başbakanlık Arşivi-Osmanlı Arşivi; see Faroqhi 1997).

Non-Muslim women are rare in both kadı registers and vilayet ahkâm defterleri, but they also show up at least occasionally. More seems to be known about Jewish than about Orthodox women, partly due to the fact that information from the Jewish gravestones of Istanbul has been published and many of them contain at least indirect information concerning the subjects' age at death (Rozen 1996). In addition, the responsa of a number of Sephardic rabbis have been analyzed with respect to their views on women. On females from among the Orthodox population, the evidence accessible to me through the secondary literature comes mainly from the nineteenth century. As to Armenian women, quite a few among the sources not written in Armenian refer to women on the stage: throughout the empire's duration, female roles even in plays written in literary Ottoman were always played (and sung) by Armenian actresses. These artists are thus documented in the theatrical programs and newspaper reviews of the time (further information in And 1972, 147ff.).

Research on the famous temettuat defterleri, lists of potentially taxable resources compiled in the 1840s, is only in its beginnings; to what extent these enormous masses of registers contain information on the empire's better-off women remains to be seen (in the Başbakanlık Arşivi-Osmanlı Arşivi, Istanbul). For the period following 1880, marriages were officially recorded at least in Istanbul, and the relevant registers contain some information on brides (Duben and Behar 1990; the relevant census data are in the Nüfus Müdürlükleri, Directorates of Population, of the different sections of Istanbul, see 252–3). But the major resource for this time-span is the periodicals written for women and the separate "women's pages" in publications directed primarily at male readers (Çakır 1994; a full collection of these journals can be found in the Kadın Eserleri Kütüphanesi in Istanbul). These newspapers and journals can be supplemented by lengthier publications by a

few female literati such as Halide Edip (Adıvar). While written much later, her memoirs shed some light on the formation of a woman intellectual in the late nineteenth century (Edip 1926).

WOMEN OF THE IMPERIAL FAMILY

From 1703, when Ahmed III had to promise that henceforth he would reside in Istanbul, his daughters, and at a later date the female descendents of other sultans as well, came to play an enhanced part in forming the public image of the dynasty. This was reflected in the elaborate villas (yalı) on the shores of the Bosphorus that these princesses were assigned often shortly after birth, or at the latest when as very young girls they were married off to this or that vizier. As the husbands of these princesses were often sent to the provinces, while they themselves did not leave the capital, these villas came to be associated with their permanent inhabitants (Artan 1993).

This state of affairs was reflected in the architecture, for often the harem section was more elaborate than that intended for the vizier and his male visitors. Architectural refinement was probably considered all the more necessary as sultans frequently visited their daughters or sisters on the shores of the Bosphorus. Certain princesses took a lively interest in the rebuilding of their villas: thus Hatice Sultan, sister to Selim III, commissioned one of the first Istanbul buildings in the neo-classical style from the French architect Antoine Ignace Melling (Perrot, Hitzel, and Anhegger 2001). A correspondence between this princess and her court artist and "all-round designer" Melling is extant, with the latter's wife possibly acting as an intermediary (information kindly provided by Tülay Artan). When a princess died, her villa did not pass on to her heirs but as a kind of "official residence" was reassigned to another princess.

Unlike the female partners of the sultans who lived in the palace and had few contacts with the outside world, some of the married daughters and sisters of eighteenth-century sultans were thus able to create a public persona for themselves; this included their appearance at festivities organized by and for the female members of the elite (Aynur 1995). A few acted as patronesses of the arts: thus the Mevlevi poet Şeyh Galib dedicated some of his works to Beyhan Sultan (1765–1824), another sister of Selim III who shared her brother's interest in music.

By the mid-nineteenth century, the choir of the sultan's pages, well known from seventeenth-century accounts, had acquired a female counter-part whose members prided themselves on their professional skills. Promising young girls from the harem were, suitably chaperoned, given lessons by the most accomplished teachers available, studying both Ottoman and European music (Saz 1991; see also Sagaster 1989). To the very end of the dynasty, musical practice remained important for the female relatives of the sultans: princesses were photographed along with their instruments (for an example see Renda ed. 1993, 249). The last caliph, Abdülmecid Efendi, who had trained as an academic painter in the European mode, is still remembered for his rendition of a concert of Beethoven's music in the palace precincts.

Certain female members of the dynasty during the eighteenth and nineteenth centuries established pious foundations. Zevki Kadın, one of the inmates of the harem of Sultan Osman III in 1755 founded a school embellished with a handsome fountain in Fındıklı, on the road from Galata to Beşiktaş. Zeyneb Sultan (d. 1774) built a still extant mosque complex across from the Aya Sofya, while Şebsafa Kadın (d. 1805) endowed an ensemble of mosque and primary school in which provision was made for girl students. In the nineteenth century, the mother of Sultan Abdülmecid, the Valide (sultana mother) Bezm-i Alem, also was known for her interest in schools: to show his support for his mother's venture, the sultan himself enrolled two of his children in the institution she had established. It functions down to the present day, and so does the hospital for "poor strangers" (Gureba Hastanesi) founded by the same personage. One of the daughters of the Khedive Mehmed Ali (Muḥammad ʿAlī) Paşa, once a rival of Mahmud II for the Ottoman throne, was known in Turkey as Zeyneb Kâmil (1825–82) after her husband; similarly to the ladies of the sultan's family, she also founded a sizeable hospital that still operates, albeit in a new building. The last valide sultan to imprint her name on the cityscape by means of lavish pious foundations was Pertevniyal, the mother of Abdülmecid's successor, Sultan Abdülaziz. She founded the eclectic-style mosque still to be seen in the Istanbul quarter of Aksaray, along with the adjacent school that continues to function as such and bears her name. Taking up a tradition of certain seventeenth-century valide sultans, she also established a foundation with a military purpose, namely a new section of the Istanbul dockyards intended for the construction of ships for the navy. With the deposition of Sultan Abdülhamid II in 1909, the age-old institution of the sultan's harem was dissolved; some of the numerous

serving women were taken in by their families or married off, but quite a few were forced to fend for themselves as best they could (for an account by one of Sultan Abdülhamid's daughters, see Osmanoğlu n.d., 131–53).

Patronage required financial resources, and many eighteenth-century princesses were extremely rich, due to the lifetime tax farms that they were able to acquire. Their agents in the provinces were thus extremely powerful figures, in some cases a source of trouble for provincial taxpayers. This is well attested in the case of Hacı Ali Ağa, who in the late eighteenth century administered the tax farms of Princess Esma Sultan (1726–88) in Athens (Strauss 2002). Their households being extremely lavish, most of these princesses died heavily indebted (Artan 1993, 91–2). Thus an oversized budget for luxuries, which has often been viewed as concomitant with the growing interest on the part of Ottoman imperial women for European consumer goods from the 1850s onwards, actually goes back much further in time.

ELITE WOMEN AND CONSUMPTION

Recent studies of consumption in the eighteenth- and nineteenth-century Ottoman Empire have focused on the growing role of women from elite families in asserting their own social status, as well as that of their husbands, sons, and fathers (Zilfi 2000). Historians are inclined to regard the eighteenth century as a period in which Istanbul women of some wealth took a more active role in consumption: the numerous sultanic commands attempting to repress "modish" fashions are taken as indicators of this change, as well as the complaints from male writers concerning the perceived assertiveness and material demands of their womenfolk (Zilfi 1995, 1996). However, caution is in order: late nineteenth-century authors such as Ahmed Midhat were inclined to view not females but rather young men as the most spendthrift consumers.

Several studies have focused on the entry of European-style fashions into the private spheres of well-to-do women, this lifestyle being known as köşk hayatı (Micklewright 1987, 1990, Seni 1995). From the 1880s onwards these women, and princesses as well, typically wore French-inspired clothes at home and at private parties, covering them up with coats and veils when appearing in public. It was only during these years that certain women adopted the black all-enveloping çarşaf that had not been part of "traditional" Ottoman clothing; in fact, Sultan Abdülhamid forbade this

garment in the vicinity of the palace because he considered it a security risk.

Of particular interest has been the fact that foreign fashions were not adopted wholesale, but rather combined with elements from older clothing styles (Frierson 2000). Thus an Ottoman-type garment might be embellished with details cut according to French models, or else the fabrics might be local and the cuts of foreign inspiration. Such adaptations, as well as differences between generational fashions can be read off the studio photographs that were becoming popular among Muslim families by the end of the nineteenth century and the beginning of the twentieth. These proceedings are consonant with the observation that Ottoman textile manufactures did not all collapse with the entry of machine-made foreign products into the eastern Mediterranean market, but that many producers survived due to their ability to cater to local tastes (Quataert 1993).

Another kind of consumption only the wealthy could afford was the ownership of slaves (Toledano 1998, Erdem 1996). Leylâ (Saz) devoted a chapter of her memoirs to household slavery among the Istanbul elite, which, apart from a few eunuchs, was mainly a female affair (Saz 1991, 50–109). African slave women were normally employed as servants, while male owners preferred Caucasian women as concubines. As this preference was also typical of the sultan's harem, the latter connived at Circassian families resident in Anatolia flouting Muslim religious law by selling their daughters into slavery, the enslavement of subjects of a Muslim ruler, regardless of creed, being forbidden by the şeriat (Sharī'a). While the trade in black slaves had been prohibited in 1857, it continued unofficially throughout the nineteenth century, although the numbers involved were considerably reduced. Among the intellectually minded, Ottoman writers from the 1870s onwards contributed towards delegitimizing the practice by their insistence that all attachments between men and women must be voluntary (Parlatır 1987, 39 and passim).

Regarding slavery in provincial Ankara between about 1785 and 1850, it has been established that well-to-do people, including the occasional Ottoman Christian or even resident foreigner, acquired slaves both male and female through recognized slave-traders. While most slave owners seem to have been male, a few women were also on record as owners of slaves. Many of the latter were described as coming from "Arab ve Acem"; this expression presumably

referred to black people (Arab) and natives of the Caucasus (Acem), who were sometimes described more specifically as Georgians (Özdemir 1986, 128–9).

SAFEGUARDING FAMILY STATUS AND FORTUNE

Studies on the Ottoman Empire's Arab provinces have shown that within and between elite groups, connections were typically forged through marriages. At the time these linkages were negotiated, the youth of the brides precluded them from having any kind of say in the matter, yet some of the women in question were able, later in life, to defend the patrimonies of their families and thus, presumably, to occupy positions of power within them. For the Balkans and Anatolia, far fewer studies have been undertaken that examine the roles of women in urban and rural notable families. We do, however, possess an article on the Peloponnesian Benaki family, whose head joined the uprising in the peninsula after the landing of a Russian corps in 1770 and as a result had to flee for his life. A female relative remained on Ottoman territory and was able ultimately to re-acquire a sizeable share of the lost patrimony (Veinstein 1986). Other women are known to have contributed to family foundations, a gesture that also presupposes a degree of control over their own property and perhaps destiny (Faroqhi 1992).

In certain dervish orders, the wife of the shaykh of a major lodge might also occupy a position of some prestige; thus among the Celvetis of Istanbul this personage might undertake responsibility for feeding inmates and guests, and thus come to be known as the "mother of the dervishes" (Clayer forthcoming). Other women descended from dervish shaykhs might inherit positions as foundation administrators, although it is almost impossible to tell how much real power such a position might permit its holder to exercise.

With respect to women of some wealth and/or status, both Muslims and non-Muslims, the circumstances under which they managed to represent family interests vis-à-vis the Ottoman authorities have aroused some interest. This type of representation might occur when husbands were incapacitated because they had to take flight, or, albeit less clearly apparent from the sources, through sickness or old age. Women defending the interests of their families are documented mainly when they petitioned the central administration concerning the injustices that their menfolk, and more rarely their female relatives,

had suffered: local enemies, about whom we usually have no corroborating information whatsoever, are accused of extortion, intimidation, and sometimes even murder. It is worth noting that at least in the eighteenth century, other male relatives did not automatically intervene to defend the interests of families temporarily or permanently deprived of their male heads (Faroqhi 2002).

DEMOGRAPHY: THE FEMALE HALF OF THE OTTOMAN POPULATION

Information on female – and for that matter, male – life cycles is hard to come by with respect to the eighteenth century. Reasonably complete genealogies can only be reconstructed in a very few cases. As it was not customary to indicate age at death on Muslim gravestones or in post mortem inventories, we are for the most part limited to the lists of heirs to the deceased person in question that form a regular part of the latter documents (in the larger cities, post mortem inventories may form separate record books, catalogued along with the regular *kadı* registers; more normal is the inclusion of such inventories in the *kadı*'s ordinary *sicil*s). Such lists enumerate only those family members alive at the moment the person dies; therefore they are not helpful in determining the total number of children born to a given marriage. Moreover this source material shows that the number of children surviving a mother or father was usually quite small. Whether this was due to high infant mortality or at least partly to conscious family limitation is impossible to tell.

As wives always inherited, these lists do indicate the existence or non-existence of polygyny, the only marriages involving more than one wife that are typically missing from this kind of record being those in which one of the wives had died before her spouse. From this evidence it has been deduced that in the towns of the central Ottoman provinces, polygyny was not a frequent occurrence; this observation has been formally established for Salonica around 1840 (Anastassiadou 1997, 215), and confirms the impression gained when casually reading through post mortem inventories of eighteenth-century Bursa.

Better evidence is available for Istanbul: from the 1880s till the early 1900s, marriage records indicate that polygyny involved no more than 2 percent of all Muslim marriages. Moreover, this kind of union was limited to certain social groups, namely juridical *cum* religious scholars ('*ulamā*') and certain high court dignitaries, who presumably imitated the customs of the dynasty. Merchants and artisans might divorce, but did not

marry more than one wife at a time. This conso-nance of observations from Bursa, Salonica, and Istanbul makes it seem possible that here as in other matters, models typical of the capital had been adopted in the larger provincial towns.

In late nineteenth-century Istanbul, brides were normally 19 to 20 years old, and the age at first marriage showed a clear tendency towards increasing yet further. Thus marriage at puberty was not customary in the capital at that time. In the absence of documentation, we cannot tell whether this had been true in earlier periods as well, or whether it was due to economic difficul-ties retarding the establishment of new families at first, and the gradual spread of female education after 1908 (Duben and Behar 1990, 126–7).

Precious information on the demographic his-tory of nineteenth-century Balkan peasants comes from a few Catholic Bulgarian villages whose priests had been trained in Rome and thus kept registers of baptisms, weddings, and funerals according to Roman Catholic norms, while the Orthodox did not produce such documentation (Todorova 1993). As the villagers in question lived under the same overall conditions as their non-Catholic neighbors, it can be assumed that the demographic patterns observed in these docu-mented localities are more or less representative of wider trends. Nineteenth-century Bulgarians were obviously living through the demographic transition from a society with high birth and death rates to a different type, in which death rates were decreasing while births did not follow suit before the mid-1920s, long after the end of our period. Bulgarian village women could thus count on marrying at an early age and bearing many children, of which they were still liable to lose quite a few, especially due to smallpox. They also were likely to die themselves during parturi-tion or shortly thereafter; however those women who had survived this high-risk period could count on a somewhat longer lifespan than their husbands. Given the age difference between spouses, this situation made for a sizeable number of widows.

WOMEN AND THE STATE: CONTROL OF THE BODY AND FORMAL EDUCATION

Well before 1700, the Ottoman state had now and then attempted to regulate the manner in which women presented themselves in public by sultanic edicts, for instance by prescribing par-ticular fabrics for Muslim or else non-Muslim women. In the early and mid-eighteenth century,

such attempts at state control over women's behavior, especially in the sartorial sector, was intensified, at least if the number of references in the primary sources is a reliable indication. This has been linked to the administration's attempt to legitimize itself through a vigilant concern with public order, and perhaps also to the observation that better-off Istanbul women were now showing increased assertiveness, particularly in the con-sumption sector (Zilfi 1995, Quataert 1997).

However, in the reign of Selim III the Ottoman state began to intervene in order to prevent and penalize abortion. This matter had not previously been referred to at all in sultanic commands, as Islamic religious law in its Ḥanafī version permits abortion during the first four months of preg-nancy, subject to the husband's consent. Abortion was also forbidden in an edict promulgated in 1839, contemporary with the first efforts at state restructuring known as the Tanzimat. This pro-hibition was not, however, included in the first Ottoman penal codes promulgated in 1840 and 1851, possibly in order to avoid the odium involved in penalizing something allowed by reli-gious law. In all likelihood for the same reason, later legislation did not address itself to the women who had abortions, nor to the husbands who in many cases must have abetted them. Rather the legislator's attention was focused on doctors, pharmacists, and midwives, who were deemed to possess the relevant technical know-how. As a rationale, some texts written by high-level officials affirmed that a large population was necessary for a powerful state, and as a secondary religious consideration asserted that it was a sin not to raise offspring given by God. In early drafts of this later legislation, poor families with many children were promised state aid; this clause was not however incorporated into the final text. Mothers, fathers, and midwives were thus left to contend with the problems of extreme poverty and unwanted babies as best they could (Somel 2002).

Throughout the 1700s and 1800s, some edu-cated women might well have attended a Qur'ān school before puberty, but most of their training would have been pursued at home. Even in the palace, basic training in reading and writing Ottoman does not seem to have led to uniform literacy standards among the women educated in this institution (Uluçay 1985, 18). Certainly the fact that many harem women came from out-side the Ottoman domain, and thus had to learn Turkish as a foreign language, must have aug-mented the difficulties. In the sultan's harem, the

education of young girls apparently emphasized respect for hierarchy, elegance, and musical skills, rather than academic subjects. From the later 1800s onwards, girls of the elite might acquire a knowledge of French from European governesses or in private boarding schools; this kind of upper-class education is a topic that would repay closer investigation.

In 1858, the Ottoman state opened the first advanced primary school (*rüşdiyye*) for girls. An article published shortly afterwards in the official gazette proclaimed that educated women would be able to make their husbands more comfortable, while a knowledge of both religion and worldly affairs would make it easier for them to preserve their virtue. In 1869–70, the first seminary to train women teachers for girls schools was established in Istanbul. By the 1880s, local administrators in reasonably well-off provincial districts were beginning to set up primary schools on a regular basis (Somel 2002, 2001, 57, 115, 135). But given the fact that in most provinces, schooling even for Muslim boys was quite insufficient, provision for girls was even less satisfactory.

However, most women who received formal schooling in the closing years of the nineteenth century did so either in schools run by the different minority communities, or else in missionary establishments. In Istanbul, the American School for Girls and Notre Dame de Sion, which also prepared its graduates for teaching careers, established themselves as secondary schools favored by the Muslim elite. This was true even though the government of Abdülhamid II very strongly disapproved of Muslim children attending missionary schools, from which they would presumably graduate with an insufficient grounding in Islamic morality and undue sympathies for a foreign culture (Fortna 2001). In fact such attendance was forbidden in the later 1890s. However, since missionary schools favored by the elite generally gave up attempts at overt proselytizing, and since state-sponsored secondary schools were all but unavailable to women, the daughters of the Istanbul elite after 1908 attended these schools in sizeable numbers, and this situation continued well into the republican period.

ELITE AND URBAN WOMEN AS WRITERS AND ARTISTS

Problems in accessing formal education explain why the women who distinguished themselves as writers (or musicians) normally came from families whose male members had long been trained in schools of divinity and religious law (*medrese*) in the modern schools opened in Istanbul after the late eighteenth century, or else had studied abroad. Thus the best-known Ottoman woman poet of the eighteenth century was Fitnat (originally Zübeyde, d. 1780), who was closely related to two *şeyhülislam*s: Esad Efendi was her father and Şerif Efendi her brother, and both were known for their literary interests. Her social position probably permitted her to freely exercise her talent for repartee, which made her famous. Leylâ Hanım (d. 1848), who left a collection of poetry reflecting the pleasures of the Istanbul upper classes on the Bosphorus and elsewhere, was the daughter of a man who as *kadıasker* had reached the next-to-highest rank in the religious and juridical bureaucracy. In addition she had been trained by a relative who was himself a distinguished author.

Among the poets and novelists operating in the post-1850s context, elite recruitment was also normal. A well-known poet was Nigâr Hanım bint Osman (1862–1918), the daughter of a Hungarian officer who had fled to the Ottoman Empire after the failed revolution of 1848, become a Muslim, and taught at the General Staff college (for a portrait, see Renda 1993, 248). Of an established Istanbul family, her mother had also received a literary education, and Nigâr Hanım was encouraged to follow in her footsteps, acquiring an amazing knowledge of foreign languages en route. She was later noted for her literary salon. Another Leylâ Hanım (later Leylâ Saz, 1850–1935) was the daughter of one of Sultan Abdülmecid's doctors, who later embarked on an administrative career and became a minister of commerce. An accomplished musician even when she was very young, Leylâ Hanım was raised in the palace as a companion to a young princess, and continued her activities as a writer and composer throughout her life. Fatma Aliye (1862–1936), whose writing career spanned the last decades of the Ottoman Empire, was the daughter of the grand vizier and historian Ahmed Cevdet Paşa (Findley 1995, 1995b). While Ahmed Cevdet, the sworn enemy of the constitutionalist Midhat Paşa, was known for his conservative politics, the education of his children was a different matter: when he came to the conclusion that Fatma Aliye was very gifted, she was carefully educated and encouraged to develop her writing skills. Her novels reflect upper-class life in late nineteenth- and early twentieth-century Istanbul.

Somewhat broader, though probably still largely from the upper levels of society, was the recruitment of female authors who wrote for

the Istanbul women's press. The weekly journal *Terakki* (Progress) in 1868 featured complaints supposedly sent in by Istanbul ladies about, for instance, the poor condition of the women's compartments on the steamboats that had begun to handle much of Istanbul's local traffic. More such letters reached the public a year later in the same journal's women's magazine *Terakki-i Muhadderat* (Progress for the veiled ones, i.e., respectable women), first appearing on the market in 1869 and of which 48 issues were published. These letters were signed either with the writers' first names or else with sobriquets such as "an inhabitant of Üsküdar."

While it is impossible to verify which letters were genuinely received and which were rewritten and perhaps even invented by the editors, they are of interest because they verbalize issues that the publisher must have believed would interest female readers. Some of these letters discuss the problems of women writers wishing to make their work known. Thus under the signature *mektebli kız* (an educated girl) the periodical *İnsaniyet* (Humanity) printed a letter demanding that women's journals should give priority to works authored by women, as at the time most female writers who wanted to reach the public were obliged to use male pen-names (Çakır, 1993, 23–5). These remarks indicate that not only did men write about what they considered fit for women, but also that a female author may be hiding behind a male signature.

In 1886 *Şükûfezar* (Petal), the first journal written entirely by women, attempted to find a public; the owner was also a female. Unfortunately the penury of information on women in the standard biographical dictionaries of the time makes it impossible to say much about journalists such as Münire, Fatma Nevber, and Fatma Nigâr. The journal *Hanımlara mahsus gazete* (Ladies' own journal), published from 1895 to 1908, had a staff of both male and female writers, which included Fatma Aliye. In a well-known article, the latter pointed out that all over the world, men had reached the higher levels of culture well ahead of their womenfolk, and now did not relish competition from educated females. Other women authors of elite background also wrote for the journal, including the poets Nigâr Hanım and Leylâ Saz. Moreover, at least one of the women journalists had a strong political commitment, namely to the Committee of Union and Progress (CUP). Gülistan İsmet, an 1891 graduate of the American School for Girls, was a secret member of the CUP and often translated its press releases into English (Çakır 1993, 27–31; possibly identical

with the Gülistan bint Tevfik who graduated in 1890 according to Graham-Brown 1988, 197).

Acting, both in spoken theater and on the musical stage, in the second half of the nineteenth century, was a province of Armenian women artists. At this time literary men such as İbrahim Şinasi and Namık Kemal, with the help of the impresario Güllü Agop (after his conversion to Islam, Güllü Yakub Efendi) struggled in order to establish norms of modern educated speech through a Turkish-language theater. Yet their plans could not have come to at least partial fruition without actresses such as Aznif Hratchia, in certain cases bilingual in Ottoman and Armenian, who trained in the classes associated with Güllü Agop's theater. Madame Hratchia published her memoirs and thus was a precursor of the many performing artists who wrote such books appearing in republican Turkey (on this publication and other details see And 1972, 121–2).

EXTREMES OF WEALTH AND POVERTY: SOME EXAMPLES OF CHRISTIAN AND JEWISH WOMEN

Armenian women have been approached through the study of certain aristocratic families of financiers (*sarraf*) such as the Dadian. Many members of this family clan held office in Istanbul, but certain branches also established matrimonial links with prominent Armenians from Iran, and especially after 1850, with well-to-do and socially eminent Europeans as well (Ter Minassian 1995). Family links often served to cement business connections; as a result the maintenance of ties between even quite remote cousins, and also of strict hierarchy within the group, were considered essential. Before the mid-nineteenth century, girls were married off in their middle or even early teens, which must have limited opportunities for education. Yet increasingly from the 1820s onwards, a knowledge of French and other foreign languages came to be considered desirable, and we find women of the Dadian family acting as translators when female members of European royal families visited the imperial harem.

Certain Greek Orthodox records are special because for once, they shed some light on very poor women. Thus the archives of the church of the Panaghia in Istanbul-Beyoğlu, whose congregation consisted largely of immigrants, date from the second half of the nineteenth century and cover a foundling hospital associated with the church. These materials contain information on mothers forced to abandon their babies (both male and female) due to poverty. They provide

some indication concerning child survival rates and wet nurses, but also concerning the criteria by which orphanage administrators tried to determine which women were likely to take back their children when their circumstances improved, and which foundlings would not be reclaimed and should be given up for adoption (Anastassiadou 2002).

Another group of poor women of mostly Greek and Armenian background is documented in connection with early Ottoman factories, especially the Bursa establishments in which silk was reeled prior to export. Girls were usually hired out by their families so they would save the money needed for their dowries and trousseaus; they were preferred by factory owners because of the very low wages they were paid for an often 16-hour work day in insalubrious surroundings. The workers were housed in dormitories and supervised by watchmen under conditions giving rise to all kinds of abuse; in spite of protests, these conditions did not improve substantially until the demise of the industry during the First World War (Quataert 1983, 498).

A comparable situation existed among the young Jewish women who in Salonica during this same period worked for a few years in order to assemble the wherewithal for marriage. Sephardic families on the whole rejected women's entry into the workforce. As a result, the classes given by the schools financed by the Alliance israélite universelle, whose archives contain a great deal of information on nineteenth-century Jewish education, have little to say about the instruction of Sephardic women. Female apprenticeships also were quite rare (Dumont 1982). In Salonica, statistics pertaining to the last 20 years of the nineteenth century refer to some young Jewish women trained as manufacturers of braid, in addition to a few girls learning to be dressmakers and embroiderers. But many if not most of these young women worked as untrained laborers: originally household service had been an important source of employment, but increasingly work in the tobacco industry took its place. But possibly because their employment was viewed as so marginal, female workers seem to have scarcely figured in the formation of the Ottoman and later post-Ottoman working classes, although the city of Salonica played a central role in this process.

IN CONCLUSION

On a relatively mundane level, possibilities lie in the expansion of research projects dealing with the sixteenth or seventeenth century to encompass the 1700s and 1800s as well. This includes a more systematic evaluation of *kadı* registers and *vilayet ahkâm defterleri*; it is rather remarkable that the limited number of surviving registers from the 1500s and 1600s have been better studied with respect to the affairs of women than the much greater number of such items surviving from the period addressed here. Obviously the formulaic character of these records, and also the fact that women occur only intermittently, make monographic studies on the women of a given region rather difficult. But only through these materials can we find out something about female weavers or women who worked in the gardens belonging to their families; due to the relative density of surviving documentation, it seems worthwhile to focus on Istanbul, Bursa, and the hinterlands of these two cities. As a beginning, it might for instance be useful to check the ten published volumes of selections from Istanbul's *vilayet ahkâm defterleri* for the names of women they contain, and the female activities that they reflect (Kal'a 1997–).

As to historians who decide to work on women in the public view, and on the second half of the nineteenth century as well, their research might become easier and more fruitful if a data bank, and maybe later an encyclopedia, of the relevant women could be put together. As yet we possess no collective biography of any category of Ottoman women at all. Yet in the Istanbul publishing sector, such an undertaking does seem feasible, especially if the early twentieth century is included. Another category of late Ottoman women on whom a study might be feasible are the teachers, both Ottoman subjects and foreigners; perhaps the archives of some of the foreign schools may yield information on these early career women.

Ottoman women's history has been heavily weighted in favor of the elites, if only because the records tell us most about women who owned some property. In the case of "ordinary" women, historians have focused upon those who engaged in publicly visible activities such as factory work. It is undeniable that such undertakings are better documented than for instance, women's work in the reproduction sector. However, once historians are willing to attempt filling this rather glaring gap, certain possibilities of accessing the "silent majority" among Ottoman women do present themselves. Thus we should probably take a leaf from the book of historians of the Arab provinces, who have worked intensively on family and household structures, and also on the insertion of women into their town quarters (for a recent study on an Istanbul *mahalle* and its women, see Behar 2003, 144–5).

At the same time "cross-fertilization" between scholars working on Greek, Armenian, or Jewish women and those whose focus is on Muslims and Ottoman-language sources is just beginning, but could be carried much further. Thus certain Greek islands with Muslim minorities, such as Chios, possess local sources such as notary records that may contain information on women regardless of creed. On the other hand, *kadı* registers sometimes preserve data on Orthodox women, as some couples in the Peloponnesus, for instance, had their marriages registered by the scribes of the local *kadı*'s tribunal (Alexander 1985). Materials produced by Ottoman Muslim authorities should thus be checked for what they can tell us about non-Muslim women, and vice versa. At a time when intercultural studies are coming into their own, this is a real challenge.

BIBLIOGRAPHY
On individual princesses and writers, as well of the former's pious foundations, much information has been collected from the relevant articles in, *Dünden Bugüne Istanbul Ansiklopedisi*, 8 vols., Istanbul 1993-5. Many of these pieces were authored by Necdet Sakaoğlu.

A. Akgündüz et al. (eds.), *Şeriye sicilleri*, 2 vols., Istanbul 1988-9.
A. Akyıldız, *Mümin ve müsrif bir Padişah Kızı. Refia Sultan*, Istanbul 1998.
J. Alexander, Law of the conqueror (the Ottoman State) and law of the conquered (the Orthodox Church). The case of marriage and divorce, in Comité International des Sciences Historiques, *XVIᵉ congrès international des sciences historiques. Rapports*, Stuttgart 1985, i, 369-71.
M. Anastassiadou, *Salonique, 1830-1912. Une ville ottomane à l'âge des réformes*, Leiden 1997.
——, La protection de l'enfance abandonnée dans l'Empire ottoman au XIXᵉ siècle. Le cas de la communauté grecque de Beyoglu-Istanbul, in *Südost-Forschungen* 59-60 (2000-1), 272-323.
M. And, *Tanzimat ve istibdat döneminde Türk tiyatrosu 1839-1908*, Ankara 1972.
H. Angelomatis-Tsougarakis, Greek women, 16th-19th century. The travellers' view, in *Mesaionika kai nea Ellenika* 4 (1992), 321-403.
Anonymous, *Başbakanlık Osmanlı arşivi rehberi*, Ankara 2000.
T. Artan, From charismatic leadership to collective rule. Introducing materials on the wealth and power of Ottoman princesses in the eighteenth century, in *Toplum ve Ekonomi* 4 (1993), 53-94.
——, Aspects of the Ottoman elite's food consumption. Looking for "staples," "luxuries," and "delicacies" in a changing century, in Donald Quataert (ed.), *Consumption studies and the history of the Ottoman Empire, 1550-1922. An introduction*, Albany, N.Y. 2000, 107-200.
H. Aynur, *The wedding ceremony of Saliha Sultan. 1834. Textual analysis, critical edition and facsimile*, 2 vols., Cambridge, Mass. 1995.
C. Behar, *A neighborhood in Ottoman Istanbul. Fruit vendors and civil servants in the Kasap İlyas Mahalle*, Albany, N.Y. 1993.

N. Clayer, Life in an Istanbul *tekke* in the eighteenth and nineteenth centuries according to a *menakıbnâme* of the Cerrahi dervishes, in S. Faroqhi and C. K. Neumann (eds.), *The illuminated table, the prosperous house. Food and shelter in Ottoman material culture*, Orient-Institut der DMG (forthcoming).
S. Çakır, *Osmanlı kadın hareketi*, Istanbul 1994.
F. Davis, *The Ottoman lady. A social history*, New York 1986.
S. Delibaş, Behice Sultan'ın ceyizi ve muhallefatı, in *Topkapı Sarayı Yıllığı* 3 (1988), 63-104.
A. Duben and C. Behar, *Istanbul households. Marriage, family, and fertility 1880-1940* Cambridge 1991.
P. Dumont, La structure sociale de la communauté juive de Salonique à la fin du dix-neuvième siècle, in *Revue historique* 263:2 (1982), 351-93.
H. Edip, *Memoirs*, New York 1926.
Y. H. Erdem, *Slavery in the Ottoman Empire and its demise, 1800-1909*, Houndsmills, Basingstoke 1996.
S. Faroqhi, Two women of substance, in C. Fragner (ed.), *Osmanistik, Turkologie, diplomatik. Festgabe an Josef Matuz*, Berlin 1992, 37-56.
——, Crime, women and wealth in the eighteenth-century Anatolian countryside, in M. Zilfi (ed.), *Ottoman women*, Leiden 1997, 6-27.
——, *Approaching Ottoman history. An introduction to the sources*, Cambridge 1999.
——, Women as representatives. Defending the interests of Ottoman families in the middle of the eighteenth century, in S. Faroqhi, *Stories of Ottoman men and women. Establishing status, establishing control*, Istanbul 2002, 179-96.
C. V. Findley, Fatma Aliye. First Ottoman novelist, pioneer feminist, in D. Panzac (ed.), *Histoire économique et sociale de l'Empire ottoman et de la Turquie (1326-1960)*, Louvain 1995a, 783-94.
——, La soumise, la subversive. Fatma Aliye, romancière et féministe, *Turcica* 27 (1995b), 153-72.
B. Fortna, *Imperial classroom, Islam, the state and education in the late Ottoman Empire*, Oxford 2002.
E. Frierson, Unimagined communities. Women and education in the late-Ottoman Empire, 1876-1909, in *Critical Matrix* 9:2 (1995), 55-90.
——, Mirrors out, mirrors in. Domestication and rejection of the foreign in late-Ottoman women's magazines (1875-1908), in D. Fairchild Ruggles (ed.), *Women, patronage and self-representation in Islamic societies*, Albany N.Y. 2000.
G. Goodwin, *The private world of Ottoman women*, London 1997.
S. Graham-Brown, *Images of women. The portrayal of women in photography of the Middle East*, New York 1988.
A. Kal'a et al. (eds.), *İstanbul külliyatı I. İstanbul ahkâm defterler*, Istanbul 1997-.
C. Kayra and E. Üyepazarcı, *İkinci Mahmut'un İstanbul'u. Bostancıbaşı sicilleri*, Istanbul 1992.
Leylâ Saz, *Le harem impérial et les sultanes au XIXe siècle. Leïla Hanoum: souvenirs adaptés au français par son fils Youssouf Razi*, Paris 1925, repr. with preface by Sophie Basch, Brussels 1991.
B. Melman, *Women's Orients. English women and the Middle East, 1718-1918. Sexuality, religion and work*, London 1992.
N. Micklewright, Tracing the transformations in women's dress in nineteenth-century Istanbul, in *Dress. The Annual Journal of the Costume Society of America* 13 (1987), 33-43.
——, Late nineteenth-century Ottoman wedding cos-

tumes as indicators of social change, *Mukarnas* 6 (1990), 161–74.

Lady M. W. Montagu, *Turkish embassy letters*, ed. A. Desai and M. Jack, London 1993.

A. Osmanoğlu, *Babam Abdülhamid*, Istanbul n.d.

R. Özdemir, *XIX. Yüzyılın ilk yarısında Ankara*, Ankara 1986.

İ. Parlatır, *Tanzimat edebiyatında kölelik*, Ankara 1987.

J. Perrot, F. Hitzel, and R. Anhegger, *Hatice sultan ile melling kalfa. Mektublar*, Istanbul 2001.

D. Quataert, The silk industry of Bursa, 1880–1914, in J. Bacqué-Grammont and P. Dumont (eds.), *Contributions à l'histoire économique et sociale de l'Empire ottoman*, Leuven 1983, 481–503.

——, *Ottoman manufacturing in the age of the industrial revolution*, Cambridge 1993.

——, Clothing laws. State and society in the Ottoman Empire, 1720–1829, in *International Journal of Middle East Studies* 29 (1997), 403–25.

G. Renda (ed.), *Anadolu kadınının 9000 yılı*, Istanbul 1993.

M. Rozen, The life cycle and the meaning of old age in the Ottoman period, in D. Porat, A. Shapira, and M. Rozen (eds.), *Daniel Carpi memorial volume*, Tel Aviv 1996, 109–75.

B. Sagaster, *Im Harem von Istanbul. Osmanisch-türkische Frauenkultur im 19. Jahrhundert*, Rissen, Germany 1989 (on Leylâ Saz).

N. Seni, Fashion and women's clothing in the satirical press of Istanbul at the end of the 19th Century, in S. Tekeli (ed.), *Women in modern Turkish society. A reader*, London 1995.

A. S. Somel, Osmanlı modernleşme döneminde kız eğitimi, in *Kebikeç* 10 (2000), 223–38.

——, *The modernization of public education in the Ottoman Empire 1839–1908. Islamization, autocracy and discipline*, Leiden 2001.

—— Osmanlı son döneminde iskat-ı cenin meselesi, in *Kebikeç* 13 (2002), 65–88.

J. Strauss, Ottoman rule experienced and remembered. Remarks on some local chronicles of the Tourkokratia, in F. Adanır and S. Faroqhi, *Ottoman historiography. Turkey and Southeastern Europe*, Leiden 2002, 193–222.

A. Ter-Minassian, Une famille d'amiras arméniens. Les Dadian, in D. Panzac (ed.), *Histoire économique et sociale de l'Empire ottoman et de la Turquie (1326–1960)*, Paris 1995.

M. N. Todorova, *Balkan family structure and the European pattern. Demographic developments in Ottoman Bulgaria*, Washington 1993.

E. Toledano, *Slavery and abolition in the Ottoman Middle East*, Seattle 1998.

M. Ç. Uluçay, *Osmanlı sultanlarına aşk mektupları*, Istanbul 1950.

——, *Harem'den mektuplar*, Istanbul 1956.

——, *Padişahların kadınları ve kızları*, Ankara 1980.

——, *Harem*, Ankara 1985².

M. Zilfi, Ibrahim Paşa and the women, in D. Panzac (ed.), *Histoire économique et sociale de l'Empire ottoman et de la Turquie (1326–1960)*, Paris 1995, 555–9.

——, Women and society in the Tulip Era, 1718–1730, in A. El Azhary Sonbol (ed.), *Women, the family, and divorce laws in Islamic history*, Syracuse, N.Y. 1996, 290–306.

——, Goods in the *mahalle*. Distributional encounters in eighteenth-century Istanbul, in D. Quataert (ed.), *Consumption studies and the history of the Ottoman Empire, 1550–1922. An introduction*, Albany, N.Y. 2000, 289–312.

SURAIYA FAROQHI

Morocco: Mid-18th to Early 20th Century

INTRODUCTION

Scholarship on the history of women in premodern Morocco is a new field still confined to a handful of Moroccan scholars. Reconstructing past women's lives calls for an expertise in literary Arabic and in the courtly (*makhzanī*) style, an ability to decipher manuscripts, and a familiarity with the techniques of local research. Bureaucratic traditions were not well developed, and the mechanisms for preserving official documents haphazard. The court records, notarial documents, censuses, and other statistical documentation that form the substance of historical research in the former Ottoman territories are few and far between. For the eighteenth century, there is an irreparable void. The situation improves somewhat in the nineteenth century, especially after 1830, when record keeping improved. Consular archives, foreign ethnographies, and travel literature help fill the gaps, but these sources pose methodological problems of their own and require special treatment in order to compensate for inherent biases.

TOOLS OF RESEARCH

In addition to chronicles, correspondence, and literary texts, sources such as oral histories, poetry, anecdotes, and even aphorisms are helpful in conceptualizing mentalities and constructing a narrative framework. Historians of women must be prepared to become "fieldworkers," interviewing respondents, visiting sites, and observing with attentiveness. The Geertzian method of reproducing local context by "thick description" is the order of the day. A recent study exemplifying this approach is social historian Mohammed Ennaji's *Serving the Master: Slavery and Society in Nineteenth-Century Morocco*. Using techniques borrowed from anthropology and literary criticism, Ennaji gathered bits of information buried in diverse sources and wove them into an account of the enslaved woman's experience. He used official correspondence, registers (*kanānīsh*), and legal texts (*nawāzil* and *ajwiba*) to reconstruct the world of these women, exposing their multiple roles and centrality to the domestic economy. Ennaji's study demonstrates that groundbreaking work in Moroccan women's history is possible when sources are used creatively and with attention to the broader cultural and political milieu.

Some of the more important tools of research available to the historian are the following:

1. *The chronicles* (*ḥawliyyāt*). As historian Mohamed El Mansour has pointed out, professional historians did not exist in precolonial Morocco; rather, educated men adopted the métier as an extension of their preoccupation with *adab*, or *belles lettres*. The more important chroniclers were secretary-scribes (*kuttāb*), appointed by the ruling sultan to record the events of his reign. They concentrated on the wars and catastrophes that formed the backdrop to their times, writing accounts that are court-centered, panegyric, and rarely concerned with the lives of ordinary people. Moreover, chroniclers were usually urban-based *'ulamā'* concerned with paying deference to notables of their own social class. Yet a close reading of the chronicles is a necessary prelude to all forays into Moroccan history. Depending on the skill and objectivity of the author, the chronicle recreates the broader social and political environment in which women's history played itself out. The most important chronicle for the eighteenth century is the *Nashr al-mathānī* of Muḥammad b. al-Ṭayyib al-Qādirī (d. 1187/1773), published in a recent scholarly edition by A. Tawfīq and M. Ḥajji; the portion covering the years 1665–1756 has been admirably translated and annotated by Norman Cigar. Al-Qādirī's mother occupies an important place in this work, and other women make occasional appearances, such as the learned and pious Ḥajja Malwaniyya, who made the *ḥajj* 27 times. The landmark work for the nineteenth century is the *Kitāb al-istiqṣā'* of Aḥmad b. Khālid al-Naṣīrī (d. 1315/1897).

2. *Official correspondence* is found in three Rabat depositories: the Hassaniyya (Royal) Library, the Direction des archives royales, and the archives of the Bibliothèque générale. These collections contain correspondence, tax records, property inventories, customs receipts, and other data. Letters from local officials to the court are especially instructive about the conduct of everyday life, yielding information on domestic violence, famines and epidemics, and household economics. However, local officials had concerns of their own, the fear of royal displeasure among them, so that the accuracy and objectivity of the reporting is compromised. Knowl-

edge of the local context, a sense of geography, and a familiarity with family networks is essential for understanding this type of material.

3. *European archives* are a prolific source for the social history of Morocco in the premodern period up to 1912. Foreign representatives were confined mainly to the port city of Tangier. Some remained in their posts for years, learning Arabic and developing a deep understanding of Moroccan society. John Drummond Hay served as Britain's representative in Morocco for much of the nineteenth century. His dispatches reflect the mindset of his day, but they are also a treasure trove for women's history, especially when he writes about issues such as prison reform. To what extent are European accounts a reliable source for local conditions? Clearly, the principal aim of personalities like Drummond Hay was to aggressively pursue national political goals while parrying the thrusts of his European rivals. As a result, diplomatic accounts must be used selectively, but when combined with local sources, they can become a powerful component of research.

4. *Waqf documents*. While court records from the precolonial period are scarce, having disappeared into private hands long ago, many documents of the *waqf* (public trust) or *ḥubūs* (as it is known in the Mālikī tradition) have been preserved and contain vital details about transfers of property. Women were often present in these transactions, making it possible to form an impression of patterns of female property ownership. The *ḥubūs* registers, or *ḥawālāt*, found in the Bibliothèque générale are organized by city and are most informative for the first part of the twentieth century; however, some go back as far as the eighteenth century. Marriage contracts are sometimes included in these records, adding another dimension vital to women's history.

5. *Legal documents*, especially *nawāzil*, are a priceless source for social and women's history. The *nawāzil* are collections of legal responses to questions of a practical nature. The *nāzila*, or question, was submitted to the jurist; in composing his response, he was given the opportunity to explore earlier texts and to produce an answer reconciling the prevailing social behavior with legal precedence. The abundance of this genre in Morocco reflects a concern on the part of the legal community to integrate customary practices into formal law. Texts reach into the most intimate recesses of private life, revealing matters pertaining to sexuality and male-female relations. For example, the nineteenth century jurist al-Wazzānī was asked

questions such as: How many times in a day may a husband require sexual intercourse with his wife? (No more than eight.) What methods of contraception are acceptable? Can a couple make love in the nude? Responses show that the doctors of law formed the first line of defense protecting women against the male brutality that was endemic in hard times. Husbands could beat and even kill their wives with impunity, the only restraint being a moral one imposed by the written opinions of scholars often distant from the scene in time and place. The *nawāzil* literature has been rediscovered in recent years by feminist historians and other social scientists who see in it an accurate reflection of the social reality. The most important published collections of *nawāzil* for this period are those of al-Masnāwī (d. 1259/1843) and al-Wazzānī (d. 1341/1923).

6. *Censuses and other surveys* were rare in nineteenth-century Morocco. The systematic collection of data did not become a regular practice until the arrival of the Protectorate in 1912. However, examples from the late nineteenth century initiated within Morocco's Jewish community show that the census was not alien to the Moroccan experience. A detailed house-by-house census of the Jewish quarter (*mallāḥ*) of Marrakesh was carried out in 1890 by officials of the *makhzan*, perhaps in response to demands for additional housing. The census gives details of family size and composition, relationships among members of the household, and the disposition of space within the house. The high number of unattached adult women listed as "widows" (*ayamāt*) in the census raises questions about their status in the family and their means of livelihood.

More prevalent as a statistical source is the official register, or *kunnāsh* (pl. *kanānīsh*). These were notebooks kept by officials concerning matters such as tax revenues, customs duties, lists of property, or expenses, such as the costs of rebuilding walls and fortifications. Because they often record data over time, the *kanānīsh* are especially important for establishing patterns of behavior. A *kunnāsh* of statistics relating to the women's prison in Marrakesh for the period 1916–19 studied by historian Mohammed Ennaji offers a profile of the female prison population: age, place of origin, and the nature of the crimes for which the women were incarcerated. The majority (75 percent) were beyond the age of marriage and jailed for crimes ranging from prostitution to murder. Ennaji speculates that the turmoil created by the French occupation of 1912 took a huge toll on

family life and suggests that the prison *kunnāsh* offers concrete evidence of the victimization of women by harsh circumstances.

7. *Travel literature*, both Moroccan and European, enters into the female domain. Women participated in the *hajj* and other pilgrimages, although their experience was rarely documented. A more familiar category is travel by Moroccans to the West on government-inspired missions. One such traveler, the scholar Muḥammad al-Ṣaffār, wrote a vivid account of his journey to Paris in 1845–6, in which his acute sensitivity toward the female "other" became a central motif of the voyage. On the basis of a few brief encounters, he drew firm conclusions about the place of women in French society and the nature of male-female relations among Europeans. His comments limn the contours of the Moroccan male consciousness on questions of sexuality, showing how travel literature, if read with imagination, can offer new perspectives on gender relations in the local setting.

Foreign visitors were captivated by Moroccan women, and European travel books from the eighteenth and nineteenth centuries are a primary source for depictions of them. The underlying intention of many of these books was to prove the moral superiority of Christians over Muslims, and often these accounts are deficient in knowledge of the country. Yet certain observers wrote accounts that resonate with authenticity. The captive Englishman Thomas Pellow circumambulated Morocco as a member of Sultān Mawlay Ismā'īl's army in the late eighteenth century. His stories of the powerful women at court and of the strains on family life caused by military service provide insights into women's lives at both elite and ordinary social levels.

Two well written travel narratives from the nineteenth century deserve special mention, the first by Eugène Aubin, the pseudonym of a French diplomat who observed Moroccan society with rare sensitivity, and the second by Auguste Mouliéras, a French scholar with a consuming taste for detail. Women travelers had privileged access to female space, but on the whole their accounts offer little that is new. An exception was Amelia Perrier, a British gentlewoman who wrote a witty if barbed account of native society during her winter in Tangier in the early 1870s.

8. *Biography*. Hagiographical literature (*manāqib*) enjoyed great popularity in Morocco, offering stories about marginalized people that more formal genres ignored. Saintly women figure prominently in al-Tādilī's medieval compilation, *Tashawwuf ilā rijāl al-taṣawwuf* (compiled 617/1220), but they mysteriously disappear in the later dictionaries. Halima Ferhat, a Moroccan social historian of the medieval period, speculates that pious women may have lost their social standing when Sufi practice became increasingly imbricated with questions of noble descent through the male line in the sixteenth century. The hagiographical literature transmits a positive image of women, while at the same time it expresses a view that is deeply misogynistic. Ferhat claims that the roots of the popular stereotype of women as ill-tempered, cruel, and shrewish can be found here, contributing to the layered notion of the female persona widely held today.

For later centuries, oral sources become more important in fleshing out the saintly personality. The fieldwork of anthropologist Edward Westermarck, carried out in the early decades of the twentieth century, preserved some of this oral tradition. Westermarck's insights fundamentally shaped the formulations of the later colonial ethnography, and continue to influence Moroccan social science. A full-length study devoted to the impact of his work on women's studies is yet to be written.

9. *Visual sources*. Finally, the importance of visual sources for the study of women in Morocco, especially in the nineteenth century, must be mentioned. As foreign curiosity about Morocco grew, so did an interest in photographing women in varieties of native dress. Photography studios were established in Tangier toward the end of the nineteenth century, among them the atelier of the Spaniard Cavilla, and the studio of a British citizen, G. W. Wilson. Both created albums of Moroccan scenes that were sold to tourists on the streets of Tangier. The garish titillation practiced by photographers in Algeria, who sometimes pictured women partially dressed, is unknown in Morocco, where women are shown in modest, covered poses. Photographs were used to illustrate travelogues and tourist guides; a good example is Edmondo de Amicis's *Morocco: Its People and Places*, first published in Italian, lavishly illustrated with photos including rare images of rural women. The advent of the box camera and its adoption by tourists meant that women were often caught incidentally in the camera's eye, as in the Morocco albums of Leslie N. Wilson, found in the Fogg Museum at Harvard University. The Moroccan woman in Western art could be the theme of an extended monograph of its own; from Delacroix to Sargent and Matisse, the female figure was the subject of painterly attention, expressing the poetry, mystery, and exoticism with which foreign artists experienced this unknown land.

THE CHALLENGE AHEAD

What is needed is to establish a coherent and meaningful historical narrative that places women at its center, while adding depth to our present state of scholarship. Much of the source material clusters around three principal themes: legal and political issues, including woman's changing juridical status and the impact of modernity; the evolving economy and woman's productive role in it; and woman's involvement in cultural and social life outside the family.

1. *Legal and political issues*. How were the lives of rural women different from those of city women from the legal standpoint? In rural areas populated mainly by Berbers, customary law – both written and oral – played a predominant role in establishing women's status. Religious scholars were prone to issue judgments that took into account local conditions, even if it meant setting aside the better-known authoritative sources. A case in point is the study by historian Aḥmad Tawfīq of a fatwa written by a religious scholar of the Middle Atlas, Muḥammad al-Kīkī (d. 1186/1772) on the validity of contracts in which women make gifts of land to male kinsmen. At issue was the fact that these contracts were sometimes made coercively and against the woman's will, thus invalidating their intent in the eyes of law. Al-Kīkī's fatwa, as analyzed by Tawfīq, demonstrates the keen sensitivity of the rural jurist to the peculiarities of the local context.

On the political level, the late nineteenth century witnessed the acceleration of the process of state formation, the centralization of power, the growing role of the *makhzan* in everyday affairs, and the introduction of European goods. Yet we have few studies that investigate the impact of these important changes on women's lives. How did the introduction of new technologies affect women and the family? Novel products, new methods of production, and changing tastes are documented in the sources. French traveler Charles René-Leclerc lists products of European manufacture for sale in Fez in 1905, including metal cooking pots, colanders, and knives; we can only conjecture the extent of their impact on the household routine. In the port cities in particular, new standards of hygiene were introduced, medical assistance became available to women even of the poorer classes, and concepts of health and healing were revised. Even simple tasks, such as supplying the household with water, underwent change. Documenting these transformations from a woman's perspective will advance our understanding of how Moroccan society as a whole faced the challenges of modernity.

2. *Economic issues*. What roles did women play in the violent economic shifts that transpired in this period? What were the differences between rural and urban women, rich and poor? To what extent were women integrated into local economies, into trading networks, and into long distance trade? How did the profound effects of the prolonged nineteenth-century economic crisis affect the family? None of these questions can be answered with any degree of certainty at the present time. We do know that woman's work generally went without compensation in both urban and rural settings, and as geographer Mohamed Houbbaida points out, the debate concerning the right of women to benefit from the fruits of their labors was ongoing. In the countryside, women's contribution was considered an organic component of the labor furnished by males. The role of women in the crafts industries is also documented in the sources; texts refer to women artisans as makers of rugs and weavers of mats and cloth. Historian Roger Le Tourneau notes how Jewish women in Fez were a mainstay of the profitable industry of producing *sqalli*, or golden thread, working alongside men at critical stages of production. Georges Salmon, a French sociologist working in Tangier at the turn of the last century, noted how women sellers in the weekly market came from both urban and rural origins. Early photographs provide additional testimony of their presence in public space as vendors and buyers. Women were property owners and landlords, owners of slaves, managers of businesses. Their power and efficacy in the economy is indisputable, yet this role awaits systematic historical treatment.

3. *Social issues*. The social climate in which women operated in the precolonial period is the subject of both anecdotal and legal evidence. Popular imagery often refers to women in a derogatory manner. Sayings found in popular literature such as: "The peasant is both woman and donkey," reveal common attitudes that structured the social hierarchy. We have noted the physical dangers that beset women from their male relatives, raising the question of the disciplinary role of men as an excuse for cruelty. The Middle Atlas jurist al-Kīkī decries excessive use of force, saying that the ideal would be to correct with a gentle instrument, such as the stick, in order not to cause serious injury. Mohammed Ennaji writes how victimized rural women would take flight to neighboring tribes, or join the floating population of the socially marginal who sought refuge in a nearby *zāwiya*. His careful combing of the official correspondence

from the late nineteenth century has yielded plentiful information on topics unspoken in the "official" chronicles, such as prostitution, slavery, and runaway women. Legitimated violence toward women continued to be accepted until a recent date, underscoring the need for a careful historical analysis of its forms and practices.

On the positive side, we should note women's constructive role in social organizations such as brotherhoods. Women took part in public processions, adding a dimension of spectacle and drama. Members of the Aysawa brotherhood set out each year en masse from their home lodge in Meknes to Tangier, with women followers of the sect figuring prominently in their cross-country march. Women regularly traveled to visit a favorite saint. These independent experiences outside the male purview appear to have been treasured moments of freedom; nineteenth-century Jewish marriage contracts from northern Morocco guarantee the woman's right to make the annual pilgrimage to the shrine of Rabbi ʿAmram b. Dīwān at Azjen. Women were dancers and musicians, performing sometimes together with men, at other times separately. Women's artistic presence altered public and private space. Careful research into these hidden aspects of women's experience will put an end to conventional notions that minimize their cultural influence.

BIBLIOGRAPHY

PRIMARY SOURCES

N. Cigar (ed. and trans.), *Muhammad al-Qadiri's Nashr al-mathani. The chronicles*, Oxford 1981.
M. Kīkī, *Mawāhib dhī al-jalāl fī nawāzil al-bilād al-saʾiba wa-al-jibāl*, ed. A. Tawfīq, Beirut 1997.
A. al-Masnāwi, *Nawāzil*, Fez 1929.
A. al-Nasīrī, *Kitāb al-istiqṣāʾ lī-akhbār duwal al-maghrib al-aqṣā*, 9 vols., Casablanca 1956.
T. Pellow, *The adventures of Thomas Pellow, of Penryn, mariner, three and twenty years in captivity among the Moors*, ed. R. Brown, London 1890.
M. al-Qādirī, *Nashr al-mathāni lī-ahl al-qarn al-hādī ʿashar wa-al-thānī*, ed. A. Tawfīq and M. Ḥajjī, 4 vols., Rabat 1977–86.
M. al-Wazzānī, *al-Nawāzil al-kubrā*, 11 vols., Fez 1900.

SECONDARY SOURCES

E. de Amicis, *Morocco. Its people and places*, trans. M. H. Lansdale, 2 vols., Philadelphia 1897.
E. Aubin, *Morocco of today*, London 1906.
R. Bourqia, Droit et pratiques sociales. Le cas des *nawāzil* au XIXᵉ siècle, in *Hespéris-Tamuda* 35 (1997), 131–45.
M. El Mansour, Moroccan historiography since independence, in M. Le Gall and K. Perkins (eds.), *The Maghrib in question. Essays in history and historiography*, Austin, Tex. 1997, 109–19.
A. El Moudden, The eighteenth century. A poor relation in the historiography of Morocco, in M. Le Gall and K. Perkins (eds.), *The Maghrib in question. Essays in history and historiography*, Austin, Tex. 1997, 201–9.
M. Ennaji, Note sur le document makhzenien, in *Hespéris-Tamuda* 30 (1992), 66–74.
——, *Serving the master. Slavery and society in nineteenth-century Morocco*, trans. Seth Graebner, New York 1999.
E. Gottreich, Jewish space in the Moroccan city. A history of the *mellah* of Marrakesh, 1550–1930, Ph.D. diss., Harvard University 1999.
M. Le Gall and K. Perkins (eds.), *The Maghrib in question. Essays in history and historiography*, Austin, Tex. 1997.
R. Le Tourneau and M. Vicaire, L'industrie du fil d'or au *mellah* de Fès, in *Bulletin économique et social du Maroc* 3 (1936), 185–90.
E. Lévi-Provençal, *Les historiens des Chorfas. Essai sur la littérature historique et biographique au Maroc du XVIᵉ au XXᵉ siècle*, Paris 1922.
S. G. Miller (ed. and trans.), *Disorienting encounters. Travels of a Moroccan scholar in France in 1845–1846. The voyage of Muhammad as-Saffar*, Berkeley 1992.
M. Monkachi (ed.), *Pour une histoire des femmes au Maroc. Eunoe* [sic] *groupe de recherches sur l'histoire des femmes au Maroc. Actes du colloque de Kenitra, 4–5 avril 1995*, Casablanca 1995.
A. Mouliéras, *Le Maroc inconnu*, 2 vols., Paris 1895–9.
A. Perrier, *A winter in Morocco*, London 1873.
C. René-Leclerc, *La commerce et l'industrie à Fès. Rapport au comité du Maroc*, Paris 1905.
G. Salmon, Le commerce indigène et le marché de Tanger, *Archives marocaines*, 1 (1904), 38–55.
Y. D. Semach, Une chronique juive de Fès. Le "Yahas Fès" de Ribbi Abner Hassarfaty, *Hespéris* 19 (1934), 79–94.
E. Westermarck, *Ritual and belief in Morocco*, 2 vols., London 1926.

SUSAN GILSON MILLER

Qājār Iran: Mid-18th to Early 20th Century

Scholarly work on women in Qājār Iran has been immensely valuable since it has brought a new outlook to Iranian history and a vision for the future. In addition to novel interpretations of history based on "gender" and "woman," many unknown facts about women's lives have been brought to light through analysis of previously unused sources and innovative usage of the sources that had been used in the past.

In analyzing these sources, as well as the epistemologies and methodologies used in the studies of women in Qājār Iran, categories of class, gender, race/ethnicity, and sexuality have been considered essential. Similarly the interconnections and interrelations between the political, economical, social, cultural, and sexual are emphasized in what the Italian philosopher Antonio Gramsci calls a "circular movement within an organic whole" (Adamson 1980, 179).

A large number of the writings on women in this period are concentrated on two events at the beginning and at the end of Qājār rule, the Bābī movement (1844–50) and the Constitutional Revolution (1905–11). These studies place their emphasis on certain historical figures for understanding historical changes. Consequently many writings about women in this period (in Persian and English) are about two historical figures, Ṭāhira Qurrat al-ʿAyn, a female leader of the Bābī movement, and Tāj al-Salṭana, a Qājār princess. The studies also focus on women from the elite, who lived in the harems. As a result, historical transformations in many domains of life that started before the Qājār era and intensified during their reign, with far-reaching impacts on the lives of women, remain unexplored.

THE BĀBĪ MOVEMENT (1844–50)
Women who joined the Bābī movement aspired to freedom in both the secular and spiritual domains. The Bābī movement projected not only the dissatisfaction of the merchants, the "rising bourgeoisie," with the prevailing economic and social order, but also their disenchantment with the dominant norms of Islam (Ivanov 1939). The Bābīs searched for truth not in the literal meaning of the Qurʾān and prophetic tradition but in "esoteric interpretation" and "messianic ethos," which

placed emphasis on "intuitive endeavor" (Amanat 1989, 295, 330).

In writings about women in the Bābī movement, Ṭāhira Qurrat al-ʿAyn becomes the subject of scrutiny rather than the majority of women who participated in it. Her act of removing the veil is the principal subject that scholars write about. Qurrat al-ʿAyn is mostly treated as an ahistorical figure living in a vacuum and not as a representative of many women and men of her class. This explains why, despite the existence of many studies about her, important questions about her life remain unanswered. For example, why does she appear at this historical juncture? Is she the product of a specific historical period? What is her class position? What is the reason for her adherence to the Bābī movement? What did Bābism offer women in temporal as well as spiritual domains that attracted her to this movement? Could her inclination be due to the fact that Bābī ideology, which placed emphasis on the esoteric dimensions of religion and the importance of intuition, created a space for women like her who could affirm their spiritual freedom and authority and extend it to their daily lives?

THE CONSTITUTIONAL REVOLUTION (1905–11)
Women's participation in the Constitutional Revolution revolved around opposition to the despotic rule of the Qājārs, the British and Russian colonial powers, and aspirations for national independence, as well as demands for gender equality, and especially equal citizenship. The role of women in the Constitutional Revolution has received the most attention from scholars in women's studies, who concentrate on women who became involved in political life. Considering Iran's semi-colonial situation and the British and Russian colonial aspirations in Iran at the time, their studies demonstrate the emancipatory aspects of nationalism and portray women's participation in revolutionary activities as positive.

Studies of women in the Constitutional Revolution mostly focus on the perspectives of well-to-do women in the cities. Concerns about the vote and the veil become dominant in these writings and the views of the majority of women from the

marginalized sections of cities, and from villages and tribal areas, for whom vote and veil were not the most pressing issues, are absent. This problem in part stems from the generalization by scholars of the position of upper- and middle-class women and is also the result of their reliance on state archives, that is, the parliamentary debates that revolved around issues relevant to these women. Scholarly works on these debates rarely make a critique of "modernity," that is, the interest of the elite male reformers in acquiring a "civilized image" and the cultivation of "civilized house-wives" (Jayawardena, 8), both of which were required for the creation of a "modern nation." Similarly, these studies do not question the way in which "racialized notions of national identity" were constructed, or how it became necessary for Iranian men to "learn manliness if they were to achieve enlightened reforms" (De Groot 1993, 257, 262). Moreover, these studies, written mainly from a political perspective, concentrate on the events of the Constitutional Revolution and not on the profound economic changes that had transformed Iranian society and women's lives in the nineteenth century and that led to the Constitutional Revolution.

PRIMARY SOURCES USED FOR WRITING ABOUT WOMEN IN THE QĀJĀR ERA

Autobiography. Amanat (1993) uses the auto-biography of Tāj al-Salṭana, the Qājār princess, along with a historical sketch and pictures from the Qājār era, to place her life in historical perspective. The autobiography is important because it represents the ideals of a woman from the upper classes. Tāj al-Salṭana's desire to embrace modernity, independence, and a "liberated life," however, were not the ideals of most women from villages, tribes, and less privileged parts of the cities who found their identity in their community and not through their individuality. In this account of Tāj al-Salṭana, the issues of "modernity," "identity," and "individuality" remain unproblematized. Vanzan (1990) uses Tāj al-Salṭana's autobiography as a "sociohistorical document," emphasizing its importancce in providing an account of women's lives and consequently a portrait of Persian society at the turn of the last century. Vanzan also uses the autobiography as a "reflection of the impact of Western ideas on Persian society." Here the issue of class remains mostly unexplored and the myth of the essential difference between the values of Western and Persian cultures remains unexamined.

Books on children's education. Najmabadi (1998) examines nineteenth-century books on the education of children, newspapers that deal with educational issues, and the traditional books on ethics, to demonstrate how modernity created a shift in the notions of "mother" and "wife" and offered both "emancipatory" and "disciplinary" regimes to women in the modern period.

Cartoons and drawings. Afary (1993, 1996) and Najmabadi (1998) use cartoons and drawings published in the Constitutional period newspapers to demonstrate the critique by intellectuals of gender inequality, masculinity, and trafficking of young girls, as well as the symbolic portrayal of "woman" as mother nation.

Ethics and manners treatises. Najmabadi (1992) uses the analysis of Maʿāyib al-Rijāl (Vices of men), a nineteenth-century manuscript, to demonstrate the relation between modernity and women's disciplined body and language.

Gazettes, newspapers and periodicals, parliamentary debates. Afary and Najmabadi use these sources, which address issues of veil, vote, illiteracy, education, seclusion, polygamy, and easy male divorce. They also demonstrate women's activism for the nationalist and Constitutionalist causes. Najmabadi (1998) also uses these sources to write about the trafficking of young girls and women among men in Iran at the turn of the nineteenth century.

Lampoon and burlesque treatises. The appearance of these manuscripts in the Qājār era demonstrates a shift in gender relationships from the Safavid era, with direct impact on the sexual arena. These "genitally centered" (Foucault 1990, 36) lampoons and burlesques were used for entertainment in the Qājār court and in elite men's gatherings (Fahid 1997).

Life stories and letters. Najmabadi (1996) uses letters, addresses, certifications of the ministry of education, orations, newspaper reports, reports to the ministry of education, proclamations, and statements to construct the lives of a vanguard mother and daughter of the Qājār era.

Missionaries' diaries, letters, memoirs, and reports. These documents are imbued with "civilizing mission," middle-class values of propriety, and the Orientalist gaze. The semi-colonial position of Iran and its consequent powerlessness in relation to Europe and the United States was essential in shaping missionary women's objective in "civilizing" the Iranian people. Scholarship is divided in its approach to these missions. Some scholars historicize the missions and analyze the way in which unequal power relations shaped them. Consequently they demonstrate their nega-

tive impacts. Francis-Dehqani (1999) and Naghibi (2002) choose such an approach. Other scholars, including Mansoori (1986) and Zirinsky (1992), view the work of the missionaries as positive, especially in the areas of education and medicine. As for people's reactions to missions, some scholars, such as Berberian (2000), demonstrate people's sentiment against them, and others, such as Ringer (2001), indicate that people chose "opposition, tolerance, [and] approbation" in different circumstances.

Paintings. Najmabadi (1998) uses paintings of the Qājār era to analyze the representation of gender as relations of power. Among them are the paintings of Shaykh-i Sanʿān and the Christian maiden. Najmabadi demonstrates the "double displacement" of the Christian "virgin girl" by the sexualized European woman and Christendom by Europe, which she maintains is a sign of "gender anxiety" and "national anxiety" during this period.

Pictures. Amanat (1993) uses pictures from the Qājār era to provide a visual account of the lives of women.

Sexual and medicinal prescriptive treatises. These manuscripts appear under the headings of the "Bah," "Bakhīa," and "khirqa." Even though they were written by men, their emphasis on women's sexual pleasure demonstrates women's influence in their content and direction (Fahid 1997).

Women's press. Rostam-Kolayi (2002) uses a woman's journal and the documents of the Board of Foreign Missions of the Presbyterian Church in the United States to demonstrate how women's press and missionary education created the "discourse of scientific domesticity" in early twentieth-century Iran.

THE USE OF SOURCES: PROBLEMS AND FUTURE DIRECTIONS

Scholars in women's studies have used these sources and applied new methods for rewriting Iranian history. An epistemological problem that appears in these writings is the essentialist approach. The categories of "veil," "vote," "Iranian nation," "Iranian women," "Islam," and "Muslim women" that came to symbolize the "essential difference" between Western and Iranian people in colonialist writings, are the ones that have been emphasized by most women's studies scholars, and also by the Constitutionalists, whose agenda was to oppose foreign domination. This is despite the fact that dominant cultural norms, such as veiling, were not the cultural practices of the majority of women in the villages and tribes at the time. The scholarship in general does not question the way in which nationalism became a "normalizing project" and how peoples' imaginations were "colonized" (Chatterjee 1993, 5), so that "'imported' models of the nation state" became "the" model for building a community. As a result, the "compulsory" (Zubaida 1989, 121) nature of the nation-state building, despite the fact that it was mediated by Iranian history and culture, and the negative consequences of nation building for women are not explored by women's studies scholars. Postcolonial feminist studies can offer important insights in this regard since they create spaces for contemplating questions such as: How did nation building became a compulsory project? How is nation building related to state building? How did the adaptation of Western nation-state models affect the idea of citizenship, and particularly women's citizenship? Were nation and state building beneficial or detrimental to women's lives? (Joseph 1999, 162–4).

The categories of "gender" and "woman" that are used for analysis become essentialized in many writings about women in this period. The category "woman," in most cases, is treated as a unitary category for a homogeneous group of women without reference to their class, region, tribe, ethnicity, and other similar factors. Moreover, the ahistorical treatment of the category "woman" and "gender" has led some women's studies scholars to the assumption that they are eternal notions that do not need to be historicized. Such approaches do not address the historical contingency of the categories "woman" and "gender."

"Cultural essentialism" (Narayan 2000, 80) is another problem in writings about women in nineteenth-century Iran. Some women's studies scholars assume an essential distinction between "Western" and "Iranian" or "Islamic" culture and the existence of progressive ideals in the former and their absence in the latter. Aspiration to gender equality and yearning for freedom in social arenas, as well as in the realms of religion and spirituality in Iranian history, are therefore attributed to the influence of Western ideas by these writers. Such studies fail to acknowledge the influence of many social, religious, spiritual, and mystical traditions before and during the nineteenth century, in which these aspirations played an important part in creating demands for gender equality. Those scholars of women's studies, however, who are familiar with the existence of visions of egalitarian relationship between the sexes and the prevalence of anti-orthodox sentiments in

Iranian history place such longings in the context of the history of conflict between the privileged and marginalized classes and focus on the long history of challenges by ʿurafāʾ (philosophers) to fuqahāʾ (jurists) in matters of religion and spirituality (Bayat-Philipp 1981, 47). These studies demonstrate that social and spiritual movements in Iran were not distinct and separate arenas and that yearnings for equality in the political, social, and economic realms were concomitant with desire for freedom in the religious and spiritual domains. And, most important of all, they affirm the fact that such ideas were not the product of Western imports to Iran but had roots in social and philosophical thinking in Iranian history.

Emphasis on the "essential differences" (Narayan 2000, 82) between Western and Iranian culture, moreover, has led some women's studies scholars to claims of both a particular Iranian cultural identity and a distinct gender identity. Certain features of Iranian culture prevalent during the Qājār era, such as the veil, or the architecture of a house, in terms of andarūnī (interior) and bīrūnī (exterior), has led these scholars to conclude that such features have created different psyches (that is, different from Western norms) in Iranian men and women. This approach ignores the fact that the creation of a contrasting portrayal of cultures was itself part of the colonial agenda. Nor do they account for the massive participation of women either in the Bābī movement or the Constitutional Revolution. Likewise, they do not deal with the question of how Iranian women took part in the Constitutional Revolution while wearing the veil, carrying arms under their veils, and living in andarūnī. It is important to note that even though an analysis of cultural particularities is important in understanding gender relationships and women's status, it is not culture alone that defines such relationships.

Another problem in the research on women in this period is literal readings of the manuscripts of the era. For example, male authors' emphasis on the necessity of women's obedience to their husbands is read solely as the manifestation of male dominance, rather than the resistance by women to men's authority that had created the need for such writings.

Research in many areas of women's lives during the nineteenth century remains scant. These include the state, economy, race/ethnicity, sexuality, and spirituality. The state, an important factor in the lives of women during the Qājār era, is the subject of only a few studies. The extensive and far-reaching changes that transformed the nature of the Iranian state and the lives of women and that promoted masculinity during this period remain largely unexplored.

Another important area that only rarely becomes the focus of study is the economy. The growth of capitalism and the global market economy, along with Iran's semi-colonial position vis-à-vis an expanding Europe, had far-reaching consequences for the Iranian economy and consequently the lives of women, and yet these issues do not occupy a central place in the scholarly work on women.

Race/ethnicity is also poorly studied. Even when ethnicities are studied, the impact of immense political and economic transformations that created deep-seated changes in women's lives remains unexamined. The state's promotion of a nationalist ideology through the belief in the homogeneity of a people and the belief in ethnicities or "culturally defined people" (Gailey and Patterson 1987, 8) transformed the lives of many women but the impact of these developments is scarcely reflected in women's studies research in this period.

Research on sexuality during the Qājār era is also scant. Like all other aspects of life this domain was also transformed during the Qājār period. Relations between men and women, including sexual relations, were transformed as a result of changes in other arenas (political, economical, social, and cultural/ideological).

Spiritual aspects of women's lives and the impact of the transformation in the arenas of cosmology and philosophy in the nineteenth century have seldom informed women's studies. In regard to spirituality, Qurrat al-ʿAyn remains almost the sole figure whose ideas are studied but even then studies are confined to Bābī ideology rather than the profound changes that had taken place in the spiritual, religious, and philosophical arena during the seventeenth, eighteenth, and nineteenth centuries from which Bābī ideology emerged.

These considerations, of course, need to go beyond religious and spiritual dimensions. Sectarian tendencies and philosophical orientations in Iran were not separate from the economic changes the country was undergoing. According to Ivanov (1939), Bābīs in essence projected the dissatisfaction of the "rising bourgeoisie," who wished to have more freedom to follow their own independent economic and spiritual path. Research on the class composition of Qurrat

al-ʿAyn and other Bābī women is essential to understand the relation between the secular and spiritual aspects of the movement and women's adherence to it.

Research on women in Qājār Iran would benefit from an approach that addresses the historic specificity of the relationship between the sexes, historicizes "woman" and "gender," and remains attentive to the intersections between class, race/ethnicity, gender, and sexuality. Such an approach not only historicizes Islam, but decenters it as well. Despite the limitations of the field, work on women and gender in the Qājār era has reshaped our understanding of history and signals a new era in the rewriting of Iranian history.

BIBLIOGRAPHY

PRIMARY SOURCES

Autobiography
Khātirāt-i Tāj al-Salṭana (Tāj al-Salṭana's memoirs), Central Library, Tehran University, MS no. 5741.

Cartoons and Drawings in journals
1906–7
Āẕarbāyjān, Mullā Naṣr al-Dīn, Vatan.

Children's Education
M. T. ibn-i Iskandar Mīrzā ibn-i ʿAbbās Mīrzā, *Educating children* [in Persian], Tehran 1300/1882 (lithograph).
T. Kāshānī, *Education. An essay on the rules of training and educating children* [in Persian], Isfahan 1299/1881, lithograph.
M. Māzandarānī ibn-i Zayn al-ʿĀbidīn (Miftāḥ al-Mulk), *Educating children* [in Persian], Tehran 1293/1875, lithograph.
M. ibn-i Yūsuf, *Educating children* [in Persian], Iran, 1300/1882, lithograph.

Endowment Documents
Vaqf Nāma-yi Zubayda Baygum va Sayyid Shujāʿ al-Dīn Iṣfahānī, Central Library, Tehran University, Microfilm no. 3231.
Vaqf Nāma-yi Zubayda Khānūm, Marʿashī Library, MS no. 3791.

Ethics and Manners Treatises
B. K. Astarābādī, Maʿāyib al-rijāl (Vices of men), Majles-i Shūra Library, MS no. 8984; Malek Library, MS no. 6297; Central Library, Tehran University, microfilm no. 2203 (copied from the manuscript at the Library of Ḥāfeẓ Farmāyān).
Taʾdīb al-nisvān (Educating women), Mellī Library, MS no. 7554.

Gazettes, Newspapers and Periodicals
1890s–1920s: Adab, ʿAdālat (formerly Hadīd), Ādamiyyat, Aʾīna-yi Ghaybnamā, Akhtar, Ālām-i Nisvān,

Anjuman, Āẕarbāyjān, Bahār, Bishārat, Dānish, Habl al-Matīn (Tehran and Calcutta), Irān-i Naw, Irānshahr, al-Jamāl, Kashkūl, Kāva, Maʿārif, Muḥākimāt, Majles, Makātib va Madāris, Maktūb-i Qafqāz, Mullā Naṣr al-Dīn, Musāvāt, Nāhīd, Nidā-yi Vatan, Parvarish, Qānūn, Rahbar-i Irān-i Naw, Rāhnamā, Rūh al-Qudus, Sitāra-yi Irān, Shafaq, Sharaf, Sharāfat, Shikūfa, Subh-i Ṣādiq, Sūr-i Isrāfil, Surayyā, Tarbiyyat, Tamaddun, Tūfān, Vaqayiʿ-i Ittifāqiyya, Vatan.
1908–11: *The Times* (London).

Idioms
Istilāhāt-i zanān-i Hamadān (The idioms of the women of Hamadān), Majles Library (Fīruz Collection), MS no. 57/3.

Lampoon and Burlesque Treatises
Dībācha-yi nuh sūrākhiyya (The preface to nine holes), Majles Library, MS no. 5066/5.
V. S. Gurjistānī, Risāla-yi fujūriyya (Treatise on debauchery), Mellī Library, MS no. 1425/F.
I. al-Qazvīnī, Kitābcha va Risālat al-Nisvān (The notebook and treatise on women), Majles Library, MS no. 582.

Life Stories and Letters
N. M. Mallāh, *Bībī Khānūm Astarābādī and Khānūm Afẓal Vazīrī. Pioneering Mother and Daughter for Women's Education and Rights in Iran*, comp. and ed. A. Najmabadi, Chicago 1996.

Marriage Contracts
F. Batmanglich, design, F. Adl and P. Shahvarani, photography, *Iranian wedding contracts of the nineteenth and twentieth centuries* [in Persian], Tehran 1355/1976.
ʿAqd Nāmcha, Central Library, Tehran University, MS no. 9874/6.
ʿAqd Nāma-yi Nikāh, Central Library, Tehran University, MS no. 8959/5.
ʿAqd Nāma-yi Zafraʾī, Qabāla-yi Izdivāj-i Muḥammad ʿAlī-i Zafraʾī ba Habība Dukhtar-i Muḥammad ʿAlī Rajāʾ-i Zafraʾī, Mellī Library, MS no. 2794.

Missionaries' diaries, letters, memoirs, and reports
Board of Foreign Missions of the Presbyterian Church in the U.S.A., *A century of mission work in Iran, 1834–1934*, Beirut 1936.
M. Y. Holliday, 1883–1920, Letters, Smith Library, Indiana Historical Society.
M. W. Park (Jordon), 1898–1941, Presbyterian Historical Society, Philadelphia.
S. B. Sherwood (Hawkes), 1882–1919, Letters, Presbyterian Historical Society, Philadelphia.
A. W. Stocking (Boyce), 1906–49, Presbyterian Historical Society, Philadelphia.

Parliamentary Debates
Muzākirāt-i Majlis (Parliamentary debates), 1906–11.

Pictures
Bīutat (Royal Collection), Central Library, Tehran University, File no. 6884.

Bīūtat (Royal Collection), Central Library, Tehran University, File no. 7024.

Pilgrimage accounts

Safarnāma-yi Makka, az hamrāhān-i Zīa' al-Salṭana dukhtar-i sivvūm-i Nāṣir al-Dīn Shāh (The Meccan travel account of one of the companions of Zīa' al-Salṭana, the third daughter of Nāṣir al-Dīn Shāh), Malek Library, MS no. 3732.

Safarnāma-yi Makka-yi Shāhzāda Khanūm dukhtar-i Mu'tamid al-Dawla Farhād Mīrzā, hamsar-i Nāṣir al-Dawla az tarīkh-i 1297 ta 1298 (The Meccan pilgrimage of the princess, the daughter of Mu'tamid al-Dawla Farhād Mīrzā, the wife of Nāṣir al-Dawla, 1879–80), Majles-i Sena Library, MS no. 1225.

Sexual and medicinal prescriptive treatises

Favā'id-i Bahīa (The Benefits of Bahīa), Mellī Library, MS no. 1171/F.

Khirqa-yi Murtizā Bayk-i Shāmlū (Murtizā Bayk-i Shāmlū's *Khirqa*), Mara'shī Library, MS no. 7409.

Risāla-yi Bakhīa (Bakhīa treatise), Central Library, Tehran University, MS no. 3157/9.

Travel Accounts

F. A. C. Forbes-Leith, *Checkmate. Fighting tradition in Central Persia*, New York 1927, 180–93.

M. E. Hume-Griffith, *Behind the veil in Persia and Turkish Arabia. An account of an Englishwoman's eight years' residence amongst the women of the East*, London 1909.

T. Laurie (Rev.), *Dr. Grant and the mountain Nestorians*, Boston 1853.

——, *Woman and her saviour in Persia. By a returned missionary*, Boston 1863.

E. de Lorey and D. Sladen, *Queer things about Persia*, London 1970.

J. Perkins (Rev.), *A residence of eight years in Persia, among the Nestorian Christians. With notices of the Muhammedans*, Andover, Mass. 1843.

——, *Historical sketch of the mission to the Nestorians*, Boston 1866.

I. Pfeiffer, Persia, in I. Pfeiffer, *A woman's journey round the world. From Vienna to Brazil, Chili, Tahiti, China, Hindostan, Persia and Asia Minor*, London 1852, 271–90.

C. C. Rice, *Persian women and their ways*, London 1923.

L. Sheil, *Glimpses of life and manners in Persia*, London 1856.

E. C. Sykes, The Persian woman, in E. C. Sykes, *Persia and its people*, London 1910, 196–209.

——, Persia, in T. A. Joyce and N. W. Thomas (eds.), *Women of all nations. A record of their characteristics, habits, manners, customs, and influence*, iv, New York, 1915, 633–45.

C. J. Wills, *Behind an Eastern veil. A plain tale of events occurring in the experience of a lady who had a unique opportunity of observing the inner life of the ladies of the upper class in Persia*, Edinburgh 1894.

J. B. Yohannan, *Woman in the Orient*, St. Louis, 1901.

I. M. Yonan (Rev.), *Persian women. A sketch of woman's life from t he cradle to the grave, and missionary work among them, with illustrations*, Nashville, Tenn., 1898.

SECONDARY SOURCES

J. Afary, On the origins of feminism in early twentieth-century Iran, in *Journal of Women's History* 1:2 (Fall 1989), 65–87.

J. Afary, comp., A. Sadat, trans., Cartoons from Mullā Naṣr al-Dīn's periodical, 1906 [in Persian], in *Nīmeye-Dīgar* 17 (Winter 1993), 86–95.

J. Afary, The women's council and the origins of the women's movement in Iran, in J. Afary, *The Iranian Constitutional Revolution, 1906–1911. Grassroots democracy, and the origins of feminism*, New York 1996, 177–208.

A. Amanat, Qurrat al-'Ayn. The remover of the veil, in A. Amanat, *Resurrection and renewal. The making of the Babi Movement in Iran, 1844–1850*, Ithaca, N.Y. 1989, 295–331.

Q. Amin, *The liberation of women*, trans. S. S. Peterson, Cairo 1992; trans Y. Ashtiani as *E'tisām al-Mulk* (Educating women), Tabriz 1900.

E. L. Anderson, Qurratu'l-Ayn Tahirih: A study in transformational leadership, Ph.D. diss., United States International University 1992.

B. K. Astarābādī, *Vices of men* [in Persian], ed. A. Najmabadi, Chicago 1992.

G. Audibert, trans., *La femme persane, jugée et critiquée par un Persan* (a translation of *Ta'dīb al-Nisvān*), Paris 1889.

M. Bayat-Philipp, Women and revolution in Iran, 1905–1911, in N. R. Keddie and L. Beck (eds.), *Women in the Muslim world*, Cambridge 1978, 295–308.

——, Tradition and change in Iranian socio-religious thought, in M. E. Bonine and N. R. Keddie (eds.), *Modern Iran. The dialectics of continuity and change*, Albany, N.Y. 1981, 35–56.

H. Berberian, Armenian women in turn of the century Iran. Education and activism, in R. Matthee and B. Baron (eds.), *Iran and beyond. Essays in Middle Eastern history in honor of N. R. Keddie*, Costa Mesa, Calif. 2000, 70–98.

J. De Groot, The dialectics of gender. Women, men and political discourses in Iran c. 1890–1930, in *Gender and History* 5:2 (1993), 256–68.

S. Fahid, Gender and power in Safavid and Qajar Iran, Ph.D. diss., Temple University, Philadelphia 1997.

G. E. Francis-Dehqani, Religious feminism in an age of empire. CMS women missionaries in Iran, 1869–1934, Ph.D. thesis, University of Bristol, U.K. 1999.

S. Mahdavi, Women and ideas in Qajar Iran, in *Asian and African Studies* 19 (1985), 187–97.

——, Taj al-Saltaneh. An emancipated Qajar princess, in *Middle Eastern Studies* 23:2 (April 1987), 188–93.

——, Women, ideas and customs in Qajar Iran, in M. Marashi (ed.), *Persian studies in North America. Studies in honor of Mohammad Ali Jazaery*, Bethesda, Md. 1994, 373–93.

H. Mahmoudi, Tahira. An early Iranian "feminist," in A. Fathi (ed.), *Women and the family in Iran*, Leiden 1985, 79–85.

A. Mansoori, American missionaries in Iran, 1834–1934, Ph.D. diss., Ball State University, Indiana 1986.

E. Powys Mathers, trans., *Ta'dīb al-Nisvān* (The education of wives), in E. Powys Mathers, *Eastern love*, vol. 3, London 1927.

S. Mazumdar, Societal values and architecture. A sociophysical model of the interrelationships, in *Journal of Architectural and Planning Research* 11:1 (1994), 66–90.

F. Milani, Becoming a presence. Tahereh Qorratol 'Ayn, in F. Milani, *Veils and words. The emerging voices of Iranian women writers*, Syracuse, N.Y. 1992, 77–99.

N. Mottahedeh, Representing the unpresentable. Historical images of reform from the Qajars to the Islamic Republic of Iran, Ph.D. diss., University of Minnesota 1998.

——, The mutilated body of the modern nation. Qurrat al-'Ayn Tahirah's unveiling and the Iranian massacre of the Babis, in *Comparative Studies of South Asia, Africa, and the Middle East* 18:2 (1998), 38–50.

N. Naghibi, Lifting the veil on global sisters. Contesting imperialist models of feminism for comtemporary Iran, Ph.D. diss., University of Alberta, Canada 2002.

A. Najmabadi, A different voice. Taj os-Saltaneh, in A. Najmabadi (ed.), *Women's autobiographies in contemporary Iran*, Cambridge, Mass. 1990, 17–31.

——, Veiled discourse – unveiled bodies, in *Feminist Studies* 19:3 (Fall 1993), 487–518.

——, Zanha-yi millat. Women or wives of the nation? in *Iranian Studies* 26:1–2 (Winter-Spring 1993), 51–72.

——, "Is our name remembered?" Writing the history of Iranian constitutionalism as if women and gender mattered, in *Iranian Studies* 29:1–2 (Winter-Spring 1996), 85–109.

——, Crafting an educated housewife in Iran, in L. Abu-Lughod (ed.), *Remaking women. Feminism and modernity in the Middle East*, Princeton, N.J. 1998, 91–125.

——, Reading for gender through Qajar painting, in L. S. Diba and M. Ekhtiar (eds.), *Royal Persian paintings. The Qājār epoch, 1785–1925*, New York 1998, 76–85.

——, The story of the daughters of Quchan. Gender and national memory in Iranian history, Syracuse, N.Y. 1998.

M. M. Ringer, Missionary and foreign schools in Iran, 1830–1906, in M. M. Ringer, *Education, religion, and the discourse of cultural reform in Qajar Iran*, Costa Mesa 2001, 109–137.

J. K. Rostam-Kolayi, Foreing education. The women's press and the discourse of scientific domesticity in early twentieth-century Iran, in N. R. Keddie and R. Matthee (eds.), *Iran and the surrounding world. Interactions in culture and cultural politics*, Seattle 2002, 182–202.

S. M. Ṣadr Hashīmī (ed.), *Parliamentary debates* [in Persian], 2 vols., Tehran 1946.

Z. Taheri Haghigi, The depiction of women in Persian ethical texts, Ph.D. diss., University of California, Berkeley 1996.

Taj al-Salṭana, *Crowning anguish. Memoirs of a Persian princess from the harem to modernity*, ed. A. Amanat, Washington, D.C. 1993.

A. Vanzan, Studies on the "Khaterat" by Taj As-Saltane, a Qajar princess, Ph.D. Diss., New York University 1990.

M. Zirinsky, Harbingers of change. Presbyterian women in Iran, 1883–1949, in *American Presbyterians' Journal of Presbyterian History* 70:3 (1992), 173–86.

OTHER SOURCES CITED IN THE TEXT

W. L. Adamson, *Hegemony and revolution. A study of Antonio Gramsci's political and cultural theory*, Berkeley 1980.

P. Chatterjee, *The nation and its fragments. Colonial and postcolonial histories*, Princeton, N.J. 1993.

M. Foucault, *The history of sexuality. An introduction*, vol. 1, New York 1990.

C. Gailey and T. Patterson, Power relations and state formation, in C. Gailey and T. Patterson (eds.), *Power and state formation*, Washington, D.C. 1987, 1–26.

M. S. Ivanov, *Babiskie Vosstaniya v Irane (1848–1852)*, Moscow 1939.

K. Jayawardena, *Feminism and nationalism in the Third World*, London 1986.

S. Joseph, Women between nation and state in Lebanon, in C. Kaplan, N. Alarcon, and M. Moallem (eds.), *Between woman and nation. Nationalism, transnational feminisms and the state*, Durham, N.C. 1999, 162–81.

U. Narayan, Essence of culture and a sense of history. A feminist critique of cultural essentialism, in U. Narayan and S. Harding (eds.), *Decentering the center. Philosophy of a multicultural, postcolonial, and feminist world*, Bloomington, Ind. 2000, 80–100.

S. Zubaida, *Islam, the people and the state. Essays on political ideas and movements in the Middle East*, London 1989.

SIMA FAHID

South Asia: Mid-18th to Early 20th Century

The history of Muslim women in South Asia from the eighteenth to the twentieth centuries presents problems of both sources and interpretation. In South Asia as elsewhere, this was a period of rapid political and social change. With the collapse of the Mughal Empire and the rise of the British, the fate of Muslims in this part of the world was particularly implicated in the change of regime, and their sense of loss of power and cultural decline was thus acute. The British administration bolstered its power and sense of civilizing mission with an ideology that criticized past Muslim rulers as despotic. Christian missionaries added the message, directed at both Hindus and Muslims in India, that their treatment of women was inhumane (T. R. Metcalf 1994, Forbes 1996).

For reasons that had much to do with cultural self-respect, therefore, Indian interpretations of the precolonial past tended to romanticize or glorify that past as a golden age when kings, though mighty, were just, and women, though secluded, were educated and enjoyed considerable power within the household. At the same time, it was clear to leading Indo-Muslim intellectuals and reformers that something had gone wrong, otherwise the Mughals and their Muslim successor states would not have lost power to the British, and Muslim society – and the women along with it – would not have fallen on hard times. Colonial histories and Indian responses to them need to be read with caution, for women in these discourses are symbolic of either what was wrong with Indian and Indo-Muslim civilization, or what was worthy of defense and preservation (B. D. Metcalf 1994, Minault 1998a). Out of this ideological debate emerged an extensive literature of religious and social reform that led ultimately to anti-colonial political movements. Women were both objects of these debates and movements as well as actors in their own right. Understanding the history of real women in the discursive tangle of colonial and anti-colonial ideologies is necessarily problematic.

MUSLIM WOMEN IN THE TRANSITION TO COLONIAL RULE IN SOUTH ASIA: SOURCES, RESEARCH TOPICS, AND METHODS

Most recent research into the history of Muslim women in South Asia has concentrated on the colonial and nationalist periods in the nineteenth and twentieth centuries, which will be discussed below. Uncovering the history of Muslim women in the precolonial period is more difficult, for the scholar is faced with a paucity of sources for all but the literate few. Further, the private or domestic life of Indo-Muslim families – whether of princes, administrators, minor gentry, or divines – is seldom seen in histories written by Muslim chroniclers or by European observers, and hence even literate women seldom appear. Still, as Leslie Peirce has argued for the Ottoman Empire, one cannot assume that only public power mattered, for women exercised power over male behavior in the private domain and thus influenced the public domain as well (Peirce 1993, Kozlowski 1998). One must be constantly aware, therefore, of the interdependence and permeability of the public and private realms in order to assess the roles of women in Indo-Muslim society. On the other hand, one also has to contend with an attitude toward harem politics, whether on the part of European commentators or of Muslim social and religious reformers, that exaggerates the negative and sees the harem as only a baleful and weakening influence.

European travelers, merchants, and missionaries commented on women whom they saw in the streets and marketplaces of India, but also on the fact that they occasionally had to do business in port cities or rural districts where elite women were revenue holders. Comments by East India Company officials on the sinuousness of harem politics – though negative – indicate that women in princely and high administrative families had both political and economic leverage. The records of the British East India Company, part of the India Office Archives now housed in the British Library in London, contain voluminous references to British dealings with Indian powers, most extensive after the mid-eighteenth century. The same library houses an extensive collection of European manuscripts, the private papers of great and lesser officials that contain vast, often untapped resources. Other private collections of papers can be found in Oxford and Cambridge and other university libraries throughout the United Kingdom, and in the Scottish Records Office in Edinburgh. The National Archives of India in New Delhi and

state archives in Lucknow, Calcutta, and Hyderabad also contain extensive documentation on the early years of British-Indian relations. Similarly, the Dutch East India Company (VOC) archives in the Hague contain documentation concerning Dutch trade in the Indian Ocean region. Dutch trade was concentrated in what is today Indonesia, but the Dutch also had trading ports in India that gave them access to Indian society.

As the British gradually established their rule in India in the late eighteenth century, and the East India Company transformed itself from a trading concern into a government, British officials increasingly took note of instances of Indian injustice toward women. The custom of *sati*, or the burning of Hindu widows on the funeral pyres of their husbands, became an issue, as did Muslim purdah and polygamy. The British hesitated to abolish customs that were religiously sanctioned, but made an exception in the case of *sati* in 1829, after an eloquent advocacy of its abolition by the Bengali reformer, Ram Mohan Roy. The vulnerability of Indian women, and their protection against such customs, became part of the British ideology of empire – the civilizing mission that provided justification for the expansion and continuation of British rule (Mani 1998, T. R. Metcalf 1994).

Less noticeable in British imperial histories arc instances where women wielded power effectively, though ultimately losing out to the foreign rulers along with their male counterparts. The impeachment of Warren Hastings, the first governor-general of British India, was brought about in large measure because of his dealings with the Begams of Awadh, whose revenues he was accused of plundering in the 1770s. The Begams were the power behind the throne of the Nawabs of Awadh, a kingdom that maintained an increasingly precarious independence from the British until 1856. Though Hastings was ultimately acquitted, his policies toward the Begams of Awadh show that women were players in the power conflicts of eighteenth-century India as the British sought to advance their rule (Barnett 1998, Fisher 1998). Subsequently, one of the leaders of the revolt of 1857 that shook the foundations of British rule in India was the Rani of Jhansi, who led her troops in battle. The Rani, a Hindu princess, was defeated, but she became a symbol of Indian resistance for later nationalists (Lebra-Chapman 1986).

More successful were four generations of Begams who ruled the small central Indian state of Bhopal in the nineteenth and early twentieth centuries. Educated themselves, the women of this Muslim dynasty patronized education for Muslim girls throughout India. The Begams of Bhopal left memoirs, travel accounts, speeches, and other writings, as well as state archives that have been the subject of some recent scholarship (Minault 1998a, Preckel 2000, Lambert-Hurley 1998). The Begams, as "princes," were members of an Indian ruling class that has been stereotyped as lapdogs of the British. The Begams of Bhopal, however, defied the princely stereotype in a number of ways, not only as women, but also in their subtle resistance to British dominance. The last of the line, Sultan Jahan Begam (r. 1901–26), left purdah and supported the All-India Women's Conference (AIWC), an organization for social and educational reform that was supportive of Indian nationalism.

Indian women influenced the lives of early British administrators in India in more intimate ways as well. The topic of intermarriage has been relatively ignored until recently. Percival Spear, in *The Nabobs*, noted that British merchants and officials in India before the nineteenth century often had Indian wives or concubines. This situation changed gradually as British power grew and as improved transportation during the course of the nineteenth century made it possible to bring European wives to India. The usual accounts of official society in India describe British families in exile, but the history of the Indian women partners of earlier European merchants, officials, and freebooters and their Eurasian families is just beginning to be explored. The sources in the records of the East India Company and in private manuscript collections are abundant, and the cases of such blended families provide a fascinating counterpoint to the usual official story (Ghose 2000, Dalrymple 2002).

Begam Samru, the Indian widow of a German adventurer, maintained a mansion in Delhi that was frequented by the British. General Sir David Ochterlony, one of the earliest British residents at the Mughal court in Delhi, had at least one Muslim wife who inherited his property. British officials in the late eighteenth century, such as General William Palmer, William Linnaeus Gardner, and James Achilles Kirkpatrick, all married Muslim women who were members of noble families. These marriages provided the Englishmen with a heightened understanding of local politics and culture, as well as possible conflicts of interest in dealings with Indian states while serving as representatives of British power (Dalrymple 2002). Maharaja Ranjit Singh of the Punjab hired a number of ex-Napoleonic officers to command his Sikh armies and insisted that they marry local women as a way of cementing their loyalty to him (Lafont 2000,

205–49). Travel narratives by European men and women, in addition to private correspondence and colonial archives, yield many such instances of intermarriage that pose a challenge to the image of European social isolation in India.

An interesting example of the marriage of a European woman to an Indian man is that of Mrs. Meer Hassan Ali, who lived in Avadh in the 1820s and left a two-volume account of this experience, *Observations on the Mussulmauns of India*. Fanny Parks, the intrepid wife of a British official at about the same time, produced a delightful narrative, *Wanderings of a Pilgrim in Search of the Picturesque*, that included visits with several of these blended families. It is clear that social relations between Indians and Europeans in the early stages of empire were more open than they became later, when the increasing differentiation brought about by changing power relations and ideas of racial prestige got in the way of cross-cultural attraction.

In most of these examples of Muslim women from the early colonial era, women appear in the records as players in power relations thanks to their marriage ties, and as members of society described and dominated by men. The few exceptions confirm the rule, but complicate the picture nevertheless. The voices of women in the historical record are rare, but where they appear, in private letters or in poetic expression, they testify to the fact that there was a tradition of literacy among women in high families. The courtesan milieu also produced literate women. A notable female poet was Mahlaqa Bai Chanda (1767–1824), a courtesan of Hyderabad who wrote in Dakhani Urdu (Tharu and Lalita 1991, i, 120–2). Courtesans, as trained poets and musicians, played an important role as transmitters of culture to their noble clientele, but they also controlled property and thus had a certain economic autonomy (Oldenburg 1991).

From the company of courtesans of Lucknow and Delhi in the early nineteenth century a form of Urdu poetry emerged called *rekhti* that expressed women's emotions in women's language, although it was the work of male poets. Though disparaged by critics because it was written in women's idiom, *rekhti* was more explicit in portraying emotions and in expressing desire (Petievich 2001). Sufi devotional poetry also frequently portrays the devotee (whether male or female) in feminine terms (Abbas forthcoming). One can argue that part of the appeal of Urdu poetry is its ambiguity of gender and subject that permits the portrayal of carnal desire in a society where relations between the sexes are tightly controlled, and of mystical desire in a religion where God is transcendent

(Russell 1969). Subversive emotion, mystical faith, and even political opposition can be expressed in Urdu lyrical metaphors. Perhaps *rekhti* was disparaged because it was not ambiguous enough. In any case, women poets, women's language, and the extent to which female idioms differ from the dominant male forms of expression are all subjects that deserve greater study (Minault 1994).

MUSLIM WOMEN IN COLONIAL SOUTH ASIA: SOURCES AND RESEARCH STRATEGIES

Studying Muslim women in British India involves similar problems, the paucity of sources for all but the literate, the dominance of male voices, the need to read between the lines of texts and to ask new questions of old materials, but also to constantly search for new sources representative of female and non-elite voices that become more numerous in modern times. The ideological discourses outlined above continue to be relevant, but so does a growing nationalistic discourse, both of Indian nationalism that subsumes Muslim identity, and a separatist Muslim nationalism that asserts Islamic distinctiveness. Both nationalisms seek to define women's identities and roles in terms of their own ideologies. Women sometimes play along and at other times assert their own ideas and priorities. Women remain symbolic both of everything that is wrong with society, and of everything that men want their society to be, but women's emerging voices add to the discursive cacophony.

Strategies for studying Indian Muslim women in their historical context include the one outlined above that considered women as an issue in the colonial encounter of cultures in the nineteenth century. Foreign impressions of Indian customs concerning women, from *sati* to veiling, form part of a pattern of cultural criticism of India, designed to justify British assumption of power and to convert Indians to their "civilizing mission." Indian responses ranged from rejection to collaboration, with most falling somewhere in between. In analyzing this colonial encounter, the historian must guard against the assumption that Western culture is the agent of change and Indian tradition the inert matter, the limitation to change. Indigenous and precolonial sources and motivations for social and cultural change are constantly in play, complicating the story. The process of interaction between the colonial and the indigenous is a continuous one involving negotiation, translation, and naturalization.

One of the parties to this process of negotiation is an indigenous middle class, a group that represents continuity with precolonial Indian society.

The Indian middle class, whether Hindu or Muslim, emerged from social groups whose traditional statuses predisposed them to contact with outsiders or government: the literate, scribal, and commercial castes among Hindus, and Muslim groups who had served the Mughal state as military, civil, or religious functionaries. These latter were not the most powerful nobles or *nawab*s, but rather minor service gentry remunerated by revenue assignments, often associated with administrative centers and market towns (Bayly 1988).

The Indian Muslim middle class in the nineteenth century had fewer resources than their ancestors who had served the Mughals, but they saw themselves as part of a continuum involving high status. Maintaining that status meant husbanding scarce resources while retaining literary and religious culture and advancing their professional position. Consequently, women's roles in the household economy and as transmitters of culture were increasingly matters of concern. One marker of respectable status was education. That women lacked it became a constant theme in the writings of male reformers. Women were backward, unable to provide intelligent companionship to their husbands or discipline to their sons. Not only that, but they were ignorant of the basic tenets of their faith, and tied to wasteful customs and household rituals. If the *nawabi* lifestyle had squandered resources, so too did the *zenana*, or women's quarters. Control over women's behavior was thus an essential aspect of the reformers' programs, whether educational, religious, or economic.

The paradigmatic Muslim reformer for whom women were symbolic of his community's decline was Sir Sayyid Ahmad Khan (1817–98), the founder in 1875 of Aligarh College, the first institution in India to combine English education with Islamic religious instruction for the sons of the Muslim middle class (Lelyveld 1978). Sir Sayyid was no champion of women's education, for men's education was his top priority. He felt, as did most men at that time, that women were physically and mentally inferior to men.

In a memoir about his family, however, Sir Sayyid reminisced about his mother, who was educated at home, knew Arabic and Persian, and had been a tremendous influence on his own love of learning. In some of his other writings, he also reflected on the custom of purdah, as it was practiced in India. He felt it had been carried to extremes, and this was the cause of women's isolation and ignorance. In the great days of Islam, he said, women had been educated. They could inherit property and had to be able to manage it.

Hence, they needed to know not only the scriptures, but also how to write and figure. With the decline of Islamic civilization, the status and rights of women had also declined. With the reform of the Muslim community as a whole, women too would benefit. This patriarchal model of reform was standard for his day (Minault 1998a, 14–19).

A number of Sir Sayyid's disciples at Aligarh went further than he in advocating programs of improvement for women. Alṭāf Ḥusayn Ḥālī (1837–1914) created *Majālis al-nisā* (Assemblies of women), discourses on women's education and its benefits for child-rearing and overall social improvement (Minault 1986). The didactic novels of Nazīr Aḥmad (1830–1912) such as *Mir'āt al-'arūs* (The bride's mirror) provided models of women, educated at home, who were pious, frugal, and superb managers, without ever leaving the confines of purdah (Ahmad 2001, Minault 1998a, 31–55).

The *'ulamā* also joined the debate. North India produced a school of reformist *'ulamā* in the late nineteenth century, the Deoband *madrasa*, founded in 1867. These reformers sought to improve the quality of Islamic education, to increase personal piety, and to spread the observance of Islamic law more broadly in the lives of Muslims in India. The Deoband *'ulamā* sought to Islamicize women's religious observances and so attacked many customary rituals. The *'ulamā* advocated these reforms in the interests of a return to a pristine form of Islam. The Aligarh school may have had a different motivation, but the attack on custom was the same. Many of the customs decried by the *'ulamā* were "un-Islamic" but many more were simply wasteful. For example, musical entertainment and excessive gift giving at weddings were characteristics of a worldly lifestyle, and hence were inappropriate in a modest, pious home. The leading Deobandi work for women was the tome, *Bihisti Zewar* (Heavenly ornaments), by Mawlana Ashraf 'Ali Thānawī (1864–1943). This book is a veritable encyclopedia of religious and family law, household management, Islamic medicine, and biographies of the pious women of early Islam. It also saw women's practice of wasteful and un-Islamic customs as the source as well as the symbol of Islamic decline (B. D. Metcalf 1990). This volume was a standard item in many Muslim brides' dowries for several generations.

Bihishti Zewar, *Majālis al-nisā*, other textbooks and guides, and the social novels of Nazīr Aḥmad are examples of the improving literature for women written by men in the late nineteenth and early twentieth centuries. As accounts of the

way things were in Muslim homes, all these sources should be used with caution, for obvious reasons. Writing the history of women's lives from either normative or descriptive works by men is akin to writing the history of nationalist movements using only the accounts of colonial administrators. On the other hand, as evidence of changing norms, or as accounts of the practice of customs and rituals that the reformers disliked, these works are invaluable.

The strategy of viewing women as symbols of men's ideological debates needs to be joined to a second strategy: that of regarding women as the objects of men's programs of reform, as students of schools, as readers of improving literature, and as subscribers to magazines designed to disseminate new knowledge. This strategy yields a wealth of sources, from the articulation of programs and policies for the founding of schools, to speeches delivered to associations for social and political action. Plans for curricula deemed appropriate for women included debates over how to preserve cultural continuity while meeting the challenges of modern society. Many writings about and programs for women's education and social reform draw upon Islamic intellectual traditions, Muslim patterns of religious controversy, and traditional networks of relationship, discipleship, and patronage. At the same time, even the most religiously minded of reformers are not reluctant to adopt organizational forms and printing technologies from the West (B. D. Metcalf 1982). Schools as corporate entities, *anjuman*s (associations) to advance specific social and educational goals, polemical tracts and pamphlets, learned journals, and newspapers are all parts of the reformers' stock in trade. So too is the production of literature suitable for women readers: social novels, short stories, verse, and especially women's magazines, containing useful knowledge about such topics as household management, child care, and nutrition. Though founded or managed by men, most of the magazines encourage women to contribute.

The India Office Archives in the British Library in London, the National Archives of India in New Delhi, the National Archives of Pakistan, and local and state archives can yield documents pertaining to education, as well as some journals and newspapers, but more important for locating these sources are college and public libraries. Aligarh University Library, Isabella Thoburn College in Lucknow, the Punjab Public Library Oriental Section in Lahore, the Library of the Deoband Madrasa, Osmania University Library, the Idarah-i-Adabiyat-i-Urdu, and the Urdu Research Centre in Hyderabad, and the Nehru Memorial Museum in New Delhi with its superb collection of newspapers, personal manuscripts, and oral histories all have printed books, periodicals, and the collected writings and speeches of some of the principal figures. Haunting the second-hand book bazaars can also yield some finds. Social and educational reform organizations such as the Muslim Educational Conference, with its collected papers in Aligarh, or the Anjuman-i-Himayat-i-Islam, with its journal and proceedings housed in the Research Society of Pakistan in Lahore, and the Anjuman-i-Taraqqi-i-Urdu collection in Karachi also reward the patience of the researcher.

The strategies that involve studying women through the eyes and in the writings of men, however, cannot tell the whole story. Woman, whether seen as a symbol, an issue, or an object, is a passive and abstract figure in those sources. Another strategy is necessary in order to discern the views of Muslim women concerning their family relations, religion, education, purdah, and the changes taking place in their lives. Sources for this inquiry are even harder to find for Muslim women in India than for Hindu women (cf. Karlekar 1991). One has to read creatively between the lines of men's accounts, or seek out women's oral accounts using techniques derived from cultural anthropology, or analyze women's writings when they begin to appear in the late nineteenth and early twentieth centuries in a growing number of Urdu magazines for women. These magazines yield the richest materials for the analysis of Muslim women's views, along with autobiographical writings, short stories, and novels by women that start to appear in the same period, encouraged in no small measure by the proliferating women's magazines (Minault 1998b).

It is not easy to find these periodicals, however. Major libraries and collections, while they saved newspapers and literary journals, seldom saved women's magazines. Families who subscribed threw them out or sold them as waste paper after a time. The standard histories of Urdu literature (Sadiq 1984, Suhrawardy 1945) barely mention them. Some university and women's college libraries contain runs of the better known, or more literary, of the women's journals. Most important are the collections of the Aligarh Women's College, and the Urdu Research Centre in Hyderabad. The descendants of the founding editors of some journals are helpful when they can be found, as are private collectors and second-hand Urdu book dealers. These periodicals are invaluable sources for social movements, ideas, lifestyles, and creative

writings of women, and for trends in the social history of their time. Along with etiquette books, cookbooks, and various types of "how-to" manuals, they constitute a vision of everyday reality that is hard to duplicate in other literary forms.

Women's magazines were usually classified as either educational or literary, but most were a mixture of: (1) practical information about health, child care, and nutrition, along with recipes and embroidery patterns; (2) news about schools for girls, women's associations, and women in other countries; and (3) creative writing – short stories, serialized novels, and poetry on themes deemed suitable for female readers. Other types of articles might include arguments for or against certain social and educational reforms, discussion of customs deemed useless and wasteful, of women's rights in Islamic law, and letters from readers offering opinions and asking for information or advice.

Emerging women's magazines in Urdu stressed enlightened domesticity and respectability, but also practical knowledge to cope with the changing times. Unlike similar publications in the West, however, these Indian women's magazines did not stress consumption of new products and household conveniences, nor was fashion much of an issue. There were heated discussions of purdah – its necessity or not, various degrees of its observance, and so on – and as the nationalist movement spread, discussions of simplified dress, spinning, and *swadeshi* (home-made cloth), but fashion sketches appeared rarely, if at all. The covers might feature line drawings in addition to calligraphy, and most illustrations were also hand-drawn. Photographs did appear in some of the glossier magazines beginning in about the 1930s, and provide some of the only available portraits of early women writers.

Also in contrast to Western women's magazines, the accent in Indian women's magazines was upon breaking down women's mental isolation rather than glorifying their separate sphere. The interdependence of the home and the world was emphasized, particularly as the twentieth century brought new challenges, the spread of education, the development of nationalist politics, and the emergence of debates over legal rights and suffrage. After the collapse of the Khilafat-Noncooperation movement in the 1920s that had seen unprecedented women's involvement in nonviolent nationalist demonstrations, discussions of women's rights in Islam became an issue that mirrored, or was a surrogate for, concerns about Muslim rights in the emerging Indian polity. Women's magazines focused on the domestic lives of women, but they indirectly reflected the social and public concerns of men.

The pioneers in Urdu journalism for women were men: Mumtaz 'Ali, who founded the first Urdu newspaper for women, *Tahzib un-Niswan*, in Lahore in 1898 in partnership with his wife, Muhammadi Begam; Shaykh 'Abdullah, who established the monthly educational journal, *Khatun*, in Aligarh in 1904, also with the participation of his wife, Wahid Jahan; and Rashidul Khairi, a prolific novelist who founded the literary monthly, *'Ismat*, in Delhi in 1908. These three were the major early women's periodicals in Urdu, two of them lasting until after independence. They were joined by many others as the years went by, in Bhopal, Hyderabad, Lahore, Lucknow, and elsewhere – some of them edited by women.

Sayyid Mumtaz 'Ali (1860–1935) came from a family of Islamic scholars and minor government officials. He was the author of *Huquq un-Niswan*, a reforming treatise on women's rights in Islam. His best-known venture, however, was *Tahzib un-Niswan*, the women's weekly newspaper edited by his wife, Muhammadi Begam (1878?–1908). She was also a prolific author of novels, poetry, housekeeping manuals, cookbooks, and a guide to etiquette, in addition to articles, written in a down-to-earth style that appealed to a newly literate readership. Her articles in *Tahzib* discussed education, housekeeping, and child care, gave recipes, advice to the young daughter-in-law on how to get along with her mother-in-law, and tips on etiquette (Minault 1992).

After Muhammadi's untimely death in 1908, the paper continued under Mumtaz 'Ali's direction, always with a woman as editor. The content reflected women's growing levels of education and variety of activities outside their homes. The style, still conversational, became more complex; vocabulary expanded. The journal began to print the names of women passing their BAs, MAs, and medical degrees, and speeches by women to women's organizations. As the years went by, reports of political events also appeared, as did foreign news and literary criticism of contemporary novels and short stories. Women sent in travel accounts of the *hajj* pilgrimage, and of sightseeing in India and Europe. By the 1930s, younger women readers and contributors began to question purdah, polygamy, and unilateral divorce.

Another husband and wife active in women's education who started a journal were Shaykh 'Abdullah of Aligarh (1874–1965) and Wahid Jahan Begam (1886–1939). In 1902, Shaykh 'Abdullah became the secretary of the Women's Education

Section of the All-India Muslim Educational Conference, and in 1904, he founded the Urdu monthly *Khatun* as the journal of that organization. The chief purpose of the journal was to advocate Muslim women's education, with the emphasis on the 'Abdullahs' project of founding a school for girls in Aligarh. They established their school in 1906, and by 1914 had raised enough money to build a hostel and transform their local primary school into a boarding school. Wahid Jahan's life – documented in a biography by her husband – was devoted to supervising the school and ensuring its survival. It eventually became the Women's College of Aligarh Muslim University (Abdullah 1954, Minault 1982). The archives of the Muslim University in Aligarh, its library, and that of the Women's College contain a wealth of documentation on the history of education and reform among Indian Muslims.

The third major Urdu periodical for women from the early twentieth century was *'Ismat* of Delhi, edited by Rashidul Khairi. Khairi (1868–1936) was one of the most popular Urdu novelists of his day. He was the nephew of another well-known Urdu novelist: Nazīr Aḥmad. Rashidul Khairi's earliest writings were didactic novels close in style and subject matter to those of his uncle. In 1908, he founded *'Ismat*, his literary journal for women. *'Ismat* was billed as a magazine for "respectable Indian women," which would contain high-minded articles concerning useful and necessary knowledge: intellectual, cultural, scientific, historical, and literary, but *not* political. In particular, Khairi sought to advance the cause of women's literature, especially writings by women but also writings by men specifically addressed to women. Many of the earliest women writers in Urdu contributed short stories or serialized novels to the pages of *'Ismat*.

With the development of the nationalist movement and women's education, women were becoming more politically involved. In the 1920s, Muslim women took part in the Khilafat-Noncooperation movement and Gandhian nonviolent protests. As early as 1917, a Muslim woman participated in the delegation of Indian women that met with Sir Edwin Montagu, the Secretary of State for India, to ask for women's suffrage. Further evidence of Muslim women's new outspokenness came in 1918, when the Anjuman-i-Khawatin-i-Islam (also known as the All-India Muslim Ladies' Conference), meeting in Lahore, passed a resolution condemning polygamy. Rashidul Khairi, much to the shock of many loyal readers of *'Ismat* who were also members of the

Anjuman-i-Khawatin, attacked the resolution as unacceptable and un-Islamic. The women were astonished, because he had exposed the evils of polygamy in several of his novels. Yet, when women themselves addressed the problem, Rashidul Khairi was shocked, and indicated that since Islam permits polygamy, it would not do for Muslim women to seek its abolition (Khairi 1936, Minault 1989).

In the 1920s, Raziqul Khairi replaced his father as editor of *'Ismat* and opened its pages to a greater variety of subject matter. *'Ismat* increasingly covered political topics that had formerly been taboo, such as support for Muslim women's rights to inheritance and divorce as the Shariat Application and the Dissolution of Muslim Marriages Bills were being debated in 1937–9 (Gilmartin 1981). Women's movements in other countries, notably Egypt and Turkey, were discussed, as was the issue of suffrage in European countries, with reference to the Indian nationalist movement. All of this was further evidence of women's greater activism and articulation of their own views.

In the early twentieth century, numerous other women's magazines in Urdu appeared, some edited by men, but many by women. Some of them enjoyed long runs and good literary reputations; others were more ephemeral. Some were nationalist in their tone and sympathies; others maintained an apolitical stance. It is difficult to generalize about the content and style of these periodicals from random volumes found in scattered places, but the mixture described above seems to persist at least into the 1930s. Articles on education and social reform, tips on health and household management, and creative writing make up most of these journals. Political coverage crept into their pages by the 1920s and 1930s, associated with the ongoing debate over women's rights in Islamic and other civil laws, and with emerging women's associations like the Anjuman-i-Khawatin-i-Islam and the AIWC. Some AIWC proceedings and its journal, *Roshni*, are available on film at the Nehru Memorial Library and at the AIWC headquarters, both in New Delhi.

Another Urdu journal that deserves special mention is the monthly *Zillus Sultan* that appeared from Bhopal starting in 1913. The mouthpiece of its patron, Sultan Jahan, the ruling Begam of Bhopal, it contained some creative literature, but most of the articles dealt with such topics as health, women's education, the reform of customs, and notices about women's meetings and the founding of schools. The proceedings of the Women's Education Section of the Muslim Educational

Conference were covered in its pages, as were speeches by various figures associated with the Aligarh movement, especially those of the Begam herself.

Hyderabad was also a center of Urdu culture and publication. Urdu was the official language in the Nizam's city and state on the Deccan plateau. Many talented Muslims from the north had been recruited into the Nizam's administration and maintained links with their native places. Urdu periodicals from northern cities such as Lahore, Delhi, and Lucknow circulated in Hyderabad, and Hyderabadi publications likewise found subscribers in the Urdu-speaking heartland. The many libraries and private collections in Hyderabad still constitute some of the best storehouses of Urdu books, newspapers, and periodicals in India.

This sketch of some of the leading Urdu women's magazines is an example of what can be learned from such periodicals, but much more remains to be done. The political as well as literary content of these and other women's journals deserve much greater attention than they have received. Not only publications in Urdu, but also women's magazines and writings in other regional languages such as Bengali, Gujarati, and Tamil deserve greater study. Only Bengali Muslim women have been studied in any detail (Amin 1996). The regional languages of Pakistan such as Punjabi and Sindhi also contain hidden treasures that will reward both historical and ethnographic research.

Further research on early women writers in Urdu, their novels, short stories, and poetry will also yield rich detail about their times. Works of fiction can be problematic as biographical sources, but as sources for social history they afford glimpses of women's changing viewpoints and the ways they deal with new social and political pressures. From the generation that contributed to the earliest women's magazines, we have already mentioned Muhammadi Begam, the first editor of *Tahzib un-Niswan* and the author of several novels and some affecting poetry. Nazr Sajjad Hyder was another early novelist, editor, and social activist whose daughter, Qurratul-'Ain Hyder, is one of the most prolific novelists of contemporary Urdu. Rashid Jahan, the eldest daughter of Shaykh 'Abdullah and Wahid Jahan Begam, received her early education at Aligarh before going on to become a medical doctor and a member of the Urdu Progressive Writers' movement, and an author of socially realistic short stories about poor women encountered through her clinical work. 'Ismat Chughtai, perhaps the best-known woman writer in Urdu, was inspired by Rashid Jahan to write frankly

about women's emotions, desires, and social conflicts. Because of these and other outspoken women, the Urdu novel and its offshoots in radio, television, and the cinema have been a vibrant force in Indo-Muslim and Pakistani culture. Literary studies need to be joined by analyses of these works as both sources for history and catalysts for social change (Suhrawardy 1945, Minault 1998a).

PARADIGMS REVISITED

The sources, methods, and interpretations reviewed here by no means exhaust the possibilities or the problems of the topic. The apparent changes in women's lives, viewpoints, and possibilities over the two centuries discussed here should not obscure the fact that access to knowledge was and still is an elite phenomenon, and the ideology of reform was intimately tied up with social status, relative both to other classes and religious communities. For this reason, concern for continuity mingled with and often predominated over arguments favoring change. The role model of educated Muslim women as omnicompetent managers of the domestic realm, helpmates to their husbands, and nurturers of the young was repeatedly emphasized, as was the need for women to know the scriptures, their rights and duties in Islam, and to discern useless custom and superstition from true religion. Women's education, purveyed in various forms of suitable literature, by improved home schooling, and by the newer schools, was the key to enlightened domesticity and the pious life. These, in turn, were the keys to the spiritual reform and the worldly advancement of the Muslim middle class as it confronted the economic and political challenges of the twentieth century. The home and the world were interdependent.

This vision was entirely in keeping with the ideology enunciated by male social reformers in the late nineteenth century, in which women were to be trained better to fulfill their traditional roles, not to undertake new ones. This ideology looked back to Muslim patterns of reform and revival in the pre-British era, just as Hindu social reformers looked back to a golden age that was, not incidentally, pre-Muslim, in order to bolster their ideology of reform. Neither Hindu nor Muslim reformers wanted to ape the West in their programs of civilizational resuscitation, even though the changing institutional structures of their public lives and the heightened importance of the print media in conveying information and ideas were obvious by-products of the colonial encounter. Their vision of enlightened domesticity and

middle-class rectitude owed much to similar bourgeois values that had emerged in Victorian society, but Indian reformers naturalized their model of the ideal woman. The reformed Indian middle-class woman would not be like her Western counterpart because of the continuities of seclusion (albeit liberalized), of ritual (albeit purified), and of kinship, all mechanisms of control over individual idiosyncrasy.

Indeed, Muslim social reformers had plenty of precedents from their own tradition to call upon in meeting modern challenges, not the least of which were reinterpretation of scripture, citation of prophetic precedent, and purification of individual practice. These themes of continuity challenge the notion, generated during colonial times but amplified in contemporary postcolonial analysis, of colonial rule as the source of agency and Muslim culture as invariably resistant. Women authors and activists developed their own variations on these themes but did not challenge the basic ideology. This is not surprising. Middle- and upper-middle-class women had nothing to gain and much to risk from asserting the importance of individual fulfillment. They had much to gain from the enhancement of their position in the household, while maintaining the status of their male kin. The men's programs of social reform and political self-determination, in turn, depended upon the women symbolizing what their community could be.

Just as the paradigms of middle-class reform did little to address the condition of the lower classes, so too the methods and strategies outlined here for rendering Muslim women visible to history do nothing to illumine the lives of working class and peasant women. In spite of the fact that egalitarianism was a factor emphasized by reformers in sketching the dynamism of the Islamic message, "subalterns" were more likely to be regarded as sources of bad custom and un-Islamic influence. Working-class women may have been objects of the compassion and social service of reformist Muslim women (just as the women had been objects of men's beneficence), but other than the social realism of the Urdu progressive writers, there is scant investigation of the plight of lower class women in the sources outlined above. To examine the lives of non-elite Muslim women requires a different approach: research into legal and revenue records, reports by local governments and social service organizations on agriculture, famine, labor, criminality, and prostitution, and oral histories such as interviews with victims of riots, floods, and epidemics. Subaltern studies have done much to illuminate non-elites in Indian history, but subaltern Muslim women still await their historian.

BIBLIOGRAPHY

S. B. Abbas, The female voice in Sufi ritual. Devotional practices of Pakistan and India, University of Texas Press (forthcoming).
S. 'Abdullah, The biography of Begam 'Abdullah [in Urdu], Aligarh 1954.
N. Ahmad, The bride's mirror (Mirat ul-'arus). A tale of life in Delhi a hundred years ago, trans. G. E. Ward, London 1903, repr. New Delhi 2001.
Mrs. M. H. Ali, Observations on the Mussulmauns of India, 2 vols., London 1832, repr. Delhi 1973.
S. M. 'Ali, Huquq un-niswan, Lahore 1898.
S. N. Amin, The world of Muslim women in colonial Bengal, 1876–1939, Leiden 1996.
R. B. Barnett, Embattled begams. Women as power brokers in early modern India, in G. R. G. Hambly (ed.), Women in the medieval Islamic world, New York 1998, 521–36.
C. A. Bayly, Indian society and the making of the British Empire, Cambridge 1988.
W. Dalrymple, The white Mughals. Love and betrayal in eigthteenth-century India, London 2002.
M. H. Fisher, Women and the feminine in the court and high culture of Awadh, 1722–1856, in G. R. G. Hambly (ed.), Women in the medieval Islamic world, New York 1998, 488–519.
G. H. Forbes, Women in modern India, Cambridge 1996.
D. Ghose, Colonial companions. Bibis, begums, and concubines of the British in North India, 1760–1830, Ph.D. diss., University of California, Berkeley, 2000.
D. Gilmartin, Kinship, women, and politics in twentieth-century Punjab, in G. Minault (ed.), The extended family. Women and political participation in India and Pakistan, Delhi 1981, 151–73.
'Ismat, Urdu women's magazine, Delhi.
M. Karlekar, Voices from within. Early personal narratives of Bengali women, Delhi 1991.
R. Khairi, 'Ismat ki kahani, Delhi 1936.
Khatun, Urdu women's magazine, Aligarh.
G. Kozlowski, Private lives and public piety. Women and the practice of Islam in Mughal India, in G. R. G. Hambly (ed.), Women in the medieval Islamic world, New York 1998, 469–88.
J.-M. Lafont, Indika. Essays in Indo-French relations, New Delhi 2000.
S. Lambert-Hurley, Contesting seclusion. The political emergence of Muslim women in Bhopal, 1901–1930, Ph. D. diss., School of Oriental and African Studies, University of London 1998.
J. Lebra-Chapman, The Rani of Jhansi. A study in female heroism in India, Honolulu 1986.
D. Lelyveld, Aligarh's first generation. Muslim solidarity in British India, Princeton, N.J. 1978.
L. Mani, Contentious traditions. The debate on sati in colonial India, Berkeley 1998.
B. D. Metcalf, Islamic revival in British India. Deoband: 1860–1900, Princeton, N.J. 1982.
——, Reading and writing about Muslim women in British India, in Z. Hasan (ed.), Forging identities. Gender, communities, and the state, New Delhi 1994, 1–21.
T. R. Metcalf, Ideologies of the Raj, Cambridge 1994.
G. Minault, Shaikh Abdullah, Begam Abdullah and sharif education for girls at Aligarh, in I. Ahmad (ed.), Modernization and social change among Muslims in India, New Delhi 1982, 207–36.

———, 'Ismat. Rashidul Khairi's novels and Urdu literary journalism for women, in C. Shackle (ed.), *Urdu and Muslim South Asia*, London 1989, 129–36.

———, Sayyid Mumtaz Ali and *Tahzib un-niswan*. Women's rights in Islam and women's journalism in Urdu, in K.W. Jones (ed.), *Religious controversy in British India*, Albany 1992, 179–99.

———, Other voices, other rooms. The view from the Zenana, in N. Kumar (ed.), *Women as subjects. South Asian histories*, Charlottesville, Va. 1994, 108–24.

———, *Secluded scholars. Women's education and Muslim social reform in colonial India*, Delhi 1998a.

———, Women's magazines in Urdu as sources for Muslim social history, in *Indian Journal of Gender Studies* 5:2 (1998b), 201–14.

———, (trans.), *Voices of silence. English translation of Altaf Husain Hali's Majalis-un-nissa and Chup ki dad*, Delhi 1986.

V. T. Oldenburg, Lifestyle as resistance. The case of the courtesans of Lucknow, in D. Haynes and G. Prakash (eds.), *Contesting power. Resistance and everyday social relations in South Asia*, Berkeley 1991, 23–61.

F. Parks, *Wanderings of a pilgrim in search of the picturesque*, 2 vols., London 1850, repr. Karachi 1975.

L. Peirce, *The imperial harem. Women and sovereignty in the Ottoman Empire*, New York 1993.

C. Petievich, Gender politics and the Urdu ghazal. Exploratory observations on *rekhta* versus *rekhti*, in *Indian Economic and Social History Review* 38:3 (2001), 223–48.

C. Preckel, *Begums of Bhopal*, New Delhi 2000.

R. Russell, The pursuit of the Urdu ghazal, *Journal of Asian Studies* 29:1 (1969), 107–24.

M. Sadiq, *A history of Urdu literature*, Delhi 1984².

P. Spear, *The nabobs. A study of the social life of the English in eighteenth century India*, London 1932, rev. ed. 1963.

S. Suhrawardy (Ikramullah), *A critical survey of the development of the Urdu novel and short story*, London 1945.

Tahzib un-Niswan, Urdu women's magazine, Lahore.

S. Tharu and K. Lalita (eds.), *Women writing in India*, 2 vols., New York 1991.

Ashraf 'Ali Thānawī, *Perfecting women. Maulana Ashraf 'Ali Thanawi's* Bihishti Zewar, trans. B. D. Metcalf, Berkeley 1990.

Zillus Sultan, Urdu women's magazine, Bhopal.

GAIL MINAULT

Sub-Saharan Africa: Mid-18th to Early 20th Century

INTRODUCTION

There is little information on Muslim women in Sub-Saharan Africa from any source for the eighteenth century to the early nineteenth century. But during the nineteenth century the situation changes for many parts of the continent and the amount of relevant materials increases through the turn of the twentieth century. Many factors account for this, including the spread of Islam itself; the efforts of those involved to record and promote their activities; the linked enterprises of European exploration and colonialism; and the efforts of early Western historians and ethnographers in Sub-Saharan Africa. The intellectual perspectives that scholars of the twentieth and twenty-first centuries have brought to bear on recognizing and understanding these sources have developed and changed considerably themselves over the decades.

The inherent complexities of writing fairly and fairly objectively about historical realities are compounded for those seeking to represent the lives of Muslim women in Sub-Saharan Africa through multiple filters. For this time period, it is necessary to look through, around, and beyond filters of colonialism, of Western chauvinism, of class, of race, of gendered social dominance, of religious hegemonies, and of failing to officially acknowledge what is unofficially known. Interpretive advances have been made and will be identified and discussed, although more needs to be done. Yet in general, this is a very exciting period for contemporary research, with many studies as models and even more opportunities for future scholarship.

HISTORICAL OVERVIEW

Islam in Sub-Saharan Africa between the eighteenth and early twentieth centuries was primarily concentrated in two areas: a large West African region and a smaller, coastal-oriented East African region. In addition, there were scattered communities of initially Muslim male immigrants in what is today South Africa.

Introduced from Mediterranean Africa beginning in the ninth century by Arab and Berber traders, West African Islam was dominated by Sufi religious orders and their characteristic brotherhoods, charismatic leaders, and fundamentalist concerns. Rural-urban dynamics were crucial to the vitality of Islam in West Africa. The faith was spread by *malam*s and traders and was later expanded through military conquest of pre-existing states and reinforced by periodic jihads, receiving an ironic boost in converts during the advent of Western Christian colonialism.

Different forces were at work in the establishment of Islam in East Africa. Growing from a very early Muslim settler presence and bolstered by repeated waves of immigrants from the Arabian Peninsula, many forms of Islam were represented. Powerful city-states developed from the Horn south down along the Indian Ocean coast, yet few proselytizing efforts were made. Instead, Islam spread gradually, through intermarriage and the adoption of institutions such as legal systems. The development of the Swahili culture epitomizes this process. Along with Western colonial interference, East African Islam was challenged by the forces of Arabization during the nineteenth century.

There was also an Islamic presence in southern Africa as labor demands pulled Muslims from the Indian subcontinent and Southeast Asia as well as from the eastern African coast. These immigrant communities were centered in Cape Town, Natal, and later the Transvaal. Operating independently of one another and representing different schools of Islamic thought, eighteenth- and nineteenth-century Muslim communities in South Africa developed in relative isolation and in response to highly localized events.

During this time period, African Muslim men – and to a more limited degree women – remained in closest intellectual contact with the areas that had first influenced them, for example, by traveling to regional centers for further education or by receiving *malam*s from them. Yet believers had little historical contact with each other as self-consciously African Muslims until the emergence of pan-Islamic and pan-African concerns in the mid-twentieth century. For this overview, it is best to view Sub-Saharan Islam as an aggregate of distinctive parts, each with its own unique experiences and source materials, and not as a unified whole. However, there are important historical and cultural parallels to be explored as well as shared investigative methods and concerns for future research.

A NEW PERSPECTIVE ON NAMED WOMEN

Research of the last three decades informed by a feminist perspective has revealed considerable new information about a number of prominent nineteenth- and early twentieth-century Muslim women scholars and leaders. Never forgotten by their local communities, these women have been the subject of our attention more recently through the efforts of contemporary researchers. Perhaps the foremost example of this process is Nana Asma'u (1793–1864), Hausa scribe, poet, and teacher. She was the daughter of Usman dan Fodio, whose jihad established the Sokoto caliphate of northern Nigeria. Although much has been written about him and about his sons and male advisors, virtually nothing was known about Nana Asma'u until research starting in the 1970s (Mack and Boyd 2000, ix–xv). The variety and richness of source material contributing to our understanding of Asma'u include her own corpus of poetry, letters, modern oral sources about her, and extant material culture such as the room where she lived and worked and the original copies of her writings. A fascinating figure in herself, Asma'u was also a chronicler and teacher whose texts – in Hausa, Fulfulde, Arabic, and Tamachek (the Tuareg language) – give insight into women's roles not only in the intelligentsia into which she was born but also in creating a post-jihad Islamic community. Yet unusual as Asma'u was, she was not unique; her sisters and other women in her family were scholars and teachers. Surviving Asma'u was the Yan Taru (Sisterhood) movement that she founded, made up of women trained to spread Muslim education among rural women through oral recitation of key texts (Mack and Boyd 2000, 89–91). In other parts of West Africa, women spiritual leaders include Shaykha Khadijia, a nineteenth-century Mauritanian teacher who instructed 'Abd al-Qādir, the leader of the Torodo revolution. From Kano, Nigeria came several women muqaddamāt (Sufi teachers) who were well known during the early decades of the twentieth century, including 'A'isha, Safiya 'Umar Falke, Hijiya Iya, and Umma Makaranta (Dunbar 2000, 400–1, Hutson 1999, 43).

East African historical parallels of educated Muslim women writing to support their faith include Mwana Kupona of Mombasa, Kenya who wrote poetry in Swahili during the mid-1800s (Berger 1999, 25) and Shaykha Mtunwa bt. 'Ali b. Yusufu who received an ijāza at Zanzibar and introduced the Qadiriyya ṭarīqa to Malawi in the 1920s (Alpers 2000, 312–13).

In nineteenth-century Somalia, Shaykh al-Kaylai had women students known as murīdāt, including his daughter Shaykha Fatima who went on to become a religious figure of local standing (Kapeteijns 2000, 235). Dada Masiti lived in Brava on the Benadir Coast in the 1800s. She was a religious scholar, poet, and mystic and the only female saint in Somalia whose tomb is honored by an annual ziyāra (Dunbar 2000, 404).

SOURCES: PRIMARY AND SECONDARY, APPROACHES AND METHODS

The mid-eighteenth to early twentieth centuries were the heyday of Western discovery of the continent. There were many travelers who left descriptions, including explorers, traders, missionaries and colonial officials, each informed by their own professional and cultural agenda.

These Western narratives of Islam in Sub-Saharan Africa were inherently conflicting. On the one hand, there was respect for Muslim civilization with its literacy, arts, and urban centers. Islamic religious practices based on a shared monotheistic tradition were often viewed as superior to "primitive" African ones. Muslim legal and political institutions were appreciated, so much so that, for example, British High Commissioner Frederick Lugard developed his famous colonial policy of Indirect Rule to govern through the pre-existing political and bureaucratic apparatus of northern Nigeria's caliphates. Yet Islam was also perceived as threatening, particularly in terms of competing with European economic interests; moreover, it was distressing to Western sensibilities that Islam continued to gain more converts in Africa than Christianity did. One cause that galvanized Western concerns was the continuation of the so-called Arab slave trade. Unlike its transatlantic counterpart of the fifteenth to nineteenth centuries, the northward- and eastward-directed trade was longer in duration (in place by the eighth century and continuing well into the twentieth) but fewer in numbers, was controlled by Muslims with different cultural beliefs about the institution of slavery, and selected women over men in a ratio of approximately two to one (Segal 2001, 4). Many Western expeditions to Africa during the eighteenth and nineteenth centuries were spearheaded by the cause of replacing the trade in Africans with the "legitimate" trade of the Europeans. An anti-slavery agenda is central to the writings of most, from James Richardson (1806–51) to David Livingstone (1813–73) and Henry Morton Stanley

(1841–1904). But at the same time, Western travelers left some useful glimpses into the lives of the Muslim men and women they encountered throughout Sub-Saharan Africa, albeit limited by their Victorian perspectives. Among such primary sources are descriptions from Mungo Park (1771–1806), James Bruce (1730–94), Réné-Auguste Caillé (1799–1838), Heinrich Barth (1821–65), Richard Burton (1821–90) and John Hanning Speke (1827–64).

The European age of exploration ended with widespread colonialism and a new set of observers. By the turn of the twentieth century a number of government ethnographers and amateur historians were working among Islamic peoples of Sub-Saharan Africa. Functioning under the auspices of the colonial powers, their first-hand descriptions are invaluable despite predictable political and gender biases. Some of the more prominent include, for example, R. S. Rattray (the first government anthropologist to be appointed in an African colony), Maurice Delafosse, and Paul Marty. As with the scholarship on explorers, each region has its own, some more widely published than others, some better observers than others. What set them apart from earlier writers was a burgeoning appreciation of local Muslim peoples and societies, a perspective that was especially problematic for French scholars. France controlled the largest number of Islamic territories in Sub-Saharan Africa. At first it was supportive of the Islamic institutions and states it encountered, but as elements in these became threatening to colonial administrations, concepts such as *Islam noir* – presented as inferior to Arab Islam – were invented as ideological rationalizations for changes in colonial policy. As was also the case with the British, French government policies towards Muslims rarely resulted in any positive changes for women living under colonial rule and often involved negative changes, with the important although not unproblematic exception of education.

After the Second World War, professional anthropologists and historians began to specialize in African studies. One noteworthy example is Mary Smith's 1954 biography, *Baba of Karo: A Woman of the Muslim Hausa*, which was an influential study of an African Muslim woman. Scholarly research included a focus on historical reconstruction and often contained materials – such as chronologies, oral histories, and title lists – pertinent to earlier periods. In general, among Africanist scholars there was often a blurring of disciplinary lines because for so long few researchers were working in any given part of the continent. Anthropologists and folklorists would take on the documenting and reconstruction projects typically associated with historians while historians and art historians made productive use of the field techniques of anthropologists, such as intensive interviewing, participant-observation, and the life history approach. Yet while the projects may have been more open in scope, scholars did tend to remain bounded by traditional disciplinary methodological orientations. For example, the ethnographic approach privileged data gathered through face to face interactions, with the corollary that few anthropologists systematically examined relevant written sources, especially unpublished ones in Arabic and in Sub-Saharan African languages. In a frank appraisal of her graduate student fieldwork in Ghana during the late 1960s, Enid Schildkrout speaks for more than one generation of scholars as she describes the anthropological training that steered her away from regional libraries and literary sources and thus diminished her understanding of locally-produced texts (Schildkrout 1996, 368–9). Although the desire for unsullied field data remained for some researchers, more came to appreciate and use the manuscripts increasingly available in translation.

The painstaking work of scholars to collect and translate key African historical documents from Arabic into English and French (and to a lesser degree documents in regionally-significant African languages such as Swahili, Hausa, and Wolof) during the late colonial and independence eras was critical in establishing the importance of a written, non-Eurocentric historical tradition in Sub-Saharan Africa. Yet few of these documents are directly relevant to the study of women. Likewise, there is much that is worthy of note in such works as the multi-volume Arabic Literature of Africa project edited by John Hunwick and Sean O'Fahey, but only a small percentage of the authors translated are women. Efforts to make scholarship international include the recent establishment of the Institute for the Study of Islamic Thought in Africa at Northwestern University (Illinois, U.S.A.) with a focus on the many archival and library collections found within African countries as well as in various Islamic centers of learning; it remains to be seen how much of this scholarship will focus on matters pertaining to gender.

For those seeking to understand the experiences of the great majority of Muslim women living in Sub-Saharan Africa during the mid-eighteenth to early twentieth centuries, it is therefore necessary to go beyond the written word. In order to gain insight into the lives of ordinary unnamed Muslim

women in Sub-Saharan Africa, different and supplemental sources and methods are required. These alternative sources are of two primary types: visual and oral.

VISUAL SOURCES

The technological development of the camera in the late nineteenth century coincided with Western expansion into Sub-Saharan Africa, and Muslim women appear in a range of photographic materials including postcards, stereographs, and book illustrations. Far from the truthful representations they appear to be, these images were often staged and costumed to fit the agenda of the photographer. For example, between 1901 and 1918, more than 7,200 different photographic postcards are estimated to have circulated throughout West Africa, carrying an essentialist, pro-colonial message (Prochaska 1991, 40). This limits but does not negate the usefulness of these early photographs; instead, they require interpretative skills similar to those needed when working with colonial era written accounts. Current research has also emphasized that private readings of such photographs can and do exist alongside official readings and that different audiences may have different reactions to the same images. Finally, some of the most interesting contemporary research uses early photographic materials as mnemonic devices to initiate discussions of the past.

African Muslim women's arts are another visual source of information. Museum holdings of these materials are, unfortunately, uneven, partly because many women's arts were in the realm of the decorative, the practical, and the domestic and until recently were not always considered worthy of collection. However, studies of works of art such as highly embellished gourds, heirloom jewelry, and prestige cloths have provided a starting point for understanding decades-old, and even centuries-old, networks of female production and patronage of valued items in Islamic areas.

It can be instructive to look for information beyond the standard sources. A revealing approach was that of Marian Johnson in her study of the symbolism and role of gold jewelry among Wolof and Tukular women of Senegal that included examination of women's private collections. The historical depth of this study is revealed not only in terms of the symbolism of personal objects and the empowerment of their owners that emerges but also in the names and commemorative events that these objects embody. History is lived in a unique way when a woman commissions a goldsmith to create a *san u sébé*, a Tukulor pendant

style from the late eighteenth century, originally made for the wife of a Bamana king (Johnson 1994, 39).

Architectural history and archaeology can also augment current knowledge of daily life in Muslim Sub-Saharan Africa during the eighteenth to early twentieth centuries. Research has included studies of house styles as exemplars of class, ethnic, and gender relations; documentation on vernacular architecture, including local African styles of mosques; and archaeological excavations, including comparisons of pre- and post-Islamic settlement patterns in particular regions. In their focus on the domestic sphere and the uses of space, many of these studies are important supplemental sources relevant to gender issues that are only starting to be fully utilized.

ORAL SOURCES

It is helpful to think about the tremendous number of Sub-Saharan African oral historical sources as those that are overtly concerned with preserving and narrating history and those that exist for other purposes but are also relevant to social historical questions. Many of those trained with a Western perspective of history have focused on the former, including chronologies, praise songs, genealogies, dynastic king lists, epics, migration narratives, and the like. A concern to record these oral sources for posterity has driven the ongoing large-scale national projects being carried out in many African countries. Some examples include collections of oral traditions in Ghana, Senegal, Cameroon, and Mali (Gutelius 2002, 11).

As crucial as these efforts are, it is important to note that they generally deal with versions of history that are sanctioned by the status quo. As such, they do not necessarily present women or their history in an objective way. The oral genres that are less privileged are often neglected, and at times better, sources of information on women. They include anecdotes, memorats and legends, praise poems, eulogies, and songs. Also of historical significance is information about past religious and political offices reflected in special names and titles for women as well as gender roles in annual commemorations such as festivals and saints' days. An example of this double standard in African historiography is the case of the *griot/griotte*.

Perhaps the most famous bearers of West African oral history, *griots* are praise-singers, historians, and musical entertainers among such Muslim people as the Mande, the Wolof, and the Fulbe. The term originally referred to a caste-based occupational group that was linked to royal families

and it is generally applied to professionals in Mali, Guinea, the Gambia, Senegal, Côte d'Ivoire, Burkina Faso, and Guinea Bissau, although it has sometimes been extended to any bearer of oral tradition throughout Sub-Saharan Africa. The great Manding epic, *Sundiata*, was preserved, elaborated upon, and passed down by generations of *griots*. Alex Haley relied upon local *griots* in the Gambia when researching his popular book *Roots*. Given the widespread popular embracing of the *griot* it is all the more surprising that information about the very existence and research into the roles of women *griottes* was not widely available until the 1990s with the work of Marloes Janson, Thomas Hale and Duran, and others. As sources of historical and cultural information, *griottes* are just now beginning to be fully heard.

RESEARCH DESIGN: SOURCES
AND MODELS FOR FUTURE
INVESTIGATION

One of the most promising areas for conducting research on women and Islamic cultures in Sub-Saharan Africa from 1700 to 1900 is the great wealth of archival and oral source material that is now waiting for scholarly investigation (although much is available in translation, there is an obvious advantage to studying texts in the original). Court cases and legal records from both Islamic and colonial archives are a particularly rich source of information on women's social and economic history and offer a view of female agency that is otherwise lost.

A synthesizing approach of combining and supplementing oral, archival, and other sources is crucial to piecing together information about Muslim women for this time period. Barbara Cooper provides one example of combining sources in her historically-informed study of Hausa marriage patterns in Niger between 1900 and 1989.

Especially important as a contemporary research method is the role of collaborative research. Lidwien Kapteijns provides a model of this when she acknowledges the importance of transcriber and translator Maryan Omar Ali in her tour-de-force account of northern Somali orature from 1899 to 1980.

Sometimes information comes from work in other regions, such as the African diaspora research of Sylviane Diouf who examined enslaved Muslims in the New World. She reports what little is known about certain women, born in Sub-Saharan Africa and raised there as Muslims, and thus provides hints to us about their eighteenth- and nineteenth-century pre-slavery life experiences.

Diouf also links a widespread New World African American tradition of giving food in the form of rice cakes, called "saraka" on the Georgia Sea Islands, to the Islamic tenet of *ṣadaqa* (voluntary alms). As a practice that "represents the only recorded example of Islamic behavior specifically expressed by slave women" its cultural importance is underscored by women's efforts to continue it despite nearly impossible circumstances (Diouf 1998, 66).

Other fruitful areas of research include the continued and systematic use of visual materials from the arts, photography, museum collections, architectural surveys, and archaeological excavations with a strongly gender-oriented perspective as well as careful and creative examination of the understudied women's genres of folklore and oral history.

BIBLIOGRAPHY

N.B. Even limited to written works in Arabic, English, French, and Portuguese, there are far too many primary sources for sub-Saharan Africa to be representatively listed here. The reader is referred to the secondary sources below for guidance.

E. Alpers, East Central Africa, in N. Levtzion and R. Pouwels (eds.), *The history of Islam in Africa*, Athens, Ohio 2000, 303–25.
R. Austen, *Africans speak, colonialism writes. The transcription and translation of oral literature before World War II*, Boston 1990.
I. Berger, Women in East and Southern Africa, in I. Berger and E. F. White, *Women in Sub-Saharan Africa. Restoring women to history*, Bloomington, Ind. 1999, 5–62.
J. Boyd and B. Mack, *The collected works of Nana Asma'u, 1793–1864*, Ann Arbor 1997.
C. Coles and B. Mack, *Hausa women in the twentieth century*, Madison, Wis. 1991.
B. Cooper, *Marriage in Maradi. Gender and culture in a Hausa society in Niger, 1900–1989*, Portsmouth, N.H. 1997.
S. Diouf, *Servants of Allah. African Muslims enslaved in the Americas*, New York 1998.
R. Dunbar, Muslim women in African history, in N. Levtzion and R. Pouwels (eds.), *The history of Islam in Africa*, Athens, Ohio 2000, 397–417.
L. Duran, *Stars and Songbirds. Mande female singers in urban music 1980–1999*, London 1999.
C. Geary, Old pictures, new approaches. Researching historical photographs, in *African Arts* 24:4 (1991), 36–9, 98.
D. Gutelius (ed.), *Saharan Studies Association Newsletter* 10:2 (2002).
T. Hale, *Griots and griottes. Masters of words and music*, Bloomington, Ind. 1998.
J. Hunwick with S. O'Fahey, *Assessing the Islamic intellectual tradition in Africa. The Arabic Literature of Africa Project (ALA)*. Reproduced at <www.sum.uio.no/research/mali/timbuktu>.
A. Hutson, The development of women's authority in the Kano Tijaniyya, 1894–1963, in *Africa Today* 46:3/4 (1999), 43–64.
T. Insol, *The archaeology of Islam in Sub-Saharan Africa*, Cambridge 2003.

M. Janson, *The best hand is the hand that always gives. Griottes and their profession in Eastern Gambia*, Leiden 2002.

M. A. Johnson, Gold jewelry of the Wolof and the Tukulor of Senegal, in *African Arts* 27:1 (1994), 36–49, 94.

L. Kapteijns, Ethiopia and the Horn of Africa, in N. Levtzion and R. Pouwels (eds.), *The history of Islam in Africa*, Athens, Ohio 2000, 227–50.

L. Kapteijns with M. Ali, *Women's voices in a man's world. Women and the pastoral tradition in northern Somali orature, c. 1899–1980*, Portsmouth, N.H. 1999.

B. Mack and J. Boyd, *One woman's jihad. Nana Asma'u, scholar and scribe*, Bloomington, Ind. 2000.

D. Prochaska, Fantasia of the photothèque. French postcard views of colonial Senegal, in *African Arts* 24:4 (1991), 40–7, 98.

E. Schildkrout, Politics and Poetry. Mohammed Rashid Shaaban's History of Kumasi, in J. Hunwick and N. Lawler (eds.), *The cloth of many colored silks. Papers on history and society Ghanaian and Islamic in honor of Ivor Wilks*, Evanston, Ill. 1996, 367–91.

R. Shell, Islam in southern Africa, 1652–1998, in N. Levtzion and R. Pouwels (eds.), *The history of Islam in Africa*, Athens, Ohio 2000, 327–48.

R. Segal, *Islam's black slaves. The other black diaspora*, New York 2001.

M. Smith, *Baba of Karo. A woman of the Muslim Hausa*, London 1954.

M. Strobel, *Muslim women in Mombasa, 1890–1975*, New Haven, Conn. 1979.

E. F. White, Women in West and West-Central Africa, in I. Berger and E. F. White, *Women in Sub-Saharan Africa. Restoring women to history*, Bloomington, Ind. 1999, 63–129.

ALICE E. HORNER

North America: Early 20th Century to Present

The field of "Women and Islamic cultures in North America" is multi-layered and fluid. While some sources for research in this area are framed in terms of ethnically based categories such as "Arab American women" (Shakir 1997, Kadi 1994) or "South Asian Women" (Women of South Asian Descent Collective 1993), others are organized according to the broader religious identification, "Muslim American Women" or "Muslim Women in North America." The ethnically based categories refer to persons from varying religious backgrounds who share sociocultural experiences significantly shaped by Islamic histories and values. The religion based category includes women from diverse ethnic, linguistic, and cultural backgrounds who live in North America and self-identify as Muslim. An alternative approach to research on women and Islamic cultures in North America is to focus on women converts to Islam.

Scholars agree that the three largest Muslim American groups are African Americans, Arab Americans, and South Asians. The Western Atlantic slave trade brought the first African Muslims to North America, but large-scale African American Muslim organizations and movements did not emerge until the twentieth century. From the early twentieth century, historically specific African American interpretations were shaped in the context of migration from the south between the two world wars and the concomitant social, economic, and racial struggles (Leonard in preparation, McCloud 1991).

The category "Arab American" refers to persons who trace their ancestry to the North African countries of Morocco, Tunisia, Algeria, Libya, Sudan, and Egypt and the western Asian countries of Lebanon, occupied Palestine, Syria, Jordan, Iraq, Bahrain, Qatar, Oman, Saudi Arabia, Kuwait, United Arab Emirates, and Yemen (El Badry 1994). Arabs began migrating to the United States in the late 1880s; the majority were Christian until the late 1960s when Arab Muslim migration rapidly increased (Abraham and Shryock 2000, Suleiman 1989).

India, Pakistan, Bangladesh, and Afghanistan are the major countries of origin for women from South Asian Islamic cultures. Nearly all South Asian immigrants to the United States are from Pakistan, Bangladesh, and Afghanistan, and 12 percent of those from India are Muslim (Leonard in preparation). Scholars estimate that South Asians are the largest single group among American Muslims. The broader categories Asian American, Asian Pacific Islander, and South Asian Diaspora are also useful for exploring South Asian women's experiences in North America. Most South Asian Muslims migrated to the United States in the aftermath of the 1965 Immigration and Naturalization Act.

Scholars, community members, and United States state and media representatives are increasingly invoking the categories "Muslim American women" or "Muslim women in North America (Aswad and Bilgé 1996, Haddad and Smith 1994) to frame discourses and research on women and Islamic cultures in North America. The classification "Muslim American" is relatively new and reflects the post-1960s rapid influx of Muslim immigrants and the historical and political context in which "the Muslim" has increasingly emerged as a central figure within United States state and media discourses. Historical and political shifts have alternately given rise to the self-identification "Muslim American" or "American Muslim."

While there are no reliable national surveys that estimate the Muslim population in the United States, one study suggests that American Muslims are 42 percent African American, 24.4 percent South Asian, 12.4 percent Arab, 6.2 percent African, 3.6 percent Iranian, 2 percent Southeast Asian, 1.6 percent European American, and 5.4 percent other (Nu'man 1992, cited in Leonard in preparation). An alternative report maintains that 30 percent of Muslims in North America are "Americans," 33 percent are Arabs, and 29 percent are South Asians (Ba-Yunis and Siddiqui 1999, cited in Leonard in preparation).

Four types of sources are useful for research on women in Islamic cultures in North America: 1. primary sources; 2. networking tools; 3. online collections; and 4. scholarly publications.

PRIMARY SOURCES

Vital records. Useful primary sources are federal, state, and city records, religious documents, academic archives, and ethnic magazines and newspapers. Federal census records include data

such as birth date, gender, mother and/or father of foreign birth, year of immigration, naturalization status, year of naturalization, native language, employment, and occupation. These materials provide information on women's migration patterns, generational status, and labor experiences. State archives (such as the City of Boston's Registry Archives) and city records (such as Massachusetts Department of Vital Statistics) complement census materials by including data on birth, marriage, and death. Some city records (such as Boston's Police Archives) also include women's employment records. Yet the categories used in the United States to classify Islamic cultures may pose challenges to researchers (Naber 2000). In the late nineteenth century, the United States classified Arabs within the same category as Turks, Armenians, and other non-Arabic speaking peoples (El Badry 1994). Currently, the United States census marks persons from the Middle East and North Africa as white/Caucasian but recognizes their origins in an ancestry section. It counts some Middle Easterners and North Africans as refugees and others as nationals of their last country of residence. Several scholars agree that vital records undercount Arab Americans and are inconsistent. State institutions have also classified South Asians through ambiguous and shifting categories along a continuum of "white," "non-white," "Asian Indian," and "Asian American." Intermarriage further complicates United States census categories. Punjabi Muslim men who migrated in the early 1900s, for example, married Mexican American women, producing mixed communities of Punjabi-Mexicans (Leonard 1992).

Immigration and Naturalization Service (INS) records contain information about foreign nationals who enter or attempt to enter the United States for temporary or permanent residence in a variety of categories, such as refugees, asylees, nonimmigrants, naturalizations, emigration, illegal immigrants, or foreign born. INS records are useful for exploring women's naturalization certificates, family histories, and immigrant arrival records. Special Reports by the INS might be useful for research on women and Islamic cultures in North America, including: "Mail Order Bride Industry and Its Impact on US Immigration Census Reports"; "Historical Census Statistics on the Foreign-Born Population of the United States: 1850–1990"; and "Report on Women and Naturalization." Researchers interested in Chinese Muslim women might explore the INS special collection, "Chinese Immigrant Files." "Immigrant Passenger Lists, 1883–1945" can be found in the National Archives and Records Administration's (NARA) records.

Religious records. Religious records complement vital records. Housed within mosques, archdiocese archives, congregational libraries, and diocesan libraries and archives, they assist in determining women's religious affiliations since religious categories are absent from federal, state, and city records. Religious records also provide information on birth, marriage patterns, divorce, inheritance, and death.

Academic archives. While there is no collection that focuses specifically on Muslim Americans or Muslim American women, archives are organized in terms of women's studies and/or ethnic studies. The Balch Institute for Ethnic Studies (Philadelphia) contains materials on women's histories, Lebanese Ame-ricans, and African Americans. Other helpful collections are organized in terms of particular ethnic groups. Several components of the Faris and Yamna Naff Family Arab American Collection (National Museum of American History, Washington, D.C.) permit research on Arab American women. Some sections provide historical and sociological materials on Arab American histories and experiences. These include scholarly articles on discrimination and economic endeavors, books, dissertations, community directories, and statistics. Within the Naff Collection, a section called Arab American Press holds articles and magazines by and about women. Other sections that include primary and secondary sources on women are: Family Life and Values, Women, Folklore, Traditions and Customs, Literature, Music and Art, Bibliographies on Arab Americans, Personal Papers (including letters and diaries), and the Oral History Project (conducted in the 1980s).

Several archives on African Americans and African American women exist, including African American Resources (Maryland State Archives), and the African American Women's Archives (Duke University).

Currently, the Doe Library at the University of California, Berkeley is developing an archive on South Asian immigrants to the United States, Canada, and other parts of the world. This resource will include materials such as memorabilia, personal papers, correspondence, photographs, early publications, ephemera, posters, and newsletters of early community organizations. Other archival materials on South Asian American women can be found within archives organized under the category "Asian American Studies."

Ethnic magazines and newspapers. Several magazines and newspapers such as *India Today*

and *Arab American News* have emerged out of particular ethnic and religious communities. Some cities, such as Boston, hold special archives of local ethnic newspapers. Some magazines and newspapers are not organized around the topic of women but include articles by and about women. Other magazines and newspapers are produced and written by and about women, such as *Azizah*, a magazine that strives to connect Muslim women in North America and to provide a forum for discussion while empowering Muslim women to forge their own identity.

NETWORKING TOOLS

Networking tools include community organizations that are religious, social, cultural, and/or political in scope. These sources are useful for making contacts within and between communities and for tracing issues facing women living within and between Islamic cultures in North America. Ethnically based networking tools are either pan-ethnic or based upon a common country of origin. Examples of pan-ethnic women's organizations are Asian Immigrant Women Advocates (AIWA), Arab Women's Solidarity Association (AWSA), and South Asian Women's Network (SAWNET). Examples of country-based organizations focusing on women are the General Union of Palestinian Women, the Iranian American Women's Association, and Asian Indian Women in America. A few pan-ethnic organizations highlight issues facing gays, lesbians, and queers, such as South Asian Lesbian and Gay Association (SALGA) and South West Asian and North African Bay Area Queers (SWANABAQ). Religion based organizations that are organized in terms of the category "Muslim" or "Muslim American" include the Muslim Women's League and Karamah: Muslim Women Lawyers for Human Rights. While these organizations vary in their goals, they provide rich resources for research on feminist practices, the tensions between feminism and nationalism, and women's empowerment.

Community-based organizations provide alternative tools for networking with women activists and exploring sites of tension and empowerment between women and their communities. Pan-ethnic organizations include the American Arab Anti-Discrimination Committee (ADC); the Arab American Action Network (AAAN); the Association of Arab American University Graduates (AAUG); Arab Community Center for Economic and Social Services (ACCESS); and Asian Pacific Islanders for Community Empowerment (API-Force). Religion based organizations include the American Muslim Alliance (AMA); the American Muslim Council (AMC); the Council on American-Islamic Relations (CAIR); and the National Council on Islamic Affairs (NCIA). The Nation of Islam is a significant resource for research on women living in African or African American Islamic cultures in North America.

ONLINE COLLECTIONS

Rich archival materials are becoming increasingly available online. The South Asian Women's Forum, for example, includes articles on family and gender among the South Asian diaspora. Duke University's Special Collections Library provides archives on African American women within their online archival collections. This collection contains materials ranging from reports of personal experience to abstract discussions of general living conditions and events. It incorporates the perspectives of black educators and laborers, slaves and slaveholders, women's grassroots organizers and elected officials, McCarthy-era investigators, and Black Panther revolutionaries. With differing amounts of detail, these sections provide information on the lives of black women in relation to work, politics, family, and community. The American Women's History/Women Immigrants On-Line Collection provides links to bibliographies, networking tools, and primary sources on Arab American and Asian American lives and experiences.

SCHOLARLY PUBLICATIONS

Most scholarly work has been ethnographic and sociological and methods for writing on women and Islamic cultures in North America have been primarily descriptive (Cainkar 1996, Hermansen 1991). While Leonard (in preparation) adds that research on gender and sexuality among Muslim American women has been comparative only in the sense that research on one community is printed next to research on another community in conference or topical volumes, theoretical and comparative approaches are increasingly emerging.

The largest body of literature on women and Islamic cultures focuses on South Asian American women. Several researchers have focused on the processes by which South Asian women have reconstructed their identities in the diaspora (Desai 1999, Women of South Asian Descent Collective 1993). Some scholars have highlighted issues of family (Gupta 1999), while others have focused on issues of women's clothing (Govindjee 1997). Research on queer South Asian diasporas is also emerging that focuses on queer South Asian

women's identities in the context of the reconstruction of masculinist cultural nationalisms in the United States (Gopinath 1997).

Scholarly literature on Arab American women is limited. South End Press published the first anthology of Arab American women writers, *Food for our Grandmothers: Writings by Arab-American and Arab-Canadian Feminists* (Kadi 1994). This anthology includes writings by 40 Arab American and Arab Canadian women artists, poets, and writers who explored issues such as family dynamics, migration, racialization, feminism, war, and love. Another work focused on the unsettled transitions of migration and their impact on postpartum concerns of Arab immigrant women (El Sayed 1986), and another highlighted stories about the histories and experiences of Arab American women in the United States through a collection of interviews with women from various immigrant and United States born generations (Shakir 1997). Two key issues have emerged within the literature on Arab American women: family life (Faragallah, Schumm, and Webb 1997) and the negotiations over gendered identities between the demands of cultural authenticity and Americanization (Naber 2001). More theoretical research is needed in this area.

Due to the historical circumstances of African Americans, issues of race and racialization have been centralized within the literature on African American Muslim women. While limited research on African American Muslim women exists (McCloud 1991, 1996), some studies have focused on the processes by which they find alternatives to the pressures of racism within the dominant United States society (Bying 1999). Few studies have explored the patriarchal construction of womanhood within African American Muslim communities from a feminist perspective (Pierce and Williams 1996). An alternative approach has been to highlight African American Muslim female activism (S'thembile 1996).

More and more scholars are taking interest in the field of literature classified as "Muslim American Women," "Muslim Women in North America," or "Muslim American families" (Aswad 1994, 1996, Haddad and Smith 1994). Within this field, several studies have addressed the *ḥijāb* (veil) controversy (Moore 1998). Other scholars have explored issues of family, marriage, and patriarchal authority among Muslim American communities (Aswad 1994, Aswad and Bilgé 1996). Most social scientists argue that interpretations of Islam are shaped by the social, historical, and political context. Some researchers have thus traced the relevance of idealized Islamic family ideals to Muslim American families. Several scholars have explored the ways in which constructions of gendered identity, sexuality, marriage, and motherhood are shaped and reshaped by American Muslims.

Some studies have addressed the ways that generational shifts are gendered (Aswad and Bilgé 1996) while others have focused on issues of domestic violence (Hassouneh-Phillips and Saadat 2001). Others have either explored immigrant Muslim women's adaptation to American society (Ross-Sheriff 2001) or have compared and contrasted immigrant Muslim, African American, Asian Pacific Islander, and American Indian families and populations (McAdoo 1999).

BIBLIOGRAPHY
N. Abraham and A. Shryock (eds.), *Arab Detroit. From margin to mainstream*, Detroit 2000.
B. Aswad, Attitudes of immigrant women and men in the Dearborn area toward women's employment and welfare, in Y. Haddad and J. Smith (eds), *Muslim communities in North America*, New York 1994, 501–20.
——, Arab Muslim families in the United States, in M. Bozorgmehr and A. Feldman (eds.), *Middle Eastern diaspora communities in America*, New York 1996, 64–7.
B. Aswad and B. Bilgé (eds.), *Family and gender among American Muslims. Issues facing Middle Eastern immigrants and their descendents*, Philadelphia 1996.
I. Ba-Yunis and M. Siddiqui, *A report on the Muslim population in the United States*, New York 1999.
M. Bying, Mediating discrimination. Resisting oppression among African American Muslim women, in *Social Problems* 45 (1998), 473–87.
L. Cainkar, Immigrant Palestinian women evaluate their lives, in B. Aswad and B. Bilgé (eds.), *Family and gender among American Muslims. Issues facing Middle Eastern immigrants and their descendents*, Philadelphia 1996, 41–58.
J. Desai, Rooted homelands, routed hostlands. (En)gendered mobility in the South Asian diaspora, Ph.D. diss., University of Minnesota 1999.
S. El Badry, The Arab-American market, in *American Demographics* (January 1994), 22–30.
M. H. Faragallah, W. Schumm, and F. Webb, Acculturation of Arab American immigrants. An exploratory study, in *Journal of Comparative Family Studies* 28 (1997), 182–203.
G. Gopinath, Nostalgia, desire, diaspora. South Asian sexualities in Motion, in *Positions* 5 (1997), 467–89.
H. N. Govindjee, South Asian-American women. Clothing, identities, and communities, master's thesis, University of California, Davis 1997.
S. Gupta, *Emerging voices. South Asian American women redefine self, family, and community*, Walnut Creek 1991.
Y. Haddad and J. Smith, *Muslim communities in North America*, Albany, N.Y. 1994.
D. S. Hassouneh-Phillips and D. Saadat, Marriage is half of faith and the rest is fear of Allah. Marriage and spousal abuse among American Muslims, in *Violence against Women* 7 (2001), 927–46.
M. K. Hermansen, Two way acculturation. Muslim

women in America between individual choice (liminality) and community affiliation (communias), in Y. Haddad (ed.), *The Muslims of America*, New York, 1991, 188–204.

J. Kadi, *Food for our grandmothers. Writings by Arab-American and Arab-Canadian American feminists*, Boston, Mass. 1994.

K. Leonard, *Making ethnic choices. California's Punjabi Mexican Americans*, Philadelphia 1992.

——, *American Muslims. History and state of research* (in preparation).

H. P. McAdoo, *Family ethnicity. Strength in diversity*, Thousand Oaks 1999.

A. B. McCloud, African American Muslim women, in Y. Haddad (ed.), *The Muslims of America*, New York 1991, 177–87.

——, "This is a Muslim home." Signs of difference in the African American row house, in B. D. Metcalf (ed.), *Making Muslim space in North America and Europe*, Berkeley 1996, 65–73.

K. Moore, The *hijab* and religious liberty. Anti-discrimination law and Muslim women in the United States, in Y. Haddad and J. Smith (eds), *Muslims on the Americanization path?* Atlanta, Ga. 1998, 129–58.

N. Naber, Ambiguous insiders. An investigation of Arab American invisibility, in *Journal of Ethnic and Racial Studies* 23:1 (2000), 37–61.

——, Arab San Francisco. On gender, cultural citizenship, and belonging, Ph.D. diss., Department of Anthropology, University of California, Davis 2002.

F. H. Nu'man, *The Muslim population in the United States. A brief statement*, Washington, D.C. 1992.

P. Pierce and B. F. Williams, "And your prayers shall be answered through the womb of a woman." Insurgent masculine redemption and the nation of Islam, in B. F. Williams (ed.), *Women out of place. The gender of agency and the race of nationality*, New York 1996, 186–216.

F. Ross-Sheriff, Immigrant Muslim women in the United States. Adaptation to American society, in *Journal of Social Work Research and Evaluation* 2 (1997), 283–94.

E. Shakir, *Bint Arab. Arab and Arab American women in the United States*, London 1997.

C. S'thembile, Revisiting female activism in the 1960s. The Newark branch nation of Islam, in *Black Scholar* 26 (fall-winter 1996), 41–8.

B. Williams, *Women out of place. Gender of agency and the race of nationality*, New York 1996.

Women of South Asian Descent Collective, *Our feet walk the sky. Women of the South Asian diaspora*, San Francisco 1993.

NADINE NABER

Arab States Overview: Early 20th Century to Present

For a sense of the complex epistemological and conceptual issues this entry raises, one need only to go to the Library of Congress online catalogue and type in the keywords "women" and "Arab countries." The thousands of entries displayed encompass works on subjects as diverse as the place of women in the Palestinian nationalist movement, women's writing in the Arab world, oral history collections of Arab-American women, family structures in the Middle East, and women and gender in Islam. Such conceptual slippage – between the "Middle East" and the "Arab world," between Arab women and women in Arab states and, perhaps most prevalently, between Arab and Muslim – has structured the body of scholarship on women in the Arab states since its inception in the late nineteenth century. The twentieth century marked the advent of modern scholarship on women in the Arab states, bringing with it conceptual categories, methodological issues, and theoretical tools that depart radically from other periods. Nationalism (both Arab and nation-state), decolonization, the establishment of modern nation-states, development paradigms and, more recently, globalization have impacted both the kinds of sources (and access to those sources) that are available for the study of women and analytical categories themselves.

This entry is concerned with "women in the Arab states" and not "Arab women" in the twentieth century for what the former term makes possible conceptually and methodologically. The category of Arab states encourages comparative work and helps scholars to get beyond the reliance on the category of Arab or Muslim women to include work on women who live in the region but belong to one of its various ethnic and religious minorities. It also allows for a certain flexibility in choosing not only how comparisons between women are to be made regionally but also comparisons between the ways in which women are positioned within individual national and nation-state political projects.

CONCEPTS AND CATEGORIES

One of the continuing methodological issues that must be confronted by researchers and scholars is the political and social salience of Islam when dealing with gender issues in the Arab states. As a body of literature, scholarship about women in the Arab states continues to be focused predominately on Muslim women, either explicitly or as a way to generalize about the position and experiences of women across the region. While this has yielded much excellent research about women in the region, privileging Islam as an explanatory category has a number of methodological shortcomings. One of the most persistent elements of Western as well as indigenous studies of women in the Arab states is the assumption that their conditions are all characterized by fixity and uniformity and have not changed over time (because Islam is held as a constant, unchanging essence) and that there are no variations in the lives of Muslim women across the geographic boundaries of the Arab states, the Middle East, and the Islamic world. In reality, it is important to underline the diversity and variations in the lives of Muslim women, not only across time, and not only between one country and another, but also within the same country. The rural-urban distinction is only one distinction to be made within a country, and social class also allows for differences within a society. And it is sometimes not clear that to speak about "Muslim women" as such is in fact a useful analytic category. What are the similarities between women in urban centers like Amman or Beirut, and rural Mauritania? And are the similarities always due to shared faith or are they also due to shared cultural traditions? In *The Republic of Cousins*, for example, Tillion illustrates that what the Arab states share in terms of gender conditions is also shared with areas of southern Europe. The category of Muslim women risks eliding the differences between Muslims, and also excludes the significant number of women living in the region who belong to other confessional communities and obscures cross-regional similarities.

The problematic of Islam and gender stems not only from the cultural and historical legacies of Islam but also from its institutionalized position within modern nation-state structures. The ways in which Islam has been deployed by modern states in the codification of legal codes, the establishment of new systems of juridical governance, the nationalization of education, and the establishment of bureaucracy have been critical in

shaping women's lives, possibilities, and experiences, both Muslim and non-Muslim. In particular, it is important to be attentive to how political projects (be they nation-state or otherwise) construct certain practices as Islamically permissible and others as not at particular historical moments. In Egypt, for example, the national family planning program encourages women to use contraception by citing fatwas (legal opinions) by state-appointed religious officials that birth control is religiously permissible (and in fact encouraged), while elective abortion is asserted as forbidden under Islam and, thus, remains illegal in Egypt, but not in Tunisia.

The state has also been implicated in the ways in which religious values are inculcated through public education. The inclusion of girls within national education systems in the region was legitimated precisely because public education aimed to transform young women into good mothers, good citizens, and good believers. Lesson plans, images in textbooks, school uniforms, the organization of space in the classroom or within schools themselves serve to create and underpin a gendered vision of national citizenship and cultural belonging, in which religiosity plays an important part. The differences between the educational systems of different countries – the extent to which religious instruction is part of the curriculum, whether or not there is co-education and at what levels, and the existence of various alternatives to public education such as private confessional or foreign language schools – means that the impact of education on the lives of women varies greatly from nation to nation and from social class to social class.

Another example of the ways in which particular versions of Islam become institutionalized within state structures is the partial prominence of Sharī'a laws in modern Arab states. How useful are references to Sharī'a in the face of Piscatori's (1986) persuasive demonstration that legal codes in all Muslim countries (including Iran and Saudi Arabia) are a hybrid mix of Sharī'a and Western civil codes? To be sure, in the area of personal status laws, the religious hierarchies and the state have insisted on an exclusive monopoly. Personal status laws determine the choices for women in areas of marriage, divorce, and inheritance, but Islamic law has always allowed for *ḥiyal* (literally tricks, meaning the permissible loopholes in Islamic laws). The existence of extensive collections of Sharī'a court records for many of the Arab states represents a way to complicate the understanding of the impact of Islamic laws on

Muslim women's lives (Sonbol 2000). Studies of inheritance practices in the Mashriq (Syria, Lebanon, Palestine, Jordan, and Iraq), for example, indicate that many families have been giving their daughters full shares and not half shares, required by the Sharī'a. Similarly, what explains the permissibility of *khul'* (the right of a woman to initiate a divorce) in Egypt and its impermissibility in Saudi Arabia has to do with the flexibility of interpretations of the Sunnī Islamic schools of jurisprudence, not to mention the views of Shī'ī Muslims, who also make up a significant percentage of the population in some Arab states. In contrast, court records have been used less frequently in the study of non-Muslim women in the Arab states, reflecting a tendency to generalize Arabness from the vantage point of Islam and Islamic institutions.

ARAB WOMEN VERSUS WOMEN IN THE ARAB STATES

To what extent can one speak about Arabs and the Arab states with any sort of uniformity? As the site of Islam's historical emergence and the region where the majority of the world's Arab population resides, the conceptual interchangeability of Arabs, the Arab states, and Islam has often been taken as axiomatic. Beginning in the 1950s, scholars (for example, Rafael Patai) who felt that Arab tradition and the Beduin ethos explain much about the character and temperament of the Arabs tended to accept the utilitarian value of the Arab world or the Arab region. The Arab people are thus seen as a group sharing the same cultural tradition going all the way to the nomads of Arabia. Such works, which emerged within the context of an emerging post-Second World War bipolar order and the discovery of oil in the region, reflected both new sorts of interests in Arabness (now defined as a coherent category) and new sorts of Western geopolitical and strategic concerns. This school, of course, exaggerates the political and sociological prominence of the Beduin ethos, forgetting that nomads are now a dying element of the Arab population. It also ignores the complex history of the region, where nomadic tribal culture and practices overlapped, existed alongside, and interacted with those of urban, sedentarized, and pre-existing populations.

Emerging from a different political and historical trajectory, the popularity of Arab nationalist ideologies like pan-Arabism and Ba'thism that emerged in the 1960s prompted the production of a large number of works in Arabic and Western

languages about Arab women across nation-state lines. These works reflected not only the increased political salience of "Arab" as a category of analysis in the region, but also the establishment of new networks of exchange and collaboration between indigenous researchers and the emergence of new academic and scholarly institutions such as the Center for Arab Unity Studies (founded in 1975) and the Institute for Women's Studies in the Arab World (founded in 1973) in Lebanon, which produce scholarship in Arabic and English. Much of this literature has been (and continues to be) policy-oriented, drawing on statistics concerning women's participation in the labor force, the development of women's education, their political participation, and health indicators. International organizations such as the United Nations, the World Bank, and the International Monetary Fund and various other Western donor organizations have produced a large body of similar development-oriented literature over the last half-century, the most recent of which is the much publicized *Arab Human Development Report* of 2002 published by the UNDP. Such literature has become increasingly focused on women and gender issues in the region, particularly as development paradigms shifted to be explicitly concerned with "gender mainstreaming" as a key to effecting social, economic, and political progress in the global south. In its effort to chart macro-level social and economic transformations, however, development literature has been exclusively concerned with objective, quantitative markers of women's status across a broad population. This kind of approach tends to leave out local specificities and the voices of women themselves (who are the objects of such research and not its subjects), and because such studies are policy-oriented, they tend to be limited by the policy objectives of the institutions producing them, whether those be national, international, nongovernmental, or academic. Furthermore, those studies, not unlike mainstream Western feminist studies, reflect the voice of professional upper-class women and not the majority of poor women in our regions.

Ethnographic work, by contrast, has aimed to locate the subjective experiences of women in the region within economic, political, and social structures and practices without privileging them as either an object of study or as an explanatory factor. For this reason, the field of ethnographic studies by anthropologists has been one of the most effective tools of academic research on Arab women. For the first time, the lives of women, most of them non-elites, in the region were observed by women (mostly), rather than men; in recent decades there have been more female anthropologists from the region producing ethnographies about their own cultures (see Altorki and El-Solh 1994 for the autobiographical essays written by such scholars). Anthropologists of the Arab world have allowed us to enter the region's homes and permitted women to report about themselves without the barriers of gender and classical Orientalist dogmas. It is, however, the nature of ethnography to be concerned with the experiences and affiliations of particular local communities; ethnographic accounts, while invaluable sources of information about the complicated ways in which particular gender identities are negotiated through an engagement with political, social, and economic forces on a micro-level, are perhaps perhaps less useful for suggesting broader cross-regional comparisons between women.

In addition to the empirically-focused quantitative literature on policy and development, the other body of work that has most often deployed the category of Arab women broadly is that of literary production, biography, and autobiography. A large body of literature in Arabic, by and about women in the Arab states, ranging from autobiographical accounts, to novels and poetry, to the women's press, emerged over the twentieth century. There has been a laudable effort to translate the works of women and their memoirs resulting in collections that encourage comparative readings and analysis. Margot Badran and Miriam Cooke (eds.), *Opening the Gates: A Century of Arab Feminist Writings* is a notable example, as is the work of the Women and Memory Forum, located in Cairo. Women's autobiographical writings in particular are essential tools because they fill the gaps in the literature about the direct experiences and feelings of women in the region. Some hazards inherent in these works should be pointed out. Women who write autobiography and literature are invariably educated, or highly educated, and belong to the middle and upper classes. The politics of translation – whose works get translated, from what languages, and on what terms – raises other methodological issues. Such works are most often translated from Arabic or European languages. Non-Arab women writing in Arabic or French may, on occasion, be included in translated collections of Arab women's writing while the writings of women in other regional languages (such as Armenian and Kurdish) are largely excluded.

Both sets of literature, despite their qualitative differences (a focus on the objective quantifiable aspects of women's material circumstances on the one hand and on their subjective, interpersonal experiences on the other) tend to share a conceptual reliance on the category of Arab women, which may, wittingly or unwittingly, reproduce the terms of Arab nationalist discourse. The foundational categories of Arab nationalism, because of its secular orientation, have encouraged the inclusion of non-Muslim women in scholarship of the region by highlighting common experiences and cultural affiliations while downplaying (if not rejecting outright) the importance of confessional ties and how religious minorities are positioned within Arab nationalist ideologies. In definition (if not always in practice), this prevents the inclusion of non-Arab women's particular experiences as members of minority communities. The category of Arab states, however, allows the inclusion of women who belong to the region's ethnic minorities (Nubian, Berber, Circassian, Armenian, Assyrian, Kurdish, and so forth).

THE NATION-STATE

For some issues, it may be useful to study women in Arab states using a country-by-country approach. The legal and cultural differences between Arab and Arab Muslim countries are such that differences may be obscured by the general all-encompassing approach where Tunisia (where abortion is legal and polygamy is illegal) and Saudi Arabia (where women are subject to a legal regime based on Islamic law) are placed in the same category. The nation-state has, in fact, provided a central paradigm for the study of women (particularly in the disciplines of history and political science) since the 1950s and 1960s, when struggles for independence and decolonization in the region, most notably in North Africa, resulted in the establishment of independent nations with indigenous leaders and bureaucratic apparatuses that, for the most part, were inherited from the colonizing powers. Postcolonial scholarship on women in the Arab states has attempted both to chart the legacies of the colonial period for the ways in which women are incorporated into the nation-state (Lazreg 1994, Charrad 2001) and to counter the body of colonial ethnography, which provided the earliest literature on women.

Early works on women in the region emerged directly out of the region's encounter with European colonialism. Much of the scholarship on women in the late nineteenth and early twentieth centuries was produced by European travelers, ethnographers, and colonial officials. Written accounts by female travelers, though fewer in number, produced a body of "harem" literature, which focused largely on women and domestic practices in elite Muslim households. What these accounts shared was a focus on the exotica of "Oriental" custom and practice (veiling, folklore, sexual habits, superstition, polygamy, popular religious ritual), a complete absence of indigenous women's voices, and an over-determined reliance on Islam as an explanatory category (Goribon 1927, Fraser 1911) For example, the preoccupation of members of the French school of colonial ethnography (Montagne 1930) with women's status in Islam served to stress the uniformity of women's position and experiences in spite of differences of class, ethnicity, geographical position, local affiliation, and historical location. It was also heavily polemical; the cause of Muslim women was often used merely to discredit Islam and to advance the interests of colonial projects (the moral component of colonialism or *la mission civilisatrice*). Writing against such literature, one of the tasks with which postcolonial scholarship has been explicitly concerned, is writing the political, broadly conceived, into the study of women in Arab countries.

The reliance by scholars on the nation-state as a category of analysis for the study of women and gender in part reflects the centrality of women to national political projects as well as attempting to write beyond the limits of colonial ethnography. As Deniz Kandiyoti (1991) has pointed out, nationalist projects delineate women as the boundary markers of communal national identity, and signifiers for the nation's modernity. Such boundaries are produced and maintained not only through legislation, the education system, social policy, and state-building projects, but through the mass media, literature, and visual culture, not to mention repressive armies. The emergence of nation-state bureaucracies in the aftermath of colonial rule has meant a proliferation of government agencies concerned with the management of national populations. Tools such as censuses, household and demographic surveys, project feasibility reports, and knowledge, attitude, and practice tests (used to assess attitudes toward family size and contraceptive usage) represent an important body of sources for the study of women in the Arab states (particularly rural and working-class women) even as they reveal the extent to which such sources help to delineate the nation's women as the targets of state reform and tutelage.

Scholars availing themselves of these sources must attend to what kinds of information about women states prioritize (and what they leave out), and also to how that knowledge is implicated in national political projects that structure the relations between the state and its citizens and between various groups within the nation. It is not enough, for example, to look at census statistics concerning the various minority groups (ethnic, confessional, and so forth) that make up a part of the Arab states' populations without interrogating the critical role those statistics play in defining the very terms of the distinction between minority and majority. A risk of relying on the nation unproblematically as a conceptual category is that it implicitly privileges the nation-state formation as the primary locus of identity and affiliation for women in the Arab states. Local ties, supra- and sub-national affiliations have historically intersected (and continue to intersect) in complex ways with national identities, with complicated, often contradictory ramifications for women's lives. A key challenge to scholars of women in the Arab states, then, will be how to interrogate the nation-state as a category of analysis by recognizing the importance of local, regional, and global configurations, while at the same time acknowledging that for many of the region's inhabitants, the nation (both the Arab nation and individual nation-states) remains a critical referent in their lives.

ISSUES OF ACCESS

It is not only epistemological categories that have served to give a particular shape to the body of work on women in the Arab world. The issues of access and (geo)political considerations have also played a major role in delineating the parameters of scholarship on women in the Arab states. When (and where) archives are available to scholars, how much and what sort of access researchers have to local populations, what sort of information is relatively available, and which is "classified" or unavailable has contributed to determining the types of knowledge that are produced about women in the Arab states.

Recent scholarship on Iraq, for example, has remained confined largely to statistical accounts (often produced by non-governmental organizations and international organizations such as the United Nations) of the effects on the Iraqi population of the economic sanctions the country has been subject to since the end of the Gulf War in 1991. Such studies may or may not contain information on how the regime of sanctions has impacted the lives of women specifically. The primary accounts of women's lived experiences under sanctions have been autobiographies written by Iraqi women (Radi 1998, Mikhail 1999) and documentaries. To date, there are only a handful of works in English (Khayyat 1996) that have focused on any aspect of Iraqi women's lives during the pre-Gulf War period. That such work has been confined to ethnography reflects the extremely restricted access that scholars were given by the Iraqi government to state archives, statistical material, and ruling Baʿth party documents. The full implications of the burning of the Iraqi national archives in April 2003 in the wake of the U.S. invasion of Baghdad have yet to be assessed. It seems clear, however, that the destruction of historical documents ranging from the ʿAbbāsid period to the twentieth century will have a fundamental impact, not only in the kinds of research that can be undertaken on women, but on the very ways in which history and memory are understood.

The civil war in Lebanon (1975–90) gave rise to a substantial body of scholarship on women and war but largely circumscribed other sorts of studies. Postwar reconstruction in Lebanon, which has become an increasing subject of study over the last decade, has not produced an equivalent body of scholarship on Lebanese women in the postwar period. Suad Joseph's work on citizenship and the family is an exception (1991, 1999, 2000). It is only in the last several years that researchers have begun to take advantage of increased access to Lebanese state and private archival materials and sources (such as government documents, autobiographies, diaries, and the press), and produced historical accounts locating women within the major forces – colonialism, nationalism, migration – shaping Lebanese history in the first half of the twentieth century (Thompson 2000, Khater 2001). By contrast, Egypt, owing to its relative political stability and comparatively easy access to government and private archives, has been a much wider and varied focus of study resulting in a proliferation of studies on women and gender over the last two decades (see Clarissa Pollard's article in this volume).

A thirteen-year civil war between the Algerian states and Islamist insurgents (1990 to the present) has also played a role in determining how Algerian women have been studied over the last decade and in what contexts. While a fairly substantial and varied body of literature in English on Algerian women exists for the pre-civil war period (see Donna Lee Bowen's article in this

volume) recent work, in both English and French, has tended to focus on Algerian women's encounter with Islamism and their experiences of the civil war (Messoudi 1998, Hessini 1998, Imache and Nour 1994). It must be pointed out, however, that even these works are limited in number. Travel restrictions to Algeria implemented by Western governments, lack of access to archives and the hazards of doing fieldwork in a conflict zone have meant that the ability of foreign scholars to carry out research in Algeria has been severely curtailed (although Algerian scholars, mostly writing in French, continue to produce work on Algerian women). It is perhaps not surprising, then, that one of the areas in which work on Algerian women seems to be burgeoning is literary translation and literary criticism. The works of Algerian women writers such as Assia Djebar have been extensively translated from French and a number of very recent studies exist on issues of gender and women's writing in Algerian literature (Cox 2002, Donadey 2001). What these novels and works of literary criticism share is a focus on the fractured nature of identity and memory, the shattering of linear narratives, and the silences and erasures within national history, themes that reflect the failure of the Algerian national project and the profound ruptures war has produced within Algerian society.

BEYOND THE NATION-STATE AND THE ARAB STATES

A final challenge to scholars of women in the Arab states remains in broadening the scope of analysis beyond the geographical and politicized boundaries of the nation and the states that make up the region. There are an increasing number of works dealing with issues of immigration, migration, globalization, and Arab states diaspora communities in other parts of the globe (Doumato and Posusney 2003). Studies of Arab-American women in particular have proliferated over the last two decades (Kadi 1994, Shakir 1997, Benson 2002). How to bring the issues that such works raise into dialogue with those being produced about women within the Arab states themselves continues to be a question of methodological and theoretical importance for the field and a task for future researchers.

BIBLIOGRAPHY
E. Accad, Sexuality and war. Literary masks of the Middle East, New York 1990.
M. Alloula, The colonial harem, Minneapolis, Minn. 1986.
S. Altorki and C. El-Solh (eds.), Arab women in the field. Studying your own society, Syracuse, N.Y. 1988.
M. Badran and M. Cooke (eds.), Opening the gates. A century of Arab feminist writing, Bloomington, Ind. 1990.
K. Benson, A community of many worlds. Arab Americans in New York City, Syracuse, N.Y. 2002.
Center of Arab Women for Training and Research, Globalization and gender. Economic participation of Arab women, Tunis 2001.
M. Charrad, States and women's rights. The making of postcolonial Tunisia, Algeria, and Morocco, Berkeley 2001.
M. Cooke, Women's other voices. Women writers and the Lebanese civil war, Cambridge 1988.
D. Cox, Politics, language, and gender in the Algerian Arabic novel, Lewiston, N.Y. 2002.
R. Deguilhem and M. Man, Writing the feminine. Women in Arab sources, London 2001.
A. Donadey, Recasting postcolonialism. Women writing between worlds, Portsmouth, N.H. 2001.
E. Doumato and M. P. Posusney (eds.), Women and globalization in the Arab Middle East. Gender, economy, and society, Boulder, Colo. 2003.
H. M. El-Shamy (trans.), Tales Arab women tell and the behavioral patterns they portray, Bloomington, Ind. 1999.
F. Faqir (ed.), F. Faqir and S. Eber (trans.), In the house of silence. Autobiographical essays by Arab women writers, Reading, U.K. 1998.
E. Fernea, Guests of the sheik. An ethnography of an Iraqi village, Garden City, N.Y. 1965.
J. F. Fraser, The land of veiled women. Some wanderings in Algeria, Tunisia and Morocco, London 1911.
A. M. Goribon, La vie féminine au Mzab. Etude de sociologie musulmane, Paris 1927.
L. Hessini, From uncivil war to civil peace. Algerian women's voices, New York 1998.
N. Hijab, Womanpower. The Arab debate on women at work, Cambridge 1988.
N. Hopkins and S. E. Ibrahim, Arab society. Class, gender, power and development, Cairo 1997.
D. Imache and I. Nour, Algériennes entre islam et islamisme, Aix-en-Provence 1994.
S. Joseph, Elite strategies for state-building. Women, family, religion, and the state in Iraq and Lebanon, in D. Kandiyoti (ed.), Women, Islam, and the state, Philadelphia 1991, 176–200.
——, Women between nation and state in Lebanon, in C. Kaplen et al. (eds.), Between women and nation, Durham, N.C. 1999, 162–81.
——, Civic myths, citizenship and gender in Lebanon, in S. Joseph (ed.), Gender and citizenship in the Middle East, Syracuse, N.Y. 2000, 107–36.
J. Kadi (ed.), Food for our grandmothers. Writings by Arab American and Arab Canadian feminists, Boston, Mass. 1994.
D. Kandiyoti, Identity and its discontents. Women and the nation, in Millenium 20:3 (1991), 429–43.
A. Khater, Inventing home. Emigration, gender, and the middle class in Lebanon 1870–1920, Berkeley 2001.
S. Khayyat, Honour and shame. Women in modern Iraq, London 1996.
N. Khoury and V. Moghadam, Gender and development in the Arab world. Women's economic participation. Patterns and policies, London 1995.
M. Lazreg, The eloquence of silence. Algerian women in question, New York 1994.

L. Majaj, *Intersections. Gender, nation, and community in Arab women's novels*, Syracuse, N.Y. 2002.

Markaz al-dirāsāt wa-al-buḥūth al-duwāl al-nāmiyya, *al-Mar'a wa-al-tanmiyya*, Cairo 1999.

K. Messoudi, *Unbowed. An Algerian woman confronts Islamic fundamentalism*, Philadelphia 1998.

D. Mikhail, *Diary of a wave outside the sea*, Cairo 1999.

M. Mikhail, *Seen and heard. A century of Arab women in literature and culture*, New York 2003.

R. Montagne, *Villages et kasbas berbères. Tableau de la vie sociale des Berbères sédentaire dans le Sud du Maroc*, Paris 1930.

R. Patai, *The Arab mind*, New York 1973.

J. Piscatori, *Islam in a world of nation-states*, Cambridge 1986.

N. Radi, *Baghdad diaries*, London 1998.

B. Shaaban, *Both right and left handed. Arab women talk about their lives*, Bloomington, Ind. 1991.

E. Shakir, *Bint al-Arab. Arab and Arab American women in the United States*, London 1997.

'A. Shalaq, *al-Mar'a wa-dawruhā fī ḥaraka al-waḥda al-'Arabiyya*, Beirut 1993.

L. Shehadah (ed.), *Women and war in Lebanon*, Gainesville, Fla. 1999.

A. Sonbol (ed.), *Women, the family, and divorce laws in Islamic history*, Syracuse, N.Y. 1996.

E. Thompson, *Colonial citizens. Republican rights, paternal privilege, and gender in French Syria and Lebanon*, New York 2000.

G. Tillion, *The republic of cousins. Women's oppression in Mediterranean society*, London 1983.

J. Tucker, *Arab women. Old boundaries, new frontiers*, Bloomington, Ind. 1993.

M. Ṭūqān, *al-Taṭwīr, al-ta'līm wa-al-mujtama' fī al-duwal al-'Arabiyya*, Beirut 2000.

United Nations Development Programme, *Arab human development report 2002*, New York 2003.

——, *Arab women 1995. Trends, statistics, and indicators*, New York 1997.

J. Zeidan, *Arab women novelists. The formative years and beyond*, Albany, N.Y. 1995.

LAURA BIER

Egypt: Early 20th Century to Present

Inquiries into the role of women in twentieth-century Egypt have to a great extent been shaped by scholarship that traces the rise and subsequent transformations of the Egyptian nation-state. Indeed, the Egyptian revolution of 1919, Gamal Abdel Nasser's revolution of 1952, Anwar Sadat's *infitāḥ*, or open-door capitalist economic policies, and Husni Mubarak's current attempts to meld the dominant ideologies of the twentieth century – Arabism, capitalism, state-socialism and Islamism – into a cogent political program have each given rise to a body of literature about the Egyptian state in both its local and international contexts. Within this literature, inquiries into the relationship between state and citizen have held pride of place, and the various positions women hold in the body politic, the economic arena, and civil society have not been ignored. Scholars have attempted to quantify and qualify women's experiences with and within the nation-state, illustrating their successes (and failures) as political and economic agents and highlighting the differences (and similarities) between the behavior of men and that of women within the political arena.

Scholarship on women from the era of the 1919 revolution, for example, in which Egyptians secured their independence from Great Britain, has been shaped by discussions of the revolutionary role women played in the struggle against colonial occupation. In *Feminists, Islam, and Nation: Gender and the Making of Modern Egypt*, for example, Margot Badran accounted for the number of upper-class women who participated in demonstrations, strikes, and boycotts, as well as the ability of women to use their financial resources to provide behind-the-scene assistance to male politicians. Accompanying discussions about female revolutionaries have been inquiries into Egyptian women's attempts to secure an active political role for themselves in the Egyptian body politic after independence had been secured. Similarly, increases in the number of literate Egyptian women in the revolutionary era, the rise of women as informed, nationalist consumers, as illustrated by Mona Russell's "Creating the New Woman: Consumerism, Education, and National Identity in Egypt," and the tremendous growth of the female-sponsored press as chronicled by Beth Baron in *The Women's Awakening in Egypt:*

Culture, Society, and the Press have all contributed to a body of literature on women and Egypt's early experiences with self governing. In Egypt's national archives (Dār al-wathā'iq al-qawmiyya), material from the period prior to and accompanying the British occupation of 1882 offers illustrations of women's early experience within the nation-state. Additionally, the archives of the ministry of Awqāf as well as Dār al-wathā'iq and Dār al-maḥfūẓāt al-ʿumūmiyya – also in Cairo – each hold records and legal documents from Islamic law (Sharīʿa) courts and Western civil courts. Marriage and divorce papers and inheritance records have served both to paint a portrait of upper-class women's lived experiences and to illustrate the rise of women's political and economic interests. (Permission to use Egyptian archives is normally obtained through the Egyptian ministry of education; the ministry of Awqāf oversees permission to use its archives.)

In Nasser's Egypt (1952–70) suffrage brought women into a new relationship with the political arena, and the possibilities for them within the political and economic programs sponsored by Nasser's regime proliferated. Historians and political scientists, in particular, have mapped women's entrance into the political realm in the 1950s and 1960s, using Egyptian state-archival materials and the media to illustrate not only the kinds of programs and positions available to women, but also the effects of Nasserism on the lived experience of women of all classes. (Scholarly production concerning the relationship between the nation-state and non-elite women in the Nasser era is much greater than similar inquiries from earlier periods.) Themes from 1919 continue to surface in scholarship on the Nasser era, especially inquiries into the female-sponsored press and the expansion of the Egyptian educational system. The work of Selma Botman, Ghada Talhami, and Earl Sullivan on women in politics has illustrated the relationship between women and the body politic in the Nasser era.

In scholarship concerning Sadat's regime (1970–81) the state/women nexus has tended to produce two particular kinds of scholarship. To begin with, the tendency to focus on the number of women with access to the state has continued – as illustrated by Earl Sullivan, in particular –

and the political experiences of female members of Sadat's new bourgeoisie have received great attention. Additionally, the educational, professional, and intellectual experiences of the female by-products of Westernization Sadat-style have come to constitute a substantial body of literature.

But the results of the Sadat era have also given rise to new terrains in the study of modern Egyptian women. *Infitāh*'s failure to improve, or even secure, the economic well-being of many Egyptians – male and female alike – has drawn the attention of scholars away from the relationship of women and the state toward addressing questions of how women achieve agency outside of the state's "official" realms. The activities of women of all classes in the informal economy, for example, shape inquiries into Sadat's Egypt as well as that of his successor, Husni Mubarak. Hoda Hoodfar's *Between Marriage and the Market: Intimate Politics of Survival in Cairo* illustrates the experiences of Cairene women whose relationship to the formal economy is one of circumvention. Women's work within non-governmental organizations (NGOs), and the large number of women who participate in professional syndicates of lawyers, engineers, journalists – to name only a few – have been the subject of scholarly inquiry into the Sadat and Mubarak regimes. As in earlier eras, researchers have not lost interest in women's education and its role in flooding the workforce with women and the role of women in the media; and the experiences of females continue to serve as categories of inquiry.

Indeed, the frequent failure of the Egyptian nation-state to wholly include women or to fully address their political and economic needs has given rise to another body of literature. Here, the state is often included in analyses of women's experiences, and state-produced archival materials are sometimes drawn on. But, with the emphasis off of the state as producer or provider of political and economic experiences, women's agency has more readily been highlighted. In the 1919 era, the failure of the independent nation-state to grant women suffrage has given rise to a substantial body of literature on the history of feminism in Egypt. In the decades preceding Nasser's rise to power, women's roles as outlaws, suffragists, educators, philanthropists, lecturers, journalists, and organizers have been well chronicled. Sources for this period are rich, including both state-produced accounts of women's activities as well as women's own written experiences. Badran's *Feminists, Islam, and Nation* and Cynthia Nelson's account of Egyptian feminist Doria Shafik offer nuanced accounts of the early feminist movement.

Nasser granted women suffrage while at the same time circumscribing all but state-sponsored notions of feminism. Scholarship covering women who resisted Nasser's plans for them has thus diverged from inquiries into the experiences of women who worked within Nasser's giant bureaucracy, sat on one of his many councils, or took part in his cooperatives. Women persisted in articulating alternative versions of feminism, led strikes and demonstrations against the state and in condemnation of regional politics, and shared their knowledge of and faith in Islam with one another – often in direct challenge to Nasser's authority.

The increased disparity between rich and poor in Sadat's Egypt gave rise to similarly divergent accounts of women's experiences with the Egyptian nation-state and its policies. Accounts of women's resistance to the state, as well as their struggle to achieve or maintain economic solvency in Sadat's era have been rich and varying in their approaches. Egyptian women have left accounts of their experiences with economic and political policies that often gave them greater opportunities while at the same time limiting their civil rights. At the same time, the inability of Sadat's state to meet population growth and subsequent rises in unemployment and housing shortages with effective policies has been traced by historians, political scientists, and anthropologists. Scholars have examined such topics as women's efforts to secure housing for themselves and their families in unofficial structures and neighborhoods; women's endeavors in the unofficial economy; women's use of medical practices that fall outside the state's dominion; women's role in shaping familial and extra-familial networks; women's choice of traditional clothing both to lower expenditures and to lessen the challenges of life in congested areas. Each of these topics has shaped a body of literature that includes women's experience with the state but that illustrates the value of women's accomplishments and challenges outside of the state's grasp. Sources for such inquiries have typically not been archival, and have relied instead on fieldwork, interviews, and lived experience among middle- and working-class women. Nadje al-Ali's comprehensive account of the Egyptian women's movement chronicles women's extra-state activities, as well as their attempts to work within the body politic.

Inquiries into women outside the state's dominion have extended into the Mubarak era in which

the increased presence and activities of NGOs and professional syndicates have provided fertile sources for the examination of women's activities relative to but slightly outside of what we might consider to be state-sponsored political and economic projects. In such analyses, women perform para-political roles: they run for elections, sit on governing bodies, make executive decisions. While researchers would not necessarily include such women in head-counts of female politicians, these women actively address the social and economic agendas that have fallen beyond the state's grasp.

The role of the state in changing and regulating the role of women within the family and the household has recently offered new vistas in Egyptian women's studies. In the early decades of the twentieth century, for example, the British used images of the Egyptian family – both real and imaginary – to critique Egyptian politics. Nationalists, in turn, offered suggestions for how Egyptian families might be reformed in order to illustrate their political agendas. In the Nasser era, family planning programs accompanied a cosmology of state-sponsored projects aimed at promoting the ideals of Arab socialism. In each case, prescriptions for motherhood, domestic roles, and the size and function of families have served to display political agendas.

Egypt's political and economic circumstances have not always allowed women to meet the standards set for them by the state – a disparity that has increasingly been addressed by scholars. Women of all classes work outside the home, rendering the focus on the domestic realm and child-rearing that was prescribed for women in state-produced textbooks over the course of the twentieth century impossible. Gaps between real and ideal illustrate the extent to which the Egyptian state is both relevant and superfluous to family life. In a similar vein, inquiries into households among the urban poor in particular function as states, ordering social and economic relationships between individuals and the community in the absence of strong state presence. Dianne Singerman's *Avenues of Participation: Family, Politics and Networks in Urban Quarters of Cairo* illustrates the attempts of families to do for themselves that which the state does not do for them.

Finally, the tendency of nation-states to use images of women as symbols of political and economic agendas has been the most recent focus of scholarship on women in Egypt, both extending and complicating earlier agendas. Such scholarship has tended to bypass traditional analyses of the role of women in politics, asking questions about the symbolic role of "womanhood" in shaping and building nation-states and national identities rather than quantifying women's participation in the political arena. Archival studies have been combined with literary critical analyses in order to uncover not only how nation-states are built, but also how they are represented. Women – or images of them – have often been found to be more central to the symbolic realm than they have been to the actual construction of the body politic.

In the decades leading up to the 1919 revolution, for example, the Woman Question burned hotly in intellectual debates about the future shape and function of the nation-state. Traditionally, accounts of debates over "women" have been treated as attempts by certain men (and women) to either extend or circumscribe women's roles and rights in the public realm. Recent treatments of the Woman Question have revealed that images of women – rather than actual women – were the object of such debates, shaping discussions of abstract concepts and ideals such as modernity, capitalism, and constitutionalism. (While such studies do not negate the very real concerns that reformers had about women and their position in Egyptian society they do uncover new and crucial avenues of inquiry in "women's" studies.) Lila Abu-Lughod, Marilyn Booth, and Lisa Pollard have each recently illustrated the ways in which tension was created between the aspirations of real women and the symbolic power of ideal womanhood. Inquiries into women as symbols have been extended into the more recent period to illustrate how "women" have been symbolic of pan-Arabism, the United Arab Republic, and socialism. Recent scholarship has also revealed how images of women have been central to shaping the platforms of the state's opponents, in particular those who challenge the state in the name of Islam, as illustrated in Mervat Hatem's "Secular and Islamist Discourses on Modernity in Egypt and the Evolution of the Postcolonial Nation-State."

BIBLIOGRAPHY

L. Abu-Lughod (ed.), *Remaking women. Feminism and modernity in the Middle East*, Princeton, N.J. 1998.
L. Ahmed, *A border passage. From Cairo to America – a woman's journey*, New York 2000.
N. Al-Ali, *Secularism, gender and the state in the Middle East. The Egyptian women's movement*, Cambridge 2000.
M. Badran, Transforming culture. More than a century of feminism in Egypt, in J. E. Tucker (ed.), *Arab women. Old boundaries, new frontiers*, Bloomington. Ind. 1993, 129–48.

——. *Feminists, Islam and nation. Gender and the making of modern Egypt*, Princeton, N.J. 1995.

B. Baron, The making and breaking of marital bonds in modern Egypt, in N. Keddie and B. Baron (eds.), *Women in Middle Eastern history. Shifting boundaries in sex and gender*, New Haven, Conn. 1992, 275–91.

——, *The women's awakening in Egypt. Culture, society and the press*, New Haven, Conn. 1994.

——, Nationalist iconography. Egypt as a woman, in J. Jankowski and I. Gershoni (eds.), *Rethinking nationalism in the Arab Middle East*, New York 1997, 105–24.

M. Booth, *May her likes be multiplied. Biography and gender politics in Egypt*, Berkeley 2002.

S. Botman, *Engendering citizenship in Egypt*, New York 1999.

J. R. I. Cole, Feminism, class and Islam in turn-of-the-century Egypt, in *International Journal of Middle East Studies* 13 (1981), 387–405.

E. Early, *Baladi women of Cairo. Playing with an egg and a stone*, Boulder, Colo. 1993.

M. Hatem, Secular and Islamist discourses on modernity in Egypt and the evolution of the postcolonial nation-state, in Y. Y. Haddad (ed.), *Islam, gender and social change*, Oxford 1998, 85–99.

——, Pitfalls of the nationalist discourses on women in Egypt, in S. Joseph (ed.), *Gender and citizenship in the Middle East*, Syracuse, N.Y. 2002, 33–57.

H. Hoodfar, *Between marriage and the market. Intimate politics and survival in Cairo*, Berkeley 1997.

M. Inhorn, Urban Egyptian women in the informal health care sector, in Richard A. Lobban (ed.), *Middle Eastern women and the invisible economy*, Gainsville, Fla. 1998, 113–31.

S. Joseph (ed.), *Gender and citizenship in the Middle East*, Syracuse, N.Y. 2000.

B. K. Larson, Women, work and the informal economy in rural Egypt," in R. A. Lobban (ed.), *Middle Eastern women and the invisible economy*, Gainsville, Fla. 1998, 148–65.

R. A. Lobban (ed.), *Middle Eastern women and the invisible economy*, Gainsville, Fla. 1998.

A. E. MacLeod, *Accommodating protest. Working women, the new veiling, and change in Cairo*, New York 1991.

C. Nelson, *Doria Shafik Egyptian feminist. A woman apart*, Gainseville, Fla. 1996.

L. Pollard, The family politics of colonizing and liberating Egypt, 1882–1919, in *Social Politics* 7:1 (2000), 47–79.

A. Rugh, *Family in contemporary Egypt*, Syracuse, N.Y. 1984.

——, *Reveal and conceal. Dress in contemporary Egypt*, Syracuse, N.Y. 1986.

M. Russell, Creating the new woman. Consumerism, education, and national identity in Egypt, 1863–1922, Ph.D. diss., Georgetown University 1997.

N. al-Saʿdāwī, *A daughter of Isis. The autobiography of Nawwal El-Saadawi*, trans. S. Hetata, London 1999.

H. Shaʿrāwī, *Harem years. The memoirs of an Egyptian feminist 1879–1924*, trans., ed., and intro. M. Badran, New York 1986.

F. C. Shorter, *Cairo's leap forward. People, households, and dwelling space*, Cairo 1981.

D. Singerman, *Avenues of participation. Family, politics, and networks in urban quarters of Cairo*, Princeton, N.J. 1995.

D. Singerman and H. Hoodfar (eds.), *Development, change, and gender in Cairo. A view from the household*, Bloomington, Ind. 1996.

A. El Azhary Sonbol (ed.), *Women, the family and divorce laws in Islamic history*, Syracuse, N.Y. 1996.

E. L. Sullivan, *Women in Egyptian public life*, Syracuse, N.Y. 1986.

G. H. Talhami, *The mobilization of Muslim women in Egypt*, Gainesville, Fla. 1996.

H. Watson, *Women in the city of the dead*, London 1992.

U. Wikan, *Life among the poor in Cairo*, trans. A. Henning, London 1980.

LISA POLLARD

North Africa: Early 20th Century to Present

In the latter decades of the twentieth century, research on women from the North African nations of Libya, Tunisia, Algeria, and Morocco flourished. The research collected and analyzed data on women's lives and situations through the lenses of various disciplines: history, literature, political science, demography, health, development, anthropology, religious studies, sociology, law, and gender studies. The state's political agenda, in terms of both colonialism and development strategy, was a major influence on the data collected and the methods used in the research on women.

The wars fought to establish foreign rule, the foreign political, cultural, and economic colonization, and the differing conditions of each nation's struggle for independence have all affected the situation of women. France colonized North Africa beginning with Algeria in 1830, Tunisia in 1881, and Morocco in 1912 (Spain occupied Northern Morocco and the Western Sahara). Libya, invaded by Italy in 1911 and given independence in 1951, is the one exception to French hegemony. Each country gained independence in the 1950s or 1960s, but under different circumstances. Algeria (1962) fought a bloody civil war, while Tunisia and Morocco pursued political paths to independence, which each received in 1956. The states in North Africa share much that is similar in history, religious status, cultural influences, and relations with the West. However, each state not only diverged in addressing their colonial situations, but also differed in their means of gaining independence, the system of governance each established, and in their national policies toward women citizens. These differences are reflected in research that has been done on women in the three countries colonized by France and also in the methods used in this research.

In past decades, the United States and Europe have emphasized issues of women's status and human rights and have addressed the status of women in Muslim, Middle Eastern, and North African countries. This article largely refers to literature published and distributed in the United States, Western Europe, and by the larger North African publishers. Articles published in the popular media are not included in this study.

During the colonial period, studies on women were mostly written by French scholars who studied women within the context of the family. A comprehensive bibliography on Moroccan women notes that most of the research concerned women's roles in their families, including childbirth and nursing, as well as exotica about women: prostitution, magic, tattoos, costumes, harems, polygamy. A secondary theme that arises in the latter part of the protectorate period introduces questions on women in Islamic law and religion (Belarbi 1984, 75–8). Major sources for this research were ethnographic studies, travel literature, historical and religious literature in Arabic, French censuses, and data generated by government ministries. French research was structured with the goal of using knowledge about the newly-colonized societies to govern effectively and weaken nationalist groups. For the most part, women were aggregated with their family groups. Research on their educational and legal situation became a baseline from which the French advocated selected reforms designed to westernize women in order to weaken ties to nationalists. Stereotypes based on images of women's passivity led researchers to downplay women's activity in the nationalist movement. The role of Algerian women in supporting their national movement and their involvement in the war for independence has been documented (Lazreg 1994). The roles of women in the national struggles in Tunisia and Morocco have yet to be well documented.

Following independence, research conducted on North African women's lives and status reflects national priorities and political concerns. The ways women's lives are conceptualized as well as factors influencing their role in their family, society, and the nation seem to be linked to the political policies of the given nation-state. To a large extent, the research conducted on women's issues reflects the concerns of the regimes in power and multilateral and bilateral development and lending groups. The voices of the women themselves and their understanding of their needs tend to be submerged in material that is written about them from the standpoint of state-driven and international priorities.

Since independence, research on women has followed three main directions: 1. Discussions of

women's roles in later twentieth-century society, including an expanding number of studies on politics, legal codes, and family responsibilities. Sources for this research include censuses, legal codes, books and statements by religious and academic figures, court documents, family records, and personal interviews; 2. studies on aspects of social change that primarily impact women and women's status including urbanization, literacy and education, health-related issues, family planning, and employment. In addition to the sources already mentioned, this research also relies on demographic studies, government statistics, data from appropriate ministries, cartographic services, data from labor unions, chambers of commerce, and records from private employers; 3. women writing about their lives and events which affect their lives. These sources are largely literary, biographical and autobiographical, and include letters.

WOMEN'S ROLES

Research on women's roles generally takes as its starting point the definition of women as citizens of states and the expectations and obligations that citizenship entails. Works on law and legal status (Abderrazak 1985, 1991) establish that the primary expectation for women citizens lies within the family through giving birth to new citizens and through reproductive labor, caring for her family-member citizens. Her access to active citizenship is restricted first through legal codes that subordinate her rights to those of males in her family and secondarily through limiting her citizenship role in public affairs. Women's access to decision-making positions in both the private and public sphere is consistently marginalized (Daoud 1993, Brand 1998). Marnia Lazreg (1994) synthesizes the familial, political, and religious influences Algerian women experience. She situates Algerian feminism in women's resistance to colonialism and their subordination under state socialism. Lazreg integrates religious influence into her study as one aspect of the influences that define Algerian women's status.

Although the North African countries share similar histories and colonial situations, they have developed different personal status laws and different patterns of women's social and political participation. All four countries are predominantly Muslim, employ patrimonial political systems, and do not enjoy representative, accountable governments, yet the women of each country differ in access to legal rights, representation in govern-

ment, and social freedoms. For example, Tunisian women enjoy more freedom in employment areas, greater access to education, earlier and wider availability of contraception and abortion, and greater inclusion of women in public affairs than Algeria or Morocco (Charrad 2001). The nation-state plays a critical role in defining both women's status and her role within her family and society. The differences between personal status codes in North African countries confirm the role the state plays in defining women's status through defining their role and rights within the family.

Soon after independence Tunisia promulgated a liberal personal status code that outlawed polygamy, allowed women to file for divorce, and affirmed women's rights to child custody and inheritance. Personal status codes in Morocco and Algeria reflect traditional Islamic values. These different legal codes and the position of women that each code promulgates conditioned the environment for research done in each country. However, state supervision of official women's groups, along with patriarchal patterns that govern cultural expectations, and state unwillingness to offend conservative segments of the society, resulted in a relatively small number of publications on women's issues. Over the past three decades the work of professors, highly-trained ministry officials, and researchers and independent scholars has added to the body of research.

For Muslims, the role of women in Islam cannot be divorced from state policy. In each North African country, Islamic tenets are the major reference for the construction of personal status law. The laws themselves are written by jurists who depend upon the reading of Islamic law supported by Muslim scholars in each state. North Africa largely follows the conservative Mālikī school although the Ḥanafī school is also represented in Tunisia. These Islamic legal tenets are major sources of personal status law, although their interpretation is influenced by politics in each country, the reforms conducted in India and Egypt, and by Western legal codes. Contemporary North African feminist scholarship has questioned the methods and assumptions used by scholars of Islamic history and law when interpreting the Qur'ān, *sunna*, and *ḥadīth* on women's issues (Mernissi 1987). This question has taken on increased import with the rise of the Algerian Islamist opposition party, FIS (Front islamique du salut), and to a lesser extent, Islamist groups in Tunisia and Morocco who advocate a conservative, family-centered role for women. As

the power of Islamist groups increases there is added pressure for restriction of women's freedoms, most prominently the rights to divorce, equal inheritance, public participation, and restrictions on polygyamy. This has been the case particularly in Algeria. Fatima Mernissi and other female professors throughout North Africa critically address issues of Islam and women using the research methodologies of contemporary social science, legal studies, and textual criticism. To this point, there has not been a prominent example of Maghribi Muslim feminist writing that reasons from within the Islamic scholarly tradition and utilizes traditional methods of juridical science.

In reaction to the research documenting the social restrictions on women, women have authored research that addresses aspects of contemporary North African women's sexuality. The best known is a sociological study, *Au-delà de toute pudeur*, by Soumaya Naamane-Guessous. This book was the first attempt to apply survey methodology to gender issues. It succeeded in documenting actual practice rather than reiterating normative values for women. The data collected revealed the everyday aspects of sexuality for Moroccan girls and women. Women's sexuality is bounded by social restrictions and also by ignorance of a woman's body. Folk practices and superstitions perpetuated by women are more prevalent and accepted than science and medicine. The book's popular success established these issues as a legitimate part of women's studies. A study published in 1975, *La sexualité en islam* by Abdelwahab Bouhdiba, looked at sexuality from the standpoint of Islamic theological sources (Qur'ān, *ḥadīth*, Qur'ānic commentary) as well as Islamic theological texts, jurisprudence (*fiqh*), sociology of religion, psychology, and sociology and ethnographies of North Africa. Abdessamad Dialmy, a Moroccan sociologist, also looks at women's issues through a religious lens (1998). He evaluates contemporary sexual practices by contrasting statistical studies with interviews with both young people and professors of Islamic studies to assess the impact of normative values upon contemporary practice.

STUDIES ON ASPECTS OF SOCIAL CHANGE

Over the past 20 years concern over development issues and women's access to health, education, employment, and social services has engendered a wide literature. Much of this literature has roots in bilateral and multilateral programs to promote economic development. The rapid social transformation of the newly-independent nation states – increased migration to urban areas, increased access to education, better sanitation, access to health care, secularization, industrialization – over time produced major changes in women's lives. Much of the research done on these issues was not descriptive, but prescriptive, aimed at improved state economic productivity.

The largest category of research in this area concerns women's reproductive health and aspects of family planning. The rise in life expectancy following the Second World War and the accompanying demographic transformation as population growth rates rose was perceived by Western development officials as a threat to economic development. Attempts to lower population growth rates centered on convincing women to utilize contraceptive measures. Over 10 percent of the research produced on North Africa concerns areas of reproductive health and family planning, with the majority focusing on Morocco and Tunisia, the countries that cooperated with bilateral and multilateral agencies in developing family planning programs. Studies of these programs indicate that the emphasis on family planning preceded concern for maternal-child and women's health and for women's education. These data coordinate well with the national prominence given to the need to constrict population growth to emphasize economic growth. Nation-state priorities, as demonstrated through the family planning issue, considered women's status and well-being as secondary to population decrease. Research done in the last two decades establishes that emphasis on women's status indicators will result in a decrease in a nation's population growth rate; the North African experience furnishes data for this conclusion.

The North African nations have conducted regular censuses that provide reliable data. Tunisian, Algerian, and Moroccan demographers' analysis of census data on women's status is published regularly (for examples see Royaume de Maroc 1990, 1994). Demographic and health surveys done in cooperation by Tunisian and Moroccan demographers contain a wealth of data on women and family health and status indicators (Azelmat 1996). These documents have been published regularly and produce important data on the situation of women in Morocco, in particular.

WOMEN WRITING ABOUT THEMSELVES

The third category encompasses literature and biography. This genre allows women to speak

for themselves and address the limitations that subordinate citizenship places on their lives. These volumes range from novels based on women's lives (Abouzeid 1989), to narratives dictated to researchers, to autobiographies and histories. The prison memoirs of Malika Oufkir and Fatna El Bouih (2002) tell of human rights violations. In particular, the former has been decisive in persuading both Moroccans and other Middle Eastern citizens to consider human rights as a critical issue.

Fatima Mernissi began, and then continued through work with her students, the collection of women's narratives. This method of research began with her book, *Le Maroc raconté par ses femmes* and has been followed by works by Evelyne Accad, Alison Baker, and others. Her autobiography, *Dreams of Trespass*, told through the prism of her childhood household, is a highly structured narrative that demonstrates through beguiling stories the impact the colonizers and the independence movement had on herself and other Moroccan women. The reader realizes the impact of family – both male and female – upon the formation of a young female consciousness caught between the strictures of the French colonizers and the Moroccan nationalists, the men with authority in her family and the women who held informal power. A study of nineteenth-century protests at colonial presence (Clancy-Smith 1994) presents an Algerian woman with a saintly reputation and her political role through letters she wrote. This historical method allows Zaynab to emerge as a rebel, leader, and strategist operating on behalf of her community. These books mirror and often feature the restrictions placed on women, but they also allow women the freedom to present their own views on their lives. This genre of research reflects the state's influence on depictions of women. Women's participation in the nationalist movement (Abouzeid 1989) and their desire for education and respectable labor (Mernissi 1984) reflects the development agenda of the state. The literature also criticizes and turns the state's agenda on its head by speaking from an intensely personal point of view and with an individual voice. By voicing a woman's thoughts, doubts, ambitions, and hopes, the state's construction of women's needs, social identity, and political rights is undermined, and the concerns of an individual are documented.

Current research conveys a willingness to take up subjects previously avoided for reasons of politics or propriety. Women considered marginal, whether for reasons of imprisonment and political activity (Slyomovics 2001), poverty (Royaume de Maroc 1990, 1994), socioeconomic class (Mernissi 1984), indicate an important direction for new research. Studies by Dialmy (1998) on sexually transmitted illness, and Bowen (1997) on abortion, link normative religious statements, and men's and women's fertility and health practices, with Islamic legal and theological sources, statistical data, and interviews. The historical research of D. Larguèche and A. Larguèche (1992) takes up prostitution, women prisoners, and victims of crime. The sources for this research utilize personal narratives, oral histories, survey research, census and ministry statistics, government archives, legal codes, government proclamations, histories, ethnographies, and prison registries. Susan Slymovics's research (2001) on women imprisoned for union organizing and other political offenses builds on individual narratives as well as government documents. Current research also displays a readiness to examine the total lives of women and incorporate factors such as politics, religion, and employment as well as their position within the family. This use of multiple types of research methods and sources spells a readiness on the part of scholars to examine the various aspects of women's experience: sexual, religious, domestic, legal, professional, and political from a variety of perspectives by using multiple research methods.

ARCHIVES
The national archives of each country of the Maghrib house major collections of historical materials. Tunis contains the major holdings for historic Tunisia: sixteenth century through 1881, and some materials for the French period. The archives for the protectorate and colonial period (1881–1956) for French protectorates, which include Tunisia and Morocco, are housed in the Archives d'outre mer, Nantes, France. Algerian materials are housed in the national archives in Algiers. Materials for the colonial period are found in the French colonial archives in Aix-en-Provence. Moroccan materials are housed in the national archives in Rabat and in Nantes. The library La Source in Rabat is an excellent source of publications on Moroccan history and ethnography. The Tangier American Legation Museum in Tangier has extensive holdings on the colonial and postcolonial period. Family archives and private libraries in regional centers such as Tetouan contain important holdings. In Tunis the Institut des belles lettres arabes (IBLA) is an important source for Tunisian history and sociology.

Material on women can be found in Tunisia in the Center for Research, Documentation and Information on Women (CREDIF). Another source is the documentation center run by the Office de la famille et de la population. Morocco's Centre d'études et de recherches démographiques (CERED) and the Direction de la statistique, both in Rabat, house useful libraries of government-published studies, including those on women. Ḥubūs (awqāf) documents are found in the national archives and through consultation with the ministry of Islamic affairs.

BIBLIOGRAPHY

M. R. Abderrazak, La condition de la femme au Maroc, Rabat 1985.
——, La femme et la loi au Maroc, Casablanca 1991.
L. Abouzeid, The year of the elephant. A Moroccan woman's journey toward independence and other stories, Austin, Tex. 1989.
M. Azelmat, M. Ayad, and El Arbi Housni, Enquête de panel sur la population et la santé (EPPS) 1995, Rabat 1996.
A. Baffoun, Research in the social sciences on North African women. Problems, trends, and needs, in Social science research and women in the Arab world, London 1984, 41–58.
A. Belarbi, Research in the social sciences on women in Morocco, in Unesco, Social science research and women in the Arab world, London 1984, 59–81.
A. Bouhdiba, La sexualité en Islam, Paris 1975.
R. Bourquia, M. Charrad, and N. Gallagher (eds.), Femmes, culture et société au Maghreb, Casablanca 1996.
D. L. Bowen, Islam, abortion and the 1994 Cairo population conference, in International Journal of Middle East Studies 29:2 (May 1997), 161–84.
L. Brand, Women, the state, and political liberalization. Middle Eastern and North African experiences, New York 1998.

M. Charrad, States and women's rights. The making of postcolonial Tunisia, Algeria, and Morocco, Berkeley 2001.
J. Clancy-Smith, Rebel and saint. Muslim notables, populist protest, colonial encounters, Berkeley 1994.
Z. Daoud, Féminisme et politique au Maghreb. Sept décennies de lutte, Paris 1993.
A. Dialmy, Féminisme, islamisme, soufisme, Paris 1997.
——, Moroccan youth, sex and Islam, in Middle East Report 206 (Spring 1998), 16–17.
F. El Bouih, Une femme nommée Rachid, Casablanca 2002.
F. Hakiki and C. Talahite, Human sciences research on Algerian women, in Unesco, Social science research and women in the Arab world, London 1984, 82–93.
D. Larguèche and A. Larguèche, Marginales en terre d'islam, Tunis 1992.
M. Lazreg, The eloquence of silence. Algerian women in question, New York 1994.
F. Mernissi, Le Maroc raconté par ses femmes, Rabat 1984; published as Doing daily battle, trans. Mary Jo Lakeland, New Brunswick, N.J. 1989.
——, The veil and the male elite. A feminist interpretation of women's rights in Islam, trans. Mary Jo Lakeland, Reading, Mass., 1987.
——, Dreams of trespass. Tales of a harem girlhood, Reading, Mass., 1994.
S. Naamane-Guessous, Au-delà de toute pudeur, Casablanca 1992.
M. Oufkir, Stolen lives. Twenty years in a desert jail, trans. Ros Schwartz, New York 2001.
Royaume de Maroc, Statut économique et social de la femme au Maroc, Rabat 1990.
——, Femmes et condition feminine au Maroc, Rabat 1994.
S. Slyomovics, Hassiba Ben Bouali, If you could see our Algeria . . ., in Middle East Report 192 (January-February 1995), 8–13.
——, This time I choose when to leave. An interview with Fatna El Bouih, in Middle East Report 218 (Spring 2001), 42–3.

DONNA LEE BOWEN

Arabian Peninsula: Early 20th Century to Present

The formation of nation-states in the Arabian Peninsula (Oman, Yemen, and Saudi Arabia) and the Gulf (Bahrain, Kuwait, Qatar, and U.A.E.) was conditioned by the dominant mode of production in the pre-nation era, the social groups that figured prominently in the formation process, and the different historical legacy of imperial rule (Ottoman or British) experienced by these countries. Accordingly, two distinct areas can be demarcated: the coastal and the hinterland.

Historically, long-distance trade was the main economic activity in the coastal area where mercantile towns of ethnically mixed communities of rich merchants and craftsmen emerged. These cities were ruled by tribal sheikhly families whose authority was always challenged by merchants and other competing families. In the hinterland, a pastoral economy prevailed and agriculture was limited to the valleys and highlands of southern Arabia. This area was ruled by dynasties with fluctuating frontiers, whose authority was based either on their representation of distinct Islamic schools of thought supported by noble descent, as in the case of the Zaydi Imamate of Yemen, or by tribal affiliation, as was the case of the Wahhābī tribal ruling family of Saudi Arabia.

In the mid-nineteenth century, the coastal area came gradually under British rule, whereas the hinterland remained within the domain of the Ottoman Empire. The politics of Ottoman-British competition and the later dismemberment of the Ottoman Empire triggered a process of territorial definition, in the course of which ruling families and dynasties competed to enlarge their territory. Oil production, which began in the 1930s, strengthened the central state's role in oil-producing countries, whereas in other countries, such as Yemen, the state remained weak and dependent on foreign aid.

The emerging nation-states' visions of their identity and of the making of their own citizens were shaped by these differing political projects of nation-states, with their distinct utilization of Islamic idioms, and by the competing discourses of locally powerful groups, such as the ruling elites, the *ʿulamāʾ*, the merchants, the tribes, and existing political movements, Islamic, national, or socialist. Women figure notably in such visions.

They were manipulated to represent symbolically the new nation and its cultural integrity and their morality became the space where interpretations of modernity and authenticity were debated, while the politics of family and motherhood were continuously reconstructed. The tension between states efforts to mobilize women's productive and reproductive capabilities and state concern with female morality had bearings on the new legal codes regarding women and on the state's imagining of female education and labor.

SOURCES AND METHODOLOGY

Sources for the first era of state-formation (1900–60) include the Ottoman and British archives as well as national archives and records, some of which go back to the nineteenth century, as in the case of Bahrain, Kuwait, and Oman. They also include biographical dictionaries and memoirs, published or in manuscript, and newspapers and travelers' accounts. These sources, which usually concern public life, can fill gaps in our knowledge of the political and intellectual history of this era, but they may, however, prove of very little use as far as women are considered. The records of *awqāf*, published fatwas, judicial writings, and personal documents are more useful, especially with regard to women's legal rights and position.

During the second era (1960–2003), the elaborate bureaucracies set up by nation-states become the major knowledge-producers on issues of national concern. Offices entrusted with the tasks of managing the citizens' daily lives through new legislation and the courts system, of instilling state ideology through public education and mass media, and of mobilizing the labor force through state-sponsored development programs systematically generate knowledge relevant to their tasks. The official statistical organizations and the ministries of education, labor, and social affairs produce annual yearbooks and reports on population, economic development, labor, and education. Oil-producing countries also produce vital statistics on marriage, divorce, and birth rates among nationals. The serious demographic imbalance due to the presence of foreign workers, maids, and wives, which supposedly causes a

threat to national identity and cultural integrity, is researched continuously. State-sponsored studies on family and marriage, laws regulating mixed marriages, marriage funds, and the family studies program at Zayed University (U.A.E.) give insights into state efforts to regulate women's bodies.

Court records, some of which go back to the 1960s, as in the case of Yemen, are crucial for understanding women's legal position and rights as played out in everyday life, provided that these records are socially and culturally contextualized. The new court system has not completely replaced legal patrimonial institutions, such as family, kin groups, or neighborhood organizations, nor was local customary law done away with. Litigation is therefore a long and complex process in which different institutions, formal and informal, may get involved and different codes of law may be applied throughout the process. Thus, court records constitute no more than an abridged version of disputes and marital grievances; what is absent from this version are disputes solved outside the court as well as the process of mediation before and after the case is taken to court.

Sharī'a constitutes the only source for legislation on family and marital laws in all the nation-states of Arabia and the Gulf with the exception of the former People's Democratic Republic of Yemen (South Yemen, 1967–90) where they were modified to promote greater equality for women. After the unification with North Yemen, the "liberal" laws were replaced by the strict Sharī'a laws employed in the north. In practice, Sharī'a marital laws constitute a frame of reference that is continuously redefined to accommodate the profound socioeconomic changes impacting the family, especially in oil-producing countries. Within this framework, social actors negotiate their position with regard to pressing issues, such as mixed marriages. National women can invoke Sharī'a laws that give them the right to marry non-national Muslims, a right that is denied them by the state and the family. In Saudi Arabia, to absorb the excess of unmarried women that allegedly constitutes a national crisis threatening the social order and the integrity of the family, a form of marriage called misyār was made legal in the mid-1990s that departs from Sharī'a law in the sense that the husband need not provide a home for his wife.

Literature, especially works of social sensibilities, such as Cities of Salt by the Saudi Abdel Rahman Munif and the works of the Yemeni Abdel Wali, constitutes an important, yet understudied, source for socioeconomic changes and their impact on women. Women's writing, including poetry, fiction, and non-fiction, as well as verbal arts, such as songs and proverbs, are underrepresented in scholarship on women in the Middle East and North Africa (MENA) in general and women in Arabia and the Gulf in particular. The writing of Saudi women, studied by Arebi (1994), provides insight into women's representation of their distinct experience and their negotiation with dominant social groups for self identification. The poetry of Nabīla al-Zubayr of Yemen and her recent novel, Hadhā Jasadī (This is my body, which won the Naguib Mahfouz prize for literature in 2002), provide a literary representation of women's sexuality and their resistance to the dominant patriarchal ideology. Magazines, such as Zahrat al-Khalīj of the U.A.E., constitute a useful source material on a wide range of topics including women's daily concerns and the commercially-driven constructions of female sexuality. Life histories recorded by the oral history program of the King Abdulaziz Foundation for Research and Archives, and social studies by nationals or research centers, such as Princess Sarah al-Sudayri Center for Women's Studies in Saudi Arabia, are valuable secondary sources.

Women in Arabia and the Gulf are relatively understudied in comparison to women in other MENA countries. This is partly due to the fact that these countries were not open to researchers until the 1970s, as in the case of Yemen, or later. Two major theoretical approaches dominate the studies of women in this area: development and social hierarchy. Islam constitutes a major theme in these studies and is generally addressed as a discourse or a value system utilized in one way or another by the competing social groups, including women.

The earliest studies (Myntti 1985) focus on women's education and their participation in the labor force and public life as indicators of improvement in women's status and of the level of social development. Such studies usually draw on available national statistics supplemented by other sources and/or field research. State statistics, usually inflated to highlight the state's achievement, represent women as a homogeneous group, ignoring class differences and detaching women's education and labor from the wider socioeconomic and cultural context. The major issue in women's education is not percentages or numbers, but rather the politics of education and the discourses of different social groups on the "making" of women as envisioned in laws gov-

erning girls' education as well as in the assigned curricula and textbooks. The jurisdiction of girls schools in Saudi Arabia, for instance, is entrusted to a commission of *'ulamā'* whose duties include designing a "proper" curriculum and selecting teachers. Thus, schools constitute a space where the imagining of the new Muslim mothers and wives is inculcated and where women's morality and national responsibilities are defined.

Recent studies of female labor in oil-producing countries, mainly ethnographic, depart from the assumptions of modernization theory and pro-vide a more complex framework that takes into consideration recent dramatic socioeconomic changes and their impact on the imagining of female nationals' labor and on the politics of motherhood. In Gulf countries, the influx of labor migrants rendered the nationals a privileged minority – 18 percent in U.A.E., 20 percent in Qatar, and 29 percent in Kuwait. Mughni (1993) researches Kuwaiti women's labor in relation to the state's desire to mobilize women's productive and reproductive capabilities. To nationalize labor and decrease dependency on migrants, women are called upon to increase their participation in the public and private sectors; at the same time, they are expected to have large families to correct the existing demographic imbalance and to protect the national identity threatened by migrants.

Longva (1997) focuses on the cultural significance of female labor in Kuwait, interpreting it in terms of the new social hierarchy created by the presence of migrants. In this context, citizenship becomes a status marker and labor in general and female labor in particular a sign of national identity. National women differentiate their labor from that of foreign women by respecting "orthodoxy" and choosing to work in a "protected" environment away from non-nationals and occupying only culturally acceptable jobs, such as teaching. Longva's interpretation tends to homogenize female nationals and fails to account for Kuwaiti professional and business women who ignore "orthodoxy" and work in "mixed" environments. Paradoxically, in non-oil-producing countries, it is usually professional women and rural illiterate poor women who opt for "unorthodox" occupations that entail leaving their cities or villages and traveling unaccompanied by a male relative.

Women's status and role are also interpreted in terms of social hierarchy whereby women become symbols of status distinction (vom Bruck 1992/3), and their daily life the enactment of their families' honor (Meneley 1996). Vom Bruck addresses

social hierarchy as a form of regulating the marriage of Yemeni women *sāda* (sing. *sayyid*), the descendants of the Prophet. The contested interpretation by the *sāda* of the Islamic marital rule of *kafāʾa* (equality of spouses) as including descent as well as piety, and their manipulation of the cultural perception of the wife's honor as being subordinate to that of her husband, allow them to legitimize their women's endogamous marriages. Since *sayyid* women's exogamous marriages jeopardize their purity and consequently that of the Prophet's house, the imposed endogamous marriage keeps the *sāda*'s honor intact and sustain their political and social status. The marriage of women of privileged social groups whose benefits are based on the exclusion of others always has a political significance. In the Gulf where nationals constitute a privileged minority, national women who marry foreigners face the danger of losing their citizenship. Thus, the bodies of national women are manipulated to define the borders of the imagined community and to guard the interests of its citizens.

Meneley sees women's daily gatherings in Zabid (Yemen) as constituting the women's public sphere where everyday politics is played out. These gatherings form spaces where all sorts of social hierarchy, gender, race, and class, are enacted and where family honor symbolized by generosity and hospitality is displayed. Thus, in taking part in competitive hosting, women engage in the politics of creating their family honor. Meneley locates politics in acts of generosity and hospitality displayed in the domestic space, excluding those who cannot take part in such acts from everyday politics. Those who do participate do not have any agency; they participate in the game as passive representatives of their male kin. Unlike Meneley, Mundy (1995) addresses the domestic sphere (the household and the house) as the basic unit of politics and production and locates it within the wider patterns of domination. Her analysis of the domestic sphere and of its articulation with the wider context renders the dichotomy of private/public irrelevant and makes the domestic an affair of men as well as women and politics an affair of women as well as men.

Many of the administrative records, reports, and statistics mentioned above are available at the Arab World Documentation Unit at Exeter University, U.K. (<www.Ex.ac.uk\awdu\>). National archive and manuscript libraries, set up in most of the states of the Arabian Peninsula and the Gulf, usually house early state records and copies of the first national newspapers.

BIBLIOGRAPHY
S. Arebi, *Women and words in Saudi Arabia. The politics of literary discourse*, New York 1994.
G. vom Bruck, Enacting tradition. The legitimation of marriage practices amongst Yemeni Sadah, *Cambridge Anthropology* 16:2 (1992/3), 54–68.
A. N. Longva, *Walls built on sand. Migration, exclusion, and society in Kuwait*, Boulder, Colo. 1997.
A. Meneley, *Tournaments of value. Sociability and hierarchy in a Yemeni town*, Toronto 1996.
H. Mughni, *Women in Kuwait. The politics of gender*, London 1993.

M. Mundy, *Domestic government. Kinship, community and polity in North Yemen*, London 1995.
C. Myntti, Women, work, population, and development in the Yemen Arab Republic, in J. Abu Nasir, H. Khoury, and H. Azzam (eds.), *Women, employment, and development in the Arab world*, Berlin 1985, 39–58.

LUCINE TAMINIAN

Jordan, Israel, and Palestine: Early 20th Century to Present

The post–Second World War states of Jordan, Israel, and the emergent Palestine are products of colonial history, although in different ways.[1] After the First World War Britain obtained a mandate (a form of quasi-colonial authority) over the former parts of the Ottoman Empire that are now referred to as Israel, the West Bank, the Gaza Strip, and Jordan. In 1921 this area was divided into two. The parts east of the Jordan River became the Emirate of Transjordan, recognized by Britain as an independent state (Jordan) in 1946. The area west of the Jordan River became the Palestine Mandate, where the British had promised to create a Jewish national home. The war of 1947–8 resulted in the establishment of the State of Israel and the displacement of about three-quarters of the Palestinian population; in 1950 Jordan annexed the West Bank, while the Gaza Strip had come under Egyptian control. After the 1967 war Israel occupied these remaining parts of the former mandatory Palestine. After the first Palestinian intifada and as a result of the Oslo agreements between Israel and the Palestine Liberation Organization, the Palestinian National Authority (PNA) was established in parts of the West Bank and the Gaza Strip in 1994. The Israeli army reoccupied parts of these areas again in 2002.

Especially in settings where political tensions run high, the sources available and the methods used for research need to be critically evaluated. Reflecting on the relation between sources and the political projects of these nation-states is even more necessary when the focus is on women, as women have been a powerful symbol in debates about national identity and cultural authenticity. Each set of sources and methods, be it statistics, ethnography, oral history, or the mass media, not only provides some, if partial, knowledge about social life, but simultaneously needs to be interrogated for the ways in which this information is framed and for what is left out.

Whereas some of these sources, notably print media, Sharīʿa court data, (colonial) state records, travel accounts, and some ethnographic and statistical material are also available for the earlier part of the twentieth century, the development of the nation-state (producing statistical information and

setting up state radio and television), the growth of women's and subaltern movements (developing research centers, NGOs, and oral history projects), and processes of globalization (central for internet and satellite television) have been of major importance for broadening the range of sources for research on women and gender.

THE STATE AND ITS POPULATION: THE POLITICS OF STATISTICS

Statistical data provide a prime example of an area in which it is necessary to pay attention to the process of data production. One set of source material consists of statistical information that has been collected by colonial and postcolonial state institutions and made public in the format of statistical abstracts and reports. In collecting and presenting statistical material, particular forms of categorizing are employed. In the case of gender, the level of gender awareness always needs to be questioned with respect to both how information is collected in the field and how categories are defined. For this very reason the Palestinian women's movement argued for the inclusion of a gender statistics unit when the PNA set up its Central Bureau of Statistics.

Political sensitivities and agendas have an impact on the quality and the nature of the material available. Depending on the levels of trust of particular sections of the population towards state institutions, the quality of the data collected may vary considerably (see Tamari 1994). Also the categorizations of the population are linked to the political projects of the nation-states. In Israeli statistics the population is divided into Jews, Muslims, Christians, and Druze; from 1995 the Christians are further subdivided into Arab Christians and other Christians. Jews, in turn, are subdivided into those born in Africa, Asia, Europe, the United States, and Israel; hence, the number of Arab Jews is invisible as they are integrated within the larger category. In the case of Jordan, the sensitive issue of the divide between Jordanians originating from the East Bank and Palestinians with Jordanian citizenship is avoided by not making publicly available statistical material that differentiates between these two categories of citizens (Brand 1998).

Finally, in all these settings the ways in which citizenship is defined, that is along ethnic/religious lines, also need to be taken into account (see the contributions of Jad et al., Amawi, and Swirski to Joseph 2000).

With respect to Palestinian refugees on the West Bank, in the Gaza Strip, and in Jordan, UNRWA (United Nations Relief and Works Agency, established in 1950 to take care of the basis needs of the Palestinian refugees) is a crucial institution as it has amassed an enormous archive of data on individual households (see Tamari and Zureik 2001). The UNRWA data also need to be scrutinized for the ways in which this institution defines who is a refugee and, more generally, for the ways in which it structures Palestinian refugees' lives. CERMOC (Centre d'études et de recherches sur le Moyen-Orient contemporain) in Amman has been active in bringing together researchers who have studied the influence of UNRWA's administrative policies and classification schemes on such fields as family structures, which also have a strong impact on women.[2]

Another source of information is the religious courts. In all three settings matters of family law are delegated to religious courts; the option of civil marriage is not available (Joseph 2000). The Sharī'a courts are an especially rich depository of research material, varying from marriage contracts and divorce registrations to detailed descriptions of court cases. Such material has been used for research dealing with different historical periods and working from different perspectives. Recently published studies informed by a gender perspective include the work of Agmon (1998) on women and class in Jaffa and Haifa in the early twentieth century, Tucker (1996) on gender and the 1917 Ottoman Law of Family Rights, and Welchman (2000), who studied the interpretation and application of family law on the West Bank, covering Jordanian rule, Israeli military occupation, and the beginnings of the PNA.

LOCATING SOURCES: RESEARCH INSTITUTES, NGOS, AND FUNDING

Statistical data, survey reports, and, more generally, all sorts of "gray literature" (including unpublished theses) may be available not only at state archives (including the British colonial archives, the Zionist archives, and the Institute of Palestine Studies), but also at universities and research centers, especially those that have a history of faculty and staff members with an interest in women's studies. In Israel researchers working in the field of

women's studies can be found at virtually all universities; a women and gender studies program opened at Tel Aviv University in 2001. In Jordan a women's studies program was initiated at the faculty of graduate studies of the University of Jordan in 2000, while Yarmouk University has a long history of faculty interested in this field of research who have supervised a substantial number of M.A. theses on topics such as the gender division of labor and women's access to resources, inter- and intra-household relations, shifting family structures, and so on.[3] With respect to Palestine, the Institute of Women's Studies at Bir Zeit University was established in 1995. It coordinates a masters program in gender, law, and development, and researchers have produced a large number of reports and publications based on extensive field research. Their latest publication includes contributions by Abu Nahleh, Giacaman, Hammami, Hilal, and Johnson on such topics as the gendered nature of education, the division of labor, the household, and child and marriage preferences (Giacaman and Johnson 2002). In addition, women's research centers have developed, such as the Women's Studies Center in Jerusalem, the Center for Women's Affairs in Gaza and the Women and Family Affairs Center in Nablus, and the Women's Center for Legal Aid and Counseling in Jerusalem.

Fields of interest and research projects at these universities have been influenced by women's activism outside academia. In Palestine a long tradition of women's activism has been instrumental in developing women's studies, and the Institute for Women's Studies aims at contributing to forming effective strategies to build a society based on gender equality. In Israel, shifting orientations in the women's movement have had their effects on women's studies. While historically the women's movement has been heavily oriented towards the interests of Ashkenazi women, during the last decade Palestinian and Mizrahi women have become involved in the production of knowledge and have been able to make an impact on the research done at universities.[4]

There is also a considerable number of NGOs (often supported by foreign donors or international organizations) that have been actively involved in commissioned research. After the Oslo agreements, the Palestinian women's movement has increasingly turned towards institutionalization, including a shift towards NGO work. In Jordan, with the liberalization in the 1990s, the number of NGOs that also engage in producing reports and organizing seminars and conferences has rap-

idly increased. In this field, activities associated with members of the royal family have become increasingly important (Brand 1998).

Such NGO-commissioned research highlights the problem of research funding. Especially in the Palestinian areas and in Jordan, local researchers are often only able to do field research if they engage in contract research or if they take part in internationally funded projects, as national universities lack resources. Foreign donors, however, may well have their own agendas, something that has become increasingly visible after the Oslo agreements. In general, externally-funded research often involves survey research, sectorial surveys, and opinion polls (for example, FAFO 1993). Some NGOs have, however, also engaged in publishing books based on interviews and other methods, such as Amawi (2001) on women's participation in Jordanian politics. Also, forms of collaborative research have developed with the aim of involving local researchers as equal partners, such as the CIMEL-INTERIGHTS project on strategies to address "crimes of honor," which was initiated in 1999 and in which Jordanian and Palestinian NGOs participate.[5]

ETHNOGRAPHY AND RELATED FIELDS

More than other methods, ethnographical fieldwork depends on the person of the researcher, with personal characteristics, such as gender and nationality, enabling or disabling access to particular fields. One of the earliest published ethnographies is the work of Hilma Granqvist (1931–5) on marriage conditions in the village of Artas in Palestine. More contemporary ethnographies include Kanaaneh (2002) on the politics of reproduction in the Galilee and Moors (1995) on women's access to property in the Nablus region, while Layne (1994), an ethnography of a tribal confederation of the Jordan Valley, has substantial sections on constructing tribal and national identity through dress as well as on domestic space. Significant articles by anthropologists include Peteet (1997) on "maternal activism" amongst Palestinian women in the camps, Jean-Klein (2000) on gender in everyday life and organized activism on the West Bank, and Shami and Taminian (1990) on women and labor in Jordan (with a select annotated bibliography of studies on women in Jordan at the end).[6]

Travel accounts may also yield information about everyday life, but the context in which they were produced needs to be taken into account (Melman 1992). Travel writings are often strongly influenced by the definition of Palestine and parts of Transjordan as the Holy Land. Its Arab population is then seen as a valuable source for the understanding of everyday life in the time of Christ, while, in contrast, both the British presence and the new Jewish immigrants are seen as the great modernizers. In addition to such temporal displacements, in the case of women another discourse also is at stake: Arab women are seen not only as exotic remnants of the past, but also often as oppressed and downtrodden in contrast to the new Jewish immigrants whose equality with their menfolk is highlighted (Moors 1996).

Another related field is that of ethnographic or folkloric museums and other collections of material culture, which are especially widespread in Jordan and on the West Bank. There is a large number of NGOs, often women's associations such as In'āsh al-usra on the West Bank, with a long history of collecting items of material culture; women's dresses have been very popular. In some cases they also have collected folktales and oral traditions. For instance, the collection of Widad Kawar is very well documented (Institut du monde arabe 1988). Setting up folkloric museums and exhibitions may well be considered a women's field. Many museums in Jordan, including the two folkloric museums that were established in the 1970s in Amman, were started by women. Again, these projects are not simply interesting for the items that they have collected and preserved, but also for the ways in which they select and frame them; they are involved in producing a particular national identity through representations of the past (see Layne 1989).

ORAL HISTORY AS HISTORY FROM BELOW

Oral history is a particularly valuable source or method because it enables voices to be heard that have been excluded from written material. But again one needs to be aware of the political agendas of all actors (narrators, researchers, and institutions) involved. Especially in settings where nations are contested, there may well be tensions between investigating how historical accounts are constructed and the need to root one's existence in a particular territory. In Jordan oral history has mainly been employed in collecting tribal histories through male informants. In Palestine (especially in the Galilee) from the 1980s there has been a proliferation of individuals (often community activists) and NGOs who have begun to collect oral history material often with a focus on the

nakba (the 1948 catastrophe) and the destroyed villages. As oral history is often subaltern history, this work is very much of a grassroots nature, with little interest amongst donors to fund these projects. A rich source of information on Palestinian oral history projects is the 2002 special issue of *al-Jana*, edited by Rosemary Sayigh, one of the pioneers in this field in the Middle East. Work has also been done at various universities, such as Bir Zeit (the project on destroyed villages) and Bethlehem University, often initiated by individual researchers. While many of these oral history projects include interviews with elderly women, women's narratives are central to Fleischmann's (2002) account of the Palestinian women's movement under the British Mandate. At the PNA ministry of planning Faiha Abdulhadi has set up a Palestinian oral history project focusing on women's activism in the period 1936–65.

THE MASS MEDIA: SOURCE, REPRESENTATION, AND COMMUNICATION

The mass media are an important source for the investigation of both current and historical debates. Politically or culturally sensitive issues have often been addressed first by journalists and writers rather than by academic researchers. In Jordan, for instance, honor killing became an issue of debate and then of research after the persistent reporting of its occurrence by Rana Husseini in the *Jordan Times*. Realist novels may also raise sensitive issues, such as incest, prostitution, and collaboration, as has been the case in the work of Palestinian author Saḥar Khalīfa. Both print and electronic media can be employed for their informational content, but the different genre conventions need to be taken into account. Historical and contemporary photographs can be used as a source for social history (see Graham-Brown 1988) and may be analyzed for their employment in processes of nation and state building (Moors forthcoming). In a similar vein, representations of women in video productions and film have been analyzed for the ways in which the nation-gender nexus is at stake (see, for instance, Shohat 1991 for representations of different categories of women in Israeli cinema).

The internet is another resource for research that is simultaneously a means of communication and a field of representation. One issue that is particularly salient for researchers in the settings discussed here is that access to "the field," including official records and archives, is restricted for researchers of the "wrong" background. Such limitation may well have made research through the internet,

where neither the nationality, the ethnicity, nor the gender of the researcher are visible, particularly attractive. This, in turn, may work to the detriment of research that calls for engagement in ethnographic fieldwork and audience research, for working with informal interviews and observations, and for the collection of oral histories and life stories. Still, for all three settings discussed here it is clear that all sources and methods used need to be investigated for the ways in which they are linked to processes of nation and state formation.

NOTES

1. As EWIC intends to cover women in every society where Islam has had an important presence, in the case of Israel the emphasis in this entry is on the Palestinian Arab population and the Mizrahim, that is Jews originating from Asia and Africa, often Muslim majority countries.

2. This refers to the UNRWA project 'A History Within a History' at CERMOC, which was started in 1996. The results have been included in a number of (as yet unpublished) Ph.D. theses. The work of Randa Farah, Stéphanie Latte Abdallah, and Hana Jaber includes interviews with and oral histories of women.

3. Seteney Shami has set up the first graduate department of anthropology in Jordan at Yarmouk University; amongst those working on gender-related issues were Martha Mundy (faculty), Willy Jansen (visiting professor, see Jansen 1993), Lucine Taminian, and Farha Ghannam (M.A. students).

4. See, for instance, Shohat (1996) and Motzafi-Haller (2001) on Mizrahim and Shalhoub-Kevorkian (1999) and Abu-Bakr (1999) for Palestinians.

5. CIMEL is the Centre of Islamic and Middle Eastern Law at the School of Oriental and African Studies, London, and INTERIGHTS is the International Centre for the Legal Protection of Human Rights, an international human rights law center based in London.

6. Due to limitations of space this list of anthropological articles is highly selective. I have limited myself to work that has been influenced by insights from women's studies. This means that the older work of anthropologists, such as Rosenfeld, is not referred to here.

BIBLIOGRAPHY

K. Abu-Bakr, *A rocky road. Arab women as political leaders in Israel*, Ranana, Israel 1999.

I. Agmon, Women, class and gender. Muslim Jaffa and Haifa at the turn of the twentieth century, in *International Journal of Middle East Studies* 30 (1998), 477–500.

A. Amawi, *Against all odds. Jordanian women, elections and political empowerment*, Amman 2001.

L. Brand, *Women, the state, and political liberalization. Middle Eastern and North African experiences*, New York 1998.

E. Fleischmann, *The nation and its "new" women. Feminism, nationalism, colonialism, and the Palestinian women's movement, 1920–1948*, Berkeley 2002.

R. Giacaman and P. Johnson (eds.), *Inside Palestinian households*, Bir Zeit 2002.

S. Graham-Brown, *The portrayal of women in photography of the Middle East, 1860–1950*, New York 1988.

H. Granqvist, *Marriage conditions in a Palestinian village*, 2 vols., Helsinki 1931–5.

M. Heiberg et al., *Palestinian society in Gaza, West Bank, and Arab Jerusalem. A survey of living conditions*, Oslo 1993.

Institut du monde arabe, *Mémoire de soie. Costumes et parures de Palestine et de Jordanie*, Paris 1988.

al-Jana (English) 2 (2002), ed. Rosemary Sayigh, special issue on oral history.

W. Jansen, Creating identities. Gender, religion and women's property in Jordan, in M. Brügmann et al. (eds.), *Who's afraid of femininity? Questions of identity*, Amsterdam 1993, 157–67.

I. Jean-Klein, Mothercraft, statecraft, and Palestinian subjectivity during the intifada, in *American Ethnologist* 27:1 (2000), 100–27.

S. Joseph (ed.), *Gender and citizenship in the Middle East*, Syracuse, N.Y. 2000.

R. Kanaaneh, *Birthing the nation. Strategies of Palestinian women in Israel*, Berkeley 2002.

L. Layne, The dialogics of tribal self-representation in Jordan, in *American Ethnologist* 16:1 (1989), 24–39.

——, *Home and homeland. The dialogics of tribal and national identities in Jordan*, Princeton, N.J. 1994.

B. Melman, *Women's Orients. English women and the Middle East 1718–1918*, Ann Arbor 1992.

A. Moors, *Women, property, and Islam. Palestinian experiences, 1920–1990*, Cambridge 1995.

——, On appearance and disappearance. Representations of women in Palestine during the British Mandate, in *Thamyris* 3:2 (1996), 279–310.

——, From "women's lib." to "Palestinian women." The politics of picture postcards in Palestine/Israel, in D. Crouch and N. Lubbren (eds.), *Visual culture and tourism*, Berg (forthcoming).

P. Motzafi-Haller, Scholarship, identity, and power. Mizrahi women in Israel, in *Signs* 26:3 (2001), 697–734.

J. Peteet, Icons and militants. Mothering in the danger zone, in *Signs* 23:1 (1997), 103–29.

N. Shalhoub-Kevorkian, Towards a cultural definition of rape. Dilemmas in dealing with rape victims in Palestinian society, *Women's Studies International Forum* 22:2 (1999), 157–73.

S. Shami and L. Taminian, Women's participation in the Jordanian labour force. A comparison of rural and urban patterns, in S. Shami et al., *Women in Arab society. Work patterns and gender relations in Egypt, Jordan, and Sudan*, London 1990, 1–86.

E. Shohat, Making the silences speak in the Israeli cinema, in B. Swirski and M. Safir (eds.), *Calling the equality bluff. Women in Israel*, New York 1991, 31–41.

——, Mizrahi feminism. The politics of gender, race, and multi-culturalism, in *News from Within* 12:4 (1996), 17–26.

S. Tamari, Problems of social science research in Palestine. An overview, in *Current Sociology* 42:2 (1994), 69–86.

S. Tamari and E. Zureik (eds.), *Reinterpreting the historical records. The uses of Palestinian refugee archives for social science research and policy analysis*, Washington 2001.

J. Tucker, Revisiting reform. Women and the Ottoman law of family rights, in *Arab Studies Journal* 4:2 (1996), 4–18.

L. Welchman, *Beyond the code. Muslim family law and the sharīʿa judiciary in the Palestinian West Bank*, The Hague 2000.

L. Welchman, R. Hammami, P. Johnson, and F. Labadi, Islamic law and the transition to Palestinian statehood. Constraints and opportunities for legal reform, in L. Welchman (ed.), *Islamic family law in comparative perspective*, Zed Press (forthcoming).

ACKNOWLEDGMENTS

I am grateful to Penny Johnson, Shifra Kisch, and Seteney Shami for their help in producing this entry.

ANNELIES MOORS

Malaysia and Singapore: Early 20th Century to Present

Malaysia

GENERAL CONTEXT

Located on the southeast edge of the Asian continent, Malaysia comprises a peninsula, known as Malaya until 1963, and the states of Sabah and Sarawak in a part of the large island of Borneo in the South China Sea. The country ranks among the smaller nations of Asia. Yet, it was one of the most fought over from the sixteenth century because the Straits of Malacca, which derive their name from one of the states in Malaysia, was the narrow sea-route that controlled shipping and trade from Europe to Asia. Malaysia was colonized by the Portuguese in 1511, the Dutch in 1641, and the British in 1874. The chronological dates that define one period of conquest from another are not indicative of how these boundaries are blurred by the osmosis of diverse cultural and religious influences via trade and travel that have shaped the nation's history and its people. Therefore, although most studies on religion in Malaysia focus their descriptions of historical context from the advent of Islam, or that of the Portuguese on a people who were Muslims, it is important to recognize the strong external influences on the nation before, during, and after these periods.

Most scholars agree that Islamization occurred during the twelfth century and was spread largely from neighboring Sumatra as well as through Sufi traders, missionaries, and travelers from the Middle East and India, but even these accounts do not adequately reflect the conglomeration of influences at work. Historian Anthony Reid (1998) indicates this by referring to a "Southeast Asianized Islam" amongst "Indian-influenced syncretic faiths" before the arrival of the colonizers. The history before the fifteenth century is difficult to reconstruct with any real certainty, historians tell us, but references to the peninsula and to the trading city-state of Malacca (Melaka) are found in the Alexandrine geographer Ptolemy's description of "the Golden Khersonese," Chinese records from as early as the fifth century C.E., Thai records of tribute from Malay states, Arab travel accounts, and descriptions by Hindu and Buddhist pilgrims. What these diverse sources point toward is the perspective that even before colonialism and not just during the imperial era until the modern age, the country and its people were not insular. The religion and culture that evolved in peninsular Malaysia – Islam and Malay culture – were in significant ways amalgams of religious, social, cultural, and political confluences. For example, there were Hindu and Persianized ideas of kingship and mysticism that played important roles in legitimating notions of Muslim authority in the Malay Peninsula.

However, normative authorized scholarship maintains that Malay culture is Muslim culture, although the cultural context of Islamic text and tradition is the Middle East. Islam is written about largely as a monolithic term to denote a unitary sense of Malay identity; Islam is a definitive marker of Malay ethnic identity because the constitution of Malaysia defines a Malay as a Muslim. Thus, Hindu and Buddhist influences are acknowledged as beginning in the first century B.C.E., but marked off as distinct from the next period, Islamization. Authorized scholarship often describes how the Hindu-Buddhist period of Malaysian history ended with the penetration of Islam into the area. However, there are widely-referenced history texts that do not share such categorical distinctions and this disjuncture is indicative of an interesting area for research on the constructions and ambivalences of nationalist discourses, and their ramifications for women and Islam.

Islam in Malaysia included and continues to include Malay culture or *adat* (traditional Malay kinship patterns that have evolved from the pre-Islamic period). Magic and pantheism were intertwined with religion as is evident from the continued but diminished existence of *bomohs* (Malay shamans) and *adat*. One example of the importance and use of magic was for the purpose of maintaining political authority, a notion that to some extent can be said to continue up to the present.

So, despite the more rigid notions of Islam that now prevail and that are sometimes not empowering of women, Islam – especially early Islam –

in Malaysia was amorphous and embraced a variety of influences including those that enabled women.

The present population of Malaysia reflects its heterogeneous history. According to the government census conducted in 2000, the total population of Malaysia is 23.27 million. Malays and indigenous people comprise 65.1 percent, Chinese 26.0 percent, Indians 7.7 percent, and the rest Eurasians, Arabs, citizens of other races, and other minority groups; 36.7 percent of the population is below 15 years of age.

Women in Malaysia are implicit in most analyses and discourses of the nation, but largely by default. Most analyses and research are by ethnic, religious, or class categories. If women are mentioned, they are most often written about in an undifferentiated way that combines women of various races, religions, and classes. The obvious exception is when women write about themselves or are written about. Most statistics are gender-blind; that is they do not allocate resources or analyses by gender differentiation. The reason for this is partly historical; the greater part of the historical literature concerning Southeast Asia says little about women. Writers have concentrated on those individuals associated with decision-making and power, areas where men have featured predominantly. Analyses by women themselves, including those who are activists, acknowledge that women are not a homogeneous group but they continue to write about "women" generically, possibly out of expedience.

Muslim women in Malaysia are very present in the public sphere. *Adat* includes matrilineal traditions in the state of Negeri Sembilan, and women's participation in public space as traders, for example. Nationalist awakenings and the struggle for independence from the British during the twentieth century included Malay Muslim women as active protagonists.

Muslim women have equal access to education and job opportunities. The Malaysian constitution was amended in 2001 to add gender to prohibitions against discrimination on the basis of race and religion. Muslim women have been appointed to some of the highest positions in the nation: minister for trade and industry, governor of the Central Bank, a former attorney-general, and deans of major faculties or schools in public universities. These high-profile appointments notwithstanding, there still exists discrimination against women in the higher echelons of management in both private and public sectors, although at lower and middle-management levels women sometimes constitute up to 50 percent of human resources.

However, in terms of political participation, women are often relegated to supportive roles only. For example, in the tenth general elections in 1999, only 53 out of over 300 candidates who stood for election were women, although women constituted 55 percent of registered voters. Women won 20 out of 193 seats in parliament, the largest gains ever by women.

Nevertheless, Muslim women activists are on record as complaining that they have fewer rights than non-Muslim women in terms of divorce, maintenance, and custody and guardianship of their children. Some Muslim women have articulated and documented discriminatory practices in the interpretation and application of the Shariʿa because of flaws in its implementation.

As well as the political parties of the ruling coalition and its opposition, Malaysian NGOs and women activists – both Muslim and non-Muslim – are among the most prominent voices in the nation. Women's issues and agendas have received substantial media coverage, especially by the English-language mainstream print media, and such platforms have been important in the way women have been able to shape public policy significantly, if not always consistently.

A benchmark in the way women have enabled the evolution of the nation was the formulation and dissemination before the elections in 1999 of a document entitled "The Women's Agenda for Change" (WAC), which can be accessed at <www.wa4change.tripod.com>. The WAC was the outcome of the work of a group of NGOs, individuals, and a national consultation. It is a comprehensive document detailing changes demanded by women in eleven areas that constitute public life in Malaysia: Development, Participatory Democracy, Culture and Religion, Violence, Land, Health Services, the Law, Work, AIDS, the Environment, and Health and Sexuality. The WAC is the first blueprint or envisioning by women of an ideal Malaysian nation, beyond the ambit of women-specific issues. In the 1999 elections, the Women's Candidacy Initiative (WCI) fielded a Muslim woman as candidate under the aegis of a multiethnic opposition political party. She campaigned on the platform of the WAC, and although she lost to the incumbent in the seat she contested, she reduced his majority significantly.

In September 1999, two months before the elections, members of parliament as well as politicians who were likely to be candidates in the elections were asked to endorse the WAC and raise its issues

as part of their election platforms. Only 7 members of parliament responded to the exercise. Out of 15 women members of parliament, none committed to the WAC, indicating that despite their efforts and substantial successes, women and their issues continue to be marginal. The reasons for this continue to be a rich area for research.

SOURCES FOR RESEARCH ON WOMEN AND ISLAMIC CULTURES IN MALAYSIA

Texts written about women in Malaysia are mostly ethnographies by anthropologists from Malaysia, as well as from the United States and Australia. Other material is written in the discourse of women and development because economic development and technological progress are overwhelming priorities of the government in Malaysia.

The majority of the texts and articles on women and Islam are on marriage, divorce, and the Sharīʿa. At least two-thirds of all the material written on women, and women and Islam, are in English. It is significant, and worthy of study, that there is a difference beyond language between the resources in English and those in Malay. The material in Malay is written for an exclusively domestic, Malay-Muslim audience, while the material in English is often premised on more universal feminist perspectives. Most of the material on women and Islam is written by academics, but significant and substantial interventions have been made by the NGO Sisters in Islam (also known as SIS), in terms of memoranda to the government, press releases, and letters to the media. All these are available from the SIS website, <www.muslimtents.com/sistersinislam>. The interventions by SIS, from an activist premise in reaction to events or public policies and legislation, have considerable impact in shaping public policy. Nevertheless, significant numbers of Malaysian Muslims indicate that they do not identify with all or even many of SIS interventions, and such opinions are expressed freely in the media or in research fieldwork interviews. This disjuncture would constitute an interesting research project in terms of the triangulated negotiation of women activists, the fluid evolution of Islamic identity and notions of fidelity to Islam in a highly politicized public discourse, and the modernizing, developmental agendas of a postcolonial state.

Although there are substantial textual resources on Islam and the corpus of work on women in Islam is growing steadily, a very rich resource is material that is often classified under Malay ethnicity and culture. Since Islam and Malay ethnic identity are conflated, Malay literature, cultural traditions, periodicals, and manuscripts contain references to Islam and being Muslim. Most of the material available has a recent chronology, since no Malay manuscript earlier than about 1600 survives, except for a few letters sent by the sultan of Ternate to the rulers of Portugal. Among more recent sources, Malay short stories and novels provide important insights although the literary genre is rarely used to unpack Islam and women. Virginia Matheson Hooker's *Writing a New Society: Social Change through the Novel in Malay* is very helpful as a starting point. One of the most important repositories for Malay manuscripts is ATMA or the Institute of Malay World and Civilization at Universiti Kebangsaan Malaysia, which focuses on creating databases of bibliographies and material on everything related to the study of the Malays (<www.atma.ukm.my>). Most Malaysian public university libraries have collections of Malay manuscripts. However, some Malay manuscripts in practically all libraries are arranged not according to subject matter, in the manner of printed materials, but by accession number or serial numbers assigned to their respective collectors and donors, and this system complicates searches.

METHODOLOGIES: POSSIBILITIES AND CONSTRAINTS

Other possibilities for further work on women in Islamic culture in Malaysia include:

1. A core-periphery dynamic defines Islam in Southeast Asia, including Malaysia. In this dynamic, the heartland of Islam – the Middle East – is the core and Southeast Asian Muslims perceive themselves as the periphery. This is because of an inability to read the huge corpus of theology, philosophy, exegesis, and jurisprudence that is the rich heritage of a Muslim, as most of it is in Arabic. The significance of the cultural Islam of the Middle East has increasing authoritative coherence after over 30 years of exponential growth of Islamic revivalism and Islamization of state and identity. This core-periphery dynamic also gives rise to an infantilized religiosity among many ordinary Muslims who rely increasingly on the mediators of Islam – the ʿulamāʾ – to interpret and guide. What transpires then is an abdication by many of the ability to decide and define how Islam will evolve in their particular milieu, giving increasing power to the ʿulamāʾ and those

who claim to be authoritative, and whose fidelity is not only to literal and selective applications of text and tradition but also to how this coheres with the heartland, the Middle East. This dynamic has significant repercussions on how Islam is constructed, and how it constrains women.

2. Islam is invoked and deployed for political legitimacy and political expedience by both the ruling coalition and the main Islamist opposition party. Much of the material that deals with this paradigm locates women as victims or at least inconsequential in this consuming dynamic of nationhood in Malaysia. Studies that explore how women enable, negotiate, and/or combat this dynamic as well as the effects of politicized Islam on women would be a useful contribution to the substantial corpus of work that explores Islam and politics in Malaysia.

3. Women in Malaysia negotiate their needs, issues, and agendas when their empowerment coheres with the nation's priority of achieving developed nation status by the year 2020. An industrialized country such as Malaysia, with its small population, requires women who are educated and empowered beyond the domestic sphere and out in the workforce. However, women also become expedient for these national agendas. Women's needs and rights are made subservient to national priorities, when the agendas of both do not cohere. More than 30 percent of the books and articles on women in Malaysia have been written in terms of women and economic development. However, substantial work that is critical or written from the women and post-development perspective or that is significantly evaluative of Malaysia's developmental paradigm is lacking. Some Malaysian academics have coined the term "developmentalism" for the way economic well-being is prioritized over fundamental rights. The tension between women, developmentalism, and Islam would be an interesting study.

4. In a nation with a substantial non-Muslim minority population, Malaysian Muslim women are the bearers and markers of racial and religious difference and elitism. As such, their bodies and behavior are both policed and disciplined to effect rigid boundaries and identities. At the same time, the inherent diversity and pluralism of Malaysia's multiethnic and multireligious population expands definitions of what constitutes normative dress and behav-

ior. This paradox is hardly explored. The policing and disciplining of women's bodies and behavior are most often interpreted only in terms of the Islamization of polity and public space, and the competition between Malaysian Malay-Muslim political parties is deemed "more Islamic."

5. Research beyond the more superficial analysis of Islam for political expedience is an imperative in terms of women. Except for some academics and activists, few women understand or care about the ramifications of the Malaysian prime minister's declaration in September 2001 that Malaysia is an Islamic state and the Muslim opposition party's continuing legislation to effect an Islamic state with the primacy of the Shari'a in the two states it controls in the northeast of the country. Since the advent of the British, the Shari'a has been relegated to personal law for Muslims, dealing with inheritance, marriage, and divorce. However, because Islamic law is enacted by the 13 individual states of Malaysia and not at the federal level or in parliament, there is insufficient attention to such legislation, which sometimes curtails fundamental freedoms and women's rights.

6. Unlike other segments of the population – such as political parties – Muslim and non-Muslim women activists have coalesced quickly and easily around issues to campaign and lobby for women's rights. This is a unique collaboration across the rigid boundaries of race and religion in Malaysia, and one that both women activists and academics are unself-conscious about. This ability to work relatively seamlessly across the divisiveness of race and religion would be a rich area for exploration, with important ramifications.

7. There is a substantial corpus of work on marriage and divorce laws, and campaigns, letters, and memoranda about the issue of polygyny. Comparative studies examining marriage, divorce, and polygyny in Malaysia and other Muslim nations would be very interesting, as would work that explores context: why the increase in polygyny in Malaysia, for example, amidst high literacy and empowered women in public space?

8. The delineation and exploration of the many "Islams" in Malaysia is another area that would provide rich material for study. It would include the various strands described above, as well as the exploration of the power to define the monolithic invocations and expressions of

what Islam is by a variety of actors and institutions. The way women contribute, negotiate, harness, and are contained by this power to define would enable other studies about the issues that Muslim women deal with and engender.

9. From the perspective of women's studies, significant areas for study would be (a) exploring the Islamic revivalism that swept through Malaysia in the 1970s and that continues to the present; (b) the recuperative project of the return to text and tradition to find meaning and solutions to the dilemmas of the twentieth and twenty-first centuries that have ensued; and (c) growing Muslim radicalization especially since the attacks on the United States in September 2001 and how this development impacts on women. Such work would include how have women participated, contributed, and negotiated these turning points in the evolution and configuration of Islam in Malaysia.

Singapore

GENERAL CONTEXT
British trader Stamford Raffles established a port on the island of Singapore in 1819, and it evolved into the modern, economically and technologically developed, wealthy, cosmopolitan city-state that is an Asian center for air and sea transportation.

Singapore, the island nation-state at the tip of the Malay Peninsula, has a minority Muslim population who constitute less than 20 percent of the country's people. This is the reverse of Malaysia, where Malay Muslims are the majority. Singapore Muslims are mostly Malays with close cultural, ethnic, and sometimes even family ties to Malaysian Malays, but there is a significant presence of Arab descendents from all over the Middle East, especially Yemen, as well as Muslims whose forefathers were from India and Pakistan. Singapore has a secular constitution, with the Sharīʿa as personal law for Muslims.

Muslims in Singapore face many of the challenges that often beset minority populations. Muslim women have the additional pressures identified earlier for Malaysian Muslim women, as the bearers and markers of difference amidst racial and religious diversity. The state in Singapore is dominant in evolving public life and discourse, and oversees the main religious infrastructure of Muslims. Two of the main state-sponsored Muslim institutions are the Muslim Council of Religious Affairs (MUIS or Majlis

Ugama Islam Singapore) and the Sharīʿa Court along with the Muslim Registry of Marriages, and the most important legislation over the lives of Muslims is the Administration of Muslim Law Act (AMLA). The president and board of MUIS, which includes the mufti of Singapore, are appointed by the president of Singapore. On behalf of the Muslim community, MUIS functions as the authorized agent in dealing with the government and all governmental agencies.

The formation of the Singapore Council of Women in 1952 marks the beginning of a formal women's movement in Singapore. The Women's Charter of 1961 ensures women's basic rights, and covers laws dealing with marriage, divorce, custody, maintenance, inheritance, property rights, and protection against violence, but it is unevenly applied to Muslim women who are also covered by Islamic law. The Women's Charter provides what can be described as a legal definition of feminine identity codified around marriage, divorce, and relationship to children.

SOURCES FOR RESEARCH ON WOMEN IN ISLAMIC CULTURES IN SINGAPORE
In tandem with Malaysia, resources on Islam in Singapore are considerably expanded if one includes ethnic Malay as well as diaspora Middle Eastern collections. Public and university libraries have the most repositories including Malay newspapers, Malay and Muslim periodicals, as well as dissertations and theses, which are also important sources. A bibliography entitled *Singapore Malay/ Muslim Community 1819–1994* is available at the National University of Singapore library, and it is an invaluable starting point. There is a Centre for Research on Islamic and Malay Affairs (RIMA), which is a subsidiary of the Association of Muslim Professionals. However, to supplement a dearth of material, a researcher would need to be more adventurous in identifying sources such as family collections, mosque documents, and oral interviews and histories.

METHODOLOGIES: POSSIBILITIES AND CONSTRAINTS
The possibilities for further work on women in Islamic culture in Singapore include many of the areas described earlier for Malaysia. Other areas could include:

1. As a minority, the Singapore Muslim community negotiates its fidelity to Islam and an Islamic identity through many layers of complex contexts defined by a paternal state. An examination of these complexities and how

the community engages the state and with what results is paradigmatic and relevant even to other Muslim minorities in other state-centric nations.

2. Muslim women negotiate their rights, issues, and needs in terms of both their community and the state, through the aegis of a dominant, secular state. There are considerable ramifications of such a tension, both in terms of how women are enabled as well as constrained.

3. There is little research or analysis concerning how Muslim women demarcate and configure racial and religious difference, and what they themselves think about their agency. The 2002 uproar over Muslim parents who challenged the secular school system by insisting their daughters wore a headscarf is only one – albeit prominent – element, but throughout the episode, women were objectified. Research about Muslim women as subjects, and how they articulate their agency (including the lack of it) would be a vital contribution to the study of Islamic culture and women in Singapore.

4. The relevance or absence of feminist activism for Singapore Muslim women who are a minority would be useful: most studies acknowledge difference but nevertheless generalize about women's issues and activism from the majority's perspective.

BIBLIOGRAPHY

N. F. Abdul Manaf and M. A. Quayum, *Colonial to global. Malaysian women's writing in English 1940s–1990s*, Kuala Lumpur 2001.
B. W. Andaya and L. Y. Andaya, *A history of Malaysia*, Honolulu 2001².
Bibliografi sastera Melayu tradisi, Bangi 1990.
Ding Choo Ming, Access to materials in and on Malay studies from Leiden to Bangi. A model of information repackaging on the information superhighway, paper presented at the ATMA KITLV Colloquium on Dutch scholarship and the Malay world. A critical assessment, Universiti Kebangsaan Malaysia 2000.
S. Goldberg, Mixed messages. Public policy and women in Singapore, in *Commentary. Journal of the National University of Singapore Society*, 7:2–3 (1987), 25–37.
G. Heng and J. Devan, State fatherhood. The politics of nationalism, sexuality, and race in Singapore, in A. Parker, M. Russo, D. Sommer, and P. Yaeger (eds.), *Nationalisms and sexualities*, New York 1992, 343–64.

M. B. Hooker, *The personal laws of Malaysia. An introduction*, Kuala Lumpur 1976.
V. M. Hooker, *Writing a new society. Social change through the novel in Malay*, Honolulu 2000.
R. Ismail (ed.), *Hudud in Malaysia. The issues at stake*, Kuala Lumpur 1995.
A. H. Johns, Islam in Southeast Asia. Reflections and new directions, in *Indonesia* 19 (April 1975), 33–55.
Z. Kamaruddin (ed.), *Islamic family law issues 2000*, Kuala Lumpur 2001.
Lai Ah Eng, *Meanings of multiethnicity. A case-study of ethnicity and ethnic relations in Singapore*, Kuala Lumpur 1995.
J. Lam Lin (ed.), *Voices and choices. The women's movement in Singapore*, Singapore 1993.
Majlis Ugama Islam Singapura (MUIS), *Muslims in Singapore. A shared vision*, Singapore 1994.
P. Martinez, Complex configurations. The women's agenda for change and the women's candidacy initiative, in M. Weiss and S. Hassan (eds.), *Social movements in Malaysia. From moral communities to NGOs*, London 2003, 75–96.
M. Mohamed Ali, Uniformity and diversity among Muslims in Singapore, M.A. thesis, National University of Singapore 1989.
H. Mutalib, *Islam in Malaysia. From revivalism to Islamic state*, Singapore 1993.
H. Mutalib, H. Johari, R. Mentol, et al. (eds.), *Singapore Malay/Muslim community 1819–1994. A bibliography*, Singapore 1995.
N. Norani Nik Badlishah, *Marriage and divorce. Law reform within Islamic framework*, Kuala Lumpur 2000.
M. Taib Osman (ed.), *Islamic civilization in the Malay world*, Kuala Lumpur 1977.
Norani Othman (ed.), *Shari law and the modern nation-state. A Malaysian symposium*, Kuala Lumpur 1994.
——, *Shari'a and the citizenship rights of women in a modern nation-state. Grounding human rights arguments in non-Western cultural terms*, IKMAS Working Papers, Bangi 1996.
A. Reid, Female roles in pre-colonial Southeast Asia, in *Modern Asian Studies* 22:3 (1988), 629–45.
RIMA (Centre for Research on Islamic and Malay Affairs, Singapore), *Malays/Muslims and the history of Singapore*, Occasional Paper Series, no. 1–98, 1998.
W. R. Roff. *Bibliography of Malay and Arab periodicals published in the straits settlements and peninsular Malay states, 1876–1941*, London 1972.
——, The Malayan-Muslim world of Singapore at the close of the nineteenth century, in *Journal of Asian Studies* 24:1 (November 1964), 75–90.
S. Siddique, The administration of Islam in Singapore, in T. Abdullah and S. Siddique (eds.), *The administration of Islam in Singapore*, Singapore 1986, 56–71.
University of Malaya Library 1980, *Katalog Koleksi Melayu Perpustakaan Universiti Malaya*, Kuala Lumpur.

PATRICIA MARTINEZ

Philippines, Thailand, Singapore, Burma, Cambodia, Laos: Early 20th Century to Present

Although they comprise the most populous religious group in the region, Muslims in Southeast Asia are geographically placed on the periphery of the Islamic world. Countries such as the Philippines, Thailand, Singapore, Cambodia, Burma, and Laos are located on the outskirts of Muslim populated regions in Southeast Asia. Their territorial boundaries as nation-states cut across the boundary between the Islamic and non-Islamic world, and this has resulted in Muslims becoming one of the minority religious groups within the nation-state formation.

In the process of building modern nation-states, these countries have been struggling over the issue of how to integrate their religious minorities. Political authorities have been prone to the influence of the religious majority, and hence the discontent of the Muslim minorities in the Philippines, Thailand, and Burma has fostered separatist movements that have come into armed conflict with their respective central governments. Political disturbances have been one of the major hindrances to conducting studies on women and Islamic cultures in these regions. Although the roles and positions of Muslim women may vary in these countries, their actual situation is not well known to researchers. The scarcity of empirical studies and sources is the biggest problem confronting research on Muslim women.

THE PHILIPPINES

Muslims are the largest minority group in the Philippines, where 90 percent of the population is Christian. Official estimates placed their number at about 5 percent (3.9 million) in 2000. The 1903 census indicated the population of Moro (the term was originally used by the Spanish and derives from the word Moors) belonging under the category of "wild inhabitants." The censuses of 1918, 1939, 1948, 1960, and 1970 also record statistics for the Muslim population. However, censuses after 1975 do not give statistics pertaining to religious affiliations. Muslim Filipinos comprise more than ten ethno-linguistic groups, living mainly in Mindanao, Palawan, and the Sulu islands, southern Philippines. The Maguindanao, Maranao, Samal, and Tausug are among the major groups in terms of political power and demographics.

It is said that the actual integration of Muslims into the territorial space of the Philippine nation-state began during the American colonial regime (1898–1946). The Americans implemented a policy of divide and rule, placing Muslims under a special administrative division with the intention of assimilating and integrating them step-by-step into the mainstream category of "Filipino" (Gowing 1977). However, with the increasing Filipinization of the government, special provisions previously granted to the Muslim areas were gradually withdrawn. With the creation of the Commission on National Integration in 1957, the process of administrative integration of Muslims into the Philippine state system was completed. Muslim leaders found themselves in a political structure that functioned without their consultation and consent (Gowing 1979, Abinales 2000).

Meanwhile, the American colonial government, the succeeding Commonwealth government (1935–46) and the Philippine independent government (1946 to the present), have all implemented migration policies to encourage northern Christians to settle down in the south. Consequently, the ratio of the non-Muslim population in the south grew substantially in the 1960s and Muslims' feelings of loss deepened. Some young religious leaders who had a chance to study Islam in the Middle East also became discontented with the Christian-centered Philippine social system. As a result, Muslims in the Philippines started to form separatist movements in the late 1960s. The Moro National Liberation Front (MNLF) was the strongest of these. Fighting between Muslims and the Armed Forces of the Philippines escalated in the 1970s and 1980s. In 1996, after almost 25 years of antagonism, the MNLF and the government of the Philippines signed a peace agreement. However, peace has not yet been secured in the south since other Muslim separatist groups, such as the Moro Islamic Liberation Front (MILF) and Abu Sayyaf, continue their fight today (Gearlan and Stankovitch 1999, Vitug and Glenda 2000).

The Muslim separatist movements have pressured the government to grant various rights.

Among major concessions granted by the government side to ease the frustration of discontented Muslims was the promulgation of the Code of Muslim Personal Laws in 1977. In 1990, the Autonomous Region of Muslim Mindanao (ARMM) was established. The five provinces of Basilan, Lanao del Sur, Maguindanao, Sulu, Tawi-Tawi, and Marawi city were designated as the ARMM after a referendum held in 2001. Under the ARMM, Muslims now enjoy some rights of self-governance within the purview of the National Constitution.

On the other hand, the systematic incorporation of Muslim women into modern state institutions was carried out through the establishment of the public school system, which started during the American regime. The schools were initially considered to be the means of converting Muslims to Christianity. Parents were generally fearful that their daughters would marry a Christian boy. For a while, girls were not allowed to continue schooling once they reached marriageable age. Oral histories record much informal debate in the past over whether girls should be sent to school. Now that people recognize schools to be the channel to upward social mobility, they tend to send their children to higher educational institutions regardless of gender.

Studies on women and Islamic cultures in the Philippines remain scarce. Some ethnographical works contain patchy descriptions of women and gender issues. Kiefer wrote about the relationship between men and women in the observation of family and kinship in a Tausug society (1972, 35–51). Casiño touched upon the socialization process of Jama Mapun girls in a chapter focused on ritual and value (1976, 94–103). Both of these works are based on extensive fieldwork and are valuable sources for the understanding of Philippine Muslim societies in the 1960s. There are limited numbers of studies that deal with topics such as intermarriage with Christians and female education. L. Q. Lacar (1980, 1992) traced the changing attitudes of Maguindanao women with regard to education, marriage, and their social role. By conducting structured questionnaires, C. S. Lacar (1996) tried to understand the salient characteristics, career development experiences, career visions, leadership behavior, and factors influencing the careers of Maranao women educational administrators. The *Dansalan Quarterly*, published by the Peter Gowing Research Center (formerly the Dansalan Research Center), has printed several papers written by Muslim women in the Philippines (Maidan 1985,

Sarip 1985–6, Usodan-Sumagayan 1988). Their surveys are based on quantitative rather than qualitative analyses. Further, research subjects have so far been confined to the members of the major Muslim groups. The difference between women at the center of Muslim society in the Philippines and those at the periphery is not yet fully understood. The limited ethnographical works that do exist are based on fieldwork carried out in the 1950s and 1960s, due to the prolonged period of armed conflict that has prevented researchers from conducting fieldwork since the 1970s. This means that the actual situations of women have scarcely been studied or written about since the 1970s. It is only recently that the situation has changed, allowing scholars to visit Muslim-populated areas for research purposes (McKenna 1998). Attempts are being made by a few scholars to reveal the perspective of women who experienced destruction and reconstruction in their daily lives during the armed conflicts. Angeles (1996) tried to grasp the significance of the MNLF movement for women by carrying out a questionnaire survey on 25 women, 23 of whom were also interviewed by telephone. Ishii (2002) approached the socioeconomic change of Mindanao Island and its impact on the Muslim societies from the stories of Muslim women who lived through the armed conflict in the 1970s and 1980s.

THAILAND

Thailand is a predominantly Buddhist country in which Muslims accounted for 5 percent (approximately 3.06 million) of the official population in 2000. The censuses of 1911, 1919, and 1929 do not give statistics pertaining to religious affiliations, but censuses conducted after 1937 do record such information. Muslims in Thailand also comprise several groups. First, about half out of the total population of Muslims are Malay-speakers living in the southernmost provinces of Narathiwat, Pattani, and Yala. Second, there are Thai-speaking Muslims in the adjacent provinces to the north of these three provinces. Third, there are Muslims who are the descendants of Iranians, Chams, Chinese, Indians, Malays, and Pakistanis living in Bangkok and its suburbs. Fourth, there are the Muslims living in the northern provinces, the majority of whom originally come from southern China. They are generally called "Haw" by Thai people, and are engaged in trade that cuts across Yunnan, northern Thailand, Burma, and Laos. Muslims of Indian and Pakistani origin also reside in the northern provinces.

Gradual incorporation of Malay Muslims into the administrative structure of the Thai Kingdom was initiated by King Rama I, who placed Pattani under direct Thai control in 1789. It is commonly understood that the policy of assimilation became stronger after the establishment of the constitutional government in 1932. In 1932, Islam was officially placed under Thai royal patronage. Since then, every new Thai constitution has consistently upheld the principle of freedom of conscience. However, the real intention of the nation-state political project was to integrate Muslims into the Thai territorial state, thereby creating a Thai identity among Muslims.

Assimilationist policies of the Thai government continued well after the Second World War. In relation to women, the Rattaniyom movement, which started during the Phibun regime, restricted the practice of Islam and forced Malay-speaking Muslims to adopt Thai language and Thai dress. It was reported that Thai police harassed women wearing Malay attire such as the *baju kurong* and *selendang*. From around 1960, a package of socioeconomic development policies was initiated under the Sarit regime. The state's system had penetrated further into Malay life through the administration of economic development. The registration of Islamic schools (*pondok*) was made obligatory in the 1960s. Classes are taught in Thai to promote the assimilization of Malay-speaking Muslims. The state administration of Islam is headed by the Office of the Chularajmontri (the king's adviser on matters relating to Islam), the Provincial Committee for Islamic Affairs, and the Mosque Committee. Research results published in the 1990s generally conclude that assimilationist polices have succeeded in politically integrating Malay-speaking Muslims (Bajunid 1999).

Beginning in the 1950s, anti-assimilationist sentiments rose among Malay-speaking Muslims and various armed separatist groups were formed. Incidences of political violence and guerrilla wars escalated from the 1950s to the early 1980s. There is much research and writing concerned with the separatist aspects of the Malay-speaking Muslims (Surin Pitsuwan 1985, Chaiwat Satha-Anand 1987, Wan Kadir Che Man 1990). However, gender analysis has been overlooked and the roles of women are highlighted only in a limited number of works. Chavivun Prachuabmoh (1980) investigated the role of women in maintaining ethnic identity and boundaries. She holds that Malay-speaking Muslims maintain their distinc-

tive ethnicity through informal institutions, such as family, kinship, community, friendship networks, and religious education. She focuses on the significant role of women in these informal institutions. To be concrete, women maintain the group's cultural symbols, such as clothing and language, and further strengthen the group's boundary by maintaining a strong stance against intermarriage and minimizing interaction with outsiders. By contrast, Nishii (2001) found from a case study on the Thai-speaking Muslims in Satun province that Muslims intermingle with their Buddhist neighbors at the same time as maintaining difference in religious matters. Chaiwat Satha-Anand (1994) examined the so-called *ḥijāb* crisis, the debate over whether to allow Muslim female students to wear Muslim dress at Yala Teachers' Training College, which took place in 1987–8. He analyzed it as a manifestation of contrasting sets of legitimation rather than as an expression of gendered discourse.

Some research deals with the economic development and social changes in the South, and how these alterations have been affecting the social and religious values of Muslim women. They focus on unchanging and changing aspects with regard to such topics as family planning and fertility (Suchart Prasithrathsint 1985), participation in secular education (Arin Sa-idi et al. 1993), activities in "public" and "private" domains (Chavivun Prachuabmoh 1980), and work and economic activities. Many of them adopt the quantitative survey as a methodology.

Singapore

The official statistics of Singapore categorize four constituent ethnic groups: Chinese, Malays, Indians, and Others. The population of Singapore was 3.26 million in 2000, with Chinese forming the majority (76.7 percent), followed by Malays (13.9 percent), Indians (7.9 percent), and Others (1.4 percent). Most of the Malays, and some Indians, are Muslim. Malay Muslims in Singapore in turn consist of diverse ethnic groups. While some Malays are native to Singapore, the majority are of Bawean, Javanese, Bugis, Batak, Minagkabau, or Indonesian and Malaysian origin.

Since it became independent in 1965, maintaining Singapore's independence has been the mandate of the ruling People's Action Party (PAP). How the different ethnic groups fare in the highly diverse social setting was a key issue, which resulted in the PAP's attempt to introduce ideologies of meritocracy and multiracialism.

These ideologies accord equal status to Chinese, Malays, Indians, and Others in terms of official policies, such as those related to religion, language, and culture. However, in reality, the Malay community persistently remains on the socioeconomic, educational, and political margins of society.

Although the Singaporean constitution enshrines the freedom of religion, the government has adopted policies to institutionalize the various Muslim organizations under its control. In 1955, the Syariah Court was established. In 1996, the Women's Charter was passed. The latter imposed a monogamous marriage regime on all Singaporeans except Muslims, although Muslim men married to non-Muslims under the terms of the Women's Charter were prohibited from polygamous marriages. All Muslim marriages must be registered at the Registry of Muslim Marriages. In 1966, the parliament passed the Administration of Muslim Law Act. Accordingly, the Singapore Muslim Religious Council (Majlis Ugama Islam Singapura, or MUIS) was established in 1968 as a statutory board to advise the government on matters relating to Islam. The MUIS administers and manages mosques and endowment properties, and coordinates the annual pilgrimage to Mecca. The Ministry of Community Development administers the Syariah Court, the Registry of Muslim Marriages and the MUIS. In 1982, MENDAKI (Council on Education for Muslim Children) was founded. It was intended to be a Malay Muslim self-help body, whose goal was to uplift the social, economic, and educational situation of the Malay community. In 1989, MENDAKI enlarged its activities and was renamed MENDAKI II. Rahim (1998) critically investigates the cultural deficit ideology of MENDAKI, revealing how it functions to accord legitimacy to the meritocratic and multiracialism ideal, despite the fact that it fails to narrow the educational gap between the Malay and the non-Malay communities.

There are a great number of studies focusing on the themes of ethnicity and nation-state building. However, studies on Muslim women as part of this topic are not conspicuous. Issues related to the participation of Muslim Malay women in national economic development have been discussed increasingly as many women have begun to be hired by multinational corporations, particularly since the 1980s. In accordance with the increasing number of wage-earning women, household change became the topic of research. Studies have been conducted into the extent to which key aspects of Malay culture have been affected as Singapore further proceeds along its course of rapid economic development. Li (1989) has shown the dynamic relationship between the form of Malay household and community cultural practices, and the economic structure of Singapore. Her ethnographic description of roles of a husband and a wife, marriage, socialization of children, budgeting, and domestic labor gives insights into the understanding of women and Malay Islamic culture in Singapore. The multiethnic women's organization, the Association of Women for Action and Research (AWARE), raises the issue of exploited low-waged Malay women. However, the government has not yet acknowledged that discrimination against minorities in the workforce is a problem that needs to be seriously addressed.

Burma, Cambodia, and Laos

In Burma, Muslims are divided into four distinct communities. The 1983 census accounted for a Muslim population of only 3.9 percent of the country's 34 million people. They consist of Burmese Muslims, Indian Muslims, Muslims in Arakan, and a small number of Muslims of Chinese descent who populate the Shan state bordering China.

As soon as Burma began to build a modern nation-state, the question of how to accommodate non-Buddhists became a serious political problem. During the height of Burmese nationalism in the late colonial period, non-Buddhists were not considered part of the Burmese nation, and the exclusion of Indians was also severe. Aung San, the leader of the Anti-Fascist People's Freedom League, was fully aware of political sensibilities regarding religious matters. He therefore stood his ground on secularism and separated religion from politics. The 1947 constitution accorded Buddhism with a special position, but did not recognize it as the state religion. However, once U Nu became prime minister, he placed great emphasis on the Buddhist heritage. In 1961, the constitution was amended and Buddhism was made the state religion. However, despite further constitutional amendments in the following year in order to assure equal status to all religions, non-Buddhists remained unsatisfied and resentment continued, and this ultimately contributed to the political turmoil leading to Ne Win's coup d'état in 1962. The 1974 constitution provided that religion was a personal matter, and clearly prohibited the politicization of religions.

Each Muslim community in Burma has had a very different relationship with the mainstream Buddhist society and with various central authorities. Burmese Muslims consider themselves to be Muslims by religion, but Burmese by nationality, and they dress and behave "Burmese" in every respect, whereas Indian Muslims have attachments to the Islamic world outside Burma, and identify with Arab countries.

It is said that Burmese Muslims and Indian Muslims sometimes differ on issues regarding women. For example, the Jam'iyyat al-'Ulamā', Burma, originally established in 1922 as the first religious Muslim organization, split up in 1958. One of the conflicts leading up to this split centered on the dress and deportment of Muslim women. Whereas Indian Muslim members objected to inviting women to public meetings and to the wearing of Burmese dress at prayer, the Burmese Muslim 'ulamā' were in favor of these practices (Yegar 1972, 89).

Similar arguments were raised by the All-Burma Muslim Women's League, which was officially founded in 1946. One of its activities included evening classes for women and demanded the abolition of purdah, which was worn only by Indian Muslim women. In contrast, the Muslim Chamber of Commerce, founded in 1942, the members of which were Indian Muslims, demanded that the government of Burma allow women wearing the purdah to obtain their official papers without having to be photographed (Yegar 1972, 85–8). In this way, Muslim women's issues have been part of the discourse of disputes between the two parties, and Burmese Muslim women have been generally described as enjoying more freedom than Indian Muslim women. However, to what extent this description reflects the subjective perspectives of women remains unknown.

One of the many revolts with which Burma was afflicted shortly after achieving independence was a Muslim insurrection in Arakan. During the British colonial regime, there was massive Indian migration into Arakan. The relationship between Muslims and Buddhists in Arakan deteriorated in the 1930s and during the Second World War when Muslims sided with the British and Buddhists supported the Japanese. The so-called "Mujahid" demanded the autonomy of a part of Arakan, or the inclusion of that region in Pakistan. From 1951 to 1954, every year was marked by a big government offensive against the Mujahid. After 1954, they were no longer a great military threat. In the 1970s, conflict between the

Buddhists and the Muslim Arakan, who call themselves Rohingya, flared up. In 1977, the government conducted the Nagamin operation in the name of "inspecting illegal migrants," and more than 200,000 Muslims took refuge in Bangladesh. In 1991–2, the State Law and Order Restoration Council (SLORC) intensified military operations in the name of "development," and 260,000 Muslims were reported to have fled Burma (Asia Watch 1992, FIDH 2000). The situation has not improved under the State Peace and Development Council (SPDC). Human rights violations against Muslims, such as forced labor, forced relocation, and land confiscation still prevail, and a number of Muslim women were reportedly raped (FIDH 2000, Amnesty International 2000).

In Cambodia, the Khmer (Cambodian) made up 90 percent of the population of 11.4 million in 1998. Most of them are Buddhists and maintain a strong influence on national politics, economics, and culture. The Muslim community is mainly composed of the Chams. They are considered to have originated from the former Kingdom of Champa. Official statistics placed the number of Cham at around 200,000 in 1995. According to Omar Farouk Bajunid (1998), no single work on the Muslims in Cambodia has yet been published. There is one unpublished ethnographical work on Chams (Collins 1996). Many Cham rural women are said to be engaged in vending.

Due to internal and external political disturbances, Cambodia has lacked consistent national integration policies. Freedom of religion was guaranteed both in the first constitution of the Kingdom of Cambodia in the independent era, and in the republican constitution of 1970–5. The political participation of Muslims in Cambodian national politics was promoted especially under Sihanouk's patronage (Bajunid 1998). Article 20 of the Constitution of Democratic Kampuchea, enacted during the Pol Pot regime in 1976, specified both the right to worship and the right not to worship according to any religion. At the same time, it forbade any reactionary religions that were considered detrimental to Democratic Kampuchea and Kampuchean people. This policy, which seemingly endorses religious freedom, in fact resulted in the oppression of Buddhists by the Khmer Rouge, and in the genocide that was inflicted on all Cambodians being targeted with particular severity on Muslims. An unknown number were killed, and thousands fled the country to nearby refugee camps or settlements

overseas. The 1993 constitution made Buddhism the state religion, but it allowed the re-institution of religious freedom. Muslims have increasingly moved into important government posts; however, the number of those who have done so is still relatively small. No questions have been asked regarding this national policy. Muslims in Cambodia maintain good relations with the majority of Buddhist communities and conflicts have scarcely occurred. Omar Farouk Bajunid (1998) conducted a valuable survey on the reconstruction of Islam in the post-UNTAC period. Khana Chuol Kapuol Islam Kampuchea or mufti is the highest officially-recognized authority on Islam in Cambodia today.

In Laos, it is estimated that there are several thousand Chams who follow Islam, but no known studies on this population exist. The actual situation of Muslim women in Laos is not well known.

Muslims have become a minority religious group and women have been placed in a marginal position as a result of nation-state political projects. There have been many debates regarding how to integrate Muslim minorities, resulting in various attempts by central governments to invent constitutions, laws, and various institutions to accommodate them to the state system. However, Muslims remain on the political and socioeconomic margins of society and suffer both severe discrimination and political instability especially in the Philippines and Burma. This situation affects the characteristics of sources and materials on Muslim women in these countries.

First, political sensitivity: the Muslim position within the nation-state formation hinders the collection of reliable and comprehensive official data. For example, some Muslim groups in the Philippines, Thailand, and Burma claim that official statistics are manipulated to give a lower number for the Muslim population, and these groups give different estimates. Second, political instabilities in these regions have prevented researchers from conducting fieldwork, and empirical studies are scarce. The voices of Muslim women themselves are not heard and there have been few studies incorporating the subjective experiences of women. For example, women's issues are sometimes made into nationalistic discourses, as shown in the case of Muslims in Thailand as well as in that of Burmese Muslims and Indian Muslims in Burma. However, to what extent these discourses reflect the actual situation of women is not known. Further attempts are needed to reveal the reality of women who have experienced the process of nation-state formation.

BIBLIOGRAPHY
P. N. Abinales, *Making Mindanao. Cotabato and Davao in the formation of the Philippine nation-state*, Quezon City 2000.
Amnesty International, Unsung heroines. The women of Myanmar, at <www.amnesty.org.uk/deliver/document/14089>.
V. SM. Angeles, Women and revolution. Philippine Muslim women's participation in the Moro National Liberation Front, in *Muslim World* 86:2 (1996), 103–47.
Asia Watch, *Burma. Rape, forced labour and religious persecution in northern Arakan*, New York 1992.
O. F. Bajunid, The reconstruction of Islam in Cambodia [in English], in Seiji Imanaga (ed.), *Research reports of scientific research on Muslim communities in Northern Thailand, Laos, and Cambodia* [in Japanese], n.p. 1998.
——, The Muslims in Thailand. A review, in *Southeast Asian Studies* 37:2 (1999), 210–34.
E. Casiño, *The Jama Mapun. A changing Samal society in the southern Philippines*, Quezon City 1976.
W. A. Collins, The Chams of Cambodia, in Center for Advanced Study, *Interdisciplinary research on ethnic groups in Cambodia*, Phnom Penh 1996 (mimeo).
FIDH (Fédération international des ligues des droits de l'homme), Burma. Repression, discrimination and ethnic cleansing in Arakan, at <www.fidh.org/asie/rapport/2000pdf/angl/araksum.pdf> 2000.
K. Gaerlan and M. Stankovitch (eds.), *Rebels, warlords and ulama. A reader on Muslim separatism and the war in southern Philippines*, Quezon City 1999.
P. Gowing, *Mandate in Moroland. The American government of Muslim Filipinos 1899–1920*, Quezon City 1977.
——, *Muslim Filipinos. Heritage and horizon*, Quezon City 1979.
M. Ishii, *Stories of Muslim women in the Philippines. Armed conflict, development and social change* [in Japanese], Tokyo 2002.
W. Kadir Che Man, *Muslim separatism. The Moros of southern Philippines and the Malays of southern Thailand*, Singapore 1990.
T. M. Kiefer, *The Tausug. Violence and law in a Philippine Moslem society*, New York 1972.
C. S. Lacar, Maranao Muslim women educational administrators. An initial study of the emerging Muslim women leaders in the Philippines, Ph.D. diss., Western Michigan University 1996.
L. Q. Lacar, *Muslim-Christian marriage in the Philippines*, Quezon City 1980.
——, Philippine Muslim women. Their emerging role in a rapidly changing society, in M. Turner, R. J. May, and L. R. Turner (eds.), *Mindanao. Land of unfulfilled promise*, Quezon City 1992.
T. Li, *Malays in Singapore. Culture, economy, and ideology*, Singapore 1989.
T. M. McKenna, *Muslim rulers and rebels. Everyday politics and armed separatism in the southern Philippines*, Berkeley 1998.
R. M. Maidan, The influence of some socio-economic and cultural factors on the family planning knowledge, attitudes and practices of selected Maranao housewives. Urban-rural contrast, in *Dansalan Quarterly* 4:3–4 (1985), 181–262.

R. Nishii, *Death and practical religion. Perspectives on Muslim-Buddhist relationship in southern Thailand* [in Japanese], Tokyo 2001.

S. Pitsuwan, *Islam and Malay nationalism. A case study of the Malay-Muslims of southern Thailand*, Bangkok 1985.

C. Prachuabmoh, The role of women in maintaining ethnic identity and boundaries. A case of Thai-Muslims (the Malay speaking group) in southern Thailand, Ph.D. diss., University of Hawaii 1980.

S. Prasithrathsint, *Ethnicity and fertility in Thailand*, Singapore 1985.

L. Rahim, *The Singapore dilemma. The political and educational marginality of the Malay community*, Kuala Lumpur 1998.

A. Sa-idi et al., Women in rural, southern Thailand. A study of roles, attitudes, and ethno-religious differences, in *Southeast Asian Journal of Social Science* 21:1 (1993), 81–97.

L. H. Sarip, A profile of the economic activities of Maranao women in Marantao, Mulondo and the Islamic city of Marawi, Lanao del Sur, in *Dansalan Quarterly* 7:1–2 (1985–6), 5–83.

C. Satha-Anand, *Islam and violence. A case study of violent events in the four southern provinces, Thailand, 1976–1981*, Tampa, Fla. 1987.

——, *Hijab* and moments of legitimation. Islamic resurgence in Thai society, in C. F. Keyes, L. Kendall, and H. Hardacre (eds.), *Asian visions of authority. Religion and the modern states of East and Southeast Asia*, Honolulu 1994, 279–300.

A. P. Usodan-Sumagayan, The changing role of Maranao women in a Maranao rural society, in *Dansalan Quarterly* 9:4 (1988), 165–228.

M. D. Vitug and G. M. Gloria, *Under the crescent moon. Rebellion in Mindanao*, Quezon City 2000.

M. Yegar, *The Muslims of Burma. A study of a minority group*, Wiesbaden 1972.

MASAKO ISHII

Indonesia: Early 20th Century to Present

Much of our knowledge of women in Indonesia is intertwined with the history of the formation of the modern state, from the grand colonial project that was the Dutch East Indies to the independent state of Indonesia. This history, founded upon the penetration of international capital and the ascendancy of print, has had a profound effect on the discourse on women, and on the intersection of gender and Islam in the archipelago.

A fairly large volume of literature indicates that the majority of women in the region enjoy high status and a measure of power in societies marked by low gender differentiation in linguistic and other symbolic systems. On the other hand, an increasing corpus of feminist critique has begun to reveal the systemic subordination of women within patriarchal state ideology. The influence of Islam has been implicated in the rise of patriarchy, and the emergence of militant Islamic discourse after the fall of President Suharto in 1998 would appear to reinforce this perception. However, critical analysis of the discourse of state formation – colonial as well as independent – reveals that a rapid process of domestication of women and of Islam was integral to the foundation of the colonial state. Ironically, state policies vis-à-vis Islam, particularly with regard to the legal system, served to formalize and thereby exacerbate gender inequality as the fixed and uniform letter of the law narrowed the range of interpretation.

Islam entered the archipelago in the thirteenth century. Records going back to the earliest European penetration into the region to establish monopoly in the spice trade provide evidence of politically astute and active women, particularly in the Muslim sultanates of the Moluccan "spice islands." In a number of cases, senior women were rulers or – partly because of the complications to royal succession presented by polygamy – became the power behind the throne. The screens that kept some women hidden from the view of European males did not necessarily mean that women were isolated from the politics of the day, for they were able to serve as unseen but distinctly present witnesses to negotiations or to forestall potentially explosive situations. The records also indicate trafficking in slaves, including female slaves from Java and other islands, to labor on Dutch nutmeg and clove plantations in the Moluccas. Though Muslim traders were involved in the slave trade, Muslim women were protected from this extreme type of exploitation.

Despite the prerequisite set out in the *Taj us-Salatin*, an early seventeenth-century Acehnese Malay treatise on kingship, that a ruler should be "male, because woman lacks good character," (Abdullah 1993) the sultanate of Aceh Darussalam was ruled by a succession of queens between the seventeenth and eighteenth centuries. The most influential of these, Safiatuddin, styled Sultan Taj-ul-ʿalam was responsible for the codification of the *Adat Aceh* (Acehnese royal custom), and engaged in international diplomatic and trade negotiations and agreements. Her name appears alongside that of her famous father, Iskandar Muda, on the royal stamp used by subsequent rulers. Under these female rulers, Aceh enjoyed its longest period of peace. The line of women rulers ended not because of Islamic injunctions against the rule of women, for Taj-ul-ʿalam's rule was officially recognized by Rum (Turkey), the political center of Islam, but rather as a result of internal power struggles.

Court manuscripts written in Jawi, the Malay language in the Arabic script, refer to mythical female figures as the source of royal power. These texts make abundant references to the indigenous foundational narrative of the princess hidden in a bamboo, whose emergence marks the beginning of a royal line and the state of civilization. Also known are female crown-givers, like the woman of Gunung Ledang in the *Sulalat us-Salatin* (*Sejarah Melayu* or Malay annals). Such mythical female figures survive to this day in oral and ritual form not merely as interesting folk-tales; rather, the narratives in which they are preserved constitute the matrix of indigenous local knowledges regulating human activities such as fishing, forestry, and agriculture. More significantly, these female figures are the point generating community memory. The stories of founding mothers (such as Bundo Kanduang of the Minangkabau, Nen Mas Il in the Kei islands, Nang Hale of northeastern Flores, Ni Pohaci in West Java, the earth mother of the Kamoro in West Papua, the Banjarese Princess of the Foam in Kalimantan, and the Green Goddess of the Malays of North Sumatra and the Javanese – the female genius of place) fix local geographies of land, water, and sea. Not only do they serve to

mark stable centers of human space, they also enable a logic of movement, and particularly the *rantau* (travels, generally but not always, of males) for trade and thus the expansion of horizons and the enrichment and elaboration of knowledge itself. It is these crucial memories that have been undergoing a well-nigh inexorable process of marginalization as the nation finds itself increasingly subject to the logic of print-based knowledge and the pressures of a global market economy. For these narratives of the culture of orality are threatened not only by what has come to be understood as the ephemeral nature of the spoken word. The imagination/ideology of the modern state transcends and violates the constraints of local imaginations. Having reconstructed radically the conception of space and boundaries to encompass anonymous audiences, the state requires the uniform reproducibility of print and print-based text for uniform applicability to reduce the possibility of (mis)interpretation and to impose limits upon unregulated variation. The stories are losing their purchase – to use the term in its connotative complexity – also because of their female centeredness. The print-based imagination that entered the archipelago was patriarchal in intent and effect.

By the nineteenth century, detailed reports of the various islands in the archipelago were enlisted in the colonial project to catalogue domains claimed and those yet to be appropriated. Descriptions of indigenous systems of kinship and resource-management merged with evolutionist theories in natural and human history. Particularly influential in this early globalizing thrust of thinking was J. J. Bachofen's theory of the history of mankind, which constructed the evolution of human civilization and law on the principle of a universal gender struggle. This struggle, in Bachofen's Hegelian model, had achieved synthesis in the West in the triumph of patriarchy. By contrast, the "Asiatic" mode had remained in a state dominated by "mother right" (*Mutterrecht*). This vision contributed much to subsequent policies upon which the colonial state was constructed and maintained. As it was taken up in the overarching discourse of colonial state policy, the concept of matriarchy was used not simply to comprehend indigenous community dynamics. Bachofen's theory had much to do with the nature of human laws and the evolution of property and inheritance rights away from their material/maternal base, especially important in relation to land. In the colonial reworking, matriarchal communities were distinguished by extended families and communal property, and came to be identified with a state of civilization

inimical to the individuation of males as inheritors and property owners empowered to alienate – i.e. to sell off – their holdings in the process of positive, codified, law. Matriarchy came to stand for anti-individualist communalism (also called "primitive communism") and resistance to the concept of private property ownership, especially of land. Thus constructed, the idea of a matriarchy entrenched in the materiality of land signified a fundamental obstacle to private ownership, resource extraction, capital accumulation, and, ultimately, enlightened progress within a modern state as blessedly fictitious as capital, legal corporate entities, and paternity itself. This perception undergirds the foundational works of colonial state policy and legal systems in the Dutch East Indies well into the first half of the twentieth century.

The establishment of a Western-style educational system naturalized the subject population into this mode of thinking, which became equated with modernity and progress. A state-owned publishing house produced educational reading material in formal print Malay. An early novel, *Sitti Noerbaja* (1922) – officially recognized as the first Indonesian novel – was set in the matrilineal Minangkabau region. Commonly defined as a work about the problem of forced marriage, the novel is also a powerful emotional argument for the supralocal colonial state and monogamous patriarchy. It was followed by other novels elaborating upon the theme. In this flourishing of print in Malay (later to become Indonesian), the central role of the mother figure is supplanted by the virginal young woman – the apple of her father's eye – who would find fulfillment only as a wife in a nuclear family. The tragic conclusion of most of these novels is largely blamed on the failure of an old, still powerful, tradition to recognize the new needs of a young, literate generation on the brink of imagining and claiming a modern, urban-centered state extending far beyond the boundaries of territories delineated and preserved by mere word of mouth.

Colonial state formation was not an even process. It has been argued that the antagonism between Islam and rival traditions was a construction of Western colonial thought that has survived to some extent in current scholarly work (Reid 1993). In encounters with armed rebellion and resistance from movements linked to international Islam, the hegemonic discourse of colonialism mobilized vestiges of indigenous structural "matriarchy" along with the indigenized Hindu and Buddhist cultural heritage to distinguish what was more appropriately indigenous from that which was seen as the imposed alien influence of an increasingly modern-

izing and scripturalist Islam. Even the work of Snouck Hurgronje, the pre-eminent Dutch colonial scholar of Islam betrays this tendency. In the field of the law, Snouck Hurgronje's concept of *adat* law in the Netherlands Indies divorced local custom (*adat*) from Islamic law (*syariʿat*), and by doing so, prevented the formation of a unified legal system. Significantly, the systematic codification of oral *adat* (including evidence from only one woman) inducted these practices into the law as *raison écrit*, and, while intended to preserve the ethnic specificity of particular *adat* domains, effectively arrested their development.

The idea of matriarchy and orality as a remnants of a premodern past was taken over by the founding fathers of the independent state. An outstanding example of this is Sukarno's *Sarinah*, a compilation of his lectures on the role of women in the new state. In this work, Indonesia's first president describes a modern nation progressing beyond a defunct matriarchy and outlines a future socialist state actively supporting reproductive labor in an enlightened patriarchy. Such a state, it maintains, would protect the nuclear family, freed from the burden of domestic labor, and women's *kodrat* (destiny determined by biology) to give pure love as wife and mother. This definition of female destiny survived the bloody transition from Sukarno to Suharto's New Order regime in 1965–6. The demonization of women in organizations allied with the Communist party goes deeper into the mythical depths of Bachofen's theory, depicting women in an orgiastic frenzy attacking captured generals in what amounts to an Amazonian male-killing mode. The horror inspired by this narrative, memorialized and re-enacted annually by the state, did much to suppress women and the non-urban masses. Female *kodrat* became further entangled in policies designed to merge the nation into the free market economy. Chief among these was the introduction of hybrid rice dependent on modern technology and credit schemes which marginalized large numbers of rural women. Concurrent with these shifts in economic policy in the 1970s, laws were passed to fix patriarchal gender relations (1974 Marriage Law) and to disenfranchise traditional communities (1979 Village Administrative Law). These paved the way for land-grabbing schemes for extractive enterprise, industrial estates and large-scale plantations, and the mobilization of female labor in manufacturing industries.

Print has become an area of contestation and empowerment, as exemplified by the deconstruction of religious texts that have contributed to the subjugation of women. Projects underway to record and transcribe oral narrative appear to offer a remedy. However, without full enfranchisement of subject communities, such projects may serve only to perpetuate relations of inequality between those who control and benefit from print-based knowledge and those positioned as the inert source of material from which knowledge is produced.

BIBLIOGRAPHY

T. Abdullah, The formation of a political tradition in the Malay world, in A. Reid (ed.), *The making of an Islamic political discourse in Southeast Asia*, Clayton, Vic. 1993, 35–58.

Adat Atjèh. Reproduced in facsimile from a manuscript in the India Office Library. With an introduction and notes by G. W. J. Drewes and P. Voorhoeve, xxiv, 's-Gravenhage 1958.

J. J. Bachofen, *Myth, religion and mother right*, trans. R. Manheim, Princeton, N.J. 1967.

A. Haga, *Nederlandsch Nieuw Guinea en de Papoesche eilanden. Historische bijdrage 1500–1883*, Batavia 1884.

G. Hart et al. (eds.), *Agrarian transformations. Local processes and the state in Southeast Asia*, Berkeley 1989.

T. Iskandar, *De Hikajat Atjéh*, xxvi, 's-Gravenhage 1958.

A. D. A. de Kat Angelino, *Staatkundig beleid en bestuurzorg in Nederlandsch Indie* (State policy and administration in the Netherlands Indies), 's-Gravenhage 1930.

J. Koning et al. (eds.), *Women and households in Indonesia. Cultural notions and social practices*, Richmond, Surrey 2000.

Roesli Marah, *Sitti Noerbaja*, Weltevreden 1922.

L. M. Marcoes-Natsir and Johan H. Meuleman, *Wanita Islam Indonesia dalam Kajian Tekstual dan Kontekstual* (Indonesian Muslim women in textual and contextual studies), Jakarta 1993.

A. Reid (ed.), *The Making of an Islamic political discourse in Southeast Asia*, Clayton, Victoria 1993.

B. Schrieke, *Indonesian sociological studies*, Bandung 1960.

J. Siapno, *Gender, Islam, nationalism and the state in Aceh. The paradox of power, co-optation and resistance*, Richmond, Surrey 2002.

Snouck Hurgronje, Ch. *De Atjehers*, Batavia 1893–4.

Soekarno 1901–70, *Sarinah*, Djakarta 1963.

J. Suryakusuma, The state and sexuality in New Order Indonesia, in L. Sears (ed.), *Fantasizing the feminine in Indonesia*, Durham, N.C. 1996, 92–119.

F. Valentijn, *Oud en nieuw Oost-Indien*, Dordrecht 1724–6.

C. van Vollenhoven, *De Ontdekking van het Adatrecht* (The discovery of *adat* law), Leiden 1928.

——, *Het adatrecht van Nederlandsch-Indië* (The *adat* law of the Netherlands Indies), Leiden 1925.

Saskia Wieringa, The politicization of gender relations in Indonesia. The Indonesian women's movement and Gerwani until the New Order State, Ph.D. diss., University of Amsterdam 1995.

Oral sources: men and women in traditional communities in Indonesia; activists for indigenous community rights. I am especially indebted to Roem Topatimassang, John Balla, Zadrak Wamebu, Mama Yosefa, Mama Yusan, and Nursyahbani Katjasungkana for both memories and insights.

SYLVIA TIWON

Islam in Southeast Asia: Early 20th Century to Present

Academic works on East and Southeast Asian women did not begin to proliferate until the mid-1970s. Until then, scholars studying the region had paid only scant attention to women. The reasons for this neglect appear to stem from both the perspective of the scholars and the paucity of sources. Social scientists, anthropologists, and historians have critically pointed out the invisibility of women in sociological, anthropological, and historical works. This was because these works had been conducted and written from a male perspective (Chipp and Green 1980, Locher-Scholten and Niehof 1987). This is also true of social-scientific and historical studies on East and Southeast Asia. It has been pointed out that Western anthropologists working in Southeast Asia had failed to recognize gender differences existing in the region because they were marked in ways unfamiliar to them (Errington 1990). Their masculine bias had prevented them from bringing forth the language and idiom of the dominant male groups their women informants had to use when expressing themselves (Locher-Scholten and Niehof 1987).

Male bias has rendered potential sources for the study of women in East and Southeast Asia infertile. Colonial archives and writings in Indonesia, for example, contain very limited information about women and their role in society. It appears that the colonial officials who wrote and collected them did not include women in their priorities (Locher-Scholten and Niehof 1987). More information about women in colonial Indonesia can be extracted from other sources, such as colonial literature by women, ethnographic reports, and studies on colonial agrarian laws and traditional rules. Caution is still needed, however, because these sources are not entirely free from Western and male bias either. A more balanced perspective and more information can be found in Javanese literature and oral history. In general, anthropological accounts tell little about women, and historical material on women in East and Southeast Asia has been scarce (Chipp and Green 1980).

Sources for the study of Muslim women in the region are even scarcer. This is especially true in countries in the region where Muslim populations are small minorities – the Philippines, Singapore, Thailand, Cambodia, Burma, Laos, Vietnam – or almost non-existent – Japan, Korea, and Taiwan. In China, there is an estimated Muslim population of about 25 million. Yet in terms of percentage it is a small minority. Furthermore, Muslims in China have been perceived as isolated from the rest of the Muslim world. Sources for the study of Muslim women in China are no less scarce (Pillsbury 1982). Studies of Islamic cultures in Southeast Asia tend to focus on Malaysia and Indonesia (Ibrahim et al. 1985). Obviously, this is because Muslim populations are majorities in these two countries. In Indonesia, where an estimated 90 percent of its population is Muslim, colonial and national archives and records that pertain to women, with all their male bias, would very likely pertain to Muslim women. This, to a lesser extent, is also true in Malaysia.

THE MID-1970S AND INDUSTRIALIZATION

The proliferation of academic works focusing on East and Southeast Asian women that began in the mid-1970s occurred after the establishment of academic programs in women's studies in American and European universities. Two decades later, similar programs were established in universities in East and Southeast Asia. This development has helped remedy the male bias in approaches employed in the academic studies of women. It has encouraged new ways of understanding the situation of women. In the meantime, national projects of industrialization, on which the nation-states in the region embarked almost simultaneously in the 1970s, also had a great impact on the issues and sources for the study of women in the region in the last two decades of the twentieth century.

POWER, AGENCY, AND SUBJECTIVITY

In the last two decades of the twentieth century the study of women in the industrializing East and Southeast Asia came to be concerned with the notions of power, agency, and subjectivity. These notions have emerged from the confluence of

developments in Marxist tradition, poststructuralist thought, cultural anthropology, and popular cultural studies. Marxist thought has helped foreground the issue of power relations between the sexes and throw light on the subordinate position of women. Its view of power, however, tends to be monolithic and leads to the view of women as powerless victims and survivors. This view has been rejected in favor of a view of women as active agents, a subject capable of resistance. Although the notion of agency was envisioned within the Marxist tradition, in its later development it has become more pronounced with the advent of poststructuralist critique. In poststructuralist thought, power is seen as not monolithic but dispersed, accessible to individuals irrespective of sex. Such a view of power allows for the envisioning of individual agency capable of resisting industrial and capitalist forces. For women, individual agency means power to resist patriarchy and to craft their own space.

Marxist and poststructuralist thought has also influenced the development of cultural studies. Marxist scholars' concern with the exploration of working-class culture has encouraged feminist scholars to explore women's culture. The view of women as active agents has further led feminist scholars in cultural studies working on East and Southeast Asia to explore ways in which women in the region craft their own identities and cultures in resistance to industrialization and capitalist culture (Sears 1996, Sen and Stivens 1998). While the fact of the inequality of power relations between the sexes continues to be recognized, it is now seen as characterized by a shifting dynamic. Poststructuralist thought has also influenced feminist culturalists with the idea of the construction of subjectivity. Feminist scholars translate this idea into the notion of the construction of gender. Some interested in the East and Southeast Asia have used the notion as a basis to understand the situation of women in the region (Locher-Scholten and Niehof 1987, Atkinson and Errington 1990). This approach reveals how power relations between the sexes are manifested on the ideological and discursive levels where identities and meanings are constructed and contested, and how gender has shaped modernity and its meanings in the region (Sears 1996, Sen and Stivens 1998).

Cultural anthropology has contributed the idea of culture as webs of meanings and symbols, or forms of discursive construct imposed on facts. Feminist concern with power relations between the sexes and women's agency has led to the view that cultural meanings and symbols are also ideological constructs. In this view, ideas about gender circulating in a culture are not only part of the mechanism of the dominant system to keep women in their position, but also part of the strategy that women employ to resist the domination. Anthropological work on women in East and Southeast Asia has thus come to investigate how cultural meanings change in the process of industrialization and how they function in the efforts of harnessing women's energy to support industrial production as well as in women's efforts to resist this domination (Ong 1987). Obviously, these theoretical developments in women's studies have had an effect on the studies more specifically focused on Muslim women in the region.

SOURCES AND THEIR USE

As the states in East and Southeast Asia carried out the projects of industrialization and modernization in the last three decades of the twentieth century, there was a dramatic entry of large numbers of women into the work- and marketplaces (Horton 1996). At the same time, sweeping social and cultural changes, brought by industrialization and economic development, were transforming the region. Women came to be implicated in the policies supporting state-led industrialization and modernization projects. The significant role that women played as a source of cheap but indispensable labor led the states to mobilize them to become sustainers of the industrialization process. This coincided with the necessity to prevent population growth from offsetting the gains of economic developments. Practically all the states in the East and Southeast Asian region adopted similar policies. They sponsored national family planning programs and, to buttress them, put their administration of marriages and divorces in order. In countries where Muslims are in the majority, like Indonesia and Malaysia, state efforts to regulate marriage and divorce practices in terms of national laws have complicated the issues of reproduction. The position of women in Islam is brought to the fore as an object of interrogation and state intervention in the lives of women is an unavoidable issue in studies focusing on women in the region.

The projects of industrialization in East and Southeast Asia in the past two decades have produced records pertaining to the female populations in the region. These records include statistics produced in conjunction with periodic national censuses and surveys, and data about the national family planning programs. Feminist scholars have made use of these sources. They have also utilized

the various discourses, both official and unofficial, concerning women. These include documents containing official statements on the role of women in the process of industrialization as well as in the broader process of nation building. In some states in the region, efforts to regulate marriage and divorce practices have produced legislation that serves as a source of analysis. In Indonesia, this includes a compilation of Islamic laws used as a reference by the Islamic courts. In countries where Islamic courts are operative, records of trials concerning marriage and divorce are also available for researchers interested in certain aspects of the situation of the Muslim women in the region. Unofficial statements of regional leaders have also provided sources for the analysis of how images of women get produced and strengthened. The mobilization of religion has also allowed the use of religious discourses as they contribute to the construction of gender.

Anthropologists working in the region continue their contribution through their ethnographic work. Cultural studies scholars also make use of popular cultural discourses and the media to analyze the dynamic of women's entry into modernity and consumer culture in the region. Historians, meanwhile, produce oral history.

It needs to be noted, however, that sources for the study of Muslim women in countries in East and Southeast Asia where Muslims are the minority population remain scarce. It has been suggested that in China, for example, where there is a substantial Muslim minority, information about women has come only through scanty journalistic reporting that is not free from male bias (Pillsbury 1982). Those who are interested in gaining deeper knowledge have to rely on fieldwork.

Social scientists and anthropologists who are interested in documenting broader social and cultural changes in Southeast Asia have made use of the abundant sources in fruitful ways (Karim 1992, Jones 1994). Gavin M. Jones, for example, makes extensive use of available censuses, surveys, and marriage and divorce records in Southeast Asia in his *Marriage and Divorce in Islamic South-East Asia*. He uses statistical methods to analyze changes in marriage and divorce patterns in the region from the 1950s to the 1980s. According to Jones's analysis, Muslim women in Southeast Asia appear generally to have acquired better lifestyles during industrialization and modernization. In the 1980s, adolescent females no longer experienced tight parental control or early arranged marriages, as they had in the 1950s. They could postpone, or even ignore, marriage. Divorce rates had come

down, partly because of the state policies and pressures from women's groups. Polygamy, too, with divorce procedures tightened, became less common. There were fewer divorcees of childbearing age, most of whom had suffered economic hardships.

Delayed marriage, meanwhile, in Jones's account, had resulted in Muslim women in the region having fewer children. Higher education had translated for some of them into high-paying jobs and independence. Opportunities to pursue their own careers were partly responsible for the decision of some of them not to marry. With these changes, Jones points out, new patterns of interactions between the sexes emerged that tended to be viewed as problematic. Prolonged adolescence, for example, had brought about a freer pattern of mixing between young men and women and a tendency for more premarital sexual relationships. Women with higher education had increasing difficulty finding husbands, partly because they became more careful in selecting husbands and partly because men still preferred women with less education for wives. The difficulty of divorce, meanwhile, tended to make it harder for women to escape unsatisfactory marriages. On the whole, though, in Jones's account, Muslim women in Southeast Asia in the 1980s had come to enjoy much better lives, socially and economically, than their grandmothers.

FEMINIST VIEWS
Jones's book paints vivid, comprehensive pictures of the broad social changes that Muslim women in Southeast Asia underwent during the process of industrialization. However, most feminist scholars today have abandoned this objective stance. The feminist concern with power relations between the sexes and the notions of agency and gender construction has led to the enrichment of the analysis of the social processes of industrialization and modernization, and their impact on women, by adding a dimension of meaning. It leads to the examination of what it means to be a modern woman – in many cases, Muslim – in the industrializing states of East and Southeast Asia. It also leads to analyses that bring out various pre-existing power relations between the sexes that emerge as the states in the region industrialize. These analyses show that as women in the region come out to work in the factories and companies, to be consumers in the marketplace, and to be part of the state bureaucracy, they enter the power structures and power relations of their cultures and those of the industrial capitalist system as the latter

impose themselves on and transform the former. They examine the various ways in which women are implicated in these power structures and relations by focusing on the changes in the understanding of the public and the private and by analyzing the ideologies of family and domesticity as they relate to women's work outside the home (Sears 1996, Sen and Stivens 1998). Their interrogation of the discourses in the various sites of modernity – household, consumption, the media, factories, the state, and social class – reveals that the female situation in the region in a modernizing age is fraught with contradictions and ambivalence.

In these analyses, therefore, as the region deals with the anxieties of social and cultural transformations, women, who are moving in droves to the workplace, are still conceived of as the bearers of the national traditional values. While playing the role of sustainers of state-led industrialization, they are simultaneously burdened with the task of being the guardians of traditional family and cultural values as these are being redefined, thus "threatened," by the process of modernization. The new affluence that has freed them from the restrictions of traditions and allowed them to enjoy modern luxuries has also brought them to the world of commodities where their bodies are used as a means of selling those commodities. The advent of the capitalist economy has also deprived many women in the region of forms of social support they had previously enjoyed. At the same time, with higher education and economic independence, women in the region have become adept at understanding their situation and the problems they are facing. They are empowered to express their thoughts and assert themselves and can resist, to some extent, social and cultural restrictions imposed upon them.

ISLAMIC TEXTS

Muslim feminist scholars in the region have, to some extent, adopted methods of analysis that have developed within women's studies and applied them to Islamic texts, including the Qur'ān, the ḥadīth, and texts produced by the tradition of the religious scholarship, especially fiqh, or Islamic legal scholarship (Hasyim 1999). In the analysis of Qur'ānic text, they adopted the strategy of emphasizing the conflicting depictions of women in the Qur'ān. Women are sometimes portrayed as subordinate to men and sometimes as equal to or even elevated above men. They thus reveal how Islamic legal scholarship has stressed the Qur'ānic depictions of the inferiority of women and ignored those of their equality. Critical interrogations in terms of

gender construction of the canonical texts of the Islamic traditional legal scholarship also disclose prescriptions of domestic gender relations that encourage husbands to oppress their wives. These analyses show the class and gender bias of the male scholars entrenched in the scholarship they produced. Similar analysis of the ḥadīth, combined with historical method, also reveals there was a case when the Prophet Muḥammad did not allow polygamy. It shows that at the inception of Islam, the allowance of four wives was conceived as a mechanism to regulate marriage and divorce with the ultimate goal of protecting the dignity of women. Thus it can be argued that polygamy is not an irreversible divine injunction but a social necessity that could be adopted if it were in women's interests. It is this ultimate goal that should be used as a basis today to decide whether polygamy should continue or stop.

ANTHROPOLOGICAL WORKS

Anthropological works complement these discursive analyses of Islamic texts by exploring the meaning of Muslim women's experience of modernity in the region. One anthropological analysis of Muslim women in China and Taiwan shows how they have to cope with the difficulties and demands emerging from the intersection of Islam, patriarchy, and being in a minority in modern times (Pillsbury 1982). Another work, which analyzes personal narratives of Javanese Muslim women, shows how personal decisions made by these women to wear the veil affect the formation of modernity in Indonesia (Brenner 1996). In Brenner's account, the women use veiling as a way to define their identities amid the flux of cultural and social changes. They also view veiling as a way to participate in the effort to shape modernity in Indonesia on Islamic terms. For them, veiling represents their commitment to Islam as a force to break from tradition and as a basis for the building of a new society. They envision this new society as "modern," yet in a sense that contrasts with that of the Western model; it is a modernity characterized by a deepening religiosity. Thus decisions made by these Javanese Muslim women in the private sphere contribute to the efforts of crafting a public space of modernity conceived in terms of a certain understanding of Islam in Indonesia.

CONCLUSION

It should be evident now that sources for the study of Muslim women in East and Southeast Asia became abundant in the last three decades of the twentieth century in countries where Muslims

are majority populations, especially Indonesia and Malaysia. In the rest of the countries in the region, however, these sources remain scarce. Methods in women's studies that have developed from the intersection of the feminist notions of power, agency, and subjectivity and the interest in aspects of modernity in the region have also been applied to the analysis of these sources where available, as well as to Islamic texts, producing rich analyses of the complexities of the situation of Muslims. These methods of analysis confront squarely the biases embedded in the sources, be they gender, class, race, ethnic, or religious.

The concept of gender construction is also useful in solving the problem of authenticity of voice. This is especially true for non-native (Western) scholars whose authority to speak for the women of the region is sometimes questioned. In fact, the concept of the construction of gender problematizes authenticity itself. The idea of woman as a construct annuls any claim of an essential female position from which to speak most authoritatively. It makes it clear that what makes a voice count is not that it is the voice of a woman, but that it brings to the fore the workings of the male ideology of control and makes it visible. A voice is feminist when it disrupts such ideology and the symbolic and social structures that marginalize women.

BIBLIOGRAPHY

J. M. Atkinson and S. Errington (eds.), *Power and difference. Gender in Island Southeast Asia*, Stanford, Calif. 1990.

S. Brenner, Reconstructing self and society. Javanese Muslim women and "the veil," in *American Ethnologist* 23:4 (1996), 673–97.

S. A. Chipp and J. J. Green, Introduction. Women's changing roles and status," in S. A. Chipp and J. J. Green (eds.), *Asian women in transition*, University Park, Pa. 1980, 1–11.

S. Errington, Recasting sex, gender, and power, in J. M. Atkinson and S. Errington (eds.), *Power and difference. Gender in Island Southeast Asia*, Stanford, Calif. 1990, 1–58.

S. Hasyim (ed.), *Measuring the value of women* [in Indonesian], Jakarta 1999.

S. Horton, *Women and industrialization in Asia*, London 1996.

A. Ibrahim, S. Siddique, and Y. Hussain (comps.), *Readings on Islam in Southeast Asia*, Singapore 1985.

G. M. Jones, *Marriage and divorce in Islamic South-East Asia*, Kuala Lumpur 1994.

W. J. Karim, *Women and culture. Between Malay* Adat *and Islam*, Boulder, Colo. 1992.

E. Locher-Scholten and A. Niehof (eds.), *Indonesian women in focus. Past and present notions*, Dordrecht 1987.

A. Ong, *Spirits of resistance and capitalist discipline. Factory women in Malaysia*, Albany, N.Y. 1987.

B. L. K. Pillsbury, Being female in a Muslim minority in China, in L. Beck and N. Keddie (eds.), *Women in the Muslim world*, Cambridge, Mass. 1982, 651–73.

L. J. Sears (ed.), *Fantasizing the feminine in Indonesia*, Durham, N.C. 1996.

K. Sen and M. Stivens (eds.), *Gender and power in affluent Asia*, London 1998.

MUHAMMAD FUAD

Eastern Europe: Early 20th Century to Present

Wars, decades of communist/socialist regimes, and ongoing nation-state building characterize the twentieth century in Eastern Europe. These events and processes have deeply affected the people as well as the collection and maintenance of public records and their comparability over time. During the twentieth century the major research concerns of scholars of Eastern Europe were political structures, national histories, and economic policies. From 1900 to 1990, research on women in Eastern Europe was of secondary interest at best, and research on Islamic cultures in Eastern Europe, except in Bosnia, was of even less concern. However, the final decade of the twentieth century brought the disintegration of the communist regimes and the rise of conservative nationalist states, along with wars in Bosnia and Kosova in which Islamic cultures had new or revived prominence. Eastern European societies were suddenly more open to research despite the violence. The growing international interest in research on women translated into research on how the post-socialist reforms and conservative social agendas affected the status and social welfare of women in Eastern Europe, and how women coped in these times of radical instability.

Eastern Europe is partly a construct of the cold war, a grouping of countries between the West and the former Soviet Union, but earlier was in the orbit or shadow of the Soviet Union. As such, the great variety in the region, including the influence of Islam, has been downplayed.

Islam first came to southeast Europe with Ottoman armies and Sufi missionaries in the late fourteenth and early fifteenth centuries. While some Muslim settlers from Anatolia came to the Balkans with the Ottoman troops, especially to Bulgaria and Macedonia, more significant was the gradual conversion of local Balkan peoples to Islam, particularly in the western Balkans among Bosnians and Albanians, but also throughout the region. Balkan Muslim statesmen of Bosnian, Serbian, Albanian, and Bulgarian background served as grand viziers, the highest civil office in the empire. But as the Ottoman Empire declined, so did the position of Muslims in the Balkans. In the nineteenth century, first Greece, then Serbia, Bulgaria, and Romania became independent states while Austria-Hungary took over Bosnia. During this time there were forced migrations, massacres, and expulsions of Muslims to what became Turkey, for the new Balkan states were largely conceived as ethnic units tied to language and a form of Christianity. Exceptions to this were Albania and Bosnia. Albanian Muslims stayed in the western Balkans and came to constitute 70 percent of the state of Albania. Most Bosnian Muslims, themselves Slavs, remained although many of their elite left for Istanbul. Communities of Turkish Muslims also remained, especially in Bulgaria, as well as Slavic Muslims like the Pomaks in Bulgaria, and Roma, many of whom were Muslim.

Thus while it could be argued that all of southeast Europe was influenced by Islamic culture during the five centuries of Ottoman rule, these influences remain the strongest in Albania, Bulgaria, and former Yugoslavia where there continue to be significant Muslim communities. The contrasts and comparisons of the situation of women in these lands are most revealing. In addition, research on women in surrounding East European lands complements and suggests directions of research (Gal and Kligman, 2000). For while many countries in Eastern Europe used to be quite isolated from each other, a development in the last decade of the twentieth century has been more regional openness through trade, refugees, and crime, as well as through conferences and regional research anthologies.

Balkan societies are traditionally highly patriarchal, with many of the rural areas still patrilocal. Earlier extended households were the pattern across the Balkans and while these have been split up by political and economic pressures, many of the reciprocal relationships from these extended households persist. Simić (1983) has argued persuasively for cryptomatriarchy in the traditional Yugoslav family in the sense that mothers gain in power with age, they have a moral superiority from their "sacrifice for their children," and the emotional attachment between mothers and sons is relatively more intense than other dyadic relationships. This is common in Albania and Bulgaria as well, but does not negate the overall patriarchal structure of the societies. A current challenge is to determine what features of family structure have strengthened, weakened, or changed in the transformations of the last half of the twentieth century.

Women's organizations were first founded in southeast Europe in the late nineteenth century, and increased in number in the 1920s in Serbia and Bosnia. Women did not, however, receive the vote until after the Second World War. Under socialism, the equality of men and women was an ideological tenet and considerable changes were made, but actual equality in work opportunities, education, political power, and social status was not achieved. Still, women made significant strides in legal status, literacy, health care, and in social expectation during these times. But since the 1990s, the participation of women in politics has actually decreased and the reproductive rights that they had under socialism have been challenged if not abrogated.

In the context of research on Islam, Balkan Muslims have received little attention, partly because they were converted after the main Islamic institutions had been established. Reinforcing this neglect, Balkan nation states across the twentieth century – from the fragile monarchies in the early decades, to the socialist/communist states of the following 50 years, and the current nationalist regimes – all have denigrated their own Ottoman past. Apart from Bosnia, they have all treated Islam as an artifact of earlier times and Muslims as problematic in their national ideological structures. These nations have sought to distance themselves from their Ottoman past as they aspire to become more fully part of Europe.

SOURCES AND METHODS OF RESEARCH FOR EARLY NATION-STATES: 1900–39

Most scholarly research on the earlier period of the twentieth century has been consumed with the wars and political growth of the new nation-states. While archival sources for this period have been under-utilized, systematic information on women or Muslim minorities is scanty.

Creative scholars can draw from official government census records, school records, and health records, some of which include sex disaggregated data, in former Yugoslavia, Bulgaria, and to a much lesser extent in Albania. For the first decade of the twentieth century, the Ottoman and Austro-Hungarian Empires controlled Albania and parts of former Yugoslavia, so the Ottoman census of 1910 as well as the Vienna Archives have valuable data on Balkan Muslim peoples in these times.

Legal codes, legal documents, local newspapers, travelers' accounts, memoirs, novels, diaries, and women's journals provide further interesting sources of information and commentary on the status of women. Newspapers from the Turkish communities in Bulgaria, many in Ottoman Turkish, are a source of knowledge of community concerns and practices. Local newspapers and journals, but especially women's journals, like *Ženski Pokret* of the Society for the Enlightenment of Woman and the Defense of her Rights, founded in Belgrade in 1919 and in Sarajevo later in 1919, are particularly rich sources of commentary on women's health, education, political, and legal concerns through the 1920s (Emmert 1999). A current area of research is the history of women's organizations in each of these countries.

With so many women illiterate and living in rural areas, accounts by women travelers during these times take on more value. English writer Rebecca West chronicled her travels in former Yugoslavia in 1939 in her book, *Black Lamb and Grey Falcon*, albeit with a strong Serbian nationalist slant. Edith Durham, also English, who traveled earlier in what were to become Yugoslavia and Albania in the first two decades of the twentieth century, wrote *High Albania* (1927), among other accounts. Durham also became involved in war relief in Macedonia, Albania, and Montenegro, and in border issues in northern and southern Albania, lobbying successfully in Britain for Albania.

Folklore collections are another source of data of this period. Embroidery and wedding gowns from this time are found in textile museums in North America and Europe. Photographs cataloguing the different ethnic groups in the late Ottoman Empire include valuable documentation of differences in dress of ethnic and religious communities. The work of Milman Parry and Albert Lord on Yugoslav epic singers was conducted to a considerable extent among Muslims in the Sandžak region of Serbia and in Bosnia-Hercegovina, and their collections at Harvard University include hundreds of songs by women of the region. *Voices in the Shadows,* by Hawkesworth (2000), on women and verbal art in Serbia and Bosnia of this time and earlier, is a valuable contribution. Overall, the challenge is to contextualize these songs and gowns in the fabric of daily life and its meanings.

Educational records of schools, teaching staff, students, and textbooks all provide information on educational conditions, government policies, and social strictures, particularly on the inclusion or exclusion of Muslims of different ethnic groups, of levels of participation of girls as students, and of employment of women as teachers. Among Turkish Muslims of Bulgaria, such educational records are a main source of understanding of the relationship with the government in Sofia (Şimşir 1988).

Here it is important to research non-participation as well.

There has however been a severe loss of documents of local Muslim peoples of the western Balkans from the destruction of Islamic monuments and archives in the Bosnian and Kosova wars in the 1990s. A major loss was the Sarajevo Oriental Institute, with its renowned collection of Bosnian Muslim documents and records, that was directly targeted and destroyed, as were many mosques, including the great mosques of Banja Luka and Foča, medreses, the famous Ottoman bridge at Mostar, and Muslim cemeteries. In Kosova in 1999 municipal records were carted off, and a third of the mosques destroyed.

SOURCES AND METHODS OF RESEARCH FOR THE SOCIALIST PERIOD: 1940–89

The main research concerns of the socialist period were social change and political economy. It was at this time that Albania, Bulgaria, and Yugoslavia – all communist regimes under long-standing leaders (Hoxha, Zhivkov, Tito) – took different paths. Albania became an isolated Stalinist state, Bulgaria remained the most loyal of the Eastern Bloc to the Soviet Union, while Yugoslavia moved to nonaligned status with a more open society than any other in Eastern Europe. Yet in matters of religion and women there were important similarities. With rhetoric ranging from "an opium of the people" in Albania, to "a private affair," in Yugoslavia, religion was denigrated directly or indirectly by communist leaders in all the countries. The fact that many Muslims were also of minority ethnic groups – largely Turks in Bulgaria, and largely Albanians in Serbia – brought them double indemnity. Equality of women with men was a tenet of communist ideology of all the regimes, but it was imposed from above. A major area of research, begun largely by foreign scholars like Scott (1976), Ramet (1984), Wolchik and Meyer (1985), and Corrin (1992) during the communist period, but with added impetus by Balkan scholars since the fall of communism, has been to understand the improvements, limitations, and burdens of these socialist regimes on the lives of women.

The sources for research on women during socialist times are much more varied than for the earlier period, with more official data in sex disaggregated form. In all countries there is official data on educational attainment of girls and women, particularly literacy, but also completion of eighth grade, as well as data on female teachers. The improvement in literacy levels is one of the true achievements of the socialist regimes.

Official health data is also available, showing increasing life expectancy and decreasing child mortality. But state health concerns for women in both former Yugoslavia and Bulgaria became increasingly focused on the declining birth rate. In the 1950s, birth rates plummeted in all countries in the Eastern Bloc except Albania, which had prohibited abortion, and Romania which rescinded it. However a closer look showed that while the birth rate had declined sharply among the majority Slav populations, minorities, often Muslim populations, showed no such decrease. More varied understanding of this majority birth rate decline is now being put forth to include housing shortages, and strictures of work, but at the time, the socialist regimes treated it unitarily as a women's health issue. According to Engels, private property was the cause of the oppression of women, so under socialism the quality of relationships of people would improve and this should have resulted in an increase in the birth rate. The issue of growing ethnic dissension and friction through the socialist era, beginning in the late 1950s in Bulgaria, and in the 1970s in Yugoslavia, was exacerbated by the differential birth rate. More holistic study on reproduction during the socialist period and the dynamics of ethnic dissension are important areas of research.

Public media are also a source of information on women and Islamic cultures; however, they were strictly controlled by the state in much of Eastern Europe, and regulated by the state in Yugoslavia. Film, television, popular novels, radio programs and songs all provide a broader perspective on national ideologies of the times. Journals published for women are noteworthy. However, unlike journals in the earlier period, these were often organs of the state, except in Yugoslavia where editors of women's magazines had considerable freedom. In Yugoslavia in the 1980s, women's organizations became active in urban areas, like *Žena I Društvo* (Women and society) in Zagreb, a successor organization of which set up SOS Telefon in the spring of 1988, the first rape hotline in Eastern Europe.

In the whole area of work and employment of women in the socialist period, scholars have produced excellent studies, although most analyze the more open countries of Yugoslavia, Czechoslovakia, or Hungary. The policies of the new socialist states, combined with the shortage of men after the Second World War, led women into the work force where they were needed for the new industrializing

economies. Indeed, women's liberation was often narrowly conceived as participation in the work force, while the inequalities of the double burden with domestic responsibilities were not addressed. Contrasting records of male and female leadership, membership in the party, in professional and apprentice programs, and in rural collectives are sources for ongoing research on biases and patterns of work within the socialist system. It should be noted that women did relatively better in southeast Europe than in much of the West in that there were quotas for female participation in political spheres that were met and women sometimes attained high positions in other work areas as well.

More problematic than sources on women during the socialist period are sources on Muslims. As mentioned, Muslims did not fit easily into the socialist nationalist paradigm. Bulgaria is a case in point. After 1956, Bulgaria stopped collecting official data on ethnic groups, most of which were Muslim. Since all were to become "bulgarized," the government noted there was no need to keep such figures. However, the ongoing reductions of instruction of Turkish in schools, the forced adoption of Slavic Bulgarian names for Pomaks and Turks, the outlawing of circumcision, and the repeated emigrations to Turkey by Muslims all provide documentation of the problematic nature of this process. In Albania, Muslim and Christian leaders were imprisoned, often to die in prison or in forced labor camps. Properties of religious communities were expropriated and their buildings put to other uses. In 1967, as an echo of the Cultural Revolution in China, Albania declared itself officially atheist. Court documents could help explicate the actual process of resistance and state action.

Bosnia in Yugoslavia is the exception to this pattern, in that there was ongoing interest in Muslims who, by the 1960s, constituted 40 percent of the population. Before the Second World War, Muslims had been considered a religious community. But after the war, with the secularization of the Communist Party and growing importance of "nationalities" in Bosnia, they officially became "a nation," that is, the highest status of Yugoslav categories (nation, nationality, ethnic group) under the name of "Muslimani" in 1968. With the warfare in the 1990s, the ambiguity of "Muslim" as a religion or ethnic group became a problem. Now the ethnic term for a Bosnian Muslim is "Bošnjak." More problematic during the socialist period were the Albanian Muslims, especially those in Kosova and Macedonia. For political rea-

sons, the census repeatedly undercounted them although sometimes they too sought to avoid being counted for reasons of taxation or military draft.

The methods of research, like the sources, were controlled during socialist times. There were large-scale statistical studies of demographics that were particularly unreliable with respect to minorities. Surveys and polls were common methodologies – some said because they had multiple authors and therefore were safer for the researchers than single author methods. There were some ethnographic-type studies by local scholars, largely of folklore. Only in Yugoslavia, which was relatively open, were extended ethnographic studies by a few outsiders permitted, like the Halperns in Serbia, and Lockwood in Bosnia. In the late 1980s there was also the work of De Jong and Silverman in Bulgaria, that of Reineck in Kosova, as well as a remarkable study of Muslim identity through the perspective of women in a mixed village in Bosnia, *Being Muslim the Bosnian Way* (1995), by Norwegian scholar Tone Bringa. To get permission to do the study in the late 1980s, Bringa had to apply to focus on village women's issues, for Islam had become too problematic in the growing nationalistic politics of the country. Bringa also followed the Muslim villagers through the years of the Bosnian war to the burning of their homes and their new status as refugees. This sensitive study of identity shows the rich potential of ethnography for illuminating daily life and relationships during a time of great change.

SOURCES AND METHODS OF RESEARCH FOR THE TRANSITION: 1990–2000

The transitions from socialist regimes, more accurately understood as transformations, did not occur at the same time or pace. Major research concerns of the decade were the growth of nationalist parties and democratization across Eastern Europe, the process of privatization and the move to a market economy, ethnic conflict and refugee issues, and reassessment of the socialist period. In Albania, Bulgaria, and former Yugoslavia, right-wing nationalist parties, for whom women's concerns were of low priority, took power.

Sources for research on women and Islamic cultures during this decade included women and Muslims themselves in the Balkans to a much greater degree than was previously permitted, but interest in gender issues at the governmental level lessened in postsocialist times. And research methodologies, which had been highly restricted during the

socialist period in Albania and Bulgaria, were more open, with qualitative methodologies coming to the fore. Thus there are life histories, narrative accounts, and interviews with a broader spectrum of people – for people were less afraid to be interviewed and scholars less constrained. A prime example is Post's *Women in Modern Albania: Firsthand Accounts of Culture and Conditions from over 200 Interviews*, which could never have been attempted in the previous decade. East European research institutions had limited funds, but a broader range of their scholars' and leaders' voices were heard through their media, through United Nations sponsored conference publications, and through Western publications that sought out local voices, like Renne's *Ana's Land: Sisterhood in Eastern Europe* or Gal and Kligman's *Reproducing Gender: Politics, Publics and Everyday Life after Socialism*. Indeed the anthology became the research genre of the decade, promoting both local perspectives as well as bases for comparative study.

Despite the overall openness to society, this was nevertheless a time when local writers could be pilloried for criticizing actions of their new nation states. Most famous is the case of the "five witches," namely Rada Iveković, Jelena Lovrić, Slavenka Drakulić, Dubravka Ugrešić, and Vesna Kesić, whose feminist perspectives and speaking out against the nationalistic manipulation of rape made them targets for public abuse in Zagreb newspapers in 1992 and after (Kesić, 1999). Women's movements against war, beginning with the First World War, and continuing to the Women in Black of Belgrade during the Bosnian War (Zajoviać, 1997), B.a.B.e. (*Budi aktivna, Budi emancipirana*, Be active, be emancipated) in Zagreb, *Motrat Qiriazi* and the Kosovar women's bread march in 1998, as well as groups seeking justice, such as Women of Srebrenica in Bosnia, and Kandiç's Humanitarian Law Center in Belgrade, all represent alternative responses to actions or inactions of their nation-states. A comparative study of leadership, participation, projects, and interaction with other antiwar women's groups would bring greater understanding to this courageous field and how it fits in the larger peace movement.

Sources of changes in employment, including closures of state owned industries like textiles, leather, and tobacco where women had been concentrated, as well as reductions in social services where many women worked and on whose services they were dependent, all provide important information for how postsocialist reforms affected women. Local media provide commentary on these changes. To augment larger macro-economic studies, there is also need for studies of barter, of small market economy, of ways of coping with scant resources, and of how rural women responded to the changes and instability of postsocialist times.

Official records of the new governments provide data on employment, reproduction, health, and education that relate to women. But caution should be used in interpreting them. For what does it mean to count people as employed when they haven't been paid in many months? Or why count an Albanian village school if there are no teachers because they have gone to Greece to try to find a living wage? These official records also relate to Muslims. Bulgaria's new government conducted a census in 1992, the first since 1956, in which it collected information on ethnic groups that are largely Muslim. The public response to the census was also telling, including the outcry and refusal to accept the numbers of Pomaks, some of whom had identified themselves as Turks. Obviously there need to be ongoing studies of ethnic relations in these countries.

As in socialist times, surveys continued to be a major form of research. However, scholars should be aware that the decades of socialist government control and manipulation, preceded by centuries of Ottoman rule, have created deep distrust in people and therefore a greater tendency to provide the safe response.

Information on new political party membership, lists of candidates for elections, and lists of the few women elected provide a perspective of women's declining public space at this time. Again local media are important sources of commentary, as are political and policy slogans like "An unborn Croat is still a Croat," to meld the nationalist with the anti-choice. This was also a time of growth of women's organizations, many of which were increasingly concerned with violence in their societies, in war and in "peacetime."

Main sources of research on violence against women in the Bosnian war are data from refugees, 84 percent of whom were women and children. Refugee accounts, such as those collected by Mertus et al. (1997), are valuable sources, as are interviews by international journalists like Roy Gutman and Alexandra Stiglmayer on mass rape, and witness testimony from the International War Crimes Tribunal for the Former Yugoslavia. In contrast, the national media of the times, particularly television from Belgrade and Zagreb, give

little reliable information other than documenting the extent to which they had become instruments of war. The horrors of the war, the inaction of Western governments, and the ineffectiveness of the United Nations led researchers to activism and activist methodologies. Scholars and journalists worked with refugee relief, helped fund local centers, worked on legal questions, conducted seminars in Bosnia, and supported restoration of library records destroyed by the war. An example of activist methodology in the aftermath of the ethnic conflict was Cockburn's study (1998) of a woman's clinic in Zenica, Bosnia.

Further, the internet is a source of much information on the nationalist parties and platforms, political actions and policies, and attempts to counter some of these forces in Bosnia and Kosova. The internet especially served to link people in the diaspora to their compatriots and relatives in the Balkans. It is not known to what extent this influenced the wars. Women's groups have begun to use the internet as well. Certainly its influence will be an issue for future research. Meanwhile the internet also serves to help market literature and memoirs, often published by small presses, of people who served long prison terms, and terms of internal or external exile during the socialist period, or who were displaced by the wars of the 1990s.

Ethical questions abound in the unstable conditions of disintegrating and reintegrating nation states. In one important study on fieldwork dilemmas, edited by DeSoto and Dudwich (2000), researchers explored situations where they were expected to become advocates for particular causes, where their safety was in question, and where local people had misconstrued history. This was not to say there had not been ethical questions for researchers in the socialist period where loyalty, betrayals, and official minefields had to be negotiated. But the ethical questions of the time of transition could be made public in ways earlier ones had had to be more circumspect. These continue to be worthy of study.

BIBLIOGRAPHY
T. Bringa, Being Muslim the Bosnian way. Identity and community in a central Bosnian village, Princeton, N.J. 1995.
M. Buroway and K. Verdery (eds.), Uncertain transitions. Ethnographies of change in the postsocialist world, Lanham, Md. 1999.
C. Cockburn, The space between us. Negotiating gender and national identities in conflict, London 1998.
C. Corrin, Superwomen and the double burden. Women's experience of change in Central and Eastern Europe and the former Soviet Union, London 1992.
B. Denich, Sex and power in the Balkans, in M. Rosaldo and L. Lamphere (eds.), Woman, culture, and society, Stanford 1974, 243–62.
H. DeSoto and N. Dudwick (eds.), Fieldwork dilemmas. Anthropologists in postsocialist states, Madison, Wis. 2000.
B. Einhorn, Cinderella goes to market. Citizenship, gender and women's movements in East Central Europe, London 1993.
T. A. Emmert, Ženski Pokret. The feminist movement in Serbia in the 1920's, in S. Ramet (ed.), Gender politics in the Western Balkans, University Park, Pa. 1999, 33–50.
A. Eminov, Turkish and other Muslim minorities in Bulgaria, London 1997.
N. Funk and M. Mueller (eds.), Gender politics and postcommunism. Reflections from Eastern Europe and the former Soviet Union, New York 1993.
S. Gal and G. Kligman (eds.), Reproducing gender. Politics, publics, and everyday life after socialism, Princeton, N.J. 2000. The introduction to this book is expanded in S. Gal and G. Kligman, The politics of gender after socialism, Princeton, N.J. 2000.
T. Gjelten, Sarajevo daily (Oslobodjenje). A city and its newspaper under siege, New York 1995.
C. Hawkesworth, Voices in the shadows. Women and verbal art in Serbia and Bosnia, New York 2000.
D. S. Iatridis, Social justice and the welfare state in Central and Eastern Europe. The impact of privatization, London 2000.
B. Jancar-Webster, Women and revolution in Yugoslavia 1941–1945, Denver, Colo. 1990.
O. Kesič, Women and gender imagery in Bosnia. Amazons, sluts, victims, witches, and wombs, in S. Ramet (ed.), Gender politics in the Western Balkans, University Park, Pa. 1999, 187–202.
J. Mertus, J. Tesanovic, H. Metikos, and R. Borić (eds.), The suitcase. Refugee voices from Bosnia and Croatia, Berkeley 1997.
S. E. P. Post, Women in modern Albania. Firsthand accounts of culture and conditions from over 200 interviews, Jefferson, N.C. 1998.
H. Poulton and S. Taji-Farouki (eds.), Muslim identity and the Balkan state, London 1997.
P. Ramet, Women, work and self-management in Yugoslavia, in East European Quarterly 17:4 (1984), 459–68.
S. P. Ramet (ed.), Gender politics in the Western Balkans. Women and society in Yugoslavia and the Yugoslav successor states, University Park, Pa. 1999.
T. Renne (ed.), Ana's land. Sisterhood in Eastern Europe, Boulder, Colo. 1997.
M. Rueschemeyer (ed.), Women in the politics of postcommunist Eastern Europe, New York 1994.
H. Scott, Women and socialism. Experiences from Eastern Europe, London 1976.
A. Simić, Machismo and cryptomatriarchy. Power, affect, and authority in the contemporary Yugoslav family, in Ethos 11:1 (1983), 66–86.
B. Şimşir, The Turks of Bulgaria (1878–1985), London 1988.
A. Stiglmayer (ed.), Mass rape. The war against women in Bosnia-Herzegovina, Lincoln, Nebr. 1994.
United Nations, The impact of economic and political reform on the status of women in Eastern Europe. Proceedings of a UN regional seminar (Vienna), New York, April 1991.
S. Wolchik and A. Meyer (eds.), Women, state, and party in Eastern Europe, Durham, N.C. 1985.

A. Young, *Women who become men. Albanian sworn virgins*, Oxford 2000.

S. Zajoviać (ed.), *Women for peace*, Beograd 1997.

FRANCES TRIX

With special acknowledgment of Balkan Table – Professor John Fine, Janet Crayne, Donna Parmelee, and Meghan Hays – for careful readings and valuable contributions to this article.

Iran: Early 20th Century to Present

INTRODUCTION

Much of what applies to the study of women and gender in Iranian history since 1925 applies to the study of any theme or episode in modern Iranian history. Five general categories of information are available to today's researchers: archival and quantitative sources, the periodical press, memoirs and oral history, the internet, and artistic sources (literature and cinema).

In recent decades the study of women and gender in Iran has become interdisciplinary, reflecting the contemporary methodologies of literary criticism, sociology, and anthropology. Work continues also in a descriptive mode as new sources are discovered and lost narratives are recovered. As women became more visible professionally and artistically in the later twentieth century, the study of women and gender in Iran has capitalized on their greater cultural presence.

SOURCES

Archival and quantitative sources. Iranian archival sources are mostly available through published document sets produced by scholars under government supervision, be it Pahlavi or Islamic Republican. Three collections of documents relating to the Women's Awakening Project of 1936–41 were published (two in 1992 and one in 1999). Despite the editorial bias against the project, these collections provide insight into the bureaucratic challenges and ideological priorities of the project. British Foreign Office correspondence and records of the United States State Department are useful for their diplomatic reports on a range of topics and events, economic data, press clippings, and other cultural material. Each decade since 1956, the Iranian government has gathered and published census data. Statistical information prior to 1956 must be gathered from United States and American diplomatic archives (and much of this consists of estimates). The one important exception is information gathered by the Ministry of Culture regarding Iranian educators and students recorded by grade level and gender. Another potential source of statistical information prior to 1956 is provided by Iranian government yearbooks. Last but not least, the proceedings of the Iranian parliament during the late Qajar, Pahlavi, and Islamic Republican periods are invaluable

due to the many debates and discussions on the Woman Question.

The periodical press. The richest resource for modern Iranian studies is the Iranian periodical press. The press is wonderful source for both official ideology and popular opinion; one can easily track intellectual and cultural currents, especially as they relate to the Woman Question and changing conceptions of gender. Careful reading of the classifieds and advertisements can provide insight into what Iranian women (and men) were being sold in terms of lifestyle and products, as well as the goods and services they sought. Finally, the press is the one modern institution in which Iranian women have consistently participated as owners, editors, correspondents, consumers, and op-ed contributors from the late nineteenth century onwards. Thus, the press is a vital source for events and voices neglected by later historians and archival sources.

One should not restrict inquiry to "women's periodicals," such as ʿĀlam-i Nisvān (Women's world, 1919–35), one of the longest running women's magazines prior to the Second World War, ʿĀlam-i Zanān (Women's world, 1944), and Ṣadīqa Dawlatābādī's Zabān-i Zanān (Women's voice, 1940s). For example, Iran's longest-running and most widely circulated daily since 1926, Iṭṭilāʿāt (Information) provides an invaluable source. Finally, one should consult non-Iranian press. The *New York Times*, for example, has a thorough index for all of its issues since 1913 (and searchable on-line versions).

Published Memoirs and Oral History. Aside from published memoirs (e.g. that of Badr al-Moluk Bamdad), there are two rich collections of oral histories that are readily accessible to scholars: the Harvard Iranian Oral History Project (IOHP) and the Oral History Collection of the Foundation for Iranian Studies (FIS). In addition to audio tape transcripts available at a number of research academic institutions, IOHP Project Director Habib Ladjevardi has begun to edit and publish oral history transcripts as memoirs (see <www.ibexpub.com/ibexiohp.html>). The FIS collection is available for listening and reading at their research center in Bethesda, Maryland. In the Islamic Republic, the genre of publishing interviews as books has resulted in interesting autobiographical

material from such individuals as author Simin Daneshvar and communist activist Maryam Firuz (half-sister to Sattareh Farmanfarmaian, whose own autobiography *Daughter of Persia* was published in the United States in 1991).

These memoirs are important for several reasons. First, the most obscure aspect of feminist activism in Iran remains the inner workings and institutional histories of feminist organizations of all types (state, party-affiliated, and independent). We do not know as much as we should about the Patriotic Women's League (1919–35), the Pahlavi regime's Women's Society (1935–1940s) and the diverse women's organizations of the 1940s and early 1950s (such as Saffiyeh Firuz's Women's Party). Although much valuable research has been generated through interviews by scholars such as Ziba Mir-Hosseini (a sociologist) and Shahla Haeri (an anthropologist), the sheer immediacy of challenges facing Iranian women today has resulted in the neglect of history. Second, oral history can record voices in the twentieth and twenty-first centuries that are usually lost to those researching earlier periods. While the number of early activists may be few, many from the first and second generation of women professionals, industrial workers, and more traditional sectors of Iranian society survive, and their perspective on the twentieth century must also be recorded.

Internet. In addition to the increasing number of research databases available on-line, there is a thriving Iranian internet culture in which official and unofficial Iranians participate. The Independent Iran Observer is a gateway to official and unofficial news about Iran (<www.ambadane. teheran.suite.dk/news.htm>). The catalog for the FIS Oral History Collection (<www.fis-iran.org>) and the catalog for MEDOC's Persian Periodicals on microfilm (<www.lib.uchicago.edu/e/su/mideast/ CatIntro.html>) provide but two academic examples. The Iranian government provides a number of statistics related to women's education and employment in Iran today through its Canadian embassy (<salamiran.org/Women>). In addition, sites such as The Iranian (<www.iranian.com>) provide a valuable window on the globalization of Iranian culture on-line, a trend that cannot be ignored by contemporary researchers.

Literary and Cinematic Sources. Students of the Constitutional Period and Pahlavi Dynasty through the White Revolution of 1963 will be rewarded by examining the works of 'Alī Akbar Dihkhuda (the "Charand va Parand" column in Ṣūr-i Isrāfīl, 1907–09), Īraj Mīrzā (the 'Arifnāma, ca. 1920), Muḥammad 'Alī Jamālzāda (*Fārsi*

Shikar Ast, 1920). While the works of Ṣādiq Hidāyat (d. 1951) and many of his contemporaries have been examined, the works of "lesser" writers such as Mushfīq Kazīmī, Muhammad Mas'ūd and Muḥammad Ḥijāzī have been mostly neglected. Yet they are important sources because of the subsequent political and journalistic careers of the authors. Students of women's literary production in the twentieth century should begin with the poetry of Parvīn I'tisāmi (d. 1941) and Furūgh Farrukhzād (d. 1968) and the prose of Sīmīn Dānishvar. Farrukhzād is especially important because of the nature of her work, the development of her career (she also became a documentary film maker) and because her generation of poets (Aḥmad Shāmlū, Nādir Nādirpūr, and others) embraced and developed a new, freer style of poetry introduced by Nīmā Yūshīj in the the 1920s.

Since the founding of the Islamic Republic in 1979/80, women's literary voices, like all cultural voices, have bifurcated into "diaspora" and domestic manifestations. Diaspora artists, like diaspora scholars, have focused on the losses of the Revolution of 1978/9 and the anti-feminism of the Islamic Republic. An instructive work in this genre is Mahshīd Amīrshāhī's 1986 *Dar Ḥaḍar* ("At Home"). Some women, such as Shahrnūsh Pārsīpūr, joined the Iranian exile community later when the cost of their feminist artistic engagement became too high (Pārsīpūr 1992, 1998, 1996).

Cinematic sources can be very useful in exploring notions of gender in popular culture, elaborating upon themes introduced in modern literature and illustrating competing sociopolitical agendas in Iranian society. The very first Iranian commercial film, *Dukhtar-i Lūr* (1933) was produced in India and was an elaborate male rescue fantasy involving an erstwhile government official, Ja'far, and a captive dancer, Golnar, in a provincial roadside café. After the 1950s, in addition to the many "second-tier" *filmfārsī* movies produced in Iran (yet influenced by Hollywood), researchers will note the appearance of many film adaptations of literary works of male authors like Ṣādiq Hidāyat's *Dāsh Ākul* (1971), Ṣādiq Chūbak's *Tangsīr* (1973), Hūshang Gulshīrī's *Shāzda Iḥtijāb* (1974), or the television mini-series version of Iraj Pizishkzād's *Dā'ī Jān Napul'un*, as well the emergence of "art" films such as the annoyingly abstract *Mughul-hā* (Parvīz Kīmyāvā'ī, 1972).

Ironically, the Islamic Republic's restrictive cultural policies have proven a boon to Iranian cinema. Since the release of *Bāshū: The Little Stranger* by Bahrām Baydā'ī (Beyza'i) in 1989, Iranian art films have become a hot commodity in

the international film market. The banning of most Hollywood imports to Iran and restrictions on how women were to appear on film have had an interesting effect. Female characters in Iranian art films since the 1980s (at least since *Bāshū*), have tended to be stronger and more clearly defined. Furthermore, the Iran-Iraq war (1980–88) and its aftermath provide a compelling context to study gender ideology both in war propaganda films (e.g. *Visa* and *Footprints in the Sand*) and in films by more critical observers like Muḥsin Makhmalbāf (*Marriage of the Blessed*, 1989). Even among serious film makers, there are diverse takes on Iranian society ranging from the nuanced and optimistic Koker trilogy of 'Abbās Kiyārustamī (Kiarostami) to the darker views of Ja'far Panāhī (*The Circle*, 2000). Contrasts such as these will provide rich analytical terrain for students of gender and culture in Iranian society. There is also a greater presence of women actors and directors (e.g. Tahmīna Mīlānī, *Two Women*, 2000) than ever before and studies of their careers and art might provide further insight into the dynamics of women's entrance into male-dominated professions.

METHODOLOGY

The earliest scholarship on women and gender in Iranian society dates from the White Revolution in the 1960s. Both Badr al-Moluk Bamdad's history of Iranian women since the Constitutional Revolution of 1905–6 and Parī Shaykh al-Islāmī's work on women activists and journalists are merely descriptive and somewhat compromised by the fact that they were written to present Pahlavi state engagement with the Woman Question in the most favorable light. Shaykh al-Islāmī's work owes something to the traditional genres of bibliographical compilation that were prevalent through the nineteenth century but, of course, draws upon modern autobiographical and journalistic sources. European and American trained scholars such as Janet Afary, Eliz Sanasarian, Parvin Paidar, Afsaneh Najmabadi, Shahla Haeri, and Erika Friedl published their works in the wake of the rich interdisciplinary atmosphere of Euro-American academia from the 1960s onwards and the rise of the Islamic Republic.

Sanasarian, Afary, Najmabadi, and Paidar all introduce an interpretive paradigm to their largely historical research. In *The Women's Rights Movement in Iran* (1981), Sanasarian adapted Jo Freeman's (1975) model for understanding American women's political activism in the 1960s. Following Deniz Kandiyoti's argument that patriarchy is best defined by women's resistance to it rather than as a formal dogma emanating from ideological texts (the Qur'ān and body of *ḥadīth* included), some researchers have begun to focus on the social and institutional continuities that run through distinct political periods. Drawing on census data from the late Pahlavi period onwards and oral histories, Poya was able to illustrate the role of economic forces and women's resistance in modifying ideology-driven Islamic Republican barriers to women's economic and political participation in Iranian society. Paidar has argued for a "patriarchal consensus" embraced by the political left, Islamicists, and secular modernists from the Constitutional Revolution to the Islamic Republic. Moghissi's *Populism and Feminism in Iran* (1994) also posits patriarchy as having a logic independent of any ideological framework. The work of Friedl and Haeri was based on field research covering the late Pahlavi and republican periods and both found much in Iranian culture that operated with reference to a social context that was not immediately transformed by political or ideological tone set in Tehran. The shift in scholarly attention from politics and formal ideology to the development of culture and institutions has produced a more complicated picture of the history of gender in Iranian society. Najmabadi has illustrated the crucial role of gender in shaping Iran's modern education system, judicial system, and parliament during the Constitutional Revolution. Amin's study of the Women's Awakening of 1936 has also considered gender ideology as a point of intersection among different ideologies and institutions (the press and the state). Throughout these shifts in academic focus and theoretical orientation, new information has enriched the narratives about women and gender in Iranian history either due to re-examinations of existing sources (press and archival) or the incorporation of neglected or previously unavailable sources (census data, press, and oral history).

For all scholars, the Revolution of 1978/9 has forced a reconsideration of the state and Islam in perpetuating gender discrimination in modern Middle Eastern societies. The first question is why did so many Iranian women join men in rejecting Pahlavi modernism in favor of Islamic feminism? Indeed, Western and expatriate Iranian scholarship in the early 1980s had a polemical quality, exposing the misogyny of traditional Islamic texts and the contemporary injustices of the Islamic Republic. As scholars have looked back to the Constitutional Revolution of 1905/6, the Women's Awakening project of 1936–41, the women's

suffrage movement of the 1940s and 1950s, the White Revolution of 1963, and the Family Law of 1967 – all moments of feminist progress – new questions emerged. Why did women gain so little from the Constitutional Revolution? Why was women's liberation from the veil forced? How did the meaning of the veil change over time? What is the cost of allying feminist advances with autocratic regimes? These questions have a practical urgency at the beginning of the twenty-first century as the Woman Question has again become a contentious political frontier – this time between "reformist" and "hard-line" Islamic republicanism.

BIBLIOGRAPHY

General
C. M. Amin, *The making of the modern Iranian woman. Gender, state policy and popular culture, 1865–1946*, Gainesville, Fla. 2002.
A. Najmabadi, *The story of the daughters of Quchan. Gender and national memory in Iranian history*, Syracuse, N.Y. 1998.
P. Paidar, *Women and the political process in twentieth-century Iran*, Cambridge 1995.
M. Poya, *Women, work and Islamism. Ideology and resistance in Iran*, London 1999.
N. Rahimieh, *Missing voices. Discovering voices in Iranian cultural history*, Syracuse 2001.
E. Sanasarian, *The women's rights movement in Iran. Mutiny, appeasement, and repression from 1900 to Khomeini*, New York 1982.
Parī Shaykh al-Islāmī, *Zānān-i rūznāma-nigar va andīshmand-i Īrān*, Tehran 1351/ 1972/3.

Women in Literature and Film
P. Chelkowski, Popular entertainment, media and social change in twentieth-century Iran, in P. Avery, G. Hambly, and C. Melville (eds.), *The Cambridge history of Iran. Volume 7. From Nadir Shah to the Islamic Republic*, Cambridge 1991, 765–814.
F. Lewis and F. Yazdanfar (comp., trans., and intro.), *In a voice of their own. A collection of stories by Iranian women written since the revolution of 1979*, Costa Mesa 1996.
F. Milani, *Veils and words. Emerging voices of Iranian women writers*, Syracuse, N.Y. 1992.
H. Moayyad (ed.), *Stories from Iran. A Chicago anthology 1921–1991*, Washington, D.C. 1991.

H. Naficy, Iran, in Gorham Kindem (ed.), *The international movie industry*, Carbondale, Ill. 2000.
——, Veiled voice and vision in Iranian cinema. The evolution of Rakhshan Banietemad's films, in *Ladies and gentlemen, boys and girls. Gender in film at the end of the twentieth century*, Albany, N.Y. 2001, 36–53.
Shahrnūsh Pārsīpūr, *Zanān bidūn-i mardān*, Los Angeles 1992.
——, *Khātirāt-i zindān* (Prison memoirs), Spanga 1996.
——, *Women without men. A novella*, trans. Kamran Talattoff and Jocelyn Sharlet, Syracuse, N.Y. 1998.

Sources on the Press
Ḥusayn Abū Torābiyān, *Maṭbūʿāt-i Īranī*, Tehran 1366/ 1987.
Kāvah Bayāt and Masʿūd Kūhistānī Nizhād (eds.), *Asnād-i maṭbūʿāt (1286–1320 HS)*, Tehran 1372/ 1993.
Muḥammad Ṣadr-Hāshimī, *Tarīkh-i jarāyid va majallāt-i Īrān*, Isfahan 1327–32/1948–53, repr. 1363–4/1983–4.
Ghulām R. Salāmī and Muḥsin Rūstāyī (eds.), *Asnād-i maṭbūʿāt-i Īrān 1320–1332*, i, Tehran 1374/1995.

Iranian Feminist Writings
Badr al-Moluk Bamdad, *From darkness into light. Women's emancipation in Iran*, trans. F. R. C. Bagley, Hicksville, N.Y. 1977.
Talʿat Bassari, *Zandokht: Pīshāhang-i nahḍat-e āzādī-i bānuvān-i Īrān*, Tehran 1345/ 1966/7.
Ṣadīqa Dawlatābādī, *Ṣadīqa Dawlatābādī. Nāma-hā va nivishta-hā va yād-hā*, comp. and introduced by Mahdukht Sanʿati and Afsaneh Najmabadi, New York 1998.

STUDIES USING ORAL HISTORY
Interviews
H. Esfandiari, *Reconstructed lives. Women and Iran's Islamic revolution* Baltimore, Md. 1997.
S. Haeri, *Law of desire. Temporary marriage in Shiʾi Iran*. Syracuse, N.Y. 1989.
Z. Mir-Hosseini, *Gender and Islam. The religious debate in contemporary Iran*, Princeton, N.J. 1999.

Published Document Sets
Khushūnat va farhang. Asnād-i maḥramāna-i kashf-i ḥijāb (1313–1322), Tehran 1371/ 1992/3.
Vāqīʿa-i kashf-i ḥijāb. Asnād-i muntashir nashuda, ed. Jaʿfar Mortaza, Soghra Ismaʿilzada and Maʿsuma Farshchi, Tehran 1371/ 1992/3.
Taghīr-i libās va kashf-i ḥijāb bah rivāyat-i asnād, Tehran 1378/ 1999/2000.

CAMRON MICHAEL AMIN

Afghanistan: 19th and 20th Centuries

Both primary and secondary sources for the study of women and Islamic cultures in Afghanistan for most of the nineteenth and twentieth centuries are limited. The richest and most accessible archival sources are those of British imperial India. There are also a variety of travelers' tales and more recent ethnographies, most of which, like the secondary social studies and political histories of the country, rarely go beyond the genre conventions of the period when they were written.

Accounts since the coup d'état of 1973, the Soviet invasion of the country in 1979, and the subsequent civil and American wars are of a different order. These latter materials focus on national politics, Afghan resistance, and the rise of Islamism. Here the primary sources include government, NGO, and journalists' reports, as well as the newspapers of political parties. Much of the secondary literature treats the relation between international politics and the political situation in the country as a whole. In these respects, recent materials are comparable to the crisis literatures from Palestine, Somalia, and Kosovo.

Most of the sources from both periods are uncritically Orientalist in two respects. First, they reproduce the dominant masculinisms of Afghan and international politics that assert an unproblematized, categorical division between women and men. Secondly, they tend to generalize and reify "Islam," treating idealized or elite accounts of religious belief and practice, while ignoring the complexities and contradictions in the religious practices of ordinary people. For both reasons, the Afghan literature is very strongly male-biased. The literature thus invites innovative new studies that adopt imaginative, and particularly comparative, methodologies. Inspiration might come from ethnographies and social histories from other countries. These should focus on gender (and not women per se) as the study of the knowledge and social organization of sexual differentiation, and on the everyday practice of Islam by both women and men of different classes, in exile, in refugee camps, and in adjacent rural and urban settings. Torab's (1996, 2002) Iranian ethnography, for instance, offers a comparative model that combines these two perspectives to consider the mutual construal of gendered, religious identities.

Another difficulty with studies in the 1990s and this century is that they have almost completely ignored the historical sources and ethnographies based on fieldwork done in the 1960s and 1970s (since the 1980s extended fieldwork based on participant-observation has not been possible). This unwillingness to look back is coupled with another kind of blind spot. Almost all recently published work has actually ignored the massive changes in Afghan society produced by more than two decades of war, at least a million deaths, the movement of half the population into internal or foreign exile, and considerable urbanization. Many recent studies implicitly assume that the current configuration of both gender and Islam are somehow traditional. Yet both gender relations and Islamic beliefs and practices have changed greatly during this period because Islam and Islamic understandings of gender have been central to the ideologies of all sides in both the civil wars, and in the resistance to Russian and American invasions.

In these circumstances, previous studies must necessarily be the basis for critical theoretical approaches to the processes of radical social change. For example, theoretically challenging new studies might explore the nuanced range of gendered identities previously available to women and men of a particular class or community and consider how processses of gendering, sexuality, and embodiment have altered in the face of war, exile, and perhaps previously unanticipated poverty. Equally, there are as yet no detailed, located studies of the processes whereby previous religious dispositions and practices have changed in the tragic circumstances of the past three decades. Such studies could raise new, and acutely important, questions of general and theoretical interest about the relation between gender and ritual responsibility, and the relation between people's lives and changing ideas about the nature of suffering, evil, martyrdom, or the afterlife.

NINETEENTH-CENTURY TRAVELERS' AND COLONIAL ACCOUNTS

The Afghan travel accounts published by European and Asian men were part of the public discourse on the Great Game of imperial conquest played out between the Russian and British em-

pires throughout the nineteenth century. Many of the travelers were directly or indirectly in imperial service, and their work also included a variety of secret military and government reports and maps. Russians wrote of the north (Khanikoff 1845, Grodekoff 1880), while agents associated with the British traveled more widely in Afghanistan, but tended to write of the south and east (Masson 1842, Mohan Lal 1846, Raverty 1888). In both the published and archival sources, there are rarely more than the most fleeting references to domestic life or practiced Islam. Of course, some materials can be extrapolated from the travelers' books, from detailed reports such as that by the political agent, Rawlinson (1841), and the later series of Afghan gazetteers (Adamec 1974), which provide information on demographics, tribal and ethnic groupings, taxation and local economies.

Robertson's late (1896), detailed and sympathetic account of the everyday lives of the *kāfirs* (or pagans) of northeastern Afghanistan is exceptional in this respect, and includes chapters on the position of women, life course rituals, and village life. Jones's 1974 ethnography of Nuristanis continues this broad focus. Pierre Centlivres's 1992 account of the *baccha* dancing boys who often entertained travelers offers an excellent model for the re-examination of early sources. Lindisfarne (1997) develops this theme via a series of previously unasked ethnographic questions about homosexuality and transgendering.

Another exception is Lady Sale's journal of the first Afghan war. This describes life in the British cantonment in Kabul, and Lady Sale's nine months as a hostage captured in the aftermath of the British retreat from Kabul in 1841. Some 16,000 soldiers and camp followers died in the retreat that has been described as the greatest defeat inflicted upon the British by an Asian enemy until the fall of Singapore in the Second World War (Macrory 1969, ix). In part to explain the catastrophe, subsequent British accounts of the Afghans, and particularly the Pashtun/Pakhtun tribespeople of the northwest frontier, exaggerated their treachery and ruthless ferocity. The attributions of a supermasculine identity to the "wily Pathans," and of barbarism to bloodthirsty Pashtun women, was perpetuated by the British defeats in the second and third Anglo-Afghan wars of 1878 and 1919 (see, for example, Bellew 1880, Pennel 1909; and compare Kipling 1990, 337).

ETHNICITY

Another source of Pashtun bias stems from the place ethnicity played in the consolidation of the Afghan state. Amīr al-Raḥmān relied heavily on his fellow Pashtuns to conquer the Hazarajat and Nuristan, and secure the northern marches in Afghan Turkestan. To consolidate his rule, he offered Pashtuns tax breaks, exemption from military service, and land grants in traditionally non-Pashtun regions of the country. In so doing, he opened sores of ethnic rivalry that have festered in Afghanistan for the past century.

Yet in much literature on Afghanistan, ethnicity, instead of being problematized, is taken as a given, thus naturalizing the "tribal," and thus implicitly, "primitive" or "medieval" character of the Afghan people. This ignores differences of social class, hides the feudal character of rural land tenure and the feudal state, and creates the ahistorical euphemism of "warlordism" as if it is not a structural feature of inequalities among Afghan citizens. The problem is perpetuated because of the self-fulfilling aspects of ethnic labeling. Particular groups of people come to describe themselves and others by ethnic and/or tribal labels. Following which, even the more careful ethnographic studies tend to be couched, quite uncritically, in ethnic terms, while ignoring the historical and state-building processes that have created, and continue to alter, the Afghan discourse on ethnicity. Indeed, ethnicity has become much more salient since 1989, and changed its meanings again since the American war. In this respect, it is important to see "tribes" and "the state" as mutually construed, and to problematize the notions of "ethnicity" and "identity" that frame so much of recent Afghan scholarship (R. Tapper 1983, 1988). R. Tapper (1984) offers a brief but cogent case study suggesting how ethnic identification was, in the early 1970s, interpolated in class politics in northern Afghanistan. There is much further new work to be done in this area.

The focus on ethnicity has both directed scholarly attention away from processes of gendering and practiced Islam and distorted other studies. For example, the power of the ethnic stereotypes, and the political and economic domination of Pashtuns, continues to be reproduced in often crude accounts of Pashtunwali, or the Pashtun "honor code." Pashtun "honor" is also sometimes understood by Afghans and others as residing in Pashtun men's willingness to fight over "women, gold, and land" (*zan, zar, zemin*). Comments about Pashtun "honor" – that is, about hospitality, sanctuary, feud, tribal councils, purdah, and *jihād* – are frequently used to explain the present politics of the Afghan state, the resistance

parties, and most recently the rise and fall of the Taliban. Typically, the focus on Pashtunwali misses the economic, or property, component of political attributions of "honor" and "shame." Yet "honor" and "shame" are local idioms for explaining the class dimensions of gendered differences, purdah, marriage practices, and, indeed, the subversive power of "shame" as a "weapon of the weak" which is available to both women and men. For a radical reconsideration of the notions of "honor" and "shame" in Middle Eastern ethnography, see Lindisfarne (1994). See also Rubin (1997) and Lindisfarne (2002) on reasons for the present salience of gender in Afghan and international politics.

The fierce "Afghan" (also known as Pashtun/Pakhtun) stereotype hides much else as well. It hides gender blurring or inversion in childhood, and in a variety of other contexts (Centlivres 1992), including an early twentieth-century account of a young widow who became a bandit leader after her husband's execution (N. Tapper 1991b, 195–6). It also hides the disciplined nonviolent independence movement of Pukhtun Redshirts, or "Servants of God," in British India from 1930 to 1947. This movement was grounded in Pakhtunwali, Islam, and Gandhism; it involved the active participation of both women and men. It is described in Banerjee's (2000) superb oral and archival history. Edwards too has re-examined the "moral fault lines" on the frontier, offering a interesting discussion of the contrasting use of gendered and religious metaphors by the Pakhtuns and British at the end of the nineteenth century (1989, 1996; for the place of Pakhtunwali in the colonial period and in the Afghan-Soviet war, 1986).

TWENTIETH-CENTURY ACCOUNTS

Political histories perpetuate the focus on Pashtuns, tribalism and nomadism, as well as the Pashtun biases of the Afghan state itself (see, for example, Gregorian 1969, Kakar 1979, but compare Mohammad 1914–15). These histories leave largely unexamined the topics of feudalism, class politics, and the dominant practices of Sunnī Islam, and certainly of women and gender. Kemali's (1985) account of matrimonial law does necessarily treat these topics. So too do accounts of the reign of the modernizing Amir Amanullah, who promoted dress reform (Scarce 1975), and women's education, in ways comparable to the reforms also taking place in Iran, Turkey, and Egypt during the same period. With hindsight,

a tragic irony colors the theoretically flawed literature, which treats changes in "the position of women," as inevitable, straightforward, and linear aspects of "progress" (see, for example, Knabe's sociological account 1977, or the anecdotal histories collected by Delloye 1980 and Lajoinie 1980). More rigorous studies of women's health, such as that by Hunte (1985), and by Michelle and Robin Poulton (1979) are as valuable as they are unusual.

ETHNOGRAPHIES

Gilsenan (1990) has noted that there was "something oddly unproblematic" about Middle Eastern anthropology of the 1960s and early 1970s, the period when most of the Afghan field studies were done. At the time, ethnographic "coverage" was an important impetus in the anthropology of the Middle East. Most studies were deeply conservative and reproduced the bias towards rural, "romantic" subjects, while ignoring questions of political economy, social stratification, or, more simply, "history and power." At the time, gender and practiced Islam were, at best, topics of marginal ethnographic interest. Heterogeneous, descriptive, and theoretically undemanding, the Afghan ethnographies are barely known to scholars outside the region. Yet, sadly, these studies now have an archival value no one could have anticipated 30 years ago.

Given the oddly unproblematic character of ethnographies of the period, it is not surprising that they perpetuate a Pashtun bias. However, there are, among the anthropological studies of Pashtuns/Pakhtuns some that offer nuanced, gender-sensitive accounts (Glatzer 1977, Boeson 1978–80, Anderson 1982, Lindholm 1982, Tavakolian 1984, and N. Tapper 1991a). See also Tapper and Tapper 1986 as a model for exploring the mutual construal of gender and practiced Islam, in this case through food and commensal practices. Grima's later study (1992), carried out in Pakistan, is exceptional in its focus on performance, text, and storytelling, and its feminist commitment to describing how "honorable" Pakhtun women are defined through rituals of grief and suffering.

The unevenness of the descriptions of women's lives is itself remarkable in the ethnographies of non-Pashtun groups (Ferdinand 1964 on Persian-speaking peoples of the central part of the country, Singh Uberoi 1971, and Michelle and Robin Poulton 1979 on Tajiks, Shahrani 1979 on the Kirghiz and Wakhi of the northeast, and Barfield

1981 on Arabs. For Turkmen, Uzbeks, and others, see Kreuger 1963, Stucki 1978, Shalinsky 1979, and Rao 1981). Ironically, religious beliefs and practices are best described for the Hazara Shī'ī minority who live in the central part of the country (Canfield 1973, Mousavi 1997). And the "coverage" itself is uneven: for example, there is little literature on Afghan Baluch.

Only a few Afghan ethnographies have an urban focus. Pierre Centlivres's study (1972) of the Uzbek-dominated Tashgurghan bazaar is of particular importance in this respect. Centlivres (1998) and Micheline Centlivres-Demont (1988) have worked for more than 40 years in Afghanistan. Their publications form the richest body of ethnographic materials on the country. Their work has also consistently responded thoughtfully to changing scholarly debates outside of the region, resulting in many perceptive, varied, but always theoretically sophisticated, papers on gender and practiced Islam. Two scholars working in the city of Herat also offer models for the study of gender and practiced Islam. Doubleday's *Three Women of Herat* (1988, and see also Slobin 1976) is an important, highly readable autobiogaphy about women and women's music. Margaret Mills's insights (1985, 1991) come from her dual commitment: to attend to gender issues, and to treat folktales within a postmodernist framework as "open works" that explore subtle interpretations and negotiations of position and meaning through the idioms of gender, religion, and secular politics.

RECENT LITERATURE

The dominant rhetoric of resistance in Afghanistan since the nineteenth century has been Islamic. This tradition has been revived in the internal resistance to the communist parties who ruled Afghanistan after 1977, and against the Soviet invaders. Islamic idioms have also framed discourse about Afghanistan during civil war, through the rise of the Taliban, and the American "War on Terrorism." This focus on Islam is evident in writing after Dā'ūd's coup of 1973. Since the Soviet invasion of 1979 there have been some Afghan, but virtually no foreign, scholars working in the country. Apart from official government publications, most of the recent literature is by journalists, members of NGOs, and the Afghan political parties themselves.

Over the past 20 years, *Afghanistan Info* has been the most consistent source on a wide range of topics. Other sources (MERIP, Roy 1985, Rubin 1995, Rashid 1999, and Neale 2001) provide important political background to the Afghan revolutions and the Islamic resistance, as do a number of edited works. Of the latter, a number include papers on women (Shahrani and Canfield 1984, Farr and Merriam 1987, WUFA 1990, Weiner and Banuazizi 1994, Atabaki and O'Kane 1998, and Maley 1999).

Gauhari's autobiography (1996) of her flight from Kabul to find refuge in the United States anticipates further accounts of middle-class Afghan exiles. Smith, a women's health worker, lived in north and central Afghanistan for several years before the rise of the Taliban. Smith's brave account (2001) is refreshingly free of NGO jargon. Importantly, she documents the engaged flexibility of women's responses to war in ways that confound the stereotypes of passive, isolated "traditional Afghan women" and a reified notion of "Afghan culture." Too often elsewhere in discussions of human rights and humanitarian aid (Piquard 1989, Christensen 1990, and the Amnesty Report 1995), the categories "women," and "Afghan culture" are treated as self-evident. Where this occurs, little or no attention is then paid to "gender" as way of construing social difference, hierarchy, and indeed particular religious identities. Ellis (2000), the Canadian feminist and anti-war activist, sees women as active agents, and she reports on all the women involved in the Afghan wars, including the Soviet women and Afghan refugees in Moscow and elsewhere in the former Soviet Union. Yet in its very breadth of concern, her focus on "women" as a self-evident category is surprising. Gender (as it defines women and men) in only one of many ways in which Afghans experience difference and inequality today. Ellis's book is also, and probably inevitably, anecdotal, as is typical of crisis literatures, which, by definition, focus on what is discontinuous, acute, and unusual in people's lives. In tragic circumstances, this is not wrong. But it is a bias against arguments and insights about continuity, processes of routinization, and, most important, structures that replicate and promote fragmentation, uncertainty, and "instability." Moreover, crisis literature is prone, as Dupree warns of the Amnesty document (1999, 147, n. 8), to the repetitious reporting of fears and rumors which lack adequate verification. Yet Ellis's work is also to be treasured for its sentiment, and dedication, and Ellis usefully includes a chronology of Afghan women's history, and a list of organizations working with Afghan women.

BIBLIOGRAPHY

Nineteenth- and early twentieth-century sources

L. W. Ademec, Notes on the Afghanistan Gazetteer Project, in *Afghanistan journal* 1:4 (1974), 118.

H. W. Bellew, *The races of Afghanistan, being a brief account of the principle nations inhabiting that country*, Calcutta 1880.

India, Army, General Staff Branch, *Historical and political gazetteer of Afghanistan*, ed. L. W. Adamec, 6 vols., Graz 1972–85.

N. I. Grodekoff, *Colonel Grodekoff's ride from Samarcand to Herat, through Balkh and the Uzbek states of Afghan Turkestan*, London 1880.

N. Khanikoff, *Bokhara. Its amir and its people*, London 1845.

R. Kipling, *Rudyard Kipling. The complete verse*, London 1990.

P. Macrory (ed.), *Lady Sale. Military memoirs. The first Afghan war (1843)*, London 1969.

C. Masson, *Narrative of various journeys in Baluchistan, Afghanistan and the Punjab*, 3 vols., London 1842.

F. Mohammad, *Light of history* [in Persian], 3 vols., Kabul 1914–15.

M. Lal, *Travels in the Panjab, Afghanistan, Turkistan, to Balkh, Bokhara, and Herat*, London 1846.

T. L. Pennel, *Among the wild tribes of the Afghan frontier. A record of sixteen years of close intercourse with the natives of the Indian marches*, London 1909.

M. G. Raverty, *Notes on Afghanistan and parts of Baluchistan. Geographical, ethnographical, and historical*, London 1888.

H. C. Rawlinson, Report by Lieutenant (now Sir) Henry C. Rawlinson, on the Dooranee tribes, London, India Office Library, 19 April 1841.

G. S. Robertson, *The Kafirs of Kafiristan*, Oxford 1896.

Twentieth-century ethnographies and histories

J. W. Anderson, Social structure and the veil. Comportment and the composition of interaction in Afghanistan, in *Anthropos* 77:3–4 (1982), 397–420.

M. Banerjee, *The Pathan unarmed. Opposition and memory in the north west frontier*, Oxford 2000.

T. J. Barfield, *The Central Asian Arabs of Afghanistan. Pastoral nomadism in transition*, Austin, Tex. 1981.

I. W. Boesen, Women, honour and love. Some aspects of the Pashtun women's life in eastern Afghanistan, in *Folk* 21–2 (1979–80), 229–39.

R. L. Canfield, *Faction and conversion. Religious alignments in the Hindu Kush*, Ann Arbor 1973.

P. Centlivres, *Un bazar d'Asie centrale. Forme et organisation du bazar de Tashqurghan (Afghanistan)*, Wiesbaden 1972.

——, Le jeu des garçons, in J. Hainard and R. Kaehr (eds.), *Les femmes*, Neuchâtel 1992, 55–80.

——, *Chroniques afghanes, 1965–1993*, Amsterdam 1998.

P. Centlivres and M. Centlivres-Demont, *Et si on parlait de l'Afghanistan? Terrains et textes 1964–1980*, Neuchâtel 1988.

I. Delloye, *Des femmes d'Afghanistan*, Paris 1880.

V. Doubleday, *Three women of Herat*, London 1988.

D. Edwards, Pretexts of rebellion. The cultural origins of Pakhtun resistance to the Afghan state, Ph.D. diss., University of Michigan 1986.

——, Mad mullahs and Englishmen. Discourse in the colonial encounter, in *Journal of the Society for Comparative Study of Society and History* 31:4 (1989), 649–70.

——, *Heroes of the age. Moral fault lines on the Afghan frontier*, Berkeley 1996.

K. Ferdinand, Ethnographical notes on Chahâr Aimâq, Hazâra, and Moghôl, in *Acta Orientalia* 28:1–2 (1964), 175–203.

M. Gilsenan, Very like a camel. The appearance of an anthropologist's Middle East, in R. Fardon (ed.), *Localizing strategies. Regional traditions in ethnographic writing*, Washington 1990, 222–39.

B. Glatzer, *Nomaden von Gharjistan. Aspekte der wirtschaftlichen, sozialen und politischen Organisation nomadischer Durrani-Paschtunen in Nordwestafghanistan*, Wiesbaden 1977.

V. Gregorian, *The emergence of modern Afghanistan. Politics of reform and modernization, 1880–1946*, Stanford, Calif. 1969.

B. Grima, *The perfomance of emotion among Paxtun women. "The misfortunes which have befallen me,"* Austin, Tex. 1992.

P. A. Hunte, Indigenous methods of fertility regulation in Afghanistan, in L. F. Newman (ed.), *Women's medicine. A cross-cultural study of indigenous fertility regulation*, New Brunswick, N.J. 1985, 44–75.

S. Jones, *Men of influence in Nuristan. A study of social control and dispute settlement in Waigal Valley, Afghanistan*, New York 1974.

H. K. Kakar, *Government and society in Afghanistan. The reign of Amir ʿAbd al-Rahman*, Austin, Tex. 1979.

M. H. Kamali, *Law in Afghanistan. A study of the constitutions, matrimonial law, and the judiciary*, Leiden 1985.

E. Knabe, *Frauenemanzipation in Afghanistan. Ein empirischer Beitrag zur Untersuchung von soziokulturellem Wandel und sozio-kultureller Beständigkeit*, Meisenheim am Glan 1977.

——, Women in the social stratification of Afghanistan, in C. A. O. van Nieuwenhuijze (ed.), *Commoners, climbers and notables*, Leiden 1977, 329–43.

J. Krueger (ed.), *The Turkic peoples. Selected Russian entries from the great Soviet encyclopedia*, Bloomington, Ind. 1963.

S. B. Lajoinie, *Conditions de femmes en Afghanistan*, Paris 1980.

C. Lindholm, *Generosity and jealousy. The Swat Pukhtun of northern Pakistan*, New York 1982.

N. Lindisfarne, Variant masculinities, variant virginities. Rethinking "honour and shame," in A. Cornwall and N. Lindisfarne (eds.), *Dislocating masculinity. Comparative ethnographies*, London 1994, 82–96.

——, Questions of gender and the ethnography of Afghanistan, in J. Hainard and R. Kaehr (eds.), *Dire les autres. Réflexions et pratiques ethnologiques*, Lausanne 1997, 61–73.

M. Mills, Sex role reversals, sex changes, and transvestite disguise in the oral tradition of a conservative Muslim community in Afghanistan, in R. Jordan and S. Kalčik (eds.), *Women's folklore, women's culture*, Philadelphia 1985, 187–213.

——, *Rhetoric and politics in Afghan traditional storytelling*, Philadelphia 1991.

S. A. Mousavi, *The Hazaras of Afghanistan*, London 1997.

M. Poulton and R. Poulton, *Ri Jang. Un village Tajik dans le nord de l'Afghanistan. Traditions sociales et économiques face au développement*, 3 vols., Paris 1979.

A. Rao, Qui sont les Ǧat d'Afghanistan? in *Afghanistan Journal* 8:2 (1981), 55–64.

J. M. Scarce, The development of women's veils in Persia and Afghanistan, in *Costume. The Journal of the Costume Society* 9 (1975), 4–14.

M. N. Shahrani, *The Kirghiz and Wakhi of Afghanistan. Adaptatation to closed frontiers*, Seattle 1979.

A. Shalinsky, *Central Asian émigres in Afghanistan. Problems of religious and ethnic identity*, New York 1979.

J. P. Singh Uberoi, Men, women and property in northern Afghanistan, in S. T. Lokhandwalla (ed.), *India and contemporary Islam*, Simla 1971, 398–416.

M. Slobin, *Music in the culture of northern Afghanistan*, Tucson 1976.

A. Stucki, Horses and women. Some thoughts on the life cycle of Ersari Türkmen women, in *Afghanistan Journal* 5:4 (1978), 141–9.

N. Tapper, *Bartered brides. Politics, gender and marriage in an Afghan tribal society*, Cambridge 1991a.

——, Women and power. A perspective on marriage among Durrani Pashtuns of Afghan Turkistan, in S. Akiner (ed.), *Cultural change and continuity in Central Asia*, London 1991b, 181–97.

N. Tapper and R.Tapper, Eat this, it'll do you a power of good. Food and commensality among Durrani Pashtuns, in *American Ethnologist* 13:1 (1986), 62–78.

R. Tapper (ed.), *The conflict of tribe and state in Iran and Afghanistan*, London 1983.

——, Ethnicity and class. Dimensions of intergroup conflict in north-central Afghanistan, in M. N. Shahrani and R. L. Canfield, *Revolutions and rebellions in Afghanistan. Anthropological perspectives*, Berkeley 1984, 230–46.

——, Ethnicity, order and meaning in the anthropology of Iran and Afghanistan, in J.-P. Digard (ed.), *Le fait ethnique en Iran et en Afghanistan*, Paris 1988, 21–32.

B. Tavakolian, Women and socioeconomic change among Sheikhanzai nomads of western Afghanistan, in *Middle East journal* 38:3 (1984), 433–53.

A. Torab, Piety as gendered agency. A study of *jalaseh* ritual discourse in an urban neighbourhood in Iran, in *Journal of the Royal Anthropological Institute* 2:2 (1996), 235–52.

——, The politicization of women's religious circles in post-revolutionary Iran, in S. Ansari and V. Martin (eds.), *Women, religion and culture in Iran*, London 2002, 143–67.

THE RECENT PERIOD

Afghanistan Info (Neuchâtel, Comité suisse de soutien au peuple afghan), 1980 onwards.

Amnesty International, *Women in Afghanistan. A human rights disaster*, London 1995.

T. Atabaki and J. O'Kane (eds.), *Post-Soviet Central Asia*, London 1998.

H. Christensen, *The reconstruction of Afghanistan. A chance for rural Afghan women*, Geneva 1990.

N. H. Dupree, Afghan women under the Taliban, in W. Maley (ed.), *Fundamentalism reborn? Afghanistan and the Taliban*, London 1999, 145–66.

D. Ellis, *Women of the Afghan war*, Westport, Conn. 2000.

G. M. Farr and J. G. Merriam (eds.), *Afghan resistance. The politics of survival*, Boulder, Colo. 1987.

F. Gauhari, *Searching for Saleem. An Afghan woman's odyssey*, Lincoln, Nebr. 1996.

N. Lindisfarne, Starting from below. Fieldwork, gender and imperialism now, in *Critique of anthropology* 22:4 (2002), 403–23.

W. Maley (ed.), *Fundamentalism reborn? Afghanistan and the Taliban*, London 1999.

MERIP (Middle East Research and Information Project), *Afghanistan, Middle East report* 89 (1980).

J. Neale, The long torment of Afghanistan, in J. Rees (ed.), *Imperialism. Globalisation, the state and war. International socialism* 93 (2001), 31–57.

B. Piquard, Métamorphoses de l'identité chez les réfugiés afghans au Pakistan, bachelor's dissertation, Département de sociologie, Université catholique de Louvain 1989.

A. Rashid, *Taliban. Islam, oil and the new great game in Central Asia*, London 1999.

O. Roy, *Afghanistan. Islam et modernité politique*, Paris 1985.

B. R. Rubin, *The fragmentation of Afghanistan. State formation and collapse in the international system*, New Haven, Conn. 1995.

——, Women and pipelines. Afghanistan's proxy wars, in *International Affairs* 73:2 (1997), 283–96.

M. N. Shahrani and R. L. Canfield (eds.), *Revolutions and rebellions in Afghanistan. Anthropological perspectives*, Berkeley 1984.

M. Smith, *Before the Taliban. Living with war, hoping for peace*, Aberdour, U.K. 2001.

M. Weiner and A. Banuazizi (eds.), *The politics of social transformation in Afghanistan, Iran, and Pakistan*, Syracuse, N.Y. 1994.

WUFA (Writers Union of Free Afghanistan), *Journal of Afghan affairs* (Peshawar), special issue (October–December 1990).

NANCY LINDISFARNE

Soviet Central Asia and Azerbaijan: 1917–1991

THE LATE COLONIAL PERIOD

Sources that permit a multi-faceted inquiry into the lives of Central Asian and Azerbaijani women become far more available in the period following the Russian conquest than previously. Russians began the conquest of the Kazakh steppe in the late 1700s, and ended their Central Asian campaigns with the conquest of the Pamirs and Gok-Tepe in the 1880s. Russia obtained sections of the Caucasus, including Azerbaijan, from Iran in 1828.

Native written sources, better preserved for the post-conquest period than previously, are more abundant for the sedentary peoples than for nomadic peoples. Substantial collections of records from Islamic courts can illuminate material aspects of women's lives. Court documents include marriage contracts, *mahr* agreements, and divorce decisions, all of which reveal typical patterns of women's property ownership and control among town and city dwellers. Transactions concerning women slaves are found in Bukharan Islamic court records in the late nineteenth century. Social changes following the Russian conquest, the beginning of the Jadid, or Islamic modernist movement, an increase in secular writing, and access to publishing technologies, make available native writings on women, especially when Central Asians first published their own newspapers in 1906. A few Central Asian women's writings were published between 1906 and 1917, in Central Asian newspapers such as *Sada-i Fargana* and *Turkistan Vilayetining Gazetasi*, in collections of poetry, in the Crimean Tatar women's newspaper *Alem-i-Nisvan*, and the Kazan Tatar women's journal, *Suyum Bike*. In addition to newspaper and journal articles written by men, focusing on women's morals, the Woman Question, and women's education, men's literary productions and plays made women's lives and roles a matter of public attention.

External representations of Central Asian women in the late Russian colonial period are found in the works of scholars and colonial administrators from Russia, and in travel accounts by Russians and other foreigners. Russian colonial efforts to codify Central Asian law and custom established and supported Russian images of the downtrodden Central Asian woman; Graf Palen's account of his review of Central Asian native courts in 1909 included, within an overall disparagement of justice by and for Central Asians, descriptions of maltreatment of women and applications of Sharī'a that Palen used as evidence of Central Asian backwardness. Ethnographers in government service, and influenced by Morgan, Engels, and others, sought the "primitive" in Central Asia, and mentioned women in schematic ways within descriptions of extended family, marriage, and property (Ostroumov 1908, Grebenkin 1872, Lykoshin 1915). In 1886, Vladimir Nalivkin and Maria Nalivkina published *Observations on the Daily Lives of Women of the Sedentary Native Population of Fargana*, the only scholarly monograph on Central Asian women from the colonial period. The Nalivkins based their work on a year living as ethnographers in Nanai, where they compared women's roles of local sedentary people and nomads. Their knowledge of Uzbek and Nalivkina's access to women's daily lives make this one of the few essential works for the researcher in this period. Other scholars published articles focusing on particular aspects of the treatment of women, such as A. N. Samoilovich on forbidden words among married "Kirgiz" (Kazakh) women. Like ethnographers, travelers, who were mostly male, had little access to Central Asian women, and limited their comments to what men told them. Accounts by astute observers such as the American diplomat Eugene Schuyler (1876) include brief sections on women. Women travelers in the colonial and early Soviet periods wrote more substantial observations about Central Asian women; of particular value is Annette Meakin (1915). Foreign travel accounts combine empathy and occasional admiration for Central Asian women with exoticism.

THE SOVIET PERIOD

The Bolshevik revolution brought a dramatic increase in government and Communist Party attention to Azerbaijani and Central Asian women, a burst of publication, vast growth in collection of information, and ongoing research by and about Central Asian and Azerbaijani women. In the 1920s, the women's division of the

Communist Party directed efforts to create knowledge about Central Asian women as well as efforts to transform them. Sources from 1917 until the mid-1950s include publications by Central Asian and Azerbaijani women about themselves, published materials written by government and party workers, archival materials from government and party divisions that dealt with women, studies by Soviet ethnographers, and accounts by foreign travelers. With the Khrushchev "thaw," starting in 1956, in addition to these types of sources, academic studies of women in Soviet Central Asia and Azerbaijan grew dramatically until the late 1980s. Sources on Central Asian and Azerbaijani women in the Soviet period also include women's magazines, literature, memoirs, and biography.

Scholarly studies of women in Central Asia and the Caucasus during the Soviet period were designed to show the success of Soviet policies toward women. Thus modernizing achievements were presented in positive terms, while practices deemed anti-modern were marginalized as "leftovers from the past." An ideologically-driven scholarship emerging from growing national units of the Soviet Academy of Sciences produced a solid body of knowledge about women's increasing participation in public life. By contrast, Western, that is European and American, studies of women in Soviet Central Asia and Azerbaijan usually focused on the shortcomings of Soviet policies.

1917–1930s

From the 1917 revolution until 1930, the volume of information about women in Central Asia and Azerbaijan grew exponentially. Between February and October 1917, a free press allowed Muslim women and men to articulate their desires; women published pleas for education in the Tatar women's journal *Suyum Bike* (Kazan), as well as in the Turkic language press in general. After the Bolshevik revolution, state control of the press diminished free speech, while state support of non-Russian language media allowed native-language papers and journals to flourish in Central Asia and Azerbaijan. With party support and direction, women's magazines were founded, such as *Sharq Gadini* (Azerbaijan 1923), *Yangi Yo'l* (Uzbekistan 1924), and *Erkin Ayal* (Kazakhstan 1925). Some of the material in these journals was translated from the Russian press, but much of it was written by Muslim women, and expressed their concerns for education and for women's protection in domestic and civil matters. Muslim

women journalists of the 1920s also contributed regular columns on women's issues to general newspapers such as *Qizil O'zbekiston*. Russians wrote about Central Asian women in Russian journals such as *Novyi Vostok*. The native language press and the Russian language press often differed: the Russian language press was very critical of Central Asian society; the native language press was also critical but far more nuanced, and contained many more contributions from Central Asians.

The women's division of the Communist Party made Muslim women their own project; the Moscow-based Russian-language journal *Kommunistka* featured articles on "women of the East" in every issue. These articles focused on the success and failure of the Communist Party in enforcing new civil laws in Muslim areas, and in bringing about cultural revolution to change Islamic and customary practices. Scholars, especially ethnographers sent to Central Asia and Azerbaijan by Moscow and Leningrad academies, sought and published materials that would demonstrate to the Russian elite Muslims' backwardness or even primativeness through accounts of marriage and religious practices, such as Troitskaia's work on women Sufis. To prompt state investment in the party project for drawing women into paid work, the women's division carried out studies of women's unpaid labor. State and party archives contain details of Muslim women's lives in papers from divisions and ministries of education, medicine, justice, the women's division, and the commission for improving working women's lives.

The Communist Party archives contain detailed records of the *Hujum*, or Assault, campaign of 1927–9, with reports from local party cells noting who supported and who resisted this party-led effort at a cultural revolution that attempted to transform Muslim women's lives rapidly and radically, and that met with violent backlash in Uzbekistan and Tajikistan.

In the 1930s, increased party control and surveillance turned the press in Central Asia and Azerbaijan into a relentlessly propagandist media, reducing the merits of newspapers and journals as sources for that period. Government ministries gathered less information about women. The Communist Party, though it closed its women's division, remains the most important source of documentation about women's lives in the 1930s, with its observers attentive to signs of state success in transforming women as well as signs of

continuing practices and attitudes limiting women. Most archival documents are in Russian, although there are petitions from individuals and court records in native languages, sometimes untranslated. In the 1920s and 1930s, native language documents produced by government bodies often appear in the archives with Russian translations.

1930S: CENSUSES

From the late 1930s through the end of the Soviet period, the means by which the government assembled information about women were systematized. Decennial censuses, beginning in 1939, produced statistics that aided the Soviet government's portrait of continuous improvement in women's lives. Academies of science in Central Asia and Azerbaijan, as well as those in Moscow and Leningrad, trained ethnographers to collect information and material on daily life, marriage, and family. The same academies began promoting a remembrance of women's history, starting in the late 1950s. In the late 1950s, after the Khrushchev thaw and de-Stalinization, old Communist activists wrote about the party's early efforts to liberate Muslim women. The academies produced volumes on women in Central Asia, including histories of the Soviet period, document collections, studies concerning women and labor, women and law, and women and Islam.

The Soviet censuses provided the basis for much statistical and empirical study of women in Central Asia and Azerbaijan. Censuses included gender, age, and nationality breakdowns for each republic, and for most categories of inquiry. The census paid attention to work and education, providing detailed proof of the Soviet Union's success in increasing educational access, and showing clearly the gendered patterns of labor emerging in the Soviet Union. In addition, the census depicted living standards, and included tables that made comparisons among republics, for everything from average food consumption, to living space per capita in public housing, to numbers of hospital beds and doctors and nurseries per region or republic. More specific breakdowns of women's participation in areas of the economy are found in annual volumes called *Narodnoe Khoziaistvo SSR* (National economy of the USSR), but these lack detailed breakdowns by ethnic group; more specific exploration of demographic issues is found in *Vestnik Statistiki* (Bulletin of statistics). In the 1970s and 1980s, some republics put out booklets of statistics on women. These presentations were ideologically driven, designed to show that the "great October socialist revolution liberated women from exploitation and slavery" (*Women of Soviet Uzbekistan*, 4). Numbers and percentages of women in higher education and professions, nurseries, numbers of children per mother, and production of goods for women and children were detailed, but very little information was given on divorce, abortion, and none on use of contraception. Statistical information was published in Russian.

1940S: ETHNOGRAPHY

Ethnography of Central Asia and the Caucasus provided the richest source of information about women from the 1940s through 1991. Ethnography adhered closely to the Marxist-Leninist description of human development, and continually sought to document Central Asian emergence from the feudal stage to the socialist stage, skipping the capitalist stage. These intellectual frameworks and political sensitivities directed and proscribed topics of ethnographic study, but nonetheless, ethnographers produced excellent studies of Central Asian cultures. Religious observance, though investigated by some, was presented as a dying relic of the past, or simply as historical, as in Sukhareva's work on Uzbekistan (1960). Material culture studies thrived in the 1970s, with studies of women's costume providing a wealth of knowledge on women's social practices. Examinations of family life and marriage (Bikzhanova 1959, Zhakipova 1971, Zhumagulov 1960, Kisliakov 1959) were often framed by assumptions that socialism would break down extended family structures. All manner of studies pitted the "backward" against the "modern" and the socialist, with confidence that the latter was winning the struggle; in this framework, women's work outside the home, nuclear families, homes furnished "European-style," abandonment of traditional dress, and adoption of the Red Wedding were all destined to be found and lauded. However ideologically shaped ethnographic studies were, their substance makes them well worth reading. Soviet ethnographers worked expedition-style, with a professor leading a team of researchers and graduate students in intensive interviewing in a location for several weeks. Long-term individual participant-observation was not a typical Soviet practice. The strength of the Soviet approach was in depth of quantitative data.

1950S AND 1960S

Beginning in the 1950s, memoirs and biographies of women who were party members became common among publications in Central Asia and

Azerbaijan. Short autobiographies of heroines of socialist labor had been staples for the periodical press since the 1930s, and occasionally these were gathered into collective biographies. One impetus for publishing women's biographies in the late 1950s and afterward was a party effort to promote the Soviet version of "women's liberation" to countries that the Soviet Union was trying to influence, especially in Asia and the Middle East. The Khrushchev thaw also promoted studies of the lives of early party activists.

By the 1960s, the formal study of the Communist Party's efforts to change women's lives occupied a permanent place within the topics covered by the academies of science. That the Communist Party had changed women's lives was not questioned or contested; articles and chapters were frequently entitled "the resolution of the woman question." Women's congresses in the 1950s and 1960s prompted the remembrance and study of women's division activities in the 1920s, and the publication of collective biographies of activists, as well as memoirs and histories by politicians and former activists (Nasriddinova 1964, Liubimova 1967). Akima Sultanova, a party activist in the 1920s, combined memoir with historical research in her works on women in Azerbaijan. The Turkmen scholar Bibi Pal'vanova produced a more general history of the party's work in Central Asia. Many of these volumes, all published in Russian, had a popularizing tone that sought to convince the reader of the party's effectiveness in liberating women from the "chains of Islam and tradition," as the authors wrote.

1970s

Histories of Central Asian women in the Soviet period became more sophisticated in the 1970s, based on archival and published documents; examples include works by Tatybekova (Kyrgyzstan), Nabieva (Tajikistan), Shukurova and Aminova (Uzbekistan). In Uzbekistan, more than in the other republics, scholars wrote specifically about the Hujum, commemorating women who were killed for unveiling and activism in the 1920s. While scholars from other republics mentioned the Hujum, the campaign had greater salience in the history of Uzbekistan, partly because of the large numbers of women victims.

To aid researchers and teachers, in the 1970s academies began publishing collections of documents related to women. These document collections, both by republic and collective for Central Asia, followed the canons of Soviet historiography in sequence and choice of materials. For the 1920s, government decrees and party documents show the revolution's dedication to changing law and life for Muslim women. Access to archival materials for the 1930s was very limited, so researchers instead presented newspaper accounts and party autobiographies of hero worker and kolkhoz women. Sections or volumes were devoted to documents and testimonials to women's activism during the "Great Patriotic War," and for the 1950s and 1960s, the document collections focused on government reports showing improvement in women's education, health, and labor participation. The documentary collections have almost nothing about religion or custom. The researcher can find much that is valuable in these volumes, but should maintain an awareness of their selectivity, with documents presented only to prove rather than to challenge a Soviet narrative of progress. Like scholarly monograph publications from this period, most of these document collections were published in Russian, although scholars published articles in republican publications in either their native language or Russian. Alimova's historiographical writings, both in Russian and in Uzbek, provide a thorough introduction to sources and works on the history of women in Central Asia in the twentieth century, with strong attention to periodical literature.

Memoirs of actresses, musicians, and poets (Mahmudova) and profiles of notable women (Tillia, Azizbekova) were popular, culturally and politically approved. These followed certain narrative forms, with the narrator emphasizing a childhood of poverty and lack, and a transformation brought about through the leadership of the Communist Party, creating opportunity for artistic, intellectual, or work-related development for the protagonist. Small biographical booklets present memorable moments from the lives of famous women, while more substantial autobiographies are replete with details of the intellectual and cultural development of the Central Asian republics and Azerbaijan. Republican presses published biographies and autobiographies in both Russian and native languages.

Legal studies provide some of the most concrete scholarship showing the intersection and opposition of Soviet law with Central Asian practice. Works by Suleimanova and Mogilevskii analyze the development and application of Soviet law. Although Mogilevskii draws on egregious crimes to illustrate his work on law and women in Turkmenistan, the volume is nonetheless rich in detail and pointed in its critique of the shortcomings of Soviet law's protection of women.

Sociology emerged as an approved academic discipline in the Soviet Union in the early 1970s, and Central Asian scholars produced sociological studies of women. Like other disciplines, sociology analyzed Central Asian societies within a Marxist-Leninist framework of backwardness and progress; unlike other disciplines, sociology was unafraid of studying religion. O. Pal'vanova's study of the religious beliefs of factory women in Turkmenistan (1983) provides a serious examination based on questionnaires and interviews. Pal'vanova's study led her to the predictable conclusion that only the least educated are believers while the most educated factory workers are atheists, and thus religious belief is dying out as education spreads. Her work thus overlapped with the works of professional "Marxist-Leninist" instructors who lectured to women on the evils of Islam, and followed in the path of the historian Vagabov, whose earlier work *Islam and Women* (1968) portrayed Islam in Central Asia and the Caucasus as backward and unremittingly harsh toward women, with the situation of women resolved by the introduction of Communism. Other sociologists surveyed women's attitudes toward reproduction, while party activists, economists, and social scientists discussed women's roles in the labor force (Bekkhodzhaeva 1978, Ubaidullaeva 1969, Muradov 1974). Concern for increasing women's activism in the party and in society also prompted studies (Uzbekistan Communist Party 1976).

1980S AND 1990S

Across the spectrum of disciplines, during the Soviet period scholars who studied women in Central Asia and Azerbaijan worked within academy plans, rubrics, and restrictions. Under the leadership of the Communist Party certain social and economic changes were inevitable, it was believed. The party liberated women, and scholarship was directed to find proof of the party's success. Where women's real lives did not resemble the liberated life of the ideal Soviet women, observed realities were explained as the relic of a dying past. Scholars nonetheless presented some of the aspects of women's lives that did not conform to ideal Soviet images, a trend that became more pronounced, and acceptable, in the late 1980s liberalization of thought and speech (glasnost). Liushkevich (1989) addressed the persistence of bridewealth without resort to the "dying relic" explanation, while Alimova (1991) raised issues of factual inequality for women. The press published critical articles, addressing numerous women's issues, including underemployment, fieldwork health hazards, coerced marriage, poor pre-natal and maternity health care, and the late 1980s wave of women's suicide by self-immolation. Poliakov published his anthropology of rural Central Asia (1992), which argued that everything Soviet scholarship had claimed about Central Asia was false, and that women, in particular, were still thoroughly bound by tradition, and quite unchanged by the Soviet experience. In his work, "Central Asian women" are portrayed in aggregate, undifferentiated by region or ethnic group, allowing considerable freedom in use of evidence to support his critical generalizations.

NON-SOVIET WORKS

Among works written by non-Soviets during the Soviet period, there are numerous travel accounts with significant focus women in Central Asia. Some of the most interesting accounts are those of American fellow-traveler Anna Louise Strong (1929); German fellow-traveler Fannina Halle (1938), French Communist Paul Vaillant-Courterier (1932), and American poet Langston Hughes (1956).

Scholarly works about women in Central Asia and Azerbaijan written by non-Soviets during the Soviet period were relatively few, and generally used Soviet published works as their sources. While Soviet scholarship served a Communist agenda by untiringly presenting Soviet success in achieving "women's liberation," Western scholars approached Soviet achievements with skepticism, or overtly tried to demonstrate that Soviet achievements were unsuccessful for Central Asian women. Uzbekistan received more attention from non-Soviet scholars than the other Central Asian republics or Azerbaijan, largely because the volume of Soviet publication about and from Uzbekistan concerning women was greater than for the other republics of Central Asia. Gregory Massell's *The Surrogate Proletariat* (1974), is the defining work for the study of Central Asian women in English; his thesis, that the Soviets tried to turn Central Asian women into their loyal supporters, in lieu of a working class, has shaped Western understandings of the Soviet project in Central Asia. Massell's sources were published works in Russian. Rorlich (1986) wrote of Azerbaijani women's history, and included substantial discussion of women in Tatar history. Many other scholarly works drew attention to Central Asian women within a broader context, for example, Medlin on education (1965), Bacon on anthropology (1966), Sacks on work (1982),

and Lapidus on women in Soviet society (1978). Hayden (1979) gave substantial attention to women in Azerbaijan in her work on the Women's Division of the Communist Party. Montiel (1982) and Zeyons (1971) used published accounts and direct observation for their historical and contemporary discussions of women in Central Asia. Lubin's work on labor policy in Uzbekistan (1984), with considerable focus on women's roles and the gap between Soviet promise and outcome, was unusual in drawing on field research as well as published materials. Olcott's assessment of conditions for Soviet Central Asian women (1991), drawing on the recent glasnost era spate of critical publishing, concluded that the Soviet project had failed, and that Central Asian women were thoroughly shaped by "tradition." Following Poliakov, she dismissed Central Asian women's public presence as unimportant and asserted that Central Asian women find empowerment through Islam.

USE OF SOURCES

The scholar who makes use of the wealth of sources and studies on women in Central Asia and Azerbaijan in the Soviet period must do so with care. Biases led Soviet scholars to make exaggerated claims for the success of the liberation project – and the effectiveness of socialism. Cold war competition drove non-Soviet scholars to dismiss the dramatic growth of women's education and representation in the Soviet period as inadequate – and hence socialism as inadequate.

BIBLIOGRAPHY

A. Abdulkadirova and M. Abilova (eds.), Women of Kazakhstan. Active builders of socialism, 1918–1945, a collection of documents and materials [in Russian], Kazakhstan 1981.

D. A. Alimova, The woman question in Central Asia. History of study and contemporary problems [in Russian], Tashkent 1991.

R. Kh. Aminova, The October Revolution and women's liberation in Uzbekistan, trans. B. M. Meerovich, Moscow 1977.

P. A. Azizbekova, A memorable meeting [in Russian], Baku 1974.

E. Bacon, Central Asians under Russian rule. A study in culture change, Ithaca, N.Y. 1966.

S. Bekkhodzhaeva, Socio-economic problems of women's labor in the economy of Kirgizia [in Russian], Kyrgyzstan 1978.

M. A. Bikzhanova, Family in the collective farms of Uzbekistan. Based on materials from collective farms of Namangan Oblast' [in Russian], Tashkent 1959.

A. D. Grebenkin, Tajiks and Uzbeks, in Russian Turkestan. A collection of publications on the occasion of the politechnic exhibition [in Russian], ed. V. N. Trotskii, ii Moscow 1872, 1–109.

F. Halle, Women in the Soviet East, trans. M. Green, New York 1938.

C. E. Hayden, Feminism and Bolshevism. The Zhenotdel and the politics of women's emancipation in Russia, 1917–1930, Ph.D. diss., University of California, Berkeley 1979.

L. Hughes, I wonder as I wander, New York 1956.

N. A. Kisliakov, Family and marriage among Tajiks. Based on materials from the end of the nineteenth to the beginning of the twentieth century [in Russian], Moscow 1959.

K. S. Kuznetsova, Iu. P. Dzagurova, et al. (eds.), Great October and the liberation of women of the north Caucasus and Transcaucasus: 1917–1936. A collection of documents and materials [in Russian], Moscow 1979.

G. W. Lapidus, Women in Soviet society. Equality, development, and social change, Berkeley 1978.

S. T. Liubimova and E. I. Bochkarova, The bright path. The Communist Party of the Soviet Union – fighter for the freedom, equal rights, and happiness of women [in Russian], Moscow 1967. Russian.

F. D. Liushkevich, Traditions of interfamily links of the Uzbek-Tajik population of Central Asia. Toward the problem of the continuing existence of kalym and other patriarchal customs, in Sovetskaia Etnografiia 4 (1989), 58–68.

N. Lubin, Labour and nationality in Soviet Central Asia. An uneasy compromise, Princeton, N.J. 1984.

N. S. Lykoshin, "Good form" in the East [in Russian], Petrograd 1915.

San'at Mahmudova, One heart's hundred courages. A story with documents [in Uzbek], Tashkent 1989.

G. Massell, The surrogate proletariat. Moslem women and revolutionary strategies in Soviet Central Asia, 1919–1929, Princeton, N.J. 1974.

A. Meakin, In Russian Turkestan. A garden of Asia and its people, London 1915.

W. K. Medlin, F. Carpenter, and W. M. Cave, Education and social change. A study of the role of the school in a technically developing society in central Asia, Ann Arbor 1965.

A. L. Mogilevskii, Defense of women's rights in the Turkmen SSR [in Russian], Ashkhabad 1979.

V. Montiel, Les musulmans soviétiques, Paris 1982.

Sh. M. Muradov, Socio-economic problems in using the female labor supply in the Azerbaijan SSR [in Azerbaijani], Baku 1974.

R. Nabieva, Women of Tajikistan in the struggle for socialism [in Russian], Dushanbe 1973.

V. Nalivkin and M. Nalivkina, Observations on the daily lives of women of the sedentary native population of Fargana [in Russian], Kazan 1886.

Ya. A. Nasriddinova, Women of Uzbekistan [in Russian], Tashkent 1964.

M. B. Olcott, Women and society in Central Asia, in William Fierman (ed.), Soviet Central Asia. The failed transformation, Boulder, Colo. 1991, 235–54.

N. P. Ostroumov, Sarts. Ethonographic material [in Russian], Tashkent 1908.

B. Pal'vanova, Daughter of the Soviet East [in Russian], Moscow 1961.

O. Pal'vanova, The role of the labor collective in determining religious survivals among women. Based on materials from the industrial enterprises of the TSSR [in Russian], Ashkhabad 1983.

S. P. Poliakov, Everyday Islam. Religion and tradition in rural Central Asia, trans. A. Olcott, Armonk, N.Y. 1992.

A. M. Pushkareva and Zh. S. Tatybekova (eds.), Liberation of women of Kirgizia by the great October Socialist Revolution (1917–1937). A collection of documents and materials [in Russian], Kyrgyzstan 1973.

A. Rorlich, The "Ali Bairamov" club, the journal *Sharg Gadini*, and the socialization of Azeri women: 1920–1930, in *Central Asian Survey* 5:3–4 (1986), 221–39.

M. P. Sacks, *Work and equality in Soviet society. The division of labor by age, gender, and nationality*, New York 1982.

A. N. Samoilovich, Forbidden words in the language of Kazakh-Kirgiz married women [in Russian], in *Zhivaia Starina* 26 (1915), 161–8.

E. Schuyler, *Notes of a journey in Russian Turkistan, Khokand, Bukhara, and Kuldja*, New York 1876.

Kh. S. Shukurova, *Socialism and women of Uzbekistan* [in Russian], Tashkent 1970.

—— (ed.), *The Communist Party of Uzbekistan and work among women of the republic (1938–1958). A collection of documents* [in Russian], Tashkent 1982.

Women of Soviet Uzbekistan. A short statistical collection [in Russian], Tashkent 1987.

A. L. Strong, *Red star in Samarkand*, New York 1929.

O. A. Sukhareva, *Islam in Uzbekistan* [in Russian], Tashkent 1960.

——, *History of Central Asian costume* [in Russian], Moscow 1982.

Kh. S. Suleimanova, *History of Soviet government and law of Uzbekistan* [in Russian], 3 vols., Tashkent 1960.

A. N. Sultanova, *Fortunate women of Soviet Azerbaijan*, [in Russian] Baku 1964.

——, *Aina Sultanova* [in Russian], Baku 1976.

Zh. S. Tatybekova, *Great October and women of Kyrgyzstan* [in Russian], Kyrgyzstan 1975.

S. Tillia, *Among the very first* [in Russian], Tashkent 1963.

A. L. Troitskaia, Women's *dhikr* in old Tashkent [in Russian], in *Sbornik muzeia antropologii i etnografii*, Leningrad 1927, 173–99.

R. A. Ubaidullaeva, *Women's labor in the agricultural economy of Uzbekistan* [in Russian], Tashkent 1969.

Uzbekistan Communist Party, *Activities of the Communist Party of Uzbekistan toward strengthening the social activeness of women. A collection of documents and materials (1959–1975)* [in Russian], ed. Sh. Abdurazakova, Tashkent 1986.

M. V. Vagabov, *Islam and woman* [in Russian], Moscow 1968.

Paul Vaillant-Couturier, *Free Soviet Tajikistan*, Moscow 1932.

S. Zeyons, *La révolution de femmes au coeur de l'Asie soviétique*, Paris 1971.

A. Z. Zhakipova, *Development of family and kin relations in Kazakhstan* [in Russian], Kazakhstan 1971.

A. Zhumagulov, *Family and Marriage among Kirgiz of the Chu Valley* [in Russian] Kyrgyzstan 1960. Russian.

MARIANNE R. KAMP

Central Asia: Post-Soviet Period

This entry discusses a variety of research sources and methodology in post-Soviet Central Asia regarding issues of gender and culture. These sources are represented by printed material of different formats, such as books and articles, human development reports (Saidova 1996, WLDI 1999), sociocultural surveys (Grant 1995, Griffin 1996), doctoral dissertations (Kuehnast 1997), manuals about ethnic minorities and human rights (Akiner 1997b), civil codes (Laws and Decrees of the Republic of Uzbekistan, 1992) and newspaper articles (Grebennikov 1998). In addition to the printed material there are also websites (CESWW), web published manuscripts (Berdigalieva and Shaimardanova 2000, Sultanova 1999), and visual material (*Mladshaya*) that deal with issues of gender and culture in post-Soviet Central Asia.

PRIMARY SOURCES

Statistical data, surveys, and law codes are often used as primary data for further research on gender and cultural issues in the region. Some human development reports, by national and international experts, build their analyses on a wide variety of statistical data, such as birth and mortality rates (Saidova 1996, 101), or a country's development profile (Saidova 1996, 16). Other sources (Akiner 1997b) utilize sociocultural surveys as a basis for generalizations. These surveys usually include a set of questions about a population's opinions regarding gender issues such as women's rights (Grant 1995) and women's position within their respective families (Tokhtakhodjaeva 1996). The surveys are accompanied by either a brief statistical analysis of the data (Grant 1995) or an extensive discussion of it (Tokhtakhodjaeva 1996).

Central Asian states are still unable to address the parallel existence of two legal systems: the post-Soviet state laws on the one hand, and Sharīʿa (Islamic law) and customary law on the other (Hidoa 1994). The Uzbek Family Code, adopted in 1998, states that religious marriages are illegal and only marriage registered in the civil status centers are legally recognizable (Article 13). But Article 8 of the same code states that local traditions and customs are applicable to family affairs, as long as they do not contradict the spirit of the Uzbek state legislation. These legal sources serve as a natural introduction to the discussions of gender and cultural issues.

SECONDARY SOURCES

The secondary sources concerning issues of culture and gender in post-Soviet Central Asia can be grouped according to the following disciplines: history (Akiner 1997a, Kamp 2001); ethnography/ethnology (Alimova and Azimova 2000); political science and human rights (ICRW 1999); and religious studies (Fathi 1997, Sultanova 1999). There is also a vast body of sources with interdisciplinary focuses on politics and the economy (Akiner 2001, Kandiyoti 1996, 1998); family health (Welsby and Esengalieva 1994) and planning (Storey 1997); and gender roles and political ideology (Tabyshalieva 1998, Tokhtakhodjaeva 1995). These sources either concentrate directly on gender and cultural issues (Chatterjee, Majumdar, and Sengupta 1997, Baştug and Hortaçsu 2000), or tackle these issues as some of the variables in the discussion (Akiner 2001, Tabyshalieva 2000).

THEMATIC FOCUSES: HISTORICAL SOURCES

Historical sources, such as Massell's work (1974) on the rapid transformation of women's roles during the Soviet period, serve as a necessary background against which current gender and cultural issues in Central Asia are considered. These sources situate issues of gender and culture within a historical continuum starting with the pre-Soviet and moving into the Soviet and post-Soviet periods. They can be divided into four groups. Historical-proper sources provide comprehensive historical accounts of ongoing sociocultural and politico-economic transformations in Central Asia up till the last decade of the twentieth century (Allworth 1994). Historical sources investigate origins of gender roles and explain current gender issues in terms of particular historical developments (Tabyshalieva 1998). Contextualized historic accounts represented by life and oral histories embody history, politics, economics, and religion and become a corrective to the overarching historical accounts (Kamp 2001). Interdisciplinary projects with a strong historical perspective examine how such factors as economic, political, and religious

transformations continue to affect issues of gender and culture in post-Soviet Central Asian societies (Akiner 1997a).

Historical accounts can be both descriptive and prescriptive. Chatterjee (1997), for example, advocates models of women as individuals who "had a crucial voice in the economic and political organization of their societies," and stresses the contemporary relevance of these models for Central Asian women (Chatterjee, Majumdar, and Sengupta 1997, 105–6).

ETHNOGRAPHIC ACCOUNTS

A criticism of Soviet policies and an emphasis on the importance of sociocultural context in women's lives unite the majority of the ethnographic works about the post-Soviet period in Central Asia. These sources talk about women's roles in their respective communities, such as women's guardianship of traditions reproduced through ritual practices (Alimova and Azimova 2000). Women also challenge these traditions by forming a space for a dissemination of ideas by "modern and revolutionary women Islamists" (Fathi 1997, 41).

There are new areas in ethnographic research in post-Soviet Central Asia, such as the reproduction of tradition and national identity through changes and continuities in practice and discourse; processes of group transformation; and human agency. The first research area is exemplified by the critical analysis by Baştug and Hortaçsu of the Turkmen sociocultural system, which inherently disadvantages women by reproducing women's highest social value in terms of their roles as wives and mothers (Baştug and Hortaçsu 2000, 121). Similarly, Sultanova's web publication has video streaming talks about the reproduction of the traditions (sic) through ritual practices in the context of the new religious restrictions in Uzbekistan. The author suggests that the analysis of women's ritual practices contributes to our understanding of how national identity relates to female activity in the region (Sultanova 1999).

Kandiyoti explores the second research area – group transformation – through a critical analysis of social networks in Uzbekistan. The author analyzes *gaps*, networks of kinship and economic and social support, as the strategies used by households in the changing macroeconomic environment of the region (1998, 526, 573).

Ethnographic works, such as that by Colette Harris (2000), deal with issues of ideological construction of gender identities and human agency in post-Soviet Central Asia. The author argues that it would be inaccurate to insist that gender ideals are either socially imposed or simply imposed by men (Harris 2000). Harris suggests that women often assume and enact these ideals as a "part of women's won strategies, both for self-protection and for maintaining of high self-esteem." Women's conformity to the "ideal" identity of submission becomes a strategy to allow men to retain their "ideal" masculine identity and women their self-esteem (Harris 2000, 209–10). Furthermore, Harris sees new influences on women's identities in Tajikistan as coming from other Central Asian societies regionally and from socioeconomic transformations, and not the West or politicized Islam.

In the post-Soviet environment in Central Asia, it became increasingly important to concentrate on individuals, their everyday life experiences, and their own descriptions of their positions vis-à-vis each other and the state. Kamp's research in oral history (2001), although not narrowly ethnographic, focuses on an individual's experience and agency in post-Soviet Central Asia. The author successfully argues that a person's identity is plural, historical, and situational: it reflects and deflects social structures of the Soviet and post-Soviet states. Hence, sociocultural and political contexts both enable and constrain the individual's choices.

LEGAL SOURCES

Legal systems in Central Asia serve as an important context for gender issues in the post-Soviet nation building processes. The Soviet legal system was established as a parallel to traditional and Sharīʿa systems; although their power decreased, popular respect for and practice of these still endure. For example, an Islamic ṭalāq (act of divorce) is illegal, yet it is sanctioned by the state courts even if it "was performed before recourse to the court" (Makhmudov 1990, 290). Customary law is also widely used in dealings within a person's *maḥalla* (neighborhood) and in decision-making regarding inheritance and family relationships (Dzhabbarov 1996). The majority of women in the region, however, are still unfamiliar with their rights (and limitations) provided by Sharīʿa and customary law. As a result they are unable to deploy these rights to improve their social positions (Akiner 1997a). Hence, such Islamic judicial concepts as that of male guardianship are becoming the main reasons for gender discrimination (Tokhtakhodjaeva 1995, 219–43, 252).

These and other secondary sources critically

question the problematic relationship between primary legal sources and existing practices in Central Asian communities (ICRW 1999), but they fail to create a methodological paradigm for change of legal systems.

INTERDISCIPLINARY SOURCES

The absence of the Soviet ideology and the search for national identities frame the interdisciplinary material dealing with post-Soviet Central Asia (Tabyshalieva 2000). Following Akiner (1997a), there are three elements that contribute to a production of gender relations in post-Soviet Central Asia: the restoration of Islamic values and practices; the revival of the pre-Soviet Islamic institutions; and the reinstatement of patriarchal authority "through the symbolization of the president as the 'Father of the Nation'" (Akiner 1997a, 284). On the other hand, there is a neo-modernization tendency to use either Soviet (Doi 1998) or Western models of nationhood as a resource for the construction of post-Soviet Central Asian identities, and consequently to address issues of gender and culture in the material. For example, Giovarelli and Duncan (1999), while looking at gender and land issues in the region, suggest that the Western legal paradigm will help in the matter of gender discrimination regarding land ownership in Central Asia.

There are also sources that represent a third trend in post-Soviet Central Asia. These sources criticize the other two tendencies, expose diverse experiences of women in the region, and suggest contextual ways of addressing gender and cultural issues in the region (Baumgertner 1998). Tokhtakhodjaeva (1998), a representative of post-Soviet Central Asian feminism, points to a lack of criticism in public opinion, mass media, academic scholarship, and in the discourse of political leadership regarding women's social problems and rights in the region. The author suggests looking for a different model of womanhood, one not reducible to traditionalism and modernism.

Anara Tabyshalieva also critically evaluates the impact of Soviet policies and Islamic and ethnic traditions, such as polygamy (sic), on the present positions of women in the region. The author criticizes not only Western and Soviet models of womanhood, but also Central Asian women's often uncritical acceptance of gender roles "imported" from the Middle East and Pakistan (2000, 55). To counteract this "reversal of female emancipation" in Central Asia, Tabyshalieva suggests a multidimensional effort, which will include indigenous (sic), legislative, economic, and political reforms and an increased sensitivity by the external actors of change to the contextual gender relations in Central Asia (2000, 51).

VISUAL SOURCES

Visual sources for gender and cultural issues in post-Soviet Central Asia include fiction and non-fiction films and cultural programming. Some of this material is produced to satisfy an audience's persisting demand for images of an exotic Orient. Thus informed, gender issues in the region are often under-represented. The Lonely Planet series includes a documentary segment, *Central Asia: Kyrgyzstan and Uzbekistan* (1997), which is about an exotic and adventurous region known for its ancient architecture, traditional gender roles, norms, and values. Another documentary, *People's Artist of Uzbekistan* (1984), lures the audience with enchanting Central Asian dances filmed by Uzbekistan state television. While reflecting different economic and political incentives, these visual materials focus on women's cultural performances, hence masking the complexities of women's everyday lives.

There is, however, visual material that addresses the issues of gender and culture in post-Soviet Central Asia both directly and indirectly. The *Witness Online* documentary series by the UNHCR is a web-based media project. A part of it is a nine-part series entitled *A Journey through Central Asia: Detours along the Silk Road* (1997). One of the episodes, *Tangled Threads*, describes the extremely problematic socioeconomic and political context of Osh (Kyrgyzstan) and situates women's lives within this context.

Similarly, *Crossroads* (1994), a Kazakh soap opera about an inter-ethnic marriage, indirectly addresses women's issues in Kazakhstan at the beginning of the twenty-first century. Fiction films also question certain Islamic practices and cultural expectations of women in post-Soviet Central Asia in either a dramatic (*Mladshaya* 1994) or a witty and poetic manner (*Voiz* 2001).

The documentary film *Yallanga* (1988) openly confronts such immediate issues as women's labor and traditional gender roles. Situated on the margins between Soviet and post-Soviet visual material, through personal interviews it examines some of the reasons behind female self-immolation. Another documentary film, *Cycle of Seasons: Four Visits to an Uzbek Village* (1997) also deals directly with the lives of the women in one Uzbek family. The film is created around four seasonal

visits to a family and tells a story about changes and continuities in women's lives.

METHODS

There are three general methodological tendencies that underlie post-Soviet scholarship on gender and cultural issues in Central Asia: an articulation of historical continuity and transformation of gender and women's issues; a search for new models of and for Central Asian women in light of nation-state building and the construction of a post-Soviet national identity; and a search for internal and external forces, such as economic instability, which affect gender issues in the region.

Among these general tendencies, the authors use diverse methods for data gathering and analysis. These methods include but are not limited to the collecting of administrative statistics, conducting surveys and interviews, doing archival research, and participating in and observing different events. The problem with such methods as statistical analysis and survey research is the assumption that a relatively stable and willing population is surveyed. In reality, however, such data does not account for regional and extra-regional migration (Grant 1995).

Furthermore, population surveys concerning Islamic issues are highly challenging in light of the governments' growing control of religious beliefs and practices. Gender surveys also posit a problem in terms of willingness on the part of both men and women to talk about family relationships, especially with regard to such taboo topics as family hierarchy, fertility, and violence against women. Finally, primary and secondary sources that base their analyses on these methods are affected by rarely admitted biases, such as the goals and philosophies of international development agencies (Akiner 1997b, 23), World Bank and International Monetary Fund (Griffin 1998, 22, 27) and Central Asian governments (Griffin 1998, 26).

The majority of scholarship on the issues of gender and culture in the post-Soviet period use broad categories, such as Central Asian women, Uzbek women, age groups, or rural women, as the primary units of analysis (Akiner 1997a, Allworth 1994). This approach assumes homogeneity of women's experiences and the stable nature of the regional and sub-regional groups. It fails to address class, ethnic, and age differences among women in regional and group conflicts.

Some of the ethnographic accounts, for example, use groups as a unit of analysis by focusing more on the function of women than women themselves (Fathi 1997). Hence in many accounts individual experiences are often absent. There are, however, sources that are beginning to treat issues of gender on the level of the individual actor (Kamp 2001), and sources that see an individual actor as being situated within a larger network of relationships (Kandiyoti 1998).

All of the accounts in the post-Soviet period are influenced by the diverse intellectual interests of their respective authors and methodological/analytical paradigms, which served as the foundation for their respective arguments, for example, the structural functionalism in the work of Alimova and Azimova (2000). The rapid changes in Central Asian societies make assumptions of social coherence and stability very much open to doubt, and hence make such paradigms extremely questionable.

Additionally, pre-Soviet and Soviet material on Central Asia either romanticized the past of Central Asia, or treated it as backward. Travelers' accounts (Terzani 1997) and travel/entertainment websites exemplify the former tendency, while the historic-materialist assessments of some Soviet writers exemplify the latter (Pal'vanova 1982, Pesin 1971). Earlier works continue to shape contemporary sources, in that the post-Soviet material and its methodological paradigms are often a critical response to the earlier literature on gender and culture in Central Asia.

There are several methods that are worth pursuing in further research on issues of gender and culture in the region. Long-term ethnographic research is one of the methodological paradigms that includes participation in and observation of everyday practices of women in the region. It includes the collection of life histories and network analysis that will help to contextualize regional political and economic history and identify an individual actor's immediate environment that bears directly on the actor's everyday lived experience. The data collected with these methods will provide a background for developing a methodological paradigm that will constructively address the issues of gender and culture in Central Asia.

BIBLIOGRAPHY

S. Akiner, Between tradition and modernity. The dilemma facing contemporary Central Asian women, in Mary Buckley (ed.), Post-Soviet women. From the Baltic to Central Asia, Cambridge 1997a, 261–304.
——, Central Asia. Conflict or stability and development? London 1997b.
——, Tajikistan. Disintegration or reconciliation? Washington D.C. 2001.

E. A. Allworth (ed.), *Central Asia, 130 years of Russian dominance. A historical overview*, Durham, N.C. 1994³.

D. Alimova and N. Azimova, Women's position in Uzbekistan before and after independence, in F. Acar and A. Güneş-Ayata (eds.), *Gender and identity construction. Women of Central Asia, the Caucasus and Turkey*, Leiden 2000, 293–306.

S. Baştug and N. Hortaçsu, The price of value. Kinship, marriage and metanarratives of gender in Turkmenistan, in F. Acar and A. Güneş-Ayata, *Gender and identity construction. Women of Central Asia, the Caucasus and Turkey*, Leiden 2000, 117–43.

R. Berdigalieva and Z. Shaimardanova, The development of Kazakhstan. The source of cultural development, at <www.ifla.org/IV/ifla66/papers/059-151e.htm>, 2000.

V. Baumgertner, Uzbekistan's businesswomen in characters [in Uzbek], in *Public Opinion* 1 (1998), 106–12.

CESWW (Central Eurasian Studies World Wide), at <www.fas.harvard.edu/~casww>.

S. Chatterjee, M. Majumdar, and A. Sengupta. Unveiling stereotypes. Transitional politics and gender in Central Asia, in Ranabir Samaddar (ed.), *Women in Asia. Work, culture and politics in South and Central Asia*. Delhi 1997, 101–22.

M. M. Doi, 1998. Concerts and constitutions. Repertoires of Uzbek nationhood, in *Anthropology of Eastern Europe Review*, 16:2 (1998), at <www.depaul.edu/~rrotenbe/aeer/aeer16_2.html>.

S. Dzhabbarov, *Sharīʿa, family, and customary law in Uzbekistan. History and reality* [in Russian], Tashkent 1996.

O. H. Fathi, The unknown women clerics of Central Asian Islam, in *Central Asian Survey* 16 (1997), 27–43.

R. Giovarelli and J. Duncan, Women and land in Eastern Europe and Central Asia, at <www.wisc.edu/ltc/live/baseur9908a.pdf> 1999.

S. A. Grant, *Women in Central Asia. Genders, nationalities differ on some issues*, Washington D.C. 1995.

Y. Grebennikov, 1998. Who are we and how do we live? in *Central Asian Post*, Bishkek, Kirgistan, 4 May 1998.

K. Griffin et al. (eds.), *Social policy and economic transformation in Uzbekistan*. United Nations Development Programme, International Labor Office 1995.

C. Harris, The changing identity of women in Tajikistan in the post-Soviet period, in F. Acar and A. Güneş-Ayata (eds.), *Gender and identity construction. Women of Central Asia, the Caucasus and Turkey*, Leiden 2000, 205–29.

Hidoa, *Commentary on Islamic law* [in Russian], i, Tashkent 1994.

ICRW (International Center for Research on Women). *Promoting and defending human rights. Building capacity among women in Central Asia*, Washington D.C. 1999.

M. Kamp, Three lives of Saodat. Communist, Uzbek, survivor, in *Oral History Review* 28:12 (2001), 21–58.

D. Kandiyoti, Women and social policy, in K. Griffin et al. (eds.), *Social policy and economic transformation in Uzbekistan*, United Nations Development Program, International Labor Organization 1996, 129–47.

——, Rural livelihoods and social networks in Uzbekistan. Perspective from Andijan, in *Central Asia survey*, 17:4 (1998), 561–78.

K. R. Kuehnast, Let the stone lie where it has fallen. Dilemmas of gender and generation in post-Soviet Kyrgyzstan, Ph.D. diss., University of Minnesota 1997.

Laws and Decrees of the Republic of Uzbekistan, Tashkent 1992.

M. A. Makhmudov, *Legal methods for marriage stability* [in Russian], Dushanbe 1990.

G. J. Massell, The surrogate proletariat. Moslem women and revolutionary strategies in Soviet Central Asia, 1919–1929. Princeton, N.J. 1974.

Bibi Pal'vanova, *Emancipation of a Muslim woman* [in Russian], Moscow 1982.

Ia. E. Pesin, *Development of women's rights in Uzbekistan* [in Russian], Tashkent 1971.

G. Saidova (ed.), *Human development report. Uzbekistan 1996*, Tashkent 1996.

J. D. Storey, A. Ilkhamov, and B. Saksvig, Perceptions of family planning and reproductive health issues. Focus group discussions in Kazakhstan, Turkmenistan, Kyrgyzstan, and Uzbekistan, *IEC Field Report*, 10 (August 1997).

R. Sultanova, Uzbekistan. Female rites as a musical phenomenon, in *Proceedings of the XV European seminar in ethnomusicology, SOAS, London 12–15 November 1999*, at <www.santacecilia.it/italiano/archivi/etnomusicologico/esem99/musicspace/papers/sultanova/sultanova.htm>.

A. Tabyshalieva, A reflection in time [in Russian], Bishkek, Kyrgyzstan 1998.

——, Revival of traditions in post-Soviet Central Asia, in M. Lazreg (ed.), *Making the transition work for women in Europe and Central Asia*, Washington D.C. 2000.

T. Terzani, *A fortune-teller told me. Earthbound travels in the Far East*, trans. J. Krakover Hall, London 1997.

M. Tokhtakhodjaeva, *Between the slogans of communism and the laws of Islam*, Lahore 1995.

——, *Daughters of Amazons. Voices from Central Asia*. Lahore 1996.

——, The Oriental woman. What doors are open for her? in *Central Asian post*, Bishkek, Kirgistan 4 May 1998, 17:4.

S. Welsby and G. Esengalieva, Overall executive summary of the documentation on women and children's health in five Central Asian republics, unpublished paper compiled for USAID 1994.

WLDI (Women, Law and Development International), *Promoting and defending human rights. Building capacity among women in Central Asia. Report-in-brief from Step by Step. Training women to use the international human rights system to promote and defend women's human rights in Central Asia. Final end-of-project report from PROWID to the Center for Development and Population Activities*, Washington, D.C. 1999.

FILMOGRAPHY

A journey through Central Asia. Detours along the Silk Road, web documentary directed by Gary Matoso and Randall Koral 1997.

Central Asia: Kyrgyzstan and Uzbekistan, documentary produced by Lonely Planet Publications 1997.

Crossroads, soap opera, Kazakhstan national television 1994.

Cycle of seasons. Four visits to an Uzbek village, documentary directed by Oliver L. Wei and Boris Lebedev 1997.

Mladshaya (The junior, 65 mins.), directed by Rano Kubaeva 1994.

People's artist of Uzbekistan, documentary directed by Hamid Kakhramanov, 1984.

Voiz (The Orator, 83 mins.), directed by Jusuf Razykov
2001.

Yallanga (The flame), documentary directed and pro-
duced by Shukhrat Makhmudov 1988.

SVETLANA PESHKOVA

South Asia: Early 20th Century to Present

INTRODUCTION

What was the Indian sub-continent before its partition in 1947, now comprises three nation-states: India, Pakistan, and Bangladesh. Together they account for 360 million of all the Muslims of the world. In 1947 the sub-continent became the two states of India and Pakistan and in 1971 Pakistan itself became the two states of Pakistan and Bangladesh. The region is unique in that Muslims are a majority in some areas and a minority in others, a consequence of certain historical processes and the political re-mapping of the sub-continent in 1947 and 1971. In all areas, Muslims inhabit a space in which there are substantial populations of other communities: Hindus, Christians, Parsis, and Buddhists. The experiences of Muslim women in this region are therefore shared with women of other communities in their respective nation-states, even though there are important differences. The plurality of cultures, histories, and traditions, along with factors such as class and caste make for a very complex shaping of identities of Muslim women as well as of women of other communities. Unfortunately, the richness of the plurality was accompanied by considerable violence at the time of the creation of these nation-states. Some element of this violence continues to impact women even today as communities seek to define the nation-state in particular ways. The 1900–2000 period was thus very eventful and significant in defining and redefining women's identities in this region.

This contribution is divided into two parts: the first deals with the period up to 1947 when the sub-continent became independent from colonial rule and the second deals with the three nation-states of India, Pakistan, and Bangladesh thereafter.

1900–47

It is widely recognized that the sources for writing women's history are limited by the biases of recorders, almost invariably male the world over. In South Asia this was a smaller circle than elsewhere as writing and learning were the privileges of only a few, mainly the religious literati. However, the emergence of a print culture from about 1830 fed directly into the formation of a public culture in the second half of the nineteenth century. Among the most significant issues to feature in this newly constituted public sphere was what came to be called the "Women Question" – broadly the need for a series of reforms in the "status" of women, which was regarded as "unsatisfactory" by sections of the emerging middle class. Colonial rule was instrumental in making connections between the status of women and the civilization of a people, generating changes in the sensibility and perceptions of men who spearheaded the move for reforms. The result was a dramatic expansion of sources such as newspapers, journals, pamphlets, and a host of other literary genres that provided the means to debate the Woman Question in the public sphere. At the beginning of the twentieth century women themselves had begun to participate in the print culture by writing diaries, memoirs, and essays on topics pertaining especially to the need for reform in women's status. Women were even writing letters to the editor in various newspapers on subjects that were being debated, such as widow remarriage among Hindus and the practice of purdah among both Muslims and Hindus of different regions.

Processes of class formation shaped the specific issues that became the focus of the Woman Question in the late nineteenth century and within that education remained the most important subject to surface in writings throughout the early 1900s. Men seeking to have companionate wives and enlightened mothers for their children spearheaded education for women but there was strong resistance too. The Muslim communities on the sub-continent had been dislocated by colonial rule. Because of the loss of political power and the loss of their specific identity these communities were slower to grasp the opportunities of work introduced by the colonial government for an educated gentry than the Hindus were in regions like Bengal. By the 1870s Sir Sayyid Aḥmad Khān's campaign for English education for Muslims is recorded in the speeches and writings of the period and they indicate the notion of separate spheres for men and women. These records also suggest that there was less enthusiasm for a modern education for Muslim women since it was argued that they were not going to enter paid

employment as "clerks." Clearly there was much anxiety about respectable women occupying jobs in a reconstituted public sphere as part of the processes of modernity. Education came to be divided along the lines of gender. Sir Sayyid Aḥmad's speeches have been compiled by S. M. I. Panipati, in the collection *Khutbaat-e-Sir Syed* (Lahore, Majlis-e-Tarraqi-e-Adab, 1973). Later this gender divide fed into the provision of a separate curriculum for women.

Modern education for Muslim girls continued to be vigorously debated well into the twentieth century. The two main positions were reflected in Nazīr Aḥmad's novel *Mir'āt al-'arūs* (The bride's mirror, 1869) and Alṭāf Ḥusayn Ḥālī's didactic work *Majālis al-nisā'* (Assemblies of women, 1874), which argued for a modernized education for Muslim women, and in Ashraf 'Alī Thānawī's, *Bihishti Zewar* (Heavenly ornaments, 1905), favoring a more traditional curriculum of "schooling" women to be good traditional wives, which also required an education. *Bihishti Zewar* was a monumental female instructional guidebook often given to a bride as she departed to her new home. But so was the reformist novel *Goodar-ka-Lal* (Jewel in rags, 1907). Beginning in 1873 in Bengal, and especially after 1900, schools for girls were started in a number of towns. Journals advocating reforms such as *Tahzib un-Niswan*, *Khatun*, and *Ismat*, which became an institution, began to be published. The paper *Haquq-e-Niswan* was launched to advocate the cause of women's education and rights. These publications became a means for women to write on a wide range of issues apart from reform; for example Atiya Fyzee of Bombay sent in an account of her travels in Europe that was serialized in *Tahzib un-Niswan*. A culmination of sorts for advocating education for women was a tract called *Stri Shiksha* published in Calcutta in 1908. All these texts and journals are important resources for women's history. While some dealt with education others carried writings on a range of issues such as purdah and women's rights. As education was among the great mediators between the private and public spheres, between the home and the world in a changing society, sources provide more records for it than other areas of women's lives (Minault 2003).

The process and extent of Muslim women's education during the colonial period has also been recorded in terms of aggregates in a number of sources. These include educational statistics collected by the colonial government (Progress of Education in India, Quinquennial Reviews, De-

cennial Census Records). The 1901 census recorded, for instance, that 400 Muslim girls had learnt English in the inner quarters of their homes. Institutional histories such as those of Eden College in Dacca, Bethune College in Calcutta, and Kinnaird College in Lahore are an important resource; additionally schools and colleges as corporate entities often formed *anjumans* or associations to advance their educational goals, kept records, and some have created their own archives. Memoirs and writings on women who pioneered women's education are also important sources for the interventions made by women and the difficulties they faced or the support they received from others.

ROKEYA

Among the most important and well-respected figures in the fields of education for girls and women's rights was Begum Rokeya Sakhawat Husain (1880–1932). Childless and widowed early in life she converted adversity into strength. Her personal troubles at home led her into making important social interventions. She opened a school for girls in Calcutta in 1911 that still exists. She was a pioneer nationalist, educationist and social reformer. Her wide-ranging writings, including the important text, *Sultana's Dream*, re-visioning gender relations by reversing the public/private divide in which women occupy the public sphere and men move into the private sphere, have been compiled as a collection. She vividly portrayed the lives of contemporary women in her writings and the obstacles and persecutions women like her suffered in a male-dominated and traditional society.

Sources pertaining to Muslim women for the late nineteenth to mid-twentieth centuries also contain material on the debates on the purdah system, on reconstituting the family, and what has come to be described as the "New Woman." Purdah was a concept that had accumulated an ideology behind it, and a practice that came to be viewed as placing limitations upon women and that pervaded the fields of education, family, work, and culture. Apart from many articles on the subject in journals and newspapers women themselves focused considerable attention on it as a campaign issue. *Motichur* is a collection of essays by Rokeya Sakhawat who regarded purdah as a form of enslavement and "religious" regula-

tion as mediated by men; purdah was a social rather than a religious custom. In her fictional work *Sultana's Dream* she inverted the regulations and put men within purdah while women ran the country. Similarly Iqbalunnissa Hussain wrote critically about purdah in *Changing India: A Muslim Woman Speaks* (1940). An article by an anonymous writer in a Hyderabad based paper (*Mu'allim un-Niswan* 10:2 [1896], 27–8) posed the question: why don't men go into purdah? But the ruler of Bhopal who herself ruled while maintaining purdah defended the institution in many pieces of writing, such as *Al Hijab and Why Purdah is Necessary*, even though she was an enthusiastic champion of education for women. The custom of purdah was also vigorously debated within particular sects of the Muslims (such as Shī'ī Bohras of Western India), in journals advocating reform such as *Aage Kadam* (A step forward), a Gujarati monthly, and *Bombay Samachar*, which reported a speech of a woman called Shireen Mandiwala advocating the end of purdah. Following this report there were 27 letters written by Bohras in response to her position, many by men who were critical of women giving up the practice; the sources record that when Mandiwala refused to apologize for making her speech she was excommunicated.

Ideas of reconstituting the family and the process of creating what has been termed as the notion of "moral mothers" and women as custodians of the family spawned a series of writings outlining the new domestic ideologies. Texts such as *The Muslim Home, A Present to the Married Couple*, and *Samajhdar Bibi* (The intelligent wife) redefined the Muslim household and the role of women within it. *Moqsudul Momenin o Stri Shiksha* discussed the role of reformed model housewives. Similarly the New Woman was outlined as a trained mother in numerous articles by men and women in papers like *Masik Mohommedi* and *Mahila* and tracts such as *Prasuti o Shishu Mangal* and *Mayer Shiksha*.

As an aspect of the status of women, the safeguarding, restoring, and advancing of women's rights was a major issue in sources on women, and the need for reforms in the legal domain was thus advocated in a series of writings. Women were especially concerned about polygamy and it was discussed at various meetings. Records of meetings of women's organizations and conference proceedings and reports of such meetings in the newspapers indicate that women regarded polygamy as being against the "true" spirit of Islam; a resolution to this affect, passed in 1918 in

Lahore, was reported in the *Tahzib un-Niswan*. The resolution caused a minor furore and journals such as *'Ismat* carried attacks on it; sources for the period indicate that when it came to the crunch male reformers did not want women to set the agendas for themselves (*'Ismat* 20:3, March 1918). The question of property rights of women granted under the Sharī'a but eroded through customary practices in most of South Asia, which denied property rights to women, led to major changes through the passing of the Shariah Act in 1939. Women were to receive their due share and the act also safeguarded divorce rights. Muslim women's right to property was written about as early as 1915 in *Al-Eslam* in Bengal where Rokeya bemoaned its erosion in an essay titled *Griha* (Home). Rokeya wrote powerfully about the essential homelessness of women as they had no property rights at all in actual practice (*Nabanur* 2:5, [Ashwin 1311 B.S.], 243). However, the situation changed when the law formally recognized women's right to property according to the Sharī'a. The debates on Muslim women's entitlement to property preceding the passing of the Shariah Act are recorded in the *Legislative Assembly Debates of 1937–1939* (Simla: Government of India Press 1937, 1939). In conferring rights on women the act also provided for a common Muslim identity across India, overriding local custom.

By far the most important aspect of change in Muslim women's status, which, in a sense, encapsulated but went far beyond reform was the anticolonial struggle and the movement for national independence. Political rights for women and their participation in national struggles is documented in newspaper reports, memoirs, essays, papers, and records of women's organizations and in the proceedings of conferences. The All India Muslim Ladies' Conference (Anjuman-i-Khawatin-i-Islam) was founded in Aligarh in 1914 and reports of its proceedings were published every year. Female emancipation and the nationalist movement were conflated in women's writings and most significantly in their actions. The annual report of the twentieth session of the All India Ladies' Conference (1940), recorded the statement of Begum Hamid 'Ali urging men to "play fair" and drop their double standards: freedom meant not having reservations about it when it was proposed for women. Bi Amman, the mother of the famous 'Ali brothers who were key leaders of the Khilafat movement linked national freedom and religious freedom. Speaking before a mixed assembly she lifted the veil of

her burqa and announced that since all the men in the audience were her sons there was no need to maintain purdah – her family included all nationalists (*Independent*, Allahabad, 28 September 1921). It was Bi Amman who provided the metaphor of the nation as an extended family.

However, women's participation in national struggles did not automatically provide the resolution of the women's rights question: women's writings and reports of their speeches raise the question of whether women participated in national liberation struggles or in women's rights struggles, or in both. At the time of independence from colonial rule the question was yet to be answered. In the case of Muslim women in the national movement another crucial issue was whether women were part of a sisterhood across the religious divide or proponents of separatism and the two-nation theory, like many of the men were. These questions are discernible in the sources such as records of meetings of women's organizations and newspaper reports. The memoir of a prominent Muslim woman Shaista (Suhrawardy) Ikramullah who entered public life was titled *From Purdah to Parliament* and provides some understanding of political questions. Her memoir offers a valuable insight into the interior world of a Muslim household, class relations between domestic servants and mistresses, and many other vignettes of social life. It also describes a young woman's entry into politics and the growing divide between Muslims and Hindus leading to the formation of the Muslim League and the demand for Pakistan.

To summarize, the sources for 1900–47 are heavily influenced by the major concerns in building the identities of the Muslim community in the context of nation-state building processes. There are many sources for plotting the histories of Muslim women in the fields of education, families in transition, legal and social changes, and participation in nationalist struggles. In a sense all the sources – writings, records of speeches, essays, tracts, books and pamphlets – are issue driven as each has been written to persuade the readership about a point of view in the larger project of reform of Muslim society and culture. However, because the reformist positions were always contested the picture that the sources present is not one-sided; in fact we can even hear the voices of women going beyond the mainstream agenda of the time. Also, because there was a great deal of "organic" writing, especially in languages like Urdu and Bangla, not dictated by official considerations of the colonial rulers, there is a multiplicity of points of view. There was little writing sponsored by the government on Muslim women in particular as purdah removed women from scrutiny both literally and figuratively (see Minault 2003). Some of the sources available on Muslim women focus on "recording" events regarded as important by nations in the making. However the broad canvas of changes in the family in the process of transition is particularly well captured especially in women's memoirs, diaries, and essays. Unknown family archives such as the Tyabji papers and family diaries are beginning to come to light and be used; these archives sometimes possess rich collections not only of memoirs and diaries written by both men and women but also of letters written over an extensive period of time. An important novel-cum-memoir, *Sunlight on a Broken Column* by Attia Hossain, captures with great sensitivity the decades of the 1920s–40s as perceived by a girl from a declining landowning family. Another novel, *Aangan* (The inner courtyard), by Khadija Mastur is set in a Muslim household and is told from the point of view of its female protagonists; it is a politically sensitive though not a directly political novel that etches a world in transition. Similarly Qurratulain Hyder's *Aag Ka Darya* (River of fire) provides a sweeping and powerful view of a rich civilization torn asunder by the impending partition of the sub-continent.

The class-specific dimension of these sources is striking: they represent the emerging middle class and the declining class of the large landowning elite, which were the classes that defined the embryonic nation. The limitations imposed by the sources mean that we do not know enough about the domestic labor of women, even of the middle class. Virtually nothing is known about other categories of women who formed the laboring underclass and were the bulk of the people in this region, a large lacuna. In a recent study Sonia Amin, a feminist historian, has supplemented the written sources for Muslim women in the Bengal region who are now living in Bangladesh by interviewing 50 women – housewives, teachers, writers, educationists, politicians, and so forth – to examine the nature of changes in the family, society, and culture of Muslim women in the Bengal region of the sub-continent. But since the interviews are confined to the middle-class woman, who was the focus of her study, this addition of a "new" set of source materials, which opens up a useful methodology, needs to be used more widely across the class spectrum to enable writing on other categories of women. One such study

by Kavita Panjabi, where the oral interviews are complete but have not yet been published, is on the participation of peasant and laboring women in a movement of share-croppers called the Tebhaga movement in undivided Bengal in 1945-6.

Because of the nature of research interests the available sources have not been fully utilized. Legal documents and court records, for example, await serious attention and have rarely been examined. One significant essay by Asiya Siddiqi, however, should serve as an example of the potential of this under-utilized archive: "Ayesha's World: A Butcher's Family in Nineteenth-Century Bombay." As the narrative of a legal case unfolds we see the emergence of new property relations as an unlettered woman negotiates her way through the labyrinths of the court. She is aided in her case by members of newly forged communities in urban settings and by lawyers as she struggles to retain a bungalow willed to her by her husband.

A field that could become a rich resource for the social history of Muslim women is the photographic archive; except for a few collections this archive is as yet only in the process of making. A photographic archive of the ruling family of Bhopal is available in the India Office Library in London. Research by Sabeena Gadihoke is currently under way to explore the history of the *janana* (*zenana*) studio in Hyderabad where women in purdah were photographed, most likely by other women. Many families have photographs that are likely to disappear if they are not immediately retrieved and preserved as a source for the study of women.

1947-2002: PAKISTAN

Pakistan, the land of the pure, was carved out of the Indian sub-continent in 1947 and comprised two major wings: West Pakistan and East Pakistan. As a new nation-state ideologically justified on the principle of religious unity it had attracted considerable interest from women in the anticolonial struggle, which does not find adequate mention in official literature or other government sources. However, a well written and well received novel, *The Divided Heart* by a woman writer, Mumtaz Shah Nawaz, from a well known and active political family of Pakistan, captures the period before the formation of Pakistan and ends in 1947. Official records of the colonial government provide the grand narrative of the birth of the "nation" – meetings between leaders and treaties signed by them, the drawing of boundaries – but in these neither women nor

their concerns figure. The real challenge in the recording of historical events came as soon as the borders were established and the movement of people across these borders began. This was then accompanied by large-scale violence on both sides of the two borders that impacted women in specific ways, including their abduction by men of another community. Official records of the governments of India and Pakistan do provide some basic information – speeches in the national assembly, newspaper reports, and other types of writing of prominent national leaders. The Inter-Dominion Treaty between the new nation-states of India and Pakistan to trace women who had been abducted in the course of the violence is an important official document. It records the processes for the recovery and restoration of the abducted woman to her natal or her original marital family. But women's own experiences of the partition including its violence and the rehabilitation of women's lives do not feature in official documents. This lacuna is currently being filled in by oral history, by seeking accounts from women who were affected by the events of 1947-8 in a project now underway in Pakistan, and one that has already been completed on the Indian side, conducted by a team of women researchers. Since women researchers have felt the need to examine certain events they have had to generate their own source materials such as the study on partition and also on many other areas of women's lives. The continuing consequences of "partition" within Pakistan, between various communities regarded as locals and outsiders, especially in Karachi, studied for example by Rubina Saigol (*The Partitions of Self: Mohajir Women's Sense of Identity and Nationhood*) have also generated data and analyses on women in conflict situations by various independent research units associated with non-governmental organizations (NGOs).

All the nation-states in South Asia have sought to provide official accounts of historical events and these have been colored by statist interests to varying degrees. Data compiled by governmental organizations in Pakistan, as elsewhere, have focused on subjects such as education, mortality, family size, and work, continuing the colonial government's practice of conducting the decadal census. Apart from the census the departmental generation of statistics, such as in the field of education and health, as well as the statistics compiled for the purpose of the five-year plans, also provide baseline data. The government of Pakistan appointed a commission to inquire into

the status of women that was published in 1985 as the *Report of the Pakistan Commission on the Status of Women*. The utility of such large-scale aggregative data notwithstanding, there has been a marked shift in recent years to many other bodies such as UN development agencies, the World Bank, and NGOs associated with development interventions in generating data as well as in providing analyses of women's condition and status in a variety of fields.

None of the statistical data mentioned above can provide qualitative analyses on women. For the qualitative experiences of women reports of women's organizations such as the All Pakistan Women's Association as well as the accounts that are available in biographies and memoirs of leading members of such organizations are being used. Transformations in the legal position of women as the nation-state tried to reform the laws affecting women were first initiated with the adoption of the Muslim Family Laws Ordinance in 1961. The ordinance resulted typically in a debate on the validity of polygamy, reported in newspapers like *Dawn* and the *Pakistan Times*, as the new law sought to restrict its practice and was therefore opposed by the conservative sections of Muslim society. More fundamental changes occurring in 1979 in the form of the Hudood Ordinances have been significant in women's resistance movements and the birth of the Women's Action Forum (WAF) a women's group with branches across Pakistan. Its records provide documentary evidence for the women's movement and the campaigns that it conducted around the law and on violence against women. Campaigns and legal interventions in the last two decades of the twentieth century to safeguard women's rights also form an important set of documents.

By drawing attention to the existing bases of knowledge and the limitations of traditional sources, feminist scholarship has focused on the need for new methodologies in generating data on women. Apart from anthropological studies, women-centered NGOs have spearheaded field-based studies in Pakistan on women's education, health, development, work, occupation, access to property, and violence against them. Women's groups are now collaborating with government departments to conduct studies. They are also generating their own data on particular aspects of women's work, health, and fertility behavior among other areas of focus as well as creating and maintaining their own informal archives. The working of customary law and traditional forms of punishment are being documented by journalists and women's rights activists, especially practices like *karo-kari* and what is euphemistically called "honor" killings. Court records and case proceedings as reported in compilations such as the annual publication of the *Pakistan Legal Decisions* for different benches and other selections like the *Key Law Reports* put together by members of the bar are also being used to examine state institutions as they curtail or expand women's rights through judicial pronouncements. Research on violence against women in particular is based upon the legal arguments and judgments in cases that have tested the legal system in Pakistan. A major work, *Shaping Women's Lives: Laws, Practices and Strategies in Pakistan* (1998), documents and examines legal practices with relation to the working of family laws and to violence in the everyday lives of women, as well as the working of distinctive and contradictory legal systems. It is the outcome of the Woman and Law Country Project sponsored by an NGO.

Following the emergence of the women's movement in Pakistan in the early 1980s there have also been some attempts at documenting the women's movement itself, not just through writing its history but in new ways. One area that is being explored is the visual field, through short films such as *When This Day is Named* on women's groups such as the WAF and the Sindhiani Tehereek, a movement of women in Sindh. Plays crafted to mobilize opinion against the Hudood Ordinances have also been filmed on video. Visual documentation is a developing field that is making for a new methodology in creating alternative sources for women's history. The lives of creative artists, actresses, singers, and artists are also being documented, both visually and in written accounts. An important intervention in the archiving of sources for 1900–2002 is the setting up of the South Asian Research and Resources Center in Islamabad, which houses material like the women's journals and other sources for the period as well as pamphlets, manuscripts, published and unpublished documents, posters, and other campaign materials produced by women's groups. This venture needs to be replicated in all the South Asian countries as the ephemera produced by women's groups is a rich resource on women and is likely to disappear otherwise.

Another rich resource for Pakistani women's experience has been the field of creative writing.

Women have written powerfully of their lives, of purdah, and domestic violence in short stories, novels, and above all in verse form. Feminist *mushāïra*s where women read out their poetry or sing their *ghazal*s provide a forum for self-expression, for reiteration of their solidarity for the feminist project and disseminating women's views. These sessions are being video-taped and will add to the visual and oral corpus of material available on women. The women's movement has also tried to uncover the lost histories of poor and marginalized women. One such recovery is the life of Mai Bakhtawar who died resisting feudal oppression in Sindh.

Mai Bakhtawar

The first known martyred peasant woman in Sindh was Mai Bakhtawar. She was born in the small town of Talhi in the Umerkot district in the Lashari caste. In the 1940s a peasant movement began in Sindh against the oppressive conditions imposed by the landlords. Mai Bakhtawar's family was very active in this movement. In June 1949 a peasant conference was held at Judho, which all the men of Mai Bakhtawar's family attended, leaving only her and an old man behind. It was the season when the produce is divided. Taking advantage of the absence of the peasant men the landlord's musclemen tried to take away a huge share of the wheat crop. Mai Bakhtawar stood firm and refused to let them carry away the wheat, refusing also to be cowed by the threat to kill her. Finally she was shot on the orders of the landlord, falling upon the wheat that she refused to let go. The peasant movement gathered momentum after this and the government was forced to accept the demand of half share for the sharecroppers. Mai Bakhtawar's resistance is part of the oral folklore of the region.

Bangladesh

Although Bangladesh became an independent nation-state only in 1971 its history is often taken back to 1905 when a strong movement swept over the colonial province of Bengal, or to 1947 when Pakistan was created following the partition of the sub-continent into two territorial units: East Pakistan comprising the Bengali speaking region and West Pakistan comprising the rest of the regions. Fairly soon thereafter questions of the distinctive identity of East Pakistan began to surface with the language movement of 1951; ultimately Bangladesh separated from Pakistan after a violent struggle in 1971.

Sources for women's history have been strongly shaped by these political developments. During 1947–71 the focal point of social intervention in the field of women's development remained education in the province of East Pakistan. A woman's weekly journal published in Bangla, *Begum*, reflected the concerns of a new community in the combining of religious identity with a linguistic and cultural identity that was unique to the region. Newspaper interviews with Begum Sufia Kamal, an important poet and literary figure, as well as accounts of her life and work, also reflect these multiple identities and concerns. She was the co-founder of a weekly magazine titled *Sultana* and a member of the Purba Pakistan Mahili Samiti, a women's organization of East Pakistan; the records of both are a source for Bangladesh for the 1950s and 1960s. Sufia Kamal's *Ekattarer Diary* (1971 diary) is a day-by-day account of the 1971 struggle for the liberation of her people.

The crucial moment in the nationalist consciousness of Bangladesh, shared by its women, was the war of 1971 and the birth of Bangladesh. Formal recognition of this nationalist consciousness was given in 1977 when the government of Bangladesh took the initiative of forming a commission for the writing of the history of Bangladesh going back to 1905 but concentrating on 1971. *Bangladesh Swadhinata Juddha Dalilpatra* (Dhaka: Bangladesh Government 1982–5), the collection of documents pertaining to the war, comprises 15 volumes that provide an important set of official sources that are a resource for women's history too. A major marker in the lives of men and women, 1971 has been written about in memoirs and other personal accounts. Jahanara Imam's *Ekattarer Dinlipi* (Dhaka 1994) and Begum Mushtari Shafi's, *Swadhinata Amar Raktajhara Din* (My bloody days of independence, Dhaka 1992) provide an account of 1971 as perceived by women who watched their families being arrested and killed or themselves experienced violence at the hands of an army of occupation.

More recently a volume of oral narratives of ordinary, unknown and unsung women who lived through the Bangladeshi war of liberation in 1971 has been published by the Ain-o-Salish Kendro, a women's legal intervention group. Comprising testimonies of victims of rape and other forms of

violence this new source seeks to make up for the silences in the official accounts of the state; the official accounts may refer to rape but only as part of the dishonor of a community. They do not concern themselves with the way women experience such events. Women's own testimonies in the *Narir 71 Juddho Poroborthi Kothho Kahini* (1971 for women: testimonies after the war), as the editors point out, reveal that 1971 represents not just a single event experienced by women but an unending series of indignities that standard histories never allude to.

A documentary film portrayal of 1971, *Muktir Katha* (The story of liberation), by Tariq Masud provides a realistic account of the Bangladeshi war of liberation. Another film, *Itihaser Kanya* (Daughter of history), also provides a semi-fictionalized history of 1971 dealing with the lives of a middle-class family deeply affected by the violence of the war of liberation.

Sources for women for the period after 1971 are mainly available in the many field-based works of anthropologists and development specialists who have generated their own data on the rapid economic and social changes underway in Bangladesh. The Bangladesh Rural Advancement Committee (BRAC) has compiled data on literacy and empowerment. Intensive fieldwork by scholars has researched women's participation in labor in various manufacturing sectors, especially the garment industry. On the basis of these studies feminist scholars have tried to analyze the impact of work on the mobility of workers and the choices that they make and their perception of their own changed status following their entry into the labor market (Kabeer 2000). The backlash to the empowerment of women in terms of opposition from conservative and fundamentalist segments is also the subject of field-based studies. The lives of rural development workers who form the personnel for large-scale NGO activity in Bangladesh have also been studied. All the field-based sources provide an insight into the shifting and complicated perceptions of purdah. As always, legal records are an important source for women's history; apart from the published reports of the *Dhaka Law Reporter* and the *Bangladesh Law Digest* the records of the Ain-o-Salish Kendro in Dhaka comprise an archive in the making. These sources have enabled an understanding of women's rights to property, divorce, and maintenance and of the relationship between Islamic law and constitutional law in Bangladesh.

A recent work by Perveen Ahmad examines an aspect of women's daily lives in the form of the craft of *kantha* making. The *kantha* was a way of using old cloth that was stitched together to make items of daily use such as babies' bedclothes and light coverings for use at night. These *kanthas* are reflections of the rich syncretic traditions, Buddhist, Islamic, tribal, and Hindu so typical of the region, absorbed by women, and the aesthetics and vocabulary through which they express themselves. This kind of research is an example of the attempt to use new sources and alternative methodologies to established ways of producing knowledge.

INDIA 1947–2002

The partition of the sub-continent in 1947 was accompanied by large-scale violence between communities that affected women in specific ways. For about three decades this historical experience remained undocumented except in official accounts produced by the colonial government and the two new governments of India and Pakistan, and in the fiction of Urdu writers on both sides of the border. At the turn of the millenium, an epistemic shift was spearheaded by feminist writers who pioneered the field of partition studies. They used the "conventional" sources available for the period – official documents and treaties between the two new countries – along with sources not used till then. These include memoirs written by women who were involved in the rehabilitation efforts of dislocated women, and oral narratives of women who lived through 1947 collected by these writers to provide new accounts focused on women, children, and other marginalized groups (Ritu Menon, *Borders and Boundaries*, 1998 and Urvashi Butalia, *The Other Side of Silence*, 1998). An important memoir of 1947–8, by Anis Kidwai, a woman who lost her husband in the violence and then threw herself into the work of rehabilitation is *Azadi ki Chhaon Mein* (In the shadow of independence). Another is Kamlaben Patel's *Mool Suta Ukhdela* (Torn by the roots). An important legal case questioning the forcible restraining of a woman and her right to protection by the state that went up to the high court is a classic example of a legal battle around a young woman who was "abducted" but never actually spoke herself throughout the period when the case was being heard.

The period 1947–86 has remained relatively undocumented and under-researched for women of all communities in India; the secular principles upon which post-independence India organized its generation of data meant that not much specific

information or data on Muslim women as a distinctive category are available. For example, the Commission on the Status of Women (1975) looked at women as an aggregate category: divisions were based on class rather than caste or religious community. However, Shaheeda Latif (1990) conducted her own survey in nine cities in the 1970s to examine the relationship between the position of the Muslim community in society and the status and role of Muslim women in a minority community. Anthropological field-based data and analyses of the data of specific Muslim communities in different locations including a focus on women were also conducted and provide a source for the period. Patricia Jeffery's *Frogs in a Well* (1979) documents the lives of women observing purdah in Delhi and explores the link between women's work and their families. Similarly Sabiha Hussain's study (1998) of Muslim women in North Bihar addresses the question of women's work outside the home against the backdrop of the customary restraints of exclusion and seclusion. Leela Dube's work (1996) on matriliny in a Muslim community in Lakshwadweep, an island off the southwestern coast of India provides a source for the accommodation of Islam with local custom, and other studies are a source for education, family structures, and rituals amongst Muslims of certain regions. All the anthropological work points to the wide variation in the status and experiences of women according to region, class, and other factors. This wide variation is never recognized, however. For example, many works of fiction provide an account of women's lives during this period, as do popular films. While the former is suggestive of the variations the latter invariably flattens the variations; here a specific genre of films has focused on Muslim households of Uttar Pradesh in North India and has given rise to what are called the Muslim "socials," which are represented as if there is only one kind of Muslim household in all of India. A different and low-key account of a woman from a wealthy and conservative Muslim family who traveled to England and studied to become an eye surgeon is provided by Hamida Saiduzzafar's autobiography (1921–88) and includes some charming photographs.

One region that had a majority Muslim population was the valley of Kashmir, where identity formation within a distinctive region provided the ground for a major thrust in reform and change and the opening of opportunities for women among both the majority community of Muslims and the minority community of Hindu Kashmiri Pandits. These changes, especially in the field of education, are the focus of a new study by Farida Abdulla Khan (forthcoming) using official data, institutional histories, and oral narratives from women who participated in the process of the expansion of education since 1948.

In 1986 a famous case of maintenance and its interpretation within the Sharīʿa, popularly known as the Shah Bano case, precipitated a more intensive focus on Muslim women in India, and especially on Muslim personal law (Hasan forthcoming). The law and its application in a plural society led to much writing that continues to engage with the centrality of Muslim women in identity formation in relation to the identity of Muslims as a minority community in India. This focus on the question of legal equality in the matter of personal law also "politicized" the Woman Question, as the editors of a forthcoming book (Hasan and Menon) based on a new study point out, and contextualized it with reference to larger political forces at play in India and between communities. At the same time the awareness generated by the Shah Bano case also directed attention to the limitations of existing research and the lack of reliable data on the status of Muslim women in India. This led to a number of projects that are a combination of qualitative data and the raising of new questions in the field of education, work, marriage, divorce, maintenance, and inheritance patterns amongst Muslim women. These studies will go part of the way to fill the existing lacuna on Muslim women in India.

Since legal questions have been at the forefront of the public debates on the status of Muslim women and the need for reform, the diversity of customary practices amongst Muslim communities and the wide range of solutions sought by women both in the formal legal sphere of the courts and the community councils are being studied through projects of different dimensions. The project entitled "The Diversity of Muslim Women's Lives" has proceeded along two tracks: one is devoted to generating baseline data on a variety of indices, and the other is concerned with focused studies of education, legal status, and culture. One segment of this project by Nasreen Fazalbhoy and Sylvia Vatuk is exploring marriage, inheritance, and property issues and the means by which disputes in these areas are resolved in the *jamaat*s of Chennai in southern India and Mumbai in western India.

An important source in the visual field are films that explore the complexities of Muslim women's lives within the framework of social and political

challenges faced by the community (for example, Saeed Mirza's *Naseem*, 1994 and Shyam Benegal's *Hari Bhari*, 2000, especially the segment titled *Ghazala's Story*). Serials such as *Heena* have been popular on television and have contributed to stereotypical representations of Muslim women and thus contributed to a certain perception of Muslim women's identities as inevitably determined by Muslim personal law, especially of the triple *ṭalāq*, a peculiarity of South Asia. On the other hand the accounts of Muslim women in the arts such as music, theater, and particularly cinema, are not only an important contemporary resource, but also a crucial source for breaking stereotypes. One interesting intervention in the visual field, *In Search of Safia Khan*, deals with the pursuit of historical figures from the pre-partition period who have "disappeared" from the public imagination after their migration to Pakistan. To make up for more everyday forms of disappearances there continues to be the need to locate primary materials from family sources, from institutions, and from other places where they could be gathering dust. At the same time there is the need to use creative strategies to form new sources and expand the methodologies that feminist scholars have initiated to compensate for the silences, biases, and limitations in the existing sources. These strategies will help to form a body of knowledge about women that captures the many dimensions of their lives whatever their social and economic location may be. In this context the manner in which Muslim women and women of other communities in South Asia have sought to cross the limitations set by national boundaries has been significant. Research on themes such as violence against women, the working of personal laws, and access to resources within a South Asian perspective as in the partition studies cited above have opened up new fields. A powerful short story, "The Earth is Ablaze and the Heaven's are Burning," by the Pakistani feminist writer Zahida Hina on Shah Bano is an important statement pertaining to Muslim women across the boundaries of nation-states.

CONCLUSION

Before independence and up until the birth of the women's movements of the late 1970s in the three nation-states of India, Pakistan, and Bangladesh, giving rise to the emergence of a more self-conscious feminist scholarship, sources for research on women were conventional mainstream sources with their concomitant limita-

tions – in the main, ranging from silence, to marginalization, to trivialization. There was no conscious attempt to create a feminist archive or use a feminist methodology although throughout 1900–80 sources were being generated. In the last two decades of the last millenium and continuing into the new millenium there has been a conscious attempt to move to the use of new methodologies in order to compensate for the limitations of existing knowledge. These methodologies have given rise to a new set of questions to be explored in order to make up for the limitations of mainstream scholarship, and the conventional archive relied upon hitherto historians; it is these questions that have yielded almost all of the studies cited here.

BIBLIOGRAPHY

PRIMARY SOURCES
N. Ahmad, *Collected works*, Lahore 1994.
Shaheen Akhtar and Moushumi Bhowmik (eds.), *Janana mehfil*, Calcutta 1998.
Beyond belief. Contemporary Urdu feminist poetry, Lahore 1990.
Khwaja Altaf Hussain Hali, *Chup ki dad* (Homage to the silent) Delhi 1986; first published in *Khatun* 2:12 (December 1905).
S. S. Ikramullah, *From purdah to parliament*, Oxford 1997.
A. Kidwai, *Azadi ki chaon men* (In the shadow of independence), Delhi 1990.
Khatun, journal published from Aligarh, files available at the Aligarh Women's College, Aligarh.
Muʿallim un-Niswan, vols. 8–14, 1894–1901, Library of the Idarah-i-Adabiyat-i-Urdu, Hyderabad and the Sajan Lai collection of newspapers at the Osmania University Library, Hyderabad, India.
An-Nissa, Hyderabad 1925–. Humāyūn Mīrzā files available at Urdu research centre, Hyderabad, India.
Kamlaben Patel, Mool Suta Ukhadela (Torn by the roots), English translation, unpublished ms.
Malka Pukhraj, *Song sung true. A memoir by Malka Pukhraj*, trans. Salim Kidwai, Delhi 2003.
Rokeya rachanabali (Collected works of Rokeya), Dhaka 1980.
Sakhawat Hossain Rokeya, *Sultana's dream*, ed. and trans. Roushan Jahan, New York 1988; first published in the *Indian Ladies Magazine*, Madras 1905.
Sachhe Moti, Lahore 1930.
Hamida Saiduzzafar, *Autobiography*, ed. Lola Chatterji, Delhi 1996.
Sharif Bibi, Lahore; files available at Urdu Research Centre, Hyderabad.
Smriti o Katha 1971, Ain-o-Saalish Kendra, Dhaka 1999.
Jahanara Shah Nawaz, *Father and daughter*, Lahore 1971.
Jehan Begam Sultan, *An account of my life (Gohar-I-Iqbal)*, trans. C. H. Payne, London 1912.
Tahzib un-niswan, Lahore; partial files available at the Library of the Aligarh Muslim University, the Aligarh Women's College Library, and the Urdu Research Centre, Hyderabad, India.
Zafar ʿAli Begum, *Mere shab-e roz*, Srinagar 1983.

TYABJI FAMILY PAPERS

Akhbar-ki Kitab (Mrs. Tambi Mattoo).

Akhde-Surayya minutes, ca. 1888–1976 (Mrs. Camar Sikander Futehally).

Safia Jabir Ali, Memoir, BTFP VI.

Asaf A. A. Fyzee, The autobiography of Tyabjee Bhymeeah. With an introduction and notes, in Journal of the Asiatic Society (N.S.), 36–37 (April 1964), special supplement.

Khutoot-e-Shibli, Letters of Maulana Shibli Nomani to Atiya and Zorra Fyzee, ca. 1906, ed. Md. Amin Zuberi, foreword by Abdul Haq, Lahore 1935.

Abbas Tyabji, Autobiography.

Amiruddin Tyabji, Letters written from Le Havre, France, 1870.

Badruddin Tyabji, Akhbar-ki Kitab, 1880–1906, 5 vols., copied by Safia Jabir Ali 1958 (Badruddin Family Papers VI BTFP VI).

Faiz Tyabji collection, diaries, account books, letters, fee books of the Tyabji clan ca. 1890–1930 in Urdu and English (Camruddin Tyabji).

Unpublished papers in the Nehru Memorial Museum and Library, New Delhi, and in private collections, Bombay.

SECONDARY SOURCES

Aage Kadam, Gujerati monthly journal.

S. N. Amin, Nari-o-Samaj, in Siraj-ul-Islam (ed.), Bangladesher Itihas, vol. 2, Dhaka 1992.

——, The world of Muslim women in colonial Bengal 1876–1939, Leiden 1996.

ASR film unit, When this day is named (film on the women's movement in Pakistan) Lahore.

Bombay Samachar, daily newspaper

U. Butalia, The other side of silence. Voices from the partition of India, New Delhi 1998.

——, Legacies of departure. Decolonisation, nation-making and gender, in Phillipa Levine (ed.), Oxford history of the British Empire. Companion volume on gender, Oxford University Press (forthcoming).

U. Chakraborty, Muslim women at the crossroad. Quest for identity, in J. Bagchi et al., Education and empowerment. Women in South Asia, Calcutta 2001, 75–116.

——, Muslim Nari, Uchcha Shiksha (Higher education for women), Bethune College, Itihas Anusandhan, vol. 13.

L. Dube, Who gains from matriliny? Men, women and change on an Indian island, in R. Palriwala and C. Risseew (eds.), Shifting circles of support. Contextualising gender and kinship in South Asia and Sub-Saharan Africa, Delhi 1996.

J. L. Erdman with Z. Segal, Stages. The art and adventures of Zohra Segal, New Delhi 1997.

N. Fazalbhoy, Muslim women and property, in Z. Hasan and R. Menon (eds.), The diversity of Muslim women, Oxford University Press (forthcoming).

——, Sociology of Muslims in India. A review, in Economic and Political Weekly 32:26 (1997), 1547–51.

A. Flavia, Judgement call. An insight into Muslim women's right to maintenance, Bombay 2001.

S. Gadihoke, The photographic practices of women in India 1840–2000, in preparation.

G. Geetanjali and S. Kazi, Customary practices among Muslims in Gomia, Bihar, in Women living under Muslim laws, Dossier 18, July 1997, 109–123.

R. Ghadially, The campaign for women's emancipation

in an Ismaili Shia (Daudi Bohra) sect of Indian Muslims: 1929–1945, in Women living under Muslim laws, Dossier 14/15, September 1996, 64–85.

D. Gilmartin, Kinship, women and politics in 20th-century Punjab, in G. Minault (ed.), The extended family. Women and political participation in India and Pakistan, New Delhi, 1983, 151–73.

Z. Hasan, article on the Shah Bano affair, in EWIC II, Brill (forthcoming).

—— (ed.), Forging identities. Gender, communities and the state, New Delhi 1994.

Z. Hasan and R. Menon, The diversity of Muslim women in India, Oxford University Press (forthcoming).

S. Hashmi, Uncovering the visible. Women artists of Pakistan, Lahore 2002.

S. Hussain, Attitudes and aspirations of Muslim women towards employment. A case study of Darbhanga, in H. Hashia (ed.), Muslim women in India since independence. Feminine perspectives, New Delhi 1998.

N. Husain, S. Mumtaz, and R. Saigol (eds.), Engendering the nation-state, vol. 1, Lahore 1997, 242–59 and 199–241 (see in particular N. Shah, Role of community in honour killings in Sindh, and N. Husain, Narrative appropriations of Saima. Coercion and consent in Pakistan).

Q. Hyder, Aag ka darya (River of fire), New Delhi 1998.

In search of Safia Khan, video, Mumbai 1999.

A. Jalal, The convenience of subservience. Women and the state of Pakistan, in D. Kandiyoti (ed.), Women, Islam, and the state, Philadelphia 1991, 77–114.

P. Jeffery, Frogs in a well. Indian women in purdah, London 1979.

H. Jilani, Human rights and democratic development in Pakistan, Lahore 1998.

N. Kabeer, The power to choose. Bangladeshi women and labour market decisions in London and Dhaka, London 2000.

S. Kamal, Mother of pearls and other poems, ed. and intro. S. Kamal, Dhaka 2001.

F. Kazmi, Muslim socials and the female protagonist. Seeing a dominant discourse at work, in Z. Hasan (ed.), Forging identities. Gender, communities and the state, New Delhi 1994, 226–43.

F. A. Khan, Other Muslims, other histories. Fifty years of women's education in Kashmir, in Z. Hasan and R. Menon (eds.), The diversity of Muslim women, Oxford University Press (forthcoming).

M. Khatija, Aangan (The inner courtyard), Lahore 2000.

M. Khawar and F. Shaheed (eds.), Women of Pakistan. Two steps forward, one step back? London 1987.

S. Kidwai, Images of Muslim women. A study on the representation of Muslim women in the media 1985–2001, in Z. Hasan and R. Menon (eds.), The diversity of Muslim women, Oxford University Press (forthcoming).

G. C. Kozlowski, Muslim women and the control of property in north India, in J. Krishnamurti, Women in colonial India. Essays on survival, work and the state, New Delhi 1989, 163–81.

S. Latif, Muslim women in India. Political and private realities, New Delhi 1990.

Lutfullah, Autobiography of Lutfullah. An Indian's perception of the West, New Delhi 1985.

Maleka Begum, Banglar Nari Andolan (Bangladesh women's movement), Dhaka 1989.

M. Maskiell, Women between cultures. The lives of Kinnaird alumnae in British India, Syracuse, N.Y. 1984.

R. Menon and K. Bhasin, *Borders and boundaries*, New Brunswick, N.J. 1998.

G. Minault, Sisterhood or separatism. The All India Muslim Ladies' Conference, in G. Minault, *The extended family. Women and political participation in India and Pakistan*, Delhi 1981, 83–108.

——, Shaikh Abdullah, Begam Abdullah and sharif education for girls at Aligarh, in I. Ahmed (ed.), *Modernisation and social change among Muslims in India*, New Delhi 1983, 207–36.

——, *Secluded scholars. Women's education and Muslim social reform in colonial India*, Delhi 1998.

——, Mid-18th to Early 20th Century: South Asia, in EWIC I, Brill 2003.

Y. Mitha et al., *Patterns of female employment in mining and construction industries*, Islamabad 1988.

——, *Solid foundations, solid contributions. Women in the brick kiln industry*, Lahore 1989.

——, *Building your dreams. Women in the construction industry*, Lahore 1989.

——, *Another form of stoning. Women at the quarries*, Lahore 1989.

Muslim women speak. Testimonies of women, Women's Action and Resource Unit, Ahmedabad 2000.

C. M. Naim, How Bibi Ashraf learnt to read and write, *Annual of Urdu Studies* 6 (1987), 99–115.

V. Nainar, *Muslim women's views on personal laws. The influence of socio-economic factors*, Bombay 2000.

J. Nishat, *A poem slumbers in my heart*, Mumbai 1999.

K. Panjabi, *Women in the Tebhaga movement. Oral narratives and perpectives*, work in progress.

H. Papanek and G. Minault (eds.), *Separate worlds. Studies of purdah in South Asia*, Delhi 1982.

A. Perveen, *The aesthetics and vocabulary of Nakshi Kantha*, Dhaka 1997.

N. Said Khan, Identity, violence and women. A reflection on the partition of India 1947, in N. Said Khan et al., *Locating the self*, Lahore 1994, 157–71.

——, *Voices within. Dialogues with women on Islam*, Lahore 1992.

R. Saigol, *The partitions of self. Mohajir women's sense of identity and nationhood*, Islamabad 2002.

M. Shah Nawaz, *The heart divided*, Lahore 1990.

F. Shaheed et al., *Shaping women's lives. Laws, practices and strategies in Pakistan*, Lahore 1998.

A. Siddiqi, Ayesha's world. A butcher's family in nineteenth-century Bombay, in *Comparative Studies in Society and History* 43:1 (2001), 101–29.

S. Sultan Jahan, A brief account of Muslim female pioneers of education, in J. Bagchi et al., *Education and empowerment. Women in South Asia*, Calcutta 2001.

Tyabji Salima, *A nineteenth-century family document from Bombay. The Tyabji family Akhbar-ki Kitab*, in preparation.

Voice of the voiceless, Muslim women's forum, New Delhi 2000.

H. Zahida, The earth is ablaze and the heavens are burning, in S. Rehman (ed.), *In her own write. Short stories by women writers in Pakistan*, Lahore 1994, 109–33.

UMA CHAKRAVARTI

Sub-Saharan Africa: Early 20th Century to Present

INTRODUCTION

Research on Muslim women in Sub-Saharan Africa specifically is sparse, and the topic has only recently received scholarly attention. In fact, the study of African women in general is a neglected area for a number of historical reasons. The paucity of sources and methods of research on Muslim women in the region affects the study of all women living in Sub-Safaran Africa. While African women were invisible in terms of scholarly research for most of the twentieth century, some noticeable changes took place in its final two decades (Mama 1996, 3). Since the 1980s there has been a visible increase in the allocation of resources for advancing women's causes in Sub-Saharan Africa. Much of this was dedicated to women's development, education, and health. The collateral effect of this focused allocation of resources has made at least a small impact on our understanding of the lives and histories of women on the continent.

For a long time African Muslim women were studied only by colonial authorities and by non-African scholars from Europe and North America. At first most of these studies were undertaken by anthropologists and colonial officials. Later, sociologists and political scientists gave some attention to African societies, including women, especially in the post-independence period of the middle of the twentieth century. In the last two decades the most positive development of all has taken place: a large number of African scholars are themselves studying their societies and examining the conditions of women in a variety of disciplines including gender studies, politics, sociology, literature, and anthropology. In addition to the view of outsiders, we now also have the voice of Africans about their lived experience.

Several initiatives are responsible for putting the spotlight on women in Sub-Saharan Africa. In 1985 the United Nations Decade for Women held its final conference in the Kenyan capital of Nairobi. That meeting brought significant dividends for African women. It resulted in an improved understanding between Western and African women, especially of each other's political viewpoints and agendas. This was markedly different from the mutual acrimony that was displayed between the two sides at previous United Nations conferences a decade earlier. The Nairobi conference gave visibility to the plight and struggles of African women and increased awareness of their needs. International aid also began targeting women through more aggressive funding for education and through developmental programs via non-governmental organizations (NGOs), religious charities, and institutions of civil society. The most devastating pandemic that threatens the lives of millions of Africans has also been the cause for greater attention given to African women. It is now well established that women are most at risk of being affected by the deadly HIV/AIDS virus among all sectors of the population. Paradoxically, the scourge of disease and poverty is bringing greater attention to the needs of the continent. While aid and monetary resources are directed at women's populations generally, and are not aimed at women in terms of their religious affiliation, Muslim women have certainly benefited from improved conditions of women in Africa.

Muslims constitute roughly 27 percent, or some 129 million people, in 48 Sub-Saharan countries, and are the majority in 9 states. If by conservative estimates women make up half the population, this means that there are roughly 65 million Muslim women south of the Sahara. If one goes by a higher 60 to 70 percent ratio of women to men, then the number of Muslim women rises significantly. Literacy levels, life expectancy and income levels in these countries are generally among the lowest in the world. Thus, in addition to countering cultural biases against women, extremely challenging material conditions also affect Muslim women in this part of the continent.

For much of the twentieth century African societies have been in transition from one momentous set of changes to another. The most notable was the aftermath of colonial rule, producing struggles for independence and efforts in state-formation after independence. Subsequently, there has also been chronic instability through one-party rule, military coups, neo-imperialism, and struggles for democracy and pluralism. Thinkers, scholars, and political leaders are constantly addressing the causes for the lack of success in African societies compared to rapid development in parts of Asia and Latin America. This has sparked new struggles for democracy, the rule of law, and human rights.

Moreover, attention has rightly been given to the conditions under which women live and efforts to empower them in order that they may make an effective contribution to their societies.

HISTORIOGRAPHY

"Much of the literature on African women's history," writes one historian, "is both 'fugitive' and fragmented" (Hay 1988, 432). It is fugitive because for the most part it is not published in the mainstream academic journals. Much of it is not easily accessible because it is published in edited collections or special issues of journals. Otherwise, material is produced in the form of unpublished reports, incomplete dissertations, or writings that are not circulated in the conventional publishing and distribution forums. The mode of knowledge production in itself is part of a structural problem that makes African women invisible and only reinforces the ghettoization of women's history. In the last decade some very modest changes have taken place, giving the field of women's studies greater visibility compared to the 1980s. If women's history is marginalized generally in a part of a continent as diverse and complex as Sub-Saharan Africa, then the history of Muslim women is an even greater subaltern of obscurity.

While one must give credence to these very serious concerns, the current circumstances do not preclude an informed assessment of the state of Muslim women's studies in Sub-Saharan Africa. It goes without saying that given the difficulties of access and the state of our knowledge of what has been produced, the assessment will by its very nature be provisional. In the study of women in Africa we can discern several paradigms, including the nationalist and Africanist, the development-cum-dependency, the Marxist, and the cultural theory approach to mention only the most prominent (Zeleza 1997, 94, Mama 1997, 63).

Among the earliest writings on women were those by African nationalists whose pre-eminent concern was to combat the effects of imperialism and racial historiography constructed by colonial officials and their intellectual handmaidens. The popular myths in circulation were that Africans had no history prior to European colonialism. In their zeal to recover their own history, nationalist writers were often political in their thrust and elitist in their class predisposition, and they viewed the world from a male perspective. Thus their research had very little to say about the exploitation of women, gender, or class hierarchies. Historians concerned with economic development surely gave a great deal of attention to questions of economic exploitation, but in turn they did not put class, society, and gender discrimination into the calculus of exploitation. It was the critiques of Marxist historians that alerted nationalist and economistic historians to the fact that they were actually creating another set of elitist narratives by ignoring vital class struggles. But even Marxist historiography has come under criticism for being too dogmatic in search of precolonial modes of production in order to relate these to colonial modes of production. In all, the analytical approaches to gender analyses were terribly neglected.

Cultural theory, with its emphasis on the interdisciplinary approach to the study of women in Africa, holds greater promise. Its great advantage is that it offers a variety of analytical tools that mutually reinforce each other. It also has the advantage of hindsight; it will not repeat the errors that have already been highlighted in the critiques in each exclusive disciplinary field of study. Scholars are in agreement that there is a need to recover the precolonial and colonial history of women as well as to analyze the deep socioeconomic, class, and gendered structures in African society that inhibit the advancement of women.

Some writers believe that African feminist historiography has much more in common with Africanist historiographies in terms of methodology than with economistic and Marxist methodologies (Zeleza 1997, 99). In African sub-cultures where written sources are negligible or absent, oral history is a vital source for the recovery of African history. In some places the only written sources are those created during the colonial period. These sources often reflect the history of colonial officials and not the experiences of the people whose lives were rendered invisible by colonialism, let alone the lives of women. Feminist historians tend to privilege oral methods in order to dismantle entrenched biases and to give voice to historically suppressed groups, among whom women are more silenced than others.

However, in some of the colonial documents, especially court records, we can glean a great deal of information on the conditions of women. The work of Richard Roberts examining colonial court records in West Africa provides us with micronarratives on the conditions of Muslim women as they brought their cases to colonial courts for resolution. This field of study has the potential to shed much more light on the conditions of women as more scholars take up the challenge.

Records of Muslim judges (*kadhi*s or *qāḍi*s) wherever they survive, juridical *responsa* (fatwas) of Muslim scholars and religious authorities, as

well as documents from emirs' courts also offer a tremendous amount of information and remain an under-researched area. The collections of private libraries dating back a few centuries discovered in Mali and in the Niger basin again provide rich material for studies that can shed light on the conditions of women before the twentieth century as well as in later periods. Legal documents of any kind are invaluable sources of information on the structure and nature of relationships between people and in relationship to the state. Sociolegal studies remains a field from which women's studies can be vastly enriched.

IDEOLOGIES AND VOCABULARIES

The use of terminology and how one describes a phenomenon are perhaps two of the most crucial issues in the field of women's studies. For the study of women is not a benign activity, but ultimately a political act. The outcome will necessarily interrogate the relationships of power between women and men, and is thus bound to become a terrain of contestation. This contestation occurs at the level of symbolism, meaning, interpretation, distribution of resources, and appropriation of power. In such a contested space, the very act of naming the object of study, the act of scholarship or of activism, are in themselves fraught with risks and controversies, like walking a political tightrope.

While the term "feminism" is a contested one, in some parts of Sub-Saharan Africa it has acquired greater currency compared to others. The preferred term is "women's studies," a specialized focus on the study of women. Some scholars prefer to use the more neutral "gender studies," which signifies as objects of study both the perpetrator of gender oppression (the male) and the victim (female) (Mama 1996, 3). Others, in turn, prefer to describe their work as "gender analysis," which signifies a political commitment to the liberation of women with a view to construct egalitarian gender relationships (Imam 1997, 5, 15). Gender analysis is viewed as different from women's studies. Where the latter is the specific study of women as a social group, gender analysis specifically explores those gender relations in which women are constructed as subjects. But the term is not employed, notes one feminist, in order to neutralize and soften the challenge posed by feminist analysis (Imam 1997, 6). Rather the analysis is poised to expose male bias against women as a historical fact and then proceeds to provide solutions as to how such distortions can be rectified by both the recognition and restoration of the rights of women.

Cultural resistance to the idea of specialized studies *on* women, *for* women, *by* women in Africa is only one dimension of the problem. Surely, the deep-seated patriarchy embedded in African societies that pre-dates the advent of Islam, but is often reinforced by certain religious practices, is the source of a great deal of anguish to women. What often complicates matters is that women's studies arise at a conjuncture when African societies are grappling with legacies of the past and the challenges of the present. These include the legacy of colonialism and modernization. The memory of colonialism and postcolonial misrule has left an enduring suspicion that modern secular knowledge and its alliance with liberal capitalism continues to have designs of power and control over African societies.

The colossal failure of the postcolonial nation-state to restore dignity, democracy, and freedom to African peoples and the continued alliances of ruling elites with Atlantic powers at the expense of their own people, complicates the environment for new and creative initiatives. Thus, in some places any new ideas that have a Western pedigree are met with local resistance and suspicion. In the ranks of nationalists, Islamists, and even socialists, women's studies and feminism were viewed as part of the machinations of Western powers used to control African societies. It took several decades for the idea of women's studies to be accepted in the academy and at public levels. The success of the women's movement thus far can only be measured at the level of its reception in urban areas and is largely a city phenomenon. In rural areas customary rule and crude forms of Islamic patriarchy continue to prevail with little challenge or resistance.

In Sub-Saharan Africa, as elsewhere, women's studies/gender studies/gender analysis is not a monolith and neither does it represent a single ideology. Muslim women in this region are as diverse as their counterparts elsewhere. Ideological contestations within and among women's movements reflect a fascinating plurality of discourses that are in effect contestations over meaning, and result in a competition for power. What distinguishes different forms of women's discourses from each other are the narratives through which they articulate themselves. It is critical to pay attention to the nature and complexity of these narratives. Thus, it is not sufficient to assume that if a woman identifies herself as a Muslim she would automatically engage with the discourse of Islamic law, Qur'ān exegesis, or theology. She may be deploying Islam in very different ways: as a cultural index, as an index of religion in a private sphere, as an ideological category, or in a variety of mixes.

In other Muslim contexts such as the Middle East, the Atlantic world, and in Asia, the term Islamic feminism is a category that some Muslim women feel comfortable to adopt. However, it is not a term that Muslim women use in connection with themselves in Sub-Saharan Africa. The exceptions may be a few women's groups in South Africa, Nigeria, and Senegal, where greater transnational Islamic influences have made an impact. The term "feminism" here is employed as a generic and heuristic category in order to overcome the complex minefield of terminologies.

Thus for heuristic purposes, one can differentiate between two categories: Muslim feminism and Islamic feminism. One must bear in mind that in the articulation of either Islamic feminism or Muslim feminism, the term "Islam" and "Muslim" means and signifies something that is shared, but at the same time it also signals something that is different depending on how it is appropriated in each instance. It is thus critical to our understanding of Muslim women's discourses to grasp how the term Islam is invoked, then appropriated and articulated.

Muslim feminism. Often confessing Muslim women engage in gender activism but they employ the approach and methodology of the social sciences in their liberative project. Even though African Muslim women have a critical engagement with social sciences in order not to fall victim to European and Western biases, it is fair to say that the secular sciences are clearly influential. Muslim feminists embrace a secular language to pursue an analysis of gender ideology by employing the discourses of the social sciences that are imbued with Marxism, liberalism, Africanist/nationalist ideologies, or complex hybrids of these. While they employ a secular language, it does not imply that they are hostile to religion. Religion has a different value in their analytical grid. Muslim feminism is certainly widespread in Sub-Saharan Africa.

Many women activists identify with Islam as a religion, in the post-Enlightenment sense as a private endeavor, and thus do not necessarily see Islam as an ideological project. Nor do they draw substantial intellectual sustenance from Muslim discursive traditions in order to pursue societal change and renewal. There is no doubt an appreciation that religion is influential in shaping people's lives, but Muslim feminists often do not view religious discourse as a viable public discourse for transformation and societal renewal in societies that are secular or aspire to be secular. It is not clear from the writings of Muslim feminists if they view

Islam as being antithetical to the secular. Often Islam is viewed as part of a cultural artifact that occupies a private and not a public space.

Islamic feminism. In this model, Islam, as a complex as well as varied historical and intellectual tradition, is consciously deployed in gender analysis. This is done in order to give the analysis a distinct Islamic form, compared to situations in which religious identity is accidental and not integral to the analysis. In this instance, the term "Islam" is invoked as a civilizational category and an elaborate discursive tradition. Islamic feminism often starts out as a project associated with "political Islam." In other words, it is part of a broader ideological contestation over power, self-assertion, identity, and the construction of the self.

Islamic feminism signifies the interdependence of theory and practice toward the goal of women's emancipation in terms of values and reference points that have a distinct Muslim intellectual pedigree. Here the narratives are framed in discourses that employ as their reference points the Qur'ān, exegetical traditions, discourses in Islamic law, Muslim theology and philosophy, as well as ethical theories and Muslim history. In addition, some Islamic feminists also draw on analytical categories from modern social sciences. This varies in terms of the sophistication of the analyst. At times the social sciences are employed as a supplement to the master Muslim narratives. On other occasions, there is a serious attempt to foster dialogical ethics and a critical cosmopolitanism.

Together these discourses are deployed in order to interrogate issues of women's oppression, labor, rights, duties, politics, and their role in the family, among a myriad issues. Often Muslim women embrace Islamic narratives with a view to reclaim what they assumed were women's rights as part of the normative values in Islamic teachings. However, many Islamic feminists soon discover that there is a dissonance between the rhetoric of women's rights and its practice. In fact, many Islamic feminists realize that they have to struggle in order to recuperate women's rights in Islam from the dominant androcentric interpretations of the faith. Thus, far from viewing Islamic feminism as a given, many female Islamic activists come to recognize that women's rights are part of a struggle in the reinterpretation of Islamic discursive traditions. This has in places sparked off an energetic engagement with texts, disciplines, and social contexts where new formations of Muslim subjectivity are being expressed. So Muslim women subject the canonical sources as well as the disciplines of Mus-

lim intellectual traditions to new ways of reading and interpretation in order to offer alternative models of practice for women. Of course the breadth and sophistication of these Islamic feminisms differ from place to place and are very context specific. It is also far too early to judge the extent of their success and what the outcome will be in the long term.

HISTORICAL SOURCES

Irrespective of whether they are scholars, activists, or whether they subscribe to a specific ideological orientation, African Muslim women have often aimed to reinscribe their selfhood in history. This is due to the fact that too often mainstream (malestream) history has excluded women. In recent years a steady flow of monographs and essays documenting the role and place of African women in previous centuries has made an appearance and has slowly shifted the debate.

Boyd, Last, and Hutson have shown that some women played significant roles in education and public life in the late nineteenth century, roles that continued in different ways into the twentieth century (Boyd and Last 1985, Hutson 1999). The most prominent roles that women occupied were as teachers and leaders in the spiritual brotherhoods (*tarīqāt*) of West Africa. The most prominent figure is Nana Asma'u (1793–1864), the daughter of Shehu Usman Dan Fodio, the leader of the Sokoto caliphate in northern Nigeria, who serves as a paradigmatic role model. It is now well established that throughout the twentieth century women continued to study her writings in Hausaland and that she continues to inspire women in the present. Several biographies of Asma'u are now available, including an English translation of her works (Boyd and Mack 1984). Nana Asma'u was the most prolific of the Shehu's daughters; some of his other daughters were equally active in religious affairs but left fewer written materials.

An extremely influential women's pilgrimage organization known as the Yan Taru (The associates) that grew around Nana Asma'u continues till the present. Through the Yan Taru, Asma'u and her sisters spread women's education into the rural areas. Education for women, especially literacy in religious teachings, was one of the issues that Shehu Usman Dan Fodio strongly advocated. But Nana Asma'u and her sisters were not exceptional in what they did. In Mauritania, Khadīja of the Ahl al-'Āqil group is reported to have educated 'Abd al-Qādir, the leader of the Torodo revolution. In East Africa, for instance Bibi Zawadi bint Hamad Ibn Sa'id (1854–1936) taught the leading scholar of the region, Shaykh Abdullah Saleh al-Farsi (1912–1982). The latter is best known for translating the Qur'ān into Swahili.

Dunbar and Hutson have both shown that throughout the twentieth century women continued to have authority in northern Nigeria within such elaborate networks of scholarship and practices of piety as the Tijāniyya and Qādiriyya Sufi orders (Dunbar 2000, 400 Hutson 1999, 47). Within Sufi orders women frequently reached the status of *muqaddama*, namely one who may induct others into the order. Many women continued to lead study circles in homes and provided education to women and sometimes even to men. Dunbar's comprehensive essay is an excellent survey of the positive roles and activities undertaken by women in several regions of Sub-Saharan Africa in much of the twentieth century.

In Kano during the 1980s, for instance, Hajiya Iya Isiaku and Hajiya 'Aisha Muhmoud continued the tradition of private education by tutoring students at home. Famous for her exegesis (*tafsīr*) of the Qur'ān was Hajiya Maria Mai Tafsiri, also based in Kano. She ran an Islamiyya school for married women and children. In addition, she had access to a large public audience. Her recitation and commentary on the Qur'ān was first broadcast on radio and later she also appeared on television. Hajiya Laraba Karaba became a leader in the Qādiriyya Sufi brotherhood, while social workers such as Hajiya Hauwa Adamu directed the social outreach program for the voluntary association, Society for the Support of Islam.

For several decades now Aisha Lemu, a British Muslim now permanently resident in northern Nigeria, has produced voluminous writings on different aspects of Islam. She has not failed to highlight the plight of women in Muslim societies and the need for their education. Lemu and her associates work within traditional-cum-reformist networks and have been influential on a pan-African stage, being able to reach women's groups as far as South Africa. In southern Africa, especially in South Africa, there is an established tradition of women educating other women privately in religious disciplines. It is an important historical fact that the property for the first mosque to be built in South Africa in the city of Cape Town in the early nineteenth century was donated by a woman known as Saartjie van de Kaap. In the twentieth century several Muslim women's organizations in South Africa also became part of the backbone of civil society during the period when the damaging influence of apartheid was in full effect.

THEMATICS

Several key themes serve as guides to sources for the study of Muslim women in Sub-Saharan Africa. Even though these themes are not exhaustive, they provide discrete and complex narratives for understanding the lives of women. Three of these themes are discussed: spirit possession, family or personal law, and women's organizations.

Spirit possession. Known as *bori* in West Africa and *zar* in northeastern Africa, spirit possession is a phenomenon rife among Muslim communities, especially among women. Although it is strongly condemned by scripturalist and reformist interpretations of Islam as involving practices that are contrary to conventional teachings, some versions of traditional Islamic orthodoxy nevertheless do not dismiss it entirely. The reason is that many ideological orientations do subscribe to an enchanted universe. In other words, many traditional Islamic discourses are not adverse to notions of spirits, jinn, and miracles, even though more modern scripturalist interpretations of Islam downplay the importance of such concepts and practices. They would, however, be hard pressed to deny them entirely. For instance, the Sokoto jihad leaders condemned *bori* as un-Islamic, while the Emir Abbas later on was lenient towards such practices.

Scholars have wondered if spirit possession and the associated rituals that accompany it say something more than meets the eye about what women are trying to achieve. Are these elaborate strategies on the part of women to express their individual aspirations? Were these ways to negotiate favorable deals to exit from the burdens of their domestic situations? Others have asked if spirit possession offers some relief and serves as a buffer to patriarchal hegemony. Recent research has demonstrated that *bori* offers married women an opportunity to celebrate, dance, and play music within the confines of their homes. Women within the kin, through networks of family and relatives, as well as the husbands, provide gifts as atonement to the affected women; this creates contexts for women to negotiate different levels of attention.

In other parts of Sub-Saharan Africa to the northeast corner, *zar* is viewed as part of the completion of orthodox duties. It plays a dynamic role in women's institutional life, especially where space is gendered by physical, social, political, and religious conventions (Dunbar 2000, 399). In fact, some scholars have argued that women do not see *zar* as involving practices that are opposed to religion but often see these practices as supplementary rituals playing a role comparable to Sufi rituals,

where there is a great emphasis on the remembrance of God (*dhikr/zikr*). This has lead Kenyon to remark that "zar and zikr fulfill similar needs, ritual, emotional, and social and largely cater to mutually exclusive members ... They differ in methods, organization and ritual, but not in doctrine or basic belief" (Kenyon 1991, 42–3).

Muslim family law or Muslim personal law (MPL). This provides another rich source for the study of Muslim women. The field will benefit from further research. Apart from the general surveys on Islamic law in Africa done by J. N. D. Anderson, Spencer Trimingham, and Josef Schacht in the early part of the twentieth century there have been few synthetic studies on the law. Allan Christelow's study of Islamic law in colonial Algeria and Senegal is among the few that investigate the state of the law generally (Christelow 1992). While Islamic law differs from African customary law, its appropriation in Africa often results in hybrid versions.

The patriarchal character of traditional Islamic law acquires a stronger accent when it blends with African customs and practice. Studies are required to explore how women's agency, identity, and practices shape and form Muslim family law and how women negotiate their existential conditions. Christelow's pioneering study on women in early twentieth-century Kano in Nigeria from court records yields great insights. For instance, he shows that changes to the laws affecting slavery under colonialism resulted in the redemption of many women slaves, an offer that their masters could not reject. On the surface this appeared to be a beneficial outcome. But it often happened that the men who redeemed women by paying a sum of money to their owners were third-party men who then married them, and this frequently turned out to be just a legal form of concubinage (Christelow 1991, 143).

Ironically, some women were also slave-owners. Owning slaves gave women control over reproductive power outside the marriage since, under Islamic law, the children of a slave belonged to her owner. Slave-ownership gave women power to preside over an economically viable domestic unit. Paradoxically, as a result of the colonial legal policies regarding redemption of slaves, wealthy women lost power and status, since they could no longer hold on to their slaves if someone else made an offer and payment of redemption. There was more jeopardy for women in the redemptive process. Slave women who were redeemed now became part of their husband's extended house-

holds. Within the complexities of these new family units, Christelow's records show that violence against women also increased.

Complementing the work of Christelow, albeit with a different approach and in a later twentieth-century setting, is Susan Hirsch's major anthropological study on *qāḍī* (kadhi) courts in Kenya (Hirsch 1998). Hirsch's study examines the passage of cases brought by female petitioners to the traditional *qāḍī* courts in the Mombasa area. The anthropologist's gaze allows her to look at both the practices of the *qāḍī*s and the forms of juridical discourses centered around the cases, discourses in which the female petitioners actively construct their narratives. In-depth examinations of the lives and concerns of Swahili-speaking female petitioners to the courts reveal a great deal more about the self-understanding of Muslim women and their views about gender, men, and society. All the cases she studies are related to family law matters.

Hirsch's study is crucial to our understanding of Islamic law in practice at a grassroots level. Contrary to the stereotypes of Islamic law in relation to gender, she shows that Muslim women on the African East Coast are not content to tolerate patriarchy in silence. She locates a pattern of women's agency where they negotiate, debate, and manipulate the legal complexities of Islamic law from behind the scenes through subtle and, at times, not too subtle forms of social diplomacy. In conjunction with studies of doctrinal reforms and interpretations of the status of women in Islam, this study highlights the ways practices transform the understanding and application of laws, especially the creative ways in which *qāḍī*s interpret and apply them. More studies on how *qāḍī*s apply family law in contemporary Zanzibari family law courts are already underway.

Christelow and Hirsch touch on the topic of Muslim family law, which is well researched in Asian, North African, and Middle Eastern contexts but completely neglected in Sub-Saharan Africa. Colonial rule, by indirect means, delegated ethnic governance to tribal chiefs and customary law. While Islamic law was often treated as different from customary law, the colonial response often varied with respect to Muslim law. It depended on the colonial power in charge and the nature of the territory. What survives of Islamic law is what is known as MPL, which deals with issues of marriage, divorce, inheritance, and custody of children. In many countries MPL became part of the postcolonial legal regimes. In places where MPL is absent, Muslim communities have been engaged in political struggles to have their family law recognized by the state and applied via state courts.

Given that MPL is embedded in patriarchal systems of law, it is often in conflict with human rights charters and the aspirations of modern and urbanized Muslim women. MPL is perceived to perpetuate women's oppression and make them subservient to male authority. Often it is male religious authorities that petition for the application of MPL and its retention in the most traditional guise. Opposed to this version of MPL are Muslim women and men who contest it and propose progressive and gender egalitarian interpretations of Islamic law. Family law thus becomes a site of contestation between traditionalist interpretations of Islam and progressive and feminist interpretations of the law.

Despite the obvious difficulties, Muslims of different persuasions nevertheless do see the application of MPL based on religion to be a major contest over identity within secular nation-states. Postcolonial African states have grappled with variable rates of success with the issue of legal pluralism in order to accommodate Islamic and customary laws within a centralized and secular legal system inherited from the colonial period. Given that many state-centered policies are predisposed to patriarchy, insufficient attention is given to the impact that patriarchal laws have on women, family, and children in social conditions that are vastly different from those in which these laws were originally legislated. Governments and ruling elites are at times caught on the horns of a dilemma, wanting to be sensitive to the needs of religious communities while also advancing modern human rights values. Often they are reluctant to advance women's causes through law reform fearing they would offend the religious and customary elites.

NGOs and progressive as well as some reformist Muslim groups, have had some success in creating awareness about the substance of MPL and the need for reform. The transnational group, Women Living Under Muslim Laws, has done a great deal of work to create awareness of the discriminatory effects of Islamic laws against women and has actively engaged in legal processes to avert such discrimination. However, ordinary Muslim women are often caught in the middle of these volatile and charged contestations: they wish to be loyal to Islam but also do not wish to be the victims of repressive patriarchal laws. It is often the case that they do not have the education and tools to respond to their concerns with integrity and fall into a cycle of patient perseverance.

In regions where Islamic revivalist trends have

become hegemonic, such as Northern Nigeria, Niger, Tanzania, Uganda, and parts of Mali, it is obvious that the politics of identity have trumped the politics of gender equality. It is increasingly the case that Muslim women often promote Islamic law, and especially Muslim family law, as God's law, arguing that such a law is immune to reform and change. Advocates of Islam-centered reform efforts are often marginalized, treated with suspicion, and charged with advocating Western designs in Muslim societies. But these contestations and rhetorical wars are often symptomatic of larger economic and political problems, where states and governments have chronically failed to provide effective governance.

Justice in some of the specialized Islamic family law courts is often swift and cheap but lacks proper procedures. Compared to the secular courts, they are often ramshackle infrastructures where the *kadhi*s lack appropriate training and legal education. In those countries where Muslim law is administered in the secular courts, judges in turn do not have enough familiarity with Islamic law to be able to apply it correctly. In many places the family law is not even properly codified. Given the appalling state of judicial affairs in countries like Tanzania, Uganda, and certain parts of Central Africa and rural Mozambique, Muslim family law is frequently administered at the level of informal Islamic tribunals. Most often, women are at the receiving end of harsh, unreformed, and patriarchal applications of the laws.

In the Muslim dominated provinces of northern Nigeria, state governments have gone beyond the adoption of family law and have legislated Islamic penalties for criminal offences such as theft, consumption of alcohol, and extra-marital sex offences. Since an unreformed Muslim law often advances the cause of patriarchy it comes as no surprise that in Nigeria, Muslim women become both the targets and victims of Sharīʿa based criminal laws. Two celebrated cases have gained media attention in Northern Nigeria. One woman was given a sentence of stoning to death for adultery, a decision that was later reversed on appeal, while the second case awaits appeal. The palpable injustice even by the standards of Islamic law is so offensive to a sense of justice and equity, that some advocates of Sharīʿa law in Nigeria are themselves prepared to revisit in some measure the nature of the application of Islamic law. Needless to say, in a country like Nigeria, the question of family law is part of larger contestations over power and authority between ethnic and religious groups.

Court records are excellent sources for the discovery of what kinds of issue have over time required state intervention or judicial resolution. Even though they provide one level of insight to the question at hand, they are most effective when used in conjunction with other sources. If court records are effectively mined, they can become an invaluable resource in recovering history, especially the history of women. Although court records of the precolonial period may be hard to come by, there are copious resources dating to the colonial and postcolonial periods. The emir's judicial council in northern Nigeria is one such resource and sheds some light on the matter. Christelow has produced a collection containing selected cases from the rulings of Emir Abbas (Christelow 1994).

In East Africa, court records dating back to Omani rule and subsequent British rule on the African East Coast are well preserved at the Zanzibar archives and deserve the attention of scholars. Scholars have yet to make use of these archives in a sustained manner in order to retrieve the social and cultural history of the period. These records will no doubt shed light on the status of women in these societies, the rates of marriage and divorce, distribution of property, and a great deal more. Modern African courts have adopted the conventions of law reports but, due to poor administration and the absence of adequate resources, these records are often not regularly produced or have deficiencies.

Muslim women's organizations. As the movement for the empowerment of women gradually makes an impact on the African continent, women's organizations have mushroomed in the realm of civil society. These date back to the middle of the twentieth century with the rise of independence movements. Most political parties also had women's wings, which over time either integrated into the party or continued to press for gender reforms in their societies from the sidelines. The rise of Muslim revivalist and reformist tendencies in areas traditionally more inclined to Sufi brotherhoods also brought with it distinct forms of women's organization. For instance, the rise of the pro-reformist Federation of Islamic Associations of Senegal also included women in their ranks. In francophone African countries Muslim women pursued their cultural and political ambitions through secular associations such as the Association of Nigerien Women, established in 1975 in Niger. It was this body that advocated reform of

Muslim family laws but was stifled by Muslim and chiefly opposition groups. Until recently proposals for legislation regarding family law for Muslims were still being hotly debated in Niger.

In 1985 Nigeria saw the birth of the Federation of Muslim Women's Association (FOMWAN) whose goal was to reclaim women's self-esteem and collectively address the issues Muslim women face in their day-to-day lives (Yusuf 1993, 284). FOMWAN also became very active in public policy issues affecting women's lives. There was clearly some tension between FOMWAN and the secular National Council of Women's Societies over questions of inheritance. FOMWAN opposed legislation that was not in keeping with the Sharīʿa and provided solutions to some chronic social problems based on Islamic teachings. It strongly advocated that Sharīʿa courts be established in the southern states in order to serve Muslims living there, who in the absence of Islamic law were compelled to follow customary law.

In East Africa there are several research institutions that focus on women's issues, such as the Women's Research and Documentation Project (WRDP), which aims to advance the position of women in Tanzania. WRDP is a product of the Institute of Development Studies and became an independent unit in 1982. The pan-African Association of African Women for Research and Development (AAWORD) is one of the most influential research networks on the continent. AAWORD has branches in different regions and offers valuable support to grassroots women's groups and also makes interventions in policy related issues.

In South Africa there are a number of Muslim women's groups representing different interest groups. The Gender Desk of the Muslim Youth Movement, while modest in size, is perhaps the most influential of progressive Muslim groups at the level of outreach and impact on policy issues. One of the more important roles that these specialized research units play is to provide valuable statistical information, surveys on a whole range of questions pertaining to women's health, poverty, education, political participation, and access to opportunities for wealth creation.

The study of Muslim women in Sub-Saharan Africa cannot be examined in isolation from the complex layers of cultural history or the economic and political forces sweeping the region. Sources are plentiful, but in unconventional forms, and require sophisticated and nuanced approaches in order to yield the most interesting results.

BIBLIOGRAPHY

J. Boyd and M. Last, The role of women as "agents religieux" in Sokoto, in Canadian Journal of African Studies 19:2 (1985), 283–300.

J. Boyd and B. B. Mack (eds.), Collected works of Nana Asma'u, daughter of Usman dan Fodiyo 1793–1864, East Lansing 1984.

A. Christelow, Women and the law in early-twentieth-century Kano, in C. Coles and B. B. Mack (eds.), Hausa women in the twentieth century, Madison, Wis. 1991, 130–44.

——, The Muslim judge and municipal politics in Colonial Algeria and Senegal, in J. R. I. Cole (ed.), Comparing Muslim societies, Ann Arbor 1992, 133–62.

——, Thus ruled Emir Abbas. Selected cases from the Emir of Kano's judicial council, East Lansing 1994.

R. A. Dunbar, Muslim women in African history, in N. Levtzion and R. L. Pouwels (eds.), The history of Islam in Africa, Athens, Ohio 2000, 397–417.

M. J. Hay, Queens, prostitutes and peasants. Historical perspectives on African women, 1971–1986, in Canadian Journal of African Studies 22:3 (1988), special issue, Current research on African women, 431–47.

S. F. Hirsch, Pronouncing and persevering. Gender and the discourses of disputing in an African Islamic court, Chicago 1998.

A. S. Hutson, The development of women's authority in the Kano Tijaniyya, 1894–1963, in Africa Today 46:3/4 (1999), 43–64.

A. Imam, Engendering African social sciences. An introductory essay, in A. M. Imam, A. Mama, and F. Sow, Engendering African social sciences, Dakar 1997, 1–30.

S. M. Kenyon, Five women of Sennar. Culture and change in Central Sudan, Oxford 1991.

A. Mama, Women's studies and studies of women in Africa during the 1990s, Dakar 1996.

——, Shedding the masks and tearing the veils. Cultural studies for a post-colonial Africa, in A. M. Imam, A. Mama, and F. Sow, Engendering African social sciences, Dakar 1997, 61–80.

M. Strobel, Muslim women in Mombasa 1890–1975, New Haven, Conn. 1979.

B. Yusuf, Da'wa and contemporary challenges facing Muslim women in secular society – a Nigerian case, in N. Alkali et al. (eds.), Islam in Africa. Proceedings of the Islam in Africa conference, Ibadan 1993, 276–95.

T. Zeleza, Gender biases in African historiography, in A. M. Imam, A. Mama, and F. Sow, Engendering African social sciences, Dakar 1997, 81–115.

EBRAHIM MOOSA

Turkey: Early 20th Century to Present

It is possible to group works on women in twentieth-century Turkey chronologically, in three broad categories: 1. ideological works written by the advocates of the new republic; 2. works carried out (1940–80) by social scientists working within a modernist paradigm; and 3. works carried out by students of social science and history that are influenced by feminist movements or feminist scholarship.

IDEOLOGICAL WORKS

The Republic of Turkey, established in 1923, initiated a project of modernity in which the establishment of a Westernizing secular nation-state was the primary goal. Reforms such as the abolition of Sharīʿa, the adoption of a secular civil code in which women had rights equal to men in marriage, divorce, and inheritance, and the granting of suffrage to women were the founding blocks of this modernization project. Interest in and study of women were organically linked with these reforms. In this context, there was a conscious effort to resuscitate the pre-Islamic Turkish past and use it to legitimize the new project. The main ideologue of Turkish nationalism, Ziya Gökalp, whose writings prior to the establishment of the republic inspired the nationalist visions of the new political elite, elaborated on the feminism of the pre-Islamic Turks. In his seminal work, *The Principles of Turkism* (1968), Gökalp identified the confines of male-female equality among pre-Islamic Turks. His study, which was important in legitimizing the new reforms and changing the status of women, was based on a rereading of certain anthropological works, myths, and legends.

During this period of state feminism when reforms improving the status of women were instrumental in promoting the project of a secular, Westernizing nation-state, the reformist leaders instructed that Turkish history be rewritten. Afet Inan, Atatürk's adopted daughter whose education in Switzerland Atatürk personally supervised, was among those who were told to research Turkish history. Her book *Tarih Boyunca Türk Kadınının Hak ve Görevleri* (Rights and responsibilities of the Turkish woman in history, 1975), a shorter version of which was published by UNESCO, is a product of this ideological struggle

to rewrite Turkish history and legitimize the republican reforms. The book is a survey of "the Turkish woman" in the singular, from pre-Islamic to republican times, and its primary goal is to present an uncritical adulation of the reforms and Atatürk's single-handed role in granting women their rights. It is written like a text book but has no formal references; instead there are textual allusions to sources covering a range of material from personal letters to state documents. Other researchers, after Afet Inan, reproduced this ambitious, chronological format and added more formal references to an ecclectic set of texts including speeches, magazines, daily newspapers, and some history books. Substantively, they still provided only a cursory, superficial coverage of the subjects surveyed (Taşkıran 1973, Caporal 1982, Doğramacı 1984).

THE MODERNIST PARADIGM

The radical reforms of the republic, which set the emerging nation-state on the path of Western modernization, prompted social scientists to study the transformation of the society that was taking place. In the 1940s and 1950s, sociologists moved into the field and began gathering empirical evidence about life in villages to register what it was like prior to the changes that would take place (Berkes 1942, Boran 1945). Even though these works did not prioritize information about women and lacked theoretical focus, examination of family life, marriage patterns, and the division of labor in the few villages studied provided preliminary empirical data on women in Turkey. By the 1960s, nationwide surveys could provide data on questions of female fertility, family planning, and family structure in the society (Özbay 1990, Timur 1972).

As social sciences developed, the concept of sex roles was used as an analytical tool to study questions of women's status and personal identity (Kağıtçıbaşı 1982) in the context of social change (Kandiyoti 1977). Abadan-Unat, who studied migration, drew attention to its effects on women's roles (1977). Kıray, who studied structural change in social relationships, pointed to the critical role women played in their positions as mother/wife within the family. Mothers or wives

made societal change possible at the macro level by acting as buffer mechanisms and accommodating friction between children who precipitated change and fathers who resisted it (Kıray 1981). Kıray's work had important implications concerning the impact of women's power in the private realm and how it could translate into the public realm. Works classified under the "modernization paradigm" aimed to explore the dynamics of social change and focused on women to the extent that they played a part in this process.

THE FOCUS ON WOMEN AND GENDER

As the second wave of feminism soared in the West, studies on women gained a new perspective. The pioneering work that focused solely on women's issues in Turkey was edited by Nermin Abadan-Unat, in Turkish and later in English (1981). Abadan-Unat was able to bring together a collection of original essays; some were drawn out of previous research on social change and others were extensions of work with broader focuses, such as religion and political development in Turkey. The book included essays on women's fertility, health, economic and political participation, changes in sex roles, and relation to religion. Some of the essays were based on empirical observation, others integrated macro level statistics with original interpretations. The respectability of the contributors as social scientists who had proven themselves with major works on societal transformation legitimized research on women.

By the 1980s, parallel to developments in the West, a women's movement that brought the significance of women's problems to public attention emerged in Turkey. Studies on Turkish women, which used new frameworks and concepts such as patriarchy and gender, duly proliferated. These works focused directly on women and prioritized women's experiences as deserving investigation. The new generation of social scientists in Turkey were at a critical distance from the republican reforms that had expanded women's opportunities in the country. They employed concepts and tools introduced by feminist scholarship in the West, critically assessed these tools in the Turkish context, and used them to shed light on the Turkish scene.

Among the new generation of social scientists whose work focused exclusively on women, Şirin Tekeli was a forerunner with her book on women and sociopolitical life (1982). Tekeli argued that the reforms initiated by the founders of the republic had symbolic significance and were important in promoting a democratic image for this elite. Tekeli's coverage was extensive, including Marxist approaches to the question of women, the evolution of women's fight for their rights, women's voting patterns and political participation in capitalist and socialist countries, along with a section on women in Turkish politics. The Marxist framework of the book strained her extensive coverage and diffused her focus on the local context.

Tekeli's attention to women in politics had repercussions. Women in formal institutions of power were further examined within a theoretical framework that discarded the Marxist approach and instead prioritized the significance of the multi-layered patriarchal framework of the polity (Y. Arat 1989). The concept of patriarchy thus began to be used to explain women's predicaments. The significance of Kemalist reforms in expanding opportunities for women was analyzed with attention to the different functions the reforms played in promoting not merely a democratic image, but also the ideological core of the republic, that is, secularism and nationalism (Y. Arat 1989, 28–33, Kandiyoti 1987, 1988). Besides women politicans, women's voting behavior, perceptions of politics (Güneş-Ayata 1995, Koray 1991), and sexism in politics (Sancar-Üşür 1998) were studied by empirical methods of interviewing and questionnaires.

The existential significance of the Kemalist reforms for women was also investigated by social scientists who turned their attention to the late Ottoman Empire and the transition to the republic. Women's journals, periodicals, and the few memoirs that exist were studied to carry out research on this period (Kızıltan 1990, Frierson 1995). The Women's Library and Information Center in Istanbul published two critical bibliographies on women's periodicals, one covering 1869–1927, the other 1928–96 (Toska et al. 1992, Davaz-Mardin 1998). Locating and appreciating the Ottoman sources written in Arabic script was difficult because there had been a determined attempt to sever cultural ties with the Ottoman past. This research challenged the prevailing rhetoric that women in Turkey did not have to fight for the rights that the Kemalist founders had granted them. Women's activism of the early twentieth century even when recognized was, till then, described as merely social welfare activism or as nationalistic support of the independence war. New research brought to light not only that women wanted to found a political party (Toprak 1988) but that they were very active in politics

(Çakır 1994, Baykan 1994) and eagerly sought their political rights (Zihnioğlu 2001). It drew attention to feminist activists of the period and the tension between them and the political elite. The difficulties of doing research on women of the late Ottoman, early republican period became glaringly apparent as feminist research discovered that men had used women's names both to write in and to publish women's journals of the era (Zihnioğlu 2001).

As well as their interest in the struggle for women's rights and reforms, female social scientists sought to establish how women identified themselves under the changing circumstances of the Kemalist project of modernity. Research was carried out on how women carved out Kemalist as opposed to feminist identities for themselves and the gender dynamics of modernization during the early period of the republic was traced (Durakbaşa 1988, 2000, Z. Arat 1994). Questions of nationalism and how it was predicated on gender relations and how nationalism shaped gender roles were investigated (Altınay 2000, Şerifsoy 2000).

In order to study this period in depth, a group of women within the framework of the Women's Library and Information Center in Istanbul initiated a pilot project of oral history. They inquired into women's experiences of the process of secularization and social transformation during the formative years of the republic using oral history techniques (Ilyasoğlu 1996). The project resulted in the acquisition by the Women's Library of oral history interviews, which are now available for research purposes. The data still need to be studied and brought to public attention by researchers.

The focus by social scientists on women allowed them to bring their analysis of the project of modernity beyond the formative years of the republic, into the contemporary era. Contemporary secular feminists were studied (Tekeli 1986, 1998, Sirman 1989, Y. Arat 1997, 2000), but also Islamist women. The emergence of Islamist women in contemporary public life was examined from different angles, mostly using in-depth interviews. Their significance was explored from a feminist perspective (Y. Arat 1995); in the context of the Kemalist project of secularism (Göle 1996); in terms of the evolution of an Islamist identity (İlyasoğlu 1998, Özdalga 1998, Berktay 2001); as party activists (Y. Arat 1999); and in the context of alternative lifestyles and communities (Saktanber 2001). Nilüfer Göle's work (1996) was groundbreaking in its comparative focus on secular and Islamist women in order to understand the changing nature of the modernization process in the country.

Other gender-focused research on women expanded the confines of the respective disciplines in which they were carried out. Anthropologists inquired into women's networks and strategies in their everyday lives to reveal how they improved their status and increased their power vis-à-vis other women and men in historically specific patriarchal contexts (Sirman 1995, Yalçın Heckmann 1995, White 1994). Economists examined socioeconomic life beyond macro level statistics in studies ranging from those on women working in the manufacturing sector (Ecevit 1995) to women carpet weavers in rural Turkey (Berik 1995). In the context of a globalizing world economy, they studied the impact of the shift from import substituting industrialization to export-led growth on women in the manufacturing sector (Çağatay and Berik 1990). Women as managers in the business world were studied (Kabasakal 1998). Sociological studies brought to light problems of women's education or the oppression of women in Eastern Anatolia (Ertürk 1995, İlkkaracan 1998). Taboo subjects such as domestic violence (Yüksel 1995) and the honor code based on virginity (Cindoğlu 1997, Parla 2000) were studied both to illuminate their impact on women and to reveal the complex dynamics of patriarchy in the local context.

CONCLUSION
Studies on women that were undertaken for the purpose of legitimizing the new republic evolved over time to become important means for understanding societal transformation. By studying women it was possible to explore the gender dynamics that prompted this transformation, and was affected by it and critical of it. Much remains to be done.

There is still need for more quantitative and qualitative studies comparing women of different classes, regions, ethnic backgrounds, and religious affiliations both in Turkey and other countries in Islamic world. Work on women carried out in Turkey primarily focuses on Muslim women. Our knowledge of, for example, Kurdish women or non-Muslim women of Turkey, is limited to a few pioneering studies (Yalçın-Heckman 1995, Bilal et al. 2001). On the other hand, even though Islamist women, who remain critical of, if not outside the secular paradigm of the republic, have been the subjects of many research projects, they themselves have produced few non-polemical works

that go beyond a faithful defense of Islamism and a pejorative depiction of the secular establishment (Aktaş 2000, Ramazanoğlu 2000). Unlike in other Muslim countries, in Turkey Islamic sources and references have not been critically studied from a woman's perspective, either. The secular educational system neither provides the tools necessary for this task (such as the learning of Arabic), nor does it encourage the venture. One exception to this trend is the work by Hidayet Şefkatli Tuksal, who studied the patriarchal elements in sayings attributed to the Prophet (Tuksal 2000).

Literature, photography, film, and arts undertaken by women or about women still need to be critically evalutated. Pioneering works on women writers and novelists in Turkey (Cindoğlu 1986, Paker 1991, Parla 2000) or women in cinema (Cindoğlu 1991) can be cultivated. The Women's Library and Information Center published samples of work by women painters (1991), women photographers (1992), women in cinema (1993), women ceramic artists (1994), and women sculptures (1999), in its yearly almanacs. Women artists still need to be critically appraised. Work on women in Turkey can benefit from this diversification and it should continue to explore the nature of democracy, religious affiliation, ethnicity, and nationalism in the country by focusing on gender dynamics. Current scholarship on gender has pointed toward the key that will unlock the door to the significant forces underlying societal problems and the key needs to be put to use.

BIBLIOGRAPHY
N. Abadan Unat, Dış göç akımının Türk kadınının özgürleşme ve sözde özgürleşme sürecine etkisi, Amme idaresi dergisi 10:1 (1977), 107–32.
—— (ed.), Women in Turkish society, Leiden 1981.
F. Acar, Turkish women in academia. Roles and careers, in METU Studies in Development 10 (1983), 409–46.
A. Afetinan, Tarih boyunca Türk kadınının hakları ve görevleri, Istanbul 1964.
C. Aktaş, Kamusal alanda İslamcı kadın ve erkeklerin ilişkilerinde değişim üzerine. Bacıdan bayana, in Birikim 137 (2000), 36–47.
A. Altınay, Ordu-millet kadınlar. Dünyanın ilk kadın savaş pilotu Sabiha Gökçen, in A. Altınay (ed.), Vatan, millet, kadınlar, Istanbul 2000.
Y. Arat, The patriarchal paradox. Women politicians in Turkey, Rutherford, N.J. 1989.
——, Feminism and Islam. Considerations on the journal Kadın ve aile, in Ş. Tekeli (ed.), Women in modern Turkish society, London 1995, 66–78.
——, The project of modernity and women in Turkey, in S. Bozdoğan and R. Kasaba (eds.), Rethinking modernity and national identity in Turkey, Seattle 1997, 95–112.

——, Political Islam in Turkey and women's organizations, Istanbul 1999.
——, From emancipation to liberation. The changing role of women in Turkey's public realm, in Journal of International Affairs 54:1 (fall 2000), 107–26.
Z. Arat, Turkish women and the republican reconstruction of tradition, in M. Göçek and S. Balaghi (eds.), Reconstructing gender in the Middle East, New York 1994, 57–78.
A. Baykan, The woman. An adventure in feminist historiography, in Gender and History 6:1 (April 1994), 101–16.
G. Berik, Towards an understanding of gender hierarchy in Turkey. A comparative analysis of carpet-weaving villages, in Ş. Tekeli (ed.) Women in modern Turkish society, London 1995, 112–28.
N. Berkes, Bazı Ankara köyleri üzerine bir araştırma, Ankara 1942.
F. Berktay, Grenzen der Identitatspolitik und Islamistische Frauenidentitat, in Barbara Pusch (ed.), Die Neue Muslimsche Frau. Standpukte und Analysen, Istanbul 2001, 67–87.
M. Bilal, L. Ekmekçioğlu, and B. Mumcu, Hayganuş Mark'ın (1885–1966) hayatı, düşünceleri ve etkinlikleri. Feminizm. Bir adalet fermanı, in Toplumsal Tarih, 15:87 (March 2001), 48–56.
B. Boran, Toplumsal yapı araştırmaları. İki köy çeşidinin mukayeseli tetkiki, Ankara 1945.
N. Çağatay and G. Berik, Transition to export-led growth in Turkey. Is there feminization of employment?, in Review of Radical Political Economics 22:1 (1991), 115–34.
S. Çakır, Osmanlı kadın hareketi, Istanbul 1994.
B. Caporal, La femme turque à travers le Kemalisme et le post-Kemalisme 1919–1970, Lille 1982.
D. Cindoğlu, Women's writing and women's fiction in 1970–85 period of Turkey, M.A. thesis, Boğaziçi University 1986.
——, Reviewing women. Images of patriarchy and power in modern Turkish cinema, Ph.D. diss., State University of New York at Buffalo 1991.
——, Virginity tests and artificial virginity in modern Turkish medicine, in Women's Studies International Forum 20 (1997), 253–61.
A. Davaz-Mardin, Hanımlar Alemi'nden Roza'ya, Istanbul 1998.
E. Doğramacı, The status of women in Turkey, Ankara 1984.
A. Durakbaşa, Kemalism as identity politics in Turkey, in Z. Arat (ed.), Deconstructing images of "the Turkish woman," New York 1998, 139–55.
——, Halide Edip, Istanbul 2000.
Y. Ecevit, The status and changing forms of women's labour in the urban economy, in Ş. Tekeli (ed.), Women in modern Turkish society, London 1995, 81–8.
Y. Ertürk, Rural woman and modernization in South-Eastern Anatolia, in Ş. Tekeli (ed.), Women in modern Turkish society, London 1995, 141–52.
E. Frierson, Unimagined communities. Women and education in the late-Ottoman Empire, in Critical Matrix 2 (1995), 55–90.
Z. Gökalp, Türkçülüğün esasları, Istanbul 1968.
N. Göle, The forbidden modern. Civilization and veiling, Ann Arbor 1996.
A. Güneş-Ayata, Women's participation in politics in Turkey, in Ş. Tekeli (ed.), Women in modern Turkish society, London 1995, 235–49.

P. İlkkaracan, Doğu Anadolu'da kadın ve aile, in A. B. Hacımirzaoğlu (ed.), *75 yılda kadınlar ve erkekler*, Istanbul 1998, 173–92.

A. İlyasoğlu, Religion and women during the course of modernization in Turkey, in *Oral History* 24:2 (1996), 241–61.

——, Islamist women in Turkey, in Z. Arat (ed.), *Deconstructing images of "the Turkish woman,"* New York 1998, 241–61.

H. Kabasakal, A profile of top women managers in Turkey, in Z. Arat (ed.), *Deconstructing images of "the Turkish woman,"* New York 1998, 225–39.

Ç. Kağıtçıbaşı (ed.), *Sex roles, family, and community in Turkey*, Bloomington, Ind. 1982.

D. Kandiyoti, Sex roles, family and social change. A comparative appraisal of Turkey's women" in *Signs* 3:1 (1977), 57–73.

——, Emancipated but unliberated? Reflections on the Turkish case, in *Feminist Studies* 13:2 (1987), 317–38.

——, Women and the Turkish state. Political actors or symbolic pawns?, in N. Yuval-Davis and F. Anthias (eds.), *Women, nation, state*, Houndmills, Basingstoke, Hampshire 1988, 126–49.

M. Kıray, Women of small town, in N. Abadan Unat (ed.), *Women in Turkish society*, Leiden 1981, 259–74.

M. Kızıltan, Öncü bir kadın yazar. Fatma Aliye Hanım, in *Journal of Turkish Studies* 14 (1990), 283–322.

M. Koray, *Günümüzdeki yaklaşımlar ışığında kadın ve siyaset*, Istanbul 1991.

F. Özbay, Development of studies on women in Turkey, in F. Özbay (ed.), *Women, family and social change in Turkey*, Bangkok 1990.

S. Paker, Unmuffled voices in the shade and beyond. Women's writing in Turkish, in Helena Forsås-Scott (ed.), *Textual liberation. European feminist writing in the twentieth century*, London 1991, 270–300.

A. Parla, The honor of the state. Virginity examinations in Turkey, in *Feminist Studies* 7:1 (spring 2001), 1–24.

J. Parla, The burden and Bildung. The nightmare of history in Turkish women's writing, paper delivered at Boğaziçi University, Symposium on the Centennial of Women in Turkey, 12–14 April 2000.

Y. Ramazanoğlu, *Osmanlı'dan cumhuriyet'e kadının tarihi dönüşümü*, Istanbul 2000.

A. Saktanber, *Living Islam. Women, religion and the politicization of culture in Turkey*, London 2002.

Sancar-Üşür, Siyasal alanda cinsiyetçilik ve kadınların söylemsel kuşatılmışlığı, in O. Çitçi (ed.), *20. Yüzyılın sonunda kadınlar ve gelecek*, Ankara 1998, 531–42.

——, Feminism in Turkey. A short history, in *New Perspectives on Turkey* 3:1 (fall 1989), 1–34.

S. Şerifsoy, Aile ve Kemalist modernizasyon projesi, 1928–1950, in A. Altınay (ed.), *Vatan, millet, kadınlar*, Istanbul 2000, 155–88.

N. Sirman, Friend or foe? Forging alliances with other women in a village of western Turkey, in Ş. Tekeli (ed.), *Women in modern Turkish society*, London 1995, 199–218.

T. Taşkıran, *Cumhuriyetin 50. Yılında Türk kadın hakları*, Ankara 1973.

S. Tekeli, *Kadınlar ve siyasal toplumsal hayat*, Istanbul 1982, 179–99.

——, Emergence of the new feminist movement in Turkey, in D. Dahlerup (ed.), *The new women's movement*, London 1986, 179–99.

——, Birinci ve ikinci dalga feminist hareketlerin karşılaştırmalı incelemesi üzerine bir deneme, in A. B. Hacımirzaoğlu (ed.), *75 yılda kadınlar ve erkekler*, Istanbul 1998, 337–46.

S. Timur, *Türkiye'de aile yapısı*, Ankara 1972.

Z. Toprak, Cumhuriyet halk fırkasından önce kurulan parti. Kadınlar halk fırkası, in *Tarih ve toplum*, March 1988, 30–1.

Z. Toska et al. (eds.), *Kadın dergileri bibliyografyası* (1869–1927), Istanbul 1992.

H. Ş. Tuksal, Kadın bakış açısına sahip olmalıyız, in *Birikim* 137 (September 2000), 48–59.

L. Yalçın-Heckmann, Gender roles and female strategies among the nomadic and semi-nomadic Kurdish tribes of Turkey, in Ş. Tekeli (ed.), *Women in modern Turkish society*, London 1995, 219–31.

Ş. Yüksel, A comparison of violent and non-violent families, in Ş. Tekeli (ed.), *Women in modern Turkish society*, London 1995, 275–87.

J. B. White, *Money makes us relatives. Women's labor in urban Turkey*, Austin, Tex. 1994.

Y. Zihnioğlu, Nezihe Muhittin. Bir Osmanlı-Türk kadın hakları savunucusu, M.A. thesis, Boğaziçi University 2001.

YEŞIM ARAT

Feminist accounts usually state that the control of women and their sexuality has been central to national community building in the Muslim world, while, at the same time, women have been relegated to the margins of the polity. In Europe, the condition of Muslim women is also instrumentalized – not because Muslim women cannot be defined as mothers of nations and used as legitimate icons of national advancement, but because their history and social condition is embedded in the history of Muslim immigration in Western Europe. This immigration has two major characteristics: it is postwar and it is postcolonial.

MUSLIM WOMEN IN EUROPE: THE POSTCOLONIAL CONDITION

In the last two decades, Islam has emerged as the unthinkable consequence of labor migration to Europe, bringing unexpected cultural and ethnic changes to European societies. The first wave of immigration, from the end of the Second World War to the 1970s, was dominated by mass movements of surplus workers from the Third World and Eastern Europe. During the period of the great economic boom that swept across the Western world from 1945 to 1969, economic growth, an abundant labor supply, and productivity gains were strongly correlated in the industrial countries of Western Europe. These factors induced an organized and state-sponsored migration from North Africa, India, Pakistan, and Turkey, bringing masses of male workers who happened also to be Muslim. Recruitment of foreign workers by European states ended with the 1973 oil shock, but this cessation did not curtail other forms of immigration, such as family reunification, seasonal migration, and border commuting. Thus, the second wave consisted principally of a secondary migration of family members and has not ebbed since the 1980s. Muslim women were the major component of it. The third and latest wave of migration is composed of refugees and asylum seekers. The severe restrictions on legal immigration imposed by Western European governments during the 1970s and the economic, social, and political upheavals associated with the Eastern European revolutions of the 1990s were the two major catalysts of this third migratory wave, which, for the first time, includes many single women coming on their own to the European continent.

This postwar migration has deeply transformed Europe. Not only has it stimulated the dramatic economic growth of the postwar period, but it has also induced notable changes in the social and cultural basis of each society and exacerbated social conflicts. The result has been a continuous politicization of state immigration policy as well as attempts to change the rules of citizenship.

Studies on Islam as a new religious minority in Europe first ignored women, and then began to focus on women as the object of growing interest. The earliest Muslims were male workers who had little formal education and entered European labor markets at the lowest levels. They tended to view their residence in the various host societies as temporary, undertaken purely for economic purposes. Therefore they lived together in large groups, sharing rental payments with only one aspiration: to maximize their savings and return home. Muslim women were very rare at this first stage. The Islamic dimension was completely neglected in the first accounts and studies of immigration. It has to be said that the sociology of immigration in the 1960s and 1970s was religion-blind and gender-blind: analyses of the impact of the Muslim immigration on the job or housing market are plethoric but very few accounts of the religiosity of these Muslim workers can be found. At the same time that immigration was being limited and then finally stopped in 1974, family reunions became more frequent and a shift away from viewing residence in Europe as temporary was noticeable within all Muslim communities. In this context, most first generation Muslim women arrived as dependents of men. Research then began on Muslim women within the larger context of ethnic and multicultural studies. In their attempt to explain the condition of Muslim women in Europe, most of these studies adopted, consciously or unconsciously, the colonial prism of interpretation.

This prism of interpretation presupposes a radical opposition between Islam and the West. This opposition forms the basis of Orientalism, which is characterized by a substantialist approach to religion and a linear vision of history; the politics of the Islamic world, according to this view, are

inherently theocratic and recidivistic. A survey of the current scholarship on politics and Islam in the Arab and Muslim world often reveals a similar perspective. Rationalized language disguises a normative and value-laden approach, which tends to disparage the political legacy of the Muslim world while equating the Western political tradition with moderation, democracy, and human rights. Scholarship on Muslims in Europe falls prey to the same essentialist approach that characterizes much political analysis of the Arab world. This approach mistakenly supposes that all immigrants of Muslim origin are devoutly religious and observe all the principles of Islamic law. It thereby overlooks the variations in Muslim belief and practice resulting from the impact of migration, as well as the influence of the pluralistic environment of Western Europe. To consider Muslims to be an undifferentiated whole legitimates the view of Islam as a threat, which is prevalent in much European scholarship on Muslim minorities.

The influx of migrants from the old colonies has been seen as eroding the putative authenticity of the host country's culture by hollowing it from within. For example, in the United Kingdom, Margaret Thatcher infamously voiced her concern over this trend, remarking that the country "might be swamped by people with a different culture" (Mohammad 1999, 3). This trend was also reflected in the return to Victorian values as part of a neoconservative remythification of the imperial past. These values were evident in the 1980s with the establishment of a national curriculum in schools, a key instrument for the transmission of a national hegemonic culture and a shared national identity. All over Western Europe, Asian, Turkish, and North African immigrants were often seen as embodying the antithesis of national culture. Such feelings were evident even in the rhetoric of some politicians who described immigrants in pejorative terms, often stating that they smelled of curry or wore funny clothes.

Centering on this recurring theme, explanations of the Muslim "threat" vary from one country to another. In France, various experts and journalists focus on the negative influence of Islam in the suburbs. These accounts have produced a kind of moral panic over the imagined rise of home-grown Muslim extremists. In the autumn of 1995, French police killed Khaled Khelkhal, the chief suspect in a terrorist bombing campaign. This incident sparked widespread public debate about the phenomenon of alienated young French

Muslims joining violent Islamic groups. In the United Kingdom, the Runnymede Trust supported the publication of a report on Islamophobia in 1997. The report, describing "the prejudice and discrimination" that Muslims encounter in everyday life, revealed the prevalence of closed-minded and xenophobic attitudes toward Muslims in Britain. In Germany, Heitmeyer's *Verlockander Fundamentalismus*, which implicitly equated Islam with violent and subversive activities and branded Muslim youth as "at risk," generated heated public debate.

In the aftermath of the September 11 attacks, hostility and suspicion vary from one national context to another. Outbursts of racial hatred against Muslims can be found almost everywhere, and are accompanied by specific reactions. In Belgium, Germany, the Netherlands, and Denmark, extreme right-wing parties are gaining support, while in the United Kingdom, reinforcement of anti-terrorism laws and racial profiling is discussed.

Two major trends emerge within the growing knowledge of Islam in Europe: one concerns the relationship between ethnicity, gender, and culture. The second focuses on the controversial link between Islam, gender, and "fundamentalism."

ETHNICITY, GENDER, AND CULTURE
A number of studies investigate the effect of the migration process on the roles played by Muslim women. All emphasize the marginality of the ethnic groups to which Muslims belong and highlight the high rates of unemployment and poor housing conditions. Religion and culture are seen as markers of otherness and bases for exclusion. The crucial question asked in these studies is: how do groups reconstruct their identities? They all consider the importance of ethnicity in the reformulation of Muslim identities in the European context. In other words, different cultures and ethnic boundaries affect both the meaning and the content of Muslim identities, while Islamic references and identifications reinforce the building of ethnic communities.

Some studies highlight the influence of patriarchal values in the lives of South Asian, Turkish, and North African women. They demonstrate how some violent and discriminatory practices generally attributed to Islam, such as excision, mistreatment of women, and arranged marriages, actually reflect patriarchal values rooted in a culture that predates Islam.

Along this line, some authors describe how

international kinship is consolidated through marriage in the case of Pakistani, Turkish, and North African migration. One study notes that Pakistani, Turkish, and North African males prefer wives from their countries of origin, rather than from among second generation Muslim women in Europe. Their preference for "native daughters," who are by reputation more religiously observant, actually reflects a wish to remain close to native culture as much as a yearning to remain close to Islam. Others examine the socio-spatial regulation of male/female relationships in Muslim groups and describe the control of female circulation outside the home. Since the two spaces allowed for women are school and work, it is not surprising that most of the studies describe women in schools and at their jobs. It is regrettable that most of this research relies on a stereotypical definition of patriarchy that does not question or explore the changing status of Muslim women either in their countries of origin or in Europe. The conventional approach to patriarchal systems insists on the restriction on women's freedom in order to preserve the fathers' patrimony. In the case of Muslim societies, some authors like Fatima Mernissi emphasize the role of Islamic ideology, which posits the primacy of the male believer's relationship with God. However, very few take into account material conditions, such as urbanization and changes in the role of family, that are affecting and transforming this classic patriarchy. Moreover, these studies characterize all the different facets of patriarchal influence by the same implicit dichotomy between in/out cultures (ethnic Muslim versus Western culture) and take for granted the opposition between the realms of values and behavior. Therefore, these analyses reinforce an artificial and misguided opposition between Islam and modernity. They prevent readers from understanding that references to patriarchal or Islamic values do not signify a perpetuation of archaic attitudes, but instead demonstrate the capacity of different cultures to adapt to the consequences of social and cultural modernization. For example, what some analyses might identify as a fundamentalist practice can be the result of individual choice as in the case of women who wear the ḥijāb (headscarf), independent of male pressure, as an expression of spiritual self and social emancipation in an urban context. In order to capture the meaning of this modernized use of tradition, it is necessary to go beyond the discourse of gender in the abstract to examine gender relations in the European context.

ISLAM, GENDER, AND FUNDAMENTALISM

The same bias, perhaps to an even greater degree, exists in the studies concerning the relationship between gender, Islam, and so-called fundamentalism. In general, most feminist accounts of Muslim women – whether in Muslim societies or in Muslim communities within European societies – argue that where Islam plays a determining role in shaping postcolonial sociopolitical discourse, the control of women and their sexuality is central to national and ethnic processes. In contrast to the constant fight for an Islamic state in the Muslim world, Muslim women in Europe focus on empowering their own community group. The dominant trend exhibited by many essays is to envision religious revivalism within Muslim groups in Europe as a mark of fundamentalism. As Glavanis points out, such analyses equate all new religious movements with "fundamentalism," making little reference to substantive social research within different European societies (Glavanis 1998a, 391–410). These studies appear to derive their understanding of "fundamentalism" from an implicit acceptance of an analytical and political dichotomy between progressive modernity and traditional religion. Thus, they are also able to argue that the struggle against "fundamentalism" should constitute a central component of feminism. In this respect, it is not surprising that they can conclude that secularism is a necessary component of the empowerment of women, including Muslim women. The trend, therefore, is to reproduce uncritically the conventional neo-Orientalist juxtaposition of Islam and secularism, with no reference to gender relations in Muslim communities. Any intensification of female religiosity is seen as an influence of fundamentalism and the marker of a dominated condition. Often such assertions rely primarily on a reading of texts and discourses by Muslim theologians and Islamists and do not reflect any extensive social research.

Fortunately other studies take into account the specificity of the European social context. They go beyond the representation of gender to address gender relations as such by analyzing Muslim women in historical terms. Studies of the veil are representative of these attempts. Most of them point out that the veil should be understood in the specific historical context in which it is adopted. During the colonial domination, the veil became a potent signifier not only of the social meaning of gender but also of nationalism and culture. It has

been locked in the opposition between the West and authentic indigenous values. Most of the analyses of the veil in Europe transposed this framework, describing the veil as a form of symbolic resistance, a signifier for a contested cultural politics concerning the meanings of national, cultural, and religious identity in contemporary France and Germany. They insist on the various symbolic meanings of the veil according to social class and age. Others identify a sort of Islamic feminism associated with the veil and other religious attributes and describe the veil's paradoxical power of emancipation in the European context. A few authors have described female religiosity, especially in its esoteric forms, as a way to empower the female condition. There is little doubt that the sociological investigation of Islamic religiosity in general and female religiosity in particular will be the major increasing trend in studies of Islam in Europe.

Besides the ethnic and the fundamentalist Muslim woman in Europe, there is also the secular woman who is far less known. The absence of interest in this category is probably related to the neo-Orientalist bias that presupposes conflict between European and Islamic values and norms. This bias prevents research interest in any kind of cultural hybridization. Secularized Muslims, particularly women, are for the most part born or schooled in Europe. Without always sticking to the rules of the cult, they consider Islam to be part of their familial and cultural inheritance. That immense, silent majority is re-positioning Islamic tradition in the private sphere with the utmost discretion. While this secularization does not attract the attention of the media, its practice constitutes a cultural revolution.

Without abandoning identification with Islam, secularized Muslims envision their religion as a source of values that imbue their lives with meaning. This does not, however, lead them to religious practice. The process of "mobilization-subjectivication" of values disconnects the Islamic message from the contents and established norms of tradition. In this way, the subject sets him/herself apart from the group and situates him/herself as the mediator between the contents of the code and its application. When these norms are disconnected from their original and strict determination, individuals may exercise choice and creativity in applying them. This trend brings to mind other new forms of religiosity in modern societies, in which the believer no longer obeys norms transmitted by institutions or tradition, but instead chooses spiritual values as a function of individu-

ality. The collective dimension of Islam is thus regulated by an individual logic, which constitutes a totally unprecedented mode of adherence to Islam. This new mode is only in its first stages in Europe and needs to be studied more intensively.

It is also regrettable when scholars use only indirect knowledge to learn about the transmission of Islam and adaptation of Islamic family law to the European context. For example, lawyers who are interested in the adaptation of Sharīʿa (Islamic law) to the Western context examine marriage, divorce, and inheritance laws to try to understand how the basic prescriptions of Islam are still valid in a different juridical environment. This examination, however, does not address the social condition of Muslim women. For example, a scholar who looks at only the application of laws would conclude that traditional patriarchal laws regarding marriage, divorce, and inheritance prevail in Muslim communities in Western Europe. However, it is clear that there is an increasing empowerment of women in all these areas. For example, even though women may formally respect the ṭalāq (divorce) procedure, there is much more negotiation between husbands and wives regarding traditional practices.

Finally, it can be said that Muslims in general, and women in particular, have not only adjusted to postmodernity, urbanity, and globalization in the European context, but they have also adapted to a "culture of separateness," which presupposes autonomy and independence in even the religious realm. Consequently, identities that are integrated in Muslim countries are automatically broken down into religious, social, and ethnic components in the West. In this regard, Muslim practices are by now far more advanced than studies and data would suggest.

BIBLIOGRAPHY
H. Afshar and M. Maynard (eds.), *The dynamics of race and gender. Some feminist interventions*, London 1994.
L. Ahmed, *Women and gender in Islam*, New Haven, Conn. 1992.
S. Andessian, Migrant Muslim women in France, in T. Gerholm (ed.), *The new Islamic presence in Western Europe*, London 1988, 196–204.
F. Anthias and N. Yuval-Davis (eds.), *Woman, nation, state*, London 1989.
F. Anthias and N. Yuval-Davis, *Racialized boundaries. Race, nation, gender, colour and class and the antiracist struggle*, London 1992.
A. Bastenier, J. Carlier, and M. Verwilghen (eds.), *Le statut personnel des musulmans. Droit comparé et droit international privé*, Brussels 1992.
B. Botiveau, Islamic law in the French legal context, *Cambridge Anthropology* 16:2 (1992), 85–96.
A. Brah, Race and culture in the gendering of labour

markets. South Asian young Muslim women and the labour market, *New Community* 9:5 (1994), 441–8.

L. Brouwer, Binding religion. Moroccan and Turkish runaway girls, in W. A. Shadid and P. S. Van Koningsveld (eds.), *The integration of Islam and Hinduism in Western Europe*, Kampen, The Netherlands 1992, 75–89.

J. Cesari, *Musulmans et républicains. Les jeunes, la France et l'islam*, Brussels 1998.

F. Gaspard and F. Khosrokhavar, *Le foulard et la république*, Paris 1995.

P. Glavanis, *The struggle for identity. Race, ethnicity and difference in post-war Britain*, London 1998a.

——, Political Islam within Europe. A contribution to the analytical framework, *Innovation* 11:4 (1998b), 391–410.

N. Göle, *The forbidden modern. Civilization and veiling*, Ann Arbor 1996.

F. Halliday, *Islam and the myth of confrontation*, London 1996.

W. Heitmeyer, *Verlockender fundamentalismus*, Frankfurt 1996.

D. Kandiyoti (ed.), *Women, Islam and the state*, London 1991.

D. Kandiyoti, Identity and its discontents. Women and the nation, in P. Williams and L. Chrisman (eds.), *Colonial discourse and post-colonial theory. A reader*, New York 1993, 376–91.

G. Kepel, *Allah in the West. Islamic movements in America and in Europe*, Stanford, Calif. 1997.

C. Lacoste-Dujardin, *Yasmina et les autres de Nanterre et d'ailleurs. Filles de parents maghrébins en France*, Paris 1992.

T. Modood, British Asian Muslims and the Rushdie affair, in J. Donald and A. Rattansi (eds.), *Race, culture and difference*, London 1992, 260–77.

R. Mohammad, Marginalisation, Islamism, and the production of the "other's" "other," in *Gender, Place and Culture*, 6:3 (1999), 221–40.

D. Pearl and W. Menski (eds.), *Muslim family law*, London 1998.

S. Poulter, Multiculturalism and human rights for Muslim families in English law, in M. King (ed.), *God's law versus state's law*, London 1995, 81–7.

G. Saghal and N. Yuval-Davis, *Refusing holy order. Women and fundamentalism in Britain*, London 1992.

C. Saint-Blancat, *L'islam in Italia. Una presenza plurale*, Rome 1999.

A. Shaw, *A Pakistani community in Britain*, Oxford 1988.

N. Venel, *Musulmanes françaises. Des pratiquantes voilées à l'université*, Paris 1999.

S. Vertovec, *Annotated, select bibliography of academic publications regarding Islam and Muslims in the United Kingdom*, Oxford 1993.

JOCELYNE CESARI

Methodologies, Paradigms and Sources for Studying Women and Islamic Cultures

Disciplinary Entries

Anthropology

The historical trajectory of the anthropological literature on Muslim societies reflects key developments within the discipline of anthropology since its inception. We find, therefore, that not unlike ethnographies produced on other parts of the world, early anthropological work on Muslim societies tended to largely ignore women (e.g. Barth 1965, Evans-Pritchard 1940, Geertz 1968, Gellner 1961, Westermark 1926). This was in part due to the male bias that has historically characterized academic disciplines in general, and in part due to the absence of women anthropologists within the field. This trend was slowly rectified as women anthropologists entered the discipline and began paying attention to women's activities and lives in a manner that was quite unprecedented. There began to emerge a tradition of ethnographic documentation of women's lives in a variety of cultures; foremost among these were ethnographies produced on women's rural and urban existence in Muslim societies (Aswad 1967, Fernea 1969, Grinqvist 1931, Mohsen 1967, Sweet 1967). It was not until the 1970s, however, that the "anthropology of women" came into its own, and introduced the analytical concept of gender to the study of social and cultural phenomena in a manner that has transformed the discipline substantially.

One of the key contributions of this development to the discipline of anthropology has been the argument that an analytical focus on gender does not simply describe "women's lives" but helps elucidate the production of social relations of inequality in general, shedding light on how even public institutions of politics, statehood, and economic production – in which women have been historically marginalized – are sustained and reproduced (Rosaldo and Lamphere 1974, Mac-Cormack and Strathern 1980, Yanagisako and Collier 1987). Notably, gender in this literature is conceptualized as a relational category, rather than something that pertains to women's lives alone, thereby bringing the lens of gender inequality to bear upon the workings of historically specific socioeconomic and cultural formations. Cynthia Nelson's work (1974) is well known for introducing this argument into the anthropology of the Middle East. Since then a number of sensitive studies have been produced that examine, for

example, how a focus on gender transforms the analysis of property relations (Maher 1974), political culture (Joseph 1983, al-Torki 1986), or tribal structure and its discourses (Abu-Lughod 1986). Similarly, in Islamic cultures outside of the Middle East, there now exists a rich body of scholarship that elucidates how an analysis of gender is crucial to understanding the operations of modern capitalism (Ong 1987), the symbolic binaries of public/private and production/reproduction (Delaney 1991, Papanek 1973), religious power and spirituality (Boddy 1989), and urban/rural market relations (Strobel 1979) – to mention just a few topics that this scholarship addresses.

THE CRITIQUE OF ORIENTALISM AND REFLEXIVE ANTHROPOLOGY

The anthropology of women in Muslim societies had already been established as a robust field when two critical currents swept the discipline of anthropology in the 1980s, introducing a new set of debates that have been critical to the development of the discipline. The first of these addressed the intertwined character of anthropological knowledge and colonial projects, drawing attention to the power that Western disciplines such as anthropology have historically commanded in representing "Other" cultures. From within the discipline of anthropology, Talal Asad's *Anthropology and the Colonial Encounter* (1973) was one of the first publications to deal with this issue, followed by Edward Said's *Orientalism* (1978), written from the perspective of a literary critic. These scholars argued that many of the tropes that anthropologists used to characterize non-Western cultures were not only poor depictions of the social reality they were meant to capture, but were also used by institutions of Western colonial power to intervene and remake non-Western traditions, practices, and institutions as part of the modernist imperial project to conquer and reshape the world. Subsequent anthropologists have expounded and written on this theme, heralding a new era within anthropology that has focused on the production of cultural difference as a site of colonial and postcolonial hegemony and power (Clifford 1988, Dirks 1992, Marcus and Fischer 1986, Scott 1994).

The second issue raised in the 1980s focused

more specifically on anthropological claims to "objective" knowledge, and drew attention to those aspects of fieldwork that entail ambiguity, approximation, subjective judgment, and inequality of relations between the observer and the observed (Clifford and Marcus 1986, Behar and Gordon 1995). Since this critique was aimed at those aspects of disciplinary knowledge that are unique to anthropology, a number of influential anthropologists responded by coining a new genre of ethnographic writing glossed as "reflexive anthropology," in which the anthropologist foregrounded her own privileged position as a researcher, drawing attention to the problems of reductionism, reification, ventriloquism, and essentialism that are endemic to any anthropological enterprise (Crapanzano 1980, K. Dwyer 1982, Koptiuch 1999, Lavie 1990).

These disciplinary critiques impacted the study of women in Muslims societies in at least two significant ways. The first critique provided an analytical space for the expression of the uneasiness that many scholars of Muslim societies had felt with essentialist and ahistorical depictions of Islam that treated Islam as an ideational system largely insulated from forces of political, economic, and social change (Geertz 1968, Gellner 1961). This understanding of Islam as a monolithic system, frozen in time, was all the more pronounced in analyses that focused on women in Muslim societies. These depicted Islam as the sole determinant of the patriarchal character of these societies, often ignoring how socioeconomic and political arrangements contributed to culturally and historically specific forms of gender inequality (Abu-Lughod 1989, Ahmed 1982, Hammami and Rieker 1988, Lazreg 1989, Mohanty et al. 1991). Furthermore, critics charged that the trope of the passive oppressed Muslim woman had served as a convenient tool for colonial powers to justify the superiority of Western civilization over the Muslim world, allowing them to couch their imperial interventions in the benign language of saving Muslim women from the patriarchal oppression of their indigenous culture (Ahmed 1992, Alloula 1986). Not only was this disingenuous, these scholars argued, but such an approach also made gender inequality appear to be a consequence of religious tenets and scriptural authority rather than a product of complex social and cultural factors in which colonial rule as much as religion had played a key role.

This critique of existent approaches to the study of women in Muslim societies led to a burgeoning of anthropological scholarship that helped displace the stereotype that women in the Muslim world were passive victims of patriarchal oppression, drawing attention to the myriad ways in which they created complex worlds, resisting (and at times colluding in the sustenance of) hegemonic norms and values that surrounded them (Abu Lughod 1993, Boddy 1989, Callaway 1994, Friedel 1989, Hegland 1991, Mies 1982, Tohidi 1998). These studies also pointed out that Islam was one among many religious traditions practiced within Muslim societies – a fact that required scholars to pay adequate attention to the specificities of social, economic, and political contexts in which Muslim as well as non-Muslim women lived in these societies.

The second critique, aimed at the discipline's claims to objective knowledge, which inspired the tradition of reflexive ethnography, has also exerted considerable influence on the scholarship on women living in Muslim societies. This is evident in the attention the anthropologist brings to her own subject position as a researcher, which is no longer synonymous with an Anglo male subject position, but entails other kinds of privileges, complications, and contradictory demands requiring different analytical strategies and presuppositions (Abu-Lughod 1993, Altorki and El-Solh 1988, Behar and Gordon 1995). Anthropologists writing in this vein have emphasized how their own ethnic identity, as well as their location in the Western academy, inevitably tends to affect the kind of knowledge they produce about Muslim societies (see Koptiuch 1999, Lavie 1990, Lazreg 1989). As must be clear by now, since the inception of the discipline of anthropology, the study of women in Muslim societies has undergone substantial changes and reformulations. There now exists a considerable body of literature that is diverse in its historical, theoretical, and thematic focus.

POST-ORIENTALIST SCHOLARSHIP

It is precisely because such strides have been made in the scholarship on this topic that there is now the space to evaluate and rethink the questions opened up by this work, and to reflect on new directions and lacunae that need to be addressed. Despite the considerable changes that the field of anthropology has undergone, especially in its study of women in Muslim societies, this history cannot be represented simply as a march of progress wherein incorrect ways of thinking have been replaced by more enlightened modes of analysis. This is because old ways of thinking are often hard to discard, but also because new scholarship tends to generate fresh conceptual problems

that are a product of new historical conditions and shifts within regnant analytical paradigms. Consequently, it is important to trace some of the new questions that have been generated by the post-Orientalist scholarship on women in Muslim societies, and think about the different ways in which these may be approached.

One of the immediate issues that confront the analyst is the problematic nature of the category "Muslim women," a category that is taken for granted but actually requires some unpacking. The problems entailed in the collectivity that the term Muslim women signifies immediately become apparent when we compare it to the term "Christian women." Clearly the latter term, while used to describe activist or devout Christian women, is rarely used to designate women who live in countries as diverse as South Africa, Tanzania, the United States, Poland, France, Italy, and Australia – all of which have majority Christian populations. In fact, it is more common to refer to women living in predominantly Christian societies by their nationality, rather than by their relationship to a faith. (For example, even though France is predominantly a Catholic country, one refers to women living in France as French rather than Christian.) In other words, the term Christian women often refers to a group of women who actively profess the Christian faith, and seldom includes those who do not. No parallel distinction, however, seems to hold in regard to the term Muslim women.

The problem becomes even more compounded when faced with the fact that large non-Muslim populations inhabit many of the regions that comprise the Muslim world (such as Indonesia, Malaysia, India, Egypt, Palestine, and so forth). Indeed, the phrase "women in Islamic cultures" – used in the title of this encyclopedia – attempts to partially address this problem by suggesting that this project is concerned with documenting the lives of all women (whether Muslim or not) who live in various parts of the Muslim world, or what the encyclopedia calls Islamic cultures. As a quick survey of the anthropological literature shows, while studies on the topic of Muslim women abound, there are few ethnographies that document the complexity of the lives non-Muslim women live in Islamic cultures (for exceptions, see Joseph 1983, Peteet 1991). This gap is especially problematic given the fact that large non-Muslim populations have historically inhabited Muslim lands. These non-Muslim populations have had an enormous impact on the kind of Islam that is practiced in these areas, and their own identity

and self-image has been fundamentally shaped by the political form Islam has taken. (For example, the Coptic community living in Egypt has, since the inception of the postcolonial nation-state, often defined itself as part of the "Islamic civilization.") In light of the recent emergence of popular Islamic movements, some of which support the adoption of Islamic law, it has become all the more important to interrogate how non-Muslim women have been affected by such developments in the Muslim world.

Even the phrase "Islamic cultures" used in the title of this encyclopedia to address some of the issues raised above is not free of problems. The first question that comes to mind is, how does one define such an object? The perennial anthropological question haunts the term Islamic culture: can one describe a culture by reference to the religion practiced by its inhabitants? How do we describe a cultural practice as Islamic when Muslims and non-Muslims alike observe it, and when its origins cannot be traced to Islamic scriptural sources? How do we analyze other forms of belonging – nationalist, ethnic, religious – that are not encompassed by Islam, and whose modes of existence are only tangentially related to Islam? In other words, how does one give equal analytical weight to various aspects of social life encompassed by the term "culture" without reducing one to the other?

The issue gets even more complicated when one thinks about Muslim minorities who live in non-Muslim majoritarian countries. For example, does it make sense to say that Indian Muslims – who comprise the largest minority Muslim population in the world today – live in an "Islamic culture," or are they the inhabitants of a "Hindu culture?" Can the two be separated, and if so, on what basis, and by whom? Given the long history of Muslim rule in India and the vast cultural heritage this legacy commands, this question points to the complicated ways in which the ideology of nationalism has forced questions of religious belonging through the narrow funnel of majority and minority categories. As is clear from the communal riots that have swept India in the last two decades and the increasing anti-Muslim violence, these are not simply academic questions. It is crucial for a scholar interested in these issues to ask how the rubric of "Islamic cultures" articulates with the limited discourse of nationalism. Here the logic of majoritarianism requires that all minority claims be necessarily framed through the forms of belonging authorized by the project of building a single nation, with a unified culture, language, and religion.

It may be argued in response that one can avoid taking a position on such questions by simply letting "native voices" speak through the ethnography, without any mediating anthropological and political categories, so as to provide a "true account" of the heterogeneity of life in the Muslim world. This argument is in part fueled by the research methodology of participant observation and fieldwork unique to the discipline of anthropology, one that requires that the anthropologist live in intimate proximity to her informants, gathering her data from the observations she makes of her informants' daily lives. It is often believed that the anthropologist's proximity to her research subjects gives her a distinctive ability to capture the density and texture of life as it is experienced and lived by her informants. A number of anthropologists who have sought to displace the stereotypical representations of women living in the Muslim world have used this anthropological claim to advocate an ethnographic style of writing which faithfully records the complexity of life lived by these women, while at same time refusing to frame their narrative in terms of received anthropological categories that reduce this complexity to simple generalizations (D. Dwyer 1983, Early 1993, Friedel 1989).

Such work, while salutary in its aims, raises some troubling questions. Part of the problem resides in assuming that by virtue of providing a "thick cultural description," or an untainted record of "native voices," a scholarly work can somehow avoid imposing the anthropologist's own categories of analysis. Such an assumption is problematic because it obfuscates the fact that any anthropological description involves a process of selection, translation, and organization, all of which impose in one form or another the anthropologist's system of classification on the data. Thus the problem of finding appropriate analytical categories and theoretical frameworks cannot be avoided in the name of descriptive anthropology. Rather, thorny questions about how one defines culture, religion, and the category of women need to be addressed in order to produce analytically insightful scholarship on the Muslim world.

Is economic transformation to women as Islamic culture is to men?

The political force that religion came to command in the last century raises further analytical dilemmas for the study of women living in Islamic cultures. Contrary to modernist expectations that religious forms of belonging would decline in the twentieth century, there has been a sharp rise in popular interest in religion all over the world. In the last 30 years, the Muslim world has seen the dramatic rise of Islamist movements (often referred to as the "Islamic revival") that are comprised not only of Islamist political parties, but a range of cultural and associational activities organized around Islamic principles and practices (Hefner 2000, Hirschkind 2001, Mahmood forthcoming, Peletz 2002). Indeed, no contemporary discussion about the Muslim world would be complete without paying adequate attention to this phenomenon, given its wide sweep (from Southeast Asia, to Central Asia, the Middle East, and Africa), and the challenge it poses to nationalist and leftist ideologies that had held sway in the Muslim world since the 1930s. Notably, the phenomenon of the Islamic revival is also currently flourishing among Muslims living in North America and Europe. This development has increasingly caught the attention of anthropologists and a number of interesting dissertations are currently being produced on the subject.

One of the paradoxes of the Islamist movement is that despite a strong following among women, it remains highly patriarchal in character, and many of the male as well as female participants uphold those Islamic edicts and practices that promote gender inequality. As a result there has been a re-emphasis on those Qur'ānic verses and *aḥadīth* that support the superiority of males over females, and that have been historically used to justify restrictions placed on women's entry into public domains. Despite the resurgence of these kinds of interpretive practices, however, Islamist movements paradoxically have also served as critical avenues for women's unprecedented entry into domains of religious pedagogy, scriptural interpretation, and religious activism (Brenner 1996, Mahmood 2001, Mir-Hosseni 1999).

Scholars have tried to analyze this contradictory aspect of the Islamist movement through a variety of theoretical perspectives. A significant number argue that the patriarchal character of the Islamist movement may be explained by the threat posed to men by the inroads women have made in the modern period into public domains (such as education, employment, and public office) that were previously restricted to men. This argument has been made in relation to Islamic movements in areas as disparate as Morocco, Malaysia, and Bangladesh, to take just a small sample (Mernissi 1987, Ong 1990, Siddiqi 1999). The argument goes something like this: while modern opportunities have transformed women's lives by opening

the door to education and employment, the men of these societies, feeling competition and insecurity at women's entry into the public domain, have resorted to longstanding patriarchal Islamic values to exclude and punish women for their intrusion. Muslim men, these scholars argue, perceive women's participation in public life as an "erotic aggression," to which they respond either by meting out Islamic punishments to women (hence the support for the institutionalization of Islamic law), or aggressively asserting conservative social mores drawn from Islamic injunctions (hence the popularity of modest dress styles and traditional social customs) (Ong 1990, Mernissi 1987).

One of the problems with this argument is that it compartmentalizes women's and men's ideological worlds: while Islamic patriarchy appears to govern male identity in this analysis, women's identity, in contrast, is seen to emerge in relation to economic transformation, role changes, and modern lifestyles. Furthermore, this form of argument seems to suggest that while men suffer from anxiety brought about by socioeconomic transformations (hence their attacks on women's mobility), women embrace these changes quite comfortably – the only impediment to this accommodation being the opposition they face from their male counterparts. Given that men and women living in Muslim societies have both been subject to Islamic patriarchal values as well as to modern socioeconomic transformations, is it not wrong to assume that only men are invested in preserving Islamic ideology and that women remain antithetical to it? Moreover, recent research on Islamist movements suggests that many of the Islamic practices associated with patriarchal forms of Islam (such as wearing the veil) are not forced upon women by men, but are the result of women's increasing conviction that this is the "correct" interpretation of Islam (Brenner 1996, El-Guindi 1981, Göle 1996, Hale 1996, Mahmood 2001, Zuhur 1992). If one does not want to revert to exhausted explanatory paradigms of "false consciousness," that have been successfully challenged by a range of feminists on a number of grounds, then the question that follows is: how does one explain this form of reasoning on the part of women without treating "choice" as a fetishized expression of individual autonomy that has no relationship to the force of cultural, political, and social fields that encompass the enactment of these choices? (For different kinds of answers to this question, see Abu-Lughod 2002, Göle 1996, Hirschkind and Mahmood 2002, Mahmood 2001).

This critique is not meant to single out authors for their faulty reasoning, but to point to the analytical difficulties entailed in maintaining a critical balance between a perspective that gives adequate attention to Islamic ideological formations and one that is attentive to processes of material and socioeconomic change that have transformed the Muslim world (as well as the interpretation of scriptures) in the modern period. While it is clear that the intent of many scholars writing in this vein is to avoid presenting a temporally frozen picture of Islam, their work nonetheless ends up equating Islamic scripture with male identity and interests, and economic change with female lives, thereby separating both the analysis of ideology from material change, and the analysis of social forces that shape the world of women from those that affect men.

One of the key reasons why this problem surfaces repeatedly in the anthropological studies of gender is because it is assumed that all women, regardless of which discursive formation they are a product of, hold the desire for freedom from relations of domination and male subordination as their coveted goal. As a result this scholarship has tended to naturalize the desire for freedom from structures of male domination, and ignore those desires and aspirations that are either indifferent to the goal of freedom or simply inattentive to it (see my discussion of this point in Mahmood 2001; see also Strathern 1987). Yet if we concede that all forms of desires are socially constructed, as a number of feminists have argued in the last several decades, then it is crucial that anthropologists inquire into a range of different kinds of desires (even those for subordination to male authority), and not naturalize those that are more conducive to certain kinds of political projects than others. Such an approach would require the analyst to *not* assume that while men are motivated by the desire to uphold relations of gender inequality as enshrined in Islam, women are constitutionally predisposed to oppose such a system. Rather, such an approach requires that the anthropologist pay attention to specific kinds of investments, understanding of the self and its relationship to social authority, as well as structures of hierarchy that bind women to the very forces that subordinate them.

Importantly, such an analytical approach would have to be careful not to commit the same mistakes as those made by Orientalist scholarship, wherein the desire for freedom, equality, and autonomy was equated with "Western values," and its absence was held to be synonymous with

"Islamic cultures." It is important to realize that the project of developing an analytically appropriate language that captures different kinds of personal and social commitments is not the same as finding an essential cultural essence that defines all people who live in a given society. It would be just as wrong to say that all women live by a commitment to freedom and equality in Islamic cultures as it would be incorrect to assume that none do. One of the key challenges that faces scholars today, following the important critique of Orientalist scholarship, is to develop a conceptual language that analyzes different kinds of commitments that are not necessarily attributable to a culture at large, but attend to different kinds of discursive and political formations that simultaneously inhabit a single cultural space. Just as scholars have been attentive to the multiplicity of commitments, ideals, and goals that co-exist in any given Western liberal society, it is equally important to be attentive to the variety of projects, conceptions of selfhood, structures of authority, and goals that exist among women living in Islamic cultures, none of which are reducible to a singular framework (such as religion, economic self-interest, gender equality, and so on). Careful analysis of the ways in which ordinary people inhabit the world differently is perhaps the strongest insight that anthropology can bring to the study of women who live in Muslim societies.

New directions

While the research agenda I have spelled out here for the anthropological study of gender is challenging, there is no other topic than the one covered by this encyclopedia that is better suited to meet its demands. This is because of the wide range of social, cultural, and historical contexts women inhabit in what are called "Islamic cultures" today, and the radically different social formations of which they are a part. This complexity is evident if one simply looks at the variety of geographical regions represented in this volume alone: they range from the Far East, South and South East Asia, to the Near and the Middle East, Africa, Europe, and North America.

The complexity entailed in the study of women living in Islamic cultures is further compounded by two other factors that I mentioned briefly before: not only does a large percentage of the Muslim population live as a minority in diverse regions of the world, but a significant portion of the populations living in what are termed "Islamic cultures" is non-Muslim. The complexity only deepens even if we were to examine the first of these two populations, namely Muslim minorities. For example, Muslim women who live in North America and Western Europe as a minority face very different kinds of social, familial, and political pressures than those Muslim minorities who live in places like India or Central Asia. As a result, the kind of Islam practiced among these women varies dramatically, even as it shares a central corpus of Islamic scriptures and juristic tradition. The work of scholars working on these areas reveals the enormous range of questions characterizing women's lives comprised in the demographics of "Muslim minorities" (see, for example, Aswad and Bilgé 1996, Haddad and Smith 1994, Hasan 1994, Jeffery and Basu 1998, Rath 2001).

A different set of interesting questions emerges when one focuses on non-Muslim populations in majoritarian Islamic cultures. That the history of non-Muslim women is linked with the political and social struggles of Muslim women is evident in various parts of the world. Consider, for example, the key role Christian Palestinians have played in the struggle against the Israeli occupation in the modern period; or the history of anti-colonial struggle that Indian Muslims shared with Indian Hindus and Christians, a history that was further cemented with the founding of the postcolonial secular state. This cooperation across religious lines is due in part to the secular history of these struggles wherein Palestinians and Indians shared a political vision that was not predicated upon their religious affiliations. This history of political solidarity has come under some strain in the last two decades as religious movements have gained ground in both Palestine and India (Islamist and Hindutva respectively), and the secular values that had provided the ideological glue for collective projects have been lost. The same set of developments may be observed, to varying degrees, in Sudan, Malaysia, Indonesia, and Egypt.

Faced with these challenges, secular women's groups have tried to create institutional and political ties that cut across religious lines, motivated by the belief that religious differences should be bracketed in the interest of political solidarity. With few exceptions (Jeffery and Basu 1996, Hasan 1994, Peteet 1991), anthropological accounts of these alternative secular women's struggles are lacking, however, and this is an area that requires further attention. Given the politically conflicted world in which we currently live, the importance of this scholarship cannot be overestimated.

Indeed, anthropology as a discipline seems eminently well positioned to undertake such a project.

This is not only because anthropology has a long history of analytical exploration of the thorny question of cultural difference, one that was particularly energized by the critiques launched in the 1970s and 1980s, but also because the anthropological method of participant observation allows one to explore how people themselves understand and describe the world they inhabit. Anthropology has a long-standing tradition of paying close attention to the terms and concepts used by the people being studied, so as to think through how these terms and concepts constitute a linguistic and material world, rather than assuming that these are simply cultural glosses over a universally shared, homogeneous world.

BIBLIOGRAPHY
L. Abu-Lughod, Veiled sentiments, Berkeley 1986.
——, Zones of theory in the anthropology of the Arab world, in Annual Review of Anthropology 18 (1989), 267–306.
——, Writing women's worlds, Berkeley 1993.
——, Do Muslim women really need saving? Anthropological reflections on cultural relativism and its others, in American Anthropologist 104 (2002), 783–90.
L. Ahmed, Western ethnocentrism and perceptions of the harem, in Feminist Studies 8 (1982), 521–34.
——, Women and gender in Islam. Roots of a modern debate, New Haven, Conn. 1992.
M. Alloula, The colonial harem, Minneapolis, Minn. 1986.
S. Altorki, Women in Saudi Arabia. Ideology and behavior among the elite, New York 1986.
S. Altorki and C. El-Solh (eds.), Arab women in the field. Studying your own society, Syracuse, N.Y. 1988.
T. Asad (ed.), Anthropology and the colonial encounter, London 1973.
B. Aswad, Key and peripheral roles of noble women in a Middle Eastern plains village, in Anthropological Quarterly 40 (1967), 139–52.
B. Aswad and B. Bilgé (eds.), Family and gender among American Muslims, Philadelphia 1996.
F. Barth, Political leadership among Swat Pathans, London 1965.
R. Behar and D. Gordon (eds.), Women writing culture, Berkeley 1995.
J. Boddy, Wombs and alien spirits. Men and women in the Zar cult in North Africa, Madison 1989.
S. Brenner, Reconstructing self and society. Javanese Muslim women and "the veil," in American Ethnologist 23 (1996), 673–97.
——, The domestication of desire, Princeton, N.J. 1998.
B. Callaway, The heritage of Islam. Women, religion, and politics in West Africa, Boulder, Colo. 1994.
J. Clifford, The predicament of culture. Twentieth-century ethnography, literature and art, Cambridge 1988.
J. Clifford and G. Marcus (eds.), Writing culture, Berkeley 1986.
V. Crapanzano, Tuhami. Portrait of a Moroccan, Chicago 1980.
C. Delaney, The seed and the soil, Stanford 1991.
N. Dirks (ed.), Colonialism and culture, Ann Arbor 1992.
D. Dwyer, Images and self-images. Male and female in Morocco, New York 1983.
K. Dwyer, Moroccan dialogues, Baltimore, Md. 1982.
E. Early, Baladi women of Cairo, Boulder, Colo. 1993.
F. El-Guindi, Veiling infitah with Muslim ethic. Egypt's contemporary Islamic movement, in Social Problems 28 (1981), 465–83.
E. Evans-Pritchard, The Nuer, Oxford 1940.
E. Fernea, Guests of the sheik, New York 1969.
E. Friedel, Women of Deh Koh, Washington 1989.
C. Geertz, Islam observed, Chicago 1968.
E. Gellner, Saints of the Atlas, Chicago 1969.
N. Göle, The forbidden modern, Ann Arbor 1996.
H. Granqvist, Marriage conditions in a Palestinian village, Helsinki 1931.
Y. Haddad and J. Smith (eds.), Muslim communities in North America, Albany, N.Y. 1994.
S. Hale, Gender politics in Sudan. Islamism, socialism, and the state, Boulder, Colo. 1996.
R. Hammami and M. Reiker, Feminist Orientalism and Orientalist Marxism, in New Left Review 170 (1988), 93–106.
Z. Hasan (ed.), Forging identities, Boulder, Colo. 1994.
R. Hefner, Civil Islam, Princeton, N.J. 2000.
M. Hegland, Political roles of Aliabad women. The public-private dichotomy transcended, in N. Keddie and B. Baron (eds.), Women in Middle Eastern history. Shifting boundaries in sex and gender, New Haven, Conn. 1991, 215–30.
C. Hirschkind, Civic virtue and religious reason. An Islamic counter-public, in Cultural Anthropology 16 (2001), 3–34.
C. Hirschkind and S. Mahmood, Feminism, the Taliban, and politics of counter-insurgency, in Anthropological Quarterly 75 (2002), 339–54.
P. Jeffery, Frogs in a well, London 1979.
P. Jeffery and A. Basu (eds.), Appropriating gender. Women's activism and politicized religion in South Asia, New York 1998.
S. Joseph, Working-class women's networks in a sectarian state. A political paradox, in American Ethnologist 10 (1983), 1–22.
K. Koptiuch, A poetics of political economy in Egypt, Minneapolis, Minn. 1999.
S. Lavie, Poetics of military occupation, Berkeley 1990.
M. Lazreg, Feminism and difference. The perils of writing as a woman on women in Algeria, in M. Hirsch and E. F. Keller (eds.), Conflicts in feminism, New York 1989, 326–48.
C. MacCormack and M. Strathern (eds.), Nature, culture and gender, Cambridge 1980.
V. Maher, Women and property in Morocco, New York 1974.
S. Mahmood, Feminist theory, embodiment, and the docile agent. Some reflections on the Egyptian Islamic revival, in Cultural Anthropology 16 (2001), 202–36.
——, Pious transgressions. Embodied disciplines of the Islamic revival, Princeton University Press (forthcoming).
G. Marcus and M. Fischer, Anthropology as cultural critique, Chicago 1986.
F. Mernissi, Beyond the veil, Bloomington, Ind. 1987.
M. Mies, The lace makers of Narsapur, London 1982.
Z. Mir-Hosseini, Islam and gender. The religious debate in contemporary Iran, Princeton, N.J. 1999.
C. Mohanty et al. (eds.), Third world women and feminism, Bloomington, Ind. 1991.
S. Mohsen, The legal status of women among Awlad Ali, in Anthropological Quarterly 40 (1967), 167–83.
C. Nelson, Public and private politics. Women in the Middle Eastern world, in American Ethnologist 1 (1974), 551–63.

A. Ong, *Spirits of resistance and capitalist discipline*, Albany, N.Y. 1987.

——, State versus Islam. Malay families, women's bodies, and the body politic in Malaysia, in *American Ethnologist* 17 (1990), 258–75.

H. Papanek, Purdah. Separate worlds and symbolic order, in *Comparative Studies in Society and History* 15 (1973), 289–35.

M. Peletz, *Islamic modern. Islamic courts and cultural politics in Malaysia*, Princeton, N.J. 2002.

J. Peteet, *Gender in crisis. Women and the Palestinian resistance movement*, New York 1991.

J. Rath, *Western Europe and its Islam*, Leiden 2001.

M. Rosaldo and L. Lampher (eds.), *Women, culture, and society*, Stanford 1974.

F. Sabbah, *Woman in the Muslim unconscious*, New Haven, Conn. 1984.

E. Said, *Orientalism*, New York 1978.

D. Scott, *Formations of ritual. Colonial and anthropological discourses on the Sinhala Yaktovil*, Minneapolis, Minn. 1994.

D. Siddiqi, T. Nasreen, and others, The contest over gender in Bangladesh, in H. Bodman and N. Tohidi (eds.), *Women in Muslim societies*, London 1998, 205–27.

M. Strathern, An awkward relationship. The case of feminism and anthropology, in *Signs* 12 (1987), 276–93.

M. Strobel, *Muslim women in Mombasa*, New Haven, Conn. 1979.

L. Sweet, The women of 'Ain ad Dayr, in *Anthropological Quarterly* 40 (1967), 167–83.

N. Tohidi and H. Bodman (eds.), *Women in Muslim societies*, London 1998.

E. Westermark, *Ritual and belief in Morocco*, London 1926.

S. Yanagisako and J. Collier (eds.), *Gender and kinship. Essays toward a unified analysis*, Stanford, Calif. 1987.

S. Zuhur, *Revealing reveiling. Islamist gender ideology in contemporary Egypt*, Albany, N.Y. 1992.

SABA MAHMOOD

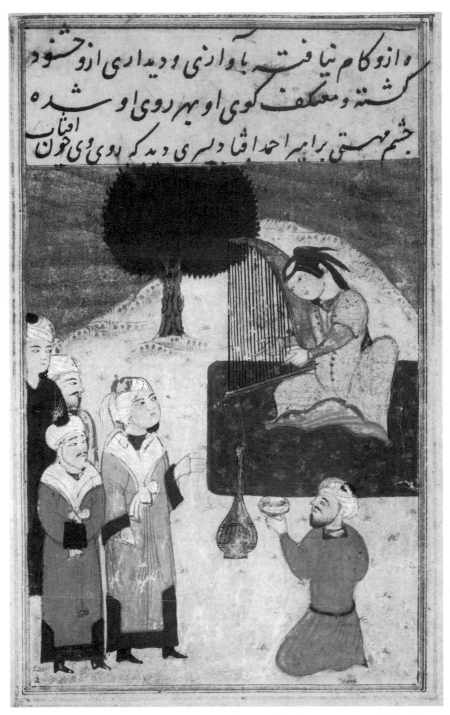

This miniature from a Persian manuscript in the British Library (Or. 8755, f.29v) depicts the legendary poet Mahsatī entertaining a group of male admirers. See page 44, 'Literature: 9th to 15th Century' by Marlé Hammond. (*By permission of the British Library.*)

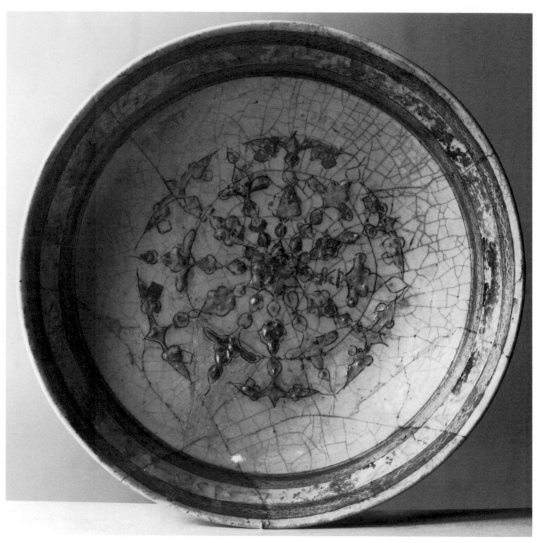

The exterior of this ceramic bowl, which is found in the collection of the Victoria and Albert Museum in London (no.C 86 –1918), features a quatrain attributed to Mahsatī. See page 48, 'Literature: 9th to 15th Century' by Marlé Hammond. (*Photo provided by the V&A Picture Library.*)

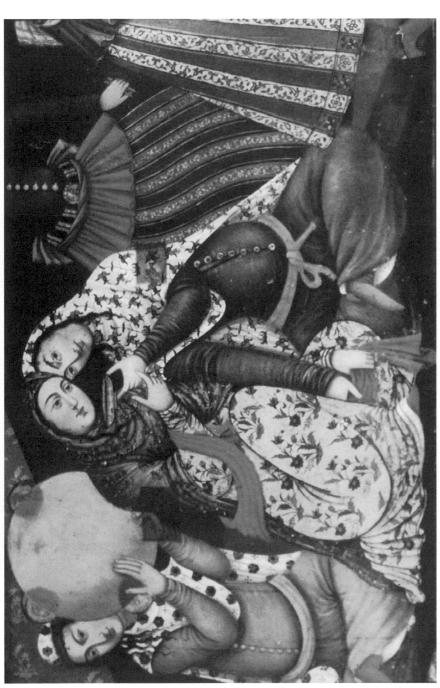

Wall painting in the reception hall of the forty-pillared (Chihil Sutūn) palace in Isfahan that portrays a female entertainer smilingly offering her partner a cup of wine while rubbing her groin with the other hand, and all this in the midst of a royal feast held in honor of the Uzbek ruler Vali Muḥammad Khān. See page 93, 'Safavid Iran: 16th to mid-18th Century' by Kathryn Babayan.

(Photo: © Sussan Babaie)

Lara Baladi's *Um El-Donia* project displayed this image as a billboard on the streets of Cairo in 2001. See 'Art and Architecture' (pages 315–320) by Heghnar Watenpaugh. (*Photo: Medina Magazine.*)

The Grameen Bank Housing Project provided loans to low-income families to build their own homes based on a standard module in Dhaka, Bangladesh, 1984. See 'Art and Architecture' (pages 315–320) by Heghnar Watenpaugh. (*Photo: Aga Khan Trust for Culture.*)

General View of the Yeni Valide Mosque Complex, Istanbul, first half of the seventeenth century. Patron: royal mother Safiye Sultan. See 'Art and Architecture' (pages 315–320) by Heghnar Watenpaugh. (*Photo: German Archaeology Institute, Istanbul.*)

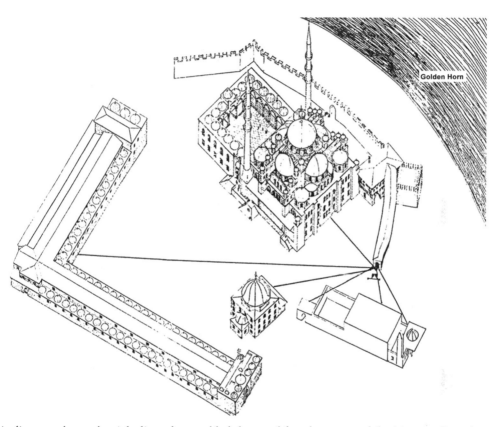

Golden Horn

This diagram shows the sight lines that enabled the royal female patron of the Mosque Complex of Yeni Valide to see out without being visible herself, Istanbul, first half of the seventeenth century. Prepared by Arzu Ozsavasci. See 'Art and Architecture' (pages 315–320) by Heghnar Watenpaugh. (*From: L.Thys-Senocak, Ottoman Women Builders: The Architectural Patronage of Turhan Sultan. Aldershot: Ashgate Press, forthcoming.*)

Art and Architecture

In the last 30 years, the study of art and architecture in Islamic societies has evolved to form a recognized, if still rather small, field within the discipline of art history, with its own historiographic tradition and influential contributions. However, the study of women and gender remains an unexplored area within the visual culture of the Islamic world. This article outlines the sources available for this type of research, presents an overview of the methods used in the scholarship, and points to avenues for future research. (See also the illustration section following page 314.)

SOURCES

The most commonly invoked reason why the intersection of gender and visual culture in the Islamic world is little explored maintains that very few primary sources – visual or textual – address or illuminate these very issues. However, primary sources are poorly explored in practically every aspect of Islamic studies; and as no systematic investigation of the sources that are available for the study of gender has actually been done, it is difficult to state with certainty that they do not exist. Additional research is the only path to gain a more accurate picture of the range of available sources and the most productive way to interrogate them. In addition to locating "new" primary material, however, much can be learned from reading the available sources critically, and from reading them for gender. For example, Afsaneh Najmabadi has shown that modern heterosexist readings of premodern Sufi poetry have consistently obscured and elided the homoerotic content of these texts (Najmabadi forthcoming).

Clearly, the field presents a range of challenges to the researcher interested in gender issues. At this point it may be useful to present a short overview of the types of sources available. The nature of the sources and their investigation by scholars differ according to geographic context. For example, while studies of gender and art in societies dominated by various Turkic groups exist, Muslim women in sub-Saharan African societies are all but invisible in the literature. Recently there have been several exemplary studies of the gendered production and use of art in sub-Saharan societies (Prussin 1995, Perani and Smith 1998), yet issues of gender and visual culture relating to Islamic groups south of North Africa have all but disappeared in the interstices between fields of area studies as currently defined in Western academe.

Significant differences in scholarship also result from temporal contexts. A major cleavage exists in the nature of sources between the contemporary period and the premodern and early modern period. Today the institutional settings of the production of art and the practice of architecture allow the emergence of major women artists (Shirin Neshat, Mouna Hatoum), film makers (Assia Djebar), architects and theorists (Zaha Hadid), performers and political activists (Shabana Azmi) (Nashashibi 1994, 1998). In addition to studying exceptional persons, one can also conduct fieldwork and oral history to document the lives and works of poor women in so-called traditional crafts such as textiles or nomadic architecture (Prussin 1995, Stillman and Micklewright 1992, Stillman 2000). Work of the latter kind has provided a deeper understanding of these visual productions as well as new ways of thinking about gender and labor, the meaning and value of art, and the commodification of the "traditional" object. It is also possible today to interview and observe women and men and learn about their uses of space: anthropologist Susan Slyomovics's work on women and public space in 1990s Algeria relies on interviews and observation in addition to research on textual sources to map the behavior of women and men in public space (Slyomovics 1995).

The range of sources for earlier times is different. While informants are not available for the early modern period, the nineteenth and early twentieth centuries have left behind a wealth of written sources. The advent of the printing press and the emergence of modern formats of writing about the self provide important starting points for research. Outside of art/architectural history, for example, writing by early twentieth-century Egyptian feminists and Ottoman-language journals aimed at a female public were used by Margot Badran and Elizabeth Frierson to construct complex images of female social actors (Badran 1995, Frierson 2000). In addition, the higher survival rate of visual materials makes for a varied and rich evidentiary field: Afsaneh Najmabadi studied nineteenth-century photographs of female prostitutes in Tehran (Najmabadi 1998). Zeynep Çelik focused on urban renewal projects for Algiers under French colonial

rule by examining the gendered terms of architectural discourse on the colony, as well as the interplay between urbanism, French scholarship on the "indigenous" architecture of North Africa, and the perceptions of the social roles of Algerian women (Çelik 1992, 1996, 1997). Nancy Micklewright used surviving items of clothing, photographs, and memoirs in her study of the changes in sartorial choices of Ottoman women in a modernizing society (Micklewright 2000).

By contrast, the challenge of doing research on women in the premodern period lies in creatively outfoxing the limitations imposed by both the small volume and the nature of the surviving sources and works of art. The visual productions of the poor and the less powerful rarely survive, which means that this section of society is usually excluded from discussion. Any investigation into the intersection of gender and sexuality and visual culture must begin with a systematic interrogation, for gender, of conventionally used sources. This type of research requires one to use the analytical tools and methods provided by theory, and to commit to rethinking many of the accepted conventions and methods of art history, and specifically of Islamic art history. Some of the methodological problems in the field of Islamic art history have had particular consequences for the study of women and gender. These problems include a marked pattern for producing work that is heavily descriptive rather than analytical, partly, but not entirely, due to the fact that so much of the basic work of inventorying, cataloguing, excavating, and surveying remains to be done in practically every aspect of Islamic visual culture. Another problem is presented by analytical approaches that consider art a transparent depiction of reality, rather than taking stock of art history's methodological advances in situating art in its social and historical context, in framing a work of art as a representation that functions within a field of other visual materials and techniques of visual analysis that go far beyond considerations of formal properties and issues of provenance, authorship, and stylistic change. For example, endowment deeds (*waqfiyya*s) represent the most important and frequently used source to document architecture. While rich in architectural information endowment deeds are also limited by the fact that they are composed according to well rehearsed formulae. A deep knowledge of the nature of the sources enabled Leslie Peirce to detect unusual or telling aspects of endowment deeds that she correlated with the gender of the patron and the resultant social expectations (Peirce 2000).

The questions to ask are, which premodern discourses map issues of sex and gender? How does the information gleaned from these sources inform the practice of creating visual culture and of using it? The literature one can draw upon ranges from archival materials to epigraphy, medical manuals, legal *responsa*, Sufi poetry and epic history. The challenge for the premodern period, then, is to map what kinds of discourses address, even tangentially, issues of gender in a manner relevant to the study of art and architecture.

OVERVIEW OF SCHOLARSHIP AND METHODS

Art historians who ask questions about gender in the context of Islamic societies have had to face the issues related to locating and scrutinizing sources as outlined above, as well as grappling with problems related to method. Research on women and gender in the broader discipline of art and architectural history has made major strides since Linda Nochlin's landmark article, "Why have there been no great women artists?" (1971). Feminist art history initially focused on the recovery of evidence on women artists that was ignored by mainstream historiography. A significant amount of the scholarship focused on exceptional individuals, usually exceptional woman artists. Recently feminist art history shifted towards embracing critical theory, especially gender theory emerging from disciplines such as film studies and literature, in interpreting artistic representations in a historical context. Major methodological breakthroughs led scholars to focus productively on the institutional contexts of the production and consumption of works of art (Pollock 1988), the politics of the representation of women in Western art, especially of the nude female body (Nead 1992), and on the exploration of the gendered nature of architecture and spatial practices (McLeod 1996, Agrest 1991, among others). However, the overwhelming majority of this work has focused on Western art and Western contexts, addressing non-Western women only in the context of their representation in Western art (e.g. the important work on Orientalist imagery: Alloula 1981, Nochlin 1983, Porterfield 1994). These studies provide valuable insights into representation and alterity (Lewis 1996) and have injected issues of sexuality and space in these discussions (Schick 1999). Yet little work has been done on the intersection of gender and visual culture and the built environment specifically in non-Western contexts, and particularly in Islamic societies. Such a situation presents challenges, as well as unprecedented opportunities.

The extant scholarship on the study of gender

and visual culture in the Islamic world has responded to the critical directions taken by the discipline of art history. Several studies fall within the vein of the recovery project, that is, the drive to retrieve historical information about women and art routinely ignored or considered unimportant. Within the Islamic world, scholars have privileged the study of the key contribution of women to art and architecture through their role as patrons. This has seemed especially pertinent as there appears to be practically no evidence of female practitioners of works of art and architecture for the premodern period. A pioneering work in this vein was the 1993 special issue of *Asian Art*, devoted to "Patronage by women in Islamic art." Some of the essays in a recent edited volume, *Women, Patronage, and Self-Representation in Islamic Societies*, also inscribe themselves in the recovery project by focusing on the patronage of women of high rank in a variety of geographical and chronological contexts (Ruggles 2000). In some fields, the accumulation of successive layers of research has allowed the emergence of detailed and sophisticated studies. The insights on the architectural patronage of Ottoman women gained through Ülkü Bates's work (1978, 1993) have been followed by Tülay Artan's more specific study, which used extensive archival research to investigate the intersection of material culture, wealth, and power among Ottoman princesses in eighteenth-century Istanbul (Artan 1993). In her study of the life and patronage activity of Nūr Jahān (1577–1645), the wife of the Mughal emperor Jahangir and the mother of the emperor Shāh Jahān, Ellison Banks Findly showed that she built tombs, mosques, and caravanserais in accordance with the norms of her social class, and additionally often blended artistic forms and techniques from the Persianate and Hindu traditions as developed on the Indian subcontinent (Findly 1993a, 1993b, 1996, 2000). Since the process of patronage highlights the intersection of status and gender, most of the studies focus on the patronage of wealthy and powerful women. They are therefore in a sense more revealing about status than about gender or sexuality in a given society. Visual materials can be used as evidence for issues of gender, but reading visual materials in Islam placing gender at the center requires great care. Architecture, like any kind of visual production, is a representation that is formulated in relation to a field of practice. Furthermore, within the recovery project there has been less effort to investigate art and building practices less likely to be conventionally categorized as art and included in histories – such as vernacular architecture or low-cost art objects. The few studies that deal with these topics in Islamic contexts do not foreground issues of gender.

Studies that inscribe themselves within the recovery project vein of feminist scholarship play a valuable role in the evolution of the field. They point to ignored sources and actors, and provide new material. However, in a general sense this work is not driven by the goal to question the assumptions of the field of art history or raise methodological issues. Within the discipline, a more radical vein of feminist scholarship has critiqued the gendered nature of architectural/art history itself. It has revealed the gendered, masculinist nature of art/architectural discourse, as it has challenged what constitutes "Art" or "Architecture," and how works are produced in institutional contexts. This kind of writing is informed by critical and gender theory. Several studies within Islamic art history have complicated the discussion of patronage by asking critical questions. Lucienne Thys-Senocak analyzed the configuration of institutional complexes commissioned by royal women in seventeenth-century Istanbul in terms of their gendered use by women. She investigated how the restrictions on the movement and visibility of women of rank prompted specific solutions to architectural problems. For instance, female patrons mandated the creation of sight lines to enable themselves to look out from certain privileged viewpoints without being visible to the public. In so doing, Thys-Senocak highlighted how vision stages relations of power (Thys-Senocak 2000). Several important interventions in this line have originated from scholars whose main field of inquiry is a discipline other than art/architectural history. Historian Leslie Peirce, through systematic examination of the patronage of urban institutional complexes by high-ranking female members of the Ottoman royal household, charted the expectations of patronage by women by tracking the shifts in the type of buildings commissioned and through a study of responses to such commissions (Peirce 2000). Afsaneh Najmabadi read Qājār period paintings as visual texts to discern shifts in the conception and representation of the gendered human body, providing fresh ideas and provocative conclusions, as well as an antidote to more traditional art historical formal visual analyses of such objects (Najmabadi 1998).

AVENUES FOR FUTURE RESEARCH
The study of gender and visual culture in Islamic societies may provide unexpected opportunities for methodological innovation for the researcher.

Aspects of Islamic visual history that have been difficult to classify and to interpret with the conventional methods of art history, can become opportunities for methodological innovation and theoretical advances if approached in innovative ways that break away from many of the disciplinary assumptions of art history. For example, the relative paucity of named artists, especially for the period prior to the nineteenth century, is often bemoaned in studies that reconstruct the careers of artists through the art historical textual genre of the *catalogue raisonné*, which assumes a degree of continuity and causal link between the works produced by an individual over a number of years and is concerned with formal issues of stylistic evolution and influence. However, the fact that the evidence does not allow one to fall back on a well-established method can fuel alternative approaches: a shift away from the (usually male) individual maker, towards a focus on institutional or professional practices; a move away from formal concerns of style and authentication and towards issues such as functional contexts and the participation of works of art in broader social, political, religious, and other practices.

Clusters of material with potential implications for feminist analysis await investigation. The case of premodern Persianate painting presents a good example. Several of the essays in the 1993 *Asian Art* issue focused on portraits representing specific historical female figures. One can move beyond a project of recovering such evidence to inquire into the very means of making gender legible in the format of the illustrated book. Researchers are often struck by the fact that it is difficult to identify the gender of the human figures depicted in Timurid painting, which have sometimes been called "asexual" (Grabar 2000, 57). However, closer examination reveals that while the bodies are depicted identically – that is, gender is not represented on the body itself through anatomical markers – gender is represented through other means: head-dresses, clothing, compositional conventions – all markers of social identity. A discussion of the depiction of gender in the context of Persian painting, freed from the burden of locating gender on the body, as it is in Western art, can become an opportunity to discuss the social role of gender, its intersection with power, and its relation to other social categories such as status, kinship group, and profession. This also highlights the hollowness of some basic assumptions in conventional Western art history about gender and its visual representation. At the same time, the example of Persianate painting brings to the fore the complexity of interpreting visual representation – in this context, the fact that the bodies of males and females were depicted in an identical manner certainly did not correlate with any degree of social equality, but rather reflected notions of abstract beauty (Najmabadi forthcoming).

The issues of the frequency of the depiction of women, the manner of these depictions, and the context of their use, are complex and require careful consideration. Islamic art provides an opportunity to theorize issues of visibility and invisibility. While the public invisibility of women in Islamic society is often attributed to disempowerment, this correlation is far from being clear-cut or simple. Indeed, the seclusion of women and notions of privacy were often ideal practices associated with the wealthy and powerful, rather than all members of Islamic society. To complicate the issue of invisibility and power even further, one can consider the position taken by many contemporary feminist artists in the West. Most prominently, Mary Kelly has rejected the depiction of the female body as a gesture of protest against the historical use of the female body as an empty signifier in Western art, and as a feminist strategy of empowerment.

Another productive direction for feminist research in this discipline must interrogate the categories used for the built environment. Within the urban and architectural history of Islamic societies (indeed, within urban history in general), a binary opposition has dominated: public space is characterized as masculine while private and domestic space is characterized as feminine. Traki Zannad has investigated the relationship between space and the body in an Islamic context (Zannad 1984). Furthermore, studying a work of art or architecture clearly includes the context of production of the work (the artist, architect, patron, the process of making or building), but it also includes the context of its reception and consumption. What is the role of audiences, viewers, users of public spaces, such as worshippers in the women's section at the mosque? Those who use works of art and architecture and those who interpret them participate in creating their meaning, which is constantly negotiated. Art historian Carel Bertram investigated how the meaning of domestic architecture was created by its users through analyzing the image of the house in the construction of the self for mid-twentieth-century Turkish women (Bertram 1998).

Finally, one can productively enlist the concepts of performativity of gender theory to investigate the category of space as a pivotal location for the performance of gender. One can also view the

body, and its representation, as a key site where gender is performed.

Pioneering work on issues of gender in the discipline of art history has opened the path for complex discussions and opportunities to challenge and enrich the field. Many avenues for creative research on gender in Islamic societies in the discipline of art and architectural history remain wide open.

BIBLIOGRAPHY

D. Agrest, *Architecture from without. Theoretical framings for a critical practice*, Cambridge Mass. 1991.

M. Alloula, *Le harem colonial. Images d'un sous-érotisme*, n.p. 1981.

——, *The colonial harem*, trans. Myrna Godzich and Wlad Godzich, Minneapolis, Minn. 1986.

T. Artan, From charismatic leadership to collective rule. Introducing materials on the wealth and power of Ottoman princesses in the eighteenth century, in *Toplum ve Ekonomi* 4 (Nisan 1993), 53–92.

Asian Art, Special issue: Patronage by women in Islamic art, 6:2 (1993).

M. Badran, *Feminists, Islam, and nation. Gender and the making of modern Egypt*, Princeton, N.J., 1995.

Ü. Bates, Women as patrons of architecture in Turkey, in L. Beck and N. Keddie (eds.), *Women in the Muslim world*, Cambridge, Mass. 1978, 245–60.

——, The architectural patronage of Ottoman women, in *Asian Art*, Special issue: Patronage by women in Islamic art, 6:2 (1993), 50–65.

C. Bertram, Restructuring the house, restructuring the self. Renegotiating the meanings of place in the Turkish short story, in Zehra F. Arat (ed.), *Deconstructing images of "the Turkish woman,"* New York 1998, 263–74.

Z. Çelik, Le Corbusier, orientalism, colonialism, in *Assemblage* 17 (April 1992), 58–77.

——, Gendered spaces in colonial Algiers, in D. Agrest, P. Conway, and L. Kanes Weisman (eds.), *The sex of architecture*, New York 1996.

——, *Urban forms and colonial confrontations. Algiers under French rule*, Berkeley 1997.

E. B. Findly, *Nur Jahan. Empress of Mughal India (1611–1627)*, New York 1993.

——, The pleasure of women. Nur Jahan and Mughal painting, in *Asian Art*, Special issue: Patronage by women in Islamic art, 6:2 (1993), 66–86.

——, Nur Jahan's embroidery trade and flowers of the Taj Mahal, in *Asian Art and Culture*, 9:2 (1996), 7–25.

——, Women's wealth and styles of giving. Perspectives from Buddhist, Jain and Mughal sites, in D. Fairchild Ruggles (ed.), *Women, patronage, and self-representation in Islamic societies*, Albany, N.Y. 2000, 91–121.

E. Frierson, Mirrors out, mirrors in. Domestication and rejection of the foreign in late-Ottoman women's magazines (1875–1908), in D. Fairchild Ruggles (ed.), *Women, patronage, and self-representation in Islamic societies*, Albany, N.Y. 2000, 177–204.

L. Golombek, Timur's gardens. The feminine perspective, in M. Hussain, A. Rehman, and J. L. Westcoat, Jr. (eds.), *The Mughal garden. Interpretation, conservation and implications*, Lahore 1996, 29–36.

O. Grabar, *Mostly miniatures. An introduction to Persian painting*, Princeton, N.J. 2000.

H. Harithy, Female patronage of Mamluk architecture in Cairo, in *Harvard Middle Eastern and Islamic Review*, 1:2 (1994), 152–74.

R. S. Humphreys, Women as architectural patrons of religious architecture in Ayyubid Damascus, in *Muqarnas* 11 (1994), 35–54.

R. Lewis, *Gendering orientalism. Race, femininity and representation*, London 1996.

M. McLeod, Everyday and "other" spaces, in D. Coleman et al. (eds.), *Architecture and feminism*, New York 1996, 3–37.

N. Micklewright, Musicians and dancing girls. Images of women in Ottoman painting, in Madeline C. Zilfi (ed.), *Women in the Ottoman Empire. Middle Eastern women in the early modern era*, Leiden 1997, 153–68.

A. Najmabadi, Reading for gender through Qajar painting, in L. S. Diba with M. Ekhtiar (eds.), *Royal Persian paintings. The Qajar epoch, 1785–1925*, London 1998, 76–89.

——, *Male lions and female suns. The gendered tropes of Iranian modernity*, University of California Press, forthcoming.

S. M. Nashashibi, Gender and politics in contemporary art. Arab women empower the image, in S. Zuhur (ed.), *Images of enchantment. Visual and performing arts in the Middle East*, Cairo 1998, 12–37.

S. M. Nashashibi, L. Nader, and E. Adnan, Arab women artists. Forces of change, in S. M. Nashashibi et al. (eds.), *Forces of change. Artists of the Arab world*, Washington, D.C. 1994, 13–37.

L. Nead, *The female nude. Art, obscenity, and sexuality*, London 1992.

L. Nochlin, Why have there been no great woman artists? in *Art News* 69 (1971), 21–76.

——, The imaginary Orient, in *Art in America* 71:5 (1983), 118–31, 187–91.

L. Peirce, Gender and sexual propriety in Ottoman royal women's patronage, in D. Fairchild Ruggles (ed.), *Women, patronage, and self-representation in Islamic societies*, Albany, N.Y. 2000, 53–68.

J. Perani and F. T. Smith, *The visual arts of Africa. Gender, power, and life cycle rituals*, Upper Saddle River, N.J. 1998.

G. Pollock, *Vision and difference. Femininity, feminism, and histories of art*, London 1988.

T. Porterfield, Western views of Oriental women in modern painting and photography, in S. M. Nashashibi et al. (eds.), *Forces of change. Artists of the Arab world*, Washington, D.C. 1994, 59–71.

L. Prussin et al., *African nomadic architecture. Space, place, and gender*, Washington 1995.

G. Renda, *9000 Years of the Anatolian woman*, Istanbul 1993.

D. Fairchild Ruggles (ed.), *Women, patronage, and self-representation in Islamic societies*, Albany, N.Y. 2000.

N. Sadek, In the Queen of Sheba's footsteps. Women patrons in Rasulid Yemen, in *Asian Art*, Special issue: Patronage by women in Islamic art, 6:2 (1993), 14–27.

I. Schick, *The erotic margin. Sexuality and spatiality in alteritist discourse*, London 1999.

A. Singer, The mülknames of Hürrem Sultan's waqf in Jerusalem, in *Muqarnas* 14 (1997), 96–102.

S. Slyomovics, Hassiba Ben Bouali, if you could see our Algeria. Women and public space in Algeria, in *Middle East Report* 192 (1995), 8–13.

L. Thys-Senocak, The Yeni Valide mosque complex of Eminönü, in *Muqarnas* 15 (1998), 58–70.

——, Gender and vision in Ottoman architecture, in D. Fairchild Ruggles (ed.), *Women, patronage, and self-representation in Islamic societies*, Albany, N.Y. 2000, 69–89.

Y. K. Stillman, *Arab dress. A short history from the dawn of Islam to modern times*, ed. N. Stillman, Leiden 2000.

Y. K. Stillman and N. Micklewright, Costume in the Middle East, in *Middle East Studies Association Bulletin*, 26:1 (1992), 13–38.

L. Whalley, Urban Minangkabau Muslim women. Modern choices, traditional concerns in Indonesia, in H. L. Bodman and N. Tohidi (eds.), *Women in Muslim societies. Diversity within unity*, Boulder, Colo. 1998, 229–49.

T. Zannad, *Symboliques corporelles et espaces musulmans*, Tunis, 1984.

HEGHNAR ZEITLIAN WATENPAUGH

Demography

DEMOGRAPHY AS A FEMALE-ORIENTED DISCIPLINE

"It will be helpful, at least for the moment, to treat our subject in its application to only one of the two sexes. For practical reasons we choose the female population" (Lotka 1998, 113). This is how, in 1939, mathematical demography was born, excluding men from consideration. Lotka's basic equations involve only females, from which male numbers are simply drawn through the sex ratio at birth, a biological constant. In his view, modeling the whole population through its female component was of course just a methodological convenience, justified by the fact that "the period of reproduction is more precisely defined for women than for men, and maternal parentage is almost always known" (Lotka 1998).

Later on, the acceleration of demographic growth in developing countries – as a result of a dramatic increase in life expectancy – and the emergence of a "population and development" challenge, the need for fertility and mortality estimates as well as interpretative models of population growth, confirmed demography as a female-oriented discipline. The agenda of demographic research met that of family planning, a social movement that grew from women's rights campaigns before reaching the agenda of international agencies (McNicoll 1992).

In the 1960s, at a time when accurate figures were still lacking for three-quarters of the world population, Brass et al. (1968) devised a series of indirect methods in order to estimate fertility and mortality in countries with no data or with defective data, through the collection of "maternal histories" (children ever born by age of mother and present status of the children, alive or dead), and the use of Lotka's equations. These methodologies were to inspire the largest surveys ever conducted on a world scale according to a strictly standardized pattern: the World Fertility Survey (late 1970s, first half of the 1980s) and the Demographic and Health Survey (from the mid-1980s until now). Thanks to questionnaires filled by hundreds of thousands of women of reproductive age (15 to 50), an extremely detailed picture of population trends was unveiled for the first time in history, and within the span of two decades.

Women had become major informers of the world demography.

They became so because they were recognized as the principal agents of population change. The consensus that emerged among the international community on a commitment to women's empowerment represented a paradigmatical shift of the discourse about population, previously dominated by developmentalism (Presser and Sen 2000). Together with population dynamics, determinants of these dynamics were disclosed by focusing on women. Bongaarts's (1978) proximate determinants of fertility model, one of the models most extensively applied during the last quarter century throughout the developing world, takes as determinants factors that all relate to women: age at which they become sexually active, duration of breastfeeding, their use of contraception, and abortion. Likewise, the conceptual framework for child survival produced by Mosley and Chen (1984), which has had important research and policy impacts, attributes a major role to woman-related factors in the level of infant and child mortality.

There is a huge amount of empirical evidence that the transition from high to low mortality and fertility rates in developing countries during the second half of the twentieth century is more linked to women-related variables than to any others. The spread and lengthening of school education among girls always comes first in correlation with demographic outcomes. Then variables such as age at first marriage, employment outside the household, and a few others are found. In most cases, male education or poverty reduction add little or no statistical explanation.

That women are active agents of demographic change, not passive patients, and that they take responsibility in doing things or not doing them, is shown by the debate on whether the supply by governments of family planning facilities is a cause, or just a means of the expansion of birth control. It has been found that the actual level of fertility has very little to do with the accessibility of contraceptive services, when controlled by the desired level of fertility. A world comparative analysis of data on desired and actual family size shows that the growing use of contraception is the

result of a reduction in the number of children wanted by women and not the cause of declining birth rates (Pritchett 1994). That women fit their acts to their words, or vice versa, means that empowerment acts on fertility by changing the aspirations of women rather than enhancing their capacity to fulfill their aspirations.

Empowerment of women, or their greater "agency" (Sen 1999), understood as their capacity for acting, is a key of modern demographic change. Women's literacy and education, their ability to earn income and to have independent employment outside the home, bring benefits not only to themselves and their own family, but also to the larger society, since educated women become active participants in public debates and decisions. Research on how the elevation in women's education, or their share of income, exert a global influence on fertility and child survival, including of illiterate and inactive women in their community or in larger society, is still to be done.

GENDER AND DEMOGRAPHY IN ISLAMIC SOCIETIES

In the spring of 1994, a violent diatribe exploded in the media of Cairo, which was to last the whole summer and to divide the Egyptian political scene between supporters and opponents of the International Conference on Population and Development that convened in September of the same year. For its detractors, like 'Adil Ḥusayn, columnist in the newspaper al-Sha'b, the conference was a conspiracy against Islam. Not only because issues such as adolescent sexuality, abortion, or homosexuality – all insults to the values of Islam – were to be discussed in the city of al-Azhar, but also because family planning, which was on the conference agenda, is "a fight against the vitality of Islam," the high fertility prevailing in Muslim countries being "a movement that surpasses the will of mankind and comes under the will of God to announce the imminent victory of the faithful" (leading article, al-Sha'b, 22 April 1994).

Considered as a block and compared to the world average, Islamic countries still display some particular features: relatively high fertility and high maternal mortality, female disadvantage in infant and child survival, high illiteracy among adult women, and low female employment. These features are, to some extent, linked to each other, and they are commonly attributed to Islamic culture that favors males and limits free exchanges between sexes. In the pluralistic context of India,

it has been found that, after female literacy, being Muslim or non-Muslim was the second statistical determinant of demographic outcomes, while, independently of female literacy, variables such as poverty, male literacy, or urbanization contributed nothing in these outcomes (Drèze and Murthi 2001).

Islamic countries are thus under the watchful eye of the feminists and the international population community. The responsibility attributed to rapid population growth in the failure of developmentalist ideals was a key factor in the creation of the United Nations Population Fund in 1969, which soon became the largest international source of population programming assistance. The responsibility attributed to low status of women for maintaining rapid population growth, and to social systems of Islamic countries for keeping the lowest women's status, certainly played a role in the appointment of Muslim women at the head of the organization, the Pakistani Nafis Sadik (1986–2000), then Thoraya Obaid (from 2001), the first Saudi Arabian national to head a United Nations agency. In several declarations, they both made use of their capacity as Muslim women to publicly advocate empowerment of woman in the name of Islam.

For example, Nafis Sadik declared at a forum in Khartoum: "Female genital mutilation is very common in this country. Let me assure you, as a Muslim, and one who has personally consulted many of the leading authorities, that the practice has no basis in Islamic teaching. . . . Maternal mortality rates in Sudan should be much lower than they are: this is more than an international principle or a national objective – it is a moral responsibility and an Islamic duty," and Thoraya Obaid in New York: "I went to Koranic school at the age of three because my parents wanted me to learn to read and write, like my brothers. They correctly believed that as good Muslims they were obligated to educate their children" (http://www.unfpa.org/about/ed/executivedir.htm).

Of course, the Muslim world is not a block, and exhibits extreme internal demographic diversity. Moreover, the fact that demographic transition has been late does not mean that it has been slow. In various parts of the Islamic world, recent demographic changes have been surprisingly fast. In countries like Morocco in the 1980s, Algeria and Libya in the 1990s, changes in fertility have been so rapid that statistics produced by international agencies continuously lagged behind true evolutions. It is the Islamic Republic of Iran that has experienced the fastest fertility transi-

tion ever recorded in history, with a drop from a pre-transitional 6.40 children per woman in 1986, to a below-replacement level of 2.06 in 1998 (Abbasi-Shavazi 2001): only twelve years were necessary to accomplish a jump which had taken two centuries in the West. This happened in a society dominated by Shi'i fundamentalism, and was encouraged by theologians for whom the Islamic permissibility of coitus interruptus was to be extended to modern non-terminal methods of birth control. There is a consensus among Muslim theologians that family planning is permissible (Omran 1992), which is not the case in Christianity. Algeria, which in 2001 was about to cross the line of below-replacement fertility, experienced a pronounced reduction of birth rates in the context of a rising influence of Muslim fundamentalists.

It has been convincingly argued that if poor demographic achievements of various Muslim countries were effectively related to low status of women, this low status was not the product of religion, but of social and political systems (Makhlouf-Obermeyer 1992), and less convincingly of the rise of Islamic fundamentalism opposing Western cultural imperialism (Oppenheim Mason 1997). In Iran, Islam could be evoked by the same Islamic regime to legitimate opposite stances vis-à-vis demographic issues, according to changing political circumstances. During the war against Iraq, pronatalism was claimed in the name of a Muslim duty of strengthening the community of the faithful, while Malthusianism was soon adopted when the economy collapsed and then legitimated by the permissive stance of Islam on contraception (Ladier-Fouladi 2003, Mehryar 2000).

Even nuptiality is a domain where Islam has not blocked modernization. Contrary to most civil laws in Islamic countries, family laws are relatively exempt from European influences, since the judicial provisions most clearly stated in the Qur'ān and sunna precisely relate to matters such as marriage and divorce, inheritance and child custody. Thus, the legal norms that regulate marriage project an image of great stability over time. By contrast, the statistical norm projects the very different picture of a radical evolution. Universal developments, such as the spread of mass education, urbanization, or the dominance of the service sector in the economy, have considerably delayed the age of women at marriage: in Libya, it has increased from 18 to 30 years on average in less than three decades.

Gender equality in schooling has now been reached in most Islamic countries and birth rates are on the decline, with Afghanistan, Pakistan, and some Sahelian countries lagging far behind. However, two features seem to be persistently attached to Islamic settings: son preference and exclusion of most married women from economic activities.

Girls and boys do not enter life with equal chances of survival. While nature favors females at all ages, society does not. "Gender" as opposed to "sex" factors might produce disadvantages for girls. Numbers of women are missing, dying during childhood or maternity as a result of the unequal distribution of care (Sen 1990). There is statistical evidence that patriarchal systems produce higher female infant and child mortality rates than those expected on the basis of girls' biological advantage. A comparative study of 38 countries throughout the world found the Middle East to have the highest female infant and child mortality disadvantage (17 percent above the world average). It also found that none of the health-related variables (such as immunization, morbidity for the main childhood diseases, treatment for these diseases, nutritional status, etc.) could explain these differentials, which were thus attributable to other – still unidentified – social processes (Hill and Upchurch 1995).

Islamic populations have, on average, the lowest women's rates of economic activity, a feature attributed to their lack of freedom of movement outside the home. In nine Arab countries around 1990, at the age of maximum enrolment in labor markets (25–29), only 21.7 percent of women were employed (Fargues, unpublished results). The rate was almost twice among never-married (31.2 percent) than ever-married women, whether they had borne children (17.7 percent) or not (17.1 percent). In any society, labor outside the home and rearing children are activities competing for time, but in Arab societies, competition begins before children are born, at the very moment of the marriage. The existence of a husband, not of young dependent children, removes women from the labor market. Female employment exists, notably in education and health, a sign that the larger society welcomes it, but these positions are mainly held by unmarried women, a sign that the family is reluctant to accept working wives. It may well have been different in the past. Population statistics are products of modern states and do not inform on previous stages, during which women might have had a higher economic involvement (Tucker 1985, al-Sayyid Marsot 1995). The same holds true for

the future: women's labor force participation increased in the 1990s in response to the decline of men's real wages that accompanied economic reforms (Moghadam 1998).

Conservatism appears to be rooted in social structures, not in religion. Family systems prevailing in most Islamic countries are commonly considered patriarchal, characterized by two strong hierarchies: between generations to the benefit of elders, and between sexes to the benefit of men. However, patriarchy is being challenged. The decline of birth rate brings into question the hierarchy between generations, which rests on the subordination of younger brothers to the eldest boy. In the two-children family – on average a boy and a girl – this subordination simply disappears for lack of younger brothers. The hierarchy between sexes is weakening with the rising education of women. There are signs that the autumn of the patriarch is approaching (Fargues 2000). In Pakistan, one of the less advanced countries with regard to demographic achievements, it was found that a serious obstacle to contraceptive use

Gender related and other demographic indicators in Islamic countries

Indicator	Islamic countries*	Other countries
Proportion Muslim	0.908	0.055
Population 2000 (millions)	1066	5028
GDP/Capita PPP 2000	3,093.8	7,080.3
Human Development Index 1999	0.589	0.695
Gender Related Development Index 1999	0.546	0.677
Maternal mortality	233.2	155.5
Total Fertility Rate 1970–75	6.1	4.6
Total Fertility Rate 1995–2000	3.5	2.6
Female Activity Rate 1998	44.0	56.5
Female literacy Rate (% age 15 and above) 1998	46.2	73.2
Female literacy rate as % of male rate 1998	58.5	83.2
Demographic multiplyer 1950–2000	3.24	2.31

* Countries with a Muslim demographic majority
Sources: Indicators computed from UNDP Development Report, 2000. Muslim proportion computed from P. Fargues, "Demographic Islamization: Non-Muslims in Muslim Countries," in SAIS Review (The Paul H. Nitze School of Advanced International Studies, Johns Hopkins University, Washington) 21:2 (Summer–Fall 2001), 103–16.

was the women's feeling that it would conflict with husbands' views; however the same survey showed that women's perception of their husband's views were not entirely accurate, and that patriarchal values would less and less inhibit demographic change (Casterline et al. 2001).

CONCEPTUAL LIMITS OF DEMOGRAPHY

Three methodological arguments are commonly opposed to too-causalistic interpretations of the relationship between low status of women and delayed demographic transition.

Firstly, intermediate variables between changes in the status of women and the fall of death and birth rates are not properly identified. For example, education raises the opportunity cost of time spent by a woman on her children, lightens the dependence of a mother on her sons for old-age security, gives her a greater autonomy in defining her goals, opens her to the outside world and alternative models, or makes her better able to avoid unwanted pregnancies; these are different mechanisms through which education may reduce fertility. Demographers have not established which ones are really effective. In addition, lower birth rates are not purely external to women's agency; they are true components of it since they enhance freedom.

Secondly, women's status is assessed through proxies. Being educated, generating cash income, or not getting married too young are indeed linked with agency, but they do not subsume the actual ability to exert power on decisions. In addition, proxies can be context-dependent. For example, husband's education, commonly interpreted as reflecting the socioeconomic status of the family, has been found in Turkey to be an indicator of gender relations within the family and a better one than wife's education. Multiplying proxies just offers a statistical panacea (Kishor 2000).

Thirdly, proxies are not always accurately captured through collected data. Data collection is made in the real society, which holds its own gender biases. This is particularly true for the measurement of female economic activity. In most Muslim countries, population censuses are a male affair: male heads of households typically provide to male interviewers information on each member of their household, including women. Respondents are inclined to consider that only formal paid work outside the home is an economic activity. Statistics thus miss all women's work which lies somewhere on the continuum

from housework to full non-familial employment (Donahoe 1999, Anker and Anker 1995). Self-classification does not necessarily give better results, since women incorporate social representations of work that are constructed in the gender-biased context where they live. This bias proper to patriarchal societies is reinforced in Islamic countries by the legal frame, since providing for the family is by law the duty of the man, while income earned by his wife remains her own property.

A fourth argument should be made: there might be a missing link between changes in the status of women and demographic outcomes. Fertility is everywhere on the decline and a world convergence toward low fertility is emerging, while no true convergence becomes apparent in matters of women's agency. The most radical drop in fertility occurred in Iran, without the hypothesized dependent variables changing at any comparable rate: female education has increased among young generations, but only gradually, and no perceptible change has been recorded in other important dimensions of women's agency, such as earning income or enjoying freedom of movement.

It has been pointed out that gender systems could have a conditioning effect, rather than be a direct causation (Oppenheim Mason 1997). Equality gained by women in the family, despite persisting inequalities in non-family institutions (such as the labor market), could create a propitious context for other changes to influence their decision power in matters of family building (McDonald 2000). However, the search for causes remains open. Economic and political factors, susceptible to rapid reversals, could be good candidates. The discontinuation of welfare policies by most governments of developing countries for structural adjustment requirements, combined with their lack of power to contain beyond political borders the flows of information and models disseminated through new world media, have created a complex of awareness, aspirations, and frustrations that might have played a role in triggering demographic change.

BIBLIOGRAPHY

M. J. Abbasi-Shavazi, Below replacement-level fertility in Iran. Progress and prospects, paper presented at "International perspectives on low fertility," IUSSP seminar, Tokyo 2001.
R. Anker and M. Anker, Measuring female labour force with emphasis on Egypt, in N. Khoury and V. Moghadam (eds.), Gender and development in the Arab world, London 1995, 148–77.
J. Bongaarts, A framework for analyzing the proximate determinants of fertility, in Population and Development Review 4:1 (1978), 105–32.
J. B. Casterline, Z. A. Sathar, and M. ul Haque, Obstacles to contraceptive use in Pakistan. A study in Punjab, New York 2001.
D. A. Donahoe, Measuring women's work in developing countries, in Population and Development Review, 25:3 (1999), 543–76.
J. Drèze and M. Murthi, Fertility, education, and development. Evidence from India, in Population and Development Review 27:1 (2001), 33–63.
P. Fargues, Générations arabes. L'alchimie du nombre, Paris 2000.
K. Hill and D. M. Upchurch, Gender differences in child health. Evidence from the demographic and health surveys, in Population and Development Review 21:1 (1995), 125–51.
S. Kishor, Empowerment of women in Egypt and links to the survival and health of their infants, in H. B. Presser and G. Sen, Women's empowerment and demographic processes. Moving beyond Cairo, Oxford 2000, 119–56.
M. Ladier-Fouladi, Population et société en Iran. De la monarchie à la république islamique, Paris 2003.
A. J. Lotka, Analytical theory of biological populations, trans. D. P. Smith and H. Rossert, New York 1939, 1998[2].
C. Makhlouf-Obermeyer, Islam, women, and politics. The demography of Arab countries, in Population and Development Review 18:1 (1992), 33–59.
P. McDonald, Gender equity in theories of fertility transition, in Population and Development Review 26:1 (2000), 427–39.
G. McNicoll, The agenda of population studies. A commentary and complaint, in Population and Development Review 18:3 (1992), 399–420.
A. H. Mehryar, Ideological basis of fertility changes in post-revolutionary Iran. Shiite teachings vs. pragmatic considerations, unpublished paper, Institute for Research on Planning and Development, Tehran 2000.
V. M. Moghadam, Women, work and economic reform in the Middle East and North Africa, Boulder, Colo. 1998.
H. W. Mosley and L. C. Chen, An analytical framework for the study of child survival in developing countries, in Population and Development Review, supplement to vol. 10 (1984), 25–45.
A. R. Omran, Family planning in the legacy of Islam, London 1992.
K. Oppenheim Mason, Islam, the status of women, and reproductive behavior in five Asian countries. Draft outline, Paris 1997.
H. B. Presser and G. Sen, Women's empowerment and demographic processes. Laying the groundwork, in H. B. Presser and G. Sen, Women's empowerment and demographic processes. Moving beyond Cairo, Oxford 2000.
L. H. Pritchett, Desired family and the impact of population policies, in Population and Development Review 20:1 (1994), 1–55.
A. L. al-Sayyid Marsot, Women and men in late eighteenth-century Egypt, Austin, Tex. 1995.
A. Sen, More than a hundred million women are missing, in New York Review of Books, 20 December 1990.
——, Development as freedom, Oxford 1999.
J. E. Tucker, Women in nineteenth-century Egypt, Cambridge 1985.

PHILIPPE FARGUES

Economics

CLASSICAL ECONOMICS

In discussing the term economics, it is important to distinguish between studies of economic processes and outcomes, which have been carried out by scholars trained in various disciplines including economics, anthropology, sociology, history, and geography, among others, and the discipline of (neoclassical) economics. Neoclassical economics is the predominant epistemological and methodological approach subscribed to by the majority of economists in academia (particularly in the United States) and international research and policy institutions (particularly the World Bank and the International Monetary Fund). Many neoclassical economists believe that the market is the best mechanism for distributing resources and wealth, and that government intervention in markets should be minimal. These free market advocates, sometimes also labeled neoliberal or "Washington Consensus" economists, have significant power to dictate economic policies globally.

Economics remains a discipline strongly rooted in positive, "scientific" theory. While a recognition of the positionality of researchers and the difficulties (or impossibility) of conducting objective research has become standard in a number of disciplines, epistemological debates in economics generally focus on the type of positivist approach that is most effective. Mathematical modeling is the primary way in which economists develop theory and it is seen as the most sophisticated and error free way of modeling human behavior. A series of mathematical equations is almost a universal requirement in scholarly papers published in the best journals, as defined by mainstream economists. Bias, economists believe, can be avoided by careful use of mathematics and statistics.

FEMINIST ECONOMICS

While most economists adhere to this strict, positivist approach, a small but growing number of economists, as well as numerous non-economists, have applied feminist, postmodern, and postcolonial critiques to economics, effectively describing how the positionality of researchers biases the subjects they choose to research, as well as their findings. Feminist economists have challenged androcentric aspects of economics, in particular the ways male theorists have assumed that

male experiences are universal. They have examined the contradictions surrounding economists' assumptions concerning rationality, altruism, selfishness, and individualism. They have also raised the question of whether the impact of markets and policies is gender neutral (see Peterson and Lewis 1999 for an overview of feminist economics.)

WESTERN BIAS

While a feminist sub-discipline within economics is now well established (although still marginalized), many of the theoretical criticisms of neoclassical economics remain Western centered. As an example, while scholars have challenged the notion that economic actors are detached, individualistic, selfish decision makers, the major focus has been on examining male individualism and contrasting this with female connectivity in the context of present-day Western culture. Focusing on their own experiences, these feminists have often ignored the possibly varying impact that culture and differing political histories and forms of patriarchy may have in shaping gender and self-identity, not to mention economic institutions and other factors that influence economic outcomes. Feminist economists studying the West and particularly the United States have tended to ignore the contributions of authors focusing on non-Western communities (and even, in some cases, on countries other than the United States). For instance, discussions of income inequality and occupational segregation often focus exclusively on patterns in industrialized countries. Many of the entries in the Peterson and Lewis volume exhibit these biases. Publications by international organizations have generally provided better global coverage. For instance, Anker (1998) examines occupational segregation throughout the world. Unfortunately, while his geographical coverage and feminist critique of economic theory are excellent, his discussion of the influence of Islam is not particularly nuanced.

WOMEN IN NON-WESTERN COMMUNITIES

Studies of women in non-Western communities, where most Muslim women are located, have generally been categorized within "development" economics, a field that is itself somewhat margin-

alized within economics. Few economists have specifically focused on the intersections between gender, Islam, and economics, and the handful of studies by economists that have addressed Islam explicitly have tended to approach the question rather simplistically. Islam is generally portrayed as a particularly patriarchal religion, and Muslim women, especially those located in "developing" countries, are often portrayed as submissive or devoid of agency.

Andro- and ethnocentrism, as well as various epistemological issues contribute to the reasons more economists have not focused on non-Western economies in general and women in Muslim communities in particular. Because most economists perceive economic theory as universal and gender neutral, they assume that the same theory is applicable when modeling the behavior of women in Pakistan or men in the United States. As such, economists fail to see the need to test their theories using data from non-Western societies. At the same time, when economic models do not perform well in analyzing data from non-Western communities, economists (somewhat contradictorily) assume these communities are somehow "abnormal," due to political instability or differing cultural norms, and that such studies cannot shed light on universally applicable economic theory. Finally, a more practical reason why women in Muslim communities have not received more attention from economists is the lack of large national level data sets necessary for the type of empirical analysis most economists prefer to do.

METHODS

The epistemological structure of economics is closely linked to the methods used and accepted forms of evidence. Economists are trained in economic theory (read: mathematical models) and econometrics (statistical analysis). Empirical economic analyses generally require large data sets, and research questions are often driven by data availability, rather than a motivation to study a particular community or country. Training in other methods is nonexistent, and economists rarely raise questions about the appropriateness of statistics in answering research questions. Discussions instead revolve around the appropriateness of using various types of statistical analysis and techniques. Textual sources, oral histories, and fieldwork are considered inappropriate methods and are often dismissed by economists as anecdotal, soft, and biased.

Feminists have been among those pushing for an expansion of accepted methods as well as raising questions about the limits of statistical analysis. These critics have pointed out the unexamined values embedded in quantitative measures, as well as arguing that the use of statistical analysis may not be the only way of telling economic stories. Measures of national income (such as gross domestic product) for instance, generally exclude economic contributions that do not go through markets. Women's work (including subsistence agriculture and reproductive labor) may in particular be undercounted.

A recent collection in *Feminist Economics*, edited by Pujol (1997), provided a feminist critique of economic methods and methodology. It is significant that three of the contributors (Gunseli Berik, Simel Esim, and Jennifer Olmsted) were feminist economists doing research in predominantly Muslim countries (Turkey and Palestine), given that only a small percentage of economists focus on gender issues in Muslim countries. Because of the dearth of data, each of these authors found it necessary to collect her own. In the process, all three also became more aware of the ambiguities upon which much quantitative analysis is based. Both Olmsted and Berik have argued that while most economists are content in describing outcomes, processes may be of particular concern to feminist scholars, and that quantitative methods, particularly statistical analysis, may not adequately address such concerns. For instance, feminist economists may be interested in power dynamics and gender relations within households, and may feel that existing data sources, and quantitative analysis more generally may not adequately address such issues. Feminist economists researching Muslim societies may be particularly suited for raising questions about the appropriateness of the methods used in economics, not only because they may be forced because of a lack of data to collect their own statistics, but also because they may discover, in doing fieldwork, that existing theories and methods in economics are inadequate for addressing economic processes occurring in Muslim communities.

Feminist economists who advocate more contextualized studies of women in Muslim communities do not necessarily advocate rejecting statistical evidence, but instead call for an expansion of the definition of acceptable evidence in economics. At the same time, many argue that to convince policymakers and address androcentric and Western oriented biases in economics, more and better data are needed. The ability to describe women's access to education, health care, and government assistance, the extent and patterns of wage discrimination and occupational

segregation, and the nonmarket labor contributions of women depend on the availability of reliable national statistics broken down by sex. Yet such statistics are not available consistently in many Muslim countries (and, in the case of measures of nonmarket work, even in many industrialized countries). The situation is improving, though. International organizations such as the United Nations Development Fund, the International Labor Organization, and the World Bank have worked, in recent years, to augment data sources broken down by sex for as many countries as possible. (Recent World Bank statistics on women are available at <http://genderstats.worldbank.org/menu.asp>.) Since 1995 the United Nations Human Development Report has included two gender specific measures of well-being: the Gender Development Index (GDI) and the Gender Empowerment Measure (GEM). While these measures have been critiqued by feminist scholars for various reasons, they do provide a starting point for categorizing the position of women in various countries, including many countries where the majority of the population is Muslim.

DEVELOPMENT ECONOMICS

In addition to broadening discussions about methods and methodology, feminist and postcolonial theorists have critiqued the theoretical underpinnings of development theory, as well as many of the policy recommendations linked to globalization and structural adjustment. Deconstructing notions of "development," as well as the idea that non-Western women are submissive victims, these scholars have challenged the notion that the West is superior, while the non-West is "underdeveloped." Recent issues of *World Development* (edited by Cagatay, Elson, and Grown, 1995) and *Feminist Economics* (edited by Beneria, Floro, Grown, and MacDonald, 2000) provide feminist critiques of development and globalization, while Zein-Elabdin and Charusheela (forthcoming) have put together a collection applying a postcolonial critique to development economics. Other recent collections containing articles addressing the gendered impact of structural adjustment and globalization on women in various Muslim communities include Afshar and Barrientos (1999), Sparr (1994), and Aslanbeigui, Pressman, and Summerfield (1994). With the exception of Olmsted's piece (in Zein-Elabdin and Charusheela, forthcoming), which discusses Orientalism in economics, these studies do not usually directly address the question of Islam, but they do provide an important critique of development studies and economic modeling and a number of the issues they raise are relevant to women in Muslim communities.

GENDER AND ECONOMICS

While it is impossible to list them all, in addition to the authors and collections discussed above, a number of feminist scholars both in and outside the discipline of economics, including Bina Agarwal, Leila Ahmed, Ruhul Amin, Sajeda Amin, Dawn Chatty, Arlene Dallalfar, Leslie Gray, Wardah Hafidz, Barbara Harriss-White, Mervat Hatem, Rema Hammami, Nadia Hijab, Homa Hoodfar, Naila Kabeer, Deniz Kandiyoti, Linda Lim, Fatemeh Moghadam, Valentine Moghadam, Semsa Ozar, Ivy Papps, Agnes Quisumbing, Claire Robertson, Ratna Saptari, Mark Tessler, Dzodzi Tsikata, Benjamin White, Jenny B. White, Diane Wolf, and Isik Zeytinoglu, have made excellent contributions to our understanding of gender and economics in Muslim communities. Many of these individuals have challenged the notion of disciplinary training as well as neoclassical economic theory, providing nuanced studies of the complex and contradictory impacts of economic changes, particularly of industrialization and globalization on women. These analyses have included examinations of women traders in Ghana, factory workers in Indonesia and Turkey, women's access to land and credit in South Asia, as well as studies of the impact of changes in technology, government spending, and trade patterns in various communities. The studies confirm that generalizing about the economic circumstances facing Muslim women is impossible and that considerably more detailed analysis of the intersectionality of history, culture, class, and politics in determining economic practices and outcomes is needed.

FUTURE STUDY

Although the discipline of neoclassical economics remains resistant to epistemological and methodological challenges, and is steeped in a positivistic and rather Western and androcentric model of the economy, a growing number of feminist and postcolonial scholars and activists have begun to challenge the narrow confines of "economics," and even the concept of disciplinary boundaries, and among them have been some focusing on women living in Muslim communities. These researchers, if they can avoid the pitfalls of Orientalism, may be able, precisely because of their focus on women in communities that have been historically marginalized in eco-

nomics, to make a number of unique contributions to the field.

BIBLIOGRAPHY

H. Afshar and S. Barrientos (eds.), *Women, globalization and fragmentation in the developing world*, New York 1999.

R. Anker, *Gender and jobs. Sex segregation of occupations in the world*, Geneva 1998.

N. Aslanbeigui, S. Pressman, and G. Summerfield (eds.), *Women in the age of economic transformation. Gender impact of reforms in post-socialist and developing countries*, London 1994.

Feminist Economics 3:2 (1997), ed. M. Pujol, special issue on fieldwork and methodology.

—— 6:3 (2000), ed. L. Beneria, M. Floro, C. Grown, and M. MacDonald, special issue on globalization.

J. Peterson and M. Lewis (eds.), *The Elgar companion to feminist economics*, Cheltenham, U.K. 1999.

P. Sparr (ed.), *Mortgaging women's lives. Feminist critiques of structural adjustment*, London 1994.

United Nations Development Programme, *Human development report 1995*, available online at <http://hdr.undp.org/reports/global/1995/en/default.cfm>.

World Development 23:11 (1995), ed. N. Cagatay, D. Elson, and C. Grown, special issue on gender adjustment and macroeconomics.

E. Zein-Elabdin and S. Charusheela (eds.), *Postcolonialism meets economics*, Routledge (forthcoming).

JENNIFER C. OLMSTED

Folklore

In recent decades scholars in the field of folklore have been working to adapt the nature and method of their inquiry both to enrich their field and to address concerns regarding social relevancy and the ethics and efficacy of fieldwork.

Definition

Folklore studies is very much a multidimensional, interdisciplinary field. Folklorists work in a number of university departments, including anthropology, literature, linguistics, cultural studies, women's studies, history, ethnomusicology, art history, as well as in various departments of ethnic and area studies. The media of folklore are as varied as human expression can be, encompassing types of verbal art (narratives of all sorts, poetry, songs, jokes, proverbs, verbal duels), material culture, dance, ritual, theater, and music. Folklorists treat these means of expression in diverse ways. Most traditionally, folklorists have studied folklore as relics of a disappearing past. Often included in this sort of study are attempts to trace a definitive history of a tradition and to preserve a dying art form. Approximately three decades ago, some folklorists began to shift their attention away from the disappearing past to the ephemeral present, broadening their area of study to include expressions that are very much alive today, such as the urban legend, playground chants, joke cycles, and personal narratives, and focusing their inquiry on the relationship between these forms of folklore and the present time in which they are performed or created. This shift was made in part by a redefinition of "folk" from the traditional static, often geographically and linguistically defined ethnic group, to the more dynamic "small group," characterized loosely as any interactive gathering of people (Paredes and Bauman 1972). A central concern of the new folkloristics has been differential identity, which suggests that gender configuration should be an important factor in defining the small group (Mills 1993). The inclusion of gender implies the cross-cutting of boundaries between groups, even at the lowest level, thereby opening the door to considering decentered, overlapping, and varied social membership. A shared defining feature of the genres of the new folklore, and what connects them to the genres of folklore that are studied in more traditional ways is the concept of group ownership and authorial anonymity. Folklore, then, may be loosely defined as the cultural expression of a group rather than an individual, although individuals within the group may be recognized as particularly fine practitioners of the folk art in question.

Uses

The nature of folklore, both traditional and ephemeral, means that it can be used for apparently contradictory ends. The field of folkloristics was born in nineteenth-century Europe in direct connection with the rise of nationalism. Early folklorists concentrated their studies mainly on uneducated peasants with the aim of tracing archaic customs and beliefs to their remote origins. As a symbol (and in some cases source) of identity as well as ethnic, territorial, or political unity, folklore has since been used extensively by states in the service of nationalism and totalitarianism, and has served as a tool for the marginalization and oppression of minorities. Numerous studies have been done, for instance, on the uses to which folklore and folkloristics were used by the Nazis, the Franco regime, and others to justify fascism and ultra-nationalist ideologies.

Since folklore can be enlisted for political aims, researchers in the field must be ever aware of the particular uses to which their scholarship may be put. In Turkey, for example, the government has appropriated folklore for nationalist purposes, closing departments at Turkish universities whose folklorists refuse to reshape their material in the service of a new national mythology. In this situation, a folklorist who decontextualizes her or his material from its sociopolitical, historical, and cultural context risks being used as a pawn of the state (Conrad 1998). In Morocco, Shikhat dancers, who are usually hired to perform at weddings and other festive occasions and who have traditionally been considered socially marginal figures, have been appropriated by the state as tokens of Moroccan nationalism, appearing regularly on state run television (Kapchan 1994).

Nonetheless, the work of collecting and cataloguing disappearing forms of folklore in the Islamic world continues to be an important part of folkloristics since many older forms (oral epic and other genres of oral poetry, tales, song, handicrafts,

dance, and music, to name a few) are dying out in the face of globalization and the spread of popular culture, or are being transformed by these forces into popular commercial genres (Caton 1990). Folkloristics of this type continues, often manifesting itself in catalogues of motifs, tale types, and other texts whose main purpose is the documentation and categorization of material.

SUBALTERN GROUPS

Folklore has also been used to great effect by subaltern groups in their struggle for political independence or recognition. Palestinians in Israel, in the Occupied Territories, and in exile have been engaged in large and continuous projects to collect, categorize, and disseminate their folklore. Efforts have been made to create museums of folk art and to publish volumes of traditional poetry. Organizations such as al-Badia train and employ women to produce traditional Palestinian embroidery, an art which has not only survived but flourished and developed in ways that would not have been possible without this conscious intervention.

However, because of its ephemeral nature, folklore is also used extensively by subalterns both to define and maintain their own subnational group identities and as a safe means of communicating potentially dangerous ideas. In *Domination and the Art of Resistance*, James Scott (1990) describes what he calls the hidden transcript through which subalterns express ideas and feelings that are in some way at odds with those of elites. Although the hidden transcript may include many strategies such as work slowdowns or grumbling that would not be categorized as folklore, it is often through folklore that controversial information, ideas, or emotions may be transmitted. Spirituals with coded messages of freedom and trickster tales, such as those of Brer Rabbit or Anansi the spider, in which a powerless creature uses his or her wits to outsmart a more powerful adversary, are some of the folklore traditions Scott describes as vehicles for expression of the subaltern position. In the Middle East, Juha/Guha in the Arabic tradition and Hoja Naṣr al-Dīn in the Turkish often play the role of a trickster figure and serve a similar purpose.

WOMEN AND CODING

Folklore as a hidden transcript for a subaltern position can, of course, also be found in the context of power inequities that characterize relationships across genders. The various essays in Joan Radner's *Feminist Messages: Coding in Women's Folklore* (1993) explore some of the ways that women have employed coding, that is, covert expressions of disturbing or subversive ideas, in their folklore. Strategies for coding are varied and may include, among others, appropriation (adapting androcentric images of the feminine for feminist purposes), juxtaposition (the ironic arrangements of texts or artifacts), distraction (drawing attention away from a feminist message as a means of masking it from those that are not meant to read it), indirection (using metaphors, impersonation, or hedging to mask one's message), and incompetence (claiming incompetence in a conventionally feminine activity as a means of expressing resistance). A particularly common strategy is trivialization (using forms or genres such as gossip or jokes that are not accorded cultural value; Muhawi and Kanaana [1989], for instance, note how the tales of Palestinian women are often dismissed as mere nonsense). Or a combination of any two or more of these strategies may be used. The work of Khalil Joreige and Joana Hadjithomas suggests that the very act of creative expression, even when devoid of political content, can serve as a coded message of defiance and self determination. In their film *Khiam* (2000) they document the artistic production of prisoners in Khiam Prison in South Lebanon who, when denied all access to conventional materials that would allow them to create (pen and paper, needle and thread, and so forth), used found objects such as olive pits and stones to create objects of both artistic and practical merit.

The Islamic world has many rich traditions of folklore associated with religious practice, including, but not limited to, the activities and material and verbal art associated with festivals, visits to shrines, and Sufi *dhikr*. Although this remains an under-studied area, the nature of these practices suggests that Radner's theory of coding can be fruitfully applied in this context. Olson (1994), for example, notes that the Turkish shrines she studied are usually located far from centers of orthodox Islam and often at the outskirts of cities, at least in part so that women can practice uninhibited by the scrutiny of male-centered normative religious institutions. At these shrines, which she describes as important sites of both social interaction and empowerment where women can assume authoritative voices, she observed women sharing songs, tales, wishes, vows, and healing practices, any of which can serve as vehicles for the coding. Many scholars studying shrines in Africa, including Egypt, the Maghrib, and Ethiopia, as well as in Central Asia (Afghanistan) have noted their importance as gendered spaces. Studies of the coding embedded in the folklore produced and performed at these sites may well uncover important

insights into women's Islam and help to alter perceptions of Islam as "a religion for men [where the] women's universe emerges as a sort of cultural enclave surrounded by Islam" (Coulon quoted in Gibb 2001, 32). Such studies would complement research into the women-centered rereading of Islamic texts that women throughout the Muslim world have been undertaking in recent years.

As Radner and Lanser (1987) point out, the difficulty for the researcher, of course, is being able to identify coding when it occurs while avoiding the mistake of assigning coding when it does not exist. Since the purpose of coding is to mask the subversive message from the more powerful, it can be used to hide information from the researcher who may also be in a position of power vis-à-vis those she or he studies. The problem is further complicated by the fact that coding may be used unconsciously by a practitioner of folklore but nonetheless communicate disturbances and/or subversions to others (Radner and Lanser). Thus folklorists will not accurately interpret coded messages unless they have built relationships of trust with informants that somehow address the power relationship between the two. Even if a folklorist is able to obviate this power discrepancy, the recognition and correct interpretation of coded messages will require a precise understanding of the context in which a particular genre of folklore is practiced.

FIELDWORK: ETHICAL AND METHODOLOGICAL PROBLEMS

If the coded messages women send through folklore are to be studied and understood, there are serious and troubling ethical considerations that folklorists must address before conducting their fieldwork. Most importantly, folklorists must be aware of the social and political contexts in which they work and the ways in which their studies and collections may be used by others, and how their work may affect those from whom they have collected their material. They must learn to operate appropriately within given social structures. Additionally, in societies like many in the Islamic world where there may be a high level of sex segregation, how folklorists comport themselves can affect the nature of the material they collect. Abu-Lughod (1986), for example, describes how the participation of her father in introducing her to the Beduin with whom she was to work and live was important in defining her as a valued daughter in a respectable family, an identity that became important in the relationships she developed with the Beduin. She also made a conscious decision to restrict herself largely to women's society, in accordance with the practice of other women of her age and marital status. Her access to the poetry that became the subject of her book arose directly out of the close relationships with women afforded by that decision. In this regard, Abu-Lughod is, to some extent, following in the footsteps of anthropologist Elizabeth Fernea who during her fieldwork in Iraq chose to conform to the gender norms of the community in which she lived. In her study of historical narratives of Kelibia, Webber found, on the other hand, that her gender often prevented her from attending the all-male story telling sessions that she studied, forcing her to rely on male friends to collect tales for her (Webber 1991, 71).

Though it may assist a folklorist in establishing relationships and developing an understanding of the material she or he collects and studies, assuming a gender role appropriate to the society one studies does not by itself obviate the unequal power relationship that exists between researcher and subject. Inequalities arise from differences in education, socioeconomic background, and the researcher's membership in a different (and usually more powerful) cultural and political entity. Even those scholars who attempt to circumvent at least some of these power discrepancies by providing space within their works for their informants' voices, who work collaboratively with their informants, or who are *of* the culture (though often trained elsewhere) do not always succeed in bridging the divide (Altorki and El-Solh 1988, Abu-Lughod 1990).

PERFORMANCE CONTEXT

Another major development arising out of the redefinition of folklore that took place in the early 1970s has been a recognition of the significance of performance context (Bauman 1977). For those folklorists who are less interested in folkloristics as a tracing of the vestiges of an ancient ethnic identity than in its study in relation to the group in which it is to be found, how folklore relates to that group has become vitally important. In these studies, folklore is recognized as being emergent in performance, always responsive to the particularities of any given context, and hence constantly being recreated. For some, performance context became the defining feature of folklore (Limón and Young 1986). Context sensitive studies of folklore (Caton 1990, Reynolds 1993, Webber 1991) have illuminated the vibrant role that folklore plays in the development of self, community, attachment to place, and other aspects of individual identity. However, attention to performance context has

given rise to questions about methods of recording and preserving folklore, for if folklore can only fully be understood in its performance context, then the need to preserve aspects of performance context (the occasion for a performance, the audience and its reaction or participation, interactions between performers, rules of interaction, dress, somatic elements, and so on) is essential.

In Islamic cultures that continue to be characterized by strict sex segregation and clearly defined gender roles, studies of the relationship between text and performance context can be particularly important to a thorough understanding of women's mores and values. In many Islamic cultures folklorists who have incorporated considerations of performance context into their research have uncovered important strategies for gender construction and alternative codes of behavior and honor for women. Grima's study (1991) of personal narratives told by and for women in Afghanistan illustrates the importance of suffering in the construction of a female code of honor. Both Mills (1991) and Ramanujan (1991), writing respectively about Afghani and South Asian tales, found that whereas men's stories tended to end with marriage, with the bride as the prize earned by the hero through his exploits, women's tales were more likely to begin with marriage, take place in the domestic sphere, and involve considerable, usually unmerited, hardship. Thus, women's tales reflect and perpetuate world-views and codes of behavior markedly distinct from that of their male counterparts. Moreover, these women's tales, told by and for women, present women as "gazing and enunciating subjects and not just gazed-upon objects" (Appadurai, Korom, and Mills 1991, 8).

The focus on performance context, in turn, has led to another concern in verbal folklore: that is, what differentiates folklore (or, for that matter, any verbal art) from other types of verbal interaction? Hence, the concept of entextualization, that is, those features that define an utterance as a discrete text that maintains its identity as verbal art even when removed from its performance context (Bauman and Briggs 1990). Some folklorists have also called for a feminist view of performance context, one that focuses on the audience's reception of the performance and emphasizes emotions as well as intellect (Sawin 2002, 56).

ORALITY AND LITERACY
Because folkloristics often treats oral texts, the field has also been at the forefront of research on orality and literacy (and more recently secondary orality) and the effects of literacy and other technologies on verbal art. The rich intertwining of the oral and verbal that has characterized Islamic cultures has been instrumental in problematizing the dichotomy between orality and literacy and improving our understanding of the various ways in which they interact and affect each other. In his study of nineteenth-century Yemen, for example, Messick (1993) has shown how the oral and literary transmission of texts have not only coexisted but complemented each other. Sweeney (1987) has undertaken extensive studies of the interdependency of orality and literacy in Malay verbal art. In oral Palestinian wedding poetry, poets are less interested themselves in distinctions between oral and verbal texts than in questions of authorship and definitions of authorial voice.

BIBLIOGRAPHY
L. Abu-Lughod, *Veiled sentiments. Honor and poetry in a Bedouin society*, Berkeley 1986.
——, Can there be a feminist ethnography? in *Women and Performance* 5 (1990), 7–27.
S. Altorki and C. F. El-Solh, *Arab women in the field. Studying your own society*, Syracuse, N.Y. 1988.
A. Appadurai, F. Korom, and M. Mills (eds.), *Gender, genre, and power in South Asian expressive traditions*, Philadelphia 1991.
R. Bauman, *Verbal art as performance*, Prospect Heights, Ill. 1977.
R. Bauman and C. Briggs, Poetics and performance as critical perspectives on language and social life, in *Annual Review of Anthropology* 19 (1990), 59–88.
S. Caton, *"Peaks of Yemen I summon." Poetry as cultural practice in a North Yemeni tribe*, Berkeley 1990.
J. Conrad, The political face of folklore. A call for debate, in *Journal of American Folklore* 111 (1998), 409–13.
E. Early, *Baladi women of Cairo. Playing with an egg and a stone*, Boulder, Colo. 1993.
E. W. Fernea, *Guests of the sheik. An ethnography of an Iraqi village*, New York 1965.
C. Gibb, Negotiating social and spiritual worlds. The gender of sanctity in a Muslim city in Africa, in *Journal of Feminist Studies in Religion* 16 (2001), 25–42.
B. Grima, The role of suffering in women's perforance of *Paxto*, in A. Appadurai, F. J. Korom, and M. A. Mills (eds.), *Gender, genre, and power in South Asian expressive traditions*, Philadelphia 1991, 81–101.
D. Kapchan, Moroccan female performers defining the social body, in *Journal of American Folklore* 107 (1994), 82–105.
J. E. Limón and M. J. Young, Frontiers, settlements, and development in folklore studies, 1972–85, in *Annual Review of Anthropology*, 15 (1986), 437–60.
B. Messick, *The calligraphic state. Textual domination and history in an Islamic society*, Berkeley 1993.
M. A. Mills, Gender and verbal performance style in Afghanistan, in A. Appadurai, F. J. Korom, and M. A. Mills (eds.), *Gender, genre, and power in South Asian expressive traditions*, Philadelphia 1991, 56–80.
——, Feminist theory and the study of folklore. A twenty-year trajectory toward theory, in *Western Folklore* 52 (1993), 173–92.
I. Muhawi and S. Kanaana, *Speak bird, speak again*, Berkeley 1989.

E. A. Olson, The use of religious symbol systems and ritual in Turkey. Women's activities at Muslim saints' shrines, in *Muslim World* 84 (1994), 202–16.

A. Paredes and R. Bauman (eds.), *Toward new perspectives in folklore*, Austin, Tex. 1972.

J. Radner and S. Lanser, Strategies of coding in women's culture, in *Journal of American Folklore* 100 (1987), 412–25, reprinted in J. Radner (ed.), *Feminist messages. Coding in women's folk culture*, Chicago 1993, 1–29.

J. Radner (ed.), *Feminist messages. Coding in women's folk culture*, Chicago 1993.

A. K. Ramanujan, Toward a counter-system. Women's tales, in A. Appadurai, F. J. Korom, and M. A. Mills (eds.), *Gender, genre, and power in South Asian expressive traditions*, Philadelphia 1991, 33–55.

D. Reynolds, *Heroic poets, poetic heroes. The ethnography of performance in an Arabic oral epic tradition*, Ithaca, N.Y. 1993.

P. Sawin, Performance at the nexus of gender, power, and desire. Reconsidering Bauman's *Verbal Art* from the perspective of gendered subjectivity as performance, in *Journal of American Folklore* 115 (2002), 28–61.

J. Scott, *Domination and the art of resistance*, New Haven, Conn. 1990.

A. Sweeney, *A full hearing*, Berkeley 1987.

S. Webber, *Romancing the real. Folklore and ethnographic representation in North Africa*, Philadelphia 1991.

NADIA G. YAQUB

Geography

Anglophone human geography of the twentieth century is a diverse discipline whose various aims come together under the umbrella of the study of human and environment interaction. The subfield of feminist geography is extensive, and while the bulk of feminist geographic work was formerly concentrated primarily on American and European cultural terrains, today feminist geographers perform research all over the world. Studies of women in Islamic cultures constitute a fairly new and growing field within the discipline of geography, and reflect the diversity of theoretical, methodological, and topical approaches of the discipline as a whole. This entry will discuss the important geographic question of Islam and its gendering of space. It will also situate a review of geographic studies of women in Islamic cultures within a discussion of the theories and methodologies of geography. Studies of gender intersect with geography in that power is always spatial. Geography is the co-constitutive context for social action; it may reflect and reproduce, or allow the transgression of, gendered social roles. Geographers explore the interconnections between gendered roles in home spaces to larger structures of power, such as nationalist policies or global economic processes. Geographic studies of women's relationships to place explore the spatial nature of identity construction. As all social relationships are also spatial, geography is essential to scholarship on women in all places.

THE GENDERING OF SPACE IN ISLAM

One of the most important geographic questions for the study of women in Islamic cultures is the question of how and whether Islam genders space. This question is embedded in the historiography of the "Islamic City" model, an Orientalist construct that describes particular social and physical characteristics shared in common by Middle Eastern cities as they reflected the influence of Islam. According to the model, Islam played a role in gendering space in that it created certain environments that constituted the setting for the seclusion of women and the segregation of men and women as prescribed by Islam. This resulted in the differentiation between public and private spaces in the home, in the architectural creation of, for example, the Ottoman *haremlik*

and *selâmlık* (the social segregation of spaces in the home defined by their use by women and family, and by men and visitors), and features such as grilled windows that prevented foreign male eyes from seeing women in the family space. The wall-lined, winding, narrow, dead-end, and sometimes gated neighborhood streets protected the neighborhood's local women from the gaze of strangers by controlling movement. The street pattern discouraged the accidental presence of foreigners in neighborhoods by clustering residences off of main thoroughfare streets. The Islamic City model makes the assumption that Islam provides the dominant cultural value in societies where it is the dominant religion. It reads the architecture and organization of cities, down to the level of the private house, as the physical manifestation of Islamic values.

In her 1987 article, Janet Abu-Lughod shattered the future of the Islamic City model as a tool for meaningful geographic studies of societies where Islam is the dominant religion. She revealed its Orientalist origins, proving it to be derivative of a few French studies of a few French colonial cities that spawned the beginning of a long and self-referencing chain of scholarship. The very formation of a model called the Islamic City assumed an essential and deterministic quality of Islam and its ability to shape urban environments, reflecting its Orientalist perspective that defined cities of Islamic societies first in terms of their opposition to and difference from cities of Europe. Abu-Lughod asks, "Why would one expect Islamic cities to be similar and in what ways?" (1987, 160). Her question raises the problem of assuming that Islam is understood, practiced, or manifested spatially in similar ways in societies as geographically diverse as those in Southeast Asia, Southwest Asia, North Africa, or in other parts of the world. It also raises the obvious point that the relationship between Islam, the creation and lived use of social space, and the gendering of society, cannot possibly work consistently for the immense diversity of histories, geographical areas, economic or political situations, or other places for which these questions have meaning. Further, viewing the seclusion of women, and the segregation of male and female spaces, as a primary characteristic of the "Islamic

City," ignores that "the restriction of women to 'private' domains is a feature of rural and urban, capitalist and socialist, societies" (S. Ardener referenced in McDowell, 2002, 121); it is not a feature particular to cities in Islamic cultures.

The awareness of the problems of the Islamic City model has not rendered the question of the relationships between space, gender, and Islam meaningless, however. Anna Secor, for example, uses a spatial approach to examine the practice of veiling in Istanbul, Turkey. Her study reveals the ways in which various practices of veiling are spatialized across the city, and suggests links between the gendered production of Islamic knowledge and women's mobility in the city. This study emphasizes the importance of the study of the spatialization of everyday life for women and suggests that Islam plays a significant but complex role in the context in which women negotiate the practices of everyday life.

Secor examines the spatialization of a gendered bodily practice; her research is an example of the kind of contribution contemporary geography can make to the question of Islam and its gendering of space. One of the most important recent theoretical developments in geography involves geographical analysis of the body. This type of geographical analysis assumes that the everyday activities that produce (or contest, or reinterpret, or make meaning of) social space begin and happen through the body. Bodies are inscribed with meaning by ourselves and others; it is the body that identifies one to others, and it is with the body that one narrates, by signs or gestures or language, oneself to other people. Self-identity is formed in the process of telling who we are, and this telling always happens in relation or opposition to others. It can acquire meaning as it aligns with the larger narratives of groups and becomes part of a collective identity.

All bodily actions, the expressions of self-telling that distinguish one from others, are spatial in that they both produce and are constituted by the social space in which they happen. "Space underpins the collective, dialogical, ongoing negotiation of the construction of self- and group-identities . . . Given that the polysemous construction of identity occurs in situ, it is no surprise that many geographers have turned their attention towards examining spaces as the sites of the bodily construction of the self" (Dear and Flusty 2002, 305). Feminist geography assumes that spaces are gendered by the way gendered bodily actions produce space; geographical studies of the body in Islamic societies can open new ways

of exploring the relationship between Islam and the production of space in Islamic cultures, including: comparing women's and men's experiences of particular spaces; research on sexuality and identity; the gendered dimensions of new spaces created by globalization and capitalization; or women's spaces in religious political movements. Other research may be inspired by the disembodiment of the production of certain spaces, such as those created by communication technology. Susan Bastani's study on the use of the internet by Muslim women, for example, explores the way communication technology forms a multinational and multicultural space of meeting and support for immigrant Muslim women in North America who are otherwise isolated from Islamic society.

FEMINISM IN GEOGRAPHY: THE THEORETICAL CONTEXT OF GEOGRAPHIC STUDIES OF WOMEN IN ISLAMIC CULTURES

Contemporary geographic studies of Islam, gender, and space have inherited the intellectual history of feminism in geography. When feminist geographers brought feminism to geography, they criticized the discipline for how it reflected a masculinist construction of geographical knowledge. These geographers raised new epistemological research questions and also re-evaluated the core theoretical and methodological assumptions of the discipline. Since the early 1980s, entire issues of geography journals such as *Antipode, Canadian Geographer, Professional Geographer*, and the journal *Gender, Place, and Culture* have been sites of debate concerning the impact of feminist geography on geographic theory and methodology. Feminist geographers in the 1970s sought to valorize feminine difference, arguing that the geography of women and of women's spaces had previously been ignored (see Janice Monk's early influential article, 1982). This trend brought attention to the spatialization of gendered power structures and new topics of research to the fore, such as the study of the socio-spatial relationships of everyday life. Geographers traced the paths of women in the spaces of their everyday lives, illustrating that the movement of women in public space is limited by a prevailing masculinist ideology that places women in the domestic, private space of the home (Rose 1993).

Feminist geography brought activism to the academic discipline as well as to applied, professional geographic practice. One of the most explicitly political manifestations of feminist

geography emerged in the 1980s in the growth of ecofeminism as a political movement. Ecofeminism developed at the urging of women in non-Western countries concerned with the relationships between local environments, global processes, resource use, and women's involvement in environmental activism. While united by their concern for women and the environment, ecofeminists are diverse in their origins and aims. Some argue that the woman-nature connection is grounded in a patriarchal ideology that works to subordinate women and nature, whereas others celebrate the connection between women and nature, finding in it a claim to strength. Ecofeminists have called attention to the political economy of the relationships between international development institutions and local peoples and environments. They argue that disparity results from the gendered social roles that condition the ways men and women use environmental resources. They work in local grassroots movements to expose the interconnections between systems of oppression, arguing that the exploitation of natural environments is derivative of the modes of oppression in human relations.

Feminism also brought new perspectives on academic methodology to geography. Geographic methodology began to shift more deliberately to include women and pay particular attention to the diversity of research subjects in general. Attention also shifted to the use of non-hierarchical qualitative methods and geographers began to become aware of positionality of the researcher and the researched in information-gathering and knowledge-creating (see Hanson 1992). For geographers, this positionality is inherently spatial; the location of interviews can serve to either oppress or empower the interviewer or interviewee. For these geographers, meaning is produced in a spatial, as well as social or cultural context.

Feminist geographers' interests in the production of geographic knowledge coincided with studies of gender in the sciences as well as revisionist historiographies of the history of geography that placed it within the history of European expansionism and colonial oppression. Feminists linked geographic knowledge with power and illustrated the role of white, male, European colonialists in the history of geographic inquiry (see Domosh 1991). So, while some geographers focused on including women in the study of the production of geographic knowledge, others examined the masculinist way in which geographic knowledge was produced at its very foundational theoretical level, in the tropes and concepts

with which it conceived and explained the world (see Massey 1994). Feminist geographers have changed the way geography is understood and practiced within all of its subdisciplines. Geographic studies of women in Islamic cultures reflect these impacts and have offered new avenues of research, including: the roles of women in development initiatives and environmental resource management; urban studies of migration practices and political Islam; the female transgression of the cultural norms of place in literature; and the relationship between Islam and the gendered production of space.

POLITICAL ECOLOGY AND THE STUDY OF WOMEN IN ISLAMIC CULTURES

The study of the role of human agency in transforming the natural environment was the focus of the work of geographer Carl Sauer, whose concept, landscape morphology, remains core to academic cultural geography. The theoretical and methodological approaches of landscape morphology became the trademark of "the Berkeley school," in which the physical landscape was understood to be a "cultural spoor," which could be visually observed and analyzed as the "real" expression of culture on land. The morphology of landscape referred to the process of change wrought by human activity as it imprinted its mark on the physical environment. The practices of agricultural technology and settlement patterns, for example, were understood as environment- and culture-specific, and geographers studied the spatial diffusion of these processes into culture regions. Field research was the foundation of geographic methodology, and while it included foreign language study, it relied heavily on the visual observation of the landscape in its material form. The subfield of contemporary cultural ecology stems from the early landscape studies of the Berkeley school, and focuses on the adaptive technologies of pastoralists, hunter-gatherers, and peasantries of developing countries. Political ecologists explore these practices in their larger social and political context, and feminist geographers have been among those to examine the power relationships that influence cultural adaptation to the environment.

It is in the arenas of political ecology and development studies that geographic studies of women in Islamic cultures are most developed, although they are not nearly as numerous as studies of the impact of gender relations on environmental resource management in the regions of Africa,

Asia, and Latin America. An example of such work is that of Diana Davis who has brought questions of gender to the study of pastoralism and rangeland management in Morocco. She has examined the impact of women's roles in animal management practices and ethnoveterinary medicine on environmental change in an area experiencing desertification. The influence of social, economic, and ecological contexts on gendered roles in resource management tasks in this region is considered. The gender focus of this study brings a crucial perspective to studies of environmental change in the Sahel. Other geographic research on the role of women in agriculture and environmental resource management has been performed in Bangladesh, Turkey, Egypt, and Muslim communities in Tanzania. By exploring the gendered nature of social dynamics involved in daily household practice regarding livestock and environmental resource management, this perspective illuminates previously ignored dimensions of human-environment interaction.

THE "NEW CULTURAL GEOGRAPHY" AND URBAN STUDIES

Many of the geographic studies of women in Islamic cultures interrogate the gendered spaces and meanings of urban life. Urban cultural studies are part of a post-1980 intellectual movement in which geographers began to re-evaluate the understanding of culture underlying the foundational concepts of landscape and the culture region. The geographic focus on the material form faced criticism for its view of culture as an undifferentiated, single agent unreflective of the gendered, social, political, or economic contexts within which it was produced. Underlying these theoretical shifts in geography was a new concern for the processes that shape landscapes, a trajectory that stemmed first from Marxism, but that also felt the influence of feminism, literary criticism, postcolonial theory, cultural studies, and other intellectual trends of the last few decades. Drawing from the work of Henri LeFebvre on the production of space and also from that of Michel de Certeau (among others), cultural geographers began to focus explicitly on the power relationships inherent in the social processes that shape the environment. The subject of study turned to the environments and cultures of mundane, everyday life. The landscape itself began to be conceived as continually reproduced by a plurality of actors whose agency is conditioned by their relative political or economic positions. Further, space

was viewed as not merely produced by human action but also the constitutive context within which action occurred. The movement of criticism concerning the underlying assumptions of the discipline of geography was termed the "new cultural geography" and journals such as *Antipode*, *Ecumene*, and *Society and Space* were founded as forums for discussion on the issues raised. While early cultural geography studied rural and traditional or "folk" environments, geographical research has long since expanded to encompass cultural hybridity and transnational subjects, nonmaterial cultural landscapes such as those in the imaginary geographies of textual and visual representations, the spatiality of relationships in the new media of internet and communications technology, and identity formation in the context of globalization. One of the largest bodies of research formed is in urban geographic studies of the spatialization of inequality generated by the capitalist economy of the last several decades (see the work of Mike Davis, Michael Dear, David Harvey, Edward Soja, and Sharon Zukin, for example). These authors have examined the formation of new environments that correspond with the new political economy, and explore the place of the city, and the places of new cities, in the formation of global and local cultures.

Urban studies of women in Islamic cultures have explored in various ways the spatialization of gendered social roles in cities, and the new possibilities or conditions for women presented by the growth of new urban spaces. These studies have examined, for example: the effect of migration on women's social roles; the roles of women in developing economic networks and other survival strategies in new settlements; the gendering of space in squatter settlements and refugee camps; and the identity construction of migrant women in oral histories that narrate their places of origin. Underlying these studies is the conceptual assumption that all social, political, and economic events have gendered impacts, and that studies of their spatiality reveal new avenues of research query and understanding. A survey of recent doctoral theses in geography reveals that work on migration and women has been done in places as diverse as Afghan refugee camps, rural Sudan, Sri Lanka, Tunisia, Turkey, and among Beduin in the Negev. The Islamic world is increasingly urbanized; urban cultural studies of women and their relationships to the economic, political, cultural, and social environments of cities will only become more significant.

PLACE STUDIES

Studies of women in Islamic cultures have used the geographic concept of place to explore the relationship between gender, space, and identity as well as the spatialized nature of gendered power relations. Place studies began as a response to geography's quantitative revolution in the 1960s, which prompted some geographers to argue for a more humanistic approach to the relationship between people and environment. The concept place encompassed qualitative elements such as subjective meaning. If space was the container in which social activity happened, place was space made meaningful: geographers such as Anne Buttimer, Edward Relph, and Yi Fu Tuan explored place as a site of sensory perception, spiritual presence, memory, meaning, imagination, or feeling. Like landscape, place is a foundational concept for cultural geographic studies.

Ideas surrounding the social production of space impacted place studies with criticism that suggested place had become understood as static and unchanging, a discrete locality whose character could be threatened by change and become "placeless." Geographers such as Doreen Massey offered an understanding of place as existing in terms of its spatial relationships with other places, the flows between which produce and reproduce place continuously. Place became a nexus, or site, of interconnected social actions that layer a locality with meanings, ever evolving, sometimes disputed and conflicting, and never essential or static.

Place also became important for geographic studies of identity construction. At a basic level, place and identity are mutually constitutive as the memories with which we construct our own histories, which necessarily happen in specific places; places come to embody narratives about ourselves. As research expanded to explore the relationship between place and identity, studies of place began to embrace the themes of difference, positionality, embodiment, and reflexivity so significant for feminist geography. Emerging through this trajectory of research were studies on the politicization of place and the examination of place as an empowering site of resistance. Geographers began to explore how the meanings of place can empower those who challenge the dominant culture, or how narratives of the meanings of places can work to reinforce or subvert the power relations of the social activities that create place. The study of place becomes the study of the spatial context in which gendered social roles are performed and gendered power relations exert their influence. It is in this vein that geographic studies of women in Islamic cultures began to explore the relationship between women and place. Carel Bertram (1998), for example, suggests that in Turkish literature women's relationships to place embody both the traditional cultural roles ascribed to them and their active contestation of these roles. Such research reflects trends emerging with the influence of cultural studies theory in geography.

THE GEOGRAPHY OF WOMEN IN ISLAMIC CULTURES

Geographic theories and methodologies are as diverse as the terrains, environments, and cultures geographers study. There is no consistent methodology used by geographers who study topics related to women in Islamic cultures; methodologies vary according to the available tools of the geographer, the social or political context of her research, and the nature of her questions. Quantitative methodologies such as remote sensing, soil sample collection, and landscape analysis may be used with interviews and participant observation to determine the culture of the land use of a particular region and its gendered dimensions. Urban geographers have used large-scale survey analysis and focus groups, as well as long-term participant observation and open-ended interviews. Still other geographers interrogate literature and film for the meanings embedded in the spaces of women in Islamic cultures. A geographic perspective makes it clear that the creation and use of spaces, and their interpretation or reappropriation by women, are contextually bound and are flexible. Islam relates to such complicated contexts in various ways. Geographic theories and methods offer terms with which to describe and analyze the complexity of women's places in Islamic societies and the various elements that shape (and are shaped by) their everyday lives, be they economic, political, social, or religious in nature. While there is no single database or archive for geographic studies of women in Islamic cultures, an online database of feminist geographic literature is maintained by the Geographic Perspectives on Women specialty group of the Association of American Geographers at <www.emporia.edu/socsci/fembib/index.htm>. Articles on women in Islamic cultures have been published in journals such as *Gender, Space and Culture, Arab Geographer, Geographic Review*, and the *Annals of the Association of American Geography*.

BIBLIOGRAPHY

J. Abu-Lughod, The Islamic city – historic myth, Islamic essence and contemporary relevance, in *International Journal of Middle East Studies* 19 (1987), 155–76.

S. Bastani, Muslim women on-line, in *Arab World Geographer* 3:2 (2000), 40–59.

C. Bertram, Restructuring the house, restructuring the self. Renegotiating the meanings of place in the Turkish short story, in Z. Arat (ed.), *Deconstructing images of the Turkish woman*, New York 1998, 263–74.

D. Davis, Gender, indigenous knowledge, and pastoral resource use in Morocco, in *Geographical Review* 86:2 (1996), 284–8.

M. Dear and S. Flusty, Emplaced bodies, embodied selves, in M. Dear and S. Flusty (eds.), *The spaces of postmodernity. Readings in human geography*, Oxford 2002, 306–6.

M. Domosh, Towards a feminist historiography of geography, in *Transactions of the Institute of British Geographers* 16 (1991), 95–104.

S. Hanson, Geography and feminism. Worlds in collision? in *Annals of the Association of American Geographers* 82:4 (1992), 569–86.

J. P. Jones III, H. J. Nast, and S. M. Roberts *Thresholds in feminist geography. Difference, methodology, representation*, Lanham, Md. 1997.

D. Massey, *Space, place, and gender*, Minneapolis, Minn. 1994.

L. McDowell, Towards an understanding of the gender division of urban space, first appeared in *Society and Space* 1:1 (1983), 59–72, reprinted in M. Dear and S. Flusty (eds.), *The spaces of postmodernity. Readings in human geography*, Oxford 2002, 120–6.

J. Monk, On not excluding half of the human in human geography, in *Professional Geographer* 34:1 (1982), 11–23.

G. Rose, *Feminism and geography. The limits of geographical knowledge*, Minneapolis, Minn. 1993, 17–40.

A. Secor, The veil and urban space in Istanbul. Women's dress, mobility, and Islamic knowledge, in *Gender, Place and Culture*, 9:1 (2002), 5–22.

AMY MILLS

History: Middle East and North Africa

INTRODUCTION

The history of women in the Middle East and North Africa developed in the anglophone West in the context of changes that took place in the discipline of history as well as in the field of Middle Eastern/Islamic studies in the 1970s. This decade saw the first anthologies with women as the subject, and several important journal articles that focused on the economic and social aspects of women's lives and on the problems associated with the construction of a historiography of women.

The events that made possible the emergence of a Middle Eastern/Islamic women's history as a coherent field included the publication of Edward Said's *Orientalism*; the embrace of social history by a generation of scholars who came of age in the United States and Western Europe during the anti-war, civil rights, and women's rights struggles of the 1960s and 1970s; the so-called second wave of the feminist movement and the emergence of feminist theory and methodology; and the rise of post-structuralism and its challenge to history on an epistemological level.

EDWARD SAID'S ORIENTALISM

Said's *Orientalism*, which was published in 1978, challenged the prevailing paradigm for studying the Middle East or the East in general. Using the theory of discourse from Michel Foucault, Said argued that Orientalism was "a systematic discipline by which European culture was able to manage – and even produce – the Orient politically, sociologically, militarily, ideologically, scientifically, and imaginatively during the post-Enlightenment period" (Said 1978, 3) Said contended that the Orientalist representation of Eastern societies was based on a dichotomy between self and other in which the European self was superior to the Oriental other. He criticized the way in which Orientalists represented the East as timeless and outside of history. In part, this view flowed from the idealist epistemology of Orientalism that presumed that Islamic societies were knowable across time and space through texts. This method of producing knowledge about the Orient resulted in a representation of Islam as monolithic and impervious to change both as a religion and a culture.

Said's critique was also directed at the inadequacy of the sources and methodology used by Orientalist scholars. The sources, which were primarily textual, included the Qur'ān and the *ḥadīth*, commentaries on the sacred texts, treatises on religion and jurisprudence and biographies such as those written about the Prophet. Thus, Orientalist scholarship was based mainly on the discovery and interpretation of key texts as well as the translation of these texts into Western languages. The idealist epistemology of Orientalism and the training that scholars received prevented the field of Middle Eastern studies from developing a "modern" approach to history, political science, and other disciplines. Scholars of Middle Eastern studies tended to be isolated from their colleagues who studied other regions of the world, and were slower to adopt new methodologies in their disciplines. Said's critical reading of the Orientalists liberated the field of Middle East Studies from Hegelian idealism and allowed historians to adopt historicism as a methodology. With analytical empiricism as their method, historians were able to focus on the social and economic lives of their subjects and to uncover and use appropriate sources for their research. Said's *Orientalism* also underscored the need for the historical study of imperialism and for the formerly colonized people of the world, not just in the Middle East, to represent themselves by producing their own historical narratives.

EMERGENCE OF WOMEN'S HISTORY

The publication of Said's *Orientalism* coincided with the coming of age of a younger generation of scholars whose training took place at a time of social upheaval and cultural change brought about by the movement against the United States war in Vietnam, workers' and students' activism, a burgeoning women's rights movement in the second wave of the feminist movement, and the increasing visibility of social and political conflict in the Middle East. Social historians challenged the notion that history was made by political elites and proposed instead a view of history in which formerly marginalized individuals and groups such as peasants, workers, and women could act as agents of historical change.

These developments opened a space for women's history, which began rapidly to develop as a separate field within the wider discipline of

history. With the historians of the United States
and European women taking the lead, feminist
theory and a feminist methodology began to
develop with the two-fold goal of restoring
women to history and revealing the sources of
female subordination. Feminism as it evolved in
the West became not only a theory and methodol-
ogy but also an epistemology and a political
movement aimed at achieving equity and justice
for women.

POSTSTRUCTURALISM AND
POSTMODERNISM

Women's history and women's studies in gen-
eral were also affected by theorizing known as
poststructuralism and postmodernism, which
challenged universalizing systems and essentialist
or reductive thinking. In the field of Middle East
studies, this had the effect of validating Said's cri-
tique of Orientalism. It made scholars of non-
Western societies more sensitive to the connection
between knowledge and power and the way in
which knowledge, particularly of the "other," was
constructed. As a critique of universalizing sys-
tems of knowledge, poststructuralism urged schol-
ars in various disciplines to look for the local and
the particular and to concentrate on personal
experiences and narratives. Thus, the postmodern
climate, although chilly toward essentialist cate-
gories such as gender and women, was more con-
genial theoretically to studies focusing on the
everyday lives of women that social historians
sought to uncover and on the asymmetry of power
in social relations that practitioners of gender
studies sought to reveal.

Within women's studies, the poststructuralist
challenge to universalist categories such as
"woman" stimulated a discussion of the direction
of the field as well as the feminist political project.
The issues that have animated this discussion have
not been resolved. On the one hand, there have
been attempts to theorize a connection between
poststructuralism and gender that would allow
scholarship on women to incorporate the insights
and theories of poststructuralism. One of the first
attempts to bridge the apparent gap between post-
structuralism and gender studies was the very
influential article by Joan Wallach Scott, "Gender:
A Useful Category of Historical Analysis." On the
other hand, some feminist theorists have noted
that the critique of categories such as "woman"
and the alleged death of the subject appeared at a
time when women and the formerly colonized
were beginning to speak and write as subjects of
their own history.

GENDER AS A TOOL OF HISTORICAL
ANALYSIS

As Western women's studies matured in the
academy, historians shifted from research and
writing aimed at restoring women to the historical
record to the use of gender as an analytical tool to
uncover and understand how societies are organ-
ized. Scott and another historian, Elizabeth Fox
Genovese, discussed in separate articles written in
the 1980s their concerns that women's history as
the chronicle of women's experiences distinct from
that of men added women to history but did not
place women's history in history. Since gender is
embedded and expressed in religious, educational,
scientific, legal, and political institutions, they
argued, the use of gender as a primary tool of his-
torical analysis enables us to understand the
dynamics of any social system and "inaugurates
the essential restoration of women to historical
process" (Genovese 1982, 15). As the sociologist
Deniz Kandiyoti has noted, the result of this
phase of Western feminist scholarship has been to
produce a gradual but significant shift from
"woman" to "gender" as a central analytical cat-
egory (Kandiyoti 1996, 6).

With the expansion of women's studies in terms
of courses, programs, and publications as well as
geographically to venues outside of the United
States and Western Europe, First World academics
and researchers were often criticized by Third
World women and women of color in the United
States for ignoring their concerns and for assum-
ing a hegemonic position within academic
women's studies as well as in organizations and
movements focused on women and women's
issues. Non-Western women often accused West-
ern women of applying theories derived from the
experiences of North American or European
women to them although their histories and life
experiences were very different.

SHORTCOMINGS OF WESTERN
FEMINIST THEORY

In 1988, Chandra Mohanty published her in-
fluential essay, "Under Western Eyes: Feminist
Scholarship and Colonial Discourses," which crit-
icized Western liberal feminist approaches to
the study of women in Asia and Africa. Marnia
Lazreq, who has written on Algerian women, has
raised similar issues in her writings, particularly in
her article, "Feminism and Difference: The Perils
of Writing as a Woman on Women in Algeria."
Miriam Cooke has argued that a turning point in
Middle Eastern women's studies occurred in 1988
when the recently formed Association for Middle

Eastern Women's Studies convened a panel to celebrate twenty years of United States women's research about women in the Middle East. According to Cooke, the panel launched a debate that would continue over ten years concerning who has the right and authority to speak for whom (Cooke 2001, 147).

By the end of the millennium, feminism in the singular had been replaced by feminisms in the plural in recognition of the global span of organized women's movements, the different approaches to analyzing and solving the problems facing women, and the contested meaning of feminism and feminist in different cultures. In Middle Eastern women's studies, scholars like Hatem, Badran, Al-Ali, Najmabadi, Afary, and Cooke have examined the meaning and use of the words "feminist" and "feminism" as well as the various feminist movements in the region both historically and in contemporary society, including secular nationalism and the newly emergent Islamic feminism.

As a result, women's history has become more attentive to differences of race, class, and ethnicity and more aware of the shortcomings of Western feminist theory when applied to non-Western societies. Also, Western scholars have recognized the necessity of incorporating into the historiography indigenous women's research and writing, such as that produced by the Egyptian organization of women scholars known as the History and Memory Forum. Two collections, *Middle Eastern Muslim Women Speak* and *Opening the Gates: A Century of Arab Feminist Writing*, testify to the importance given to hearing women's unmediated voices and allowing women to represent themselves through their writings.

SOURCES AND METHODOLOGY

Middle Eastern/Islamic women's history began later than comparable programs in Western women's history and lagged behind methodologically and theoretically. However, once history as a discipline was unshackled from Orientalist representations of "other" cultures and societies and from its sources and methodology, Middle Eastern history, including women's history, began to develop its own historiography, new sources for research and a historical methodology. Even though poststructuralists were attacking historicism and its claims to objectivity and truth, analytical empiricism proved liberating for historians of Middle Eastern societies who were finally able to historicize their subjects and focus on their social and economic lives.

Armed with training in the appropriate languages and in the methods of archival research, the post-Orientalist generation of historians began to write the social and economy history of the Middle East and North Africa. In the 1970s, the discipline began to move in the direction of economic and social history although very little attention was paid, at first, to women's history. By the 1980s, the new sources and methods were adapted by the founding generation of Middle Eastern women's history as a distinct field within the discipline.

EARLY ACCOUNTS

The earliest historical accounts of women in Middle Eastern/Islamic society were written in the 1940s by Nabia Abbott who was also the first woman admitted to the University of Chicago's Oriental Institute. In a series of journal articles and two monographs, Abbott examined women's lives before and after the coming of Islam and wrote the first historical account of ʿĀʾisha, the Prophet's favorite wife. Although Abbot used some of the same sources as the Orientalist scholars, such as *ḥadīth* collections and biographies of the Prophet, she used them very differently. The women Abbott wrote about were not the uniformly oppressed subjects of a timeless Islamic society but rather women, alive at a particular historical moment, who often acted autonomously and who played important roles in the newly emerging Islamic state, socially, economically, and politically. Subsequent works by scholars of the early period of Islamic history, such as those by Ahmed and Mernissi, have relied on Abbott's accounts of women's lives in the Jāhiliyya and the classical period of Islamic history.

In 1939, Gertrude Stern wrote an important account of marriage in Arabia during the early Islamic period and an article on women converts to Islam. However, it was not until the late 1960s that women's history as a separate and distinct field began to emerge. In 1968, Nada Tomiche wrote "The Situation of Egyptian Women in the First Half of the Nineteenth Century." In 1973, Aḥmad ʿAbd al-Rāziq published his monograph in French on Mamluk women in Egypt; and in 1975, Ronald Jennings wrote the first article on women from sources unused before, namely, Sharīʿa court archives.

At the time Tomiche's article was published, the prevailing paradigm in Middle Eastern studies was modernization theory, an offspring of Orientalism, which appeared Eurocentric to many scholars in the field after the publication of Said's

critique. Modernization theory, like Orientalism, is based on the perceived difference between so-called traditional, backward, and stagnant Eastern societies and the modern, progressive, and dynamic societies of the West. The modernization paradigm presumes that the Western penetration of Eastern societies was benign and that progress, economic and social, came from Westernization. Colonialism and imperialism were generally regarded as beneficial forces if they were considered at all. As for women, although it was conceded that Islam at one time gave women some rights, women in the East were regarded as having fallen behind women in the West and only secularization, legal reform, and capitalist transformation on the Western model would improve their position.

Baer, for example, wrote that "the Arab countries have witnessed certain changes in women's social, legal, and political status. The background to these changes is fundamentally the closer contact of the Middle East with the West" (Baer 1964, 2).

Tomiche's article, one of the earliest in the field of women's history, was included in a volume entitled *Beginnings of Modernization in the Middle East: The Nineteenth Century* that followed the modernization paradigm. Tomiche's view was that Egyptian society had not changed for centuries until the French invasion of 1798 shook it out of its complacency and disturbed its equilibrium. According to Tomiche, the status of women had not evolved for centuries and women remained illiterate, secluded in their harems, treated as property by their fathers and husbands and deprived of even those rights given to them by the Qur'ān. Tomiche's sources for her article were largely the writings of Western (French and English) observers and travelers, with the exception of al-Jabartī and his monumental chronicle of Egyptian life.

Tomiche's article exemplifies the problems and obstacles facing scholars interested in women's history. The field of Middle Eastern women's history and women's studies generally was burdened by conceptualizations, sources, and a methodology that had developed within the framework of Orientalism. Historically, in travel literature, scholarly works, and artistic representations, women were portrayed as sexual objects virtually imprisoned in harems to satisfy the sexual desires of their masters, uneducated, economically inactive, and oppressed in ways that were unknown in the West. This view of the degraded condition of women and their low status was incorporated into Western social science. It also became a metaphor for the decadence and backwardness of Middle Eastern/Islamic society as a whole. Notions of Western superiority could be constructed on and around the primary symbol of Middle Eastern/Islamic social decay – women. The tenacity of this image is due in part to its usefulness in the West as a continuous reminder of the alleged superiority of Western civilization and as a guide to Western policymaking.

THE 1970S

Given the burden of the past both epistemologically and historiographically, the task of constructing the field of women's history was a formidable one. Two articles published four years apart in the *International Journal of Middle East Studies* by Nikki R. Keddie (1979) and Judith E. Tucker (1983) focused on the problems involved in the study of Middle Eastern women and in the historiography of women. The two scholars agreed that while empiricism continued to be important in order to add women to the historical record, a theoretical approach was also necessary, as Tucker said, to show how women's roles and status are related to the economic, political, and social organization of society (Tucker 1983, 327). Both scholars also argued for the expansion of the historical sources used to study women's lives in the past and the present.

In 1978, two collections devoted to women signaled the beginning of women's studies as a field. They are *Middle Eastern Muslim Women Speak* and *Women in the Muslim World*. The first announced its intention to correct the distortions of the Orientalists and ethnographers regarding women and to reread and reinterpret the sacred texts of Islam that concern women. The second located itself within the Western feminist movement and the field of women's studies. It included five historical chapters that focused on women in the Ottoman Empire during the classical age (Dengler); women as patrons of architecture in Turkey (Bates), women's participation in the nationalist politics in Egypt (Philipp) and in the revolutionary movement in Iran between 1905 and 1911 (Bayat-Philipp), and women in upperclass Egyptian harems (Marsot). The authors relied on a variety of sources such as travel accounts, an ethnography of Turkish women, and newspapers. Marsot, innovative in her use of sources, used mainly interviews with women who had lived in the harem, some of whom were Marsot's relatives. Her article challenged the stereotype of harem women and argued that when

female seclusion ended, upper-class women were able to manage large philanthropic enterprises such as hospitals and schools because their duties included managing homes the size of small hotels.

SOCIAL AND ECONOMIC HISTORY: THE USE OF COURT RECORDS

In 1975, an article by Ronald Jennings, "Women in the Early Seventeenth-Century Ottoman Judicial Records: The Shari'a Court of Anatolian Kayseri," appeared at a time when historians were beginning to recognize the importance of court records for social and economic history. Jennings's article was of signal importance for women's history because it helped to demolish stereotypes about Muslim women: that they were the virtual property of their fathers and husbands, that they could not own or control property in their own right, that they were sold into marriage and had no say in their marriages and no right to the dowry (mahr), and that they had no legal recourse when their rights were infringed because they did not use the courts. Jennings, who examined more than 1,800 cases in the Kayseri court between 1600 and 1625, presented evidence of women's economic activity, their presence in court to argue on their own behalf, as well as important information about marriage, divorce, and married life. Jennings's work showed how the court records could be used as sources for women's history and in fact suggested that researchers consult other types of judicial records dealing specifically with inheritance, dowry, and religious endowments (awqāf).

The first monograph to appear based on court records was Judith Tucker's Women in Nineteenth-Century Egypt, published in 1985. Tucker used the Shari'a courts of Cairo and the provinces to focus on peasant and urban lower-class women. Tucker's contribution to historiography was to demonstrate how to use court documents for information about various aspects of women's lives and to develop a theoretical framework for women's history. Tucker, like Keddie, was interested in doing more than adding women to the historical record. She advocated a theoretical approach that would show why women's history is significant, and why knowledge of women's lives contributes to or revises our understanding of history.

Tucker used a variety of court cases in her monograph on nineteenth-century women while other historians have used particular kinds of documents to chart women's economic activity, to learn more about marriage, the dowry, or women's access to divorce, and to extend our understanding of family life and women's role in the family. One category of court records has proved to be an important source of information for the social and economic history of women. These are the records of women's religious endowments. They are a particularly important source of historical information about women for the medieval and early modern periods. Waqf documents have been used for women's history in Ottoman Istanbul (Baer) and Edirne (Gerber), in eighteenth- and nineteenth-century Aleppo (Meriwether, Roded), and nineteenth-century Syria (Doumani). Waqf documents have also been important for the history of women in Mamluk Egypt. 'Abd al-Malik and Crecelius analyzed the waqf of a sister of one of the most important eighteenth-century Mamluks, Muḥammad Bey Abū al-Dhahāb, and Fay used waqf records in her study of women in the eighteenth-century Mamluk household demonstrating not only women's economic activity but also their importance to the reproduction of Mamluk political power. Petry analyzed 283 awqāf listed under women's names in the monumental work of the Egyptian medievalist Muḥammad Muḥammad Amīn who catalogued about 1,000 awqāf endowed between 239/853 and 922/1516.

Other researchers have used court records pertaining to marriage, divorce, and the family to examine issues such as payment of the dowry (mahr) and support (nafaqa); women's access to divorce or khul'; the appointment of women as guardians (waṣīs); the stipulations in marriage contracts made to protect women's interests; and the structure of the family or household and inheritance by women (Abdal Rahim, Ivanova, Agmon, Hanna). This research has significantly altered the perception of women by showing them as economically active and engaged in productive activities; as able to exert control over the choice of marriage partner and the conditions of marriage; to obtain a divorce under certain conditions; and to retain custody of children in the case of divorce or death of the children's father. Much of this research is contained in two collections that in particular illustrate the importance of judicial records for understanding women's lives. They are Women, the Family and Divorce Laws in Islamic History, edited by Amira El Azhary Sonbol and Women in the Ottoman Empire: Middle Eastern Women in the Early Modern Era, edited by Madeline C. Zilfi. Sonbol's volume aimed to demonstrate that modernization was at best a mixed blessing for women. Although women may

have benefited in some ways such as education
and health care, the so-called legal reforms of the
modern period often resulted in the curtailment
of women's autonomy and control over issues of
personal status, such as marriage, divorce, and
custody of children.

SOURCES FOR A GENDERED
POLITICAL HISTORY

As the field of women's history has developed,
two major trends have appeared. One is the use of
court records to write social and economic history
with women/gender at the center and the other is
a gendered political history that has used a variety
of sources including biographies and autobiogra-
phies; memoirs, letters, diaries and other published
and unpublished writings by women; newspapers,
government documents including those of the
major colonial powers in the region; and personal
interviews. This reformatted political history, often
referred to as the Woman Question in the modern
period, examines issues such as the gendered dis-
course of nationalism and modern state building,
the issue of women's citizenship, women's involve-
ment in nationalist and/or revolutionary move-
ments, the creation of feminist movements, and
the complex relationship between nationalism,
feminism, and imperialism. Two early contribu-
tions to this literature, one examining the early
modern period and the other the modern are
Peirce's *The Imperial Harem* (1993), and Badran's
*Feminists, Islam and the Nation: Gender and the
Making of Modern Egypt* (1995).

In the case of the early modern Ottoman
Empire, Peirce examined the political power and
public prominence achieved by the women of the
sultan's harem in the sixteenth and seventeenth
centuries. Peirce's research revised views of the
harem by showing that segregation and seclusion
were not barriers to the exercise of power in the
sultan's household. Peirce's sources include a vari-
ety of government documents related to the impe-
rial administration and particularly those dealing
with the expenses of the imperial household.
Badran, in her study of Egyptian feminism and the
development of modern Egypt, used a wide array
of sources including published and unpublished
memoirs, letters, documents of Egyptian and
international women's organizations, lectures,
essays, and personal interviews.

By far, most studies of women and the state
have focused on the modern state, which in the
Middle East began to emerge in most places in the
nineteenth century. One of the most developed
historiographies on this subject is of Egypt, which
has also produced several monographs and

numerous articles (Tucker, Badran, Baron, Booth,
Botman, Nelson, and Hatem). Baron studied the
rise of a women's press in Egypt while Booth used
"Famous Women" biographies in compilations or
newspapers to examine the gendered discourse
of modern Egyptian nationalism. The historical
literature on women and the state in Iran is also
expanding (Paidar, Najmabadi, Nashat, and
Afary). Interest in women in Iran and the origins
of feminism has intensified since the Iranian
revolution of 1979, the creation of the Islamic
Republic, and the emergence there of an "Islamic
feminism."

Historians have not as intensively studied
other regions of the Middle East and North Africa,
but work has been done on Syria (Thompson),
Palestine (Fleischman, Jad), Algeria (Lazreq and
Clancy-Smith), and Turkey (Kandiyoti) whose
sources include newspapers, British and French
government documents, and personal interviews.
The least studied region of the Middle East and
North Africa is the Arabian Peninsula and the
Gulf but a recent monograph by Doumato on
Saudi Arabia demonstrates the kinds of sources
that are available for historical research on
women, including government documents of vari-
ous kinds, personal interviews, travel literature,
and the archives of the Dutch Reformed Church,
as well as the private papers of individual mis-
sionaries. The collections, *Islam, Gender and
Social Change*, *Gender and National Identity:
Women and Politics in Muslim Society* and
Women, Islam and the State contain articles on
this topic, not all of them by historians. The col-
lections attempt to be comprehensive and to dis-
cuss the Woman Question in less well studied
areas of the Middle East and North Africa as well
as outside the region. The authors make use of a
variety of source material including newspapers
and magazines, government documents, colonial
government archives, essays and other writings,
and oral interviews.

The historiography of women and imperialism
has not advanced as far in Middle East studies as
it has for other regions of the world such as India
or Africa. Algeria and Palestine have attracted
most of the scholarly attention with a focus on
women's participation in national liberation
movements, on the relationship between women
and the colonial governments and, for Palestinian
women, their lives and activities in the refugee
camps, particularly in Lebanon (Peteet and
Sayigh). Julia Clancy-Smith and Marnia Lazreq
writing on women in Algeria demonstrate how
important the records of the French colonial gov-
ernment are for understanding women's lives in

the Maghrib during the period of French colonial rule. Although this field is developing, Middle East historians have not yet incorporated the theoretical insights of subaltern studies or postcolonialism into their work.

In 1991, Keddie and Baron published a collection of articles entitled *Women in Middle Eastern History: Shifting Boundaries in Sex and Gender* that shows the variety of sources being used to produce historical studies of women. The collection is organized chronologically from the early Islamic period to the twentieth century and covers such diverse topics as education, women and the family, marriage and divorce, education, women's economic activity and role in production, gender and the body, women singers and biography. The source material ranges from classical texts such as *ḥadīth* collections, legal and religious treatises, legal compendia, and biographical dictionaries, to judicial records, newspapers, memoirs, and journals. Although most of the historical writing on women is concentrated on the early modern and modern periods, a collection of articles devoted to women in the medieval world appeared in 1998, *Women in the Medieval Islamic World: Power, Patronage, and Piety*. The articles, which demonstrate the vitality of scholarship on medieval women, use a variety of sources such as the *Shāh-nāme* or Persian book of kings, the *Oguz-nāme* or Turkish book of kings, biographical collections, Ottoman court records, travel literature, and manuscripts of various kinds.

OTHER CATEGORIES

Although much of the women's history written in the past 30 years falls into the two categories described above, there are other subjects for research on women including women and travel, which examines the writings of travelers to the Middle East and their representations of women (Melman, Mabro, Kabbani, Clancy-Smith, Fay), women and work (Quataert, Clancy-Smith, Meriwether, Lazreq), women in the family (Tucker, Moors, Meriwether, Doumani, Fay), and minority women within the Dār al-Islām (Qattan, Afifi, and Doumato).

Recently and in conjunction with the rise of Islamism in the region and in the Muslim world generally, there has been renewed interest in Islamic texts as sources for women's history. However, scholars who use these texts do not use them in the same way as did the Orientalist scholars criticized by Said and do not draw similar conclusions from them (Stowasser, Spellberg, Lutfi). While the sources may be the same – the Qur'ān, *ḥadīth* and legal and religious treatises – the

methodology and conclusions of this generation of scholars are different. They do not assume that religious and legal treatises represent the actual conditions of women's lives or social practice, and the writings themselves are placed in their historical and social context. For example, Spellberg in her study of ʿĀʾisha's participation in the Battle of the Camel used sources such as the *ḥadīth* collections of al-Bukhārī and Ibn Ḥanbal and Ibn Saʿd's biographical dictionary. However, Spellberg raises questions about the authenticity and reliability of the *ḥadīth* and points out that the first written sources dealing with the Battle of the Camel appeared 150 years after the event and were orally transmitted. Spellberg's conclusion is that the ninth-century *ḥadīth*, compiled by men who apparently did not share Muḥammad's more egalitarian vision of relations between the genders, "extended and refined the idea that women were basically flawed and dangerous to the maintenance of the political order" (Spellberg 1991, 54).

In a series of articles and a monograph, Stowasser has explored issues of contemporary relevance such as women's political rights through a rereading and reinterpretation of key Islamic texts such as the Qur'ān and *ḥadīth*. For example, in "Women and Citizenship in the Qur'ān," she argues that the issue of women's political rights in Islamic society has been interpreted in three different ways although proponents of each of the three paradigms claim Qur'ānic authority for their perspectives. Lutfi has examined the writings of the medieval writer of a prescriptive religious text, Ibn al-Ḥajj, as a social historian. Lutfi argued that in spite of religious mandates that women should remain inside the home, lower- and middle-class Cairene women participated in public life. In her opinion, "prescriptive religious literature should not be taken as a reflection of reality" (Lutfi 1991, 102).

In addition to the Islamic trend in women's history, based on a critical and contextualized reading of Islamic texts, another important trend in the field has been the blurring of boundaries between history and other disciplines, primarily anthropology, literature/literary criticism, and religious studies. For historians this has meant the incorporation of methodology and theory from other disciplines into their work, and for non-historians, it has involved situating their studies in a historical context, adopting a historical methodology for all or part of their work and using archival sources in their research. The anthropologist Annelies Moors used court records in her study of women and property in Palestine between 1920 and 1990, while the ethnographer, Cynthia

Nelson, crossed disciplinary boundaries to write a biography of the Egyptian feminist, Doria Shafik. Booth, whose field is literature and translation, historicized her study of "Famous Women" biographies by showing how the conception of women's proper role in Egyptian society changed over time. Mernissi, the Moroccan sociologist, has used historical subjects and methodology in her research and writings such as *The Forgotten Queens of Islam*. A recent collection edited by Tucker and Meriwether, *A Social History of Women and Gender in the Modern Middle East*, contains contributions from two anthropologists and a political scientist as well as two historians. The collection, published in 1999, is indicative of the direction that women's history is taking not only in Middle Eastern studies but in the wider field as well.

CONCLUSION

Although Middle Eastern women's history is strong in the field of social history and the burgeoning field of gendered political history, it has been slow to respond to the epistemological challenge of poststructuralism and to developments within the discipline of history, such as the emergence of cultural history and cultural studies, the so-called linguistic turn in historical studies or postcolonialism. One exception is in the emerging field of memory studies and oral history in Iranian and Palestinian history (Najmabadi, Sayigh, Fleischman). In her monograph, *The Story of the Daughters of Quchan: Gender and National Memory in Iranian History*, Najmabadi explores the selling of young girls and women in 1905 by needy peasants to pay taxes in a bad harvest year and, in the same year, the taking of women as booty by Turcoman tribes. She uses these incidents to examine the gendered political culture of modern Iran, the constitution of national memory, and modernist historiography.

Historians of the Middle East have not entered into the debate about the future of history that has developed in the wake of poststructuralist theorizing and that has had important repercussions in Europe and the United States. There are several possible explanations for this. Historians generally tend to be reluctant theorizers, and indeed, women's history has benefited from the theorizing done by anthropologists, sociologists, and literary critics. Another explanation is the delayed development of history as a discipline because of the dominance in Middle Eastern Studies of the Orientalist paradigm with its own sources and methodology. Just as poststructuralism was pos-

ing its challenge to historical truth claims, to rationality and objectivity, Middle Eastern studies was unshackling itself from Orientalism and historians were embracing the methodology of analytical empiricism. Methodologically, analytical empiricism remains dominant with gender increasingly important as an analytical tool and theoretical framework.

As for sources, historians as researchers remain yoked to their documents, usually housed in archives across the region maintained by governments or private institutions. Some scholars have made innovative use of non-traditional sources such as personal interviews, photographs, film, music, and dance to write their histories of women.

However, the internet and computer technology have now made it possible for historians to expand their access to sources and resources for research and teaching. Anyone with a computer linked to the internet can gain access to the catalogues of major research libraries with Middle East centers and holdings in Middle East history, such as Columbia University, the University of Texas at Austin, and Georgetown University, as well as the Library of Congress, which has an important Middle East collection. These sites link the user to directories, encyclopedias, journals and newspapers, photographs and other images, and atlases. Data-bases available through university libraries allow the researcher to locate, read, or print the full texts of articles. Scholars can also go directly to the internet sites of Arabic-language newspapers published in the Middle East. There are also various organizations and institutes that maintain sites on the internet that have useful information for scholars and provide sources for research, such as Women Living Under Muslim Laws. Access to online resources for women's history is limited only by the researcher's curiosity and ingenuity and the capabilities of her search engine.

BIBLIOGRAPHY
A. 'Abd ar-Rāziq, *La femme au temps des Mamloukes en Egypte*, Cairo 1973.
B. 'Abd al-Malik and D. Crecelius, A late eighteenth-century Egyptian *waqf* endowed by the sister of the Mamluk Shaykh al-Eyey [sic] Muhammad Bey Abou al-Dhahab, in *Arab Historical Review for Ottoman Studies* 1–2 (1990), 9–14.
N. Abbott, Women and the state on the eve of Islam, in *American Journal of Semitic Languages and Literature* 58 (Jan.–Oct. 1941), 259–85.
——, *Aishah, the beloved of Mohamed*, Chicago 1942.
——, Women and the state on the eve of Islam I and II, in *Journal of Near Eastern Studies* 1 (1942), 106–26 and 341–61.

J. Afary, *The Iranian constitutional revolution, 1906–1911. Grassroots democracy, social democracy and the origins of feminism*, New York 1996.

L. Ahmed, *Women and gender in Islam. Historical roots of a modern conflict*, New Haven, Conn. 1992.

M. Badran and M. Cooke (eds.), *Opening the gates. A century of Arab feminist writing*, Bloomington, Ind. 1990.

M. Badran, *Feminists, Islam and nation. Gender and the making of modern Egypt*, Princeton, N.J. 1995.

G. Baer, *Population and society in the Arab East*, New York 1964.

L. Beck and N. Keddie (eds.), *Women in the Muslim world*, Cambridge 1978.

M. Booth, *May her likes be multiplied. Biography and gender politics in Egypt*, Berkeley 2001.

J. A. Clancy-Smith and Frances Gouda (eds.), *Domesticating the empire. Race, gender, and family life in French and Dutch colonialism*, Charlottesville 1998.

M. Cooke, *Women claim Islam. Creating Islamic feminism through literature*, New York 2001.

E. Abdella Doumato, *Getting God's ear. Women, Islam and healing in Saudi Arabia and the Gulf*, New York 2000.

M. A. Fay, Women and *waqf*. Toward a reconsideration of women's place in the Mamluk household, in *International Journal of Middle East Studies* 29 (1997), 33–51.

E. W. Fernea and B. Q. Bezirgan (eds.), *Middle Eastern women speak*, Austin, Tex. 1978.

E. Fox Genovese, Placing women's history in history, in *New Left Review* 133 (1982), 5–29.

Y. Yazbeck Haddad and John L. Esposito (eds.), *Islam, gender and social change*, Oxford 1998.

G. Hambly (ed.), *Women in the medieval Islamic world. Power, patronage and piety*, New York 1998.

R. C. Jennings, Women in early 17th century Ottoman judicial records. The Sharia court of Anatolian Kayseri, in *Journal of the Economic and Social History of the Orient* 18 (1975), 53–114.

D. Kandiyoti, Contemporary feminist scholarship and Middle East studies in D. Kandiyoti (ed.), *Gendering the Middle East. Emerging perspectives*, Syracuse 1996, 1–27.

—— (ed.), *Women, Islam and the state*, Philadelphia 1991.

N. R. Keddie and B. Baron, *Women in Middle Eastern history. Shifting boundaries in sex and gender*, New Haven, Conn. 1991.

N. R. Keddie, Problems in the study of Middle Eastern women, in *International Journal of Middle East Studies* 10 (1979), 225–40.

M. Lazreq, Feminism and difference. The perils of writing as a woman on women in Algeria, in *Feminist Studies* 14:1 (spring 1988), 81–107.

——, *The eloquence of silence. Algerian women in question*, New York 1994.

H. Lutfi, Manner and customs of fourteenth-century Cairene women. Female anarchy versus male shariʿ order in Muslim prescriptive treatises, in N. R. Keddie and B. Baron, *Women in Middle Eastern history. Shifting boundaries in sex and gender*, New Haven, Conn. 1991, 99–121.

M. L. Meriwether and J. E. Tucker (eds.), *A social history of women and gender in the modern Middle East*, Boulder, Colo. 1999.

F. Mernissi, *The Forgotten queens of Islam*, Minneapolis, Minn. 1993.

V. M. Moghadam, *Gender and national identity. Women and politics in Muslim society*, London 1994.

C. Mohanty, Under Western eyes. Feminist scholarship and colonial discourses, in *Feminist Review* 30 (Autumn 1988), 65–88.

A. Moors, *Women, property and Islam. Palestinian experiences 1920–1990*, Cambridge 1995.

C. Nelson, *Doria Shafik, Egyptian Feminist. A woman apart*, Gainesville, Fla. 1999.

A. Najmabadi, *The story of the daughters of Quchan. Gender and national memory in Iranian history*, Syracuse, N.Y. 1998.

G. Nashat, Women in the Islamic Republic of Iran, in *Iranian Studies* 13:1/4 (1980), 165–94.

—— (ed.), *Women and revolution in Iran*, Boulder, Colo. 1982.

P. Paidar, *Women and the political process in twentieth-century Iran*, Cambridge 1995.

L. P. Peirce, *The imperial harem. Women and sovereignty in the Ottoman Empire*, New York 1993.

J. Peteet, *Gender in crisis. Women and the Palestinian resistance movement*, New York 1991.

C. Petry, Class solidarity versus gender gain. Women as custodians of property in larger medieval Egypt, in N. R. Keddie and B. Baron, (eds.), *Women in Middle East history. Shifting boundaries in sex and gender*, New Haven, Conn. 1991, 122–42.

E. Said, *Orientalism*, New York 1978.

R. Sayigh, Engendered exile. Palestinian camp women tell their lives, in *Oral History* 25:2 (1997), 38–48.

J. W. Scott, Gender. A useful category of historical analysis, in J. W. Scott, *Gender and the politics of history*, New York 1988, 42.

A. El Azhary Sonbol, *Women, the family and divorce laws in Islamic history*, Syracuse, N.Y. 1996.

D. Spellberg, Political action and public example, in N. R. Keddie and B. Baron, *Women in Middle Eastern history. Shifting boundaries in sex and gender*, New Haven, Conn. 1991, 45–57.

——, *Politics, gender, and the Islamic past. The legacy of ʿAʾisha bint Abi Bakr*, New York 1994.

B. Stowasser, Women and citizenship in the Qurʾān, in A. El Azhary Sonbol (ed.), *Women, the family and divorce laws in Islamic history*, Syracuse, N.Y. 1996, 23–38.

——, *Women in the Qurʾān. Traditions and interpretations*, Oxford 1994.

E. Thompson, *Colonial citizens, republican rights paternal privilege and gender in French Syria and Lebanon*, New York 2000.

N. Tomiche, The situation of Egyptian women in the first half of the nineteenth century, in W. R. Polk and R. L. Chambers (eds.), *The beginnings of modernization in the Middle East in the nineteenth century*, Chicago 1968, 171–84.

J. E. Tucker, Problems in the historiography of women in the Middle East. The case of nineteenth-century Egypt, in *International Journal of Middle East Studies* 15 (1983), 321–36.

——, *Women in nineteenth-century Egypt*, Cambridge 1985.

——, *Arab women. Old boundaries, new frontiers*, Bloomington, Ind. 1993.

——, *In the house of the law. Gender and Islamic law in Ottoman Syria and Palestine*, Berkeley 1998.

M. C. Zilfi, *Women in the Ottoman Empire. Middle Eastern women in the early modern era*, Leiden 1997.

MARY ANN FAY

History: East, South, and Southeast Asia

This essay provides an overview of sources and methodologies for the study of the history of women in Muslim societies in Southeast and South Asia (SESA) where the majority of Muslim women outside the Middle East and North Africa (MENA) live. Some reference will also be made to the history of Muslim women in China. As will be described below, history has not been the primary discipline for researchers on Muslim women in these regions, although many writings using other disciplines provide some historical context for their studies.

To date, there has been little direct debate about the concept of a "Muslim woman" and no examination of the meaning of time (a vital element in any historical study). Both questions are fundamental to a deeper appreciation of the history of women in Muslim societies, particularly to those outside the heartland of Islam. In SESA and China, Islam encountered complex and well-established local belief systems that were vastly different from those native to the Middle East and that never entirely disappeared after the acceptance of Islam. The concept of a Muslim woman, therefore, had to be constructed in those societies where Islam became the predominant belief system and the construction varied according to place, culture, and time.

The concept of time is central but rarely analyzed or explored. In Islam time and Allah are One, uncreated and unending, and human actions must be performed in this context. This is not the understanding of time in the societies of SESA or China. In SESA, time is understood as a series of recurring cycles going from perfection to decline, in which the present seeks to regain some of the glory of a past golden age. The conditions of the non-golden eras are such that it is impossible for humans to attain perfection although efforts may be made to work towards improvement. Muslim understandings of the past are rather different. The period before Islam, it is believed, was one of ignorance and barbarity (*jāhil*) and the possibility of perfection became available only to those who embraced the new message brought by the Prophet Muḥammad. The primary function of a Muslim ruler, Allah's shadow on earth, was to provide the conditions for living according to the directions of the

Qur'ān and it is in this framework that Allah's time and human lifetimes intersect. That is in theory. In practice this rarely occurred but it remained (and remains) the ideal of Muslim leadership.

The values of Islam necessary for social living are manifested in the Sharīʿa. The interpretation and implementation of the Sharīʿa, however, have to be expressed in human time, that is, become specific as to temporal time and place (see further M. B. Hooker 2003). It is in the Sharīʿa that the social status, obligations, rights, and legal limitations concerning women are expressed and the public face of Islam in many Muslim societies is "identified with the appearance and manners of women in public" (M. B. Hooker 2003, 155). Any understanding of "Muslim women" as a category and as individuals must, therefore, attend to the application of the Sharīʿa to them and be specific as to time and place.

How has this conceptual background influenced historical research concerning Muslim women? By way of answering this question, we shall consider first the range of methodologies and approaches that researchers have chosen. We turn then to the issue of sources and conclude with examples of how some Muslims are rereading old sources and recreating their historical context to understand better their messages about women.

METHODOLOGIES

The study of the history of women in Muslim societies can be exemplified by *The Oxford History of Islam* (Esposito 1999) and its predecessor, *The Cambridge History of Islam* (first published 1970), which contain minimal references to the history of Muslim women. Each of these authoritative works has as its focus Islam as a religion and thought system and uses political history as the primary methodology of presentation. Women become a subject, only in passing, to illustrate attitudes to education and modernity developed by Egyptian and Turkish reformers. In other words, they are studied not for their own histories but for their roles in social reform programs. Concerning China, one scholar has described the situation thus: "More has been written, it seems, about the horses proudly owned and ridden by Muslims in China than about Muslim women" (Pillsbury 1978, 657).

The state of the history of women in Southeast Asia generally has been addressed by Barbara Andaya and the paucity of research explained by the postcolonial emphasis on analyzing nationalism and economic development at the expense of other subjects (B. W. Andaya 2000b, 1–2). Responding to male-centered histories of nationalism, historians have provided some accounts of women's contributions to state formation but most have remained within the nationalist framework (as for example, Taylor 1997, Hefner and Horvatich 1997). While historians, Andaya notes, were preoccupied with concepts of the state, the feminist scholars of the 1970s recognized the need for increased research on women but identified social issues as being the primary area for research (B. W. Andaya 2000b, 3). It has been in the social sciences, development studies, sociology, and anthropology that most attention has been given to questions of methodology.

Some political histories include descriptions of the rise of women's organizations, including Muslim women's groups, but the women's contributions are presented in the context of political development (for example, Manderson 1980). Exceptions are some recent postgraduate theses and as yet unpublished work on Muslim women's activities in Indonesia. The approach generally taken is that of women's studies combined with history or political science.

There has been increasing interest in gender studies and the concept of gender in SESA has received some attention (Atkinson and Errington 1990, Ong and Peletz 1995, Sears 1996). In the construction of gender categories, some Southeast Asian societies recognize four genders (see, for example, L. Y. Andaya 2000, 27), whereas Islam recognizes only two, male and female. The effect of Islam on concepts of gender has been very little studied. Barbara Andaya has been involved in a project to encourage more research into gender relations in Southeast Asia and to analyze not only the ways in which femininity is culturally created but to "be more alert to comparisons in the modes by which masculinity is culturally created" (B. W. Andaya 2000b, 9).

Interest in writing women's history has been linked with new methodologies for reading sources in ways for which they were not intended, to extract maximum historical information. Thus poetry, law codes, inscriptions, texts of dynastic legitimation, narrative epics, and didactic texts have been scrutinized (or "read") for all the material they might yield about women (see the section on sources below). The general interest in the potential of post-structuralism as a method for analyzing the history, cultures, and societies of SESA developed in much the same way as that outlined for MENA. Where terms such as "gender" and "woman" had been previously accepted as working concepts, post-structuralists began by questioning their meaning and usefulness and introducing their own term of "construction" to indicate the problematic and artificial aspects of cultural institutions.

For historians interested in gender relations, the works of Michel Foucault stimulated the analysis of texts as sites of "subjects," "objects," and "regimes of power and truth" (Hekman 1990, 19) in which everything can be questioned as being a construction. The theories of Jacques Derrida concerning differences (particularly as exemplified through meanings in language) were developed by feminist scholars as being more effective ways to conceptualize femininity and masculinity. Rather than understanding them as opposites, they were encouraged by Derrida's approach to seek multiplicities of relationships and to expand the possible interrelationships and nuances of linkage (Culler 1979, 171, Scott 1990, 136).

The potential for using post-structuralism as a methodology for writing a history of women in traditional Malay literature is shown in the research essay of Fane (1993). She concludes that even in male-authored, rather formulaic texts it is possible to "decentre the texts to some extent so that women can be seen in a multiplicity of relations and positions. While women were primarily mothers, daughters and wives, they were also rulers, politicians, advisers, economists, and victims within a structure of patriarchal power" (Fane 1993, 106). An extended study focusing primarily on Muslim women and using this approach has not yet appeared.

Gender studies as an approach to researching women's issues in Indian communities, including those of Muslim women, is discussed in the strong essays in Hasan (1994). Historiography of South Asia in general had been boosted a decade earlier by the publication of two books of seminal importance in 1982. In her stimulating study of the Deoband movement in northern India, Barbara Metcalf argued that the history of Muslims in South Asia had been neglected and that the topic was one of critical importance for understanding India's past (Metcalf 1982, 7). In the same year, the first volume of a multi-volume series, *Subaltern Studies: Writings on South Asian History and Society*, appeared and announced that its aim was to

"promote a systematic and informed discussion of subaltern themes in the field of South Asian studies, and thus help to rectify the elitist bias characteristic of much research and academic work in this particular area" (Guha 1982, vii). Although presented initially as a counterbalance to history of the elites of India, it was soon realized that women (whatever their social status) were also subalterns and that this approach to the writing of history and the analysis of societies and ideologies could be a powerful method for a new historiography of women. It took another decade for Metcalf's call for more Muslim history and Guha's for more focus on subalterns to be combined and research undertaken into the history of Muslim women in India.

In the mid-1990s, Sonia Amin published her study of middle-class Muslim women in Bengal during the critical period of transition between the late colonial period and the Second World War (Amin 1996). Her approach was to chart the changes to middle-class Muslim families as salaried professionals modernized their families and their attitudes to the roles of their wives and daughters. Thereafter opportunities for education for girls outside the home and even for higher education increased. Writing both fiction and non-fiction was taken up by many middle-class Muslim women and Amin shows how they reveal a significant change of mentality clearly apparent by the 1920s. Coinciding with what is termed the "awakening" this period saw girls schools, clubs and associations for Muslim women, and the recognition that major social change was occurring. Linked closely with this was the movement from private to public patriarchy where in the world outside the home men still dominated professional activities.

Gail Minault has developed a corpus of writing based on her close readings of the writings of Indian Muslim women from the nineteenth to the mid-twentieth century. Looking from the household to the world beyond the home and tracing developments in the demand for schooling and then higher education, her book *Secluded Scholars* (Minault 1998) draws from and extends much of her earlier research. Her introductory chapter, "Portraying Invisibility: Strategies, Sources, Generations," stands as an impeccable survey of the state of the art in women-centered historiography (and much else) of Indian Muslim women (Minault 1998, 1–13).

Barbara Andaya is one of the few historians of Southeast Asia to concern herself with an extended historical study of gender relations in the region

between 1500 and 1800. Although her full study is not completed, she has published one essay that looks at the influence of Islam on the status of women in Southeast Asia. Andaya takes the theme of inside and outside/private and public (also identified by Amin as important in early twentieth-century Bengal) and, focusing on a much earlier period, examines the "interplay between gender and politico-cultural change," particularly the rise of Islamic states (B. W. Andaya 2000c, 232–3). Her careful research suggests that the link between women of high status and concealment or seclusion predates the acceptance of Islam but that Islamic kingdoms incorporated existing seclusion practices and strengthened them. While cautioning against overgeneralization she concludes that "certain conceptions of how 'good' women should conduct themselves were inextricably bound up with the social stratification that accompanied the rise of the state. As elsewhere, these conceptions have cast a long shadow" (B. W. Andaya 2000a, 24).

Published histories about Muslims in China emphasize the strategies devised by Muslims to ensure their survival as ethnic, cultural, and religious minorities in the face of discrimination and persecution, which increased from the early nineteenth century (Israeli 1978, Gladney 1991). Evidence about the lives of Muslim women in China before the twentieth century is scarce, but references by foreign travelers and current practices suggest that although there was no institutionalized confinement, "some ritual separation of the sexes did exist." This is exemplified by the special mosques for women that were constructed in cities with sizeable Muslim populations (Pillsbury 1978, 658). Women were educated by female religious teachers in the basics of Islam in Arabic and were expected to raise their children according to religious laws. Although ritual boundaries existed between Muslim men and women to whom they were not related, the strongest boundaries were those which separated Muslim women from non-Muslims. As with Muslims in minority communities in southern Thailand, the fear is that social mixing with non-Muslims will result in contact with "unclean" food, particularly pork. Gladney's anthropological study of one ethnic group of Muslims in China (the Hui) links this fear of pollution through ritually impure food with the issue of ethno-nationalism and identity (Gladney 1991).

In studies of women in Southeast Asia and China, including those written by historians, limited and closely focused studies predominate. Most published research has taken the form of multi-authored collections of essays. Book-length studies

(that is, sustained and thematic) are still rare. Even more rare are historically based, single-authored studies of Muslim women. While the scarcity of sources for information earlier than the nineteenth century may explain the "case-study" approach to studies of the earlier periods, it does not explain the same approach for the modern and contemporary periods. For Muslim women in the SESA region who want to conduct their own research, it is extremely difficult for them to find the financial support they need to devote themselves to full-time writing. Ironically, their best opportunities often come from grants and scholarships to study and work in overseas centers that can provide the funding for them to study their own societies.

SOURCES

Premodern period (fifteenth to nineteenth century): indigenous texts. Historians using indigenous sources, the great majority of which are texts, find references to women so fragmentary that they take material from wherever it can be found, and consider genre to be of secondary importance. Verse, prose works, religious texts, court chronicles, and legal codes have all been used to piece together information about the lives of women, including Muslim women, before the nineteenth century. In Southeast Asia, Malay was the language of Islam and Arabic texts were taught through Malay, or sometimes Javanese. A wide-ranging overview of manuscript traditions of the Indonesian archipelago is in Kumar and McGlynn (1996). Studies of the representation of Muslim women in premodern texts include Kumar (1980 and 2000), Fane (1993), Hashim (2000), B. W. Andaya (2000c), and Johan (1999). Ricklefs (1998) used court texts from Central Java (listed in a special bibliography) to reveal the spiritual accomplishments of several Javanese noblewomen who were masters of various aspects of Islam.

Premodern period (fifteenth to nineteenth century): non-indigenous sources. European archives have relatively rich collections of records describing precolonial encounters with the peoples of Southeast Asia. Portuguese, Spanish, Dutch, British, French, German, and Scandinavian explorers, travelers, and merchants have left accounts of their impressions, some of which contain material about Muslim women. A major study using these materials and some indigenous texts is Reid (1988 and 1993). Barbara Andaya (2000c) provides a more focused analysis of the relationship between Islam, the status of women, and the rise of the state in Southeast Asia. The lives of the women who surrounded Bābur (1483–1530) when he ruled northern India and central Asia are described by Hambly (2002).

Nineteenth century: indigenous texts. From the nineteenth century our knowledge of indigenous sources improves dramatically because of better preservation of texts both in local and in European collections. Manuscripts from the royal collections in Central Java have been used by Florida (1996) to analyze the lively sexual relationships between Muslim men and women, which were described with almost brutal frankness in a genre of verse usually devoted to topics concerning Islamic mysticism.

A special issue of the journal *Review of Indonesian and Malaysian Affairs* (Mukherjee 1997) includes fine-grained studies of Muslim women in the Malay-Indonesian world using indigenous texts from the mid-nineteenth century to the late twentieth. The editor characterizes the volume as "not a theoretical exercise but an empirical one," a description which could apply to much of the historical research on Muslim women in SESA.

Twentieth century. Researchers of twentieth-century Muslim women's history are blessed with an outpouring of printed material: local journals, newspapers, and books as well as published memoirs and reports by foreign, mostly colonial, administrators and interested observers. Increasing numbers of tertiary educated woman from SESA and China ensure that the history of Muslim women will eventually be told by Muslim women themselves. Islamic universities, well attended by Muslim women, are supporting research into areas such as credit facilities for women, the effects of working mothers on children, divorce, women's reproductive rights, and identity markers, such as choice of dress. International funding bodies such as the Ford Foundation provide funding for projects that will empower women. Research reports funded by the Ford Foundation are publicly available and will make excellent sources for writing contemporary history.

The nineteenth and twentieth centuries are bridged by a new genre of locally produced Muslim literature written to help women and their husbands live a pious but modern life. Metcalf (1990) emphasizes the far-reaching influence of a didactic manual like the early twentieth-century *Bihishti Zewar* (Heavenly ornaments) written in Urdu by Mawlana Ashraf 'Ali Thanāwī (1864–1943), a leader of the Deobandi reform movement in northern India. Metcalf notes that such works lie "at the heart of significant socio-political change" (Metcalf 1990, 5). The manual was taken to Muslim communities in Southeast Asia well as to Britain

and Europe through the Tablighi Jama'at. A similar didactic text for modernizing Muslims in the Malayo-Indonesian world is the *Hikayat Faridah Hanum* (Story of Faridah Hanum) by the Arab-Malay writer and journalist Syed Syekh al-Hadi (1867–1934). Published in two volumes in 1925/6 it reappeared in countless new printings and provided a powerful (fictional) model of a Western-educated and doctrinally sophisticated Muslim woman who became a model wife and worker for Islamic reform (see V. M. Hooker 2000, chap. 1). Both Amin (1996) and Minault (1998) provide in-depth studies of the worlds of change embraced by many middle-class Muslim women in South Asia, drawing on late nineteenth- and early twentieth-century journals, newspapers, literature, and life-histories. Similar in-depth studies of communities of Muslim women in the Malayo-Indonesian world have not yet appeared.

Historical studies of Muslim women in Southeast Asia generally begin in the late nineteenth century, and take the form of biographies highlighting the achievements of pioneers who became role models for advocates of Islamic modernism, like the young Javanese aristocrat Kartini (1879–1904) who established vocational schools for the girls of her locality (Cote 1995). A general history of women's movements in colonial Indonesia, including accounts of pioneers of Muslim women's education, is that of Vreede-de Stuers, which, although published in 1960, remains unchallenged as the basic account of the pre-war period. A more detailed history of Aisyiyah, the women's wing of the reformist Indonesian movement known as Muhammadiyah, is being prepared as a doctoral thesis (White 2003). An innovative collection of historical biographies of Indonesian female 'ulamā (a term usually reserved for men) is found in Burhanudin (2002).

Most studies of Malaysia that include, or focus specifically on, Muslim women have been the work of anthropologists and sociologists. A rich literature now exists based on fieldwork and personal interviews and many authors provide some historical background to their studies. The 1990s saw the publication of excellent analyses of local societies on the Malay Peninsula. In her study of a matrilineal group in Negeri Sembilan, one of the peninsular states, Stivens examines the "historical encounter" between "matriliny" and "modernity" using feminist theory. In attempting to account for the complex relationships between gender and agrarian transformations she emphasizes the historical specificity of her case study and uses the term "cultural *reconstitution*" to describe the complex processes of change in her region (Stivens 1996, 2–7). Peletz also chose Negeri Sembilan for his study of representations of gender for both males and females. To understand the complex kinship and gender relations currently operating in Negeri Sembilan he reconstructed its nineteenth-century history to reveal that "the system of marriage and affinal exchange focused on the exchange of men" but the local political system was dependent on the exchange of women (through marriage) and articulated through an official Islamic discourse on gender (Peletz 1996, 309). Peletz's concluding chapter (among many other things) emphasizes the productive value of ambivalence as a concept for understanding ideologies of gender and kinship. It closes with a comparative examination of Islamic themes apparent in several Southeast Asian societies and that of the Beduin. Peletz's wide-ranging and stimulating study is supported by a rich bibliography that serves as strong research tool for historians and anthropologists alike.

The history of Muslim minorities also includes valuable material about Muslim women, although the main focus of such works is usually not women. Mobini-Kesheh 1999, for example, describes the period of "awakening" in the Hadrami community in Indonesia in the period leading up to the Second World War. A women's wing of the Hadrami modernist movement, al-Irshad, was established during the 1930s to encourage modern education among Hadrami women. To support their case the women quoted the *ḥadīth* that recommends that "seeking knowledge is a duty of every Muslim, male and female" (Mobini-Kesheh 1999, 83). Siapno (1994) provides a historical context for the experiences of Muslim women in the southern Philippines where resistance to rule from predominantly Christian Manila has been expressed through Islam.

Following the establishment of the People's Republic of China it was difficult to obtain first-hand information about the situation of those Muslim women who stayed on the mainland. It was known that all Muslim children had to attend mainstream schools and that religious education was no longer conducted in the mosque but had to take place after hours at home. In Taiwan, research can be conducted through personal interviews, and the rapid modernization of Taiwan has brought major changes to lifestyles of Muslim women that are apparent (see Pillsbury 1978, 567–73).

THE RECENT PAST: MULTI-DISCIPLINARY APPROACHES AND NEW SOURCES

Since the late 1990s studies of Muslim women have deliberately tested the traditional boundaries set by discipline and method. Research into the more recent history of Muslim women in China, for example, uses the "symbolic landscape" of Muslim architecture – religious schools and women's mosques – as a "powerful visual documentation of challenge to the androcentrism of Islam" (Jaschok and Shui 2000, 5). The presence of women's mosques was used to track the strong presence of women in the teaching and organization of Islam in China and oral life-stories, and legal and economic histories were used to supplement the sparse documentary evidence. Providing a historical context for the study was achieved by situating "the various use-values assigned to Muslim wives and mothers within specific, shifting political and cultural configurations defining historical relations between successive imperial administrations and Muslim populations" (Jaschok and Shui 2000, 8).

Although Islam is not a minority religion in Indonesia, the people of Aceh (northern Sumatra) have been actively resisting integration into the Indonesian nation-state since the 1950s. Seeking to analyze how female agency is constructed under these conditions, Siapno has used historical, ethnographic, literary, and politico-economic approaches to interrogate textual and oral sources. While her study fits well with the growing number of studies of resistance, she has moved beyond that to explore the interaction between indigenous matrifocality and Islamic practices and responses to political violence and social dislocation, which, she argues, have undermined the traditionally strong position of women in Acehnese society. Addressing the assumption that "women are universally subordinated in all nationalist movements" Siapno argues that in Aceh, at least, women's absence from these movements is not necessarily an indication of their subordination. In this instance the women themselves chose not to participate for a variety of reasons, and have developed other institutions with which they organize their lives and achieve independence and agency. For this approach Siapno has drawn from subaltern historiography, which sought "discursive formations outside nationalism and nationalistic movements" (Siapno 2002, 3–4). She also emphasizes that she seeks to focus on rural and non-elite Islamic practices rather than the urban-elite practices of political Islam. Siapno thus articulates an ongoing concern for historians of Muslim women's history: how to find a balance between studies of urban middle-class women, about whom there is relatively plentiful information, and rural, non-elite women about whom there is relatively little on the public record. Against this background the question of "What is a Muslim woman?" remains of critical importance.

Muslim women themselves are seeking answers to this question and we turn now to Indonesia and Malaysia for examples of how they are approaching the issue.

NEW READINGS OF OLD SOURCES

In the early 1990s, a small number of Muslim professional women in Kuala Lumpur formed a group, which they called Sisters in Islam, to "foster an enlightened and contemporary understanding of enduring Qur'anic imperatives" (Othman 1994, v). Their conviction that it is crucial to establish the historical context of the textual sources of Islam is emphasized by the quotation from Malek Bennabi that opens one of their most influential publications, *Islam and the Modern Nation State*: "Whoever does not understand the *shari'a* historically does not understand the *shari'a*; whoever does not understand Islam historically does not really understand Islam" (see Othman 1994). Their search for the historical evolution of Islamic law, particularly as it has been applied to women, is inspired by the work of Sudanese scholar and human rights activist, Dr. Abdullahi An-Na'im. Another influential publication from a scholar closely associated with Sisters in Islam is that of Wadud-Muhsin (1992), a study of the concept of woman based on a close textual reading of the Qur'ān and highlighting the need to return to the original source of Islam for a direct understanding of its message concerning women.

In December 1991, about the same time as Sisters in Islam were establishing their identity and aims, a seminar on Indonesian Muslim women was held in Jakarta. The contributors addressed issues such as the concept of woman in the Qur'ān and *ḥadīth*, the history of Muslim women's organizations in Indonesia, and the profile of Muslim women in various kinds of Indonesian publications. The seminar's concluding recommendations urged future researchers to treat text and context with equal attention. It was necessary, the recommendation continued, to use new approaches that attended to the social conditions, culture, place, and time of a text's composition in order to achieve dynamic and creative reinterpretations of basic

sources concerning Muslim women (Marcoes-Natsir and Meuleman 1993, 233).

During the 1990s there was an explosion of published material in Indonesian, for and about Muslim women. It was sustained and driven by increased activity for greater recognition of women in general in Indonesia (for comments about Muslim feminism see Feillard 1997). There was also increased interest in rereading older texts that had long been basic sources in traditional Muslim boarding schools (*pesantren*). Following the recommendations of the 1991 Jakarta seminar, texts for the guidance of women, like *ʿUqūd al-lujjayn* (The union of two waves) by Imām al-Nawawī (1813–98), are being translated into Indonesian and provided with exegetical commentaries to clarify and expand crucial points (Forum Kajian Kitab Kuning 2001). One of the projects to reinterpret classical guides for women is led by Dra. S. Nuriyah Abdurrahman Wahid, wife of Indonesia's former president and herself an authority on women's issues. Another result of seeking new interpretations of older material concerning women is a collection of essays on women in *tafsīr, ḥadīth, fiqh, kalām*, philosophy, and Sufi literatures (Munhanif 2002) and a special compilation of *fiqh* specifically for women, annotated and explained by one of Indonesia's leading religious teachers (K. H. H. Muhammad 2001).

This essay began with a discussion of the importance of the Sharīʿa to any understanding of the concept of Muslim woman. The survey of methods and sources for the history of Muslim women in SESA and China suggests that the Sharīʿa has rarely been considered as a crucial element in histories written by non-Muslims. However, if we take Indonesia and Malaysia as examples of the interests of Muslim women themselves, another picture emerges. They are turning to history to seek the original context of sources of the Sharīʿa in order to understand its essence according to time and place so that they may lead a pious life, but with access to the benefits that science, technology, and medicine make available to them. When it is the turn of these Muslim women of the late twentieth and early twenty-first centuries themselves to be the subjects of history, one of the themes must be their attention to seeking the meaning of the classical texts of Islam and their desire to understand them according to their personal and social needs.

BIBLIOGRAPHY

PRIMARY SOURCE

B. D. Metcalf, *Perfecting women. Maulana Ashraf Ali Thanawi's* Bihishti Zewar. *A partial translation with commentary*, Berkeley 1990.

SECONDARY SOURCES

S. N. Amin, *The world of Muslim women in colonial Bengal, 1876–1939*, Leiden 1996.

B. W. Andaya (ed.), *Other pasts. Women, gender and history in early modern Southeast Asia*, Honolulu 2000a.

——, Introduction, in B. W. Andaya (ed.), *Other pasts. Women, gender and history in early modern Southeast Asia*, Honolulu 2000b, 1–26.

——, Delineating female space. Seclusion and the state in pre-modern Island Southeast Asia, in B. W. Andaya (ed.), *Other pasts. Women, gender and history in early modern Southeast Asia*, Honolulu 2000c, 231–53.

L. Y. Andaya, The Bissu. Study of a third gender in Indonesia, in B. W. Andaya (ed.), *Other pasts. Women, gender and history in early modern Southeast Asia*, Honolulu 2000, 27–46.

J. M. Atkinson and S. Errington, *Power and difference. Gender in Island Southeast Asia*, Stanford, Calif. 1990.

J. Burhanudin (ed.), *Indonesian women religious scholars* [in Indonesian], Jakarta 2002.

J. Cote, *On feminism and nationalism. Kartini's letters to Stella Zeehandelaar 1899–1903*, Clayton, Victoria 1995.

J. Culler, Jacques Derrida, in J. Sturrock (ed.), *Structuralism and since*, Oxford 1979, 154–80.

B. Fane, Against the grain. A poststructuralist analysis of the representation of women in traditional Malay literature, honours thesis, Faculty of Asian Studies, Australian National University 1993.

A. Feillard, Indonesia's emerging Muslim feminism. Women leaders on equality, inheritance and other gender issues, in *Studia Islamika* 4:1 (1997), 83–112.

N. K. Florida, Sex wars. Writing gender relations in nineteenth-century Java, in L. J. Sears (ed.), *Fantasizing the feminine in Indonesia*, Durham, N.C. 1996, 207–24.

Forum Kajian Kitab Kuning, *The new face of the marriage relationship. An analysis of the ʿUqūd al-lujjayn* [in Indonesian], Yogyakarta 2001.

D. C. Gladney, *Muslim Chinese. Ethnic nationalism in the People's Republic*, Cambridge, Mass. 1991.

R. Guha (ed.), *Subaltern studies I. Writings on South Asian history and society*, Delhi 1982.

G. R. G. Hambly, *Babur's women. Elite women in late medieval Central Asia and North India*, Basingstoke, U.K. 2002.

Z. Hasan (ed.), *Forging identities. Gender, communities and the state*, Boulder, Colo. 1994.

R. Hashim, Bringing Tun Kudu out of the shadows. Interdisciplinary approaches to understanding the female presence in *Sejarah Melayu*, in B. W. Andaya (ed.), *Other pasts. Women, gender and history in early modern Southeast Asia*, Honolulu 2000, 105–24.

R. W. Hefner and P. Horvatich (eds.), *Islam in an era of nation-states. Politics and religious renewal in Muslim Southeast Asia*, Honolulu 1997.

S. J. Hekman, *Gender and knowledge*, Cambridge 1990.

M. B. Hooker, *Indonesian Islam. Social change through contemporary fatawa*, Sydney 2003.

V. M. Hooker, *Writing a new society. Social change through the novel in Malay*, St. Leonards, N.S.W. 2000.

R. Israeli, *Muslims in China. A Study in cultural confrontation*, London 1978.

M. Jaschok and Shui J. J., *The history of women's mosques in Chinese Islam. A mosque of their own*, Richmond, U.K. 2000.

A. Jalal, *Self and sovereignty. Individual and community in South Asian Islam since 1850*, Lahore 2001.

K. Johan, The Undang-Undang Melaka. Reflections on Malay society in fifteenth-century Melaka, in *Journal of the Malaysian Branch Royal Asiatic Society* 72:2 (1999), 131–50.

W. J. Karim, *Women and culture. Between Malay adat and Islam*, San Francisco 1992.

A. Kumar, Javanese court society and politics in the late 18th century. The record of a lady soldier, in *Indonesia* 29 (1980), 1–46 and 30 (1980), 67–112.

——, Imagining women in Javanese religion. Goddesses, ascetes, queens, consorts, wives, in B. W. Andaya (ed.), *Other pasts. Women, gender and history in early modern Southeast Asia*, Honolulu 2000, 87–104.

A. Kumar and J. H. McGlynn (eds.), *Illuminations. The writing traditions of Indonesia*, New York 1996.

E. Locher-Scholten and A. Niehof (eds.), *Indonesian women in focus. Past and present notions*, Dordrecht 1987, repr. Leiden 1992.

L. Manderson, *Women, politics and change. The Kaum Ibu UMNO, Malaysia 1945–1972*, Kuala Lumpur 1980.

L. M. Marcoes-Natsir and J. H. Meuleman (eds.), *Textual and contextual studies of Indonesian Muslim women* [in Indonesian], Jakarta 1993.

B. D. Metcalf, *Islamic revival in British India. Deoband, 1860–1900*, Princeton, N. J. 1982.

——, Reading and writing about Muslim women in British India, in Z. Hasan (ed.), *Forging identities. Gender, communities and the state in India*, Boulder, Colo. 1994, 1–21.

G. Minault, *Secluded scholars. Women's education and Muslim social reform in colonial India*, Delhi 1998.

N. Mobini-Kesheh, *The Hadrami awakening. Community and identity in the Netherlands Indies*, Ithaca, N.Y. 1999.

K. H. H. Muhammad, *Women's fiqh. A religious teacher's reflections on the discourse of gender and religion* [in Indonesian], ed. F. Abdul Kodir, Yogyakarta 2001.

W. Mukherjee (ed.), *Empowered women, Review of Indonesian and Malaysian Affairs* 31:2 (1997).

A. Munhanif (ed.), *Hidden pearls. Women in classical Islamic literature* [in Indonesian], Jakarta 2002.

A. Ong, State versus Islam. Malay families, women's bodies and the body politic, in A. Ong and M. G. Peletz (eds.), *Bewitching women, pious men. Gender and body politics in Southeast Asia*, Berkeley 1995.

N. Othman (ed.), *Shari'a law and the modern nation state. A Malaysian symposium*, Kuala Lumpur 1994.

M. G. Peletz, *Reason and passion. Representations of gender in a Malay society*, Berkeley 1996.

B. L. K. Pillsbury, Being female in a Muslim minority in China, in L. Beck and N. Keddie (eds.), *Women in the Muslim world*, Cambridge, Mass. 1978, 651–76.

C. Prachuabmoh, The role of women in maintaining ethnic identity and boundaries. A case of Thai Muslims in South Thailand, *South East Asian Review* 14:1/2 (1989), 113–50.

A. Reid, *Southeast Asia in the age of commerce 1450–1680*, 2 vols., Yale 1988 and 1993.

M. C. Ricklefs, *The seen and unseen worlds in Java 1726–1749. History, literature and Islam in the court of Pakubuwana II*, Sydney 1998.

K. Robinson and S. Bessell, *Women in Indonesia. Gender, equity and development*, Singapore 2001.

J. W. Scott, Deconstructing equality-versus-difference. Or, the uses of poststructuralist theory for feminism, in M. Hirsch and E. Fox Keller (eds.), *Conflicts in feminism*, New York 1990, 134–48.

L. J. Sears, *Fantasizing the feminine in Indonesia*, Durham, N.C. 1996.

J. Siapno, Gender relations and Islamic resurgence in Mindanao, southern Philippines, in C. F. El-Solh and J. Mabro (eds.), *Muslim women's choices. Religious belief and social reality*, Oxford 1994, 184–201.

——, *Gender, Islam, nationalism and the state in Aceh. The paradox of power, co-optation and resistance*, London 2002.

G. C. Spivak, Subaltern studies. Deconstructing historiography, in R. Guha (ed.), *Subaltern Studies no. 5. Writings on South Asian history and society*, Delhi 1985, 252–76.

M. Stivens, *Matriliny and modernity. Sexual politics and social change in rural Malaysia*, St. Leonards, N.S.W. 1996.

——, (Re)framing women's rights claims in Malaysia, in V. Hooker and N. Othman (eds.), *Malaysia. Islam, society and politics. Essays in honour of Clive S. Kessler*, Singapore 2003, 126–46.

J. G. Taylor (ed.), *Women creating Indonesia. The first fifty years*, Clayton, Victoria 1997.

C. Vreede-de Stuers, *The Indonesian woman. Struggles and achievements*, s'Gravenhage 1960.

A. Wadud-Muhsin, *Qur'an and woman*, Kuala Lumpur 1992.

S. White, Reformist Islam. Gender and marriage in late colonial Dutch East Indies, Ph.D. thesis, Research School of Pacific and Asian History, Australian National University 2003.

VIRGINIA MATHESON HOOKER

History of Science

By all rights, this entry shouldn't exist. The field of history of science, though well established in Western historiography since the eighteenth century and in Islamic studies for even longer, has yet to identify issues of women and gender in the Islamic world as part of its purview. Neither "female," "gender," nor "women" figure in the subject index to the most recent encyclopedic survey of the field (Rashed 1996), and the number of important scholarly studies in the field can be counted on one hand. This neglect is nearly the same in the allied field of history of medicine, where women as practitioners or patients in the Islamic world have hardly figured. The fact that the editors of *EWIC* had to ask a non-specialist in Islamic history to write this essay is evidence enough. Still, the reasons for this neglect are worth exploring briefly, first by examining the influences that led women's history and gender issues to impact Western history of science, and then by looking at the ways in which the historiography of science and medicine of the Islamic world has developed.

HISTORIOGRAPHICAL TRENDS

Gender issues in the history of Western science and medicine peaked at precisely the same moments that feminism did in the West. In the Renaissance, when the Woman Question was first debated among intellectuals, lists of famous women were compiled that included women known for their medical or scientific achievements. Similarly, the nineteenth-century feminist movement in Europe and North America was accompanied by women entering medical schools and scientific training who, upon becoming professionals, desired to find and document their foremothers. Second wave feminism of the 1960s and 1970s likewise led to a questioning of women's presence in the sciences and medicine, and gender issues now form distinct and highly sophisticated subdisciplines within the fields of history of science and medicine. However, the focus of this historiography has overwhelmingly mirrored the Western focus of the history of science and medicine generally. While earlier historians could be wonderfully universal in their approaches (incorporating the mythic as well as the historical), none of their late twentieth-century successors went outside the parameters of Western history to search for women or the ways in which gender functions in their fields (Harding 1998, Schiebinger 1987 and 1999).

The Islamic world has never depended on the West to articulate its historiographic traditions, though increasingly more symbiotic relations between Western and non-Western scholarly traditions have proved mutually beneficial (the critique of Orientalism and the rise of the field of postcolonial studies being the most obvious examples). The historiography of science and medicine in the Islamic world has a long pedigree, stretching back to the medieval biographical dictionaries of such writers as Ibn Abī Uṣaybiʿa. To my knowledge, no female scientists or healers appear in these biographical encyclopedias. Since the modern historiographic tradition has adhered so closely to the "great men of science and medicine" tradition carved out long ago, it is not surprising that the modern field has yet to acknowledge either women or gender as important categories of analysis. Several state-of-the-art essays on the historiography of science and medicine in the Islamic world, all published within the last decade and a half, lay out trends in the field (the best of which is Savage-Smith 1988). None articulate issues touching on women or gender as emerging fields or as desiderata for future research.

There are reasons other than mere traditionalism to explain why there has been this gap between the subdisciplines of (Western) gender and science/medicine and Islamic science/medicine. Certainly the most obvious are the same ones that keep Islamic studies isolated from mainstream history more broadly: the Eurocentric focus of most historiographic traditions, complicated by the lack of specialized linguistic training among most historians of science and medicine that is the *sine qua non* of Islamic studies. (This lack of dialogue is in fact paradoxical in the field of science and medicine since medieval Islamic traditions have always figured prominently in the master narrative of Western history, the translation of Arabic science and medicine being acknowledged as having laid the groundwork for Western science.) A further reason for the failure of gender issues to flourish in the Islamic historiographic traditions may be the particular kind of methodological conservatism that has characterized scholarship on Islamic science

and medicine. The continued (and, in its way, crucially necessary) focus on producing editions of premodern scientific and medical texts has come at the cost of pursuing other kinds of historiographic analysis (Savage-Smith 1988). Western historiography on women and gender was able to develop beyond the initial phase of "women worthies" (biographies of singular women) only because of the broadening influences of social history, an area that has thus far not been well developed in the field of Islamic science or medicine.

WOMEN AS THE SUBJECTS AND OBJECTS OF SCIENCE AND MEDICINE

The paucity of obvious sources for constructing a history of women in science and medicine has surely also been a factor. To my knowledge, no scientific or medical texts are known to have been written by women prior to the modern period and few specify women as their object of study. Beyond one or two texts translated into Arabic from ancient Greek, only three medical texts from the medieval period take women's health (or at least women's fertility) as their chief concern. In tenth-century Muslim Spain, 'Arīb ibn Sa'd wrote his *Kitāb khalq al-janīn wa-tadbīr al-ḥabālā wa-al-mawlūdīn* (Book on the generation of the fetus and the treatment of pregnant women and newborns). Nearly contemporaneous is the work of Ibn al-Jazzār (282–369/895–979), *Siyāsat al-ṣibyān wa-tadbiruhum* (The care of children and their management), which deals with various aspects of pre-, post-, and neonatal care, including breastfeeding and the choice of a wetnurse. Similarly, a treatise attributed to Abū al-Ḥasan Sa'īd Hibat Allāh (437–95/1045–1101) and called "Maqāla fī khalq al-insān" (Treatise on the creation of man) addresses the anatomy of the male and female reproductive systems, management of pregnancy and parturition, and care of the child. The first text has been edited and translated, the second edited, while the third is still available only in the single extant manuscript.

Beyond these three works, gynecology seems never to have developed as an independent textual field in the medieval Islamic world; rather, chapters on diseases of the female reproductive organs and complications in childbirth would be addressed in the large medical encyclopedias, in which writers of the Muslim world excelled. Studies have been done on the gynecological and obstetrical sections of some of the great medieval medical encyclopedias, such as those of 'Ali ibn 'Abbās al-Majūsī, al-Zahrāwī, and Ibn Sīnā. The existence of several

late medieval illustrations of a Caesarean section had long led to the belief that the practice was common in the Muslim world, though derivation from an iconographic tradition imported from Western depictions of the birth of Julius Caesar now seems more likely. Medical and legal texts have been surveyed for their attitudes toward breastfeeding, leading to the surprising finding that women may have deliberately nursed certain boys in order to broaden the circle of men with whom they could have unfettered social relations (Giladi 1999). Another area of research has been on theories of male versus female contributions to generation, which were a major point of contention between adherents of Aristotle (who believed women contributed nothing more than the matter of their menstrual blood) and adherents of Galen (who believed that what we now call ovaries were in fact female "testicles" that produced a seminal fluid similar to males). Some studies have focused quite narrowly on the philosophical issues of this debate (Weisser 1983), but the path-breaking work of Basim Musallam in 1983 moved out of the narrow confines of intellectual history to assess the whole panorama – medical, legal, and social – of attitudes toward sexuality and birth control in the Islamic world.

Musallam laid out the path, but few have followed. In the 20 years since his work was published, only a handful of articles have appeared addressing aspects of women's healthcare in the premodern Islamic world. (A survey of *Index Islamicus* for the five years prior to 2001 produced as much work on the healthcare of horses and camels as on women.) The modern period has fared somewhat better, where two studies in particular stand out for their methodological sophistication and implications for future research. The American anthropologist Marcia Inhorn surveyed the historical development of theories of generation and women's contributions to fertility (or infertility) as background to her study of Egyptian women's quest for conception (Inhorn 1994). Inhorn's work and that of other scholars (mostly anthropologists; Inhorn and van Balen 2002) who have studied the stigma of infertility on women pose a powerful challenge to Western historiography, which has put more emphasis on women's concerns to limit their fertility (by means of birth control and abortion), with the result that infertility has been largely overlooked in modern policy decisions about what constitutes women's health.

The other major study on the modern period, the recently completed dissertation of Hibba Abugideiri (2001), likewise deals with Egypt, assessing

the impact of Western medicine as it was adopted in the late nineteenth and early twentieth centuries under English colonialism. Abugideiri employs not only political theorists such as Michel Foucault and Antonio Gramsci, but also Western feminist critics of science and medicine. What distinguishes Abugideiri's work is not simply the breadth of her research and analysis, but also her constant insistence on interrogating her own and others' theoretical perspectives to ensure that they are indeed applicable to the Egyptian case. Abugideiri's work is thus pioneering not simply as a study of the history of Islamic women and medicine, but because it has so much to teach *Western* historians of science and medicine about how gendered medicine can function within larger arenas of political change.

FUTURE DIRECTIONS

As Abugideiri rightly recognizes, Western historiography of women and gender in the sciences and medicine cannot be assumed to be universally applicable in either its methods or its epistemological assumptions. The legal, economic, religious, and cultural factors that, for example, allowed some women in the West to have companionate marriages with their husbands (and so participate in their scientific work) or allowed others to demand legal rectification of discriminatory educational or hiring practices may be completely irrelevant to women in Muslim societies. Conversely, issues such as purdah or genital cutting have no parallel in the Western tradition and demand their own culture-specific analyses. Nevertheless, Western historiography on women and gender has developed valuable techniques that can address such common problems as how to find "invisible" women in sources written in and for a masculine public culture.

The simple fact of women's omnipresence in every Islamic society should be an obvious starting point. Since children are always being born and women often suffer in the process, that universality of experience would be a good place to start to look for women's medical practices. In his discussion of how to excise bladder stones, the tenth-century Spanish surgeon al-Zahrāwī admits the inherent difficulty of the procedure for male doctors practicing on female patients: one must either find a woman doctor learned in the procedure (rare) or a eunuch physician who can serve as one's colleague (also rare) or a midwife who can be instructed how to perform the procedure under the physician's guidance (possible but risky). Al-Zahrāwī's complaint also reminds us that women's

education is a crucial starting-point for chronicling their involvement in the sciences and learned medicine, since without basic literacy and other propaedeutic studies, engagement with scientific learning is impossible.

Western historiography on women in science and medicine may be more applicable to recent history, when Western science and biomedicine have made their most immediate impact in the Islamic world. Indeed, work such as that on women in twentieth-century United States science (Rossiter 1995) may serve as an important model for comparable studies that need to be done on women scientists in the Islamic world where (recent figures suggest) women are fast approaching the same representation as students and practitioners of the sciences and medicine that they enjoy in Western countries (Hassan 2000, Cohen 2001, Holden 2002).

It is legitimate to question, of course, how far a historiography of women and science/medicine in the Islamic world should try to integrate itself into Western or other historiographies (for example, that on Chinese science/medicine). Certainly, translations into Western languages of texts composed in Arabic or the other vernacular languages used in the Islamic world open up possibilities for comparative study. For example, the recent publication of the portion of Ibn al-Jazzār's medical encyclopedia on conditions of the reproductive organs (1997) makes possible comparison with women's medicine in medieval Christian Europe, for his text (in Latin translation) served as the foundation for the most important European texts on women's medicine for 400 years, the so-called *Trotula* texts (Green 2001). Research on Jewish communities within the Muslim world likewise has comparative possibilities (Barkaï 1998). But the study of women and gender/science and medicine in the Islamic world is necessary for its own sake, and it needs to be pursued by scholars fully trained in the requisite skills. Science and medicine, whether they are indigenous to Muslim societies or imported (sometimes forcefully) from the West, have been major influences on the lives of women and will inevitably have an even greater impact in the future. It is to be hoped that this preliminary attempt to assess the field will very quickly be superseded by the more advanced and sophisticated work these issues deserve.

BIBLIOGRAPHY

PRIMARY SOURCES
R. Barkaï, *A history of Jewish gynaecological texts in the Middle Ages*, Leiden 1998.
A. Arjona Castro (ed.), *El libro de la generación del feto, el tratamiento de las mujeres embarazadas y de los*

recien nacidos de 'Arib ibn Sa'd (Tratado de ostetricia y pediatria hispano árabe del siglo X), Cordoba 1983.

M. H. Green, The "Trotula." A medieval compendium of women's medicine, Philadelphia 2001.

M. H. al-Haylah (ed.), Siyāsat al-ṣibyan wa-tadburuhum, Tunis 1968.

Ibn al-Jazzār, Ibn al-Jazzār on sexual diseases and their treatment (Arabic text with facing-page English translation), ed. and trans. G. Bos, London 1997.

'Arib Ibn Sa'd, Le Livre de la génération du foetus et le traitement des femmes enceintes et des nouveau-nés, Arabic text ed. and trans. H. Jahier and N. Abdelkader, Algiers 1956.

The midwife of Khumarawaih and her sister, in B. Lewis (ed.), Land of enchanters. Egyptian short stories from the earliest times to the present day, London 1948, 105–7.

SECONDARY SOURCES

H. E. Abugideiri, Egyptian women and the science question. Gender in the making of colonized medicine, 1893–1929, Ph.D. diss., George Washington University 2001.

F. Aubaile-Sallenave, Les nourritures de l'accouchée dans le monde arabo-musulman méditerranéen, in Médiévales. Langue, textes, histoire 33 (1997), 103–24.

P. Cohen, Muslim women in science, in Science Online, 22 February 2001. (A response to F. Hassan's article, listed below.)

A. Giladi, Infants, parents, and wet nurses. Medieval Islamic views on breastfeeding and their social implications, Leiden 1999.

S. Harding, Gender and science, in E. Craig (general ed.), Routledge encyclopedia of philosophy, London 1998, iii, 861–8.

F. Hassan, Islamic women in science, in Science 290:5489 (6 October 2000), 55–6.

C. Holden, Euro-women in science, in Science 295:5552 (4 January 2002), 41.

M. C. Inhorn, Quest for conception. Gender, infertility, and Egyptian medical traditions, Philadelphia 1994.

M. C. Inhorn and F. van Balen (eds.), Infertility around the globe. New thinking on childlessness, gender, and reproductive technologies, Berkeley 2002.

S. M. James and C. C. Robertson (eds.), Genital cutting and transnational sisterhood. Disputing U.S. polemics, Urbana, Ill. 2002.

B. F. Musallam, Sex and society in Islam. Birth control before the nineteenth century, Cambridge 1983.

R. Rashed (ed.), Encyclopedia of the history of Arabic science, 3 vols., London 1996. French translation, Histoires des sciences arabes, 3 vols., Paris 1997.

M. Rossiter, Women scientists in America. Before affirmative action, 1940–1972, Baltimore 1995.

E. Savage-Smith, Gleanings from an Arabist's workshop. Current trends in the study of medieval Islamic science and medicine, in Isis. An International Review Devoted to the History of Science and its Cultural Influences 79 (1988), 246–72.

L. Schiebinger, The history and philosophy of women in science. A review essay, in Signs. Journal of Women in Culture and Society 12 (1987), 305–32.

——, Has feminism changed science? Cambridge, Mass. 1999.

R. L. Verma, Women's role in Islamic medicine through the ages, in Arab Historian 22 (1982), 21–48. (Should be used with caution.)

U. Weisser, Zeugung, Vererbung, und pränatale Entwicklung in der Medizin des arabisch-islamischen Mittelalters, Erlangen 1983.

MONICA H. GREEN

Islamic Studies

INTRODUCTION

The geographical spread of Islam today means that Muslim women can be found in a vast majority of cultures and countries around the world. The demographic changes of the last quarter of a century imply the co-existence of old regional continuities and new transnational discontinuities in how Muslim communities manage their religious identities. The growing global discourse on women's solidarity against patriarchal oppression, initially motivated in the first-wave feminism by a white middle- and upper-class Western feminist discourse, is presently in the third-wave process of integrating a broad cultural and ethnic variety of female perspectives, including Muslim women's voices from diverse and at times competing points of view, in a broad variety of languages. To take one example from my own social location as a Christian French-Canadian man writing in the United States, the new diasporic Muslim communities in North America in particular and the West in general are developing new forms of being Islamic as they integrate the political cultures of their respective host nation-states. No two nation-states are the same; no two national Muslim communities are the same, thereby significantly adding to the already rich mosaic of older Islamic cultures from majority Muslim areas now themselves transformed into new forms of nation-states. Thus the search for understanding not only how Muslim women have lived their own ongoing and often changing multiple identities in the course of a long fourteen-century history, but also how these contemporary identities continue to be transformed in the vast array of Islamic contexts and transnational movements worldwide represent the collective challenge that researchers of women and Islamic cultures share in common today.

In this overview, the aim is to point out broad trends and specific directions and problems in recent investigations on women and Islamic cultures. The intersections with the interdiscipline or transdiscipline of women and gender studies are particularly important as are those of the overlapping disciplines of Islamic and religious studies, themselves becoming very heterogeneous in terms of disciplinary input, especially on the scholarship of religious women, which is experiencing an exponential growth.

In order to facilitate this understanding, I suggest distinguishing between the following five interrelated areas of theoretical investigation: general questions, broad disciplinary intersections, disciplinary focuses, comparisons, and applications. Each area is fraught with competing ideological underpinnings that may not always be rendered explicit in this short article. Indeed, the aim here is to provide a comprehensive overview without any pretense to being exhaustive. I hope it will provide insights into past and potential avenues of research with increasing sensitivity to the complex theoretical and methodological issues collectively attained thus far in the academy. The bibliography provided at the end, with all the limitations that any classification system entails, will supplement the reader's further needs.

GENERAL THEORETICAL QUESTIONS

For many scholars of women and Islamic cultures, "theory" has become a necessary end because it provides a way to pull together into a meaningful whole the myriad ways in which women and Islamic cultures have been studied, or need to be. As for "method," it has become a necessary means without which no academic journey is possible. Yet "theory" and "method," as categories of knowledge, share in common at least one aspect with the categories of "women" and "Islam": the manner in which each category is used, with often very different meanings, reflects, implicitly or explicitly, a set of working definitions that strategically locates their authors within their inescapable and unique contexts of gender, time, and place.

As producers of knowledge, researchers aim for methodological integrity in the pursuit of knowledge, and struggle with two interrelated theoretical questions: what is the purpose and application of their production of knowledge? What is their own identity in relation to that of their objects and subjects of inquiry? These two questions are central because together they link the objectives behind any particular choice of research topic to the unavoidable subjectivity of the researcher. In other words, are the aims and goals of one's pro-

duction of knowledge to describe, improve, or defend the understanding and/or the state of affairs of a particular group of people, in this case Muslim women? If so, is the researcher directly affecting or affected by the possible results of the investigation if she identifies with the identity category of Muslim women? What if the researcher is a Muslim man or a non-Muslim woman? What if the researcher is married to one or the other but does not share the same religious identity? What if a female researcher strongly identifies with, or adamantly rejects, a particular set of patriarchal values often linked to traditional interpretation of the family, whether she defines herself as Muslim or not? What about the location of the researcher: is he or she writing from the perspective of the majority or a minority identity, or a combination thereof, in his or her primary geographical and/or national identity (i.e. Indonesian, Egyptian, Arab, American, Westerner, etc.)?

These multiple identities of gender, race, ethnicity, social class, location, nationality, and so forth, are often organized and contrasted within binary sets such as insider/outsider, believer/non-believer, practicing/non-practicing, educated/illiterate, citizen/foreign, majority/minority, disciplinary trained/un-trained, central/marginal. Yet these dichotomies are often reductive of the complexity of our multiple identities as human beings and how fluid these identities can be as we move from one context to another. For example, where would an Islamic feminist woman scholar be located in the above set of polarities? By upholding feminist values of interpretation, she is an insider to Islam by identity, faith, and possibly practice, yet an outsider to many Islamic communities and most Islamic institutions of learning because of their implicit patriarchal world-views. By way of this one example among many, it becomes clear how difficult it is to generalize and categorize about method and theory in the study of women in Islam.

With the increasing sophistication of theoretical debates on the production of knowledge, researchers are expected to address the above two questions with the greatest possible amount of self-reflectivity and transparency. They describe how their own set of identities relates to their chosen topic of investigation and how this unique approach distinguishes them from other producers of knowledge. They explain their choice of both methodology and language, as it directly affects the audience they wish to reach. They can also address the limits of their unique set of sub-

jectivities as it pertains to any given topic. While this degree of intellectual honesty and ethical integrity has not been historically part of the scholarly norm, the combined influence of postmodernist sensitivities and feminist values on the highly sensitive field of women in Islam today requires struggling with such theoretical and methodological issues: it has become a mark of sound scholarship.

Debates and exchanges about theory and method allow researchers to uncover new meanings and potentialities for increased understanding and transformation towards a better world, however subjective and at times contradictory this "better" may be conceived to be. Researchers, whether male or female, as well as women as objects and subjects of research are free from neither collective trends in identity politics nor politicized personal identities: women too, like men and with men, play in power games, intertwined into each other's lives, competing for ultimate claims to reality as well as seeking control over unfairly distributed earthly resources, all of this in the midst of unjust gender hierarchies. Moreover, these intersect with various other identities from race to class to education, and so forth. The women (and some men) who produce academic knowledge on women in Islam dressed up in the latest fashions of theoretical garb compete for attention and power to change the world, or at least their part of our interdependent world, towards often undisclosed ends, whether it be gender balance, equity, or equality, each one being linked to either the so-called "universalizing" ethos of secular human rights or the "particularizing" ethos of cultural and religious rights. These latter are not necessarily exempt from universalizing claims either, as many particular religious world-views often seek more than a global recognition: in a missionary spirit, they hope for a universal takeover.

Here, the myth of a sisterhood united in a common aim to put an end to patriarchy worldwide is exposed: it collapses in front of the sheer magnitude of different perspectives among women worldwide, including within the ranks of those who identify themselves as Muslim. For example, some Muslim women's perspectives reflect a codependency, whether with traditional Islamic patriarchy or, at the other end of the spectrum, with liberal Western feminist discourse, which is itself often anti-Islamic. Other voices seek interdependency, keeping a balance between the traditional and the progressive needs of various Muslim men

as well as their own. The result is a fascinating juxtaposition of often competing approaches among women in Islam today: from cooperative to polemical, maternalistic to apologetic, manipulative to compassionate.

As the academic turf comes to be shared by an ever increasing variety of voices and its edges become ever more ambiguous, at least two more questions arise. Who manages this relatively new space for women to engage in scholarship in ways that have profoundly challenged the nature of academic inquiry in the last 25 years? And, more importantly, who stands to benefit from this new space? The agency of women as knowledge gatherers, producers, and recipients, is often in competition with men's predominantly patriarchal production. While there are a growing number of exceptions in the form of feminist men's writings, there are also, more importantly, various apologetic stances on the part of mostly religious women who subscribe to and reproduce patriarchal world-views. It is clear therefore that no organized body of women manages this new and highly sought academic space, whether in the study of women in general or that of Muslim women in particular. Nor should this space be limited only to the academy. As for the benefits, if there are any, they remain highly debatable and disputed depending on which perspective is used to analyze the situation.

The questions surrounding the study of women and Islamic cultures are fraught with dangers because for more than two centuries they have been at the center of a Western hegemonic Orientalist discourse of oppression and distortion that perpetuates itself today in the guise of a popular attention to veiled women and Islamic cultures, often treated as the Other par excellence. For example, the disproportionate attention to the question of the veil in both Western media and academic publishing reflects this long history of the manipulation of women's bodies for men's (intellectual) gaze. The Western media thrive on pictures of veiled women as if that were the only way to represent Islam visually. Academic publishers are not far behind either, given all the book covers that use such pictures as well as the book titles that utilize one form or another of the word "veil" for marketing purposes. This impulse is the result of mostly non-Muslim Westerners projecting their own unique and recent history of feminist liberation that has taken the particular form of a gradual "dress less" process over the course of the twentieth century. From this perspective, the increased use of the veil, or the "dress more"

process, however interpreted by many Muslim women worldwide including the younger generation, seems like a direct contradiction to the particular liberating practices developed in the Western liberal feminist movement. It is not surprising that these two opposing processes, "dress more" versus "dress less," have been increasingly clashing over the last century. This situation continues today despite the now prevalent post-Orientalist sensitivities reigning in most Western academic circles. This new approach recognizes the importance of gender in the production of knowledge and in the reproduction of institutional power dynamics as is the case with any other subaltern identity whether it is rooted in race, ethnicity, class, or religion. Often in the name of promoting diversity, members of various identity groups are often competing more than cooperating over who should have access to and thereby control the grounds of academic knowledge production.

The most famous of these debates opposes Orientalists to various post-Orientalists. The pre-1978 approach of Orientalism and its subsequent post-Orientalist rival seem to be in opposition to one another; the latter strives towards making more transparent the normativity of patriarchy, not to mention whiteness, heterosexuality, wealth, higher education, and so on, with all of their privileges and biases embedded within most cultures and religious communities worldwide, including both the Islamic community (or *umma*, in which "Arabness" replaces "whiteness") and the academic community. Yet, these two theoretical perspectives represent different methodological approaches that may at times be complementary because they focus their attention on different aspects of reality out of different human needs.

Whatever currently constitutes the most appropriate theories and methods in the study of women and Islamic cultures is secondary to the task of linking each one of them to three inseparable goals. First, the nurturing of multiple theoretical and methodological approaches enriches our individual and collective understanding of women and Islamic cultures. Second, the recognition of our interdependence as producers of knowledge who live with complex personal identities requires critical cooperation rather than competition. Third, the application of this new knowledge enables researchers to play a pivotal role in the transformation of societies for the common good, however this "good" may be defined in various localities. These three goals imply that scholars recognize and share their privileges by

taking social responsibilities according to their own respective contexts. In addition, to understand women and Islamic cultures better (the subjective goal behind the quest for theory and method), it is vital to empower more Muslim women to gain access to the scholarly production of knowledge. Thriving debates on theory and method require an open participation of the widest range of voices committed to a variety of world-views even if this means sharing the grounds of academia with all voices, even those that may be antithetical to the very idea of open and transparent scholarship. Not to foster such openness is to fall into the trap of manipulating access to power within the academy and beyond for one's own ideological end rather than for the broader principle of full inclusivity.

BROAD DISCIPLINARY INTERSECTIONS

The study of women and Islamic cultures lives at a busy crossroads full of intersecting roads and overpasses. The main arteries of theory and praxis often cross over one another without affecting each other. While intimately intertwined, both theory and praxis rarely make up entire books. A potential fourth-wave feminism, when theory and praxis as well as religious identities will be truly integrated, is hardly present in the study of women and Islamic cultures. At this point in time, many disciplinary avenues, from anthropology to theology, feed into the crossroads at different angles on the ground level, adding much new knowledge about specific aspects of women and Islamic cultures, past and present. Yet, this multiplicity of disciplinary boundaries also sometimes causes unnecessary confusion because the many separate insights do not fit neatly into a cohesive picture. In response to this problem, some intellectual engineers have tried to combine new bi-disciplinary or multi-disciplinary avenues, often turning them into one-way streets in the hope of helping to decongest the traffic. But beware of the poor users who do not have a map to know how to get around this maze! Even if they spoke English or Arabic (respectively the first and second hegemonic languages around issues of women in Islam), they would not necessarily find an interlocutor to help them translate their needs and questions into one of the numerous languages used at the crossroads of women and Islamic cultures.

The intersection of various languages is itself a reflection of power dynamics from the individual to the global, best exemplified today by the linguistic realities and limitations of the internet. Each bi- or multi-lingual producer of knowledge becomes a bridge in the transnational movements of ideas and perceptions, a kind of ideational business(wo)man. Because of the complexity of the crossroads' infrastructure as well as the babelesque quality of its social space, most users feel at a loss. But rather than giving up, a growing number prefer to take the latest subway that has carved its way underground as an interdisciplinary effort (i.e. woman and gender studies) to make sense of what life must be like for those living in or using this complex crossroads (a kind of sightseeing from below). Or they may choose, by way of transdisciplinarity (sightseeing from above), to take a plane to fly over this crossroads with all the advantages of a bird's-eye view and the disadvantages of physical distance. But the plane flies far enough to discover many more topical crossroads, all of them tying each one of us on this planet into an invisible web of material, intellectual, emotional, and spiritual interdependence.

The study of women and Islamic cultures, as any other topic for that matter, requires a great awareness of how each crossroads functions, what advantages and disadvantages one kind of road or another might bring to crossing it, as well as how those crossroads relate to one another. The challenge and beauty of crossroads remain in the availability, given the right economic privileges for access, that such an array of theoretical and methodological approaches makes possible. Gone are the days when a method is debated as either good or bad; celebrating methodological and theoretical plurality is "in," although at times at the cost of clarity and purpose. Key to any academic endeavor today is the clarity with which the methodological choices are made in order to assess and reassess our collectively shared theoretical frameworks, or so goes the ideological aim of those who believe in the possibility of ever reaching rational "unity through theory." Equally vital is the practice of clearly describing the boundaries of one's efforts so as to avoid dangerous generalizations. "A city is not built in one day" and nor are the theoretical crossroads where we meet (or should meet!) to share our latest intellectual discoveries.

DISCIPLINARY FOCUSES

By "disciplinary focuses" I mean the traditional academic disciplines sometimes organized around the four liberal arts quadrants (the humanities, social sciences, pure and applied sciences, and arts). Understandably, the greatest production of

knowledge on women and Islamic cultures has emerged from the first two quadrants: the humanities and the social sciences. Very little production exists on Muslim women's contributions to the arts and even less to the pure and applied sciences. I now briefly focus on the disciplines in which the greatest amount of production has emerged, recognizing the growing fluidity between those disciplinary boundaries both within each quadrant and across them.

An increasing number of women are trained in the study of religion and choose to focus on women and Islamic cultures. In addition, because it has become imperative today for men teaching religion in institutions of higher education to incorporate the popular topic of women in Islam, many have subsequently been able to integrate it into their own scholarship too. Some of the best results of both women and men scholars of Islam are in the sub-field of Islamic law. A few courageous advances are also noticeable in Islamic theology. Yet the field of religious studies as a whole has not witnessed the expected explosion of serious academic writings on Muslim women, although much material has seen the light of day under various marketing pressures to meet the popular demands influenced by sexist media coverage.

Even though only a minority of the scholars on women and Islamic cultures are trained historians, most recognize the importance of history and integrate it into their methodologies. As a result, there are now valuable monographs and overviews on Muslim women in various periods of Islamic history, although much more needs to be done to cover all regions where Muslims settled or local populations converted to Islam over the last fourteen centuries. The general bias towards studying the Arab world, Iran, and Turkey, a bias inherited from the Western Orientalist tradition, continues up to the present. Much more needs to be done to cover such important regions as sub-Saharan Africa as well as Central, South, East, and Southeast Asia.

Anthropologists have contributed in part to overcome this regional imbalance with their now numerous studies of Muslim women worldwide. The increasing number of Muslim women trained in this field has also allowed for many insights inaccessible to men. A similar trend is noticeable in sociology and political science, the other two disciplines in which most of the production of knowledge on women in Islam is concentrated. The growing presence in the academy of native speakers of local languages also enriches the possibilities of cross-cultural understanding. Of course, this phenomenon exists across the disciplines now, resulting in local disciplinary production in a variety of languages, especially in Arabic, Persian, Turkish, and Bahasa-Indonesian.

COMPARISONS

Comparisons are tricky because they can dangerously juxtapose two or more elements without both carefully considering their respective and unique contexts as well as honestly articulating their limits. Yet, the constant interplay between similarities and differences begs comparisons. They are as natural to human communication as generalizations: there is no way to live without them. The challenge is to learn how to manage these comparisons in order both to ascertain the limits of their usefulness in any given situation and to minimize their manipulations due to unavoidable competing world-views and ideologies.

In the case of women and Islamic cultures, the overarching comparison that has implicitly framed most comparative work is the polarizing (and thus reductionist) dichotomy between "Muslim women" and "liberated or feminist women." The impact of the ideology of feminism (one form of liberative discourse that emerged in the latter half of the twentieth century along with liberation theologies of various kinds) on the development of women and gender studies in particular and on postmodern scholarship in general, both of which are generally at the powerful end of the imbalanced discursive competition against embattled religious women, especially so-called "fundamentalist" women, means that the whole theoretical apparatus developed in recent years to study women in general, especially women in their respective religious contexts, including Islam, implicitly reproduces variants of an Enlightenment world-view that judges any dimension of faith as necessarily blind (i.e. irrational). Of course, such judgment immediately becomes suspect to those for whom faith matters. The challenge is to create spaces where the limits of intellectual articulations of the boundaries of both faith-centered and theory-centered discourses can be experienced. Such a task is only possible if its proponents realize their complete interdependence. The mirroring of each other's blind spots reveals greater awareness and intellectual clarity of one's own limitations and boundaries. In fact, this task is not only necessary intellectually but emotionally too, since much intellectual blindness is caused by emotional stumbling blocks. In this

respect, producers of knowledge, thanks to their above-average educational training, carry greater responsibility for ensuring that such spaces and interactions take place, whether through direct face-to-face encounters or mediated through written exchanges.

APPLICATIONS

The realm of applications, also referred to as praxis, is what many disciplines have called their "applied" branch. In all cases, this "applied" dimension is eminently focused on the present and short-term future. It includes the policy implications of new understandings about women and Islamic cultures in a variety of areas from education to health to government for those in various levels of policy decision-making. It also includes many implications for activists who aim to transform power relations at a grassroots level, especially through the worldwide mushrooming of non-governmental organizations. In particular, a number of books on the rights of Muslim women fall within the highly politicized question of women's rights as human rights. The reason why these applications are important to theory and method is that many scholars' understanding of issues of theory and method is directly affected by their active engagement in empowering women in one form or another, for various ideological or religious ends. Whether through teaching within and without the academy or participating directly in governmental and non-governmental decision-making processes, their scholarship informs and is informed by such activities. As theory seeks to cover all aspects in the lives of both researchers and those being researched because it recognizes their interrelatedness, method requires integrating those old and new applications of our latest understanding about women and Islamic cultures together with the varieties of ways in which religious identities coalesce with multiple identities. When and if this integration is achieved, we will have entered a fourth-wave feminism.

BIBLIOGRAPHY

General theoretical questions
C. Allen and J. A. Howard (eds.), *Provoking feminisms*, Chicago 2000.
R. Alsop and K. Lennon, *Theorizing gender*, New York 2002.
P. S. Anderson, *A feminist philosophy of religion*, Oxford 1998.
S. Benstock, S. Ferriss, and S. Woods, *A handbook of literary feminisms*, Oxford 2002.
L. E. Donaldson and K. Pui-Lan (eds.), *Postcolonialism, feminism, and religious discourse*, New York 2002.

S. Gamble (ed.), *The Routledge companion to feminism and postfeminism*, New York 2001.
S. Hesse-Beber, C. Gilmartin, and R. Lydenberg (eds.), *Feminist approaches to theory and methodology*, Oxford 1999.
T. Saliba, C. Allen, and J. A. Howard (eds.), *Gender, politics, and Islam*, Chicago 2002.
A. Sharma and K. K. Young (eds.), *Feminism and world religions*, Albany, N.Y. 1999.
D. C. Stanton and A. J. Stewart (eds.), *Feminisms in the academy*, Ann Arbor 1995.

Intersections
H. Afshar, *Islam and feminisms. An Iranian case-study*, New York 1998.
M. Badran, *Feminists, Islam, and nation. Gender and the making of modern Egypt*, Princeton, N.J. 1995.
E. A. Castelli (ed.), *Women, gender, religion. A reader*, New York 2001.
A. M. Clifford, *Introducing feminist theology*, Maryknoll, N.Y. 2001.
N. A. Falk and R. M. Gross, *Unspoken worlds. Women's religious lives*, Belmont, Calif. 2001.
L. A. Finke, *Feminist theory, women's writing*, Ithaca, N.Y. 1992.
M. Franzmann, *Women and religion*, New York 2000.
Y. Y. Haddad and J. I. Smith (eds.), *Muslim World* 92:1/2 (spring 2002), special issue: Islam in the West.
R. M. Harik and E. Marston, *Women in the Middle East. Tradition and change*, New York 1996.
J. S. Hawley (ed.), *Fundamentalism and gender*, New York 1994.
Z. Mir-Hossein, *Islam and gender. The religious debate in contemporary Iran*, Princeton, N.J. 1999.
A. S. Roald, *Women in Islam. The Western experience*, London 2001.
L. M. Russell and J. S. Clarkson (eds.), *Dictionary of feminist theologies*, Louisville, Ky. 1996.
S. Sabbagh (ed.), *Arab women. Between defiance and restraint*, New York 1996.
A. Sharma, *Today's woman in world religions*, Albany, N.Y. 1994.

Disciplinary Focuses
K. Abou El Fadl, *Speaking in God's name. Islamic law, authority, and women*, Oxford 2001.
L. Abu-Lughod, *Writing women's worlds. Bedouin stories*, Berkeley 1993.
—— (ed.), *Remaking women. Feminism and modernity in the Middle East*, Princeton, N.J. 1998.
M. Cooke, *Women claim Islam. Creating Islamic feminism through literature*, New York 2001.
M. Ebtekar as told to F. A. Reed, *Takeover in Tehran. The inside story of the 1979 U.S. embassy capture*, Burnaby, B.C. 2000.
J. L. Esposito with N. J. DeLong-Bas, *Women in Muslim family law*, Syracuse, N.Y. 1982, 2001².
N. R. Keddie and B. Baron (eds.), *Women in Middle Eastern history. Shifting boundaries in sex and gender*, New Haven, Conn. 1991.
F. Mernissi, *The harem within. Tales of a Moroccan girlhood*, Toronto 1994.
S. Murata and A. Schimmel, *The Tao of Islam*, Albany, N.Y. 1992.
G. Nashat and J. E. Tucker, *Women in the Middle East and North Africa. Restoring women to history*, Bloomington, Ind. 1999.
A. Schimmel, *My soul is a woman*, trans. S. H. Ray, New York 1997.

D. A. Spellberg, *Politics, gender, and the Islamic past. The legacy of ʿAʾisha bint Abi Bakr*, New York 1994.

ʿAbd al-Raḥmān al-Sulamī, *Early Sufi women*, ed. and trans. R. E. Cornell, Louisville, Ky. 1999.

W. Walther, *Women from medieval to modern times*, Princeton, N.J. 1993.

Comparisons

J. H. Bayes and N. Tohidi (eds.), *Globalization, gender, and religion. The politics of women's rights in Catholic and Muslim contexts*, New York 2001.

J. C. Raines and D. C. Maguire, *What men owe to women*, Albany 2001.

Applications

G. Ascha, *Du statut inférieur de la femme en islam*, Paris 1987.

——, *Mariage, polygamie et répudiation en islam. Justifications des auteurs arabo-musulmans contemporains*, Paris 1997.

C. W. Howland (ed.), *Religious fundamentalisms and the human rights of women*, New York 1999.

V. Narain, *Gender and community. Muslim women's rights in India*, Toronto 2001.

PATRICE BRODEUR

Legal Studies

INTRODUCTION

The grounds upon which contemporary legal studies have been founded contain a principle that is found not only in the liberal theories of Locke, Bentham, and Rousseau, but in ancient Greek philosophy as well. That principle is known as *legality*, or, in other words, the ideal that societies function under *the rule of law*. For both ancients and moderns, a society operates under the rule of law when public and private forms of power are regulated and constrained by law. Ideally, law should function as a single authoritative set of norms that prevent political corruption and promote equality.

In the modern view, the rule of law serves two additional and important functions: it provides (a) fair notice and (b) legal accountability. Fair notice requires that the state notify persons before it intervenes in their lives, thus promoting a sense that all people operate within a clearly-defined "zone of freedom." Legal accountability entails checkpoints; it means that those who wield public power are accountable to a pre-set body of authoritative norms that are generally known and applicable to all, clear in meaning, enacted in accordance with existing law, and enforced consistently and apropos to their meaning. Thus, in this modern sense law regulates and constrains power to secure individual freedom from governmental tyranny, and the ideals of fair notice and legal accountability are central to the protection of liberty (Altman 1990, 22–6).

A number of problems arise from this account of the principle of legality. First and foremost, the conception of law reflected here stresses the abstract in the sense of law as an ideal, or law as a statement of principles. In contrast, we can see that the institutional arrangements (courts, legislatures, regulatory bodies) that secure legality in any society are subject to contending pressures about what is good (efficient) and right (just). What is good and right is not necessarily the same in every case. Competing conceptions of good and right often lead decision-makers to compromise, producing settlements that are contextual, that apply to specific circumstances and players, rather than generating rules that apply to all. Another point to consider is that judgments about the relative merits of each side in a disputed matter are obviously not made in a vacuum. Virtually every contemporary legal thinker acknowledges the influences of differing normative conceptions and socio/economic/cultural backgrounds that affect the decisions of judges, juries, lawyers, lawmakers, and other officers of the law. Third, in contemporary liberal societies, administrative and regulatory agencies exercise extensive discretionary power, guided by only the vaguest of public rules. This casts serious doubt on the notion that the rule of law effectively confines and regulates state power. In spite of all the effort put toward maintaining the distinction between law and politics, the fact remains that legal systems are vulnerable to the criticism that they do *not* embody the essential features associated with the model of the rule of law (i.e. the clearcut boundaries guarding individual freedom and equality from abuses of power).

CONTEMPORARY LEGAL STUDIES

These problems continue to have resonance in the field loosely defined as "contemporary legal studies." From the apparent shortcomings and inconsistencies of the rule of law model have come volumes of critical analysis and defense, which have led many to think deeply not only about the nature of law, but about the operations of law as well. By the turn of the nineteenth into the twentieth century, the formalism associated with the rule of law model, and the jurisprudential emphasis on judges discovering what the truth of the law is through abstract reasoning based on precedents, were sharply contested. As Oliver Wendell Holmes, Jr. (then chief justice of the Massachusetts Supreme Judicial Court, and later, U.S. Supreme Court Justice) put it, the substance of the law inevitably reflected not abstract legal logic, but the "felt necessities" of the times and other social and practical influences. The legal realist movement, which emerged out of American law schools in the first half of the twentieth century, adopted the Holmesian concentration on practices, rather than principles, in studying the law. The profound contribution of legal realism to our understanding of law is the by now commonplace observation that the social

attributes of the parties involved in a case – not only the victims and the perpetrators, but the judges and jurors as well – affect how a case is handled and how it will turn out. Critical accounts of the power of law and of the place of rights in liberal societies pointed in new directions of intellectual inquiry. Legal realism opened the way for more scholarly attention to social and behavioral dimensions of law, providing an important foundation for contemporary legal studies.

In the final decades of the twentieth century several contemporary schools of jurisprudence emerged within the law academy. While many students of law continued to identify strongly with a "traditional" school of jurisprudence, accepting the assumptions of the rule of law model, others accepted or followed an alternative school of jurisprudence that sought to modify or radically alter conventional assumptions. Many of these are interdisciplinary, borrowing heavily from a wide range of disciplines, including economics, anthropology, sociology, and political science. At least some of these schools differed from the traditional schools of jurisprudence in their focus on practical problems within the realm of law, such as the standing of women or minority claimants before the law. The contemporary schools of jurisprudence include the Law and Economics movement (an extension of utilitarianism); Interpretive Jurisprudence (associated with law professor Ronald Dworkin); Critical Legal Studies (rejecting the notion of the rule of law); Critical Race Theory (race is the predominant basis of inequity in the system); Feminist Jurisprudence (law is patriarchal); Narrative Jurisprudence (storytelling); and Postmodern Jurisprudence (rejects grand theories that claim to wholly capture human experience). For the purposes of studying women of Middle Eastern heritage and in Islamic societies, the most interesting and possibly the most relevant of these approaches are Feminist Jurisprudence and Narrative Jurisprudence.

FEMINIST JURISPRUDENCE

Feminist Jurisprudence is dedicated to exposing the patriarchal basis of the law and legal principles and to identifying and articulating the perspectives, needs, and rights of women. More specifically, feminist legal scholars say, within the Anglo-American jurisprudential and legal traditions, doctrine based on liberal notions of individual rights, freedom, and reasonableness, while claiming to be gender-neutral and objective, actu-

ally favors the interests of men. Furthermore, the law has restricted the entry of women into the public sphere and has done little or nothing to intervene in instances of male dominance or abuse in the private sphere. There is a strong conviction that male dominated jurisprudence perpetuates women as objects. Society is viewed basically as patriarchal, organized and dominated by men, and, as a result, not very hospitable to women. Law professor Catharine MacKinnon is most notably associated with Feminist Jurisprudence. She argues that the modern liberal state is organized on behalf of men, and that the law reflects male-oriented norms and the rule of men over women. Moreover, she asserts that sex and sexual relations are at the core of a society where men dominate and women submit. MacKinnon has been a leading legal advocate for the abolition of pornography on the grounds that it is a key means of "actualizing" the dynamic of social inequality into sexuality and contributes to the ongoing domination of women and to the practice of men inflicting harm, including rape, on women (MacKinnon 1987, 1989, 1993). In addition to the issue of pornography, many feminist legal scholars have influenced legal developments in the reform of rape law and in the introduction of laws that have defined sexual harassment in the workplace. They have also been involved in domestic violence legislation and litigation, and in expanding options and choices available for women generally, including the right to legal abortion. For many feminist students of the law, conceptions of gender, the role of women, the status of motherhood, reproductive rights, and the meaning of privacy and of equality remain contested areas and still require the exposure of practices that are unfair to women.

NARRATIVE JURISPRUDENCE

The other illustrative field is Narrative Jurisprudence (Delgado 1989, Elkins 1990, Abrams 1991). Narrative Jurisprudence has a dual focus; it is concerned with law *in* literature as well as law *as* literature. The former concern looks to the treatment of law and justice in literature, as a literary subject. The latter emphasis looks at the law itself (for example, capital punishment sentencing, torts and claims, and so forth) as a form of literary activity that can be analyzed like any other literary activity. Law professor James Boyd White explores how judges and lawyers conceive of and talk about their experiences and how these modes of thought and expression alter the legal imagination (White 1984, 1985, 2001). He has combined

legal education and literary studies in ways that highlight the letters' distinctive contribution to our understanding of law. Some critics question whether literature can promote a deeper ethical sensibility in lawyers, as it is posited to do. The limitations of this approach include its failure to produce generalizable results, and the difficulty in verifying its claims.

SOCIAL SCIENTIFIC CONTEXT OF LAW

The study of law and sociolegal phenomena has not been the exclusive domain of law schools, however. It is now also the purview of many disciplines in the social sciences and humanities. As part of the larger "sociological movement in law" in the mid-1970s, social scientists took law out of the hands of the legal professionals (Brigham 1996, 10). Many students of the societal context of law form a continuum between viewing society as rooted in broad consensus, and viewing society as rooted in conflict among major social groups with the powerful using the law to impose their will on the weak. Some have studied how daily life is permeated in all its aspects by a belief in authority, and the accompanying tension between authoritative descriptions of the world and our own individual perceptions of life. Others have illuminated the reach of law into social and political life through an examination of the constitutive aspects of law, showing how the law affects one's ways of thinking and acting. For example, in describing the closing of the San Francisco bath houses during the early years of the HIV epidemic, political scientist John Brigham argues that rights claims – and the belief that law is powerful – were important in constructing the gay community itself (Brigham 1996, 29–50). Rights claims, concomitant with deference to the institutional channels and professional discourses that comprise the legal domain, are seductive because they bear a vague promise that the state eventually will recognize and support one's position.

POSITIVISTIC TRADITION

Two traditions of social scientific analysis have predominated in the field of legal studies: the positivistic and the humanistic traditions. The positivistic accounts of law look to the natural sciences as their model. Theories are formulated, and hypotheses are generated and tested for empirical verification. Specific methods used in this tradition include experiments, surveys, observational studies, content analysis, and secondary data analysis. Sociologist Donald Black, a noted proponent of positivism, defines law as govern-

mental social control, as something that is a quantifiable variable: law is arrests, cases, trials, decisions, complaints, and accusations. Law is a dependent variable and can be measured. It increases and decreases from one setting to another. Some specific empirical hypotheses generated by Black include the following:

1. Law varies inversely with other forms of social control.
2. More stratification produces more law (i.e., the more social and economic inequality in a society, the more law there is).
3. Downward law is greater than upward law (i.e., more law is produced by the powerful and wealthy that has an impact on the poor and powerless).
4. Law increases as intimacy decreases, but law declines when people are wholly unconnected to each other (i.e., there is a curvilinear relationship, and there is little law between people who are intimately connected with each other and between people so far removed from each other's lives that they have no contact, with the most law existing between people who have regular contact with each other without intimacy).
5. Rules become more prominent as society grows and becomes more complex (Black 1976; see also 1989 and 1993).

Black's work has been controversial in the field of the sociology of law. Some have criticized it for the lack of logical connections between the propositions and the failure of empirical testing to be relevant (for example, Baumgartner 1999). Others have attacked his contribution on the grounds that it misses the important questions about how and why people behave and believe as they do, and how law itself is a "linguistic practice" through which various moral choices are channeled (for example, Frankford 1995). Black, then, is a positivist scholar who tests the limits of empirical research and stimulates us to make sense of the relation between the legal and the social.

HUMANISTIC TRADITION

In contrast, the humanistic tradition looks to the humanities – philosophy, history, literature, and cultural studies – to generate its model. This tradition asserts that the sociolegal world is fundamentally different from the natural and physical world. Thus positivistic methods are viewed as irrelevant for the study of law. Instead law and the sociolegal are more likely to be interpreted than explained. Stories about disputes are sources

that are preferred over statistical analyses. By applying appropriate philosophical concepts to the sociolegal, or by providing a detailed historical account, or by reading literary accounts, students can presumably arrive at a rich understanding of how law and society interact. A noteworthy approach – the narrative approach of telling stories from everyday life – has arisen in the humanistic tradition. This entails the study of the discourses of disputing, to show how power operates discursively to constitute categories, and how persons use these categories through interactive speech and sometimes contest their construction within the limitations of these categories. That is, it takes the stories of those who take part in the operations of state law and investigates how the consciousness of the storytellers is subtly influenced by their own multiple identities in their interpretation of social phenomena (such as gender or race). An example would be the stories of jurors in death penalty cases, both black and white, who frame and impart meanings of "race" in their experiences as capital sentencing jurors (Fleury-Steiner 2002), or the stories of ordinary people in the context of their everyday lives about problematic situations that produce conflict and disputes – for example, consumer problems, landlord-tenant disputes, public nuisance troubles, and failed relationships (Ewick and Silbey 1998, Merry 1990). Another example is the stories of police officers who draw on their multiple identities – as law enforcement officers, parents, whites or blacks, women or men – to make discretionary decisions in the field in ways that are inextricably bound to their institutional roles (for example, as state actors) yet connected also to their personal understandings of morality and the law (Oberweis and Musheno 2001). This line of scholarship explicitly analyzes language uses in disputes and explores the formulation of legal consciousness as a cultural practice.

ISLAMIC LEGAL HISTORY

Another area worth noting because of its significance for the study of women in Islamic societies is the development of Islamic legal history. Most Western scholarship has held that Islamic law is immutable, unchanging, and timeless, and that Islamic jurisprudence is static, or even worse, has been in decline since the tenth century C.E. The idea that the "gate of *ijtihād*" (interpretation) in Islamic jurisprudence had swung shut at that point, and that Muslim jurists since have worked with nothing but "stable sacred texts" – merely mechanically applying legal texts rather than

interpreting God's law – had long been accepted as an objective truth established by much Orientalist scholarship (for example, the works of Joseph Schacht, Ignaz Goldizer, Carl Heinrich Becker, and a number of others; see Hallaq 2002/3, 1).

However, recent historical scholarship has sharply questioned the depiction of the stasis and stagnation of Islamic law during the last millennium. More than a few scholars have shown that many Muslim treatises have held that Islamic law is far from being immutable; the law must continue to change, because circumstances change. Some historians have demonstrated that Muslim jurists in the seventeenth, eighteenth, and nineteenth centuries in fact were *not* confined to rote application of the law in a mechanical fashion. Power struggles fought out among villagers and local notables; the property rights of women; and marriage, divorce, and custody issues all provided ample opportunity for jurists to assess – that is, think through – the merits of a legal dispute against indicants of justice derived from the Qur'ān and *sunna* as well as previous decisions (see Zilfi 1997, Tucker 1998). Likewise, historian Wael Hallaq asserts that while the practice of *ijtihād* may have been controversial, there never was a definitive consensus that the law was not open to interpretation (Hallaq 1996). Ebrahim Moosa posits that in the postcolonial era, Muslims have focused on matters of culture, politics, the nation-state, and secularism, all of which have been affected by the late twentieth-century gender debate. Further, he writes, the "radically different lives" of contemporary Muslims – compared to the milieu in which the panoply of hermeneutical methods of interpreting canonical texts was devised – necessitate a fundamental rethinking of the interpretive enterprise (Moosa 2001/2).

Some scholars have paid particular attention to legal practices, as opposed to jurisprudence, as a means of contesting the inherited wisdom. A few have investigated the fatwa genre of legal *responsa* (Islamic religio-legal opinion) as a source of social, economic, and religious history, finding it a rich terrain for research due to the access it provides to the actual, daily problems of specific societies. A merit of fatwas is their contextual character; the opinion-giver, or mufti, draws on scriptural sources (Sharī'a-based knowledge) and combines this with "concrete" knowledge of the local setting so that the fatwa responds to questions in a relevant fashion. Mohammad Masud, Brinkley Messick, and David Powers (1996) have

proffered an important volume containing essays in Islamic law, history, and anthropology that attempt to provide some insight into the historical contingencies and actual circumstances of muftis in specific, local settings in premodern, early modern, and contemporary periods. The purpose of the volume is to show that the fatwa is a kind of legal interpretation, distinct from the official judgments of state-appointed judges, or *qāḍīs*, which, while non-binding, did serve to communicate an authoritative opinion from the legal interpreter to the public. The combined effort of the contributors to the volume provides the history, structure, and modern transformation of the legal form of fatwa as the practice of fatwa-giving evolved from a private activity, independent of state control, into an increasingly important component of judicial administration. The essays demonstrate how the mufti began as an independent interpreter of the law, pronouncing legal opinions in response to specific questions posed by private citizens within parameters set forth by an existing school of Islamic legal thought, and became someone who plays an important legitimation function vis-à-vis the state. While today the situation of muftis varies in accordance with their polities, we see that secular law and the institutions that have constricted their authority have largely displaced them. Still, whether obtained privately or through state-run agencies, fatwas continue to be influential in constructing and maintaining a sense of legal stability as well as a justification for the authority of law. Seen as adjuncts to the Islamic legal system, fatwas interpretively extracted legal principles from available sources – textual sources, logic, and Islamic beliefs – for Muslims faced with daily problems. Since muftis commonly are affiliated with particular schools of law and hail from a wide range of regions, they present a challenge for the scholars and judges receiving fatwas to read for culturally specific details and distinct local traditions of Muslim legal writing and styles of argumentation. The fatwas themselves provide an invaluable record of the preoccupations and interests of Muslims of their age.

MUSLIM WOMEN AND THE LAW

The task that remains, then, is to bring together the insights of contemporary legal studies and contemporary feminist studies of women of Middle Eastern or Muslim ancestry. The remainder of this entry serves to identify the points of congruence and disparities between developments in recent years within contemporary legal theory and within the range of critical gender studies of Middle Eastern or Muslim societies that have sought to explore the historical, textual, and social mechanisms of women's oppression. In a number of recent feminist-legal theoretical works, for instance, we find critical accounts of the power of law in which the legal construction of female sexuality, reproductive rights and choices, submissiveness, maternal roles, inequities in the marital relationship, and victimization in rape and domestic abuse cases, has assumed a central significance. Additionally the question of male dominance, and of the relationship between patriarchy and class, poverty, and race in a capitalist liberal state, has generated a substantial volume of work concerning its implications for women. While enlightening, such work tends to be concerned primarily with the ways in which law constructs women and women's experiences, rendering the "object" (i.e. women) relatively passive in the hands of the law (for example, Smart 1989, 1990, 1995, Fineman and Thomadsen 1991, Fineman 1995).

An important goal is to connect the more abstract and universal realities explicated in legal theory to specific local conditions. The object of study in gender studies of Middle Eastern and Islamic societies has been the historical, textual, and social processes of oppression and subjugation of women. The specifics of the term "patriarchy" come to light in many of these studies, often illustrated by the intimate inner workings of culturally and historically distinct arrangements between the genders. Sociologist Deniz Kandiyoti's work is an example of this, where she offers a particularistic analysis of women's strategies and coping mechanisms that leads to a more culturally and temporally grounded understanding of patriarchal systems (for example, Kandiyoti 1988, 1991, 1996, 2002). Similarly, anthropologist Susan Hirsch analyzes gender, discourse, and Islamic law within the particular cultural context of an Islamic court in coastal Kenya, and produces a refined portrait of the enactment and transformation of gender through dispute resolution in and outside of courts (Hirsch 1998). In addition, several studies have highlighted the prevailing patriarchal conditions in Iran that have often prevented women from participating in the public sphere (Afshar 1985, Haeri 1989, 1992, Afkhami and Friedl 1994, Göçek and Balaghi 1994).

In some accounts of women in Middle Eastern or Islamic societies the effects of law and legal regulation have figured heavily (e.g. Zilfi 1997,

Hirsch 1998, Tucker 1998). With very few excep-
tions, however, what has *not* been within the
scope of these works has been a critical engage-
ment with the power of law from a perspective
that is informed by recent developments in legal
theory and in jurisprudential texts that take seri-
ously the feminist critique of the power of mas-
culinity in the law. The power of law either tends
to be taken for granted, or does not figure at all in
these studies of women and gender in the Middle
East and/or Muslim societies. To a large extent,
analysis of legal form grounded in local social
relations is undertheorized. That law mirrors the
interests of a specific grouping of men, and that
theirs is the world-view of the socially powerful
has been explored in depth in only a handful of
works on Muslim women (Mernissi 1987, 1991,
1995). Debates in Islamic feminism have made
tremendous efforts of late to reread the Islamic
tradition and to insert the place of women in con-
temporary Islamic thought, but few of these
debates attempt to engage issues of jurisprudence
(see Moosa 2001/2).

LAW, GENDER, AND CULTURE

Yet there have been some significant works
recently that have focused on the role of law in
social relations in specific societies in the Middle
East or Muslim world, that have mapped out
some fruitful avenues for research on the intersec-
tion of law, gender, and culture. In the area of
rights – women's rights and human rights in par-
ticular – the seeming stability of the contemporary
Islamist discourse about Islamic law and its
canonical texts is challenged. For instance, Judith
Tucker's *In the House of the Law: Gender and
Islamic Law in Ottoman Syria and Palestine* pro-
vides a fascinating historical account of the activ-
ities of the Islamic courts of Damascus, Nablus,
and Jerusalem in the eighteenth century (1998).
Tucker uses court material and collections of fat-
was to get at the question of gender relations. In
the important tradition of Fatima Mernissi,
Tucker looks at the Islamic legal discourse regard-
ing gender relations and exposes the ahistorical
and apolitical approach to Islamic law displayed
by contemporary Islamists, which "posits Islamic
law on gender as unitary, unchanging, and sacro-
sanct, a law whose roots in the early Islamic
period serve to define and structure gender differ-
ence for all time" (Tucker 1998, 9). She asserts
that in reaching back to the days of the Prophet
Muḥammad and his early followers in order to
construct a set of norms to govern male-female
relations in the present, and to criminalize illicit

sexual activity, today's "Islamist thinkers display
little or no systematic interest in the intervening
centuries of Islamic history or thought" (ibid.).
Her purpose, then, is to challenge the narrative of
origins the Islamists have on what Islamic law has
to say about gender, and to delineate how Islamic
law has in fact evolved over time through inter-
pretations of authoritative texts and the decisions
of Muslim jurists.

EARLY MODERN SYRIA AND PALESTINE

Tucker argues that the possibility of change in
interpretations of Islamic law pressured by all
sorts of sources – including local custom, political
expedience, and the whims of local officials –
makes it vitally important to take a closer look
at the decisions of local jurists to see how legal
doctrine was understood in relation to specific
situations or problems. She gives full considera-
tion to the key role of fatwas in the evolution
of Islamic doctrine. Some of the fatwas from
seventeenth- to eighteenth-century Syria and
Palestine that Tucker writes about were precipi-
tated by formal legal cases brought before a *qāḍī*,
or judge, in an Islamic court. The court func-
tioned mainly as an official registry office for the
Ottoman Empire – recording "the buying, selling
and endowing of real estate, the establishment
of business partnerships, the certification of loans,
the partition of estates" – but was also the site
of a modest amount of litigation, for purposes
of judgment instead of registration (1998, 17–
18). Residents of the local community came to
the courts to register marriages, dispute marital
arrangements, negotiate some types of divorce,
argue about child custody, and protest sexual
assault. The *qāḍī*s of the courts produced enforce-
able judgments in litigation and other disputes,
and were paid officials of the Ottoman Empire.

But what was the function of the mufti? While
*qāḍī*s were paid officials of the empire, muftis
were mostly local men, not forming part of the
ranks of Ottoman officialdom. Muftis were not
acting as officials of the state when they clarified
legal pronouncements found in Islamic texts, but
were instead responding to individual requests
for a legal opinion. Tucker tells us that the mufti's
primary mission was that of delivering legal
advice to the local community of which they were
a part. Since many fatwas were delivered without
reference to a pending court case, we can assume
that at least in part muftis were acting as dispute
mediators for people who wished to avoid the
court altogether (1998, 21).

Yet the impact of muftis on the courts cannot

be easily dismissed. They dealt with many local customs and social issues that are not often mentioned in the official court record; in effect they channeled legal issues in such a way that their activities limited the kinds of issues the urban population brought to court, and subsequently how the "official" judges (the *qāḍī*s) applied legal doctrine. This in turn shaped the development of Islamic jurisprudence on matters of everyday life (for example, marriage, child custody, sexual assault) by limiting the occasions for the official court record to expound upon the effects of changing social and political circumstances. According to Tucker, the muftis may have "maintained a direct line to their local communities and a willingness to take on legal problems raised outside of a court venue" (1998, 22). Moreover, muftis "brought their knowledge of legal doctrine and past experiences to bear on the concrete situations of members of their communities, in the course of issuing fatwas that might then be pressed into service, both inside and outside the court system, for the resolution of problems and disputes" (1998, 179).

POSTCOLONIAL KENYA

While Tucker worked on legal records in early modern Syria and Palestine, anthropologist Susan Hirsch provides us with an analysis of the discursive construction of gender in the *qāḍī* (kadhi) courts of postcolonial coastal Kenya. In *Pronouncing and Persevering: Gender and the Discourses of Disputing in an African Islamic Court*, Hirsch shows us how the discourses of disputing are "constitutive of gendered individuals and thus determinative of their abilities, opportunities, and tendencies" with respect to narrative testimony and other speech forms in an Islamic courtroom setting (1998, 33). The title of her book refers to the image of the Muslim husband pronouncing divorce in accordance with Islamic law, and his persevering wife silently enduring the hardships of marriage and divorce without complaint. Yet, Hirsch tells us, this is not entirely true. In the postcolonial period, at least, these images of Islamic law and gender relations are "neither rigid molds to which everyone conforms nor antiquated ideals easily ignored or dismissed" (1998, 3). Husbands and wives sometimes contest these roles. Swahili Muslim women actively pursue claims in court and tell "eloquent stories that challenge the circumstances of their lives and their gendered, legal, and linguistic positions" (1998, 10). This book focuses on legal practices, on the legal challenges brought by men and women to a

qāḍī's court in order to improve their lives. In the telling, it demonstrates how gender is socially constructed and transformed in fundamental ways through the legal processes associated with the *qāḍī* court.

Hirsch situates the *qāḍī* courts of Mombasa and Malindi within the broader context of courts of law in Kenya, and points out that, in reality, the authority of these courts is quite tenuous. Muslim men can exercise competing authority outside of the courtroom by pronouncing some legal decisions, such as divorce, without the backing of the court or by ignoring the court's decisions altogether. In fact, "Swahili Muslims are quite critical of Khadi's Court, which is seen as disempowering men and allowing women to air shameful stories in public" (199, 10). Hirsch writes:

> outside court, Muslim men complain bitterly about cases or mediations that did not go their way and about the khadis' alleged tendency to favor women. The Khadi's Courts have lost their legitimacy in the postcolonial period, and khadis are routinely criticized for their connection to the state as well as their partiality. Men's inability to retain control and authority in Khadi's Court is often attributed to the illegitimate intervention of the secular state, thus suggesting that, if the courts were really Muslim, men would have even more power over their wives. (1998, 239)

Furthermore, a *qāḍī*'s authority is contested not only from assessments made by the public, as Swahili Muslims question the court, but also by virtue of his position vis-à-vis the nominally secular state in Kenya, where Muslims constitute a minority community and Christians remain a powerful majority in a polity that recognizes a plurality of legal systems.

In Kenya, Muslims are entitled to adjudicate family law matters, such as marriage, divorce, inheritance, and child custody, in a *qāḍī*'s court; yet, as Hirsch tells us, this presents a double-edged sword. Women's use of the *qāḍī* courts is devalued even when they win their cases. First, they have broken community norms by narrating personal problems in a public forum. Second, their performance of gender in their testimony and other speech forms refracts through the gendered norms and commonly recognized subject positions of women in Islamic law, thereby reinforcing ingrained cultural understandings about how women and men stand in relation to each other. These courts provide sites for complex reworking of gender relations, and Swahili women turn to them as an institution that destabilizes men's authority in the community (1998, 239). Yet this comes at a price. For instance, in

1992, a *qāḍī* who had been assaulted on the streets of Mombasa because of his decision to grant a woman a divorce, admitted that many men are unhappy about what happens to them in court; however, in spite of his wounds (he had been stabbed several times), he resolved to "continue doing justice for women, in the name of Islam" (ibid.).

CONCLUSION

It may seem bewildering to be confronted with such a diversity of perspectives on the law. The different approaches to the study of law suggests very different starting points for understanding what law is, what it ought to be, and upon what grounds legal decision-making is based. No single framework characterizes contemporary legal studies. Rather, the law is viewed as diffuse, dynamic, and multifaceted. Generally these approaches share in common the foundation that law can only be understood in relation to a social and political context, in terms of the ways in which the law is elaborated in response to concrete political, economic, and social conditions. Thus armed with the disciplinary tools found outside the field of law – in economics, sociology, anthropology, philosophy, political science, history, and literature – legal studies scholars proceed to examine, interpret, and explain contingent sociolegal phenomena.

Debates about the subordination of women continue to account for much of the scholarly production in gender studies in the Middle East and Muslim world. The influence of feminist theory has made itself increasingly felt in recent years. The normative and material underpinnings of patriarchy in many of these societies, as well as the increasing attraction of conservative ideologies, has become the subject of "thick description," as demonstrated by the work of scholars of the ilk of Judith Tucker and Susan Hirsch. Not only the oppression and subordination of women, but the agency of women as well, is increasingly being examined and explained in a more complex theoretical field, one in which the analytic strength of the abstract term "patriarchy," and its relationship to Islam, are given better definition. The focus on the role of law in the processes of socioeconomic and cultural transformation of these regions, however, has been under-studied, and remains a crucial area for us to understand as greater pressures toward "globalization" incorporate many of these affected regions into the world economy.

BIBLIOGRAPHY

K. Abrams, Hearing the call of stories, in *California Law Review* 79 (1991), 971–1054.

M. Afkhami and E. Friedl (eds.), *In the eye of the storm. Women in post-revolutionary Iran*, London 1994.

H. Afshar, The legal, social, and political position of women in Iran, in *International Journal of the Sociology of Law* 13 (1985), 47–60.

A. Altman, *Critical legal studies. A liberal critique*, Princeton, N.J. 1990.

M. P. Baumgartner (ed.), *The social organization of law*, San Diego 1999².

D. Black, *The behavior of law*, New York 1976.

——, *Sociological justice*, New York 1989.

——, *The social structure of right and wrong*, San Diego 1993.

J. Brigham, *The constitution of interests. Beyond the politics of rights*, New York 1996.

R. Delgado, Storytelling for oppositionists and others. A plea for narrative, in *Michigan Law Review* 87 (1989), 2411–41.

J. Elkins (ed.), Pedagogy of narrative. A symposium, in *Journal of Legal Education* 40 (1990), 1–250.

P. Ewick and S. Silbey, *The common place of law*, Chicago 1998.

M. Fineman, *The neutered mother, the sexual family, and other twentieth century tragedies*, New York 1995.

M. Fineman and N. Thomadsen (eds.), *The boundaries of law. Feminism and legal theory*, London 1991.

B. Fleury-Steiner, Narratives of the death sentence. Toward a theory of legal narrativity, in *Law and Society Review* 36 (2002), 549–76.

D. M. Frankford, Social structure of right and wrong. Normativity without agents, in *Law and Social Inquiry* 20 (1995), 787–828.

F. Göçek and S. Balaghi (eds.), *Reconstructing gender in the Middle East. Tradition, identity, and power*, New York 1994.

S. Haeri, *Law of desire. Temporary marriage in Shiʿi Iran*, Syracuse, N.Y. 1989.

——, Temporary marriage and the state in Iran. An Islamic discourse on female sexuality, in *Social Research* 59 (1992), 201–23.

W. B. Hallaq, Was the gate of ijtihad closed? in *International Journal of Middle East Studies* 16 (1984), 3–41.

——, Ijtihad in Sunni legal theory. A developmental account, in M. K. Masud, B. Messick, and D. S. Powers (eds.), *Islamic legal interpretation. Muftis and their fatwas*, Cambridge, Mass. 1996, 33–43.

——, The quest for origins or doctrine? Islamic legal studies as colonialist discourse, in *UCLA Journal of Islamic and Near Eastern Languages* 2 (2002/3), 1–45.

S. F. Hirsch, *Pronouncing and persevering. Gender and the discourses of disputing in an African Islamic court*, Chicago 1998.

D. Kandiyoti, Bargaining with patriarchy, in *Gender and Society* 2:3 (1988), 274–90.

——, *Women, Islam and the state*, Philadelphia 1991.

——, *Gendering the Middle East. Emerging perspectives*, New York 1996.

D. Kandiyoti and A. Saktanber, *Fragments of culture. The everyday in modern Turkey*, New Brunswick, N.J. 2002.

C. MacKinnon, *Feminism unmodified. Discourses on life and law*, Cambridge, Mass. 1987.

——, *Toward a feminist theory of the state*, Cambridge, Mass. 1989.

——, *Only words*, Cambridge, Mass. 1993.

M. K. Masud, B. Messick, and D. S. Powers (eds.), *Islamic legal interpretation. Muftis and their fatwas*, Cambridge, Mass. 1996.

F. Mernissi, *Beyond the veil. Male-female dynamics in a modern Muslim society*, Bloomington, Ind. 1987 (rev. ed.).

——, *The veil and the male elite. A feminist interpretation of women's rights in Islam*, trans. M. J. Lakeland, New York 1991.

——, *The harem within*, New York 1995.

S. E. Merry, *Getting justice and getting even. Legal consciousness among working-class Americans*, Chicago 1990.

E. Moosa, The poetics and politics of law after empire. Reading women's rights in the contestations of law, in *UCLA Journal of Islamic and Near Eastern Law* 1 (2001/2), 1–46.

T. Oberweis and M. Musheno, *Knowing rights. State actor's stories of power, identity, and morality*, Aldershot, U.K. 2001.

C. Smart, *Feminism and the power of law*, London 1989.

——, Law's truth. Women's experience, in R. Graycar (ed.), *Dissenting opinions. Feminist explorations in law and society*, Sydney 1990, 1–20.

——, *Law, crime and sexuality. Essays in feminism*, Thousand Oaks 1995.

J. Tucker, *In the house of the law. Gender and Islamic law in Ottoman Syria and Palestine*, Berkeley 1998.

James B. White, *When words lose their meaning. Constitutions and reconstitutions of language, character, and community*, Chicago 1984.

——, *The legal imagination*, Chicago 1973, abridged ed. 1985.

——, *The edge of meaning*, Chicago 2001.

M. C. Zilfi (ed.), *Women in the Ottoman Empire. Middle Eastern women in the early modern era*, Leiden 1997.

KATHLEEN M. MOORE

Linguistics

This entry gives an overview of the study of gender in the field of linguistics in relation to Islamic cultures. Gender has been specifically studied in relation to society in the sub-field of sociolinguistics, which is concerned with the interaction between language and society. The entry deals first with the sources used by linguists to study gender in the Islamic world. Then the methods used to examine language in relation to gender are discussed, and the problems that occur in examining data, whether these problems are methodological or source-related. Note that the entry is limited in some ways. It concentrates on studies carried out on the Arab world, which is the result of two factors. First, the Arab world has been studied extensively by linguists and there are numerous English publications of work done on the Arab world. Second, Arabic is the author's field of linguistic studies and she can thus discuss and criticize them more effectively. References to works beyond Arabic have been included in the bibliography.

Sources used in linguistic gender studies

Linguists studying gender mostly use recordings of interviews, questionnaires, or word lists read aloud. For example, Stillman and Stillman (1978) used women's stories and songs in Morocco as a source of studying the language of women. These were collected in women's gatherings during work or play, or on semi-religious occasions such as weddings, circumcisions, and death. They studied songs dealing with topics that are of interest to women rather than men, and thus with a different form and content from men's songs. Abu-Lughod (1986) studied the sociolinguistic function of Beduin poetry of men and women of the Awlād ʿAlī in Egypt. Another interesting source is the one used by Hayasi (1998), an episode from a popular Turkish soap opera.

A recent study (Eid 2002) uses obituaries as a source in three communities, the Egyptian, the Persian, and the American. She obtained her data from three major newspapers, Al-Ahrām (Egypt), Iṭṭilāʿat (Iran), and the New York Times (United States). Her data was collected for a period of one month at ten-year intervals from 1938 to 1998.

Methods

Theoretical approaches. Some linguists have examined the semantic and pragmatic aspects of gender, others the morpho-syntactic, and a large group of linguists have examined the phonological (segmental) and prosodic features pertaining to gender differences.

The semantic and pragmatic aspects of gender have been studied by linguists like Hurreiz (1978), who compares and contrasts the use of specific expressions by men and women in formal and informal situations in Khartoum. Abu-Lughod's study (1986) of poetic discourse argues that poetry and songs are used by men and women to express different attitudes and feelings ranging from love to anger and defiance. She also points out how poetry defines and redefines the degree of intimacy between individuals. This is an example of a study that examines the symbolic nature of language when used by males and females. Jabeur (1987) studies the use of interjections in the urban dialect of Rades in Tunisia. Hayasi's study on Turkish (1998) shows the difference between men and women in relation to terms of address, interjections, and the use of religious expressions. He measures the frequency of occurrence of these features in the language of a husband and a wife in one episode of a Turkish television series. There was also a morpho-syntactic aspect to his study, the use of the emphatic first person singular pronoun in the language of men and women. Hirsch (1998) also studies the discourses of disputing in an African Islamic court in relation to Swahili. Finally there is the comparative study conducted by Eid (2002) in which she is concerned with the use of linguistic forms (especially terms of address) to represent symbolically identities of different individuals.

Morpho-syntactic studies include that of Jabeur (1987) of diminutives in the urban dialect of Rades. In addition, Owens and Bani Yasin (1987) in their study of the Banī Yasīn tribe of Jordan, examine the use of concord in the speech of men and women.

Phonetic, phonological, and prosodic features have been studied in relation to gender by a number of linguists. For example the consonant /q/ used in Arabic and its realizations by men and women have been studied by Kanakri (1984) in

relation to Jordanian Arabic. In his study of Rades, Jabeur (1987) also examines the realization of "q" as /q/ in the urban dialect, and as /g/ in the rural one. Daher (1999) studied the use of /q/ and the glottal stop in Damascene Arabic in relation to the language of men and women.

Other studies that concentrate on phonetic, phonological, and prosodic features are mentioned chronologically: Roux (1936) examined the differences between men's and women's speech in Morocco in relation to specific consonants, such as /s/, /z/, /r/. Hurreiz (1978) in his study of Khartum examined the use of intonation. Royal (1985) studied the relation between pharyngealization, class, and gender in Egypt. Intonation has also been studied in relation to gender by El Kareh and Abdel Alim (1988) with emphasis on the Egyptian Arabic of Alexandria. Al-Khateeb (1988) studied a number of consonants used in Irbid in Jordan which include /q/, /k/, /t/, and one vowel /a/. He studied them in relation to gender, education, and age. Al-Muhannadi (1991) studied the articulation of some segments including the /q/ in the speech of Qatari women. He found that certain segments characterize the speech of the Beduin community, while others characterize the speech of urban communities. Trabelsi (1991) studied the use of diphthongs and monophthongs in relation to gender in Tunisia. Haeri (1996) tried to provide evidence from certain phonological variables showing the difference between men and women in fronting and backing processes and relating these to social factors. Intonation was also examined by Rosenhouse (1993) in the speech of Beduin women's and men's stories in Palestine.

Data collection. The main problem facing linguists dealing with real life data is the observer's paradox. According to Labov (1972, 209) the aim of linguists is to find out how people talk when they are not observed, but one can only find out how they talk by observing them, which changes how they behave. This problem is not completely solved in the field of linguistics in general and sociolinguistics in particular.

The most prevalent method used in collecting data is the interview. The interview is either used by itself or with other methods and observations. For example, in his sociolinguistic study of Rades, Jabeur (1987) decided first to gather information about the history of the place, the reasons for the increasing population, internal rural migration, and the phenomenon of increasing residential mobility. He undertook a study of the socio-demographic characteristics. He studied the language of

twelve women, and to overcome the observer's paradox, he adopted the social network approach (Milroy 1980) in collecting his data, which is based on the idea that people behave differently in a group, influenced by their network. Therefore, a linguist has to study background information on the group that is being examined. For example, Jabeur introduced himself as "a friend of a friend," thereby depending on existing relations within a community rather than creating new relationships. He carried out interviews by recording information in places were people usually meet to drink tea; since they were network members this would reduce the effect of observation.

In her study of Egypt, Haeri (1996) also used the sociolinguistic interview, in addition to radio and television programs for children and adults and word list reading. She also adopted the social network approach, introducing herself as a friend of a friend. Her Muslim background also helped her. She analyzed the speech of 87 speakers, 50 women and 37 men and limited her study to traditional urban and modern or industrial urban groups in Cairo. To overcome the observer's paradox, she not only used the social network approach, but also tried to speak about personal things with her informants, such as childhood games, school days, family, falling in love, and local customs.

It is worth noting that there are a number of other linguists who tried to overcome the observer's paradox using the social network approach including, for example, Daher (1999), who directly referred to it in his study. Abu-Lughod (1986) did not refer to it by name in her study, but used it indirectly since she used her father's Arab background as an asset in her research, taking the role of "an adoptive daughter" (1986, 15). Though she started her fieldwork mainly as an anthropologist, she ended up with a study on the discourse significance of poetry in that community. Still, the methods she used to integrate in that community were not different from those used by others, such as Haeri (1996).

A number of the studies mentioned above depend on a technique different from the interview, for example, oral poetry, songs, television series, court disputes, and obituaries.

Data analysis. Most of the linguists dealing with the issue of gender, especially those dealing with it in the Islamic world, build their studies on the concept of quantitative studies. Quantitative studies aim to examine the correlation between linguistic variation and other variables, in particular social class (Coates 1993, 61). The dominant

method for examining data and measuring the occurrence of a certain variable or variables in relation to gender, class, or age is statistical analysis. Studies that rely on statistics that relate gender to other social correlates include Hurreiz's study (1978) of Khartum and the relation between language, gender, age, and education. Owens and Bani Yasin (1987) examine language used by men and women in the Banī Yasīn Jordanian dialect in relation to level of education and age. Abu-Haidar (1989) also compares the language used by men and women in a Baghdadi community in relation to language change.

There are statistical studies relating gender to social class. Haeri (1992), for example, in her study of Cairene Arabic, provides statistics that compare the linguistic behavior of men in three social classes with that of women belonging to the upper middle class. She found that the process of palatalization is associated with the lower middle class, and that upper middle-class women avoid it. She also used statistical methods in the same study to relate gender to age and/or social class. Daher (1999) uses statistics to establish the relation between gender and age and education, bearing in mind other factors such as word frequency and phonological environment. Finally, Eid (2002) uses statistics that parse different kinds of information. She measured the impact of gender, culture, and time, both independently and combined, on obituaries.

There are certain differences between the linguistic situation in the Arabic-speaking world and that in most of the Western world. In the Arabic-speaking world there is a difference between a prestige language and a standard one. There is also a diglossic situation in which two languages exist side by side, each with a different function (Ferguson 1959). There is a standard Arabic, which is used in education and sometimes in formal occasions, and there are also the different vernaculars of different countries (Bassiouney 2002). Many linguistic studies in the Arab world have shown that for most people there is a prestige vernacular, the identity of which depends on many geographical, political, and social factors within each country. In Egypt for example, for a non-Cairene it is Cairene. It is usually the urban dialect of the big cities. This linguistic situation does not exist in many Western societies, with the consequence that at first glance the results reached by some Western linguists concerning language and gender seem to contradict those reached by some

linguists in the Arab world. For example Labov (1972) concludes that women use a more prestigious form of language. Gall (1978–9) in her study of a village in Austria found that women use the prestigious variety of German more than men as a form of securing their position in society. Daher's conclusion (1999) that specific women of a specific background may not use some standard features of language does not contradict the findings of Labov and others, since women may still use the prestige form of language, which is different from the standard one. Note also the claim made by Abu-Haidar (1988, 210) that young women in the Arab world are more sensitive to linguistic changes and more innovative than men, whether young or old. This is in line with the claim made by Labov (1972, 243) that women are more sensitive than men to prestige patterns. Al-Muhannadi (1991) also mentions the diglossic situation in her study of Qatari women.

Most studies acknowledge the changing position of women in the Islamic world and the different roles women are now playing outside their homes and their participation in education and work as a factor that influences linguistic choices (Jabeur 1987).

There is a great deal to be done in the field of linguistics on gender-related issues. For example, we need more studies that examine job interviews, like the one that examines verbal interactions between men and women using recordings of several job interviews in Dutch companies (Bogaers 1998). Studies that concentrate on the media (for example, studies that examine advertisements) and how women are represented there linguistically are also needed.

When it comes to the methods used in studying language and gender, one finds that linguists studying the Islamic world, specifically the Arab world, use the same techniques as their Western counterparts: they concentrate on quantitative studies, they use social correlates, statistics, and finally they also try to overcome the observer's paradox. But no linguist has overcome the observer's paradox completely. As Haeri posits: "Investigating interactions between Iconic values based on sex differences and social structure is an inherently difficult task, and the data that would be required to completely examine the issue are not available" (1996, 106).

A main challenge of some of the studies mentioned above is that they are studies built on social

class. The term social class is a vague term that has been criticized by Milroy (1980). In some societies the idea of class does not exit.

Linguists studying language and gender in the Arab world need to expand their horizon and include more studies that examine gender in relation to code switching, for example, like that by Walters (1996) in Tunisia, and the diglossic situation should be considered more. Pragmatic studies that examine the language of men and women in relation to politeness are also needed. For example, Keating (1998) studied women's role in constructing status hierarchies, by examining honorific language in Pohnpei, Micronesia. Similar studies need to be undertaken on the Islamic world.

Many Muslim countries are multireligious societies. While there are studies that examine the linguistic differences between Muslims and non-Muslims, like that of Abu-Haidar (1992), which examines the Muslim and Christian dialects of Baghdad, there are few if any that directly compare women's language in a community with different religions. We need more studies that compare the linguistic situation of Christian and Muslim women in Egypt, for example, or between women speakers of other languages or dialects of the Islamic world, such as in India, Malaysia, or Indonesia. More studies that concentrate on semantic/pragmatic features, morpho-syntactic features, and phonological and prosodic features across more than one Islamic community, i.e. comparing the language of women and men in different Islamic communities, are also needed.

BIBLIOGRAPHY
F. Abu-Haidar, Male/female linguistic variation in a Baghdadi community, in A. K. Irvine, E. B. Serjeant and G. R. Smith (eds.), A miscellany of Middle Eastern articles. In memoriam Thomans Muir Johnstone 1924–83. Professor of Arabic in the University of London 1970–82, Harlow 1988, 151–62.
F. Abu-Haidar, Shifting boundaries. The effect of modern standard Arabic on dialect convergence in Baghdad, in Symposium on Arabic Linguistics, Perspectives on Arabic Linguistics IV, Amsterdam 1992, 91–106.
Lila Abu-Lughod, Veiled sentiments. Honor and poetry in a Bedouin society, Berkeley 1986.
M. A. A. Al-Khateeb, Sociolinguistic change in an expanding urban context. A case study of Irbid city, Jordan, Ph.D. thesis, University of Durham 1988.
M. Al Muhannadi, A sociolinguistic study of woman's speech in Qatar, Ph.D. thesis, University of Essex 1991.
R. Bassiouney, Functions of code switching in Egypt (evidence from monologues in the 1990s), D. Phil thesis, University of Oxford 2002.
W. O. Beeman, Language, status and power in Iran, Bloomington, Ind. 1986.

I. E. W. M. Bogaers, Gender in job interviews. Some implications of verbal interactions of women and men, in International Journal of the Sociology of Language (The Hague) 129 (1998), 35–58.
J. Coates, Women, men and language, London 1993.
D. Crystal, A dictionary of linguistics and phonetics, Oxford 1996.
J. Daher, Gender in linguistic variation. The variable (q) in Damascus Arabic, in Perspectives on Arabic Linguistics. Amsterdam Studies in the Theory and History of Linguistic Science, Series iv 11 (1998), 183–206.
M. Eid, The world of obituaries. Gender across cultures and over time, Detroit 2002.
S. El-Kareh and O. Abdel Alim, Correlation between intonation contours and sociolinguistics, in Federation of Acoustical Societies of Europe, Speech '88. Proceedings, Edinburgh 22–26 August 1988, 7th FASE symposium, ed. W. A. Ainsworth and J. N. Holmes, Edinburgh 1988.
C. Ferguson, Diglossia, in Word 15 (1959), repr. in P. Giglioli (ed), Language and social context, Harmondsworth, Middlesex, U.K. 1972, 232–51.
E. Friedl, Women in contemporary Persian folktales, in L. Beck and N. Keddie (eds.), Women in the Muslim world, Cambridge, Mass. 1978, 629–50.
G. Grandguillaume, Père subverti, langue interdit, in Mediterranean Peoples 33 (Oct.–Dec. 1985), 163–82.
N. Haeri, Why Do women do this? Sex and gender differences in speech, in G. Guy, C. Feagin, D. Schiffrin, and J. Baugh (eds.), Towards a social science of language. Papers in honor of William Labov, Amsterdam 1996.
——, The sociolinguistic market of Cairo. Gender, class, and education, London 1996.
T. Hayasi, Gender differences in modern Turkish discourse, in International Journal of the Sociology of Language 129 (1998), 117–26.
S. F. Hirsch, Pronouncing and persevering. Gender and the discourses of disputing in an African Islamic court, Chicago 1998.
S. H. Hurreiz, Social stratification and linguistic variation in Khartoum and its vicinity, in Occasional Papers in Linguistics and Language Learning 5 (1978), 41–9.
M. Jabeur, A sociolinguistic study in Tunisia. Rhades, Ph.D. thesis, University of Reading 1987.
M. A. Kanakri, Linguistic variation in the Jordanian Arabic dialect of males and females, M.A. diss., Wayne State University 1984.
E. Keating, A woman's role in constructing status hierarchies: using honorific language in Pohnpei, Micronesia, in International Journal of the Sociology of Language 129 (1998), 103–6.
W. Labov, Sociolinguistic patterns, Philadelphia 1972.
L. Milroy, Language and social networks, Oxford 1980.
J. Owens and R. Bani Yasin, The lexical basis of variation in Jordanian Arabic, in Linguistics 25 (1987), 705–38.
J. Rosenhouse, Contribution to the study of Moroccan Judeo-Arabic, Zeitschrift fur Arabische Linguistik 26 (1993), 66–87.
A. M. Royal, Male/female pharyngealization patterns in Cairo Arabic. A sociolinguistic study of two neighbourhoods, Ph.D. diss., University of Texas, Austin 1985.
A. Roux, Quelques mots sur le langage des musulmanes marocaines, in Orbis (1936), 376–84.
N. A. Stillman and Y. K. Stillman, The art of a Morrocan folk poetess, in ZDMG 128 (1978), 65–89.

Ch. Trabelsi, De quelques aspects du langage des femmes de Tunis, in *International Journal of Sociology of Language* 87 (1991), 87–99.

K. Walters, Gender, identity, and the political economy of language. Anglophone wives in Tunisia, in *Language in Society* 25 (1996), 515–55.

REEM BASSIOUNEY

Literary Studies

INTRODUCTION

The relation of the discipline of literary studies to the "women and Islamic cultures" of our present encyclopedic endeavor is first of all the relation of "women and Islamic cultures" to the category of literature itself. For this latter – literature, in its *modern* sense – and its attendant field of "literary studies" is a relatively recent intellectual and academic construction. Though poetry or epic or drama long pre-date the modern period and its concept of "literature," for literary studies they are understood in the modern world as specific genres contained within the broader category of literature. This was not the understanding of the ancient or classical worlds. Epic was recited by bards and inspired by the gods or the muses. It told of the lives of great mortal or semi-divine heroes and, infrequently, heroines – Gilgamesh or Innana, Odysseus or Achilles, for example – and of their relationships with the divine world and its gods as well as with the human world and its mortals. Drama had its origins in religious ritual. Poetry developed diversely in most languages of the ancient and classical worlds – love songs, elegiac verse, commemorative verse, praise songs, lyric poetry. These forms – and commentary on them – are millennia old. But the concept, term, and category of literature – and, thus, of "literary studies" – is a much later phenomenon, even if its critical "tradition" includes classical works of philosophy, rhetoric, narratives, or poetry. It is specifically in the modern period, with its construction of the category of literature and of literary studies, that we can speak of the relationship of literary studies to "women" and to "women and Islamic cultures."

MODERN LITERATURE

"Literature" comes into modern English, and into modern European Romance languages, from the Latin root *littera* or "letter." It designates, most basically, a written text – a text composed of letters. And it was, then, directly linked to the ability to decipher letters – to literacy. Literature and its study were a marker of status and class – of education, culture, manners – and of faith. And, whether or not the term and concept of literature in other languages (in the Arabic *adab*, for example) is based on the word for "letter" (and it is not in Arabic), the historical understanding of literature and access to it as the mark of culture and breeding, of textual access to religious scriptures and books, is shared from its earliest origins.

Religious literature. If specific genres – poetry, drama, epic – that are now folded into the modern category of literature have existed for millennia, so too have written texts. The sacred books of the three monotheistic religions – Christianity, Judaism, and Islam – though each with their origins in the spoken word, were all ultimately recorded and passed down as written texts as were the sacred texts of many other religions and regions. They constitute, then, "religious literature." For such religious literature, what we now call the discipline of "literary studies" was more properly textual scriptural studies – the study of the sacred word. It was a careful, serious, and faith-based linguistic endeavor. Thus, the answer to the question of whether or not there is an Islamic literature *in this sense* is unquestionably affirmative. There is a vast and rich body of religious texts that we might call – that, in fact, have been called for centuries – Islamic or Christian or Jewish or Buddhist literature.

But this is not the literature of modern literary studies. And the distinction is crucial, I think. In fact, if we are to posit a category of *modern* Islamic literature, its most productive understanding would not be as a necessarily religious or even religiously informed literature. Nor would it necessarily be a literature written by Muslims. Rather, Islamic literature is *modern* literature informed by the great multiple traditions of Islamic culture – which suffuse the literary and cultural contexts of the modern Arab world (though not only there). Thus, "Islamic" culture imbues the visual and textual and cultural production by a diverse range of artists, regardless of their specific religious affiliation or of any religious affiliation at all.

Literacy. Modern literature does, however, bear the weight of traditions from across the centuries of literature as the written religious text, and of the man – or sometimes the woman – of literature as he or she who reads and understand the sacred word. And modern literature bears the weight of traditions for which he or she who reads is, by

extension, educated, cultured, mannered, and even
moral. And the foundation of that morality, cul-
ture, manner, and education was literacy, defined
as the ability to read the sacred book or books. So,
as in late sixteenth-century England: "hes nocht
sufficient literatur to undirstand the scripture" (he
hasn't sufficient literature [or letters] to under-
stand scriptures) (quoted in Williams 1976, 184).
Still and already, in the emergence from the classi-
cal or Byzantine or Islamic or classical Chinese
worlds, literature and its reading – if not yet its
study as in the "literary studies" of our present
topic – was increasingly associated with books of a
wider purview than sacred texts. In the medieval
Islamic world, a learned man or woman could read
the sacred texts of Islam. But he or she could also
read works of geography, history, philosophy,
poetry, medicine, and travel narratives. In a paral-
lel fashion, in the late European medieval world,
and especially for Renaissance Europe, the con-
cepts of literacy and literature, while closely inter-
twined, were also more expansive, including more
than works of a sacred nature.

Late 18th – early 20th century. Modern litera-
ture, in modern as opposed to ancient or classical
or medieval languages, emerges, then, subsequent
to the traditions of sacred texts. It is enabled and
shaped by the spread of a shared vernacular lan-
guage, by the rise of printing presses, of news-
papers, of educational systems that began to
include broader social strata than a royal or court
or clerical elite. And modern literature is crucially
informed by the simultaneous modern historical
movements of nationalism, international capital-
ism and colonialism – which are, as Etienne Balibar
sagely reminds us, diversely interwoven. "In a
sense, every modern nation is a product of colo-
nization: it has always been to some degree colo-
nized or colonizing, and sometimes both at the
same time" (Balibar and Wallerstein 1991, 89). For
colonizing *and* colonized peoples, these social,
economic, and political conditions contributed to
a notion of literature as more widely accessible, as
presumably secular, and also as presumably an
articulation of the history and "character" of a
(national) people. Modern literature – that is,
written texts designated and valued as "literary"
from the period beginning in the late eighteenth
century to the early nineteenth century – unques-
tionably enfolded within its boundaries earlier
written and oral traditions – of sacred texts, of
oral poetry, of folk song and folk legend, of earlier
classical or medieval texts. But modern literature
was pressed into service as the textual illustration
of the culture and history of a presumably *national*

and *modern* people. (Alternatively, of course, it
could be used as "evidence" of the non-modernity
and non-national or "backward" character of a
people.)

The nations emerging as ideological, cultural,
economic, and political entities from the great
empires of the "East" and "West" – from the
Austro-Hungarian, Ottoman, or Russian Empires –
or expanding as new imperialist powers – France
and England, following on their predecessors,
Portugal and Spain – increasingly sought to legiti-
mate their aspirations to being (or, in their pre-
ferred self-image, to already being) modern and
unified nations via literature (and culture). That is
to say, modern literature in modern languages is
implicated far more directly than earlier textual
traditions in the value-laden categories of empire,
nation, ethnicity, and race. While these concepts
and their social realities certainly were not new
to the modern period, they were doubtless dif-
ferently relevant and certainly differently config-
ured for ancient or classical societies or for
medieval societies or for monotheistic religions
and their texts.

The nation-state. The category of modern litera-
ture, then, increasingly came to be identified with
(the preferred self-image of) a people or a nation
and with their modern and vernacular or at least
modernized national language. In this formula-
tion, modern literature reveals the essential char-
acteristics and cultural continuity of a people –
the general – through its very particularity or
specificity – the literary text and its particular
workings. Parenthetically, this formulation of
modern literature as simultaneously particular –
the individual literary text and its unique work-
ings – and general – what the literary text manifests
about a broader category of a people, a class, a
nation – echoes a very venerable argument indeed.
In a classical quarrel between the particular and
the general, Aristotle's *Poetics* designated poetry as
more universal (and hence more philosophical)
than history – which is concerned only with the
particulars. Modern literature seems to want it
both ways. And one of the tasks of *modern* literary
studies, then, would be to trace the workings of
both in the modern literary text. Thus the disci-
pline of literary studies as a theoretical reflection
on and analysis of the creative practice of litera-
ture was called upon to pay careful attention to
literature and its organization, to its language and
linguistic use – to literary content, tropes, images,
and symbols. For, if sacred texts were a manifesta-
tion or revelation – or at least a suggestion – of the
traces of the divine, modern, "secular," vernacular

texts were some sort of manifestation or revelation as well, though now no longer of the divine but of a people or nation. (Romanticism and its legacies also offer us the literary text as the manifestation or revelation of the unique style and insight – if of an individual author more often than of a people or a nation.) This formulation of literature and of its concomitant discipline of literary studies was largely the articulation of an emerging elite of the nascent nation or nation-state. And, not surprisingly, the preferred self-image of "modern literature" and of the discipline of literary studies, as of modern nations and elites, was inconceivable without the construction of other *non*-elites, *non*-nationals, and *non*-moderns. (G. W. F. Hegel's *Phenomenology of Spirit* with its trajectory of a progression of cultural and spiritual development of [European] nations or Matthew Arnold's *Culture and Anarchy* with its exhortation to the teaching of culture as an antidote to the threat of the lower classes are familiar and influential European illustrations of this configuration.)

WOMEN IN ISLAMIC CULTURES

The crucial importance of this relatively recent category of modern literature to the cultural *and* political production of what came to be called, in the last decades of the twentieth century, "representations of identity" is critical to a consideration of the discipline of literary studies as it attempts to account for "women and Islamic cultures." For in earlier formulations of "literary studies," the study of women and/or of Islamic cultures was not in the manifest foreground of the discipline; such study would barely have registered at the disciplinary margins. (Eric Auerbach's magisterial *Mimesis: The Representation of Reality in Western Literature*, though in fact written in the Muslim "East" during the Second World War – in Istanbul, scarcely attended to "women and Islamic cultures." Nor did Wellek and Warren's *Theory of Literature*, another foundational text for literary studies in the first half of the twentieth century. More concerned with defining a field and its disciplinary foci that contained a presumably agreed-upon literary tradition, "women" or "women and Islamic cultures" were not within the range of their critical attention.) The categories of "women" and "Islamic cultures," if present at all, would have been largely relegated to vaguely titillating quasi-anthropological fantasy on the one hand (women) and exotic and vaguely titillating quasi-anthropological displays that largely confirmed the cultural and moral superiority of the west on the other (Islamic cultures). (For numerous literary exam-

ples of this phenomenon with an astute historical view, see Mohja Kahf's *Western Representations of the Muslim Woman* with its contrast between medieval and Renaissance views of Muslim women and those of the modern period.) Though in fact foundational to the constitution of notions of the "modern" and the "West," since the modern must necessarily posit itself against a non- or anti-modern and the West against a non- or anti-West, women and Islamic cultures were hardly considered central to the discipline of literary studies. More precisely, they were not considered relevant. Concerns of linguistic or structural formalism, discussions of genius and stylistic innovation, of civilizational superiority, or of authorial biography dominated the discipline. It is only in more recent decades, from the post-Second World War period but most especially from the 1970s, that literary studies turned its attention beyond a designated canon of a literary tradition that fairly uniformly excluded women and Islamic cultures – as it excluded many other peoples and cultures.

POSTCOLONIAL STUDIES

Edward Said's *Orientalism*, based on earlier and simultaneous work in France, became a foundational text for literary studies in the English-speaking world of the ways in which this modern eighteenth- and nineteenth-century construction process worked – most specifically for Said, of the ways in which the "West" constructed the "East." And in the folds of Said's analysis of the "Western" postulation of a largely imaginary "East" are compelling suggestions of the ways in which the "West" constructed not just the "East" but itself in the process. Said's *Orientalism* would become one of the founding texts of a field of literary studies – "postcolonial studies" – that would include as one of its proper objects "women and Islamic cultures." And the study of women and/or of Islamic cultures from this critical perspective sought not just to provide yet another story from yet another previously ignored perspective. More radically, it sought to refocus the very definition of the "Western" itself by illustrating in textual action the crucial dependency of elite notions of what was "Western" or "male" or "European" or "rational" or "civilized" on the creation of what was postulated as its polar opposite. In this context, the study of women and of women in Islamic cultures became one among a number of important ways to challenge and seek to disassemble the narrative of the unremitting march of reason, truth, light, and civilization over against the dark, erotic, violent,

feminized East. (This deadly series of oppositions is still in place, even if with some minor rhetorical tinkering, in the early twenty-first century. It is lethally mobilized once again to wage war or to justify wars already being waged against parts of the Arab world, though not only there.) Literary studies contributed to this disassembling effort its traditionally careful attention to language, to the construction of literary form, to the use of image and figure, of metaphor and symbol. And these characteristics of a (literary or non-literary) text were no longer referred to as simply the marks of the genius and creativity of an author, a language, or a great cultural tradition. They registered the fault-lines of exclusion and inclusion, of repression and silence, of power and domination. (See Leela Gandhi's *Postcolonial Theory* for a concise and clear formulation by a literary scholar of post-colonial theory's intersections with feminism, nationalism, and with the challenge of not effacing differences amongst peoples.)

SUBALTERN STUDIES

Roughly simultaneous with this Anglo-French development in literary studies was the equally important and wide-ranging (though not necessarily literary) work of the subaltern studies group in South Asia. (For an introduction to their work, see Guha and Spivak, eds., *Selected Subaltern Studies*; for a suggestive extension of Subaltern Studies' South Asian origins elsewhere, including to pointed considerations of gender, see Ileana Rodriguez, ed. *The Latin American Subaltern Studies Reader: Latin America Otherwise*.) Drawing from "Eastern" and "Western" theoretical traditions, subaltern studies sought to (re)construct the story of subaltern or non-dominant history that was missing both from colonial and from post-independence elite histories of India. They focused their intellectual attention on the role of groups of people almost completely missing from official, elite history – the urban poor, the peasantry, the large masses of people in India who were engaged in the making of modern India. In this context, the roles of women and of religion were included in their field of critical attention. Mining official colonial records as well as previously ignored historical documents, subaltern studies sought not just to construct a counter-narrative to an official history that allocates a "spurious primacy" to national elites. More boldly, subaltern studies as a linguistic, textual, cultural, and historical enterprise suggests, at its best, a deconstruction or problematizing of the very categories that inform colonial and national histories. The theo-

ries of cultural, social, and historical change, implicit in the work of the subaltern studies group, as the (violent) transition between sign systems situates its efforts – if metaphorically – on a terrain shared with literary studies that would study the workings of sign systems in literary texts.

So too, feminist theories and analyses – particularly, but not exclusively, with literary focuses – would take as their objects of analysis the category of "women" as it was absent from or silenced in the dominant narrative of "literature" or "culture" or "civilization." (The classic French text is Simone de Beauvoir, *The Second Sex*; for English and nineteenth-century English literature in particular, rather than language as a whole in de Beauvoir, one of the classic early texts is Gilbert and Gubar's *Madwoman in the Attic*.) And the categorical rubric of "women" grew to include not only a putatively universal concept of "woman" but also women "elsewhere." (For an incisive critique of feminism's myopia, see Chandra Talpade Mohanty's still important essay of the mid-1980s, "Under Western Eyes: Feminist Scholarship and Colonial Discourses.") This acknowledgment of women elsewhere – that is, outside of the presumably white, European origins of the "Western" feminist movement (though this construction of the origins of Western feminism ignores a rich array of women's activism that is neither) – included various kinds of attention to "women in Islamic cultures." As well, to the extent that French intellectual life in the post-Second World War period was directly confronted with and challenged by the French colonial legacy in North Africa, most famously in Algeria, French political, literary and feminist theories were even more explicitly drawn to a consideration of "women and Islamic cultures." The situation of women in Islamic cultures became an object of political or historical or literary attention for some feminist thought. (See, for example, the work of the Algerian-Jewish-French feminist theorist, Hélène Cixous, but also the work of sociologist Marnia Lazreg, or literary scholar Winifred Woodhull, or that of Miriam Cooke or Fedwa Malti-Douglas, the latter two writers informed by the French feminist tradition if not necessarily operating from within its parameters.) And, albeit with uneven attention to their rich and diverse traditions, writings by women from or in the Islamic worlds began to be translated. (For excellent and accomplished translations and contextualization, see for example, the work of Marilyn Booth or of Salma Khadra Jayyusi and the Project for the Translation of Arabic, which she directs.) In addi-

tion, the influence of psychoanalytic theory – originating in the work of the nineteenth-century Austrian "father of psychoanalysis," Sigmund Freud, and evolving substantially in the work of the twentieth-century psychoanalytic theorist, Jacques Lacan, and the numerous appropriations of his work – in the field of feminist literary studies is noteworthy in this instance as it summons attention to language and its (often unintentional) tropic use as an optic for understanding gendered cultures. (See, for example, Evelyn Accad's *Sexuality and War* or the insightful performance of a literary analysis profoundly informed by psychoanalysis and by questions of race and gender – though the focus of her attention is not women and Islamic cultures – in Barbara Johnson's excellent *The Feminist Difference: Literature, Psychoanalysis, Race, and Gender*.)

CONCLUSION

This brief survey of broad categories of thought and analysis – of modern literature and its attendant discipline of literary studies, of attention to (or ignoring of) "women and Islamic cultures" – reiterates an abiding concern of literary studies that has inflected that discipline's effort to "study" women and Islamic cultures. Postcolonial or feminist or subaltern studies have each refocused attention on women and (Islamic) cultures within the field of literary studies. (See also the compelling intersection of these approaches in a work such as Ania Loomba's *Colonialism/Postcolonialism*.)

Studying literature – learning to read with careful attention to language and form, to structure and content, to historical and social context, to literary traditions – provides a way of reading and "learn[ing] to learn from the singular and unverifiable" of literature (Spivak 1998, 145, n. 49). It can remind us, if only figuratively, of how we "study" and "read" the world beyond the literary text. A great diversity of epistemologies (ways of knowing), theories (generalized optics or ways of seeing), and methods (ways of disciplinary practice) inhabits the discipline of literary studies. Nevertheless it attempts to take up questions of gender ("women"), of relative cultural difference ("Islamic cultures"), and of unequal relations of cultural and social power – though it has not always done so – literary studies can afford a useful reminder of the ways in which the study of literature teaches us to read, to query, and to learn differently, and to be attentive to the silences, lapses, and ambiguities of (literary) language, text, and context.

If literature interrupts the familiar use patterns and conventions of language, in so doing it offers

an opportunity to the reader to reflect anew on the (literary) word, on the literary world, and on the extra-literary world. If literature interrupts the familiar use patterns and conventions of language, it can also engage in a similar and similarly productive interruption of patterns and conventions of thought. It can call attention to the ways in which the unheeding or intellectually careless study of women and Islamic cultures can construct away the object of critical attention. For inclusive study carries its own dangers, as Gayatri Chakravorty Spivak shrewdly signals:

> This demand [on the inhabitant of the Third World to speak up as an authentic ethnic fully representative of his or her tradition] ... in principle ignores an open secret: that an ethnicity untroubled by the vicissitudes of history and neatly accessible as an object of investigation is a confection to which the disciplinary pieties of the anthropologist, the intellectual curiosity of the early colonials and the European scholars partly inspired by them, *as well as* the indigenous elite nationalists, by way of the culture of imperialism, contributed their labors, and the (proper) object (of investigation) is therefore "lost" (1998, 60).

Yet still, within the field of literary studies as it reads and studies literature, "learning to learn" from the "singular and the unverifiable," we might also learn to learn from that which is not the same, not a confection of repeatable identity, not simply a quiescent object for literary or any other study. We might also be able to learn to learn *from* women in Islamic cultures. And perhaps *about* women and Islamic cultures. All the while questioning those categories of thought that appear to us as a given – "women" or "culture" or "literature," or yes, even "Islamic."

BIBLIOGRAPHY
E. Accad, *Sexuality and war. Literary masks of the Middle East*, New York 1992.
M. Arnold, *Culture and anarchy*, New Haven, Conn. 1994.
E. Auerbach, *Mimesis. The representation of reality in Western literature*, trans. W. R. Trask, Princeton, N.J. 1968.
E. Balibar and I. Wallerstein, *Race, nation, class. Ambiguous identities*, trans. Chris Turner, New York 1991.
S. de Beauvoir, *The second sex*, trans. H. M. Parshley, New York 1988.
M. Booth (trans.), *Stories by Egyptian women. My grandmother's cactus*, Austin, Tex. 1993.
H. Cixous, *The Hélène Cixous reader*, ed. S. Sellers, New York 1994.
H. Cixous and M. Calle-Grubar, *Hélène Cixous, rootprints. Memory and life writing*, trans. E. Prenowitz, New York 1997.
M. Cooke, *Women claim Islam. Creating Islamic feminism through literature*, New York 2000.
L. Gandhi, *Postcolonial theory*, New York 1998.
S. Gilbert and S. Gubar, *The madwoman in the attic. The woman writer and the nineteenth-century literary imagination*, New Haven, Conn. 1979.

R. Guha and G. C. Spivak (eds.), *Selected subaltern studies*, New York 1988.

G. W. F. Hegel, *Phenomenology of spirit*, trans. A. V. Miller, New York 1977.

S. K. Jayyusi (ed.), *Anthology of modern Palestinian literature*, New York 1992.

——, *The literature of modern Arabia. An anthology*, Austin, Tex. 1989.

——, *Modern Arabic poetry*, New York 1991.

——, *The legacy of Muslim Spain*, New York 2000.

B. Johnson, *The feminist difference. Literature, psychoanalysis, race and gender*, Boston 1998.

M. Kahf, *Western representations of the Muslim woman. From termagant to odalisque*, Austin, Tex. 1999.

M. Lazreg, *The eloquence of silence. Algerian women in question*, New York 1994.

A. Loomba, *Colonialism/postcolonialism*, New York 1998.

F. Malti-Douglas, *Woman's body, woman's word. Gender and discourse in Arabo-Islamic writing*, Princeton, N.J. 1992.

C. T. Mohanty, Under Western eyes. Feminist scholarship and colonial discourses, in *Feminist Review* 30 (1988), 61–85 and C. T. Mohanty, A. Russo, and L. Torres (eds.), *Third world women and the politics of feminism*, Bloomington, Ind. 1991, 191–208.

I. Rodriguez (ed.), *The Latin American subaltern studies reader. Latin America otherwise*, Durham, N.C. 2001.

Nawal el-Sa'adawi, *Memoirs from the women's prison*, trans. Marilyn Booth, Berkeley 1994.

E. Said, *Orientalism*, New York 1978.

G. C. Spivak, *A critique of post-colonial reason. Toward a history of the vanishing present*, Boston 1998.

Sahar Tawfiq, *Points of the compass. Stories*, trans. M. Booth, Fayetteville, Ark. 1995.

R. Wellek and A. Warren, *Theory of literature*, New York 1956.

R. Williams, *Keywords. A vocabulary of culture and society*, New York 1976.

W. Woodhull, *Transfigurations of the Maghreb. Feminism, decolonization, and literatures*, Minneapolis, Minn. 1993.

Laṭīfa Zayyāt, *Open door*, trans. M. Booth, Cairo 2000.

MARY LAYOUN

Oral History

The revival of oral history was spearheaded in the 1950s and 1960s by socialist historians who sought to chronicle the lives of the working classes and ordinary people. With the establishment of the British Oral History Society in the 1970s, an international movement gained momentum and a number of projects with radical sociopolitical agendas were initiated. In general, by shifting attention from the annals of the rich and famous, the subject matter of official history, and by giving primacy to the lives of ordinary people, oral history was perceived as a powerful tool for radical social transformation and democratization. Feminist historians, in response to the question posed by the women's movement, "Where are the women in history?" set out to redress the balance by searching for women who had been marginalized or silenced in official histories. Documentation of the oral history of women was conducted within a feminist agenda that consciously sought to recover silenced voices, to challenge dominant histories that excluded women's experiences, and hence to effect social change. The motto of most pioneering projects was: research by women, about women, and for women.

From the moment of inception, the discipline of oral history has been at the center of debate and controversy. To begin with, its legitimacy was, and still is, challenged by traditional historians who question the reliability of oral sources and cast doubt on their truth value. Objectivity as a principle of historical research is pitted against the assumed subjectivity of oral accounts. Oral historians have had to fight to gain acceptance for their sources and to enlarge the space for historical research. They pointed out that although historians have always resorted to oral accounts for verifying their records, it was only in the nineteenth century that institutionalized academic research privileged archival sources and undermined oral narratives. They also drew upon postmodern theories that exposed the myth of "objectivity" in the various sciences and demonstrated how all scientific research projects were laden with assumptions and prejudices of a situated knower who belonged to a particular sociopolitical context. Moreover, they argued that one of the distinguishing characteristics of oral history was that

it was not so much about what happened, as it was about the meaning of what happened. And, to understand the complexities of meaning, we needed to pay attention to the processes of construction and articulation of this meaning.

In other words, orality and the workings of memory become key principles in oral history research. Oral historians succeeded in revising the two concepts that were used to undermine oral history by giving them primacy and value. They challenged the Eurocentric binary opposition which privileged literacy over orality and uncovered the inherent potential of oral traditions and narratives in shaping social consciousness and effecting social transformation. For example, Alessandro Portelli foregrounded the workings of memory, and maintained that the perceived unreliability of oral sources was in fact a strength rather than a weakness, because "memory is not a passive depository of facts, but an active process of creation of meanings ... changes reveal the narrator's effort to make sense of the past and to give a form to their lives, and set the interview and the narrative in their historical context" (Portelli 1990, 53–6). He also highlighted the orality of the oral narrative, drawing attention to matters of language, intonation, narrative form, and subjectivity. Like the best work on oral history, Portelli's approach is interdisciplinary. Oral historians have drawn upon insights and research methodologies developed within the fields of anthropology, sociology, literary criticism, linguistics, cultural studies, and psychology. This has moved the debates on oral history from the confines of what is true or false, fact or fiction, to the realms of consciousness, awareness, and the relationship between social memory and subjectivity.

INTERPRETING MEMORY

The interpretation of oral narratives has been the primary concern of historians in the last decade. In an influential work, Luisa Passerini pointed out that "the raw material of oral history consists not just in factual statements, but is preeminently an expression and representation of culture, and therefore includes not only literal narrations but also the dimension of memory, ideology and subconscious desires" (Passerini 1998, 54). Old sociological models for analyzing life

stories are relinquished in favor of concepts developed within the discipline of literary criticism, such as narratology and textual analysis. Researchers have approached oral interviews as discourse, as text, and as narrative. Some have explored not only the verbal, but also the nonverbal language of the text, highlighting the performative aspects of the dialogue situation inscribed in all interviews. To give one specific example, Kathryn Anderson and Dana Jack offered three approaches for listening to an oral narrative. The first focuses on the narrator's "moral language" where relations between self-concept and cultural norms are evaluated. The second attends to the narrator's "meta-statements," which reveal the perceived discrepancy between what is expected and what is actually said. The third explores "the logic of the narrative," paying attention to repetitions, inconsistencies, choices, and other textual issues (Anderson and Jack 1991, 18–20).

Researchers have also been concerned with the social implications of these interpretations of modes of subjectivity. In fact, many have expressed their alarm and dismay at what is perceived as a move away from the social to the subjective. The challenge has been how to deduce from an analysis of narrative techniques general indications about social memory and social structures. In "What is Social in Oral History?" Samuel Schrager suggests a number of strategies for linking the individual with the social. He compares the similarities and differences between the narratives of the same event; he explores the implications of the position of the teller to the events; and finally and most importantly he examines the ambivalences and complexities of the shifting points of view that the narrator adopts in order to present his perspective as well as the perspective of others in his community. Through an analysis of a primarily literary concept, the point of view, Schrager is able to go beyond the subjectivity of the speaker and to shed light on the social forces at work (Schrager 1998, 76–7).

Researchers have also shown interest in the gendered dimensions of oral narratives. Drawing upon linguistics and narrative psychology, they raised questions about the potential differences between men and women in modes of speech and communication, in their presentation of themselves, in interpreting questions, and so forth. Feminist researchers have argued that women's oral narratives can only be understood within the sociopolitical context that devalues women's concerns and perspectives. Hence, women are more liable than men to understate their interests and to

undermine their achievements or their activities. Also, and again unlike men, women's life stories are not only about their relation with the world, but they are also usually told in response to the representations of women in society as a whole. Gender as a category of analysis and interpretation of oral narratives has benefited substantially from the noted boom in autobiographical theory and women's writings in the last decade of the twentieth century.

ETHICAL AND THEORETICAL DEBATES

The growing vitality of scholarship on oral narratives has led to a revision of many of the initial concepts and approaches that inspired the field in the early phase. The initial feminist motto of doing research by women, about women, and for women has come under close scrutiny on ethical and theoretical grounds. The ethical dilemma facing oral historians centers on the unequal power relations embedded in the interview dynamics. Like feminist anthropologists, who have made a concerted effort to counter the hierarchical relationship between the interviewer and the interviewee in traditional anthropological practices – emphasizing participant observation methods, more interaction between the two parties involved, less distance – oral historians have posed some disturbing questions about their feminist goals. How does the interview really benefit the women concerned? How does it support or advance their agendas? What happens when the interviewer and the interviewed have conflicting agendas? Whose voice is finally heard when the interview is published or made public by the researcher? Who has the final control over the manuscript? To what extent does the interviewed woman control "her words"? Finally, what are the real political consequences of doing oral history? Will textual analysis that exposes oppressive hegemonic discourses succeed in changing the situation of women in the real world?

As an example of an attempt to deal specifically with the last question, Claudia Salazar (1991) offered a number of strategies for action, which include inverting the hierarchies of discourse, making the marginal central, and developing forms of community based writing. Sondra Hale (1991) also raised many of the issues mentioned in relation to her experience interviewing a leading Sudanese feminist, and proceeded a step further. After reflecting on questions about the fallacy of shared goals and who is entitled to use whom in an interview situation, she found that

her experience gave her some valuable insights regarding "the flaws in certain western feminist ideas about methodology". She argued that the trend to privilege the process over the product has led to a great deal of personalizing and some false assumptions about identification that have only curtailed the analytic abilities of the researcher. Many researchers have suggested that a critical self-awareness of unequal power relations and methodological problems can contribute towards an amelioration of research hierarchies. Others are extremely sceptical about the effectiveness of this, perceiving it to be an indulgent catharsis that does not lead to any changes in the power hierarchies and only serves to make researchers feel better about themselves.

Current theoretical debates mainly revolve around the postmodern turn in the analysis of historical texts, and the problematic of "experience." Postmodern theories have led to many insights regarding the interpretation of oral narratives, bringing to the fore issues of language and subjectivity. Nevertheless, many historians are becoming critical of what they perceive to be an exaggerated emphasis on the textuality and the constructed nature of the oral text. They are concerned that the question of agency will inevitably be subsumed within a postmodern indeterminacy, and that the search for historical causality will be abandoned. The challenge to researchers can be summarized in this question: how can postmodern insights in language and subjectivity be combined with a materialist analysis of history?

The issue of interpreting "experience" is equally challenging. Feminist research in history has been prompted by a belief in the necessity of giving voice to women as a prerequisite for empowerment. Along with several other theorists, Gayatri Spivak (1985) asked whether the subaltern could speak and be heard in spite of dominant cultural formations that had already set the rules of discourse, and that inevitably direct and shape meaning and consciousness. She drew attention to two issues: first to the assumed ability/disability of the speaker to express or construct her subjectivity outside/inside the domain of dominant discursive practices; and second to the role of the mediator/researcher/oral historian, mediating between the voice and the world. Furthermore, voices do not exist in a vacuum: they operate – they are constructed, voiced, and understood – within historically specific discourses and situated regimes of truth. Joan Scott (1991) makes a case for a vigilant "historicizing" of experience to avoid the pitfalls of equating experience with truth.

On another level, shared experience, or the assumed sisterhood between women from different backgrounds, has been radically revised by researchers. Again, the postmodern emphasis on diversity and specificity, as well as the critiques of essentialist categories that lumped people together in unrealistic groups and alliances, have highlighted differences at the expense of similarities. Researchers engaged themselves in investigating the implications of differences in class, race, gender, and culture for the mediator and interpreter of women's experiences. To what extent can we understand the complexities of different experiences, given the fact that both researcher and researched speak from constructed positions that reflect a host of different variables? These directions, particularly with the focus on issues of "othering" and representation, have raised questions about the shifting boundaries between the researcher and the researched, about who is entitled to do research about whom, and about who can be considered an insider or an outsider, about who has the prerogative to speak for whom.

THE ORAL HISTORY OF WOMEN IN ISLAMIC CULTURES

In addition to the debates about oral history in general, documenting, disseminating, and conducting practical and theoretical research on the oral narratives of women in Islamic cultures raise further questions. These are intricately linked to the challenges presented to the editors of this encyclopedia in the process of defining concepts, identifying potential audiences and making difficult decisions about processes of inclusion and exclusion. How can we represent the narratives of Muslim women to an international (English speaking) audience, given that the existing representations of Islam, Islamic cultures, and women in Islamic cultures are subject to very serious international power struggles that are further complicated by a colonial heritage? A discussion of this issue needs to address two points: the influence of the colonial past on the representation of women in Islamic cultures in the present, and the geopolitical implications of the production and dissemination of knowledge.

Negative representations of "Muslim woman" dominate colonial discourses in the past as well as in the present. She is the quintessentially traditional, or even "backward" "other," who functions as the perfect antithesis to the superior and modern self of the Western woman. Her

perceived weakness or disadvantaged position within her culture is used to support claims about the intrinsic backwardness and "anti-modern" condition of Islamic cultures. As a reaction, women became instituted in their cultures as the bearers of tradition and gradually became the symbols of those "unchanging" qualities in Islamic cultures that have been successfully preserved by Muslim societies in spite of Western colonial onslaught. Hence, current representations of women in Islamic cultures are caught between colonial and nationalist discourses. And most discussions of the representations of women are forced to carry the burden of this legacy: they may react to it, challenge it, deconstruct its assumptions, but they cannot disregard it.

This leads to the second point regarding the effect of geography on the production of knowledge. More specifically, what is the state of oral history projects recording the life stories of women in the Arab world? To date, there are no formally established institutions that house oral history archives of women in Arab countries. There are a number of projects and some publications. In Tunis, a series of projects on women's oral narratives was conducted in association with the oral history unit in the Institute of the History of the Nationalist Movement in the University of Tunisia I. In Palestine, a project to document the political oral history of Palestinian women was undertaken by the Ministry of Planning and International Cooperation. In Egypt, the Women and Memory Forum has initiated a project to build an oral history archive of voices of Egyptian women who played a role in public life in the first half of the twentieth century. Still, the bulk of the work done to document oral narratives of women is conducted by anthropologists for the purpose of a research publication, and the sources or the oral material do not end up in an archive that could be made available to other researchers.

Added to this, most of the scholarship on women in Islamic cultures is produced by Western researchers, or researchers situated in Western universities or research organizations. Consequently, all the theoretical paradigms and assumptions behind the work have not been produced within the countries under research, but by the countries doing the research. This point is further complicated if we take into consideration other variables that regulate the research relationship between East and West, such as the modest academic standards of local research institutions, the scarcity of resources available to local researchers, as well as the unequal power relations of many Muslim countries vis-à-vis the "West."

All of this poses some troubling questions regarding the production and consumption of knowledge. Who produces knowledge and for what purpose? Who is the consumer of knowledge and how is it assimilated and used? The fate of the oral narratives of women in Islamic cultures is intricately linked to the politics of production, reception, and consumption in a global context. What a narrative means varies depending on the geopolitics of reception. Issues of interpretation and theoretical and ethical dilemmas facing oral historians discussed here gain urgency within a context of contested meanings and power struggles. The final challenge remains: to what extent can "women in Islamic cultures" gain control over their voices, or the representation of their voices?

To conclude, I wish to refer to the fortunes of Nawāl al-Sa'dāwī, the prominent Egyptian feminist, as a case in point. In an article about the framing and reception of al-Sa'dāwī in the West, Amal Amireh found that in spite of her visibility and strong presence in Western academia, she has not succeeded in controlling her representation. She traces how al-Sa'dāwī became entangled in "a story of resistance and complicity" where she often had to confront forces beyond her control (Amireh 2000, 219). The story makes the responsibility of representing women in Islamic cultures a formidable, but worthwhile, task.

BIBLIOGRAPHY
A. Amireh, Framing Nawal El Saadawi. Arab feminism in a transnational world, in *Signs. Journal of Women in Culture and Society* 26:1 (2000), 215–49.
K. Anderson and D. C. Jack, Learning to listen. Interview techniques and analyses, in Sherna Berger Gluck and Daphne Patai (eds.), *Women's words. The feminist practice of oral history*, London 1991, 11–26.
S. Hale, Feminist method, process, and self-criticism. Interviewing Sudanese women, in Sherna Berger Gluck and Daphne Patai (eds.), *Women's words. The feminist practice of oral history*, London 1991, 121–36.
L. Passerini, Work ideology and consensus under Italian fascism, in R. Perks and A. Thomson (eds.), *The oral history reader*, London 1998, 53–62.
A. Portelli, *The death of Luigi Trastulli and other stories. Form and meaning in oral history*, Albany, N.Y. 1990.
C. Salazar, A third world woman's text. Between the politics of criticism and cultural politics, in S. Berger Gluck and D. Patai (eds.), *Women's words. The feminist practice of oral history*, London 1991, 93–106.
S. Schrager, What is social in oral history? in R. Perks and A. Thomson (eds.), *The oral history reader*, London 1998, 76–7.

G. C. Spivak, "Can the subaltern speak?" in *Wedge* 7:8 (1985), 120–30 and C. Nelson and L. Grossberg, *Marxism and the interpretation of culture*, Urbana, Ill. 1988, 271–313.

J. Scott, "Experience," in *Critical Inquiry* 17 (Summer 1991), 773–97.

HODA ELSADDA

Orientalism

INTRODUCTION

There is no doubt that Edward Said's *Oriental-ism* (1978) caused a considerable stir in a variety of fields, including gender, postcolonial, cultural, and literary studies, and, more generally, the fields of cinema, photography, and painting. Said's thesis attracted much attention and admiration and also criticism. It has been vehemently debated, (mis)appropriated, extensively quoted, (mis)understood, simplified, and reinterpreted in so many various ways that the task of covering the impact of Orientalism on the study of women and Islamic cultures has become far from simple.

By questioning the assumptions of the various paradigms of thought about the "Orient" as a system of representations constructed by Western travelers, academics, and the Western empire, Said demonstrated how the Orient was a counter-mirror image of the "other", the superior West. His thesis, that the depiction of a single cohesive Orient leads to the essentializing and stereotyping of images, whereby the Orient is classified as backward, unchanging, irrational, menacing, and to be dominated sexually, was challenging. The harem and *ḥammām* fantasies, key tropes in European imagination, were more than ever put to the fore as stereotypical sexual symbols of the imagined East. Salient for our purpose here is that, looking into nineteenth-century travel and literary accounts, Said touched upon the issue of Western male fantasies: the feminine and weak Orient had to undergo the conquest of the powerful sexually dominant West. He is given the credit for making us aware of the notion of gendered colonialism. It is doubtful, however, that Said's work should be viewed as being mainly concerned with gender issues per se, or that his work intentionally focused on sexuality and image construction. Nevertheless, his thesis certainly stimulated anthropological and historical studies; a rethinking took place concerning the intricate relations of domination between the West and the East. Said's thesis led to a refinement of feminist approaches and the boosting of postcolonial studies; it was Said who first associated travelers' sexual fantasies with escapism to the Orient. This awareness resulted in a significant intellectual production that borrowed its approach from Foucault and his theorizing on power, and aimed at deconstructing the stereotypes in scholar-ship on Muslim societies. Said's work has been continued by many others, such as Mary Louise Pratt, Peter Hulme, Homi Bhabha, Rana Kabbani, and Gayatri Spivak (Mills 1992, 2). Since the appearance of *Orientalism*, an amazing quantity of works in various fields of humanity has emerged. Post-Said intellectual production focused on biases, stereotypical cultural representations, and preconceived assumptions about gender in the colonial and the postcolonial period. This has been undertaken on two levels: through textual analysis and in anthropological studies.

THE FANTASIES OF THE ORIENT

What triggered the interest of feminists regarding sexual fantasies was Said's stimulating analysis of the travel writing of Gérard de Nerval and Gustave Flaubert and their vision of Oriental femininity, which had a macabre bent. He observes that Flaubert's field notes betray a taste for perverse, excessive animality but with extreme refinement (Said 1978, 184). Perhaps the relationship Flaubert had with Kuchuk Hanem, the prostitute, her learned sensuality, delicacy, and (according to Flaubert) mindless coarseness (Said 1978, 186–7) is what triggered the interest in West-East sexual dynamics in Said's work. Flaubert's perceptions of Kuchuk Hanem are of dumb, irreducible sexuality, and emotional carelessness. Kuchuk is a disturbing symbol of fecundity, peculiarly Oriental in her luxuriant and seemingly unbounded sexuality (Said 1978, 187). She is the prototype of Flaubert's Salambo. Said argues that both Flaubert and Nerval displayed sadomasochistic tastes, a fascination with the macabre, with the notion of the femme fatale, and with secrecy and occultism. This explains their attraction towards such figures as Cleopatra, Salome, and Isis (Said 1978, 180).

DECONSTRUCTION IN MULTIPLE FIELDS

In the wake of post-Orientalism came an enormous deconstructionist movement involving textual analysis and historical, sociological, and anthropological studies that rethought the relationship between empire and colonized. Deniz Kandiyoti criticized some varieties of post-Orientalist scholarship: "they often remain locked into the categories of colonizers versus colonized, East

versus West, Islam versus Christianity, Western Self versus Native Other in ways that keep our gaze fixed upon the discursive hegemony of the West. This usually occurs to the detriment of more self-referential analysis of culture and society which should inform local feminist criticism" (Kandiyoti 1996, 16).

The debate even had resonance among urban planners and sociologists who looked at colonial city planning from the perspective of the dialectical relationship between the so called traditional "Islamic city" versus the open, modern, grid architecture and boulevard planning of the colonial town. For example, Zeynep Celik's *Urban Forms and Colonial Confrontations: Algiers under French Rule* points to the imagined gendered sensuality of the casbah of Algiers. In colonial literature, as well as among French architects and colonial administrators, the casbah became identified with a single, undifferentiated, and sensual woman (Celik 1997, 22). This image was probably associated with the difficulty of penetrating the mysterious space of that old and tortuous part of the town. Celik notes that French intellectuals, the military, and administrative officers made Algerian woman the "key symbol of the colony's cultural identity" (Celik 1997, 22). Also concerned with the gendered imaginary, Mrinalini Sinha's *Colonial Masculinity: The "Manly Englishman" and the "Effeminate Bengali" in the Late Nineteenth Century*, researches the sharp stereotypes created by the colonial encounter between the British and the Bengalis during the nineteenth century. The British were perpetuating ideal notions of masculinity identified with a love for sports such as hunting, disdain for bookishness, and being ready for anything. The Bengali babu was seen as the antithesis of this image. He was portrayed as "effeminate, bookish, lustful, languorous and lacking self-discipline." Sinha argues throughout her work that the categories of the colonizer and the colonized are neither fixed nor self-evident (Sinha 1995, vii).

In *Colonial Fantasies* (1998), Meyda Yeğenoğlu provides a rich and fascinating study of the cultural representation of the West to itself through the other. She looks into Orientalism and its articulation of sexual and cultural differences. She analyzes both gendered categories and Orientalism in order to reformulate the Orientalist discourse. She focuses on the concepts of fantasy and desire and relates them to a historically specific construction and to a collective process. She looks precisely at how the veil, the practice of veiling, and the harem have been perceived and gazed at in Western fantasies, starting with Frantz Fanon's observations

about the veil in Algeria. The Orient was seen as the embodiment of sensuality; it was understood in feminine terms. The harem represented the mysterious world of the Orient, the hidden and forbidden space of women. Yeğenoğlu rethinks the accounts of Western female travelers and how they supplemented male accounts with "knowledge from inside."

Domesticating the Empire (Clancy-Smith and Gouda 1998) is a stimulating edited volume addressing a variety of subjects related to postcolonial studies, gender, and Orientalism. Sexuality, Creole, images of femininity, and relationships between Javanese domestic servants and Dutch women in the empire are beautifully treated. The chapter by Pamela Pattynama is an interesting discussion of interracial sexuality in *The Hidden Force*, by Dutch colonial novelist Louis Couperous. This is one of the best known Dutch novels set in the East India Netherlands. It narrates the "mysteries" of the Oriental world. In Pattynama's reading, this novel reveals a mixture of Orientalism, covert sexual desire, and Western ambivalence. Emphasis is placed on the Creole femme fatale, the good looking Indo-European who is sexually threatening. Sara Mills's *Discourses of Difference* is concerned with the large quantity of travel writing by British women in the period of "high imperialism" in the nineteenth century. Mills focuses on three travel accounts: Alexandra David-Neel, *My Journey to Lhasa* (1927), Mary Kingsley, *Travels in West Africa* (1897), and Nina Mazuchelli, *The Indian Alps and How We Crossed Them* (1876). Mills argues that discursive frameworks varied according to the colonial situation. She attempts to locate women travelers within the colonial context rather than seeing them as individuals struggling against social conventions of the Victorian period. She finds Edward Said and Michel Foucault inspiring but disappointing for feminists: they both ignore women writers in their work, Said mentioning only one woman writer, Gertrude Bell (Mills 1991, 13).

Reina Lewis's *Gendering Orientalism* considers nineteenth-century women's involvement in visual Orientalism, focusing on two cultural productions: the Orientalist paintings of the French artist Henriette Browne (active 1855–78) and the implicitly Orientalist depiction of the Jew as the Orientalized other in George Eliot's novel *Daniel Deronda* (1876). Lewis concentrates on the relationship between imperialism, women, and culture. She discusses the complexity and plurality of the links between gender, race, and subjectivity, and particularly how the position of women varies:

"Women's differential, gendered access to the positionalities of imperial discourse produced a gaze on the Orient and the Orientalized 'Other' that registered difference less pejoratively and less absolutely than was implied by Said's original formulation" (Lewis 1996, 4). Women's Orientalism is difficult to categorize as being either supportive or oppositional; rather it is fragmented (quoted from Liddle and Rai 1998, 499). Lewis's book is aesthetically very appealing and it is enriched by the contrast of the paintings of Browne with other male contemporary painters. Both Mills and Lewis highlight the multiple and diverse positions within Orientalist discourse.

In *Black Body: Women, Colonialism, and Space*, Radhika Mohanram reflects on the continual recategorization she underwent in the United States and New Zealand. She was variously classified as an Indian national, as "black" in New Zealand, and as "brown" in America. This led her to consider the process of representation in relation to Western notions of identity. Her work focuses on theories of identity in the context of place and landscape, and to do this she explores the female body and notions of embodiment. Mohanram attempts to relate the concept of place/landscape to postcolonial studies, which incorporates "the politics of place/displacement, the concept of diasporic identity versus indigenous identity, the identity of woman in the nation and the spatial construction of femininity, the identity of the black body and its natural relationship to nature and landscape as opposed to that of the white body and its relationship to knowledge" (Mohanram 1999, xv).

ALTERNATIVE VOICES

One consequence of the deconstruction of Orientalism was the emergence of alternative and plural voices stemming from the colonized other. It is important here to mention the work of Gayatri Spivak (1985) who questioned the possibility of recovering subaltern voices, including women. On the other hand, the growing consciousness of the multiplicity of voices facilitated the opening of new fields of knowledge. In postcolonial studies textual analysis of empire literature with a dialectical perspective flowered. The mirrored colonized/colonizers discourse and representations were discussed and the concept of the interplay between gender, race, and hybridity was refined. The variety of voices engaged in discussions of the emergence of alternative modernities. Cynthia Nelson and Shahnaz Rouse examine the lives of three women from different cultures (one Egyptian, Doria Shafiq, and Jahanara Shahnawaz and

Hamida Akhtar Hussein from the Indian subcontinent). They hold that "the colonized 'other' in her confrontation with modernity generates various forms of struggles and ways of speaking which articulate and grapple with the contradictions that modernity generates" (Nelson and Rouse 2000, 97). The contradictions contained within modernity create a plurality of voices and generate different languages and idioms through which women's struggles for rights come to be articulated (Nelson and Rouse 2000, 97). Following the same mood, Hoda Elsadda published in Arabic an edited volume, *Aṣwāt badīla* (Alternative voices), which contains translated works of intellectuals concerned with Third-World feminist and subaltern studies, including Gayatri Spivak, Mervat Hatem, Deniz Kandiyoti, Afsaneh Najmabadi, Anne McClintock, Uma Narayan, and others, evidence that postcolonial and subaltern studies are gaining momentum in the Middle East. Cynthia Nelson's excellent article, "Old Wine, New Bottles: Reflections and Projections concerning Research on Women in the Middle East," provides an extensive panorama of previous anthropological studies; the problems and issues encountered in the study of women in the Middle East points to the paradigmatic shifts that took place from the late 1960s onwards in Western social sciences.

Lila Abu-Lughod's *Remaking Women* is another work that looks at the issues of modernity, nation-state building, and postcolonialism in relation to the history of feminism in the Middle East. In rethinking the Woman Question in the Middle East, Abu-Lughod's main concern is to look at how "notions of modernity have been produced and reproduced through being opposed to the nonmodern in dichotomies ranging from the modern/primitive of philosophy and anthropology to the modern/traditional of Western social theory and modernization theory, not to mention the West/non-West that is implied in most of these dichotomies" (Abu-Lughod 1998, 7).

INDIGENOUS VERSUS "WESTERN"?

One could view the debate over alternative modernities as a continuity of the older discussion of the decolonization of anthropology and social sciences and the attempt to indigenize social sciences. This discussion tackled the domain of the sociology of knowledge; the conditions and the fields of the production of knowledge were put into question. In recent years social scientists have raised issues related to the struggle in the field between indigenous and international scholars. The issue of whose knowledge counted more and

the bargaining over who knows reality better were also addressed. The debate over the indigenization of social sciences as a postcolonial discourse and the varying competing forces within the sociological field was analyzed by Morsy, Nelson, Saad, and Sholkamy (1991). In feminist studies this critique triggered discussions about the biases of Western ethnography in looking into the "other" as a subject of study. Also at the forefront of debate was the issue of the status of the insider/outsider, the "outsider within," and the "indigenous" (mostly female) observer studying her own society, but from a different class and cultural background. One of the first studies to broaden the scope of anthropological studies for the next generation was the edited work by Soraya Altorki and Camillia Fawzi El-Solh, *Arab Women in the Field: Studying Your Own Society*. Nadje Al-Ali's *Secularism, Gender, and the State in the Middle East* is another work in which, by deconstructing dichotomies such as East and West, indigenous and Western, the author reveals the breadth of the discourse of secular-oriented women activists in Egypt. While Al-Ali expresses admiration for Said's *Orientalism* and *Culture and Imperialism*, she wishes to transcend the discourse of Orientalism (Al-Ali 2000a, 22). She borrows heavily from Edward Said, Lila Abu-Lughod, and Gayatri Spivak to delineate a criticism of the term postcolonialism. Al-Ali points to the vast literature that debates the concept as applied to various historical moments. The periodization and the use of "post" imply that the chapter on colonialism has ended. Furthermore, postcolonial scholars are criticized for "their complicity with western 'high theory' and their embeddedness in western academic institutions" (Al-Ali 2000a, 22).

In an instructive article on the state of the art in gender studies today, Lila Abu-Lughod addresses the issue of the impact of Said's *Orientalism* on gender studies. She argues that "the historical recovery of feminism in the Middle East, emerging from this new abundance of research, has, in turn, stimulated a re-examination of that central issue in Orientalism, East/West issues" (Abu-Lughod 2001, 101). Her focus is the Middle East in relation to post-Orientalism and she refers to the works of Cynthia Nelson, Fatima Mernissi, Leila Ahmed, Margot Badran, Zehra Arat, Afsaneh Najmabadi, Elizabeth Fernea, Ziba Mir-Hosseini, Deniz Kandiyoti, and others.

Deniz Kandiyoti's *Gendering the Middle East* is a crucial study providing a wide array of debates including that on the effect of post-Orientalism on gender studies. Kandiyoti's analysis is rich, demonstrating that feminist scholarship in the West and the studies on women in the Middle East have overlapping trajectories. She shows that the way feminist studies have been integrated in Middle Eastern studies has been partial and selective (Kandiyoti 1996, 18).

An example of the deconstruction of representations is Hoda Elsadda's analysis of the representation of 'Ā'isha, the youngest wife of the Prophet, among both Orientalists and "indigenous" intellectuals and scholars. Elsadda focuses on six works of twentieth-century biographical writing by Nabia Abbott, Zāhiyya Qadūra, 'Abbās Maḥmud al-'Aqad, 'Ā'isha 'Abd al-Raḥmān (Bint al-Shati'), Fatima Mernissi, and Ghassan Ascha. In spite of the fact that these representations are different, they have a common denominator: they all look at 'Ā'isha's life to derive some direction for the twentieth-century Muslim woman (Elsadda 2001, 44). Elsadda's aim is to look at the relationship between power, representations of identity as knowledge, and nationalism.

On another level, the very concept of feminism becomes a source of controversy. During her fieldwork among Egyptian women, Nadje Al-Ali realized that the label "feminism" was problematic and ideologically loaded. She thus prefers to use the term "women's activism." In the eyes of many Egyptian women, North American feminists are man-hating, aggressive, and obsessed with sex. She classifies these representations of feminism and the perception of the West as the other side of the coin, namely Occidentalism (Al-Ali 2000b).

Joanna Liddle and Shirin Ray (1998) looked at how the "Indian woman" is represented in the writings of two North American female writers, to demonstrate how they took up aspects of imperialist discourse.

Mervat Hatem (1999) uses a Foucauldian deconstructionist approach of the meaning and praxis of power to rethink the complex dynamics of mother-daughter relations in Egypt. By focusing on the micro-dynamics of power in the life of 'Ā'isha Taymūr, Hatem proposes an alternative reading of her relationship with both her mother and father, and later of the tragic relationship with her daughter who died at an early age.

THE PRODUCTION OF KNOWLEDGE AND UNEQUAL INTERACTION

Azza Karam follows Said's critique of Western scholarship and goes further in terms of perspective in order to highlight two points. First, Western academia is harshly dealt with because of its unequal interactive mechanisms for the production of knowledge. Karam's main argument is that there

exist strong asymmetrical power relations between Western academia and "indigenous" or native scholars. By focusing on the politics of social research and how and why certain texts are written and how certain forms of knowledge are reproduced, Karam aims at denouncing Western feminists and academics for remaining Eurocentric. She stresses the fact that the "othering" processes undertaken by Western academics in positions of power can be potentially counterproductive. Karam expresses anger and a great concern about the unequal exchange between Western and native scholarship, stating that many native researchers experience a process of "delegitimation" of their work by Western academia. In order to be acknowledged in their home country they first have to pass through Western circuits of knowledge production and obtain their blessing, a process that is not without pitfalls. Quite often, according to Karam, the native researcher's work is devalued and silenced and the academic identities "dehumanized." This process of devaluation is achieved "by outright denial of the 'objective' researcher's validity of work carried out, or simply by ignoring the substantial scholarly input, and sometimes physical presence, of the native non-Western researcher. In other instances aspects of the native researcher's work are simply appropriated as their own – thus denying the originality of the ideas presented and ignoring the researcher's labor. The power dynamics render it such that to complain about this is to risk pitting the reputation of established educators against that of the starting and as yet even untenured researcher" (Karam 2000, 6).

Karam's second point is to argue that the process of othering has often ignored the important phenomenon of Islamist feminists or activists of political Islam, a research agenda that she then decides to undertake. Karam's observations are important in that they may open new questions about competing agents (indigenous versus Western) and their location (for example, working in Western metropolises as against the Third World) in the international division of labor of the academic market. Whether the alternatives voices have succeeded in finding a space and recognition and whether this will lead to further just relations is also perhaps another question.

BIBLIOGRAPHY

L. Abu-Lughod, Remaking women. Feminism and modernity in the Middle East, Cairo 1998.
——, Orientalism and Middle East feminist studies, in Feminist Studies 27:1 (spring 2001), 101–13.
L. Ahmed, Women and gender in Islam. Historical roots of a modern debate, New Haven, Conn. 1992.
N. Al-Ali, Secularism, gender and the state in the Middle East. The Egyptian women's movement, Cambridge 2000a.
——, Women's activism and occidentalism in contemporary Egypt, in Civil Society. Democratization in the Arab World 9:100 (April 2000b), 14–19.
S. Altorki and C. F. El-Solh, Arab women in the field. Studying your own society, Cairo 1988.
Z. Celik, Urban forms and colonial confrontations. Algiers under French rule, Berkeley 1997.
J. Clancy-Smith and F. Gouda (eds.), Domesticating the empire. Race, gender and family life in French and Dutch colonialism, Charlottesville, Va. 1998.
H. Elsadda, Discourses on women's biographies and cultural identity. Twentieth-century representations of the life of 'Aisha Bint Abi Bakr, in Feminist Studies 27:1 (spring 2001), 37–65.
—— (ed.), Aṣwāt badīla (Alternative voices), Cairo 2002.
M. Hatem, The microdynamics of patriarchal change in Egypt and the development of an alternative discourse on mother-daughter relations, in S. Joseph (ed.), Intimate selving in Arab families, Syracuse, N.Y. 1999, 191–208.
R. Kabbani, Europe's myths of Orient, London 1986.
D. Kandiyoti, Gendering the Middle East. Emerging perspectives, London 1996.
A. Karam, The dilemma of the production of knowledge in Western academia and Islamist feminists, paper given at a seminar on Sufism jointly organized by CSIC and IMIR, Sofia, Bulgaria, May 2000 (<www.arts-web.bham.ac.uk/mdraper/transnatsufi/research_papers/Karam.htm>, 36).
R. Lewis, Gendering Orientalism. Race, femininity, and representation, London 1996.
J. Liddle and S. Rai, Feminism, imperialism and Orientalism. The challenge of the "Indian Woman," in Women's History Review 7:4 (1998), 495–519.
S. Mills, Discourses of differences. An analysis of women's travel writing and colonialism, London 1991.
R. Mohanram, Black body. Women, colonialism, and space, Minneapolis, Minn. 1999.
S. Morsy, C. Nelson, R. Saad, H. Sholkamy, Anthropology and the call for indigenization of social science in the Arab world, in E. L. Sullivan and J. S. Ismael (eds.), The contemporary study of the Arab world, Edmonton, Canada 1991, 88–111.
C. Nelson, Old wine, new bottles, reflections and projections concerning research on women in the Middle East, in E. L. Sullivan and J. S. Ismael (eds.), The contemporary study of the Arab world, Edmonton, Canada 1991, 127–52.
C. Nelson and S. Rouse, Gendering globalization. Alternative languages of modernity, in C. Nelson and S. Rouse (eds.), Situating globalization. Views from Egypt, Bielefeld 2000.
E. W. Said, Orientalism, New York 1978.
M. Sinha, Colonial masculinity. The "Manly Englishman" and the "effeminate Bengali" in the late nineteenth century, Manchester, U.K. 1995.
G. C. Spivak, Can the subaltern speak? Speculations on widow-sacrifice, in Wedge 7:8 (1985), 120–30 and C. Nelson and L. Grossberg (eds.), Marxism and the interpretation of culture, Urbana, Ill. 1988, 271–313.
M. Yeğenoğlu, Colonial fantasies. Towards a feminist reading of Orientalism, Cambridge 1998.

MONA ABAZA

Philosophy

Like its monotheistic siblings, Islam is a patriarchal religion. God (Allah) is believed to be utterly transcendent and beyond human attributes, yet the masculine pronoun is used for God, and the social structure reflected in both the revealed and institutional sources is male dominated. As in Western society, this patriarchal heritage has three implications for the status of women in Islamic philosophy. First, the voices of women are not heard in classical philosophical works. Second, the subject of women is rarely dealt with in Islamic philosophy. Third, the evaluation of women, when they are mentioned in Islamic philosophy, is generally negative. Nonetheless, Islamic ideals (as distinguished from realities) concerning women are largely positive, even within the patriarchal context. In the modern era, therefore, reform movements challenging the low status of women in the Islamic world often reflect religious themes of human dignity and equality. These movements have focused on religious, legal, and philosophical issues, tending to blur disciplinary distinctions in contemporary Islamic thought.

THE DISCIPLINE OF PHILOSOPHY IN CLASSICAL ISLAM

In contrast to the status of philosophy in Christianity, the discipline of philosophy is not central to Islamic tradition. The dominant discipline in Islam is law, the "queen" of Islamic sciences. Rational articulation and clarification of religious principles derived from revelation was undertaken by scholars in the field of theology (kalām). Because its intellectual pursuits were kept within the limits of revelation, theology was also considered a legitimate, if not central, pursuit in Islam. Philosophy (falsafa), on the other hand, was not limited to questions raised by revelation. It included as well issues raised by the ancient Greek, Greco-Roman, and other classical thinkers, whose works were available through translation by the second century of Islam (ninth century C.E.), with no theoretical limits to rational inquiry. In cases in which the results of such inquiry seemed to conflict with revelation, reason dictated that revelation simply had not been properly understood. Muslim philosophers typically concluded that revelation should be understood as metaphor for deeper truths inaccessible to the untrained mind. Such conclusions

were generally unacceptable to religious scholars (ʿulamāʾ) and were, in any case, irrelevant to the majority of practicing Muslims.

Despite these limitations, philosophical inquiry was pursued by some notable premodern Islamic thinkers. Their work generally reflected the misogyny of mainstream Islamic social and legal institutions. The fact that it relied heavily on the major Hellenistic philosophers only reinforced this orientation. For Plato, women were really no more than failed men. In the *Timaeus*, for example, he claims that it is reasonable to assume that cowards and criminals are reincarnated as women. Aristotle agreed that women are by nature inferior to men. They are carnal and passionate relative to men who are spiritual and rational, and therefore must be in control. While the classical Islamic philosophers generally rejected the transmigration of souls and with it the notion of women's inferior creation, they did not question the general absence of women in their discourse or the association of women with concupiscence when they were mentioned.

Among the earliest major Muslim philosophers was Abū Bakr al-Rāzī (d. 311–320/923–32), whose rationalist explanation for creation was meant to demonstrate how the perfect, changeless, and all good God could be the creative source of an imperfect and changing world imbued with evil. Al-Rāzī identified five eternal principles: God, Soul, prime matter, absolute (infinite) space, and absolute (infinite) time. Soul, in this scenario, is a feminine principle, and al-Rāzī's description of creation reflects the view of femininity as driven by passion, and therefore in need of (masculine) rationality. According to him, the world was created as a result of God's merciful effort to soothe Soul's desire for matter and at the same time teach her to overcome this desire – the source of suffering – through reason.

Some Muslim philosophers attempted to correct other philosophers' deviations from traditional Islamic teachings, and accord rationalism with Islamic norms. Best known among these early reformers was al-Ghazālī (d. 505/1111). He criticized mainstream philosophers for "incoherence" (*Tahāfut al-falāsifa*, The incoherence of the philosophers). But, like them, he considered women to be hopelessly substandard. In his *Iḥyāʾ*

ʿulūm al-dīn (The revivification of the religious sciences), he cautioned men never to sink to the level of women in any pursuit. Furthermore, women must not be allowed to distract men from their proper religious pursuits; women exist for the sake of procreation and serving men.

One aberration from this overall trend in medieval philosophy is found in the work of the famous Andalusian philosopher, Ibn Rushd (d. 595/1198), who rebutted al-Ghazālī's attacks on philosophers in his *Tahāfut al-tahāfut* (The incoherence of the incoherence). Ibn Rushd attacked the prevailing negative attitude toward women, attributing the weakness and poverty in Muslim states to the prevention of women from pursuing any activities other than child-rearing. However, Ibn Rushd was an anomaly, and far ahead of his time. It would be centuries before the low status of women would be addressed in mainstream Islamic discourse.

WOMEN IN PHILOSOPHY

As in the Muslim world, women were absent from philosophical discourse in the West until the modern era. Among the first women philosophers to be published was Mary Wollstonecraft (d. 1797). In *A Vindication of the Rights of Woman* (1792) she argued that male dominance of society has kept human beings – both males and females – from reaching their true potential and creating a virtuous society. Roughly one century later, Bengali Muslim writer Rokeya Sakhawat Hossain struck a similar theme in her story "Sultana's Dream." Hossain describes a utopia in which men's natural belligerence is kept under control by keeping them involved in menial tasks and away from the structures of power. However, neither Wollstonecraft nor Hossain reflected mainstream thought about the roles of women in their respective societies.

It was not common to hear women's voices in Western philosophy until the twentieth century, particularly in the aftermath of the First World War. This was an era of intellectual revolution as thinkers attempted to come to grips with the failed promises of modernity and the collapse of morality represented by the catastrophe of global war. In this context, Simone Weil (d. 1943) sought the cure for human angst in a Christianized utopia based on the ideal Platonic life of contemplation. Hannah Arendt (d. 1975) took the opposite approach. In the tradition of her teacher Martin Heidegger, she critiqued the Western philosophical tradition and its emphasis on cognition rather than action, the arena of moral responsibility (*The Human Condi-*

tion, 1958). For her, thought has no value in its own right; the value of thought is in its critical analysis of the moral effects of actions. The question of women's status was not broached directly in Western philosophy until the work of Simone de Beauvoir (d. 1986). De Beauvoir focused on freedom and individual identity, particularly (but not exclusively) concerning women. Going beyond her teacher and collaborator Jean-Paul Sartre, she argued that despite their ultimate existential freedom, individuals' real freedom and identity were affected by circumstances and social context.

Since the latter half of the twentieth century, Western philosophy has split along methodological lines. In England and America, the discipline is dominated by analytic philosophers. In Europe, phenomenological approaches dominate. Characterized generally as postmodern, continental philosophy crosses disciplinary boundaries with psychology, sociology, history, literary studies, and others in continued efforts to identify the sources of social marginalization and violence of all kinds.

In the Islamic world, a similar erosion of disciplinary boundaries is evident in the modern era, particularly with regard to women's studies. Contemporary Egyptian philosopher Ḥasan Ḥanafī denies that philosophy as such exists at all in the modern Islamic world. He explains that it has been replaced by a more generic intellectual effort that includes religio-legal reform, sociopolitical discourse, as well as secular sciences carried on by Muslims and non-Muslims in the Islamic world, including Marxists. Within this broader spectrum of thought, critique of traditional social conservatism is the dominant feature. Ḥanafī himself calls for recapturing the rational spirit of Islamic scripture and tradition, and the construction of a new hermeneutic to deal with contemporary realities, including restructuring Islamic ideology concerning women.

Reflecting a major trend in philosophy in the modern Muslim world, Ḥanafī's social and intellectual critique is based on historical analysis. Like other modern Islamic thinkers, paralleling the sense of crisis among twentieth-century Western phenomenologists, he is aware that reform is essential for the survival of their culture. A common theme in their work is recognition that culture in the Muslim world fell into stagnation in the Middle Ages. After a period of spectacular cultural output in all areas of the sciences and arts, the Muslim world splintered and was overcome by colonial powers that played on its weaknesses. Moroccan Muḥammad ʿĀbid al-Jābirī, for example, criticizes Islamic society overall for having

neglected its commitment to rationality. It therefore lost its ability to respond to changing conditions and became trapped in its own historic past. When it was shaken to awareness of its failings after the First World War, it rashly attempted structural reforms, often importing foreign systems and ignoring its own roots of cultural strength. The result was alienation of the majority in the community which led to a conservative religious backlash. As a corrective, al-Jābirī calls for a return to sources that are authentic to Arab-Islamic culture, and application of their rational interpretive methodologies to contemporary challenges. Historian 'Abd Allāh al-'Arwī (Abdallah Laroui) argues in a similar vein, as does sociologist 'Abd al-Kābir al-Khaṭībī. Although neither is in the field of philosophy, they represent a trend toward cultural critique aimed at freeing society from the confines of conservatism. Best known of these neo-historicists is Mohammed Arkoun, who acknowledges the need for a cultural revolution that would, among other things, incorporate women into modern philosophy. Such a revolution would have to overturn socialization and systems of identity formation that underlie women's deplorable status, and be based on biological, anthropological, and historical analyses as well.

The most influential thinkers in the modern Islamic world, however, are those who privilege religious sources in their reform efforts. Of those, Fazlur Rahman (d. 1988) has had the greatest impact on modern Islamic thought in general, and reform of Islamic thought concerning the status of women in particular. Classically trained in Islamic thought in pre-partition Punjab and in philosophy at Oxford, Fazlur Rahman described himself as a modernist. By that he meant one who recognized that revelation took place in specific times and places, as did interpretations of the implications of revelation for subsequent times and places. Therefore, revelation and interpretations of revelation, including the Islamic laws based on them, must be re-examined in light of the specific circumstances from which they emerged, and reformulated in ways appropriate to present circumstances. This entire undertaking must be based on a clear understanding of the overall spirit of the Qur'ān as well as the dynamics of today's complex society.

The core of Fazlur Rahman's philosophical method was hermeneutics. He agreed explicitly with Hans Georg Gadamer that "all experience of understanding presupposes a preconditioning of the experiencing subject" (1982, 9). Thus, he argued that understanding the intent of revealed texts requires awareness of the historical context in which revelation occurred. He also recognized that socioeconomic and historical factors, such as education and political and economic concerns, affect interpretation of all texts, including sacred texts. He therefore rejected the possibility of absolutely authoritative interpretation and called for a critical assessment of the intellectual legacy of Islam, in order to distinguish between essential Islamic principles and their particular formulation as a result of the needs of specific – and probably now outmoded – socioeconomic and political contexts. Interpreters in differing contexts could then determine how best to apply the essential principles of Islam in their own circumstances (which themselves must be critically assessed).

With regard to social issues in particular, Fazlur Rahman said that asking of any interpreter(s) an eternally applicable formula would be like asking a physician for an eternally effective cure when, in fact, people must continually seek cures as new ailments arise. This is what he called the appropriate hermeneutical method of the Qur'ān, and he believed that the legal and social status of women in Islam was one of the most obvious areas requiring this reassessment. He often gave the example of the status of women's testimony in court – according to classical interpretations, only half as credible as that of men. He noted that the passage in the Qur'ān on which this judgment is based (2:175–8) must be understood in its historical context. Doing so will allow the distinction between those verses containing general moral principles with universal applicability, and those describing responses to specific historical circumstances. The verse in question, he argues, refers to financial matters and was revealed at a time when women were generally unfamiliar with business affairs. The application of the ruling contained in this verse is therefore suitable only to similar circumstances; when women are educated and familiar with financial matters, there is no reason to assume the judgment still applies. He concluded in general: "In understanding the Qur'ān's social reforms . . . we will go fundamentally wrong unless we distinguish between legal enactments and moral injunctions. Only by so distinguishing can we not only understand the true orientation of the Qur'ānic teaching but also solve certain knotty problems with regard, for example, to women's reform. This is where the Muslim legal tradition, which essentially regarded the Qur'ān as a lawbook and not *the religious source* of the law, went so palpably wrong" (1980, 47; emphasis in the original.)

Some religious reformers remained relentlessly conservative concerning the status of women.

Pakistani founder of the Islamist organization Jamaat-i Islami Abu al-Aʿlā al-Mawdūdī (d. 1979), for example, continued to espouse a distinctly patriarchal social view, based on his interpretation of religious sources, in which women's weakness and lack of reliability require male dominance. Similarly, Zaynab al-Ghazālī, founder of the Muslim Women's Association in Egypt in 1936, espoused liberation of women from ignorance and repression, but retained an overall patriarchal view of society in which women's first duty is to be a wife and mother. Such views must be read, however, in the context of reaction against Western hegemony and an effort to distinguish Islamic morality from that of the colonizers. And despite the influence of the latter on some sectors of society, Fazlur Rahman's insistence on *ijtihād* – the Arabic term for rethinking religious sources in light of, and for application in, changed sociohistorical circumstances – continues to influence the major advocates of reform in Islamic thought concerning the status of women.

Among those advocates of reform is Azizah al-Hibri. Basing herself on Fazlur Rahman's work, al-Hibri begins with the distinction between two kinds of rules in the Qurʾān, general and specific. She claims that the majority of Qurʾānic teachings are general; specific rules are relatively few and deal mainly with matters of worship or family law, as well as some aspects of commercial and criminal law. And, like Fazlur Rahman, she calls for reassessment of classical interpretations of scripture, focusing on *ijtihād* as the vehicle of Qurʾānic interpretation and the key to reform. But she goes further than Fazlur Rahman, claiming that any capable Muslim may engage in the process of interpreting Islamic texts and Islamic law. This is clearly a reformist move reminiscent of the kind of privatization of religious interpretation that characterized the Christian Reformation. (It should be noted in this context that the Reformation was the forerunner to reassessment of the role of women in European society; the Roman Catholic church, which condemned the Reformation, has yet to undertake such a reassessment.)

Another major contemporary thinker influenced by Fazlur Rahman is South African scholar and activist Farid Esack. Esack's work is broader in scope than al-Hibri's. Working within the context of South Africa's struggle against apartheid, he called for *itjihād* to focus on Muslims' responsibility to work against social injustice of all kinds, and to work with the religious "Other" to achieve shared goals of social justice. But, he argues, that struggle is integrally related to the liberation of women as well. Again, the challenge is to integrate religious teaching with social reality. The changing nature of the family, increased literacy, and increased economic independence demand rethinking the status of women in Islamic society, as much as rethinking other issues of modernity. Traditional religious interpretations reflected a social context in which women were economically dependent, less educated than men, and therefore less active in the public arena. In the face of changes in these circumstances, Muslims must exercise *ijtihād* in order to allow religious teaching to be relevant to social realities.

CONCLUSION

Recognition of the absence of women in the public sphere developed in the West only with industrialization, urbanization, and democratization. These eroded the roots of patriarchy, gradually liberating women and allowing for recognition of their full humanity or at least civic responsibility. It was only at the end of the nineteenth century that the term *féminisme* was coined, to refer to support for women's legal and political equality with men. Even so, participation in scholarship requires education; the disparity between men's and women's education would take decades to remedy. Not until the final quarter of the twentieth century were systematic efforts undertaken to analyze and assess the absence of women in Western philosophy. Some claimed that women had indeed engaged in philosophical thought but had been marginalized. Susan Moller Okin, for example, identified a number of women who had contributed to political thought (*Women in Western Political Thought*, 1981). Others argued that philosophy itself was skewed to undermine the value of women's unique contribution (see, for example, Michèle Le Dœuff, *Hipparchia's Choice: An Essay Concerning Women, Philosophy, etc.*, 1991). These and other issues were the focus of *Hypatia*, "the only journal for scholarly research at the intersection of philosophy and women's studies" and "reclaiming the work of women philosophers," of which Azizah al-Hibri is a founding member. Whether the absence of women's voices in philosophy resulted from the underestimation of women's rationality, the overestimation of specifically male rationality, the failure to appreciate specifically female rationality, or the excessively narrow disciplinary confines of philosophy itself remains the subject of lively debate in Western philosophy.

As in the West, changing circumstances have brought a rethinking of the status of women in the Muslim world. Unlike the West, however, the Mus-

lim world has at the same time been embroiled in overwhelming struggles for independence from foreign control, and for development in the postcolonial world. Under those circumstances, large-scale social reforms remain in their infancy. The status of women, the assessment of their nature relative to that of males, and the implications of those assessments for women's participation in public life share the intellectual stage with critical discussions of democracy, development, and the role of religion in society. Nevertheless, philosophy in the Muslim world is evolving along multi-disciplinary lines, as it is in the Western continental tradition. In both cases, the transformation is driven by social and cultural critique, including the critique of the marginalization of women.

BIBLIOGRAPHY

PRIMARY SOURCES
Al-Ghazālī, *Iḥyāʾ ʿulūm al-dīn*, 5 vols., Cairo 1967–8.
A. Y. al-Hibri and M. A. Simons (eds.), *Hypatia reborn. Essays in feminist philosophy*, Bloomington, Ind. 1990.
M. ʿĀ. al-Jābirī, *Naḥnu wa-al-turāth. Qirāʾāt muʿāsira fī turāthinā al-falsafī* (We and the heritage. Contemporary readings in our philosophical heritage), Beirut 1980.
——, *Arab-Islamic philosophy. A contemporary critique*, Austin, Tex. 1999.
Aristotle, *The works of Aristotle*, ed. W. D. Ross, trans. B. Jowett, Oxford 1921.
M. Arkoun, *Rethinking Islam*, trans. and ed. R. D. Lee, Boulder, Colo. 1994.
F. Esack, *Qurán, liberation and pluralism*, Oxford 1997.
R. S. Hossain, *Sultana's dream and selections from* The Secluded Ones, ed. and trans. R. Jahan, New York 1988.
Plato, *The collected dialogues of Plato*, ed. E. Hamilton and H. Cairns, New York 1961.
F. Rahman, *Islam and modernity*, Chicago 1982.
——, *Major themes of the Qur'an*, Minneapolis 1980.
J. Rumi, *Mathnawí of Jalálu'ddin Rúmí*, ed. and trans. R. A. Nicholson, 8 vols., London 1925–40.

SECONDARY SOURCES
L. Ahmed, *Women and gender in Islam*, New Haven, Conn. 1992.
T. Sonn, Fazlur Rahman's Islamic methodology, in *Muslim World* 81:3–4 (1991), 212–30.
A. Wadud, *Qur'an and woman*, New York, 1999.
W. Walther, *Women in Islam*, trans. C. S. V. Salt, Princeton, N.J. 1981.

TAMARA SONN

Political Science

In the disciplinary field of political science, research and analyses concerning Islamic cultures have tended to focus on politics as the essence of religion. This approach is especially tenacious among analysts coming from a rational choice perspective who tend to identify resurgence of Islamic practices within a politically deterministic framework reducing Islamist-type movements to "nationalism," "radical opposition," struggle for an "Islamic state," and other easily recognizable paradigms of political activity. Most political scientists tend to focus on political Islam, and thus on Islamic opposition and militancy, while ignoring piety, and few look at the concordance between the sacred and the political within the Islamic world-view.

Ruth McVey, an eminent political scientist working on Southeast Asia, eloquently argued 20 years ago in a critical survey of the field that: "politics is not the essence of religion" – a similar argument made by Hefner and Horvatich in a more recent book, *Islam in an Era of Nation-States* (1997). McVey, who has written extensively on Indonesia, presents an excellent critique of the secular scholar's inability to comprehend Islam as a religion: "Religious ideas and beliefs are given no independent status but are subsumed under categories such as 'politics' or 'psychology' for which social scientists already have a comprehensive and comprehensible analytical vocabulary" (McVey 1981, 282).

POLITICAL SCIENCE AND THE STUDY OF WOMEN IN ISLAMIC CULTURES

Mainstream political science analyses of Islam (at least in the Southeast Asia region with which I am most familiar) is dominated by male scholars who have little to say about gender politics (Hefner 2000, Scott 1998, 1985, Emmerson 1976, 1999, Collier forthcoming, Aspinall 2001). While the situation has changed fairly dramatically in the last decade or so, with many more women scholars emerging and producing innovative works on women in Islamic cultures, some of them trained as political scientists, many of them are not in political science departments, but in history, area studies (including Asian studies), Islamic studies, anthropology, sociology, law, and other fields. I suggest here that we do not limit our discussion to those scholars who are primarily trained in and based in hegemonic Euro-American and Western knowledge-production circuits, but rather attempt a geographic and paradigmatic shift, a counter-mapping, away from the "core Islamic lands" and the "hegemonic centers of knowledge-production," to include native scholars in Indonesia, Malaysia, and the rest of Southeast Asia who are not trained as political scientists, but who have produced refreshingly original and powerful analyses of politics and gender in Islamic cultures. This would mean contesting, if not rejecting, some of the conventional and parochial boundaries of what constitutes political science.

With the exception of some excellent feminist, historical, and anthropological studies that look at Islam as a socioeconomic, religious, and cultural practice, the majority of political science analyses of Islam, especially in Southeast Asia, tend to reduce it to politics. McVey's arguement continues to be relevant today. She denounces

> the attitude of many western social scientists for whom the tenets of a faith are unimportant except as they reflect political, economic, or other such worldly behaviour. Religion thus appears as a verbalization of certain psychological and social conditions, and it is unnecessary to consider the debates within it as arguments serious in themselves. Thus one can – and Peacock does – write an account of the relationship of Islamic modernism to the spirit of capitalism without once mentioning the question of riba (usury, unlawful interest), though this is religiously central to the issue and greatly exercised Muhammadiyah and other Muslim thinking. The view that religion is a symptom of something else is particularly tempting for students of politics, who can conveniently take the historic identification of Indonesian religious groups with political organizations to mean that the struggle for political power is religion's primary concern (McVey 1981, 282).

Merle Ricklefs, another well-respected scholar of Islam in Southeast Asia, insists that "if you are going to study religious phenomena you must first of all be prepared to consider the possibility that people actually believe what they say they believe. In Political Science, too often belief is seen only in instrumental terms" (personal correspondence 2003).

In contrast to Southeast Asian studies where Islam is under-studied, it would seem that in Middle Eastern studies, there is overemphasis on Islam. Political scientist Islah Jad based in Birzeit

University (1990, 1995), sociologist Deniz Kandiyoti at SOAS (1991), and anthropologist Sondra Hale at UCLA (1996) have argued, however, that the privileging of religion and Islam as the sole dominant factor in social life is problematic, for, until it is politicized, Islam is merely one aspect of cultural life.

It would also seem, as argued by Diane Singerman, a political scientist working on the Middle East, that there are many more political scientists in Middle Eastern studies working on women in Islamic cultures. See, for example, Singerman on political participation, development, family, networks, and micro-politics in Egypt (1998, 1997, 1996, 1995); Mervat Hatem on nationalist discourses on citizenship, modernization, the state, the family, economic and political liberalization (2001, 1999, 1996, 1995); Laurie Brand on women, the state and political liberalization (1998); Sheila Carapico on civil society in Yemen (1998); Simona Sharoni on gender and women's resistance in the Israeli-Palestinian conflict (1995); Arlene Macleod on working women, the new veiling, and change in Cairo (1991); Janine Clark on democratization and civil society (2000); Lisa Weeden on politics, rhetoric, and symbols in contemporary Syria (1999); Nahla Abdo and Ronit Lentin on women and the politics of military confrontation (2002); Eleanor Doumato and Marsha Pripstein-Posusney on women and globalization (2002); Donna Lee Bowen and Evelyn Early on everyday life in the Muslim Middle East (1993); Azadeh Kian-Thiébaut on women's political activism in Iran (2002); and Roxanne Euben on Islamic fundamentalism and the limits of modern rationalism (1999). Looking beyond political scientists, there are numerous works by feminist scholars writing about politics but trained in other disciplines, such as Rhoda Ann Kanaaneh who wrote an award-winning ethnography from the perspective of medical anthropology on strategies of Palestinian women in Israel (2002); and Mary Layoun, in comparative literature, on gender boundaries, and nationalism in crisis (2001).

THE STUDY OF POLITICS, WOMEN, AND ISLAMIC CULTURES IN THE ASIA-PACIFIC REGION

In the Asia-Pacific region, the most fascinating work that has emerged in the study of politics, women, and Islamic cultures are those that are betwixt, between, and beyond the more conventional boundaries of political science, inclined to be more interdisciplinary when it comes to Muslim discursive traditions. The cutting-edge work on politics, women, and Islamic cultures is being produced by feminists from different disciplines, but in particular history, anthropology, religious studies, Islamic studies, and area studies. It includes the earlier work of Sartono Kartodirdjo on the participation of women in protest movements and agrarian unrests in rural Java (1973); Pramoedya Anata Toer's numerous historical novels on gender, colonialism, and nationalism (1957, 1988, 1995 among many); Nancy Peluso's work on resource control and resistance in Java and Indonesia more generally (1992); Hendro Sangkoyo's writings on administrative grids and the permeability of the state (1998); Norma Sullivan on leadership, masters, managers, and gender relations in urban Java (1994); Susan Bayly on saints, goddesses, and kings (1989); Anna Gade on Qur'ānic study in religious musicality and recitation in Indonesia (2003); Masako Ishii on Muslim women, social change, and armed conflict in the Southern Philippines (2000); the publications of the Sisters in Islam group based in Kuala Lumpur Malaysia, co-founded by Norani Othman; and Juliette Koning et al. on women and households in Indonesia (2000). More broadly, there are several South and Southeast Asian writers who are scholars/practitioners/public intellectuals who do not make rigid demarcations between the intellectual and the political: for example, Abdurrahman Wahid (Islamic scholar, former political party leader of Nahdatul Ulama, former president of Indonesia); Pramoedya Ananta Toer (novelist, historian, poet, long-time political prisoner, former guerrilla in the nationalist struggle); Chandra Muzaffar (Malaysian academic, human rights activist, public intellectual); Wan Azizah Wan Ismail (Malaysian politician, opposition leader, political analyst, wife of Anwar Ibrahim); Nurcholish Madjid (Indonesian scholar, public intellectual); Azyumardi Azra (Indonesian Rector of the State Institute for Islamic Studies, IAIN, public intellectual); Emha Ainun Nadjib (poet, writer, political activist); Wardah Hafidz (feminist, scholar, director of Urban Poor Consortium based in Jakarta); Nursyahbani Katjasungkana (lawyer, feminist, legal scholar); Goenawan Mohamad (public intellectual, poet, scholar); Cesar Majul (Filipino scholar on Islam, former dean of the University of the Philippines, Muslim rights activist); Mohammad Mohabbat Khan (professor of political science and public administration, and member of Bangladesh Public Service Commission), among many others.

If we shift to strictly-defined political scientists,

trained in political science, and writing on politics, women, and Islamic cultures in the Asia-Pacific region, then the picture is much more limited. There are a few scholars in particular who have made a significant contribution and impact not only in their area studies specialization (Southeast Asia), but across regions and disciplines, for example, James Scott (1998, 1985) and Benedict Anderson (1972, 1983, 1998). Yet despite the fact that their major fieldwork was conducted in strongly Islamic societies, Malaysia and Indonesia respectively, both scholars have been criticized for paying very little attention to Islam as a centrifugal religious and social force (see, for example, Lila Abu-Lughod's 1990 critique of Scott's work and Hefner and Horvatich's 1997 critique of Anderson's work). A useful theoretical exposition of the radical differences between ideas of power in modern Euro-American social science and ideas of power in political cultures in Indonesia, is Benedict Anderson's essay "The Idea of Power in Javanese Culture." The article is problematic in some ways, among them its rather indigenist/ nationalistic "culture" approach emphasizing the "uniqueness" of Javanese culture, its lack of insight, its neglect of dimensions and articulations of female power, and its marginalization of Islam as a powerful centrifugal force (see Hefner and Horvatich 1997). However, despite its flaws, political scientists who are not Southeast Asia specialists continue to refer to it as an authoritative work on power partly because other attempts to go beyond it have not been able to provide a more nuanced and convincing analysis of power. Having said this, it is important to keep in mind that there are ideas of power that, as Anderson writes, "are quite independent of the perspectives of modern political science and in many ways in fundamental opposition to them" (Anderson 1972) – an important reminder to feminists in articulating an analytics of power that is pluralistic and non-totalizing. Despite the lack on the part of these male political theorists of nuanced analysis of gender and of more sophisticated analyses of Islamic cultures, feminists working in the field of discourses of power and political theory have borrowed from and been greatly influenced by their theoretical analyses.

In the field of political science, one major tendency in terms of methods predominates: the privileging of secularized rationalism in the production of theories about power, governance, and social movements. For example, in the most recent literature on Islam in Southern Philippines and Southern Thailand, almost all the studies considered to be at the forefront of the field have little to say about Islam as a religious and social practice, but tend mostly to focus on politics as the essence of religion (see for example Collier 2002, Abinales 2000, McKenna 1998, Danguilan-Vitug and Gloria 2000, Che Man 1990). Most have little or almost nothing to say about women or gender politics, with the exception of one recent Ph.D. dissertation in international relations, by a Japanese scholar, Masako Ishii (2000). Among more recent works on Indonesia and Aceh produced by European and American-based scholars, most of the studies of this strongly Islamic society, with the exception of the work of anthropologists James Siegel (1969, 1979) and John Bowen (1991, 1993, 1998) are predominantly on Islam as a political movement (see, for example, Hefner 2000, Aspinall 2001, Kell 1995, Morris 1983, 1985, Van Dijk 1981, Emmerson 1976, 1999). Even the latest generation of recently finished Ph.D.s and graduate students being trained in political science departments and working on Southeast Asia tend to continue this paradigm (see, for example, Jacques Bertrand 2002, 2000, Ed Aspinall 2001, Suzaina Kadir 1999). For example, the majority of recent Ph.D.s written on Islam in Indonesia are on Islamic political movements such as Nahdatul Ulama, ICMI (Ikatan Cendekiawan Muslim Indonesia), and Muhammadiyah, or on the history of Islamic political opposition. Several workshops reviewing the field conducted by the Social Science Research Council, the Association of Asian Studies, and the Cornell Modern Indonesia Project have noted that field studies of religion, literature, culture, and the arts since the end of the cold war, at least in North America, rank lowest in terms of funding and number of Ph.D. students, whereas more policy-oriented, national interest, and international security driven research in economics and political science tend to get the most funding due to geopolitical, economic, diplomatic, and security interests of government and non-government funding bodies. At this historical juncture, such topics as the dynamics and management of conflict, international security studies, conflict resolution, peace studies, human rights, and development administration seem the most popular.

Another weakness in terms of methods is the continuing peripheralization and ghettoization within the field of political science of women and gender studies (except in feminist theory within the sub-field of political theory). Some political scientists may argue that "gender studies has become a fairly acceptable topic of research, and

gender is commonly used, discussed as a category of analysis in even mainstream political science" (Singerman, personal correspondence 2003). But J. Ann Tickner, at the School of International Relations at the University of Southern California, when asked to reflect on the sub-field of feminist theory within international relations, writes: "My first thought on being asked to write these reflections was how difficult a critical assessment of such a young field would be. While there are differences amongst IR feminists, engaging in self-criticism seems premature as feminist approaches still struggle to be heard in a discipline that has not been particularly open to gender approaches" (Tickner 2002). This critique reverberated in the reflections of other feminists in the field of international relations, whose work appears in Harvey and Brecher (2002), including Christine Sylvester, Marysia Zalewski, V. Spike Peterson, L. H. M. Ling, and Jan Jindy Pettman.

It is interesting that even Ruth McVey, who provided one of the more intellectually rich and subtle analyses of Islam in Southeast Asia, and who was one of the few women of her generation breaking ground in the field of political science and Southeast Asian studies, had very little to say about women or gender relations. Most political science analysis has much to say on race relations, class relations, and other social hierarchies, but hardly touches on gender relations. On the other hand, political scientists who give very sophisticated accounts of feminist analytics of power and who have radically transformed the field with powerful critiques of conventional approaches to international relations, political theory, international law, and international economics tend to privilege a secular-rationalist perspective that pays little attention to the role of religion, colonialism, and postcolonialism as powerful formative forces. Among such political scientists are Cynthia Enloe (1989, 1999, 2000); Carole Pateman (1989, 1996); Wendy Brown (1988, 1995, 2002); Jennifer Nedelsky (1990); Nancy Fraser (1989, 1994, 1998); Seyla Benhabib (2000, 2002); Anne Norton (1986, 1988, 1993); Christine Sylvester (2001); V. Spike Peterson (1992); Rebecca Cook (1994); and many others.

According to a recent solicitation for a special issue of *Signs* on "World Politics, Women, and Building Peace," organized by political scientists Carole Pateman, J. Ann Tickner, and Judith Stiehm, there are other less developed fields in feminist theory that have traditionally been male-dominated: "the international arms trade, re-definitions of security, peacemaking, peace building, and peacekeeping, the breakdown of states and the democratic reconstitution of societies and governments, and gender questions in the intervention of international agencies, both governmental and non-governmental in conflict zones." Interestingly, at the present historical juncture and in light of 11 September 2001 and the Bali bombings of October 2002, the places that raise challenging questions pertaining to these thematic topics happen to be in regions with large Muslim populations.

GENDER STUDIES AND FEMINIST POLITICAL THEORY IN THE ISLAMIC CONTEXT

Comparative studies of gender and Muslim communities is a growing and innovative field. Because feminist frameworks of studies about gender and Muslim communities are highly influenced by research on the Arab world in particular, the articulation of a profoundly different and more egalitarian gender system in places like Aceh, Sumatra, and other parts of Asia would seem to be "against the grain" of conventional assumptions regarding Muslim women (Sears 1996, Ong and Peletz 1995, Brenner 1998, Blackwood 1995, Whalley 1993, Tanner 1974, Siegel 1969, Siapno 2002, Elliston 1997). Despite the fact that Southeast Asia is the region with the largest Muslim population in the world, it has yet to be included in the works on the Islamic world, which focus primarily on "core" Islamic lands: the Middle East, Africa, and South Asia (see, for example, Abu-Lughod 1998, Tohidi and Bodman 1998, Afkhami 1995, Afkhami and Friedl 1997, Kandiyoti 1991, Fernea and Bezirgar 1977, Beck and Keddie 1978). In the field of Southeast Asian studies, the marginalization of Islam and gender may well have to do with the fact that some feminist scholarship in Indonesia, in particular the type that follows the Western secular-rationalist model, has been unwilling to grapple with Islam and Muslim discursive traditions. Some of the more unconventional work on women and Islamic cultures in the Malay/Indonesian archipelago is not produced by feminists but by male scholars writing on sexuality and masculinity, for example: Benedict Anderson, "The Happy, Sexy, Indonesian Married Woman as Transexual" (1996); James Siegel, *The Rope of God* (1969) and "Curing Rites, Dreams, and Domestic Politics in a Sumatran Society" (1978); Merle Ricklef's writings on Ratu Pakubuwana (1998 and in EWIC, vol. I); Henk Maier, "The Laughter of Kemala al-Arifin: The Tale of the Bearded Civet Cat" (1991); and

Chandra Jayawardena, "Women and Kinship in Acheh Besar, Northern Sumatra" (1977), to name a few.

There exist numerous sophisticated theoretical works on women and gender studies in Islamic cultures in Southeast Asia, mostly by anthropologists, for example: Laurie Sears (1996); Aihwa Ong (1987); Mary Steedly (1993); and Anna Tsing (1993). However, while their analysis of women and gender is quite astute, their understanding of Muslim discursive traditions is rather limited. Interestingly, due perhaps to a geographical trans-continental shift in perspective, the work of Australian-based feminist scholars working in closer proximity to Indonesia are more nuanced in their approach to studies of women in Islamic cultures compared to their North American counterparts. See for example, the writings of Kathy Robinson, Virginia Matheson-Hooker, Susan Blackburn, and Barbara Hatley (all have entries in EWIC).

WOMEN AND POLITICS IN THE THIRD WORLD

Within the debate on gender relations in Muslim communities, there are several groupings. Two camps in particular produce contentious interpretations. The first is feminist Muslim scholars who present a sympathetic, almost apologist, account of women in Islamic societies. In strong reaction to what they perceive as the colonizing impulses of Western (Euro-American) and First-World feminism, they tend to argue that Islam is not oppressive of women. This stance was expressed during the United Nations Conference on Women in Beijing in 1995 when African Muslim women seemed to retreat to Islam in resistance to "Westernization," with global feminism having become the most aggressive symbol of Westernization. The second camp is Muslim feminist activists in the Third World, some of whom have personally become targets of Islamic fundamentalists. Human rights advocates and lawyers for women's rights and are confronted daily with violations of women's rights in the name of religion, for example: Hina Jilani and Asma Jahangir on Pakistan; women who write in a radical feminist voice against misogyny in Islam and about how women are being oppressed in the name of God; Taslima Nasreen on Bangladesh; Nawal al-Saʿadāwī on Egypt; Fatima Mernissi on Morocco; Wardah Hafidz and Nursyahbani Katjasungkana on Indonesia; the late Furugh Farrokhzad writing about Iran; the scholars and human rights activists writing for Women Living Under Muslim Laws;

Indonesian feminists, including Wardah Hafidz and Lies Marcoes Natsir, in the Association for the Development of Pesantren and Society (P3M); and other public intellectuals in Jaringan Islam Liberal. These Muslim feminists do not make any qualifications in their condemnation of misogyny in the male political and religious elite's chauvinistic interpretation of the Qur'ān or the outmoded traditionalism and rigid definition and implementation of Sharīʿa law, the consequence of which has been subordination of women.

Muslim feminists in Indonesia who have strong political commitments to grassroots organizing against exploitative labor conditions, particularly with regard to the position of women workers, have produced strong criticisms of the current movements for Islamic revivalism (see, for example, Chusnul Mariah 1998, Lies Marcoes Natsir 2002, 1998). Wardah Hafidz, director of the Urban Poor Consortium based in Jakarta argues:

> The relations between women and men is one field that is evaded most in terms of change in Islamic revivalism, because changes in this field will disturb male individual and social interests. For this reason, the Islamic community in Indonesia which is still largely dominated by men is preoccupied with and more prepared to embark on changes, even radical changes if necessary, in the economic and political systems. However, when it comes to gender relations, they wish to preserve the status quo through various ahistorical theological justifications (Hafidz 1993, 41).

The debate on women in Islamic societies has been going on for some time. Several Muslim theologians and feminists are grappling with this issue at the level of the "pure philosophy" of the Qur'ān and questioning the legitimacy of the Sharīʿa and ḥadīth by exercising ijtihād (critical interpretation). Muhammad Iqbal defines ijtihād (from jahada, to exert) as the principle of movement in the structure of Islam: "in the terminology of Islamic Law it means to exert with a view to form an independent judgement on a legal question. The idea . . . has its origin in a well-known verse of the Qur'ān – 'And to those who exert we show our path'" (Iqbal 1986, 117).

Most current studies of Islamic cultures, in particular in light of the September 11 attacks and the Bali bombings, and the implications of the "war on terrorism," tend to reproduce the discourse on the essentially inegalitarian character of Islam and the assumption of an originally authoritarian Islam. With regard to gender studies in Islamic cultures, the reverberations are rather negative: a reinforcement of the conventional popular phobia of Islamic law as somehow more oppressive of women than secular law. On the contrary, other

scholars, such as James Siegel (1969), Daniel Lev (1972), and John Bowen (1998), have shown, writing about the Indonesian context, that Indonesian family law is more egalitarian and in favor of women's rights in particular in the fields of inheritance and divorce. There is a large body of literature that argues that in Indonesia and even island Southeast Asia more generally, women have a high status compared to women in South Asia and other Muslim communities. Daniel Lev, a political scientist who has conducted extensive research on Islamic courts in Indonesia, ascribes to this view:

> The Indonesian Islamic family law regime has long been one of the most liberal in the Muslim universe. Contracts of marriage are elaborate and flexible, partly because of pressure and advice by women's organizations in recent decades. In addition, the religious offices and courts have been quietly sympathetic to women in bad marriages. . . . The relatively liberal treatment of women's concerns in the religious courts is itself evidence of the standing and influence of women in much of Indonesia (Lev 1996, 193–4).

The ongoing debates about gender and Islamic law in the larger context of Indonesia, Southeast Asia, and the larger Muslim world is a complex one, yet analysts continue to reproduce simplistic assumptions that secular law and modernity are somehow more liberative for women. As Talal Asad persuasively argued in his critique of the prevailing discourse about the essentially inegalitarian character of Islam,

> Islamic religious, legal, political ideologies do not have an essential significance which moulds the minds of believers in a predictable way. They are part of changing institutions, and of discourses which can be, and often are, contested and re-constituted. To understand the authoritative limits of such contestations one must focus on religious discourses within specific historical situations, and not on a supposedly original Islamic ideology. Because it is the way in which "the word of God" is reproduced, and the (political) situation to which it is addressed, which together determine its force, and not the lexical and syntactic forms of the sacred text considered in isolation (Asad 1980, 465).

THE PROBLEM OF POWER IN METHODS AND SOURCES

In political science and government, in particular in the sub-fields of political theory, public administration, and public policy, but less so in comparative politics and international relations, the focus of research revolves around meta-narrative type topics that tend towards universalizing abstractions, such as governance (local, national, and global), theories about weak and strong states and different types of state systems (for example, colonial, socialist, capitalist, Islamic), nation-state building, nationalism, institution-building, public administration, development administration, security studies, militarization, political participation, corruption, reform, power, revolutions, social movements, social relations (for example, race, class, gender), and further related topics. Yet unless one were focusing on the "absences," "lack" or "marginalization" in these processes, most likely very little can be said or found about the majority of women, who are poor, in the public sphere and in the formal sector of politics that tend to be predominantly male and male-dominated. Or at the most we will encounter "the special difficulty of recuperating the voices of any but middle-class and elite women in the study of nationalism" (Abu-Lughod 1998, 24). In this regard, the work of senior feminist scholars and younger scholars is breaking new ground (see, for example, Kanaaneh 2002, Jad 1995, Hatem 1999, Sharoni 1995, Harders 2002, Carapico 1998, Brand 1998).

Political scientists, in particular within the subfield of political theory, who seldom do ethnographic fieldwork and rely primarily on print sources, in particular official documents, will most likely not come across the thoughts, activities, roles, and political agency of the female subaltern. The culture of classic patriarchy in print literature is very strong. The sub-disciplines of comparative politics and international relations seem more promising in terms of innovative research on women and Islamic cultures, due to their relative openness to cross-disciplinary approaches, such as postcolonial studies, postmodernism, Islamic studies, and women and gender studies, and their creativity in using sources, including oral traditions. Farzaneh Milani, an Iranian scholar of comparative literature, writing about the parallels between the silencing of women's public voices and the veiling of women's bodies writes: "Women experience their confinement not only metaphorically and mystically but also spatially, physically, and verbally in their social segregation, cultural confinement, and forced silence" (Milani 1991, 7). And, one might add, they experience it through the occlusion of the scholar who is unable to read their presences.

A promising antidote and challenge to mainstream rational-choice political science and to conventional media analyses of Islamic cultures, some of which incline towards racism, xenophobia, and anti-Muslim prejudices, or even more subtle mechanisms of ghettoization and tokenization in academia, are the diverse methodological approaches of Southeast Asian and Middle East-based scholar-practitioners, Islamic historian-

religious leaders, and philosopher-bureaucrats who do not over-privilege Euro-American centered political theory. Because these scholar-practitioners have themselves in one capacity or other been involved in government, practical politics, and praxis, their insights into conventional paradigms on patron-client politics, corruption, governance and complexity, are much more intellectually nuanced, radically multilingual, multicultural, and able to create multiple spaces where comfortable received wisdom is radically contested. Struggling to balance theory and practice, knowledge and commitment, and based in Third-World countries, they argue that Western academics do not have the moral upper hand in theorizing about political ethics, democratization, transparency, and accountability (yet they often act as if they do). Women public intellectuals in Southeast Asia who take the role of religion and indigenous belief systems seriously exemplify these scholars in Indonesia, the Philippines, Malaysia, Burma and Bangladesh (Nursyahbani Katjasungkana, Wardah Hafidz, Sylvia Tiwon, Marites Danguilan Vitug, Sheila Coronel, Wan Azizah wan Ismail, Aung San Suu Kyi). Among them too are gender-sensitive male public intellectuals, such as Chandra Muzaffar, Nurcholish Madjid, Azyumardi Azra, Muhammad Syafii Anwar, Mohammad Mohabbat Khan, and many others. At least in the Southeast Asia region, one could argue that their ground-breaking theoretical analyses of politics and governance is intellectually more subtle than the work being produced by political science scholars who tend to work primarily within European-American paradigms.

BIBLIOGRAPHY

P. Abinales, *Making Mindanao. Cotabato and Davao in the formation of the Philippine nation-state*, Quezon City 2000.

B. Anderson, The idea of power in Javanese culture in Claire Holt (ed.), *Culture and politics in Indonesia*, Ithaca, N.Y. 1972, 1–69.

——, The happy, sexy, Indonesian married woman as transexual, in Laurie Sears (ed.), *Fantasizing the feminine in Indonesia*, Durham, N.C. 1996, 271–94.

T. Asad, Ideology, class and the origin of the Islamic state, in *Economy and Society* 9:4 (1980), 450–73.

E. Aspinall, Modernity, history and ethnicity. Indonesian and Acehnese nationalism in conflict, in *Review of Indonesian and Malaysian Affairs* 36:1 (2001), 3–33.

S. Bayly, *Saints, goddesses, and kings. Muslims and Christians in South Indian society, 1700–1900*, Cambridge 1989.

L. Brand, *Women, the state, and political liberalization. Middle Eastern and North African experiences*, New York 1998.

D. L. Bowen, and E. A. Early (eds.), *Everyday life in the Muslim Middle East*, Bloomington, Ind. 1993.

J. R. Bowen, Qur'an, justice, gender. Internal debates in Indonesian Islamic jurisprudence, in *History of Religions* 38:1 (1998), 52–78.

S. Carapico, *Civil society in Yemen. The political economy of activism in modern Arabia*, Cambridge 1998.

W. K. Che Man, *Muslim separatism. The Moros of southern Philippines and the Malays of southern Thailand*, Singapore 1990.

J. A. Clark and R. B. Kleinberg (eds.), *Economic liberalization, democratization and civil society in the developing world*, Basingstoke 2000.

K. Collier, The Bangsamoro "revolution." Class and factional dynamics of an ethnonationalist struggle, in *The dynamics and management of internal conflicts in Asia*, East-West Center Papers (forthcoming).

E. A. Doumato and M. Pripstein-Posusney (eds.), *Women and globalization in the Arab Middle East. Gender, economy, and society*, Boulder, Colo. 2002.

D. A. Elliston, "Engendering nationalism. Colonialism, sex, and independence in French Polynesia," Ph.D. diss., New York University 1997.

C. Enloe, *Maneuvers. The international politics of militarizing women's lives*, Berkeley 2000.

R. Euben, *Enemy in the mirror. Islamic fundamentalism and the limits of modern rationalism*, Princeton, N.J. 1999.

A. Gade, *Perfection makes practice. Learning, emotion and the recited Qur'an in Indonesia*, Honolulu 2003.

W. Hafidz, Misogyny dalam fundamentalisme Islam, in *Jurnal Ulumul Qur'an* (1993), 38–41.

S. Hale, *Gender politics in Sudan. Islamism, socialism, and the state*, Boulder, Colo. 1996.

F. P. Harvey and M. Brecher (eds.), *Critical perspectives in international studies. Millennial reflections on international studies*, Ann Arbor 2002.

M. Hatem, The microdynamics of patriarchal change in Egypt and the development of an alternative discourse on mother-daughter relations. The case of A'isha Taymur, in S. Joseph (ed.), *Intimate selving*, Boulder, Colo. 1999, 191–208.

R. Hefner, *Civil Islam, Muslims, and democratization in Indonesia*, Princeton, N.J. 2000.

R. Hefner and P. Horvatich (eds.), *Islam in an era of nation-states. Politics and religious renewal in Muslim Southeast Asia*, Honolulu 1997.

M. Iqbal, *The reconstruction of religious thought in Islam*, Lahore 1986.

M. Ishii, *Stories of Muslim women in the Philippines. Armed conflict, development and social change*, Tokyo 2000.

I. Jad, Claiming feminism, claiming nationalism. Women's activism in the Occupied Territories, in A. Basu (ed.), *The challenge of local feminisms*, Boulder, Colo. 1995, 226–48.

C. Jayawardena, Women and kinship in Acheh Besar, Northern Sumatra, in *Ethnology* 16:1 (January 1977), 21–38.

S. Kadir, The Islamic factor in Indonesia's political transition, in *Asian Journal of Political Science* 7:2 (1999), 21–44.

R. A. Kanaaneh, *Birthing the nation. Strategies of Palestinian women in Israel*, Berkeley 2002.

T. Kell, *The roots of the Acehnese rebellion, 1989–1992*, Ithaca, N.Y. 1995.

M. M. Khan, Problems of democracy. Administrative reform and corruption, in *BIISS Journal* 22:1 (2001), 1–24.

J. Koning, R. Saptari, M. Nolten, and J. Rodenburg (eds.), *Women and households in Indonesia. Cultural notions and social practices*, Richmond, Surrey 2000.

D. Lev, *Islamic courts in Indonesia*, Berkeley 1972.

T. McKenna, *Muslim rulers and rebels. Everyday politics and armed separatism in the southern Philippines*, Berkeley 1998.

A. E. Macleod, *Accommodating protest. Working women, the new veiling, and change in Cairo*, New York 1991.

R. McVey, Islam Explained, in *Pacific Affairs* 54:2 (1981), 260–87.

L. Marcoes-Natsir, Ketika Kain Batik Menjadi Mukena, in *Jaringan Islam Liberal*, 10 November 2002, at <www.Islamlib.com>.

F. Milani, *Veils and words. The emerging voices of Iranian women writers*, Syracuse, N.Y. 1992.

V. S. Peterson (ed.), *Gendered states. Feminist revisions of international relations theory*, Boulder, Colo. 1992.

A. Reid, *The blood of the people. Revolution and the end of traditional rule in Northern Sumatra*, Kuala Lumpur 1979.

M. Ricklefs, *The seen and unseen worlds in Java: 1726–1749. History, literature and Islam in the Court of Pakubuwana II*, Honolulu 1998.

J. C. Scott, *Weapons of the weak. Everyday forms of peasant resistance*, New Haven, Conn. 1985.

——, *Seeing like a state. How certain schemes to improve the human condition have failed*, New Haven, Conn. 1998.

L. Sears (ed.), *Fantasizing the feminine in Indonesia*, Durham, N.C. 1996.

S. Sharoni, *Gender and the Israeli-Palestinian conflict. The politics of women's resistance*, Syracuse, N.Y. 1995.

J. Siapno, *Gender, Islam, nationalism and the state in Aceh. The paradox of power, co-optation and resistance*, New York 2002.

J. Siegel, *The Rope of God*, Berkeley 1969.

——, Curing rites, dreams, and domestic politics in a Sumatran society, in *Glyph* (1978), 18–31.

D. Singerman, *Avenues of participation. Family, politics, and networks in urban quarters of Cairo*, Princeton, N.J. 1995.

N. Sullivan, *Masters and managers. A study of gender relations in urban Java*, St. Leonards, N.S.W. 1994.

C. Sylvester, *Feminist international relations. An unfinished journey*, Cambridge 2001.

M. A. Tétreault and S. Ranchod-Nillson (eds.), *Women, states and nationalism. At home in the nation?* New York 2000.

J. A. Tickner, Feminist theory and gender studies. Reflections for the millennium, in F. P. Harvey and M. Brecher (eds.), *Critical perspectives in international studies. Millennial reflections on international studies*, Ann Arbor 2002, 321–9.

M. D. Vitug and G. M. Gloria, *Under the crescent moon. Rebellion in Mindanao*, Quezon City 2000.

L. Weeden, *Ambiguities of domination. Politics, rhetoric, and symbols in contemporary Syria*, Chicago 1999.

Q. Wictorowicz, *The management of Islamic activism. Salafis, the Muslim Brotherhood, and state power in Jordan*, New York 2001.

ACKNOWLEDGMENTS

I wish to thank Diane Singerman, Merle Ricklefs, and Suad Joseph for critical comments on this piece.

JACQUELINE AQUINO SIAPNO

Population and Health Studies

Population emerged as a field of study in response to the formulation of "population growth" as an alarming and dangerous phenomenon. Malthus in his seminal essay of 1789 had warned of the environmental, economic, and social time bomb engendered by unbridled population growth. This fear of the exponential increase of human populations stripping the earth of its resources became a fear of a growing "global poor" after the end of the Second World War and the emergence of a postcolonial and developing Third World (P. and A. Ehrlich 1990). From the mid-1960s population programs were aimed at the "control" of fertility and modeled on an epidemiological model espoused by the first director of population programs in the United States Agency for International Development (USAID), a medical epidemiologist called Reimert Ravenholt who postulated "excess fertility" as a disease for which contraception is the cure. The task of policy and services according to this model is to focus on the supply of the cure. Thus population programs and population studies honed in on the supply of contraception and the measurement of its prevalence (Sinding 2001). Although this simplistic model was critiqued by leaders in the field like Kingsley Davis and Philip Hauser who situated excess fertility in a socioeconomic matrix of poverty and need, the simplicity of the model and its clear assumptions as well as the quick yield and impact it promised made it attractive to donors (Sinding 2001, 3). Chief among these was the U.S. Congress who found the supply side model quick and unambiguous

The concern over contraceptive side-effects and quality of health care imposed itself on population discourses as a by product of the focus on contraceptives and their supplies. In the 1980s and after decades of critique (particularly from grassroots activists, feminists, and other engaged observers including anthropologists) of the health consequences of both fertility and the proposed therapies presented by contraceptive technologies a revision of the narrow focus of the field was set in motion. Thus a subfield concerned with health and well-being was created, populated with researchers and programs and amply funded by donors.

Situating fertility and its consequences in the context of health created disciplinary, methodological, and cultural challenges to the field of population studies. Medical anthropology and sociology as well as medicine itself became relevant fields. The study of the meaning and management of health, together with the array of therapies licensed by medical knowledge and practice, became relevant and in fact central to population studies. Even more important was the relevance of culture in structuring roles and relationships that are central to the realization of better health. In this new and grounded or ethnographically informed field the concern with fertility was complemented by a concern for reproductive morbidity, mortality, gender, sexuality, and the quality of health care. In short the conglomeration of experiences and states that informs reproductive behavior became a legitimate continuum of concern for researchers and service providers.

GENDER, RELIGION, AND SEXUALITY

Once population transcended the mere measurement of fertility, the cultures and morals of Islam gained a profound potency in the way that moral and particularly gender discourses and practices shaped reproductive behavior amongst Muslims and in areas of Islamic influence. The regions and communities associated with Islam as a dominant moral and cultural force seemed to stand out for their specificity and perceived resistance to change. At the root of this nexus of images, imaginations, perceptions, and misinformation lies a cultural construction of gender associated with Islamic law, values, and principles. Muslim societies' assumed or actual practices, such as early marriage, high fertility, male preference, and gender inequality considered to be the foundations of patriarchal family orders are cited as signifiers of Muslim social life. Similarly perceived notions of female bodily integrity, modesty, sexuality, and gender relations are associated with Muslim morality. To accept or reject such assumptions necessitates engagement with empirical realities in Muslim societies and the contribution of research to knowledge in the fields of population and health.

The reproductive role of women has been placed at the heart of much academic work that

sought to describe the social lives of men and women in the Muslim Middle East. Fertility and the power to bear sons has been used to explicate the patriarchal family, rationalize kin marriages, discuss gender inequity, evolve a theory of "Muslim procreation," and speculate on the functions and structures of spiritual, natural, and supernatural beliefs. The theory of Muslim procreation in particular has become the definitive rationale for the potency of fertility in drawing the lines of influence and power between men and women. The image of seed and soil whereby man provides the active seed and women the passive soil is not exclusive to Islam but is a feature of all monotheisms. This theory partially explains the naming of God as the father and the passivity of the nurturing female in monotheistic myths of creation. However, Islam is averse to this view of God and explicit in its reference to Allah as neither a begetter nor begotten (Qur'ān, 112:3). Yet various researchers have argued that the primacy of paternity and the degree to which the jural rights of the father eclipse those of the mother once children come of age show the relevance of this monotheistic theory of procreation to Islam and explain gender dynamics and the importance of fertility in marriage (Delaney 1992, Sholkamy 1998, Omran 1992).

Studies of gender and reproduction have also focused on the consequences of infertility, the constructions of manhood, and the dynamics of gender and family roles. Worthy of note is how essential "Islam" has been to all of these scholarly works. Equally obvious however is how loose and inadequate much of the historical, sociological, feminist, and ethnographic discussion of Islam has been. Delaney's references to Islam and monotheism to explain procreation theory in Turkey or Inhorn's description of the plight of infertile women in Egypt to illustrate the historical and ideological origins of patriarchy assume a direct link between Islamic texts and the practices of individual Muslims. In each of these examples Islam is present as the root and crucial force shaping practices and perceptions. Yet left unclear is how "Islamic ideology" operates. Analysts resort to Islam not as faith but as hegemonic ideology. Unsettling in many such sources are the assumptions of how pervasive this ideology is and how present and immediate are its tenets. Perhaps the problem lies in the inability to historicize the relationship between Islam and women's fertility and health. In addition the link between social theory and empirical practices remains tenuous and in some cases contrived. A notable exception

is Ali's work on family planning in Egypt in which he restores the dimensions of modernity, gender dynamics, culture, social conflict, and the project of the central and powerful state to describe the history and fate of family planning programs (Ali 2002).

If the message of Islam is the promotion of fertility, the moral elevation of the mother, and the legal supremacy of father, the necessity of early marriage, and the importance of the consummation of this marriage with childbirth as well as the primacy of women's reproductive roles over their productive contributions, is it not worthy of analysis to comment on how this message is delivered and by whom? Whether it is the patriarchal family, the state, the physician, or the religious establishment who delivers such messages is an important dimension of understanding religious ideology and the roots of assumed potency. High fertility amongst families in diasporas such as the case of Palestinians is an act of political engagement and an assertion of national identity (Giacaman 1997). In Egypt high fertility was a marker of dissonance and the Islamization of population discourses (Ali 2002). In Iran the promotion of family planning after the revolution was condoned and aided by the religious discourses of the state and its clerics who used their authority to favor a pragmatic Shīʿī view of social problems and their solutions (Hoodfar 2000). Both high fertility and low fertility are modern strategies that can only be fully understood in a socioeconomic and historical context.

On the other hand the presence of "Islam" as an intermediate variable in demographic studies does not give enough credit or indeed any meaning to the category "Muslim." Is it because of their belief that Muslim women evince certain reproductive behaviors? Variations in nationality, ethnicity, class, education, generation, and political context explode the category Muslim and question its relevance to reproductive behavior. This in no way questions the faith of surveyed women. However, the low fertility of Gulf societies, the relative autonomy and empowerment of European Muslim women, and the poor health status of women in Afghanistan and Pakistan show that demographers must, and thankfully do, dig deeper for explanations and justifications of reproductive practices. There are so many variations in Muslim practices and experiences that any attempt to explain this broad spectrum through a grand and unifying root paradigm cannot yield any knowledge or sense. Perhaps the ready availability of various Islamic doctrinarian

treatises and works of jurisprudence in written form makes the possibility of resort to such works too attractive for analysts to pass over. Ethnographic observation, however, shows that the availability of these texts in archives and collections does not mean that they are present as oppressive structures on the ground (Sholkamy 1999). As in all social sciences, context and history are key to understanding empirical reality, belief, and ideology.

REPRODUCTIVE HEALTH AS AN AGENDA FOR SERVICES AND ACTION

The corresponding and significant paradigm shift to the transition from population to population and health was expressed in the 1994 International Conference on Population and Development held in Cairo. The no longer new paradigm of reproductive health was formally adopted as the primary intellectual influence for the agenda of population research. Reproductive health, defined for the first time in an international policy document, includes ensuring healthy and safe childbearing, preventing sexually transmitted diseases (including HIV/AIDS), and addressing other factors that contribute to poor health, such as sexual trafficking and violence against women. The Cairo conference also called upon non-governmental organizations (NGOs) as partners in population intervention and policy. This paradigm shift is seen as a point of departure from classical population research that addressed fertility as a disease to be controlled at many and quite significant levels. Moreover the agenda of action inspired by the Cairo conference has shaped global initiatives and goals relating to women and their well-being (see Beijing Declaration 1995).

First, at the level of population goals it has shifted the focus from societal and quantifiable targets and indicators such as rates of population growth, fertility, and contraceptive prevalence to qualitative and individual indicators such as health, well-being, and women's empowerment. Reproductive morbidity, infertility, sexuality, and female autonomy and bodily integrity had been deemed low priority areas of interest and concern. However, they became a point of focus for population research as experiences that affected fertility decisions, experiences, and outcomes and that, more importantly, had an impact on well-being and quality of life.

Another significant shift associated with the previous point concerns population sciences and the disciplines they include. The methods and theories of anthropology, sociology, policy research, and of feminist and human rights activism came to supplement and in some instances supercede the more classical tools of demography and economics that had dominated the fields of population research.

A third shift occurred at the level of the subjects of research. Reproductive health transcends the narrow focus on women in their reproductive years to look at experiences and relationships that structure reproduction, sexuality, and morbidities associated with both. Youth and adolescence is recognized as a time of crucial and critical sexual experience and a time of opportunity and risk. The health of menopausal women and their role in influencing decisions of younger men and women is also recognized. So is the importance of masculinity, male sexual health, and gender roles and power relationships.

A fourth dimension of difference is located at the crossroads between research and activism. The reproductive health agenda is contingent on a rights discourse that had been injected into social science research and in the global discourse on development. This framework of individual human rights and entitlements assumes a role for activism and for research that aims to engage with or change policy. The Cairo conference was similar to other global conferences and summits of the decade where NGOs and activists played a prominent and defining role.

The field of research and measurement has thus been redrafted as interdisciplinary and broad. Its evaluation and description/measurement is no longer defined by straightforward quantitative measurements but rather by a set of indicators that are historically and culturally determined and meaningful at individual rather than at the macro societal level. In other words this shift has brought to the fore the meaning endowing agency of individuals, their socioeconomic and political realities, and the values and moralities that constitute cultures. However, this statement is accurate at the level of consciousness and less evinced by practical research.

Health and gender remain linked by a narrow array of quantitative indicators and a set of policy goals and objectives. Reproductive health has not replaced contraceptive prevalence and fertility rates as core measurements in the fields of health and population. It is hard to measure health or well-being and easier to quantify morbidity, mortality, and utilization rates of services and contraceptives. Consequently and aside from the continued effort to come up with practical indica-

tors to measure reproductive health, research favors limited fertility as a desired outcome. The branching of the field into reproductive morbidity, gender dynamics, child survival, quality of care, health sector reform, sexuality, and birthing is rationalized by the desired outcome of lower fertility, which these studies will facilitate.

Interdisciplinary work in the field of reproductive morbidity can partially transcend the fertility control model. The Giza study conducted in Egypt illustrated the importance of health perceptions to health seeking behavior and the burden of morbidity that women bear. The study also critiqued the received quality of care and opened the way for research on health providers. From the original Giza study team, the network called the Reproductive Health Working Group (RHWG) is comprised of medical and social scientists working towards the promotion of multidisciplinary and policy-oriented research in reproductive health. There are active RHWG researchers in Egypt, Jordan, Lebanon, Turkey, and Sudan working on issues such as the social content of medical education, birthing practices in facilities, sexuality, health sector reform, and ante-natal and post-natal care. The work of Alan Hill and others in the Gambia amongst Muslim and polygamous families has provided a critique of contraceptive delivery services and introduced dimensions of choice, gender empowerment, and cultural identity into the discourse on health services. The Gambia project also documented the importance of men as subjects and informers to research in the field of reproduction. These studies illustrate the trend towards in-depth, longitudinal research that utilizes an assortment of qualitative and quantitative methods and methodologies to understand and intervene on behalf of better sexual and reproductive health (Bledsoe et al. 1998).

These methodological gains are important. However, reproductive health as a morally loaded agenda merits a discussion beyond social research methods and into politics and activism. For the Arab and Islamic world reproductive health seemed to be an agenda at odds with the values of culture and religion as constructed by some social agents. Aside from exaggerated fears about cultural imperialism and the expropriation of population by Western feminists the paradigm of reproductive health came under criticism for the difficulty of its execution in the absence of clear, comparable, and cheap indicators that can be used to evaluate the impact of reproductive health policies and services. The concerns about cul-

tural specificity, feminist impositions concerning individual liberty and bodily integrity, and the permissive undertones of the whole discourse, which are deemed unsuitable for Muslims and their societies, have lingered in many hearts and minds. Confrontations between theologians and conservatives with activists, feminists, and some academics have affected the "reputation" of reproductive health as a viable alternative framework for population policies. Famously, the topic of female genital mutilation, a practice that has no foundation in Islamic law but a strong empirical association with some Muslim societies, is a case in point. While feminists saw in the reproductive health framework an opportunity to raise funds and support to eradicate this violation of the female body, conservatives reacted by finding in the practice a route to realizing Islamic prescriptions of sexual modesty.

Yet the reproductive health paradigm has empowered social activists to address issues such as the neglect of female children in Pakistan (where female child mortality exceeds males by 12 percent), honor killings in Jordan, and a myriad of other social problems that plague the lives of poor women all over the world.

The introduction of progressive ideals into population discourses is in itself a hard-won victory for researchers and activists in the field. However, progressive ideals are also cultural ones and as such may be alienating or threatening. While the conflict between cultural relativism and universal humanism has been a feature of the social sciences for decades, population scientists and researchers have always espoused global agendas bearing modernist values. The positive value placed on low fertility is by and large accepted by demographers. Reproductive health has introduced doubt and debate at the level of values in which even the modernizers are embroiled.

DATA SETS AND KNOWLEDGE SOURCES

The field of health and population is an extensively measured one. An essential tool of policy relating to the realization of various reproductive health and population goals has been the funding of periodic surveys to assess program performance and estimate their cost-efficacy. Global surveys such as the Word Fertility Survey are expensive and laborious. Regional surveys such as the Pan Arab Project for childhood and the Pan Arab Project on families (PAP-Child and PAP-Fam respectively) are attempts to collect primary data from a nationally representative sample on trends and developments in the fields of health

and population. Most demographic wisdoms and alerts are derived from national census material that is collected periodically in countries that can afford it and sporadically in others. The Demographic and Health Survey (DHS) is a tool used to assess and direct policy in countries that benefit heavily from donor assistance. The DHS also relies on samples and also allows for quicker yields of data and measurements. In Egypt a module on women, empowerment, and violence used in 1995 yielded startling results. The prevalence of female genital cutting, domestic violence, lack of choice of marital partner, and the character of domestic gender roles evinced social practices that were working against the well-being of women (DHS 1995). Sample surveys have also been successful in the field of child health in which indicators such as prevalence of immunization, infant and under-five mortality and morbidity, and maternal mortality are closely monitored and reported through UNICEF in tandem with national governments. Global development and humanitarian indices have also emerged to help gauge the situation of women all over the world. The UNDP Gender-related Development Index (GDI) and Gender Empowerment Measurement (GEM) are used to monitor the progress of current agendas favoring women and their reproductive health. Thus the macro picture of health and population is continuously changing and researchers can gauge such change thanks to the wealth of quantitative data that exists and the availability of most surveys on the internet. An obvious caveat is that numbers cannot be trusted per se and there are many critical stances concerning the significance of certain indicators and the reliability of data collection methods. However the considerable human and material cost that goes into the compilation of demographic data sets should extend beyond policymakers and planners and inform research and social analysis.

The articulation of quantitative and qualitative analysis yields relevance, insight, and valuable knowledge (Ali 2002, Khattab 2000, Obermeyer 1995). Yet this synergy of analytical frameworks remains underutilized. Analysts prefer to maintain separate spheres of interest so, at the risk of a caricature, it is as if what people do and what they think and feel are destined to remain unnecessarily uncoupled. The circulation of surveys and other quantitative data and that of ethnographies and works from the fields of history, religion, gender, and political science are separated by two main obstacles: those of size and frequency. Surveys are not designed to measure the marginal,

the unknown, the small, or the unique. Hence surveys go on measuring the same things over and over again. The qualitative traditions of history, anthropology, gender, and religious studies are intolerant to repetitions. If someone has done it then there is no point in doing it again! Moreover there is a deep and perhaps justified interest in the obscure, liminal, and tenuous borders of culture and society that fascinate researchers at the cost of researching the mainstream and obvious.

There are notable exceptions mentioned above but the existing resources for researchers are divided between the deeply interesting and the demographical updates. Indeed the interest in women's reproductive health is still divided by a fault line that separates understanding and measurement and that posits gender, sexual ideology, and social life on one side, leaving health, reproduction, and public policy on another.

Despite fractures in the discourse the field offers easy access through the variety of data resources that address its main issues. Two other important resources complement the periodically collated and reported quantitative data sets and the academic publications that mingle methods to delve into details and analysis. The first and more easily available are the numerous periodicals that focus on population and health issues.

Peer-review journals published in the West, such as *Population and Development Review*, reflect the impact of health studies and of interdisciplinary and collaborative research on demographers. The publications of the International Union for the Scientific Study of Population are a similarly mainstream and important source of information. Other publications, such as *Reproductive Health Matters*, have a feminist and activist orientation but have provided a platform for the articulation of reproductive health and feminist research.

In addition there are reams of partially analyzed study and project reports funded by agencies and governments that linger in spheres of limited circulation. The various population research institutes and organizations remain the better endowed resources for researchers interested in this field. Organizations such as the United Nations Fund for Population, the Population Council, the Arab League, and many others churn out numbers and concerns that merit further consideration and analysis. The meta-analysis of such reports and their use to inform mainstream academic, policy, and general readership is an option that can be tapped by researchers. One of the significant efforts in this field has been the New Arab Demography Project initiated by

the Social Research Center of the American University in Cairo, which encouraged demographers and social scientists to re-examine existing census and sample data to inform the analysis and understanding of population and health in the Arab world.

Concluding synthesis

The divide between research traditions and resources that address health and population and those that look at gender, religion, and sexuality remains an obfuscating and unsettling one. Bridging this divide could help to theorize health practices and experiences and dramatically inform existing dominant notions of Islam as an ideology of gender and gendered experiences. Classical theory in population and health studies locates Islam as an obstacle to modernization and modernizing sexual and reproductive practices and relationships. Yet the difference between Muslim societies is immense. Iran has a contraceptive prevalence rate of 55 percent while in Yemen it is only 10 percent (Rudi 2001). There is a clear need for comparative and interdisciplinary work that desists from facile interpretations and arguments of ideological causation and tries to fathom how and why Islam as a moral and historical construction can yield so many different elaborations on its tenets and merge in such different ways with historical and material conditions. Indeed that flexibility and historicity is the strength of Islam.

The initiative called the International Reproductive Rights Research and Action Group (IRRRAG) presents an interesting illustration of the value of comparative research. This project fostered research in a number of countries including Malaysia, Indonesia, and Egypt to investigate reproductive rights. Each chapter from each country, including Islamic countries or those with sizable Muslim populations, yielded a very different account of reproductive rights in Islam. This collaboration succeeded in deconstructing the assumed hegemony of gender and religious ideology when de-historicized because it undertook in-depth and comparative work. Rather than stress "Islam" as a barrier to change, researchers illustrated how this moral system merges with and both shapes and is shaped by the contingencies of everyday life. Interpretations of Muslim gender ideology also vary from Turkey, which enacted a civil code in 2002 to realize absolute gender equality, to Pakistan where variations between male and female health indicators such as malnutrition and death still substantially favor men.

Islam remains a dominant framework at a level of discourse, rhetoric, and faith. The logic of health practices and reproductive well-being pushes analysts to create a horizon of theoretically informed empirical research free of dogma and facile categories.

Moreover, the importance of transcending the pragmatic routes of population and health sciences to contribute to social understanding of the everyday lives and health of women and men is a goal of urgency and value. So far, the measurement of population growth and dynamics and the description of health status have been motivated by perceived needs for intervention and change. This policy orientation has yielded a set of epistemological assumptions that are constrained and obfuscated by their pragmatic origins and dispositions. As the field of population and health evolved from the fertility control model so there is a need for further evolution from measurement and description littered with essentialism of causation and motivation to a historicized and theorized field that is sensitive to agency, complexity, and multiplicity and to social, political, and historical contexts.

Bibliography

K. Ali, *Planning the family in Egypt. New bodies, new selves*, Austin, Tex. 2002.

Beijing Declaration and Platform for Action from the Fourth World Conference on Women Beijing, China 1995, at <www.un.org/womenwatch/daw/beijing/platform/declar/htm>.

C. Bledsoe et al., Constructing natural fertility. The use of Western contraceptives in rural Gambia, in *Population and Development Review* 20:1 (1994), 81–113.

C. Delaney, *The seed and the soil. Gender and cosmology in Turkish village society*, Berkeley 1992.

P. and A. Ehrlich, *The population explosion*, New York 1990.

R. Giacaman, *Palestinian women. A status report*, Birzeit 1997.

S. Greenhalgh (ed.), *Situating fertility. Anthropology and demographic enquiry*, Cambridge 1995.

H. Hoodfar and S. Assadpour, The politics of population policy in the Islamic Republic of Iran, in *Studies in Family Planning* 31:1 (2000), 1–18.

M. Inhorn, *Infertility and patriarchy. The cultural politics of gender and family life in Egypt*, Philadelphia 1996.

S. Joseph (ed.), *Intimate selving in Arab families. Self, gender and identity*, Syracuse, N.Y. 1999.

——, *Gender and citizenship in the Middle East*, Syracuse, N.Y. 2000.

H. Khattab, *The Giza morbidity study*, Cairo 2000.

A. Omran, *Family planning in the legacy of Islam*, London 1992.

C. Obermeyer (ed.), *Family, gender, and population in the Middle East. Policies in context*, Cairo 1995.

N. Rudi, Selected demographic indicators of Arab countries and Turkey, Population Reference Bureau,

Washington D.C., December 2001, available at <www.prb.org>.

H. Sholkamy, Procreation in Islam. A reading from Egypt of people and texts, in P. Loizos and P. Heady (eds.), *Conceiving persons. Ethnographies of procreation, fertility, and growth*, London 1999, 130–61.

H. Zurayk, *Women's reproductive health in the Arab world*, West Asia and North Africa regional papers no. 39 (April 1994), Cairo 1994.

HANIA SHOLKAMY

Sexualities and Queer Studies

Interest in the various aspects of and possible common points between sexualities in the Islamic world through the ages has been a minor but continuous academic concern during the last three decades, boosted by the emergence of women's and gender studies, almost synchronously with gay/lesbian studies in the mid-1980s and then queer studies in the 1990s. Three groups of epistemological issues pertaining to gender and sexual identity in Islamic societies are addressed here: the constructionist vs. essentialist approach, the relevance of constructing "Islamic sexualities" as a field of research, and the interactions between Western and traditional constructions of sexual identity in modern Islamic societies. This article will deal mainly with sources in Arabic, which remained the language of the cultured elite of the Islamic world until the twelfth century. Sources for other regions will be mentioned in the bibliography.

The field of women's studies, which deals primarily with contemporary societies from a sociological, ethnographic, or political perspective, has provided us with raw information on gender structures; however, studies devoted exclusively to male identity and culture have appeared only recently. Writers dealing with same-sex behavior in Islam or in Arab societies, although informative, often seem unaware of the deeper issues associated with the vocabulary they use. "Homosexuality," "pederasty," "inversion," and "lesbianism" are used without questioning their meanings, while Arabic terms such as *liwāṭ* and *takhannuth* are immediately equated or linked with "homosexuality" and "effeminacy" without further investigation. Although G.-H. Bousquet discusses the actual importance of *zinā'* (profligacy) in North Africa, despite its harsh condemnation in *fiqh*, he merely notes that "pederasty between children or young people does not cause great indignation . . . it is far from being unknown between adults. It is well known that a particular region of Tunisia is famous in this matter" (Bousquet 1953, 60). From a different perspective, al-Munajjid attempts to portray the sexual habits of the Umayyad and ʿAbbāsid eras, including same-sex relations, through anecdotes quoted in *adab* works. The author seems to understand these anecdotes as factual reflections of reality, concerning the whole of medieval

society, without explaining that such words as *liwāṭ* do not bear the same meaning in classical and modern Arabic, whether because he assumes his readers' knowledge of the issue or, more likely, because he himself assumes that *liwāṭ* means homosexuality. The pervasiveness of sexual matters in *adab* causes him to call the ʿAbbāsid age the "era of sex," which he attributes to an alleged "loss of religious feeling among the aristocracy" (al-Munajid 1958, 45) and, above all, to the "Persian influence."

Whether hushed up, coyly alluded to, frowned upon, or rejected as products of foreign influence and past attitudes, same-sex relations have long been a blind spot in twentieth-century Arab sources. The subject is reluctantly addressed by Pellat in his 1983 *Encyclopedia of Islam* article, written from the perspective of normative discourses produced by Islamic societies concerning *liwāṭ*. With A. Bouhdiba's ground-breaking *La sexualité en islam*, however, sexuality in Islam was made into a specific, coherent object of study. More recent research has focused on the perceptions reflected in cultural production, essentially literature, whether classical or modern, but until recently there have been very few attempts at evaluating discursive praxis in the light of gender construction theory.

Scholarly debates catalyzed by queer studies, primarily concerned with the relevance of the concept of (sexual) identity, are highly useful in the study of non-European cultures, which in turn could certainly benefit from academic debate on the construction of sexuality in Islamic societies. Interaction with non-European civilizations during the colonial era, particularly the Islamic "East" as an epitomic cultural "Other" (R. Burton's "sotadic zone"), is closely related to the Western construction of a homosexual identity, with the help of what R. C. Bleys calls the ethnographic imagination's mapping of the "geography of perversion." In return, this deconstruction may now apply to Islamic cultures and enrich a discipline that has been hitherto primarily concerned with early Greek and Roman homosexualities. The possible links between pre-Islamic substratum conceptions of gender and same-sex relations, particularly Greek and Persian, and later Arabo-Islamic cultural features, have yet to be explored. The resemblances and differences between the classical Greek *erastes/*

eromenos relationship and the Islamic poet/*amrad* (beardless youth) relation need to be studied as well. It has often been noted that the pervasiveness of homoerotic poetry begins with the 'Abbāsid caliphate period (750–1259), when the Persian heritage merged into Islamic culture. But the mere fact that the love of boys is connected with *shuʿūbiyya* (pro-Persian claims) in some belles-lettristic works does not allow the researcher to attribute the appearance of "homosexuality" in Islamic civilization to an outside influence.

Much research has been devoted to the extent to which Western definitions of homosexuality and, recently, the gay liberation movement, have influenced Islamic societies' perception of same-sex behaviors, as well as perceptions by "homosexuals" of themselves. An identity closely linked with heterosexuality probably first appeared in the nineteenth century during the age of encounters between colonial Europe and the Islamic world. The colonial era's influence on gender construction in Islamic countries often resulted in the imposition of a strict conception of heterosexuality, sometimes in a Victorian moral code that was eagerly and rapidly islamicized. B. Dunnes's work on the normalization of sexuality in Egypt shows how the colonial power pressured reluctant local authorities to outlaw homosexual practices. A similar process occurred in India and is analyzed by S. Bhaskaran. The impact of nineteenth-century European morality on the construction of Islamic sexualities is also underlined by A. Najmabadi in her work on Qājār Iran.

Following Michel Foucault, particularly the English translation of the first volume of his *Histoire de la sexualité*, researchers began to look at how sexuality is historically constructed in discourse, and how culture normalizes sexual acts so as to define genders and limits. Historians have sought to analyze the construction of homosexuality, while literary scholars explore the various bonds that define male identity, and demonstrate how each culture at different periods has conceived of sexuality. These works show how, during a long period of maturation beginning in fifteenth-century Europe and gaining speed from the eighteenth century on, "homosexuality was historically invented as a specific category and opposed to a norm that mainly defines itself by what it excludes" (Eribon 1998, 15), the assumption being that heterosexuality is not so much a natural or universal concept and way of living one's sexuality as a constructed definition of gender, excluding same-sex attraction and intercourse. Historians regarded as essentialists, on the other hand, have considered same-sex attraction to

be a universal minoritarian paradigm, regardless of its crystallization as an independent concept in history, that can rightfully be subsumed as "homosexuality" or "gayness"; they have subsequently endeavored to examine its developments at various periods and locations. Since the 1990s, queer theory can be seen as a later development of the constructionist approach, aimed at severing gay and lesbian studies from a minoritarian and identitarian approach.

Although such epistemological issues have seldom been addressed per se in studies pertaining to the Islamic domain, most authors have noticed that both normative texts (Qurʾān, *ḥadīth, fiqh*) and perceptions of sexuality (as reflected in literature or in interviews during fieldwork) deal primarily with acts linked to penetration (anal or vaginal) or behaviors seen as substitutes for penetration: intercrural intercourse (*tafkhīdh*), masturbation (*nikāḥ al-yad, dalak* or *jald ʿumayra*), and intervaginal intercourse (*saḥq*, literally "pounding," an analogy being made with the crushing of saffron leaves), with a puzzling lack of mention of oral-genital acts. All these forms of behavior are considered through the prism of licitness by doctors of the law, or through the prism of social and literary acceptability by littérateurs, but classical authorities never derive from them the definition of a minoritary identity.

The first convincing attempt from a constructivist perspective to study the medieval understanding of sexual irregularities was made by E. K. Rowson, who highlighted a number of essential points concerning medieval perception of genders and sexual behaviors in his work on medieval Arabic vice lists. Modern prioritization of sexual object choice over sexual activity does not fit this perception, which sees the adult male as penetrator and the female as penetrated. Within this framework, the preference of an other-sex or same-sex partner for the male is a matter of choice (both options are illicit outside the frame of *nikāḥ*) whereas the preference for the passive position in anal intercourse (called *ḥulāq* until the ninth century, then *ubna* or *bighāʾ*) is always perceived as an illness, and is widely discussed in *adab* literature, often in amusing fashion. Female refusal to accept male penetration is equally culpable. Parallels are drawn between active anal intercourse (*liwāṭ*) and fornication (*zināʾ*): they are both illicit but expectable attempts by the male to satisfy his instincts as penetrator whereas a beardless youth's acceptance of the role of passive partner for money, provided he derives no pleasure from it, is socially acceptable, though formally outlawed by religion.

It should be stressed, however, that such analysis should not be seen as a key to understanding contemporary attitudes toward same-sex relationships, nor as a definitive refutation of essentialist views. The concept of bisexuality, only recently discussed in academic works, could also be used to describe some same-sex behaviors. More recently, the AIDS epidemic has focused the attention of researchers on sex workers and their customers. Some articles in the Aggleton collection on male prostitution and AIDs, such as S. Khan's investigation of the South Asian zone or Boushaba's study of Morocco, suggest the idea of bisexuality might help build a slightly more balanced idea of same-sex relations in modern Islamic societies.

Particularly interesting is the case of *khināth* or *takhannuth*, which can be translated variously as effeminacy, transvestism, transsexualism, or hermaphroditism – a puzzling inconsistency that is solved when one considers that the term refers to various failings to achieve masculinity in its behavioral features. In his essay on the "effeminates" of early Medina, Rowson argues that it was not until the ninth century that *khināth* was associated with homosexual intercourse. Although interesting studies on gender-crossing are included in Murray and Roscoe, there have been no monographs until now on the different realizations of *khināth* in Islamic societies. U. Wikan discusses at large the Omani *khanīth*s she observed during fieldwork in the 1970s. The term is almost unattested in classical Arabic, ignored by Ibn Manẓūr in the *Lisān al-ʿArab*, and barely appears as an adjective in a verse by the fourteenth-century poet al-Aʿraj al-Ṣāfī, quoted by al-Ṣafadī in *al-Wāfī bi-al-wafayāt*, in which the beloved is called "Ẓaby khanīth al-dalāl" (a kid with *khanīth* coyness).

It can be noted that modern East Arabian dialects use the term *khanīth* as a derogatory insult for the passive partner in homosexual intercourse, but the transvestite/transsexual figure described is highly reminiscent of the early Islamic *mukhannath*, with the exception of homosexual prostitution, a feature of the modern *khanīth* unmentioned in discourse concerning the *mukhannath*. Wikan's conclusion that "it is the sexual act, not the sexual organs, which is fundamentally constitutive of gender" allows us to understand why "the man who enters in a homosexual relationship in the active role in no way endangers his male identity" (Wikan 1982, 175).

The high value placed on female purity renders seeking the company of a *khanīth* socially ambiguous: both a greater individual shame than seeking forbidden intercourse with a woman, through female prostitution or, worse, through intercourse with a married woman, and a lesser social shame given that it does not require the female to break sexual interdicts. The Omani institution of *khanīth* therefore sheds light not only on Islamic societies alone, but on the statute of same-sex relations in any society that puts strong emphasis on female virginity and chastity. For the same reason, *khawals*, male dancers in nineteenth-century Egypt who performed dressed as women, eventually replaced female dancers entirely after Muḥammad ʿAlī Pasha ordered a ban on female prostitutes and dancers in 1836.

Research on the variations and permanencies of the terminology of same-sex relations in various languages used in Islamic countries is needed. In the case of Arabic, it is probable that neologisms such as *shudhūdh jinsī*, sexual deviationism (early twentieth century?), and *mithliyya jinsiyya*, homosexuality (late 1990s), were coined to translate the European concepts of homosexuality. English words such as "gay" (and to a lesser extent "queer") have now become part of the usual vocabulary in the main urban centers of the Islamic world. But why and how did they partly replace traditional terms? In the Arabic-speaking world, when were the former meanings of *lūṭī* (enamoured of young men seeking the active role in anal intercourse), *muʾājir* (male prostitute), *maʾbūn* (grown man seeking the passive role in anal intercourse), *musāḥiqa* (woman flaunting penis-hate and practicing tribadism), and so forth, lost and replaced either by new meanings (*lūṭī* understood as a synonym of male homosexual, *siḥāq* identified with lesbianism) or by borrowed terms? To what extent do these neologisms cover the precise domain of homosexuality in mainstream Western culture? Do modern and ancient dialects (and urban slang or underworld languages) retain in their terminology the remembrance of premodern gender constructions, and are these consistent with elite *adab* conceptions?

Language partly allows a tempering of the constructionist idea of a dividing line between sexual acts rather than sexual preferences in classical Islamic societies: the repetition of homosexual acts, even by the active partner, might turn a mere amusement or ersatz into an illness, or something that could remotely evoke an identity; moreover, when a man often sleeps with other men, one cannot be sure of what really takes place between them, and as al-Tawḥīdī mischievously said of the tenth-century Persian vizier Ibn ʿAbbād, "*kam ḥarbatin fī al-qawmi ṣārat jaʿbatan*" (many a spear has become a quiver).

BIBLIOGRAPHY

PRIMARY SOURCES IN ARABIC – CLASSICAL PERIOD
All information concerning the early period is to be sought in eighth-century and later sources, and commands caution in terms of its historical value. Keyword searches (*liwāṭ, siḥāq, ubna, ḫulāq*, etc.) can be conducted on the www.alwaraq.com site, which offers more than a million pages of classical Arabic works online. Although awkward to use, A. Schmitt's *Bio-bibliography on male-male sexuality and eroticism in Muslim societies* (Berlin 1995) is useful. Same-sex relations are widely mentioned in tenth-century *adab* works such as al-Iṣfahānī, *Kitāb al-Aghānī*, al-Rāghib al-Aṣbahānī, *Muḥāḍarāt al-udabā'*, al-Qāḍī al-Jurjānī, *al-Muntakhab min kināyāt al-udabā'*, pseudo-Tawḥīdī, *al-Risāla al-Baghdādiyya*, etc. *Sukhf* (ribaldry) related literature at later periods offers many examples of same-sex erotica, the most famous of which is the thirteenth-century al-Tīfāshī, *Nuzhat al-albāb*. See also shadow plays by Ibn Dāniyāl, fourteenth-century al-Nawājī, or even eighteenth-century al-Shirbīnī, *Hazz al-quḥūf*.

PRIMARY SOURCES – INTERNET
"Gay Islamic" websites calling for a reinterpretation of Qur'ānic verses condemning the People of Loth include www.al-fatiha.net, www.queerjihad.org, and www.angelfire.com/ca2/queermuslims. Many gay and lesbian groups of Islamic cultural heritage in the United States and Europe have sites. See, for instance, the sites of the Gay and Lesbian Arab Society (http://www.glas.org/), Gays and Lesbians in African Studies (http://www.sas.upenn.edu/African_Studies/ASA/glas.html), Kelma (http://www.kelma.org/kelma.html), Gay Maroc (http://gay.ma.tripod.com/fr/), Homan (www.ho-man-iran.org), and Sangat for South-Asian gays (http://members.aol.com/youngal/sangat.html). Similar groups have appeared in a more timid manner in Muslim countries and countries with important Muslim communities such as Malaysia. See, for example, the site of Lambda Magazine, www.qrd.org/www/world/europe/turkey/dergi/index.html, and that of Out, www.outinmalaysia.com/index1. html. Further study of the impact of the internet on gay attitudes in Islamic countries (through personal computers or internet cafés) is much needed.

SECONDARY SOURCES
General
D. F. P. Aggleton (ed.), *Men who sell sex. International perspectives on male prostitution and AIDS*, Philadelphia 1998.
R. C. Bleys, *The geography of perversion. Male-to-male sexual behaviour outside the West and the ethnographic imagination 1750–1918*, New York 1995.
A. Bouhdiba, *La sexualité en islam*, Paris 1975.
——, *Sexuality in Islam*, trans. A. Sheridan, London 1985.
M. Chebel, *L'esprit de sérail*, Paris 1988.
D. Eribon, Traverser les frontières, in D. Eribon (ed.), *Les études gay et lesbiennes*, Paris 1998, 11–25.
M. Foucault, *Histoire de la sexualité. La volonté de savoir*, Paris 1976.
——, *The history of sexuality*, trans. R. Hurley, New York 1980.
D. F. Greenberg, *The construction of homosexuality*, Chicago 1988.
M. Ghoussoub and E. Sinclair-Webb (eds.), *Imagined masculinities*, London 2000.
E. Kosofsky, Construire des significations queer, in D. Eribon (ed.), *Les études gay et lesbiennes*, Paris 1998, 109–16.

G. H. A. Juynboll, Siḥāq (tribadism) in *Encyclopédie de l'islam*, 1997.
S. O. Murray and W. Roscoe (eds.), *Islamic homosexualities*, New York 1997.
C. Pellat, Liwāṭ (sodomy), in *Encyclopédie de l'islam*, 1983.

South Asia
S. Asthana and R. Oostvogels, The social construction of male "homosexuality" in India. Implications for HIV transmission and prevention, in *Social Science and Medicine* 52 (2001), 707–21.
S. Khan, Through a window darkly. Men who sell sex to men in India and Bangladesh, in P. Aggleton (ed.), *Men who sell sex*, Philadelphia 1999, 195–212.
——, Culture, sexualities, and identities. Men who have sex with men in India, in *Journal of Homosexuality* 40 (2001), 99–115.
R. Vanita and S. Kidwai (eds.), *Queering India. Same-sex love in India. Readings from literature and history*, New York 2000.

Sub-Saharan Africa
W. Roscoe and S. O. Murray (eds.), *Boy-wives and female-husbands. Studies of African homosexualities*, New York 1998.
D. Vangroenweghe, *Sida et sexualité en Afrique*, Anvers 2000.
See also *Dakan* (1997), a film by Guinean director Mohamed Camara, the first African film to deal with homosexuality.

Middle East and North Africa
G.-H. Bousquet, *L'éthique sexuelle de l'islam*, Paris 1953.
B. Dunne, Sexuality and the "civilizing process" in modern Egypt, Ph.D. diss., Washington, D.C. 1996.
J. Hayes, *Queer nations. Marginal sexualities in the Maghreb*, Chicago 2000.
Ibrāhīm Maḥmūd, *al-Mutʿa al-maḥẓūra, al-shudhūdh al-jinsī fī tārīkh al-ʿArab* (The forbidden pleasure. Homosexuality in Arab history), Beirut 2000.
G. Menicucci, Unlocking the Arab celluloid closet. Homosexuality in Egyptian film, in *Middle East Report* 206 (1998), 32–6.
Ṣalāḥ al-Dīn al-Munajjid, *al-Ḥayāt al-jinsiyya ʿind al-ʿArab* (Sex life of the Arabs), Beirut 1958.
A. Najmabadi, *Male lions and female suns. The gendered tropes of Iranian modernity*, University of California Press, Berkeley (forthcoming).
E. K. Rowson, The effeminates of early Medina, in *Journal of the American Oriental Society* 111 (1991), 671–93.
——, The categorization of gender and sexual irregularity in medieval Arabic vice lists, in J. Epstein and K. Straub (eds.), *Body guards. The cultural politics of gender ambiguity*, New York 1991, 50–79.
P. Sprachman, *Suppressed Persian. An anthology of forbidden literature*, Costa Mesa 1995.
U. Wikan, *Behind the veil in Arabia. Women in Oman*, Baltimore 1982.
J. W. Wright, Jr. and E. K. Rowson (eds.), *Homoeroticism in classical Arabic literature*, New York 1997.

Israel
A. Sumakai Fink, *Independence Park. The lives of gay men in Israel*, Palo Alto 1999.
L. Walzer, *Between Sodom and Eden. A gay journey through today's changing Israel*, New York 2000.

FRÉDÉRIC LAGRANGE

Religious Studies

History

Religious studies was initially a product of the Enlightenment with its emphasis on empiricism, description, induction, and reason. It encouraged sensitivity to context and historical change as well as openness to a range of religious phenomena across space and time. Religious studies self-consciously set itself apart from Christian theology, which was considered normative and closely linked with Christian evangelism and European colonialism. In addition, it set itself apart from ethics, metaphysics, and ontology, which were also considered normative and culture specific. The early name for religious studies, *Religionswissenschaft* (the scientific study of religion), reflects these concerns. The distinction between the academic and pluralistic study of world religions and their normative conceptualization and practice became especially important in the 1960s. Religious studies (or religion) departments were launched in Canadian and American universities funded by taxes, which necessitated a strict separation of church and state. (The study of Islam, on the other hand, originated in religious studies departments and thus did not present the problem posed by Christianity.)

Definition

The term "religious studies" defies easy definition. Ostensibly, it refers to any study of religion. Because the content has been analyzed by many disciplines, it can be classified with interdisciplinary or field studies. Religious studies scholars often identify themselves with one or more of the following: the phenomenology and history of religions, the philosophy of religion, the sociology of religion, the psychology of religion, the anthropology of religion, and so forth (much as women's studies and Islamic studies today draw on the specialized expertise of many disciplines).

Phenomenology

Phenomenology has been among the most important disciplines for religious studies. It began in nineteenth-century Germany and Austria with the principles: "to the things [themselves]" and "don't think but look." These referred to "direct seeing," a method by which scholars became conscious of their presuppositions and used self-criticism to remove all cultural and religious superimpositions (*epoché*). That way, they could intuit the concrete particularity of phenomena. Complementing the method of *epoché* was empathy: trying to understand phenomena positively and on their own terms. (*Epoché* and empathy were particularly important in the study of religion because these methods helped Westerners understand world religions such as Islam and Hinduism on their own terms.)

This was followed by two more steps. Scholars used imaginative variation, systematically omitting or substituting particular features, to understand what was inherent and what accidental. Next, they established similarities with and differences from related phenomena to grasp each phenomenon's distinctness and its position in a series of related phenomena. When the common aspects of concrete particulars were recognized, some phenomenologists presumed that the epistemological gap between self and other had been overcome and that there was an empirically based pattern or "essence." Further comparisons revealed additional general patterns, types, and structures. Whereas some phenomenologists emphasized invariable features or "essences," others emphasized probabilities, drawing on Wittgenstein's idea of a "family of resemblances." The resulting typologies created synchronic views of particular religions, types of religion, or even religion itself (see the works of Weber, Durkheim, van der Leeuw, Wach, and Eliade). This gave rise to another early name for the study of religion: comparative religion. The phenomenological (including the comparative) method in religious studies was used for any religious content. In his *Patterns of Comparative Religion* for instance, Mircea Eliade looked at how trees, stones, water, and sky could be hierophanies, manifestations of the sacred; in other studies he examined oral traditions (myths, rituals, festivals, pilgrimages). In still others, he examined scriptures and religious institutions.

Even though scholars claimed that phenomenology was empirical and focused on what is "out there," phenomenology of religion has contributed in no small measure to how consciousness

and personal experience influence one's understanding of a phenomenon. In part, this has stemmed from analyzing the very processes of knowing: how objects are constituted in and by consciousness, how their appearance changes with physical and emotional experience. The "things themselves" could include that which is experienced in the inner world of dreams, visions, or mystical states of oneness. By bracketing out questions of their reality, at least temporarily, these phenomena could be taken seriously as objects calling for sophisticated description and analysis. Thus, despite its insistence on the empirical study of religion, phenomenology also contributed to an appreciation of subjectivity.

Phenomenology's recognition of subjectivity (even after correction for religious and other cultural biases) led it to integrate the new discipline of hermeneutics, most broadly conceived as the analysis of understanding and interpretation and, more specifically, as the nature of a text – involving questions of semantic autonomy, authorial intention, types of readings, methods of exegesis, rules of legitimate interpretation, recognition of levels of meaning and underlying systems of interpretation, problems about how to cross barriers of understanding to enter other world-views, and so forth.

Because the "things" or "stuff" of religion are constituted partly by their contexts and by the inner worlds of viewers, as these change, so does the constitution of these phenomena. As a result, phenomenology also focused on how to describe change. This brought it to the heart of historical method and historiography, a topic closely related to hermeneutics (à la Dilthey and others). By the second half of the twentieth century, this discipline was more commonly called the history of religions, which focused on language study, texts, and careful documentation of historical change.

Feminism

With the development of second-wave feminism in the 1960s (inspired by the civil rights movement), Christianity in particular and the world religions in general were attacked for being cornerstones of male dominance, or patriarchy. The fact that women had been earning doctorates in religious studies since the mid-twentieth century, gaining the linguistic and hermeneutical skills to read religious texts and understand historical contexts in sophisticated ways, put them in key positions to document, interpret, and explain the creation and influence of patriarchy. They exposed relentlessly the absence or marginalization of women in the historical record (which consisted in premodern times largely of religious texts). Their hermeneutical expertise had trained them to read between the lines, after all, in order to tease out hidden structures and meanings, theological concepts, and interpretations that affected their status. At the heart of this was recognition of how structures of male power had become embedded in religious texts, norms, and values. This hit the field of religious studies particularly hard, because, with its roots in the disciplines of phenomenology and history of religions, it had claimed to be unbiased and inclusive. Now, the verdict was in. It had virtually ignored women's rituals and religious experiences and the feminine element in pantheons (goddesses had been viewed as a subtype of gods, for instance, and the distinctions among goddesses virtually ignored). Even when material was included, it was often distorted, because it was based on men's writings (which, all too often, denigrated women, idealized them, or considered their roles only in relation to male ones). In short, religious studies (along with most other disciplines) was condemned as biased and androcentric.

This has been the case with the study of women and Islam. Understanding the position of women in the Qur'ān has involved a careful reading with attention to the following: the origins of words; the relation of one passage with another; rhetorical, poetic, and compositional devices and their meaning in seventh-century Arabic; and the sense of the Qur'ān for its first audience (the text's historical integrity without the overlay of later interpretations). More specifically, scholars in religious studies have examined what the Qur'ān says about women and veiling, seclusion, marriage, polygamy, divorce, inheritance, male authority, and so forth. In addition, they have tried to understand what actually happened and why, how we are handicapped by our sources, and what the historical setting was. Besides scripture, other sources of authority – such as reports by witnesses (ḥadīth) – have been examined for credibility and authenticity. Are the accounts about women, such as the Prophet's wives, found, for instance, in reliable sources? Textual analysis includes the works of major Islamic thinkers, such as al-Ghazālī, and their ideas about women.

The study of religion has been interested not only in texts, however, but also in contexts. Using the latter, scholars have compared the position of women in the Qur'ān with that of women in pre-Islamic Arabia. They have examined how Qur'ānic verses have been interpreted in connec-

tion with ideas then prevalent in the broader world. This has included the topics of veiling and seclusion; they had been confined to the Prophet's wives in the Qur'ān but were extended to all women when Islam interacted with the Byzantine and Persian Empires (in which elite women were veiled and secluded). This has included views of women, moreover, in the various branches of Islam – Sunnī, Shī'ī, Sufi – and how these changed due to influences from other religions and cultures from Spain to Indonesia.

Scholarly searching through religious texts for clues about the feminine restored much information about women's religious lives to the historical record – especially that of extraordinary women, such as female saints and mystics, whose lives and works had been marginalized, distorted, or domesticated by androcentric world-views. Scholars in the field of religious studies, for instance, have examined what Muslim women such as the Basra mystic Rābi'a (early eighth century) or the Egyptian saint Sayyida Nafīsa (eighth-ninth century) reveal about themselves and how male authors have interpreted their lives.

Still, at the end of the day, it was realized that much information about women, especially ordinary women, was irretrievably lost. This inspired a change of focus in content and method away from texts and history (which had dominated religious studies despite its initial claim to include oral traditions and contemporary practices) to anthropology and sociology (although training in these disciplines was not well developed in religious studies departments). This made it possible to study real women who could speak in the first person about their own religious experiences in spite of patriarchal institutions. Moreover, it made possible scholarly interpretations by female scholars. This development changed the focus to contemporary religion.

A corollary of this interaction between religious studies and women's studies has been the politicization of religious studies, thanks partly to feminism's connection with Marxism and critical theory (the Frankfurt School and subsequent thinkers such as Herbert Marcuse, Max Horkheimer, and Theodore Adorno). Marxism had pointed to how the bourgeoisie embedded its religious values in culture in order to dominate the working class; critical theory and feminism had extended this class analysis to race, sex, and sexual orientation. Although consciousness raising was common to all, Marxism had focused more on economics and political revolution in the streets, whereas critical theory and feminism have focused more on knowledge in general and an educational revolution in the universities, professions, and media.

Deconstruction

In many circles, feminism has been combined with deconstruction, which extended and politicized hermeneutics to show that all texts are inherently unstable, and all readings inherently biased, in order to undermine existing concepts of authority. This in turn has shown that major differences have existed between women's and men's religion. And this has undermined earlier typologies and generalizations about the very nature of religion. Ironically, the claim that all knowledge is "situated" (dubbed "perspectivalism") had developed partly out of systematic study by phenomenology and hermeneutics of how consciousness helps constitute the "thing itself," which had been core to the emergence of religious studies.

Female scholars in religious studies found deconstruction's understanding of the instability of texts particularly helpful in challenging patriarchal values, a position that was furthered by deconstruction's emphasis on gaps, ruptures, and conflicts. They extended Paul Ricoeur's idea of the "hermeneutics of suspicion" and (his student) Jacques Derrida's concept of intertextual readings (in effect putting politically correct and incorrect texts side by side in order to shock readers) to expose latent sexist, classist, and racist structures, thereby raising consciousness. The politicization of religious studies drew from the concept of "engaged scholarship." Scholarship was no longer an end in itself but the means to the political goals of feminism. As a result, the academic study of women and religion developed in tandem and interactively with feminist activism, often viewing the classroom and courses on women and religion as the venue for the "knowledge revolution" and large-scale social change. For many women in religious studies, this was still not enough. Study of women's history and reality had so radicalized them that they gave up not only on participation in world religions but also on academic specialization in the study of world religions; they headed for new religions (New Age, Neo-paganism, and other Goddess religions where women have the dominant "voice"). The ultimate deconstruction of what was perceived as conventional religion had opened the door for its reconstruction.

Whereas some scholars of Islam and women were interested in "setting the record straight," for instance, others were inspired by feminism. All these studies of texts and contexts paved the way

for them in several ways: allowing them to challenge traditional interpretations of women by pointing out the interpretive biases of key verses; to discover alternative etymologies of key words and thus eliminate anti-women views; to argue that some rules were intended only for the Prophet's wives; to suggest that the eternal level of the Qur'ān can be separated from the historical; to point out that a just God would not have intended oppression, and so forth. Riffat Hassan, for instance, was inspired by feminism to challenge traditional theological assumptions about how and why woman was created and why woman was responsible for the Fall. She argued that Muslim women must do their own scholarly analysis of their religion's key texts in order to participate effectively in discussions of theology and women's needs. Women's contributions to religious arguments, she pointed out, are necessary both for political activists and legislators. In a postmodern vein, some Muslim feminists argued even that law is not immutable but only a historical construct; it can be changed.

Scholars of women and religion were inspired to develop once again a more inclusive approach to both the practice and the study of religion. Marginal groups, vernacular languages, and neglected topics – which, ironically, had been part of the original mandate of religious studies, at least in theory – now became popular again. The study of Islam, for instance, became the study of Islams in their differing cultural and linguistic contexts – which was accompanied, of course, by the anthropological study of women in these Islams.

Current debates in religious studies
Religion and secularism. Over the history of religious studies, scholars have struggled to define what is distinctive about their approach. Some have claimed that their inductive approach has made it possible to claim religion as universal, real, and central to human nature (Rudolf Otto had called this the experience of the holy, for instance, and Eliade the experience of the sacred). The corollary of this realism was that religious experiences could not be reduced to machinations of the mind or group behavior or explained away by some other reality. This, along with its avowedly academic approach, helped to define the distinctiveness of religious studies as it has sought to become established in universities since the middle of the twentieth century.

But the origin of religious studies in the Enlightenment and its many disciplines had also attracted many secular scholars. They were not convinced that there was a distinctive religious dimension to being human, but they were fascinated by religion's functions and symbols. As society as a whole secularized, so did religious studies in public universities and many private liberal arts colleges or universities. Although the former generation of (male) religious studies scholars had followed Eliade's idea of a "new humanism" (albeit named with the term homo religiosus, though one might debate whether the word "homo" refers only to men or human beings), it still held to the unifying idea of religion as sui generis, claiming its universality (and therefore its reality) on empirical and inductive grounds. But some academically inspired feminist methods – captured in the mantras "destabilizing," "complicating," "problematizing," and "naming and framing" – have dismantled even this generic view of religion, calling it essentialist. Thus, some feminists are now engaged in the ultimate act of deconstruction: that of the sui generis nature of religion. This, they claim is nothing but a fictive generalization, artificially imbued with being – an example, in Derrida's terms, of logocentrism (a fancy word for the old philosophical concept of nominalism: giving reality to a mere name or concept). "Truths," "canons," and religious authority were demoted to "perspectives." "Discourses" and "voices" were in, metaphysics and revelation out. There was another closely related phenomenon: feminism as a secular religion, an all-encompassing world-view. It has its revelation on the nature of the world, its exclusive means of interpreting it, its views of good and evil, its rituals, its distinctions between insiders and outsiders, and so forth.

Surely, one of the challenges facing Islamicists in religious studies today is how to deal with the clash between religious and secular world-views. Has religious studies – as a new humanism, secularism, or a feminist secular religion – become a congeries of competing world-views? As one Muslim scholar of Islam (in religious studies) put it, "Can I be both a feminist and religious?" To make matters even more complicated, Christian theologians, who were once relegated to seminaries, are now claiming that they too belong to religious studies departments. If feminists can admit their biases up front and view them as desirable, so can religious people. This turn toward the normative is supported by some Western academics who have become Buddhists, Muslims, Hindus, and so forth, and Western religious converts who combine their new insider status with the academic study of religion. What does this do to the old method of epoché (bracketing out one's pre-

suppositions in order to interpret another tradition)? Should one even study another foreign tradition at the graduate level if only insiders can teach a religion? But if outsiders have dominated the scholarship with their own presuppositions (including secular ones), has this not distorted the general presentation of the religion? Is a correction for that, too, not in order?

On the other hand, this support of the explicitly religious "voice" in religious studies departments introduces another set of problems. It conflates the normative and the descriptive, thereby contradicting the raison d'être of religious studies (which has been descriptive, although it arrived inductively at the recognition of religion as essential to human life by its comparative methods). It also raises again the question of what the *academic* study of religion should be. And that, in turn, raises the question of whether the study of religion should be paid for out of tax dollars and, if so, what this means for the separation of church and state. How are these questions to be addressed? Do scholars of Islam and women have something to contribute to this debate? Are there insights from Islamic philosophy on the underlying epistemological issues?

Reform and revolution. Hermeneutics and deconstruction had paved the way for reform, because they had challenged traditional authoritative interpretations of scriptures and thus created scope for change. In the study of Islam, for instance, the distinction between Qur'ānic and non-Qur'ānic elements (so that the latter could be eliminated if they did not support reforms for women), the adoption of hermeneutical strategies to deal with the problematic verses in the Qur'ān for women, and the documentation of differences within and among Islamic societies, have all destabilized traditional interpretations of scripture and law; this, in turn, has paved the way for reform. But this has sometimes been suspect, because the values underlying reforms have been viewed as Western and therefore antithetical to Islamic ones. In other words, reform is closely linked with identity. When reforms are perceived as too Western, a reaction sets in. This can amount to a revolution on the Right (or fundamentalism). When left unchecked, reforms can become a revolution on the Left (lead-ing to secularism or a secular religion). Have the resources of Islamic hermeneutics been fully explored to further a distinctive Islamic approach yet avoid the polarization caused by the "revolutions" on Right or Left? Has there been a recognition of some bottom line for Islamic identity, which modern Muslim women can live with? Can good arguments for their defense be made even if doing so means rebutting some common feminist positions and some traditional interpretations?

BIBLIOGRAPHY
M. Ferguson, *Women and religion*, Englewood Cliffs, N.J. 1995.
E. Schüssler Fiorenza, Method in women's studies in religion. A critical feminist hermeneutics, in A. Sharma (ed.), *Methodology in religious studies. The interface with women's studies*, Albany, N.Y. 2002, 207–41.
R. M. Gross, *Feminism and religion. An introduction*, Boston 1996.
——, Feminist issues and methods in the anthropology of religion, in A. Sharma (ed.), *Methodology in religious studies. The interface with women's studies*, Albany, N.Y. 2002, 41–66.
R. Hassan, Feminism in Islam, in A. Sharma and K. K. Young (eds.), *Feminism in world religions*, Albany, N.Y. 1999, 248–78.
C. A. Jones, Feminist research in the sociology of religion, in A. Sharma (ed.), *Methodology in religious studies. The interface with women's studies*, Albany, N.Y. 2002, 67–96.
D. Jonte-Pace, The impact of women's studies on the psychology of religion. Feminist critique, gender analysis, and the inclusion of women, in A. Sharma (ed.), *Methodology in religious studies. The interface with women's studies*, Albany, N.Y. 2002, 97–146.
D. Kinsley, Women's studies and the history of religions, in A. Sharma (ed.), *Methodology in religious studies. The interface with women's studies*, Albany, N.Y. 2002, 1–16.
R. R. Ruether, Methodologies in women's studies and feminist theology, in A. Sharma, *Methodology in religious studies. The interface with women's studies*, Albany, N.Y. 2002, 179–206.
M. A. Stenger, Feminist philosophy of religion, in A. Sharma, *Methodology in religious studies. The interface with women's studies*, Albany, N.Y. 2002, 147–78.
K. K. Young, Introduction and Postscript, in A. Sharma and K. K. Young (eds.), *Feminism and world religions*, Albany, N.Y. 1990, 1–24, 279–312.
——, Introduction, in A. Sharma (ed.), *Methodologies in religious studies. The interface with women's studies*, Albany, N.Y. 2002, ix–xi.
——, From phenomenology to feminism and women's studies, in A. Sharma (ed.), *Methodologies in religious studies. The interface with women's studies*, Albany, N.Y. 2002, 17–40.

KATHERINE K. YOUNG

Euro-American Women's Studies and Islamic Cultures

Over the past 30 years, women's studies has emerged as an interdisciplinary field of knowledge encompassing the studies of Islamic cultures in Euro-American academic institutions. During the early 1970s, when feminist theoretical and methodological paradigms, tools, and resources began to be applied to the study of Islamic cultures, previously held beliefs about women came under attack, none more so than the nineteenth-century conviction that "white men had to save brown women from brown men" (Spivak 1985). Defining their own civilizational superiority in terms of its lack in those whom they were destined to rule, post-Enlightenment scholars and administrators had declared that colonized men were essentially barbarians, and the major evidence of their barbarity was their brutal treatment of their women. This formulation of imperial logic was first articulated and critiqued by the Bengali-American cultural critic Gayatri Chakravorty Spivak in her seminal article, "Can the Subaltern Speak?" (1985). Spivak revealed the way the British colonizers used *sati*, or the voluntary self-immolation of Hindu widows on their husbands' funerary pyres, to indict Hindu patriarchy and to set themselves up as Hindu women's champions, even when at home in England they were not so feminist. Since her article, many have revisited the assumptions of imperial logic as applied to Muslim women. A review of the twentieth century underscores how pivotal was Spivak's intervention, yet it can only be understood against the backdrop of global Muslim women's activism.

During the early decades of the twentieth century, feminists drew attention to the disparity between the rhetoric that women in Islamic cultures were oppressed and passive and the reality that they were becoming politically effective. A few historians selected exceptional women whose stories contradicted prevalent misconceptions about the women and the cultures in which they lived. In general, the tone of this earlier work was apologetic. In some cases, it continues to be so, especially when scholars feel compelled to counter stereotypes of Muslim men's misogyny pervasive in the popular press. In 1928, five years after Hudā Shaʿrāwī, president of the Egyptian Feminist Union, publicly unveiled and thereby launched the feminist revolution in norms and values throughout the Arab world and beyond, Margaret Smith extolled the enduring influence of an exemplary eighth-century woman mystic called Rābiʿa al-ʿAdawiyya (Smith 1928). Smith's point was not to exceptionalize the famous woman saint but rather to show how significant was the place occupied by women in early Muslim society; yet she did not give these women space in her book. At the time of its publication, Smith's book was an outlier to trends in the historiography of Islamic cultures, and for the next 40 years little was published about women in Islamic cultures.

POSTCOLONIAL SCHOLARSHIP

The situation changed in the 1960s. As colonial hegemony in Asian and African Islamic cultures came to an end, there emerged a new awareness of the role of women in these societies and the need to employ new approaches in their study. Retrieval of lost voices became a central concern. Some pursued the "forgotten queens of Islam" paradigm (Mernissi 1990). Others surveyed the social scene more broadly, revealing how Muslim women, like women anywhere, are more or less oppressed or empowered depending on their individual and social circumstances.

During the late 1960s and 1970s, the Euro-American scholarship on women's history and contemporary lives in individual Islamic cultures laid out norms and practices within the explanatory framework of patriarchy. Whereas historical research limited itself to individual upper-class women because it is they who appear in the official historical documents, anthropologists dealt with the rural and urban poor who were more available to the foreign researcher. Their examinations of the lives of peasants and urban working classes uncovered ways in which women's independence is controlled (Maher 1974). Ethnographers focused on "private" women in subgroups, generally in isolation from world or even

local politics, which were part of the "public" sphere and therefore considered the natural domain of men. The concern to document the differences between men and women glossed diversity and dissent. Most anthropologists trained to view Islamic cultures as sex-segregated did not interrogate power relations within and across women's groups; they presumed that women's groups were "separate but equal" with men's groups (Friedl 1994, 92). This single-minded Western, liberal focus on women's rights without consideration of the wider context of colonial legacies and neocolonial ambitions in Asia and Africa evoked a strong response from "brown" women. It sparked acrimonious debates in 1975 at the first U.N. Sponsored World Conference on Women in Mexico City. Women from the global north demanded legal equality and sexual autonomy, while women from the south prioritized economic issues, colonialism, and imperialism.

In its earliest phase, the theoretical approach to the study of women in Islamic cultures remained descriptive and phenomenological, and mainstream academics were slow to acknowledge its importance. Trivialization of the study of Muslim women's lives and history meant that the majority of publications on the subject appeared in essay or article form only.

If the social history of women in Islamic cultures was not taken seriously in the 1960s and 1970s, their intellectual history was virtually nonexistent. Since women's education was uneven at the time, women's writings were few and the voices most readily available were oral. In 1977, some literary-minded scholars did turn their attention to the voices of women in the region. Elizabeth Fernea and Basima Bezirgan anthologized an eclectic set of excerpts by and about women in Muslim cultures from the seventh century to the twentieth century, including Qur'ānic verses, biographical sketches of famous, and not so famous women, songs, and peasant life-histories. In 1978, the first significant collection of essays about Muslim women in the Arab world, Iran, Turkey, Pakistan, and China came out in an interdisciplinary and self-consciously introductory volume edited by anthropologist Lois Beck and historian Nikki Keddie. There were few references to previous work on Muslim women because almost none existed. The volume was organized along largely binary lines: rural/urban; nomadic/sedentary; marginal/empowered; tradition/change. The analytical perspective was that of the outsider, mostly United States-based or United States-educated. Some essays examined social and kinship structures and dynamics, some dealt with the ideological, often Islamic, bases of gender relations and the difficulty of changing gendered norms and expectations, and still others focused on legal reform and socioeconomic changes. The Beck and Keddie volume and the Fernea and Bezirgan anthology laid the foundations for women's studies in Islamic cultures, not only because of their material content but also because of their format.

Anthologies and edited volumes are important in the early development of a new field, because they are usually interdisciplinary and or cross-cultural, and therefore compel comparisons. The comparative methodologies they suggest help readers to make connections, stimulate new ways of thinking and imagining the world. Beyond their role in shaping a new field or discipline, anthologies have often constituted the first step toward recognizing and legitimizing the literary production of a particular community. They may provide the building blocks for a canon that affirms the existence of a history of literary activity. For those who claimed that women in Muslim countries had only recently begun to write, Evelyne Accad's (1978) presentation of French and Arabic writings of some Middle Eastern and North African women provided a counterargument, but it sparked few immediate sequels. The myth of women's discursive silence persisted despite the well known writings of the doctor, activist, and writer Nawāl al-Saʿdāwī. She wrote about Egyptian women's struggles to survive psychologically and economically, yet her stories were dismissed by critics as too politically radical to be taken seriously as literature. Even a pioneering work like *Woman at Point Zero* (1973) was not translated into English until 1983.

At the same time that women's studies in Islamic cultures were beginning to appear in a more systematic fashion, Edward Said published his paradigm-shattering *Orientalism* (1978). It transformed the study of the Middle East and Muslim countries in general. Although Said did not deal with women or even gender, he highlighted how metropolitan scholars are implicated in the colonial designs of their governments, and his broadscale analysis compelled a self-consciousness among scholars of Islamic cultures. It entailed a new reflexivity about the role and intentions of the outsider scholar. Said's relentless thesis that colonial politics affects scholarship has been particularly influential on feminist research

in Islamic cultures. Feminist scholars began to ask what and who needs to be left out to tell a seamless narrative of progress.

POSTSTRUCTURAL CHALLENGES TO METANARRATIVES

It was during the 1980s that scholarship about women in Muslim countries took off. Historians burrowed into private library stacks and dusty archives. They looked for the everyday lives of "ordinary" women, posing them against the elites of standard histories. Applying subaltern reading strategies to texts written by men mainly about men, they introduced a gender analysis into Islamic history. They challenged established metanarratives, particularly the "savior paradigm" that described brown women in need of being saved from brown men. This kind of rhetoric was shown to serve the purposes of imperial design by dividing the men from the women to be ruled. It was also blind to its own shortcomings. The binary epistemology was reserved for the colonies, for at home these "feminist" men remained blithely patriarchal.

Feminist scholars who had focused exclusively on the lives of women began to broaden their scope in order to contextualize these women's lives within their countries' sociopolitical history. Judith Tucker (1985) accented the importance of economics to an understanding of the many ways in which colonialism influences the lives of women. Legal records provided important tools for reimagining the past through a gendered lens. These new resources revealed that, contrary to common belief, Muslim women had always owned property, although often under a male pseudonym, and that they had exercised more influence and power than formerly assumed.

Historical methodologies became more radically revisionist, more carefully textual, and more attentive to the between-the-lines where erasure takes place. The enmeshment of colonial rulers and local elites was teased out to explain the spread of European norms and values; the gaps in official history were revealed to be filled with the deeds and words of suppressed subaltern subjects. These words were not there on the page waiting to be read. Rather, it was their effects that historians and some literary scholars were tracing. The Algerian historian and novelist Assia Djebar (1985), for instance, drew on nineteenth-century French archives to insert the perspectives of those whom the colonial historians erased. Djebar knitted together "facts" gleaned from official archives with the fantasy inspired by her own witnessing of women's erasure from the story of the Algerian war of liberation (1954–62) to provide a new perspective on North African colonial history. Literature thus became a medium for historical and political critique.

If women's historical contributions were routinely forgotten, their physical forms as objects of desire remained center-stage. The colonial fantasy of the Oriental woman that had been captured in nineteenth-century daguerreotype provided a new source for information on women absent from the pages of the history books. Scholars combed through archives in search of photographs and other images, like postcards. Malek Alloula (1981) produced a coffeetable album of early twentieth-century postcards of alluring urban and Beduin women that French colonizers sent home while they were in Algeria. These images of simultaneously available and forbidden women projected colonial desire to penetrate the feminized land. Sarah Graham-Brown (1988), assembling photographs taken between 1860 and 1950, documented a moment in the creation of a Western-style middle class in the Middle East. She notes how European imperialism in Muslim majority countries coincided with the invention of photography in the West. She also observes with irony how a fledgling feminist movement in Europe paralleled the enthusiastic reception of Orientalist representations of passive and eroticized women. Images became more than resources for studying aspects of women's lives that did not figure in the written records; they also pointed out contradictions in the valuation of women from the region.

During the 1980s, a new corpus of women's literary writings appeared that allowed for a paradigm shift in literary criticism. The 1970s focus on gender-specific structural inequalities in Islamic cultures gave way to a recognition of women's selfhood constructed within class, regional, and generational boundaries. Euro-American scholars began to celebrate the many ways in which women successfully negotiate power relations. The evolving awareness of women's power in Islamic cultures helped to subvert the story of a patriarchy which pitted men against women because it could no longer explain the fluctuations and contradictions in human relations. Indeed, it was in the stories women wrote about themselves that one could begin to discern how gender norms are not genetically inscribed but subject to change. Literary descriptions of women's behaviors, roles, and status in their different milieus nuanced scholarship across the disciplines so that women were no longer essen-

tialized as simple objects of undifferentiated discrimination, and nor were they totally empowered. They were sometimes both and sometimes neither.

More than other literary topoi, postcolonial wars provided women in Islamic cultures with material that allowed for new narrative strategies. Women's war stories undermined conventional ways of telling the experience of organized violence and offered a surprising new lens on women's experiences and expressions. Miriam Cooke (1988, 1997) and Evelyne Accad (1990) analyzed women's writings on war, especially the Lebanese civil war, focusing on the ways in which middle-class women articulated their understandings of an event that they were said not to have experienced. Responding to Algerian women's marginalization after their participation in the war of liberation, Lebanese and Palestinian women writers insisted that writing was crucial to the transformation of women's consciousness. This new literature, revealing the contested nature of gender norms and practices, gave rise to revisionist methodologies and new theoretical approaches to the study of women in Islamic cultures.

CONTESTING EURO-AMERICAN FEMINIST APPROACHES

Women wrote about themselves not only during times of national conflict, but also in less dramatic times. All women's writings provided unprecedented resources for literary scholars, historians, and anthropolgists and complicated previous approaches. Gendered analyses of the relationships between men and women that are forged within the same institutional constraints replaced women-centered works. The "equal but separate" approach gave way in many disciplines to highly contextualized analyses of gender-based inequalities and women's struggles to challenge them. United States-based scholars, excited to find so many powerful women conscious of their own agency, celebrated their achievements. They did not consider the implications of their critique, which recalled the imperial paradigm of civilized brown women oppressed by barbaric brown men. Their previously welcomed interest in the region came under suspicion. Debates raged about the feminist, or rather the implicitly Western feminist and therefore neo-Orientalist, bias in these studies. The work of scholars from Islamic cultures began to circulate in Euro-American academic institutions. Subject speaking position became a yardstick to measure the validity of claims made

on behalf of women's rights and responsibilities in Islamic cultures. The growing ease of communication across the globe put diverse scholars in touch with one another. Collaborations and clashes ensued.

Sociologist Valentine Moghadam asserts that 1985, the year of the third U.N. Sponsored World Conference on Women in Nairobi, was a turning point in women's associations transnationally. For the first time, women from the global north and south found themselves facing similar issues: Thatcherism, Reaganism, and reduced economic opportunities for women everywhere showed how globalization affects everyone regardless of location. Pressure from religious fundamentalists, who were depriving them of their rights and control of their bodies, pushed women from the south "to recognize the pertinence of 'body politics'" (Moghadam 2000, 61). Increasingly, activist agendas from north and south were converging and compelling new methodologies in women's studies in Islamic cultures. Activism was acknowledged to be necessary to the development of women's studies; academics had to retain accountability for what happens to women beyond the rhetoric of the academy.

Mobilizing for these U.N. sponsored conferences played a significant role in the establishment of women's associations that outlived their original function. In 1985, Marie-Aimée Hélie-Lucas formed in France an international solidarity network for women living in Muslim countries and also for women from Muslim countries, regardless of their religion. Called Women Living Under Muslim Laws, the association monitors laws affecting women in Muslim communities and publicizes injustices. Throughout the 1990s, they were engaged in a transnational Muslim personal law reform project that brings together activists and academics in pursuit of justice for women in Islamic cultures. Also in 1985, anthropologist Suad Joseph founded the Association for Middle East Women's Studies. The first organization to bring together students of women in Islamic cultures, it provided a framework for conversations among primarily United States-based scholars. Until then, most had been working in isolation from one another and with little institutional support for what were considered to be marginal topics.

Terminology and identity became intertwined in writings by postcolonial feminist scholars who entered the United States academy in the mid-1980s. Were women who called for gender justice "feminists"? Was feminism essentially a Western

ideology and therefore inappropriate to describe the actions and identities of people outside the Euro-American sphere? Were women victims or survivors? These terminological concerns were not limited to Islamic cultures, rather they were being hotly debated in United States women's studies: women who had suffered rape and incest crimes were no longer to be called victims but rather survivors of the crimes visited upon their bodies. The Indian American political scientist Chandra Mohanty's (1984) call to refuse the label of victim for women in Third-World countries found a strong echo in the Muslim world. The fact that a woman might be secluded or exposed to exploitation and sometimes even to violence did not mean that she was a passive victim.

Identity politics dominated the late 1980s. Who had the right to speak for whom? What were the differences between native and non-native women's scholarship on women in Muslim countries? How did brown women relate to other women, especially white women? Location mattered in the production of knowledge, but also in its reception. Studies revealing the dynamics of women's empowerment were read differently according to whether the author established a Western or a local context for her identity. Lila Abu-Lughod (1986) introduced her ethnography about Beduin women in the Western Desert of Egypt with her Arab Palestinian father handing her over to an adopted tribal father. Ethnic identification became a key to her successful integration and understanding of Beduin women's poetic strategies. Non-native women came to be read very differently. When they championed women's causes in Asia and Africa, they were criticized for complicity in a neocolonial project. Camillia Fawzi El-Solh and Soraya Altorki (1988) collected essays by some Arab and Arab-American women anthropologists who reflexively interrogated the different kinds of scholarship produced by Arab women and white women with their privileged, because not gender-specific, access to "native" communities.

The coincidence of this scholarship with the first serious attempts to translate women's literary writings into English heightened the concern about the cooptation of women's struggles and writings in Islamic cultures. For whom were Muslim women writing when they expected to be translated and widely read? In 1986, the first International Women's Bookfair in London put the Lebanese Hanan al-Shaykh (1986) and the Egyptian Alifa Rifaat (1986) into world libraries and bookstores and on to university syllabuses.

Women's writings out of Islamic cultures became more and more available to scholars not trained in the languages or cultures of the region. For the first time such literature could be placed into a global context and it could be studied by people without specific linguistic or cultural expertise. The exponential growth in the translation industry provided new resources for non-area specialists. Works in translation could be compared with Euro-American works. Conversely, critics of women's literature in Islamic cultures had to become cognizant of trends in world literature.

MAINSTREAMING WOMEN'S STUDIES

It was during the 1990s that the conditions promoting political, economic, and cultural globalization led to new kinds of connections and social associations among women that cut across regions in unprecedented ways. Women began to form transnational feminist networks (Moghadam 2000) that were then studied by sociologists and political scientists (Chatty and Rabo 1997). Scholars examined organizational dynamics and the ways in which women relate to the state and engage with public policies (Kandiyoti 1991). Women's associations came to be considered critical elements in constructing a civil society; their political activism would help to democratize authoritarian regimes (Moghadam 1993, Joseph 2002).

Historical methodologies increasingly relied on archives and material culture rather than on secondary sources in European languages, or even only speculation. Monumental architecture inscribed with women's names confirmed what could only be guessed from official documents, and that was that Islamic history was full of influential women. Historians turned to well documented periods, like the Mamluk, Safavid, Ottoman, and of course the entire modern period, looking at the impact of European colonialism on the lives of colonized and colonizers alike (Melman 1995). The study of Ottoman Turkish became even more indispensable than ever for dealing appropriately with the history of lands under Ottoman dominion from the sixteenth to the twentieth centuries. Leslie Peirce (1993) opened up the world of the sultan's household in all its complexity, while Afaf Lutfi al-Sayyid Marsot (1995) combed legal documents for information about urban Egyptian women's access to official institutions. Calling for greater attention to *waqf* and litigation records and property deeds, al-Sayyid Marsot demonstrated how women's agency was curtailed in the nineteenth century

due to the centralization of authority under the new nation-state system. Julia Clancy-Smith (1994) examined a century of interaction among French colonizers and Algerian and Tunisian subject peoples through the prisms of religion, education, family, and gender. As more in-depth studies are published, more comparative perspectives and methodologies are enabled so that the experiences of Central Asian women can be juxtaposed with those of Turkish, Iranian, South Asian, and Arab women (Hambly 1998).

Some were less interested in trying to reconstruct the past than in tracing how attitudes to women changed over time. Leila Ahmed (1992) took on the sweep of Islamic history from the founding moment in the seventh century until the present day. Denise Spellberg (1994) examined the legal texts of the founding and classical periods to show how Shīʿī scholars had used the life of ʿĀʾisha, one of the Prophet's wives, to justify their misogyny. Other historians systematically studied social movements, state actions concerning women, and the role of women in politics. In the short two years between 1995 and 1997, cutting-edge monographs were published on the Egyptian (Badran 1995), Sudanese (Hale 1996), and Iranian (Paidar 1995) feminist movements. In each case the political movement was carefully contextualized within Islamic and state ideologies. This stage of archival research in history is increasingly interdisciplinary, applying the methodologies of sociology, literature, and anthropology (Duben and Behar 1991). This scholarship is more attentive to class, regional, and linguistic differences, and it is supplemented and authenticated by oral histories and ethnographic methodologies. Rather than brown versus white women, this stage in the study of women in Islamic cultures represented the collective effort of diverse women scholars.

Scholarship on and by women in Islamic cultures was accelerating and some recognized the need to organize and categorize it. Literary production was in greatest need of systematic review. Jūzīf Zaydān compiled bibliographies of women writers throughout the Arab world. His 1986 publication included 480 names of women who had written between 1880 and 1980. The revised edition, which covers two centuries (1800–1996), came out in 1999 and it had grown by 700 names. Others produced anthologies of writings by and about women in Islamic cultures. Badran and cooke (1990) organized their selections of a century of Arab women's writings according to stages in feminist consciousness. The concern was to link these women to each other transnationally and diachronically to highlight the collective political importance of their literary production. During the 1990s, the first generation of Saudi women to be educated in their own country were beginning to publish literature. Sadeeka Arebi's (1994) ethnographic study of the writings of nine Saudi women revealed an uncompromising challenge to male discursive and sociopolitical power. For them literature was a political tool to go public, to reinterpret religion, tradition, and history, and to effect social transformation while remaining invisible. Farzaneh Milani (1992) traced Iranian women's first available writings back to the beginning of the nineteenth century. They then became the literary foremothers of the women writing in and outside of the Islamic Republic. Beth Baron (1994) wrote about upper- and middle-class Egyptian women between 1890 and 1920 who had been active not only in journalism but also in polemical debates about women's rights. Marilyn Booth (2001) used literary, political, social, and economic methodologies to examine biographies of exemplary women placed in journals of the late nineteenth and early twentieth centuries. They provide a prism on the preoccupations of reformers concerned with the Woman Question and its role in modernizing a society in transition.

The realization that women had long been writing created a new interest in the past and in notable literary figures of the present. Who were the literary foremothers? The pre-Islamic poet al-Khansa and Rābiʿa al-ʿAdawiyya became cornerstones for a long and distinguished women's discursive tradition in Islamic cultures (Cornell 2000, Kahf 2000). It also became possible to focus on single women without running the risk of exceptionalizing the individual. For instance, Fedwa Malti-Douglas (1995) presented the complicated poetics and radical politics of the numerous writings of Nawāl al-Saʿdāwī.

Anthropologists have been the most strenuously self-critical, constantly assessing the effectiveness of their methodology. During the 1990s, participant observation gave way to a more interpersonal process of exchanging stories in order to equalize investment in the outcome of the research. In their own accounts about themselves and each other, women reveal their identitites more reliably. Rosemary Sayigh's (1994) work on the impact of wars and politics on women in Palestinian refugee camps in Lebanon and in the Israeli occupied territories emphasized that life stories should evolve naturally, they should

not be driven by the interviewer's questions. Using women's oral texts and performances to examine the process of gender construction in post-revolutionary Iran, Erika Friedl considered the various ramifications of Islamization and other pressures on the lives and social status of rural Iranian women (1989).

Anthropologists' interest in life stories has been matched by a proliferation in life writing, namely biographies and autobiographies. Historians and literary scholars have been rethinking the meanings of premodern texts and emphasizing the biographical elements. Mary Ann Fay (2001) collected essays that dealt with the life stories of individuals. These particular narrations were claimed to be more truthful than the single truth of History. While biographical writing challenges the claims of male-dominated historiography to write the past, autobiographies unveil the complex strategies involved in constructing the self.

In all disciplines, scholars from the global north and south are struggling to find ways to talk about cultural differences without essentializing and reifying otherness. How can a multicultural methodology avoid the pitfalls of cultural relativism? How are the science of politics and the truth of history changed once they are viewed through the prism of gender? Such questions have brought different units of analysis and different disciplines into conversation with each other. The family and the state, for instance, have engaged historians, anthropologists, and political scientists. Suad Joseph (1999) has focused on what she calls intimate selving which explains how kin acquire subjectivity within established relationships. Making distinctions between women based on class, date, area, and different modes of production, the scholars have questioned the binary epistemology that split the spaces and experiences of modern and traditional peoples, of urban and rural or nomad and sedentary women, and have shown how complex is the interplay between the multiple conditions that shape women's lives in contemporary Islamic cultures.

ISLAMIC FEMINIST METHODOLOGIES

The 1979 Islamic revolution in Iran spawned a vast production of studies about the roles and status of women in history and in this newly Islamized society. Indeed, it can be seen to have consolidated the field of women's studies in Islamic cultures by compelling scholars from various disciplines to pay attention to each other's work. The exportation of Islamic norms and values across the globe, whether from Shīʿī Iran or Sunnī Saudi Arabia, foregrounded the role of women as religio-cultural emblems.

Most of the Iranians who wrote about women's social and political adaptation to their alarming circumstances were Western-educated or in exile (Afkhami and Friedl 1994) and they were preoccupied by the veil. At first a symbol of their national loyalty and independence from the westernized regime of the Shah, it became the official dress code designed to restrict the movements of these same women. The veil was not the only area of ambivalence characterizing the impact of the Iranian revolution on women. A surprising development was the institution of temporary marriage (Haeri 1989).

From 1981 onwards, historians, anthropologists, and political scientists had been questioning the changing relationship among women and the religious symbols attached to them. Despite appearances to the contrary, several argued, women were not passively accepting restrictions, rather they were active in the choices they were making. Most of the research on veiling in the 1980s focused on Egypt. Anthropologist Fedwa al-Guindi (1981) revealed the emancipatory possibilities of the veil, even in the most conservative contexts like membership in Islamist associations. Historian Leila Ahmed (1982) suggested that the meanings conventionally attached to specific behaviors and expectations had to be questioned and perhaps changed. Veiling and sex segregation were not necessarily oppressive but might, under favorable circumstances, promote sisterhood and women's empowerment. Political scientist Arlene MacLeod (1991) complicated the symbology of the veil, observing lower middle-class Cairene women who had to earn money to maintain their family's precarious social status, while preserving its honor through modest dress codes. The woman who veiled demonstrated her piety and could thus enter otherwise forbidden space and claim her rights. Clearly the meaning of the veil differs according to who wears it, when, and with whom (Göle 1996).

When the cold war ended in 1990, Islamic fundamentalism seemed to some to be the only alternative to the global spread of a United States-dominated capitalist hegemony. Islamic symbols and discourse gained new legitimacy, even in places that had previously projected a secular national profile. Islamist reformers concentrated much of their attention on the roles, behavior, and appearance of women who were turned into emblems of the purity and piety of their cultures.

Revisions in Muslim personal law, often at the expense of women's rights, galvanized feminist research and compelled attention to the connections between women, nationalism, human rights, and Islamism in places like South Africa, Malaysia, Algeria, Bangladesh, and Afghanistan (Moghadam 1994). Whereas the colonial focus on women's rights, and especially the lack of such rights as sanctioned by Islamic scripture served to underscore Muslim society's alterity in the modern world, today's advocacy of women's rights cannot be so easily dismissed as part of imperial logic (Afkhami 1995). Implementation of the 1995 Beijing Platform for Action which declared the the high incidence of violence against women to be an impediment to equality, development, and peace has helped to universalize women's rights.

Islamization of many societies has elicited activist and academic responses. Religious studies scholars are the most recent arrivals to women's studies in Islamic cultures. Scholars are examining the gendered formation of Islamic epistemology, careful not to question the sacrality of the Qur'ān, only the temporality of its interpretations. They are objecting, above all, to the fact that the Qur'ān has been interpreted and history has been recorded and passed down almost exclusively by men.

The voices of Muslim scholar-activists from the United States and South Africa, until recently considered marginal to the Muslim world, began to be heard as they claimed the right to speak on their own behalf (Webb 2000). Amina Wadud-Muhsin (1992) systematically interprets Qur'ānic verses connected with women to show how even the most negative might be understood in a positive light. The debate is being joined by some South Africans who call for rigorous analysis that does not lapse into apologetics (Esack 1996). Ebrahim Moosa (2002) insists that an Islamic feminist methodology cannot rely on the Qur'ān alone but must seriously examine the discourse and assumptions of the foundational period of Islamic law so as to understand how the juristic tradition brought the Qur'ān into conversation with social and historical realities.

Reinterpretations of Islamic sources and discourses is energizing women's studies in Islamic cultures. Never before has theory had such strong implications for practice. There is a new awareness of the importance of religious inquiry. Social scientists and some humanists are integrating its insights into their own disciplinary methodologies (Stowasser 1994, Yamani 1996, Cooke 2001).

Sociologists (Mernissi 1987), and historians (Djebar 1991) are training themselves in religious hermeneutics and legal modes of inquiry. They are examining foundational texts for what they tell of the reasoning processes of the founding fathers in order to understand how women do and do not gain access to common goods.

Some have extolled the earliest Islamic periods, others pre-Islamic eras as their golden age for women. Whereas Arabs idealize the life and times of the Prophet Muḥammad, non-Arabs tend to hark back to pre-Islamic norms and values which were corrupted by the introduction of Islam in the region (Keddie 2002). The volume by social anthropologists Karin Ask and Marit Tjomsland (1998) about Muslim women's religious identity at the individual, communal, national, and international levels draws on the symbolic capital provided by the Qur'ān and ḥadīth. Islamic feminism is the term coined to describe the actions and discourse of those who advocate women's rights within a well understood Islam (Yamani 1996). Some, however, reject the very possibility of using the term. Haideh Moghissi (1999) refuses to accept that activism on behalf of women can square with the imposition of religious norms that favor men. A radical critique of cultural relativism, this work asserts that feminism is at odds with Islamic orthodoxy and orthopraxis.

Legal considerations have always informed scholarship on women in Islamic cultures. Whereas in the earlier pro-women work, scholars emphasized the liberating potential of secular and colonial law, the most recent work is concerned with Islamic law. Although Muslim personal law was instrumental in creating a structure of resistance to colonial domination and thus gave it a special place in communal self-definition, its recent imposition has negative implications for women. Afsaneh Najmabadi (1998) and Ziba Mir-Hosseini (1999) are examining male religious discourse and the emergence of a specifically Islamic feminist (with no apologies for the use of the word) trend in fin-de-siècle Iran which can be found in the progressive journal *Zanan*, in the daily practice of Islamic divorce courts, and in the radically divergent interpretations of Islamic sources by contemporary mullahs. While some in the early days of the Iranian revolution thought that Islam must block women's access to rights and opportunities, 20 years of women's resistance have shown that there are legal and scriptural resources in the religion that allow for a reinterpretation of sources to advocate an Islamically-based feminist world-view. The critical insights of

Islamic feminist scholars are beginning to inform the production of knowledge in Euro-American women's studies (Eisenstein 2002).

CONCLUSION

Synthetic overviews of the state of the field and retrospective surveys in several disciplines mark the maturity of research on women in Islamic cultures (e.g. Keddie 2000, 2002). In a decade, tools and resources for women's studies in Islamic cultures have jumped from Dār al-Kutub (the unwieldy archives in Cairo) to Google (the most comprehensive and quickest search engine of the world wide web). Resources are proliferating exponentially and becoming available at the push of a computer button. Digitization is creating virtual libraries that provide easy access to previously unavailable resources, like taped field interviews, censored films, and rare manuscripts. The world wide web allows for the distribution of ephemera that are so precious to researchers, particularly on women's issues. Immediate access to sources that not so long ago required travel, permits, and lengthy stays in remote places is compelling new methodologies.

The revolution in communications has accelerated international networking. Action alerts concerning injustice to women are quickly distributed across the globe, bringing electronically linked activists and academics closer together as they seek solutions through collaborations. The documents these networks publish provide a treasure trove of resources about the ways in which women in Islamic cultures are fighting for their rights transnationally. International meetings, increasingly streamed live to remote areas, are providing arenas for the renegotiation of positions, agendas, and methodologies. While the differences between the global south and north persist, in the future there will be more occasions for meetings on equal footing. For instance, virtual conferences with participants staying in situ allow for communication across huge distances from the comfort of the home institution. Telepresence highlights the location of knowledge production. Compromises and concessions, often forced by the rules of hospitality in real space, tend to be more voluntaristic in cyberenvironments.

From Margaret Smith, who was writing at the time that the veil was first coming into serious question, to instant fatwas online, the study of women in Islamic cultures has been transformed from apologetic to critical. New notions of what constitutes an appropriate source have compelled new methodologies and theories that rely increasingly on interdisciplinary and transnational comparative approaches. The change of focus from women to gender has provided a new lens on old material. New methodologies are invented to deal with old resources, which then deliver new information that leads to the discovery of new resources. The process is circular and intertwined and evolving.

BIBLIOGRAPHY
L. Abu-Lughod, *Veiled sentiments. Honor and poetry in a Bedouin society*, Berkeley 1986.
E. Accad, *Veil of shame. The role of women in the contemporary fiction of North Africa and the Arab world*, Sherbrooke, Québec, Canada 1978.
——, *Sexuality and war. Literary masks of the Middle East*, New York 1990.
M. Afkhami, *Faith and freedom*, Syracuse, N.Y. 1995.
M. Afkhami and E. Friedl, *In the eye of the storm. Women in post-revolutionary Iran*, Syracuse, N.Y. 1994.
L. Ahmed, Western ethnocentrism and perceptions of the harem, in *Feminist Studies* 8:3 (1982), 521–34.
——, *Women and gender in Islam. Historical roots of a modern debate*, New Haven, Conn. 1992.
M. Alloula, *Le harem colonial. Images d'un sous-erotisme*. Geneva 1981.
S. Arebi, *Women and words in Saudi Arabia. The politics of literary discourse*, New York 1994.
K. Ask and M. Tjomsland (eds.), *Women and Islamization. Contemporary dimensions of discourse on gender relations*, Oxford 1998.
M. Badran, *Feminists, Islam and nation. Gender and the making of modern Egypt*, Princeton, N.J. 1995.
M. Badran and m. cooke (eds.), *Opening the gates. A century of Arab feminist writings*, London 1990.
B. Baron, *The women's awakening in Egypt. Culture, society, and the press*, New Haven, Conn. 1994.
L. Beck and N. Keddie (eds.), *Women in the Muslim world*, Cambridge, Mass. 1978.
M. Booth, *May her likes be multiplied. Biography and gender politics in Egypt*, Berkeley 2001.
D. Chatty and A. Rabo (eds.), *Organizing women. Formal and informal women's groups in the Middle East*, Oxford 1997.
J. Clancy-Smith, *Rebel and saint. Muslim notables, populist protest, colonial encounters. Algeria and Tunisia 1800–1904*, Berkeley 1994.
M. Cooke, *War's other voices. Women on the Lebanese civil war*, Cambridge 1988.
——, *Women and the war story*, Berkeley 1997.
——, *Women claim Islam. Creating Islamic feminism through literature*, New York 2001.
R. E. Cornel, *Sufi women*, Louisville, Ky. 2000.
A. Djebar, *L'amour, la fantasia. Roman*, Paris 1985.
——, *Loin de Médine. Filles d'Ismael*, Paris 1991.
A. Duben and C. Behar, *Istanbul households. Marriage, family, and fertility 1880–1940*, New York 1991.
Z. Eisenstein, Feminism and Afghan women before and after September 11, in *Social text* 20:3 (2002), 79–99.
F. Esack, *Qurán, liberation and pluralism. An Islamic perspective of interreligious solidarity against oppression*, Oxford 1996.
M. A. Fay (ed.), *Auto/biography and construction of*

identity and community in the Middle East, New York 2001.

E. Fernea and B. Bezirgan (eds.), *Middle Eastern Muslim women speak*, Austin, Tex. 1977.

E. Friedl, *Women of Deh Koh*, Syracuse, N.Y. 1989.

——, Notes from the village. On the ethnographic construction of women in Iran, in F. M. Göçek and S. Balaghi (eds.) *Reconstructing gender in the Middle East*, New York 1994, 85–99.

N. Göle, *The forbidden modern. Civilization and veiling*, Ann Arbor 1996.

S. Graham-Brown, *Images of women. The portrayal of women in photographs of the Middle East 1860–1950*, London 1988.

F. al-Guindi, Veiling "infitah" with Muslim ethic. Egypt's contemporary Islamic movement, in *Social Problems* 28:4 (1981), 465–85.

S. Haeri, *The law of desire. Temporary marriage in Shīʿi Iran*, Syracuse, N.Y. 1989.

S. Hale, *Gender politics in Sudan. Islamism, socialism, and the state*, Boulder, Colo. 1996.

G. Hambly (ed.), *Women in the medieval Islamic world*, New York 1998.

S. Joseph (ed.), *Intimate selving in Arab families. Gender, self, and identity*, Syracuse, N.Y. 1999.

——, Civil society, the public/private, and gender in Lebanon, in Fatma Muge Göçek (ed.), *Social constructions of nationalism in the Middle East*, Albany, N.Y. 2002, 167–89.

M. Kahf, Braiding the stories. Women's eloquence in the early Islamic era, in G. Webb, *Windows of faith. Muslim women scholar-activists in North America*, Syracuse, N.Y. 2000, 147–71.

D. Kandiyoti (ed.), *Women, Islam, and the state*, Philadelphia 1991.

N. Keddie, The study of Muslim women in the Middle East. Achievements and remaining problems, in *Harvard Middle Eastern and Islamic Review* 6 2000, 26–52.

——, Women in the limelight. Some recent books on Middle Eastern women's history, in *International Journal of Middle East Studies* 34:3 (2002), 553–73.

B. Laslett, J. Brenner, and Y. Arat (eds.), *Rethinking the political. Gender, resistance, and the* state, Chicago 1995.

A. E. Macleod, *Accommodating protest. Working women, new veiling, and change in Cairo*, New York 1991.

V. Maher, *Women and property in Morocco*, London 1974.

F. Malti-Douglas, *Men, women, and god(s). Nawal El Saadawi and Arab feminist poetics*, Berkeley 1995.

G. Massell, *The surrogate proletariat. Moslem women and revolutionary strategies in Soviet Central Asia*, Princeton, N.J. 1974.

B. Melman, *Women's orients. English women and the Middle East 1718–1918. Sexuality, religion, and work*, Basingstoke, U.K. 1995.

F. Mernissi, *Le harem politique*, Paris 1987, published as *Women and Islam*, trans. Mary Jo Lakeland, Oxford 1991.

——, *Sultanes oubliées. Femmes chefs d'état en islam*, Paris 1990, published as *The forgotten queens of Islam*, trans. Mary Jo Lakeland, Cambridge 1993.

F. Milani, *Veils and words. The emerging voices of Iranian women writers*, Syracuse, N.Y. 1992.

Z. Mir-Hosseini, *Islam and gender. The religious debate in contemporary Iran*, Princeton, N.J. 1999.

V. M. Moghadam, *Modernizing women. Gender and social change in the Middle East*, Boulder, Colo. 1993.

—— (ed.), *Gender and national identity. Women and politics in Muslim societies*, London 1994.

——, Transnational feminist networks. Collective action in the era of globalization, in *International Sociology* 15:1 (2000), 57–85.

H. Moghissi, *Feminism and Islamic fundamentalism. Limits of postmodern analysis*, London 1999.

C. Mohanty, Under Western eyes. Feminist scholarship and colonial discourses, in *Boundary* 12:3–13:1 (1984), 333–58.

E. Moosa, Poetics and politics of law after empire. Reading women's rights in the constestations of law, in *UCLA Journal of Islamic and Near Eastern Law* 15:1 (2001–2), 185–215.

A. Najmabadi, "Years of hardship, years of growth." Feminisms in an Islamic republic, in Y. Haddad and J. Esposito (eds.), *Islam, gender, and social change*, New York 1998, 59–84.

P. Paidar, *Women and the political process in twentieth-century Iran*, Cambridge 1995.

L. Peirce, *The imperial harem*, Oxford 1993.

A. Rifaat, *Distant view of a minaret*, trans. D. Johnson-Davies, London 1986.

N. Saadawi, *Woman at point zero*, trans. Sherif Hetata, London 1983.

R. Sayigh, *Too many enemies. The Palestinian experience in Lebanon*, London 1994.

A. L. al-Sayyid Marsot, *Women and men in late eighteenth-century Egypt*, Austin, Tex. 1995.

H. al-Shaykh, *The story of Zahra*, London 1986.

M. Smith, *Rābiʿa the mystic and her fellow-saints in Islām*, Cambridge 1928.

C. F. El-Solh and S. Altorki (eds.). *Arab women in the field. Studying your own society*, Syracuse, N.Y. 1988.

D. Spellberg, *Politics, gender, and the Islamic past. The legacy of ʿAʾisha Bint Abi Bakr*, New York 1994.

G. C. Spivak, Can the subaltern speak? in *Wedge* 7:8 (1985), 120–30 and C. Nelson and L. Grossberg (eds.), *Marxism and the interpretation of culture*, Urbana, Ill. 1988, 271–313.

B. Stowasser, *Women in the Qurʾan, traditions, and interpretation*, New York 1994.

J. Tucker. *Women in nineteenth-century Egypt*, Cambridge 1985.

A. Wadud-Muhsin, *Qurʾan and woman*, Kuala Lumpur 1992.

G. Webb (ed.), *Windows of faith. Muslim women scholar-activists in North America*, Syracuse, N.Y. 2000.

M. Yamani (ed.), *Feminism and Islam. Legal and literary perspectives*, New York 1996.

J. Zaydān, *Maṣādir al-adab al-nisāʾī al-ʿālam al-ʿArabī al-ḥadīth* (Bibliography of women's literature in the modern Arab world), Jeddah 1986.

——, *Maṣādir al-adab al-nisāʾī al-ʿālam al-ʿArabī al-ḥadīth, 1800–1996* (Bibliography of women's literature in the modern Arab world 1800–1996), Beirut 1999.

MIRIAM COOKE

Women's Studies/Gender Studies

This entry reviews critically the ways in which concepts of Islam and Muslim women have figured in the interdisciplinary field of knowledge constituted by Euro-American women's studies over the past several decades.

SECOND WAVE FEMINISM

The 1970s saw the rise of "women's liberation" and women's global alliances in the United States and in Europe. The arguments that were made during this time about women's universal oppression and their subjection to patriarchy date back to early organized feminist movements of the late nineteenth and early twentieth centuries; however, the "second wave" of feminism in the 1970s is often seen as the period of the popularization of feminist ideas and consequently the institutionalization of women's studies in the United States academy. This is also the period during which eighteenth- and nineteenth-century notions about the widespread oppression of Muslim women were consolidated within Western feminist discourse.

The configuration of Muslim women as unequivocally oppressed and backward enabled Western women in the nineteenth century to argue for their full participation in the traditionally male colonial project. By using their gender as a strategy of unique emplacement, Western women claimed that, unlike men, they would have access to the women's quarters in the East, and thus to the mothers of the Oriental races and nations. Western women, then, shouldered their own specific "white woman's burden," to borrow Antoinette Burton's expression, by attempting to bring the light of Christ to women in the Muslim world whom they saw as living under the tyranny of Islam.

The discourse of "missionary feminism" continues to inform Western women's campaigns to "save" women in Islamic countries and to liberate them from their portable prison, the Islamic *ḥijāb*. The Western feminist impulse to save Muslim women from their religion and the tendency to configure Islamic practices as incommensurate with feminism has repeatedly impeded any possibility of cross-cultural feminist alliances. The key difficulty with this model of savior feminism is that structural inequalities are built into a relationship that hinges on the assumption that one

group of women is always more advanced or enlightened than another. This model of feminism, which claims women's oppression as universal and at the same time posits hierarchical differences between women of different nations and religions, has historical roots in early feminist writings of the eighteenth and nineteenth centuries, and continues to manifest itself in some contemporary feminist discourses. This model of hierarchical sisterhood reached its peak, however, during the second wave of American and European feminism.

Although the high period of the second wave is generally associated with the publication of Kate Millett's *Sexual Politics* (1970), many of the ideas that influenced the second wave feminist movement, as well as many of the ideas that some feminists worked to challenge, can be traced back to Simone de Beauvoir's *The Second Sex* (1949), and Betty Friedan's *The Feminine Mystique* (1963). In their ground-breaking work, both de Beauvoir and Friedan draw comparisons between the status of European and American women and that of oppressed races and cultures. The tendency to draw parallels between the subordinate position of Western women and the population of colonized nations, and particularly the women of Muslim nations, is one which has a long history dating back at least to the eighteenth century and the Enlightenment period. Invoking the image of the harem or seraglio woman as the epitome of female oppression is a strategy perhaps most famously employed by Mary Wollstonecraft in her *Vindication of the Rights of Woman* (1792). However, the impulse to configure women as universally oppressed in ways similar to other oppressed classes, nations, or races became repopularized in a much more global way in the 1960s and 1970s.

Although de Beauvoir published her influential text in 1949, many second wave feminists acknowledge an indebtedness to her work. De Beauvoir sets up a parallel between the predicament of the colonized subject and that of women; this is an analogy that was popular with second wave feminists as they drew comparisons between the inferior status of women worldwide and that of colonized peoples or of minority cultures in metropolitan centers. According to de Beauvoir, there are strong similarities between the situation

of women and that of African Americans. She posits a parallel between the Jim Crow laws in the United States, which promoted systemic discrimination against blacks under the guise of an "equal but separate" discourse and the nineteenth-century notion of the equality in difference of the two sexes. De Beauvoir believes that the nineteenth-century anti-feminist argument that women are equal to but different from men reproduces similar modes of discrimination against women such as racial segregation laws against African Americans, and she ends her book with a plea to stop what she calls the slavery of women.

Like de Beauvoir, Friedan draws a parallel between the situation of disenfranchised women and African Americans. She argues that through women's participation in anti-slavery organizations they realized that they, too, were in a form of bondage and that they, too, required liberation. Friedan's and de Beauvoir's aligning of the early origins of the white, middle-class feminist movement, and its concerns, with the plight of African slaves in the United States highlights the feminist movement's tendency to universalize forms of oppression and, in doing so, to elide the complexities and specificities of gendered, racial, and cultural otherness in Europe and in the United States.

Numerous anthologies, articles, and books have emerged recently to defend the beleaguered reputation of second wave, and particularly radical, feminists. The term "radical feminist" came into official use in 1968. Radical feminists claimed that the primary form of oppression was the oppression of women. Critiques of radical feminism focus on the movement's essentialist construction of "woman" as a category and its focus on women's oppression as primary and universal. Barbara Crow, editor of *Radical Feminism: A Documentary Reader* (2000), claims that the radical feminist movement was heterogeneous and sensitive to issues of race, culture, class, colonialism, and sexuality from the movement's inception, but that it has since been misrepresented as homogeneous and exclusionary. While some feminists believe this criticism is unjust, some of the foundational texts of the radical feminist movement perpetuate the analogy between Western women and colonized, or otherwise marginalized, peoples. In other words, the heterogeneities that the radical feminist movement purports to celebrate become homogenized as part of a universal woman's condition.

Prominent second wave and radical feminist Robin Morgan makes claims about the universal oppression of women in her 1974 essay, "On Women as a Colonized People," originally published in *Circle One: A Woman's Beginning Guide to Self Health and Sexuality*. She begins by citing Frantz Fanon and Albert Memmi who, she writes, suggest that the only way for colonized peoples to become free is by reclaiming their land. Women, too, are a colonized people, according to Morgan. Their most precious land – their bodies – has been colonized by patriarchal efforts at mystifying women's bodies. Most importantly, though, their resources have been mined: they are forced to give birth without any guarantee on the part of men that they will support, nurture, or be in any way responsible for the child. Furthermore, women have internalized misogynist ideas about women's bodies as being "unclean" and wholly in the service of male reproductive desires.

The uncompromising feminist language of the 1970s was productive for questioning such things as accepted gender roles, the sanctity of the nuclear family, and the negative assumptions surrounding female sexuality. However, the claims made by some feminists about the diversity of feminist concerns in the 1960s and 1970s is undermined by the language of universality and globalization that also emerges out of, and characterizes, this period in Euro-American feminist history. Feminists who defend the period of the second wave as one of inclusivity sometimes contend that the institutionalization of women's studies might be a factor in the homogenization of the curricula, and consequently of the issues, at the forefront of the movement.

One of the patterns in Western feminist discourse is the slippage from an assertion of women's universal sisterhood into a hierarchical relationship in which the Western woman is held up as an advanced model of womanhood to which women from other cultures and religions, particularly Muslim women, should aspire. In 1984, Valerie Amos and Pratibha Parmar published an important essay in which they argued that studies of Third-World women conducted by privileged white women from the West are inherently imperialist and oppressive. By using a feminist anthropological text, *Women United, Women Divided: Cross Cultural Perspectives on Female Solidarity* (1978) as an example of feminist imperialist scholarship, they argue that Western feminists use a limited definition of what constitutes feminism from within a Western context and then proceed to use it as a yardstick measured against which women from Third-World countries invariably fall short.

THE INSTITUTIONALIZATION AND GLOBALIZATION OF WOMEN'S STUDIES

In the United States, the first women's studies program was established at San Diego University in 1969/70. The second program was established in 1970/1 at Cornell University, and women's studies programs proliferated across the United States after that period, rising from 150 programs in 1975 to over 600 programs by the 1990s. Women involved in the feminist movement of the 1970s argue that the movement was from its inception committed to diversity and difference; at the same time, however, they are forced to acknowledge that the official discourse of institutionalized feminism is often articulated from the perspective of white, middle-class, heterosexual women in the United States. One of the debates among contemporary feminists is that there is a split between predominantly white, heterosexual academic feminists, and lesbian and cultural and racial minority feminist activists. Thus, the argument goes, the feminists with the institutional power to shape feminist discourses are also the ones who homogenize the experiences of all women.

The institutionalization of women's studies in the United States coincides with the popularization of the global feminist movement, which purports to address the issues faced by all women while universalizing the concerns of a select minority in the developed world. One of the seminal texts in the field of global feminism is Robin Morgan's edited collection, *Sisterhood Is Global* (1984). This anthology is comprised of entries from feminists from around the world who report on the situation of women in their respective countries. This project was meant to show that the feminist movement was not just a concern for women in the Western world, but that feminist concerns are global concerns, and that sisterhood is universal.

The global sisterhood movement was legitimized and sanctioned through the United Nations Decade of Women (1975–85) and four United Nations conferences on Women: Mexico City (1975), Copenhagen (1980), Nairobi (1985), and Beijing (1995). The Mexico City conference in particular, but all the conferences more generally, have come under attack by feminists who believed that the official rhetoric of United Nations – sanctioned international feminism worked in the interests of a minority of privileged women in the developed and developing nations.

The criticisms leveled against institutionalized feminism by Leila Ahmed, Valerie Amos and Pratibha Parmar, Kumari Jayawardena, Marnia Lazreq, Chandra Talpade Mohanty, Gayatri Chakravorty Spivak, among others, has been that state-sanctioned, institutionalized, and international feminism purports to speak the language of universal sisterhood, whereas in reality it reproduces the image of the abject female other upon whom the subject status of the privileged, Western feminist is predicated. One of the more popular objects of Western feminist attention is the status, in their view lamentable, of women in Islamic countries.

Leila Ahmed's 1982 essay, "Western Ethnocentrism and Perceptions of the Harem," offers an incisive critique of Western feminist scholarship on Muslim women. She argues that Western, particularly American, women occupy the position of "knowing" the Muslim women and the fact of her oppression. The Muslim women's life of subjugation and imprisonment is indisputable in American women's studies, even though very little effort is made to understand fully the various cultures and traditions of the Muslim world.

Another influential essay on this subject is Chandra Mohanty's "Under Western Eyes: Feminist Scholarship and Colonial Discourses" in which she claims that Western feminist scholarship discursively colonizes the Third-World woman by homogenizing the category of "woman." One of the examples Mohanty provides in her argument is that of representations of the monolithic category of the veiled, Muslim woman as universally and wholly oppressed.

The principal issue on which Western feminist scholarship tends to focus in analyses of Muslim women and Islam is the tradition of veiling. Once veiling became entrenched as an unequivocal symbol of Muslim women's oppression in Western discourses, it was in turn transformed from a cultural and religious symbol into a politicized one. As theorists such as Leila Ahmed and Marnia Lazreq have argued, it was through Western feminist discourse – whether mobilized by women or men – that the veil became politicized as a symbol of resistance to colonial rule and imperialist influence.

Lazreq's *The Eloquence of Silence: Algerian Women in Question* (1994) offers an incisive critique of such categories as "Muslim women" and "Middle Eastern Women," observing that the impulse to categorize and to mass together indiscriminately such large numbers of women from nations with a variety of religious and cultural differences is itself an imperious gesture, one with which Western feminist discourse needs to come

to terms. She focuses her argument on specific historical moments, such as French colonial rule in Algeria, during which the veil was taken up by French colonial officers, as well as French women, as a symbol of the barbarism of Islam and of Algerian men. This transformation of the veil into a symbol of Algerian women's total abjection became one of the justifications for French colonial interference in Algeria. Algerian women required liberation from their oppressed status in patriarchal Algerian culture, and French women in particular represented themselves as the saviors of their Algerian sisters, offering themselves as models for Algerian women to emulate. However, Lazreq argues that while the veil was deployed by French women as a signifier of Algerian women's backwardness and oppression, it also frustrated them because it forced them to contend with their inability to impose their single vision of womanhood on Algerian woman. Lazreq claims that one of the main reasons for writing her book is to demonstrate that there are different ways of being a woman, and that the impulse to uphold a single vision of what it means to be a woman is itself part of the problem of an imperialist feminist agenda.

Leila Ahmed's *Women and Gender in Islam* (1992) focuses on the ways in which the veil was mobilized by British men and women as a signifier of unequivocal oppression in nineteenth-century colonial Egypt. Veiling became a symbol of the oppression of Egyptian women, and an example of the barbarism of the Islamic faith and its mistreatment of women. Ahmed demonstrates that the language of feminism, which was actively resisted by British men in England, was then used in the service of the colonial project abroad. Lord Cromer, founding member and president of the Men's League for Opposing Women's Suffrage in England was one of the more vocal supporters of Egyptian women's liberation from beneath the veil. Ahmed suggests that the various meanings of the veil were created through Western feminist discourse; in particular, the use of the veil as a symbol of resistance against imperial domination emerged in response to Western representations of the veil as symbolic of Islam's degradation of women.

One of the more famous examples of the ways in which the veil was mobilized as a political symbol was during the Iranian Revolution of 1978/9. During the revolution, the majority of Iranian people, from all social classes, came together to call for the overthrow of the Pahlavi regime. Iranian women, many of whom had never before worn the veil, chose to indicate their discontent with the Shah's government by donning the traditional *chador* and demonstrating against what they saw as the imperialist and Westernized monarchical regime. One month after the successful toppling of the monarchy, religious leader Ayatollah Khomeini issued a statement extolling the virtues of the veil, and Iranian women began to feel betrayed by the revolution in which they had actively participated. In March of 1979, the country sustained five days of mass feminist demonstrations during which Iranian women once again filled the streets, this time unveiled, and demonstrating their visible, unveiled dissatisfaction with the revolutionary regime.

During this highly volatile political period, renowned second wave feminist Kate Millett arrived in Tehran with her Canadian partner, photographer Sophie Keir, in order to show her support for her Iranian sisters by participating in the Iranian feminist demonstrations and by speaking at a rally scheduled for International Women's Day on 8 March. Meanwhile, in the United States, other prominent American feminists such as Betty Friedan, Robin Morgan, and Gloria Steinem staged a demonstration in support of Iranian women in front of the Rockefeller Center. The demonstration, they claimed, was part of a series of international feminist demonstrations across the United States and in Paris, London, and Rome.

Shortly thereafter, 17 European women and 1 Egyptian woman from the *Comité international du droit des femmes*, an organization presided over by Simone de Beauvoir, arrived in Iran to demonstrate their support for their beleaguered sisters. This contingent of European feminists traveled to Qom, the religious center in Iran, and demanded an audience with Khomeini. He granted them a five-minute interview during which the European feminists questioned him on his intentions regarding the compulsory veiling of Iranian women, to which he responded with total silence.

Unfortunately, the unique position Iranian women carved out for themselves as feminists and as anti-imperialist nationalists was a precarious one, and one that they were forced to abandon shortly after the arrival of American and European feminists in Iran. Undoubtedly guided by the best intentions, Western feminists tried to direct the Iranian feminist movement and transform the movement into something to which they could relate as international sisters. By turning Iranian feminist concerns into an international women's concern, the particularity and specificity of anti-imperialist Iranian feminism was elided.

The involvement of Western women in an indigenous Iranian feminist struggle, as well as in the examples of Algeria and Egypt discussed above, highlight the fact that the underside to the language of liberation and rescue is a discourse of inequality. Furthermore, the nuances of veiling and unveiling by Iranian women who first donned the veil as a symbol of anti-imperialist nationalism, and then discarded it as a symbol of feminist resistance to patriarchal nationalism, were lost on Western feminists who only understood the veil as a symbol of barbaric and oppressive seventh-century Islamic practices. This representation is one that quickly translated into media reports about the revolution and its deleterious impact on Iranian women.

WESTERN FEMINISM AND THE MEDIA

Ironically, the discourse of mainstream Western feminism, which is influenced by the second wave feminist movement of the 1970s, and the discourse of the media often complement each other, even while Western feminists fight against what they perceive as the backlash against feminism in the media.

Susan Faludi's 1991 best-seller, *Backlash: The Undeclared War against American Women*, focuses on the adverse reaction to 1970s feminist issues and concerns in the mainstream media in the 1980s. Faludi laments what she perceives to be a softening of the rhetoric of the leaders of the second wave feminist movement, and she perceives this back-pedaling to be the result of a widespread media backlash against feminism. In one of her examples, she claims that Germaine Greer, a formerly flamboyant and unapologetic feminist has become uncharacteristically meek; this is evident, Faludi claims, by her position on veiling in *Sex and Destiny* (1984). Faludi claims that this formerly tough feminist who championed sexual liberation for all women now celebrates the ultimate symbol of female oppression: the *chador*. According to Faludi, Greer has backed down egregiously on women's sexual choice and freedom, and now advocates marriage, chastity, and the imprisonment of women beneath the *chador*.

In fact, in her book, Greer attempts to understand the complexities of the practice of veiling in Iran. She recognizes the oppressive rule of the Pahlavi regime and its cruel enforcement of the 1936 Unveiling Act that enforced the mandatory and violent unveiling of all women. Rather than celebrating the passage of this legislation as the "Day of Women's Liberation" as it was labeled under the Pahlavi regime, Greer attempts to understand the repercussions of celebrating, through the discourse of emancipation, the undeniable violence of such an act. However, Faludi misrepresents Greer's argument as unequivocally advocating the oppression of all women through the wearing of the veil.

The equation of veiling with Muslim women's unequivocal oppression is a favourite theme in the media, and one that Western women perpetuate in their own publications. Jan Goodwin's popular *Price of Honor: Muslim Women Lift the Veil of Silence on the Islamic World* (1994) is an example of the merging of Western feminist discourse with the discourse of the mainstream media. Her book works on the theme of imprisonment and rescue, rendered popular by the success of Betty Mahmoody's 1988 best-seller, *Not Without My Daughter*, in which an American woman's daughter is held hostage in Iran by her Iranian father. The story chronicles their dramatic escape from the tyrannical patriarchal regime of the Mahmoody family, and of Islamic Iran.

Goodwin's book also begins with a reference to a young Afghan girl whom she befriended and who was subjected to untold misery by the harsh cruelties of Islamic practices. Throughout her book, each chapter devoted to a different Muslim country, Goodwin employs an alarmist tone to describe her experiences traveling through the Islamic world. She travels to countries as culturally and politically distinct from each other as Afghanistan, Egypt, Gaza and the West Bank of the river Jordan, Iran, Iraq, Jordan, Kuwait, Pakistan, Saudi Arabia, and the United Arab Emirates. Her narrative is filled with contradictions as she first criticizes Western stereotypes of Muslims as fundamentalists, but ends up rein-scribing those same stereotypes in her own work.

Despite the diversity of ethnicities, languages, religions, and cultures of the nations Goodwin visits, she claims that everywhere she was faced with an identical Islamic rhetoric and didacticism, and an alarmingly growing Islamic extremism. She homogenizes the experiences of all women under Islam (although she takes pains to make a distinction between Islam as described in the Qu'rān and Islam as it is practiced in the Islamic world) as silenced, abused, and subjugated.

In 1998, Merle Hoffman, editor of the feminist magazine *On the Issues* went to Iran and published an account of her experiences there. Hoffman details the trauma of having to wear the mandatory *ḥijāb*, and describes the experience as a form of sexual neutering. But she extends this characterization of veiling as a form of persecu-

tion even further by drawing an analogy between Islamic *ḥijāb* and the dehumanizing practices enforced at Auschwitz prison camp. Although she moderates her tone by the end of the article, the associations she makes between veiled Iranian women and Holocaust victims seem, at the very least, excessive.

The Feminist Majority Foundation's championing of the rights of Afghan women under Taliban rule is another striking example of Western feminists' impulse to save their silenced and subjugated Muslim sisters. As part of its fundraising efforts to liberate Afghan women from beneath their shrouds, the foundation launched a successful "symbol of remembrance" campaign. Swatches of mesh fabric, meant to symbolize the *burqaʿ*, were sold for five dollars apiece, and proceeds from the sales were used to end what the foundation called the system of "gender apartheid" in Afghanistan. In its literature, the foundation describes the *burqaʿ* as a form of women's imprisonment maintained and enforced by the brutal regime of the Taliban; the fact that many Afghan women continue to wear the *burqaʿ* even after the overthrow of the Taliban is a testament to the fact that some Muslim women choose to observe their traditional cultural and religious practices without the enforcement of legislation.

The representation of Muslim women as suffocating beneath the folds of the veil, and beneath the weight of barbaric Islamic practices is a popular one in the media, and unfortunately, in some Western feminist discourses. In this way, the language of feminism and the language of the media are, rather than oppositional, quite complementary. Both discourses perpetuate the assumption that Muslim women are suffering under the yoke of Islam, and that they are living in silent submission to the men in their lives. In other words, they are waiting to be liberated by Western intervention, whether through feminist enlightenment, or in the language of the (particularly current) media, through military might. This language of women's liberation and enlightenment whose underside is colonial violence has a history dating back to nineteenth-century British and French colonial practices and continuing with more contemporary imperialist military interventions in the Muslim world. Many of the Western military ventures into Islamic countries have been fueled by a manipulation of the feminist rhetoric and language of the emancipation and liberation of oppressed Muslim women.

Bibliography

L. Abu-Lughod (ed.), *Remaking women. Feminism and modernity in the Middle East*, Princeton, N.J. 1998.
L. Ahmed, Western ethnocentrism and perceptions of the harem, in *Feminist Studies* 8:3 (Fall 1982), 521–34.
——, *Women and gender in Islam*, New Haven, Conn. 1992.
V. Amos and P. Parmar, Challenging imperial feminism, in *Feminist Review* 17 (Autumn 1984), 3–19.
S. de Beauvoir, *The second sex*, New York 1949.
M. J. Boxer, *When women ask the questions. Creating women's studies in America*, Baltimore, Md. 1998.
B. Crow (ed.), *Radical feminism. A documentary reader*, New York 2000.
S. Faludi, *Backlash. The undeclared war against American women*, New York 1991.
B. Friedan, *The feminine mystique*, New York 1963.
J. Goodwin, *Price of honor. Muslim women lift the veil of silence on the Islamic world*, Boston 1994.
D. Kandiyoti (ed.), *Women, Islam and the state*, Philadelphia 1991.
—— (ed.), *Gendering the Middle East. Emerging perspectives*, New York 1996.
C. T. Mohanty, Under Western eyes. Feminist scholarship and colonial discourses in C. T. Mohanty, A. Russo, and L. Torres (eds.), *Third world women and the politics of feminism*, Bloomington, Ind. 1991, 51–80.
R. Morgan, On women as a colonized people, in E. L. Campbell and V. Ziegler (eds.), *Circle one. A woman's beginning guide to self health and sexuality*, Colorado Springs 1974.
R. Morgan (ed.), *Sisterhood is powerful. An anthology of writings from the women's liberation movement*, New York 1970.
——, *Sisterhood is global. The international women's movement anthology*, New York 1984.
J. Peters and A. Wolper (eds.), *Women's rights, human rights. International feminist perspectives*, New York 1995.
M. Wollstonecraft, *Vindication of the rights of woman*, London 1792.

Nima Naghibi

Women and Islamic Cultures:
A Bibliography of Books and Articles
in European Languages since 1993

*Compiled by G. J. Roper, C. H. Bleaney,
and V. Shepherd*

Introduction to the Bibliography

The large number of publications in this field has hitherto been relatively well served bibliographically. In addition to general current and retrospective bibliographies on the Muslim world, such as *Index Islamicus*, and those on women's studies, such as *ViVa (a bibliography of women's history)*, there have been a number on Muslim and Middle Eastern women specifically. The most important are:

KIMBALL, Michelle & SCHLEGEL, Barbara R. von. *Muslim women throughout the world: a bibliography*. Boulder: Lynne Rienner, 1997. 2905 entries. English-language only. All countries. Cut-off: 1995.

RUIZ-ALMODOVAR, Caridad: *La mujer musulmana: bibliografía*. Granada: Universidad de Granada, 1994. *Ca.* 8100 entries. All languages. All countries. Cut-off: 1992.

PARIS, Mireille. *Femmes et sociétés dans le monde arabo-musulman: état bibliographique*. Aix-en-Provence: IREMAM, 1989. 1541 entries. Middle East only. All languages. Cut-off: 1988.

OTTO, Ingeborg & SCHMIDT-DUMONT, Marianne. *Frauenfragen im modernen Orient: eine Auswahlbibliographie*. Hamburg: Deutsches Orient-Institut, 1982. 1242 entries. + *Ergänzungsbibliographie*, 1989. All languages. Middle East only. Cut-off: 1988.

RUUD, Inger Marie. *Women's status in the Muslim world: a bibliographical survey*. Cologne: Brill, 1981. 1075 entries. All languages. All countries. Cut-off: 1980.

Together these cover a very substantial part of the field. The present bibliography aims not to duplicate them, but to supplement them. This means that our coverage is primarily of:

1. English-language material since 1996
2. Other European-language material since 1993

Unfortunately it has not been possible to include publications in Arabic, Turkish, Persian, Urdu or other non-European languages. A substantial body of relevant literature does, however, exist in these languages, which should certainly not be ignored by researchers.

The listing is arranged primarily by country or geographical area. A few subjects have, however, been listed separately, regardless of geography: the arts, bibliography, literatures. There are also general sections for publications covering more than two countries or areas: Africa (general), Arab world (general), Berbers (general), Central Asia (general), Europe (general), General, etc.

In addition, there are two indexes:

Name Index to the Bibliography: this includes authors, editors, translators and personal subjects.

Subject Index to the Bibliography: this has references (by serial numbers) to entries concerning a range of other subjects, as well as those classified under one subject but also relevant to another.

Contents

Afghanistan

Books

1 ARMSTRONG, Sally. *Veiled threat: the hidden power of the women of Afghanistan.* Toronto & London: Penguin, 2002. 221pp.

2 BRODSKY, Anne E. *With all our strength: the Revolutionary Association of the Women of Afghanistan.* London: Routledge, 2003. 320pp.

3 (BROWN, A.Widney, BOKHARI, Farhat & others) *Humanity denied: systematic denial of women's rights in Afghanistan.* New York: Human Rights Watch, 2001 (Human Rights Watch, 13/5), 27pp. Also online at www.hrw.org/reports/2001/afghan3

4 DELLOYE, Isabelle. *Femmes d'Afghanistan.* Paris: Phébus, 2002. 186pp.

5 ELLIS, Deborah. *Women of the Afghan War.* Westport: Praeger, 2000. 241pp.

6 EMADI, Hafizullah. *Politics of development and women in Afghanistan.* Karachi: Royal Book Co, 2002. 150pp.

7 EMADI, Hafizullah. *Repression, resistance, and women in Afghanistan.* Westport: Praeger, 2002. 183pp.

8 GAUHARI, Farooka. *Searching for Saleem: an Afghan woman's odyssey.* Lincoln (USA): University of Nebraska Press, 1996. 255pp.

9 IACOPINO, Vincent & others *The Taliban's war on women: a health and human rights crisis in Afghanistan.* Boston: Physicians for Human Rights, 1998. 119pp.

10 LAMB, Christina. *The sewing circles of Herat: my Afghan years.* London: HarperCollins, 2002. 338pp.

11 LATIFA & HACHEMI, Chékéba. *Cara robada: tener 20 anos en Kabul.* Tr. Andrés, Esther. Barcelona: Plaza & Janes, 2002. 265pp. [Tr. of *Visage volé: avoir vingt ans à Kaboul,* Paris 2001.]

12 [LATIFA & HACHEMI, Chékéba]. *El rostre robat: ser una noia de vint anys a Kabul* / Latifa, escrit amb la col.laboració de Xekeba Haiximi. Tr. Ubach, Mercè. Barcelona: Columna, 2002. 175pp. [Tr. of *Visage volé: avoir vingt ans à Kaboul,* Paris 2001.]

13 LATIFA & HACHEMI, Chékéba. *My forbidden face.* Tr. Appignanesi, Lisa. London: Virago, 2002. 180pp. [Tr. of *Visage volé: avoir vingt ans à Kaboul,* Paris 2001.]

14 LATIFA & HACHEMI, Chékéba. *Visage volé: avoir vingt ans à Kaboul.* Paris: Carrière, 2001. 235pp.

15 LOGAN, Harriet. *Unveiled: voices of the women of Afghanistan.* New York: ReganBooks, 2002. 101pp.

16 SKAINE, Rosemarie. *The women of Afghanistan under the Taliban.* Jefferson: McFarland, 2002. 198pp.

17 TORTAJADA, Ana. *El grito silenciado.* Barcelona: Mondadori, 2001. 269pp. [Afghan women.]

18 *Humanité bafouée: violations systématiques des droits des femmes en Afghanistan.* New York: Human Rights Watch, 2001 (Human Rights Watch, 13/5), 24pp. Also online at www.hrw.org/french/reports/afghanwomen

19 *Women's situation in Afghanistan: compilation. La situation des femmes en Afghanistan: compilation.* Grabels: Women Living Under Muslim Laws, 1998. 232pp.

20 *Women in Afghanistan: pawns in men's power struggles.* London: Amnesty International, International Secretariat, 1999. 11pp. Also online at http:// web.amnesty.org/ library/Index/engASA110111999

21 *Women in Afghanistan: the violations continue.* London: Amnesty International, International Secretariat, 1997. 6pp. Also online at http:// web.amnesty.org/library/Index/ engASA110051997

Articles

22 ACHINGER, G. Formal and nonformal education of female Afghan refugees: experiences in the rural NWFP refugee camps. *Pakistan Journal of Women's Studies. Alam-e-Niswan,* 3 i (1996) pp.33-42.

23 CENTLIVRES-DEMONT, M. Les femmes dans le conflit afghan. *SGMOIK/SSMOCI Bulletin,* 2 (1996) pp.16-18.

24 COOKE, Miriam. Saving brown women. *Signs,* 28 i (2002) pp.468-470-. Also online at http:// www.journals.uchicago.edu [From section headed "Gender and September 11". US attitude to Afghan women.]

25 CORNELL, Drucilla. For RAWA. *Signs,* 28 i (2002) pp.433-435. Also online at http:// www.journals.uchicago.edu [Revolutionary Association of the Women of Afghanistan. From section headed "Gender and September 11"]

26 DUPREE, N. H. Afghan women under the Taliban. *Fundamentalism reborn? Afghanistan and the Taliban.* London: Hurst, [1998], pp.145-166.

27 EMMOTT, S. 'Dislocation', shelter, and crisis: Afghanistan's refugees and notions of home. *Gender and Development,* 4 i (1996) pp.31-38. [Women in Afghanistan.]

28 FREMBGEN, J. W. Waffen der Pakhtun-Frauen: neue Interpretationen von Alltagsobjekten. *Archiv für Völkerkunde,* 48 (1994) pp.85-91. [Jewellery as weaponry.]

29 GOODSON, Larry P. Perverting Islam: Taliban social policy toward women. *Central Asian Survey,* 20 iv (2001) pp.415-426. Also online at www.ingentaselect.com

30 GRIFFIN, Michael. Emma Bonino: Flowers for Kabul. *Index on Censorship,* 27 ii / 181 (1998) pp.54-56. [Interview on women of Kabul.]

31 GRIFFIN, Michael. Hostages: Kabul's war widows. *Index on Censorship,* 27 ii / 181 (1998) pp.48-53.

32 GROVES, Sharon. Afghan women speak out. *Feminist Studies,* 27 iii (2001) pp.753-759.

33 IACOPINO, Vincent & RASEKH, Zohra. Education, a health imperative: the case of Afghanistan. *Health and Human Rights,* 3 ii (1998) pp.99-108. [Government denial of education to women.]

34 KHATTAK, Saba Gul. Afghan women: bombed to be liberated? *Middle East Report,* 222 / 32 i (2002) pp.18-23.

35 KRAMER, Martin. The camera and the burqa. *Middle East Quarterly,* 9 ii (2002) pp.69-76. [US war against Taliban in Afghanistan.]

36 MALEY, W. Women and public policy in Afghanistan: a comment. *World Development,* 24 i (1996) pp.203-206. [On article by V.M.Moghadam; response by Moghadam, pp.207-211.]

37 MOGHADAM, V. M. Nationalist agendas and women's rights: conflicts in Afghanistan in the twentieth century. *Feminist nationalism* / L.A.West. New York: Routledge, 1997, pp.75-100. [1920s-1990s.]

38 MOGHADAM, Valentine. Afghan women and transnational feminism. *Middle East Women's Studies Review,* 16 iii-iv (2002) pp.1-6. Also online at www.amews.org/reviews.htm

39 MOGHADAM, Valentine M. Patriarchy, the Taleban, and politics of public space in Afghanistan. *Women's Studies International Forum,* 25 i (2002) pp.19-31. Also online at http://www.sciencedirect.com/science/journal/02775395

40 MOHAMED, Shaheen. Peace vs. women's human rights - the Taliban trade-off. *Islam in America,* 3 iv (1997) pp.1-7.

41 NAWID, Senzil. The feminine and feminism in Tarzi's work. *Annali, Istituto Universitario Orientale di Napoli,* 55 iii / 1995 (1996) pp.358-366. (As a journalist.)

42 PRENTICE, E-A. Beyond the veil. *Afghanistan Forum,* 24 i (1996) pp.37-37. (British nurse describes working in Afghanistan.)

43 RASULY-PALECZEK, G. Verwandtschaft und Heirat als
 Mittel zur Festigung von Macht und Einfluss: ein
 Fallbeispiel aus Nordost-Afghanistan. *Bamberger
 Mittelasienstudien: Konferenzakten, Bamberg ... 1990 /*
 B.G.Fragner, B.Hoffmann (Hrsg.). Berlin: Schwarz, 1994,
 (Islamkundliche Untersuchungen, 149), pp.193-216.

44 REUT, M. Die Taliban und die Unterdrückung der
 afghanischen Frauen. *SGMOIK/SSMOCI Bulletin,* 9
 (1999) pp.15-16.

45 ROSTAMI POVEY, Elaheh. Women in Afghanistan:
 passive victims of the *borga* or active social participants?
 Development in Practice, 13 ii-iii (2003) pp.266-277.
 Also online at http:// www.ingentaselect.com

46 RUBIN, Barnett R. Women and pipelines: Afghanistan's
 proxy wars. *International Affairs* (London), 73 ii (1997)
 pp.283-296.

47 TARZI, Amin. Malalay: the Afghan Jeanne d'Arc. *Firmest
 Bond,* 76-77 (2000) pp.37-38.

48 SCHINASI, May. Femmes afghanes. Instruction et
 activités publiques pendant le règne *amâniya* (1919-1929).
 Annali, Istituto Universitario Orientale di Napoli, 55 iv /
 1995 (1997) pp.446-462.

49 WEBBER, Kathryn J. The economic future of Afghan
 women: the interaction between Islamic law and Muslim
 culture. *University of Pennsylvania Journal of
 International Economic Law,* 18 iii (1997) pp.1049-1084.
 (Social forces, & not Islamic law, are the main factors that
 will cause the economic oppression of Afghan women.)

50 YACOOBI, Sakena. Women educating women in the
 Afghan diaspora: why and how. *Religious
 fundamentalisms and the human rights of women.* Ed.
 C.W.Howland. Basingstoke: Macmillan; New York: St.
 Martin's Press, 1999, pp.229-235. [In Pakistan & in parts
 of Afghanistan.]

51 Women's rights in the current political backdrop of
 Afghanistan / Afghan Women's Network. *Women Living
 under Muslim Laws: Dossier,* 17 (1997) Also online at
 www.wluml.org/english/pubs

Africa (general) see also East Africa (general), Maghrib (general), West Africa (general) & Index

Books

52 *Wandern oder bleiben? Veränderungen der Lebenssituation
 von Frauen im Sahel durch die Arbeitsmigration der
 Männer.* Ed. Grawert, E., Rübcke, G. & Hamel,
 R. Münster: Lit, 1994, (Bremer Afrika-Studien, 8),
 [264]pp. [Sudan, Mali, Senegal.]

Articles

53 DUNBAR, Roberta Ann. Muslim women in African
 history. *The history of Islam in Africa.* Ed. N.Levtzion
 & R.L.Pouwels. Athens (USA): Ohio University Press;
 Oxford: Currey; Cape Town: Philip, 2000, pp.397-417.

54 GORDON, N. M. "Tonguing the body": placing the female
 circumcision within African feminist discourse. *Issue,*
 25 ii (1997) pp.24-27. [Incl. Muslims.]

55 HAYASE, Y. & LIAW, Kao-Lee. Factors on polygamy
 in sub-Saharan Africa: findings based on the demographic
 and health surveys. *Developing Economies,* 35 iii (1997)
 pp.293-327. [Senegal, Ghana, Kenya & Zimbabwe, incl.
 impact of Islam.]

56 LOCOH, T. Early marriage and motherhood in
 sub-Saharan Africa. *African Environment,* 10 iii-iv /
 39-40 (1999) pp.31-42. [Islamic & non-Islamic
 societies.]

57 LOCOH, T. Pratiques, opinions et attitudes en matière
 d'excision en Afrique. *Population* (Paris), 53 vi (1998)
 pp.1227-1243. [Incl. Muslims in Central African
 Republic, Ivory Coast, Mali, Eritrea, Sudan, Egypt.]

58 OBOLER, Regina Smith. Law and persuasion in the
 elimination of female genital modification. *Human
 Organization,* 60 iv (2001) pp.311-318. [Africa,
 including Muslim societies & countries.]

Albania and the Albanians

Books

59 ÇULI, Diana. *Ese për gruan shqiptare. Essais sur la
 femme albanaise.* Tirana: Shtëpia Botuese FPGSH "Dora
 d'Istria", 2000. 149pp. [In Albanian & French.]

60 DEDET, Joséphine. *Géraldine, reine des Albanais.* Paris:
 Criterion, 1997. 385pp.

61 DERVISHI, Zyhdi. *Gratë në syrin e ciklonit të sfidave
 dhe perspektiva: trajtesë sociologjike e problematikës
 sociokulturore të grave shqiptare në vitet '90 të shekullit
 XX.* Tirana: Shtëpia Botuese "Dora d'Istria", 2000. 190pp.

62 DISHNICA, Dhimitër. *Motrat Qiriazi: monografi.* Tirana:
 "Enciklopedike", 1997. 195pp.

63 GUINARD, Emil. *E paharrueshmja shqipëri: kujtimë të
 një kohe të vështirë 1966-1968 /* Emil Ginar. Tirana: Toena,
 1996. 140pp. [Tr. of *Inoubliable Albanie,* Paris 1996.
 French diplomat in Albania.]

64 HOXHA, Nexhmije. *Jeta ime me Enverin: kujtime.* Tirana:
 "LIRA", 1998. 398pp.

65 OSMANI, Shefik. *Trashegimi social-pedagogjike: motrat
 Qiriazi.* Prishtinë: Enti i Teksteve dhe i Mjeteve Mesimore
 i Kosoves, 1997. 183pp.

66 YOUNG, Antonia. *Women who become men: Albanian
 sworn virgins.* Oxford: Berg, 2000. 168pp.

67 ZAÇE, Valentina. *Marredheniet martesore sipas
 legjislacionit shqiptar.* Tirana: "Logoreci", 1996. 159pp.

68 *Kosovo: rape as a weapon of 'ethnic cleansing'.* New York:
 London: Human Rights Watch, 2000 (Human Rights
 Watch Report, 12 iii(D)), 39pp.

Articles

69 BIDO, Agim. The xhubleta from aesthetic viewpoint.
 Studia Albanica, 30 i-ii / 1993 (1997) pp.117-145.
 (Bell-shaped gown, worn by the highland women of
 northern Albania.)

70 CORRIN, C. Svåra sociala problem för kvinnor i Albanien.
 Tr. Henrysson, I. *Kvinnovetenskaplig Tidskrift,* 15 ii
 (1994) pp.64-67.

71 DICKEMANN, Mildred. The Balkan sworn virgin: a
 cross-gendered female role. *Islamic homosexualities:
 culture, history, and literature.* S.O.Murray & W.Roscoe,
 with additional contributions by E.Allyn [& others]. New
 York: New York University Press, 1997, pp.197-203.
 [Incl. Albanian women.]

72 IGRIC, Gordana. Benefit of silence. *Index on Censorship,*
 28 iv / 189 (1999) pp.126-127. (Rape victims in Kosovo.)

73 KEÇMEZI-BASHA, Sabile. Roli i gruas në lëvizjen
 kombëtare shqiptare. (Summary: The role of women in
 the Albanian national movement.). *Feja, kultura dhe
 tradita islame ndër shqiptarët: simpozium ndërkombëtar
 i mbajtur në Prishtinë ... 1992.* (Ed. Muhamed Pirraku).
 Prishtina: Kryesia e Bashkësisë Islame të Kosovës, 1995,
 pp.539-542.

74 KENNEDY-PIPE, Caroline & STANLEY, Penny. Rape
 in war: lessons of the Balkan conflicts in the 1990s.
 International Journal of Human Rights, 4 iii-iv (2000)
 pp.67-84. [Bosnia, Kosova.]

75 KENNEDY-PIPE, Caroline & STANLEY, Penny. Rape
 in war: lessons of the Balkan conflicts in the 1990s. *The
 Kosovo tragedy: the human rights dimensions.* Ed. Ken
 Booth. London: Cass, 2001, pp.67-84. [Bosnia, Kosova.
 Previously published in *International Journal of Human
 Rights,* 4 iii-iv (2000).]

76 LASTARRIA-CORNHIEL, Susana & WHEELER, Rachel.
 Family and property rights: implications for gender and
 farming. *Rural property and economy in post-Communist
 Albania.* Ed. Harold Lemel. New York: Berghahn, 2000,
 pp.126-154.

77 MAGUIRE, Sarah. Researching 'a family afffair': domestic
 violence in former Yugoslavia and Albania. *Gender and
 Development,* 6 iii (1998) pp.60-66. Also online at http://
 www.ingentaselect.com [Violence against wives in
 Sarajevo area & Albania.]

78 MULDER, G. Terug naar het isolement: het harde leven
 van Albanese vrouwen. *Vlucht uit het isolement: Albanië
 op zoek naar nieuwe wegen.* Sef Slootweg (red.).
 Amsterdam: Instituut voor Publiek en Politiek, 1995,
 pp.98-110.

79 PAPIC, Zarana. Kosovo war, feminists and fascism in
 Serbia. *Women Living under Muslim Laws: Dossier,* 23-24
 (2001) pp.144-152. Also online at http://
 www.wluml.org/english/pubs

80 PUFITSCH-WEBER, Margit. "Schade, dass du meine
 Sprache nicht sprichst ...": Frauenleben zwischen Tradition
 und Emanzipation. *Albanien: Stammesleben zwischen
 Tradition und Moderne.* H.Eberhart / K.Kaser (Hg.).
 Vienna: Böhlau, 1995, pp.47-63.

81 RODGERS, Jayne. Bosnia and Kosovo: interpreting the
 gender dimensions of international intervention.
 Contemporary Security Policy, 22 ii (2001) pp.183-195.

82 SENTURIA, K. D. A woman's work is never done:
 women's work and pregnancy outcome in Albania.
 Medical Anthropology Quarterly, 11 iii (1997)
 pp.375-395.

83 SILVESTRINI, M. La donna quale fattore di sviluppo.
 (Abstract: Woman as a development factor.). *Politica
 Internazionale,* 22 iii (1994) pp.221-230;297.
 (L'Albania.)

84 WALTER, Natasha. The love boat. *Index on Censorship,*
 29 i / 192 (2000) pp.78-79. (Traffic in women from
 Albania.)

85 XHAGOLLI, Agron. The witch in myths, rites and beliefs
 of the Albanians. *Studia Albanica,* 31 i-ii / 1994 (1998)
 pp.93-104.

Algeria

Books

86 AMRANE-MINNE, Danièle Djamila. *Des femmes dans
 la guerre d'Algérie: entretiens.* Paris: Karthala, 1994.
 218pp.

87 AMRANE-MINNE, Danièle Djamila. *Femmes au combat:
 la guerre d'Algérie (1954-1962).* [Algiers:] Rahma, 1993.
 298pp.

88 BELKAÏD, Leyla. *Algéroises: histoire d'un costume
 méditerranéen.* Aix-en-Provence: Edisud 1998. 185pp.

89 BENCHEIKH-HOCINE, Hadjira Dennouni. *L'évolution
 des rapports entre époux, en droit algérien de la famille.*
 Algiers: Dahlab, 1998. 191pp.

90 BRAHIMI, Denise. *Taos Amrouche, romancière:
 document.* Paris: Losfeld, 1995. 171pp.

91 DAKIA. *Dakia, fille d'Alger.* [Paris]: Flammarion, 1997
 (Castor Poche, 561), 100pp.

92 DAKIA. *Dakia, fille d'Alger.* [Paris]: Flammarion, 1998.
 88pp.

93 DJURA. *La saison des narcisses.* Paris: Lafon, 1993.
 233pp. [Algerian women.]

94 DJURA. *Und morgen dann die Hoffnung ... :
 Scheherazades Schwestern im Kampf gegen die islamische
 Tradition.* Tr. Bartsch, K. Munich: Heyne, 1994,
 (Heyne-Bücher, 19; Heyne-Sachbuch, 306), 207pp. [Tr.
 of *La saison des narcisses,* Paris 1993. Algerian women.]

95 ENGELHARDT, O. *Frauenkultur in Algerien:
 Perspektiven der Arbeitsteilung; mit einer Untersuchung
 zur Frauenarbeit im informellen Sektor des Textilbereichs
 und Darstellung des traditionellen Frauenkleides.* Berlin:
 Fischer, 1994. 347pp.

96 FATIAH. *Algérie: chronique d'une femme dans la
 tourmente.* La Tour d'Aigues: Aube 1996. 143pp.

97 FATIAH *Eine Frau in Algerien: chronik des täglichen
 Terrors.* Tr. Brilke, Elisabeth. Frankfurt a.M.:
 Fischer-Taschenbuch-Verlag, 1999. 132pp. [Tr. of
 Algerie: chronique d'une femme dans la tourmente, Paris
 1996.]

98 GACEMI, Baya. *Moi, Nadia, femme d'un émir du GIA.*
 Paris: Seuil, 1998. 199pp.

99 GACEMI, Baya. *Nadia.* Tr. Vivanco, J. Barcelona:
 Mondadori, 1999. 168pp. [Tr. of *Moi, Nadia, femme d'un
 émir du GIA,* Paris 1998.]

100 GADANT, M. *Le nationalisme algérien et les femmes.*
 Paris: L'Harmattan, 1995. 302pp.

101 GERMAIN-ROBIN, F. *Femmes rebelles d'Algérie.* Paris:
 Ed. de l'Atelier, 1996. 127pp.

102 GUERROUDJ, J. *Des douars et des prisons.* [Algiers:]
 Bouchene, [1993]. 152pp.

103 HANOUNE, Louisa. *La otra cara de Argelia:
 conversaciones con Gania Mouffok.* Tr. Cerdá, I. Madrid:
 Vosa, 1996. 302pp. [Tr. of *Une autre voix pour l'Algérie,*
 Paris 1996.]

104 HANOUNE, Louisa. *Terroristen fallen nicht vom Himmel:
 zur aktuellen Situation in Algerien.* Ed. Mathari, A. Tr.
 Müller Renzoni, B. Zürich: Rotpunktverlag, 1997. 317pp.
 [Tr. of *Une autre voix pour l'Algerie: entretiens avec
 Ghania Mouffok,* Paris, 1996.]

105 HANOUNE, Louisa. *Une autre voix pour l'Algérie:
 entretiens avec Ghania Mouffok.* Paris: Découverte, 1996.
 253pp.

106 HAYAT, Nina. *La nuit tombe sur Alger la blanche:
 chronique d'une Algérienne.* Paris: Tiresias, 1995. 116pp.

107 IMACHE, Djedjiga & NOUR, Inès. *Algériennes entre
 islam et islamisme.* Aix-en-Provence: Edisud 1994. 165pp.

108 LACOSTE-DUJARDIN, C. *Des mères contre les femmes:
 maternité et patriarcat au Maghreb.* Paris: La Découverte
 Poche, 1996. 350pp. [Algeria. Originally published 1985.]

109 LANZA, A. *Il rischio della parola: donne che vivono e
 muriono in Algeria.* Rome: Datanews, 1996. 123pp.

110 LEE, Adidi & BERROU, Jean-Paul. *Amazir veut dire
 "homme libre".* Paris: L'Harmattan, 1997. 203pp.
 [Personal story of adolescent struggle against ill-health in
 Algerian hospital system.]

111 MAKILAM. *La magie des femmes kabyles et l'unité de
 la société traditionnelle.* Paris: L'Harmattan, 1996. 328pp.

112 MAKILAM. *Signes et rituels magiques des femmes
 kabyles.* Aix-en-Provence: Edisud 1999. 160pp.

113 MAKILAM *Weibliche Magie und Einheit der
 Gesellschaft in der Kabylei: Riten, verborgene Lebensweise
 und Kultur der Berberfrauen Algeriens.* Münster: Lit, 2001
 (Ethnologie, 1), 325pp. [Tr. of *La magie des femmes
 kabyles et l'unité de la société traditionnelle,* Paris 1996.]

114 PÉREZ BELTRÁN, C. *Mujeres argelinas en lucha por
 las libertades democráticas.* Granada: Editorial
 Universidad de Granada, 1997. 387pp.

115 PÉREZ BELTRÁN, C. *Situación socio-política de las
 mujeres argelinas.* Granada: Servicio de Publicaciones,
 Universidad de Granada, 1995. 9pp. [Microfiche edition,
 with printed abstract in Spanish & English & contents
 page. 6 microfiches.]

116 PLANTADE, Nedjima. *L'honneur et l'amertume: le destin
 ordinaire d'une femme kabyle.* Paris: Balland, 1993.
 265pp.

117 REBZANI, Mohammed. *La vie familiale des femmes
 algériennes salariées.* Paris: L'Harmattan, 1997. 188pp.

118 RÜHL, B. *Wir haben nur die Wahl zwischen Wahnsinn oder Widerstand: Frauen in Algerien.* Bad Honnef: Horlemann, 1997. 182pp.

119 SCHEMLA, E. *Unbowed: an Algerian woman confronts Islamic fundamentalism.* Interviews [with Khalida Messaoudi]. Tr. Vila, A. C. Philadelphia: University of Pennsylvania Press, 1998. 166pp. [Tr. of *Algérienne debout.* Paris 1995.]

120 SCHEMLA, E. *Une Algérienne debout. Entretiens* [avec Khalida Messaoudi]. Paris: Flammarion, 1995. 213pp.

121 SCHEMLA, E. *Worte sind meine einzige Waffe: eine Algerierin im Fadenkreuz der Fundamentalisten. Gespräche mit Khalida Messaoudi.* Munich: Kunstmann, 1995. 238pp. [Tr. of *Une Algérienne debout. Entretiens,* Paris 1995.]

122 TAARJI, Hinde. *30 jours en Algérie: journal d'une marocaine.* Casablanca: EDDIF, 1998. 275pp.

123 VARONA, M. *Mujeres argelinas: la libertad prohibida.* Madrid: Federación de Mujeres Progresistas, 1995, (Colección de Mujeres Progresistas, 4), 127pp.

124 YACINE, Tassadit. *Piège ou le combat d'une femme algérienne. Essai d'anthropologie de la souffrance.* Paris: Publisud-Awal, 1995, (Collection Monde Berbère d'Hier et d'Aujourd'hui), 313pp.

125 ZÉGHIDOUR, Slimane. *Le voile et la bannière.* Paris: Hachette, 1994, (Pluriel, 8700), 181pp. [Algeria.]

126 *Dossier d'information sur la situation en Algérie: resistance des femmes et solidarité internationale. Compilation of information on the situation in Algeria: women's resistance and solidarity around the world.* Grabels: Women Living Under Muslim Laws, 1995. 453pp. [Reprinted articles from newspapers & journals, 1989-1994. On cover: *Femmes sous les lois musulmanes, No. 1, Mars 1995.*]

127 *Hinter dem Schleier: drei bewegende Lebensgeschichten.* 3. Aufl. Munich: Heyne, 1997. 543pp. [Autobiographies of Zana Muhsen (in Yemen), Fadhma Aïth Mansour Amrouche & Djura (Kabyle Algerian women).]

128 *Hommes et femmes de Kabylie: DBK, dictionnaire biographique de la Kabylie* / Institut National des Langues et Civilisations Orientales Paris, Centre de Recherche Berbère. Vol.1. Ed. Chaker, Salem. Aix-en-Provence: Edisud, 2001. 207pp.

129 LEMDANI BELKAÏD, Malika. *Normaliennes en Algérie.* Paris: L'Harmattan, 1998. 237pp.

Articles

130 ABADA, Khadidja. Les femmes: histoire d'une manipulation. *Cahiers de l'Orient,* 39-40 (1995) pp.227-240. [Algeria.]

131 ADEL, Faouzi. Formation du lieu conjugal et nouveaux modèles familiaux en Algérie. *Femmes, culture et société au Maghreb.* I: *Culture, femmes et famille.* Sous la dir. de R.Bourqia, M.Charrad, N.Gallagher. Casablanca: Afrique Orient, 1996, pp.139-155.

132 AÏT FERROUKH, Farida. Railleries à la belle-mère: chants en Kabyle et en arabe dialectal. *Etudes et Documents Berbères,* 17 / 1999 (2002) pp.199-220.

133 AÏT-MOHAMED, Salima. Seules contre tous. *Revue des Deux Mondes,* 1994 i, pp.118-126. [Algerian women.]

134 AMRANE-MINNE, Danièle Djamila. Les femmes face à la violence dans la guerre de libération. *Confluences Méditerranée,* 17 (1996) pp.87-96. (Femmes et guerres: Algérie.)

135 AMRANE-MINNE, Danièle Djamila. Women and politics in Algeria from the War of Independence to our day. Tr. Abu-Haidar, Farida. *Research in African Literatures,* 30 iii (1999) pp.62-77.

136 AMROUCHE, Fadhma Aïth Mansour. Mektoub "Der Wille Allahs geschehe". *Hinter dem Schleier: drei bewegende Lebensgeschichten.* 3. Aufl. Munich: Heyne, 1997, pp.215-409. [Tr. of *Mektoub: histoire de ma vie,* Paris 1986. Kabyle Algerian woman.]

137 ANDEZIAN, S. De l'usage de la dérision dans un rituel de pélerinage. *Annuaire de l'Afrique du Nord,* 30 / 1991 (1993) pp.283-300. (Algérie.)

138 ANDEZIAN, S. De l'usage de la dérision dans un rituel de pélerinage. *Etre marginal au Maghreb. Textes* réunis par Fanny Colonna avec Zakya Daoud. Paris: CNRS, 1993, pp.283-300. (Algérie.)

139 ANDEZIAN, S. The role of Sufi women in an Algerian pilgrimage ritual. Tr. De Clerk, M. *African Islam and Islam in Africa: encounters between Sufis and Islamists.* Ed. E.E.Rosander & D.Westerlund. London: Hurst, in co-operation with the Nordic Africa Institute, Uppsala, 1997, pp.193-215.

140 AOUIMEUR, Mouloud. Le militantisme féminin dans l'Algérie des années 30: les fédérations algériennes des femmes socialistes. *Revue d'Histoire Maghrébine / Al-Majalla al-Tārīkhīya al-Maghāribīya,* 27 / 97-98 (2000) pp.11-29.

141 ARNHOLD, B. Khalida Messaoudi et Nourredine Saadi. *Cahier d'Études Maghrébines,* 8-9, 1995-96, pp.164-176. [Interviews with Algerian intellectuals, 1992-95.]

142 ARNHOLD, B. Trois représentantes d'associations de femmes. *Cahier d'Études Maghrébines,* 8-9, 1995-96, pp.177-180. [Interview with three anonymous Algerian feminists, 1994.]

143 ASLAOUI, Leïla. Misogynie du pouvoir et violence intégriste: un même combat contre les femmes. *Femmes de Méditerranée: religion, travail, politique.* Sous la dir. de Andrée Dore-Audibert et Sophie Bessis. Paris: Karthala, 1995, pp.13-20. [Algeria.]

144 BABÈS, Leïla. Printemps de femmes. *Revue des Deux Mondes,* 1997 ix, pp.141-147. [Algeria.]

145 BARBEROUSSE, S. La propriété des femmes et l'état: l'exemple algérien. *Homme et la Société,* 119 (1996) pp.85-99.

146 BARKAT, Sidi Mohammed. Ce que peut une femme. *Awal,* 19 (1999) pp.59-69. (Une femme de petite Kabylie.)

147 BARSKA, A. Antropologiczne aspekty stroju muzułmanki w Algieri. (Summary: Anthropological aspects of female Muslim costume in Algeria.). *Plenas Arabum domos: materiały IV Ogólnopolskiej Konferencji Arabistycznej Warszawa 25-26 marca 1993.* Pod redakcją M.M.Dziekana. Warsaw: Zakład Arabistyki i Islamistyki, Instytut Orientalistyczny, Uniwersytet Warszawski, 1994, pp.27-36.

148 BARSKA, Anna. Les espaces d'activités socio-culturelles des femmes en Algérie. *Africana Bulletin,* 48 (2000) pp.113-137.

149 BEKKAR, Rabia. Femmes, filles et villes. *Demain l'Algérie.* Sous la dir. de Gérard Ignasse et Emmanuel Wallon. Paris: Syros, 1995, pp.89-103. [Algerian society.]

150 BEKKAR, Rabia. Territoires des femmes à Tlemcen: pratiques et représentations. *Monde Arabe Maghreb-Machrek,* 143 (1994) pp.126-141.

151 BEKKAR, Rabia. Women in the city in Algeria: change and resistance. *ISIM Newsletter,* 7 (2001) pp.27-27.

152 BELHOUARI-MUSETTE, Djamila. Le mouvement féministe algérien - MFA. *Cahiers du CREAD,* 53 (2000) pp.63-69.

153 BENDJABALLAH, Souad. Femmes, prisonnières du sacré. *Awal,* 20 (1999) pp.23-41. [Effects of Algerian family law.]

154 BENGUERINE, Sabéha. Formation technique supérieure et trajectoires féminines en Algérie. *Femmes, culture et société au Maghreb.* I: *Culture, femmes et famille.* Sous la dir. de R.Bourqia, M.Charrad, N.Gallagher. Casablanca: Afrique Orient, 1996, pp.127-138.

155 BENNOUNE, Karima. S.O.S. Algeria: women's human rights under siege. *Women Living under Muslim Laws: Dossier,* 18 (1997) pp.29-50. Also online at www.wluml.org/english/pubs

156 BETTAHAR, Yamina. L'enjeu des femmes en Algérie ou l'impossible individuation? *L'Algérie contemporaine. Bilan et solutions pour sortir de la crise.* Sous la dir. de G.Meynier. Paris: L'Harmattan, 2000, pp.47-68.

157 BOUALEM, Baya. Galant homme, femme galante à Oran: approche ethnolinguistique. (Résumé: Man of honour and amorous woman in Oran.). *Littérature Orale Arabo-Berbère,* 24 (1996) pp.95-114;273.

158 BOUATTA, Chérifa. Ma fille est un homme, ma fille est comme un homme. *Femmes et hommes au Maghreb et en immigration: la frontière des genres en question. Etudes sociologiques et anthropologiques.* Sous la dir. de C.Lacoste-Dujardin & M.Virolle. Coord. Baya Boualem & Narjys El Alaoui. Paris: Publisud, 1998, pp.177-181. (Changements socio-culturels intervenus en Algérie.)

159 BOUDEFA, Saliha. Femmes et mouvement associatif en Algérie. *Awal,* 20 (1999) pp.61-75.

160 BOZZO, A. Le viol en spectacle. *Confluences Méditerranée,* 17 (1996) pp.83-85. (Femmes et guerres: Algérie.)

161 BRAC DE LA PERRIÈRE, Caroline. Die algerische Frauenbewegung zwischen Nationalismus und Islamismus. *Feminismus, Islam, Nation: Frauenbewegungen im Maghreb, in Zentralasien und in der Türkei.* (Hg.) Claudia Schöning-Kalender, Aylâ Neusel, Mechtild M.Jansen. Frankfurt a.M.: Campus, 1997, pp.167-184.

162 BUCAILLE, L. L'engagement islamiste des femmes en Algérie. *Monde Arabe Maghreb-Machrek,* 144 (1994) pp.105-118.

163 CHACHOUA, Kamal. Fils de veuves ou fils de martyrs? Les enfants de *chuhada. Monde Arabe Maghreb-Machrek,* 154 (1996) pp.31-39. [Algerian War of Independence.]

164 CHAULET-ACHOUR, C. Contes d'hier, d'aujourd'hui et de demain: Kitman. *Cahier d'Études Maghrébines,* 8-9, 1995-96, pp.207-220.

165 CHAULET-ACHOUR, C. Talisman pour un avenir. *Cahier d'Études Maghrébines,* 8-9, 1995-96, pp.220-223. [Algerian women.]

166 CHAULET ACHOUR, Christiane. Portraits de femmes d'un pays en guerre. (Photographies et récits.). *Esprit Créateur,* 41 iv (2001) pp.101-112. (Algériennes.)

167 CHERIET, Boutheina. Fundamentalism and women's rights: lessons from the city of women. *Muslim women and the politics of participation: implementing the Beijing platform.* Ed. Mahnaz Afkhami & E.Friedl. Syracuse (USA): Syracuse University Press, 1997, pp.11-17. (Algeria.)

168 CHERIET, Boutheina. Gender, civil society and citizenship in Algeria. *Middle East Report,* 26 i / 198 (1996) pp.22-26.

169 CHERIET, Boutheina. Gender, civil society and citizenship in Algeria. *Women Living under Muslim Laws: Dossier,* 14-15 (1996) pp.12-20. Also online at www.wluml.org/english/pubs

170 CHERIET, Boutheina. Gender, development and policy formation. *Arab regional women's studies workshop. Al-Nadwa al-iqlīmīya li-dirāsāt al-mar'a al-'Arabīya.* Ed. C.Nelson, Soraya Altorki. Cairo: American University in Cairo, 1998, (Cairo Papers in Social Science, 20 iii (1997)), pp.94-98. [Algeria as an example. Discussion led by Shahnaz Rouse, pp.99-101.]

171 CHERIET, Boutheina. Gender, state and citizenship in Algeria. *Middle East Policy,* 5 iii (1997) pp.176-180;187-189. [1962-1990.]

172 CHERIET, Boutheina. Genre, société civil et citoyenneté en Algérie. *Women Living under Muslim Laws: Dossier,* 14-15 (1996) pp.13-22. Also online at http:// www.wluml.org/french/pubs/pdf/dossiers/dossier14-15/ D14-15fr.pdf

173 CHÉRIFATI-MÉRABTINE, Doria. Le sexe brouillé. *Femmes et hommes au Maghreb et en immigration: la frontière des genres en question. Etudes sociologiques et anthropologiques.* Sous la dir. de C.Lacoste-Dujardin & M.Virolle. Coord. Baya Boualem & Narjys El Alaoui. Paris: Publisud, 1998, pp.213-219. [L'Algérienne contemporaine.]

174 CHIKHA, Elisabeth. MFAD: des algériennes solidaires. *Hommes & Migrations,* 1206 (1997) pp.114-116. (Mouvement des Femmes Algériennes pour la Démocratie.)

175 CLANCY-SMITH, J. The colonial gaze: sex and gender in the discourses of French North Africa. *Franco-Arab encounters: studies in memory of David C.Gordon.* Ed. L.C.Brown & M.S.Gordon. Beirut: American University of Beirut, 1996, pp.201-228. [Algeria.]

176 CORNELL, Drucilla. The secret behind the veil: a reinterpretation of "Algeria unveiled". *Philosophia Africana,* 4 ii (2001) pp.27-35. ("Algeria unveiled", one of Frantz Fanon's most controversial essays, has been criticized for essentializing both gender and sex.)

177 DAOUD, Zakya. Sans larmes inutiles. *Cahiers Intersignes,* 10 (1995) pp.187-191. [Women in Algeria.]

178 DEKKAK, Mohamed. La relation homme/femme dans l'imaginaire algérien: une approche socio-linguistique. *Actes du colloque: L'homme, la femme et les relations amoureuses dans l'imaginaire arabo-musulman, Tunis ... 1992 / Ashghāl multaqā: Al-Rajul wa-'l-mar'a wa'l-ḥubb fī 'l-khayāl al-'Arabī al-Islāmī.* Tunis: Université des Lettres, des Arts et des Sciences Humaines, Tunis I, Centre d'Etudes et de Recherches Economiques et Sociales, Tunis, 1995, (Cahier du C.E.R.E.S. Série Psychologie, 8), pp.141-157.

179 DENNERLEIN, B. Changing conceptions of marriage in Algerian personal status law. *Perspectives on Islamic law, justice, and society.* Ed. R.S.Khare. Lanham: Rowman & Littlefield, 1999, pp.123-141.

180 DENNERLEIN, B. La difficile autonomie des luttes de femmes. *Monde Arabe Maghreb-Machrek,* 154 (1996) pp.16-24. (En Algérie.)

181 DENNERLEIN, Bettina. 'Legalizing' the family: disputes about marriage, paternity and divorce in Algerian courts (1963-1990). (Abstracts: La famille sous le regard des tribunaux: les affaires de mariage, paternité et divorce devant les tribunaux algériens; 'Legalisierung' der Familie: Auseinandersetzungen um Ehe, Vaterschaft und Scheidung vor Algerischen Gerichten, 1963-1990.). *Continuity and Change,* 16 ii (2001) pp.166;243-261. Also online at http:// journals.cambridge.org

182 DHOQUOIS-COHEN, Régine. Les femmes au cœur des violences. Entretien avec Fériel Lalami-Fatès. *Confluences Méditerranée,* 25 (1998) pp.203- 209. [Algeria.]

183 DIB-MAROUF, Chafika. Dot et condition féminine en Algérie. *Cahiers de l'Orient,* 47 (1997) pp.83-92.

184 DJAZIRI, Moncef. Femmes, littérature et politique en Algerie. *SGMOIK/SSMOCI Bulletin,* 1 (1995) pp.17-19.

185 DJEBAR, Assia. "Algériennes, le regard qui recule ...". *Europas islamische Nachbarn. Studien zur Literatur und Geschichte des Maghreb.* Band 2. hrsg. von Ernstpeter Ruhe. Würzburg: Königshausen & Neumann, 1995, pp.11-16. (Algeria.)

186 DJURA Der Schleier des Schweigens. Tr. Kimmig, Rudolf. *Hinter dem Schleier: drei bewegende Lebensgeschichten.* 3. Aufl. Munich: Heyne, 1997, pp.411-543. [Tr. of *Le voile du silence,* 1990. Kabyle Algerian woman.]

187 FAOUZI, Adel. La nuit des noces. *Cahiers Intersignes,* 11-12 (1998) pp.7-26. (Une enquête ... en Algérie.)

188 FILALI, A. La responsabilité de la mère divorcée du fait de ses enfants mineurs. *Revue Algérienne des Sciences Juridiques Economiques et Politiques / Al-Majalla al-Jazā'irīya li-l-'Ulūm al-Qānūnīya al-Iqtiṣādīya wa-'l-Siyāsīya,* 34 iv (1996) pp.541-549. [Algerian law.]

189 FORTIER, C. Rapports sociaux de sexe et représentation de la genèse physiologique des enfants dans le Touat-Gourara (Sahara algérien). *Femmes et hommes au Maghreb et en immigration: la frontière des genres en question. Etudes sociologiques et anthropologiques.* Sous la dir. de C.Lacoste-Dujardin & M.Virolle. Coord. Baya Boualem & Narjys El Álaoui. Paris: Publisud, 1998, pp.47-69. (Population arabophone.)

190 FORTS, J. des. Indicateurs de la santé maternelle en Algérie. Evolution de 1962 à 1992. *Population* (Paris), 53 iv (1998) pp.859-873.

191 GACEMI, Baya. Le code de la famille: compromis et résistance. *Cahiers de l'Orient*, 51 (1998) pp.67-74. [Algeria.]

192 GADANT, M. Femmes alibi. *Temps Modernes*, 580 (1995) pp.221-232. [Resistance by Algerian women.]

193 GALLAIRE, Fatima. Mère, fils et bru. Le trio méditerranéen. *Etre femme au Maghreb et en Méditerranée. Du mythe à la réalité.* Sous la dir. de Andrée Dore-Audibert & Souad Khodja. Paris: Karthala, 1998, pp.149-158. [Algeria as example.]

194 GERMAIN-ROBIN, F. Femmes rebelles. *Confluences Méditerranée*, 17 (1996) pp.79-82. (Femmes et guerres: Algérie.)

195 GIBSON, Nigel. The oxygen of the revolution: gendered gaps and radical mutations in Frantz Fanon's *A dying colonialism. Philosophia Africana*, 4 ii (2001) pp.47-62. [Algerian women & colonialism.]

196 GOODMAN, J. Dancing towards `la mixité`: Berber associations and cultural change in Algeria. *Middle East Report*, 200 / 26 iii (1996) pp.16-19.

197 GOODMAN, Jane E. "Stealing our heritage?": women's folksongs, copyright law, and the public domain in Algeria. *Africa Today*, 49 i (2002) pp.85-97. (In Algeria, discussions about the World Music genre called new Kabyle song frequently question whether new singers have adequately represented a song's folk origins to the copyright agency.)

198 GRABA, Ghania. La dualité du système juridique algérien et le code de la famille: éléments pour une problématique. *Algeria. Il disastro e la memoria. Algérie. Le désastre et la mémoire* / a cura di Federico Cresti. Rome: Istituto per l'Oriente C.A.Nallino & Cosmica, Dipartimento di Studi Politici, Università di Catania, 2003, (Quaderni di *Oriente Moderno*, 22 (83) iv / 2003), pp.95-102.

199 GUERROUDJ, Zineb. Femmes en deuil. *Cahiers Intersignes*, 10 (1995) pp.181-186. [Algeria.]

200 HADDAB, Zoubida. La formation des élites féminines dans l'Algérie indépendante. *Algeria. Il disastro e la memoria. Algérie. Le désastre et la mémoire* / a cura di Federico Cresti. Rome: Istituto per l'Oriente C.A.Nallino & Cosmica, Dipartimento di Studi Politici, Università di Catania, 2003, (Quaderni di *Oriente Moderno*, 22 (83) iv / 2003), pp.103-115.

201 HADDAB, Zoubida. Les Algériennes dans le discours colonial. *Awal*, 20 (1999) pp.77-88.

202 HADDAB, Zoubida. Transmission et ruptures dans l'univers féminin d'une famille (1890-1980). *Social Science Information sur les Sciences Sociales*, 36 ii (1997) pp.263-292.

203 HADJ ALI, Ismail. L'annonce matrimoniale: un fragment de discours sur "l'amour heureux" et la personne humaine idéale. *Actes du colloque: L'homme, la femme et les relations amoureuses dans l'imaginaire arabo-musulman, Tunis ... 1992 / Ashghāl multaqā: Al-Rajul wa-'l-mar'a wa'l-ḥubb fī 'l-khayāl al-'Arabī al-Islāmī.* Tunis: Université des Lettres, des Arts et des Sciences Humaines, Tunis I, Centre d'Etudes et de Recherches Economiques et Sociales, Tunis, 1995, (Cahier du C.E.R.E.S. Série Psychologie, 8), pp.121-130. [Algerian adverts for marriage partners.]

204 HAKIKI-TALAHITE, Fatiha. L'emploi féminin en Algérie. *Explosión demográfica, empleo y trabajadores emigrantes en el mediterráneo occidental.* J.Montabes Pereira, B.López García & D.del Pino (eds.). Granada: Universidad de Granada, 1993, pp.33-336.

205 HAYEF, Iman. Le célibat des femmes en Algérie. *Annuaire de l'Afrique du Nord*, 30 / 1991 (1993) pp.251-257.

206 HAYEF, Iman. Le célibat des femmes en Algérie. *Etre marginal au Maghreb. Textes* réunis par Fanny Colonna avec Zakya Daoud. Paris: CNRS, 1993, pp.251-257.

207 HUNGER, Bettina. Le mariage interdit d'Aurélie Picard et de Sid-Ahmed Tedjani. Chari'a et code civil en Algérie à l'époque coloniale. *Algérie - France - islam. Actes du colloque organisé par le Centre français de l'Université de Fribourg en Br. ... 1995.* Textes rassemblés par Joseph Jurt. Paris: L'Harmattan, 1997, pp.31-45.

208 JANSEN, W. Contested identities: women and religion in Algeria and Jordan. *Women and Islamization: contemporary dimensions of discourse on gender relations.* Ed. K.Ask & M.Tjomsland. Oxford: Berg, 1998, pp.73-102.

209 JOLIVALT, J-F. L'interdit d'expression: Salima Ghezali. *Intégrismes, Algérie, jusqu'où peut-on comprendre?* La Tour d'Aigues: L'Aube (1996) (Nouveaux Cahiers du Sud, 1), pp.103-111. [Editor of *La Nation*, Algiers.]

210 KATEB, K(amel). L'espérance de vie à la naissance et la surmortalité féminine en Algérie en 1954. *Population* (Paris), 53 vi (1998) pp.1209-1226.

211 KESSOUS, Naaman. National liberation: Frantz Fanon's views on women's condition in Algeria (1956-1962). *Bulletin of Francophone Africa*, 14 (1999) pp.69-74.

212 KHANNA, Ranjana. The experience of evidence: language, the law, and the mockery of justice. *Algeria in others' languages.* Ed. by Anne-Emmanuelle Berger. Ithaca: Cornell University Press, 2002, pp.107-138. (Use of French by some Algerian women in the mock trial they staged against Islamic "terrorists": during the trial, the terrorist men are made to speak standard Arabic, while the "terrorized" women, both victims and accusers, speak French.)

213 KHODJA, Souad. La réaction des Algériennes aux discours et pratiques de l'exclusion. *Femmes de Méditerranée: religion, travail, politique.* Sous la dir. de Andrée Dore-Audibert et Sophie Bessis. Paris: Karthala, 1995, pp.171-180.

214 KITOUNI-DAHMANI, Naïma. Femmes dans la tourmente coloniale. *Confluences Méditerranée*, 19 (1996) pp.37-49. [Algeria.]

215 KOPOLA, N. Definitions of Algerian women: citizenship, participation and exclusion. *The third Nordic conference on Middle Eastern Studies: Ethnic encounter and culture change, Joensuu, Finland, 19-22 June 1995.* Proceedings archive. Bergen: University of Bergen, Centre for Middle Eastern and Islamic Studies, [for] Nordic Society for Middle Eastern Studies, 1996, Online at http://www.hf.uib.no/smi/paj/default.html

216 KOPOLA, N. Lika eller olika? Kvinnoorganiseringen i Algeriet och Tunisien. *Kvinnovetenskaplige Tidskrift*, 18 iii-iv (1997) pp.47-57.

217 KOPOLA, N. Våld mot algeriska kvinnor: en fråga om politisk konstruktion av kvinnor, medborgarskap och kvinnors rättigheder. *TfMS: Tidskrift för Mellanösternstudier*, 1997 i, pp.4-18.

218 KÖPPEN, S. Femmes algériennes et littérature engagée: Christine Achour-Chaulet répond aux questions. *Cahier d'Études Maghrébines*, 8-9, 1995-96, pp.203-206.

219 KORSO, Malika el. Une double réalité pour un même vécu. *Confluences Méditerranée*, 17 (1996) pp.97-105. (Femmes et guerres: Algérie.)

220 KOUAOUCI, Ali. Continuités et ruptures dans ls trajectoires familiales. *Familles turques et maghrébines aujourd'hui: évolution dans les espaces d'origine et d'immigration.* Sous la dir. de Nouzha Bensalah. Louvain-la-Neuve: Academia-Erasme; Paris: Masionneuve et Larose, 1994, pp.9-32. (Stratégies matrimoniales ... en Algérie.)

221 KOUAOUCI, Ali. Migrations des femmes et fécondité en Algérie. *Revue du Monde Musulman et de la Méditerranée*, 65 (1993) pp.165-173. [To towns.]

222 LACHERAF, Mostefa. Chansons des jeunes filles algériennes. *Algérie Littérature / Action*, 20-21 (1998) pp.125-143. [Collected & tr. into French 1953.]

223 LACOSTE-DUJARDIN, C. Femmes kabyles: de la rigeur patriarcale à l'innovation. *Hommes & Migrations*, 1179 (1994) pp.19-24.

224 LACOSTE-DUJARDIN, C. Rôles féminins et rôles masculins en changement à travers l'observation de deux rituels sacrificiels en Kabylie. *L'islam pluriel au Maghreb*. Sous la dir. de S.Ferchiou. Paris: CNRS, 1996, pp.159-179. [Previously published in *Annuaire de l'Afrique du Nord 1994*, 1996.]

225 LACOSTE-DUJARDIN, C. Violence en Algérie contre les femmes transgressives ou non des frontières de genre. *Femmes et hommes au Maghreb et en immigration: la frontière des genres en question. Etudes sociologiques et anthropologiques*. Sous la dir. de C.Lacoste-Dujardin & M.Virolle. Coord. Baya Boualem & Narjys El Alaoui. Paris: Publisud, 1998, pp.19-31.

226 LALAMI-FATÈS, Fériel. Les associations de femmes algériennes face à la menace islamiste. *Esprit*, 208 (1995) pp.126-129.

227 LAOUEDJ, Zineb. La création féminine en Algérie: entre espoirs et cimetières. *Qantara*, 10 (1994) pp.36-36. (Dans l'Algérie d'aujourd'hui.)

228 LAZREG, Marnia. Citizenship and gender in Algeria. *Gender and citizenship in the Middle East*. Ed. Suad Joseph. Syracuse (USA): Syracuse University Press, 2000, pp.58-69.

229 LLOYD, Catherine. Organising across borders: Algerian women's associations in a period of conflict. *Review of African Political Economy*, 82 (1999) pp.479-490. (Consequences for political organisation.)

230 LLOYD, Catherine. Transnational mobilizations in contexts of violent conflict: the case of solidarity with women in Algeria. *Contemporary Politics*, 5 iv (1999) pp.365-377.

231 MAHL Algeria: ordinary fascism, fundamentalism and femicide. *Women Living under Muslim Laws: Dossier*, 23-24 (2001) pp.137-143. Also online at http://www.wluml.org/english/pubs

232 MAHL. Secularism and the construction of Muslimness: a personal account from Algeria. *WAF Journal*, 8 (1996) pp.16-17.

233 MARI, J-P. Selima Ghezali. *Cahier d'Études Maghrébines*, 8-9, 1995-96, pp.181-182. [Interview with Algerian journalist.]

234 MARX-SCOURAS, D. 'Yacef' girls'. *Maghreb Review*, 21 iii-iv (1996) pp.256-266. (Women freedom fighters.)

235 MESSAOUDI, Khalida. La nouvelle Inquisition. *Temps Modernes*, 580 (1995) pp.213-220. [Islamist persecution of women in Algeria.]

236 MESSAOUI-BARRÉCHE, Sadia. Référence à la terre et appartenance religieuse: Nanna Sabine, kabyle et chrétienne. *Confluences Méditerranée*, 20, 1996-97, pp.127-130.

237 MEYNIER, G. Le mariage avec des étrangères en Algérie à la fin des années 70. *Confluences Méditerranée*, 19 (1996) pp.87-93.

238 MOKEDDEM, Malika. De la lecture à l'écriture. *Qantara*, 10 (1994) pp.27-28. [Her childhood in Algeria.]

239 MORSLY, Dalila. Le difficile accès des Algériennes à l'Université. *Les femmes et l'université en Méditerranée*. Sous la dir. de Nicky Le Feuvre, Monique Membrado & Annie Rieu. Toulouse: Presses Universitaires du Mirail, 1999, pp.71-78.

240 MORSLY, Dalila. "Ô hommes, soyez femmes ne serait-ce qu'un jour": *A yergazen ilikum tulawin xartsum yebwas*. *Femmes et hommes au Maghreb et en immigration: la frontière des genres en question. Etudes sociologiques et anthropologiques*. Sous la dir. de C.Lacoste-Dujardin & M.Virolle. Coord. Baya Boualem & Narjys El Alaoui. Paris: Publisud, 1998, pp.191-199. (Relever dans l'arabe algérien des termes & des expressions idiomatiques bien ancrées dans la culture populaire ... ajouter l'appel adressé en Kabyle, par un responsable politique.)

241 MORSLY, Dalila. Discours sur les femmes. *Etre femme au Maghreb et en Méditerranée. Du mythe à la réalité*. Sous la dir. de Andrée Dore-Audibert & Souad Khodja. Paris: Karthala, 1998, pp.131-147. (Dans différents espaces discursifs algériens.)

242 MOUFOK, Ghania. Les femmes algériennes dans la guerre. *Peuples Méditerranéens*, 70-71 (1995) pp.209-216.

243 NAIT DJOUDI, Oulhadj. L'exhérédation des femmes en Kabylie: le fait de l'histoire et de la géographie. *Insaniyat*, 13 (2001) pp.187-201.

244 OUFREHA, Fatima-Zohra. Femmes algériennes: la révolution silencieuse? (Résumé: Algerian women: the silent revolution?). *Monde Arabe Maghreb-Machrek*, 162 (1998) pp.57-68;151.

245 OUSSEDIK, Fatma. Masculin/féminin: les Algériens et le mouvement des femmes. (Summar[y]: Male/female: Algerians and the women's movement.). *Pouvoirs*, 86 (1998) pp.117-128;221-222.

246 OUSSEDIK, Fatma. Religion, gender, and violence in Algeria. *Brown Journal of World Affairs*, 6 i (1999) pp.191-197.

247 PANDOLFI, P. Histoires d'aiguilles chez les Kel-Ahaggar: à propos d'un épisode méconnu du rituel du mariage. *Journal des Africanistes*, 64 i (1994) pp.81-90.

248 PÉREZ BELTRÁN, C. Algunos apuntes en torno al *status* socio-jurídico de la mujer beréber de Kabilia. *Vigía de Tierra*, 2-3 / 1996-7 (1997) pp.129-138.

249 PÉREZ BELTRÁN, C. Contribución a la historia del movimiento feminista argelino: el *Grupo de Investigación sobre las Mujeres Argelinas* de Orán. *Miscelánea de Estudios Árabes y Hebraicos: Sección Arabe-Islam*, 44 (1995) pp.121-150.

250 PÉREZ BELTRÁN, C. Entre erradicación y diálogo: mujeres argelinas. Crónica 1995. *Miscelánea de Estudios Árabes y Hebraicos: Sección Arabe-Islam*, 45 (1996) pp.203-232.

251 PÉREZ BELTRÁN, C. Evolución del movimiento femenino y feminista en Argelia: las mujeres y la política. (Abstract: Evolution of the feminine and feminist movement in Algeria: women and politics.). *Estudios de Asia y Africa*, 105 / 33 i (1998) pp.6-71;75-102. [Colonial to present times.]

252 PÉREZ BELTRÁN, C. La mujer árabe contemporánea: el ejemplo de la mujer argelina. *Granada 1492-1992: del reino de Granada al futuro del mundo mediterráneo*. M.Barrios Aguilera & B.Vincent (eds.). Granada: Universidad de Granada, Diputación Provincial de Granada, 1995, (Biblioteca Chronica Nova de Estudios Históricos, 39), pp.407-426.

253 PÉREZ BELTRÁN, C. La *Unión Nacional de Mujeres Argelinas*: organización femenina de masas. *Al-Andalus - Magreb*, 5 / 1997 (1998) pp.295-317.

254 PÉREZ BELTRÁN, Carmelo. La asociación de los ulemas musulmanes argelinos (1931-1954) y la cuestión de la mujer. *Homenaje al profesor José María Fórneas Besteiro*. Granada: Universidad de Granada, 1995, pp.813-820.

255 POUILLON, F. L'hôtesse arabe (Hodna 1932): à propos de "Aspects du contrat pastoral à Sidi-Aïssa" (1936). *Revue des Mondes Musulmans et de la Méditerranée*, 83-84 / 1997 (1998) pp.45-66. (Jacques Berque. Annexe, pp.58-59 & 66: "Adieux de l'Hôtesse arabe", poésie de Victor Hugo - musique de Georges Bizet.)

256 PRUVOST, Lucie. Le code algérien de la famille à la recherche d'un projet de société. *Awal*, 20 (1999) pp.7-21.

257 RAHAL-SIDHOUM, Saïda. Comme la lune et le soleil.
 Confluences Méditerranée, 17 (1996) pp.67-78. (Femmes
 et guerres: Algérie.)

258 RAHAL-SIDHOUM, Saïda. Le deuil et le fardeau ... la
 férocité en sus. Confluences Méditerranée, 11 (1994)
 pp.113-125. [Violence against women in Algeria.]

259 REBZANI, Mohammed. Algérie: incidence de l'activité
 professionnelle sur le rôle familial. Cahiers de l'Orient,
 47 (1997) pp.93-104. (Femmes algériennes.)

260 ROUADJIA, Ahmed. La lutte des femmes laïques en
 Algérie. Confluences Méditerranée, 27 (1998) pp.61-68.

261 SAADI, Djamila. Des femmes, à mots voilés. Cahiers
 Intersignes, 10 (1995) pp.169-180. [Algeria.]

262 SAADI, Nour[r]edine. La guerre des femmes. Cahiers
 Intersignes, 10 (1995) pp.209-216. [Algeria.]

263 SADIK, Fouzia. Une journée d'automne à Alger. Le
 Globe, 133 / 1993 (1994) pp.39-43. [Encounter with
 young Algerian woman between modernity & new
 Islamism.]

264 SAI, Fatima-Zohra. Les femmes algériennes: citoyennes,
 moujahidates, sœurs. Femmes, culture et société au
 Maghreb. I: Culture, femmes et famille. Sous la dir. de
 R.Bourqia, M.Charrad, N.Gallagher. Casablanca: Afrique
 Orient, 1996, pp.83-96.

265 SAKANI, Ouahiba. Gender inequalities and maternal care
 usage: the case of Algeria. CDC 27th Annual Seminar
 on population issues in the Middle East, Africa and Asia.
 Cairo: Cairo Demographic Center, 1998, (Research
 Monograph Series, 27; CDC Annual Seminar, 1997),
 pp.35-63.

266 SALHI, Zahia Smail. The wounded smile: women, politics,
 and the culture of betrayal. Critique: Journal for Critical
 Studies of the Middle East, 18 (2001) pp.101-110.
 (Algerian women's struggle.)

267 SARI, Djilali. Femmes et ressources humaines en Algérie.
 (Zusammenfassung: Frauen und soziale Ressourcen in
 Algerien; Summary: Women and social resources in
 Algeria.). Geowissenschaftliche Untersuchungen in
 Afrika III. Hrsg. B.Sponholz [& others]. Würzburg:
 Geographisches Institut der Universität, 1997, (Würzburger
 Geographische Arbeiten, 92), pp.359-374.

268 SEBAA, Fatima Zohra. Délinquance juvénile féminine en
 Algérie: entre le social et le moral. Femmes et hommes
 au Maghreb et en immigration: la frontière des genres en
 question. Etudes sociologiques et anthropologiques. Sous
 la dir. de C.Lacoste-Dujardin & M.Virolle. Coord. Baya
 Boualem & Narjys El Alaoui. Paris: Publisud, 1998,
 pp.71-75.

269 SGRENA, G. La condizione della donna. (Abstract: The
 condition of women.). Politica Internazionale, 22 ii
 (1994) pp.147-156;321. (In Algeria.)

270 SLYOMOVICS, S. `Hassiba Ben Bouali, if you could see
 our Algeria`: women and public space in Algeria. Arab
 women: between defiance and restraint. Ed. Suha Sabbagh.
 New York: Olive Branch Press, 1996, pp.211-220.

271 SLYOMOVICS, S. "Hassiba Ben Bouali, if you could see
 our Algeria": women and public space in Algeria.
 Political Islam: essays from Middle East Report. Ed.
 J.Beinin & J.Stork. London: Tauris, 1997, pp.211-219.

272 SMATI, Anissa. Quelques réflexions concernant un arrêt
 rendu le 30- 03-1993 par la cour suprême d'Alger sous le
 No 90468. Revue Algérienne des Sciences Juridiques,
 Economiques et Politiques / Al-Majalla al-Jazā'irīya
 li-l-'Ulūm al-Qānūnīya wa-'l-Iqtiṣādīya wa-'l-Siyāsīya, 41
 (2000) pp.267-269. [Matrimonial law.]

273 TAHON, Marie-Blanche. Femmes et citoyenneté en
 Algérie. Awal, 20 (1999) pp.43-60.

274 TALAHITE, Fatiha. Le pouvoir, les technocrates et le
 travail des femmes en Algérie. Futur Antérieur, 25-26
 (1995) pp.77-94.

275 TALAHITE, Fatiha. Quand la réalité prend le maquis.
 Cahiers Intersignes, 10 (1995) pp.193-202. [Women in
 Algeria.]

276 TAZI, Nadia. Féminisme et politique. Cahiers
 Intersignes, 10 (1995) pp.203-208. [Algeria.]

277 TCHOUAR, Djilali. Le mariage polygamique entre le fiqh
 et le droit positif algérien. Revue Algérienne des Sciences
 Juridiques, Economiques et Politiques / Al-Majalla
 al-Jazā'irīya li-l-'Ulūm al-Qānūnīya al-Iqtiṣādīya
 wa-'l-Siyāsīya, 25 i (1997) pp.571-518.

278 TCHOUAR, Djilali. Le régime juridique de la dot en droit
 algérien. Revue Algérienne des Sciences Juridiques
 Economiques et Politiques / Al-Majalla al-Jazā'irīya
 li-l-'Ulūm al-Qānūnīya al-Iqtiṣādīya wa-'l-Siyāsīya, 34 iv
 (1996) pp.569-596.

279 TOUATI, Aïcha. Femmes en Algérie: état des lieux et
 luttes. Bulletin of Francophone Africa, 5 / 9 (1996)
 pp.1-9.

280 VIROLLE, M. Androgynie sociale, rituelle et symbolique
 en Algérie. Femmes et hommes au Maghreb et en
 immigration: la frontière des genres en question. Etudes
 sociologiques et anthropologiques. Sous la dir. de
 C.Lacoste-Dujardin & M.Virolle. Coord. Baya Boualem
 & Narjys El Alaoui. Paris: Publisud, 1998, pp.151-164.

281 WIEN, C. Kvinder i Algeriet. Mellemøst-Information,
 10 vi (1993) pp.4-6.

282 YACINE, Tassadit. Celle qui vient après: privilèges ou
 tourments des mariages bigamiques en Kabylie. Awal, 23
 (2001) pp.87-99.

283 YACINE, Tassadit. Comment le savoir vient au femmes?
 Propos recueillis. Awal, 11 (1994) pp.159-166.
 [Algeria.]

284 YACINE, Tassadit. Femmes et création en Kabylie.
 Awal, 12 (1995) pp.23-27. [Social background of singers
 & writers.]

285 YACINE, Tassadit. L'itinéraire de Nadra ou une
 sociogenèse de la domination. Awal, 20 (1999)
 pp.153-167. [Algerian women's marriages & life between
 Algeria & France.]

286 YACINE, Tassadit. Mohamed Arkoun: De la condition
 féminine au maraboutisme: regard sur la société kabyle.
 Entretien réalisé par Tassadit Yacine. Awal, 21 (2000)
 pp.65-76.

287 YOUNSI HADDAD, Nadia. La kafala en droit algérien.
 Revue Algérienne des Sciences Juridiques, Economiques
 et Politiques / Al-Majalla al-Jazā'irīya li-l-'Ulūm
 al-Qānūnīya wa-'l-Iqtiṣādīya wa-'l-Siyāsīya, 37 iv (1999)
 pp.7-42.

288 La situation de la femme en Algérie. Cahier d'Études
 Maghrébines, 8-9, 1995-96, pp.27-31.

289 Les femmes et leur vie au nord de l'Aurès: photographies
 d'Amir Rezzoug. Annuaire de l'Afrique du Nord, 30 /
 1991 (1993) pp.313-328.

290 Les femmes et leur vie dans le nord de l'Aurès:
 photographies d'Amir Rezzoug. Etre marginal au
 Maghreb. Textes réunis par Fanny Colonna avec Zakya
 Daoud. Paris: CNRS, 1993, pp.313-328.

Arab world (general)

Books

291 ABU-HABIB, Lina. Gender and disability: women's
 experiences in the Middle East. Oxford: Oxfam, 1997.
 94pp. [Incl. case studies from Arab world.]

292 ABU-SAHLIEH, Sami A. Aldeeb. Le droit de famille
 dans le monde arabe: constante et défis. Louvain-la-Neuve:
 Centre d'Etude et de Recherche sur le Monde Arabe
 Contemporain de l'Université Catholique de Louvain 1993
 (Les Cahiers du Monde Arabe, 98), 38pp.

293 ALAMI, Dawoud el & HINCHCLIFFE, D. Islamic
 marriage and divorce laws of the Arab world. London:
 Kluwer Law International, 1996, (Centre of Islamic and
 Middle East Law Book series, 2), 279pp.

294 BARTELS, E. A. C. 'Een dochter is beter dan duizend zonen': Arabische vrouwen, symbolen en machtsverhoudingen tussen de sexen. Utrecht: Van Arkel, 1993. 256pp. [Fieldwork in Tunisia, Morocco, Netherlands.]

295 CAESAR, Judith. Crossing borders: an American woman in the Middle East. Syracuse (USA): Syracuse University Press, 1997. 175pp. [Arab world.]

296 GÜNTHER, U. Die Frau in der Revolte: Fatima Mernissis feministische Gesellschaftskritik. Hamburg: Deutsches Orient-Institut, 1993, (Mitteilungen, 46), 158pp.

297 GUTHRIE, Shirley. Arab women in the Middle Ages: private lives and public roles. London: Saqi, 2001. 268pp.

298 IRRAN, Roswitha. Die Darstellung der Frau in der arabischen Presse: am Beispiel der Wochenzeitung Ahbār al-Yawm. Hamburg: Kovač, 2000 (Schriftenreihe Philologia, 41), 138pp.

299 LEMSINE, Aïcha. Ordalias de las voces: las mujeres árabes hablan. Tr. Corral Raciti, M. Valladolid: Secretariado de Publicaciones e Intercambio Científico, Universidad de Valladolid: Ayuntamiento de Valladolid, 1998. 369pp. 497pp. [Tr. of Ordalie des voix, Paris 1983.]

300 PEIßKER-MEYER, Cosima. Heimat auf Zeit: Europäische Frauen in der arabischen Welt. Bielefeld: Transcript, 2002. 220pp.

301 SA'DĀWĪ, Nawāl al-. The Nawal el Saadawi reader. London: Zed, 1997. 292pp. [Writings on Arab women.]

302 SADOON, Nasra al. Le bateau des femmes arabes pour la paix. Paris: L'Harmattan, 1996. 111pp. [Arab women & the Gulf War of 1990-91.]

303 WALWORTH, Anna Maria. Příběh arabské ženy, aneb, Cesta ke svobodě. Prague: Ivo Železný, 1999. 102pp.

304 Arab regional women's studies workshop. Ed. Nelson, C. & Altorki, Soraya. Cairo: American University in Cairo, 1998, (Cairo Papers in Social Science, 20 iii (1997)), 141pp. [Arabic title-page: Al-Nadwa al-iqlīmīya li-dirāsāt al-mar'a al-'Arabīya.]

305 Arab society: class, gender, power, and development. Ed. N.S.Hopkins, Saad Eddin Ibrahim. Cairo: American University in Cairo Press, 1997. 583pp. [New selection of reprinted essays & articles. Previous selection published under title Arab society: social science perspectives, 1985.]

306 Arab women: between defiance and restraint. Ed. Sabbagh, Suha. New York: Olive Branch Press, 1996. 267pp.

307 El imaginario, la referencia y la diferencia: siete estudios acerca de la mujer árabe. Ed. Amo, M. del. Granada: Departamento Estudios Semíticos, 1997. 197pp.

308 Femme arabe et prise de decision. Tunis: Centre de la Femme Arabe pour la Formation et la Recherche, CAWTAR, 1998. 100pp.

309 Going global: the transnational reception of Third World women writers. Ed. Amal Amireh & Lisa Suhair Majaj. New York: Garland Publishing, 2000. 308pp. [Arabs & others.]

310 Lo specchio degli occhi: le donne arabe si raccontano. Ed. Tawfik, Younis. Turin: Ananke, [1998]. 141pp.

311 Middle Eastern women and the invisible economy. Ed. Lobban, R. A. Gainesville: University Press of Florida, 1998. 302pp. [Case studies from Arab countries.]

312 Organizing women: formal and informal women's groups in the Middle East. Ed. Chatty, D. & Rabo, A. Oxford: Berg, 1997. 244pp. [Arab world.]

313 Tales Arab women tell and the behavioral patterns they portray. Collected, translated, and interpreted by Hasan M.el-Shamy. Bloomington: Indiana University Press, 1999. 561pp.

314 The new Arab family. Ed. Nicholas S.Hopkins. Cairo: American University in Cairo Press, 2003 (Cairo Papers in Social Science, 24 i-ii / 2001), 275pp. [Arabic title-page & summary. Arabic title: Al-Usra al-'Arabīya al-jadīda.]

315 Women and globalization in the Arab Middle East: gender, economy, and society. Ed. Doumato, Eleanor Abdella & Pripstein Posusney, Marsha. Boulder: Lynne Rienner, 2003. 297pp.

316 Women in the Ottoman Empire: Middle Eastern women in the early modern era. Ed. Zilfi, M. C. Leiden: Brill, 1997, (The Ottoman Empire and its Heritage, 10), 333pp.

Articles

317 ABDALI, Salim. Det feminine Østen. Diwan: Tidsskrift for Arabisk Kultur, 1994 ii, pp.2-5. [Female nudity in Arab world.]

318 ABOU-AIANAH, Fathy M. Girls education and socio-economic transition in the Arab world. Bulletin de la Société de Géographie d'Egypte, 70 (1997) pp.3-31.

319 ABOU HABIB, Lina. Promoting learning, linkages and sharing on gender at the grassroots level: pilot initiatives in the Arab region. Middle East Women's Studies Review, 15 i-ii (2000) pp.4-5. (Improving the situation & position of poor women in the Arab world.)

320 ABUKHALIL, As'ad. Gender boundaries and sexual categories in the Arab world. Feminist Issues, 15 i-ii (1997) pp.91-104.

321 ABU-ODEH, Lama. Crimes of honour and the construction of gender in Arab societies. Feminism and Islam: legal and literary perspectives. Ed. Mai Yamani. Reading: Ithaca, for the Centre of Islamic and Middle Eastern Law, School of Oriental and African Studies, University of London, 1996, pp.141-194.

322 ABU SAHLEYA, Sami Awad al-Deeb. The need to unify personal status laws in Arab countries. Women Living under Muslim Laws: Dossier, 22 (1999) pp.51-55. Also online at http:// www.wluml.org/english/pubs

323 ABŪ ZA[Y]D, Naṣr Ḥāmid. Die Frauenfrage zwischen Fundamentalismus und Aufklärung. Tr. Salih, Salima. Islam, Demokratie, Moderne. Aktuelle Antworten arabischer Denker. Hrsg. Erdmute Heller & Hassouna Mosbahi. Munich: Beck, 1998, pp.193-210.

324 [ABŪ ZAYD, Naṣr Ḥāmid]. Women in the discourse of crisis / Nasr Abu-Zeid. Women Living under Muslim Laws: Dossier, 17 (1997) Also online at www.wluml.org/ english/pubs (In the Arab world.)

325 ACCAD, Evelyne. Truth versus loyalty. Radically speaking: feminism reclaimed. Ed. D.Bell & R.Klein. London: Zed; North Melbourne: Spinifex, 1996, pp.465-469. [As Arab woman.]

326 AMIN, Hussein. Arab women and satellite broadcasting. TBS, 6 (2001) Online at http:// www.tbsjournal.com

327 AMIREH, Amal. Framing Nawal el Saadawi: Arab feminism in a transnational world. Signs, 26 i (2000) pp.215-249. (El Saadawi and her Arab feminist work are consumed by a Western audience in a context saturated by stereotypes of Arab culture.)

328 AMIREH, Amal. Framing Nawal el Saadawi: Arab feminism in a transnational world. Gender, politics, and Islam. Ed. Therese Saliba, Carolyn Allen and Judith A.Howard. Chicago: University of Chicago Press, 2002, pp.215-249. (El Saadawi and her Arab feminist work are consumed by a Western audience in a context saturated by stereotypes of Arab culture.) [Originally published in Signs, 26 i (2000).]

329 ARENDS, I. Ongekende vrouwen: beleid en praktijk van vrouwen en ontwikkeling in het Midden-Oosten. Sharqiyyât, 8 i (1996) pp.53-68. (Arabische vrouwen.)

330 ASCHA, Ghassan. Polygamie in de moderne Arabische rechtsliteratuur. Recht van de Islam, 11 (1994) pp.25-54.

331 AZZAM, Maha. Gender and the politics of religion in the Middle East. Feminism and Islam: legal and literary perspectives. Ed. Mai Yamani. Reading: Ithaca, for the Centre of Islamic and Middle Eastern Law, School of Oriental and African Studies, University of London, 1996, pp.217-230. [Arab world.]

332 BONTE, P. Manière de dire ou manière de faire: peut-on
 parler d'un mariage `arabe'? *Epouser au plus proche:
 inceste, prohibitions et stratégies matrimoniales autour
 de la Méditerranée.* Sous la dir. de P.Bonte. Paris: Editions
 de l'Ecole des Hautes Etudes en Sciences Sociales, 1994,
 pp.371-398.

333 CAMPBELL, Oona, LEWANDO-HUNDT, G. & others,
 Profiling maternal health in Egypt, Jordan, Lebanon,
 Palestine, and Syria. *Reproductive health and infectious
 disease in the Middle East.* Ed. R.Barlow, J.W.Brown.
 Aldershot: Ashgate, 1998, pp.22-44.

334 CARAPICO, S. Replicable models: channeling aid to Arab
 women. *Middle East Policy,* 5 iii (1997) pp.181-189.

335 CHATTY, D. & RABO, A. Formal and informal women's
 groups in the Middle East. *Organizing women: formal
 and informal women's groups in the Middle East.* Ed.
 D.Chatty & A.Rabo. Oxford: Berg, 1997, pp.1-22. [Arab
 world.]

336 CONTE, E. Choisir ses parents dans la société arabe: la
 situation à l'avènement de l'islam. *Epouser au plus
 proche: inceste, prohibitions et stratégies matrimoniales
 autour de la Méditerranée.* Sous la dir. de P.Bonte. Paris:
 Editions de l'Ecole des Hautes Etudes en Sciences Sociales,
 1994, pp.165-187.

337 COOKE, M. Feminist transgressions in the post-colonial
 Arab world. *Critique: Journal for Critical Studies of the
 Middle East,* 14 (1999) pp.93-105.

338 COPHET-ROUGIER, E. Le mariage `arabe': une approche
 théorique. *Epouser au plus proche: inceste, prohibitions
 et stratégies matrimoniales autour de la Méditerranée.*
 Sous la dir. de P.Bonte. Paris: Editions de l'Ecole des
 Hautes Etudes en Sciences Sociales, 1994, pp.453-473.

339 DIALMY, Abdessamad. Féminisme et islamisme dans le
 monde arabe: essai de synthèse. *Social Compass,* 43 iv
 (1996) pp.4821-501. [Considering them as sociological
 movements.]

340 ELSADDA, Hoda. Discourses on women's biographies
 and cultural identity: twentieth-century representations of
 the life of 'A'isha bint Abi Bakr. *Feminist Studies,* 27 i
 (2001) pp.37-64. (Her legacy is considered particularly
 significant as she serves as a role model for the modern
 Arab woman.)

341 FAQIR, Fadia. Engendering democracy and Islam in the
 Arab world. *Third World Quarterly,* 18 i (1997)
 pp.165-174.

342 FARGUES, Philippe. Terminating marriage. *The new
 Arab family / Al-Usra al-'Arabīya al-jadīda.* Ed. Nicholas
 S.Hopkins. Cairo: American University in Cairo Press,
 2003, (Cairo Papers in Social Science, 24 i-ii / 2001),
 pp.247-273. [Arab world.]

343 FELDNER, Yotam. "Honor" murders - why the perps get
 off easy. *Middle East Quarterly,* 7 iv (2000) pp.41-50.
 [Examples from Arab world.]

344 FLEISCHMANN, E. L. 'Our Moslem sisters': women of
 Greater Syria in the eyes of American Protestant
 missionary women. *Islam and Christian-Muslim
 Relations,* 9 iii (1998) pp.307-323.

345 GHOUSSOUB, Mai. Chewing gum, insatiable women
 and foreign enemies: male fears and the Arab media.
 *Imagined masculinities: male identity and culture in the
 modern Middle East.* Ed. Mai Ghoussoub & Emma
 Sinclair-Webb. London: Saqi, 2000, pp.227-235.

346 GRAHAM-BROWN, S. Women and politics in the Middle
 East. *Arab women: between defiance and restraint.* Ed.
 Suha Sabbagh. New York: Olive Branch Press, 1996,
 pp.3-8.

347 GRAN, P. Organization of culture and the construction of
 the family in the modern Middle East. *Women, the family,
 and divorce laws in Islamic history.* Ed. A.El Azhary
 Sonbol. Syracuse: Syracuse University Press, 1996,
 pp.64-79.

348 GUNATILLEKE, G. The role of networks and community
 structures in international migration from Sri Lanka.
 Emigration dynamics in developing countries. Vol. II:
 South Asia. Ed. R.Appleyard. Aldershot: Ashgate, 1998,
 pp.71-112. [Incl. case studies of housemaids in Gulf,
 Lebanon, Jordan & Singapore.]

349 HADDAD, Y. Yazbeck. Islam and gender: dilemmas in
 the changing Arab world. *Islam, gender, & social
 change.* Ed. Y.Yazbeck Haddad & J.L.Esposito. New York:
 Oxford University Press, 1998, pp.3-29.

350 HELOU, Jehan. Women's court in Beirut `See the world
 through the eyes of a woman'. *Middle East Report,* 26
 i / 198 (1996) pp.18-18. (Participants came from 14 Arab
 countries.)

351 HÉRITIER-AUGÉ, F. Identité de substance et parenté de
 lait dans le monde arabe. *Epouser au plus proche:
 inceste, prohibitions et stratégies matrimoniales autour
 de la Méditerranée.* Sous la dir. de P.Bonte. Paris: Editions
 de l'Ecole des Hautes Etudes en Sciences Sociales, 1994,
 pp.149-164.

352 HIJAB, Nadia. Islam, social change, and the reality of
 Arab women's lives. *Islam, gender, & social change.*
 Ed. Y.Yazbeck Haddad & J.L.Esposito. New York: Oxford
 University Press, 1998, pp.45-55.

353 HIJAB, Nadia. Women and work in the Arab world.
 Arab women: between defiance and restraint. Ed. Suha
 Sabbagh. New York: Olive Branch Press, 1996, pp.41-53.

354 HIJAB, Nadia. Women and work in the Arab world.
 Women and power in the Middle East. Ed. Suad Joseph &
 Susan Slyomovics. Philadephia: University of Pennsylvania
 Press, 2001, pp.41-51;207.

355 JOSEPH, Suad. Gender and the family in the Arab world.
 Arab women: between defiance and restraint. Ed. Suha
 Sabbagh. New York: Olive Branch Press, 1996,
 pp.194-202.

356 JOSEPH, Suad. Theories and dynamics of gender, self,
 and identity in Arab families. *Intimate selving in Arab
 families: gender, self, and identity.* Ed. Suad Joseph.
 Syracuse (USA): Syracuse University Press, 1999,
 pp.1-17;267-271.

357 KARMI, Ghada. Women, Islam and patriarchalism.
 Feminism and Islam: legal and literary perspectives. Ed.
 Mai Yamani. Reading: Ithaca, for the Centre of Islamic
 and Middle Eastern Law, School of Oriental and African
 Studies, University of London, 1996, pp.69-85. (Arab
 society.)

358 KHALAF, Mona. The Institute for Women's Studies in
 the Arab world: the natural outcome of the first women's
 college in the Middle East. *Arab regional women's
 studies workshop. Al-Nadwa al-iqlīmīya li-dirāsāt al-mar'a
 al-'Arabīya.* Ed. C.Nelson, Soraya Altorki. Cairo:
 American University in Cairo, 1998, (Cairo Papers in
 Social Science, 20 iii (1997)), pp.132-140. (American
 Junior College for Women ... Beirut ... 1942.)

359 KHALIDI, Ramla & TUCKER, J. E. Kvinders rettigheder
 i den arabiske verden. *Menneskerettigheder i
 Mellemøsten.* Udvalgt og oversat L.Pedersen. Højbjerg:
 Intervention Press, samarbejde med Tredje Verden
 Information, Århus, 1993, pp.59-78.

360 KHALIDI, Ramla & TUCKER, J. Women's rights in the
 Arab world. *Arab women: between defiance and
 restraint.* Ed. Suha Sabbagh. New York: Olive Branch
 Press, 1996, pp.9-18.

361 KING-IRANI, L. E. Imperiled pioneer: an assessment of
 the Institute for Women's Studies in the Arab World.
 *Muslim women and the politics of participation:
 implementing the Beijing platform.* Ed. Mahnaz Afkhami
 & E.Friedl. Syracuse (USA): Syracuse University Press,
 1997, pp.101-108. (Lebanese American University,
 Beirut.)

362 KOROTAYEV, Andrey. Parallel-cousin (FBD) marriage,
 Islamization, and Arabization. *Ethnology,* 39 iv (2000)
 pp.395-407. (A systematic acceptance of parallel-cousin
 marriage took place when Islamization occurred together
 with Arabization.)

363 MAHDAOUI, Nja. Le Tribunal des Femmes Arabes.
 Cahier d'Études Maghrébines, 8-9, 1995-96, pp.33-36.

364 MAIER, John. The wisdom of the serpent: Siduri, Yamlika and Aisha Qandisha. *Maghreb Review*, 25 iii-iv (2000) pp.227-241. [Gilgamesh, Arabian Nights, ancient Mesopotamian serpent deities & Aisha Qandisha in Morocco regarded as a demoness.]

365 MANNA, Haytham. D'elle ... et pour elle. *Qantara*, 10 (1994) pp.19-21. [Arab women.]

366 MARZOLPH, U. As woman as can be: the gendered subversiveness of an Arabic folktale heroine. *Edebiyât*, 10 ii (1999) pp.199-218.

367 MATTHES, M. Shahrazad's sisters: storytelling and politics in the memoirs of Mernissi, el Saadawi and Ashrawi. *Alif*, 19 (1999) pp.68-96.

368 MERNISSI, Fatima. Le chant des femmes: destination liberté. *Qantara: Cultures en Mouvement*, 14 (1995) pp.33-35. (Extrait de *La peur-modernité: conflit Islam démocratie*, 1992.)

369 MOGHADAM, V. Arab regional symposium on gender and human development, Tunis, May 1996. *Middle East Women's Studies: the Review*, 11 iii (1996) pp.12-13.

370 MORSY, Soheir A. Feminist studies: relevance for scholarship and social equity in Arab societies. *Arab regional women's studies workshop. Al-Nadwa al-iqlīmīya li-dirāsāt al-mar'a al-'Arabīya*. Ed. C.Nelson, Soraya Altorki. Cairo: American University in Cairo, 1998, (Cairo Papers in Social Science, 20 iii (1997)), pp.5-19.

371 NELSON, C. & ALTORKI, Soraya. Why a gender / women's studies program at the American University in Cairo? *Arab regional women's studies workshop. Al-Nadwa al-iqlīmīya li-dirāsāt al-mar'a al-'Arabīya*. Ed. C.Nelson, Soraya Altorki. Cairo: American University in Cairo, 1998, (Cairo Papers in Social Science, 20 iii (1997)), pp.1-4. (Arab region.)

372 NOWAIHI, Magda M.al-. Resisting silence in Arab women's autobiographies. *International Journal of Middle East Studies*, 33 iv (2001) pp.477-502. Also online at http://journals.cambridge.org (Fadwa Tuqan, Assia Djebar, and Latifa al-Zayyat.)

373 PÉREZ BELTRÁN, C. Mujeres árabes en el espacio público: indicadores, problemas y perspectivas. *El imaginario, la referencia y la diferencia: siete estudios acerca de la mujer árabe*. M.del Amo (ed.). Granada: Departamento Estudios Semíticos, 1997, pp.91-126.

374 QUDSI, Sulayman S.al-. Labour participation of Arab women: estimates of the fertility to labour supply link. *Applied Economics*, 30 vii (1998) pp.931-941. Also online at http://taylorandfrancis.metapress.com

375 RASHAD, Hoda & OSMAN, Magued. Nuptiality in Arab countries: changes and implications. *The new Arab family / Al-Usra al-'Arabīya al-jadīda*. Ed. Nicholas S.Hopkins. Cairo: American University in Cairo Press, 2003, (Cairo Papers in Social Science, 24 i-ii / 2001), pp.20-50.

376 RAUDVERE, C. 'Writing against culture': antropologen, beduinkvinnorna och historierna. *TfMS: Tidskrift för Mellanösternstudier*, 1995 ii, pp.92-96. [Arab world.]

377 RICE, L. "Women and poverty in the Arab world": a panel chaired by Mounira Charrad. *Middle East Women's Studies Review*, 13 iv - 14 i (1999) pp.8-9;13. [MESA Conference, Chicago, 1998.]

378 ROOKE, Tetz. Arabiska kvinnors livsberättelser. *TfMS: Tidskrift för Mellanösternstudier*, 1996 ii, pp.43-62.

379 ROOKE, Tetz. Liv i marginalen - utmaning mot den falliska ordningen? (Summary: Life in the margin.). *Kvinnovetenskaplig Tidskrift*, 18 iii-iv (1997) pp.71-87. [Autobiographies of Arab women.]

380 ROSENHOUSE, J. Women's speech and language variation in Arabic dialects. *Al-'Arabiyya*, 31 / 1998 (1999) pp.123-152.

381 RUIZ-ALMODÓVAR, Caridad. El derecho de custodia (ḥaḍāna) en los códigos de estatuto personal de los países árabes. *Awrāq*, 19 (1998) pp.229-245.

382 RUIZ-ALMODÓVAR, Caridad. La dote en los códigos de estatuto personal de los países árabes. (Abstract: The dowry on the law of personal status on the Arabic countries.). *Miscelánea de Estudios Arabes y Hebraicos: Sección de Hebreo*, 49 (2000) pp.321-330. (Derecho islámico.)

383 RUIZ MORENO, Rosa María. La figura femenina a través del refranero árabe y del refranero español. *Literatura tradicional árabe y española*. Rosa María Ruiz Menocal (ed.). Jaén: Universidad de Jaén, 1999, pp.117-161.

384 SA'DĀWĪ, Nawāl al-. La femme arabe en révolte. Tr. Hirsch, M-T. *Etudes Arabes: Dossiers*, 86-87 (1994) pp.122-135. [Arabic text, with facing French translation.]

385 SA'DĀWĪ, Nawāl al-. Les pionniers arabes, hommes et femmes. Tr. Mahfouz, J[anine]. *Etudes Arabes: Dossiers*, 86-87 (1994) pp.112-111. [19th & 20th centuries. Arabic text, with facing French translation.]

386 SALGUERO ESTEBAN, L. La cuestión femenina en la prensa de la modernidad: la revista *al-Muqtaṭaf* (1876-1952). *Miscelánea de Estudios Arabes y Hebraicos*: Sección Arabe-Islam, 48 (1999) pp.353-368.

387 SALGUERO ESTEBAN, Laura. Nuevas perspectivas sobre la modernidad árabe: el debate femenino. *Miscelánea de Estudios Arabes y Hebraicos: Sección Arabe-Islam*, 51 (2002) pp.287-303. (Artículos escritos por mujeres en la revista *al-Muqtaṭaf*.)

388 SALMAN, Magida. Arab women. *Women Living under Muslim Laws: Dossier*, 20 (1998) Also online at http://www.wluml.org/english/pubs (Role of Islam in legislation on marriage, divorce and the status of women.)

389 SALMAN, Magida. Les femmes arabes. *Women Living under Muslim Laws: Dossier*, 20 (1997) pp.26-35. Also online at http://www.wluml.org/french/pubs/pdf/dossiers/dossier20/D20fr.pdf (Les lois sur le mariage, le divorce et le statut des femmes.)

390 SAMB, Babacar. Monde arabo-islamique et l'Afrique de l'Ouest: coopération culturo-religieuse informelle ou coopération culturelle institutionnelle? *La civilisation islamique en Afrique de l'Ouest. Communications du Symposium International ... 1996, Dakar, Sénégal*. Ed. Samba Dieng. Istanbul: Organisation de la Conférence Islamique, Centre de Recherches sur l'Histoire, l'Art et la Culture Islamiques (IRCICA), 1999, (Série d'Histoire des Nations Musulmanes, 4), pp.377-386.

391 SELIM, Mariam. The status of women in the Arab world. *Arab-Iranian relations*. Ed. Khair el-Din Haseeb. Beirut: Centre for Arab Unity Studies, 1998, pp.210-233.

392 [SHARABI, Hisham]. Der Weg zur Moderne: Betrachtungen über die Macht, die Frau und die Armut / Hischam Scharabi. Tr. Orth, Günther. *Islam, Demokratie, Moderne. Aktuelle Antworten arabischer Denker*. Hrsg. Erdmute Heller & Hassouna Mosbahi. Munich: Beck, 1998, pp.211-217.

393 SPOELDERS, B. Rethinking development and the feminist versus Islamist dichotomy. *Islam and Christian-Muslim Relations*, 9 iii (1998) pp.295-305. (In the Arab world.)

394 STORK, J. Gender and civil society: an interview with Suad Joseph. *Arab women: between defiance and restraint*. Ed. Suha Sabbagh. New York: Olive Branch Press, 1996, pp.203-210.

395 TAMZALI, Wassila. Femmes arabes et créativité: les rencontres de Fès. *Qantara*, 10 (1994) pp.39-40. (Cinéastes, romancières.)

396 TESSLER, M. & JESSE, J. Gender and support for Islamist movements: evidence from Egypt, Kuwait and Palestine. *Muslim World*, 86 ii (1996) pp.200-228.

397 TESSLER, Mark, NACHTWEY, Jodi & GRANT, Audra. The gender and pacifism hypothesis: opinion research from Israel and the Arab world. *Israel: the dynamics of change and continuity*. Ed. D.Levi-Faur, G.Sheffer, & D.Vogel. London: Cass, 1999, pp.265-278. [Previously published in *Israel Affairs*, 5 ii-iii (1999).]

398 TESSLER, Mark, NACHTWEY, Jodi & GRANT, Audra. The gender and pacifism hypothesis: opinion research from Israel and the Arab world. *Israel Affairs*, 5 ii-iii (1999) pp.265-278.

399 TUCKER, Judith E. Legacies of legal reform: muftis, the state, and gendered law in the Arab lands in the late Ottoman Empire. *New Perspectives on Turkey,* 24 (2001) pp.1-16.

400 WAFA'I, Zein-el-Abedeen el-. Contraceptive choice in Arab countries: access to family planning, (1982-1994). *CDC 27th Annual Seminar on population issues in the Middle East, Africa and Asia.* Cairo: Cairo Demographic Center, 1998, (Research Monograph Series, 27; CDC Annual Seminar, 1997), pp.117-135.

401 YOUNIS, Yahia O. Possession and exorcism: an illustrative case. *Arab Journal of Psychiatry. Al-Majalla al-'Arabīya li-l-Ṭibb al-Nafsī,* 11 i (2000) pp.56-59. (Jinn ... a young female ... of one of the Arab countries.)

Art (Muslim)

DEPICTION OF WOMEN IN MUSLIM ART

Articles

402 BAER, Eva. Female images in early Islam. *Damaszener Mitteilungen,* 11 / 1999 (2000) pp.13-24. + plates 2-5. (On the walls of many of the Umayyad country resorts.)

403 MAJER, H. G. Individualized Sultans and sexy women: the works of Musavvir Hüseyin and their East-West context. *Art turc. Turkish art. 10th International Congress of Turkish Art. 10e Congrès international d'art turc. Genève-Geneva. 17-23 September 1995. 17-23 Septembre 1995. Actes-Proceedings.* Geneva: Fondation Max Van Berchem, 1999, pp.463-471.

404 MASUD, Rahat Naveed. The representation of females in Mughal paintings - in relation to their social status. *Lahore Museum Bulletin,* 13 i (2000) pp.25-31.

405 MICKLEWRIGHT, N. "Musicians and dancing girls": images of women in Ottoman miniature painting. *Women in the Ottoman Empire: Middle Eastern women in the early modern era.* Ed. M.C.Zilfi. Leiden: Brill, 1997, (The Ottoman Empire and its Heritage, 10), pp.153-168.

406 NAEF, Silvia. Between symbol and reality: the image of women in twentieth century Arab art. *Writing the feminine: women in Arab sources.* Ed. by Manuela Marín and Randi Deguilhem. London: Tauris, in association with The European Science Foundation, Strasbourg, France, 2002, (The Islamic Mediterranean, 1), pp.221-235.

407 NAJMABADI, Afsaneh. Reading for gender through Qajar painting. *Royal Persian paintings: the Qajar epoch, 1785-1925.* Ed. Layla S.Diba with Maryam Ekhtiar. London: Tauris, in association with Brooklyn Museum of Art, 1998, pp.76-89.

FEMALE ARTISTS & PATRONS (PRE-MODERN)

Books

408 VANDENBROECK, P. *Azetta: Berbervrouwen en hun kunst.* Gent: Ludion, 2000. 275pp. (Tentoonsteling ... Brussel ... 2000.)

409 VANDENBROECK, P. *Azetta: l'art des femmes berbères.* Gent: Ludion; Paris: Flammarion; Brussels: Société des Expositions du Palais des Beaux-Arts de Bruxelles, 2000. 275pp. (Catalogue de l'exposition ... Bruxelles ... 2000.)

Articles

410 BHUIYAN, Mosharraf Hossain. The mosque of Mariam Saleha (a typical Mughal mosque). *Dhaka University Studies,* 54 i (1997) pp.181-188. [Dhaka.]

411 BLAKE, S. P. Contributors to the urban landscape: women builders in Ṣafavid Isfahan and Mughal Shahjahanabad. *Women in the medieval Islamic world: power, patronage, and piety.* Ed. G.R.G.Hambly. Basingstoke: Macmillan, 1998, (The New Middle Ages, 6), pp.407-428.

412 B(OUILLOC), C(hristine). Tissage de femme. *Maroc, tapis de tribus.* Aix-en-Provence: Edisud, 2001, pp.5-8.

413 DAUGHERTY, Patricia. Through the eyes of the weavers: aesthetics and culture of tribal Yürük women of Turkey. *Oriental Carpet and Textile Studies,* 5 i (1999) pp.161-166. [Carpets.]

414 (HELMECKE, G. Werkstatt und Harem - Textiles Handwerk im Osmanischen Reich:) die Stickereien. *Reich an Samt und Seide: Osmanische Gewebe und Stickereien.* C.Erber (Hrsg.). Bremen: Temmen, [1993], pp.25-33.

415 HUMER, M. Frauenhandwerk im Wandel: das Beispiel von Siwa. *Archiv für Völkerkunde,* 47 (1993) pp.47-66. (Keramik, Wulsthalbflechterei, Textilbearbeitung.)

416 HUSSAIN, Mahmood. Begumpura complex. *Mughal gardens in Lahore: history and documentation.* Ed. Muhammad Naeem Mir, Mahmood Hussain, J.L.Wescoat. Lahore: Department of Architecture, University of Engineering and Technology, 1996, pp.69-79.

417 REDDY, Nilüfer Mizanoğlu. The embroidered jacket. *Turkish Area Studies,* 52 (2001) pp.[27-37]. [From Ottoman Macedonian grandmother, with family reminiscences.]

418 TABBAA, Yasser. Ḍayfa Khātūn, regent queen and architectural patron. *Women, patronage, and self-representation in Islamic societies.* Ed. D.Fairchild Ruggles. Albany (USA): State University of New York Press, 2000, pp.17-34.

419 THYS-ŞENOCAK, L. Location, expropriation and the Yeni Valide complex in Eminönü. *Art turc. Turkish art. 10th International Congress of Turkish Art. 10e Congrès international d'art turc. Genève-Geneva. 17-23 September 1995. 17-23 Septembre 1995. Actes-Proceedings.* Geneva: Fondation Max Van Berchem, 1999, pp.675-680.

420 THYS-ŞENOCAK, Lucienne. The Yeni Valide mosque complex of Eminönü, Istanbul (1597-1665): gender and vision in Ottoman architecture. *Women, patronage, and self-representation in Islamic societies.* Ed. D.Fairchild Ruggles. Albany (USA): State University of New York Press, 2000, pp.69-89.

421 VOSSEN, Karla. Frauentöpferei in Marokko. *Afrikanische Töpfertechniken - Beispiele aus Ghana und Marokko.* Zweite, überarbeitete und aktualisierte Auflage. (Redaktion: Gundula Frieling). Bonn: Institut für Internationale Zusammenarbeit des Deutschen Volkshochschul-Verbandes e.V., 1998, (Volkshochschulen und der Themenbereich Afrika, Asien und Lateinamerika, 35), pp.104-121.

422 WOLPER, Ethel Sara. Princess Safwat al-Dunyā wa al-Dīn and the production of Sufi buildings and hagiographies in pre-Ottoman Anatolia. *Women, patronage, and self-representation in Islamic societies.* Ed. D.Fairchild Ruggles. Albany (USA): State University of New York Press, 2000, pp.35-52.

MODERN ART

Books

423 FARRUKH, Niilofur. *Pioneering perspectives: Meher Afroz, printmaker, Nahid, feminist painter, Sheherzade, potter.* Rawalpindi: Ferozsons, 1998. 94pp.

424 HATOUM, Mona. *Mona Hatoum.* [French ed.]. Paris: Editions du Centre Pompidou, 1994. 69pp.

425 WILLIAMS, Gilda. *Shirin Neshat.* London: Serpentine Gallery, 2000. 16pp. [Illustrated guide to an exhibition of photographic art, mainly depicting Iranian women.]

426 *Contemporary Arab women's art: dialogues of the present.* Ed. Fran Lloyd. London: Women's Art Library, 1999. 258pp. [Published on the occasion of the touring exhibition "Dialogue of the present, the work of 18 Arab women artists".]

427 *Gazbia Sirry: lust for color.* Ed. Mursi Saad El-Din. Cairo: American University in Cairo Press, 1998. 51+[174]pp. [Contains 4 essays, an anthology of published extracts about her artistic work & many illustrations.]

Articles

428 AHOURA, Azadeh. Interview with Lily Golestan. *Tavoos / Ṭāwūs*, 2 (2000) pp.114-116. [Director of one of the most famous art galleries in Tehran. Article in English & Persian.]

429 AROUSSI, Moulim el- & others Dialogue of the present: 18 contemporary Arab women artists. Diverse bodies of experience, artists and audience. *Contemporary Arab women's art: dialogues of the present.* Ed. Fran Lloyd. London: Women's Art Library, 1999, pp.111-246. [Catalogue containing short appreciations & illustrations.]

430 AZAR, Aimé. Gazbia Sirry: a study. *Gazbia Sirry: lust for color.* Ed. Mursi Saad El-Din. Cairo: American University in Cairo Press, 1998, pp.9-14.

431 DEBANO, Wendy. The art of Iranian American women: politics and the construction of a new identity. *Middle East Women's Studies Review,* 16 iii-iv (2002) pp.10-11. (Report from MESA ... 2001 special session ... San Francisco.)

432 GOULI, Sophie al-. Expressionism and symbolism. *Gazbia Sirry: lust for color.* Ed. Mursi Saad El-Din. Cairo: American University in Cairo Press, 1998, pp.21-22.

433 HASHMI, Salima. An intelligent rebellion: women artists of Pakistan. *Crossing boundaries.* Ed. Geeti Sen. London & Delhi: Sangam, 1997, pp.229-238.

434 HASSAN, Salah. "Nothing romantic about it!" A critique of Orientalist representation in the installations of Houria Niati. *Women, patronage, and self-representation in Islamic societies.* Ed. D.Fairchild Ruggles. Albany (USA): State University of New York Press, 2000, pp.205-226. (Algerian-born, London-based contemporary artist.)

435 IMAM, Ali, HASHMI, Salima & MIRZA, Quddus. Tributes to Zubeida Agha. *Arts & the Islamic World,* 32, [1997], pp.64-64. (One of the most modern painters of Pakistan.)

436 KAPUR, Geeta. Nasreen Mohamedi: dimensions out of solitude. *Expressions & evocations: contemporary women artists of India.* Ed. G.Sinha. Bombay: Marg, 1996, pp.61-69.

437 KEELAN, Siumee. Ensuring visibility: art, history and patronage. *Contemporary Arab women's art: dialogues of the present.* Ed. Fran Lloyd. London: Women's Art Library, 1999, pp.51-57. [Modern Arab world.]

438 KHADDA, Naget. La troisième vigie s'en est allée ... *Algérie Littérature / Action,* 26 (1998) pp.230-234. [Appreciation of Baya, Algerian painter.]

439 LLOYD, Fran. Cross-cultural dialogues: identities, contexts and meanings. *Contemporary Arab women's art: dialogues of the present.* Ed. Fran Lloyd. London: Women's Art Library, 1999, pp.13-50. (The work of Arab women artists.)

440 LUTFI, Huda. Art essay. *Feminist Studies,* 27 i (2001) pp.114-124. [Artist's statement by Egyptian scholar & artist, with examples of her work.]

441 MAJLIS, Najma Khan. Women artists of Bangladesh. *Arts & the Islamic World,* 34 (1999) pp.45-51.

442 MARWAH, Mala. Nilima Sheikh: human encounters with the natural world. *Expressions & evocations: contemporary women artists of India.* Ed. G.Sinha. Bombay: Marg, 1996, pp.117-124.

443 MEHREZ, Samia & STONE, James. Meditations on painting and history: an interview with Huda Lutfi. *Colors of enchantment: theater, dance, music, and the visual arts of the Middle East.* Ed. Sherifa Zuhur. Cairo: American University in Cairo Press, 2001, pp.405-416. + plates 15-18 between pp.362-363. [Egyptian artist.]

444 MEHREZ, Samia & STONE, James. Women, history, memory: Huda Lutfi interviewed. *Alif,* 19 (1999) pp.223-244. [Egyptian academic & painter, talking about her art. Incl. 8 plates.]

445 MERNISSI, Fatima. The artist's voice: Chaïbia Talal. Translated from Arabic. *Images of enchantment: visual and performing arts of the Middle East.* Ed. Sherifa Zuhur. Cairo: American University in Cairo Press, 1998, pp.183-186. [Interview with Moroccan painter.]

446 MONNIN, Françoise. A love of colours. *Gazbia Sirry: lust for color.* Ed. Mursi Saad El-Din. Cairo: American University in Cairo Press, 1998, pp.18-20.

447 MOORE, Lindsey. Frayed connections, fraught projections: the troubling work of Shirin Neshat. *Women: a Cultural Review,* 13 i (2002) pp.1-17. Also online at http://ninetta.ingentaselect.com (Iranian-American visual artist.)

448 NASHASHIBI, Salwa. Elements of empowerment: support systems in women's art practice. *Contemporary Arab women's art: dialogues of the present.* Ed. Fran Lloyd. London: Women's Art Library, 1999, pp.70-109. (Art in the Arab world.)

449 NASHASHIBI, Salwa Mikdadi. Gender and politics in contemporary art: Arab women empower the image. *Images of enchantment: visual and performing arts of the Middle East.* Ed. Sherifa Zuhur. Cairo: American University in Cairo Press, 1998, pp.165-182.

450 NAWWAB, Ni'mah Isma'il. Painting cultural history. *Saudi Aramco World,* 52 i (2001) pp.200-27. (Safeya Binzagr ... of Saudi Arabia.)

451 (RIZVI, Sajid). Sheikha Hessah al Maktoum - artist with a window on a private world. *Eastern Art Report,* 4 iii, [1996], pp.30-33.

452 SAAD, Shafagh. The abstraction of Iranian mentality in Ra'na Farnood's paintings. *Tavoos / Ṭāwūs,* 2 (2000) pp.36-39. [Article in English & Persian.]

453 SHERWELL, Tina. Bodies in representation: contemporary Arab women artists. *Contemporary Arab women's art: dialogues of the present.* Ed. Fran Lloyd. London: Women's Art Library, 1999, pp.58-69.

454 SINISICALCO, Carmine. The sensuality of colors. *Gazbia Sirry: lust for color.* Ed. Mursi Saad El-Din. Cairo: American University in Cairo Press, 1998, pp.15-17.

455 VOLPE, M. Suad al-Attar: new work. *Arts & the Islamic World,* 31 (1997) pp.65-66. [Iraqi artist's exhibition in London.]

456 WRIGHT, Astri. Lucia Hartini, Javanese painter: against the grain, toward the self. *Studies in Southeast Asian art: essays in honor of Stanley J.O'Connor.* Nora A.Taylor, ed. Ithaca (USA): Southeast Asia Program, Cornell University, 2000, (Studies on Southeast Asia, 29), pp.93-121.

457 (WRIGHT, Astri). Women in art: the hidden generation. *Indonesian heritage: visual art.* Volume ed. H.Soemantri. Singapore: Archipelago, 1998, (Indonesian Heritage, 7), pp.106-107. [As artists.]

458 YILDIZ, Netice. Portrait of Özden Selenge as an artist. *Kadın / Woman 2000,* 2 i (2001) pp.1-42. [Cypriot artist.]

459 ZAYA, O. Shirin Neshat y las mujeres de Allah. (Shirin Neshat and "Women of Allah".). *Atlántica Internacional,* 8 (1994) pp.28-34. [Photographic phantasies of Iranian women with guns; accompanying text in Spanish & English.]

Arts (performing)

MUSIC & DANCE

Books

460 GSELL, S. *Umm Kulthum: Persönlichkeit und Faszination der ägyptischen Sängerin.* Berlin: Das Arabische Buch, 1998. 197pp.

461 HALE, T. A. *Griots and griottes: masters of words and music.* Bloomington: Indiana University Press, 1998. 410pp. [Historically & today.]

462 KRASBERG, Ulrike. *Die Ekstasetänzerinnen von Sîdî Mustafa: eine theater-ethnologische Untersuchung.* Berlin: Reimer, 2002. 244pp.

463 MALLAH, Issam el-. *The role of women in Omani musical life. Die Rolle der Frau im Musikleben Omans.* Tutzing: Schneider, 1997. 84+76pp. + videotape. [In English, German & Arabic. Arabic title: *Dawr al-mar'a fī 'l-ḥayā al-mūsīqīya al-'Umānīya.*]

464 PECK, William H. *The dancer of Esna.* [Cambridge]: Association for the Study of Travel in Egypt and the Near East, [2003] (ASTENE Working Papers, 1), 11pp. (A consideration of the Ghawazee, their expulsion from Cairo by Mohammad Ali, relocation to Upper Egypt and the subsequent attraction they held for European[s] and Americans.)

465 RAWI, Rosina-Fawzia al-. *Grandmother's secrets: the ancient rituals and healing power of belly dancing.* Tr. Arav, M. New York: Interlink Books, 1999. 158pp. [Tr. of *Ruf der Grossmutter,* Vienna 1996.]

466 RAWI, Rosina-Fawzia B. al-. *Der Ruf der Grossmutter, oder Die Lehre des wilden Bauches.* Vienna: Promedia, 1996. 206pp.

467 SAÏAH, Ysabel. *Oum Kalsoum.* Paris: Denoël, 1995. 251pp.

468 САЙФУЛЛИНА, Гузель. *Счастье сцены: личность и судьба М.Булатовой.* Kazan: Сайфуллина, 1995. 149pp. [Tatar singer.]

469 SUGARMAN, J. C. *Engendering song: singing and subjectivity at Prespa Albanian weddings.* Chicago: University of Chicago Press, 1997. 395pp.

470 ZUHUR, Sherifa. *Asmahan's secrets: woman, war and song.* Austin: The University of Texas, 2001. 247pp.

Articles

471 AHOORA, Azadeh. An interview with Novin Afrouz: music will return to its spiritual and philosophical goals. *Tavoos / Ṭāwūs,* 2 (2000) pp.42-46. [Performer of western classical music & composer of modern Iranian music. Article in English & Persian.]

472 BENSIGNOR, F. Amina Alaoui. *Hommes & Migrations,* 1218 (1999) pp.104-107. [Interview with Moroccan singer.]

473 BENSIGNOR, F. Maryam Mursal, le destin tourmenté d'une star somalienne. *Hommes & Migrations,* 1213 (1998) pp.112-117. (Singer.)

474 BENSIGNOR, F. Oumou Sangare: malienne, femme et artiste. *Hommes & Migrations,* 1206 (1997) pp.137-139. [Singer.]

475 BRAKAL, Clara. De-sacralization and de-contextualization of female court dances in Java. *Expressions théâtrales en Indonésie. Textes réunis par Hélène Bouvier.* Aix-en-Provence: Institut de Recherche sur le Sud-Est Asiatique, 1995, (Programme SUJAMALI (Sumatra-Java-Madura-Bali) Working Papers, 1), pp.25-39.

476 BRANDES, E. Die *Imẓad:* Bau und Verbreitung des Streichinstruments der Tuareg-Frauen. *Zeitschrift für Geschichte der Arabisch-Islamischen Wissenschaften / Majallat Tārīkh al-'Ulūm al-'Arabīya wa-'l-Islāmīya,* 12 (1998) pp.313-319.

477 CHEHABI, H. E. Voices unveiled: women singers in Iran. *Iran and beyond: essays in Middle Eastern history in honor of Nikki R.Keddie.* Ed. R.Matthee & B.Baron. Costa Mesa: Mazda, 2000, pp.151-166.

478 COHEN, Judith R. *Ca no soe joglaresca:* women and music in medieval Spain's three cultures. *Medieval woman's song: cross-cultural approaches.* Ed. Anne L. Klinck and Ann Marie Rasmussen. Philadelphia: University of Pennsylvania Press, 2002, pp.66-80.

479 CORTÉS GARCÍA, Manuela. La mujer y la música en la sociedad arabo-musulmana y su proyección en la cristiana medieval. *Música Oral del Sur,* 2 (1996) pp.193-206. [In Umayyad & Abbasid east & Andalusian west.]

480 DANIELSON, Virginia. (In memoriam:) Layla Murād. *Middle East Studies Association Bulletin,* 30 i (1996) pp.143-145.

481 DANIELSON, Virginia. Listening to Umm Kulthūm. *Middle East Studies Association Bulletin,* 30 ii (1996) pp.170-173.

482 DAOUDI, Bouziane. La musique au féminin. *Qantara,* 10 (1994) pp.30-30. [Dans le monde arabe.]

483 DOUBLEDAY, V. The frame drum in the Middle East: women, musical instruments and power. *Ethnomusicology,* 43 i (1999) pp.101-134.

484 DOUGHERTY, Roberta L. Badi'a Masabni, artiste and modernist: the Egyptian print media's carnival of national identity. *Mass mediations: new approaches to popular culture in the Middle East and beyond.* Ed. W.Armbrust. Berkeley: University of California Press, 2000, pp.243-268. Also online at http:// escholarship.cdlib.org/ ucpress (Featured in satirical press).

485 DURÁN, Lucy. Women, music, and the "mystique" of hunters in Mali. *The African diaspora: a musical perspective.* Ed. I.Monson. New York: Garland, 2000, pp.137-185.

486 ERRAZKI - VAN BEEK, M. Een vrouwenmuziekgroep uit Marrakech: de *'Anṭriyat. Sharqiyyât,* 7 i (1995) pp.28-56.

487 FAIR, Laura. Music, memory and meaning: the Kiswahili recordings of Siti Binti Saad. *Afrikanistische Arbeitspapiere,* 55 (1998) pp.1-16. (A famous *taarab* musician who performed in Zanzibar during the 1920s and 1930s.) [This volume is issued as *Swahili Forum* V.]

488 FRANKEN, M. Farida Fahmy and the dancer's image in Egyptian film. *Images of enchantment: visual and performing arts of the Middle East.* Ed. Sherifa Zuhur. Cairo: American University in Cairo Press, 1998, pp.265-281.

489 FRANKEN, M. [A.]. Performance and feminine poetics in a Muslim context: a MESA panel review. *Middle East Women's Studies: the Review,* 13 i (1998) pp.4-6. [Middle East Studies Association.]

490 GOODMAN, Jane E. "Stealing our heritage?": women's folksongs, copyright law, and the public domain in Algeria. *Africa Today,* 49 i (2002) pp.85-97. (In Algeria, discussions about the World Music genre called new Kabyle song frequently question whether new singers have adequately represented a song's folk origins to the copyright agency.)

491 HELMI, Kunang. Ratna Cartier-Bresson: a fragmented portrait. *Archipel,* 54 (1997) pp.253-268. [Indonesian dancer in France.]

492 HOFFMAN, K. E. Singing the distance: gendered experiences of migration in Anti-Atlas community song. *ISIM Newsletter,* 2 (1999) pp.21-21.

493 HUNTER, M. The *alla turca* style in the late eighteenth century: race and gender in the symphony and the seraglio. *The exotic in Western music.* Ed. J.Bellman. Boston: Northeastern University Press, 1998, pp.43-73;317-323.

494 JANSEN, Jan. "Elle connaît tout le monde": a tribute to the Griotte Siramori Diabate. *Research in African Literatures,* 27 iv (1996) pp.180-197. [Malian musician.]

495 KARTOMI, Margaret. Seudati inong: the female form of the martial art genre in Meulaboh, west Aceh, Indonesia. *ISIM Newsletter,* 2 (1999) pp.12-12. (Dance.)

496 KASSAM, Margaret Hauwa. Some aspects of women's voices from Northern Nigeria. *African Languages and Cultures,* 9 ii (1996) pp.111-125.

497 KIMBERLIN, Cynthia Tse. Four contemporary Ethiopian composers and their music: Asnakech Worku, Nuria Ahmed Shami Kalid A.K.A. Shamitu, Ezra Abate Iman and Ashenafi Kebede. *Ethiopia in broader perspective. Papers of the XIIIth International Conference of Ethiopian Studies, Kyoto ... 1997.* Volume III. Ed. Katsuyoshi Fukui, Eisei Kurimoto, Masayoshi Shigeta. Kyoto: Shokado, 1997, pp.96-117. [Shamitu is Harari Muslim.]

498 LENGEL, Laura. Resisting the historical locations of Tunisian women musicians. *Gender & History,* 12 ii (2000) pp.336-365. Also online at www.nesli.ac.uk

499 LORIUS, C. Desire and the gaze: spectacular bodies in Cairene elite weddings. *Women's Studies International Forum*, 19 v (1996) pp.513-523. [Dancer's performance.]

500 MICKLEWRIGHT, N. "Musicians and dancing girls": images of women in Ottoman miniature painting. *Women in the Ottoman Empire: Middle Eastern women in the early modern era*. Ed. M.C.Zilfi. Leiden: Brill, 1997, (The Ottoman Empire and its Heritage, 10), pp.153-168.

501 MUÑOZ MOLINA, Antonio. Ziryab, el músico de Bagdad. *El esplendor de los Omeyas cordobeses. De Damasco a Córdoba, del 3 de mayo al 30 de septiembre*. Coord. de la ed. A.Rodríguez Jiménez. Cordoba: Cuadernos del Sur, [2001], pp.8-9. (Fugitivo de Oriente ... el destino último de su viaje era Córdoba.)

502 NIEUWKERK, K. van. Changing images and shifting identities: female performers in Egypt. *Images of enchantment: visual and performing arts of the Middle East*. Ed. Sherifa Zuhur. Cairo: American University in Cairo Press, 1998, pp.21-35.

503 NIEUWKERK, Karin van. Shifting narratives on marginality: female entertainers in twentieth-century Egypt. *Outside in: on the margins of the modern Middle East*. Ed. by Eugene Rogan. London: Tauris, in association with The European Science Foundation, Strasbourg, 2002, (The Islamic Mediterranean, 3), pp.231-251. [Singers and dancers.]

504 PERLMAN, M. The social meanings of modal practices: status, gender, history, and *pathet* in central Javanese music. *Ethnomusicology*, 42 i (1998) pp.45-80.

505 SAIAH, Ysabel. L'étoile de l'Orient. *Qantara* (Paris), 17 (1995) pp.50-51. (Oum Kalsoum.)

506 SBAÏ, Noufissa. Eternelles oubliées, les chanteuses publiques: "Les Chickhates". *Témoignage. Femmes rurales. / Nisā' qarawīyāt*. Collection dir. par Aïsha Belarbi. Casablanca: Éditions Le Fennec, 1995, (Approches, 7), pp.159-165.

507 SILVERMAN, C. Music and power: gender and performance among Roma (Gypsies) of Skopje, Macedonia. *World of Music*, 38 i (1996) pp.63-76. (Almost all sedentary Muslim Roma.)

508 SOUM-POUYALET, Fanny. De la femme à la *cheikha*, l'engrenage de la marginalité. *Awal*, 23 (2001) pp.115-129. (Chanteuses-danseuses populaires.)

509 SUTTON, R.Anderson. From ritual enactment to stage entertainment: Andi Nurhani Sapada and the aestheticization of south Sulawesi's music and dance 1940s-1970s. *Asian Music*, 29 ii (1998) pp.1-30. [Buginese singer & choreographer.]

510 VIROLLE-SOUIBÈS, M. Le raï de Cheikha Rimitti. *Mediterraneans / Méditerranéennes*, 4 (1993) pp.102-115. [Incl. translations of some songs.]

511 WEINRICH, Ines. Notes of salvation and joy. The repertory of Fayrūz and the Raḥbānī-Brothers. *Crisis and memory in Islamic societies. Proceedings of the third Summer Academy of the Working Group Modernity and Islam held at the Orient Institute of the German Oriental Society in Beirut* / ed. Angelika Neuwirth and Andreas Pflitsch. Beirut: Orient-Institut der Deutschen Morgenländischen Gesellschaft; Würzburg: Ergon, 2001, (Beiruter Texte und Studien, 77), pp.483-497.

512 WESSING, Robert. A dance of life. The *seblang* of Banyuwangi, Indonesia. *Bijdragen tot de Taal-, Land- en Volkenkunde*, 155 iv (1999) pp.644-682. (Trance dance performed ... in East Java.)

513 YOUNG, W. C. Women's performance in ritual context: weddings among the Rashayda of Sudan. *Images of enchantment: visual and performing arts of the Middle East*. Ed. Sherifa Zuhur. Cairo: American University in Cairo Press, 1998, pp.37-55.

514 ZAMAN, Sara. Status of traditional performing artists in Pakistan. *Engendering the nation-state*. Vol. 2. Ed. by Neelam Hussain, Samiya Mumtaz, Rubina Saigol. Lahore: Simorgh Women's Resource and Publication Centre, 1997, pp.145-156. [Musicians & especially singers or dancers, historically and in modern Pakistan.]

515 ZUHUR, Sherifa. An Arab diva in the gendered discourse of biography. *Iran and beyond: essays in Middle Eastern history in honor of Nikki R.Keddie*. Ed. R.Matthee & B.Baron. Costa Mesa: Mazda, 2000, pp.167-185. [Asmahan, born Amal al-Atrash, Syrian Druze singer in Egypt.]

516 ZUHUR, Sherifa. Asmahan: Arab musical performance and musicianship under the myth. *Images of enchantment: visual and performing arts of the Middle East*. Ed. Sherifa Zuhur. Cairo: American University in Cairo Press, 1998, pp.81-107. (Amal al-Atrash.)

517 La prophétesse résistante: les chants d'Aliin Sitoé Diatta. *Comprendre la Casamance: chronique d'une intégration contrastée*. Sous la coord. de F-G.Barbier-Wiesser. Paris: Karthala, 1994, pp.457-460. [Colonial Casamance.]

THEATRE & LIVE DRAMA

Articles

518 AMIN, Dina. Women in Arab theatre: finding a voice. *The world encyclopedia of contemporary theatre*. Volume 4: *The Arab world / Don Rubin*. London: Routledge, 1998, pp.25-30.

519 FRANKEN, M. [A.]. Performance and feminine poetics in a Muslim context: a MESA panel review. *Middle East Women's Studies: the Review*, 13 i (1998) pp.4-6. [Middle East Studies Association.]

520 GUHATHAKURTA, Meghna. Gender politics in theatre. *Crossing boundaries*. Ed. Geeti Sen. London & Delhi: Sangam, 1997, pp.239-249. [Bangladesh.]

521 GUHATHAKURTA, Meghna. Gender politics in theatre. *India International Centre Quarterly*, 24 ii-iii (1997) pp.239-249. [Bangladesh.]

522 HABIBIAN, Maryam. Beslöjade scengestalter: kvinnorna i det post-revolutionära Irans film, teater och musik. *TfMS: Tidskrift för Mellanösternstudier*, 1999 i, pp.5-18.

523 HABIBIAN, Maryam. Under wraps on the stage: women in the performing arts in post-revolutionary Iran. *CEMOTI*, 28 (1999) pp.295-311. (In cinema, theater & music.)

524 RADI, Saâdia. De la toile au voile: les actrices égyptiennes voilées et l'islamisme. (Résumé: From curtains to veils: veiled actresses and Islam.). *Monde Arabe Maghreb-Machrek*, 151 (1996) pp.13-17;141.

525 SAFDAR, Huma. The representation of women in commercial theatre. *Engendering the nation-state*. Vol. 2. Ed. by Neelam Hussain, Samiya Mumtaz, Rubina Saigol. Lahore: Simorgh Women's Resource and Publication Centre, 1997, pp.139-144. [Pakistan.]

526 SELEIHA, Nehad. Down Sunset Boulevard. *Mediterraneans / Méditerranéennes*, 8/9 (1996) pp.161-166. [Fāṭima Rushdī, Egyptian actress, d.1996.]

527 SILVA, Neluka. Women, culture and nation-building: contemporary Sinhalese and Bengali theatre. *Contemporary South Asia*, 9 iii (2000) pp.339-353. Also online at www.catchword.com (Bangladesh resistance theatre.)

CINEMA; BROADCAST & VIDEO DRAMA

Books

528 ERDMAN, J. L. & SEGAL, Zohra. *Stages: the art and adventures of Zohra Segal*. Delhi: Kali for Women, 1997. 268pp. [Reminiscences of Indian actress & filmstar.]

529 GABOUS, Abdelkrim. *Silence, elles tournent! Les femmes et le cinéma en Tunisie*. Tunis: Cérès; Tunis: Centre de Recherches, d'Etudes, de Documentation et d'Information sur la Femme, 1998. 210pp.

530 HILLAUER, Rebecca. *Freiräume - Lebensträume: arabische Filmemacherinnen*. Bad Honnef: Horlemann, 2001. 348pp.

Articles

531 AHISKA, Meltem. Gender and national fantasy: early Turkish radio drama. *New Perspectives on Turkey,* 22 (2000) pp.35-60.

532 ARIPURNAMI, S. A feminist comment on the Sinetron presentation of Indonesian women. *Fantasizing the feminine in Indonesia.* Ed. L.J.Sears. Durham (USA): Duke University Press, 1996, pp.249-258. [Mainly TV drama.]

533 ARMBRUST, W. Transgressing patriarchy: sex and marriage in Egyptian film. *Middle East Report,* 206 / 28 i (1998) pp.29-31.

534 ARMES, Roy. Reinterpreting the Tunisian past: *Les silences du palais. The Arab-African and Islamic worlds: interdisciplinary studies.* Ed. by R.Kevin Lacey and Ralph M. Coury. New York: Lang, 2000, pp.203-214. [Film made by Moufida Tlatli.]

535 AYAD, Christophe. Le star-système: de la splendeur au voile. *Egypte: 100 ans de cinéma.* Sous la dir. de Magda Wassef. Paris: Institut du Monde Arabe, 1995, pp.134-141.

536 AYARI, Farida. Images of women. Tr. Willemen, P. *African experiences of cinema.* Ed. Imruh Bakari & M.B.Cham. London: BFI Publishing, 1996, pp.181-184. [Incl. films made by Ababacar Samb & Ousmane Sembène of Senegal & Souleymane Cissé of Mali.]

537 BELYAZID, Farida. Le lieu du possible. *Qantara* (Paris), 18 (1996) pp.66-67. (Du dernier film que j'ai réalisé.)

538 BENSMAÏA, Réda. *La nouba des femmes du Mont Chenoua*: introduction to the cinematic fragment. Tr. Gage, J. C. *World Literature Today,* 70 iv (1996) pp.877-884. [Film by Assia Djebar.]

539 BLUHER, Dominique. Les "Meufs rebeus" ou la représentation des femmes maghrébines dans le cinéma français hip-hop. *Esprit Créateur,* 42 i (2002) pp.84-95.

540 BOUZID DISCACCIATI, Leyla. The image of women in Algerian and Tunisian cinema. *ISIM Newsletter,* 5 (2000) pp.37-37.

541 DABASHI, Hamid. Body-less faces: mutilating modernity and abstract women in an "Islamic cinema". *Visual Anthropology,* 10 ii-iv (1998) pp.361-380. (Post-revolutionary Iranian cinema.)

542 DANIELSON, Virginia. (In memoriam:) Layla Murād. *Middle East Studies Association Bulletin,* 30 i (1996) pp.143-145.

543 FRANKEN, M. Farida Fahmy and the dancer's image in Egyptian film. *Images of enchantment: visual and performing arts of the Middle East.* Ed. Sherifa Zuhur. Cairo: American University in Cairo Press, 1998, pp.265-281.

544 FRANKEN, Marjorie A. Egyptian cinema and television: dancing and the female image. *Visual Anthropology,* 8 ii-iv (1996) pp.267-285.

545 FRANKEN, Marjorie A. Egyptian cinema and television: dancing and the female image. *Visual Anthropology,* 8 ii-iv (1996) pp.267-285.

546 GAUHAR, Feryal. The formation of gender-based attitudes: the female image in Pakistani cinema. *Engendering the nation-state.* Vol. 2. Ed. by Neelam Hussain, Samiya Mumtaz, Rubina Saigol. Lahore: Simorgh Women's Resource and Publication Centre, 1997, pp.129-138.

547 GUPTA, V.N. Meena Kumari: story of an immortal goddess of Indian cinema. *Empowerment of the Indian Muslim women.* Ed. by Satya Pal Ruhela. Delhi: M D Publications, 1998, pp.83-85.

548 HABIBIAN, Maryam. Beslöjade scengestalter: kvinnorna i det post-revolutionära Irans film, teater och musik. *TfMS: Tidskrift för Mellanösternstudier,* 1999 i, pp.5-18.

549 HABIBIAN, Maryam. Under wraps on the stage: women in the performing arts in post-revolutionary Iran. *CEMOTI,* 28 (1999) pp.295-311. (In cinema, theater & music.)

550 ISMAILI, Ahmed. Perception et condition de la femme à travers *La plage des enfants perdus* de Jilali Ferhati. *Cinéma et société.* Coord. par Mohamed Dahane. Rabat: Université Mohammed V, 1995, (Publications de la Faculté des Lettres et des Sciences Humaines - Rabat: Série Colloques et Séminaires, 43), pp.99-104.

551 ISSA, Rose. Rediscovering Iran through its cinema and women filmmakers. *Arts & the Islamic World,* 31 (1997) pp.61-63.

552 KHAYATI, Khémaïs. Cinéma arabe au féminin: de `Tita Woong` au `Silence de Palais`. *Qantara,* 10 (1994) pp.25-26.

553 KUMMER, I. L'image de la femme dans le cinéma tunisien. *Tunisie plurielle.* Volume I. *Actes du Colloque de l'Université York, Toronto, Canada. Dir. Hédi Bouraoui.* Tunis: L'Or du Temps, 1997, pp.249-260.

554 LAHIJI, Shahla. Chaste dolls and unchaste dolls: women in Iranian cinema since 1979. *The new Iranian cinema: politics, representation and identity.* Ed. by Richard Tapper. London: Tauris, 2002, pp.215-226.

555 MORUZZI, Norma Claire. Women's space / cinema space: representations of public and private in Iranian films. *Middle East Report,* 29 iii / 212 (1999) pp.52-55.

556 MORUZZI, Norma Claire. Women in Iran: notes on film and from the field. *Feminist Studies,* 27 i (2001) pp.89-100. [Reactions among Iranian women in exile & in Iran to two films made by Iranian women.]

557 NAFICY, Hamid. Veiled vision / powerful presences: women in post-revolutionary Iranian cinema. *Life and art: the new Iranian cinema.* Ed. Rose Issa & S.Whitaker. London: National Film Theatre, 1999, pp.44-65.

558 PASSEVANT, C. Cinéma de résistance: les femmes algériennes disent non. *Homme et la Société,* 127-128 (1998) pp.113-119.

559 RAHIMIEH, Nasrin. Marking gender and difference in the myth of the nation: a post-revolutionary Iranian film. *The new Iranian cinema: politics, representation and identity.* Ed. by Richard Tapper. London: Tauris, 2002, pp.238-253. [Bahram Bayza'i's 1985 film "Bashu, The Little Stranger".]

560 RAMZI, Kamal. Des pionnières qui ont enrichi le cinéma égyptien. *Egypte: 100 ans de cinéma.* Sous la dir. de Magda Wassef. Paris: Institut du Monde Arabe, 1995, pp.74-83.

561 SAMIMI, Mehrnaz. The significant Iranian presence in Cannes. *Tavoos / Ṭāwūs,* 3-4 (2000) pp.157-166. [Bahman Qobadi, Mohammad-Hassan Yektapanah, Samira Makhmalbaf. Article in English & Persian.]

562 SHAFIK, Viola. Armut, Frauen und Islam: soziopolitische Aussagen des nordafrikanischen Films. *Wuqūf,* 10-11 / 1995-96 (1997) pp.511-527.

563 SHAFIK, Viola. Prostitute for good reason: stars and morality in Egypt. *Women's Studies International Forum,* 24 vi (2001) pp.711-725. Also online at http:// www.sciencedirect.com/science/journal/02775395 (The Egyptian film industry, its current star system & the general evaluation of stars on the artistic & moral level.)

564 SHOHAT, E. Framing post-Third-Worldist culture: gender and nation in Middle Eastern / North African film and video. *Jouvert,* 1 i (1997) Online at http:// social.chass.ncsu.edu/jouvert

565 SUNER, Asuman. Speaking the experience of political oppression with a masculine voice: making feminist sense of Yilmaz Güney's *Yol. Social Identities,* 4 ii (1998) pp.283-300. Also online at www.catchword.co.uk

566 ZUHUR, Sherifa. Victims or actors? Centering women in Egyptian commercial film. *Images of enchantment: visual and performing arts of the Middle East.* Ed. Sherifa Zuhur. Cairo: American University in Cairo Press, 1998, pp.211-228.

Australia & New Zealand

Articles

567 ABOOD, Paula. Arab-Australian women's activism.
 Arab-Australians today: citizenship and belonging. Edited
 by Ghassan Hage. Carlton South: Melbourne University
 Press, 2002, pp.161-172.

568 CHANISHEFF, Flora. My story. *Gombak Review,* 3 i
 (1998) pp.67-72. [Autobiographical essay by an
 Australian Muslim student in Malaysia, of Xinjiang origin.]

569 GIFFORD, S. M., BAKOPANOS, C., DAWSON, M-T. &
 YESILYURT, Zeynep. Risking for protection: discourses
 around 'safe sex' among Chilean, Turkish and
 second-generation Greek women living in Melbourne,
 Australia. *Ethnicity & Health,* 3 i-ii (1998) pp.95-116.

570 RALSTON, H. South Asian immigrant women organize
 for social change in the diaspora: a comparative study.
 Asian and Pacific Migration Journal, 7 iv (1998)
 pp.453-482. [Migrants, incl. Muslims, in Canada,
 Australia, & New Zealand.)

571 ROZARIO, Santi. On being Australian and Muslim:
 Muslim women as defenders of Islamic heritage. *Women's
 Studies International Forum,* 21 vi (1998) pp.649-661.
 Also online at www.sciencedirect.com/science/journal/
 02775395

572 YASMEEN, Samina. Muslim women as citizens in
 Australia: Perth as a case study. *Muslim minorities in
 the West: visible and invisible.* Ed. Yvonne Yazbeck
 Haddad & Jane I.Smith. Walnut Creek: Altamira, 2002,
 pp.217-232.

573 YASMEEN, Samina. Women as citizens in Australia.
 ISIM Newsletter, 2 (1999) pp.32-32. [With particular
 reference to Muslims.]

Azerbaijan

Books

574 HEYAT, Farideh. *Azeri women in transition: women in
 Soviet and post-Soviet Azerbaijan.* London:
 RoutledgeCurzon, 2002. 224pp.

Articles

575 HEYAT, Farideh. Azeri professional women's life
 strategies in the Soviet context. *Gender and identity
 construction: women of Central Asia, the Caucasus and
 Turkey.* Ed. Feride Acar & Ayşe Günes-Ayata. Leiden:
 Brill, 2000, (Social, Economic and Political Studies of the
 Middle East and Asia, 68), pp.177-201.

576 PFLUGER-SCHINDLBECK, I. Politische Implikationen
 der lokalen Wallfahrt von Frauen in Aserbaidschan.
 (Abstract: Political implications of local women's
 pilgrimages in Azerbaijan.). *Zeitschrift für Ethnologie,*
 122 ii (1997) pp.169-182.

577 SABI, Manijeh. The impact of economic and political
 transformation on women: the case of Azerbaijan.
 Central Asian Survey, 18 i (1999) pp.111-120.

578 TOHIDI, Nayereh. "Gendering the nation": reconfiguring
 national and self-identities in Azerbaijan. *Hermeneutics
 and honor: negotiating female "public" space in
 Islamic/ate societies.* Ed. Asma Afsaruddin. Cambridge
 (USA): Harvard University Press, for the Center for Middle
 Eastern Studies of Harvard University, 1999, (Harvard
 Middle Eastern monographs, 32), pp.89-115.

579 TOHIDI, Nayereh. "Guardians of the nation": women,
 Islam, and the Soviet legacy of modernization in
 Azerbaijan. *Women in Muslim societies: diversity within
 unity.* Ed. H.L.Bodman, Nayereh Tohidi. Boulder: Rienner,
 1998, pp.137-161.

580 TOHIDI, Nayereh. Gender and national identity in
 post-Soviet Azerbaijan: a regional perspective. *Gender
 and identity construction: women of Central Asia, the
 Caucasus and Turkey.* Ed. Feride Acar & Ayşe
 Günes-Ayata. Leiden: Brill, 2000, (Social, Economic and
 Political Studies of the Middle East and Asia, 68),
 pp.249-292.

581 TOHIDI, Nayereh. Soviet in public, Azeri in private:
 gender, Islam, and nationality in Soviet and post-Soviet
 Azerbaijan. *Women's Studies International Forum,* 19
 i-ii (1996) pp.111-123.

582 TOHIDI, Nayereh. The intersection of gender, ethnicity
 and Islam in Soviet and post-Soviet Azerbaijan.
 Nationalities Papers, 25 i (1997) pp.147-167.

583 YUNUSOVA, Leyla. Women and war. *Caucasus: war
 and peace: the new world disorder and Caucasia.* Mehmet
 Tütüncü (ed.). Haarlem: SOTA, 1998, pp.30-33. (Azeri
 refugees from Nagorno Karabakh.)

Bahrain

Articles

584 SEIKALY, May. Bahraini women in formal and informal
 groups: the politics of identification. *Organizing women:
 formal and informal women's groups in the Middle East.*
 Ed. D.Chatty & A.Rabo. Oxford: Berg, 1997, pp.125-146.

585 SEIKALY, May. Women and religion in Bahrain: an
 emerging identity. *Islam, gender, & social change.* Ed.
 Y.Yazbeck Haddad & J.L.Esposito. New York: Oxford
 University Press, 1998, pp.169-189.

586 SHIRAWI, Serene. From 105 Bani Otbah Road, Manama
 to Cambridge, MA 02138. *The American-Bahraini
 relationship: a special report.* Washington: National
 Council on U. S. - Arab Relations, [1996?], pp.17-19.

Bangladesh (since 1971) see also South Asia (before Partition)

Books

587 ABDUL MATIN, Editor. *Sheikh Hasina: the making of
 a prime minister.* 2nd ed. London: Radical Asia
 publications 1997. 40pp.

588 AFSANA, Kaosar & RASHID, Sabina Faiz. *Discoursing
 birthing care: experiences from Bangladesh.* Dhaka:
 University Press, 2000. 128pp.

589 AHMED, Sirajuddin. *Sheikh Hasina, prime minister of
 Bangladesh.* Delhi: UBS Publishers' Distributors, 1998.
 375pp.

590 AMATYA, Sushma. *Our world.* Photo Mahmud. Dhaka:
 Map Photo Agency, 2000. [Photographs of women's
 lives in Bangladesh.]

591 ARENDS-KUENNING, M. *How do family planning
 workers' visits affect women's contraceptive behavior in
 Bangladesh?* [New York:] Population Council, Policy
 Research Division, [1997], (Policy Research Division
 Working Papers, 1997/99). 71pp.

592 BARKAT, Abul, MAJID, Murtaza, AKHTER, Shahida &
 HOSSAIN, Mosharraf. *Maternal mortality and morbidity
 in Bangladesh: situation analysis, lessons learned and
 future strategies.* [Dhaka: n.p.], 1998. 59pp. (Prepared
 for Inter-Regional Workshop on South-South Collaboration
 ... Harare ... 1998.)

593 BARTON, Mukti. *Liberation spirituality as a signal of
 transcendence: Christian and Muslim women in
 Bangladesh.* Oxford: Religious Experience Research
 Centre, 1998, (Occasional paper / Religious Experience
 Research Committee: 2nd series, 18), [27]pp.

594 BARTON, Mukti. *Scripture as empowerment for liberation and justice: the experience of Christian and Muslim women in Bangladesh.* Bristol: Centre for Comparative Studies in Religion and Gender, Department of Theology and Religious Studies, University of Bristol, 1999, (CCSRG Monograph Series, 1), 195pp.

595 BOSE, Tapash Ranjan, KAMRUZZAMAN, Md. & AKHTER, Nasima. *Feasible income generating activities for rural women and their management.* Kotari: Bangladesh Academy for Rural Development, 2000. 125pp. [Bangladesh.]

596 DEEN, Hanifa. *Broken bangles.* Sydney: Anchor, 1998; Delhi: Penguin Books, 1999. 324pp. [Women of Pakistan and Bangladesh.]

597 HAMID, Shamim. *Why women count: essays on women in development in Bangladesh.* Dhaka: University Press, 1996. 183pp.

598 HAMIDUL HUQ *People's practices: exploring contestation, counter-development, and rural livelihoods.* Dhaka: Community Development Library, 2001. 228pp. [With particular reference to women in Muktinagar.]

599 HASHMI, Taj ul-Islam. *Women and Islam in Bangladesh: beyond subjection and tyranny.* Basingstoke: Macmillan, 2000. 254pp.

600 HUQ-HUSSAIN, Shanaz. *Female migrants' adaptation in Dhaka: a case of the processes of urban socio-economic change.* Dhaka: Urban Studies Programme, Dept. of Geography, University of Dhaka, 1996, (Bangladesh Urban Studies Series, 3), 224pp.

601 JORDANS, E. & ZWAARTEVEEN, M. *A well of one's own: gender analysis of an irrigation program in Bangladesh.* Rangpur: Grameen Krishi Foundation; Colombo, Sri Lanka: International Irrigation Management Institute, 1997, (IIMI Country Paper: Bangladesh, no. 1), 100pp.

602 KABEER, Naila. *'Money can't buy me love'? Re-evaluating gender, credit and empowerment in rural Bangladesh.* Brighton: Institute of Development Studies, University of Sussex, 1998, (IDS Discussion Paper, 363), 74pp.

603 KABEER, Naila. *The power to choose: Bangladeshi women and labour market decisions in London and Dhaka.* London: Verso, 2000. 464pp.

604 (KABIR, Rachel). *Adolescent girls in Bangladesh.* Dhaka: UNICEF Bangladesh Country Office, 1999. 64pp.

605 KAISER, Panna. *Freedom struggle, a prologue & an epilogue* / Panna Kaiser. Dhaka: Agamee Prakasani, 1999. 240pp. [Tr. of *Muktiyuddha, āge o pare*, an autobiographical memoir of a woman social activist from Bangladesh.]

606 KAMAL, Sultana. *Her unfearing mind: women and Muslim laws in Bangladesh.* Dhaka: Ain o Salish Kendro, 2001. 158pp.

607 KHAN, F. R. M. Ziaun Nahar & KHANAM, Rashida. *Poverty, women, and rural development in Bangladesh.* Chittagong: Kazi Rushel Mamum, 1998. 82pp.

608 KIBRIA, Nazli. *Becoming a garments worker: the mobilization of women into the garments factories of Bangladesh.* Geneva: United Nations Research Institute for Social Development, 1998, (Occasional Paper, Fourth World Conference on Women, Beijing 1995, 9), 23pp.

609 KOPPEN, B. van. *More jobs per drop: targeting irrigation to poor women and men.* Amsterdam: Royal Tropical Institute, 1998. 187pp.

610 KOPPEN, B. van & MAHMUD, Simeen. *Women and water pumps in Bangladesh: the impact of participation in irrigation groups on women's status.* London: Intermediate Technology Publications, 1996. 174+[46]pp.

611 MIZANUR RAHMAN, Md. *TV viewing habits of the house wives: a study on Dhaka City.* Dhaka: Bureau of Business Research, Faculty of Business Studies, University of Dhaka, 1997. 48pp.

612 MONSOOR, Taslima. *From patriarchy to gender equity: family law and its impact on women in Bangladesh.* Dhaka: University Press, 1999. 400pp.

613 PHILLIPS, James F. & HOSSAIN, Mian Bazle. *The impact of family planning household service delivery on women's status in Bangladesh.* New York: The Population Council, 1998, (Policy Research Division Working Papers, 1998/118), 31pp.

614 PRISKIL, P. *Taslima Nasrin: der Mordaufruf und seine Hintergründe.* Freiburg i. B. : Ahriman 1994 (Ahriman-Flugschrift, 7), 107pp.

615 QADIR, Sayeda Rowshan. *Women leaders in development organizations & institutions.* Dhaka: Palok Publishers, 1997. 117pp.

616 RAHMAN, Shahana. *Levels and characteristics of female participation in work among the urban poor in Dhaka.* Dhaka: Institute for Development Policy Analysis and Advocacy, Proshika, 1998, (Urban Livelihoods Study Working Paper, 1), 48pp.

617 SARKAR, Shikha Rani. *Role of comprehensive village development programme for the development of rural women.* Bogra: Rural Development Academy, 1998. 78pp. [Bangladesh.]

618 SIDDIQUI, Khaleda Akter. *Urban working women in the formal sector in Bangladesh.* Frankfurt a.M.: Lang, 2000 (Work, Technology Organization, Society, 9), 179pp.

619 STEELE, F., AMIN, Sajeda & NAVED, Ruchira T. *The impact of an integrated micro-credit program on women's empowerment and fertility behavior in rural Bangladesh.* New York: The Population Council, Policy Research Division, [1998], (Policy Research Division Working Papers, 1998/115). 39pp.

620 TODD, H. *Women at the center: Grameen Bank borrowers after one decade.* Boulder: Westview, 1996. 251pp.

621 ZAMAN, Habiba. *Women and work in a Bangladesh village.* Dhaka: Narigrantha Prabartana, 1996. 148pp.

622 *Fatwas against women in Bangladesh.* Ed. Hélie Lucas, Marie-Aimée & Kapoor, Harsh. [Grabels?:] Women Living Under Muslim Laws 1996. 148pp. Also online at http:// www.wluml.org/english/pubs/pdf/misc/ fatwa-bangladesh-eng.pdf

623 *I traditionens skygge.* Ed. Stinus, S. M., Kazal, L. R. & Lyhe, J. Copenhagen: Kvindernes U-landsudvalg, 1994, (Emneserien U-landskvinden / KULU, 14), 64pp. [India & Bangladesh.]

624 *Leveling the playing field: giving girls an equal chance for basic education - three countries' efforts* / The World Bank. Washington: World Bank, 1996. 38pp. [Pakistan, Bangladesh, Malawi.]

625 *Muslim feminism and feminist movement: South Asia.* Vol. 3: *Bangladesh & Sri Lanka.* Ed. Abida Samiuddin, R.Khanam. Delhi: Global Vision Publishing House, 2002. 360pp.

Articles

626 ABDUL HALIM. Mohanpur rural mothers' centres: a multidimensional approach to family planning and education for rural women. *Community development around the world: practice, theory, research, training.* Ed. H.Caampfens. Toronto: University of Toronto Press, 1997, pp.341-345.

627 ABDUL QUAYUM, Md. Wife's work participation and fertility in a less developed setting: a case study. *Bangladesh Journal of Political Economy,* 14 ii (1998) pp.87-104. [Bangladesh.]

628 ABDUL RAHMAN, Md. The saga of empowering women in Bangladesh. *Bangladesh Journal of Political Economy,* 14 ii (1998) pp.131-141. (In the economic sense of the term.)

629 ABDUL WAHEED KHAN. Women's role in upland farming development in Bangladesh. *Women in upland agriculture in Asia: proceedings of a workshop held in Chiang Mai ... 1995.* Ed. C.E.van Santen, J.W.T.Bottema, D.R.Stoltz. Bogor: CGPRT Centre, 1996, (CGPRT, no. 33), pp.173-181.

630 ABDUR RAZZAQUE Preference for children and
 subsequent fertility in Matlab: does wife-husband
 agreement matter? *Journal of Biosocial Science*, 31 i
 (1999) pp.17-28. Also online at www.journals.cup.org

631 ABU BAKAR, Md. Experiences of some special credit
 programmes in Bangladesh targeting women. *Journal of
 the Institute of Bangladesh Studies*, 21 (1998) pp.99-122.

632 AFSAR, Rita. Internal migration and women: an insight
 into causes, consequences and policy implications.
 Bangladesh Development Studies, 22 ii-iii / 1994 (1996)
 pp.217-243. [Bangladesh.]

633 AFSAR, Rita. Mainstreaming women in development
 plans: a few critical comments on the Fifth Five Year Plan.
 Empowerment, 4 (1997) pp.105-114. (Bangladesh.)

634 AHMAD, Nilufar. Women volunteers - a critical
 intervention in the urban health service. *Empowerment*,
 3 (1996) pp.1-19. [Bangladesh.]

635 AHMED, Khabir Uddin. Dissolution of Muslim marriage:
 Bangladesh perspective. *Journal of the Institute of
 Bangladesh Studies*, 22 (1999) pp.165-1178.

636 AHMED, Md. Kamil, SARKAR, Afzal H. & MIZANUR
 RAHMAN, [Md.]. Determinants of induced abortion in
 rural Bangladesh. *Demography India*, 25 i (1996)
 pp.105-118.

637 AHMED, Miyan Ruknuddin & LAARMAN, Jan G.
 Gender equity in social forestry programs in Bangladesh.
 Human Ecology, 28 iii (2000) pp.433-450. Also online
 at www.wkap.nl

638 AHMED, Nasiruddin. Investing in girls' education for
 human development in Bangladesh. *Bangladesh Journal
 of Political Economy*, 14 ii (1998) pp.105-116.

639 AHMED, Shamima. The social construction of female
 leadership in South Asia: opportunities and constraints.
 Asian Thought and Society, 21 / 61-62 (1996) pp.55-66.
 (Bangladesh, India, & Pakistan.)

640 AHMED, Syed Masud, ADAMS, Alayne, CHOWDHURY,
 A. M. R. & BHUIYA, Abbas. Income-earning women
 from rural Bangladesh: changes in attitude and knowledge.
 Empowerment, 4 (1997) pp.1-12.

641 AHMED, Syed Masud, CHOWDHURY, Mushtaque &
 BHUIYA, Abbas. Micro-credit and emotional well-being:
 experience of poor rural women from Matlab, Bangladesh.
 World Development, 29 xi (2001) pp.1957-1966.

642 AHSAN, Rosie Majid & NAJMUL AHMAD, A.S.
 International female migration for work from Bangladesh,
 1985-1997. *Oriental Geographer*, 44 i (2000) pp.17-33.

643 AHSAN, Rosie Majid, AHMAD, Nasreen, EUSUF,
 Ammatuz Zohra & ROY, Jagonnath. Prostitutes and
 their environment in Narayanganj, Bangladesh. *Asia
 Pacific Viewpoint*, 40 i (1999) pp.33-44.

644 AMIN, S. Social organisation and women empowerment.
 Muslim feminism and feminist movement: South Asia. Vol.
 3: *Bangladesh & Sri Lanka*. Ed. Abida Samiuddin,
 R.Khanam. Delhi: Global Vision Publishing House, 2002,
 pp.63-128. [Bangladesh.]

645 AMIN, Sajeda. Female education and fertility in
 Bangladesh: the influence of marriage and the family.
 *Girls' schooling, women's autonomy and fertility change
 in South Asia*. Ed. R.Jeffery & A.M.Basu. Delhi: Sage, in
 association with the Book Review Literary Trust, 1996,
 pp.184-204.

646 AMIN, Sajeda & PEBLEY, A. R. Gender inequality
 within households: the impact of a women's development
 programme in 36 Bangladeshi villages. *Bangladesh
 Development Studies*, 22 ii-iii / 1994 (1996) pp.121-154.

647 AMIN, Sajeda. The poverty-purdah trap in rural
 Bangladesh: implications for women's roles in the family.
 Development and Change, 28 ii (1997) pp.213-233.

648 AMINUL ISLAM, S. & YESMIN, Towhida. Global media
 and women in Bangladesh: representations from the above
 and representations from the below. *Journal of Social
 Studies*, 83 (1999) pp.57-78. [Broadcasting.]

649 ANWARY, Afroza. Acid violence and medical care in
 Bangladesh: women's activism as carework. *Gender &
 Society*, 17 ii (2003) pp.305-313. Also online at http://
 www.ingentaselect.com

650 ARENDS-KUENNING, Mary & AMIN, Sajeda. Women's
 capabilities and the right to education in Bangladesh.
 International Journal of Politics, Culture and Society, 15
 i (2001) pp.125-142. Also online at
 www.kluweronline.com/issn/0891-4486/current

651 BALK, D. Defying gender norms in rural Bangladesh: a
 social demographic analysis. *Population Studies*, 51 ii
 (1997) pp.153-172.

652 BEGUM, Hamida Akhtar. Psychosocial consequences of
 poverty on women in Bangladesh. *Dhaka University
 Studies*, 53 i (1996) pp.107-119.

653 BHASIN, Kamla. Gender workshops with men:
 experiences and reflections. *Gender and Development*, 5
 ii (1997) pp.55-61. Also online at http://
 www.ingentaselect.com [Discussing women in India,
 Bangladesh & Nepal.]

654 BHUIYAN, Musharraf Hossain. Women in administration:
 a study of the work environment. *Empowerment*, 3 (1996)
 pp.20-33. (In Bangladesh.)

655 BHUIYAN, Rejuan Hossain & BORHAN UDDIN Social
 and psychological scenario of arsenicosis patients: a gender
 perspective. *Oriental Geographer*, 45 ii (2001) pp.17-28.
 (Groundwater arsenic poisoning.)

656 BORHAN UDDIN, BHUIYAN, Rejuan Hossain &
 HOSSAIN, Mohammed Shahadat. Changing status of
 rural women in Bangladesh: an assessment. *Oriental
 Geographer*, 44 i (2000) pp.34-47.

657 BRUSTINOW, A. Armutsbekämpfung durch Hilfe zur
 Selbsthilfe. Frauenförderungsprojekte in Bangladesh.
 Bangladesh: dritte Heidelberger Südasiengespräche. Hrsg.
 D.Conrad & W-P Zingel. Stuttgart: Steiner, 1994,
 pp.212-222. [Discussion, pp.223-226.]

658 CANNON, Terry. Gender and climate hazards in
 Bangladesh. *Gender and Development*, 10 ii (2002)
 pp.45-50. Also online at http:// www.ingentaselect.com
 [Vulnerability of women.]

659 CHEW, Dolores. Women and work in Bangladesh.
 Labour, Capital and Society. Travail, Capital et Société,
 29 i-ii (1996) pp.187-196. [Interview with Farida Akhter,
 Dhaka.]

660 CHOWDHURY, Farah Deeba. Is participation in university
 administration a taboo for women? An exploration of the
 problem. *Empowerment*, 4 (1997) pp.115-124.
 (Bangladesh.)

661 CHOWDHURY, Farah Deeba. Women and election: issues
 in Bangladesh. *Pakistan Journal of History and Culture*,
 20 i (1999) pp.93-107.

662 CHOWDHURY, Farah Deeba. Women's participation in
 teacher's politics of the Islamic University, Bangladesh.
 Journal of the Institute of Bangladesh Studies, 19 (1996)
 pp.111-123.

663 CHOWDHURY, Masuda M.Rashid. Women
 entrepreneurs: emerging as leaders of rural Bangladesh.
 Dhaka University Studies, 55 i (1998) pp.111-143.

664 CHOWDHURY, Najma. The politics of implementing
 women's rights in Bangladesh. *Globalizaton, gender,
 and religion: the politics of implementing women's rights
 in Catholic and Muslim contexts*. Ed. Jane H.Bayes &
 Nayereh Tohidi. Basingstoke: Palgrave, 2001,
 pp.203-230.

665 CHOWDHURY, Najma. Women in Bangladesh politics.
 Bangladesh: internal dynamics and external linkages. Ed.
 Abul Kalam. Dhaka: University Press, 1996, pp.31-54.

666 CLELAND, J., KAMAL, Nashid & SLOGGETT, A.
 Links between fertility regulation and the schooling and
 autonomy of women in Bangladesh. *Girls' schooling,
 women's autonomy and fertility change in South Asia*. Ed.
 R.Jeffery & A.M.Basu. Delhi: Sage, in association with
 the Book Review Literary Trust, 1996, pp.205-217.

667 DANNECKER, Petra. Arbeitsmärkte und ihre geschlechtsspezifische Einbettung: Fabrikarbeiterinnen in Bangladesch. *Die geschlechtsspezifische Einbettung der Ökonomie: empirische Untersuchungen über Entwicklungs- und Transformationsprozesse* / Gudrun Lachenmann, Petra Dannecker (Hrsg.). Münster: Lit, 2001, (Market, Culture and Society, 12), pp.229-250.

668 DANNECKER, Petra. Collective action, organisation building, and leadership: women workers in the garment sector in Bangladesh. *Gender and Development,* 8 iii (2000) pp.31-39. Also online at http://www.ingentaselect.com

669 DANNECKER, Petra. Conformity or resistance? Women workers in the garment factories in Bangladesh. *Journal of Social Studies,* 89 (2000) pp.80-106.

670 DAS, Hena. Mahila Parishad and the women's movement in Bangladesh. *State, development and political culture: Bangladesh and India.* Ed. B.De, R.Samaddar. Delhi: Har-Anand, 1997, pp.167-176.

671 DELAHANTY, Julie & SHEFALI, Mashuda Khatun. From social movements to social clauses: assessing strategies for improving women's health and labour conditions in the garment sector. *Development,* 42 iv (1999) pp.98-102. Also online at www.ingentaselect.com [Bangladesh.]

672 DUZA, Asfia. Women's studies in Bangladesh: some critical observations. *Contributions to Bengal studies: an interdisciplinary and international approach.* Ed. Enayetur Rahim, Henry Schwarz. Dhaka: Pustaka, 1998, pp.99-107.

673 EGERÖ, B. Bangladesh in the fertility transition: the role of social change and gender. *South Asia,* 21 ii (1998) pp.87-106.

674 ELLICKSON, Jean. Never the twain shall meet: aging men and women in Bangladesh. *Journal of Social Studies,* 81 (1998) pp.33-55.

675 FELDMAN, S. Feminist interruptions: the silence of East Bengal in the story of Partition. *Interventions,* 1 ii (1999) pp.167-182.

676 FELDMAN, Shelley. Exploring theories of patriarchy: a perspective from contemporary Bangladesh. *Signs,* 26 iv (2001) pp.1097-1127. Also online at www.journals.uchicago.edu/signs/journal (Households, work, *purdah,* and veiling.)

677 FELDMAN, Shelley. Gender and Islam in Bangladesh: metaphor and myth. *Understanding the Bengal Muslims: interpretative essays.* Ed. Rafiuddin Ahmed. Delhi: Oxford University Press, 2001, pp.209-235. (The increased prominence of Islamic religio-political movements.)

678 GOETZ, A. M. & SEN GUPTA, Rina. Who takes the credit? Gender, power, and control over loan use in rural credit programs in Bangladesh. *World Development,* 24 i (1996) pp.45-63.

679 GOLDFIEM, J. de. Bangladesh: amère victoire pour la Bégum Zia. *Défense Nationale,* 52 v (1996) pp.187-189.

680 GRUBBE, P. Nur noch Stehplätze in Bangladesh? Mit der Frauenemanzipation gegen die Übervölkerung. *Evangelische Kommentare,* 26 i (1993) pp.37-39.

681 HADI, Abdullahel, NATH, Samir R. & CHOWDHURY, A.M.R. The effect of micro-credit programmes on repoductive behaviour of women in rural areas of Bangladesh. *Fertility transition in South Asia.* Ed. Zeba Ayesa Sathar and James E.Phillips. Oxford: Oxford University Press, 2001, pp.263-280.

682 HAMID, Shamim. Non-market work and national income: the case of Bangladesh. *Bangladesh Development Studies,* 22 ii-iii / 1994 (1996) pp.1-48. (Women's contribution to the national income.)

683 HANCHETT, S. Women's empowerment and the development research agenda: a personal account from the Bangladesh Flood Action Plan. *Feminist Issues,* 15 i-ii (1997) pp.42-71.

684 HAQUE, Y.A. The woman friendly hospital initiative in Bangladesh: a strategy for addressing violence against women. *Development,* 44 iii (2001) pp.79-81. Also online at www.ingentaselect.com

685 HASHEMI, Syed N., SCHULER, S. R. & RILEY, A. P. Rural credit programs and women's empowerment in Bangladesh. *World Development,* 24 iv (1996) pp.635-653.

686 HOLMAN, Darryl J. & GRIMES, Michael A. Colostrum feeding behaviour and initiation of breast-feeding in rural Bangladesh. *Journal of Biosocial Science,* 33 i (2001) pp.139-154.

687 HOSSAIN, Lamis. No paradise yet: women and child custody laws in Bangladesh. *No paradise yet: the world's women face the new century.* Ed. Judith Mirsky and Marty Radlett. London: Panos/Zed, 2000, pp.61-80.

688 HOSSAIN, Sara & HOSSAIN, Hameeda. Feminism and feminist movement in Bangladesh. *Muslim feminism and feminist movement: South Asia.* Vol. 3: *Bangladesh & Sri Lanka.* Ed. Abida Samiuddin, R.Khanam. Delhi: Global Vision Publishing House, 2002, pp.1-62.

689 HOSSEIN, Hameeda. Encore plus de miettes pour les femmes? *Women Living under Muslim Laws: Dossier,* 14-15 (1996) pp.30-34. Also online at http://www.wluml.org/french/pubs/pdf/dossiers/dossier14-15/D14-15fr.pdf (Bangladesh.)

690 HOSSEIN, Hameeda. More crumbs for women? *Women Living under Muslim Laws: Dossier,* 14-15 (1996) pp.28-32. Also online at www.wluml.org/english/pubs (Bangladesh.)

691 HUNT, Juliet & KASYNATHAN, Nalini. Pathways to empowerment? Reflections on microfinance and transformation in gender relations in South Asia. *Gender and Development,* 9 i (2001) pp.42-52. Also online at http:// www.ingentaselect.com (Three NGOs in Bangladesh and one NGO based in Bihar in India.)

692 HUQ, Naznin Afrose & KHATUN, Hafiza. Cycle-rickshaw repairing: women with toolkits. *Oriental Geographer,* 42 i (1998) pp.70-85. (In Dhaka.)

693 HUQ-HUSSAIN, Shanaz. Migration and social change among the urban poor women in the slums of Dhaka city. *Urban Bangladesh: geographical studies.* Ed. Nazrul Islam, Rosie Majid Ahsan. Dhaka: Urban Studies Programme, Department of Geography, University of Dhaka, 1996, (Bangladesh Urban Studies Series, 6), pp.107-120.

694 HUSSAIN, Md. Imam. Marriage and cohabitation pattern of urban tribal women in Bangladesh: a case study. *Pakistan Journal of Women's Studies. Alam-e-Niswan,* 3 i (1996) pp.61-66.

695 HUSSAIN, Tarek Mahmud. Indicators for gender equity: taking measure of women's lives in rural Bangladesh. *Development,* 42 ii (1999) pp.97-99. Also online at www.ingentaselect.com

696 HUSSAIN, Tarek Mahmud & SMITH, John F. Women's physical mobility in rural Bangladesh: the role of socio-economic and community factors. *Contemporary South Asia,* 8 ii (1999) pp.177-186.

697 HUQ, Jahanara. History of literacy efforts for women in Bangladesh: various issues and dimensions. *Empowerment,* 4 (1997) pp.79-104.

698 ISLAM, Mahmuda. Women look forward. *Bangladesh in the new millennium.* Ed. Mohiuddin Ahmad. Dhaka: Community Development Library, 2000, pp.1-34.

699 ISLAM, Md.Zulfiquar Ali. Dislocations in marital status among the riverbank erosion displacees in Bangladesh. *Journal of the Institute of Bangladesh Studies,* 22 (1999) pp.37-48.

700 ISLAM, Salma. Mobility pattern of middle income women in Dhaka city. *Oriental Geographer,* 42 i (1998) pp.57-69.

701 JAHAN, Nilufar & ALAUDDIN, Mohammad. Have women lost out in the development process? Some evidence from rural Bangladesh. *International Journal of Social Economics,* 23 iv-v-vi (1996) pp.370-390.

702 JAHAN, Nilufar & ALAUDDIN, Mohammad. Women and the environment with special reference to rural Bangladesh. *Development, governance and the environment in South Asia: a focus on Bangladesh.* Ed. Mohammad Alauddin & Samiul Hasan. Basingstoke: Macmillan; New York: St. Martin's Press, 1999, pp.301-313.

703 JAMALY, Rumana & WICKRAMANAYAKE, E. Women workers in the garment industry in Dhaka, Bangladesh. *Development in Practice,* 6 ii (1996) pp.156-160.

704 JESMIN, Sonia & SALWAY, Sarah. Marriage among the urban poor of Dhaka: instability and uncertainty. *Journal of International Development,* 12 v (2000) pp.689-705. Also online www.interscience.wiley.com

705 KABEER, Naila. 'Education is my daughter's future'. *Index on Censorship,* 27 iii / 182 (1998) pp.154-160. (Bangladeshi women.)

706 KABEER, Naila. Conflicts over credit: re-evaluating the empowerment potential of loans to women in rural Bangladesh. *World Development,* 29 i (2001) pp.63-84.

707 KABEER, Naila. Women, wages and intra-household power relations in urban Bangladesh. *Development and Change,* 28 ii (1997) pp.261-302.

708 KAMAL, Sultana. Legal status of Muslim women in Bangladesh. *Muslim feminism and feminist movement: South Asia.* Vol. 3: *Bangladesh & Sri Lanka.* Ed. Abida Samiuddin, R.Khanam. Delhi: Global Vision Publishing House, 2002, pp.129-147.

709 KAMRUNNESSA BEGUM. Female literacy: barriers and bridges in the perspective of literacy situation in Bangladesh. *Pakistan Journal of Women's Studies: Alam-e-Niswan,* 4 ii (1997) pp.57-63.

710 KAZAL, L. R. Bangladesh. *I traditionens skygge.* Red. S.M.Stinus, L.R.Kazal & J.Lyhe. Copenhagen: Kvindernes U-landsudvalg, 1994, (Emneserien U-landskvinden / KULU, 14), pp.43-63.

711 KHAN, Salma. Good governance and judiciary: equal rights of women. *Governance: South Asian perpectives.* Ed. Hasnat Abdul Hye. Dhaka: University Press, 2000, pp.137-144. (Bangladesh.)

712 KHANAM, R. Militant feminism and Islamic fundamentalism. *Muslim feminism and feminist movement: South Asia.* Vol. 3: *Bangladesh & Sri Lanka.* Ed. Abida Samiuddin, R.Khanam. Delhi: Global Vision Publishing House, 2002, pp.247-276. [Bangladesh.]

713 KHANUM, Sultana Mustafa. Knocking at the doors: impact of RMP on the womenfolk in project adjacent areas. *Journal of the Institute of Bangladesh Studies,* 23 (2000) pp.77-97. (Rural Maintenance Programme (RMP) ... Bangladesh.)

714 KHATUN, Habiba & KHATUN, Hafiza. Livelihood of women living in slums of Dhaka: a case study. *Pakistan Journal of Women's Studies. Alam-e-Niswan,* 3 i (1996) pp.43-53.

715 KHATUN, Hafiza. Role of wife's property in the intra-urban residential migration pattern of old Dhakaiya household. *Oriental Geographer,* 44 i (2000) pp.48-60.

716 KHATUN, Shamsun Neda & NAZMUL KARIM, A.K. Feminist approach in a Bangladeshi Muslim family: process of transformation. *Muslim feminism and feminist movement: South Asia.* Vol. 3: *Bangladesh & Sri Lanka.* Ed. Abida Samiuddin, R.Khanam. Delhi: Global Vision Publishing House, 2002, pp.159-192.

717 KHATUN, Sharifa. Education and political process: role of women in nation building in Bangladesh. *State, development and political culture: Bangladesh and India.* Ed. B.De, R.Samaddar. Delhi: Har-Anand, 1997, pp.177-200.

718 KHOGALI, Hisham & TAKHAR, Parmjit. Empowering women through cash relief in humanitarian contexts. *Gender and Development,* 9 iii (2001) pp.40-49. Also online at http:// www.ingentaselect.com [Incl. case stuy of cash-for-work flood rehabilitation programme, Bangladesh.]

719 (KHUNDKER, Nasreen). An analysis of gender issues in Bangladesh's development since the 1980's. *Growth or stagnation? A review of Bangladesh's development 1996.* Dhaka: Centre for Policy Dialogue, University Press, 1997, pp.415-445.

720 KIBRIA, Nazli. Culture, social class, and income control in the lives of women garment workers in Bangladesh. *Gender & Society,* 9 iii (1995) pp.289-309.

721 KIBRIA, Nazli. Employment decisions and processes of young single rural migrant women garment workers. *Asian Affairs* (Dhaka), 18 vi (1996) pp.18-31. (In Bangladesh.)

722 MAHMOOD, Raisul Awal & PAUL-MAJUMDER, Pratima. Bangladesh. *Gender & industrialisation: Mauritius, Bangladesh, Sri Lanka* / ed. by Uma Kothari, Vidula Nababsing. Stanley, Rose-Hill [Mauritius]: Editions de l'Océan Indien, 1996, pp.80-105. [Gender implications of export-oriented industrialisation in Bangladesh.]

723 MAHMUD, Simeen. Group dynamics and individual outcomes: women's informal groups in rural Bangladesh. *Bangladesh Development Studies,* 27 ii (2001) pp.115-136.

724 MAHMUD, Simeen. Reproductive change in Bangladesh and the latent demand hypothesis: what is the evidence. *Bangladesh Development Studies,* 25 i-ii / 1997 (1998) pp.125-142.

725 MAHMUD, Simeen. The gender dimensions of programme participation: who joins a microcredit programme and why? *Bangladesh Development Studies,* 26 ii-iii (2000) pp.79-101. (In Bangladesh.)

726 MAHMUD, Simeen. The role of women's employment programmes in influencing fertility regulation in rural Bangladesh. *Bangladesh Development Studies,* 22 ii-iii / 1994 (1996) pp.93-119.

727 MAHMUD, Simeen. Women's work in urban Bangladesh: is there an economic rationale? *Development and Change,* 28 ii (1997) pp.235-260.

728 MANCUSI-MATERI, Elena. Food aid for social development in post-conflict situations. *Development,* 43 iii (2000) pp.106-112. Also online at www.ingentaselect.com [Case studies involving women in Bangladesh & El Salvador.]

729 MANNAN, Haider Rashid & NURUL ISLAM, M. Determinants of breastfeeding duration in Bangladesh: a hazards model analysis. *Demography India,* 25 ii (1996) pp.249-260.

730 MANZURUL MANNAN. Women targeted and women negated: an aspect of the environmental movement in Bangladesh. *Development in Practice,* 6 ii (1996) pp.113-120. [Women's rejection of technologically improved stoves.]

731 MITRA, Sharmila. Socio-literary movements feminist leaders: Rokea Hossein and Sufia Kamal. *Muslim feminism and feminist movement: South Asia.* Vol. 3: *Bangladesh & Sri Lanka.* Ed. Abida Samiuddin, R.Khanam. Delhi: Global Vision Publishing House, 2002, pp.229-245.

732 MOHIBBUR RAHMAN & JAHAN, Hasin. Economic and social emancipation of slum women. *Sanitation and water for all. (Proceedings of the 24th WEDC Conference, Islamabad, Pakistan 1998.)* Ed. J.Pickford. Loughborough: Water, Engineering and Development Centre, 1998, pp.241-244. (Bangladesh.)

733 MOHSIN, Amena. Gendered nation gendered peace. *Journal of Social Studies,* 94-95 (2002) pp.22-49. (Post-1971 Bangladesh.)

734 MOIN, Julia. Changing role and role-conflict of the rural working women in a Bangladesh village. *Journal of the Institute of Bangladesh Studies,* 24 (2001) pp.13-22. [Unpaid domestic work & income-earning labour.]

735 MOSTAKIM, Golam. Women in education and technical training in Bangladesh: problems and prospects. *Empowerment,* 3 (1996) pp.64-79.

736 MUHURI, P. K. & MENKEN, J. Adverse effects of next birth, gender, and family composition on child survival in rural Bangladesh. *Population Studies,* 51 iii (1997) pp.279-294.

737 NAIMA HUQ Gender and law: some recent judicial interpretations. *Dhaka University Studies,* 55 i (1998) pp.87-109. (Courts in Bangladesh.)

738 NASIR, Rasheda Irshad & PERVIN, Fatema Rezina. Mahr - a study on marriage payments among the urban Muslim women. *Dhaka University Studies,* 53 i (1996) pp.93-105. [In Bangladesh.]

739 NASREEN, Mahbuba. Coping with floods: contributions of women in Bangladesh. *Dhaka University Studies,* 55 ii (1998) pp.129-157.

740 NASREEN, Mahbuba. Floods and gender in Bangladesh: a historical perspective. *Bangladesh Historical Studies,* 17 / 1996-1998 (1998) pp.134-149.

741 NAVED, Ruchira T. Empowerment of women: listening to the voices of women. *Bangladesh Development Studies,* 22 ii-iii / 1994 (1996) pp.155-178. (Rural Bangladesh.)

742 NAZNEEN, Roksana. A half step back - revival of purdah in Bangladesh. (Résumé: Un demi-pas en arrière: renaissance du purdah au Bangladesh). *Labour, Capital and Society. Travail, Capital et Société,* 29 i-ii (1996) pp.42-54.

743 NEWBY, M., AMIN, Sajeda, DIAMOND, I. & NAVED, Ruchira T. Survey experience among women in Bangladesh. *ABS: American Behavioral Scientist,* 42 ii (1998) pp.252-275. [Garment workers.]

744 NOSAKA, Akiko. Effects of child gender preference on contraceptive use in rural Bangladesh. *Journal of Comparative Family Studies,* 31 iv (2000) pp.vi-vii;x-xi;485-501.

745 NURUL ALAM Teenage motherhood and infant mortality in Bangladesh: maternal age-dependent effect of parity one. *Journal of Biosocial Science,* 32 ii (2000) pp.229-236. Also online at www.journals.cup.org

746 NURUL ALAM, SAHA, Sajal K., ABDUR RAZZAQUE & GINNEKEN, Jeroen K.van. The effect of divorce on infant mortality in a remote area of Bangladesh. *Journal of Biosocial Science,* 33 ii (2001) pp.271-278.

747 PAUL-MAJUMDER, P. & ZOHIR, Salma Chaudhuri. Dynamics of wage employment: a case of employment in the garment industry. *Bangladesh Development Studies,* 22 ii-iii / 1994 (1996) pp.179-216. [Women in Bangladesh.]

748 PAUL-MAJUMDER, Pratima. Health impact of women's wage employment: a case study of the garment industry of Bangladesh. *Bangladesh Development Studies,* 24 i-ii / 1996 (1998) pp.59-102.

749 PEREIRA, F. Post-divorce maintenance for Muslim women and the Islamist discourse. *Muslim feminism and feminist movement: South Asia.* Vol. 3: *Bangladesh & Sri Lanka.* Ed. Abida Samiuddin, R.Khanam. Delhi: Global Vision Publishing House, 2002, pp.149-157. [Bangladesh.]

750 PITT, M. M. & KHANDKER, Shahidur R. The impact of group-based credit programs on poor households in Bangladesh: does the gender of participants matter? *Journal of Political Economy,* 106 v (1998) pp.958-996.

751 RAFIQ, Nasreen & AHSAN, Rosie Majid. Age and sex differentials in mortality in rural and urban areas in Bangladesh: a micro study. *Urban Bangladesh: geographical studies.* Ed. Nazrul Islam, Rosie Majid Ahsan. Dhaka: Urban Studies Programme, Department of Geography, University of Dhaka, 1996, (Bangladesh Urban Studies Series, 6), pp.56-70. [Reprinted article.]

752 RAFIQ, Nasreen. Contribution of urban poor working women as active earning members: a micro study in Dhaka city. *Oriental Geographer,* 40 i-ii / 1996 (1997) pp.44-55.

753 RAHMAN, Rushidan Islam. Determinants of the gender composition of employment in manufacturing enterprises. *Bangladesh Development Studies,* 24 i-ii / 1996 (1998) pp.25-58.

754 RAHMAN KHAN, Mahmuda. Microfinance, wage employment and housework: a gender analysis. (Abstracts in translation: Micro-financement, travail salarié et travail domestique: une analyse en fonction du 'genre'; Micro-finanças, emprego assalariado e trabalho doméstico: uma análise de gênero; Microfinanzas, el empleo asalariado y las tareas del hogar: un análisis de género.). *Development in Practice,* 9 iv (1999) pp.424-436;512;513;514. (In Bangladesh). Also online at www.catchword.co.uk

755 RAHMAN KHAN, Mahmuda. Use of credit by wage earners and its effects on gender relations: an assessment on Ayesha Abed Foundation. *Empowerment,* 3 (1996) pp.34-63.

756 RAO, Aruna & KELLEHER, D. Gender lost and gender found: BRAC's gender quality action-learning programme. (Abstracts in translation: 'Genre' perdu et 'genre' retrouvé: le programme d'apprentissage-action de qualité de BRAC en matière de 'genre'; Descobrindo o gênero: o programa de ação-aprendizagem qualitativa; Género perdido y género encontrado: el programa de calidad de género acción-aprendizaje de BRAC.). *Development in Practice,* 8 ii (1998) pp.173-185;266;267;267-268. (Bangladesh Rural Advancement Committee (BRAC)). Also online at www.catchword.co.uk

757 RASHID, Sabina Faiz. Providing sex education to adolescents in rural Bangladesh: experiences from BRAC. *Gender and Development,* 8 ii (2000) pp.28-37. Also online at http:// www.ingentaselect.com [To girls & boys. Bangladesh Rural Advancement Committee.]

758 RASHID, Sabina Faiz & MICHAUD, Stephanie. Female adolescents and their sexuality: notions of honour, shame, purity and pollution during the floods. *Disasters,* 24 i (2000) pp.54-70. Also online at www.ingentaselect.com [Emergency living conditions.]

759 RASHIDUZZAMAN, M. The dichotomy of Islam and development: NGOs, women's development and *fatawa* in Bangladesh. *Contemporary South Asia,* 6 iii (1997) pp.239-246. (NGOs have been attacked by conservative Muslims who look upon them as cultural adversaries & the *ulama* have used *fatawa* to discourage their work.)

760 RILEY, A. P., KHAN, Nizam U. & MOULTON, L. H. Les facteurs prédictifs de l'intervalle protogénésique: une étude au Bangladesh. ([Abstracts:] Factors influencing the interval between marriage and first birth: a study in Bangladesh; Los factores predictivos del intervalo protogenésico: un estudio en Bangladesh.). *Population (Paris),* 51 iv-v (1996) pp.883-895.

761 ROZARIO, Santi. Claiming the campus for female students in Bangladesh. *Women's Studies International Forum,* 24 ii (2001) pp.157-166. Also online at ww.sciencedirect.com/science/journal/02775395

762 RUBACK, R. B., PANDEY, J. & BEGUM, Hamida Akhtar. Urban stressors in South Asia: impact on male and female pedestrians in Delhi and Dhaka. *Journal of Cross-Cultural Psychology,* 28 i (1997) pp.23-43.

763 RUHUL AMIN, ST. PIERRE, Maurice, AHMED, Ashraf & HAQ, Runa. Integration of an essential services package (ESP) in child and reproductive health and family planning with a micro-credit program for poor women: experience from a pilot project in rural Bangladesh. *World Development,* 29 ix (2001) pp.1611-1621.

764 RUHUL AMIN, BECKER, S. & ABDUL BAYES, NGO-promoted microcredit programs and women's empowerment in rural Bangladesh: quantitative and qualitative evidence. *Journal of Developing Areas,* 32 ii (1998) pp.221-236.

765 SADAQUE, Mohammed. Family development programs with women in urban slums. *Community development around the world: practice, theory, research, training.* Ed. H.Caampfens. Toronto: University of Toronto Press, 1997, pp.352-354. (Maldah Colony, Rajshahi, Bangladesh.)

766 SAEED, Amera. Awami League (Hasina): rise to power. *Regional Studies* (Islamabad), 15 i, 1996-97, pp.63-141.

767 SALAHUDDIN, Khaleda. Feminization of poverty: Bangladesh perspective. *Bangladesh Journal of Political Economy,* 14 ii (1998) pp.117-130.

768 SARKER, Profulla C. Gender dichotomisation, use of contraceptive devices and their impact on social development in Bangladesh. *Indian Social Science Review,* 1 i (1999) pp.203-211.

769 SARKER, Profulla C. Problems of female literacy in Bangladesh in socio-economic and cultural perspective. *Pakistan Journal of Women's Studies. Alam-e-Niswan,* 5 i-ii (1998) pp.87-93.

770 SCHULER, S. R., HASHEMI, Syed M. & BADAL, Shamsul Huda. Men's violence against women in rural Bangladesh: undermined or exacerbated by microcredit programmes? (Abstracts in translation: La violence masculine à l'encontre des femmes dans le Bangladesh rural: amoindrie ou exacerbée par les programmes de micro-crédit? Violência masculina contra as mulheres na zona rural de Bangladesh: redução ou aumento através dos programas de micro-crédito; La violencia del hombre contra la mujer en Bangladesh rural: ¿minada o exacerbada por los programas de microcrédito?). *Development in Practice,* 8 ii (1998) pp.148-157;265;266-267;268. Also online at www.catchword.co.uk

771 SCHULER, S. R., HASHEMI, Syed Mesbahuddin & RILEY, A. P. The influence of women's changing roles and status in Bangladesh's fertility transition: evidence from a study of credit programs and contraceptive use. *World Development,* 25 iv (1997) pp.563-575.

772 SERAJUDDIN, Alamgir Muhammad. The traditionalist and modernist response to the Muslim Family Laws Ordinance, 1961. *Contributions to Bengal studies: an interdisciplinary and international approach.* Ed. Enayetur Rahim, Henry Schwarz. Dhaka: Pustaka, 1998, pp.335-343. (A significant step in the social evolution of Bangladesh & Pakistan.)

773 SHAFIQUR RAHMAN, Md & SHAHEEN, Rukhsana. Joining brothel: social action and power in Bangladesh. *Journal of the Institute of Bangladesh Studies,* 24 (2001) pp.23-32.

774 SHAH, Wajed A. & NURI, Salina Jahan. Local vegetable seed storage methods and women's participation in development. *Indigenous knowledge development in Bangladesh: present and future.* Ed. Paul Sillitoe. London: Intermediate Technology Publications, 2000, pp.91-96. (Indigenous methods.)

775 SHAMIM, Ishrat & NASREEN, Mahbuba. Gender and local governance: a new discourse in development. *Journal of Social Studies,* 94-95 (2002) pp.50-87. [Bangladesh.]

776 SHAREEF, Shawkat. Upliftment efforts of Grameen Bank for the rural women in Bangladesh: a case study. *Pakistan Journal of Women's Studies. Alam-e-Niswan,* 4 i (1997) pp.75-83.

777 SHEHABUDDIN, Elora. Beware the bed of fire: gender, democracy, and the Jama'at-i Islami in Bangladesh. *Journal of Social Studies,* 87 (2000) pp.17-46.

778 SHEHABUDDIN, Elora. Contesting the illicit: gender and the politics of fatwas in Bangladesh. *Signs,* 24 iv (1999) pp.1011-1044. (Between January 1993 & December 1996, more than sixty incidents of fatwa-instigated violence, directed mostly at impoverished rural women were reported in Bangladesh.)

779 SHEHABUDDIN, Elora. Contesting the illicit: gender and the politics of fatwas in Bangladesh. *Gender, politics, and Islam.* Ed. Therese Saliba, Carolyn Allen and Judith A.Howard. Chicago: University of Chicago Press, 2002, pp.1011-1044. (Between January 1993 & December 1996, more than sixty incidents of fatwa-instigated violence, directed mostly at impoverished rural women were reported in Bangladesh.) [Originally published in *Signs,* 24 iv (1999).]

780 SHEHABUDDIN, Elora. Gender and the politics of fatwas in Bangladesh. *Eye to eye: women practising development across cultures* / ed. Susan Perry & Celeste Schenk. London: Zed, 2001, pp.50-70.

781 SIDDIQI, Dina M. Taslima Nasreen and others: the contest over gender in Bangladesh. *Women in Muslim societies: diversity within unity.* Ed. H.L.Bodman, Nayereh Tohidi. Boulder: Rienner, 1998, pp.205-227. (Contests over national identity, development policies, & Islamist politics.)

782 SIDDIQI, Najma. Feminization of poverty: conceptualization, evidence and a feminist critique. *Empowerment,* 3 (1996) pp.80-92.

783 SIDDIQUI, Tasneem. Politics of gender and the state in Bangladesh: the first two decades. *Dhaka University Studies,* 55 i (1998) pp.145-173.

784 SOLAIMAN, Mohammad. Growth of entrepreneurship in changing society of Bangladesh: rural women entrepreneurship. *Pakistan Journal of Women's Studies. Alam-e-Niswan,* 4 i (1997) pp.55-61.

785 STINUS, S. M. I traditionens skygge. *I traditionens skygge.* Red. S.M.Stinus, L.R.Kazal & J.Lyhe. Copenhagen: Kvindernes U-landsudvalg, 1994, (Emneserien U-landskvinden / KULU, 14), pp.3-5. [Women in India & Bangladesh.]

786 UUSIKYLÄ, H. The seeds in the container: metaphors of conception and kinship in rural Bangladesh. *Changing patterns of family and kinship in South Asia: proceedings of an international symposium ... University of Helsinki ... 1998.* Ed. A.Parpola & S.Tenhunen. Helsinki: Finnish Oriental Society, 1998, (Studia Orientalia, 84), pp.51-59.

787 WAHID, Abu N.M. Women's participation in the Grameen Bank programs of Bangladesh: a study of some unanswered questions. *Asian Affairs* (Dhaka), 20 i (1998) pp.36-51.

788 WESSON, Kate. A situational assessment study of acid violence in Bangladesh. *Development in Practice,* 12 i (2002) pp.96-100. Also online at http:// www.ingentaselect.com (Acid-throwing is a gendered violence: 74 percent of survivors were women.)

789 WILSON, Margot. "Take this child": why women abandon their infants in Bangladesh. *Journal of Comparative Family Studies,* 30 iv (1999) pp.ix;vii;687-702.

790 WILSON-MOORE, Margot. Servants and daughters: out of wedlock pregnancy and abandonment of women in Bangladesh. *Human Organization,* 55 i (1996) pp.170-177.

791 WRIGHT, Denis. Industrialisation and the changing role of women in Bangladesh. *Asian Studies Review,* 24 ii (2000) pp.230-242.

792 YOUNG, Kate. Violence against women in Bangladesh. *Soundings,* 15 (2000) pp.74-82. (Acid throwing ... most of the attacks are aimed at young girls between 11 and 20.)

793 ZAMAN, Habiba. Paid work and socio-political consciousness of garment workers in Bangladesh. *Journal of Contemporary Asia,* 31 ii (2001) pp.145-160. [Women workers.]

794 ZAMAN, Habiba. Violence against women in Bangladesh: issues and responses. *Women's Studies International Forum,* 22 i (1999) pp.37-48. Also online at http:// www.sciencedirect.com/science/journal/02775395

795 ZEITLYN, S. & ROWSHAN, Rabeya. Privileged knowledge and mother's "perceptions": the case of breast-feeding and insufficient milk in Bangladesh. *Medical Anthropology Quarterly,* 11 i (1997) pp.56-68.

796 Workshop on gender issues in export-based industrialization in Bangladesh: a joint report of UNRISD and CPD. *UNRISD Social Development News,* 14 (1996) pp.14-14.

Belgium

Books

797 COMPÈRE, Janique. *D'Iran en Belgique: regards de réfugiés politiques par rapport aux relations hommes-femmes.* Louvain-la-Neuve: Academia-Bruylant: SYBIDI, 1999 (SYBIDI papers, 22), 131pp.

798 HOUARI, Leïla & DRAY, J. *Femmes aux mille portes: portraits, mémoire.* Brussels: EPO; Paris: Syros, 1996. 114pp. [Maghribi women in Belgium & France.]

799 *Femmes marocaines et conflits familiaux en immigration: quelles solutions juridiques appropries?* Ed. Foblets, Marie-Claire. Antwerp: Maklu, 1998. 474pp. [In Belgium.]

Articles

800 BENSALAH, Nouzha. Tradition et nouvelles formes du
 mariage en immigration: le mariages turcs et marocains
 comme liens entre deux mondes. *Familles turques et
 maghrébines aujourd'hui: évolution dans les espaces
 d'origine et d'immigration.* Sous la dir. de Nouzha
 Bensalah. Louvain-la-Neuve: Academia-Erasme; Paris:
 Masionneuve et Larose, 1994, pp.107-118. (En
 Belgique.)

801 FOBLETS, Marie-Claire S.F.C. Family disputes involving
 Muslim women in contemporary Europe: immigrant
 women caught between Islamic family law and women's
 rights. *Religious fundamentalisms and the human rights
 of women.* Ed. C.W.Howland. Basingstoke: Macmillan;
 New York: St. Martin's Press, 1999, pp.167-178.
 (Moroccan women domiciled in Belgium.)

802 FOBLETS, M-C. Femmes immigrées et conflits conjugaux:
 plaidoyer pour plus de protection juridique. *Droits et
 Cultures,* 37 (1999) pp.255-276. (Femmes marocaines
 en Belgique.)

803 FOBLETS, M-C. & VERHELLEN, J. Marokkaanse
 migrantenvrouwen in gezinsgeschillen: wat zijn passende
 juridische oplossingen? *Recht van de Islam,* 17 (2000)
 pp.90-115. (In België.)

804 FOBLETS, M-C. Un droit pour ou par ses destinataires?
 Les complexités du rattachement juridique de l'alliance
 matrimoniale entre partenaires immigrés.
 Familles-Islam-Europe: le droit confronté au changement.
 Sous la direction de M-C.Foblets. Paris: L'Harmattan,
 1996, pp.125-151. [Belgium & Netherlands.]

805 MANÇO, Altay. L'organisation des familles turques en
 Belgique et la place des femmes. *CEMOTI,* 21 (1996)
 pp.161-169.

806 OUALI, Nouria. Les télévisions francophones et l'image
 des femmes immigrées. *Annuaire de l'Afrique du Nord,*
 34 / 1995 (1997) pp.971-980. (En Belgique & en Europe
 plus largement.)

Benin

Articles

807 KUHN, Barbara. `Kossam waala ceede waala` - `Keine
 Milch, kein Geld! `: zur Bedeutung der Milch für
 Fulbefrauen. (Synopsis: `Kossam waala ceede waala` -
 `No milk, no money!` The importance of milk for Fulani
 women.). *Sociologus,* 44 i (1994) pp.53-65. (In
 northern Benin.)

808 KUHN, Barbara. "Kosam wallaa ceede wallaa!" "Pas de
 lait, pas de l'argent!" L'importance du lait chez les femmes
 peules du Nord-Bénin. *Trajectoires peules au Bénin: six
 études anthropologiques.* Sous la dir. de Thomas
 Bierschenk & Pierre-Yves Le Meur. Paris: Karthala, 1997,
 pp.63-76.

Berbers (general)

Books

809 BROOKS, Geraldine. *Die Berber-Frauen: Kunst und
 Kultur in Nordafrika.* [Photographs by] Margaret
 Courtney-Clarke. Tr. Kluy, Alexander. Munich:
 Frederking und Thaler, 1997. 216pp. [Tr. of *Imazighen,*
 London 1996. Mainly pictures.]

810 BROOKS, Geraldine. *Imazighen: the vanishing traditions
 of Berber women.* [Photographs by] M.Courtney-Clark.
 London: Thames & Hudson, 1996. 192pp. [Mainly
 pictures.]

811 CHELLIG, Nadia. *Jazya: princesse berbère.* [Algiers:]
 CNRPAH-CHIHAB, 1998, (Travaux du Centre National
 de Recherches Préhistoriques, Anthropologiques et
 Historiques), 170pp.

812 HANNOUM, Abdelmajid. *Colonial histories,
 post-colonial memories: the legend of the Kahina, a North
 African heroine.* Portsmouth (USA): Heinemann, 2001.
 216pp.

813 MORILLA AGUILAR, F. *Ritos nupciales del pueblo
 beréber.* Córdoba: Universidad de Córdoba, Servicio de
 Publicaciones, [1994], (Serie Monografías, 208). 111pp.

Articles

814 BADI, Dida. Ṭin-Hinan: un modèle structural de la société
 touarègue. *Études et Documents Berbères,* 12 / 1994
 (1995) pp.199-205. [Legendary Tuareg queen.]

815 CAMMAERT, M-F. La mujer beréber en el centro de la
 vida familiar. Tr. Ouafi Olia, Karima I'. *Vigía de Tierra,*
 2-3 / 1996-7 (1997) pp.85-114.

816 DI TOLLA, A. M. A propos des spécificités linguistiques
 féminines en Berbère. *Studi Magrebini,* 24 / 1992 (1997)
 pp.125-135.

817 FIGUEIREDO, C. Identité et concitoyenneté: la
 réélaboration des relations entre hommes et femmes aux
 marges de la société Kel Adagh (Mali). *Touaregs et
 autres Sahariens entre plusieurs mondes: définitions et
 redéfinitions de soi et des autres* sous la direction de
 H.Claudot-Hawad, Aix-en-Provence: Institut de
 Recherches et d'Etudes sur le Monde Arabe et Musulman
 (1996) (Cahiers de l'IREMAM, 7-8), pp.113-134.

818 GALAND, L. Encore le nom berbère de la femme!
 *Comptes Rendus du Groupe Linguistique d'Etudes
 Chamito-Sémitiques: G.L.E.C.S.* 31 / 1987-1994 (1995)
 pp.109-115.

819 HANNOUM, Abdelmajid. Historiographie et légende au
 Maghreb. La Kâhina ou la production d'une mémoire.
 (Summar[y]: Historiography and legends in the Maghreb:
 the legend of the Kahina and the making of a memory.).
 Annales: Histoire, Sciences Sociales, 54 iii (1999)
 pp.667-686;800.

820 HANNOUM, Abdelmajid. Historiography, mythology and
 memory in modern North Africa: the story of the Kahina.
 Studia Islamica, 85 (1997) pp.85-130.

821 HANNOUM, Abdelmajid. Myth and mythmaking in
 French historiography of North Africa: writing the episode
 of the Kahina. *Hespéris-Tamuda,* 34 (1996) pp.131-158.

822 LAKHSASSI, Abderrahmane. Représentation de la femme
 dans les traités de *fiqh* en berbère. *Femmes et hommes
 au Maghreb et en immigration: la frontière des genres en
 question. Etudes sociologiques et anthropologiques.* Sous
 la dir. de C.Lacoste-Dujardin & M.Virolle. Coord. Baya
 Boualem & Narjys El Alaoui. Paris: Publisud, 1998,
 pp.33-46. (Il existe en berbère-tachelhit un genre littéraire
 d'édification religieuse.)

823 MIRÓN PÉREZ, M. D. Apuntes para la historia de las
 mujeres beréberes en la antigüedad. *Vigía de Tierra,* 2-3
 / 1996-7 (1997) pp.55-70.

824 REYSOO, F. Métaphores spatiales et sociales au Maghreb:
 pratiques corporelles des femmes arabo-musulmanes et
 berbères. *El imaginario, la referencia y la diferencia:
 siete estudios acerca de la mujer árabe.* M.del Amo (ed.).
 Granada: Departamento Estudios Semíticos, 1997,
 pp.127-141.

825 YELLES-CHAOUCHE, Mourad. Sorties, sortilèges de
 femmes. *Awal,* 13 (1996) pp.43-52. (Société berbère.)

Bibliography; publishing

Books

826 KIMBALL, M. R. & VON SCHLEGELL, B. R. *Muslim
 women throughout the world: a bibliography.* Boulder:
 Rienner, 1997. 309pp.

827 OTTO, Ingeborg & SCHMIDT-DUMONT, Marianne. *Frauen in den arabischen Ländern: eine Auswahlbibliographie. Women in the Arab countries: a selected bibliography.* Hamburg: Deutsches Übersee-Institut, Übersee-Dokumentation, Referat Vorderer Orient, 2000 (Dokumentationsdienst Vorderer Orient: Reihe A, 27), XXX+270pp.

828 PUDIOLI, Maria Cristina. *Donne dell'Islam: una ricerca bibliografica nelle biblioteche di Bologna.* Bologna: Il Nove, 1998 (Ricerche Bibliografiche: Centro Amilcar Cabral, 17), 187pp.

829 RUIZ-ALMODÓVAR, C. *La mujer musulmana: bibliografía.* Granada: Universidad de Granada, 1994. 2 vols. 890pp.

830 *Femmes et politique: bibliographie sélective.* Tunis: Centre de Recherches, d'Etudes, de Documentation et d'Information sur la Femme, 2001. 52+32pp. [Arabic title: *Al-mar'a wa-'l-siyāsa.*]

831 *Les écrits des femmes tunisiennes: bibliographie 1994/* Centre de Recherches, d'Etudes, de Documentation et d'Information sur la Femme avec le Concours du Club Culturel Tahar Haddad. Tunis: Eds. du CREDIF, 1995. 19+13pp. [Arabic title: *Kitābāt al-nisā'īya al-Tūnisīya.*]

Articles

832 BOOTH, Marilyn. Coming to light: Nour Publishing House and the production of gendered knowledge. *Middle East Women's Studies: the Review,* 12 i (1997) pp.7-8. (The First Arab Women's Book Fair, held in Cairo in November 1995... Nour Publishing House made it happen.)

833 FERNEA, E. W. Rooms of their own. *Aramco World,* 47 iii (1996) pp.28-31. (Arab Women's Book Fair.)

834 KANSOUH-HABIB, Seheir. Bücher aus Ägypten. Frauen: die Sprache der schweigenden Mehrheit. Ein Blick auf hundert Jahre Protest, Widerstand und Kampf für Gleichheit. *KAS / Auslandsinformationen,* 16 xi (2000) pp.71-100.

835 KUMAR, Anjay. A select bibliography on Muslim women. *Indian Muslim women: challenges & response.* Ed. Ram Bali Mishra. Hariharpur: Regional Sociological Research Institute, 1996, pp.205-210.

836 LACHIRI, Nadia & MORAL, C. del. Bibliografía para el estudio de las mujeres en el mundo árabe medieval, con especial referencia a Al-Andalus. *Árabes, judías y cristianas: mujeres en la Europa medieval.* Ed. C.del Moral. Granada: Universidad de Granada, 1993, pp.225-236.

837 PARIS, Mireille. Femmes, islam et politique au Maghreb et dans le monde arabe. Bibliographie en langues européennes et arabe. *Femmes de Méditerranée: religion, travail, politique.* Sous la dir. de Andrée Dore-Audibert et Sophie Bessis. Paris: Karthala, 1995, pp.209-264.

838 RAGAN, J. D. A bibliography of French women travellers in Egypt during the nineteenth century and the early twentieth century. *Travellers in Egypt: Notes and Queries,* 3 (1996) pp.12-14.

839 RAGAN, J. D. Interesting sources on French travel literature. *Travellers in Egypt: Notes and Queries,* 3 (1996) pp.10-11. [French women's accounts of Egypt in Egyptian libraries.]

840 SUNDERMAN, P. W. Hanān al-Shaykh: an annotated bibliography of primary and secondary sources. *Meisei Review,* 12 iii (1997) pp.201-230.

841 TADIÉ, A. Bibliographie de la littérature féminine égyptienne. *Peuples Méditerranéens,* 77 (1996) pp.95-112.

842 TEMSAMANI, Tourya Haji. La femme rurale au Maroc: une bibliographie annotée. *Femmes rurales. / Nisā' qarawīyāt.* Collection dir. par Aïsha Belarbi. Casablanca: Éditions Le Fennec, 1995, (Approches, 7), pp.25-43.

843 A bibliography of stories and novels by Iranian women translated into English. *In a voice of their own: a collection of stories by Iranian women written since the revolution of 1979.* Compiled and translated, with an introduction by F.Lewis & Farzin Yazdanfar. Costa Mesa: Mazda, 1996, (Bibliotheca Iranica: Persian Fiction in Translation series, 4), pp.xxxviii-xliii.

844 A select bibliography of studies on women and writing in Iran and the Middle East. *In a voice of their own: a collection of stories by Iranian women written since the revolution of 1979.* Compiled and translated, with an introduction by F.Lewis & Farzin Yazdanfar. Costa Mesa: Mazda, 1996, (Bibliotheca Iranica: Persian Fiction in Translation series, 4), pp.xliv-liv.

Bosnia-Herzegovina

Books

845 ALLEN, Beverly. *Rape warfare: the hidden genocide in Bosnia-Herzegovina and Croatia.* Minneapolis: University of Minnesota Press, 1996. 180pp.

846 PAŠIĆ, Ehlimana. *Silovane: srpski zločini u Bosni i Hercegovini.* Brčko: `Saraj`, [1993?]. 137pp.

847 WELSER, M. von. *Am Ende wünschst du dir nur noch den Tod: die Massenvergewaltigungen im Krieg auf dem Balkan.* Munich: Knaur, 1993. 191pp.

848 *Masovna silovanja kao ratni zločin.* Ed. Šeparović, Z. Zagreb: Hrvatsko Žrtvoslovno Društvo, 1993, (Documenta Croatica, Središnjica za Genocid i Ratne Žrtv), 197pp.

849 *Molila sam ih da me ubiju: zločin nad ženom Bosne i Hercegovine.* Sarajevo: Centar za Istraživanje i Dokumentaciju, Saveza Logoraša Bosne i Hercegovine, 1999. 484pp.

Articles

850 ALBANESE, Patricia. Nationalism, war, and archaization of gender relations in the Balkans. *Violence against Women,* 7 ix (2001) pp.999-1023. Also online at http://www.ingenta.com/journals/browse/sage/j322

851 ALI, Nadje al-. Gender relations, transnational ties and rituals among Bosnian refugees. *Global Networks,* 2 iii (2002) pp.249-262. [In London.] Also online at www.ingenta.com

852 ALLEN, B. Rape warfare in Bosnia-Herzegovina: the policy and the law. *Brown Journal of World Affairs,* 3 i (1996) pp.313-323.

853 BARKAN, Joane. As old as war itself: rape in Foca. *Dissent,* 49 i (2001) pp.60-66. [Muslim women raped in Bosnian war.]

854 BELJKAŠIĆ-HADŽIDEDIĆ, Ljiljana. Učešće muslimanskih žena u tradicionalnim privrednim djelatnostima u Sarajevu krajem 19. i početkom 20.stoljeća. (Summary: Participation of Muslem women in traditional economic activities in Sarajevo at the end of 19th and the beginning of 20th century.). *Prilozi historiji Sarajeva: radovi sa znanstvenog simpozija Pola milenija Sarajeva, održanog 19. do 21. marta 1993. godine.* Urednik: Dževad Juzbašić. Sarajevo: Institut za Istoriju, Orijentalni Institut, 1997, pp.301-314.

855 BENDERLY, J. Rape, feminism, and nationalism in the war in Yugoslav successor states. *Feminist nationalism.* L.A.West. New York: Routledge, 1997, pp.59-72. [Bosnian & Croatian nationalism.]

856 BOOSE, Lynda E. Crossing the river Drina: Bosnian rape camps, Turkish impalement, and Serb cultural memory. *Signs,* 28 i (2002) pp.71-86. Also online at http://www.journals.uchicago.edu [Historical background to Serb treatment of Muslim women in 1991 Bosnian war.]

857 BURIC, Ahmed. Nobody cried then. *Index on Censorship,* 27 ii / 181 (1998) pp.62-65. [Widows of Srebrenica.]

858 CAMPBELL, Kirsten. Legal memories: sexual assault, memory, and international humanitarian law. *Signs*, 28 i (2002) pp.149-178. Also online at http://www.journals.uchicago.edu [Rape and sexual assault of a Muslim woman by a Croat commander in Bosnia 1991 before international court.]

859 CARLTON, G. H. Equalized tragedy: prosecuting rape in the Bosnian conflict under the International Tribunal to Adjudicate War Crimes Committed in the Former Yugoslavia. *Journal of International Law and Practice*, 6 i (1997) pp.93-109.

860 CHESTERMAN, S. Never again ... and again: law, order, and the gender of war crimes in Bosnia and beyond. *Yale Journal of International Law*, 22 ii (1997) pp.299-343.

861 CHINKIN, Christine & PARADINE, Kate. Vision and reality: democracy and citizenship of women in the Dayton Peace Accords. *Yale Journal of International Law*, 26 i (2001) pp.103-178.

862 HELMS, Elissa. Women as agents of ethnic reconciliation? Women's NGOs and international intervention in postwar Bosnia-Herzegovina. *Women's Studies International Forum*, 26 i (2003) pp.15-33. Also online at http://www.sciencedirect.com/science/journal/02775395

863 INGLIS, Shelley. Re/constructing right(s): the Dayton Peace Agreement, international civil society development, and gender in postwar Bosnia-Herzegovina. *Columbia Human Rights Law Review*, 30 i (1998) pp.65-121.

864 KENNEDY-PIPE, Caroline & STANLEY, Penny. Rape in war: lessons of the Balkan conflicts in the 1990s. *International Journal of Human Rights*, 4 iii-iv (2000) pp.67-84. [Bosnia, Kosova.]

865 KENNEDY-PIPE, Caroline & STANLEY, Penny. Rape in war: lessons of the Balkan conflicts in the 1990s. *The Kosovo tragedy: the human rights dimensions*. Ed. Ken Booth. London: Cass, 2001, pp.67-84. [Bosnia, Kosova. Previously published in *International Journal of Human Rights*, 4 iii-iv (2000).]

866 KONSTANTINOVIĆ-VILIĆ, S. Psychological violence and fear in war, and their consequences for the psychological health of women. *Women, violence and war: wartime victimization of refugees in the Balkans*. Ed. V.Nikolić-Ristanović. Budapest: Central European University Press, 2000, pp.99-133. [Bosnia.]

867 KONSTANTINOVIĆ-VILIĆ, S. Psychological violence and fear in war, and their consequences for the psychological health of women. *Women, violence and war: wartime victimization of refugees in the Balkans*. Ed. V.Nikolić-Ristanović. Budapest: Central European University Press, 2000, pp.99-133. [Bosnia.]

868 KONSTANTINOVIĆ-VILIĆ, S. Strategies of support and help. *Women, violence and war: wartime victimization of refugees in the Balkans*. Ed. V.Nikolić-Ristanović. Budapest: Central European University Press, 2000, pp.187-194. [Bosnian war refugees.]

869 LAVIOLETTE, N. Commanding rape: sexual violence, command responsibility, and the prosecution of superiors by the International Criminal Tribunal for the Former Yugoslavia and Rwanda. (Sommaire: Donner l'ordre de violer: la violence sexuelle, la responsabilité pénale des supérieurs et les Tribunaux pénaux internationaux pour l'ex-Yougoslavie et le Rwanda.). *Canadian Yearbook of International Law. Annuaire Canadienne de Droit International*, 36 (1998) pp.93-149.

870 MAGUIRE, Sarah. Researching 'a family afffair': domestic violence in former Yugoslavia and Albania. *Gender and Development*, 6 iii (1998) pp.60-66. Also online at http://www.ingentaselect.com [Violence against wives in Sarajevo area & Albania.]

871 MRVIĆ-PETROVIĆ, N. Separation and dissolution of the family. *Women, violence and war: wartime victimization of refugees in the Balkans*. Ed. V.Nikolić-Ristanović. Budapest: Central European University Press, 2000, pp.135-149. [Bosnian war.]

872 MRVIĆ-PETROVIĆ, N. Social acceptance and the difficulty of adapting to a new environment. *Women, violence and war: wartime victimization of refugees in the Balkans*. Ed. V.Nikolić-Ristanović. Budapest: Central European University Press, 2000, pp.171-186. [Bosnian war.]

873 NAHOUM-GRAPPE, V. Purifier le lien de filiation: les vils systématiques, 1991-1995. *L'Esprit*, 227 (1996) pp.150-163.

874 NAHUM-GRAPPE, V. La haine ethnique et ses moyens: les viols systématiques. *Confluences Méditerranée*, 17 (1996) pp.39-55. (Ex-Yougoslavie.)

875 NIKOLIĆ-RISTANOVIĆ, V. Physical abuse and homicide. *Women, violence and war: wartime victimization of refugees in the Balkans*. Ed. V.Nikolić-Ristanović. Budapest: Central European University Press, 2000, pp.85-98. [Women & children in the Bosnian war.]

876 NIKOLIĆ-RISTANOVIĆ, V. Sexual violence. *Women, violence and war: wartime victimization of refugees in the Balkans*. Ed. V.Nikolić-Ristanović. Budapest: Central European University Press, 2000, pp.41-77. (In the war in Bosnia-Herzegovina.)

877 NIKOLIĆ-RISTANOVIĆ, V. The Hague Tribunal and rape in the former Yugoslavia. *Women, violence and war: wartime victimization of refugees in the Balkans*. Ed. V.Nikolić-Ristanović. Budapest: Central European University Press, 2000, pp.79-83.

878 NIKOLIĆ-RISTANOVIĆ, V. & STEVANOVIĆ, I. The method and the sample - a contribution to the feminist critique of methodology. *Women, violence and war: wartime victimization of refugees in the Balkans*. Ed. V.Nikolić-Ristanović. Budapest: Central European University Press, 2000, pp.35-39. (Interviews with sixty-nine women refugees in the Federal Republic of Yugoslavia or in Serbian-held territories in Bosnia-Herzegovina.)

879 NIKOLIC-RISTANOVIC, Vesna. Living without democracy and peace: violence against women in the former Yugoslavia. *Violence against Women*, 5 i (1999) pp.63-80. Also online at http:// www.ingenta.com/journals/browse/sage/j322

880 OLUJIC, M. B. Embodiment of terror: gendered violence in peacetime and wartime in Croatia and Bosnia-Herzegovina. *Medical Anthropology Quarterly*, 12 i (1998) pp.31-50.

881 PAVLOVIĆ, Olivera. The participation of women in politics - analysis of the 2000 local and general elections in Bosnia and Herzegovina. *South-East Europe Review*, 4 iii (2001) pp.125-140.

882 PONTCHARA, Nicole de. Dans les yeux si noirs. *La Méditerranée des femmes*. Sous la dir. de Nabil el Haggar. Paris: L'Harmattan, 1998, pp.99-106. [War in Sarajevo.]

883 RODGERS, J. Bosnia, gender and the ethics of intervention in civil wars. *Civil Wars*, 1 i (1998) pp.103-116.

884 RODGERS, Jayne. Bosnia and Kosovo: interpreting the gender dimensions of international intervention. *Contemporary Security Policy*, 22 ii (2001) pp.183-195.

885 SALZMAN, Todd A. Rape camps as a means of ethnic cleansing: religious, cultural, and ethical responses to rape victims in the former Yugoslavia. *Human Rights Quarterly*, 20 ii (1998) pp.348-378. (A systematic policy of the Serbian government.)

886 SAMIC, Josna. La femme et la guerre en Bosnie (nouvelles). *La Méditerranée des femmes*. Sous la dir. de Nabil el Haggar. Paris: L'Harmattan, 1998, pp.79-94. (Temoignages romancés des femmes qui ont survécu à la séconde guerre mondiale, de même que de témoignages de celles qui ont subi les tortures dans la guerre présente.)

887 ŠILJAK, Emir & SPAHIĆ, Zilka. Organizovano seksualno nasilje. *Vrijeme beščašća: genocid nad Bošnjacima krajem dvadesetog stoljeća*. Zenica: Centar za Istraživanje Ratnih Zločina i Zločina Genocida nad Muslimanima Zenica, 1994, pp.285-296.

888 SMAJLOVIĆ, Nermina & MALKIĆ, Rasim. Silovanje kao oblik ratnog zločina. *Vrijeme beščašća: genocid nad Bošnjacima krajem dvadesetog stoljeća.* Zenica: Centar za Istraživanje Ratnih Zločina i Zločina Genocida nad Muslimanima Zenica, 1994, pp.295-302.

889 TAMBIAH, S. J. Obliterating the "other" in former Yugoslavia. *Paideuma* (Stuttgart), 44 (1998) pp.77-95. [Rape of women as warfare.]

890 TAZI, Nadia. Le viol des Bosniaques. *Cahiers Intersignes,* 8-9 (1994) pp.149-154.

891 Vakuf-nama Aiše, kćeri Hadži Ahmeda iz Mostara: treća dekada rebiu-l-evvela 1056 (7-16. maja 1646). Tr. Nametak, Fehim. *Prilozi za Orientalnu Filologiju,* 44-45, 1994-95, pp.363-366. [Facsimile of Turkish document and Bosnian translation.]

Brazil

Articles

892 HANSEN, R. Muslimsk bryllup i Brasil. *3.Verden-Magasinet X,* 4 v (1995) pp.32-33.

Bulgaria

Articles

893 IVANOVA, S. Muslim and Christian women before the *Kadı* court in eighteenth century Rumeli: marriage problems. *Oriente Moderno,* 18 (79) i (1999) pp.161-176. (*Kadı sicils* of the towns of Sofia, Ruse, Vidin & Silistra.)

894 IVANOVA, Svetlana. The divorce between Zubaida Hatun and Esseid Osman Ağa in the eighteenth-century shari'a court of Rumelia. *Women, the family, and divorce laws in Islamic history.* Ed. A.El Azhary Sonbol. Syracuse: Syracuse University Press, 1996, pp.112-125. (Silistra.)

895 NEUBURGER, M. Difference unveiled: Bulgarian national imperatives and the re-dressing of Muslim women, 1878-1989. *Nationalities Papers,* 25 i (1997) pp.169-183.

Burkina Faso

Books

896 PUGET, Françoise. *Femmes peules du Burkina Faso: stratégies féminines et développement rural.* Paris: L'Harmattan, 1999. 319pp.

Cameroon

Articles

897 AMIN, Martin E. & FONKENG, George E. Gender and the demand for primary education in Cameroon. *Social change for women and children.* Ed. V.Demos [&] M.T.Segal. Stamford (USA): JAI Press, 2000, (Advances in Gender Research,4), pp.123-155. (Comparisons ... between predominantly Christian and predominantly Muslim areas.)

898 BARRY, L. S. Les modes de composition de l'alliance. Le "mariage arabe". (Abstract: Patterns of affinity compositions: marriage with the parallel patrilateral cousin.). *L'Homme,* 147 (1998) pp.17-50. (Données matrimoniales ... recueillies auprès des communautés peules du Nord-Cameroun.)

899 CALVÈS, A-E. & MEEKERS, D. The advantages of having many children for women in formal and informal unions in Cameroon. *Journal of Comparative Family Studies,* 30 iv (1999) pp.x;vi;617-639. [Incl. Muslims.]

900 DJINGUI, Mahmoudou. Evolution de l'espace habitable et transformation des identités féminines chez les Fulbe du Nord-Cameroun. (Abstract: The evolution of living space and the transformation of female identities among the Fulani of northern Cameroon.). *Transforming female identities: women's organizational forms in West Africa.* Ed. E.E.Rosander. Uppsala: Nordiska Afrikainstitutet, 1997, (Seminar Proceedings, 31), pp.214-226.

901 GERRARD, S. Gender and ethnicity: the organization of fishery in Mbakaou, a village in Adamawa Province, Cameroon. *Ngaoundéré-Anthropos,* 1 (1996) pp.55-69.

902 GWANFOGBE, P. N., SCHUMM, W. R., SMITH, Meredith & FURROW, J. L. Polygyny and marital life satisfaction: an exploratory study from rural Cameroon. *Journal of Comparative Family Studies,* 28 i (1997) pp.vii;xiii;55-71. [Incl. Muslims.]

903 HOLTEDAHL, L. Magic and love on the road to higher education. *Ngaoundéré-Anthropos,* 1 (1996) pp.70-89. [Magic and marriage in Muslim and Christian women's narratives about their education.]

904 HOLTEDAHL, L. Magic and love on the road to higher education in Cameroon. (Résumé: Magie et amour sur la route vers l'enseignement supérieur au Cameroun.). *Transforming female identities: women's organizational forms in West Africa.* Ed. E.E.Rosander. Uppsala: Nordiska Afrikainstitutet, 1997, (Seminar Proceedings, 31), pp.197-213. [Muslim & Christian examples.]

905 HOLTEDAHL, L. Magie, amour et études supérieures: les difficultés de la promotion féminine. (Summar[y]: Magic. love and higher education.). *Le pouvoir du savoir de l'Arctique aux Tropiques. The power of knowledge from the Arctic to the Tropics.* L.Holtedahl, S.Gerrard, M.Z.Njeuma, J.Boutrais (eds). Paris: Karthala, 1999, pp.43-62;499-500. [Muslim Fulbe & Christians of Ngaoundéré compared.]

906 MAHMOUDOU, Djingui. Transformation des images et des pratiques de la vie conjugale chez les Foulbé de Ngaoundéré. (Summar[y]: Transformation of the images and patterns of married life among the Fulani of Ngaoundere.]. *Le pouvoir du savoir de l'Arctique aux Tropiques. The power of knowledge from the Arctic to the Tropics.* L.Holtedahl, S.Gerrard, M.Z.Njeuma, J.Boutrais (eds). Paris: Karthala, 1999, pp.63-83;500-501.

907 MEKOUNDE, A. I. La naissance du groupe *Nsaw-Mboum* des femmes de Ngaoundéré. (Abstract: The creation of the women's group *Nsaw-Mboum* in Ngaoundéré, Cameroon.). *Transforming female identities: women's organizational forms in West Africa.* Ed. E.E.Rosander. Uppsala: Nordiska Afrikainstitutet, 1997, (Seminar Proceedings, 31), pp.87-95. [Muslims.]

908 MULLER, J-C. Changement des sens interdits et des rites: deux exemples contemporains chez les Dii de l'Adamawa. *Ngaoundéré-Anthropos,* 2 (1997) pp.41-51. [Changed meanings of taboos and marriage rites among the Dii, a Muslim-majority tribe in northern Cameroon.]

909 NASSOUROU, Saibou. Les femmes comme personnes politiques et détentrices du savoir: l'institution du *hiirde* dans la société peule. (Summar[y]: Women as political individuals and bearers of knowledge: the *hiirde* institution in Fulbe society.). *Le pouvoir du savoir de l'Arctique aux Tropiques. The power of knowledge from the Arctic to the Tropics.* L.Holtedahl, S.Gerrard, M.Z.Njeuma, J.Boutrais (eds). Paris: Karthala, 1999, pp.119-128;503. (Du Nord-Cameroun ... un divertissement ... à l'occasion d'une cérémonie sociale.)

910 NOUMBISSI, Amadou & SANDERSON, J-P. La communication entre conjoints sur la planification familiale au Cameroun. Les normes et les stratégies du couple en matière de féconditeé. *Population* (Paris), 54 i (1999) pp.131-144. [Incl. Muslims.]

911 SANTEN, J. C. M. van. Islam, gender and urbanisation among the Mafa of north Cameroon: the differing commitment to 'home' among Muslims and non-Muslims. *Africa: Journal of the International African Institute. Revue de l'Institut Africain International,* 68 iii (1998) pp.403-424.

912 VIRTANEN, Tea. Ambiguous followings: tracing
 autonomy in pastoral Fulbe society. *Shifting ground and
 cultured bodies: postcolonial gender relations in Africa
 and India.* Ed. Karen Armstrong. Lanham: University Press
 of America, 1999, pp.41-66. (Of the Adamawa highlands
 in Cameroun.)

913 WALLAERT, H. Pots, potières et apprenties Vere du
 Cameroun. *Ngaoundéré-Anthropos,* 2 (1997) pp.65-88.
 [The role of women potters among the Vere, a Muslim
 tribe in Cameroon.]

Canada

Books

914 KHAN, Shahnaz. *Muslim women: crafting a North
 American identity.* Gainesville: University Press of Florida,
 2000. 151pp. [Canada.]

Articles

915 ABUSHARAF, Rogaia Mustafa. Migration with a feminine
 face: breaking the cultural mold. *Arab Studies Quarterly,*
 23 ii (2001) pp.61-85. [Sudanese women migrating alone
 to North America.]

916 DOSSA, Parin. Reconfiguring the question: "Who is a
 refugee?" Coming to voice, coming to power: one woman's
 story. *Pakistan Jounal of Women's Studies:
 Alam-e-Niswan,* 9 i (2002) pp.27-55. [Iranian woman
 now living in Canada.]

917 GIBB, Camilla & ROTHENBERG, Celia. Believing
 women: Harari and Palestinian women at home and in the
 Canadian diaspora. *Journal of Muslim Minority Affairs,*
 20 ii (2000) pp.243-259. Also online at
 www.catchword.com

918 IBRAHIM, Awad el-Karim M. Becoming Black: rap and
 hip-hop, race, gender, identity, and the politics of ESL
 learning. *TESOL Quarterly,* 33 iii (1999) pp.349-369.
 [Among Somali, Jibutian, Ethiopian, Senegalese & Togoan
 English-language learners in Ontario.]

919 KHAN, Shahnaz. Muslim women: negotiations in the third
 space. *Signs,* 23 ii (1998) pp.463-494. (Two very
 different Muslim women living in Canada.)

920 KHAN, Shahnaz. Muslim women: negotiations in the third
 space. *Gender, politics, and Islam.* Ed. Therese Saliba,
 Carolyn Allen and Judith A.Howard. Chicago: University
 of Chicago Press, 2002, pp.305-336. (Two very different
 muslim women living in Canada.) [Originally published
 in *Signs,* 23 ii (1998).]

921 MCDONOUGH, Sheila. The Muslims of Canada. *The
 South Asian religious diaspora in Britain, Canada, and
 the United States.* Ed. H.Coward, J.R.Hinnells, &
 R.B.Williams. Albany (USA): State University of New
 York Press, 2000, pp.173-181.

922 MOGHISSI, Haideh. Away from home: Iranian women,
 displacement cultural resistance and change. *Journal of
 Comparative Family Studies,* 30 ii (1999)
 pp.vi;x;207-217. [In Canada.]

923 RALSTON, H. South Asian immigrant women organize
 for social change in the diaspora: a comparative study.
 Asian and Pacific Migration Journal, 7 iv (1998)
 pp.453-482. [Migrants, incl. Muslims, in Canada,
 Australia, & New Zealand.]

924 SHAKERI, Esmail. Muslim women in Canada: their role
 and status as revealed in the *Hijab* controversy. *Muslims
 on the Americanization path?* Ed. Y.Yazbeck Haddad,
 J.L.Esposito. New York: Oxford University Press, 2000,
 pp.129-144. [First published in 1998 by University of
 South Florida.]

Central Asia (general)

Articles

925 AKINER, Shirin. Between tradition and modernity: the
 dilemma facing contemporary Central Asian women.
 Post-Soviet women: from the Baltic to Central Asia. Ed.
 M.Buckley. Cambridge: Cambridge University Press, 1997,
 pp.261-304.

926 AKINER, Shirin. Frauenemanzipation: ein
 zentralasiatischer Überblick. *Feminismus, Islam, Nation:
 Frauenbewegungen im Maghreb, in Zentralasien und in
 der Türkei.* (Hg.) Claudia Schöning-Kalender, Aylâ Neusel,
 Mechtild M.Jansen. Frankfurt a.M.: Campus, 1997,
 pp.95-124.

927 ALIMOVA, Dilarom A. A historian's vision of 'Khudjum'.
 Central Asian Survey, 17 i (1998) pp.147-155. [Official
 Soviet measures to liberate Central Asian women.]

928 ALLÈS, E. Le mariage chez les Dounganes en Asie
 centrale: stratégies féminines et espaces de négociation.
 Lettre d'Asie Centrale, 3 (1995) pp.13-14.

929 FATHI, Habiba. Les *otines,* sermonnaires inconnues de
 l'islam centrasiatique. *Revue des Mondes Musulmans et
 de la Méditerranée,* 85-86 (1999) pp.185-201. [Women
 preachers.]

930 FATHI, Habiba. *Otines:* the unknown women clerics of
 Central Asian Islam. *Central Asian Survey,* 16 i (1997)
 pp.27-43. [Soviet & post-Soviet era.]

931 HARRIS, C. Women of the sedentary population of
 Russian Turkestan through the eyes of Western travellers.
 Central Asian Survey, 15 i (1996) pp.75-95.

932 IKRAMOVA, Ula & MCCONNELL, Kathryn. Women
 NGOs in Central Asia's evolving societies. *Civil society
 in Central Asia.* Ed. by M.Holt Ruffin, Daniel C.Waugh.
 Seattle: Center for Civil Society International [and] The
 Central Asia-Caucasus Institute, Nitze School of Advanced
 International Studies, Johns Hopkins University, in
 association with University of Washington Press, 1999,
 pp.198-213.

933 KNYAZEV, A. So ist es Sitte in Mittelasien ...: zur Lage
 moslemischer Frauen. *Ost-Europa,* 44 x (1994)
 pp.A571-A572. [Translated from Russian.]

934 LOBACHEVA, N. P. On the history of the *paranja.*
 Anthropology & Archeology of Eurasia, 36 ii (1997)
 pp.63-90. pp.63-90. [Central Asian women's cloak.]
 (Worn on the street, primarily among the urban Uzbek &
 Tajik population.)

935 LUBIN, Nancy. New threats in Central Asia and the
 Caucasus: an old story with a new twist. *Russia, the
 Caucasus, and Central Asia: the 21st century security
 environment.* Rajan Menon, Y.E.Fedorov, & Ghia Nodia,
 eds. Armonk: Sharpe, 1999, pp.205-225.

936 MEGORAN, N. Theorizing gender, ethnicity and the
 nation-state in Central Asia. *Central Asian Survey,* 18 i
 (1999) pp.99-110.

937 MUKMINOVA, Raziya. Le rôle de la femme dans la
 société de l'Asie centrale sous les Timourides et les
 Sheybanides. Tr. Akimova, A. *Cahiers d'Asie Centrale,*
 3-4 (1997) pp.203-212.

938 TABYSHALIEVA, A. Women of Central Asia and the
 fertility cult. Tr. Lang, S. *Anthropology & Archeology
 of Eurasia,* 36 ii (1997) pp.45-62.

939 TOGAN, Isenbike. In search of an approach to the history
 of women in Central Asia. *Rethinking Central Asia:
 non-Eurocentric studies in history, social structure and
 identity.* Ed. Korkut A.Ertürk. Reading: Ithaca, 1999,
 pp.163-195.

940 TOKHTAKHODZHAEVA, Marfua. Auf der Suche nach
 Identität: Frauen in Zentralasien. *Feminismus, Islam,
 Nation: Frauenbewegungen im Maghreb, in Zentralasien
 und in der Türkei.* (Hg.) Claudia Schöning-Kalender, Aylâ
 Neusel, Mechtild M.Jansen. Frankfurt a.M.: Campus, 1997,
 pp.251-262.

Chad

Books

941 TUBIANA, M-J. *Femmes du Sahel, Tchad-Soudan: regards donnés. Women of the Sahil, Chad-Sudan: reflections.* Textes et photographies / texts and photos. Tr. Skye, A-M. Saint-Maur-des-Fossés: Sépia 1994. 79pp.

942 WATSON, C. *The flight, exile and return of Chadian refugees: a case study with a special focus on women.* [Geneva:] United Nations Research Institute for Social Development (UNRISD), 1996, (UNRISD Report, 96. 2), 182pp.

Articles

943 Women denounce their treatment in Chad / Women's Commission of the Human Rights League of Chad & the editors. *What women do in war time: gender and conflict in Africa.* Ed. M.Turshen, C.Twagiramariya. London: Zed, 1998, pp.118-128.

China, including Xinjiang

Books

944 JASCHOK, Maria & SHUI JINGJUN *The history of women's mosques in Chinese Islam: a mosque of their own.* Richmond: Curzon, 2000. 361pp.

Articles

945 ALLÈS, Elisabeth. Des oulémas femmes: le cas des mosquées féminines en Chine. *Revue des Mondes Musulmans et de la Méditerranée,* 85-86 (1999) pp.215-236.

946 ALLES, E. L'islam chinois: femmes *ahong. Études Orientales,* 13-14 (1994) pp.163-167. (Terme d'origine persane, équivalent en chinois à imam.)

947 ALLES, E. Une organisation de l'islam au féminin: le personnel des mosquées féminines chinoises. *Transmission du Savoir dans le Monde Musulman Périphérique: Lettre d'Information,* 14 (1994) pp.1-12.

948 ALLÈS, E. Moscheen als weiblichen Institutionen - religiöse Karrieren von Frauen in China. *Der neue Islam der Frauen. Weibliche Lebenspraxis in der globalisierten Moderne: Fallstudien aus Afrika, Asien und Europa.* R.Klein-Hessling, S.Nökel, K.Werner (Hg.). Bielefeld: transcript Verlag, 1999, pp.297-312.

949 BELLÉR-HANN, Ildikó. Crafts, entrepreneurship and gendered economic relations in southern Xinjiang in the era of 'socialist commodity economy'. *Central Asian Survey,* 17 iv (1998) pp.701-718.

950 BELLÉR-HANN, Ildikó. Geschlechtsspezifische Arbeitsteilung bei den Uiguren im Nordwesten Chinas. *Die geschlechtsspezifische Einbettung der Ökonomie: empirische Untersuchungen über Entwicklungs- und Transformationsprozesse* / Gudrun Lachenmann, Petra Dannecker (Hrsg.). Münster: Lit, 2001, (Market, Culture and Society, 12), pp.321-346.

951 BELLÉR-HANN, Ildikó. Women, work and procreation beliefs in two Muslim communities. *Conceiving persons: ethnographies of procreation, fertility and growth* / P.Loizos and P.Heady. London: Athlone Press, 1999, (London School of Economics Monographs on Social Anthropology, 68), pp.113-137. (Lazi villagers in northeast Turkey; Uighurs in Xinjiang.)

952 BELLÉR-HANN, Ildikó. Work and gender among Uighur villagers in southern Xinjiang. *CEMOTI,* 25 (1998) pp.93-114.

953 CHERIF, Leïla. Ningxia, l'école au féminin. *Études Orientales,* 13-14 (1994) pp.156-162. (Les filles Hui.)

954 HALFON, C-H. Souvenirs de voyage dans le Chine islamique profonde: etre femme et musulmane à Lanzhou, au Gansu. *Études Orientales,* 13-14 (1994) pp.151-155.

955 HAWWA, Sithi. From cross to crescent: religious conversion of Filipina domestic workers in Hong Kong. *Islam and Christian-Muslim Relations,* 11 iii (2000) pp.347-367. Also online at www.catchword.com (Conversion is found to result primarily from their romantic involvement or inter-marriage with Pakistani men.)

956 HAWWA, Sithi. Religious conversion of Filipino domestic helpers in Hong Kong. *ISIM Newsletter,* 4 (1999) pp.10-10. [To Islam.]

957 MA WEI, MA JIANZHONG & STUART, Kevin. The Xunhua Salar wedding. *Asian Folklore Studies,* 58 i (1999) pp.31-76.

958 MEI ZHANG. The effect of privatisation policies on rural women's labour and property rights in Inner Mongolia and Xinjiang. *Culture and environment in Inner Asia.* Vol. 2: *Society and culture.* Ed. C.Humphrey & D.Sneath. Knapwell: White Horse, 1996, pp.61-96. [Incl. Kazakhs.]

Comoros

Articles

959 BLANCHY, S. Le partage des bœufs dans le mariage coutumier de la grande Comore. *Journal des Africanistes,* 66 (1996) pp.168-201.

960 LE HOUEROU, F. Grand mariage et exil. *Hommes & Migrations,* 1215 (1998) pp.32-39. (Comores.)

Crimea

Articles

961 ŚWIĘCICKA, Elżbieta. The diplomatic letters by Crimean Keräy ladies to the Swedish royal house. *Rocznik Orientalistyczny,* 55 i (2003) pp.57-90. [17th century.]

Cyprus

Books

962 JENNINGS, R. C. *Studies on Ottoman social history in the sixteenth and seventeenth centuries: women, zimmis and Sharia courts in Kayseri, Cyprus and Trabzon.* Istanbul: Isis Press, 1999, (Analecta Isisiana, 39), 728pp.

Articles

963 BETON, Emine I. & ERTEK, Tümay. Returns to education in North Cyprus. *ODTÜ Gelişme Dergisi. METU Studies in Development,* 24 i (1997) pp.161-168. (Male - female earnings differential.)

964 ERÖNEN, Gönül. Turkish Cypriot women and Cedaw. *Kadın / Woman 2000,* 1 i (2000) pp.61-77. (Convention on the Elimination of all forms of Discrimination Against Women.)

965 GÜVEN-LISANILER, Fatma & UĞURAL, Sevin. Occupational segregation: the position of women in the North Cyprus labor market. *Kadın / Woman 2000,* 2 i (2001) pp.117-131.

966 FASLI, Mukaddes & DAĞLI, Uğur. The changing role of Cypriot women in urban residential exterior spaces. *Kadın / Woman 2000,* 2 ii (2001) pp.49-66. [Cypriot architecture 1571-2000.]

967 HUGHES, K. Women and war: the Greek Cypriot experience. *Women: a Cultural Review,* 8 i (1997) pp.81-88.

968 KILLORAN, M. Good Muslims and "bad Muslims", "good" women and feminists: negotiating identities in northern Cyprus (or, the condom story). *Ethos,* 26 ii (1998) pp.183-203.

969 OSAM, Necdet. A sex-related attitude study in word
 choice: the case of Turkish Cypriots. *Kadın / Woman 2000*,
 2 ii (2001) pp.11-24.

970 PRODROMOU, P. Elles marchent contre le mur de la
 honte .. *Confluences Méditerranée*, 17 (1996)
 pp.165-170. (Femmes et guerres: Chypre.)

971 VASSILIADOU, Myria. 'Herstory': the missing woman
 of Cyprus. *Cyprus Review*, 9 i (1997) pp.95-120. [Since
 ancient times, incl. Ottoman period & Islamic influence.]

Denmark

Books

972 ALI, Fatuma. `Hvor kommer du fra?': min vej til
 Danmark. Copenhagen: Munksgaard/Rosinante, 1994.
 112pp.

973 HEIDE-JØRGENSEN, V. *Allahs piger*. Copenhagen:
 Aschehoug, 1996. 206pp. (8 indvandrer-piger fortæller
 om livet og kærligheden.)

Articles

974 ABEID, Galawiesh. Behovene hos kurdiske
 flygtninge-kvinder i Danmark. *Grundinformation
 Kurderne med et kort efterskrift fra februar 1991 og nyt
 indstik maj 1994*. Red. B.Frederiksen. Copenhagen: Dansk
 Flygtningehjælp, 1994, pp.27-30.

975 CAKMAK, Metin & ARABACI, Jiyan A. Multi-level
 discrimination against Muslim women in Denmark.
 Multi-level discrimination of Muslim women in Europe.
 Jochen Blaschke (ed.). Berlin: Parabolis, 2000,
 pp.139-202.

976 CARØE CHRISTIANSEN, Connie. Islamischer
 Frauenaktivismus in Dänemark aus transnationaler
 Perspektive. Tr. Hess, Michael Reinhard. *Die neue
 Muslimische Frau: Standpunkte & Analysen* / hrsg. Barbara
 Pusch. Istanbul: Orient-Institut der Deutschen
 Morgenländischen Gesellschaft; Würzburg: Ergon, 2001,
 (Beiruter Texte und Studien, 85), pp.277-294.

977 DYHR, L. Mødet mellem læger og tyrkiske
 indvandrerkvinder. *Humaniora: et Magasin om
 Humanistisk Forskning*, 11 i (1997) pp.20-23. (I
 Danmark.)

978 MØRCK, Y. Gender and generation: young Muslims in
 Copenhagen. *Muslim European youth: reproducing
 ethnicity, religion, culture*. Ed. S.Vertovec, A.Rogers.
 Aldershot: Ashgate, 1998, pp.133-144.

979 NECEF, Mehmet Ümit. Blandede ægteskaber og
 racerenhed. *Mellemøst-Information*, 10 xi (1993)
 pp.7-9. [Turks in Denmark.]

980 NECEF, Mehmet Ümit. Den muslimske Romeo og
 Julie-tragedie. *Mellemøst-Information*, 11 iv (1994)
 pp.11-14. [Suicide of Pakistani girl in Copenhagen facing
 arranged marriage in Pakistan, followed by that of her
 Iranian-Indian schoolmate.]

981 NECEF, Mehmet Ümit. Nylonpiger og nye mødomme.
 Mellemøst-information, 15 v (1998) pp.4-7. (Unge
 muslimske piger i Danmark.)

982 WIEN, C. Kvindelig omskæring - i Danmark?
 Mellemøst-Information, 11 x (1994) pp.7-10. [Somalis.]

East Africa (general)

Books

983 LINNEBUHR, E. *Sprechende Tücher: Frauenkleidung
 der Swahili (Ostafrika). Katalog*. Stuttgart:
 Linden-Museum, 1994. 58pp.

Articles

984 ASKEW, Kelly M. Female circles and male lines: gender
 dynamics along the Swahili coast. *Africa Today*, 46 iii-iv
 (1999) pp.88-102.

985 CONSTANTIN, François. Condition féminine et
 dynamique confrérique en Afrique orientale. *Islam et
 islamismes au sud du Sahara*. Sous la dir. de Ousmane
 Kane & Jean-Louis Triaud. Aix-en-Provence: IREMAM;
 Paris: Karthala, 1998, pp.31-40.

986 GOWER, R., SALM, S. & FALOLA, T. Swahili women
 since the nineteenth century: theoretical and empirical
 considerations on gender and identity construction. *Africa
 Today*, 43 iii (1996) pp.251-260.

Egypt

Books

987 ['ABD AL-HĀDĪ, Amal]. *We are decided: the struggle
 of an Egyptian village to eradicate female circumcision* /
 Amal Abdel Hadi. Revised by Nida Kirmani. Tr. Wafa,
 Man[a]r. Cairo: Cairo Institute for Human Rights Studies,
 1998, (Women Initiatives, 31), 129pp.

988 ABNOUDY, Ateyyat el. *Days of democracy: Egyptian
 women in elections*. [Cairo:] Kassem Press, 1998. 197pp.

989 ABU-LUGHOD, Lila. *Veiled sentiments: honor and
 poetry in a Bedouin society*. Updated [2nd] ed. with a new
 preface. Berkeley: University of California Press, 1999.
 317pp. [First published Berkeley 1986. Egypt.]

990 AHMED, Leila. *A border passage: from Cairo to America
 - a woman's journey*. New York: Farrar, Straus & Giroux,
 1999. 307pp.

991 AMĪN, Qāsim. *La nueva mujer*. Tr. Pacheco, Juan
 Antonio. Madrid: Instituto Egipcio de Estudios Islámicos,
 2000. 163pp. [Tr. of *Al-Mar'a al-jadīda*.]

992 AMĪN, Qāsim. *The liberation of women and The new
 woman: two documents in the history of Egyptian feminism*.
 Tr. Peterson, Samiha Sidhom. Cairo: American University
 in Cairo Press, 2000. 205pp.

993 AMIN, Sajeda & LLOYD, C. B. *Women's lives and rapid
 fertility decline: some lessons from Bangladesh and Egypt*.
 New York: The Population Council, 1998, (Policy
 Research Division Working Papers, 1998/117), 62pp.

994 BASYOUNY, Iman Farid. *"Just a gaze": female clientèle
 of diet clinics in Cairo: an ethnomedical study*. Cairo:
 American University in Cairo Press, 1998, (Cairo Papers
 in Social Science, 20 iv / 1997), 150pp. [In English.
 Arabic title-page: *Mujarrad naẓra* / Īmān Farīd Basyūnī.]

995 BIBARS, Iman. *Victims and heroines: women, welfare
 and the Egyptian state*. London: Zed, 2001. 206pp.

996 BOTMAN, S. *Engendering citizenship in Egypt*. New
 York: Columbia University Press, 1999. 141pp.

997 DAHL, T. S. *Den muslimske familie: en endersøkelse av
 kvinners rett i islam*. 2 oppl. Oslo: Universitetsforlaget,
 1993. 188pp. (Hvordan familien har fungert gjennom
 1970-, 80- og 90- årenes fattige Kairo.)

998 DAHL, T. S. *The Muslim family: a study of women's rights
 in Islam*. Tr. Walford, R. Oslo: Scandinavian University
 Press, 1997. 211pp. [Tr. of *Den muslimske familie*, Oslo
 1993. Egypt in 1970s-90s.]

999 FAWZY-ROSSANO, Didar. *Mémoires d'une militante
 communiste (1942-1990): du Caire à Alger, Paris et
 Genève: lettres aux miens*. Paris: L'Harmattan, 1997.
 287pp.

1000 HAERI, Niloofar. *The sociolinguistic market of Cairo:
 gender, class, and education*. London: Kegan Paul
 International "1996", 1997, (Library of Arabic Linguistics:
 Monograph 13), 273pp. [English, with preface and
 summary also in Arabic. Arabic title:*Al-taghayyur fī lahjat
 al-Qāhira al-mu'āṣira: dirāsa fī 'l-lisānīyāt al-'Arabīya*.]

1001 HARDERS, C. *Frauen und Politik in Ägypten: Untersuchungen zur Situation ägyptischer Politikerinnen.* Münster: Lit, 1995, (Demokratie und Entwicklung, 16), 166pp.

1002 HOODFAR, Homa. *Between marriage and the market: intimate politics and survival in Cairo.* Berkeley: University of California Press, 1997, (Comparative Studies on Muslim Societies, 24), 302pp.

1003 INHORN, M. C. *Infertility and patriarchy: the cultural politics of gender and family life in Egypt.* Philadelphia: University of Pennsylvania Press, 1996. 296pp.

1004 KARAM, Azza M. *Women, Islamisms and the state: contemporary feminisms in Egypt.* Basingstoke: Macmillan Press, 1998. 284pp.

1005 KHATTAB, Hind, YOUNIS, Nabil & ZURAYK, Huda. *Women, reproduction, and health in rural Egypt: the Giza study.* Cairo: American University in Cairo Press, 1999. 220pp.

1006 MACHAT, Sabera Neeltje. *Feuer der Wüste, Frau der Erde: 150 Tage alleine in der Wüste Sinai.* München: Erd, 1999. 136pp.

1007 NABHAN, Muna. *Der zār-Kult in Ägypten: rituelle Begegnung von Geist und Mensch: ein Beispiel komplementärer Gläubigkeit.* Frankfurt a. M. : Lang 1994 (Europäische Hochschulschriften, Reihe 19: Volkskunde/Ethnologie, B32), 334pp.

1008 NELSON, C. *Doria Shafik, Egyptian feminist: a woman apart.* Gainesville: University Press of Florida, 1996. 322pp.

1009 PECK, William H. *The dancer of Esna.* [Cambridge]: Association for the Study of Travel in Egypt and the Near East, [2003] (ASTENE Working Papers, 1), 11pp. (A consideration of the Ghawazee, their expulsion from Cairo by Mohammad Ali, relocation to Upper Egypt and the subsequent attraction they held for European[s] and Americans.)

1010 RAMLY, Eman. *Women's perceptions of environmental change in Egypt.* Cairo: American University in Cairo Press, 2002 (Cairo Papers in Social Science, 23 iv / 2000), 85pp. [Arabic abstract & t-p: *Ru'yat al-mar'a li-l-taghayyurāt al-bī'īya fī Miṣr* / Īmān al-Ramlī.]

1011 REUTER, B. *Gelebte Religion: religiöse Praxis junger Islamistinnen in Kairo.* Würzburg: Ergon, 1999, (Mitteilungen zur Sozial- und Kulturgeschichte der Islamischen Welt, 5), 286pp.

1012 [SADAT, Jehan]. *Egyiptom asszonya* / Dzsehan Szadat. Tr. Tandori, D. [Budapest:] Geomédia, 1995. 335pp. [Tr. of *A woman of Egypt*, 1987.]

1013 [SA'DĀWĪ, Nawāl al-]. *A daughter of Isis: the autobiography of Nawal El Saadawi.* Tr. Hetata, Sherif. London & New York: Zed, 1999. 294pp.

1014 SA'DĀWĪ, Nawāl al-. *Fundamentalismus gegen Frauen: die "Löwin vom Nil" und ihr Kampf für die Menschenrechte der Frau* / Nawal el Saadawi. Tr. Dallas-Mahmoud, Aminta. Kreuzlingen: Hugendubel, 2002. 235pp.

1015 SA'DĀW'I, Nawāl al-. *Memorias de la cárcel de mujeres.* Tr. Corniero, M. Madrid: Horas y Horas, 1995. 217pp. [Tr. of *Mudhakkirātī fī sijn al-nisā'.*]

1016 [SA'DĀWĪ, Nawāl al-]. *Walking through fire: a life of Nawal El Saadawi.* Tr. Hetata, Sherif. London: Zed, 2002. 251pp.

1017 SENGERS, Gerda Cornelia. *Vrouwen en demonen: Zar en korangenezing in hedendaags Egypte.* Amsterdam: Het Spinhuis, 2000. 269pp.

1018 SENGERS, Gerda [Cornelia]. *Women and demons: cultic healing in Islamic Egypt.* Leiden: Brill, 2002 (International Studies in Sociology and Social Anthropology, 86), 250pp.

1019 TALHAMI, Ghada. *The mobilization of Muslim women in Egypt.* Gainesville: University Press of Florida, 1996. 177pp.

1020 WERNER, K. *Between Westernization and the veil: contemporary lifestyles of women in Cairo.* Bielefeld: Transcript Verlag, 1997. 302pp.

1021 *Daughters of the Nile: photographs of Egyptian women's movements, 1900-1960.* Ed. Wassef, Hind & Wassef, Nadia. Cairo: American University in Cairo Press, 2001. 156+20pp. [English & Arabic. Arabic title: *Banāt al-Nīl : laqaṭāt min ḥarakāt nisā'īya, 1900-1960.*]

1022 *Development, change and gender in Cairo: a view from the household.* Ed. Singerman, D. & Hoodfar, Homa. Bloomington: Indiana University Press, 1996. 195pp.

Articles

1023 FARGHĀNĪ, Nādir. L'éducation féminine en Egypte: éléments pour un bilan ? Nader Fergany. Tr. Farag, Iman. *Egypte / Monde Arabe*, 18-19 (1994) pp.101-113.

1024 ABAZA, Mona. Perceptions of 'urfi marriage in the Egyptian press. *ISIM Newsletter*, 7 (2001) pp.20-21.

1025 ABD-ALLA, Ghada Mostafa. The economic and social impacts of girls' basic education on female's productivity in Egypt. *Population and Development Research Monograph Series*, 4 (1996) pp.480-514.

1026 ABDAL-REHIM, Abdal-Rehim Abdal-Rahman. The family and gender laws in Egypt during the Ottoman period. *Women, the family, and divorce laws in Islamic history*. Ed. A.El Azhary Sonbol. Syracuse: Syracuse University Press, 1996, pp.96-111.

1027 ABDEL-HAKIM, Sahar Sobhi. Gender politics in a colonial context: Victorian women's accounts of Egypt. *Interpreting the Orient: travellers in Egypt and the Near East*. Ed. Paul & Janet Starkey. Reading: Ithaca, 2001, pp.111-122.

1028 ABDEL MOTAAL, Doaa. Reconstructing development: women at the Muqattam *zabbalin* settlement. *The zabbalin community of Muqattam. Ḥayy al-zabbālīn fī 'l-Muqaṭṭam* / E.Volpi & Doaa Abdel Motaal. Cairo: American University in Cairo, 1997, (Cairo Papers in Social Science, 19 iv (1996)), pp.59-110.

1029 ABUGIDEIRI, Hibba. Egyptian women and the science question: gender in the making of colonized medicine, 1893-1919. *Arab Studies Journal / Majallat al-Dirāsāt al-'Arabīya*, 4 ii (1996) pp.46-78.

1030 ABU-LUGHOD, Lila. Melodramas of nationhood. *Arab nation, Arab nationalism*. Ed. D.Hopwood. Basingstoke: Macmillan: New York: St. Martin's Press, in association with St. Antony's College, Oxford, 2000, pp.103-128. (The domestic audience for television serials in Egypt.)

1031 ABU-LUGHOD, Lila. The marriage of feminism and Islamism in Egypt: selective repudiation as a dynamic of postcolonial cultural politics. *Remaking women: feminism and modernity in the Middle East*. Ed. Lila Abu-Lughod. Princeton: Princeton University Press, 1998, pp.243-269.

1032 ABU-LUGHOD, Lila. Women on women: television feminism and village lives. *Women and power in the Middle East*. Ed. Suad Joseph & Susan Slyomovics. Philadephia: University of Pennsylvania Press, 2001, pp.103-114;211-212. [Upper Egypt.]

1033 AFIFI, Mohamed. Le mariage et la vie sociale en Egypte au XVIIIe siécle. *Histoire économique et sociale de l'Empire ottoman et de la Turquie (1326-1960). Actes du Congrès international tenu à Aix-en-Provence ... 1994.* Sous la responsabilité de D.Panzac. Paris: Peeters, 1995, (Collection Turcica, 8), pp.301-304.

1034 ALI, Kamran Asdar. Conflict or cooperation: changing gender roles in rural Egyptian households. *Directions of change in rural Egypt*. Ed. N.S.Hopkins, K.Westergaard. Cairo: American University in Cairo Press, 1998, pp.166-183.

1035 ALI, Kamran Asdar. Creating bodies, organizing selves: planning the family in Egypt. *Situating globalization: views from Egypt*. Cynthia Nelson, Shahnaz Rouse (eds). Bielefeld: Transcript, 2000, pp.231-253.

1036 ALI, Kamran Asdar. Faulty deployments: persuading women and constructing choice in Egypt. *Comparative Studies in Society and History*, 44 ii (2002) pp.370-394. Also online at http:// journals.cambridge.org (Late twentieth century development initiatives.)

1037 ALI, Mohamed M. Quality of care and contraceptive pill discontinuation in rural Egypt. *Journal of Biosocial Science*, 33 ii (2001) pp.161-172.

1038 ALI, Nadje al-. "We are not feminists!" Egyptian women activists on feminism. *Situating globalization: views from Egypt.* Cynthia Nelson, Shahnaz Rouse (eds). Bielefeld: Transcript, 2000, pp.337-358.

1039 ALI, Nadje S.al-. Between political epochs and personal lives: formative experiences of Egyptian women activists. *Auto/biography and the construction of identity and community in the Middle East.* Ed. by Mary Ann Fay. New York: Palgrave, 2002, pp.155-176.

1040 ALI, Nadje Sadig al-. A mirror of political culture in contemporary Egypt: divisions and debates among women activists. *Discourses in contemporary Egypt: politics and social issues / Ishkālīyāt al-siyāsīya wa-'l-mujtama' fī Miṣr al-mu'āṣira.* Ed. Enid Hill. Cairo: American University in Cairo Press, 2000, (Cairo Papers in Social Science, 22 iv / 1999), pp.118-143.

1041 ALI, Nadje Sadig al-. Feminism and contemporary debates in Egypt. *Organizing women: formal and informal women's groups in the Middle East.* Ed. D.Chatty & A.Rabo. Oxford: Berg, 1997, pp.173-184.

1042 ALTORKI, Soraya. Feminist groups in contemporary Egypt. *Middle East Women's Studies: the Review,* 12 iv (1998) pp.15-18.

1043 AMMAR, Nawal H. & LABABIDY, Leila S. Women's grassroots movements and democratization in Egypt. *Democratization and women's grassroots movements.* Ed. Jill M. Bystydzienski & Joti Sekhon. Bloomington: Indiana University Press, 1999, pp.150-170.

1044 ARABI, Oussama. The dawning of the third millennium on Shari'a: Egypt's Law No. 1 of 2000, or women may divorce at will. *Arab Law Quarterly,* 16 i (2001) pp.2-21. Also online at www.kluweronline.nl

1045 ASSAAD, Marie. Empowering young girls of Mokattam Zabbaleen settlement. *Development,* 42 i (1999) pp.83-84. Also online at www.ingentaselect.com

1046 ASSAAD, Ragui & HAMIDI, Fatma el-. Is all work the same? A comparison of the determinants of female participation and hours of work in various employment states in Egypt. *The economics of women and work in the Middle East and North Africa.* Ed. E.Mine Cinar. Amsterdam: JAI, 2001, (Research in Middle East Economics, 4), pp.117-150.

1047 BÄLZ, Kilian. Human rights, the rule of law, and the construction of tradition: the Egyptian Supreme Administrative Court and female circumcision (appeal no. 5257/43, 28 Dec. 1997). *Egypte / Monde Arabe, 34* (1998) pp.141-153.

1048 BÄLZ, Kilian. Human rights, the rule of law and the construction of tradition: the Egyptian Supreme Administrative Court and female circumcision (Appeal no. 5257/43, 28 December 1997). *The rule of law in the Middle East and the Islamic World: human rights and the judicial process.* Ed. by Eugene Cotran and Mai Yamani. London: Tauris, in association with the Centre of Islamic Studies and Middle Eastern Law, School of Oriental and African Studies, University of London, 2000, pp.35-42.

1049 BÄLZ, Kilian. Islamisches Recht, staatliche Rechtsetzung und verfassungsgerichtliche Kontrolle: der ägyptische Verfassungsgerichtshof und der Schleier in staatlichen Schulen (Urt. 8/17 vom 18.5.1996). (Summary: Islamic law, state-enacted legislation, and constitutional review: the Egyptian Supreme Constitutional Court and the veil in secondary schools, Case 8/17, 18.5.1996.). *Zeitschrift für Ausländisches Öffentliches Recht und Völkerrecht,* 57 (1997) pp.229-242.

1050 BÄLZ, Kilian. La reconstruction séculière du droit islamique: la Haute Cour constitutionnelle égyptienne et la "bataille du voile" dans les écoles publiques. (Summary: The secular reconstruction of Islamic law: the Egyptian Supreme Constitutional Court and the "Battle over the veil" in state-run schools.). *Droit et Société,* 39 (1998) pp.277-291.

1051 BÄLZ, Kilian. The secular reconstruction of Islamic law: the Egyptian Supreme Constitutional Court and the "battle over the veil" in state-run schools. *Legal pluralism in the Arab world.* [Ed.] B.Dupret, M.Berger, Laila al-Zwaini. The Hague: Kluwer Law International, 1999, pp.229-243.

1052 BARIANI, L. Parentela e potere: uso ed abuso. Indagine sulle `madri` del Califfo Al-Ḥākim bi-Amr Allāh al-Fāṭimī. *Al-Qanṭara: Revista de Estudios Árabes,* 16 ii (1995) pp.357-367.

1053 BARON, B. Nationalist iconography: Egypt as a woman. *Rethinking nationalism in the Arab Middle East.* J.Jankowski & I.Gershoni (eds.). New York: Columbia University Press, 1997, pp.105-124;306-308. (Visual representations of the Egyptian nation from the 1870s through the 1930s.)

1054 BARON, Beth. An Islamic activist in interwar Egypt. *Iran and beyond: essays in Middle Eastern history in honor of Nikki R.Keddie.* Ed. R.Matthee & B.Baron. Costa Mesa: Mazda, 2000, pp.215-234. (Labiba Ahmad.)

1055 BAYOUMI, Jehan el-. Women and health here and there: a medical testimony. *Alif,* 19 (1999) pp.185-193. (Medical experiences which involve women & medicine ... in Egypt & ... in the USA.)

1056 BAZ, Shahida el-. The impact of social and economic factors on women's group formation in Egypt. *Organizing women: formal and informal women's groups in the Middle East.* Ed. D.Chatty & A.Rabo. Oxford: Berg, 1997, pp.147-171.

1057 BEHRENS-ABOUSEIF, D. The *Maḥmal* legend and the pilgrimage of the ladies of the Mamluk court. *Mamlūk Studies Review,* 1 (1997) pp.87-96.

1058 BERGER, Maurits. De doos van Pandora: openbare orde en conflictenrecht in Egyptisch familierecht. *Recht van de Islam,* 18 (2001) pp.99-116.

1059 BEXAR, K. Från en svensk horisont i Kairo. *Kvinnovetenskaplige Tidskrift,* 18 iii-iv (1997) pp.5-14;43. [Swedish views of Egyptian women & v.v.]

1060 BIBARS, Iman. Um Saber, Shadia and my self: the power relationship between the researched and the researcher. *Between field and text: emerging voices in Egyptian social science. Bayna al-baḥth al-maydānī wa-'l-naṣṣ: aṣwāt ṣā'ida fī 'l-buḥūth al-ijtimā'īya fī Miṣr.* Ed. Seteney Shami, L.Herrera. Cairo: American University in Cairo Press, 1999, (Cairo Papers in Social Science, 22 ii), pp.41-62. [Anthropologist in Egypt.]

1061 BINT AL-SHĀṬI', ('Ā'isha 'Abd al-Raḥmān). Islam and the new woman. Tr. Calderbank, A. *Alif,* 19 (1999) pp.194-204. (In Egypt.)

1062 BOOTH, Marilyn. Infamous women and famous wombs: biography, gender, and Islamist concepts of community in contemporary Egypt. *Auto/biography and the construction of identity and community in the Middle East.* Ed. by Mary Ann Fay. New York: Palgrave, 2002, pp.51-70.

1063 BOOTH, Marilyn. The Egyptian lives of Jeanne d'Arc. *Remaking women: feminism and modernity in the Middle East.* Ed. Lila Abu-Lughod. Princeton: Princeton University Press, 1998, pp.171-211. (Biographies of Jeanne d'Arc published in Egypt between 1879 & 1939 ... local agendas.)

1064 BOOTH, Marilyn. "May her likes be multiplied": "Famous women" biography and gendered prescription in Egypt, 1892-1935. *Signs,* 22 iv (1997) pp.827-890.

1065 BOOTH, Marilyn. *Woman in Islam:* men and the "women's press" in turn-of-the-20th-century Egypt. *International Journal of Middle East Studies, 33* ii (2001) pp.171-201. Also online at http:// journals.cambridge.org [1892-1901.]

1066 BOTIVEAU, B. Loi islamique et jugement moderne. (Abstract: Islamic law and modern judgement.). *Droit et Cultures,* 28 (1994) pp.25-45;100. (Deux situations, une séance de Cour d'Assises en Jordanie & un arrêt du Conseil d'Etat égyptien concernant la question de l'accès des femmes à la magistrature.)

1067 BRINK, J. Lost rituals: Sunni Muslim women in rural Egypt. *Mixed blessings: gender and religious fundamentalism cross culturally.* Ed. J.Brink & J.Mencher. New York & London: Routledge, 1997, pp.199-208. (The effect of fundamentalism in one village.)

1068 BRINK, J. The effect of employment and education on the status of peasant wives in Egypt. *Research in Economic Anthropology,* 18 (1997) pp.217-229.

1069 BUTLER, M. Women and home-based microenterprises. *Middle Eastern women and the invisible economy.* Ed. R.A.Lobban. Gainesville: University Press of Florida, 1998, pp.166-184. [Poultry production run by women in rural Egypt.]

1070 CHELLALI, Aïcha. Le voile à l'école: enjeux d'un décret, avatars d'un procès. *Egypte / Monde Arabe,* 20 (1994) pp.133-141.

1071 CHEMAIS, Amina. Les obstacles au divorce des femmes musulmanes en Egypte. *Les frontières mouvantes du mariage et du divorce dans les communautés musulmanes.* Grabels: Women Living under Muslim Laws, 1996, (Programme Femmes et Loi dans le Monde Musulman: Dossier Spécial), pp.50-69. Also online at http:// www.wluml.org/french/pubs/pdf/dossiers/sd/SD1.pdf

1072 CHRISTENSEN, Bodil. Bryllup i Cairo. *Jordens Folk,* 31 ii (1996) pp.64-68.

1073 COOKE, M. *Ayyām min hayati:* the prison memoirs of a Muslim sister. *The postcolonial crescent: Islam's impact on contemporary literature.* Ed. J.C.Hawley. New York: Lang, 1998, pp.121-139. (Zaynab al-Ghazali.)

1074 COOKE, Neil. James Burton and slave girls. *Unfolding the Orient: travellers in Egypt and the Near East.* Ed. Paul & Janet Starkey. Reading: Ithaca, 2001, pp.209-217. (Purchased in Egypt.)

1075 DANIELSON, Virginia. Moving toward public space: women and musical performance in twentieth-century Egypt. *Hermeneutics and honor: negotiating female "public" space in Islamic/ate societies.* Ed. Asma Afsaruddin. Cambridge (USA): Harvard University Press, for the Center for Middle Eastern Studies of Harvard University, 1999, (Harvard Middle Eastern monographs, 32), pp.116-139.

1076 DICKESCHEID, J. D., MCMURRAY, P. & NAWAR, Isis A. Rural Egyptian women, self-perception and attitudes towards male-female relationship. *Ahfad Journal,* 13 ii (1996) pp.31-42.

1077 DOUGHERTY, Roberta L. Badi'a Masabni, artiste and modernist: the Egyptian print media's carnival of national identity. *Mass mediations: new approaches to popular culture in the Middle East and beyond.* Ed. W.Armbrust. Berkeley: University of California Press, 2000, pp.243-268. Also online at http:// escholarship.cdlib.org/ ucpress (Featured in satirical press).

1078 DUNCAN, David J. Scholarly views of Shajarat al-Durr: a need for consensus. *Arab Studies Quarterly,* 22 i (2000) pp.51-69.

1079 DUPRET, Baudouin. La recherche judiciaire d'une moralité conforme: la Haute Cour constitutionnelle égyptienne et le voile. *Urbanité arabe. Hommage à Bernard Lepetit.* Textes rassemblés par Jocelyne Dakhlia. Arles: Sindbad / Actes Sud, 1998, pp.353-381.

1080 DUPRET, Baudouin. Sexual morality at the Egyptian bar: female circumcision, sex change operations, and motives for suing. *Islamic Law and Society,* 9 i (2002) pp.42-69. Also online at www.catchword.com

1081 DUVAL, Soroya. New veils and new voices: Islamist women's groups in Egypt. *Women and Islamization: contemporary dimensions of discourse on gender relations.* Ed. K.Ask & M.Tjomsland. Oxford: Berg, 1998, pp.45-72.

1082 EARLY, E. A. Nest eggs of gold and beans: *baladi* Egyptian women's invisible capital. *Middle Eastern women and the invisible economy.* Ed. R.A.Lobban. Gainesville: University Press of Florida, 1998, pp.132-147.

1083 EINARSDÓTTIR, S. Dragter i Kairo. *Jordens Folk,* 31 ii (1996) pp.73-77.

1084 EZZAT, Dina. Sacred laws and unholy deals: the road towards pro-women legal reform in Egypt. *No paradise yet: the world's women face the new century.* Ed. Judith Mirsky and Marty Radlett. London: Panos/Zed, 2000, pp.39-60.

1085 EZZAT, Heba Raouf. Secularism, the state and the social bond: the withering away of the family. *Islam and secularism in the Middle East.* Azzam Tamimi, J.L.Esposito, eds. London: Hurst, 2000, pp.124-138. (Secularising the family: the case of Egypt, pp.134-138.)

1086 EZZAT, Heba Raouf. The silent Ayesha: an Egyptian perspective. *Globalizaton, gender, and religion: the politics of implementing women's rights in Catholic and Muslim contexts.* Ed. Jane H.Bayes & Nayereh Tohidi. Basingstoke: Palgrave, 2001, pp.231-257. [Islamists & feminists in Egypt.]

1087 FAHMY, Khaled. Prostitution in Egypt in the nineteenth century. *Outside in: on the margins of the modern Middle East.* Ed. by Eugene Rogan. London: Tauris, in association with The European Science Foundation, Strasbourg, 2002, (The Islamic Mediterranean, 3), pp.77-103.

1088 FAHMY, Khaled. Women, medicine, and power in nineteenth-century Egypt. *Remaking women: feminism and modernity in the Middle East.* Ed. Lila Abu-Lughod. Princeton: Princeton University Press, 1998, pp.35-72. [Women studying medicine.]

1089 FAY, M. A. The ties that bound: women and households in eighteenth-century Egypt. *Women, the family, and divorce laws in Islamic history.* Ed. A.El Azhary Sonbol. Syracuse: Syracuse University Press, 1996, pp.155-172.

1090 FAY, M. A. Women and *waqf;* property, power, and the domain of gender in eighteenth-century Egypt. *Women in the Ottoman Empire: Middle Eastern women in the early modern era.* Ed. M.C.Zilfi. Leiden: Brill, 1997, (The Ottoman Empire and its Heritage, 10), pp.28-47.

1091 FAY, M. A. Women and waqf: toward a reconsideration of women's place in the Mamluk household. *International Journal of Middle East Studies,* 29 i (1997) pp.33-51. (18th-century Egypt.)

1092 FAY, Mary Ann. Shawikar Qadin: woman of power and influence in Ottoman Cairo. *Auto/biography and the construction of identity and community in the Middle East.* Ed. by Mary Ann Fay. New York: Palgrave, 2002, pp.95-108.

1093 GAWHARY, Karim el-. An interview with Heba Ra'uf Ezzat. *Women and power in the Middle East.* Ed. Suad Joseph & Susan Slyomovics. Philadelphia: University of Pennsylvania Press, 2001, pp.98-102. [Cairo ... a young Islamist intellectual.]

1094 GAWHARY, Karim el-. Profile of a community organizer: Sheikha in al-Waraaq. *Middle East Report,* 202 / 27 i (1997) pp.28-29. (Cairene neighborhood.)

1095 GERLACH, J. & SIEGMUND, M. Nicht mit ihnen und nicht ohne sie: die Rolle der Frauen in der Gesellschaft seit 1952. *Staat und Zivilgesellschaft in Ägypten.* Ferhad Ibrahim (hrsg.). Münster: Lit, 1995, pp.231-288.

1096 GILADI, A. Normative Islam versus local tradition: some observations on female circumcision with special reference to Egypt. *Arabica,* 44 ii (1997) pp.254-267.

1097 GILSENAN, Michael. Signs of truth: enchantment, modernity and the dreams of peasant women. (Abstract: Signes de vérité: enchantement, modernité et les rêves des paysannes.). *Journal of the Royal Anthropological Institute,* 6 iv (2000) pp.597-615. (In modern Egypt.)

1098 GIRGIS, Reda Naguib. Changing pattern of reproductive span and its impact on fertility in Egypt 1980-1992. *CDC 27th Annual Seminar on population issues in the Middle East, Africa and Asia.* Cairo: Cairo Demographic Center, 1998, (Research Monograph Series, 27; CDC Annual Seminar, 1997), pp.361-391.

1099 HAENNI, P. & FÜGER, H. Métamorphoses du voile "islamique" et distinctions sociales. *Egypte / Monde Arabe,* 26 (1996) pp.111-130. (En Egypte.)

1100 HAENNI, Patrick. Ils n'en ont pas fini avec l'Orient: de
 quelques islamisations non islamistes. *Revue des Mondes
 Musulmans et de la Méditerranée*, 85-86 (1999)
 pp.121-147. [Ḥijāb fashions & bourgeois zakat in Egypt.]

1101 HANNA, N. Marriage among merchant families in
 seventeenth-century Cairo. *Women, the family, and
 divorce laws in Islamic history*. Ed. A.El Azhary Sonbol.
 Syracuse: Syracuse University Press, 1996, pp.143-154.

1102 HARDERS, C. Transformation ohne Frauen?
 Liberalisierung und politische Partizipation in Ägypten.
 (Zusammenfassung: Transformation without women?
 Liberalization and political participation in Egypt.).
 Orient (Opladen), 38 i (1997) pp.85-106;201-202.

1103 HASSAN, Khalid el-Sayed. Socio-economic determinants
 of age at first marriage in urban Upper Egypt. *CDC 27th
 Annual Seminar on population issues in the Middle East,
 Africa and Asia*. Cairo: Cairo Demographic Center, 1998,
 (Research Monograph Series, 27; CDC Annual Seminar,
 1997), pp.318-335.

1104 HASSOUN, Jacques. Un judaïsme féministe en Egypte
 du 10 au 15ème siècle. *Los Muestros*, 34 (1999)
 pp.25-27.

1105 HASSOUN, Jacques. Un judaïsme feministe en Egypte
 du 10e au 15 siècle (2). *Los Muestros*, 35 (1999)
 pp.27-30.

1106 HATEM, Mervat F. Economic and political liberalization
 in Egypt and the demise of state feminism. *Arab women:
 between defiance and restraint*. Ed. Suha Sabbagh. New
 York: Olive Branch Press, 1996, pp.171-193.

1107 HATEM, Mervat F. Economic and political liberation in
 Egypt and the demise of state feminism. *The political
 economy of the Middle East*. Vol. 5: *The role of the state*.
 Ed. T.Niblock & R.Wilson. Cheltenham: Elgar, 1999,
 pp.190-210. [Previously published in *International
 Journal of Middle East Studies*, 24 (1992), pp.231-251.]

1108 HATEM, Mervat F. The microdynamics of patriarchal
 change in Egypt and the development of an alternative
 discourse on mother-daughter relations. The case of 'A'isha
 Taymur. *Intimate selving in Arab families: gender, self,
 and identity*. Ed. Suad Joseph. Syracuse (USA): Syracuse
 University Press, 1999, pp.191-208;285-286.
 (Upper-class family in nineteenth-century Egypt.)

1109 HATEM, Mervat F. The professionalization of health and
 the control of women's bodies as modern governmentalities
 [*sic*] in nineteenth-centuryEgypt. *Women in the Ottoman
 Empire: Middle Eastern women in the early modern era*.
 Ed. M.C.Zilfi. Leiden: Brill, 1997, (The Ottoman Empire
 and its Heritage, 10), pp.66-80.

1110 HÄUSERMANN FÁBOS, Anita. Problematizing marriage:
 minding my manners in my husband's community.
 Situating globalization: views from Egypt. Cynthia Nelson,
 Shahnaz Rouse (eds). Bielefeld: Transcript, 2000,
 pp.283-299. (Married to a Sudanese businessman in
 Cairo.)

1111 HERRERA, Linda. Downveiling: gender and the contest
 over culture in Cairo. *Middle East Report*, 219 / 31 ii
 (2001) pp.16-19.

1112 HERRERA, Linda. Downveiling: shifting socio-religious
 practices in Egypt. *ISIM Newsletter*, 6 (2000) pp.1 & 32.

1113 HÖHLING, C. Islamistisches Denken auf dem Vormarsch
 - skizziert an einigen Aspekten der Situation von Frauen
 in Ägypten. *Nachkriegsordnung oder Chaos?
 Sozioökonomische und soziokulturelle Entwicklungstrends
 in Nah- und Mittelost*. H.Grienig / A.Hopfmann (Hrsg.).
 Hamburg: Kovač, 1993, pp.80-97.

1114 HOODFAR, Homa. Contourner les obstacles juridiques:
 négociations pour le mahr et le mariage dans les
 communautés égyptiennes à faibles revenus. *Les
 frontières mouvantes du mariage et du divorce dans les
 communautés musulmanes*. Grabels: Women Living under
 Muslim Laws, 1996, (Programme Femmes et Loi dans le
 Monde Musulman: Dossier Spécial), pp.109-127. Also
 online at http:// www.wluml.org/french/pubs/pdf/dossiers/
 sd/SD1.pdf

1115 HOODFAR, Homa. Egyptian male migration and urban
 families left behind: 'feminization of the Egyptian family'
 or a reaffirmation of traditional gender roles?
 *Development, change and gender in Cairo: a view from
 the household*. Ed. D.Singerman & Homa Hoodfar.
 Bloomington: Indiana University Press, 1996, pp.51-79.

1116 HOODFAR, Homa. The impact of male migration on
 domestic budgeting: Egyptian women striving for an
 Islamic budgeting pattern. *Journal of Comparative
 Family Studies*, 28 ii (1997) pp.vii-viii;xi-xii;73-98.

1117 HOODFAR, Homa. Women in Cairo's (in)visible
 economy: linking local and national trends. *Middle
 Eastern women and the invisible economy*. Ed.
 R.A.Lobban. Gainesville: University Press of Florida,
 1998, pp.245-261.

1118 HUSSEIN, Sayed Aly. Hazard model for breast cancer
 patients (ladies) in Egypt. *CDC 27th Annual Seminar on
 population issues in the Middle East, Africa and Asia*.
 Cairo: Cairo Demographic Center, 1998, (Research
 Monograph Series, 27; CDC Annual Seminar, 1997),
 pp.713-741.

1119 IBRAHIM, Barbara, NAWAR, Laila & LLOYD, Cynthia
 B. Women's autonomy and the limits of population policy
 in Egypt. *Arab society: class, gender, power, and
 development*. Ed. N.S.Hopkins, Saad Eddin Ibrahim. Cairo:
 American University in Cairo Press, 1997, pp.123-140.

1120 IBRAHIM, Saad Eddin. State, women, and civil society:
 an evaluation of Egypt's population policy. *Arab society:
 class, gender, power, and development*. Ed. N.S.Hopkins,
 Saad Eddin Ibrahim. Cairo: American University in Cairo
 Press, 1997, pp.85-104. [First published 1995.]

1121 INHORN, M. C. Infertility and the quest for conception
 in Egypt. *Reproductive health and infectious disease in
 the Middle East*. Ed. R.Barlow, J.W.Brown. Aldershot:
 Ashgate, 1998, pp.114-129.

1122 INHORN, M. C. Population, poverty, and gender politics:
 motherhood, pressures and marital crises in the lives of
 poor urban Egyptian women. *Population, poverty, and
 politics in Middle East cities*. Ed. M.E.Bonine. Gainesville:
 University Press of Florida, 1997, pp.186-207.

1123 INHORN, M. C. Urban Egyptian women in the informal
 health care sector. *Middle Eastern women and the
 invisible economy*. Ed. R.A.Lobban. Gainesville:
 University Press of Florida, 1998, pp.113-131.

1124 JENNINGS, A. M. Nubian women and the shadow
 economy. *Middle Eastern women and the invisible
 economy*. Gainesville: University Press of Florida, 1998,
 pp.45-59.

1125 JEWETT, Jennifer. The recommendations of the
 International Conference on population and development:
 the possibility of the empowerment of women in Egypt.
 Cornell International Law Journal, 29 i (1996)
 pp.191-223.

1126 JOHNSON, Kathryn. Royal pilgrims: Mamlūk accounts
 of the pilgrimages to Mecca of the Khawand al-Kubrā
 (senior wife of the Sultan). *Studia Islamica*, 91 (2000)
 pp.107-131.

1127 JOUBIN, R. Creating the modern professional housewife:
 scientifically based advice extended to middle- and
 upper-class Egyptian women, 1920s-1930s. *Arab Studies
 Journal / Majallat al-Dirāsāt al-'Arabīya*, 4 ii (1996)
 pp.19-45. (Domestic advice presented in the new
 women's pages of the newspapers.)

1128 KAHF, Mohja. Huda Sha'rawi's *Mudhakkirati*: the memoirs
 of the first lady of Arab modernity. *Arab Studies
 Quarterly*, 20 i (1998) pp.53-82.

1129 KAHF, Mohja. Packaging "Huda": Sha'rawi's memoirs in
 the United States reception environment. *Going global:
 the transnational reception of Third World women writers*.
 Ed. Amal Amireh & Lisa Suhair Majaj. New York:
 Garland Publishing, 2000, pp.148-172.

1130 KAMPHOEFNER, K. R. What's the use? The household,
 low-income women, and literacy. *Development, change
 and gender in Cairo: a view from the household*. Ed.
 D.Singerman & Homa Hoodfar. Bloomington: Indiana
 University Press, 1996, pp.80-109.

1131 KARAM, Azza M. An apostate, a proposed new marriage contract and Egyptian women: where to now? *WAF Journal*, 8 (1996) pp.29-32.

1132 KARAM, Azza M. Contemporary Islamisms and feminisms in Egypt. *Women Living under Muslim Laws: Dossier*, 19 (1997) pp.38-50. Also online at www.wluml.org/english/pubs

1133 KARAM, Azza M. Feminisms and Islamisms in Egypt: between globalization and postmodernism. *Gender and global restructuring: sightings, sites and resistances*. Ed. M.H.Marchand & A.S.Runyan. London: Routledge, 2000, pp.194-208.

1134 KARAM, Azza M. Women, Islamisms, and state: dynamics of power and contemporary feminisms in Egypt. *Muslim women and the politics of participation: implementing the Beijing platform*. Ed. Mahnaz Afkhami & E.Friedl. Syracuse (USA): Syracuse University Press, 1997, pp.18-28.

1135 KENT, C. & FRANKEN, M. A procession through time: the *zaffat al-'arusa* in three views. *Images of enchantment: visual and performing arts of the Middle East*. Ed. Sherifa Zuhur. Cairo: American University in Cairo Press, 1998, pp.71-80. (Cairo.)

1136 KHADR, Zeinab & ZEINI, Laila O.el-. Families and households: headship and co-residence. *The new Arab family / Al-Usra al-'Arabīya al-jadīda*. Ed. Nicholas S.Hopkins. Cairo: American University in Cairo Press, 2003, (Cairo Papers in Social Science, 24 i-ii / 2001), pp.140-164. [Egyptian data.]

1137 KHAFAGI, Fatma. Breaking cultural and social taboos: the fight against FGM in Egypt. *Development*, 44 iii (2001) pp.74-78. Also online at www.ingentaselect.com [Female genital mutilation.]

1138 KHOLY, Heba el-. A tale of two contracts: towards a situated understanding of "women interests" in Egypt. *Situating globalization: views from Egypt*. Cynthia Nelson, Shahnaz Rouse (eds). Bielefeld: Transcript, 2000, pp.301-335. [Marriage contracts.]

1139 KHÛLÎ, Ramadân al-. "Pour le meilleur et pour le pire": quelques pratiques du droit familial au temps de l'expédition d'Egypte. *Egypte / Monde Arabe*, N.S.1 (1999) pp.99-113.

1140 KISHOR, Sunita. Empowerment of women in Egypt and links to the survival and health of their infants. *Women's empowerment and demographic processes: moving beyond Cairo*. Ed. H.B.Presser & Gita Sen. Oxford: Oxford University Press, 2000, pp.119-156.

1141 RASMUSSEN, L.Kofoed. Muslim woman and intellectual in twentieth-century Egyptian public debate. *The Middle East in a globalized world: papers from the Fourth Nordic Conference on Middle Eastern Studies, Oslo, 1998*. Ed. B.J.Olav & K.S.Vikør. Bergen: Nordic Society for Middle Eastern Studies, 2000, (Nordic Research on the Middle East, 6), pp.183-192. [1900s-1990s.]

1142 KUPPINGER, Petra. Death of a midwife. *Situating globalization: views from Egypt*. Cynthia Nelson, Shahnaz Rouse (eds). Bielefeld: Transcript, 2000, pp.255-282.

1143 LANE, S. D. Gender and health: abortion in urban Egypt. *Population, poverty, and politics in Middle East cities*. Ed. M.E.Bonine. Gainesville: University Press of Florida, 1997, pp.208-234.

1144 LARSON, B. K. Women, work, and the informal economy in rural Egypt. *Middle Eastern women and the invisible economy*. Ed. R.A.Lobban. Gainesville: University Press of Florida, 1998, pp.148-165.

1145 LORIUS, C. Desire and the gaze: spectacular bodies in Cairene elite weddings. *Women's Studies International Forum*, 19 v (1996) pp.513-523. [Dancer's performance.]

1146 LUTFI AL-SAYYID MARSOT, Afaf. Entrepreneurial women. *Feminism and Islam: legal and literary perspectives*. Ed. Mai Yamani. Reading: Ithaca, for the Centre of Islamic and Middle Eastern Law, School of Oriental and African Studies, University of London, 1996, pp.33-47. [18th-, 19th- & 20th-century Egypt.]

1147 MABRO, Judy. Through a veil darkly. *Index on Censorship*, 27 iii / 182 (1998) pp.83-87. [Egyptian women's clothing.]

1148 MACLEOD, A. E. The new veiling and urban crisis: symbolic politics in Cairo. *Population, poverty, and politics in Middle East cities*. Ed. M.E.Bonine. Gainesville: University Press of Florida, 1997, pp.304-325.

1149 MACLEOD, A. E. Transforming women's identity: the intersection of household and workplace in Cairo. *Development, change and gender in Cairo: a view from the household*. Ed. D.Singerman & Homa Hoodfar. Bloomington: Indiana University Press, 1996, pp.27-50.

1150 MAJCHER, Agnieszka. Feministka Zajnab al-Ghazali? *Przegląd Orientalistyczny*, 194-195 (2000) pp.244-254.

1151 MANISTY, D. Negotiating the space between private and public: women's autobiographical writing in Egypt. *Writing the self: autobiographical writing in modern Arabic literature*. R.Ostle, E.de Moor & S.Wild (eds). London: Saqi, 1998, pp.272-282;328-329.

1152 MAZLOUM, Somaya. The personal and political struggle of two pioneer feminists: Wollstonecraft and M.H.Nassef. *The proceedings of the International Conference: Comparative Literature in the Arab World, Centre for Comparative Linguistics and Literary Studies (CCLLS) ... Cairo University ... 1995. Qaḍāyā 'l-adab al-muqāran fī 'l-waṭan al-'Arabī*. Ed. Ahmed Etman. Cairo: Egyptian Society of Comparative Literature (ESCL), 1998, pp.285-300.

1153 MIKAWY, Noha el-. The informal sector and the conservative consensus: a case of fragmentation in Egypt. *Women, globalization and fragmentation in the developing world*. Ed. Haleh Afshar & S.Barrientos. Basingstoke: Macmillan; New York: St. Martin's Press, 1999, pp.77-90.

1154 MOHAMED, Ayat. Validation of an assumption in Bongaarts' model. *CDC 27th Annual Seminar on population issues in the Middle East, Africa and Asia*. Cairo: Cairo Demographic Center, 1998, (Research Monograph Series, 27; CDC Annual Seminar, 1997), pp.261-282. (Fertility levels in Egypt.)

1155 MOHAMED, Mona. Gender gap and poverty in Egypt. *Population and Development Research Monograph Series*, 6 (1999) pp.420-453.

1156 MOHAMMED, Amal Fouad. Women status and development in Egypt. *Population and Development Research Monograph Series*, 4 (1996) pp.307-341.

1157 MOON, Brenda E. Amelia Edwards, Jennie Lane and Egypt. *Interpreting the Orient: travellers in Egypt and the Near East*. Ed. Paul & Janet Starkey. Reading: Ithaca, 2001, pp.175-184. [Maid to Amelia Edwards's travelling companion & writer of a travel diary.]

1158 MOORE, K. The synergistic relationship between health and human rights: a case study using female genital mutilation. *Health and Human Rights*, 2 ii (1997) pp.137-146. [Egypt as example.]

1159 MOSTAFA, Eman. Determinants of contraceptive use in Upper Egypt. *Population and Development Research Monograph Series*, 6 (1999) pp.221-250.

1160 MOUELHY, Ibrahim el-. Contrats de mariage singuliers. *Bulletin de l'Institut d'Egypte / Majallat al-Majma' al-'Ilmī al-Miṣrī*, 74-75 / 1994-1995 (1996) pp.64-72. [Three documents from Egyptian Court Archives dated 961, 963, 1297 AH (1553, 1555, 1878).]

1161 MURĀD, Ḥilmī. Shari'a and women's rights are the points of controversy. Tr. Wafaa, Mannar & Wagdy, Wasim. *Revitalization of political thought through democracy and human rights: Islamism, Marxism and Pan Arabism*. Ed. Essam Mohammed Hassan, K.W.Harris. Cairo: Cairo Institute for Human Rights Studies, 1996, pp.184-186. (National Accord Charter and public elections in Egypt.)

1162 MURRAY, S. O. Male homosexuality, inheritance rules, and the status of women in medieval Egypt: the case of the Mamlūks. *Islamic homosexualities: culture, history, and literature*. S.O.Murray & W.Roscoe, with additional contributions by E.Allyn [& others]. New York: New York University Press, 1997, pp.161-173.

1163 NAGGAR, Nahed Ahmed el. Determinants of reproductive health: evidence from Egypt Demographic and Health Survey 1992. *CDC 27th Annual Seminar on population issues in the Middle East, Africa and Asia.* Cairo: Cairo Demographic Center, 1998, (Research Monograph Series, 27; CDC Annual Seminar, 1997), pp.339-360.

1164 NAGUIB, Saphinaz-Amal. Modelling a cosmopolitan womanhood in Egypt (1850-1950). The role of nannies and French Catholic girl schools. *Acta Orientalia* (Copenhagen), 62 (2001) pp.92-106.

1165 NASSAR, Nagla. Legal plurality: reflection on the status of women in Egypt. *Legal pluralism in the Arab world.* [Ed.] B.Dupret, M.Berger, Laila al-Zwaini. The Hague: Kluwer Law International, 1999, pp.191-204.

1166 NAVEH, Immanuel. The tort of injury and dissolution of marriage at the wife's initiative in Egyptian *Maḥkamat al-Naqd* rulings. *Islamic Law and Society,* 9 i (2002) pp.16-41. Also online at www.catchword.com

1167 NELSON, Cynthia. Feminist expression as self-identity and cultural critique: the discourse of Doria Shafik. *The postcolonial crescent: Islam's impact on contemporary literature.* Ed. J.C.Hawley. New York: Lang, 1998, pp.95-120. [1945-1957.]

1168 NELSON, Cynthia. Writing culture, writing lives: fictional boundaries. *Auto/biography and the construction of identity and community in the Middle East.* Ed. by Mary Ann Fay. New York: Palgrave, 2002, pp.201-214. [Doria Shafiq, the Egyptian feminist.]

1169 NIEUWKERK, Karin van. Shifting narratives on marginality: female entertainers in twentieth-century Egypt. *Outside in: on the margins of the modern Middle East.* Ed. by Eugene Rogan. London: Tauris, in association with The European Science Foundation, Strasbourg, 2002, (The Islamic Mediterranean, 3), pp.231-251. [Singers and dancers.]

1170 O'NEILL, Patricia. Amelia Edwards: from novelist to Egyptologist. *Interpreting the Orient: travellers in Egypt and the Near East.* Ed. Paul & Janet Starkey. Reading: Ithaca, 2001, pp.165-173. (The importance of travel writing for women writers.)

1171 OROBATON, N. Are unsafe induced abortions contributing to fertility decline in Africa? Findings from Egypt and Zimbabwe. *Demography India,* 25 i (1996) pp.261-274.

1172 OSMAN, Magued & SHAHID, Laila S. Age-discrepant marriage in Egypt. *The new Arab family / Al-Usra al-'Arabīya al-jadīda.* Ed. Nicholas S.Hopkins. Cairo: American University in Cairo Press, 2003, (Cairo Papers in Social Science, 24 i-ii / 2001), pp.51-61. (A significant increase in the number of older wife / younger husband marriages.)

1173 PACIELLO, Maria Cristina. Zaynab al-Ġazālī al-Ġabīlī, militante islamica egiziana: un modello islamico di emancipazione femminile? *Oriente Moderno,* 21 / 82 ii (2002) pp.275-319.

1174 PETERS, R. The infatuated Greek: social and legal boundaries in nineteenth-century Egypt. *Egypte / Monde Arabe,* 34 (1998) pp.53-65. [Case involving Christian man & Muslim woman.]

1175 PETRY, C. F. Conjugal rights versus class prerogatives: a divorce case in Mamlūk Cairo. *Women in the medieval Islamic world: power, patronage, and piety.* Ed. G.R.G.Hambly. Basingstoke: Macmillan, 1998, (The New Middle Ages, 6), pp.227-240.

1176 PUCHNAREWICZ, E. Social position of the modern Arab woman (the case of Egypt). *Africana Bulletin,* 46 (1998) pp.129-147.

1177 RADI, Saâdia. De la toile au voile: les actrices égyptiennes voilées et l'islamisme. (Résumé: From curtains to veils: veiled actresses and Islam.). *Monde Arabe Maghreb-Machrek,* 151 (1996) pp.13-17;141.

1178 RAGAN, J. D. Interesting sources on French travel literature. *Travellers in Egypt: Notes and Queries,* 3 (1996) pp.10-11. [French women's accounts of Egypt in Egyptian libraries.]

1179 RAGAN, John David. Jehan d'Ivray. *Egyptian encounters / Liqā' Miṣr.* Ed. Jason Thompson. Cairo: American University in Cairo Press, 2002, (Cairo Papers in Social Science, 23 iii / 2000), pp.24-42. [Nom de plume of Jeanne Puech, novelist & writer, French wife of an Egyptian doctor.]

1180 RAPOPORT, Yossef. Divorce and the elite household in late medieval Cairo. (Abstracts: Le divorce dans les ménages de la haute société au Caire, à la fin du Moyen Age; Scheidung und die Haushalte der Elite im spätmittelalterlichen Kairo.). *Continuity and Change,* 16 ii (2001) pp.164;201-218. Also online at http://journals.cambridge.org

1181 RAPOPORT, Yossef. Matrimonial gifts in early Islamic Egypt. *Islamic Law and Society,* 7 i (2000) pp.1-36.

1182 REUTER, B. Es gibt eine Menge Probleme: Interview mit Inas Taha. *INAMO-Beiträge,* 2 (1995) pp.44-45. (Redakteurin für die Frauensektion der ägyptischen Tageszeitung Al-Ahram und gegenwärtig UNESCO-Berichterstatterin für die Arabische Welt.)

1183 RICKS, Irelene P. Islamic crusades in North Africa and their impact on female human capital development in Egypt and Sudan. *Mediterranean Quarterly,* 10 i (1999) pp.116-131.

1184 RIFAEY, Tonia & ZUHUR, Sherifa. Visualizing identity: gender and nation in Egyptian cartoons. *Colors of enchantment: theater, dance, music, and the visual arts of the Middle East.* Ed. Sherifa Zuhur. Cairo: American University in Cairo Press, 2001, pp.386-404. (Egypt was frequently portrayed as a female character struggling with her identity & political circumstances earlier in twentieth century.)

1185 RODENBECK, John. 'Awalim; or, the persistence of error. *Historians in Cairo. Essays in honor of George Scanlon.* Ed. Jill Edwards. Cairo: American University in Cairo Press, 2002, pp.107-121. (Male Europeans visiting Cairo between 1790 and 1836 routinely expected to encounter dancing prostitutes ... whom they mistakenly believed to be called *almés* ... And after 1836 the error ... could be made only by travelers who had not read E.W.Lane.)

1186 RUIZ-ALMODÓVAR, Caridad. Desarrollo legislativo del derecho de familia en Egipto. *Homenaje al profesor José María Fórneas Besteiro.* Granada: Universidad de Granada, 1995, pp.1011-1020.

1187 RUIZ DE ALMODÓVAR Y SEL, C. El papel de la mujer en el proceso de configuración nacional: el caso egipcio. *Arabist: Budapest Studies in Arabic,* 15-16 (1995) pp.309-323.

1188 RUSSELL, Penny. The allure of the Nile: Jane Franklin's voyage to the Second Cataract, 1834. *Gender & History,* 9 ii (1997) pp.222-241.

1189 SAAD, Reem. "Ceci n'est pas la femme égyptienne!" L'Egypte entre représentations occidentales et discours nationaliste. *Egypte / Monde Arabe,* 30-31 (1997) pp.211-228.

1190 SAAD, Reem. Shame, reputation and Egypt's lovers: a controversy over the nation's image. *Visual Anthropology,* 10 ii-iv (1998) pp.401-412. (Reactions within Egypt to a BBC-produced documentary dealing with the life of a lower-class Cairene woman.)

1191 SA'DĀWĪ, Nawāl al-. Dissidence and creativity / Nawal el Saadawi. *The dissident word. The Oxford Amnesty lectures* / Chris Miller, editor. New York: Basic Books, 1996, pp.151-176. [Egypt & Third World.]

1192 SA'DĀWĪ, Nawāl al-. Egypte: le cas d'une jeune femme ... entre imaginaire et réalité. *Cahiers de l'Orient,* 47 (1997) pp.105-111.

1193 SEIF EL DAWLA, Aida. Women's rights in Egypt. *WAF Journal,* 8 (1996) pp.25-28.

1194 SEIF EL DAWLA, Aida, ABD [AL-]HADI, Amal & ABDEL WAHAB, Nadia. Women's wit over men's: trade-offs and strategic accommodations in Egyptian women's reproductive lives. *Negotiating reproductive rights: women's perspectives across countries and cultures.* Ed. R.P.Petchesky & K.Judd. London: Zed, 1998, pp.69-107.

1195 SHAFIK, Viola. Prostitute for good reason: stars and morality in Egypt. *Women's Studies International Forum*, 24 vi (2001) pp.711-725. Also online at http:// www.sciencedirect.com/science/journal/02775395 (The Egyptian film industry, its current star system & the general evaluation of stars on the artistic & moral level.)

1196 SHAHAM, R. State, feminists and Islamists - the debate over stipulations in marriage contracts in Egypt. *Bulletin of the School of Oriental and African Studies*, 62 iii (1999) pp.464-483.

1197 SHAKRY, Omnia. Schooled mothers and structured play: child rearing in turn-of-the-century Egypt. *Remaking women: feminism and modernity in the Middle East*. Ed. Lila Abu-Lughod. Princeton: Princeton University Press, 1998, pp.126-170.

1198 SHA'RĀWĪ, Hudá. Harem years. Tr. Badran, M. *Mediterraneans / Méditerranéennes*, 8/9 (1996) pp.139-141.

1199 SHARIF, William al-. The evolution of feminism in Egypt: the challenges of nationalism and Islamism. *Bulletin of the Henry Martyn Institute of Islamic Studies*, 16 iii-iv (1997) pp.3-57.

1200 SHOLKAMY, Hania M. Procreation in Islam: a reading from Egypt of people and texts. *Conceiving persons: ethnographies of procreation, fertility and growth* / P.Loizos and P.Heady. London: Athlone Press, 1999, (London School of Economics Monographs on Social Anthropology, 68), pp.139-159.

1201 SHOLKAMY, Hania. Rationales for kin marriages in rural Upper Egypt. *The new Arab family / Al-Usra al-'Arabīya al-jadīda*. Ed. Nicholas S.Hopkins. Cairo: American University in Cairo Press, 2003, (Cairo Papers in Social Science, 24 i-ii / 2001), pp.62-79.

1202 SINGERMAN, D. Engaging informality: women, work, and politics in Cairo. *Middle Eastern women and the invisible economy*. Ed. R.A.Lobban. Gainesville: University Press of Florida, 1998, pp.262-286.

1203 SINGERMAN, Diane & IBRAHIM, Barbara. The cost of marriage in Egypt: a hidden variable in the new Arab demography. *The new Arab family / Al-Usra al-'Arabīya al-jadīda*. Ed. Nicholas S.Hopkins. Cairo: American University in Cairo Press, 2003, (Cairo Papers in Social Science, 24 i-ii / 2001), pp.80-116.

1204 SINGERMAN, D. & HOODFAR, Homa. The household as mediator: political economy, development, and gender in contemporary Cairo. *Development, change and gender in Cairo: a view from the household*. Ed. D.Singerman & Homa Hoodfar. Bloomington: Indiana University Press, 1996, pp.xi-xl.

1205 SISSONS, E. M. Grand ideas and intimate effects: the gendered consequences of Egyptian population policy, 1971-1992. *Arab Studies Journal / Majallat al-Dirāsāt al-'Arabīya*, 4 i (1996) pp.71-85.

1206 SOETENS, Sabine. Šağarat ad-Durr: a comparative study of three historical sources. *Orientalia Lovaniensia Periodica*, 30 (1999) pp.97-112.

1207 SONBOL, Amira el-Azhary. "The woman follows the nationality of her husband": guardianship, citizenship and gender. *Hawwa: Journal of Women in the Middle East and the Islamic world*, 1 i (2003) pp.86-117. Also online at http:// leporello.ingentaselect.com/vl=16277934/cl=41/ nw=1/rpsv/cw/brill/15692078/(Egypt, 1875-1947.)

1208 SONBOL, Amira. Doctors and midwives: women and medicine at the turn of the century. *La France & l'Egypte: à l'époque des vice-rois 1805-1882* / éd. par Daniel Panzac et André Raymond. Cairo: Institut Français d'Archéologie Orientale, 2002, (Cahier des Annales Islamologiques, 22), pp.135-148.

1209 SONBOL, Amira El Azhary. Law and gender violence in Ottoman and modern Egypt. *Women, the family, and divorce laws in Islamic history*. Ed. A.El Azhary Sonbol. Syracuse: Syracuse University Press, 1996, pp.277-289.

1210 SONBOL, Amira. Rape and law in Ottoman and modern Egypt. *Women in the Ottoman Empire: Middle Eastern women in the early modern era*. Ed. M.C.Zilfi. Leiden: Brill, 1997, (The Ottoman Empire and its Heritage, 10), pp.214-231.

1211 SONBOL, Amira el-Azhary. *Ṭā'a* and modern legal reform: a rereading. *Islam and Christian-Muslim Relations*, 9 iii (1998) pp.285-294. [Egypt, 19th & 20th centuries.]

1212 SPENLEN, J. Koptisch-orthodoxe Frauen im modernen Ägypten. *Die koptische Kirche: Einführung in das ägyptische Christentum*. A.Gerhards, H.Brakmann (Hrsg.). Stuttgart: Kohlhammer, 1994, pp.119-131.

1213 STEELE, Fiona & GEEL, Fatma el-Zahraa M.M. The impact of family planning supply factors on unmet need in rural Egypt 1988-1989. *Journal of Biosocial Science*, 31 iii (1999) pp.311-326. Also online at www.journals.cup.org

1214 SULLIVAN, E. L. Women and development in Egypt. *Development in the age of liberalization: Egypt and Mexico*. Ed. D.Tschirgi. Cairo: American University in Cairo Press, 1996, pp.217-233.

1215 TADIÉ, Arlette. La lutte des femmes: à travers l'autobiographie de Latîfa es-Zayyât et de Nawâl es-Sa`dâwi. *EurOrient*, 12 (2002) pp.3-19.

1216 TELEB, Nadia Abd-el-Aziz. Reproductive health profile in Egypt: the role of women's education and work status. *Population and Development Research Monograph Series*, 6 (1999) pp.289-342.

1217 TERPIN, E. Frauen in der islamischen Welt: ein theoretischer Rahmen am Beispiel Ägyptens. *Staat und Zivilgesellschaft in Ägypten*. Ferhad Ibrahim (hrsg.). Münster: Lit, 1995, pp.197-230.

1218 TESSLER, M. & WARRINER, I. Gender and international relations: a comparison of citizen attitudes in Israel and Egypt. *Israel in comparative perspective: challenging the conventional wisdom*. Ed. M.N.Barnett. Albany (USA): State University of New York Press, 1996, pp.85-105.

1219 THORBJØRNSRUD, B. Born in the wrong age: Coptic women in a changing society. *Between desert and city: the Coptic Orthodox Church today*. Ed. N.van Doorn-Harder & K.Voigt. Oslo: Novus Forlag, [for] Instituttet for Sammenlignende Kulturforskning, 1997, (Serie B: Skrifter, XCVII), pp.167-189. [Incl. relations with Muslims.]

1220 WAFA'I, Zein-el-Abedeen el-. Regional estimation of time duration and contraceptive prevalence needed to reach replacement level of fertility in Egypt. *Population and Development Research Monograph Series*, 4 (1996) pp.379-412.

1221 WALTHER, W. Islamischer Fundamentalismus und Frauenglück: die Ägypterin Sainab al-Ghasali als Propagandistin fundamentalistischer Sozialethik. *Blickwechsel: Frauen in Religion und Wissenschaft*. D.Pahnke (Hg.). Marburg: diagonal-Verlag, 1993, pp.273-297.

1222 WASSEF, Nadia. Asserting masculinities: FGM in Egypt revisited. *Middle East Women's Studies Review*, 14 iii (1999) pp.1-3. (Female Genital Mutilation.)

1223 WASSEF, Nadia. Masculinities and mutilations: female genital mutilation in Egypt. *Middle East Women's Studies: the Review*, 13 ii (1998) pp.1-4.

1224 WASSEF, Nadia. The woman, the march, & the silent history: an interview with Germaine Arcache. *Middle East Women's Studies: the Review*, 13 i (1998) pp.1-3. [Egypt 1951.]

1225 WASSEF, Wadida. Memories. *Mediterraneans / Méditerranéennes*, 8/9 (1996) pp.177-187. [Alexandria, 1930s.]

1226 WERNER, K. Vom wilden Teenager zur Bürgerin - der Islamismus als neue Form der Vergesellschaftung junger Frauen in Ägypten. *Der neue Islam der Frauen. Weibliche Lebenspraxis in der globalisierten Moderne: Fallstudien aus Afrika, Asien und Europa*. R.Klein-Hessling, S.Nökel, K.Werner (Hg.). Bielefeld: transcript Verlag, 1999, pp.249-276.

1227 WERNER, K. Zwischen Islamisierung und Verwestlichung: junge Frauen in Ägypten. (Abstract: Between Islamization and Westernization: young women in Egypt.). *Zeitschrift für Soziologie*, 25 i (1996) pp.4-18;87.

1228 WERNER, Karin. "Coming close to God" through the
 media: a phenomenology of the media practices of Islamist
 women in Egypt. *Mass media, politics, and society in
 the Middle East* / ed. Kai Hafez. Cresskill: Hampton Press,
 2001, pp.199-216. [Tape-recorders, radio, books, TV &
 video.]

1229 WERNER, Karin. Deconstructing the issue of Islamic
 fundamentalism: approaching the issue. *Islam - motor
 or challenge of modernity.* Ed. G.Stauth. Hamburg: Lit,
 1998, (Yearbook of the Sociology of Islam, 1), pp.35-56.
 (Theoretical concepts and methods used in the study of
 the everyday life of female members of Islamic groups in
 Cairo.)

1230 WESTERN, W. C. Traiciones poscoloniales: mujeres y
 nación. (Abstract: Post-colonial treasons: women and
 nation.). *Estudios de Asia y Africa,* 107 / 33 iii (1998)
 pp.436-437;529-547. [Egypt.]

1231 WILMSEN, D. Cross-addressing: reverse gender reference
 in spoken Cairene Arabic. *Arabic grammar and
 linguistics.* Ed. Yasir Suleiman. Richmond: Curzon, 1999,
 pp.203-221.

1232 ZAID, Mohamed Ahmed. Factors associated with fertility
 in Egypt 1993. *CDC 27th Annual Seminar on population
 issues in the Middle East, Africa and Asia.* Cairo: Cairo
 Demographic Center, 1998, (Research Monograph Series,
 27; CDC Annual Seminar, 1997), pp.241-260.

1233 ZUHUR, Sherifa. The mixed impact of feminist struggles
 in Egypt during the 1990s. *MERIA Journal,* 5 i (2001)
 Online at www.biu.ac.il/SOC/besa/meria

1234 ZURAYK, Huda. The meaning of reproductive health for
 developing countries: the case of the Middle East. *Gender
 and Development,* 9 ii (2001) pp.22-27. Also online at
 http:// www.ingentaselect.com (Experience of the Giza
 Morbidity Study in Egypt.)

1235 De la confiscation des droits à des accusations d'apostasie:
 implications de la décision d'un tribunal égyptien ordonnant
 le divorce de Dr. Nasr Hamed Abu-Zeid et de son épouse,
 Dr. Ibthal Younis / Centre d'Assistance Juridique des Droits
 Humains (Center for Human Rights Legal Aid - CHRLA).
 Women Living under Muslim Laws: Dossier, 14-15 (1996)
 pp.35-47. Also online at http:// www.wluml.org/french/
 pubs/pdf/dossiers/dossier14-15/D14-15fr.pdf

1236 From confiscation to charges of apostasy: the implications
 of the Egyptian court decision ordering the divorce of Dr.
 Nasr Hamed Abu-Zeid from his wife, Dr. Ibthal Younis /
 The Center for Human Rights Legal Aid (CHRLA).
 Women Living under Muslim Laws: Dossier, 14-15 (1996)
 pp.33-44. Also online at www.wluml.org/english/pubs

1237 The women's question: new directions of inquiry and action.
 Roundtable discussion. Ed. Nelson, C. & Rouse, Shahnaz.
 *Cairo Papers 20th anniversary symposium. Twenty years
 of development in Egypt (1977-1997).* Part 2: *Society,
 culture, education, law, women. Buḥūth al-Qāhira: nadwat
 al-'īd al-'ishrīn. 'Ishrīn 'āman min al-tanmīya fī Miṣr
 1977-1997.* Ed. M.E.Kennedy. Cairo: American University
 in Cairo Press, 1999, (Cairo Papers in Social Science, 21
 iv (1998)), pp.168-190.

Eritrea & Ethiopia

Books

1238 CHRISTMANN, S. *Die Freiheit haben wir nicht von den
 Männern: Frauen in Eritrea.* Unkel a. Rhein: Horlemann
 1996. 190pp.

1239 SCHAMANEK, Claudia. *Frauenemanzipation in
 revolutionären und militärischen Kontexten: Aspekte der
 Geschlechterverhältnisse am Beispiel eritreischer
 EPLF-Kämpferinnen (1988-1992).* Vienna: AFRO-PUB,
 1998 (Veröffentlichungen der Institute für Afrikanistik
 und Ägyptologie der Universität Wien, 81; Beiträge zur
 Afrikanistik, 61), 224pp.

Articles

1240 CONNELL, Dan. Strategies for change: women & politics
 in Eritrea & South Africa. *Review of African Political
 Economy,* 76 (1998) pp.189-206.

1241 DEBELLA, Hawani & KASSAM, Aneesa. Hawani's
 story. *Being and becoming Oromo: historical and
 anthropological enquiries.* Ed. P.T.W.Baxter, J.Hultin &
 A.Triulzi. Uppsala: Nordiska Afrikainstitutet, 1996,
 pp.26-36.

1242 FRANKLAND, E. G. & NOBLE, T. A case of national
 liberation with feminist undertones: the secession of
 Eritrea. *Small Wars and Insurgencies,* 7 iii (1996)
 pp.401-424.

1243 GIBB, Camilla & ROTHENBERG, Celia. Believing
 women: Harari and Palestinian women at home and in the
 Canadian diaspora. *Journal of Muslim Minority Affairs,*
 20 ii (2000) pp.243-259. Also online at
 www.catchword.com

1244 GOW, Greg. Viewing 'Mother Oromia'. *Communal
 Plural,* 9 ii (2001) pp.203-222. Also online at
 www.tandf.co.uk/journals [Survey of Oromo women's
 reactions to a postcard showing an Oromo woman feeding
 her baby with the caption 'Mother Oromia'.]

1245 HODGIN, P. An introduction to Eritrea's ongoing
 revolution: women's nationalist mobilization and gender
 politics in post-war Eritrea. *Eritrean Studies Review,* 2
 i (1997) pp.85-110.

1246 KASSAMALI, Noor J. When modernity confronts
 traditional practices: female genital cutting in Northeast
 Africa. *Women in Muslim societies: diversity within
 unity.* Ed. H.L.Bodman, Nayereh Tohidi. Boulder: Rienner,
 1998, pp.39-61.

1247 KIBREAB, Gaim. Resistance, displacement, and identity:
 the case of Eritrean refugees in Sudan. *Canadian Journal
 of African Studies. Revue Canadienne des Etudes
 Africaines,* 34 ii (2000) pp.249-296.

1248 LEISURE, Susan. Exchanging participation for promises:
 mobilization of women in Eritrea. *Democratization and
 women's grassroots movements.* Ed. Jill M. Bystydzienski
 & Joti Sekhon. Bloomington: Indiana University Press,
 1999, pp.95-110.

1249 LVOVA, Eleonora. Forms of marriage and the status of
 women in Ethiopia. *Ethiopia in broader perspective.
 Papers of the XIIIth International Conference of Ethiopian
 Studies, Kyoto ... 1997.* Volume III. Ed. Katsuyoshi Fukui,
 Eisei Kurimoto, Masayoshi Shigeta. Kyoto: Shokado, 1997,
 pp.577-584. [Incl. Muslims.]

1250 ODEDE, Rachel & ASGHEDOM, Eden. The continuum
 of violence against women in Eritrea. *Development,* 44
 iii (2001) pp.69-73. Also online at
 www.ingentaselect.com

1251 SPADACINI, Beatrice & NICHOLS, Pamela.
 Campaigning against female genital mutilation in Ethiopia
 using popular education. *Gender and Development,* 6 ii
 (1998) pp.44-52. Also online at http://
 www.ingentaselect.com [Around 85% of Ethiopian women
 are circumcised, incl. Muslims.]

1252 STEFANOS, Asgedet. Eritrean women: defending national
 borders and challenging gender boundaries. *SAIS Review,*
 20 ii (2000) pp.167-181.

1253 TILSON, Dana & LARSEN, Ulla. Divorce in Ethiopia:
 the impact of early marriage and childlessness. *Journal
 of Biosocial Science,* 32 iii (2000) pp.355-372. Also
 online at www.journals.cup.org (Christians were more
 likely to divorce than Muslims.)

1254 VAN LIESHOUT, M. Challenges and opportunities facing
 women in post-conflict situations: focus on Eritrea.
 Trócaire Development Review, 1997, pp.61-75.

1255 Kebbedesh, a guerrilla, talks about what made her a fighter.
 *Eye to eye women: their words and worlds. Life in Africa,
 Asia, Latin America and the Caribbean as seen in
 photographs and in fiction by the region's top women
 writers.* (Ed. V.Baird). Oxford: New Internationalist, 1996,
 pp.110-112. [From *Sweeter than honey: testimonies of
 Tigrayan women,* 1989.]

Europe (general)

Books

1256 ARONOVITZ, Alberto & others *Le droit musulman de la famille et des successions à l'épreuve des ordres juridiques occidentaux: étude de droit comparé sur les aspects de droit international privé liés à l'immigration des musulmans en Allemagne, en Angleterre, en France, en Espagne, en Italie et en Suisse.* (Sami Aldeeb et Andrea Bonomi, éd.). Zürich: Schulthess, 1999 (Publications de l'Institut Suisse de Droit Comparé, 36), 353pp.

1257 HELBLING, Gianfranco. *Das völkerrechtliche Verbot der Geschlechterdiskriminierung in einem plurikulturellen Kontext: das Beispiel des Schutzes der menschenrechte muslimischer Frauen in westlichen Ländern.* Zürich: Schulthess, 2001 (Schweizer Studien zum Internationalen Recht, Bd. 113), 342pp.

1258 ROALD, Anne Sofie. *Women in Islam: the Western experience.* London: Routledge, 2001. 339pp.

1259 *Multi-level discrimination of Muslim women in Europe.* Jochen Blaschke (ed.). Berlin: Parabolis, 2000. 542pp.

Articles

1260 BARBARA, A. Unions sans frontières. *Hommes & Migrations,* 1167 (1993) pp.10-14. (Mariages ... entre Européens (chrétiens) et Maghrébins (musulmans).)

1261 CAMILLERI, C. Table ronde (III): L'immigration féminine Turque en Europe. *CEMOTI,* 21 (1996) pp.189-191.

1262 FOBLETS, Marie-Claire. Famille, droit familial et tribunaux en Europe. *Convergences musulmanes: aspects contemporains de l'islam dans l'Europe élargie* / coord. par Felice Dassetto, Brigitte Maréchal, Jørgen Nielsen. Louvain-la-Neuve: Academia Bruylant & L'Harmattan, [2001], pp.77-96.

1263 GÖKALP, Altan. Conjoints et stratégies matrimoniales dans l'immigration. *CEMOTI,* 21 (1996) pp.149-159. (Immigration turque en Europe.)

1264 KHATIB, Małgorzata al-. Małżeństwa chrześcijańsko-muzułmańskie w Europie Zachodniej a dialog pomiędzy chrześcijaństwem a islamem. *Przegląd Orientalistyczny,* 194-195 (2000) pp.217-224.

1265 WEIBEL, N. B. Islamité, égalité et complémentarité: vers une nouvelle approche de l'identité féminine. *Archives des Sciences Sociales des Religions,* 95 (1996) pp.133-141. [Islamist women in Europe.]

1266 Marriages between Christians and Muslims: pastoral guidelines for Christians and Churches in Europe / Islam in Europe Committee of the Conference of European Churches. *Journal of Muslim Minority Affairs,* 20 i (2000) pp.147-160. Also online at www.catchword.com

France

Books

1267 ATTALI, Marie. *Coeur lapidé: une française convertie à l'Islam.* Paris: A. Michel, 1995. 219pp.

1268 GASPARD, F. & KHOSROKHAVAR, Farhad. *Le foulard et la République.* Paris: La Découverte, 1995. 213pp. [Ḥijāb in France.]

1269 HAMMOUCHE, Abdelhafid. *Mariages & immigration: la famille algérienne en France.* Lyons: Presses Universitaires de Lyon, 1994. 183pp.

1270 HASSINI, Mohamed. *L'école: une chance pour les filles de parents maghrébins.* Paris: CIEMI, 1997. 271pp.

1271 HOUARI, Leïla & DRAY, J. *Femmes aux mille portes: portraits, mémoire.* Brussels: EPO; Paris: Syros, 1996. 114pp. [Maghribi women in Belgium & France.]

1272 MIMOUNA. *'Ni le voile ni l'oubli ...'. Témoignage* recueilli par Mohand Mounsi & R.Arana. Paris, Edition 1 1995. 142pp. [Algerian girl brought up in France.]

1273 MOUNIER, Martine. *Voyage au cœur d'un couple franco-algérien.* La Tour d'Aigues: Aube, 1998. 185pp.

1274 MOZZO-COUNIL, F. *Femmes maghrébines en France: 'mon pays, c'est ici, mon pays c'est là-bas'.* 2nd ed. rev. & complétée. Lyon: Chronique Sociale, [1994]. 131pp.

1275 VENEL, N. *Musulmanes françaises: des pratiquantes voilées à l'université.* Paris: L'Harmattan, 1999. 137pp.

Articles

1276 AUTANT, C. La tradition au service des transitions. Le mariage des jeunes Turcs dans l'immigration. *Migrants-Formation,* 101 (1995) pp.168-179. [France.]

1277 BARBARA, A. Différenciation hommes / femmes dans les populations maghrébines immigrées. *Femmes et hommes au Maghreb et en immigration: la frontière des genres en question. Etudes sociologiques et anthropologiques.* Sous la dir. de C.Lacoste-Dujardin & M.Virolle. Coord. Baya Boualem & Narjys El Alaoui. Paris: Publisud, 1998, pp.183-189. (En France.)

1278 BARBARA, Augustin. Le problématique "retour" des couples mixtes. *Hommes & Migrations,* 1236 (2002) pp.26-28. [Examples of couples in France incl. Maghribi & Senegalese partners.]

1279 BAROU, J. Sous le voile. *Migrants-Formation,* 102 (1995) pp.82-95. [France.]

1280 BAUBÉROT, J. L'affaire des foulards et la laïcité à la française. (Abstract: The affair of the scarves and secular education in France.). *Homme et la Société,* 120 (1996) pp.9-16;158.

1281 BELHADJ, Marnia. Les formes de mobilité sociale des jeunes femmes d'origine maghrébine: investissement scolaire et activité professionnelle. ([Abstracts:] Forms of social mobility of girls of Maghreb origin: investment in the school and vocational activity; Formen gesellschaftlicher Mobilität von Mädchen maghrebinischer Herkunft: schulischer Einsatz und Berufstätigkeit.). *Migration* (Berlin), 27 (1995) pp.45-55. [France.]

1282 BELKAÏD, Nadia. Grands-mères maghrébines et petits-enfants. De la transmission des liens familiaux à la transmission culturelle. *Migrants-Formation,* 98 (1994) pp.112-122. [France.]

1283 BENANI, Souad. Femmes actrices sociales dans l'immigration. *Cahiers de l'Orient,* 47 (1997) pp.113-120. [Muslims in France.]

1284 BERMON-FARAGO, P. Le foulard islamique ou la laïcité dévoilée. *Esprit,* 209 (1995) pp.174-186. [In French schools.]

1285 BESKI (CHAFIQ), Chahla. Les difficultés spécifiques aux jeunes filles issues de l'immigration maghrébine: de l'observation à la méthode d'approche. *Les femmes de l'immigration au quotidien.* Sous la dir. de Nadia Bentchicou. Paris: Licorne, 1997, pp.31-39.

1286 BLANK, D. R. A veil of controversy: the construction of a '*tchador* affair' in the French press. *Interventions,* 1 iv (1999) pp.536-554.

1287 BLOUL, Rachel. Engendering Muslim identities: deterritorialization and ethnicization process in France. *Women Living under Muslim Laws: Dossier,* 19 (1997) pp.21-37. Also online at www.wluml.org/english/pubs

1288 BOZARSLAN, Hamit. Femmes originaires de Turquie en France où en est l'intégration? *CEMOTI,* 21 (1996) pp.91-118.

1289 CESARI, J. La liberté de conscience par dessus tout. *Panoramiques,* 29 (1997) pp.64-67. [Hijab in France.]

1290 CHAIB, Yassine. Noces orientales. Les mariages mixtes et la mort. *Migrants-Formation,* 96 (1994) pp.175-188. [Dissensions over disposal of mortal remains between Western & Muslim families.]

1291 CHAOUITE, Abdellatif. Mères du Sud à l'épreuve de
 l'immigration. *Etre femme au Maghreb et en
 Méditerranée. Du mythe à la réalité*. Sous la dir. de Andrée
 Dore-Audibert & Souad Khodja. Paris: Karthala, 1998,
 pp.37-47. (La mère maghrébine immigrée.)

1292 CHERIFI, Hanifa. Jeunes filles voilées: des médiatrices
 au service de l'intégration. *Hommes & Migrations*, 1201
 (1996) pp.25-30. [Islamic headscarves in French
 schools.]

1293 COHEN-EMERIQUE, M. & MUÑOZ, M-. Regroupement
 familial: l'adaptation des jeunes conjoints. *Hommes &
 Migrations*, 1217 (1999) pp.108-119. [Spouses from
 home countries, especially Turks & Moroccans, in France.]

1294 DEBULA BAINES, Cynthia. *L'Affaire des Foulards -
 discrimination or the price of a secular public education
 system? Vanderbilt Journal of Transnational Law*, 29 v
 (1996) pp.303-327.

1295 DELAFONTAINE, Rozenn. Les femmes et la famille, au
 cœur de la communauté comorienne de Marseille.
 Hommes & Migrations, 1215 (1998) pp.21-31.

1296 DELCROIX, Catherine. Médiatrices socioculturelles,
 citoyennes innovantes! *Les femmes de l'immigration au
 quotidien*. Sous la dir. de Nadia Bentchicou. Paris: Licorne,
 1997, pp.41-54. [Incl. Maghribis & Turks in France.]

1297 DHOQUOIS-COHEN, R. Le foulard islamique à l'école:
 essai d'approche féministe et laïque. *Confluences
 Méditerranée*, 16, 1995- (1996) pp.65-83.

1298 DOMMERGUES, Catherine. Un plaisir bien défendu.
 Livres de chevet: pour une nuit, pour une vie. Dir Gérald
 Cahen. Paris: Autrement, 2001, (Série Mutations, 201),
 pp.97-102. (Houda, Anas, Emilie, Latifa, Hadidja ... on
 aurait tort de croire que les enfants de banlieue préfèrent
 les tags aux livres.)

1299 ESTERLE-HEDIBEL, M. Moi, je ne fume pas devant mon
 père. La culture du non-dit chez les jeunes filles d'origine
 maghrébine. *Migrants-Formation*, 98 (1994) pp.77-89.
 [France.]

1300 FACCHI, Alessandra. La escisión: un caso judicial. Tr.
 Serra, Gabriela. *Los retos de la inmigración: racismo
 y pluriculturalidad*. Jesús Contreras (comp.). Madrid:
 Talasa, 1994, pp.161-191. [Case of Malian girl in France
 as example of foreign practices deemed illegal in Europe.
 Previously published in *Cuaderni di Sociologia del Diritti*,
 3 (1992).]

1301 FARINE, P. Des lois Pasqua à l'affaire du voile.
 Migrations Société, 6 / 36 (1994) pp.33-38. [Ḥijāb in
 French schools.]

1302 GASPARD, Françoise. Femmes de la Méditerranée,
 femmes des banlieues françaises. *La Méditerranée des
 femmes*. Sous la dir. de Nabil el Haggar. Paris:
 L'Harmattan, 1998, pp.159-172. [Muslims.]

1303 GEESEY, Patricia. Identity and community in
 autobiographies of Algerian women in France. *Going
 global: the transnational reception of Third World women
 writers*. Ed. Amal Amireh & Lisa Suhair Majaj. New York:
 Garland Publishing, 2000, pp.173-205.

1304 GOLUB, Anne. Femmes immigrées femmes actives. Qui
 sont-elles? *Les femmes de l'immigration au quotidien*.
 Sous la dir. de Nadia Bentchicou. Paris: Licorne, 1997,
 pp.23-30. [Incl. Algerians & Turks.]

1305 HAMEL, C. Le mélange des genres: une question
 d'honneur: rapports sociaux de sexe chez de jeunes
 maghrébins de France. *Awal*, 19 (1999) pp.19-32.

1306 HAMMOUCHE, Abdelhafid. Mariages en situations
 migratoires. *Awal*, 23 (2001) pp.9-31. [Algerians in
 France.]

1307 HÜKÜM, Pınar. Le point de vue d'une responsable
 associative: qu'en est-il de l'intégration des femmes turques
 en France? *CEMOTI*, 21 (1996) pp.179-183.

1308 HÜKÜM, Pınar. Les femmes, entre repli et aspiration à
 l'émancipation. *Hommes & Migrations*, 1212 (1998)
 pp.62-69. [Turkish women in France.]

1309 IMLOUL, Nadia. Les mères algériennes et leurs filles.
 Hommes & Migrations, 1167 (1993) pp.38-43. (Qui
 vivent en France.)

1310 JAMOUS, Haroun. Les jeunes filles au foulard. (Abstract:
 The young girls with scarves.). *Homme et la Société*,
 120 (1996) pp.17-23;158.

1311 JASSER, Ghaïss. The twin evils of the veil. *Social
 Identities*, 5 i (1999) pp.31-45. [In the Islamic world in
 general & in France in particular]. Also online at
 www.catchword.co.uk

1312 KHOSROKHAVAR, Farhad. L'identité voilée.
 Confluences Méditerranée, 16, 1995- (1996) pp.69-84.
 [Veiled Maghribis in France.]

1313 LABAYLE, E. Ces profondes et délicates racines.
 Migrations-Santé, 74 pp.57-85; 77 (1993) pp.35-58.
 [Psychology of Algerian & Malian immigrant children &
 Moroccan & Turkish women in France.]

1314 LACOSTE-DUJARDIN, Camille. Relations des jeunes
 filles à leur mère dans l'immigration maghrébine en France.
 *Familles turques et maghrébines aujourd'hui: évolution
 dans les espaces d'origine et d'immigration*. Sous la dir.
 de Nouzha Bensalah. Louvain-la-Neuve:
 Academia-Erasme; Paris: Masionneuve et Larose, 1994,
 pp.189-201.

1315 LACOSTE-DUJARDIN, Camille. Transmission religieuse
 et migration: l'Islam identitaire des filles de maghrébins
 immigrés en France. *Social Compass*, 41 i (1994)
 pp.163-170.

1316 LANDOR, Jeremy. North African workers in France:
 processes of integration and exclusion. *Contemporary
 Politics*, 3 iv (1997) pp.381-399.

1317 LEADER, Sheldon. Minorities, moralities, and the
 judiciary. *The role of the judiciary in the protection of
 human rights* / ed. E.Cotran & Adel Omar Sherif. The
 Hague: Kluwer Law International, [for] CIMEL, SOAS,
 1997, pp.431-439. [The 'Foulard Islamique' case in
 France & a Muslim teacher dismissed for wishing to take
 part of Friday for religious observance in UK as examples.]

1318 MARCOU, J. Le Conseil d'Etat, le droit public français et
 le `foulard'. Interview de J-P.Costa, Conseiller d'Etat.
 CEMOTI, 19 (1995) pp.79-84. (L'affaire dite du `foulard
 islamique`.)

1319 MINCES, J. Le foulard islamique à l'école publique: un
 état des lieux. *Hommes & Migrations*, 1201 (1996)
 pp.18-24.

1320 MIŠČEVIĆ, Nenad. Des blue-jeans sous un voile
 islamique: pourquoi avons-nous besoin de traduction
 interculturelle? Blue jeans under the Muslim veil: why do
 we need inter-cultural translation? Tr. Bouchindhomme,
 Christian. *Transeuropéennes*, 22 (2002) pp.59-73.
 (Muslim communities & the French majority.) [Parallel
 French & English text.]

1321 MUSSO-DIMITRIJEVIC, Sandrine. L'accès aux soins des
 étrangers en situation précaire. *Hommes & Migrations*,
 1225 (2000) pp.88-93. [Experience of Moroccan woman
 in France.]

1322 NEYRAND, G. & M'SILI, Marine. Les couples mixtes
 dans la France contemporaine: mariage, acquisition de la
 nationalité française et divorce. ([Summaries:] Mixed
 couples in contemporary France: marriage, acquisition of
 French nationality and divorce; Las parejas mixtas en la
 Francia contemporánea: matrimonio, adquisición de la
 nacionalidad francesa y divorcio.). *Population* (Paris),
 52 iii (1997) pp.571-606. [Incl. Muslims.]

1323 NINI, Soraya. L'entre-deux-cultures. *Bulletin of
 Francophone Africa*, 11 (1997) pp.1-7. [Author of *Ils
 disent que je suis une beurette*, 1993 commenting on
 reactions to her book.]

1324 NOUR, Fatima. Journal d'une jeune fille marocaine née
 en France (mai-juillet 1987). *Genèses*, 12 (1993)
 pp.96-113.

1325 PEROTTI, A. Flash France: la circulaire Bayrou est-elle
 légitime? Le voile islamique face aux tribunaux.
 Migrations Société, 7 / 37 (1995) pp.115-117. [Press
 survey.]

1326 PEROTTI, A. Flash sur la presse française: des violences
 et du terrorisme en Algérie au `syndrome français' du
 foulard. *Migrations Société*, 6 / 36 (1994) pp.94-99.

1327 PETEK-SALOM, Gaye. Des gendres et des brus "importés" de Turquie par les familles. *Hommes & Migrations*, 1232 (2001) pp.41-50. [In France.]

1328 PETEK-ŞALOM, Gaye. Adolescentes et brus: nouveaux visages féminins turcs en France, conflits inter et intra-générationnels. *CEMOTI*, 21 (1996) pp.139-148.

1329 PETEK-ŞALOM, Gaye. Les femmes de l'immigration turque en France au carrefour de l'Islam turc et de la laïcité française. (Abstract: Turkish women in France between Turkish Islam and French secularity.). *Annales de l'Autre Islam*, 3 (1995) pp.365-374;511-512.

1330 POINSOT, Marie. Femmes et d'origine étrangère: la double intégration par le sport. *Hommes & Migrations*, 1226 (2000) pp.89-92. (Jeunes filles d'origine maghrébine.)

1331 POINSOT, Marie. Les violences familiales sur les jeunes filles d'origine étrangère et de culture musulmane. *Hommes & Migrations*, 1232 (2001) pp.99-104.

1332 POTTIER, C. La `fabrication' sociale de médiateurs culturels: le cas de jeune filles d'origine maghrébine. *Revue Européenne des Migrations Internationales*, 9 iii (1993) pp.188-191. (En France.)

1333 RÄDLER, Peter. Religionsfreiheit und staatliche Neutralität an französischen Schulen. Zur neueren Rechtsprechung des Conseil d'Etat. (Summary: Freedom of religion and the principle of secularism in French schools.). *Zeitschrift für Ausländisches Öffentliches Recht und Völkerrecht*, 56 (1996) pp.353-388. (Der *foulard islamique*.)

1334 RAHAL-SIDHOUM, Saïda. Féministe et de culture musulmane dans la société française. Une identité sous controle. *Confluences Méditerranée*, 27 (1998) pp.45-53.

1335 REZZOUG, Leïla. Grand-mère. *Algérie Littérature / Action*, 20-21 (1998) pp.7-16. [Algérian grandmother visits Paris.]

1336 ROCHERON, Yvette. Le mariage mixte, métaphore du génie néo-assimilationniste français. *Hommes & Migrations*, 1210 (1997) pp.120-127. [Incl. Muslims.]

1337 ROCHERON, Yvette. Ni bizarre ni banal - le couple franco-étranger. *Bulletin of Francophone Africa*, 11 (1997) pp.13-28. (Couples franco-maghrébins.)

1338 ROSELLO, M. North African women and the ideology of modernization: from *bidonvilles* to *cités de transit* and HLM. *Post-colonial cultures in France*. Ed. A.G.Hargreaves & M.McKinney. London: Routledge, 1997, pp.240-254. (*Cités-HLM* (low-rent social housing).)

1339 RUDE-ANTOINE, E. La polygamie face au droit positif français. *Migrations Société*, 6 / 35 (1994) pp.61-68. [Incl. Soninkes & Hal Pulaar from Mali, Senegal & Mauritania, Turks, Algerians & Moroccans.]

1340 ŞALOM, Gaye. Les femmes et le projet migratoire familial turc en France. *Enjeux de l'immigration turque en Europe: les Turcs en France et en Europe. Actes du Colloque international de Strasbourg ... 1991*. Recueillis par M.Anastassiadou; sous la dir. de A.Jund, P.Dumont, S.de Tapia. Paris: CIEMI/L'Harmattan, 1995, (Migrations et Changements, 41), pp.2429-255.

1341 SALZBRUNN, M. Zwischen kreativen Eigenwelten und republikanischem Druck - Musliminnen nord- und westafrikanischer Herkunft in Frankreich. *Der neue Islam der Frauen. Weibliche Lebenspraxis in der globalisierten Moderne: Fallstudien aus Afrika, Asien und Europa*. R.Klein-Hessling, S.Nökel, K.Werner (Hg.). Bielefeld: transcript Verlag, 1999, pp.62-80.

1342 SEBBAR, Leïla. Shérazade, la syllable perdue. *Cahier d'Études Maghrébines*, 6-7 (1994) pp.101-102. (Une Arabe en France.)

1343 SEKSIG, A. Ni plurielle, ni de combat: la laïcité: un débat entre Patrick Kessel, président du Comité laïcité et République et Jean-Marc Roirant, secrétaire général de la Ligue de l'enseignement. *Hommes & Migrations*, 1218 (1999) pp.64-75. [Headscarves in French schools, etc.]

1344 STREIFF-FENART, J. Ruser avec la tradition: le mariage dans les familles maghrébines en France. *Projet*, 239 (1994) pp.57-61.

1345 TERSIGNI, S. Le délit vestimentaire du voile entre universalisme et hiérarchisation en France. *Africa: Rivista Trimestrale di Studi e Documentazione dell'Istituto Italiano per l'Africa et l'Oriente*, 55 ii (2000) pp.290-298.

1346 TERSIGNI, Simona. La virginité des filles et l'"honneur maghrébin" dans le contexte français. *Hommes & Migrations*, 1232 (2001) pp.34-40.

1347 VASSBERG, Liliane M. Immigration maghrébine en France: l'intégration des femmes. *French Review*, 70 v (1997) pp.710-720.

1348 VENEL, N. Französischen Muslimas - Glaubensbiographien von Studentinnen mit Kopftuch. *Der neue Islam der Frauen. Weibliche Lebenspraxis in der globalisierten Moderne: Fallstudien aus Afrika, Asien und Europa*. R.Klein-Hessling, S.Nökel, K.Werner (Hg.). Bielefeld: transcript Verlag, 1999, pp.81-105.

1349 WAYLAND, S. V. Religious expression in public schools: *kirpans* in Canada, *hijab* in France. *Ethnic and Racial Studies*, 20 iii (1997) pp.545-561.

1350 WEBER, E. Le voile n'est que le début d'une stratégie islamiste .. *Panoramiques*, 29 (1997) pp.68-74. [In France.]

1351 WEIBEL, N.B. L'encadrement religieux au féminin. *La formation des cadres religieux musulmans en France: approches socio-juridiques*. Sous la dir. de F.Frégosi. Paris: L'Harmattan, 1998, pp.91-100.

1352 WEIBEL, N. B. Femmes, Islam et identité religieuse dans l'immigration turque en Alsace. *CEMOTI*, 21 (1996) pp.171-177.

1353 WEIBEL, N. B. L'islam action au féminin ou une rédéfinition de l'identité de genre. *Actes du Colloque: L'islam en Europe: aspects religieux, Lausanne ... 1992*. Ed. J.Waardenburg. Lausanne: Université de Lausanne, Département Interfacultaire d'Histoire et de Sciences des Religions, 1994, (Cahiers, 2), pp.69-85. [Middle East, France & Germany.]

1354 WEIL-CURIEL, Linda. Female genital mutilation in France. A crime punishable by law. *Eye to eye: women practising development across cultures* / ed. Susan Perry & Celeste Schenk. London: Zed, 2001, pp.190-197. [Case brought against Senegalese in France.]

1355 WILPERT, C. Table ronde IV: L'immigration féminine turque en France. *CEMOTI*, 21 (1996) pp.193-200.

Gambia

Articles

1356 EBRON, P. Traffic in men. *Gendered encounters: challenging cultural boundaries and social hierarchies in Africa*. M.Grosz-Ngaté & Omari H.Kokole, eds. London: Routledge, 1997, pp.223-244. (European women holiday travelers seeking Gambian male friends.)

1357 FALL, Rokhaya. Femmes et pouvoir dans les sociétés nord sénégambiennes. *Afrika Zamani*, N.S.2 / 1994 (1996) pp.69-79. (Hal Pulaar, Wolof et Serer.)

1358 SCHROEDER, R. A. "Gone to their second husbands": marital metaphors and conjugal contracts in the Gambia's female garden sector. *Canadian Journal of African Studies. Revue Canadienne des Études Africaines*, 30 i (1996) pp.69-87.

1359 SCHROEDER, R. A. "Re-claiming" land in the Gambia: gendered property rights and environmental intervention. *Annals of the Association of American Geographers*, 87 iii (1997) pp.487-508.

1360 SINGHATEH, Safiatu Kassim. Breaking culture's chains. *Women's lifeworlds: women's narratives on shaping their realities* / ed. Edith Sizoo. London: Routledge, 1997, pp.121-136. [Gambia.]

1361 WEIL, P. M. Women's masks and the power of gender in Mande history. *African Arts*, 31 ii (1998) pp.28-37;88-91;95. (Senegambia ... non-Muslim Mandinka masks & ... Muslim Mande masks.)

General; more than two countries, areas or subjects

ANTHROPOLOGY, SOCIOLOGY & DEMOGRAPHY

Books

1362 'ABD AL-HĀDĪ, Amal & 'ABD AL-SALĀM, Sihām].
Physicians' attitudes towards female circumcision / Amal
Abdel-Hadi & Siham Abdel-Salam. Revised by Amal
Abdel-Hadi & Nida Kirmani. Tr. Elgeziri, Mushira.
Cairo: Cairo Institute for Human Rights Studies, 1999,
(Women Initiatives, 30), 97pp.

1363 AÏT SABBAH, Fatna. *La mujer en el inconsciente
musulmán.* Tr. Jiménez Morell, I. Guadarrama: Ediciones
del Oriente y del Mediterráneo, 2000 (El Collar de la
Paloma, 5), 184pp. [Tr. of *La femme dans l'inconscient
musulman,* Paris 1982.]

1364 AKASHE-BÖHME, Farideh. *Die islamische Frau ist
anders: Vorurteile und Realitäten.* Gütersloh: Gütersloher
Verlagshaus, 1997. 96pp.

1365 ALVAREZ DEGREGORI, Ma Cristina. *Sobre la
mutilación genital femenina y otros demonios.* Bellaterra:
Universitat Autònoma de Barcelona, 2001. 151pp.

1366 BERKTAY, Fatmagül. *Women and religion.* Tr.
Ötüş-Baskett, Belma. Montreal: Black Rose, 1998.
191pp. [Social study, with particular reference to
Christianity & Islam.]

1367 BOUHDIBA, Abd al-Wahab. *Vrt milovanja.* Sarajevo:
Ljiljan, 1994. 261pp. [Tr. of *Sexuality in Islam.*]

1368 BROOKS, Geraldine. *Allahs döttrar: muslimska kvinnors
dolda värld.* Tr. Mazetti-Nissen, E. Malmö: Richter,
1995. 287pp. [Tr. of *Nine parts of desire,* London 1995.]

1369 BROOKS, Geraldine. *Devět částí touhy: skrytý svět
muslimských žen.* Tr. Eflerová, Petra. Prague: Knizní
Klub, 1999. 3267pp. [Tr. of *Nine parts of desire,* London
1995.]

1370 BROOKS, Geraldine. *Die Töchter Allahs.* Tr. Robben,
B. Munich: Bertelsmann, 1994. 313pp. [Tr. of *Nine
parts of desire,* London 1995.]

1371 BROOKS, Geraldine. *Les femmes dans l'islam: un monde
caché.* Tr. Lahana, J. Paris: Belfond, 1995. 323pp.

1372 BROOKS, Geraldine. *Nine parts of desire: the hidden
world of Islamic women.* London: Hamish Hamilton; New
York: Doubleday, 1995. 255pp.

1373 BROOKS, Geraldine. *Slør og begær: Islamiske kvinders
skjulte verden.* Tr. Nielsen, H. L. Copenhagen: Gyldendal,
1996. 304pp. [Tr. of *Nine parts of desire,* London 1995.]

1374 BROOKS, Geraldine. *Un mundo bajo el velo: vida oculta
de las mujeres musulmanas.* Tr. Herrera, A. Barcelona:
Grijalbo, 1996. 325pp. [Tr. of *Nine parts of desire,*
London 1995.]

1375 GIOLFO, Manuela. *Attraverso il velo: la donna nel
Corano e nella società islamica.* Turin: Ananke, 1999
(Abadir, 5), 95pp.

1376 GUINDI, Fadwa el. *Veil: modesty, privacy and resistance.*
Oxford: Berg, 1999. 242pp.

1377 HEINE, I. & HEINE, P. *O ihr Musliminnen ...: Frauen
in islamischen Gesellschaften.* Freiburg im Breisgau:
Herder, 1993, (Herder Spektrum, 4217), 218pp.

1378 HÖGLINGER, Monika. *Verschleierte Lebenswelten: zur
Bedeutung des Kopftuchs für muslimische Frauen.*
Ethnologische Studie. Maria Enzersdorf: Roesner, 2002.
146pp.

1379 IBN RASSOUL, Abū-r-Riḍā' Muḥammad ibn Ahmad.
Handbuch der muslimischen Frau. Cologne: Islamische
Bibliothek, 1996. 304pp.

1380 KVERNRØD, A-B. *En køn(net) historie om Mellemøsten:
feministisk antropologi: en analyse af etnografiske
beskrivelser af mellemøstlige kvinder fra perioden 1970
til 1993.* Højbjerg: Afdeling for Etnografi og
Socialantropologi, Aarhus Universitet, 1993. 145pp.

1381 MERNISSI, Fat[i]ma. *Etes-vous vacciné contre le
"harem"? Texte-test pour les messieurs qui adorent les
dames.* Casablanca: Fennec, 1998. 161pp.

1382 SHIRAZI, Faegheh. *The veil unveiled: the hijab in modern
culture.* Gainesville: University Press of Florida, 2001.
221pp.

1383 TILLION, G. *La condición de la mujer en el área
mediterránea.* Tr. Fort, A. & Huera, C. Barcelona:
Ediciones Península, 1993. 219pp. [Translation of *Le
harem et les cousins,* 1966.]

1384 VERCELLIN, G. *Tra veli e turbanti: rituali sociali e vita
privata nei mondi dell'Islam.* Venice: Marsilio, 2000.
257pp.

1385 ZLITNI, Mohammed Abd el Kefi. *La mujer musulmana
(a través del matrimonio).* Madrid: Vulcano, 1998 (Opalo,
11), 76pp.

1386 *Der neue Islam der Frauen. Weibliche Lebenspraxis in der
globalisierten Moderne: Fallstudien aus Afrika, Asien und
Europa.* R.Klein-Hessling, S.Nökel, K.Werner (Hg.).
Bielefeld: transcript Verlag, 1999. 315pp.

1387 *Female genital mutilation: a guide to laws and policies
worldwide.* Ed. Anika Rahman and Nahid Toubia. London:
Zed, in association with Center for Reproductive Law and
Policy, and RAINBO, 2000. 249pp.

1388 *Gender and identity construction: women of Central Asia,
the Caucasus and Turkey.* Ed. Acar, Feride &
Günes-Ayata, Ayşe. Leiden: Brill, 2000 (Social, Economic
and Political Studies of the Middle East and Asia, 68),
358pp.

1389 *Hermeneutics and honor: negotiating female "public" space
in Islamic/ate societies.* Ed. Asma Afsaruddin. Cambridge
(USA): Harvard University Press, for the Center for Middle
Eastern Studies of Harvard University, 1999 (Harvard
Middle Eastern monographs, 32), 222pp.

1390 *Islam, gender, & social change.* Ed. Haddad, Y. Yazbeck
& Esposito, J. L. New York: Oxford University Press,
1998. 259pp.

1391 *Women, patronage, and self-representation in Islamic
societies.* Ed. Ruggles, D.Fairchild. Albany (USA): State
University of New York Press, 2000. 243pp.

1392 *Women and sexuality in Muslim societies.* Ed. İlkkaracan,
Pinar. Istanbul: Women for Women's Human Rights /
Kadının İnsan Hakları Projesi, 2000. 455pp.

1393 *Women in Muslim societies: diversity within unity.* Ed.
Bodman, H. L. & Tohidi, Nayereh. Boulder: Rienner,
1998. 311pp.

1394 'ABD AL-HĀDĪ, Amal & 'ABD AL-SALĀM, Sihām].
Physicians' attitudes towards female circumcision / Amal
Abdel-Hadi & Siham Abdel-Salam. Revised by Amal
Abdel-Hadi & Nida Kirmani. Tr. Elgeziri, Mushira.
Cairo: Cairo Institute for Human Rights Studies, 1999,
(Women Initiatives, 30), 97pp.

Articles

1395 ACCAD, Evelyne. Construction de l'excision: l'écriture
de la douleur. *Peuples Méditerranéens. Mediterranean
Peoples,* 78 (1997) pp.169-192.

1396 AFKHAMI, Mahnaz. An AMEWS/MESA special session
on violence against women. *Middle East Women's Studies
Review,* 13 iv - 14 i (1999) pp.5-7;23.

1397 AFSHAR, Haleh. Women and wars: some trajectories
towards a feminist peace. *Development in Practice,* 13
ii-iii (2003) pp.178-188. Also online at http://
www.ingentaselect.com (The Islamic experience.)

1398 AIXELÀ CABRÉ, Y. Violencia de género en sociedades
árabo-musulmanas. *Studia Africana* (Barcelona), 5 (1994)
pp.153-158. (En referencia a las mujeres.)

1399 ANSARI, Walid el. The 9th International Congress on women's health issues, Alexandria, Egypt (June 1998). *Journal of the Islamic Medical Association of South Africa. Majallat al-Jam'īya al-Ṭibbīya al-Islāmīya bi-Janūb Ifrīqiyā,* 4 iii (1998) pp.79-80. [Affecting Muslim women.]

1400 AUBAILE-SALLENAVE, F. Les nourritures de l'accouchée dans le monde arabo-musulman méditerranéen. ([Abstract:] Food for the new mother in the Arabic Moslem Mediterranean world.). *Médiévales,* 33 (1997) pp.103-124. (Study of sources going back to the tenth century & of recent ethnographic descriptions.)

1401 BOOTH, Marilyn. Social change, the press, and Middle Eastern women, 1869-1945. *AMEWS Newsletter,* 10 iv (1996) pp.5-6. [MESA Conference panel, 1995.]

1402 BOWEN, D. L. Abortion, Islam, and the 1994 Cairo Population Conference. *International Journal of Middle East Studies,* 29 ii (1997) pp.161-184.

1403 BOYLE, Elizabeth Heger, MCMORRIS, Barbara J. & GÓMEZ, Mayra. Local conformity to international norms: the case of female genital cutting. (Résumé: La conformité locale aux normes internationales: le cas des mutilations génitales des femmes. Resumen: Conformidad local para con las normas internacionales: el caso de la amputación de genitales femeninos.). *International Sociology,* 17 i (2002) pp.5-33;143-144. Also online at www.ingenta.com (Egypt, Kenya, Mali, Niger and the Sudan.)

1404 CALDWELL, John C., ORUBULOYE, I.O. & CALDWELL, Pat. Female genital mutilation: conditions of decline. *Population Research and Policy Review,* 19 iii (2000) pp.233-254. [Generally & among Christian & Muslim Yorubas in Nigeria.]

1405 CHIKHAOUI, Naïma. Et si on ôtait le voile sans dénuder. *Femmes et Islam. Al-Nisā' wa-'l-Islām.* Collection dirigée par Aïcha Belarbi. Casablanca: Le Fennec, 1998, pp.35-48. (Le voile, indicateur sociologique.)

1406 ETHELSTON, S. Water and women: the Middle East in demographic tension. *Middle East Report,* 29 iv / 213 (1999) pp.8-12;44.

1407 FREMBGEN, J. W. Die Virginitätsprobe. Zur besonderen Verwendung von Geweben im islamischen Hochzeitsbrauchtum. *Baessler Archiv,* 67 / N.F. 42 ii (1994) pp.405-418.

1408 GALLAGHER, N.[E.]. Gendering medicine from the Black Sea to the Maghreb. *Middle East Women's Studies Review,* 14 iv (2000) pp.14-14. (MESA panel review.)

1409 GUINDI, Fadwa el. Veiled men, private women in Arabo-Islamic culture. *ISIM Newsletter,* 4 (1999) pp.6-6.

1410 [HĀSHIMĪ, Fā'izah]. Flying the chador. Tr. Mobasser, Nilou. *Index on Censorship,* 29 iv / 195 (2000) pp.70-71. (Islamic Women's Games.)

1411 HEATON, T. B. Socioeconomic and familial status of women associated with age at first marriage in three Islamic societies. *Journal of Comparative Family Studies,* 27 i (1996) pp.41-58. [Egypt, Indonesia, Jordan.]

1412 HIRSCHMANN, N. J. Eastern veiling, Western freedom? *Review of Politics,* 59 iii (1997) pp.461-488.

1413 HORTAÇSU, Nuran & BAŞTUĞ, Sharon. Women in marriage in Ashkabad, Baku, and Ankara. *Gender and identity construction: women of Central Asia, the Caucasus and Turkey.* Ed. Feride Acar & Ayşe Güneş-Ayata. Leiden: Brill, 2000, (Social, Economic and Political Studies of the Middle East and Asia, 68), pp.77-100.

1414 HOSNI, Djehane & CHANMALA, Adriana. Female endangerment: the case of the Middle East and North Africa. *The economics of women and work in the Middle East and North Africa.* Ed. E.Mine Cinar. Amsterdam: JAI, 2001, (Research in Middle East Economics, 4), pp.33-49. (High female illiteracy, fertility & maternal mortality rates.)

1415 H-R., B. Islam: der Wandel in der Familienstruktur. *Herder Korrespondenz,* 47 xi (1993) pp.552-554. (Die Rolle der Frau.)

1416 HUZAYYIN, S. A. Marriage and remarriage in Islam. *Bulletin de l'Institut d'Egypte / Majallat al-Majma' al-'Ilmī al-Miṣrī,* 74-75 / 1994-1995 (1996) pp.16-39. [Comparative sociological study of some Islamic countries.]

1417 JAMES, S. M. Shades of othering: reflections of female circumcision / genital mutilation. *Signs,* 23 iv (1998) pp.1031-1048. [Discussion of recent western approaches to the issue.]

1418 JASSER, Ghaïss. The twin evils of the veil. *Social Identities,* 5 i (1999) pp.31-45. [In the Islamic world in general & in France in particular]. Also online at www.catchword.co.uk

1419 KÂĞITÇIBAŞI, Çiğdem. La famille dans la société musulmane et le changement social. *Familles-Islam-Europe: le droit confronté au changement.* Sous la direction de M-C.Foblets. Paris: L'Harmattan, 1996, pp.269-291.

1420 KHATIB-CHAHIDI, Jane, HILL, Rosanna & PATON, R. Chance, choice and circumstance: a study of women in cross-cultural marriages. *Cross-cultural marriage: identity and choice.* Ed. R.Breger & Rosanna Hill. Oxford: Berg, 1998, pp.49-66. [Incl. nationals of Turkey & Iran; husbands included nationals from Turkey, Iran, Jordan, Sudan, Iraq & Egypt.]

1421 LACOSTE-DUJARDIN, C. Au sujet du texte `La femme indévoilable'. *Horizons Maghrébins,* 25-26 (1994) pp.118-120. [On Muslim women, by J.Sarocchi, *q.v.* below.]

1422 LAIL, Haifa R. Jamal al-. Muslim women between tradition and modernity: the Islamic perspective. *Journal of Muslim Minority Affairs,* 16 i (1996) pp.99-110.

1423 LEEMHUIS, F. Epouser un djinn? Passé et présent. *Quaderni di Studi Arabi,* 11 / 1993 (1994) pp.179-192.

1424 LOZA, S. Social and gender issues in the Middle East and North Africa. *Management of water demand in Africa and the Middle East: current practices and future needs.* Ottawa: International Development Research Centre, 1997, pp.46-49.

1425 MAGROUNE, Halima. Le voile, une relique médiévale d'intimidation. *Cahiers de l'Orient,* 47 (1997) pp.73-82.

1426 MARSOT, Afaf Lutfi al-Sayyid. Women and modernization: a reevaluation. *Women, the family, and divorce laws in Islamic history.* Ed. A.El Azhary Sonbol. Syracuse: Syracuse University Press, 1996, pp.39-51.

1427 MASON, Karen Oppenheim & SMITH, Herbert L. Husbands' versus wives' fertility goals and use of contraception: the influence of gender context in five Asian countries. *Demography,* 37 iii (2000) pp.299-311. (Pakistan, India, Malaysia, Thailand, & the Philippines.)

1428 MIKHAIL, Susanne Louis B. Child marriage and child prostitution: two forms of sexual exploitation. *Gender and Development,* 10 i (2002) pp.43-49. Also online at http:// www.ingentaselect.com [Girls in North Africa & the Middle East.]

1429 MOGHISSI, Haideh. Women, sexuality, and social policy in Islamic cultures. *International Review of Comparative Public Policy,* 9 (1997) pp.149-168.

1430 MOJAB, Shahrzad & HASSANPOUR, Amir. Thoughts on the struggle against "honor killing". *International Journal of Kurdish Studies,* 16 i-ii (2002) pp.81-97. [As one of many forms of patriarchal violence against Kurdish & other women, in the Middle East & in Europe.]

1431 MONDAI, Sekh Rahim. Polygyny and divorce in Muslim society - controversy and reality. *Islam, women and gender justice.* [Ed.] Asghar Ali Engineer. New Delhi: Gyan Publishing House, 2001, pp.129-142. [Islam in general & India in particular.]

1432 MURRAY, S. O. Woman-woman love in Islamic societies. *Islamic homosexualities: culture, history, and literature.* S.O.Murray & W.Roscoe, with additional contributions by E.Allyn [& others]. New York: New York University Press, 1997, pp.97-104.

1433 NABER, Nadine. Teaching about honor killings and other
 sensitive topics in Middle East studies. *Middle East
 Women's Studies Review*, 15 i-ii (2000) pp.20-21.
 (Conference reviews.)

1434 NAHAVANDI, Firouzeh. Et si nous reparlions de la
 femme musulmane? *Civilisations*, 40 ii / 1992 (1993)
 pp.278-283. (Les sociétés musulmanes sont à l'image de
 toutes les sociétés patriarcales.)

1435 OBERMEYER, C. M., REYNOLDS, R. & RATCLIFFE,
 A. Female genital surgeries: the known, the unknown,
 and the unknowable. *Medical Anthropology Quarterly*,
 13 i (1999) pp.79-106. [Incl. Muslims.]

1436 OKWUBANEGO, John Tochukwu. Female circumcision
 and the girl child in Africa and the Middle East: the eyes
 of the world are blind to the conquered. *International
 Lawyer*, 33 i (1999) pp.159-187.

1437 OBERHELMAN, S. M. Hierarchies of gender, ideology,
 and power in ancient and medieval Greek and Arabic
 dream literature. *Homoeroticism in classical Arabic
 literature*. Ed. J.W.Wright & E.K.Rowson. New York:
 Columbia University Press, 1997, pp.55-93.

1438 PIELOW, D. Dämonenabwehr am Beispiel des *Zārs* und
 des islamischen Amulettwesens . *Zeitschrift der
 Deutschen Morgenländischen Gesellschaft*, 147 ii (1997)
 pp.354-370.

1439 RABO, A. Kampen om slöjan - slöjan i kampen.
 Kvinnovetenskaplige Tidskrift, 18 iii-iv (1997) pp.62-68.
 [Veiling & reveiling by Muslim women.]

1440 RAHBARI, Reza. Unveiling Muslim women: a trajectory
 of post-colonial culture. *Dialectical Anthropology*, 25 iii
 (2000) pp.321-332.

1441 RAJAKARUNA, Saama. Honour crimes and honourable
 justice. *Nēthra*, 5 i (2002) pp.31-46. [Mainly Muslim.]

1442 RUIZ FIGUEROA, M. El código de conducta de la mujer
 musulmana. Entre la tradición y el cambio. (Abstract: The
 behavior code of Muslim women: between tradition and
 change.). *Estudios de Asia y Africa*, 107 / 33 iii (1998)
 pp.437;549-567.

1443 SAMANDI, Zeyneb. Le hijab révolutionnaire contre le
 voile traditionnel. Le corps de la femme et l'ordre social.
 *Revue Tunisienne de Sciences Sociales / Al-Majalla
 al-Tūnisīya li-l-'Ulūm al-Ijtimā'īya*, 36 / 119 (1999)
 pp.39-47.

1444 SAROCCHI, J. `Le voile humain'. *Horizons Maghrébins*,
 25-26 (1994) pp.100-102. [Women in the Muslim world.]

1445 SAROCCHI, J. La femme indévoilable. *Horizons
 Maghrébins*, 25-26 (1994) pp.103-114. [Muslim
 women.]

1446 SHWEDER, R.A. What about "female genital mutilation"?
 And why understanding culture matters in the first place.
 Dædalus, 129 iv (2000) pp.209-232.

1447 SILBERSCHMIDT, M. Omskæring af kvinder - i
 traditionens navn? *Jordens Folk*, 30 iii (1995)
 pp.101-106. (I 25 lander syd for Sahara, samt Ægypten,
 Yemen og Oman.)

1448 STACK, Carol B. Frameworks for studying families in
 the 21st century. *The new Arab family / Al-Usra
 al-'Arabīya al- jadīda*. Ed. Nicholas S.Hopkins. Cairo:
 American University in Cairo Press, 2003, (Cairo Papers
 in Social Science, 24 i-ii / 2001), pp.5-19. [Family roles,
 women's roles in Middle East.]

1449 STOWASSER, B. F. The *Ḥijāb*: how a curtain became an
 institution and a cultural symbol. *Humanism, culture,
 and language in the Near East. Studies in honor of Georg
 Krotkoff*. Ed. Asma Afsaruddin & A.H.M.Zahniser.
 Winona Lake: Eisenbrauns, 1997, pp.87-104.

1450 TERSIGNI, S. Il velo nelle società islamiche
 contemporanee. *Africa* (Rome), 52 iv / 1997 (1998)
 pp.592-613.

1451 THABET, Saeed M. A. Split hymenorrhaphy: a new
 procedure in managing imperforate hymens in Muslim
 countries. *Journal of IMA*, 31 vi (1999) pp.267-269.

1452 WALLEY, Christine J. Searching for "voices": feminism,
 anthropology, and the global debate over female genital
 operations. *Cultural Anthropology*, 12 iii (1997)
 pp.405-438. [Incl. Muslim countries.]

1453 WINKELMANN, Marieke Jule. The construction of female
 identity in Muslim modernity. *ISIM Newsletter*, 8 (2001)
 pp.4-4. [Workshop report.]

1454 Entretien avec Malek Chebel. *Cahiers de l'Orient*, 47
 (1997) pp.121-132. [About Muslim women.]

1455 Workshop report: Refuges for women in Islamic societies,
 February 9-11, 1998, Islamabad. *Pakistan Journal of
 Women's Studies. Alam-e-Niswan*, 5 i-ii (1998)
 pp.129-130.

ECONOMIC PARTICIPATION OF WOMEN

Books

1456 MOGHADAM, V. M. *Women, work, and economic
 reform in the Middle East and North Africa*. Boulder:
 Rienner, 1998. 259pp.

1457 SHUKRI, Shirin J. A. *Social changes and women in the
 Middle East: state policy, education, economics and
 development*. Aldershot: Ashgate, 1998. 118pp.

1458 *The economics of women and work in the Middle East and
 North Africa*. Ed. E.Mine Cinar. Amsterdam: JAI, 2001
 (Research in Middle East Economics, 4), 360pp.

Articles

1459 CINAR, E.Mine. Earning profiles of women workers and
 education in the Middle East. *Earnings inequality,
 unemployment, and poverty in the Middle East and North
 Africa*. Ed. Wassim Shahin & Ghassan Dibeh. Westport:
 Greenwood, 2000, (Contributions in Economics and
 Economic History, 215), pp.79-93.

1460 GÜNDÜZ-HOŞGÖR, Ayşe. Convergence between
 theoretical perspectives in women-gender and development
 literature regarding women's economic status in the Middle
 East. *ODTÜ Gelişme Dergisi. METU Studies in
 Development*, 28 i-ii / 2001 (2002) pp.111-132. (To
 compare their understanding of how development affects
 women's employment.)

1461 HARFOUSH-STRICKLAND, Samira. Formal education
 and training in non-traditional jobs. *Arab women:
 between defiance and restraint*. Ed. Suha Sabbagh. New
 York: Olive Branch Press, 1996, pp.67-70.

1462 HEES, R. G. Gender equality and the World Bank.
 *Muslim women and the politics of participation:
 implementing the Beijing platform*. Ed. Mahnaz Afkhami
 & E.Friedl. Syracuse (USA): Syracuse University Press,
 1997, pp.147-152. [Incl. Morocco, Iran, Tunisia, Pakistan,
 Egypt & other Muslim countries.]

1463 ILYAS, Qazi Shamsuddin Md. Women's participation in
 employment: its history and determinants. *Empowerment*,
 4 (1997) pp.31-52. [With particular ref. to Muslims.]

1464 KARSHENAS, Massoud & MOGHADAM, Valentine M.
 Female labor force participation and economic adjustment
 in the MENA region. *The economics of women and work
 in the Middle East and North Africa*. Ed. E.Mine Cinar.
 Amsterdam: JAI, 2001, (Research in Middle East
 Economics, 4), pp.51-74.

1465 LIN LEAN LIM & OISHI, Nana. International labor
 migration of Asian women: distinctive characteristics and
 policy concerns. *Asian and Pacific Migration Journal*, 5
 i (1996) pp.85-116. [Especially to Middle East.]

1466 MOGHADAM, V. M. Development strategies, state
 policies, and the status of women: a comparative
 assessment of Iran, Turkey, and Tunisia. *Patriarchy and
 economic development: women's positions at the end of
 the twentieth century*. Ed. V.M.Moghadam. Oxford:
 Clarendon, 1996, pp.241-268.

1467 MOGHADAM, V.M. Gender and economic reforms: a framework for analysis and evidence from Central Asia, the Caucasus, and Turkey. *Gender and identity construction: women of Central Asia, the Caucasus and Turkey.* Ed. Feride Acar & Ayşe Günes-Ayata. Leiden: Brill, 2000, (Social, Economic and Political Studies of the Middle East and Asia, 68), pp.23-43.

1468 MOGHADAM, Valentine M. Women, work, and economic restructuring: a regional overview. *The economics of women and work in the Middle East and North Africa.* Ed. E.Mine Cinar. Amsterdam: JAI, 2001, (Research in Middle East Economics, 4), pp.93-116.

1469 MUFEED, S. A. Women resource development: an Islamic perspective. *Journal of Objective Studies,* 10 ii (1998) pp.56-72.

1470 SHAFIK, Nemat. Closing the gender gap in the Middle East and North Africa. *The economics of women and work in the Middle East and North Africa.* Ed. E.Mine Cinar. Amsterdam: JAI, 2001, (Research in Middle East Economics, 4), pp.13-31.

1471 SHAH, Nasra M. & MENON, Indu. Violence against women migrant workers: issues, data and partial solutions. *Asian and Pacific Migration Journal,* 6 i (1997) pp.5-30. [Migrants from Bangladesh & other Muslim countries; migrant workers in Gulf countries.]

1472 ZANDVAKILI, Sourushe. Analysis of sex-based inequality: use of axiomatic approach in measurement and statistical inference via bootstrapping. *The economics of women and work in the Middle East and North Africa.* Ed. E.Mine Cinar. Amsterdam: JAI, 2001, (Research in Middle East Economics, 4), pp.75-91. (Earnings inequality between men & women & among women in MENA.)

HISTORY

Books

1473 BEINHAUER-KOHLER, Bärbel. *Fāṭima bint Muḥammad: Metamorphosen einer frühislamischen Frauengestalt.* Wiesbaden: Harrassowitz, 2002. 377pp.

1474 GILADI, A. *Infants, parents and wet nurses: medieval Islamic views on breastfeeding and their social implications.* Leiden: Brill, 1999, (Islamic History and Civilization: Studies and Texts, 25), 191pp.

1475 KNIEPS, C. *Geschichte der Verschleierung der Frau im Islam.* Würzburg: Ergon-Verlag, 1993, (Ethno-Islamica, 3), 476pp.

1476 MERNISSI, Fatima. *Die Sultanin: die Macht der Frauen in der Welt des Islam.* Hamburg: Luchterhand Literaturverlag, 1993, (Sammlung Luchterhand, 1134), 254pp. [Tr. of *Sultanes oubliées.*]

1477 MERNISSI, Fatima. *Las sultanas olvidadas.* Tr. Galmarini, M. A. Barcelona: Muchnik, 1997. 329pp. [Tr. of *The forgotten queens of Islam,* 1993.]

1478 NASHAT, G. & TUCKER, Judith E. *Women in the Middle East and North Africa: restoring women to history.* Bloomington: Indiana University Press, 1999. 160pp. [Part I: 8000 BC - 1800 CE; Part II: 19th & 20th centuries.]

1479 OOSTERHOFF, W. *Vrouwen van Abraham en hun invloed op de wereldgeschiedenis: een metahistorische benadering van het Midden-Oostenconflict.* Zoetermeer: Uitgeverij Boekencentrum, 1994. 134pp.

1480 SAMARAI, Nicola Lauré al-. *Macht der Darstellung: Gender, sozialer Status, historiographische Re-Präsentation: zwei Frauenbiographien aus der frühen Abbasidenzeit.* Wiesbaden: Reichert, 2001 (Literaturen im Kontext: Arabisch, Persisch, Türkisch, 6), 158pp.

1481 SCHIRILLA, Nausikaa. *Die Frau, das Andere der Vernunft? Frauenbilder in der arabisch-islamischen und europäischen Philosophie.* Frankfurt a.M.: IKO-Verlag für Interkulturelle Kommunikation, 1996 (Erziehung und Gesellschaft in Internationalen Kontext, 13), 309pp.

1482 *Les femmes: filles de Prophète, condiciples vertueuses.* Préparé par Fdal Haja. Tr. Bousserouel, Hébri. Paris: Universel, 1996. 212pp. (La place occupée par la femme au temps de Mohammed.)

1483 *Social history of women and gender in the modern Middle East* / ed. M.L.Meriwether, J.E.Tucker. Boulder: Westview, 1999. 220pp.

1484 *Women in the medieval Islamic world: power, patronage, and piety.* Ed. Hambly, G. R. G. Basingstoke: Macmillan, 1998, (The New Middle Ages, 6), 566pp.

Articles

1485 AKHTAR, M. S[hakil]. Views on breast-feeding in medical science and Islam. *Journal of IMA,* 30 iv (1998) pp.181-183.

1486 AMIRSOLEIMANI, Soheila. Women in Tārīkh-i Bayhaqī. *Der Islam,* 78 ii (2001) pp.229-248.

1487 AUBAILE-SALLENAVE, F. Les nourritures de l'accouchée dans le monde arabo-musulman méditerranéen. ([Abstract:] Food for the new mother in the Arabic Moslem Mediterranean world.). *Médiévales,* 33 (1997) pp.103-124. (Study of sources going back to the tenth century & of recent ethnographic descriptions.)

1488 AYALON, D. The harem: a major source of Islam's military might. *Sacred space: shrine, city, land. Proceedings of the international conference in memory of Joshua Prawer.* Ed. B.Z.Kedar & R.J.Z.Werblowsky. Basingstoke: Macmillan; Jerusalem: Israel Academy of Sciences, 1998, pp.140-150.

1489 BERKEY, J. P. Circumcision circumscribed: female excision and cultural accommodation in the medieval Near East. *International Journal of Middle East Studies,* 28 i (1996) pp.19-38.

1490 BLANKS, D. R. Gendering history: Europe and the Middle East. *Alif,* 19 (1999) pp.43-67. (Review article of historical research.)

1491 CANO LEDESMA, A. Reflexiones sobre pediatría y ginecología en la medicina árabo-islámica. *Arbor,* 144 / 565 (1993) pp.31-49.

1492 CHEIKH, Nadia M. el-. Describing the other to get at the self: Byzantine women in Arabic sources (8th-11th centuries). *Journal of the Economic and Social History of the Orient,* 40 ii (1997) pp.239-250. [Adab & some historiographical literature.]

1493 DAOUD, Zakya. Des houris et des hommes. *Cahiers Intersignes,* 6-7 (1993) pp.207-209. [Women in Islam.]

1494 ELAD, A. An epitaph of the slave girl of the grandson of the 'Abbassid Caliph al-Ma'mun. *Le Muséon,* 111 i-ii (1998) pp.227-244.

1495 FISHER, Michael H. Representing 'his' women: Mīrzā Abū Ṭālib Khān's 1801 'Vindication of the liberties of Asiatic women'. *Indian Economic and Social History Review,* 37 ii (2000) pp.215-237. [Based on his experience in Britain.]

1496 GELDER, G. J. [H.]van. Compleat men, women and books: on medieval Arabic encyclopaedism. *Pre-modern encyclopaedic texts: proceedings of the Second COMERS Congress, Groningen ... 1996.* Ed. P.Binkley. Leiden: Brill, 1997, (Brill's Studies in Intellectual History, 79), pp.241-259.

1497 GHERSETTI, A. Fisiognomica e stereotipi femminili nella cultura araba. *Quaderni di Studi Arabi,* 14 (1996) pp.195-206.

1498 GHERSETTI, A. Mondo classico e legittimazione del sapere nella cultura arabo-islamica: il trattato *Fī firāsāt al-nisā'* attribuito a Polemone di Laodicea. *Scienza e Islam: atti della giornata di studio (Venezia, 30 gennaio 1999)* / a cura di G.Canova. Rome: Herder, [for] Università Ca' Foscari di Venezia, Dipartimento di Scienze dell'Antichità e del Vicino Oriente, 1999, (Quaderni di Studi Arabi: Studi e Testi, 3), pp.59-68.

1499 GILADI, Avner. Breast-feeding in medieval Islamic thought: a preliminary study of legal and medical writings. *Journal of Family History,* 23 ii (1998) pp.107-123.

1500 HAMBLY, G. R. G. Becoming visible: medieval Islamic women in historiography and history. *Women in the medieval Islamic world: power, patronage, and piety.* Ed. G.R.G.Hambly. Basingstoke: Macmillan, 1998, (The New Middle Ages, 6), pp.3-27.

1501 HANISCH, Ludmila. "Grenzgängerinnen"? Female travellers in the Near East during the 19th century. *Journal of Turkish Studies*, 26 i (2002) pp.339-346.

1502 HILLENBRAND, C. Seljuq women. *The balance of truth. Essays in honour of Professor Geoffrey Lewis.* Ed. Çiğdem Balım-Harding, C.Imber. Istanbul: Isis Press, 2000, pp.145-163.

1503 KOCHIN, Michael S. Weeds: cultivating the imagination in medieval Arabic political philosophy. *Journal of the History of Ideas,* 60 iii (1999) pp.399-416. (Three medieval philosophers writing in Arabic ... Alfarabi .. Ibn Bajjah ... & Ibn Tufayl.)

1504 KÖHLER, B. Die Frauen in al-Wāqidīs *Kitābal-Maġāzī.* *Zeitschrift der Deutschen Morgenländischen Gesellschaft,* 147 ii (1997) pp.303-353.

1505 KORVIN, Gabor. Women's leadership through the history of Islam. *Journal of the Pakistan Historical Society,* 48 i (2000) pp.29-63.

1506 KORVIN, Gabor. Women's leadership through the history of Islam. *Hamdard Islamicus,* 22 iii (1999) pp.17-51.

1507 KRUK, Remke. Een dame, een paard en een toren vóór: middeleeuwse schaaksters in Oost en West. A lead of queen, knight and rook: female chess players in the medieval East and West. *Dame aan zet: vrouwen en schaken door de eeuwen heen. Queen's move: women and chess through the ages* / Remke Kruk, Yvette Nagel Seirawan, Henriette Reerink, Hans Scholten. The Hague: Koninklijke Bibliotheek, 2000, (Tentoonstellingscatalogi en -brochures, 63), pp.13-34.

1508 LECKER, Michael. The Medinan wives of 'Umar b.al-Khaṭṭāb and his brother, Zayd. *Oriens,* 36 (2001) pp.242-247.

1509 MATAR, Nabil. Britons, Muslims, and American Indians: gender and power. *Muslim World,* 91 iii-iv (2001) pp.371-380. (While in America, Englishmen seized the sexual initiative, in the encounter with Islam, it was the Muslim who seized that initiative.)

1510 PRÉMARE, A-L. de. Violence et sacré dans les premières traditions islamiques: Umm Qirfa et Salmâ, et le mythe des peuples anéantis. *Journal Asiatique,* 282 i (1994) pp.19-36.

1511 RUGGLES, D.Fairchild. Vision and power: an introduction. *Women, patronage, and self-representation in Islamic societies.* Ed. D.Fairchild Ruggles. Albany (USA): State University of New York Press, 2000, pp.1-15.

1512 SCHNEIDER, I. Gelehrte Frauen des 5./11. bis 7./13. Jh.s nach dem biographischen Werk des Dahabī (st. 748/1347). *Philosophy and arts in the Islamic world. Proceedings of the Eighteenth Congress of the* Union Européenne des Arabisants et Islamisants ... *Leuven ... 1996. Ed. U.Vermeulen & D.De Smet.* Leuven: Peeters, 1998, (Orientalia Lovaniensia Analecta, 87), pp.107-121.

1513 SHATZMILLER, M. Marriage, family, and the faith: women's conversion to Islam. *Journal of Family History,* 21 iii (1996) pp.235-266. [Mediaeval Islam.]

1514 SOUCEK, P. P. Tīmūrid women: a cultural perspective. *Women in the medieval Islamic world: power, patronage, and piety.* Ed. G.R.G.Hambly. Basingstoke: Macmillan, 1998, (The New Middle Ages, 6), pp.199-226.

1515 STILLMAN, Yedida K. 'Cover her face': Jewish women and veiling in Islamic civilisation. *Israel and Ishmael: studies in Muslim-Jewish relations.* Ed. Tudor Parfitt. Richmond: Curzon, 2000, pp.13-31.

1516 Biographie de Fâtima az-Zahrâ'. *Aux Sources de la Sagesse,* 5 / 18 (1998) pp.109-118.

LAW

Books

1517 ABAGNARA, V. *Il matrimonio nell'Islam.* Naples: Edizioni Scientifiche Italiane, 1996. 225pp.

1518 ABOU EL FADL, Khaled. *Speaking in God's name: Islamic law, authority and women.* Oxford: Oneworld, 2001. 361pp.

1519 ALI, Muhammad. *Islamic law of marriage & divorce.* Offa: Hasbunallah, 1997. 14pp.

1520 ALI, Zeenat Shaukat. *The empowerment of women in Islam: with special reference to marriage and divorce.* [2. ed.] Bombay: Vakils, Feffer and Simons 1997. 462pp. [Previous ed. entitled *Marriage and divorce in Islam,* Bombay 1987.]

1521 ASCHA, Ghassan. *Mariage, polygamie et répudiation en islam: justifications des auteurs arabo-musulmans contemporains.* Paris: L'Harmattan, 1997. 238pp.

1522 BINT BADAMASIUY, Juwayriya. *Status and role of women under the Shari'ah.* Kaduna: Zakara, 1998. 72pp.

1523 CHAFIQ, Chahla & KHOSROKHAVAR, Farhad. *Femmes sous le voile face á la loi islamique.* Paris: Félin, 1995. 239pp.

1524 DAURA, Umar Abdullahi al-Hassan. *The obligation of Hijab on Muslim women.* Maiduguri: Madarasatul Ih'ya'il Ulumiddinil Islamiya, 1997. 79pp.

1525 DOI, 'Abdul Rahman I. *Woman in Shari'ah (Islamic law).* [New ed.]. Lagos: Ad-Daawat-ul-Islamiyyah Book Centre, [2001?]. 199pp.

1526 EISSA, Dahlia. *Constructing the notion of male superiority over women in Islam: the influence of sex and gender stereotyping in the interpretation of the* Qur'an *and the implications for a modernist exegesis of rights.* [Grabels]: Women Living under Muslim Laws, 1999 (Occasional Paper, 11), 51pp. Also online at www.wluml.org/english/pubs (An internal critique of traditional Islamic jurisprudence and the historical denial of equality of rights for women in the formulation and application of Islamic law.)

1527 ENGINEER, Asghar Ali. *The rights of women in Islam.* 2nd impr. London: Hurst, 1996. 188pp.

1528 FELLER, Dina Charif. *La garde (Hadanah) en droit musulman et dans les droits égyptien, syrien et tunisien.* Geneve: Droz, 1996, (Comparativa, 59), 301pp.

1529 IQBAL, Safia. *Woman and Islamic law.* Rev. ed. Delhi: Adam Publishers & Distributors, 1997. 316pp.

1530 KHAN, Badre Alam. *Economic rights of women under Islamic law and Hindu law: a comparative study.* Delhi: Adam Pubs, 1999. 131pp.

1531 LOHLKER, Rüdiger. *Islamisches Familienrecht.* I: *Methodologische Studien zum Recht mālikitischer Schule in Vergangenheit und Gegenwart.* Göttingen: Duehrkohp & Radicke, 2002 (Göttinger Forum für Arabistik, 1), 190pp.

1532 MAHMOOD, Shaukat & SHAUKAT, Nadeem. *Muslim family laws.* 12., rev. ed. Lahore: Legal Research Centre, 1996. 305pp.

1533 MAQSOOD, Ruqayyah Waris. *The Muslim marriage guide.* [New ed.]. Beltsville: Amana, 2000. 143pp.

1534 PEARL, D. & MENSKI, W. *Muslim family law.* 3rd ed. London: Sweet & Maxwell 1998. 551pp. [New edition of *A textbook on Muslim personal law* by D.Pearl, London 1987.]

1535 SHĪRĀZĪ, *Imām* Muḥammad. *The family.* Tr. Adam, Ali. London: Fountain Books, 1999. 72pp. (Islamic teachings and laws.)

1536 *Feminism and Islam: legal and literary perspectives.* Ed. Yamani, Mai. Reading: Ithaca, for the Centre of Islamic and Middle Eastern Law, School of Oriental and African Studies, University of London, 1996. 385pp.

1537 *Islamic family law in a changing world: a global resource book.* Ed. Na'im, Abdullahi A.an-. London: Zed, 2002. 320pp.

1538 *Les frontières mouvantes du mariage et du divorce dans les communautés musulmanes.* Grabels: Women Living under Muslim Laws, 1996 (Programme Femmes et Loi dans le Monde Musulman: Dossier Spécial), 168pp. Also online at http:// www.wluml.org/french/pubs/pdf/dossiers/sd/ SD1.pdf

1539 *Muslim women and Islamic tradition: studies in modernisation.* Ed. Allana, Mariam. Delhi: Kanishka, 2000. 270pp. [Women and Islamic law.]

1540 *Shifting boundaries in marriage and divorce in Muslim communities.* Grabels: Women Living under Muslim Laws, 1996 (Special Dossier, 1), 187pp.

1541 *Talaq-i-Tafwid: the Muslim woman's contractual access to divorce: an information kit.* Ed. Carroll, Lucy & Kapoor, Harsh. [Grabels:] Women Living Under Muslim Laws, 1996. 204pp. Also online at http:// www.wluml.org/ english/pubs/pdf/misc/talaq-i-tawfid-eng.pdf

1542 *Women, the family, and divorce laws in Islamic history.* Ed. Sonbol, Amira El Azhary. Syracuse: Syracuse University Press, 1996, (Contemporary issues in the Middle East), 357pp.

Articles

1543 ABDO, Nahla. Muslim family law: articulating gender, class and the state. *International Review of Comparative Public Policy.* Vol. 9: *Islam and public policy. Series ed. N.Mercuro; Volume eds. Sohrab Behdad, Farhad Nomani.* Greenwich (USA): JAI, 1997, pp.169-193.

1544 AHMAD, Anis. Women as witness: an Islamic perspective. *Pakistan between secularism and Islam: ideology, issues & conflict.* Islamabad: Institute of Policy Studies, 1998, pp.275-287. [Discussion, pp.289-306.]

1545 ALWANI, Rokaya Taha Jaber al-. The woman's inheritance in Islam between the text and the interpretation. *Contemporary Jurisprudence Research Journal / Majallat al-Buḥūth al-Fiqhīya al-Muʿāṣira,* 56 (2002-2003) pp.43-50.

1546 'ALWĀNĪ, Ṭāhā Jābir al-. The testimony of women in Islamic law. *American Journal of Islamic Social Sciences,* 13 ii (1996) pp.173-196.

1547 ASCHA, Ghassan. Le mariage entre musulmans et non-musulmans. *Sharqiyyât,* 5 (1993) pp.39-53.

1548 BARBARA, A. Les mariages mixtes avec les musulmans. *Familles-Islam-Europe: le droit confronté au changement.* Sous la direction de M-C.Foblets. Paris: L'Harmattan, 1996, pp.227-268.

1549 BENKHEIRA, Mohammed H. Le commerce conjugal gâte-t-il le lait maternel? Sexualité, medecine et droit dans le sunnisme ancien. *Arabica,* 50 i (2003) pp.1-78. Also online at http:// www.ingentaselect.com

1550 BENKHEIRA, Mohammed Hocine. Donner le sein, c'est comme donner le jour: la doctrine de l'allaitement dans le sunnisme médiéval. *Studia Islamica,* 92 (2001) pp.5-52.

1551 BILGIN, Beyza. Gutachten zur Eheschliessung zwischen einem Christen und einer Muslimin. Tr. Bayram, Emine, Grosse-Bley, M. & Klautke, H. *CIBEDO: Beiträge zum Gespräch zwischen Christen und Muslimen,* 10 iii (1996) pp.114-116. [German translation & Turkish text. Uncorrected text was printed in 10 ii (1996), pp.64-66.]

1552 BUDELLI, Rosanna. La condizione della donna nella dottrina ḥanbalita: gli *Aḥkām al-nisā'* di Abū al-Faraǧ Ibn al-Ǧawzī (m.597/1200). *Annali (Istituto Universitario Orientale),* 56 iii / 1996 (1998) pp.334-353.

1553 BUSKENS, L. Beknopt overzicht van het islamitisch bewijsrecht, in het bijzonder inzake huwelijkssluiting en huwelijksontbinding. *Recht van de Islam,* 16 (1999) pp.27-58.

1554 CARMONA, A. Fiqh, amour et rupture. *Cahiers Intersignes,* 6-7 (1993) pp.109-117. [Islam & women.]

1555 CHALMETA, P. El matrimonio según el *Kitāb al-Wathā'iq* de Ibn al-ʿAṭṭār (s.X): análisis y observaciones. *Anaquel de Estudios Arabes,* 6 (1995) pp.29-70.

1556 DEMOSTHENOUS-PASHALIDOU, A. Rechtskollisionen bei der Auflösung von Mischehen zwischen Muslimen und Andersgläubigen. *Der Islam,* 76 ii (1999) pp.313-333.

1557 FABRE, T. & ZABBAL, F. Du mariage entre civilisations: entretien avec Ibrahim Fadlallah. *Qantara,* 11 (1994) pp.56-58. (Le mariage, en droit musulman, est un contrat.)

1558 FADEL, Mohammad. Two women, one man: knowledge, power, and gender in medieval Sunni legal thought. *International Journal of Middle East Studies,* 29 ii (1997) pp.185-204.

1559 FARUQI, Maysam J.al-. Women's self-identity in the Qur'an and Islamic law. *Windows of faith: Muslim women scholar-activists in North America.* Ed. G.Webb. Syracuse: Syracuse University Press, 2000, pp.72-101.

1560 FIRDOUS, Rehana. Polygamy in Islam (a study of modernist approach). *Pakistan Journal of Women's Studies. Alam-e-Niswan,* 5 i-ii (1998) pp.1-16.

1561 GAFSIA, Nawel. La question des "fiançailles" dans le *fiqh. EurOrient,* 7 (2000) pp.110-134.

1562 GILADI, Avner. Breast-feeding in medieval Islamic thought: a preliminary study of legal and medical writings. *Journal of Family History,* 23 ii (1998) pp.107-123.

1563 GRABAU, Fritz-René & HENNECKA, Jürgen. Die Verteilung der elterlichen Sorge nach islamischen Recht. *Beiträge zum islamischen Recht.* Hrsg. Hans-Georg Ebert. Frankfurt a.M.: Lang, 2000, pp.91-108.

1564 GUARDIOLA, María Dolores. Licitud de la venta de esclavas cantoras. *Homenaje al profesor José María Fórneas Besteiro.* Granada: Universidad de Granada, 1995, pp.983-996.

1565 HABBAL, Mohammad Jamil al- & HAQQI, Raja Ismail. The certainty of an empty uterus ('istibrā' al-raḥīm) in divorced and widowed women: a Qur'ānic-medical study of 'iddah and the reasons for variation in its duration. *Journal of IMA,* 29 iv (1997) pp.182-185.

1566 HAMADEH, Najla. Islamic family legislation: the authoritarian discourse of silence. *Feminism and Islam: legal and literary perspectives.* Ed. Mai Yamani. Reading: Ithaca, for the Centre of Islamic and Middle Eastern Law, School of Oriental and African Studies, University of London, 1996, pp.331-349.

1567 ISMAIEL, Mohammad Abd al-Shafi. The betrothal of women in Islam. A comparative fiqh (jurisprudential) study. *Contemporary Jurisprudence Research Journal / Majallat al-Buḥūth al-Fiqhīya al-Muʿāṣira,* 55 (2002) pp.8-30.

1568 JANSEN, W. Sociale aspecten van de rechtsregels omtrent melkverwantschap. *Recht van de Islam,* 13 (1996) pp.61-87.

1569 KAMAL, Sultana. *Mehr:* an advantage or dependency reinforced? *Women Living under Muslim Laws: Dossier,* 19 (1997) pp.91-95. Also online at www.wluml.org/ english/pubs

1570 KAZI, Seema. Muslim law and Women Living Under Muslim Laws. *Muslim women and the politics of participation: implementing the Beijing platform.* Ed. Mahnaz Afkhami & E.Friedl. Syracuse (USA): Syracuse University Press, 1997, pp.141-146.

1571 KHAN, Muniza Rafiq. Reform in Muslim personal law: a comparative study. *Indian Muslim women: challenges & response.* Ed. Ram Bali Mishra. Hariharpur: Regional Sociological Research Institute, 1996, pp.100-107. [Comparison with Muslim countries.]

1572 MARCOTTE, Roxanne D. How far have reforms gone in Islam? *Women's Studies International Forum,* 26 ii (2003) pp.153-166. Also online at http:// www.sciencedirect.com/science/journal/02775395 (Modern Muslim legislations regarding divorce and polygamy.)

1573 MARTÍNEZ GONZÁLEZ, E. Matrimonio y divorcio
 islámicos. Proyección histórica de España en sus tres
 culturas: Castilla y León, América y el Mediterráneo. Vol.
 III: Arabe, hebreo e historia de la medicina. E.Lorenzo
 Sanz (coord.). Valladolid: Junta de Castilla y León,
 Consejería de Cultura y Turismo, 1993, pp.125-130.
 [Legal attitudes.]

1574 MEELAD, Zaki al-. Gender equity: reviving classical
 Islamic jurisprudence. Middle East Affairs Journal, 6 iii-iv
 (2000) pp.77-91.

1575 MERON, Ya'akov. The Moslem marriage between status
 and contract. Studia Islamica, 92 (2001) pp.197-203.

1576 MIR-HOSSEINI, Ziba. The construction of gender in
 Islamic legal thought and strategies for reform. Hawwa:
 Journal of Women in the Middle East and the Islamic
 world, 1 i (2003) pp.1-28. Also online at http://
 leporello.ingentaselect.com/vl=16277934/cl=41/nw=1/
 rpsv/cw/brill/15692078/

1577 MOORS, A. Debating Islamic family law: legal texts and
 social practices. Social history of women and gender in
 the modern Middle East / ed. M.L.Meriwether, J.E.Tucker.
 Boulder: Westview, 1999, pp.141-175.

1578 MOORS, A. Debating women and Islamic family law:
 disciplinary shifts, different perspectives. ISIM
 Newsletter, 1 (1998) pp.26-26.

1579 MOOSA, Najma. Women's eligibility for the qadiship.
 Awrāq, 19 (1998) pp.203-227.

1580 MUSTAFA, Faizan. Domestic work as work: recognizing
 joint property rights for wives. Islamic and Comparative
 Law Review, 15-16, 1995- (1996) pp.118-130. [Incl.
 Islamic law.] (Marital status law.)

1581 NIMR, Raga' el-. Women in Islamic law. Feminism and
 Islam: legal and literary perspectives. Ed. Mai Yamani.
 Reading: Ithaca, for the Centre of Islamic and Middle
 Eastern Law, School of Oriental and African Studies,
 University of London, 1996, pp.87-102.

1582 NØRGAARD, M. H. Ammelslægtskab. Jordens Folk,
 31 ii (1996) pp.69-72. [Breast-milk, family & marriage
 in Islamic law.]

1583 OSMAN, Samia. Ehe und Familie im Islam. Muslime
 und schweizerische Rechtsordnung. Les musulmans et
 l'ordre juridique suisse. René Pahud de Mortanges, Erwin
 Tanner (Hrsg./éd.). Freiburg (Switzerland):
 Universitätsverlag Freiburg, 2002, (Freiburger
 Veröffentlichungen zum Religionsrecht, 13), pp.363-374.
 [Islamic law.]

1584 PEREIRA, Faustina. Post divorce maintenance for Muslim
 women and the Islamist discourse. Women Living under
 Muslim Laws: Dossier, 22 (1999) pp.60-65. Also online
 at http:// www.wluml.org/english/pubs

1585 PRUVOST, L. Le mariage interreligieux au regard de
 l'islam. Hommes & Migrations, 1167 (1993) pp.30-33.

1586 PUENTE, C. de la. Esclavitud y matrimonio en
 Al-mudawwaṇa al-kubrā de Saḥnūn. Al-Qanṭara: Revista
 de Estudios Árabes, 16 ii (1995) pp.309-333.

1587 PUENTE, Cristina de la. Juridical sources for the study of
 women: limitations of the female's capacity to act
 according to Mālikī law. Writing the feminine: women
 in Arab sources. Ed. by Manuela Marín and Randi
 Deguilhem. London: Tauris, in association with The
 European Science Foundation, Strasbourg, France, 2002,
 (The Islamic Mediterranean, 1), pp.95-110.

1588 REINHART, A. K. When women went to mosques:
 al-Aydini on the duration of assessments. Islamic legal
 interpretation: muftis and their fatwās. Ed. Muhammad
 Khalid Masud, B.Messick, D.S.Powers. Cambridge:
 Harvard University Press, 1996, pp.116-128;346-347.
 (The entire apparatus of Islamic law is designed to produce
 assessments (aḥkām) of acts.)

1589 RIECK, Jürgen. Die Rolle des Islam bei Eheverträgen mit
 einem nichtmoslemischen Ehepartner. Beiträge zum
 islamischen Recht. Hrsg. Hans-Georg Ebert. Frankfurt
 a.M.: Lang, 2000, pp.69-90.

1590 RISPLER-CHAIM, V. Islamic law of marriage and divorce
 and the disabled person: the case of the epileptic wife.
 Welt des Islams, 36 i (1996) pp.90-106.

1591 RISPLER-CHAIM, Vardit. Islamic law and Jewish law
 on deserted wives / missing husbands: humanitarian
 considerations. Judaism and Islam: boundaries,
 communication and interaction. Essays in honor of William
 M.Brinner. Ed. B.H.Hary, J.L.Hayes, F.Astren. Leiden:
 Brill, 2000, (Brill's Series in Jewish Studies, 27),
 pp.257-267.

1592 RUBIERA MATA, M. J. La mujer en el Corán como
 fuente de la Xaria: posibilidad de nuevas interpretaciones.
 Anales de Historia Contemporánea, 13 / 1997 (1998)
 pp.17-23.

1593 RUIZ-ALMODÓVAR, C. La mujer en la legislación
 musulmana. Árabes, judías y cristianas: mujeres en la
 Europa medieval. Ed. C.del Moral. Granada: Universidad
 de Granada, 1993, pp.63-75.

1594 ṢĀBŪNĪ, 'Abd al-Raḥmān al-. La dissolution du mariage
 (le ṭalâq). Tr. Borrmans, M. Etudes Arabes: Dossiers,
 86-87 (1994) pp.42-71. [Arabic text, with facing French
 translation.]

1595 SACHEDINA, Abdulaziz. Woman, half-the-man? Crisis
 of male epistemology in Islamic jurisprudence.
 Perspectives on Islamic law, justice, and society. Ed.
 R.S.Khare. Lanham: Rowman & Littlefield, 1999,
 pp.145-160.

1596 SACHEDINA, Abdulaziz. Woman, half-the-man? The
 crisis of male jurisprudence. Intellectual traditions in
 Islam. Ed. Farhad Daftary. London: Tauris, in association
 with the Institute of Ismaili Studies, 2000, pp.160-178.

1597 [SA'ĪD-ZĀDAH, Sayyid Muḥsin]. Foundations of the
 equality perspective. Modern fiqh: the case of divorce /
 Hojjat al-Eslam Sa'idzadeh. Women Living under Muslim
 Laws: Dossier, 21 (1998) pp.60-63. Also online at http://
 www.wluml.org/english/pubs

1598 SAMOUR, Nahed. The principle of "just exchange" in the
 private and public spheres of Islamic law: the consequences
 of the construction of property and proprietor for the Hanafi
 woman. Yearbook of Islamic and Middle Eastern Law, 7
 / 2000-2001 (2002) pp.85-114.

1599 SAMRA, Hussein Ahmed Abdul-Ghani. Reasons of
 annulling wife's alimony. Contemporary Jurisprudence
 Research Journal / Majallat al-Buḥūth al-Fiqhīya
 al-Mu'āṣira, 58 (2003) pp.23-35.

1600 SAMRAH, Hussein Ahmed Abdul-Ghani. Guardianship
 and witness in marriage contract. Contemporary
 Jurisprudence Research Journal / Majallat al-Buḥūth
 al-Fiqhīya al-Mu'āṣira, 50 (2001) pp.22-42.

1601 SARDAR ALI, Shaheen. Is an adult Muslim woman sui
 juris? Some reflections on the concept of "consent in
 marriage" without a wali (with particular reference to the
 Saima Waheed case). Yearbook of Islamic and Middle
 Eastern Law, 3 / 1996 (1997) pp.156-174. (Lahore High
 Court.)

1602 SHAABAN, Bouthaina. The muted voices of women
 interpreters. Women Living under Muslim Laws: Dossier,
 17 (1997) Also online at www.wluml.org/english/pubs
 (Of Islamic law.)

1603 SHABBIR, Mohammad. Pinnacle of the vision of
 womanhood in socio-legal constructs of Islam. Journal
 of Objective Studies, 10 i (1998) pp.50-68.

1604 SHUḤRŪR, Muḥammad. La femme en Islam: exemple
 du droit nouveau. Tr. Borrmans, M. Etudes Arabes:
 Dossiers, 86-87 (1994) pp.92-111. [Arabic text, with
 facing French translation.]

1605 SIDAHMED, Abdel Salam. Problems in contemporary
 applications of Islamic criminal sanctions: the penalty for
 adultery in relation to women. British Journal of Middle
 Eastern Studies, 28 ii (2001) pp.187-204.

1606 SIDDIQUI, Mona. The defective marriage in classical
 Ḥanafī law: issues of form and validity. Studies in Islamic
 and Middle Eastern texts and traditions in memory of
 Norman Calder / ed. G.R.Hawting, J.A.Mojaddedi &
 A.Samely. Oxford: Oxford University Press, on behalf of
 the University of Manchester, 2000, (Journal of Semitic
 Studies Supplement, 12), pp.271-286.

1607 SPECTORSKY, Susan A. Women of the People of the Book: intermarriage in early *fiqh* texts. *Judaism and Islam: boundaries, communication and interaction. Essays in honor of William M.Brinner.* Ed. B.H.Hary, J.L.Hayes, F.Astren. Leiden: Brill, 2000, (Brill's Series in Jewish Studies, 27), pp.269-278.

1608 STOWASSER, B. F. What goes into a paradigm? Some reflections on gender-issue 'differences' between Sunnī law schools, and the problematic of their historical attribution. *Islam and Christian-Muslim Relations,* 9 iii (1998) pp.269-283.

1609 SUTAN, Nurasiah Fakih. The status of the wife in relation to her husband: a discussion of Bint al-Shati's opinion. *McGill Journal of Middle East Studies,* 5 (1997) pp.33-46.

1610 TABARSSI, Muhammad. Feminism and polygamy: the position of traditional Islamic law. *Hamdard Islamicus,* 23 i (2000) pp.37-48.

1611 TUCKER, Judith E. Islamic law and gender: revisiting the tradition. *New frontiers in the social history of the Middle East.* Ed. Enid Hill. Cairo: American University in Cairo, 2001, (Cairo Papers in Social Science, 23 ii / 2000), pp.99-112.

1612 YASMIN, Farhat. Muslim women's rights in marriage and divorce. *Muslim women in India since Independence (feminine perspectives).* Ed. Haseena Hashia. Delhi: Institute of Objective Studies, 1998, pp.98-108.

1613 ZAHRAA, Mahdi & MALEK, Normi A. The concept of custody in Islamic law. *Arab Law Quarterly,* 13 ii (1998) pp.155-177.

1614 ZAHRAA, Mahdi. The legal capacity of women in Islamic law. *Arab Law Quarterly,* 11 iii (1996) pp.245-263.

1615 Le mariage et le divorce dans les communautés musulmanes: enquête sur le caractère mouvant des frontières juridiques et sociales de l'autonomie des femmes. *Les frontières mouvantes du mariage et du divorce dans les communautés musulmanes.* Grabels: Women Living under Muslim Laws, 1996, (Programme Femmes et Loi dans le Monde Musulman: Dossier Spécial), pp.7-10. Also online at http:// www.wluml.org/french/pubs/pdf/dossiers/sd/ SD1.pdf

1616 The Islamic marriage contract conference, Cambridge, MA, 29-31 January 1999. *DAVO-Nachrichten,* 9 (1999) pp.57-58.

POLITICAL THOUGHT & POLITICAL MOVEMENTS; FEMINISM

Books

1617 BALCHIN, Cassandra. *Reaching out, changing our lives: outreach strategies and Women Living under Muslim Laws. Report.* Colombo: Muslim Women's Research & Action Forum, 1999. 98pp.

1618 BRAND, L. A. *Women, the state, and political liberalization: Middle Eastern and North African experience.* New York: Columbia University Press, 1998. 320pp.

1619 CARØE CHRISTIANSEN, C. & RASMUSSEN, L.Kofoed. *At vælge sløret: unge kvinder i politisk Islam.* Copenhagen: Forlaget Sociologi, 1993. 120pp.

1620 COOKE, Miriam. *Women claim Islam: creating Islamic feminism through literature.* New York: Routledge, 2001. 175pp.

1621 FERNEA, E. W. *In search of Islamic feminism: one woman's global journey.* New York: Doubleday, 1998. 430pp.

1622 HÉLIE, Anissa. *Feminism in the Muslim World Leadership Institutes: 1998 & 1999 reports. Istanbul, Turkey, September 14-26, 1998; Lagos, Nigeria, October 25 - November 5, 1999.* New Brunswick: Center for Women's Global Leadership; London: Women Living under Muslim Laws, 2000. 114pp.

1623 HOLT, Maria. *A tangle of meanings: women and contemporary Islamic movement.* Text of talk given by Maria Holt to the Middle East Society, University of Cambridge, on 7 May 1996. London: Council for the Advancement of Arab-British Understanding, [1996]. 21pp.

1624 KREILE, R. *Politische Herrschaft, Geschlechterpolitik und Frauenmacht im Vorderen Orient.* Pfaffenweiler: Centaurus, 1997. 413pp.

1625 MERNISSI, Fatima. *Die vergessene Macht: Frauen im Wandel der islamischen Welt.* Tr. Peinelt, E. Berlin: Orlanda Frauenverlag, 1993. 190pp.

1626 MERNISSI, Fatima. *El poder olvidado: las mujeres ante un Islam en cambio.* Tr. Gras, T. & Méndez, M. Barcelona: Icaria, Colección Antrazyt: Serie Mediterraneo, 83. 203pp.

1627 MERNISSI, Fatima. *Women's rebellion & Islamic memory.* London: Zed, 1996. 131pp.

1628 MOGHISSI, Haideh. *Feminism and Islamic fundamentalism: the limits of postmodern analysis.* London: Zed Books, 1999. 166pp.

1629 SVENSSON, J. *Muslimsk feminism: några exempel.* Lund: Teologiska Institutionen, 1996, (Religio, 46), 172pp. [From *Ḥadīth* to now.]

1630 *Daughters of Abraham: feminist thought in Judaism, Christianity, and Islam.* Ed. by Yvonne Yazbeck Haddad and John L.Esposito. Gainesville: University Press of Florida, 2001. 162pp.

1631 *Feminismus, Islam, Nation: Frauenbewegungen im Maghreb, in Zentralasien und in der Türkei.* (Hg.) Claudia Schöning-Kalender, Aylâ Neusel, Mechtild M.Jansen. Frankfurt a.M.: Campus, 1997. 339pp.

1632 *Gender, politics, and Islam.* Ed. Therese Saliba, Carolyn Allen and Judith A.Howard. Chicago: University of Chicago Press, 2002. 354pp. (The essays in this volume originally appeared in various issues of SIGNS: Journal of Women in Culture and Society.)

1633 *Globalizaton, gender, and religion: the politics of implementing women's rights in Catholic and Muslim contexts.* Ed. Jane H.Bayes & Nayereh Tohidi. Basingstoke: Palgrave, 2001. 280pp.

1634 *Muslim women and the politics of participation: implementing the Beijing platform.* Ed. Afkhami, Mahnaz & Friedl, E. Syracuse (USA): Syracuse University Press, 1997. 198pp.

1635 *Progressive Muslims: on justice, gender and pluralism.* Ed. Safi, Omid. Oxford: Oneworld, 2003. 351pp.

1636 *Remaking women: feminism and modernity in the Middle East.* Ed. Abu-Lughod, Lila. Princeton: Princeton University Press, 1998. 300pp.

1637 *Women and Islamization: contemporary dimensions of discourse on gender relations.* Ed. Ask, K. & Tjomsland, M. Oxford: Berg, 1998. 199pp.

1638 *Women and power in the Middle East.* Ed. Suad Joseph & Susan Slyomovics. Philadephia: University of Pennsylvania Press, 2001. 237pp.

Articles

1639 ABOU-BAKR, Omaima. Islamic feminism: what's in a name? Preliminary reflections. *Middle East Women's Studies Review,* 15 iv - 16 i (2001) pp.1-4.

1640 ABU-LUGHOD, Lila. Feminist longings and postcolonial conditions. *Remaking women: feminism and modernity in the Middle East.* Ed. Lila Abu-Lughod. Princeton: Princeton University Press, 1998, pp.3-31. [Middle Eastern women, 19th century till now.]

1641 AFKHAMI, Mahnaz. Towards global feminism: a Muslim perspective. *Radically speaking: feminism reclaimed.* Ed. D.Bell & R.Klein. London: Zed; North Melbourne: Spinifex, 1996, pp.525-527.

1642 AKTAŞ, Cihan. Die "Geschichte" der islamistischen Frau.
 Tr. Yilmaz, Nesrin & Pusch, Barbara. *Die neue*
 Muslimische Frau: Standpunkte & Analysen / hrsg. Barbara
 Pusch. Istanbul: Orient-Institut der Deutschen
 Morgenländischen Gesellschaft; Würzburg: Ergon, 2001,
 (Beiruter Texte und Studien, 85), pp.123-136.

1643 AMY, Lori E. Contemporary travel narratives and old style
 politics: American women reporting after the Gulf War.
 Women's Studies International Forum, 22 v (1999)
 pp.525-541. Also online at www.sciencedirect.com/
 science/journal/02775395 (Like 19th-century narratives
 legitimating colonial rule, contemporary travel narratives
 enact a violence of penetration, a violence of
 representation, and a violence of cultural imposition.)

1644 ANDERSON, Shelley. Crossing the lines: women's
 organizations in conflict resolutions. *Development,* 43 iii
 (2000) pp.34-39. Also online at www.ingentaselect.com
 [Examples from Bosnia, Sudan, Kosova, Armenia &
 Azerbaijan.]

1645 BADRAN, Margot. Toward Islamic feminisms: a look at
 the Middle East. *Hermeneutics and honor: negotiating*
 female "public" space in Islamic/ate societies. Ed. Asma
 Afsaruddin. Cambridge (USA): Harvard University Press,
 for the Center for Middle Eastern Studies of Harvard
 University, 1999, (Harvard Middle Eastern monographs,
 32), pp.159-188.

1646 BADRAN, Margot. Zur Verortung von Feminismen: die
 Vermischung von säkularen und religiösen Diskursen im
 Mashriq, der Türkei und dem Iran. Tr. Pusch, Barbara.
 Die neue Muslimische Frau: Standpunkte & Analysen /
 hrsg. Barbara Pusch. Istanbul: Orient-Institut der Deutschen
 Morgenländischen Gesellschaft; Würzburg: Ergon, 2001,
 (Beiruter Texte und Studien, 85), pp.213-231.

1647 BAHLUL, Raja. On the idea of Islamic feminism. *Journal*
 for Islamic Studies, 20 (2000) pp.33-62.

1648 BARAZANGI, Nimat Hafez. Vicegerency and gender
 justice in Islam. *Islamic identity and the struggle for*
 justice. Ed. Nimat Hafez Barazangi, M.Raquibuz Zaman,
 Omar Afzal. Gainesville: University Press of Florida, 1996,
 pp.77-94.

1649 BERKOVITCH, N. & MOGHADAM, V. M. Middle East
 politics and women's collective action: challenging the
 status quo. *Social Politics,* 6 iii (1999) pp.273-291.

1650 ESPOSITO, John L. Women, religion, and empowerment.
 Daughters of Abraham: feminist thought in Judaism,
 Christianity, and Islam. Ed. by Yvonne Yazbeck Haddad
 and John L.Esposito. Gainesville: University Press of
 Florida, 2001, pp.1-11. [Women in the three religions.]

1651 FLEISCHMANN, E. L. The other "awakening": the
 emergence of women's movements in the modern Middle
 East, 1900-1940. *Social history of women and gender in*
 the modern Middle East / ed. M.L.Meriwether, J.E.Tucker.
 Boulder: Westview, 1999, pp.89-139.

1652 GADANT, M. De quelle peur s'agit-il? *Peuples*
 Méditerranéens, 64-65 (1993) pp.211-215.
 (Mernissi,Fatima. *La peur-modernité, conflit*
 Islam-démocratie, Paris, 1992.)

1653 GERHARD, Ute. Unterschiede und Gemeinsamkeiten -
 Feminismus in vergleichender Perspektive: Überlegungen
 aus der Bewegungsforschung. *Feminismus, Islam,*
 Nation: Frauenbewegungen im Maghreb, in Zentralasien
 und in der Türkei. (Hg.) Claudia Schöning-Kalender, Aylâ
 Neusel, Mechtild M.Jansen. Frankfurt a.M.: Campus, 1997,
 pp.55-69.

1654 GÖÇEK, Fatma Müge. Narrative, gender, and cultural
 representation in the constructions of nationalism in the
 Middle East. *Social constructions of nationalism in the*
 Middle East / ed. Fatma Müge Göçek. Albany (USA):
 State University of New York Press, 2002, pp.1-12.

1655 GÖLE, Nilüfer. Islamism, feminism and post-modernism:
 women's movements in Islamic countries. *New*
 Perspectives on Turkey, 19 (1998) pp.53-70.

1656 GRAHAM-BROWN, Sarah. Women's activism in the
 Middle East: a historical perspective. *Women and power*
 in the Middle East. Ed. Suad Joseph & Susan Slyomovics.
 Philadelphia: University of Pennsylvania Press, 2001,
 pp.23-31;205.

1657 GUINDI, Fadwa el. Feminism comes of age in Islam.
 Arab women: between defiance and restraint. Ed. Suha
 Sabbagh. New York: Olive Branch Press, 1996,
 pp.159-161.

1658 HADDAD, Y. Yazbeck & SMITH, J. I. Women in Islam:
 the mother of all battles. *Arab women: between defiance*
 and restraint. Ed. Suha Sabbagh. New York: Olive Branch
 Press, 1996, pp.137-150. [Re. Islamist positions in regard
 to women.]

1659 HASHIM, Iman. Reconciling Islam and femimism.
 Gender and Development, 7 i (1999) pp.7-14. Also
 online at http:// www.ingentaselect.com (Arguments for
 women's equality from within Islam hold a lot of potential
 for feminists.)

1660 HASSAN, Riffat. Challenging the stereotypes of
 fundamentalism: an Islamic feminist perspective. *Muslim*
 World, 91 i-ii (2001) pp.55-69.

1661 HASSAN, Riffat. Feministische Interpretationen des
 Islams. *Feminismus, Islam, Nation: Frauenbewegungen*
 im Maghreb, in Zentralasien und in der Türkei. (Hg.)
 Claudia Schöning-Kalender, Aylâ Neusel, Mechtild
 M.Jansen. Frankfurt a.M.: Campus, 1997, pp.217-233.

1662 HEYZER, N. & LANDSBERG-LEWIS, I. UNIFEM and
 women's climb to equality: no turning back. *Muslim*
 women and the politics of participation: implementing the
 Beijing platform. Ed. Mahnaz Afkhami & E.Friedl.
 Syracuse (USA): Syracuse University Press, 1997,
 pp.153-161. (United Nations Development Fund for
 Women. UNIFEM's follow-up operations in Western Asia
 after Beijing, pp.158-161.)

1663 JOSEPH, Suad. Women and politics in the Middle East.
 Women and power in the Middle East. Ed. Suad Joseph &
 Susan Slyomovics. Philadelphia: University of Pennsylvania
 Press, 2001, pp.34-40;205-206.

1664 KARAM, Azza M. Moslim-feminisme of het belang van
 de middenpositie. *Islam in een ontzuilde samenleving.*
 Discussies over vrouwenemancipatie, kunst en onderwijs.
 [By] Metin Alkan [& others]. Amsterdam: Koninklijk
 Instituut voor de Tropen, 1996, pp.91-112.

1665 KARAM, Azza M. Muslim feminists in western academia:
 questions of power, matters of necessity. *Islam in the*
 era of globalization: Muslim attitudes towards modernity
 and identity. Ed. by Johan Meuleman. London:
 RoutledgeCurzon, 2002, pp.171-187.

1666 KAUSAR, Zeenath. Fundamental flaws in the platform
 for action: fourth world conference document on women.
 Islamic Quarterly, 43 ii (1999) pp.203-218.

1667 KAUSAR, Zeenath. Gender perspective in the UN
 document on the Fourth World Conference on Women in
 Beijing: an analysis of Platform for Action. *Renaissance*
 (Lahore), 11 vii (2001) pp.20-44. (Islamic position on
 some of the gender issues, pp.38-44.)

1668 KAUSAR, Zeenath. *Oikos/polis* conflict: perspectives of
 gender feminists and Islamic revivalists. *American*
 Journal of Islamic Social Sciences, 13 iv (1996)
 pp.475-496.

1669 KEDDIE, N. R. Women and religious politics in the
 contemporary world. *ISIM Newsletter,* 3 (1999) pp.6-6.

1670 KLEIN-HESSLING, R., NÖKEL, S. & WERNER, K.
 Weibliche Mikropolitiken und die globalisierung des Islam.
 Der neue Islam der Frauen. Weibliche Lebenspraxis in
 der globalisierten Moderne: Fallstudien aus Afrika, Asien
 und Europa. R.Klein-Hessling, S.Nökel, K.Werner (Hg.).
 Bielefeld: transcript Verlag, 1999, pp.11-34.

1671 LAWRENCE, Bruce B. Muslim networks in the
 information age: women, human rights, and transnational
 civil societies. *Brown Journal of World Affairs,* 6 i (1999)
 pp.177-189. [Internet users.]

1672 LINDISFARNE, N. Women organized in groups:
 expanding the terms of the debate. *Organizing women:*
 formal and informal women's groups in the Middle East.
 Ed. D.Chatty & A.Rabo. Oxford: Berg, 1997, pp.211-238.
 [Middle East.]

1673 MAJID, Anouar. The politics of feminism in Islam. *Signs*, 23 ii (1998) pp.321-361. [Comments by Suad Joseph & Ann Elizabeth Mayer, & author's reply, pp.363-389.]

1674 MAJID, Anouar. The politics of feminism in Islam. *Gender, politics, and Islam.* Ed. Therese Saliba, Carolyn Allen and Judith A.Howard. Chicago: University of Chicago Press, 2002, pp.53-93. [Originally published in *Signs*, 23 ii (1998).]

1675 MARTÍN MUÑOZ, G. Mujeres islamistas, y sin embargo modernas. *El imaginario, la referencia y la diferencia: siete estudios acerca de la mujer árabe.* M.del Amo (ed.). Granada: Departamento Estudios Semíticos, 1997, pp.75-89.

1676 MARTÍN MUÑOZ, Gema. Islamistes et pourtant modernes. Tr. Muchnik, Anatole. *Confluences Méditerranée*, 27 (1998) pp.33-43.

1677 MAUMOON, Dunya. Islamism and gender activism: Muslim women's quest for autonomy. *Journal of Muslim Minority Affairs*, 19 ii (1999) pp.269-283.

1678 MAYER, A. E. Aberrant "Islams" and errant daughters: the turbulent legacy of Beijing in Muslim societies. *Muslim women and the politics of participation: implementing the Beijing platform.* Ed. Mahnaz Afkhami & E.Friedl. Syracuse (USA): Syracuse University Press, 1997, pp.29-40.

1679 MERNISSI, Fatima. Muslim women and fundamentalism. *Arab women: between defiance and restraint.* Ed. Suha Sabbagh. New York: Olive Branch Press, 1996, pp.162-168.

1680 METCALF, Barbara D. Tablīghī Jamāʿat and women. *Travellers in faith. Studies of the Tablīghī Jamāʿat as a transnational Islamic movement for faith renewal.* Ed. Muhammad Khalid Masud. Leiden: Brill, 2000, (Social, Economic and Political Studies of the Middle East and Asia, 69), pp.44-58.

1681 MOGHADAM, V. M. Economic liberalization, women and politics. *Middle East Policy*, 5 iii (1997) pp.164-166;187-189.

1682 MOGHADAM, V.[M.]. Transnational feminism: notes from the field. *Middle East Women's Studies Review*, 15 iii (2000) pp.8-9;11.

1683 MOGHADAM, V. M. Women's NGOs in the Middle East and North Africa: constraints, opportunities, and priorities. *Organizing women: formal and informal women's groups in the Middle East.* Ed. D.Chatty & A.Rabo. Oxford: Berg, 1997, pp.23-55.

1684 MOJAB, Shahrzad. The politics of theorizing 'Islamic feminism': implications for international feminist movements. *Women Living under Muslim Laws: Dossier*, 23-24 (2001) pp.64-80. Also online at http://www.wluml.org/english/pubs

1685 MORRIS, Mary E. What do women want? Gender and politics in the Middle East. *Middle East Policy*, 5 iii (1997) pp.161-164;187-189.

1686 PARLA, Aysha. Feminism, nationalism, modernity: Aysha Parla interviews Lila Abu-Lughod. *ISIM Newsletter*, 2 (1999) pp.28-28.

1687 RISALUDDIN, Saba. Is there space for feminism in Islam? *WAF Journal*, 8 (1996) pp.4-5.

1688 NACHTWEY, J. & TESSLER, M. Explaining women's support for political Islam: contributions from feminist theory. *Area studies and social science: strategies for understanding Middle East politics.* Ed. M.Tessler with J.Nachtwey & A.Banda. Bloomington: Indiana University Press, 1999, pp.48-69.

1689 NORTON, A. R. Gender: politics and the state: what do Middle Eastern women want? *Middle East Policy*, 5 iii (1997) pp.155-161;187-189.

1690 SAMANDI, Zeyneb. Die islamistische Frauenbewegung: zur Problematik des Identitätsansatzes. *Feminismus, Islam, Nation: Frauenbewegungen im Maghreb, in Zentralasien und in der Türkei.* (Hg.) Claudia Schöning-Kalender, Aylâ Neusel, Mechtild M.Jansen. Frankfurt a.M.: Campus, 1997, pp.305-330.

1691 SAMANDI, Zeyneb. La question féminine entre le volontarisme politique et le conservatisme social. *Revue Tunisienne de Sciences Sociales / Al-Majalla al-Tūnisīya li-l-'Ulūm al-Ijtimā'īya*, 36 / 118 (1999) pp.121-138. [In Middle East.]

1692 SHEHADEH, Lamia Rustum. Women in the discourse of Sayyid Qutb. *Arab Studies Quarterly*, 22 iii (2000) pp.45-55.

1693 STOWASSER, Barbara. Old shaykhs, young women, and the internet: the rewriting of women's political rights in Islam. *Muslim World*, 91 i-ii (2001) pp.99-119.

1694 TAHIR, Sharifa. Leadership development for young women: a model. *Muslim women and the politics of participation: implementing the Beijing platform.* Ed. Mahnaz Afkhami & E.Friedl. Syracuse (USA): Syracuse University Press, 1997, pp.83-93.

1695 THERESE, Saliba. Gender, politics, and Islam. *Gender, politics, and Islam.* Ed. Therese Saliba, Carolyn Allen and Judith A.Howard. Chicago: University of Chicago Press, 2002, pp.1-13.

1696 TOHIDI, Nayereh. "Islamic feminism": perils and promises. *Middle East Women's Studies Review*, 16 iii-iv (2002) pp.13-16;27.

1697 WEIBEL, N. B. "Islam-action" et glissement des frontières de genre. *Femmes et hommes au Maghreb et en immigration: la frontière des genres en question. Etudes sociologiques et anthropologiques.* Sous la dir. de C.Lacoste-Dujardin & M.Virolle. Coord. Baya Boualem & Narjys El Alaoui. Paris: Publisud, 1998, pp.221-225. [Modern Islamist women.]

1698 WEIBEL, N. B. L'Islam-action au féminin ou une redéfinition de l'identité de genre. *Scholarly approaches to religion, interreligious perceptions and Islam.* Ed. J.Waardenburg. Berne: Lang, 1995, (Studia Religiosa Helvetica: Jahrbuch, 1), pp.391-410.

RELIGION

General; Qur'ān; Sunni Islam

Books

1699 ABDEL-WAHAB, Ahmad. *La situation de la femme: dans le judaïsme, le christianisme et l'islam.* Paris: A. E. I. F. Editions, [1994]. 117pp.

1700 ABU-SHABANAH, Abdel Khalek Hikmat. *A favourable aspect of the Quran in honouring the woman.* Cairo: Islamic Research Academy, 2001. 127pp.

1701 BARLAS, Asma. *"Believing women" in Islam: unreading patriarchal interpretations of the Qur'ān.* Austin: University of Texas Press, 2002. 254pp.

1702 BECHMANN, Ulrike. *Frauenkulturen: christliche und muslimische Frauen in Begegnung und Gespräch.* Düsseldorf: Klens, 2001. 182pp.

1703 ENGINEER, Asghar Ali. *The Qur'an, women and modern society.* Delhi: Sterling, 1999. 231pp.

1704 GLASER, I. & JOHN, N. *Partners or prisoners? Christians thinking about women and Islam.* Carlisle: Solway, 1998. 331pp.

1705 KABBANI, Muhammad Hisham & BAKHTIAR, Laleh. *Encyclopedia of Muhammad's women companions and the traditions they related.* Chicago: ABC International & Kazi Publications, 1998. 500pp.

1706 MALTI-DOUGLAS, Fedwa. *Medicines of the soul: female bodies and sacred geographies in a transnational Islam.* Berkeley: University of California Press, 2001. 224pp.

1707 MERNISSI, Fatima. *El harén político: el Profeta y las mujeres.* Tr. Jiménez Morell, I. Guadarrama: Ediciones del Oriente y del Mediterráneo, 1999, (El Collar de la Paloma, 4), 269pp. [Tr. of *Le harem politique*, Paris 1987.]

1708 MINCES, J. *Le Coran et les femmes.* Paris: Hachette, 1996, (Collection Pluriel, 8802), 183pp.

1709 PATEL, Ismail Adam. *Islam: the choice of thinking women.* London: Ta-Ha, 1997. 115pp.

1710 ROTTER, E. & ROTTER, G. *Venus, Maria, Fatima: wie die Lust zum Teufel ging.* Zürich: Artemis & Winkler, 1996. 270pp.

1711 SCHIMMEL, A. *La mia anima e una donna: il femminile nell'Islam.* Tr. Severi, P. Genoa: ECIG, 1998. 183pp. [Tr. of *Meine seele ist eine Frau,* Munich, 1995.]

1712 SCHIMMEL, A. *Meine Seele ist eine Frau: das Weibliche im Islam.* Munich: Kösel, 1995. 208pp.

1713 WADUD, Amina. *Qur'an and woman: rereading the sacred text from a woman's perspective.* [2nd ed.]. New York: Oxford University Press, 1999. 118pp.

1714 WILCOX, L. *Women and the Holy Quran: a Sufi perspective.* Volume 1. Riverside & Washington: M. T. O. Shahmaghsoudi, 1998. 291pp.

1715 *Die Frau im Koran: Verse des Korans, die über die Offenbarung Allahs, über die Frau, ihre Kindheit, Ehe und Mutterschaft berichten* / Mohammed Nour Eldin Ismail. Vienna: Europ. Verlag, 1999. 96pp.

1716 *Eve & Adam: Jewish, Christian, and Muslim readings on Genesis and gender.* Ed. Kvam, K. E., Schearing, L. S. & Ziegler, V. H. Bloomington: Indiana University Press, 1999. 515pp. (Anthology. 5. "Medieval readings" [incl.] Islam, pp. 178-203; 8. "Twentieth-century readings" [incl.] Sayyid Abu al-A'la Mawdudi, pp.413-419.)

1717 *For ourselves: women reading the Qur'an.* Grabels: Women Living Under Muslim Laws, 1997. 256pp.

1718 *Women in Islam: an anthology from the Qurān and Ḥadīths.* Transl. & ed. by Nicholas Awde. Richmond: Curzon, 2000. 224pp.

Articles

1719 ABDUL ALI Qâḍî 'Abd al-Muqtadir of Delhi: a distinguished eulogist of the Prophet Muḥammad. *Islamic Culture,* 75 iv (2001) pp.39-47.

1720 ABUGIDEIRI, Hibba. Allegorical gender: the figure of Eve revisited. *American Journal of Islamic Social Sciences,* 13 iv (1996) pp.518-535. [Islamic view.]

1721 ALI, Hashim Amir. A millennium-old Qur'anic puzzle: the matter on polygyny. *Encyclopaedic survey of Islamic culture.* Vol. 2: *Studies in Quran. Ed. Mohamed Taher.* Delhi: Anmol Publications, 1997, pp.223-234. [Previously published article, revised & edited.]

1722 AMIR, Safia. The Qur'an on women. *Muslim & Arab Perspectives,* 3 vii-xii / 11 (1996) pp.404-408.

1723 ANWAR, Ghazala. Reclaiming the religious center from a Muslim perspective: theological alternatives to religious fundamentalism. *Religious fundamentalisms and the human rights of women.* Ed. C.W.Howland. Basingstoke: Macmillan; New York: St. Martin's Press, 1999, pp.303-314.

1724 BEL MOUJAHID, Necera. L'énonciation dans le Coran et le statut du féminin. *Horizons Maghrébins,* 25-26 (1994) pp.142-148.

1725 BILGIN, Beyza. Das emanzipatorische Potential des Islams. *Feminismus, Islam, Nation: Frauenbewegungen im Maghreb, in Zentralasien und in der Türkei.* (Hg.) Claudia Schöning-Kalender, Aylâ Neusel, Mechtild M.Jansen. Frankfurt a.M.: Campus, 1997, pp.199-216. [Feminist reading of Qur'an.]

1726 BODMAN, H. Gender and religion. *AMEWS Newsletter,* 10 iv (1996) pp.4-5. [MESA Conference panel, 1995.]

1727 BOUNFOUR, Abdellah. Sexe, parole et culpabilité dans le récit coranique de l'origine. *Studia Islamica,* 81 (1995) pp.43-70. [Adam & Eve.]

1728 CALDERINI, S. Woman, 'sin' and 'lust': the fall of Adam and Eve according to classical and modern Muslim exegesis. *Religion and sexuality.* Ed. M.A.Hayes, W.Porter and D.Tombs. Sheffield: Sheffield Academic Press, 1998, (Studies in Theology and Sexuality, 2; Roehampton Institute London Papers, 4), pp.49-63.

1729 CHARNAY, J-P. Lire le Coran au féminin actuel. *Cahiers de l'Orient,* 47 (1997) pp.15-34.

1730 CLÉMENT, J-F. Le voile de Dieu. *Horizons Maghrébins,* 25-26 (1994) pp.132-141. [Ḥadīth.]

1731 DARWISH, L. Images of Muslim women: 'Aisha, Fatima, and Zaynab bint 'Ali in contemporary gender discourse. *McGill Journal of Middle East Studies / Revue d'Etudes du Moyen-Orient de McGill,* 4 (1996) pp.93-132.

1732 ELIAS, Jamal J. The *Ḥadīth* traditions of 'Ā'isha as prototypes of self-narrative. *Edebiyat,* N.S. 7 ii (1997) pp.215-233.

1733 FARUQI, Maysam J.al-. Women's self-identity in the Qur'an and Islamic law. *Windows of faith: Muslim women scholar-activists in North America.* Ed. G.Webb. Syracuse: Syracuse University Press, 2000, pp.72-101.

1734 FIERRO, Maribel. Women as prophets in Islam. *Writing the feminine: women in Arab sources.* Ed. by Manuela Marín and Randi Deguilhem. London: Tauris, in association with The European Science Foundation, Strasbourg, France, 2002, (The Islamic Mediterranean, 1), pp.183-198.

1735 GIANNULI, D. "Errand of mercy": American women missionaries and philanthropists in the Near East, 1820-1930. *Balkan Studies,* 39 ii (1998) pp.223-262.

1736 GUTIÉRREZ DOMÍNGUEZ, S. La virgen María en el Corán. *Boletín de la Real Academia de Córdoba,* 67 / 130 (1996) pp.9-17.

1737 GYSLING, E. & EID, Thabet. Frauen, Wohlgeruch und Gebet: Gespräch mit dem ägyptischen Gelehrten Muhammad al-Ghasâli über die Stellung der Frau und über Toleranz in der islamischen Welt. *Du,* 1994 vii-viii / 640, pp.73-73.

1738 HASSAN, Riffat. Feminist theology: the challenges for Muslim women. *Critique: Journal for Critical Studies of the Middle East,* 9 (1996) pp.53-65.

1739 HASSAN, Riffat. Vrouwen in islam en christendom: een vergelijking. Tr. Stap, T. van der. *Islam - een uitdaging voor het christendom: de ontmoeting tussen islam en christendom als wederzijdse bedreiging en als hoopvolle uitdaging.* [Ed.] H.Küng & J.Moltmann. Baarn: Gooi en Sticht, 1994, (Concilium, 1994/3), pp.31-35.

1740 JACOBI, R. Porträt einer unsympathischen Frau: Hind bint 'Utba, die Feindin Mohammeds. *Wiener Zeitschrift für die Kunde des Morgenlandes,* 89 (1999) pp.85-107.

1741 LAMCHICHI, Abderrahim. Statut des femmes dans le discours coranique et la thématique islamiste. *Femmes de Méditerranée: religion, travail, politique.* Sous la dir. de Andrée Dore-Audibert et Sophie Bessis. Paris: Karthala, 1995, pp.97-111.

1742 LEVINE, Amy-Jill. Settling at Beer-lahai-roi. *Daughters of Abraham: feminist thought in Judaism, Christianity, and Islam.* Ed. by Yvonne Yazbeck Haddad and John L.Esposito. Gainesville: University Press of Florida, 2001, pp.12-34. [Religion and feminism as they relate to Muslim/Christian understanding. Comparison of Hagar and Sarah from the Bible.]

1743 MANJARREZ WALKER, A. & SELLS, M. A. The wiles of women and performative intertextuality: 'A'isha, the Hadith of the Slander, and the Sura of Yusuf. *Journal of Arabic Literature,* 30 i (1999) pp.55-77.

1744 MERGUERIAN, G. K. & NAJMABADI, Afsaneh. Zulaykha and Yusuf: whose "best story"? *International Journal of Middle East Studies,* 29 iv (1997) pp.485-508.

1745 NETTLER, R. L. Mohamed Talbi's commentary on Qur'ān IV: 34. A "historical reading" of a verse concerning the disciplining of women. *Maghreb Review,* 24 i-ii (1999) pp.19-33.

1746 OSMAN, Fathi. Monogamy, not polygamy. *Firmest Bond,* 78-79 (2001) pp.58-59.

1747 ROALD, A. S. Feminist reinterpretation of Islamic sources: Muslim feminist theology in the light of the Christian tradition of feminist thought. *Women and Islamization: contemporary dimensions of discourse on gender relations.* Ed. K.Ask & M.Tjomsland. Oxford: Berg, 1998, pp.17-44.

1748 RUBIERA MATA, M. J. La mujer en el Corán como fuente de la Xaria: posibilidad de nuevas interpretaciones. *Anales de Historia Contemporánea*, 13 / 1997 (1998) pp.17-23.

1749 SALEEM, Shehzad. The gender of God. *Renaissance* (Lahore), 11 vii (2001) pp.57-58.

1750 SALEEM, Shehzad. Women outnumbering men in Hell! *Renaissance* (Lahore), 10 xii (2000) pp.46-48. (*Ḥadīth*.)

1751 SALEH, Walid. The woman as a locus of apocalyptic anxiety in medieval Sunnī Islam. *Myths, historical archetypes and symbolic figures in Arabic literature: towards a new hermeneutic approach. Proceedings of the International Symposium in Beirut, June 25th - June 30th, 1996.* Ed. A.Neuwirth, B.Embaló, S.Günther, Maher Jarrar. Beirut: Orient-Institut der Deutschen Morgenländischen Gesellschaft; Stuttgart: Steiner, 1999, (Beiruter Texte und Studien, 64), pp.123-145.

1752 SHAIKH, Saʿdiyya. Exegetical violence: *nushūz* in Qurʾānic gender ideology. *Journal for Islamic Studies*, 17 (1997) pp.49-73.

1753 SHAW, J. Gender and the 'nature' of religion: Lady Mary Wortley Montague's embassy letters and their place in Enlightenment philosophy of religion. *Bulletin of the John Rylands University Library of Manchester*, 80 iii (1998) pp.129-145.

1754 SPELLBERG, D. A. Writing the unwritten life of the Islamic Eve: menstruation and the demonization of motherhood. *International Journal of Middle East Studies*, 28 iii (1996) pp.305-324. (The transformation of the wife of Adam ... in the Qurʾan ...)

1755 STOWASSER, B. [F.]. Gender issues and contemporary Quran interpretation. *Islam, gender, & social change.* Ed. Y.Yazbeck Haddad & J.L.Esposito. New York: Oxford University Press, 1998, pp.30-44.

1756 STOWASSER, B. F. Women and citizenship in the Qurʾan. *Women, the family, and divorce laws in Islamic history.* Ed. A.El Azhary Sonbol. Syracuse: Syracuse University Press, 1996, pp.23-38.

1757 TOHIDI, Nayereh & BAYES, Jane H. Women redefining modernity and religion in the globalized context. *Globalizaton, gender, and religion: the politics of implementing women's rights in Catholic and Muslim contexts.* Ed. Jane H.Bayes & Nayereh Tohidi. Basingstoke: Palgrave, 2001, pp.17-60. [Catholics & Muslims.]

1758 VAHIDUDDIN, S. The place of woman in the Qurʾān. *Islamic Culture*, 70 iii (1996) pp.1-6.

1759 WADUD, Amina. Alternative Qurʾanic interpretation and the status of Muslim women. *Windows of faith: Muslim women scholar-activists in North America.* Ed. G.Webb. Syracuse: Syracuse University Press, 2000, pp.3-21.

1760 ZAHNISER, A. H. M. Sūra as guidance and exhortation: the composition of *Sūrat al-Nisā'*. *Humanism, culture, and language in the Near East. Studies in honor of Georg Krotkoff.* Ed. Asma Afsaruddin & A.H.M.Zahniser. Winona Lake: Eisenbrauns, 1997, pp.71-85.

Shiʿism & other sects

Books

1761 SADEGHI, Zohreh. *Fatima von Qum: ein Beispiel für die Verehrung heiliger Frauen im Volksglauben der Zwölfer-Schia.* Berlin: Schwarz, 1996, (Islamkundliche Untersuchungen, 203), 213pp.

Articles

1762 D'SOUZA, D. The figure of Zaynab in Shîʿî devotional life. *Bulletin of the Henry Martyn Institute of Islamic Studies*, 17 i (1998) pp.31-53.

1763 GHADIALLY, R. The campaign for women's emancipation in Daudi Bohra sect of Indian Muslims: 1929-1945 . *Muslim feminism and feminist movement: South Asia.* Vol. 1: *India.* Ed. Abida Samiuddin, R.Khanam. Delhi: Global Vision Publishing House, 2002, pp.137-163.

1764 GHADIALLY, Rehana. Campagne pour l'émancipation des femmes dans une secte Ismaili Shia (Daudi Bohra) de musulmans indiens: 1925-1945. *Women Living under Muslim Laws: Dossier*, 14-15 (1996) pp.68-91. Also online at http:// www.wluml.org/french/pubs/pdf/dossiers/ dossier14-15/D14-15fr.pdf

1765 GHADIALLY, Rehana. The campaign for women's emancipation in an Ismaili Shia (Daudi Bohra) sect of Indian Muslims: 1925-1945. *Women Living under Muslim Laws: Dossier*, 14-15 (1996) pp.64-85. Also online at www.wluml.org/english/pubs

1766 GHADIALLY, Rehana. Women and personal law in an Ismāʿīlī Shīʿah (Dāʾūdī Bohra) sect of Indian Muslims. *Islamic Culture*, 70 i (1996) pp.27-51.

1767 LAWSON, Todd. The authority of the feminine and Fatima's place in an early work by the Bab. *The most learned of the Shiʿa: the institution of the Marjaʿ taqlid.* Ed. Linda S.Walbridge. Oxford: Oxford University Press, 2001, pp.94-127.

1768 PINAULT, D. Zaynab bint ʿAlī and the place of the women of the households of the first Imāms in Shīʿite devotional literature. *Women in the medieval Islamic world: power, patronage, and piety.* Ed. G.R.G.Hambly. Basingstoke: Macmillan, 1998, (The New Middle Ages, 6), pp.69-98.

1769 ROSINY, Stephan. "The tragedy of Fāṭima al-Zahrā'" in the debate of two Shiite theologians in Lebanon. *The Twelver Shia in modern times: religious culture & political history.* Ed. R.Brunner & W.Ende. Leiden: Brill, 2001, (Social, Economic and Political Studies of the Middle East and Asia, 72), pp.207-219. (Al-Sayyid Jaʿfar Murtaḍā al-ʿĀmilī & al-Sayyid Muḥammad Ḥusayn Faḍlallāh.)

1770 WILEY, Joyce. *'Alima* Bint al-Huda, women's advocate. *The most learned of the Shiʿa: the institution of the Marjaʿ taqlid.* Ed. Linda S.Walbridge. Oxford: Oxford University Press, 2001, pp.149-160.

Religious observance & rituals

Books

1771 ABU-SAHLIEH, Sami A.Aldeeb. *Male & female circumcision among Jews, Christians and Muslims: religious, medical, social and legal debate.* Warren: Shangri-La, 2001 (Marco Polo Monographs, 5), 400pp.

Articles

1772 ABU-SAHLIEH, Sami A. Aldeeb. Verstümmeln im Namen Yahwes oder Allahs: die religiöse Legitimation der Beschneidung von Männern und Frauen. Tr. Hartstock, A. *CIBEDO: Beiträge zum Gespräch zwischen Christen und Muslimen*, 8 ii (1994) pp.64-94.

1773 D'SOUZA, Diane. Women's presence in the mosque: a viewpoints [*sic*]. *Islam, women and gender justice.* [Ed.] Asghar Ali Engineer. New Delhi: Gyan Publishing House, 2001, pp.193-217. [In general & especially in India.]

1774 JOHNSON, Kathryn. Royal pilgrims: Mamlūk accounts of the pilgrimages to Mecca of the Khawand al-Kubrā (senior wife of the Sultan). *Studia Islamica*, 91 (2000) pp.107-131.

1775 NAGRA, S. A., RAHMAN, Z. U., JAVARIA, M. & QADRI, Afshan J. Study of some biochemical parameters in young women as effected [*sic*] by Ramadan fasting. *International Journal of Ramadan Fasting Research*, 2 i (1998) Online at http:// www.labs.net/ains/ramadan.htm

1776 REINHART, A. K. When women went to mosques: al-Aydini on the duration of assessments. *Islamic legal interpretation: muftis and their fatwás.* Ed. Muhammad Khalid Masud, B.Messick, D.S.Powers. Cambridge: Harvard University Press, 1996, pp.116-128;346-347. (The entire apparatus of Islamic law is designed to produce assessments (*aḥkām*) of acts.)

1777 SAYEED, Asma. Early Sunni discourse on women's
 mosque attendance. *ISIM Newsletter*, 7 (2001) pp.10-10.

1778 TOLMACHEVA, M. Female piety and patronage in the
 medieval 'Ḥajj'. *Women in the medieval Islamic world:
 power, patronage, and piety.* Ed. G.R.G.Hambly.
 Basingstoke: Macmillan, 1998, (The New Middle Ages,
 6), pp.161-179.

Sufism

Books

1779 DIALMY, Abdessamad. *Féminisme, islamisme et
 soufisme.* Paris: Publisud, 1997. 252pp.

1780 NURBAKHSH, Javad. *Donne sufi: storie di donne
 musulmane.* Tr. Tripoli, M. & Shojai, Parinaz. Milan:
 NUR, 1993. 249pp. [Tr. of *Zanān-i Ṣūfī*.]

1781 SMITH, Margaret. *Muslim women mystics: the life and
 work of Rab'ia and other women mystics in Islam.* Oxford:
 Oneworld, 2001. 249pp.

1782 SULAMĪ, Abū 'Abd al-Raḥmān [Muḥammad b. al-Ḥusayn
 al]-. *Early Sufi women: Dhikr an-niswa al-muta'abbidāt
 aṣ-Ṣūfiyyāt.* Edited and translated from the Riyadh
 manuscript with introduction and notes by Rkia Elaroui
 Cornell. Louisville: Fons Vitae, 1999. 334pp.

1783 WILCOX, L. *Women and the Holy Quran: a Sufi
 perspective.* Volume 1. Riverside & Washington: M. T.
 O. Shahmaghsoudi, 1998. 291pp.

Articles

1784 AUSTIN, R.W.J. The sophianic feminine in the work of
 Ibn 'Arabi and Rumi. *The heritage of Sufism.* Volume
 II: *The legacy of medieval Persian Sufism (1150- 1500).*
 Edited by Leonard Lewisohn. London: Khaniqahi
 Nimatullahi Publications 1992; rp. Oxford: Oneworld,
 1999, pp.233-245.

1785 BEN MILED, Emna. Le féminin, le masculin, la
 dialectique en amour chez Ibn Arabi. *Actes du colloque:
 L'homme, la femme et les relations amoureuses dans
 l'imaginaire arabo-musulman, Tunis ... 1992 / Ashghāl
 multaqá: Al-Rajul wa-'l-mar'a wa'l-ḥubb fī 'l-khayāl
 al-'Arabī al-Islāmī.* Tunis: Université des Lettres, des Arts
 et des Sciences Humaines, Tunis I, Centre d'Etudes et de
 Recherches Economiques et Sociales, Tunis, 1995, (Cahier
 du C.E.R.E.S. Série Psychologie, 8), pp.47-60.

1786 DAIBER, H. Gottesliebe und menschliche Grösse im
 frühen Islam. Das Beispiel von Rābi'a al-'Adawīya
 (717-801). *Spektrum Iran*, 13 ii (2000) pp.5-25.

1787 HANIF, N. Rabi'a Basri: a mystic woman par excellence.
 Muslim feminism and feminist movement: South Asia. Vol.
 1: *India.* Ed. Abida Samiuddin, R.Khanam. Delhi: Global
 Vision Publishing House, 2002, pp.245-253.

1788 HOFFMAN, V. J. Le soufisme, la femme et la sexualité.
 Tr. Vatin, F. *Les voies d'Allah: les ordres mystiques
 dans l'islam des origines à aujourd'hui.* Ed. A.Popovic &
 G.Veinstein. Paris: Fayard, 1996, pp.254-257.

1789 JUILLARD-BEAUDAN, C. Le triangle amoureux: le
 soufisme, la femme et l'amour. *Cahiers de l'Orient,* 50
 (1998) pp.131-138. (Littérature soufie.)

1790 MALAMUD, M. Gender and spiritual self-fashioning: the
 master-disciple relationship in classical Sufism. *Journal
 of the American Academy of Religion,* 64 i (1996)
 pp.89-117. [Power relations between master & disciple
 compared with husband-wife relations.]

1791 MAUFROY, Muriel. Kimya. *Sufi* (London), 42 (1999)
 pp.14-20. [Adopted daughter of Jalāl al-Dīn Rūmī.]

1792 SOBH, Mahmud. *Cuarteta de amor divino* de Rābi'a
 al-'Adawiyya. *Miscelánea de Estudios Arabes y
 Hebraicos: Sección Arabe-Islam,* 51 (2002) pp.395-404.
 (Primera mujer *sūfī* del Islam.) [Trans. into Spanish.]

Religious movements; religious fundamentalism

Books

1793 DIALMY, Abdessamad. *Féminisme, islamisme et
 soufisme.* Paris: Publisud, 1997. 252pp.

1794 GERAMI, Shahin. *Women and fundamentalism: Islam
 and Christianity.* New York: Garland, 1996, (Garland
 Reference Library of the Humanities, 1516; Women's
 History and Culture, 9), 178pp.

1795 MÜLLER, Iris & RAMING, I. *Aufbruch aus männlichen
 "Gottesordnungen": Reformbestrebungen von Frauen in
 christlichen Kirchen und im Islam.* Weinheim: Deutscher
 Studien, 1998. 300pp.

Articles

1796 ABUGIDEIRI, Hibba. Hagar: a historical model for
 "gender jihad". *Daughters of Abraham: feminist thought
 in Judaism, Christianity, and Islam.* Ed. by Yvonne
 Yazbeck Haddad and John L.Esposito. Gainesville:
 University Press of Florida, 2001, pp.81-107.

1797 AFARY, Janet. The war against feminism in the name of
 the Almighty: making sense of gender and Muslim
 fundamentalism. *Women Living under Muslim Laws:
 Dossier,* 21 (1998) pp.7-31. Also online at http://
 www.wluml.org/english/pubs

1798 FREEDMAN, Lynn P. The challenge of fundamentalisms.
 Women Living under Muslim Laws: Dossier, 19 (1997)
 pp.96-119. Also online at www.wluml.org/english/pubs
 (International Conference on Population and Development,
 Cairo 1994.)

1799 GILL, Hélène. From veils to dual identities. *Bulletin of
 Francophone Africa,* 11 (1997) pp.32-42. [Muslim &
 Islamist women.]

1800 HATEM, Mervat. Gender and Islamism in the 1990s.
 Middle East Report, 222 / 32 i (2002) pp.44-47. (Muslim
 women activist-scholars.)

1801 METCALF, Barbara D. Tablīghī Jamā'at and women.
 *Travellers in faith. Studies of the Tablīghī Jamā'at as a
 transnational Islamic movement for faith renewal.* Ed.
 Muhammad Khalid Masud. Leiden: Brill, 2000, (Social,
 Economic and Political Studies of the Middle East and
 Asia, 69), pp.44-58.

1802 SHEHADEH, Lamia Rustum. Women in Islamic
 fundamentalism: the discourses of Turabi and Ghannoushi.
 Journal of South Asian and Middle Eastern Studies, 22 ii
 (1999) pp.61-79.

1803 SIKAND, Yoginder S. Women and the *Tablīghī Jamā'at.*
 Islam and Christian-Muslim Relations, 10 i (1999)
 pp.41-52.

1804 SIKAND, Yoginder S. Women and the Tablighi Jama'at.
 Islam, women and gender justice. [Ed.] Asghar Ali
 Engineer. New Delhi: Gyan Publishing House, 2001,
 pp.219-238.

Status of women; civil & human rights

Books

1805 AFKHAMI, Mahnaz & VAZIRI, Haleh. *Claiming our
 rights: a manual for women's human rights education in
 Muslim societies.* Bethesda: Sisterhood Is Global Institute,
 1996. 154pp.

1806 AFKHAMI, Mahnaz, HOFMANN NEMIROFF, Greta &
 VAZIRI, Haleh. *Safe and secure: eliminating violence
 against women and girls in Muslim societies.* In
 consultation with Afifa Dirani Arsanios. Bethesda:
 Sisterhood Is Global Institute, 1998. 164pp.

1807 ALI, Shaheen Sardar. *Gender and human rights in Islam
 and international law: equal before Allah, unequal before
 man?* The Hague: Kluwer Law International, 2000. 358pp.
 (Example of Pakistan to demonstrate the divergence
 between theory & practice of Islamic law.)

1808 ALKAN, Metin. *Islam in een ontzuilde samenleving. Discussies over vrouwenemancipatie, kunst en onderwijs.* Amsterdam: Koninklijk Instituut voor de Tropen, 1996. 173pp.

1809 ARUFFO, Alessandro. *Donne e islam.* 2. ed. Rome: Datanews, 2001. 191pp.

1810 ARUFFO, Alessandro. *Donne e islam.* Rome: Datanews, 2000. 190pp.

1811 BAUER, K. *Stichwort Frauen im Islam.* Munich: Heyne, 1994. 95pp.

1812 BENGUIGUI, Yamina. *Femmes d'Islam.* Paris: A. Michel, 1996. 185pp.

1813 BENJAMIN, Judy A. & MERTUS, Julie. *War's offensive on women: the humanitarian challenge in Bosnia, Kosovo, and Afghanistan.* West Hartford: Kumarian Press, 2000. 157pp.

1814 BEWLEY, Aisha Abdurrahman. *Islam: the empowering of women.* London: Ta-Ha, 1999. 65pp.

1815 ENAY, Marc-Edouard & HÖRNER, Karin. *Schuld sind die Männer - nicht der Koran: zur Situation der muslimischen Frau.* Saananmöser: Orient-Antiquariat, 2000. 151pp.

1816 ENGINEER, Asghar Ali. *Equity, social justice and women.* Colombo: Women's Research and Action Forum, 1999. 25pp.

1817 ENGINEER, Asghar Ali. *The Qur'an, women and modern society.* Delhi: Sterling, 1999. 231pp.

1818 HAJA, Fdal. *Guide de la femme musulmane.* Paris: Universel, 1996. 140pp.

1819 HARIK, R. M. & MARSTON, E. *Women in the Middle East: tradition and change.* New York: Franklin Watts, 1996. 224pp. [Juvenile.]

1820 HASSAN, Riffat. *Sélection d'articles: Théologie féministe et les femmes dans le monde musulman; Que signifie être musulman aujourd'hui?; Egaux devant Allah?; Les rôle et responsabilités des femmes dans la tradition juridique et rituelle de l'Islam; Les femmes dans l'Islam.* Grabels: Women Living under Muslim Laws, [1994]. 78pp. Also online at http:// www.wluml.org/french/pubs/pdf/misc/ riffatfr.pdf

1821 HEKMAT, Anwar. *Women and the Koran: the status of women in Islam.* Amherst (USA): Prometheus, 1997. 278pp.

1822 HOCAOĞLU KAPLAN, Cemaleddin. *Stellung der Frau im Islam und ihre besonderen Zustände.* Cologne: Kalifatstaat, 1996. 185pp.

1823 JAWAD, Haifaa A. *The rights of women in Islam: an authentic approach.* Basingstoke: Macmillan, 1998. 150pp.

1824 MERNISSI, Fatima. *Achter de sluier: de islam en de strijd tussen de seksen.* Tr. Peeters, M. Breda: De Geus, 1994, (Geuzenpocket, 24), 236pp. [Tr. of *Sexe idéologie Islam,* Paris 1983.]

1825 MUṬAHHARĪ, Murtaḍā. *Les droits de la femme en islam* / Mortadhâ Motahhari. Tr. Bostani, Abbas Ahmad el-. Paris: Séminaire Islamique de Paris, 1993, (Publication, 22), 321pp. [Tr. of *The rights of women in Islam.*]

1826 NASEEF, Fatima. *Droits et devoirs de la femme en islam: à la lumière du Coran et de la Sunna.* 2e éd. rev. et corr. Lyon: Tawhid, 1999. 266pp.

1827 NASEEF, Fatima Umar. *Women in Islam: a discourse in rights and obligations.* Ed. Abedin, Saleha Mahmood. Cairo: International Islamic Committee for Woman & Child; Delhi: Sterling, 1999 (IICWC book series, no. 1), 269pp.

1828 PINN, I. & WEHNER, M. *EuroPhantasien: die islamische Frau aus westlicher Sicht.* Duisburg: DISS, 1995. 257pp.

1829 SVENSSON, Jonas. *Women's human rights and Islam: a study of three attempts at accommodation.* Lund. Religionshistoriska Avdelningen, Lunds Universitet, 2000 (Lund Studies in History of Religions, 12), 250pp.

1830 WALTHER, W. *Die Frau im Islam.* 3., überarb. & neugestaltete Aufl. Leipzig: Ed. Leipzig 1997. 240pp.

1831 *Die neue Muslimische Frau: Standpunkte & Analysen* / hrsg. Barbara Pusch. Istanbul: Orient-Institut der Deutschen Morgenländischen Gesellschaft; Würzburg: Ergon, 2001 (Beiruter Texte und Studien, 85), 326pp.

1832 *Femmes de Méditerranée: religion, travail, politique.* Sous la dir. de Andrée Dore-Audibert et Sophie Bessis. Paris: Karthala, 1995. 268pp.

1833 *Femmes et Islam: Actes du Colloque Rôle et status des femmes dans les sociétés contemporaines de tradition musulmane, Paris ... 1999.* Ed. Lochon, Christian, Bodin, Véronique & Doumenge, Jean-Pierre. Paris: Centre des Hautes Etudes sur l'Afrique et l'Asie Modernes, 2000. 218pp.

1834 *Femmes et Islam.* Collection dirigée par Aïcha Belarbi. Casablanca: Le Fennec, 1998. 66+126pp. [French & Arabic. Arabic title: *Al-nisā' wa-'l-Islām.*]

1835 *Gender and citizenship in the Middle East.* Ed. Suad Joseph. Syracuse (USA): Syracuse University Press, 2000. 400pp.

1836 *Islam and equality: debating the future of women's and minority rights in the Middle East and North Africa.* New York: Lawyers Committee for Human Rights, 1999. 207pp.

1837 *La Méditerranée des femmes.* Sous la dir. de Nabil el Haggar. Paris: L'Harmattan, 1998. 202pp.

1838 *Statut de la femme musulmane: questions, réponses* / préparé par une équipe de femmes. Paris: Editions Al Qalam, 1995. 142pp.

1839 *The social role of woman.* Tehran: Al-Balagh Foundation, 2000 (Islamic Concepts, 23), 80pp.

1840 *Women in Islam and the Middle East: a reader.* Ed. Roded, R. London: Tauris, 1999. 271pp. [Anthology of extracts.]

Articles

1841 BEN ACHOUR, Sana. Etats non sécularisés, laïcité et droits des femmes. *Revue Tunisienne de Droit / Al-Majalla al-Qānūnīya al-Tūnisīya,* 1993, pp.297-311. (Islam et laïcité.)

1842 ABAZA, Mona. Images on gender and Islam: the Middle East and Malaysia: affinities, borrowings and exchanges. *Orient* (Opladen/Leverkusen), 39 ii (1998) pp.271-284.

1843 ABAZA, Mona. Vorstellungen über Geschlecht und Islam - der Mittlere Osten und Malaysia: Übereinstimmungen, Entlehnungen und Wechselbeziehungen. *Der neue Islam der Frauen. Weibliche Lebenspraxis in der globalisierten Moderne: Fallstudien aus Afrika, Asien und Europa.* R.Klein-Hessling, S.Nökel, K.Werner (Hg.). Bielefeld: transcript Verlag, 1999, pp.277-296.

1844 ABD EL FATTAH, Anisa. The status of Muslim women: a barometer for progress in Islamic movement. *Middle East Affairs Journal,* 6 iii-iv (2000) pp.53-59.

1845 ABDEL HALIM, Asma M. Reconciling the opposites: equal but subordinate. *Religious fundamentalisms and the human rights of women.* Ed. C.W.Howland. Basingstoke: Macmillan; New York: St. Martin's Press, 1999, pp.203-213. [Muslim women.]

1846 ABDEL-KRIM, Rabia. IDEEFAM, une idée de Méditerranéennes. *Hommes & Migrations,* 1167 (1993) pp.52-54. (Institut de Recherches, de Développement, d'Echanges et d'Etudes des Femmes Autour de la Méditerranée, Aix-en-Provence.)

1847 ABEDIN, Saleha M. Women in search of equality, development and peace: a critical analysis of the platform for action, Fourth World Conference on Women, and the Islamic perspective. *Journal of Muslim Minority Affairs,* 16 i (1996) pp.73-98.

1848 ABUGIDEIRI, Hibba. The renewed woman of American Islam: shifting lenses toward 'gender *jihad*'? *Muslim World,* 91 i-ii (2001) pp.1-18.

1849 AFKHAMI, Mahnaz. Claiming our rights: a manual for
 women's human rights education in Muslim societies.
 Muslim women and the politics of participation:
 implementing the Beijing platform. Ed. Mahnaz Afkhami
 & E.Friedl. Syracuse (USA): Syracuse University Press,
 1997, pp.109-120.

1850 AFKHAMI, Mahnaz. Gender apartheid and the discourse
 of relativity of rights in Muslim societies. *Religious*
 fundamentalisms and the human rights of women. Ed.
 C.W.Howland. Basingstoke: Macmillan; New York: St.
 Martin's Press, 1999, pp.67-77.

1851 AFKHAMI, Mahnaz. Promoting women's rights in the
 Muslim world. *Journal of Democracy,* 8 i (1997)
 pp.157-166.

1852 AMERONGEN, A. van. Een meisje op de Middenweg.
 Islam in een ontzuilde samenleving. Discussies over
 vrouwenemancipatie, kunst en onderwijs. [By] Metin Alkan
 [& others]. Amsterdam: Koninklijk Instituut voor de
 Tropen, 1996, pp.147-173. (Vijf interviews met
 achtereenvolgens een Algerijnse filmmaker, een
 Marokkaanse schriftster/toneelmaakster, een Egyptische
 acteur, een Marokkaanse schilderes en twee Turkse
 cabaretières.)

1853 AMMAH, Rabiatu. Women in Islam: some issues of
 concern. *Orita,* 27 i-ii (1997) pp.56-67.

1854 ASCHA, Ghassan. Moslim vrouwen: tussen sjarie'a en
 moderne tijd. *Islam in een ontzuilde samenleving.*
 Discussies over vrouwenemancipatie, kunst en onderwijs.
 [By] Metin Alkan [& others]. Amsterdam: Koninklijk
 Instituut voor de Tropen, 1996, pp.27-56.

1855 BALAGHI, Shiva. Cultural boundaries and cyberspace.
 Middle East Women's Studies Review, 15 iii (2000)
 pp.7-8. (June 2000, the Women's Learning Partnership
 ... symposium focusing on innovative tools and strategies
 for strengthening women's leadership in Muslim societies
 ... New York City.)

1856 BARON, B. Tolerable intolerance? Silence on attacks on
 women by fundamentalists. *Contention,* 5 iii / 15 (1996)
 pp.119-126. [Male Western academics & Islamic
 fundamentalists.]

1857 BASTANI, Susan. Muslim women on-line. *Arab World*
 Geographer. Le Géographe du Monde Arabe, 3 i (2000)
 pp.40-59.

1858 BENKHEÏRA, Mohammed H. Au-delà du voile, un conflit
 de normativités. *Panoramiques,* 29 (1997) pp.75-81.

1859 BENSLAMA, Fethi. La femme immémoriale. *Cahiers*
 Intersignes, 6-7 (1993) pp.119-135. [Islam & women.]

1860 BOOTH, Marilyn, DOUMATO, E. [A.], HALE, S.,
 OLMSTEAD, J. & ZUHUR, Sherifa. Teaching with
 literature and films in undergraduate courses across
 disciplines workshop. *Middle East Women's Studies: the*
 Review, 12 iv (1998) pp.1-7. (About women in the
 Muslim world.)

1861 BREDI, Daniela. Muḥammad Iqbāl sulla questione
 femminile. *Rivista degli Studi Orientali,* 73 i-iv / 1999
 (2000) pp.53-68. [In nine Urdu poems, tr. into Italian.]

1862 CARØE CHRISTIANSEN, C. & RASMUSSEN,
 L.Kofoed. The Muslim woman - a battlefield. *Contrasts*
 and solutions in the Middle East. Ed. O.Høiris & Sefa
 Martin Yürükel. Århus: Aarhus University Press, 1997,
 pp.82-94.

1863 CHOWDHURY, Masuda M.Rashid. Status of women in
 Islam. *Dhaka University Studies,* 56 i (1999) pp.231-262.

1864 CINAR, E. Mine. Privatization of education, educational
 spending and the case of the "missing girls" in grade
 schools. *Critique: Journal for Critical Studies of the*
 Middle East, 11 (1997) pp.53-64. (Middle Eastern
 countries.)

1865 CONNORS, J. The Women's Convention in the Muslim
 world. *Feminism and Islam: legal and literary*
 perspectives. Ed. Mai Yamani. Reading: Ithaca, for the
 Centre of Islamic and Middle Eastern Law, School of
 Oriental and African Studies, University of London, 1996,
 pp.351-371. (1981 ... United Nations.)

1866 COOKE, Miriam. Crusade! I mean democracy! You know:
 women! *Middle East Women's Studies Review,* 17 iii-iv
 (2002-03) pp.14-15. [U.S. gendered war talk.]

1867 DARSH, S. M. ad-. Islām and the education of Muslim
 women. *Issues in Islamic education.* London: Muslim
 Educational Trust, 1996, pp.24-27.

1868 DAWĀLĪBĪ, Muḥammad Maʿrūf al-. The emancipation
 of women: a continuing priority. *The different aspects*
 of Islamic culture: the individual and society in Islam.
 Chief ed. A.Bouhdiba, co-ed. M.Maʿrūf al-Dawālībī. Paris:
 UNESCO, 1998, (The Different Aspects of Islamic Culture,
 2), pp.185-202.

1869 DAWĀLĪBĪ, Muḥammad Maʿrūf al-. Une mission toujours
 prioritaire: émanciper la femme. *Les différents aspects*
 de la culture islamique: l'individu et la société en Islam.
 Dir. de volume A.Bouhdiba, codir. M.Maʿrūf al-Dawālībī.
 Paris: UNESCO, 1994, (Les Différents Aspects de la
 Culture Islamique, 2), pp.191-209.

1870 DONAGHY, Maureen. Life lines: the literature of women's
 human rights. *Middle East Women's Studies Review,* 15
 iii (2000) pp.6-7. [Conference, Washington 2000. Incl.
 Samar Attar & Mahnaz Afkhami.]

1871 DONNELL, A. Dressing with a difference: cultural
 representation, minority rights and ethnic chic.
 Interventions, 1 iv (1999) pp.489-499. [Incl. *ḥijāb.*]

1872 DOORN-HARDER, N.van. Between culture and religion:
 discussing Muslim women's rights. *Middle East Women's*
 Studies Review, 15 i-ii (2000) pp.21-23. (Conference
 reviews.)

1873 DOUMATO, E. A. Bui[l]ding con[s]ensus, planning for
 action: Muslim women's rights and the Fourth World
 Conference on Women. AMEWS special session with
 Rounaq Jahan, Asma Khadar, Mahnaz Afkhami, and
 Valentine Moghadam. *AMEWS Newsletter,* 10 iv (1996)
 pp.1-3.

1874 D'SOUZA, D. Women: status and comparative religions.
 Hamdard Islamicus, 19 i (1996) pp.87-97.

1875 DUVAL DE DAMPIERRE, Soraya. "Westliche" versus
 "islamische" Frauenrechte? Beobachtungen von der
 Internationalen Konferenz für Bevölkerung und
 Entwicklung. *INAMO-Beiträge,* 2 (1995) pp.41-44.

1876 ENDE, W. Solle Frauen schreiben lernen? Eine
 innerislamische Debatte und ihre Widerspiegelung in
 Al-Manār. Gedenkschrift Wolfgang Reuschel: Akten des
 III. Arabistischen Kolloquiums, Leipzig, 21.-22. November
 1991. Hrsg. D.Bellmann. Stuttgart: Steiner, [for] Deutsche
 Morgenländische Gesellschaft, 1994, (Abhandlungen für
 die Kunde des Morgenlandes, 51/1), pp.49-57.

1877 ENGINEER, Asghar Ali. Islam, women and gender justice.
 Islam, women and gender justice. [Ed.] Asghar Ali
 Engineer. New Delhi: Gyan Publishing House, 2001,
 pp.23-42.

1878 ESIM, Simel. "Images of Muslim / Middle Eastern women"
 panel. *Middle East Women's Studies: the Review,* 12 iv
 (1998) pp.10-12. [In their own countries & in Western
 magazines. Conference report.]

1879 FERJANI, Mohamed-Chérif. Islamisme et droits de la
 femme. *Confluences Méditerranée,* 27 (1998) pp.11-23.

1880 FERNEA, Elizabeth. The challenges for Middle Eastern
 women in the 21st century. *Middle East Journal,* 54 ii
 (2000) pp.185-193.

1881 FRØYEN, R. Med slør - uten slør, hvem er de? Kvinneverd
 og kvinneroller. *Mellom kors og halvmåne: kristne*
 perspektiver på møtet med islam. Red. J.Opsal &
 A.M.Bakke. Oslo: Credo, 1994, pp.35-50.

1882 GALLAGHER, N. E. Human rights education for women
 in Muslim societies: a test run at MESA. *Middle East*
 Women's Studies: the Review, 11 iv (1997) pp.4-4.
 [Conference report from Middle East Studies Association
 of North America.]

1883 HABIBI, Shahla. Die Stellung der Frau im Islam.
 Menschenbilder, Menschenrechte: Islam und Okzident:
 Kulturen im Konflikt. Hrsg. von S.Batzli, F.Kissling &
 R.Zihlmann. Zürich: Unionsverlag, 1994, pp.113-127.

1884 HAGGAR, Nabil el. La Méditerranée des femmes. *La Méditerranée des femmes.* Sous la dir. de Nabil el Haggar. Paris: L'Harmattan, 1998, pp.25-37. [Incl. Muslim world.]

1885 HALE, S. Women and human rights in Muslim communities, a conference review. *Middle East Women's Studies: the Review,* 13 ii (1998) pp.23-23.

1886 HASSAN, Riffat. Is family planning permitted by Islam? The issue of a woman's right to contraception. *Windows of faith: Muslim women scholar-activists in North America.* Ed. G.Webb. Syracuse: Syracuse University Press, 2000, pp.226-237.

1887 HASSAN, Riffat. Zijn vrouwen en mannen voor God gelijk. *Islam in een ontzuilde samenleving. Discussies over vrouwenemancipatie, kunst en onderwijs.* [By] Metin Alkan [& others]. Amsterdam: Koninklijk Instituut voor de Tropen, 1996, pp.73-91.

1888 HELIE-LUCAS, M. The face of women refugees from Muslim communities: Algeria to ex-Yugoslavia. *The suitcase: refugee voices from Bosnia and Croatia, with contributions from over seventy-five refugees and displaced people.* Ed. J.Mertus, Jasmina Tesanovic, Habiba Metikos, Rada Boric. Berkeley & Los Angeles: University of California Press, 1997, pp.205-212.

1889 HÉLIE-LUCAS, M.A. What is your tribe? Women's struggles and the construction of Muslimness. *Women Living under Muslim Laws: Dossier,* 23-24 (2001) pp.49-63. Also online at http:// www.wluml.org/english/ pubs

1890 HÉLIE-LUCAS, Marie-Aimée. What is your tribe? Women's struggles and the construction of Muslimness. *Religious fundamentalisms and the human rights of women.* Ed. C.W.Howland. Basingstoke: Macmillan; New York: St. Martin's Press, 1999, pp.21-32.

1891 HERMANSEN, M. K. Women, men, and gender in Islam. *The Muslim almanac: a reference work on the history, faith, culture, and peoples of Islam.* Ed. Azim A.Nanji. Detroit: Gale Research Inc., 1996, pp.381-390.

1892 HIBRI, Azizah Y[ahia] al-. An introduction to Muslim women's rights. *Windows of faith: Muslim women scholar-activists in North America.* Ed. G.Webb. Syracuse: Syracuse University Press, 2000, pp.51-71.

1893 HOODFAR, Homa. Muslim women on the threshold of the twenty-first century. *Women Living under Muslim Laws: Dossier,* 21 (1998) pp.112-123. Also online at http:// www.wluml.org/english/pubs

1894 HORCHANI, Malika. Rôles féminins et identité de genre dans une société en mutation. *Etre femme au Maghreb et en Méditerranée. Du mythe à la réalité.* Sous la dir. de Andrée Dore-Audibert & Souad Khodja. Paris: Karthala, 1998, pp.107-128. (Dans la culture arabo-musulmane.)

1895 HÖRNER, K. Die ideale Muslimin. *Du,* 1994 vii-viii / 640, pp.69-70.

1896 HÖRNER, K. Harem oder Peep-Show - wo ist frau freier? *Die Welten des Islam: neunundzwanzig Vorschläge, das Unvertraute zu verstehen.* Hrsg. G.Rotter, Frankfurt a. M. : Fischer Taschenbuch Verlag (1993) pp.178-184;229.

1897 HOWLAND, C. W. The challenge of religious fundamentalism to the liberty and equality rights of women: an analysis under the United Nations charter. *Columbia Journal of Transnational Law,* 35 ii (1997) pp.271-377. (Within five major religions: Buddhism, Chrisianity, Hinduism, Islam and Judaism.)

1898 JABER, Nabila. Islam revisited: wo(man)hood, nationhood, and the legitimating crisis of gender equality. *Remaking the Middle East.* Ed. P.J.White & W.S.Logan. Oxford: Berg, 1997, pp.105-127.

1899 JOSEPH, Suad. Gender and citizenship in Middle Eastern states. *Middle East Report,* 26 i / 198 (1996) pp.4-10.

1900 JOSEPH, Suad. Gender and citizenship in Muslim communities: a report on the Residency Seminar at the University of California Irvine Humanities Research Institute. *Middle East Women's Studies Review,* 14 ii (1999) pp.3-6. (1999.)

1901 JOSEPH, Suad. Gendering citizenship in the Middle East. *Gender and citizenship in the Middle East.* Ed. Suad Joseph. Syracuse (USA): Syracuse University Press, 2000, pp.3-30.

1902 JUILLARD-BEAUDAN, C. La parole comme espace de mort. *Cahiers de l'Orient,* 47 (1997) pp.7-14. [For Muslim women.]

1903 KANDIYOTI, Deniz. Beyond Beijing: obstacles and prospects for the Middle East. *Muslim women and the politics of participation: implementing the Beijing platform.* Ed. Mahnaz Afkhami & E.Friedl. Syracuse (USA): Syracuse University Press, 1997, pp.3-10.

1904 KANDIYOTI, Deniz. The politics of gender and the conundrums of citizenship. *Women and power in the Middle East.* Ed. Suad Joseph & Susan Slyomovics. Philadephia: University of Pennsylvania Press, 2001, pp.52-58;208-209. [Middle East.]

1905 KANDIYOTI, Deniz. Women, Islam, and the state. *Political Islam: essays from* Middle East Report. Ed. J.Beinin & J.Stork. London: Tauris, 1997, pp.185-193.

1906 KAUSAR, Zeenath. Sexuality and reproductive rights in *Platform for Action* and Islam. *Encounters* (Leicester), 3 ii (1997) pp.149-163. (Document arising from the Beijing Conference.)

1907 KHAN, [Mohommed A.] Muqtedar. The condition of Muslim women: what can American Muslims do? *Middle East Affairs Journal,* 6 iii-iv (2000) pp.93-97.

1908 KHAN, Muniza R[afiq] & SRIVASTAVA, Usha. Status of women in Islam. *Indian Muslim women: challenges & response.* Ed. Ram Bali Mishra. Hariharpur: Regional Sociological Research Institute, 1996, pp.148-159.

1909 KHAWĀLIDA, Samīra Fayāḍ al-. Perspectives de l'avenir pour la femme en Islam. Tr. Ferré, A. *Etudes Arabes: Dossiers,* 86-87 (1994) pp.136-155. [Arabic text, with facing French translation.]

1910 KREILE, R. Geschlechterordnung als Schlüsselelement in islamistischen Authentizitätsdiskursen. (Zusammenfassung: Gender hierarchy as a key element of Islamist "authenticity" discourses.). *Orient: Deutsche Zeitschrift für Politik und Wirtschaft des Orients,* 40 ii (1999) pp.253-266;356-357.

1911 KREILE, R. Staat und Geschlechterverhältnisse im Mittleren Osten. (Summar[y]: State and gender relations in the Middle East.). *Peripherie,* 50 (1993) pp.37-71;110.

1912 KREILE, Renate. Der Krise "Herr" werden - Geschlechterpolitik und gesellschaftliche Transformationsprozesse im Vorderen Orient. *Der Vordere Orient an der Schwelle zum 21. Jahrhundert: Politik - Wirtschaft - Gesellschaft* / P.Pawelka, H-G.Wehling (Hrsg.). Opladen & Wiesbaden: Westdeutscher Verlag, 1999, pp.156-172.

1913 KROPÁČEK, L. Žena v islámské kultuře. (Summary: Woman in the Islamic culture.). *Religio* (Brno), 4 ii (1996) pp.157-165.

1914 LAMLOUM, Olfa. Les femmes dans le discours islamiste. *Confluences Méditerranée,* 27 (1998) pp.25-32.

1915 LINJAKUMPU, A. Islam on-line: Muslim women defined by the multicultural Internet community. *The third Nordic conference on Middle Eastern Studies: Ethnic encounter and culture change, Joensuu, Finland, 19-22 June 1995.* Proceedings archive. Bergen: University of Bergen, Centre for Middle Eastern and Islamic Studies, [for] Nordic Society for Middle Eastern Studies, 1996, Online at http:// www.hf.uib.no/smi/paj/default.html

1916 MAKAR, Ragai N. New voices for women in the Middle East. *MELA Notes,* 65-66, 1997-98, pp.14-60.

1917 MAQSOOD, Ruqaiyyah Waris. The education of Muslim women. *Issues in Islamic education.* London: Muslim Educational Trust, 1996, pp.79-82.

1918 MARCOTTE, Roxanne D. Šaḥrūr, the status of women, and polygamy in Islam. *Oriente Moderno,* 20 / 81 ii-iii (2001) pp.313-328. (Šaḥrūr's approach to religious interpretation.)

1919 MAYER, Ann Elizabeth. Religious reservations to the
 Convention on the elimination of all forms of
 discrimination against women: what do they really mean?
 Religious fundamentalisms and the human rights of women.
 Ed. C.W.Howland. Basingstoke: Macmillan; New York:
 St. Martin's Press, 1999, pp.104-116. (Governments of
 Muslim countries.)

1920 MOGHADAM, V. M. Gender and economic reforms: a
 framework for analysis and evidence from Central Asia,
 the Caucasus, and Turkey. *Gender and identity
 construction: women of Central Asia, the Caucasus and
 Turkey.* Ed. Feride Acar & Ayşe Günes-Ayata. Leiden:
 Brill, 2000, (Social, Economic and Political Studies of the
 Middle East and Asia, 68), pp.23-43.

1921 MOGHADAM, V. M. Gender and revolutions.
 Theorizing revolutions. Ed. J.Foran. London: Routledge,
 1997, pp.137-167. [Case studies, incl. Algeria, Iran,
 Turkey, South Yemen, Afghanistan.]

1922 MOGHADAM, V. [M.]. Report of a conference on
 women: the Seventh Annual Conference of the Association
 of Women of the Mediterranean Region (AWMR), July
 8-12, 1998, Gallipoli, Italy. *Middle East Women's Studies
 Review,* 13 iii (1998) pp.19-20.

1923 MOGHADAM, V. M. Gender, national identity and
 citizenship: reflections on the Middle East and North
 Africa. *Comparative Studies of South Asia, Africa and
 the Middle East,* 19 i (1999) pp.137-157. [Kemalist
 revolution in Turkey, Saur revolution in Afghanistan,
 independence struggle in Algeria & revolution in Iran.]

1924 MOGHADAM, Valentine M. Gender, national identity
 and citizenship: reflections on the Middle East and North
 Africa. *Hagar,* 1 i (2000) pp.41-70.

1925 MOGHADAM, Valentine M. Globalization and women
 in the Middle East. *Middle East Women's Studies Review,*
 17 iii-iv (2002-03) pp.16-18.

1926 NABER, N. Workshop report: May 1997 "A workshop
 on gender and citizenship in the Muslim world". *Middle
 East Women's Studies: the Review,* 12 iii (1997) pp.13-14.

1927 NAFISI, Azar, RAVICH, Samantha & TAHIR-KHELI,
 Shirin. Roundtable: three women, two worlds, one issue.
 SAIS Review, 20 ii (2000) pp.31-50. (Gender &
 international relations.)

1928 NAGGAR, Mona. `Ich bin frei, du bist unterdrückt'. Ein
 Vergleich feministischer und islamistischer Frauenbilder.
 Der Islam in den Medien. Hrsg. vom Medienprojekt
 Tübinger Religionswissenschaft. Gütersloh: Gütersloher
 Verlag-Haus, 1994, (Studien zum Verstehen Fremder
 Religionen, 7), pp.208-220.

1929 NA'IM, Abdullahi Ahmed an-. Islam and women's rights:
 a case study. *Women Living under Muslim Laws: Dossier,*
 14-15 (1996) pp.96-109. Also online at www.wluml.org/
 english/pubs [General survey.]

1930 NA'IM, Abdullahi Ahmed an-. Islam et droits des femmes:
 étude de cas. *Women Living under Muslim Laws: Dossier,*
 14-15 (1996) pp.103-117. Also online at http://
 www.wluml.org/french/pubs/pdf/dossiers/dossier14-15/
 D14-15fr.pdf [Un coup d'œil général.]

1931 OSMAN, Fathi. Muslim women in the family and the
 society. *Firmest Bond,* 76-77 (2000) pp.34-36.

1932 OSMAN, Samia. Die Stellung der Frau im Islam und im
 Okzident. *Menschenbilder, Menschenrechte: Islam und
 Okzident: Kulturen im Konflikt.* Hrsg. von S.Batzli,
 F.Kissling & R.Zihlmann. Zürich: Unionsverlag, 1994,
 pp.58-68.

1933 PINN, I. From exotic harem beauty to Islamic
 fundamentalist: women in Islam. *The Islamic world and
 the West: an introduction to political cultures and
 international relations.* Ed. Kai Hafez. Leiden: Brill, 2000,
 (Social, Economic and Political Studies of the Middle East
 and Asia, 71), pp.57-69.

1934 PINN, I. Von der exotischen Haremsschönheit zur
 obskuren Fundamentalistin: Frauen im Islam. *Der Islam
 und der Westen: Anstiftung zum Dialog.* Hrsg. Kai Hafez,
 Frankfurt a. M. : Fischer Taschenbuch Verlag (1997)
 pp.67-79.

1935 RAHMAN, Zainab. Status of women in Islam. *Muslim
 women in India since Independence (feminine
 perspectives).* Ed. Haseena Hashia. Delhi: Institute of
 Objective Studies, 1998, pp.13-21.

1936 RASMUSSEN, L. Kofoed & CHRISTIANSEN, C. C.
 Kaos eller forandring: køn i Islam. *Jyske Historiker,* 62
 (1993) pp.241-247.

1937 RICE, Laura. Insider/outsiders-emic/etic study of women
 and gender in the new millennium. *Middle East Women's
 Studies Review,* 15 iv - 16 i (2001) pp.12-14;23. (In the
 Middle East.)

1938 ROALD, A. S. & OUIS, P. Lyssna på männen: att leva i
 en patriarkalisk muslimsk kontext. *Kvinnovetenskaplige
 Tidskrift,* 18 iii-iv (1997) pp.91-108;43. (Developments
 in how prominent male Islamists have visualized women's
 role in Islam.)

1939 ROALD, A. S. Notions of 'male' and 'female' among
 contemporary Muslims: with special reference to Islamists.
 Islamic Studies, 38 iii (1999) pp.367-401. (Role for
 women.)

1940 SA'DĀWĪ, Nawāl al-. Der doppelte Standard. Tr. Kübli,
 J. *Menschenbilder, Menschenrechte: Islam und
 Okzident: Kulturen im Konflikt.* Hrsg. von S.Batzli,
 F.Kissling & R.Zihlmann. Zürich: Unionsverlag, 1994,
 pp.104-112.

1941 SADIE, Yolanda. Women's rights in the Islamic world:
 an overview of twenty-six countries. *Journal for Islamic
 Studies,* 20 (2000) pp.63-98.

1942 SGRENA, Giuliana. De Kaboul à Alger. L'islamisme, un
 projet contre les femmes. Tr. Ravenel, Bernard.
 Confluences Méditerranée, 27 (1998) pp.55-59.

1943 SHAHEED, Farida. Constructing identities - culture,
 women's agency and the Muslim world. *Women Living
 under Muslim Laws: Dossier,* 23-24 (2001) pp.33-48.
 Also online at http:// www.wluml.org/english/pubs

1944 SIJELMASSI, Aïcha. Femmes et islam: les enjeux.
 Femmes et Islam. Al-Nisā' wa-'l-Islām. Collection dirigée
 par Aïcha Belarbi. Casablanca: Le Fennec, 1998,
 pp.49-66. (Porter le hijab n'est pas anodin.)

1945 SIMMONS, Gwendolyn Zoharah. Striving for Muslim
 women's human rights - before and beyond Beijing. An
 African American perspective. *Windows of faith: Muslim
 women scholar-activists in North America.* Ed. G.Webb.
 Syracuse: Syracuse University Press, 2000, pp.197-225.

1946 STORK, J. Gender and civil society: Suad Joseph,
 interview. *Political Islam: essays from Middle East
 Report.* Ed. J.Beinin & J.Stork. London: Tauris, 1997,
 pp.64-70.

1947 TARAKI, Lisa. The role of women. *Understanding the
 contemporary Middle East.* Ed. D.J.Gerner. Boulder:
 Rienner, 2000, pp.293-317.

1948 TAZI, Nadia. Le secret du sérail. *Cahiers Intersignes,*
 6-7 (1993) pp.187-200. [Western Orientalism & women
 in Muslim world.]

1949 TÉTREAULT, Mary Ann. Gender, citizenship, and state
 in the Middle East. *Citizenship and the state in the
 Middle East: approaches and applications.* Ed.
 N.A.Butenschon, Uri Davis, & M.Hassassian. Syracuse
 (USA): Syracuse University Press, 2000, pp.70-87.

1950 TOHIDI, Nayereh. The issues at hand. *Women in Muslim
 societies: diversity within unity.* Ed. H.L.Bodman, Nayereh
 Tohidi. Boulder: Rienner, 1998, pp.277-294.

1951 VERMA, Jag Mohan Singh. Islam and Muslim women in
 modern world. *Eastern Anthropologist,* 53 iii-iv (2000)
 pp.491-500.

1952 WADUD, Amina. Woman and Islam: beyond the
 stereotypes. *Pakistan Journal of Women's Studies:
 Alam-e-Niswan,* 4 ii (1997) pp.1-14.

1953 WALTHER, W. Die Frau im Islam heute. *Der Islam in
 der Gegenwart.* Vierte, neuarbeitete & erweiterte Aufl.
 Hrsg. W.Ende, U.Steinbach, unter redaktioneller Mitarbeit
 von G.Krüger. Munich: Beck, 1996,
 pp.604-629;874-878;931-932.

1954 WALTHER, W. Frauenwelten - Männerwelten im Islam. *Islam - eine andere Welt?* Heidelberg: Winter, 1999, (Sammelband der Vorträge des Studium Generale der Ruprecht-Karls-Universität Heidelberg im Sommersemester 1998), pp.41-56.

1955 Family, state, and civil society in Islamic communities. *ISIM Newsletter,* 8 (2001) pp.5-5. [Workshop report. Family law.]

Theory of women's studies

Books

1956 KÜNZLER, E. *Zum westlichen Frauenbild von Musliminnen.* Würzburg: Ergon, 1993, (Ethno-Islamica, 4), 112pp.

1957 YEĞENOĞLU, Meyda. *Colonial fantasies: towards a feminist reading of Orientalism.* Cambridge: Cambridge University Press, 1998, (Cambridge Cultural Social Studies), 182pp.

1958 *Discourse on gender / gendered discourse in the Middle East.* Ed. Boaz Shoshan. Westport: Praeger, 2000. 176pp.

1959 *Gendering the Middle East: emerging perspectives.* Ed. Kandiyoti, Deniz. London: Tauris, 1996. 177pp.

Articles

1960 ABDO, Naila. Assessing gender / women's studies: a comparative perspective. Women's studies programs: the Middle East in context. *Arab regional women's studies workshop. Al-Nadwa al-iqlīmīya li-dirāsāt al-mar'a al-'Arabīya.* Ed. C.Nelson, Soraya Altorki. Cairo: American University in Cairo, 1998, (Cairo Papers in Social Science, 20 iii (1997)), pp.20-40. [Discussion led by Lila Abu-Lughod, pp.63-67.]

1961 ABID, Jamila-Zahra. The concept of ideal womanhood in Imam Khomeini's (R.A.) mystical-philosophical lyrics and letters. *Spektrum Iran,* 13 ii (2000) pp.107-122.

1962 ABU-LUGHOD, Lila. *Orientalism* and Middle East feminist studies. *Feminist Studies,* 27 i (2001) pp.101-113.

1963 AFSARUDDIN, Asma. The hermeneutics of gendered space and discourse. *Hermeneutics and honor: negotiating female "public" space in Islamic/ate societies.* Ed. Asma Afsaruddin. Cambridge (USA): Harvard University Press, for the Center for Middle Eastern Studies of Harvard University, 1999, (Harvard Middle Eastern monographs, 32), pp.1-28.

1964 AFSHAR, Haleh. Women's studies in the Middle East: some problems and prospects. *Arab regional women's studies workshop. Al-Nadwa al-iqlīmīya li-dirāsāt al-mar'a al-'Arabīya.* Ed. C.Nelson, Soraya Altorki. Cairo: American University in Cairo, 1998, (Cairo Papers in Social Science, 20 iii (1997)), pp.41-62. [Discussion led by Lila Abu-Lughod, pp.63-67.]

1965 AMIRA, Nora. Le point de vue de Malek Bennabi sur les femmes. *Naqd,* 11 (1998) pp.69-83.

1966 BARON, B. A field matures: recent literature on women in the Middle East. *Middle Eastern Studies,* 32 iii (1996) pp.172-186.

1967 BOXBERGER, L. Gender in political and economic change: a MESA panel. *Middle East Women's Studies: the Review,* 11 iv (1997) pp.5-6. [Conference report from Middle East Studies Association of North America.]

1968 DAVIS, S. C. Barbara Nimri Aziz: "Move over". *An ear to the ground: presenting writers from 2 coasts.* Ed. S.C.Davis. Seattle: Cune, 1997, pp.22-29. [On Western feminists' attitude to Muslim women. Interview & profile.]

1969 DOUMATO, E. A. Am I "part of the problem"? A college teacher wonders whether teaching about Muslim women promotes positive understanding, or just more misinformation. *Middle East Women's Studies: the Review,* 11 ii (1996) pp.11-13.

1970 FREAS, E. Muslim women in the missionary world. *Muslim World,* 88 ii (1998) pp.141-164. (Orientalist discourse.)

1971 HALE, S. Reconceptualizing research and policy. International gender discourses: private comparative research agendas and methodologies in the Middle East and the United States. *Arab regional women's studies workshop. Al-Nadwa al-iqlīmīya li-dirāsāt al-mar'a al-'Arabīya.* Ed. C.Nelson, Soraya Altorki. Cairo: American University in Cairo, 1998, (Cairo Papers in Social Science, 20 iii (1997)), pp.68-93. [Discussion led by Shahnaz Rouse, pp.99-101.]

1972 HARWAZINSKI, Assia-Maria. Fanatismus, Fundamentalismus, Frauen: zur Kritik kulturalistischer Interpretationsmuster in der gegenwärtigen Islamdebatte. *Politisierte Religion: Ursachen und Erscheinungsformen des modernen Fundamentalismus.* Hrsg. H.Bielefeldt u. W.Heitmeyer. Frankfurt a.M.: Suhrkamp, 1998, pp.438-449.

1973 HATEM, Mervat F. Modernization, the state, and the family in Middle East women's studies. *Social history of women and gender in the modern Middle East* / ed. M.L.Meriwether, J.E.Tucker. Boulder: Westview, 1999, pp.63-87.

1974 KANDIYOTI, Deniz. Contemporary feminist scholarship and Middle East studies. *Gendering the Middle East: emerging perspectives.* Ed. Deniz Kandiyoti. London: Tauris, 1996, pp.1-27.

1975 KANDIYOTI, Deniz. Islam and feminism: a misplaced polarity. *WAF Journal,* 8 (1996) pp.10-13.

1976 KAYE, J. The implications of a too-regular form: the Muslim woman and the European mind. *European Legacy,* 1 iii (1996) pp.900-907. [Historical stereotypes & mutual influences.]

1977 KEDDIE, Nikki R. Women in the limelight: some recent books on Middle Eastern women's history. *International Journal of Middle East Studies,* 34 iii (2002) pp.553-573. Also online at http:// journals.cambridge.org

1978 LATTE ABDALLAH, Stéphanie & POUZOL, V. Femmes du Proche-Orient. *Bulletin d'Information du CERMOC / Nashra Ikhbārīya,* 5 (1999) pp.[2-3]. (Le champ d'étude.)

1979 MELLAH, Salima & PINN, I. Wenn eine Feministin über den Orient reflektiert ... eine Replik auf Renate Kreile. (Summar[y]: A feminist's reflection on the Orient?). *Peripherie,* 50 (1993) pp.72-79;110.

1980 MOALLEM, Minoo. Middle Eastern studies, feminism, and globalization. *Signs,* 26 iv (2001) pp.1265-1268. Also online at www.journals.uchicago.edu/signs/journal [USA.]

1981 NAGEL, Caroline. Contemporary scholarship and the demystification - and re-mystification - of "Muslim women". *Arab World Geographer. Le Géographe du Monde Arabe,* 4 i (2001) pp.63-72. (Review essay.)

1982 NELSON, Cynthia & ROUSE, Shahnaz. Gendering globalization: alternative languages of modernity. *Situating globalization: views from Egypt.* Cynthia Nelson, Shahnaz Rouse (eds). Bielefeld: Transcript, 2000, pp.97-157.

1983 RICH, P. J. Muslim women and the new gender scholarship: the Achilles' heel reconsidered. *DOMES: Digest of Middle East Studies,* 6 ii (1997) pp.35-44.

1984 SAFI-EDDINE, Khadija. Rethinking the self and the other in cultural contacts. *Cultural studies, interdisciplinarity, and the university.* Edited by Mohamed Dahbi, Mohamed Ezroura, Lahcen Haddad. Rabat: The Faculty of Letters and Human Sciences, 1996, (Publications of the Faculty of Letters and Human Sciences - Rabat. Series: Conferences and Colloquia, 60), pp.55-70. [Incl. Arab women.]

1985 SAYIGH, Rosemary. Women and gender in Middle East studies: a roundtable discussion. *Middle East Report,* 205 / 27 iv (1997) pp.30-32.

1986 SCHAEFER, K. Middle East women's studies: a report on the 1998 AMEWS Round Table. *Middle East Women's Studies Review,* 13 iv - 14 i (1999) pp.1-3.

1987 SHARONI, S. Women and gender in Middle East studies: trends, prospects and challenges. *Middle East Report,* 205 / 27 iv (1997) pp.27-29.

1988 SHOHAT, Ella. Area studies, transnationalism, and the feminist production of knowledge. *Signs,* 26 iv (2001) pp.1269-1272. Also online at www.journals.uchicago.edu/signs/journal [USA Middle East studies.]

1989 VANDAL, Sajida Halder. The built environment and the gendering of space into public/private. *Engendering the nation-state.* Vol. 2. Ed. by Neelam Hussain, Samiya Mumtaz, Rubina Saigol. Lahore: Simorgh Women's Resource and Publication Centre, 1997, pp.103-115. (The issue of gender from the architectural point of view.)

1990 WEBER, Charlotte. Unveiling Scheherazade: feminist Orientalism in the International Alliance of Women, 1911-1950. *Feminist Studies,* 27 i (2001) pp.125-157.

Germany

Books

1991 ARKI, Mostafa. *Scharareh: Wandel des Emanzipationsverständnisses der iranischen Frau in Deutschland: Kurzgeschichten.* Hildesheim: Internationales Kulturwerk, 1997. 225pp.

1992 AZIZ, Sarah. *Ich leb' nicht mehr in eurer Welt.* Bergisch Gladbach: Lübbe, 1994, (Bastei Lübbe, 61302 Erfahrungen), 268pp. [Jordanian in Germany.]

1993 ÇELIK, Hıdır & SCHUBERT, A. *30 Jahre Migration, 30 Jahre Frauen in der Fremde: Migrantinnen der Region Köln-Bonn.* Bonn: Protext, 1995. 96pp. [Incl. Turks & Kurds.]

1994 ERGI, Irfan. *Lebenssituation und politische Beteiligung von ArbeitsimmigrantInnen in der Bundesrepublik Deutschland: Möglichkeiten, Probleme und Formen, dargestellt am Beispiel von TürkInnen.* Marburg: Tectum, 2000. 168pp.

1995 HOFMANN, Gabriele. *Muslimin werden: Frauen in Deutschland konvertieren zum Islam.* Frankfurt a. M. : Institut für Kulturanthropologie und Europäische Ethnologie der Universität Frankfurt, [1997], (Kulturanthropologie Notizen, 58). 306pp.

1996 KARAKAŞOĞLU-AYDIN, Yasemin. *Muslimische Religiosität und Erziehungsvorstellungen: eine empirische Untersuchung zu Orientierungen bei türkischen Lehramts- und Pädagogik-Studentinnen in Deutschland.* Frankfurt a.M.: IKO-Verlag für Interkulturelle Kommunikation, 2000 (Interdisziplinäre Studien zum Verhältnis von Migrationen, Ethnizität und Gesellschaftlicher Multikulturalität, 12), 478pp.

1997 KAYA, Devrim. *"Meine einzige Schuld ist, als Kurdin geboren zu sein": eine junge Frau auf der Flucht vor türkischer Folter und deutscher Justiz.* Hrsg. & mit einem Beitrag von Günter Wallraff. Frankfurt a.M.: Campus, 1998. 304pp.

1998 KELEK, Neclá. *Islam im Alltag: islamische Religiosität und ihre Bedeutung in der Lebenswelt von Schülerinnen und Schülern türkischer Herkunft.* Münster: Waxmann, 2002 (Jugend - Religion - Unterricht, 7), 198pp.

1999 KHOUNANI, Pascal M. *Binationale Familien in Deutschland und die Erziehung der Kinder: eine Vergleichsuntersuchung zur familiären Erziehungssituation in mono- und bikulturellen Familien im Hinblick auf multikulturelle Handlungsfähigkeit.* Frankfurt: Lang, 2000. 231pp.

2000 KLINKHAMMER, Gritt. *Moderne Formen islamischer Lebensführung: eine qualitativ-empirische Untersuchung zur Religiosität sunnitisch geprägter Türkinnen der zweiten Generation in Deutschland.* Marburg: Diagonal-Verlag, 2000 (Religionswissenschaftliche Reihe, 14), 314pp.

2001 KULTUS, Eva. *Der Preis der Freiheit: 10 Jahre im Leben einer jungen Frau türkischer Herkunft. Langzeitstudie: der mühsame Prozeß des eigenen Wegs aus einer türkischen Familie.* Frankfurt a.M.: IKO, 1998. 157pp.

2002 NÖKEL, Sigrid. *Die Töchter der Gastarbeiter und der Islam: zur Soziologie alltagsweltlicher Anerkennungspolitiken. Eine Fallstudie.* Bielefeld: Transcript, 2002. 336pp.

2003 PAULUS, C. *Interreligiose Praxis postmodern: eine Untersuchung muslimisch-christlicher Ehen in der BRD.* Frankfurt a. M. : Lang 1999 (Europäische Hochschulschriften: Reihe XXIII, Theologie, 652), 306pp.

2004 PAYANDEH, Mitra. *Emanzipation trotz Patriarchat? Türkische Frauen des Bildungsmilieus berichten über ihr Leben: eine qualitative Fallstudie.* Marburg: Tectum, 2002. 273pp.

2005 RIESNER, S. *Junge türkische Frauen der zweiten Generation in der Bundesrepublik Deutschland: eine Analyse von Sozialisationsbedingungen und Lebensentwürfen anhand lebensgeschichtlich orientierter Interviews.* 3. Aufl. Frankfurt a. M. : Verlag für Interkulturelle Kommunikation 1995 (Interdisziplinäre Studien zum Verhältnis von Migrationen, Ethnizität und Gesellschaftlicher Multikulturalität, 1), 194pp.

2006 ROSEN, R. *Mutter - Tochter, Anne - Kız: zur Dynamik einer Beziehung: ein Kultureller Vergleich.* Opladen: Leske + Budrich, 1993. 169pp.

2007 SCHRÖTER, H. *Arabesken: Studien zum interkulturellen Verstehen im deutsch-marrokanischen Kontext.* 2. durchgesehene Aufl. Frankfurt a. M. : Lang 1999 (Europäische Hochschulschriften: Reihe XI, Pädagogik, 715), 278pp. [Rif Berber women in Germany.]

2008 [WABERZECK, N.Amina]. *Ein Leben zwischen Orient und Okzident: Hommage einer Deutsch-Türkin an ihren Vater* / N.Amina Waberzeck geb. al Roschdy-Bey. Berlin: Frieling, 2001. 236pp.

2009 WEDELL, M. *Nur Allah weiss, was aus mir wird ... Alter, Familie und ausserfamiliäre Unterstützung aus der Sicht älterer Türkinnen und Türken.* Frankfurt a. M. : IKO, Verlag für Interkulturelle Kommunikation 1993 (Wissenschaft und Forschung, 20), 196pp.

2010 YURTDAŞ, Barbara. *Wo auch ich zu Hause bin: eine türkisch-deutsche Familiengeschichte.* Munich: Piper, 1994. 211pp.

2011 YURTDAŞ, Hatice. *Pionierinnen der Arbeitsmigration in Deutschland: lebensgeschichtliche Analysen von Frauen aus Ost-Anatolien.* Hamburg: Lit, 1996, (Interethnische Beziehungen und Kulturwandel, 23), 205pp.

2012 *Frauengeschichten: Musliminnen in Deutschland erzählen aus ihrem Leben.* Ed. Palm, Dorothee. Cologne: Teiresias, 2000 (Religionswissenschaft, 2), 138pp.

2013 *Muslimische Frauen in Deutschland erzählen über ihren Glauben* / hrsg. vom Senator für Arbeit, Frauen, Gesundheit, Jugend und Soziales der Freien Hansestadt Bremen und der Bremischen Evangelischen Kirche; verfasst von Frauke Biehl & Sevim Kabak. Gütersloh: Gütersloher Verlagshaus, 1999 (Gütersloher Taschenbücher, 733), 142pp.

Articles

2014 ALIX, Christian & KODRON, Christoph. Une "Affaire de foulard" en Allemagne. *Hommes & Migrations,* 1223 (2000) pp.41-47. (En 1997, dans le Baden-Wurttemberg, une jeune enseignante allemande de confession musulmane refuse d'abandoner le port du foulard en classe et se voit interdire l'accès à l'enseignement.)

2015 ANHEGGER, Robert & SCHUBERT, Gudrun. "Deutschland, du hast mir meine Frau gestohlen!" Das Bild der türkischen Frau im Spiegel der Gastarbeiterlieder. *Journal of Turkish Studies,* 26 i (2002) pp.21-35. (Der aşık.)

2016 BARRETT, S. Unterdrückung oder Befreiung? Deutsche Frauen konvertieren zum Islam. *CIBEDO: Beiträge zum Gespräch zwischen Christen und Muslimen,* 9 iii (1995) pp.81-91.

2017 BLASCHKE, Jochen & SABANOVIC, Sanela. Multi-level discrimination of Muslim women in Germany. *Multi-level discrimination of Muslim women in Europe.* Jochen Blaschke (ed.). Berlin: Parabolis, 2000, pp.37-137.

2018 HILLMANN, F. A look at the 'hidden side': Turkish women in Berlin's ethnic labour market. *International Journal of Urban and Regional Research,* 23 ii (1999) pp.267-282. Also online at www.nesli.ac.uk

2019 JONKER, Gerdien. Death, gender and memory: remembering loss and burial as a migrant. *Death, gender and ethnicity.* E. David Field, Jenny Hockey and Neil Small. London: Routledge, 1997, pp.187-201. [Migrant Greek & Turkish communities in Berlin.]

2020 JONKER, G. Religiosität und Partizipation der zweiten Generation - Frauen in Berliner Moscheen. *Der neue Islam der Frauen. Weibliche Lebenspraxis in der globalisierten Moderne: Fallstudien aus Afrika, Asien und Europa.* R.Klein-Hessling, S.Nökel, K.Werner (Hg.). Bielefeld: transcript Verlag, 1999, pp.106-123.

2021 KARAKAŞOĞLU-AYDIN, Yasemin. "Kopftuch-Studentinnen" türkischer Herkunft an deutschen Universitäten: impliziter Islamismusvorwurf und Diskriminierungserfahrungen. *Politisierte Religion: Ursachen und Erscheinungsformen des modernen Fundamentalismus.* Hrsg. H.Bielefeldt u. W.Heitmeyer. Frankfurt a.M.: Suhrkamp, 1998, pp.450-473.

2022 KARAKAŞOĞLU-AYDIN, Yasemin. "Unsere Leute sind nicht so" - Alevitische und sunnitische Studentinnen in Deutschland. *Die neue Muslimische Frau: Standpunkte & Analysen* / hrsg. Barbara Pusch. Istanbul: Orient-Institut der Deutschen Morgenländischen Gesellschaft; Würzburg: Ergon, 2001, (Beiruter Texte und Studien, 85), pp.295-322.

2023 NÖKEL, S. Islam und Selbstbehauptung - alltagsweltliche Strategien junger Frauen in Deutschland. *Der neue Islam der Frauen. Weibliche Lebenspraxis in der globalisierten Moderne: Fallstudien aus Afrika, Asien und Europa.* R.Klein-Hessling, S.Nökel, K.Werner (Hg.). Bielefeld: transcript Verlag, 1999, pp.124-146.

2024 RÄTHZEL, N. Living differences: ethnicity and fearless girls in public spaces. *Social Identities, 6* ii (2000) pp.119-142. [Hamburg, with particular ref. to Turks & Kurds]. Also online at www.catchword.com

2025 ROHE, Mathias. Islamic law in German courts. *Hawwa: Journal of Women in the Middle East and the Islamic world,* 1 i (2003) pp.46-59. Also online at http:// leporello.ingentaselect.com/vl=16277934/cl=41/nw=1/ rpsv/cw/brill/15692078/

2026 STOLL, G. "Gemeinsam diese Gesellschaft gestalten": junge Musliminnen über Dialog und Integration in Deutschland. *CIBeDo: Beiträge zum Gespräch zwischen Christen und Muslimen,* 13 iii (1999) pp.101-101.

2027 TERKESSIDIS, Mark. Global culture in Germany or: how repressed immigrant women and criminals rescue hybridity. *Communal Plural,* 8 ii (2000) pp.219-235. Also online at www.catchword.com (Well-educated young immigrant women intentionally taking up the veil, and ... young immigrant men involved in petty crime.)

2028 TIETZE, Nikola. La croix, le foulard et l'identité allemande. (Abstract: The cross, the scarf, and German identity.). *Critique Internationale,* 7 (2000) pp.79-100;184.

2029 WEIBEL, N. B. L'islam action au féminin ou une rédéfinition de l'identité de genre. *Actes du Colloque: L'islam en Europe: aspects religieux, Lausanne ... 1992.* Ed. J.Waardenburg. Lausanne: Université de Lausanne, Département Interfacultaire d'Histoire et de Sciences des Religions, 1994, (Cahiers, 2), pp.69-85. [Middle East, France & Germany.]

2030 WILPERT, C. Deux générations de femmes d'origine turque en Allemagne. *CEMOTI,* 21 (1996) pp.119-138.

Ghana

Articles

2031 KLOMEGAH, R. Socio-economic characteristics of Ghanaian women in polygynous marriages. *Journal of Comparative Family Studies,* 28 i (1997) pp.viii-ix;xiii-xiv;73-88. [Incl. Muslims.]

2032 PELLOW, D. Male praise-singer in Accra: in the company of women. *Africa: Journal of the International African Institute,* 67 iv (1997) pp.582-601. [Among Hausa Muslims.]

Great Britain

Books

2033 BASIT, Tehmina N. *Eastern values; Western milieu: identities and aspirations of adolescent British Muslim girls.* Aldershot: Ashgate, 1997. 196pp.

2034 BRIGGS, J. & BRIGGS, Zena. *Jack & Zena: a true story of love and danger.* London: Gollancz, 1997. 222pp. [Family opposition to British Muslim girl's marriage to non-Muslim.]

2035 KABEER, Naila. *The power to choose: Bangladeshi women and labour market decisions in London and Dhaka.* London: Verso, 2000. 464pp.

2036 *Muslim women in the United Kingdom and beyond: experiences and images.* Ed. Jawad, Haifaa & Benn, Tansin. Leiden: Brill, 2002 (Women and Gender: the Middle East and the Islamic World, 2), 178pp. [Incl. USA & Sweden.]

2037 *Telling it like it is: young Asian women talk.* Ed. Kassam, Nadya. London: Livewire, 1997. 131pp. [British Asians, incl. Muslims.]

2038 HARBOTTLE, Lynn. *Food for health, food for wealth: the performance of ethnic and gender identities by Iranian settlers in Britain.* New York: Berghahn Books, 2000 (The Anthropology of Food and Nutrition, 3), 184pp.

2039 HAW, K., SHAH, Saeeda & HANIFA, Maria. *Educating Muslim girls: shifting discourses.* Buckingham: Open University Press, 1998. 203pp. (In British schools.)

Articles

2040 AHMAD, Fauzia. Modern traditions? British Muslim women and academic achievement. *Gender and Education,* 13 ii (2001) pp.137-152. Also online at http:// www.ingentaselect.com

2041 ALI, Nadje al-. Gender relations, transnational ties and rituals among Bosnian refugees. *Global Networks,* 2 iii (2002) pp.249-262. [In London.] Also online at www.ingenta.com

2042 ALI, Yasmin. Les femmes musulmanes et la politique de l'ethnicité et de la culture dans le nord de l'Angleterre. *Women Living under Muslim Laws: Dossier,* 20 (1997) pp.55-72. Also online at http:// www.wluml.org/french/ pubs/pdf/dossiers/dossier20/D20fr.pdf

2043 ALI, Yasmin. Muslim women and the politics of ethnicity and culture in northern England. *Women Living under Muslim Laws: Dossier,* 20 (1998) Also online at http:// www.wluml.org/english/pubs

2044 ALI, Yasmin. Muslim women and the politics of ethnicity and culture in northern England. *Refusing holy orders: women and fundamentalism in Britain.* Ed. Gita Sahgal & Nira Yuval-Davis. [New ed.] London: Women Living under Muslim Laws, 2000, pp.106-128. Also online at www.wluml.org/english/pubs

2045 ALIBHAI-BROWN, Yasmin. Smother love: the abuse of Asian women in the UK. *Index on Censorship,* 29 ii / 193 (2000) pp.82-84.

2046 ANWAR, Muhammad & SHAH, Firsila. Muslim women and experiences of discrimination in Britain. *Multi-level discrimination of Muslim women in Europe.* Jochen Blaschke (ed.). Berlin: Parabolis, 2000, pp.203-248.

2047 BADRI, Amna M. & ABDEL MAGIED, Ahmed. Problems that face genitally mutilated immigrant Sudanese women and their awareness of available relevant health services in London - a case study. *Ahfad Journal / Majallat al-Ahfād,* 17 ii (2000) pp.29-37.

2048 BASIT, Tehmina N. 'I want more freedom, but not too much': British Muslim girls and the dynamism of family values. *Gender and Education,* 9 iv (1997) pp.425-439. Also online at http:// www.ingentaselect.com

2049 BASIT, Tehmina N. "Obviously I'll have an arranged marriage": Muslim marriage in the British context. *Muslim Education Quarterly,* 13 ii (1996) pp.4-19.

2050 BHOPAL, Kalwant. South Asian women in east London: religious experience and diversity. *Jounal of Gender Studies,* 7 ii (1998) pp.143-156. [Incl. Muslims.]

2051 BHOPAL, Kalwant. South Asian women within households: dowries, degradation and despair. *Women's Studies International Forum,* 20 iv (1997) pp.483-492. [Hindu, Sikh & Muslim women in UK.]

2052 BIRKE, Lynda & WHITWORTH, Rosalind. Seeking knowledge: women, science, and Islam. *Women's Studies International Forum,* 21 ii (1998) pp.147-159. Also online at www.sciencedirect.com/science/journal/02775395 [British Asian Muslim women & their perspectives & understandings of science.]

2053 BRAH, Avtar. `Race' and `culture' in the gendering of labour markets: young South Asian Muslim women and the British labour market. *Women Living under Muslim Laws: Dossier,* 23-24 (2001) pp.5-26. Also online at http:// www.wluml.org/english/pubs

2054 BURLET, S. & REID, H. A gendered uprising: political representation and minority ethnic communities. *Ethnic and Racial Studies,* 21 ii (1998) pp.270-287. Also online at http:// www.catchword.com [Male & female Pakistanis in Bradford, 1995.]

2055 CAMERON, Joan & ANDERSON, Karen Rawlings. 'Circumcision', culture, and health-care provision in Tower Hamlets, London. *Gender and Development,* 6 iii (1998) pp.48-54. Also online at http:// www.ingentaselect.com [Somali women.]

2056 CARROLL, Lucy. Arranged marriages: law, custom, and the Muslim girl in the U.K. *Women Living under Muslim Laws: Dossier,* 20 (1998) Also online at http:// www.wluml.org/english/pubs

2057 CARROLL, Lucy. Mariages arrangés: le droit, la coutume et la jeune-fille musulmane au Royaume Uni. *Women Living under Muslim Laws: Dossier,* 20 (1997) pp.73-79. Also online at http:// www.wluml.org/french/pubs/pdf/ dossiers/dossier20/D20fr.pdf

2058 CARROLL, Lucy. Muslim women and `Islamic divorce' in England. *Women Living under Muslim Laws: Dossier,* 19 (1997) pp.51-74. Also online at www.wluml.org/ english/pubs

2059 CARROLL, Lucy. Muslim women and 'Islamic divorce' in England. *Journal of Muslim Minority Affairs,* 17 i (1997) pp.97-115.

2060 CHAPPLE, A., LING, M. & MAY, C. General practitioners' perceptions of the illness behaviour and health needs of South Asian women with menorrhagia. *Ethnicity & Health,* 3 i-ii (1998) pp.81-93. [Incl. Muslims.]

2061 DEMACK, Sean, DREW, David & GRIMSLEY, Mike. Minding the gap: ethnic, gender and social class differences in attainment at 16, 1988-95. *Race Ethnicity and Education,* 3 ii (2000) pp.117-143. Also online www.catchword.co.uk [In Britain, incl. pupils from Pakistani & Bangladeshi families.]

2062 DHALIWAL, Spinder. Silent contributors: Asian female entrepreneurs and women in business. *Women's Studies International Forum,* 21 v (1998) pp.463-474. Also online at www.sciencedirect.com/science/journal/02775395 [Britain, incl. Muslims.]

2063 DWYER, Claire. Negotiating diasporic identities: young British South Asian Muslim women. *Women's Studies International Forum,* 23 iv (2000) pp.475-486. Also online at http:// www.sciencedirect.com/science/journal/ 02775395 [From a Mirpuri Pakistani background.]

2064 DWYER, Claire. Veiled meanings: young British Muslim women and the negotiation of differences. *Gender, Place and Culture,* 6 i (1999) pp.5-26. Also online at www.catchword.co.uk

2065 FRANKS, Myfanwy. Crossing the borders of whiteness? White Muslim women who wear the *hijab* in Britain today. *Ethnic and Racial Studies,* 23 v (2000) pp.917-929. Also online at www.ingentaselect.com

2066 GARDNER, Katy. Death of a migrant: transnational death rituals and gender among British Sylhetis. *Global Networks,* 2 iii (2002) pp.191-204. Also online at www.ingenta.com

2067 HALL, Rachel A. When is a wife not a wife? Some observations on the immigration experiences of South Asian women in West Yorkshire. *Contemporary Politics,* 8 i (2002) pp.55-68. (Indians, Pakistanis, Muslims, Hindus, Sikhs & non-religious.) Also online at www.catchword.com

2068 HENNINK, Monique, DIAMOND, Ian & COOPER, Philip. Contraceptive use dynamics of Asian women in Britain. *Journal of Biosocial Science,* 31 iv (1999) pp.537-554. Also online at www.journals.cup.org (From Indian, Pakistani & Bangladeshi backgrounds.)

2069 HENNINK, M., DIAMOND, I. & COOPER, Philip. Young Asian women and relationships: traditional or transitional? *Ethnic and Racial Studies,* 22 v (1999) pp.867-891. (From Indian, Pakistani & Bangladeshi backgrounds). Also online at www.catchword.com

2070 HOGE, Warren. Deadly affair: Pakistanis in England who wed for love. *Women Living under Muslim Laws: Dossier,* 20 (1998) Also online at http:// www.wluml.org/english/ pubs

2071 HOGE, Warren. Liaison mortelle: les Pakistanaises d'Angleterre qui se marient par amour. *Women Living under Muslim Laws: Dossier,* 20 (1997) pp.80-81. Also online at http:// www.wluml.org/french/pubs/pdf/dossiers/ dossier20/D20fr.pdf

2072 KÜÇÜKCAN, Talip. Turkish diaspora in multicultural Britain. *Zeitschrift für Türkeistudien,* 12 i (1999) pp.125-134.

2073 LEADER, Sheldon. Minorities, moralities, and the judiciary. *The role of the judiciary in the protection of human rights* / ed. E.Cotran & Adel Omar Sherif. The Hague: Kluwer Law International, [for] CIMEL, SOAS, 1997, pp.431-439. [The 'Foulard Islamique' case in France & a Muslim teacher dismissed for wishing to take part of Friday for religious observance in UK as examples.]

2074 LLOYD EVANS, Sally & BOWLBY, Sophia. Crossing boundaries: racialised gendering and the labour market experiences of Pakistani migrant women in Britain. *Women's Studies International Forum,* 23 iv (2000) pp.461-474. Also online at http:// www.sciencedirect.com/science/journal/02775395

2075 KHANUM, Saeeda. Education and the Muslim girl. *Refusing holy orders: women and fundamentalism in Britain.* Ed. Gita Sahgal & Nira Yuval-Davis. [New ed.]. London: Women Living under Muslim Laws, 2000, pp.129-145. Also online at www.wluml.org/english/pubs (Bradford.)

2076 MACEY, Marie. Religion, male violence, and the control of women: Pakistani Muslim men in Bradford, UK. *Gender and Development,* 7 i (1999) pp.48-55. Also online at http:// www.ingentaselect.com

2077 MCLOUGHLIN, S. 'An underclass in purdah'? Discrepant representations of identity and the experiences of young-British-Asian-Muslim-women. *Bulletin of the John Rylands University Library of Manchester,* 80 iii (1998) pp.89-106.

2078 MIRZA, Nighat. Educational opportunities for Muslim girls in Britain. *Issues in Islamic education.* London: Muslim Educational Trust, 1996, pp.91-94.

2079 MUSTAFA, Basil. Education for integration: case study of a British Muslim high school for girls. *Journal of Muslim Minority Affairs,* 19 ii (1999) pp.291-298.

2080 PARKER-JENKINS, M. & HAW, K. F. Equality within Islam, not without it: the perspectives of Muslim girls in a Muslim school in Britain. *Muslim Education Quarterly,* 13 iii (1996) pp.17-34.

2081 POYA, Maryam. Double exile: Iranian women and Islamic fundamentalism. *Refusing holy orders: women and fundamentalism in Britain.* Ed. Gita Sahgal & Nira Yuval-Davis. [New ed.]. London: Women Living under Muslim Laws, 2000, pp.146-166. Also online at www.wluml.org/english/pubs (London.)

2082 SAHGAL, Gita. Fundamentalism, multiculturalism and
 women in Britain. *Refusing holy orders: women and
 fundamentalism in Britain.* Ed. Gita Sahgal & Nira
 Yuval-Davis. [New ed.]. London: Women Living under
 Muslim Laws, 2000, pp.7-31. Also online at
 www.wluml.org/english/pubs [Incl. Muslim women.]

2083 SAHGAL, Gita. Secular spaces: the experience of Asian
 women organizing. *Refusing holy orders: women and
 fundamentalism in Britain.* Ed. Gita Sahgal & Nira
 Yuval-Davis. [New ed.]. London: Women Living under
 Muslim Laws, 2000, pp.167-201. Also online at
 www.wluml.org/english/pubs (London.)

2084 SAMAD, Yun[u]s. Media and Muslim identity:
 intersections of generation and gender. *Innovation: the
 European Journal of Social Sciences,* 11 i (1998)
 pp.425-438. [Media consumption by young British
 Asians.]

2085 SHAH-KAZEMI, Sonia Nûrîn. Untying the knot: divorce
 and Muslim law in the UK. *ISIM Newsletter,* 7 (2001)
 pp.31-31.

2086 SHAW, Alison. Kinship, cultural preference and
 immigration: consanguineous marriage among British
 Pakistanis. *Journal of the Royal Anthropological Institute,*
 7 iii (2001) pp.315-334. Also online at www.ingenta.com

2087 SHAW, Alison. Women, the household and family ties:
 Pakistani migrants in Britain. *Family and gender in
 Pakistan: domestic organization in a Muslim society.* Ed.
 H.Donnan & F.Selier. Delhi: Hindustan Publishing
 Corporation, 1997, pp.132-155.

2088 SIDDIQUI, Hannana. The ties that bind. *Index on
 Censorship,* 29 i / 192 (2000) pp.50-53. [Forced marriage
 among British Muslims & others.]

2089 SPELLMAN, Kathryn. Repasts and hopeful futures.
 Iranian women's religious gatherings in London. *Crisis
 and memory in Islamic societies. Proceedings of the third
 Summer Academy of the Working Group Modernity and
 Islam held at the Orient Institute of the German Oriental
 Society in Beirut* / ed. Angelika Neuwirth and Andreas
 Pflitsch. Beirut: Orient-Institut der Deutschen
 Morgenländischen Gesellschaft; Würzburg: Ergon, 2001,
 (Beiruter Texte und Studien, 77), pp.347-364.

2090 WATSON, Beccy & SCRATON, Sheila. Confronting
 whiteness? Researching the leisure lives of South Asian
 mothers. *Jounal of Gender Studies,* 10 iii (2001)
 pp.265-277. Also online at http://
 taylorandfrancis.metapress.com [In Britain, incl. Muslims.]

2091 WERBNER, P. Public spaces, political voices: gender,
 feminism and aspects of British Muslim participation in
 the public sphere. *Political participation and identities
 of Muslims in non-Muslim states.* Ed. W.A.R.Shadid &
 P.S.van Koningsveld. Kampen: Kok Pharos, 1996,
 pp.53-70.

2092 WHEELER, Erica L. Mental illness and social stigma:
 experiences in a Pakistani community in the UK. *Gender
 and Development,* 6 i (1998) pp.37-43. Also online at
 http:// www.ingentaselect.com (Pakistani women.)

Gulf (general)

Books

2093 DOUMATO, Eleanor Abdella. *Getting God's ear: women,
 Islam, and healing in Saudi Arabia and the Gulf.* New
 York: Columbia University Press, 2000. 312pp.

Articles

2094 ALYUSUF, Muna M. "Gulf women as agents of change"
 Panel. *Middle East Women's Studies: the Review,* 12 iv
 (1998) pp.12-13. [Conference report.]

2095 DOUMATO, E. A. Receiving the promised blessing:
 missionary reflections on 'Ishmael's (mostly female)
 descendants. *Islam and Christian-Muslim Relations,* 9
 iii (1998) pp.325-337. (Muslims of the Gulf & Arabian
 Peninsula.)

2096 FAKHRO, Munira A. Gender, politics and the state in the
 Gulf region. *Middle East Policy,* 5 iii (1997)
 pp.166-170;187-189.

2097 FAKHRO, Munira. Gulf women and Islamic law.
 Feminism and Islam: legal and literary perspectives. Ed.
 Mai Yamani. Reading: Ithaca, for the Centre of Islamic
 and Middle Eastern Law, School of Oriental and African
 Studies, University of London, 1996, pp.251-262.

2098 SAYEGH, Fatma Hassan al-. American women
 missionaries in the Gulf: agents for cultural change. *Islam
 and Christian-Muslim Relations,* 9 iii (1998) pp.339-356.

2099 SHAH, Nasra M. Violence against women migrant
 workers: issues for the sending and receiving countries.
 Marga, 14 iii (1997) pp.5-38. [Especially maids from
 Philippines & Sri Lanka in Gulf states.]

2100 TAZI, Nadia. Sarah ou le harem ordinaire. *L'Esprit,* 219
 (1996) pp.173-174. [Sarah Balabagan as example of
 servitude in Gulf states.]

2101 YAMANI, Mai. Health, education, gender and the security
 of the Gulf in the twenty-first century. *Gulf security in
 the twenty-first century.* Ed. D.E.Long & C.Koch. Abu
 Dhabi: Emirates Center for Strategic Studies and Research,
 1997, pp.265-279.

History see under countries & General

Horn of Africa (general)

Books

2102 HICKS, Esther K. *Infibulation: female mutilation in
 Islamic northeastern Africa.* 2nd ed., rev. and expanded.
 New Brunswick: Transaction, 1996. 319pp. [Sudan,
 Ethiopia, Eritrea, Jibuti, Somalia. First published 1993.]

Articles

2103 BADAWI, Maisoun & HORN, T. Islamic law and women
 in the Horn of Africa - two perspectives. *Middle East
 Women's Studies: the Review,* 13 ii (1998) pp.5-8.

2104 CISSÉ, B. P. International law sources applicable to female
 genital mutilation: a guide to adjudicators of refugee claims
 based on a fear of female genital mutilation. *Columbia
 Journal of Transnational Law,* 35 ii (1997) pp.429-451.
 [Describing practices in Horn of Africa & West Africa.]

India (since 1947) see also South Asia (before Partition)

Books

2105 AHMAD, Suhail. *Women in profession: a comparative
 study of Hindu and Muslim women.* Delhi: Institute of
 Objective Studies, 1996. 118pp.

2106 AZIM, Saukath. *Muslim women: emerging identity.* Jaipur:
 Rawat Publications, 1997. 232pp. [India.]

2107 BAXAMUSA, Ramala M. *The legal status of Muslim
 women: an appraisal of Muslim personal law in India.*
 Bombay: Research Centre for Women's Studies, S. N. D.
 T. Women's University, 1998, (RCWS Gender Series:
 Gender & Law, 3), 188pp.

2108 HUSSAIN, Sabiha. *Breaking stereotypes: two generations
 of Muslim women.* Delhi: Centre for Women's
 Development Studies, 1999, (Occasional Paper 32), 18pp.
 (Darbhanga.)

2109 HUSSAIN, Sabiha. *The changing half: a study of Indian
 Muslim woman.* Delhi: Classical Pub. Co., 1998. 165pp.
 [Darbhanga in North Bihar.]

2110 JEFFERY, P. & JEFFERY, R. *Don't marry me to a
 plowman! Women's everyday lives in rural north India.*
 Boulder: Westview, 1996. 294pp. [Two villages, one
 Muslim & one caste Hindu / Harijan.]

2111 KADER, S. A. *Muslim law of marriage & succession in
 India: a critique with a plea for optional civil code.*
 Calcutta: Eastern Law House, 1998. 33+166pp.

2112 KAZI, Seema. *Muslim women in India.* London: Minority
 Rights Group International, 1999, (Minority Rights Group
 International Report, 98/2), 38pp.

2113 MOINUDDIN, S.A.H. *Divorce and Muslim women.*
 Jaipur: Rawat Publications, under the auspices of
 Vidyasagar University, Midnapur (W.B.), 2000. 188pp.
 [West Bengal, India.]

2114 RAO, Aparna. *Autonomy: life-cycle, gender and status
 among Himalayan pastoralists.* New York: Berghahn,
 1998. 350pp. [Muslim Bakkarwal in Jammu & Kashmir.]

2115 SIKRI, Rehana. *Women in Islamic culture and society: a
 study of family, feminism and franchise.* Delhi: Kanishka,
 1999. 328pp. (India.)

2116 SUBZWARI, Arshad. *The Muslim Women (Protection of
 Rights on Divorce) Act, 1986: with rules.* Allahabad: Law
 Vision, 1996. 196pp. [India.]

2117 WANI, M. Afzal. *The Islamic institution of mahr: a study
 of its philosophy, working & related legislations in the
 contemporary world.* Noonamy: Upright Study Home,
 1996. 285pp. [With particular reference to Kashmir.]

2118 *Aspects of culture & society: Muslim women in India: WRAG
 report.* Bombay: Women's Research & Action Group,
 1997. 244pp.

2119 *Empowerment of the Indian Muslim women.* Ed. by Satya
 Pal Ruhela. Delhi: M D Publications, 1998. 110pp.

2120 *Indian Muslim women: challenges & response.* Ed. Ram
 Bali Mishra. Hariharpur: Regional Sociological Research
 Institute, 1996. 210pp.

2121 *Islam, women and gender justice.* [Ed.] Asghar Ali Engineer.
 New Delhi: Gyan Publishing House, 2001. 370pp. [India.]

2122 *Muslim feminism and feminist movement: South Asia.* Vol.
 1: *India.* Ed. Abida Samiuddin, R.Khanam. Delhi: Global
 Vision Publishing House, 2002. 351pp. [Before and after
 Partition.]

2123 *Muslim women in India since Independence (feminine
 perspectives).* Ed. Haseena Hashia. Delhi: Institute of
 Objective Studies, 1998. 201pp.

2124 *Shah Bano and the Muslim Women Act a decade on: the
 right of the divorced Muslim women to mataa.* Ed.
 Carroll, Lucy. [Grabels]: Women Living under Muslim
 Laws; Bombay: Women's Research Action Group, 1998.
 46pp. Also online at www.wluml.org/english/pubs

2125 *Speaking peace: women's voices from Kashmir* / ed. Urvashi
 Butalia. Delhi: Kali for Women, 2002. 314pp.

Articles

2126 ABDUL QADIR, Nurjahan. Occupational opportunities
 for women. *Muslim women in India since Independence
 (feminine perspectives).* Ed. Haseena Hashia. Delhi:
 Institute of Objective Studies, 1998, pp.165-169. [In
 India.]

2127 AGNES, F. Redefining the agenda of the women's
 movement within a secular framework. *Politics of
 violence: from Ayodhya to Behrampada.* Ed. J.McGuire,
 P.Reeves & H.Brasted. Delhi: Sage, 1996, (Studies on
 Contemporary South Asia, 1), pp.95-109. [Hindu &
 Muslim women.]

2128 AKHTAR, Neelofar Saeed. Divorce and remarriage among
 Muslims of Mumbai. *Islam, women and gender justice.*
 [Ed.] Asghar Ali Engineer. New Delhi: Gyan Publishing
 House, 2001, pp.169-178.

2129 ALI, Nuzhat Sajjad. Women's conformity and commitment
 to the Islamic way of life. *Muslim women in India since
 Independence (feminine perspectives).* Ed. Haseena Hashia.
 Delhi: Institute of Objective Studies, 1998, pp.22-28. (In
 India.)

2130 ALI, Z.S. Women rights movements in post-independence
 India. *Muslim feminism and feminist movement: South
 Asia.* Vol. 1: *India.* Ed. Abida Samiuddin, R.Khanam.
 Delhi: Global Vision Publishing House, 2002,
 pp.209-244.

2131 AMIN, Najma. Role of female teacher in pre-school
 education. *Muslim women in India since Independence
 (feminine perspectives).* Ed. Haseena Hashia. Delhi:
 Institute of Objective Studies, 1998, pp.87-97. (For
 Muslims.)

2132 ANSARI, Iqbal A. Muslim women's rights: goals and
 strategy of reform. *Islamic and Comparative Law Review,*
 15-16, 1995- (1996) pp.111-117. (Muslim personal law
 in India.)

2133 ASHRAF, Nehal. Islam and dowry. *Man in India,* 77 iv
 (1997) pp.409-414. [Among Muslims in India, today.]

2134 ASHRAF, Nehal. Islam and dowry. *Indian Muslim
 women: challenges & response.* Ed. Ram Bali Mishra.
 Hariharpur: Regional Sociological Research Institute, 1996,
 pp.69-74. [Incl. cases of dowry deaths in Bihar.]

2135 BARVE, Sushobha. Kashmir journeys. *Speaking peace:
 women's voices from Kashmir* / ed. Urvashi Butalia. Delhi:
 Kali for Women, 2002, pp.252- 261. (Young widows
 all over Kashmir valley who were left with children and
 not much help.)

2136 BASU, H. Die Heilige und das Weibliche:
 Geschlechter-Konstruktionen in indo-muslimischen
 Sufismus. *Zeitschrift für Ethnologie,* 119 ii / 1994 (1995)
 pp.27-58. [Gujarat.]

2137 BASU, H. Going for visits with a woman-fakir: the African
 diaspora in Gujarat. *ISIM Newsletter,* 3 (1999)
 pp.39-39.

2138 BAXAMUSA, Ramala M. Vocational training of Muslim
 women in Maharashtra to solve economic problems.
 Islam, women and gender justice. [Ed.] Asghar Ali
 Engineer. New Delhi: Gyan Publishing House, 2001,
 pp.315-331.

2139 BEGUM, Rokaiya. Education and the Muslim women.
 Indian Muslims: precepts & practices. Ed. Noor
 Mohammad. Jaipur: Rawat, 1999, pp.140-153.

2140 BEGUM, Rokaiya. Incidence of polygyny among Muslims
 in India. *Muslim women in India since Independence
 (feminine perspectives).* Ed. Haseena Hashia. Delhi:
 Institute of Objective Studies, 1998, pp.129-139.

2141 BHAGAT, Pamela. Interviews. *Speaking peace: women's
 voices from Kashmir* / ed. Urvashi Butalia. Delhi: Kali for
 Women, 2002, pp.268-297. [With women in Kashmir.]

2142 BHAGAT, Pamela. Reclaiming lives: the health of
 internally displaced women in Kargil District. *Speaking
 peace: women's voices from Kashmir* / ed. Urvashi Butalia.
 Delhi: Kali for Women, 2002, pp.96-112.

2143 BHATTY, Zarina. A daughter of Awadh. *Indian Journal
 of Gender Studies,* 6 ii (1999) pp.311-325. [Life as a
 Muslim woman in India.]

2144 CHAMPION, C. Le culte d'une sainte musulmane en Inde:
 Bîbî Kamâlo de Kako. *Le culte des saints dans le monde
 musulman.* Sous la dir. de H.Chambert-Loir & C.Guillot.
 Paris: Ecole Française d'Extrême Orient, 1995, (Etudes
 Thématiques, 4), pp.211-216.

2145 CHHACHHI, Sheba. Finding face: images of women from
 the Kashmir valley. *Speaking peace: women's voices
 from Kashmir* / ed. Urvashi Butalia. Delhi: Kali for
 Women, 2002, pp.189-225. [Photographs.]

2146 DAS, Y.L. Knowledge and attitude towards family
 planning among neo-literates [sic] Muslim women in Bihar.
 Indian Muslim women: challenges & response. Ed. Ram
 Bali Mishra. Hariharpur: Regional Sociological Research
 Institute, 1996, pp.30-41.

2147 DEWAN, Ritu. 'What does Azadi mean to you?'.
 Speaking peace: women's voices from Kashmir / ed.
 Urvashi Butalia. Delhi: Kali for Women, 2002,
 pp.149-161. [Impact of violence in Kashmir on women.]

2148 DHAR, Lalita & MASOODI, G.S. The women cry from
 Beijing: the world lost its soul, stop female foeticide.
 Journal of Objective Studies, 8 i (1996) pp.33-65. (Indian
 society ... Islamic law & female foeticide.)

2149 D'SOUZA, Diana. The Night of Mercy: ritual and gender
 in Indian Islam. *Eastern Anthropologist*, 53 iii-iv (2000)
 pp.427-442. [Celebrating Shab-i Barāt in Hyderabad,
 India.]

2150 D'SOUZA, Diane. Women's presence in the mosque: a
 viewpoints [*sic*]. *Islam, women and gender justice.* [Ed.]
 Asghar Ali Engineer. New Delhi: Gyan Publishing House,
 2001, pp.193-217. [In general & especially in India.]

2151 DUBE, Leela. The meaning and content of marriage in a
 matrilineal Muslim society. *Between tradition, counter
 tradition and heresy: contributions in honour of Vina
 Mazumdar.* Ed. Lotika Sarkar, Kumud Sharma, Leela
 Kasturi. Delhi: Rainbow, 2002, pp.125-146.
 [Lakshadweep.]

2152 DURRANY, Khurram Shah. Muslim women and the law.
 Islam, women and gender justice. [Ed.] Asghar Ali
 Engineer. New Delhi: Gyan Publishing House, 2001,
 pp.179-191. [India.]

2153 ENGINEER, Asghar Ali. Rights of Muslim women,
 personal law and its reform. *Indian Muslim women:
 challenges & response.* Ed. Ram Bali Mishra. Hariharpur:
 Regional Sociological Research Institute, 1996,
 pp.108-112.

2154 ENGINEER, Asghar Ali. The need for codification and
 reform in Muslim personal law in India. *Women Living
 under Muslim Laws: Dossier*, 22 (1999) pp.56-59. Also
 online at http:// www.wluml.org/english/pubs

2155 ENGINEER, Asghar Ali. Women, fundamentalism and
 role of state. *Indian Muslim women: challenges &
 response.* Ed. Ram Bali Mishra. Hariharpur: Regional
 Sociological Research Institute, 1996, pp.136-146.
 [India.]

2156 FAZALBHOY, Nasreen. Rituals of protection in a Muslim
 society. *Eastern Anthropologist*, 53 iii-iv (2000)
 pp.443-455. (Among the Kutchi Memon community of
 Mumbai.)

2157 FLUECKIGER, J. B. "There are only two castes: men and
 women": negotiating gender as a female healer in South
 Asian Islam. *Oral Tradition*, 12 i (1997) pp.76-82.
 [Hyderabad, 1990s.]

2158 GANGOLI, Geetanjali & KAZI, Seema. Customary
 practices among Muslims in Gomia, Bihar. *Women Living
 under Muslim Laws: Dossier*, 18 (1997) pp.109-123.
 Also online at www.wluml.org/english/pubs (Marriage;
 mehr; divorce; guardianship and custody; inheritance;
 contraception.)

2159 GANGOLI, Gitanjali. The discourse around Muslim
 personal law. *Islam, women and gender justice.* [Ed.]
 Asghar Ali Engineer. New Delhi: Gyan Publishing House,
 2001, pp.63-97. [India.]

2160 GHADIALLY, Rehana. Women and personal law in an
 Ismā'īlī Shī'ah (Dā'ūdī Bohra) sect of Indian Muslims.
 Islamic Culture, 70 i (1996) pp.27-51.

2161 HASAN, Zoya. Religion and politics in a secular state:
 law, community and gender. *Politics and the state in
 India.* Ed. Zoya Hasan. Delhi: Sage, 2000, (Readings in
 Indian Government and Politics, 3), pp.269-289. (Muslim
 women.)

2162 HASHIA, Haseena. Participation of Muslim women in
 household industries: a case study of Kashmir valley.
 *Muslim women in India since Independence (feminine
 perspectives).* Ed. Haseena Hashia. Delhi: Institute of
 Objective Studies, 1998, pp.152-164.

2163 HASSAN, Sakina. Muslim women's struggle for
 educational, social and political equality: a historical
 perspective. *Muslim women in India since Independence
 (feminine perspectives).* Ed. Haseena Hashia. Delhi:
 Institute of Objective Studies, 1998, pp.29-37.

2164 HUSAIN, Sahba. *Karchob se chuleh tak ...* A tapestry of
 women's lives. *Between tradition, counter tradition and
 heresy: contributions in honour of Vina Mazumdar.* Ed.
 Lotika Sarkar, Kumud Sharma, Leela Kasturi. Delhi:
 Rainbow, 2002, pp.105-124. [Muslim women
 embroiderers in Benaras.]

2165 HUSSAIN, R. & BITTLES, A.H. Sociodemographic
 correlates of consanguineous marriage in the Muslim
 population of India. *Journal of Biosocial Science*, 32 iv
 (2000) pp.433-442. Also online at www.journals.cup.org

2166 HUSSAIN, Sabiha. Attitude and aspirations of Muslim
 women towards employment: a case study of Darbhanga
 town. *Muslim women in India since Independence
 (feminine perspectives).* Ed. Haseena Hashia. Delhi:
 Institute of Objective Studies, 1998, pp.140-151.

2167 HUSSAIN, Sabiha. Gender and reproductive behaviour:
 a comparative study of two religious communities in Delhi
 slum. *Islam, women and gender justice.* [Ed.] Asghar
 Ali Engineer. New Delhi: Gyan Publishing House, 2001,
 pp.239-255. [Muslims and Hindus.]

2168 HUSSEIN, Sabiha. Mobilisation of Muslim women for
 gender justice. *Islam, women and gender justice.* [Ed.]
 Asghar Ali Engineer. New Delhi: Gyan Publishing House,
 2001, pp.143-168. [India.]

2169 IYENGAR, Vishwapriya L. The library girl. *Image and
 representation: stories of Muslim lives in India* / ed.
 Mushirul Hasan and M.Asaduddin. Delhi: Oxford
 University Press, 2000, pp.290-296. [Short story written
 in English.]

2170 JAN, Salima. Women's studies in Islamic perspective.
 *Muslim women in India since Independence (feminine
 perspectives).* Ed. Haseena Hashia. Delhi: Institute of
 Objective Studies, 1998, pp.190-210. [Studies by Indians
 of Indian Muslim women.]

2171 JAYAL, Niraja Gopal. Secularism, identities and
 representative democracy. *Comparative Studies of South
 Asia, Africa and the Middle East*, 17 ii (1997) pp.11-20.
 [Muslim women in India.]

2172 JEFFERY, P. & JEFFERY, R. What's the benefit of being
 educated? Girls' schooling, women's autonomy and fertility
 outcomes in Bijnor. *Girls' schooling, women's autonomy
 and fertility change in South Asia.* Ed. R.Jeffery &
 A.M.Basu. Delhi: Sage, in association with the Book
 Review Literary Trust, 1996, pp.150-183. [Comparison
 of Hindu & Muslim groups in rural North India.]

2173 JEJEEBHOY, Shireen J. & SATHAR, Zeba A. Women's
 autonomy in India and Pakistan: the influence of religion
 and region. (Abstracts: L'autonomie des femmes en Inde
 et au Pakistan: l'influence de la religion et de la région;
 Autonomía de la mujer en India y Pakistán: influencia de
 religión y región.). *Population and Development Review*,
 27 iv (2001) pp.687-712;823;825. Also online at
 www.popcouncil.org/pdr [Muslims & Hindus in India,
 Muslims in Pakistan Panjab.]

2174 KAMAIAH, B., BEGUM, Hajira & MOHSIN, Md.
 Labour supply, fertility and wage among married women:
 a case study of Muslims of Hyderabad city. *Asian
 Economic Review*, 41 ii (1999) pp.276-2293.

2175 KAPUR, Ratna. The two faces of secularism and women's
 rights in India. *Religious fundamentalisms and the human
 rights of women.* Ed. C.W.Howland. Basingstoke:
 Macmillan; New York: St. Martin's Press, 1999,
 pp.143-153. [Incl. Muslims.]

2176 KHAN, Ateeque. Women's right to inherit agricultural
 property in India: a socio-legal perspective. *Islamic and
 Comparative Law Review*, 15-16, 1995- (1996)
 pp.131-146. [Hindus & Muslims.]

2177 KHAN, Hasina. Socio-legal awakening and awareness
 among Muslim women. *Muslim feminism and feminist
 movement: South Asia.* Vol. 1: *India.* Ed. Abida
 Samiuddin, R.Khanam. Delhi: Global Vision Publishing
 House, 2002, pp.255-284.

2178 KHAN, I.H. Muslim personal law and women's rights.
 Muslim feminism and feminist movement: South Asia. Vol.
 1: *India.* Ed. Abida Samiuddin, R.Khanam. Delhi: Global
 Vision Publishing House, 2002, pp.97-135. [In India
 today.]

2179 KHAN, Muniza Rafiq. Muslim women's perception of status issues. *Indian Muslim women: challenges & response*. Ed. Ram Bali Mishra. Hariharpur: Regional Sociological Research Institute, 1996, pp.160-180. [In Varanasi.]

2180 KHAN, Muniza Rafiq. Reactions to the Shah Bano case among the Muslim women in eastern U.P. *Indian Muslim women: challenges & response*. Ed. Ram Bali Mishra. Hariharpur: Regional Sociological Research Institute, 1996, pp.113-135. [Maintenance for divorced Muslim women.]

2181 KHAN, Sona. Inheritance of Indian women: a perspective. *India International Centre Quarterly*, 27 ii (2000) pp.139-154. [Laws as they apply to Hindus, Muslims, etc.]

2182 KHAN-SVIK, Gabriele. Muslimische Frauen in Indien. *Zwiche Gestern und Übermorgen: Südasiatische Frauen im Spannungsfeld zwischen Gesellschaft, Politik und Spiritualität*. Traude Pillai-Vetschera (Hrsg.). Frankfurt a.M.: Lang, 2002, pp.96-128.

2183 LATEEF, Shahida. Muslim women in India: a minority within a minority. *Women in Muslim societies: diversity within unity*. Ed. H.L.Bodman, Nayereh Tohidi. Boulder: Rienner, 1998, pp.251-273.

2184 MAHMOOD, Tahir. Indian constitution and the Islamic religio-legal institutions: education, endowments and gender equality. *Islamic and Comparative Law Review*, 15-16, 1995- (1996) pp.147-156.

2185 MARKOVÁ, D. Specifičké postavení indické muslimky. (Summary: Specific status of Indian Muslim women.). *Religio* (Brno), 5 i (1997) pp.15-19.

2186 MATTOO, Neerja. The story of a women's college in Kashmir. *Speaking peace: women's voices from Kashmir* / ed. Urvashi Butalia. Delhi: Kali for Women, 2002, pp.162-170. [1952-1995.]

2187 MISHRA, Ram Bali & MISHRA, Indrawasa. Muslim women in rural U.P. *Indian Muslim women: challenges & response*. Ed. Ram Bali Mishra. Hariharpur: Regional Sociological Research Institute, 1996, pp.42-54.

2188 MISHRA, Ram Bali & MISHRA, Indrawasa. Position of Muslim women in continuity and change. *Indian Muslim women: challenges & response*. Ed. Ram Bali Mishra. Hariharpur: Regional Sociological Research Institute, 1996, pp.181-204.

2189 MISHRA, Ram Bali & SINGH, Chandra Pal. Profile of rural Muslim women: a case study. *Indian Muslim women: challenges & response*. Ed. Ram Bali Mishra. Hariharpur: Regional Sociological Research Institute, 1996, pp.55-61.

2190 MISTRY, Malika B. All India Muslim Women's education conference, 1996 - a report. *Journal of Muslim Minority Affairs*, 18 ii (1998) pp.365-368.

2191 MISTRY, Malika B. Economic problems of Muslim women in India. *Islam, women and gender justice*. [Ed.] Asghar Ali Engineer. New Delhi: Gyan Publishing House, 2001, pp.277-302.

2192 MONDAI, Sekh Rahim. Polygyny and divorce in Muslim society - controversy and reality. *Islam, women and gender justice*. [Ed.] Asghar Ali Engineer. New Delhi: Gyan Publishing House, 2001, pp.129-142. [Islam in general & India in particular.]

2193 MONDAL, Sekh Rahim. Organizing Muslim women for self-reliance. *Indian Muslims: precepts & practices*. Ed. Noor Mohammad. Jaipur: Rawat, 1999, pp.154-172. (In a Muslim village in West Bengal.)

2194 MONDAL, Sekh Rahim & BEGUM, Rokaiya. Organizing women for self reliance: an experience from a Muslim village in West Bengal, India. *Empowerment*, 4 (1997) pp.13-30.

2195 MONDAL, Sekh Rahim. Polygyny and divorce in Muslim society: controversy and reality. *Man in India*, 77 iv (1997) pp.415-428. [In India, today.]

2196 MUKHERJEE, D. P., GUHA, Pritilata, DAS, Bihan Kanti & GUHA, Abhijit. Patterns of marriage among the Muslims of a Calcutta slum: a quantitative approach. *Journal of the Indian Anthropological Society*, 30 ii / 1995 (1996) pp.153-160.

2197 MURTHY, R. K. Fighting female infanticide by working with midwives: an Indian case study. *Gender and Development*, 4 ii (1996) pp.20-27. [Incl. Muslims.]

2198 NAEEM, Hamida. The problems of Muslim women in India with special focus on Kashmiri women. *Islam, women and gender justice*. [Ed.] Asghar Ali Engineer. New Delhi: Gyan Publishing House, 2001, pp.345-363.

2199 PAL, Sarmistha. An analysis of childhood malnutrition in rural India: role of gender, income and other household characteristics. *World Development*, 27 vii (1999) pp.1151-1171. [Incl. Muslims.]

2200 PANT, Mandakini. Bandheriya of Jaipur: a study of Muslim home based women workers. *Islam, women and gender justice*. [Ed.] Asghar Ali Engineer. New Delhi: Gyan Publishing House, 2001, pp.303-314.

2201 PARASHAR, Archana. Family law as a means of ensuring gender justice for Indian women. *Indian Journal of Gender Studies*, 4 ii (1997) pp.199-229. [Incl. Muslims.]

2202 RAFAT, Zakiya. Muslim women's marriage and divorce in a town of Western Uttar Pradesh. *Muslim women in India since Independence (feminine perspectives)*. Ed. Haseena Hashia. Delhi: Institute of Objective Studies, 1998, pp.109-128.

2203 REIFELD, Helmut. Recht und Religion in Indien. Die aktuelle Forderung nach einer Vereinheitlichung des Familienrechts. *KAS / Auslandsinformationen*, 14 xii (1997) pp.44-59. (Hindus & Muslims.)

2204 RUHELA, Satya Pal. Religion, social class and educational opportunity: case studies of eight Muslim girls. *Empowerment of the Indian Muslim women*. Ed. by Satya Pal Ruhela. Delhi: M D Publications, 1998, pp.1-21.

2205 SAXENA, Sarojini. Legal rights of maintenance and guardianship of Muslim women. *Islam, women and gender justice*. [Ed.] Asghar Ali Engineer. New Delhi: Gyan Publishing House, 2001, pp.99-116. [India.]

2206 SEHERATUN NISA. Women's education is an obligation. *Muslim women in India since Independence (feminine perspectives)*. Ed. Haseena Hashia. Delhi: Institute of Objective Studies, 1998, pp.71-86. [Among Muslims in India.]

2207 SHAFI, Aneesa. Changing role and status of Muslim women: a sociological analysis. *Muslim women in India since Independence (feminine perspectives)*. Ed. Haseena Hashia. Delhi: Institute of Objective Studies, 1998, pp.179-189. (In India.)

2208 SHAHEEN, Shabana. Family environment, education and vertical social mobility: ten case studies of highly successful Indian Muslim women in different professional fields. *Empowerment of the Indian Muslim women*. Ed. by Satya Pal Ruhela. Delhi: M D Publications, 1998, pp.37-75.

2209 SHARIFF, Abusaleh. Relative economic and social deprivation in India. *Islam, women and gender justice*. [Ed.] Asghar Ali Engineer. New Delhi: Gyan Publishing House, 2001, pp.257-276. [Muslims compared with others.]

2210 SIDDIQUI, Noorjahan. Social profile of Muslim adolescent girls in the orphanages of Delhi. *Muslim women in India since Independence (feminine perspectives)*. Ed. Haseena Hashia. Delhi: Institute of Objective Studies, 1998, pp.170-178.

2211 SIDDIQUI, Noor Jahan. My life, my aspirations: case study of a Muslim female researcher. *Empowerment of the Indian Muslim women*. Ed. by Satya Pal Ruhela. Delhi: M D Publications, 1998, pp.77-85.

2212 SIDDIQ[U]I, Noor Jahan. Victims of deprivation: Muslim adolescent orphan girls. *Empowerment of the Indian Muslim women*. Ed. by Satya Pal Ruhela. Delhi: M D Publications, 1998, pp.23-36.

2213 SIGANPORIA, Munira. Post-divorce problems and social support: a study of Muslim divorced women of Maharashtra. *Islam, women and gender justice*. [Ed.] Asghar Ali Engineer. New Delhi: Gyan Publishing House, 2001, pp.117-128.

2214 SINGH, J.R. Indian Muslim women: cultural conditioning and sexual exploitation. *Indian Muslim women: challenges & response.* Ed. Ram Bali Mishra. Hariharpur: Regional Sociological Research Institute, 1996, pp.10-22.

2215 SINGH, Raghvendra Pratap & MISHRA, Ravindra Nath. Muslim women: depression and exploitation. *Indian Muslim women: challenges & response.* Ed. Ram Bali Mishra. Hariharpur: Regional Sociological Research Institute, 1996, pp.23-28. [Village women.]

2216 SIVAKUMAR, M. N. Timing of marriage and fertility in Kerala: a cohort analysis. *Eastern Anthropologist,* 52 i (1999) pp.57-67. [Incl. Muslims.]

2217 SIVASANKARAN, Sreekala. Political conflict, violence and women: a gender perspective on the Kashmir question. *Social Action,* 51 iv (2001) pp.368-377.

2218 SWAMINATHAN, P. Women's education in colonial Tamil Nadu, 1900-1930: the coalescence of patriarchy and colonialism. *Indian Journal of Gender Studies,* 6 i (1999) pp.21-42. [Incl. Muslims.]

2219 TRIPATHI, Abhinav Kumar & MISHRA, Rama Shankar. Muslim female weavers: the problems and suggestions. *Indian Muslim women: challenges & response.* Ed. Ram Bali Mishra. Hariharpur: Regional Sociological Research Institute, 1996, pp.62-68.

2220 TRIPATHI, Awadhesh K[uma]r. & TIWARI, Suresh Kumar. Anxiety in Muslim female adolescents. *Indian Muslim women: challenges & response.* Ed. Ram Bali Mishra. Hariharpur: Regional Sociological Research Institute, 1996, pp.75-98.

2221 WILKINSON-WEBER, C. M. Skill, dependency, and differentiation: artisans and agents in the Lucknow embroidery industry. *Ethnology,* 36 i (1997) pp.49-56. [Muslim women workers in India.]

2222 YADAVA, K. N. S. & JAIN, S. K. Postpartum amenorrhoea in rural eastern Uttar Pradesh, India. *Journal of Biosocial Science,* 30 ii (1998) pp.227-243. [Incl. Muslims.]

2223 Le mariage et les politiques de mutation sociale dans les communautés musulmanes de l'Inde / Women's Research and Action Group. *Les frontières mouvantes du mariage et du divorce dans les communautés musulmanes.* Grabels: Women Living under Muslim Laws, 1996, (Programme Femmes et Loi dans le Monde Musulman: Dossier Spécial), pp.142-150. Also online at http://www.wluml.org/french/pubs/pdf/dossiers/sd/SD1.pdf

2224 Women's testimonies from Kashmir / 'The Green of the Valley is Khaki' women's initiative, 1994. *Speaking peace: women's voices from Kashmir* / ed. Urvashi Butalia. Delhi: Kali for Women, 2002, pp.82-95.

Indonesia

Books

2225 AQUINO SIAPNO, Jacqueline. *Gender, Islam, nationalism and the state in Aceh: the paradox of power, co-optation and resistance.* Richmond: Curzon, 2002. 272pp.

2226 BLACKWOOD, Evelyn. *Webs of power: women, kin, and community in a Sumatran village.* Lanham: Rowman & Littlefield, 2000. 219pp. [Minangkabau.]

2227 BRENNER, Suzanne April. *The domestication of desire: women, wealth, and modernity in Java.* Princeton: Princeton University Press, 1998. 301pp.

2228 BUDIARDJO, C. *Surviving Indonesia's gulag: a Western woman tells her story.* London: Cassell, 1996. 213pp.

2229 CHOLIL, Abdullah, ISKANDAR, Meiwita Budiharsana & SCIORTINO, Rosalia. *The life saver: the mother friendly movement in Indonesia.* [Jakarta]: Galang Communication, in collaboration with the State Ministry for the Role of Women, Republic of Indonesia, in collaboration with the Ford Foundation, 1998. 104pp.

2230 DAVIS, Carol. *Women's conversations in a Minangkabau market: toward an understanding of the social context of economic transactions.* Hull: University of Hull, Centre for South-East Asian Studies, 1997, (Occasional Paper, 33), 28pp.

2231 LOCHER-SCHOLTEN, Elspeth. *Women and the colonial state: essays on gender and modernity in the Netherlands Indies, 1900-1942.* Amsterdam: Amsterdam University Press, 2000. 224pp.

2232 METJE, U. M. *Die starken Frauen: Gespräche über Geschlechter beziehungenbei den Minangkabau in Indonesien.* Frankfurt a. M. : Campus 1995. 261pp.

2233 MÜLLER, Brigitte. *Op de wipstoel: de niet-gewettigde inheemse vrouw van de blanke Europeaan in Nederlands-Indie (1890 tot 1940): een literatuuronderzoek naar beeldvorming en werkelijkheid.* Amsterdam: Vakgroep Culturele Antropologie/Sociologie der Niet-Westerse Samenlevingen, Vrije Universiteit 1995, rp., 1997, (Feministische Antropologie, 10), 131pp.

2234 OEY-GARDINER, M. *Women and men at work in Indonesia.* Jakarta: Insan Hitawasana Sejahtera, 1999. 133pp.

2235 O'NEILL, K. M. *Wanita-wanita mandiri (independent women): possibilities and constraints in women's microenterprise in Bandung, Indonesia.* North York (Canada): Faculty of Environmental Studies, York University, 1997, (FES Occasional Papers, 3/4), 68pp.

2236 REENEN, J. van. *Central pillars of the house: sisters, wives, and mothers in a rural community in Minangkabau, West Sumatra.* Leiden: Research School, CNWS, 1996, (CNWS Publications, 45), 284pp.

2237 RODENBURG, J. *In the shadow of migration: rural women and their households in north Tapanuli, Indonesia.* Leiden: KITLV Press, 1997, (Verhandelingen van het Koninklijk Instituut voor Taal-, Land- en Volkenkunde, 174), 241pp.

2238 TOLLENAERE, H.A.O.de. *The politics of divine wisdom: theosophy and labour, national, and women's movements in Indonesia and South Asia, 1875-1947.* [Nijmegen]: Uitgeverij Katholieke Universiteit Nijmegen, 1996. 459pp.

2239 WRIGHT, Jessica. *In their own words: working women of Yogyakarta.* Clayton: Monash Asia Institute, Monash University, 1997, (Monash Papers on Southeast Asia, 42), 145pp.

2240 *Fantasizing the feminine in Indonesia.* Ed. Sears, L. J. Durham (USA): Duke University Press, 1996. 349pp.

2241 *Indonesia, the damaging debate on rapes of ethnic Chinese women.* New York: Human Rights Watch, 1998 (Human Rights Watch Report, 10 v (C)), 9pp.

2242 *Women and households in Indonesia. Cultural notions and social practices.* Ed. J.Koning, M.Nolten, J.Rodenburg & Ratna Saptari. Richmond: Curzon, 2000 (NIAS Studies in Asian Topics, 27), 354pp.

2243 *Women creating Indonesia: the first fifty years.* Ed. Gelman Taylor, J. Clayton: Monash Asia Institute, Monash University, 1997, (Monash Papers on Southeast Asia, 44), 206pp. (First half of the 20th century.)

Articles

2244 ALEXANDER, Jennifer. Women traders in Javanese marketplaces: ethnicity, gender, and the entrepreneurial spirit. *Market cultures: society and morality in the new Asian capitalism.* [Ed.] R.W.Hefner. Boulder: Westview, 1998, pp.203-223.

2245 BENJAMIN, D. Women and the labour market in Indonesia during the 1980s. *Women and industrialization in Asia.* Ed. S.Horton. London: Routledge, 1996, pp.81-133.

2246 BIANPOEN, Carla. Aceh's women show the road to peace: reflections on International Women's Day. *Inter-Asia Cultural Studies,* 1 ii (2000) pp.363-366. Also online at www.catchword.com

2247 BLACKBURN, Susan. Gender relations in Indonesia:
 what women want. *Indonesia today: challenges of
 history*. Ed. Grayson Lloyd, Shannon Smith. Singapore:
 Institute of Southeast Asian Studies, 2001, pp.270-282.

2248 BLACKBURN, Susan. Gender violence and the Indonesian
 political transition. *Asian Studies Review*, 23 iv (1999)
 pp.433-448. [Gang rapes of ethnic Chinese women &
 other Indonesian citizens.]

2249 BLACKBURN, S. & BESSELL, S. Marriageable age:
 political debates on early marriage in twentieth-century
 Indonesia. *Indonesia*, 63 (1997) pp.107-141.
 [1901-1994.]

2250 BLACKBURN, Susan. Political relations among women
 in a multi-racial city. Colonial Batavia in the twentieth
 century. *Jakarta - Batavia: socio-cultural essays*. Ed.
 K.Grijns & P.J.M.Nas. Leiden: KITLV, 2000,
 (Verhandelingen van het Koninklijk Instituut voor Taal-,
 Land- en Volkenkunde, 187), pp.175-198. (European,
 Indonesian & Chinese.)

2251 BLACKBURN, S. Western feminists observe Asian
 women: an example from the Dutch East Indies. *Women
 creating Indonesia: the first fifty years*. Ed. J.Gelman
 Taylor. Clayton: Monash Asia Institute, Monash
 University, 1997, (Monash Papers on Southeast Asia, 44),
 pp.1-21. [A.H.Jacobs, 1912.]

2252 BLACKWOOD, E. Big houses and small houses: doing
 matriliny in west Sumatra. *Ethnos*, 64 i (1999)
 pp.32-56. (Minangkabau.)

2253 BLACKWOOD, E. Women, land, and labor: negotiating
 clientage and kinship in a Minangkabau peasant
 community. *Ethnology*, 36 i (1997) pp.277-293.

2254 BLACKWOOD, Evelyn. *Tombois* in west Sumatra:
 constructing masculinity and erotic desire. *Cultural
 Anthropology*, 13 iv (1998) pp.491-521. [Minangkabau
 women-loving women.]

2255 BRENNER, S. On the public intimacy of the New Order:
 images of women in the popular Indonesian print media.
 Indonesia, 67 (1999) pp.13-37.

2256 BRENNER, S. Reconstructing self and society: Javanese
 Muslim women and `the veil`. *American Ethnologist*,
 23 iv (1996) pp.673-697.

2257 BUDIANTA, Melani. Indonesian women's responses to
 violence: towards an alternative concept of human security.
 Inter-Asia Cultural Studies, 1 ii (2000) pp.361-363. Also
 online at www.catchword.com

2258 BUTT, Simon. Polygamy and mixed marriage in Indonesia:
 the application of the marriage law in the courts.
 Indonesia: law and society. Ed. Timothy Lindsey. Sydney:
 Federation Press, 1999, pp.122-144.

2259 CAMERON, Lisa A., DOWLING, J.Malcolm &
 WORSWICK, Christopher. Education and labor market
 participation of women in Asia: evidence from five
 countries. *Economic Development and Cultural Change*,
 49 iii (2001) pp.459-477. (Indonesia, Korea, Philippines,
 Sri Lanka & Thailand.)

2260 CAMERON, Lisa A. & WORSWICK, Christopher.
 Education expenditure responses to crop loss in Indonesia:
 a gender bias. *Economic Development and Cultural
 Change*, 49 ii (2001) pp.351-363. (Families with girls
 have a higher propensity to cut back on educational
 expenditure than do families with boys.)

2261 CAMMACK, M., YOUNG, L. A. & HEATON, T.
 Legislating social change in an Islamic society - Indonesia's
 marriage law. *American Journal of Comparative Law*,
 44 i (1996) pp.45-73.

2262 CAMMACK, Mark. Inching toward equality: recent
 developments in Indonesian inheritance law. *Women
 Living under Muslim Laws: Dossier*, 22 (1999) pp.7-31.
 Also online at http:// www.wluml.org/english/pubs

2263 CHAKRABORTY, Eshani. The New Order and the
 depoliticisation of women in Indonesia. *Dhaka University
 Studies*, 58 i (2001) pp.65-89.

2264 CHAMBERT-LOIR, H. & GUILLOT, C. Une mystérieuse
 épitaphe à Pacitan. *Archipel*, 47 (1994) pp.34-38.
 (L'épouse javanaise d'un surveillant de plantation ...
 décédée au début du siècle.)

2265 CHIN, C. B. N. Walls of silence and late twentieth century
 representations of the foreign female domestic worker: the
 case of Filipina and Indonesian female servants in
 Malaysia. *International Migration Review*, 31 ii (1997)
 pp.353-385.

2266 COOPER, Nancy I. Singing and silences: transformations
 of power through Javanese seduction scenarios. *American
 Ethnologist*, 27 iii (2000) pp.609-644. (Glamorous
 women singers.)

2267 COTÉ, J. The correspondence of Kartini's sisters:
 annotations on the Indonesian nationalist movement,
 1905-1925. *Archipel*, 55 (1998) pp.61-82.

2268 DAVIS, C. Images of Minangkabau women. *Indonesia
 Circle*, 69 (1996) pp.141-155.

2269 DOORN-HARDER, N.van. Between culture and religion:
 Muslim women's rights. *IIAS Newsletter*, 21 (2000)
 pp.6-6. [Indonesia.]

2270 DOWLING, J.Malcolm & WORSWICK, Christopher.
 Labor market participation of urban women in Southeast
 Asia by migration status. Evidence from microdata.
 Journal of Asian Economics, 10 i (1999) pp.91-109.
 Also online at www.sciencedirect.com/science/journal/
 10490078 (Indonesia, the Philippines, & Thailand.)

2271 DURKEE, Noura. Recited from the heart. *Aramco World*,
 51 iii (2000) pp.32-35. (Hajja Maria 'Ulfah is ...one of
 the most influential & popular Qur'an reciters in all
 Southeast Asia.)

2272 ELLIOT, J. Equality? The influence of legislation and
 notions of gender on the position of women wage workers
 in the economy: Indonesia 1950-58. *Women creating
 Indonesia: the first fifty years*. Ed. J.Gelman Taylor.
 Clayton: Monash Asia Institute, Monash University, 1997,
 (Monash Papers on Southeast Asia, 44), pp.127-155.

2273 ELMHIRST, Becky. Negotiating gender, kinship and
 livelihood practices in an Indonesian transmigration area.
 *Women and households in Indonesia. Cultural notions and
 social practices*. Ed. J.Koning, M.Nolten, J.Rodenburg &
 Ratna Saptari. Richmond: Curzon, 2000, (NIAS Studies
 in Asian Topics, 27), pp.208-234.

2274 ELMHIRST, Rebecca. A Javanese diaspora? Gender and
 identity politics in Indonesia's transmigration resettlement
 program. *Women's Studies International Forum*, 23 iv
 (2000) pp.487-500. Also online at http://
 www.sciencedirect.com/science/journal/02775395

2275 FEILLARD, A. & MARCOES, L. Female circumcision
 in Indonesia: to "Islamize" in ceremony or secrecy.
 Archipel, 56 (1998) pp.337-367.

2276 FEILLARD, A. Indonesia's emerging Muslim feminism:
 women leaders on equality, inheritance and other gender
 issues. *Studia Islamika*, 4 i (1997) pp.83-111.

2277 FEILLARD, A. The veil and polygamy: current debates
 on women and Islam in Indonesia. (Voile et polygamie:
 les femmes et l'islam dans l'Indonésie d'aujourd'hui:
 résumé.). *Moussons*, 99 (1999) pp.5-28.

2278 FERIDHANUSETYAWAN, Tubagus, ASWICAHYONO,
 Haryo & PERDANA, Ari A. Some determinants of the
 female and male labour force's participation in Indonesia.
 Indonesian Quarterly, 29 iv (2001) pp.347-360.

2279 FIRMAN, Tommy. Metropolitan expansion and the growth
 of female migration to Jakarta. *Asia Pacific Viewpoint*,
 40 i (1999) pp.45-58.

2280 FULLER COLLINS, E. (Re)negotiating gender hierarchy
 in the New Order: a south Sumatran field study. *Asia
 Pacific Viewpoint*, 37 ii (1996) pp.127-138.

2281 GELMAN TAYLOR, J. Costume and gender in colonial
 Java, 1800-1940. *Outward appearances: dressing, state
 and society in Indonesia*. Ed. H.Schulte Nordholt. Leiden:
 KITLV, 1997, (Koninklijk Instituut voor Taal-, Land- en
 Volkenkunde: Proceedings, 4), pp.85-116.

2282 GELMAN TAYLOR, J. Official photography, costume
 and the Indonesian revolution. *Women creating
 Indonesia: the first fifty years*. Ed. J.Gelman Taylor.
 Clayton: Monash Asia Institute, Monash University, 1997,
 (Monash Papers on Southeast Asia, 44), pp.91-126.
 [1945-1949.]

2283 GERKE, S. Ethnic relations and cultural dynamics in East Kalimantan: the case of the Dayak lady. *Indonesia and the Malay World*, 72 (1997) pp.176-187. [Married a Muslim & converted to Islam.]

2284 GONDOWARSITO, R. The role of women in upland agriculture: gender issues raised by case studies in Indonesia, Sri Lanka and the Philippines. *Women in upland agriculture in Asia: proceedings of a workshop held in Chiang Mai ... 1995.* Ed. C.E.van Santen, J.W.T.Bottema, D.R.Stoltz. Bogor: CGPRT Centre, 1996, (CGPRT, no. 33), pp.7-21.

2285 HANCOCK, P. J. Labour and women in Java: a new historical perspective. *Indonesian Quarterly*, 24 iii (1996) pp.290-302.

2286 HANCOCK, Peter. Rural women earning income in Indonesian factories: the impact on gender relations. *Gender and Development*, 9 i (2001) pp.18-24. Also online at http:// www.ingentaselect.com

2287 HATLEY, Barbara & BLACKBURN, Susan. Representations of women's roles in household and society in Indonesian women's writing of the 1930s. *Women and households in Indonesia. Cultural notions and social practices.* Ed. J.Koning, M.Nolten, J.Rodenburg & Ratna Saptari. Richmond: Curzon, 2000, (NIAS Studies in Asian Topics, 27), pp.45-67. (Two particular areas: the magazines produced by the numerous women's organizations ... & several examples of fiction published by women authors.)

2288 HAY, M. C. Dying mothers: maternal mortality in rural Indonesia. *Medical Anthropology*, 18 iii (1999) pp.243-279. [Two Sasak women in Lombok.]

2289 HEATON, Tim B., CAMMACK, Mark & YOUNG, Larry. Why is the divorce rate declining in Indonesia? *Journal of Marriage and the Family*, 63 ii (2001) pp.480-490. Also online at http:// ncfr.allenpress.com/ncfronline/ ?request=get-archive

2290 HELLWIG, Tineke. A double murder in Batavia: representations of gender and race in the Indies. *RIMA: Review of Indonesian and Malaysian Affairs*, 35 ii (2001) pp.1-32. [Dutch & Indonesians, 1912 & 1914.]

2291 HELLWIG, Tineke. Asian women in the lives of Dutch tea planters: two narratives from west Java. *Indonesia and the Malay World*, 29 / 85 (2001) pp.161-179. Also online at www.catchword.com [Fictional & other sources.]

2292 HELMI, Kunang. Ratna Cartier-Bresson: a fragmented portrait. *Archipel*, 54 (1997) pp.253-268. [Indonesian dancer in France.]

2293 HULL, V. J. Women in Java's rural middle class: progress or regress? *Women of Southeast Asia*. P.Van Esterik, ed. 2nd rev. ed. [De Kalb:] Center for Southeast Asian Studies, Northern Illinois University (1996) pp.78-95.

2294 IREDALE, Robyn & FEI GUO Female labour migration in Indonesia and China. *Oriental Geographer*, 44 ii (2000) pp.21-32.

2295 JAQUET, F. Vier zusters: Roekmini, Kardinah, Kartinah en Soematri na het overlijden van Kartini. *Indische Letteren*, 10 ii (1995) pp.125-141.

2296 KONING, J. Family planning acceptance in a rural central Javanese village. *Health care in Java: past and present.* Ed. P.Boomgaard, R.Sciortino & I.Smyth. Leiden: KITLV, 1996, (Koninklijk Instituut voor Taal-, Land- en Volkenkunde: Proceedings, 3), pp.147-169.

2297 KRIER, Jennifer. The marital project: beyond the exchange of men in Minangkabau marriage. *American Ethnologist*, 27 iv (2000) pp.877-897.

2298 LECLERC, J. Girls, girls, girls, and crocodiles. *Outward appearances: dressing, state and society in Indonesia.* Ed. H.Schulte Nordholt. Leiden: KITLV, 1997, (Koninklijk Instituut voor Taal-, Land- en Volkenkunde: Proceedings, 4), pp.291-305. (Excerpts, edited passages, rough drafts, & notes gathered by Jacques Leclerc to be used for an analysis of accounts concerning the incidents at Lubang Buaya.)

2299 LEEUWEN, L. van. Being rich in Jakarta, 1994: a mother and two daughters. *Outward appearances: dressing, state and society in Indonesia.* Ed. H.Schulte Nordholt. Leiden: KITLV, 1997, (Koninklijk Instituut voor Taal-, Land- en Volkenkunde: Proceedings, 4), pp.339-362.

2300 LETTE, H. 'Changing my thinking with a Western woman': Javanese youths' constructions of masculinity. *Asia Pacific Viewpoint*, 37 ii (1996) pp.195-207. ('Love affairs' with tourist women.)

2301 LEUNG, S. Titin Ayu Asih **Suwandi**, 1962-1997. *Bulletin of Indonesian Economic Studies*, 33 iii (1997) pp.61-61. [Indonesian economist.]

2302 LEV, D. S. On the other hand? *Fantasizing the feminine in Indonesia.* Ed. L.J.Sears. Durham (USA): Duke University Press, 1996, pp.191-203. [Assessing the degree of gender equality in Indonesia.]

2303 LOCHER-SCHOLTEN, Elsbeth. Colonial ambivalences. European attitudes towards the Javanese household (1900-1942). *Women and households in Indonesia. Cultural notions and social practices.* Ed. J.Koning, M.Nolten, J.Rodenburg & Ratna Saptari. Richmond: Curzon, 2000, (NIAS Studies in Asian Topics, 27), pp.28-44.

2304 LONT, Hotze. More money, more autonomy? Women and credit in a Javanese urban community. *Indonesia*, 70 (2000) pp.83-100.

2305 LOO, V. van der. Tobben in Indië: wijze vriendinnen adviseren Hollandse vrouwen. *Indische Letteren*, 9 ii (1994) pp.67-80.

2306 LUCAS, A. Images of the Indonesian woman during the Japanese occupation 1942-45. *Women creating Indonesia: the first fifty years.* Ed. J.Gelman Taylor. Clayton: Monash Asia Institute, Monash University, 1997, (Monash Papers on Southeast Asia, 44), pp.52-90.

2307 MALHOTRA, Anju. Gender and the timing of marriage: rural-urban differences in Java. *Journal of Marriage and the Family*, 59 ii (1997) pp.434-450. Also online at http:// links.jstor.org/

2308 MAR'IYAH, Chusnul. Indonesian political transition, democracy and women's movements: experience and reflections. *Inter-Asia Cultural Studies*, 1 ii (2000) pp.366-369. Also online at www.catchword.com

2309 MAS'UDI, Masdar F., SCIORTINO, R. & MARCOES, L. Learning from Islam: advocacy of reproductive rights in Indonesian *pesantren*. *Studia Islamika*, 4 ii (1997) pp.83-104.

2310 MCINTYRE, A. In search of Megawati Sukarnoputri. *Lasting fascinations: essays on Indonesia and the Southwest Pacific to honour Bob Hering.* Ed. H.A.Poeze & A.Liem. Stein: (Yayasan Kabar Sebarang/Yayasan Soekarno), 1998, (Yayasan Soekarno Monograph Series, 2; Kabar Seberang, 28/29), pp.229-255.

2311 MEIJ, D. van der. Women in Minangkabau. *IIAS Newsletter*, 9 (1996) pp.51-51. (A portrait of Joke van Reenen.)

2312 MELLINGTON, N. & CAMERON, L. Female education and child mortality in Indonesia. *Bulletin of Indonesian Economic Studies*, 35 iii (1999) pp.115-144.

2313 MUKHERJEE, Wendy. The love magic of Khadijah Terong of Pulau Penyengat. *RIMA: Review of Indonesian and Malaysian Affairs*, 31 ii (1997) pp.29-46.

2314 MULDER, J. A. N. Images of Javanese gender. *Images of Malay-Indonesian identity.* Ed. M.Hitchcock & V.T.King. Kuala Lumpur: Oxford University Press, 1997, pp.138-147.

2315 NIEHOF, A. The changing lives of Indonesian women: contained emancipation under pressure. *Bijdragen Tot de Taal-, Land- en Volkenkunde*, 154 ii (1998) pp.236-258.

2316 OETOMO, D. Gender and sexual orientation in Indonesia. *Fantasizing the feminine in Indonesia.* Ed. L.J.Sears. Durham (USA): Duke University Press, 1996, pp.259-269.

2317 OEY-GARDINER, M. The impact of the financial crisis on Indonesian women: some survival strategies. *Indonesian Quarterly*, 26 ii (1998) pp.79-90.

2318 PAK OK-YUN. Resourcefulness without resources: the
 life history of a landless Minangkabau village woman.
 Southeast Asian Journal of Social Science, 24 i (1996)
 pp.98-111.

2319 PARKER, Frances E. & SOFIARINI, Rahmi. In the eye
 of the storm: sustaining the space created by women.
 Development, 42 ii (1999) pp.47-51. Also online at
 www.ingentaselect.com [Lombok.]

2320 PLATZDASCH, Bernhard. Islamic reaction to a female
 president. *Indonesia in transition. Social aspects of
 reformasi and crisis.* Ed. Chris Manning & Peter van
 Diermen. Singapore: Institute of Southeast Asian Studies;
 London: Zed, 2000, (Indonesia Assessment, 1999),
 pp.336-349.

2321 POMPE, Sebastiaan. Between crime and custom:
 extra-marital sex in modern Indonesian law. *Indonesia:
 law and society.* Ed. Timothy Lindsey. Sydney: Federation
 Press, 1999, pp.111-121.

2322 QUISUMBING, Agnes R. & OTSUKA, Keijiro. Land
 inheritance and schooling in matrilineal societies: evidence
 from Sumatra. *World Development,* 29 xii (2001)
 pp.2093-2110.

2323 RAHARJO, Y. Women's role in demographic transition
 and human resource development. *Indonesia assessment:
 population and human resources.* Ed. G.W.Jones &
 T.H.Hull. Canberra: Research School of Pacific and Asian
 Studies, Australian National University; Singapore:
 Institute of Southeast Asian Studies, 1997, pp.167-180.

2324 REENEN, Joke van. The salty mouth of a senior woman.
 Gender and the house in Minangkabau. *Women and
 households in Indonesia. Cultural notions and social
 practices.* Ed. J.Koning, M.Nolten, J.Rodenburg & Ratna
 Saptari. Richmond: Curzon, 2000, (NIAS Studies in Asian
 Topics, 27), pp.163-179.

2325 ROBINSON, Kathryn. Indonesian women: a survey of
 recent developments. *RIMA: Review of Indonesian and
 Malaysian Affairs,* 31 ii (1997) pp.141-162.

2326 ROBINSON, Kathryn. Indonesian women's rights,
 international feminism and democratic change.
 Communal Plural, 6 ii (1998) pp.205-223.

2327 ROBINSON, Kathryn. Indonesia update 2001: gender
 equity and development in Indonesia. *Bulletin of
 Indonesian Economic Studies,* 37 iii (2001) pp.385-386.
 Also online at www.catchword.com (Conference report.)

2328 ROBINSON, Kathryn. Love and sex in an Indonesian
 mining town. *Gender and power in affluent Asia* /ed.
 Krishna Sen & M.Stivens. London: Routledge, 1998,
 pp.63-86.

2329 ROBINSON, Kathryn. Women: difference versus diversity.
 *Indonesia beyond Suharto: polity, economy, society,
 transition.* Donald K.Emmerson, editor. Armonk: Sharpe,
 1999, pp.237-261.

2330 RÖTTGER-RÖSSLER, B. Fatimahs Weg nach oben. Der
 Prozess vertikaler Mobilität und kulturellen Wandels am
 Beispiel einer Lebensgeschichte. *Zeitschrift für
 Ethnologie,* 119 ii / 1994 (1995) pp.229-248. [Sulawesi.]

2331 RÖTTGER-RÖSSLER, Birgitt. Shared responsibility.
 Some aspects of gender and authority in Makassar society.
 Bijdragen tot de Taal-, Land- en Volkenkunde, 156 iii
 (2000) pp.521-538.

2332 RÖTTGER-RÖSSLER, Birgitt. Shared responsibility.
 Some aspects of gender and authority in Makassar society.
 *Authority and enterprise among the peoples of South
 Sulawesi.* Ed. R.Tol, K.van Dijk & G.Acciaioli. Leiden:
 KITLV Press, 2000, (Verhandelingen van het Koninklijk
 Instituut voor Taal-, Land- en Volkenkunde, 188),
 pp.143-160. [Previously published in *Bijdragen tot de
 Taal-, Land- en Volkenkunde,* 156 iii (2000), pp.521-538.]

2333 SAENONG, S. & GINTING, E. The role of women in
 upland agriculture development in Indonesia with a focus
 on CGPRT crop based farming systems. *Women in
 upland agriculture in Asia: proceedings of a workshop
 held in Chiang Mai ... 1995.* Ed. C.E.van Santen,
 J.W.T.Bottema, D.R.Stoltz. Bogor: CGPRT Centre, 1996,
 (CGPRT, no. 33), pp.23-86.

2334 SAPTARI, R. Indonesian women in the household and
 beyond. *IIAS Newsletter,* 8 (1996) pp.30-30.
 (Conference, Leiden, 1995.)

2335 SAPTARI, R. WIVS: Indonesian women studies. *IIAS
 Newsletter,* 12 (1997) pp.23-23. (Werkgroep
 Indonesische Vrouwen Studies.)

2336 SAPTARI, Ratna. Networks of reproduction among
 cigarette factory women in east Java. *Women and
 households in Indonesia. Cultural notions and social
 practices.* Ed. J.Koning, M.Nolten, J.Rodenburg & Ratna
 Saptari. Richmond: Curzon, 2000, (NIAS Studies in Asian
 Topics, 27), pp.281-298.

2337 SAPTARI, Ratna. Women, family and household: tensions
 in culture and practice. *Women and households in
 Indonesia. Cultural notions and social practices.* Ed.
 J.Koning, M.Nolten, J.Rodenburg & Ratna Saptari.
 Richmond: Curzon, 2000, (NIAS Studies in Asian Topics,
 27), pp.10-25.

2338 SEARS, L. J. Fragile identities: deconstructing women
 and Indonesia. *Fantasizing the feminine in Indonesia.*
 Ed. L.J.Sears. Durham (USA): Duke University Press,
 1996, pp.1-44.

2339 SEN, Krishna. Indonesian women at work: reframing the
 subject. *Gender and power in affluent Asia* /ed. Krishna
 Sen & M.Stivens. London: Routledge, 1998, pp.35-62.

2340 SILVEY, Rachel M. Diasporic subjects: gender and
 mobility in south Sulawesi. *Women's Studies International
 Forum,* 23 iv (2000) pp.501-515. Also online at http://
 www.sciencedirect.com/science/journal/02775395

2341 SILVEY, Rachel M. Stigmatized spaces: gender and
 mobility under crisis in south Sulawesi, Indonesia. *Gender,
 Place and Culture,* 7 ii (2000) pp.143-161. Also online
 at www.ingenta.com

2342 SMYTH, I. Maternal mortality and family planning in
 Indonesia. *Health care in Java: past and present.* Ed.
 P.Boomgaard, R.Sciortino & I.Smyth. Leiden: KITLV,
 1996, (Koninklijk Instituut voor Taal-, Land- en
 Volkenkunde: Proceedings, 3), pp.131-145.

2343 SMYTH, I. Women, industrialization and the environment
 in Indonesia. *Women, globalization and fragmentation
 in the developing world.* Ed. Haleh Afshar & S.Barrientos.
 Basingstoke: Macmillan; New York: St. Martin's Press,
 1999, pp.131-149.

2344 STRAALEN, R. van. Beb Vuyk op Buru: het laatste huis
 van de wereld *in briefvorm. Indische Letteren,* 10 i (1995)
 pp.55-66. (Gepubliceerd ... in det tijdschrift *De
 Huisvrouw in Indië.*)

2345 SUNINDYO, S. Murder, gender, and the media:
 sexualizing politics and violence. *Fantasizing the
 feminine in Indonesia.* Ed. L.J.Sears. Durham (USA): Duke
 University Press, 1996, pp.120-139.

2346 SUNINDYO, Saraswati. Murder, gender and the media:
 sexualising politics and violence. *Indonesia: law and
 society.* Ed. Timothy Lindsey. Sydney: Federation Press,
 1999, pp.145-157.

2347 SURYAKUSUMA, J. I. The state and sexuality in New
 Order Indonesia. *Fantasizing the feminine in Indonesia.*
 Ed. L.J.Sears. Durham (USA): Duke University Press,
 1996, pp.92-119.

2348 SUTANTIO, Retnowulan. A personal view on matrimonial
 property law and the law on inheritance in Indonesia.
 Indonesian Law and Administration Review, 3 ii (1997)
 pp.28-33.

2349 THOMSON ZAINU'DDIN, A. Building the future: the
 life and work of Kurnianingrat Ali Sastromijoyo. *Women
 creating Indonesia: the first fifty years.* Ed. J.Gelman
 Taylor. Clayton: Monash Asia Institute, Monash
 University, 1997, (Monash Papers on Southeast Asia, 44),
 pp.156-202.

2350 THOMSON ZAINU'DDIN, A. In memoriam: Jo
 Kurnianingrat Sastroamijoyo September 14, 1919 - October
 18, 1993. *Indonesia,* 58 (1994) pp.115-119.
 [Indonesian nationalist & English language teacher.]

2351 TIWON, S. Models and maniacs: articulating the female in Indonesia. *Fantasizing the feminine in Indonesia*. Ed. L.J.Sears. Durham (USA): Duke University Press, 1996, pp.47-70.

2352 TIWON, Sylvia. Reconstructing boundaries and beyond. *Women and households in Indonesia. Cultural notions and social practices*. Ed. J.Koning, M.Nolten, J.Rodenburg & Ratna Saptari. Richmond: Curzon, 2000, (NIAS Studies in Asian Topics, 27), pp.68-84. [Women in modern Indonesia.]

2353 TJANDRANINGSIH, Indrasari. Gendered work and labour control: women factory workers in Indonesia. *Asian Studies Review*, 24 ii (2000) pp.257-268.

2354 TRIASWATI, N. Women and children labour force in Indonesia. *Indonesian Quarterly*, 24 i (1996) pp.19-30.

2355 VREEDE-DE STUERS, C. Stit Soemandari - ter herinnering. *Bijdragen Tot de Taal-, Land- en Volkenkunde*, 150 i (1994) pp.207-208. [Indonesian journalist & feminist.]

2356 WALBRIDGE, L. S. The *santri-wati* of Indonesia's *Pesantren*: orientations of students of three girls' religious schools. *Islamic Studies*, 37 iv (1998) pp.519-532.

2357 WANDITA, Galuh. The tears have not stopped, the violence has not ended: political upheaval, ethnicity, and violence against women in Indonesia. *Gender and Development*, 6 iii (1998) pp.34-41. Also online at http://www.ingentaselect.com

2358 (WATSON ANDAYA, B.). Women and the world of commerce. *Indonesian heritage: early modern history*. Volume ed. A.Reid. Singapore: Archipelago, 1996, (Indonesian Heritage, 3), pp.44-45.

2359 WEIX, G.G. Hidden managers at home. Elite Javanese women running New Order family firms. *Women and households in Indonesia. Cultural notions and social practices*. Ed. J.Koning, M.Nolten, J.Rodenburg & Ratna Saptari. Richmond: Curzon, 2000, (NIAS Studies in Asian Topics, 27), pp.299-314.

2360 WERTHEIM, W. The truth about Gerwani: the gender aspect of the Suharto regime. *Lasting fascinations: essays on Indonesia and the Southwest Pacific to honour Bob Hering*. Ed. H.A.Poeze & A.Liem. Stein: (Yayasan Kabar Sebarang/Yayasan Soekarno), 1998, (Yayasan Soekarno Monograph Series, 2; Kabar Seberang, 28/29), pp.445-460. [Indonesian women's organization.]

2361 WESSING, Robert. A dance of life. The *seblang* of Banyuwangi, Indonesia. *Bijdragen tot de Taal-, Land- en Volkenkunde*, 155 iv (1999) pp.644-682. (Trance dance performed ... in East Java.)

2362 WHALLEY, L. A. Urban Minangkabau Muslim women: modern choices, traditional concerns in Indonesia. *Women in Muslim societies: diversity within unity*. Ed. H.L.Bodman, Nayereh Tohidi. Boulder: Rienner, 1998, pp.229-249.

2363 WHALLEY, Lucy A. Putting Islam into practice: the development of Islam from a gendered perspective in Minangkabau, Indonesia. *Toward a new paradigm: recent developments in Indonesian Islamic thought*. Ed. Mark R.Woodward. Tempe: Arizona State University, 1996, pp.221-264.

2364 WIDARTI, Diah. Determinants of labour force participation by married women: the case of Jakarta. *Bulletin of Indonesian Economic Studies*, 34 ii (1998) pp.93-120.

2365 WIERINGA, S. E. Sexual metaphors in the change from Soekarno's old order to Soeharto's New Order in Indonesia. *RIMA: Review of Indonesian and Malaysian Affairs*, 32 ii (1998) pp.143-178.

2366 WOLF, D. L. Javanese factory daughters: gender, the state, and industrial capitalism. *Fantasizing the feminine in Indonesia*. Ed. L.J.Sears. Durham (USA): Duke University Press, 1996, pp.140-162.

2367 WOLF, Diane. Beyond women and the household in Java. Re-examining the boundaries. *Women and households in Indonesia. Cultural notions and social practices*. Ed. J.Koning, M.Nolten, J.Rodenburg & Ratna Saptari. Richmond: Curzon, 2000, (NIAS Studies in Asian Topics, 27), pp.85-100.

2368 WOUK, Fay. Gender and the use of pragmatic particles in Indonesian. *Journal of Sociolinguistics*, 3 ii (1999) pp.194-219. (A reflection of Indonesian cultural values.) Also online at www.ingenta.com

2369 ZIV, Daniel. Populist perceptions and perceptions of populism in Indonesia: the case of Megawati Sukarnoputri. *South East Asia Reseach*, 9 i (2001) pp.73-88.

Iran

Books

2370 ABID, Lise J. *Journalistinnen im Tschador: Frauen und gesellschaftlicher Aufbruch im Iran*. Frankfurt a.M.: Brandes & Apsel / Südwind, 2001. 192pp.

2371 ADELKHAH, Fariba. *La revolución bajo el velo: mujer iraní y régimen islamista*. Tr. Vivanco, J. Barcelona: Bellaterra, 1996, (Biblioteca del Islam Contemporáneo, 4), 312pp. [Tr. of *La révolution sous voile*, Paris 1991.]

2372 AFARY, J. *The Iranian constitutional revolution, 1906-1911: grassroots democracy, social democracy, & the origins of feminism*. New York: Columbia University Press, 1996. 448pp.

2373 AFSHAR, Haleh. *Islam and feminisms: an Iranian case-study*. Basingstoke: Macmillan; New York: St. Martin's Press, 1998. 235pp.

2374 ALIZADEH, Parvin & HARPER, Barry. *The feminisation of the labour market in Iran*. London: Department of Economics, London Guildhall University, 2000 (Discussion Paper Series, 12), 29pp.

2375 ALLAFI, Sabine. *Bitteres Erbe: Frauenleben in Iran heute*. 2. Aufl. Frankfurt: Glare, 2001 (Der Andere Orient, 12), 166pp.

2376 AMIN, Camron Michael. *The making of the modern Iranian woman: gender, state policy, and popular culture, 1865-1946*. Gainsville: University Press of Florida, 2002. 320pp.

2377 ARYANPOUR, Azar. *Behind the tall walls: from palace to prison*. Danbury: Ruthledge Books, 1998. 448pp.

2378 AZADI, Sousan. *Flucht aus dem Iran: eine Frau entrinnt den Klauen der Ayatollahs*. Erzählt von A.Ferrante. Tr. Waldhoff, W. 12. Aufl. Munich: Heyne 1994, rp. 1995. 335pp. [Tr. of *Out of Iran*, London 1987.]

2379 BAHRAMPOUR, Tara. *To see and see again: a life in Iran and America*. New York: Farrar, Straus and Giroux, 1999. 361pp.

2380 DARABI, Parvin & THOMSON, R. P. *Du wolltest fliegen: Leben und Sterben der iranischen Ärtzin Homa Darabi*. Bergisch Gladbach: Lübbe, 1997. 413pp.

2381 DARABI, Parvin & THOMSON, R. P. *Een Laatste teken: leven en dood van de Iraanse arts Homa Darabi*. Tr. Zantwijk, T. van. Houten: Van Reemst, 1998. 285pp. [Tr. of *Du wolltest fliegen: Leben und Sterben der iranischen Ärtzin Homa Darabi*, Bergisch Gladbach 1997.]

2382 DARABI, Parvin & THOMSON, R. P. *Rage against the veil: the courageous life and death of an Islamic dissident*. Amherst: Prometheus, 1999. 274pp. [Tr. of *Du wolltest fliegen: Leben und Sterben der iranischen Ärtzin Homa Darabi*, Bergisch Gladbach 1997.]

2383 ESFANDIARI, Haleh. *Reconstructed lives: women and Iran's Islamic revolution*. Washington: Woodrow Wilson Center Press; Baltimore: Johns Hopkins University Press, 1997. 234pp.

2384 FRIEDL, E. *Die Frauen von Deh Koh: Geschichten aus einem iranischen Dorf*. Tr. Ostendorf, J. Munich: Droemer Knaur, 1993. 277pp. [Tr. of *Women of Deh Koh*, Washington 1989.]

2385 GHORASHI, Halleh. *Iranian Islamic and secular feminists - allies or enemies? A question rethought by participating in the NGO forum during the Fourth International Women's Conference in China.* Amsterdam:Middle East Research Associates (MERA), 1996 (Occasional Paper, 27), 28pp.

2386 HARRIS, Sara & BELL, Barbara Mosallai. *Byla jsem íránskou princeznou: skutečný životní příběh Američanky a jejích dcer, vlákané do světa brutální aristokracie v monarchistickém i revolučním Íraánu.* Tr. Rybáková, Ivana. Příbam: IRY, 1998. 243pp. [Tr. of *The peacock princess*, Boca Raton 1995.]

2387 HAUTPOUL, J. M. *Les dessous du tchador: la vie quotidienne en Iran selon le rêve de Khomeyni.* Paris: L'Harmattan, 1994. 271pp.

2388 HOODFAR, Homa. *The women's movement in Iran: women at the crossroads of secularisation and Islamization.* [Grabels]: Women Living under Muslim Laws, 1999 (Women's Movement Series, 1), 46pp. Also online at www.wluml.org/english/pubs

2389 HOODFAR, Homa. *Volunteer health workers in Iran as social activists: can "governmental non-governmental organisations" be agents of democratisation?* [Grabels]: Women Living under Muslim Laws, 1998 (Occasional Paper, 10), 30pp. Also online at www.wluml.org/english/pubs (Low-income women.)

2390 HOWARD, Jane. *Inside Iran: women's lives.* Washington: Mage, 2002. 253pp.

2391 JOZANI, Niloufar. *La beauté menacée: anthropologie des maladies de la peau en Iran (d'après des entretiens réalisés à Téhéran en 1983 et 1986).* Tehran: Institut Français de Recherche en Iran, 1994, (Bibliothèque Iranienne, 43), 317pp.

2392 KAMALKHANI, Zahra. *Women's Islam: religious practice among women in today's Iran.* London: Kegan Paul International, 1998. 203pp.

2393 KARI, H. *Auf verbotenen Wegen: die Rückkehr einer Iranerin in ihre Heimat.* Tr. Krüger-Wirrer, G. Munich: Droemer Knaur, 1993, (Knaur, 65019), 288pp. [Tr. of *L'exilée*, Paris 1991.]

2394 KAYANÍ, Azadé. *Entre coronas y turbantes: la mujer en el país de los ayatolás.* Barcelona: Flor del Viento, 1998, (De los Cuatro Vientos, 20), 207pp.

2395 KIAN-THIÉBAUT, Azadeh. *Les femmes iraniennes entre islam, Etat et famille.* Paris: Maisonneuve et Larose, 2002. 318pp.

2396 KOUSHA, Mahnaz. *Voices from Iran: the changing lives of Iranian women.* Syracuse (USA): Syracuse University Press, 2002. 244pp.

2397 KREMER, H. *Freiwillig unter dem Schleier: als Deutsche im Iran.* 2. Aufl. Freiburg i. B. : Herder 1994. 191pp.

2398 KUSHA, Hamid R. *The sacred law of Islam: a case study of women's treatment in the Islamic Republic of Iran's justice system.* Aldershot: Ashgate, 2002. 314pp.

2399 LILIEQUIST, M. *I skuggan av `Inte utan min dotter`: exiliraniers identitetsarbete.* Stockholm: Carlsson, 1996 (Etnologiska Skrifter, 7) . 164pp.

2400 MAHMOODY, Betty & HOFFER, William. *Bez dcerky neodejdu.* Tr. Thomasová, Anna. 2. Vyd. Prague: Ikar, 1993. 366pp. [Tr. of *Not without my daughter*, New York 1987. American wife in Iran.]

2401 MAHMOUDI, Akbar. *Angst vor weiblicher Sexualität als Hemmfaktor im Entwicklungsprozess der säkularisierten Mädchenerziehung und Frauenbildung in Iran.* Frankfurt a. M. : Lang 1999 (Europäische Hochschulschriften. Reihe XI, Pädagogik, 767), 298pp.

2402 MIR-HOSSEINI, Ziba. *Islam and gender: the religious debate in contemporary Iran.* Princeton: Princeton University Press, 1999. 305pp.

2403 MOSTESHAR, C. *Unveiled: one woman's nightmare in Iran.* New York: St. Martin's Press, 1996. 352pp. [Published in London as *Unveiled: love and death among the Ayatollahs*, 1995.]

2404 NAGEENY, Hedieh. *Lettres persanes sur la virginité: des femmes iraniennes témoignent.* Nîmes: HB Ed., 2001. 142pp.

2405 NAJMABADI, Afsaneh. *The story of the daughters of Quchan: gender and national memory in Iranian history.* Syracuse (USA): Syracuse University Press, 1998. 241pp. [1905.]

2406 PAIDAR, Parvin. *Gender of democracy: the encounter between feminism and reformism in contemporary Iran.* Geneva: United Nations Research Institute for Social Development (UNRISD), [2001] (Gender Justice, Development and Rights: Substantiating Rights in a Disabling Environment), 34pp. Online at www.unrisd.org/enindex/research/genjus.htm

2407 POYA, Maryam. *Women, work and Islamism: ideology and resistance in Iran.* London: Zed, 1999. 186pp.

2408 RABINYAN, D. *Persian brides.* Tr. Lotan, Y. Edinburgh: Canongate, 1998. 200pp. [Tr. of *Simṭat ha-sheqediyot be-'Omerig'an*, Tel Aviv, 1995. Novel set in Iran by writer from Iranian Jewish family.]

2409 ROOHIZADEGAN, Olya. *Olya's Geschichte.* Tr. Kruse, T. Bergisch Gladbach: Lübbe, 1995. 315pp. [Tr. of *Olya's story: a survivor's dramatic account of the persecution of Bahá'ís in revolutionary Iran*, Oxford 1993.]

2410 SABOURI, Rouzbeh. *Par-delà les voiles: changements sociaux et condition féminine en Iran.* Paris: L'Harmattan, 1995. 223pp.

2411 SHAFII, Rouhi. *Scent of saffron: three generations of an Iranian family.* London: Scarlet, 1997. 240pp.

2412 [THURAYYĀ, *Princess*]. *Palast der Einsamkeit: die erste Autobiographie* / Prinzessin Soraya. Tr. Poyda, Ulrike. Munich: Ferenczy bei Bruckmann, 1994. 272pp. [Iran. Tr. of *Palais des solitudes*, Paris 1991.]

2413 *Journey of a thousand miles begins with `one step`: Beijing reports, 95.* Ed. Matine-Daftary, Maryam. Plessis Bouchard: International Association for Women's Rights and Solidarity with Iranian Women, 1996. 231pp. [Persian text of three Iranian women's reports of the Beijing International Women's conference, with documentary appendices in English. Persian title: *Bā yak qadam safarī-i ṭūlānī āghāz shud: guzārishhā-yi Pikin.*]

2414 *Les femmes en Iran: pressions sociales et stratégies identitaires.* Ed. Yavari-d'Hellencourt, Nouchine. Paris: L'Harmattan, 1998. 233pp.

2415 *Women, religion and culture in Iran.* Ed. Sarah Ansari and Vanessa Martin. Richmond: Curzon, in association with The Royal Asiatic Society of Great Britain and Ireland, 2002. 231pp.

Articles

2416 AAWANI, Shahin. Musliminnen zwischen Tradition und Moderne. *Spektrum Iran,* 14 iv (2001) pp.105-128. [In general & in Iran in particular.]

2417 'ABD EL FAT[T]AH, Anisa. The third model of Islamic womanhood: an interview with Minister Zahra Shojaie. *Middle East Affairs Journal,* 5 i-ii (1999) pp.71-77. (Minister for Women's Affairs ... in the Islamic Republic of Iram.)

2418 ABID, Liselotte J. Die Rolle der iranischen Frauenzeitschriften in Geschichte und Gegenwart. *Wiener Zeitschrift für die Kunde des Morgenlandes,* 89 (1999) pp.7-32.

2419 ABID, Liselotte J. Journalistinnen und Gesellschaftspolitik im Iran - drei Beispiele aus einem breiten Spektrum. *Die neue Muslimische Frau: Standpunkte & Analysen* / hrsg. Barbara Pusch. Istanbul: Orient-Institut der Deutschen Morgenländischen Gesellschaft; Würzburg: Ergon, 2001, (Beiruter Texte und Studien, 85), pp.233-249.

2420 ADELKHAH, Fariba. Iran: voiler pour mieux mobiliser. *CEMOTI,* 17 (1994) pp.293-298.

2421 AFKHAMI, Mahnaz. At the crossroads of tradition and modernity: personal reflections. *SAIS Review,* 20 ii (2000) pp.85-92. [Iran, before & after 1979.]

2422 AFSHAR, Haleh. Age, gender and slavery in and out of the Persian harem: a different story. *Ethnic and Racial Studies*, 23 v (2000) pp.905-916. Also online at www.ingentaselect.com (One woman's experiences in twentieth-century Iran.)

2423 AFSHAR, Haleh. Gendering the millennium: globalising women. (Abstracts in translation: Intégrer le 'genre' dans le nouveau millénaire: mondialisation des femmes; Tornando o milênio mais feminino: mulheres globalizadas; El milenio del género: globalización de la mujer.). *Development in Practice*, 10 iii-iv (2000) pp.527-534;579;586;593. (Islamist feminism in Iran). Also online www.catchword.co.uk

2424 AFSHAR, Haleh. The impact of global and the reconstruction of local Islamic ideology, and an assessment of its role in shaping feminist politics in post-Revolutionary Iran. *Women, globalization and fragmentation in the developing world*. Ed. Haleh Afshar & S.Barrientos. Basingstoke: Macmillan; New York: St. Martin's Press, 1999, pp.54-76.

2425 AFSHĀR, Haleh. Islam and feminism: an analysis of political strategies. *Feminism and Islam: legal and literary perspectives*. Ed. Mai Yamani. Reading: Ithaca, for the Centre of Islamic and Middle Eastern Law, School of Oriental and African Studies, University of London, 1996, pp.197-216. (Iranian women.)

2426 AFSHĀR, Haleh. Women and the politics of fundamentalism in Iran. *Women and politics in the Third World*. Ed. Haleh Afshar. London: Routledge, 1996, pp.121-141.

2427 [AḤMADĪ KHURĀSĀNĪ, Nūshīn]. Le pouvoir politique et les femmes en Iran / Nouchine Ahmadi-Khorassani. Tr. Jahanguiri, Guissou. *Cahiers de l'Orient*, 60 (2000) pp.137-141.

2428 ALIZADEH, Parvin. The state and the social position of women: female employment in post-revolutionary Iran. *The economy of Iran: dilemmas of an Islamic state*. Ed. by Parvin Alizadeh. London: Tauris, 2000, pp.261-287.

2429 ALKHALIFA, Waleed Saleh. *Al-mut'a*, matrimonio de placer: aceptación o prohibición (su dimensión política en Irán a partir de la Revolución islámica). *Miscelánea de Estudios Arabes y Hebraicos: Sección Arabe-Islam*, 49 (2000) pp.225-236.

2430 AMIN, Camron Michael. Propaganda and remembrance: gender, education, and "the women's awakening" of 1936. *Iranian Studies*, 32 iii / 1999 (2000) pp.351-386.

2431 AMIN, Camron Michael. Selling and saving "Mother Iran": gender and the Iranian press in the 1940s. *International Journal of Middle East Studies*, 33 iii (2001) pp.335-361. Also online at http:// journals.cambridge.org

2432 AMIRPUR, Katajun. Islamischer Feminismus in der Islamischen Republik Iran. (Zusammenfassung: Islamic feminism in the Islamic Republic of Iran.). *Orient: Deutsche Zeitschrift für Politik und Wirtschaft des Orients*, 40 iii (1999) pp.439-452;519.

2433 AZAD, Maryam. Sisters of darkness. *Index on Censorship*, 29 ii / 193 (2000) pp.60-65. [Female enforcers of ḥijāb in Iran.]

2434 BABAYAN, K. The "Aqā'id al-nisā": a glimpse at Safavid women in local Isfahānī culture. *Women in the medieval Islamic world: power, patronage, and piety*. Ed. G.R.G.Hambly. Basingstoke: Macmillan, 1998, (The New Middle Ages, 6), pp.349-381.

2435 BADRY, Roswitha. Zum Profil weiblicher 'Ulamā' in Iran: neue Rollenmodelle für "islamische Feministinnen"? *Welt des Islams*, 40 i (2000) pp.7-40.

2436 BAUER, Janet L. Desiring place: Iranian "refugee" women and the cultural politics of self and community in the Diaspora. *Comparative Studies of South Asia, Africa and the Middle East*, 20 i-ii (2000) pp.180-199.

2437 BERBERIAN, Houri. Armenian women in turn-of-the-century Iran: education and activism. *Iran and beyond: essays in Middle Eastern history in honor of Nikki R.Keddie*. Ed. R.Matthee & B.Baron. Costa Mesa: Mazda, 2000, pp.70-98.

2438 BETTERIDGE, A. H. La controverse des vœux rituels prononcés par des musulmanes iraniennes en milieu urbain. *La religion par les femmes*. Sous la dir. de N.Auer Falk & R.M.Gross. Geneva: Labor et Fides, 1993, (Religions en Perspective, 6), pp.175-188. [Tr. of *Unspoken worlds*, 1989.]

2439 BORGER, Julian. Iran's moral enforcers beat a retreat. *Women Living under Muslim Laws: Dossier*, 21 (1998) pp.64-66. Also online at http:// www.wluml.org/english/pubs

2440 CHAFIQ, Chahla. Le voile des femmes, miroir magique de la société iranienne contemporaine. (Abstract: Women's veil: a magical mirror of contemporary Iranian society.). *Trimestre du Monde*, 33 (1996) pp.87-102;234.

2441 CHEHABI, H. E. Voices unveiled: women singers in Iran. *Iran and beyond: essays in Middle Eastern history in honor of Nikki R.Keddie*. Ed. R.Matthee & B.Baron. Costa Mesa: Mazda, 2000, pp.151-166.

2442 DADVAR, Elmyra. Imam Khomeini was chosen by God to revive Islam. Interview with Ms Khadijeh Alavi. *Al-Tawhid*, 16 iii (2000) pp.158-166. (An American national who converted to Islam ... & is now working in Iran.)

2443 DE GROOT, J. Gender, discourse and ideology in Iranian studies: towards a new scholarship. *Gendering the Middle East: emerging perspectives*. Ed. Deniz Kandiyoti. London: Tauris, 1996, pp.29-49.

2444 EBADI, Shirine. Mère et actrice sociale: le cadre juridique. *Les femmes en Iran: pressions sociales et stratégies identitaires*. Sous la dir. de Nouchine Yavari-d'Hellencourt. Paris: L'Harmattan, 1998, pp.81-93.

2445 EBTEKAR, Massoumeh. The status of women in contemporary Iran: trends and prospects. *Arab-Iranian relations*. Ed. Khair el-Din Haseeb. Beirut: Centre for Arab Unity Studies, 1998, pp.201-209.

2446 FALLAH, Hajieh. Changement socal et fécondité. *Les femmes en Iran: pressions sociales et stratégies identitaires*. Sous la dir. de Nouchine Yavari-d'Hellencourt. Paris: L'Harmattan, 1998, pp.41-50.

2447 FARHI, Farideh. Religious intellectuals, the "woman question", and the struggle for the creation of a democratic public sphere in Iran. *International Journal of Politics, Culture and Society*, 15 ii (2001) pp.315-339. Also online at www.kluweronline.com/issn/0891-4486/current

2448 FATHI, Asghar. Communities in place and communities in space: globalization and feminism in Iran. *Women, religion and culture in Iran*. Ed. Sarah Ansari and Vanessa Martin. Richmond: Curzon, in association with The Royal Asiatic Society of Great Britain and Ireland, 2002, pp.215-224.

2449 FERRIER, R. W. Women in Safavid Iran: the evidence of European travelers. *Women in the medieval Islamic world: power, patronage, and piety*. Ed. G.R.G.Hambly. Basingstoke: Macmillan, 1998, (The New Middle Ages, 6), pp.383-406.

2450 FRANCIS-DEHQANI, Guli. CMS women missionaries in Persia: perceptions of Muslim women and Islam, 1884-1934. *The Church Mission Society and world Christianity, 1799-1999*. Ed. Kevin Ward & Brian Stanley. Grand Rapids: Eerdmans; Richmond: Curzon, 2000, pp.91-119.

2451 FRANCIS-DEHQANI, Gulnar Eleanor. CMS women missionaries in Iran, 1891-1934. Attitudes towards Islam and Muslim women. *Women, religion and culture in Iran*. Ed. Sarah Ansari and Vanessa Martin. Richmond: Curzon, in association with The Royal Asiatic Society of Great Britain and Ireland, 2002, pp.27-50.

2452 FRIEDL, E. Ideal womanhood in postrevolutionary Iran. *Mixed blessings: gender and religious fundamentalism cross culturally*. Ed. J.Brink & J.Mencher. New York & London: Routledge, 1997, pp.143-157. (Anthropological fieldwork.)

2453 FRIEDL, E. L'Islam et les femmes dans la société tribale d'un village iranien. *La religion par les femmes*. Sous la dir. de N.Auer Falk & R.M.Gross. Geneva: Labor et Fides, 1993, (Religions en Perspective, 6), pp.205-218. [Tr. of *Uspoken worlds*, 1989.]

2454 GHAFFARI, Setareh. La francophonie en Iran: recul et féminisation. (Abstract: `Francophonie' in Iran: decline and feminization.). *Trimestre du Monde,* 26 (1994) pp.77-81;168.

2455 GHEYTANCHI, El[h]am. Chronology of events regarding women in Iran since the Revolution of 1979. *Women Living under Muslim Laws: Dossier,* 23-24 (2001) pp.107-120. Also online at http:// www.wluml.org/english/pubs

2456 GHEYTANCHI, Elham. Civil society in Iran: politics of motherhood and the public sphere. *International Sociology,* 16 iv (2001) pp.557-576. Also online at www.ingenta.com

2457 GHORAYSHI, Parvin. Women, paid-work and the family in the Islamic Republic of Iran. *Journal of Comparative Family Studies,* 27 iii (1996) pp.453-466.

2458 GHORAYSHI, Parvin. Women and social change: towards understanding gender relations in rural Iran. *Canadian Journal of Development Studies. Revue Canadienne d'Études du Développement,* 18 i (1997) pp.71-92.

2459 GIVENS, Benjamin P. & HIRSCHMAN, Charles. Modernization and consanguineous marriage in Iran. *Journal of Marriage and the Family,* 56 iv (1994) pp.820-834. Also online at http:// links.jstor.org/

2460 GOLESTAN, Kaveh & RANJBAR, Nahid. Privacy behind bars. *Index on Censorship,* 26 vi (1997) pp.184-188. (Photographs ... taken inside the women's ward of Tehran's infamous Evin prison.)

2461 HAERI, Shahla. Mut'a: regulating sexuality and gender relations in postrevolutionary Iran. *Islamic legal interpretation: muftis and their fatwás.* Ed. Muhammad Khalid Masud, B.Messick, D.S.Powers. Cambridge: Harvard University Press, 1996, pp.251-261;362-363.

2462 HEGLAND, M. E. Gender and religion in the Middle East and South Asia: women's voices rising. *Social history of women and gender in the modern Middle East* / ed. M.L.Meriwether, J.E.Tucker. Boulder: Westview, 1999, pp.177-212. [Iran & Pakistan.]

2463 HOODFAR, Homa. Devices and desires: population policy and gender roles in the Islamic Republic. *Political Islam: essays from* Middle East Report. Ed. J.Beinin & J.Stork. London: Tauris, 1997, pp.220-233. (Iran.)

2464 HOODFAR, Homa. Iranian women at the intersection of citizenship and the family code: the perils of "Islamic criteria". *Gender and citizenship in the Middle East.* Ed. Suad Joseph. Syracuse (USA): Syracuse University Press, 2000, pp.287-313.

2465 HOODFAR, Homa. Women and personal status law in Iran: an interview with Mehranguiz Kar. *Middle East Report,* 26 i / 198 (1996) pp.36-38.

2466 JALALI NAINI, Ziba. Le parlement et la présence politique des femmes en Iran: la loi sur les bourses d'état. *CEMOTI,* 22 (1996) pp.330-339.

2467 KAMALKHANI, Zahra. Gendered Islam and female preachers in contemporary Iran. *Discourse on gender / gendered discourse in the Middle East.* Ed. Boaz Shoshan. Westport: Praeger, 2000, pp.29-36;145-146.

2468 KAMALKHANI, Zahra. Reconstruction of Islamic knowledge and knowing: a case of Islamic practices among women in Iran. *Women and Islamization: contemporary dimensions of discourse on gender relations.* Ed. K.Ask & M.Tjomsland. Oxford: Berg, 1998, pp.177-193.

2469 [KAR, Mehrangiz]. Women's strategies in Iran from the 1979 revolution to 1999 / Mehranguiz Kar. *Globalizaton, gender, and religion: the politics of implementing women's rights in Catholic and Muslim contexts.* Ed. Jane H.Bayes & Nayereh Tohidi. Basingstoke: Palgrave, 2001, pp.203-230.

2470 KAR, Mehrangiz. Zum rechtlichen Status iranischer Frauen. Tr. Nurtsch, Ceyda. *Die neue Muslimische Frau: Standpunkte & Analysen* / hrsg. Barbara Pusch. Istanbul: Orient-Institut der Deutschen Morgenländischen Gesellschaft; Würzburg: Ergon, 2001, (Beiruter Texte und Studien, 85), pp.251-259.

2471 KAR, Mehranguiz & HOODFAR, Homa. La loi sur le statut personnel telle que définie par la République Islamique d'Iran: une évaluation. *Les frontières mouvantes du mariage et du divorce dans les communautés musulmanes.* Grabels: Women Living under Muslim Laws, 1996, (Programme Femmes et Loi dans le Monde Musulman: Dossier Spécial), pp.11-36. Also online at http:// www.wluml.org/french/pubs/pdf/dossiers/sd/ SD1.pdf

2472 KEDDIE, Nikki R. Women in Iran since 1979. *Women Living under Muslim Laws: Dossier,* 23-24 (2001) pp.81-106. Also online at http:// www.wluml.org/english/pubs

2473 KHALATBARI, Firouzeh. L'inégalité des sexes sur le marché du travail: une analyse des potentiels économiques de croissance. *Les femmes en Iran: pressions sociales et stratégies identitaires.* Sous la dir. de Nouchine Yavari-d'Hellencourt. Paris: L'Harmattan, 1998, pp.159-187.

2474 KIAN, Azadeh. Women and politics in post-Islamist Iran: the gender conscious drive to change. *Women Living under Muslim Laws: Dossier,* 21 (1998) pp.32-55. Also online at http:// www.wluml.org/english/pubs

2475 KIAN-THÉBAUT, Azadeh. Women's religious seminaries in Iran. *ISIM Newsletter,* 6 (2000) pp.23-23.

2476 KIAN-THÉBAUT, Azadeh. From Islamization to the individualization of women in post-Revolutionary Iran. *Women, religion and culture in Iran.* Ed. Sarah Ansari and Vanessa Martin. Richmond: Curzon, in association with The Royal Asiatic Society of Great Britain and Ireland, 2002, pp.127-142.

2477 KIAN-THIÉBAUT, Azadeh. L'Iran post-islamiste: l'émergence d'un discours féminin: un enjeu politique. *Cahiers de l'Orient,* 47 (1997) pp.55-72.

2478 KIAN[-THIÉBAUT], Azadeh. La formation d'une identité sociale féminine post-révolutionnaire: un enjeu de pouvoir. *Les femmes en Iran: pressions sociales et stratégies identitaires.* Sous la dir. de Nouchine Yavari-d'Hellencourt. Paris: L'Harmattan, 1998, pp.135-158.

2479 KIAN-THIÉBAUT, Azadeh. La mère active iranienne entre famille, état et société. *Revue des Mondes Musulmans et de la Méditerranée,* 85-86 (1999) pp.163-184.

2480 KIAN-THIÉBAUT, Azadeh. Women and politics in post-Islamist Iran: the gender conscious drive to change. *British Journal of Middle Eastern Studies,* 24 i (1997) pp.75-96.

2481 KOTOBI, Laurence-Donia. Gestion de la santé au féminin: de la tradition à la modernité. *Les femmes en Iran: pressions sociales et stratégies identitaires.* Sous la dir. de Nouchine Yavari-d'Hellencourt. Paris: L'Harmattan, 1998, pp.67-80.

2482 KOUSHA, Mahnaz. Ties that bind: mothers and daughters in contemporary Iran. *Critique: Journal for Critical Studies of the Middle East,* 11 (1997) pp.65-83.

2483 LADIER-FOULADI, M. Etude démographique du divorce en Iran. Le cas de la ville de Shiraz en 1996. *CEMOTI,* 28 (1999) pp.287-295.

2484 LAMLOUM, Olfa. Femmes, islamisme et féminisme en Iran. Entretien avec Fariba Adelkhah. *Confluences Méditerranée,* 27 (1998) pp.95-103.

2485 LUTRAND, M-C. Clivages de vision du monde chez les femmes dans l'Iran d'aujourd'hui. (Abstract: Women's world vision distinction in Iran today.). *Homme et la Société,* 120 (1996) pp.25-39;158.

2486 MAGHSOUDI, Manizheh. Le mariage chez les Turkmènes. *Luqmān,* 12 ii / 24 (1996) pp.59-73. (D'Iran.)

2487 MAHDAVI, Shireen. Women, Shi'ism and cuisine in Iran. *Women, religion and culture in Iran.* Ed. Sarah Ansari and Vanessa Martin. Richmond: Curzon, in association with The Royal Asiatic Society of Great Britain and Ireland, 2002, pp.10-26. [Historical.]

2488 MATTHEE, Rudi. Prostitutes, courtesans, and dancing girls: women entertainers in Safavid Iran. *Iran and beyond: essays in Middle Eastern history in honor of Nikki R.Keddie*. Ed. R.Matthee & B.Baron. Costa Mesa: Mazda, 2000, pp.121-150.

2489 MAYER, A. E. Islamic rights or human rights: an Iranian dilemma. *Iranian Studies*, 29 i-ii / 1996 (1997) pp.269-296.

2490 MEHRAN, Golnar. A study of girls' lack of access to primary education in the Islamic Republic of Iran. *Compare*, 27 iii (1997) pp.263-276.

2491 MEHRDAD, A. Les femmes dans le droit civil iranien 1905-1995. *Women Living under Muslim Laws: Dossier*, 14-15 (1996) pp.92-102. Also online at http://www.wluml.org/french/pubs/pdf/dossiers/dossier14-15/D14-15fr.pdf

2492 MEHRDAD, A. Women in Iranian civil law 1905-1995. *Women Living under Muslim Laws: Dossier*, 14-15 (1996) pp.86-95. Also online at www.wluml.org/english/pubs

2493 MIR HOSS[EI]NI, Ziba. Hojjat al-Eslam Sa`idzadeh - Iran. *Women Living under Muslim Laws: Dossier*, 21 (1998) pp.56-59. Also online at http:// www.wluml.org/english/pubs [Pro-feminist religious scholar, arrested June 1998.]

2494 MIR-HOSSEINI, Ziba. Debating gender with ulema in Qom. *ISIM Newsletter*, 5 (2000) pp.21-21.

2495 MIR-HOSSEINI, Ziba. Debating women: gender and the public sphere in post-revolutionary Iran. *Civil society in the Muslim world: contemporary perspectives*. Ed. by Amyn B.Sajoo. London: Tauris, in association with The Institute of Ismaili Studies, 2002, pp.95-122.

2496 MIR-HOSSEINI, Ziba. Islam, women and civil rights: the religious debate in the Iran of the 1990s. *Women, religion and culture in Iran*. Ed. Sarah Ansari and Vanessa Martin. Richmond: Curzon, in association with The Royal Asiatic Society of Great Britain and Ireland, 2002, pp.169-188.

2497 MIR-HOSSEINI, Ziba. Mariage et divorce: une marge de négociation pour les femmes. *Les femmes en Iran: pressions sociales et stratégies identitaires*. Sous la dir. de Nouchine Yavari-d'Hellencourt. Paris: L'Harmattan, 1998, pp.95-118.

2498 MIR-HOSSEINI, Ziba. Negotiating the politics of gender in Iran: an ethnography of a documentary. *The new Iranian cinema: politics, representation and identity*. Ed. by Richard Tapper. London: Tauris, 2002, pp.167-199. [Problems author encountered when she wanted to shoot"Divorce Iranian Style" (1988), based on her book *Marriage on trial*.]

2499 MIR-HOSSEINI, Ziba. "Rethinking gender": diskussioner med ulama i Iran. *Semiramis*, 6 (1999) pp.103-123. (Fra *Critique: Journal for Critical Studies of the Middle East*, Efterår 1998.)

2500 MIR-HOSSEINI, Ziba. Rethinking gender: discussions with ulama in Iran. *Critique: Journal for Critical Studies of the Middle East*, 13 (1998) pp.47-59.

2501 MIR-HOSSEINI, Ziba. Stretching the limits: a feminist reading of the *Shari'a* in post-Khomeini Iran. *Feminism and Islam: legal and literary perspectives*. Ed. Mai Yamani. Reading: Ithaca, for the Centre of Islamic and Middle Eastern Law, School of Oriental and African Studies, University of London, 1996, pp.285-319.

2502 MIR-HOSSEINI, Ziba. Stretching the limits: a feminist reading of the Shari'a in post-Khomeini Iran. *Women Living under Muslim Laws: Dossier*, 17 (1997) Also online at www.wluml.org/english/pubs

2503 MIR-HOSSEINI, Ziba. The conservative-reformist conflict over women's rights in Iran. *International Journal of Politics, Culture and Society*, 16 i (2002) pp.37-53.

2504 MIR-HOSSEINI, Ziba. The making of *Divorce Iranian style*. *ISIM Newsletter*, 2 (1999) pp.17-17. (Documentary film.)

2505 MIR-HOSSEINI, Ziba. The rise and fall of Fa'ezeh Hashemi: women in Iranian elections. *Middle East Report*, 218 / 31 i (2001) pp.8-11.

2506 MIR-HOSSEINI, Ziba. Women and politics in post-Khomeini Iran: divorce, veiling and emerging voices. *Women and politics in the Third World*. Ed. Haleh Afshar. London: Routledge, 1996, pp.142-170.

2507 MOGHADAM, Fatemeh Etemad. Iran's new Islamic home economics: an exploratory attempt to conceptualize women's work in the Islamic Republic. *The economics of women and work in the Middle East and North Africa*. Ed. E.Mine Cinar. Amsterdam: JAI, 2001, (Research in Middle East Economics, 4), pp.339-360.

2508 MOGHADAM, Fatemeh Etemad. The political economy of female employment in postrevolutionary Iran. *Women and power in the Middle East*. Ed. Suad Joseph & Susan Slyomovics. Philadelphia: University of Pennsylvania Press, 2001, pp.191-203;216 -218.

2509 MOGHADAM, Valentine M. Gender and revolutionary transformation: Iran 1979 and East Central Europe. *Gender & Society*, 9 i (1995) pp.60-78.

2510 MOGHADAM, Valentine M. Hidden from history? Women workers in modern Iran. *Iranian Studies*, 33 iii-iv (2000) pp.377-401.

2511 MOGHADAM, Valentine M. Islamic feminism and its discontents: toward a resolution of the debate. *Gender, politics, and Islam*. Ed. Therese Saliba, Carolyn Allen and Judith A.Howard. Chicago: University of Chicago Press, 2002, pp.15-51. [Iran. Originally published in *Signs*, 27 iv (2002).]

2512 MOGHADAM, Valentine M. Islamic feminism and its discontents: toward a resolution of the debate. *Signs*, 27 iv (2002) pp.1135-1171. Also online at http://www.journals.uchicago.edu [Iran.]

2513 MOGHADAM, Valentine M. Women's socio-economic participation and Iran's changing political economy. *The economy of Iran: dilemmas of an Islamic state*. Ed. by Parvin Alizadeh. London: Tauris, 2000, pp.233-260.

2514 MOGHADEM, Fatemeh E. Ideology, economic restructuring, and women's work in Iran (1976-1996). *Earnings inequality, unemployment, and poverty in the Middle East and North Africa* / ed. Wassim Shahin & Ghassan Dibeh. Westport: Greenwood, 2000, (Contributions in Economics and Economic History, 215), pp.205-224.

2515 MOÏNFAR, Mohammad Djafar. L'expression du mariage en persan. (Abstract: The expression of marriage in Persian.). *Cahiers des Sciences Humaines*, 31 i (1995) pp.145-148;271.

2516 MOKRI, Mohammad. Pleureuses professionnelles et lamentations funéraires en Iran occidental : la mort de Chîrîn. *Cimetières et traditions funéraires dans le monde Islamique / İslâm dünyasında mezarlıklar ve defin gelenekleri*, 1. Ed. J-L.Bacqué-Grammont & Aksel Tibet. Ankara: Türk Tarih Kurumu Basımevi, 1996, (Atatürk Kültür, Dil ve Tarih Yüksek Kurumu, Türk Tarih Kurumu Yayınları, 26 vi), pp.73-96. [Modern laments derived from classical Persian texts.]

2517 MORUZZI, Norma Claire. Women in Iran: notes on film and from the field. *Feminist Studies*, 27 i (2001) pp.89-100. [Reactions among Iranian women in exile & in Iran to two films made by Iranian women.]

2518 MOTTAHEDEH, Negar. The mutilated body of the modern nation: Qurrat al-'Ayn Tahirah's unveiling and the Iranian massacre of the Babis. *Comparative Studies of South Asia, Africa and the Middle East*, 18 ii (1998) pp.38-50. (1848-1852.)

2519 NAFISI, Azar. Tales of subversion: women challenging fundamentalism in the Islamic Republic of Iran. *Religious fundamentalisms and the human rights of women*. Ed. C.W.Howland. Basingstoke: Macmillan; New York: St. Martin's Press, 1999, pp.257-267.

2520 NAGHIBI, Nima. Bad feminist or *bad-hejabi*? Moving outside the *hejab* debate. *Interventions*, 1 iv (1999) pp.555-571. (Iran ... 1936 Unveiling Act ... 1983 Veiling Act.)

2521 NAJMABADI, Afsanch. `Is our name remembered?': writing the history of Iranian constitutionalism as if women and gender mattered. *Iranian Studies*, 29 i-ii (1996) pp.85-109. (Daughter-selling ... & the Turkoman raid.)

2522 NAJMABADI, Afsaneh. (Un)Veiling feminism. *Women Living under Muslim Laws: Dossier*, 23-24 (2001) pp.121-136. Also online at http:// www.wluml.org/ english/pubs (The veiling work of feminism as a boundary marker for secularism of Iranian modernity.)

2523 NAJMABADI, Afsaneh. Crafting an educated housewife in Iran. *Remaking women: feminism and modernity in the Middle East*. Ed. Lila Abu-Lughod. Princeton: Princeton University Press, 1998, pp.91-125. [1900-1911.]

2524 NAJMABADI, Afsaneh. Feminism in an Islamic Republic: "years of hardship, years of growth". *Islam, gender, & social change*. Ed. Y.Yazbeck Haddad & J.L.Esposito. New York: Oxford University Press, 1998, pp.59-84.

2525 NAJMABADI, Afsaneh. Writing history as if women and gender mattered. *ISIM Newsletter*, 3 (1999) pp.23-23. (Iran, 1905-06.)

2526 NAKANISHI, Hisae. Power, ideology, and women's consciousness in postrevolutionary Iran. *Women in Muslim socteties: diversity within unity*. Ed. H.L.Bodman, Nayereh Tohidi. Boulder: Rienner, 1998, pp.83-100.

2527 O'SHEA, Maria. Medic, mystic or magic? Women's health choices in a Kurdish city. *Women of a non-state nation: the Kurds*. Ed. Shahrzad Mojab. Costa Mesa: Mazda, 2001, (Kurdish Studies Series, 3), pp.161-179. (In Iran.)

2528 PAIDAR, Parvin. Feminism and Islam in Iran. *Gendering the Middle East: emerging perspectives*. Ed. Deniz Kandiyoti. London: Tauris, 1996, pp.51-67.

2529 PASQUALINI, Maria-Gabriella. La révolution islamique iranienne et les femmes. *Femmes de Méditerranée: religion, travail, politique*. Sous la dir. de Andrée Dore-Audibert et Sophie Bessis. Paris: Karthala, 1995, pp.135-140.

2530 PINN, I. Iranerinnen und der Iran in der `Schleierliteratur`. *Spektrum Iran*, 9 iii-iv (1996) pp.33-64.

2531 PLATT, Katherine. Places of experience and the experience of place. *The longing for home* / ed. Leroy S.Rouner. Notre Dame (USA): University of Notre Dame Press, 1996, (Boston University Studies in Philosophy and Religion, 17), pp.112-127. (Three examples .. the Eastern European Jewish stetl ... the childhood home places of women in rural Iran, & the Arab peasant villages of pre-1948 Palestine.)

2532 RIAHI, Niloufar. Les représentations populaires de la femme et de l'enfantement. *Les femmes en Iran: pressions sociales et stratégies identitaires*. Sous la dir. de Nouchine Yavari-d'Hellencourt. Paris: L'Harmattan, 1998, pp.51-65.

2533 RIZVI, Kishwar. Gendered patronage: women and benevolence during the early Safavid empire. *Women, patronage, and self-representation in Islamic societies*. Ed. D.Fairchild Ruggles. Albany (USA): State University of New York Press, 2000, pp.123-153.

2534 ROSTAM-KOLAYI, Jasamin. Foreign education, the women's press, and the discourse of scientific domesticity in early-twentieth-century Iran. *Iran and the surrounding world: interactions in culture and cultural politics*. Nikki R.Keddie, Rudi Matthee, editors. Seattle: University of Washington Press, 2002, pp.182-202. (Introduced by foreign and missionary girls' schools in Iran.)

2535 SABAHI, Farian. Gender and the army of knowledge in Pahlavi Iran, 1968-1979. *Women, religion and culture in Iran*. Ed. Sarah Ansari and Vanessa Martin. Richmond: Curzon, in association with The Royal Asiatic Society of Great Britain and Ireland, 2002, pp.99-126. (The Women's Literacy Corps programme.)

2536 SADEGHI-FASSAEI, Soheila & KENDALL, Kathleen. Iranian women's pathways to imprisonment. *Women's Studies International Forum*, 24 vi (2001) pp.701-710. Also online at ww.sciencedirect.com/science/journal/ 02775395

2537 SALEHI-ISFAHANI, Djavad. Fertility, education, and household resources in Iran, 1987-1992. *The economics of women and work in the Middle East and North Africa*. Ed. E.Mine Cinar. Amsterdam: JAI, 2001, (Research in Middle East Economics, 4), pp.311-337.

2538 SCARCIA AMORETTI, B. Dames persanes de Constantinople. *Les Iraniens d'Istanbul*. Sous la dir. de T.Zarcone & F.Zarinebaf. Paris: Institut Français de Recherches en Iran & Institut Français d'Etudes Anatoliennes, 1993, (Bibliothèque Iranienne, 42; Varia Turcica, 24), pp.91-93. [From Italian Foreign Affairs Ministry archives of 1908.]

2539 SCARCIA AMORETTI, B. L'Iran: pays des femmes? Notes de voyage. *Oriente Moderno*, 16 / 77 i / 1997 (1998) pp.47-56. (Présence massive & envahissante des femmes ... dans les rues comme dans les universités.)

2540 SCHNEIDER, Irene. "Der unglücklichste König der Welt": Person und Politik des Qāǧārherrschers Nāṣir ad-Dīn Šāh (reg. 1848-1896) im Urteil seiner Tochter Tāǧ as-Salṭana. *Saeculum*, 48 ii (1997) pp.254-274.

2541 SHAHIDI, Hossein. Women and journalism in Iran. *Women, religion and culture in Iran*. Ed. Sarah Ansari and Vanessa Martin. Richmond: Curzon, in association with The Royal Asiatic Society of Great Britain and Ireland, 2002, pp.70-87. [1910 to 1997.]

2542 SHAHIDIAN, Hammed. Iranian exiles and sexual politics: issues of gender relations and identity. (Abstracts: Les exilés iraniens et les politiques sexuelles: problématiques liées au relations entre les sexes et à l'identité; Iraner im Exil und Sexualpolitik: Los exilados iraníes y la política sexual.). *Journal of Refugee Studies*, 9 i (1996) pp.43-72;113;114-115;116. [In Canada, UK & France.]

2543 SHAHIDIAN, Hammed. Women and clandestine politics in Iran, 1970-1985. *Feminist Studies*, 23 i (1997) pp.7-42.

2544 SØLTOFT, M. Landet langt væk med de undertrykte kvinder. *Semiramis*, 6 (1999) pp.95-101. [Iran.]

2545 SPETS, U. Vykort till världen: Mozhgan Afrakute. *Kvinnovetenskaplige Tidskrift*, 18 iii-iv (1997) pp.88-90. [Iranian biologist in Sweden & Iran.]

2546 SULLIVAN, Zohreh T. Eluding the feminist, overthrowing the modern? Transformations in twentieth-century Iran. *Remaking women: feminism and modernity in the Middle East*. Ed. Lila Abu-Lughod. Princeton: Princeton University Press, 1998, pp.215-242.

2547 SZUPPE, M. La participation des femmes de la famille royale à l'exercice du pouvoir en Iran safavide au XVIe siècle. *Studia Iranica*, 23 ii (1994) pp.211-258. (16th century.)

2548 SZUPPE, M. La participation des femmes de la famille royale à l'exercice du pouvoir en Iran safavide au XVIe siècle (seconde partie): l'entourage des princesses et leurs activités politiques. *Studia Iranica*, 24 i (1995) pp.61-122.

2549 SZUPPE, M. The 'jewels of wonder': learned ladies and princess politicians in the provinces of early Ṣafavid Iran. *Women in the medieval Islamic world: power, patronage, and piety*. Ed. G.R.G.Hambly. Basingstoke: Macmillan, 1998, (The New Middle Ages, 6), pp.325-347.

2550 THORBJØRNSRUD, B. Barnekidnapping og rasisme. *Midtøsten Forum*, 10 i-ii (1996) pp.48-51. (Betty Mahmoody's bok `Ikke uten min datter' ... åpnet verdens øyne for problemet barnekidnapping på tvers av landegrensene.)

2551 TOHIDI, Nayereh. International connections of the Iranian women's movement. *Iran and the surrounding world: interactions in culture and cultural politics*. Nikki R.Keddie, Rudi Matthee, editors. Seattle: University of Washington Press, 2002, pp.205-231.

2552 TORAB, Azam. Piety as gendered agency: a study of *jalaseh* ritual discourse in an urban neighbourhood in Iran. ([Abstract:] La piété comme force sociale marquée par la différence sexuelle: étude du discours rituel *jalaseh* dans un quartier urbain en Iran.). *Journal of the Royal Anthropological Institute*, 2 i (1996) pp.235-252.

2553 TORAB, Azam. The politicization of women's religious circles in post-Revolutionary Iran. *Women, religion and culture in Iran*. Ed. Sarah Ansari and Vanessa Martin. Richmond: Curzon, in association with The Royal Asiatic Society of Great Britain and Ireland, 2002, pp.143-168.

2554 VAZIRI, Haleh. The quest for gender justice in the Islamic Republic: torment or triumph for Iranian women. *Journal of South Asian and Middle Eastern Studies*, 25 i (2001) pp.48-61.

2555 YAVARI D'HELLENCOURT, Nouchine. Discours islamiques, actrices sociales et rapports sociaux de sexe. *Les femmes en Iran: pressions sociales et stratégies identitaires*. Sous la dir. de Nouchine Yavari-d'Hellencourt. Paris: L'Harmattan, 1998, pp.189-229.

2556 YAVARI-D'HELLENCOURT, Nouchine. Le féminisme post-islamiste en Iran. *Revue des Mondes Musulmans et de la Méditerranée*, 85-86 (1999) pp.99-119.

2557 YAZDEKHASTI, Behjat & LUTRAND, Marie-Claude. La semaine de la femme. *Les femmes en Iran: pressions sociales et stratégies identitaires*. Sous la dir. de Nouchine Yavari-d'Hellencourt. Paris: L'Harmattan, 1998, pp.119-133.

2558 ZARINEBAF-SHAHR, Fariba. Economic activities of Safavid women in the shrine-city of Ardabil. *Iranian Studies*, 31 ii (1998) pp.247-261.

2559 ZIRINSKY, Michael. A Presbyterian vocation to reform gender relations in Iran: the career of Annie Stocking Boyce. *Women, religion and culture in Iran*. Ed. Sarah Ansari and Vanessa Martin. Richmond: Curzon, in association with The Royal Asiatic Society of Great Britain and Ireland, 2002, pp.51-69.

2560 Babel: wear the chador on the inside. *Index on Censorship*, 27 v (1998) pp.176-181. [Interviews with Iranian teenagers & adults.]

2561 Women in Iran: an online discussion. Ed. Keddie, Nikki R. *Middle East Policy*, 8 iv (2001) pp.128-143.

Iraq

Books

2562 KARRER, Cristina. *"Sie haben unsere Männer verschleppt ...": Frauen und Krieg in Irakisch Kurdistan*. Berne: eFeF-Verl., 1998. 190pp.

Articles

2563 ALI, Nadje al-. Sanctions and women in Iraq. *Sanctions on Iraq: background, consequences, strategies*. Cambridge: Campaign Against Sanctions on Iraq, 2000, pp.73-84.

2564 BEGIKHANI, Nazand. Etre femme, kurde et irakienne. *Monde Arabe Maghreb-Machrek*, 163 (1999) pp.194-195.

2565 EFRATI, Noga. Productive or reproductive? The roles of Iraqi women during the Iraq-Iran war. *Middle Eastern Studies*, 35 ii (1999) pp.27-44.

2566 ELDÉN, Å. Saddams kvinnor - stöttepelare och akilleshälar: könsdikotomisering och konstruktion av nationell identitet i Saddam Husseins tal till de irakiska kvinnorna. *Kvinnovetenskaplig Tidskrift*, 18 iii-iv (1997) pp.24-43.

2567 HADI, Ali & BIBLAWY, Heyam el-. Trends and structure of female labour force in Iraq (1977-1987). *CDC 27th Annual Seminar on population issues in the Middle East, Africa and Asia*. Cairo: Cairo Demographic Center, 1998, (Research Monograph Series, 27; CDC Annual Seminar, 1997), pp.526-552.

2568 ISMAEL, Jacqueline S. & ISMAEL, Shereen T. Gender and state in Iraq. *Gender and citizenship in the Middle East*. Ed. Suad Joseph. Syracuse (USA): Syracuse University Press, 2000, pp.185-211. [In 20th century.]

2569 KADHIM, Wala'a Saïd. Irak: la condition féminine sous un régime "laïc". *Cahiers de l'Orient*, 47 (1997) pp.35-41.

2570 KAMP, Martina. Philanthropie als Partizipation. Die bürgerliche Frauenbewegung im vorrevolutionären Irak. *Die islamische Welt als Netzwerk. Möglichkeiten und Grenzen des Netzwerkansatzes im islamischen Kontext* / hrsg. Roman Loimeier. Würzburg: Ergon, 2000, (MISK: Mitteilungen zur Sozial- und Kulturgeschichte der Islamischen Welt, 9), pp.461-476.

2571 KHOURI, Dina Rizk. Drawing boundaries and defining spaces: women and space in Ottoman Iraq. *Women, the family, and divorce laws in Islamic history*. Ed. A.El Azhary Sonbol. Syracuse: Syracuse University Press, 1996, pp.173-189.

2572 KHOURY, Dina Rizk. Slippers at the entrance or behind closed doors: domestic and public spaces for Mosuli women. *Women in the Ottoman Empire: Middle Eastern women in the early modern era*. Ed. M.C.Zilfi. Leiden: Brill, 1997, (The Ottoman Empire and its Heritage, 10), pp.105-127. (In the eighteenth & nineteenth centuries.)

2573 KHYATT, Muzahim Kassim al-, DABBUGH, Samim al- & ABOUSH, Nawal. Breast self examination in Iraq: a community-based study. *Journal of IMA: Islamic Medical Association of North America*, 32 i (2000) pp.19-21.

2574 MELEK, Maysoon. The poet who helped shape my childhood. *Intimate selving in Arab families: gender, self, and identity*. Ed. Suad Joseph. Syracuse (USA): Syracuse University Press, 1999, pp.77-91;273. (Nazik al-Malaika.)

2575 'UMARI, Khayri al-. Der Kampf gegen die Verschleierung im Iraq. Tr. Heine, P. *Al-Rafidayn: Jahrbuch zu Geschichte und Kultur des Modernen Iraq*, 3 (1995) pp.81-87.

2576 WAITE, Louise. How is household vulnerability gendered? Female-headed households in the collectives of Suleimaniyah, Iraqi Kurdistan. *Disasters*, 24 ii (2000) pp.153-172. Also online at http:// www.ingentaselect.com

2577 WILEY, Joyce. 'Alima Bint al-Huda, women's advocate. *The most learned of the Shi'a: the institution of the Marja' taqlid*. Ed. Linda S.Walbridge. Oxford: Oxford University Press, 2001, pp.149-160.

Islamism see under countries & General: religion

Israel see also Palestine & the Palestinians

Articles

2578 ADELMAN, Madelaine. No way out: divorce-related domestic violence in Israel. *Violence against Women*, 6 xi (2000) pp.1223-1254. Also online at http:// www.ingenta.com/journals/browse/sage/j322 [Incl. Muslim Palestinians.]

2579 COHEN-ALMAGOR, R. Female circumcision and murder for family honour among minorities in Israel. *Nationalism, minorities and diasporas: identities and rights in the Middle East*. Ed. K.E.Schulze, M.Stokes & C.Campbell. London: Tauris Academic Studies, 1996, (Library of Modern Middle East Studies, 8), pp.171-187. (Female circumcision is currently practiced in the southern part of the Gaza Strip ... and amongst some six Bedouin tribes in the south of Israel.)

2580 CWIKEL, Julie, LEV-WIESEL, Rachel & KRENAWI, Alean al-. The physical and psychosocial health of bedouin Arab women of the Negev area of Israel: the impact of high fertility and pervasive domestic violence. *Violence against Women*, 9 ii (2003) pp.240-257. Also online at http:// www.ingenta.com/journals/browse/sage/j322

2581 DINERO, S. C. Female role change and male response in the post-nomadic urban environment: the case of the Israeli Negev Bedouin. *Journal of Comparative Family Studies*, 28 iii (1997) pp.vii-viii;xii-xiii;248-261.

2582 ESPANIOLY, Nabila. Violence against women: a Palestinian women's perspective. Personal is political. *Women's Studies International Forum*, 20 v-vi (1997) pp.587-592. [In Israel.]

2583　FENSTER, T.　Culture, human rights and planning (as control) for minority women in Israel. *Gender, planning and human rights.* Ed. T.Fenster. London: Routledge, 1999, pp.39-54. (The Muslim Bedouin and the Ethiopian Jews.)

2584　FENSTER, T.　Ethnicity, citizenship, and gender: manifestations in spatial patterns and planning - the Israeli experience. *The mosaic of Israeli geography.* Ed. Y.Gradus & G.Lipshitz. Beer Sheva: Negev Center for Regional Development, Ben-Gurion University of the Negev Press, 1996, pp.45-52. (The indigenous Bedouin and the Ethiopian Jewish immigrants.)

2585　FENSTER, T.　Relativism vs. universalism in planning for minority women in Israel. *Israel Social Science Research,* 12 ii (1997) pp.75-96. (Muslim Beduin & the Ethiopian Jews.)

2586　FOGIEL-BIJAOUI, S.　Women in Israel: the social construction of citizenship as a non-issue. *Israel Social Science Research,* 12 i (1997) pp.1-30. [Incl. Israeli Palestinians.]

2587　GROSSBARD-SCHECHTMAN, S. & NEUMAN, S.　The extra burden of Moslem wives: clues from Israeli women's labor supply. *Economic Development and Cultural Change,* 46 iii (1998) pp.491-517. [Jewish, Muslim & Christian women in Israel.]

2588　HERZOG, H.　A space of their own: social-civil discourses among Palestininian-Israeli women in peace organizations. *Social Politics,* 6 iii (1999) pp.344-369. (Israeli-Arab women.)

2589　HERZOG, H.　Double marginality: "Oriental" and Arab women in local politics. *Ethnic frontiers and peripheries: landscapes of development and inequality in Israel.* Ed. O.Yiftachel & A.Meir. Boulder: Westview, 1998, pp.287-307.

2590　HERZOG, Hanna.　Women's status in the shadow of security. *Security concerns: insights from the Israeli experience.* Ed. Daniel Bar-Tal, Dan Jacobson, & Aharon Klieman. Stamford: JAI, 1998, (Contemporary Studies in Sociology, 17), pp.329-346. (The Palestinian community in Israel, pp.340-342.)

2591　KRENAWI, Alean al- & GRAHAM, John R.　The story of Bedouin-Arab women in a polygamous marriage. *Women's Studies International Forum,* 22 v (1999) pp.497-509. Also online at www.sciencedirect.com/ science/journal/02775395 [Palestinians in Israel.]

2592　MANSIYA, *pseud.*　The story of the forgotten. *Women Living under Muslim Laws: Dossier,* 19 (1997) pp.120-121. Also online at www.wluml.org/english/pubs [Arab lesbian in Israel.]

2593　RADAY, Frances.　Religion and patriarchal politics: the Israeli experience. *Religious fundamentalisms and the human rights of women.* Ed. C.W.Howland. Basingstoke: Macmillan; New York: St. Martin's Press, 1999, pp.155-165. [Incl. Muslims.]

2594　ROSENHOUSE, Judith.　A comparative analysis of stories narrated by bedouin and sedentary male and female speakers. *Zeitschrift für Arabische Linguistik,* 39 (2001) pp.64-83. (Linguistic features ... stories from Israel.)

2595　SEGINER, Rachel & HALABI-KHEIR, Hoda.　Adolescent passage to adulthood: future orientation in the context of culture, age and gender. *International Journal of Intercultural Relations,* 22 iii (1998) pp.309-328. (Israeli Druze ... & Jewish ... adolescents.)

2596　SHARROCK, David.　Under siege in Jerusalem: three women caught between two cultures. *Women Living under Muslim Laws: Dossier,* 22 (1999) pp.43-46. Also online at http:// www.wluml.org/english/pubs [Israeli Arabs in West Jerusalem.]

2597　STORPER-PEREZ, Danielle & POUZOL, Valérie.　Femmes engagées pour la paix (1990-1998). Les héroïnes sont-elles fatiguées? *Confluences Méditerranée,* 26 (1998) pp.119-128. (Une palestinienne, une Israélienne, & une Palestinienne vivant en Israél.)

2598　SWIRSKI, Barbara.　The citizenship of Jewish and Palestinian Arab women in Israel. *Gender and citizenship in the Middle East.* Ed. Suad Joseph. Syracuse (USA): Syracuse University Press, 2000, pp.314-344.

Italy

Books

2599　COSTANZO, Simona.　*Migration aus dem Maghreb nach Italien: soziale und räumliche Aspekte der Handlungsstrategien maghrebinischer Migranten und Migrantinnen in Kampanien, Süditalien.* Passau: L.I.S.-Verlag, 1999 (Münchener Geographischer Hefte, 80), 223pp.

Articles

2600　CAMPANI, Giovanna.　Muslim women and discrimination - the Italian case. *Multi-level discrimination of Muslim women in Europe.* Jochen Blaschke (ed.). Berlin: Parabolis, 2000, pp.249-339.

2601　CARMIGNANI CARIDI, Settimio.　Libertà di abbigliamento e velo islamico. *Musulmani in Italia. La condizione giuridica delle comunità islamiche* / a cura di S.Ferrari. Bologna: Il Mulino, 2000, pp.223-234. [In Italy.]

2602　FAVRETTO, A. R.　Infibulation: une problème nié? Quelques brèves notes sur le problème des mutilations sexuelles en Italie. *Droit et Cultures,* 25 (1993) pp.143-147. (Femmes somaliennes.)

2603　MAHER, V.　Les femmes maghrébines et les autres femmes immigrées en Italie: une comparaison des formes d'identification et des réseaux sociaux. *El imaginario, la referencia y la diferencia: siete estudios acerca de la mujer árabe.* M.del Amo (ed.). Granada: Departamento Estudios Semíticos, 1997, pp.59-73.

2604　MAI, Nicola.　Transforming traditions: a critical analysis of the trafficking and exploitation of young Albanian girls in Italy. *The Mediterranean passage: migration and new cultural encounters in Southern Europe.* Ed. Russell King. Liverpool: Liverpool University Press, 2001, pp.258-278.

2605　RESTA, Patrizia.　Immigrazione e prostituzione. *L'immigrazione albanese in Puglia: saggi interdisciplinari* / a cura di G.Da Molin. Bari: Cacucci, 1999, pp.169-190. (Donne albanesi.)

2606　SAINT-BLANCAT, Chantal.　Le donne fra transizione ed alterità. *L'islam in Italia. Una presenza plurale* / a cura di Chantal Saint-Blancat. Rome: Lavoro, 1999, (Derive, 6), pp.141-157.

2607　SAINT-BLANCAT, C.　Les Marocaines en Vénitie: le changement sans rupture. *Migrations Société,* 10 / 55 (1998) pp.107-115.

2608　SALIH, Ruba.　Confronting modernities: Muslim women in Italy. *ISIM Newsletter,* 7 (2001) pp.1;32.

2609　SALIH, Ruba.　Reformulating tradition and modernity: Moroccan migrant women and the transnational division of ritual space. *Global Networks,* 2 iii (2002) pp.219-231. (In Europe (mainly Italy).) Also online at www.ingenta.com

2610　ZONTINI, Elisabetta.　Family formation in gendered migrations: Moroccan and Filipino women in Bologna. *The Mediterranean passage: migration and new cultural encounters in Southern Europe.* Ed. Russell King. Liverpool: Liverpool University Press, 2001, pp.231-257.

Ivory Coast

Articles

2611　PELEIKIS, A.　"Ich bin kein Symbol, eine Frau bin ich!". Weibliche Identifikationsmuster im 'Globalisierten Dorf': Südlibanon und Elfenbeinküste. *Der neue Islam der Frauen. Weibliche Lebenspraxis in der globalisierten Moderne: Fallstudien aus Afrika, Asien und Europa.* R.Klein-Hessling, S.Nökel, K.Werner (Hg.). Bielefeld: transcript Verlag, 1999, pp.208-228.

Jibuti

Articles

2612 HAMAD-ACINA, Emma Moussa & ANIS, J. Abandon précoce de l'allaitement maternel à Djibouti. *Sciences et Environnement,* 10 i (1996) pp.33-40.

Jordan

Books

2613 SHUKRI, Shirin J. A. *Arab women: unequal partners in development.* Aldershot: Avebury, 1996. 214pp. (In a rural village in Jordan.)

2614 SONBOL, Amira A. *Women of Jordan: Islam, labor, & the law.* Syracuse (USA): Syracuse University Press, 2002. 300pp.

Articles

2615 AMAWI, Abla. Gender and citizenship in Jordan. *Gender and citizenship in the Middle East.* Ed. Suad Joseph. Syracuse (USA): Syracuse University Press, 2000, pp.158-184.

2616 AMAWI, Abla M. Jordan's Leila Sharaf: an interview. *Arab women: between defiance and restraint.* Ed. Suha Sabbagh. New York: Olive Branch Press, 1996, pp.26-32.

2617 AMAWI, Abla M. Women and property rights in Islam. *Arab women: between defiance and restraint.* Ed. Suha Sabbagh. New York: Olive Branch Press, 1996, pp.151-158. (Two aspects of the question of women as they relate to debates within Islamist circles in Jordan today, women in politics and women and property.)

2618 AMAWI, Abla. Women's education in Jordan. *Arab women: between defiance and restraint.* Ed. Suha Sabbagh. New York: Olive Branch Press, 1996, pp.84-85.

2619 'ARABĪ, Muhammad Ahmad al-. Females' education and the fertility levels in Jordan 1983. *Mu'tah* (Series A), 11 v (1996) pp.267-283.

2620 ARAJI, Sharon K. & CARLSON, John. Family violence including crimes of honor in Jordan: correlates and perceptions of seriousness. *Violence against Women,* 7 v (2001) pp.586-621. Also online at http:// www.ingenta.com/journals/browse/sage/j322

2621 BOTIVEAU, B. Loi islamique et jugement moderne. (Abstract: Islamic law and modern judgement.). *Droit et Cultures,* 28 (1994) pp.25-45;100. (Deux situations, une séance de Cour d'Assises en Jordanie & un arrêt du Conseil d'Etat égyptien concernant la question de l'accès des femmes à la magistrature.)

2622 BRAND, L. A. Women and the state in Jordan: inclusion or exclusion? *Islam, gender, & social change.* Ed. Y.Yazbeck Haddad & J.L.Esposito. New York: Oxford University Press, 1998, pp.100-123.

2623 BRAND, Laurie A. Arab women and political liberalization: challenges and opportunities. *Democracy and its limits: lessons from Asia, Latin America, and the Middle East.* Howard Handelman & Mark Tessler, eds. Notre Dame: University of Notre Dame Press, 1999, pp.242-261. [Case studies of Jordan & Tunisia.]

2624 CLARK, Janine Astrid & SCHWEDLER, Jillian. Who opened the window? Women's activism in Islamist parties. *Comparative Politics,* 35 iii (2003) pp.293-312. (Jordan and Yemen between 1995 and 1998.)

2625 FAQIR, Fadia. Intrafamily femicide in defence of honour: the case of Jordan. *Third World Quarterly,* 22 i (2001) pp.65-82. Also online at www.tandf.co/journals/carfax/01436597.html

2626 FREIJ, Hanna Y. Political liberalization, gender and electoral opportunity structure: an analysis of Jordanian elections. *Journal of South Asian and Middle Eastern Studies,* 25 iii (2002) pp.27-52.

2627 JABER, Hana'. Impact de l'ajustement structurel sur l'emploi des femmes et les ménages urbains. The impact of structural adjustment on women's employment and urban households. *Jordanies,* 4 (1997) pp.148-166. [Parallel French & English text.]

2628 KAWAR, M. Implications of the young age structure of the female labour force in Amman. ([Abstract:] La main d'œuvre féminine à Amman: implications de sa structure par age.). *Amman: ville et société: the city and its society / 'Ammān: al-madīna wa-'l-mujtama'.* Ed.J.Hannoyer & Seteney Shami. Beirut: Centre d'Etudes et de Recherches sur le Moyen-Orient Contemporain, 1996, pp.233-263. [Commentary by Seteney Shami, pp.295-300.]

2629 KAWAR, M. Le travail des jeunes femmes à Amman: ses répercussions sur la structure des familles et l'organisation des lieux de travail. Young working women in Amman: workplace and household perspectives. *Jordanies,* 2 (1996) pp.107-113. [Parallel French & English text.]

2630 KAWAR, Mary. Transitions and boundaries: research into the impact of paid work on young women's lives in Jordan. *Gender and Development,* 8 ii (2000) pp.56-65. Also online at http:// www.ingentaselect.com

2631 LATTE ABDALLAH, S. Les crimes d'honneur en Jordanie. Honour crimes in Jordan. *Jordanies,* 4 (1997) pp.184-192. [Parallel French & English text.]

2632 LOWRANCE, S. R. After Beijing: political liberalization and the women's movement in Jordan. *Middle Eastern Studies,* 34 iii (1998) pp.83-102.

2633 MOGHADAM, Valentine M. Economic restructuring and the gender contract: a case study of Jordan. *Gender and global restructuring: sightings, sites and resistances.* Ed. M.H.Marchand & A.S.Runyan. London: Routledge, 2000, pp.99-115.

2634 NANES, Stefanie Eileen. Fighting honor crimes: evidence of civil society in Jordan. *Middle East Journal,* 57 i (2003) pp.112-129.

2635 POUZOL, V. "Il n'ya plus de femme au parlement jordanien": Analyse et mise en perspective du score féminin dans les élections parlementaires de novembre 1997. "The Jordanian Parliament no longer has a female deputy": Analysis and perspective on the results of women in the parliamentary elections of November 1997. *Jordanies,* 5-6 (1998) pp.261-272. [Parallel English & French text.]

2636 POUZOL, V. Les associations de femmes palestiniennes en Jordanie: du militantisme à l'action caritative: (perspectives de recherche). Associations for women of Palestinian origin in Jordan: from militancy to charity: (a research agenda). *Jordanies,* 2 (1996) pp.114-118. [Parallel French & English text.]

2637 SAWALHA, Leah. Barriers of silence: reproductive rights for women in Jordan. *Development,* 42 i (1999) pp.41-46. Also online at www.ingentaselect.com

2638 SHAMI, Seteney. Domesticity reconfigured: women in squatter areas of Amman. *Organizing women: formal and informal women's groups in the Middle East.* Ed. D.Chatty & A.Rabo. Oxford: Berg, 1997, pp.81-99.

2639 SHAMI, Seteney. Gender, domestic space, and urban upgrading: a case study from Amman. *Gender and Development,* 4 i (1996) pp.17-23. [Palestinian refugees.]

2640 TARAKI, Lisa. Islam is the solution: Jordanian Islamists and the dilemma of the modern women. *Women Living under Muslim Laws: Dossier,* 20 (1998) Also online at http:// www.wluml.org/english/pubs

2641 TARAKI, Lisa. Jordanian Islamists and the agenda for women: between discourse and practice. *Middle Eastern Studies,* 32 i (1996) pp.140-158.

2642 TARAKI, Lisa. L'Islam est la solution: les islamistes jordaniens et le dilemme de la "femme moderne". *Women Living under Muslim Laws: Dossier,* 20 (1997) pp.82-102. Also online at http:// www.wluml.org/french/pubs/pdf/dossiers/dossier20/D20fr.pdf

2643 WER, Enam al-. Why do different variables behave
 differently? Data from Arabic. *Language and society in*
 the Middle East and North Africa: studies in variation and
 identity. Ed. Yasir Suleiman. Richmond: Curzon, 1999,
 pp.38-57. (Speech of Jordanian women.)

2644 YOUNG, E. G. Palestinian women and health: a
 perspective from al-Hussein refugee camp, Amman,
 Jordan. *Arab Studies Journal / Majallat al-Dirāsāt*
 al-'Arabīya, 4 i (1996) pp.131-140.

2645 Ghayda' Khazna Katibi, historian University of Jordan.
 Al-'Usur al-Wusta, 13 ii (2001) pp.44-44. (MEM scholar
 profile.)

Kazakhstan

Books

2646 BAUER, Armin, BOSCHMANN, Nina & GREEN, David.
 Women and gender relations in Kazakhstan: the social
 cost. Manila: Asian Development Bank, 1997. 138pp.

Articles

2647 ALTMANN, F-L. Statistik sind nicht nur Zahlen ...
 Erfahrungen einer Wirtschaftswissenschaftlerin aus
 Kasachstan. *Ost-Europa,* 45 ii (1995) pp.A77-A82.

2648 BERDIGALIEVA, Rosa A. & SHAIMARDANOVA,
 Zarema D. The women of Kazakstan: the source of
 cultural development. *66th IFLA Council and General*
 Conference, Jerusalem, Israel, 13-18 August 2000:
 Conference programme and proceedings. [The Hague:]
 International Federation of Library Associations and
 Institutions, 2000, Online at www.ifla.org/IV/ifla66/papers/
 059-151e.htm

2649 HERRICK, Rebekah & SAPIEVA, Almira. Perceptions
 of women politicians in Kazakhstan. *Women & Politics,*
 18 iv (1997) pp.27-40.

2650 MICHAELS, P. A. Kazak women: living the heritage of
 a unique past. *Women in Muslim societies: diversity*
 within unity. Ed. H.L.Bodman, Nayereh Tohidi. Boulder:
 Rienner, 1998, pp.187-202.

2651 MICHAELS, P. A. Medical traditions, Kazak women, and
 Soviet medical politics to 1941. *Nationalities Papers,*
 26 iii (1998) pp.493-509.

2652 MICHAELS, Paula A. Motherhood, patriotism, and
 ethnicity: Soviet Kazakhstan and the 1936 abortion ban.
 Feminist Studies, 27 ii (2001) pp.307-333.

2653 SAKHANOVA, Goulmira & DEEB, Bothaina el-.
 Socio-economic variations in maternal health in Kazakhstan.
 CDC 27th Annual Seminar on population issues in the
 Middle East, Africa and Asia. Cairo: Cairo Demographic
 Center, 1998, (Research Monograph Series, 27; CDC
 Annual Seminar, 1997), pp.444-473.

2654 WERNER, C. A. Women and the art of household
 networking in rural Kazakstan. *Islamic Quarterly,* 41 i
 (1997) pp.52-68.

Kenya

Books

2655 HIRSCH, S. F. *Pronouncing & persevering: gender and*
 the discourses of disputing in an African Islamic court.
 Chicago: University of Chicago Press, 1998. 360pp.
 [Kenya.]

Articles

2656 BECK, Rose Marie. Ambiguous signs: the role of the
 kanga as a medium of communication. *Afrikanistische*
 Arbeitspapiere, 68 (2001) pp.157-169. [Texts on
 women's clothing in Mombasa. This volume is issued as
 Swahili Forum VIII.]

2657 DOSSA, P. A. Reconstruction of the ethnographic field
 sites: mediating identities: case study of Bohra Muslim
 woman in Lamu (Kenya). *Women's Studies International*
 Forum, 20 iv (1997) pp.505-515.

2658 KAMERI-MBOTE, Patricia G. Gender dimensions of law,
 colonialism and inheritance in East Africa: Kenyan
 women's experiences. *Verfassung und Recht in Übersee,*
 35 ii (2002) pp.373-398. [Including Muslims.]

2659 SCHMITT, E. & BECK, R-M. Leso: Spiegel islamischer
 Frauenkultur in Mombasa. *Die Gärten des Islam.* Hrsg.
 H.Forkl, J.Kalter, T.Leisten, M.Pavaloi. Stuttgart: Mayer,
 in Zusammenarbeit mit dem Linden-Museum Stuttgart,
 1993, pp.315-316. (Portugiesisch für (Taschen-)Tuch.)

Kurds

Books

2660 KARRER, Cristina. *"Sie haben unsere Männer verschleppt*
 ... ": Frauen und Krieg in Irakisch Kurdistan. Berne:
 eFeF-Verl., 1998. 190pp.

2661 SCHUMANN, G. *Mujeres en Kurdistán.* Tr. Santamaría
 Urkaregi, I. Hondarribia: Hiru, [1998], (Otras Voces, 4).
 201pp.

2662 ZANA, Leyla. *Ecrits de prison.* Textes traduits du kurde
 et du turc par Kendal Nezan. Paris: Des Femmes, 1995.
 114pp.

2663 *Women of a non-state nation: the Kurds.* Ed. Shahrzad
 Mojab. Costa Mesa: Mazda, 2001 (Kurdish Studies Series,
 3), 263pp.

Articles

2664 ALAKOM, Rohat. Kurdish women in Constantinople at
 the beginning of the twentieth century. Tr. Chyet, Michael
 L. *Women of a non-state nation: the Kurds.* Ed.
 Shahrzad Mojab. Costa Mesa: Mazda, 2001, (Kurdish
 Studies Series, 3), pp.53-70.

2665 ALLISON, Christine. Folklore and fantasy: the
 presentation of women in Kurdish oral tradition. *Women*
 of a non-state nation: the Kurds. Ed. Shahrzad Mojab.
 Costa Mesa: Mazda, 2001, (Kurdish Studies Series, 3),
 pp.181-194.

2666 BEGIKHANI, Nazand. Etre femme, kurde et irakienne.
 Monde Arabe Maghreb-Machrek, 163 (1999) pp.194-195.

2667 BEGIKHANI, Nazand. La femme kurde face à la montée
 islamiste. *Cahiers de l'Orient,* 47 (1997) pp.43-53.

2668 BÖTTCHER, A. L'élite féminine kurde de la Kaftâriyya,
 une confrérie naqshbandî damascène. *Annales de l'Autre*
 Islam, 5 (1998) pp.125-139.

2669 BÖTTCHER, Annabelle. Portraits of Kurdish women in
 contemporary Sufism. *Women of a non-state nation: the*
 Kurds. Ed. Shahrzad Mojab. Costa Mesa: Mazda, 2001,
 (Kurdish Studies Series, 3), pp.195-208. (Damascus.)

2670 BRUINESSEN, Martin van. From Adela Khanum to Leyla
 Zana: women as political leaders in Kurdish history.
 Women of a non-state nation: the Kurds. Ed. Shahrzad
 Mojab. Costa Mesa: Mazda, 2001, (Kurdish Studies Series,
 3), pp.95-112.

2671 GALLETTI, M. Donne curde in guerra. (Abstracts: Kurd
 women at war.). *Politica Internazionale,* 26 i-ii (1998)
 pp.189-194;241.

2672 GALLETTI, Mirella. Western images of women's role in
 Kurdish society. *Women of a non-state nation: the Kurds.*
 Ed. Shahrzad Mojab. Costa Mesa: Mazda, 2001, (Kurdish
 Studies Series, 3), pp.209-225. [Travel accounts &
 political reports.]

2673 HAJO, Siamend. Kurdinnen in Syrien. *AMI:*
 Anti-Militarismus Information, 26 i (1996) pp.11-16.

2674 HASSANPOUR, Amir. The (re)production of patriarchy
 in the Kurdish language. *Women of a non-state nation:*
 the Kurds. Ed. Shahrzad Mojab. Costa Mesa: Mazda, 2001,
 (Kurdish Studies Series, 3), pp.227-263.

2675 KLEIN, Janet. En-gendering nationalism: the 'woman question' in Kurdish nationalist discourse of the late Ottoman period. *Women of a non-state nation: the Kurds.* Ed. Shahrzad Mojab. Costa Mesa: Mazda, 2001, (Kurdish Studies Series, 3), pp.25-51.

2676 MCDONALD, Susan. Kurdish women and self-determination: a feminist approach to international law. *Women of a non-state nation: the Kurds.* Ed. Shahrzad Mojab. Costa Mesa: Mazda, 2001, (Kurdish Studies Series, 3), pp.135-157.

2677 MIRZELER, Mustafa Kemal. The formation of male identity and the roots of violence against women: the case of Kurdish songs, stories and storytellers. *Journal of Muslim Minority Affairs,* 20 ii (2000) pp.261-269. Also online at www.catchword.com

2678 MOJAB, Shahrzad. "Honor killing": culture, politics and theory. *Middle East Women's Studies Review,* 17 i-ii (2002) pp.1-7. Also online at http:// www.amews.org/ review/reviewarticles/mojabfinal.htm (Kurdish women.)

2679 MOJAB, Shahrzad. Conflicting loyalties: nationalism and gender relations in Kurdistan. *Of property and propriety: the role of gender and class in imperialism and nationalism* / ed. Himani Bannerji, Shahrzad Mojab, & Judith Whitehead. Toronto: University of Toronto Press, 2001, pp.116-152.

2680 MOJAB, Shahrzad. The solitude of the stateless: Kurdish women at the margins of feminist knowledge. *Women of a non-state nation: the Kurds.* Ed. Shahrzad Mojab. Costa Mesa: Mazda, 2001, (Kurdish Studies Series, 3), pp.1-21.

2681 MOJAB, Shahrzad & HASSANPOUR, Amir. Thoughts on the struggle against "honor killing". *International Journal of Kurdish Studies,* 16 i-ii (2002) pp.81-97. [As one of many forms of patriarchal violence against Kurdish & other women, in the Middle East & in Europe.]

2682 MOJAB, Shahrzad. Women and nationalism in the Kurdish Republic of 1946. *Women of a non-state nation: the Kurds.* Ed. Shahrzad Mojab. Costa Mesa: Mazda, 2001, (Kurdish Studies Series, 3), pp.71-91. [Iran.]

2683 O'SHEA, Maria. Medic, mystic or magic? Women's health choices in a Kurdish city. *Women of a non-state nation: the Kurds.* Ed. Shahrzad Mojab. Costa Mesa: Mazda, 2001, (Kurdish Studies Series, 3), pp.161-179. (In Iran.)

2684 PLOQUIN, J-C. Leyla Zana: une `détermination d'acier` pour la cause kurde. *Confluences Méditerranée,* 17 (1996) pp.159-164. (Femmes et guerres: Turquie.)

2685 SEUGERT, G. Türkei: Leyla Zana - eine Kurdin im Parlament. *Zum Beispiel Kurden.* Red. A.Metzger. Göttingen: Lamuv Verlag, 1996, pp.63-66.

2686 STARR SERED, S. The religious world of Jewish women in Kurdistan. *Jews among Muslims: communities in the precolonial Middle East.* Ed. S.Deshen & W.P.Zenner. Basingstoke: Macmillan, 1996, pp.197-214.

2687 WAITE, Louise. How is household vulnerability gendered? Female-headed households in the collectives of Suleimaniyah, Iraqi Kurdistan. *Disasters,* 24 ii (2000) pp.153-172. Also online at http:// www.ingentaselect.com

2688 WEDEL, H. Binnenmigration und ethnische Identität - Kurdinnen in türkischen Metropolen. (Zusammenfassung: Internal migration and ethnic identity - Kurdish women in Turkish metropolises.). *Orient* (Opladen), 37 iii (1996) pp.437-452;553-554.

2689 WEDEL, H. Internationales Netzwerk für kurdische Frauenstudien. *DAVO-Nachrichten,* 8 (1998) pp.111-113.

2690 WEDEL, H. Kemalistische identitätspolitik und die Kurdinnen in der Türkei. *SGMOIK/SSMOCI Bulletin,* 7 (1998) pp.8-11.

2691 WEDEL, H. Kurdinnen in türkischen Metropolen: Migration, Flucht und politische partizipation. *Ethnizität, Nationalismus, Religion und Politik in Kurdistan.* C.Borck, E.Savelsberg, S.Hajo (Hrsg.). Münster: Lit, 1997, (Kurdologie, 1), pp.155-84.

2692 WEDEL, Heidi. Kurdish migrant women in Istanbul: community and resources for local political participation of a marginalized social group. *Women of a non-state nation: the Kurds.* Ed. Shahrzad Mojab. Costa Mesa: Mazda, 2001, (Kurdish Studies Series, 3), pp.115-134.

2693 YALÇIN-HECKMANN, Lale. Some notes on the religious life of Kurdish rural women. *Annales de l'Autre Islam,* 5 (1998) pp.141-160. [Turkey.]

2694 [ZANA, Leyla]. Lettre de Leyla Zana au premier ministre turc. Tr. Ravenel, Bernard. *Confluences Méditerranée,* 34 (2000) pp.127-129. (Députée kurde de Turquie condamnée en 1994.)

2695 Kara Fatima at Constantinople. *International Journal of Kurdish Studies,* 15 i-ii (2001) pp.87-88. [Kara Fatima Hanoun, Kurdish ally of the Sultan. Reprinted from *The Illustrated London News,* 1854.]

2696 Kurdish women in history. *Kurdish Life,* 17 (1996) pp.11-12. [Vignettes from some of the writings held in the Kurdish Library.]

Kuwait

Books

2697 MUGHNI, Haya al-. *Women in Kuwait.* London: Saqi, 2001. 220pp.

Articles

2698 AARTS, P. Onderwacht cadeau voor Koeweits vrouwen. *Soera,* 7 ii (1999) pp.26-27.

2699 ALQUDSI-GHABRA, Taghreed. Women in Kuwait. *Arab women: between defiance and restraint.* Ed. Suha Sabbagh. New York: Olive Branch Press, 1996, pp.229-231.

2700 ALY, Hassan Y. & QUISI, Issa al-. Determinants of women's labour force participation in Kuwait: a logit analysis. *Middle East Business and Economic Review,* 8 ii (1996) pp.1-9.

2701 BADRAN, M. Gender, Islam, and the state: Kuwaiti women in struggle, pre-invasion to postliberation. *Islam, gender, & social change.* Ed. Y.Yazbeck Haddad & J.L.Esposito. New York: Oxford University Press, 1998, pp.190-208.

2702 CHISHTI, Salim & KHALAF, Badria. Earnings, education, experience, and gender: Kuwaiti evidence. *Earnings inequality, unemployment, and poverty in the Middle East and North Africa.* Ed. Wassim Shahin & Ghassan Dibeh. Westport: Greenwood, 2000, (Contributions in Economics and Economic History, 215), pp.153-169.

2703 KAZI, Lubna al-. Kuwaiti women and work: old boundaries and new frontiers. *Arab Journal for the Humanities / Al-Majalla al-'Arabīya li-l-'Ulūm al-Insānīya,* 18 / 69 (2000) pp.278-305.

2704 KOCH, C. Der kuwaitische Frauenverein für Kultur und Soziales. *INAMO-Beiträge,* 1 (1995) pp.51-52.

2705 LONGVA, Anh Nga. Kuwaiti women at a crossroads: privileged development and the constraints of ethnic stratification. *Arab society: class, gender, power, and development.* Ed. N.S.Hopkins, Saad Eddin Ibrahim. Cairo: American University in Cairo Press, 1997, pp.407-422. [First published 1993.]

2706 MENAYES, Jamal J. al-. Mass media use, gender and religiosity as predictors of attitudes towards Israel in Kuwait. *Gazette: the International Journal for Communication Studies,* 59 iii (1997) pp.235-246.

2707 MUGHNI, Haya al- & TÉTREAULT, Mary Ann. Citizenship, gender, and the politics of quasi states. *Gender and citizenship in the Middle East.* Ed. Suad Joseph. Syracuse (USA): Syracuse University Press, 2000, pp.237-260. (Kuwait.)

2708 MUGHNI, Haya al-. From gender equality to female
 subjugation: the changing agendas of women's groups in
 Kuwait. *Organizing women: formal and informal
 women's groups in the Middle East.* Ed. D.Chatty &
 A.Rabo. Oxford: Berg, 1997, pp.195-209.

2709 MUGHNI, Haya al-. Women's organizations in Kuwait.
 Middle East Report, 26 i / 198 (1996) pp.32-35. Also
 online at http:// www.jstor.org

2710 MUGHNI, Haya al-. Women's organizations in Kuwait.
 Women and power in the Middle East. Ed. Suad Joseph &
 Susan Slyomovics. Philadephia: University of Pennsylvania
 Press, 2001, pp.176-182;216.

2711 TÉTREAULT, Mary Ann. A state of two minds: state
 cultures, women, and politics in Kuwait. *International
 Journal of Middle East Studies,* 33 ii (2001) pp.203-220.
 Also online at http:// journals.cambridge.org

2712 TÉTREAULT, Mary Ann & MUGHNI, Haya al-. From
 subjects to citizens: women and the nation in Kuwait.
 Women, states, and nationalism: at home in the nation?
 Ed. S.Ranchod-Nilsson & Mary Ann Tétreault. London:
 Routledge, 2000, pp.143-163.

2713 TÉTREAULT, Mary Ann. Women's rights in Kuwait:
 bringing in the last Bedouins? *Current History,* 99 / 633
 (2000) pp.27-32. Also online at www.currenthistory.com

Kyrgyzstan

Books

2714 BAUER, Armin, GREEN, David & KUEHNAST,
 Kathleen. *Women and gender relations: the Kyrgyz
 Republic in transition.* Manila: Asian Development Bank,
 1997. 134pp.

Articles

2715 AITMATOVA, Roza. Wise women of Kyrgyzstan. Tr.
 Maryniak, Irena. *Index on Censorship,* 27 ii / 181 (1998)
 pp.152-154.

2716 BECKER, C. M., BIBOSUNOVA, Damira I., HOLMES,
 G. E. & IBRAGIMOVA, Margarita M. Maternal care
 vs. economic wealth and the health of newborns: Bishkek,
 Kyrgyz Republic and Kansas City, USA. *World
 Development,* 26 xi (1998) pp.2057-2072.

2717 HANDRAHAN, L.M. Gendering ethnicity in Kyrgyzstan:
 forgotten elements in promoting peace and democracy.
 Gender and Development, 9 iii (2001) pp.70-78. Also
 online at http:// www.ingentaselect.com (Women's
 potential positive role in preventing and arresting ethnic
 conflict.)

2718 HANDRAHAN, Lori M. Gender and ethnicity in the
 'transitional democracy' of Kyrgyzstan. *Central Asian
 Survey,* 20 iv (2001) pp.467-496. Also online at
 www.ingentaselect.com

2719 KUEHNAST, K. From pioneers to entrepreneurs: young
 women, consumerism, and the 'world picture' in
 Kyrgyzstan. *Central Asian Survey,* 17 iv (1998)
 pp.639-654.

2720 TADINA, N. A. Svadebnaya obryadnost' kak istochnik
 po ètnokul'turnym svyazyam kirgizov i altaïtsev.
 *Kyrgyzy: ètnogeneticheskie i ètnokul'turnye protsessy
 vdrevnosti i srednevekov'e v Tsentral'noĭ Azii. Materialy
 mezhdunarodnoĭ nauchnoĭ konferentsii,
 posvyashchennoĭ1000-letiyu èposa Manas, 22-24
 sentyabrya 1994 g., g.Bishkek.* Bishkek: Kyrgyzstan, 1996,
 pp.83-101.

Lebanon

Books

2721 ABDELNOUR, Elham Chamoun. *Asma: une jeune fille
 du Liban: roman.* Paris: L'Harmattan, 1999. 205pp.

2722 BÉCHARA, Souha & PARIS, Gilles. *Résistante.* Paris:
 Lattès, 2000. 200pp. [Lebanese war & Israeli invasion.]

2723 [BÉCHARA, Souha]. *Zehn Jahre meines Lebens für die
 Freiheit meines Landes: eine Libanesin im Widerstand /*
 Suha Bechara. Tr. Viviani, Annalisa. Kreuzlingen:
 Hugendubel, 2001. 206pp. [Tr. of *Résistante,* Paris 2000.
 Lebanese war & Israeli invasion.]

2724 BIZRI, Dalal el-. *L'ombre et son double: femmes
 islamistes, libanaises et modernes.* Beirut: Centre d'Etudes
 et de Recherches sur le Moyen-Orient Contemporain, 1995,
 (Cahiers du CERMOC, 13), 114pp.

2725 CHIKHANI-NACOUZ, Léla & ARACTINGI, P. *Les
 mères à l'épreuve du Liban: essai.* Paris: L'Harmattan,
 1993. 213pp.

2726 FIGUIÉ, Gerard & SABA SAYEGH, Rita. *Femmes du
 Liban.* Beyrouth: Anthologie, 1997. 246pp.

2727 GHOUSSOUB, Mai. *Leaving Beirut: women and the wars
 within.* London: Saqi, 1998. 187pp.

2728 KANAFANI, Fay Afaf. *Nadia, captive of hope: memoir
 of an Arab woman.* Armonk: Sharpe, 1998. 346pp.
 (Recounts experiences in Lebanon and Palestine from the
 close of World War I in 1918 to the Israeli invasion of
 Lebanon in 1982.)

2729 KHAIRALLAH, Shereen. *The sisters of men: Lebanese
 women in history.* Beirut: Institute for Women Studies in
 the Arab World, Lebanese American University, 1996.
 280pp.

2730 KHATER, Akram Fouad. *Inventing home: emigration,
 gender, and the middle class in Lebanon, 1870-1920.*
 Berkeley: University of California Press, 2001. 257pp.
 Also online at http:// escholarship.cdlib.org/
 ucpressbooks.html

2731 KHOURI, Ghada. *Women in Lebanon: the role of
 sectarianism & patriarchy in the struggle for equal rights.*
 [Buffalo:]Ohio State University, Muslim Students
 Association, 1997. Online at http:// msanews.mynet.net/
 Scholars/KhouriG/leb.html

2732 LATEEF, Nelda. *Women of Lebanon: interviews with
 champions for peace.* Jefferson: McFarland, 1997. 283pp.

2733 LORFING, I. *Women, media and sustainable development.*
 Beirut: Institute for Women Studies in the Arab World,
 Lebanese American University, 1997. 96pp. [Lebanon.]

2734 [NUWAYHID, Jamāl Salīm]. *Abu Jmeel's daughter and
 other stories: Arab folk tales from Palestine and Lebanon
 /* told by Jamal Sleem Nuweihed; tr. by members of her
 family with Christopher Tingley. New York: Interlink
 Books, 2002. 348pp.

2735 PELEIKIS, A. *Migration and gender in a global village:
 Lebanese women at home and in West-Africa: a lecture ...
 June 12, 1996.* Beirut: Orient-Institut der Deutschen
 Morgenländischen Gesellschaft, 1997, (Beyrouth Zokak
 el-Blat(t), 6), 28pp.

2736 *Women and war in Lebanon.* Ed. Lamia Rustum Shehadeh.
 Gainesville: University Press of Florida, 1999. 363pp.

Articles

2737 KUTTAB, Eileen. Case studies from Palestine and
 Lebanon. Women studies [*sic*] program in Palestine:
 between criticism and new vision. *Arab regional women's
 studies workshop. Al-Nadwa al-iqlīmīya li-dirāsāt al-mar'a
 al-'Arabīya.* Ed. C.Nelson, Soraya Altorki. Cairo:
 American University in Cairo, 1998, (Cairo Papers in
 Social Science, 20 iii (1997)), pp.118-131. (Birzeit
 University.)

2738 ABU-HABIB, Lina. The use and abuse of female domestic
 workers from Sri Lanka in Lebanon. *Gender and
 Development,* 6 i (1998) pp.52-56. Also online at http://
 www.ingentaselect.com

2739 ABU NASSR, Julinda. The effects of war on women in
 Lebanon. *Arab women: between defiance and restraint.*
 Ed. Suha Sabbagh. New York: Olive Branch Press, 1996,
 pp.95-99.

2740 ABU SABA, Mary Bentley. Profiles of foreign women in
 Lebanon during the civil war. *Women and war in
 Lebanon.* Ed. Lamia Rustum Shehadeh. Gainesville:
 University Press of Florida, 1999, pp.229-256.

2741 AMYUNI, Mona Takieddine. Libanaise, arabe, méditerranéenne: qui suis-je? *La Méditerranée des femmes*. Sous la dir. de Nabil el Haggar. Paris: L'Harmattan, 1998, pp.119-129.

2742 BARRAK, Anissa & MULLER, B. `Que suis-je sans la guerre et sans lui?` Entretien avec Marie Seurat. *Confluences Méditerranée*, 17 (1996) pp.155-158. (Femmes et guerres: Liban.)

2743 [BAYDŪN, 'Azza Sharāra]. Le fossé entre la réalité et ses expressions / Azza Charara Beydoun. Tr. Beydoun, Ahmed. *Cahiers de l'Orient*, 64 (2001) pp.129-136. (Femmes du Liban.)

2744 BEYDOUN, Sarah. Un regard sur la prostitution à travers un centre de réinsertion sociale "Dar al Amal". *Annales de Sociologie et d'Anthropologie* (Beirut), 9 / 1998 (1999) pp.149-200. (Au Liban.)

2745 BOUKHARI, Houda. Invisible victims: working with mothers of children with learning disabilities. *Gender and disability: women's experiences in the Middle East*. / Lina Abu-Habib. Oxford: Oxfam, 1997, pp.36-45. [Lebanese & Palestinians in Beirut.]

2746 CHAHAL, Nahla. La tourmente et l'oubli. *Confluences Méditerranée*, 17 (1996) pp.143-152. [Lebanon: autobiography, 1967-77.]

2747 CHEIKH, Nadia M.el-. The 1998 proposed civil marriage law in Lebanon: the reaction of the Muslim communities. *Yearbook of Islamic and Middle Eastern Law*, 5 / 1998-1999 (2000) pp.147-161.

2748 C(ORNU), G. Les costumes féminins de la grotte de Hadath. *Liban: l'autre rive. Exposition présentée à l'Institut du monde arabe ... 1998 ... 1999*. Paris: Flammarion & Institut du Monde Arabe, 1998, pp.258-259.

2749 DOUMANI, Beshara [B.]. Endowing family: *Waqf, property devolution, and gender in greater Syria, 1800 to 1860. Comparative Studies in Society and History*, 40 i (1998) pp.3-41. (Extant Islamic court records ... Nablus & Tripoli.)

2750 FAHD, Nada & others A double discrimination: blind girls' life-chances. *Gender and disability: women's experiences in the Middle East*. / Lina Abu-Habib. Oxford: Oxfam, 1997, pp.46-52. [Observations from Lebanon.]

2751 FARHOOD, Leila. War trauma and women: predisposition and vulnerability to adverse psychological health outcomes. *Women and war in Lebanon*. Ed. Lamia Rustum Shehadeh. Gainesville: University Press of Florida, 1999, pp.259-271.

2752 HABIB, Naïla. The search for home. *Journal of Refugee Studies*, 9 i (1996) pp.96-102. [Lebanese in exile.]

2753 HADDAD, Reem. A modern-day "slave trade": Sri Lankan workers in Lebanon. *Middle East Report*, 29 ii / 211 (1999) pp.39-41.

2754 HAMADEH, Najla S. Wives or daughters. Structural differences between urban and bedouin Lebanese co-wives. *Intimate selving in Arab families: gender, self, and identity*. Ed. Suad Joseph. Syracuse (USA): Syracuse University Press, 1999, pp.141-173;281-284.

2755 HAYKAL-KAYYAL, Katia. Trois biographies de françaises dans les couples mixtes franco-libanais à Tripoli. *Annales de Sociologie et d'Anthropologie* (Beirut), 9 / 1998 (1999) pp.1-148.

2756 HOLT, Maria. Lebanese Shi'i women and Islamism: a response to war. *Women and war in Lebanon*. Ed. Lamia Rustum Shehadeh. Gainesville: University Press of Florida, 1999, pp.167-194.

2757 HUSSEINI, Randa. Promoting women entrepreneurs in Lebanon: the experience of UNIFIM. *Gender and Development*, 5 i (1997) pp.49-52. Also online at http:// www.ingentaselect.com (United Nations Development Fund for Women.)

2758 JOSEPH, Suad. Brother/sister relationships: connectivity, love, and power in the reproduction of patriarchy in Lebanon. *Arab society: class, gender, power, and development*. Ed. N.S.Hopkins, Saad Eddin Ibrahim. Cairo: American University in Cairo Press, 1997, pp.227-261. [First published 1994.]

2759 JOSEPH, Suad. Brother-sister relationships. Connectivity, love, and power in the reproduction of patriarchy in Lebanon. *Intimate selving in Arab families: gender, self, and identity*. Ed. Suad Joseph. Syracuse (USA): Syracuse University Press, 1999, pp.113-140;273-281.

2760 JOSEPH, Suad. Civic myths, citizenship, and gender in Lebanon. *Gender and citizenship in the Middle East*. Ed. Suad Joseph. Syracuse (USA): Syracuse University Press, 2000, pp.107-136.

2761 JOSEPH, Suad. Civil society, the public/private, and gender in Lebanon. *Social constructions of nationalism in the Middle East* / ed. Fatma Müge Göçek. Albany (USA): State University of New York Press, 2002, pp.167-189.

2762 JOSEPH, Suad. Marcel: straddling visible and invisible Lebanese economies. *Middle Eastern women and the invisible economy*. Ed. R.A.Lobban. Gainesville: University Press of Florida, 1998, pp.233-244.

2763 JOSEPH, Suad. My son/myself, my mother/myself. Paradoxical relationalities of patriarchal connectivity. *Intimate selving in Arab families: gender, self, and identity*. Ed. Suad Joseph. Syracuse (USA): Syracuse University Press, 1999, pp.174-190;284-285. [Christian village in Lebanon.]

2764 JOSEPH, Suad. The reproduction of political process among women activists in Lebanon: 'shopkeepers' and feminists. *Organizing women: formal and informal women's groups in the Middle East*. Ed. D.Chatty & A.Rabo. Oxford: Berg, 1997, pp.57-80.

2765 KARAM, Elie G. Women and the Lebanon wars: depression and post-traumatic stress disorder. *Women and war in Lebanon*. Ed. Lamia Rustum Shehadeh. Gainesville: University Press of Florida, 1999, pp.272-281.

2766 KARAMÉ, Kari H. Maman Aida: a Lebanese godmother of the combatants: fighting without arms. *Women and war in Lebanon*. Ed. Lamia Rustum Shehadeh. Gainesville: University Press of Florida, 1999, pp.195-208.

2767 KHATER, Akram Fouad. `House' to `Goddess of the house': gender, class, and silk in 19th century Mount Lebanon. *International Journal of Middle East Studies*, 28 iii (1996) pp.325-348.

2768 [KHUWAYRĪ, Jusalin]. From gunpowder to incense / Jocelyn Khweiri. Tr. Shehadeh, Lamia Rustum. *Women and war in Lebanon*. Ed. Lamia Rustum Shehadeh. Gainesville: University Press of Florida, 1999, pp.209-226.

2769 KLAES, Ursula. "Ich habe in der Wissenschaft mein Glück gefunden" - zur Bedeutung von Bildung bei Frauen in der libanesischen Hizb Allah. *Der neue Islam der Frauen. Weibliche Lebenspraxis in der globalisierten Moderne: Fallstudien aus Afrika, Asien und Europa.* R.Klein-Hessling, S.Nökel, K.Werner (Hg.). Bielefeld: transcript Verlag, 1999, pp.200-207.

2770 LABAKI, Boutros. Les femmes dans la filature libanaise de soie en fin de période ottomane. *Industrialisation, communication et rapports sociaux en Turquie et en Méditerranée orientale. Actes du colloque de Paris-UNESCO ... 1991*. Ed. J.Thobie & Salgur Kançal en collaboration avec Aksel Tibet & F.Hitzel. Paris: L'Harmattan, 1994, (Varia Turcica, 20), pp.203-210.

2771 LAKKIS, Sylvana. Mobilising women with physical disabilities: the Lebanese Sitting Handicapped Association. *Gender and disability: women's experiences in the Middle East*. / Lina Abu-Habib. Oxford: Oxfam, 1997, pp.28-35.

2772 MAKDISI, Jean Said. Powerlessness and power: women and the war in Lebanon. *Women: a Cultural Review*, 8 i (1997) pp.89-91.

2773 MAKDISI, Jean Said. The mythology of modernity: women and democracy in Lebanon. *Feminism and Islam: legal and literary perspectives*. Ed. Mai Yamani. Reading: Ithaca, for the Centre of Islamic and Middle Eastern Law, School of Oriental and African Studies, University of London, 1996, pp.231-250.

2774 MAKSOUD, Hala. The case of Lebanon. *Arab women: between defiance and restraint*. Ed. Suha Sabbagh. New York: Olive Branch Press, 1996, pp.89-94.

2775 MEHANNA, Zeina J. La fonction paternelle et ses effets chez des filles universitaires libanaises. *Annales de Psychologie et des Sciences de l'Education*, 16 / 2000 (2001) pp.83-111.

2776 MOKBEL-WENSLEY, Souad. Statutory discrimination in Lebanon: a lawyer's view. *Feminism and Islam: legal and literary perspectives*. Ed. Mai Yamani. Reading: Ithaca, for the Centre of Islamic and Middle Eastern Law, School of Oriental and African Studies, University of London, 1996, pp.321-329.

2777 NAMMOUR, Magda. L'image de la femme occidentale dans la presse libanaise entre 1858 et 1914. *Les Européens vus par les Libanais à l'époque ottomane*. Ed. B.Heyberger et C-M.Walbiner. Beirut: Orient-Institut der Deutschen Morgenländischen Gesellschaft; Würzburg: Ergon, 2002, (Beiruter Texte und Studien, 74), pp.141-173.

2778 NOTTARIS, I. Femmes fantômes au royaume du paradoxe. *Confluences Méditerranée*, 17 (1996) pp.133-140. (Femmes et guerres: Liban.)

2779 PELEIKIS, A. "Ich bin kein Symbol, eine Frau bin ich!". Weibliche Identifikationsmuster im 'Globalisierten Dorf': Südlibanon und Elfenbeinküste. *Der neue Islam der Frauen. Weibliche Lebenspraxis in der globalisierten Moderne: Fallstudien aus Afrika, Asien und Europa*. R.Klein-Hessling, S.Nökel, K.Werner (Hg.). Bielefeld: transcript Verlag, 1999, pp.208-228.

2780 PETEET, J. Icons and militants: mothering in the danger zone. *Signs*, 23 i (1997) pp.103-129. [In camps in Lebanon, 1968-82.]

2781 PETEET, Julie. Gender and sexuality: belonging to the national and moral order. *Hermeneutics and honor: negotiating female "public" space in Islamic/ate societies*. Ed. Asma Afsaruddin. Cambridge (USA): Harvard University Press, for the Center for Middle Eastern Studies of Harvard University, 1999, (Harvard Middle Eastern monographs, 32), pp.70-88. [Palestinians in Lebanon 1968-1982, & in Palestine 1987-91.]

2782 PETEET, Julie. Mothering in the danger zone. *Gender, politics, and Islam*. Ed. Therese Saliba, Carolyn Allen and Judith A.Howard. Chicago: University of Chicago Press, 2002, pp.133-159. [In camps in Lebanon, 1968-82. Originally published in *Signs*, 23 i (1997).]

2783 PETEET, Julie. Nationalism and sexuality in Palestine. *Social constructions of nationalism in the Middle East* / ed. Fatma Müge Göçek. Albany (USA): State University of New York Press, 2002, pp.141-165. [PLO & Palestinian women in Lebanon 1968-82.]

2784 PETEET, Julie. Women and the Palestinian movement: no going back? *Women and power in the Middle East*. Ed. Suad Joseph & Susan Slyomovics. Philadephia: University of Pennsylvania Press, 2001, pp.135-149;213-214. (1968-82, Lebanon.)

2785 SABBAGH, Suha. Lebanon's civil war through different eyes: an interview with Jean Said Makdisi. *Arab women: between defiance and restraint*. Ed. Suha Sabbagh. New York: Olive Branch Press, 1996, pp.100-103.

2786 SAYIGH, R. Researching gender in a Palestinian camp: political, theoretical and methodological problems. *Gendering the Middle East: emerging perspectives*. Ed. Deniz Kandiyoti. London: Tauris, 1996, pp.145-167. (In Lebanon.)

2787 SAYIGH, Rosemary. Femmmes réfugiées, narratrices de l'histoire. Tr. Polo, A-L. *Revue d'Etudes Palestiniennes*, N.S.16 / 68 (1998) pp.30-42. [In Lebanon.]

2788 SAYIGH, Rosemary. Palestinian camp women as tellers of history. *Journal of Palestine Studies*, 27 ii / 106 (1998) pp.42-58. [In Lebanon.]

2789 SAXENA, P. C. & AOUN, Habbouba Y. Women's education, economic activity and fertility: relationship (a study based on a Lebanese community). *Al-Abhath*, 45 (1997) pp.25-39.

2790 SHEHADEH, Lamia Rustum. Art, the chemistry of life. *Women and war in Lebanon*. Ed. Lamia Rustum Shehadeh. Gainesville: University Press of Florida, 1999, pp.129-141. [Reaction to the war of Lebanese artists, many of them Christians.]

2791 SHEHADEH, Lamia Rustum. The legal status of married women in Lebanon. *International Journal of Middle East Studies*, 30 iv (1998) pp.501-519.

2792 SHEHADEH, Lamia Rustum. Women in the Lebanese militias. *Women and war in Lebanon*. Ed. Lamia Rustum Shehadeh. Gainesville: University Press of Florida, 1999, pp.145-166.

2793 SHEHADEH, Lamia Rustum. Women in the public sphere. *Women and war in Lebanon*. Ed. Lamia Rustum Shehadeh. Gainesville: University Press of Florida, 1999, pp.45-70.

2794 SLIM, Souad & DUPONT, Anne-Laure. La vie intellectuelle des femmes à Beyrouth dans les années 1920 à travers la revue *Minerva*. *Revue des Mondes Musulmans et de la Méditerranée*, 95-96-97-98 (2002) pp.381-406. (Revue animée par des femmes greques-orthodoxes, elle défendait à la fois le nationalisme arabe et la cause des femmes arabes.)

2795 TOUMA, Viviane Matar. Séparation précoce père/fille et engagement de vie. *Annales de Psychologie et des Sciences de l'Education*, 16 / 2000 (2001) pp.69-82. (Société libanaise.)

2796 WARD, S. Dhimmi women and mourning. *Islamic legal interpretation: muftis and their fatwás*. Ed. Muhammad Khalid Masud, B.Messick, D.S.Powers. Cambridge: Harvard University Press, 1996, pp.87-97;342-344. (Requests for fatwas ... sent from Tripoli ... to Taqi al-Din al-Subki.)

2797 WEHBI, Samantha. "Women with nothing to lose": marriageability and women's perceptions of rape and consent in contemporary Beirut. *Women's Studies International Forum*, 25 iii (2002) pp.287-300. Also online at http:// www.sciencedirect.com/science/journal/ 02775395

2798 WITTKOWSKI, K. M. & others. Knowledge of risks of HIV infection and methods of prevention among women in three Beirut hospitals. *Reproductive health and infectious disease in the Middle East*. Ed. R.Barlow, J.W.Brown. Aldershot: Ashgate, 1998, pp.175-190.

2799 YABROUDI, P. & others. Substance use and abuse: the Lebanese female and the Lebanon wars. *Women and war in Lebanon*. Ed. Lamia Rustum Shehadeh. Gainesville: University Press of Florida, 1999, pp.282-320.

2800 YAHFOUFI, Najwa el. Les rôles conjugaux et la structure familiale au Liban. *Annales de Psychologie et des Sciences de l'Education*, 10-11, 1994- (1995) pp.163-180.

2801 ZAKHARIA, Leila F. & TABARI, Samia. Health, work opportunities and attitudes: a review of Palestinian women's situation in Lebanon. *Journal of Refugee Studies*, 10 iii (1997) pp.411-429.

Libya

Books

2802 DARGEL, C. & PLAMBÖCK, I. `Sie behält das Haus': Frauenpolitik in Libyen. Hamburg: Theorie-und-Praxis, 1994. 144pp.

2803 QADHDHĀFĪ, Mu'ammar al-. *Khadaffi parle: de l'Afrique, des femmes, de l'Islam, de l'Amérique, de la littérature des Arabes, des Juifs, du terrorisme de l'Occident*. Paris: ABC, 1993. 180pp. [Interviews.]

Articles

2804 EBERT, H. Das Personenstandsrecht in Libyen unter besonderer Berücksichtigung der Stellung der Frau. *Libyen im 20. Jahrhundert: zwischen Fremdherrschaft und nationaler Selbstbestimmung*. Hrsg. S.Frank & M.Kamp. Hamburg: Deutsches Orient-Institut, 1995, (Mitteilungen des Deutschen Orient-Institut, 52), pp.149-164.

2805 PISTOR-HATAM, A. Reisebeschreibungen aus einer vergessenen Provinz: 'Abdülqādir Gāmī Bey und die Frauen des Fezzān. *Wiener Zeitschrift für die Kunde des Morgenlandes*, 89 (1999) pp.163-186.

Literatures

GENERAL

Books

Books

2806 *Feminism and Islam: legal and literary perspectives.* Ed.
Yamani, Mai. Reading: Ithaca, for the Centre of Islamic
and Middle Eastern Law, School of Oriental and African
Studies, University of London, 1996. 385pp.

2807 *Femmes écrivains en Méditerranée.* Sous la dir. de Vassiliki
Lalagianni. Paris: Publisud, 1999. 201pp.

2808 *Hoops of fire: fifty years of fiction by Pakistani women* / ed.
Aamer Hussein. London: Saqi, 1999. 175pp.

2809 *So that you can know me: an anthology of Pakistani women
writers.* Ed. Yasmin Hameed & Asif Aslam Farrukhi.
Reading: Garnet & Unesco Publishing, 1997. 167pp.
(Translations from the Punjabi, the Pushto, the Seraiki, the
Sindhi & the Urdu.)

Articles

2810 BAMIA, Aida, EROL, Sibel, ALJEFFRI, Shariafah Zuriah
& KASSAM-HAHN, Zayn. Muslim women writers.
*The Muslim almanac: a reference work on the history,
faith, culture, and peoples of Islam.* Ed. Azim A.Nanji.
Detroit: Gale Research Inc., 1996, pp.391-405. [In
classical & modern Arabic, modern Turkish, in classical
Persian, in Malay, & in modern South Asian languages.]

2811 NAJMABADI, Afsaneh. Reading - and enjoying - "wiles
of women" stories as a feminist. *Iranian Studies,* 32 ii /
1999 (2000) pp.203-222. [Stories from the *1001 Nights*
& *Sindbādnāmah.*]

2812 PONZANESI, Sandra. Writing against the grain: African
women's texts on female infibulation as literature of
resistance. *Indian Journal of Gender Studies,* 7 ii (2000)
pp.303-318. [Nawāl al-Sa'dāwī, Alice Walker & Sirad
S.Hassan.]

2813 STOFFERAHN, Steven A. New reflections in medieval
mirrors: reinterpreting images of women in *Andarz* and
Akhlāq literature. *Jusūr,* 14 (1998) pp.35-54. [Pahlavi,
Turkish & Persian texts from 3rd to 15th centuries CE.]

2814 ZABUS, Chantal. Writing women's rites: excision in
experiential African literature. *Women's Studies
International Forum,* 24 iii-iv (2001) pp.335-345.
[Anglophone & Francophone literature, incl. Muslims.]
Also online at ww.sciencedirect.com/science/journal/
02775395

ALBANIAN

Books

2815 GUSHI-KADARÉ, Helena. *Une femme de Tirana: roman.*
Tr. Vrioni, Jusuf & Autissier, A-M. Paris: Stock, 1995.
266pp. [Tr. of *Një grua nga Tirana.*]

2816 KADARE, Helena. *Një grua nga Tirana: roman.* Tirana:
MCM, [1994?], (Konstelacione, 2). 177pp.

AMHARIC

Articles

2817 ASFAW, Zerihun. Women in the works of Ethiopian short
story writers. *Ethiopia in broader perspective. Papers
of the XIIIth International Conference of Ethiopian Studies,
Kyoto ... 1997.* Volume III. Ed. Katsuyoshi Fukui, Eisei
Kurimoto, Masayoshi Shigeta. Kyoto: Shokado, 1997,
pp.118-127. [In Amharic, incl. Mohammed Ali.]

ARABIC - PRE-MODERN

Books

Books

2818 ASMA'U, Nana. *Collected works of Nana Asma'u,
daughter of Usman dan Fodiyo, (1793-1864)* [edited] by
J.Boyd & B.B.Mack. East Lansing: Michigan State
University Press, [1997], (African Historical Sources
Series, 9). 753pp. [Works in Hausa, Fulfulde & Arabic.]

2819 BORG, G. *Mit Poesie vertreibe ich den Kummer meines
Herzens: eine Studie zur altarabischen Trauerklage der
Frau.* Leiden: Nederlands Historisch-Archaeologisch
Instituut te Istanbul, 1997, (Uitgaven van het Nederlands
Historisch-Archaeologisch Instituut te İstanbul, 81),
256pp.

2820 CHEBEL, Malek J. *La féminisation du monde: essai sur
les Mille et Une Nuits.* Paris: Payot & Rivages, 1996.
310pp.

2821 ḤAWRĀNĪ, 'Abd al-Raḥīm al-. *Désirs de femme.* Ed.
établie sur les manuscrits originaux par René R.Khawam.
Paris: Phébus, 1996. 184pp.

2822 ḤAWRĀNĪ, 'Abd al-Raḥīm al-. *Les femmes et les rois.*
Traduit sur les manuscrits originaux par René R.Khawam.
Paris: Esprit des Péninsules, 2000. 157pp.

2823 ḤAWRĀNĪ, 'Abd al-Raḥīm al-. *Les ruses des femmes.*
Trad. de l'arabe; texte établi sur les manuscrits originaux
par R.R.Khawam. Paris: Phebus, 1994. 245pp.

2824 [JĀḤIẒ, Abū 'Uthmān 'Amr b.Baḥr al-]. *Ephèbes et
courtisanes* / Al-Jahiz; trad. Maati Kabbal; préface & notes
de Malek Chebel. Paris: Payot & Rivages, 1997. 185pp.
[Tr. of *Mufākharat al-jawārī wa-'l-ghilmān.*]

2825 PENNACCHIETTI, F. A. *Susanna nel deserto: riflessi
di un racconto biblico nella cultura arabo-islamica.* Turin:
S. Zamorani, 1998. 125pp. [Incl. Arabic text of MS.Gotha
Orient.A2756 with Italian trans.]

2826 ROUHI, Leyla. *Mediation and love: a study of the
medieval go-between in key Romance and Near-Eastern
texts.* Leiden: Brill, 1999 (Brill's Studies in Intellectual
History, 93), 311pp. [Ch. 3: The medieval Near-Eastern
go-between, pp.135-203; Ch. 4: The medieval Spanish
alcahueta, pp.204-285. Persian & Arabic literature & its
influence in Spain.]

2827 ṢUBḤ, Maḥmūd. *Poetisas arábigo-andaluzas* / Mahmud
Sobh. 2a ed. Granada: Diputación Provincial, 1994,
(Biblioteca de Ensayo, 5), 152pp. [Arabic & Spanish.
Arabic title: *Al-shawā'ir al-Andalusīyāt.*]

2828 [THA'LABĪ, Abū Isḥāq Aḥmad al-]. *Storia di Bilqīs,
regina di Saba* / Ta'labī. A cura di G.Canova. Venice:
Marsilio, 2000. 108pp.

2829 *Classical poems by Arab women* [compiled by] Abdullah
al-Udhari. London: Saqi Books, 1999. 240pp. [Arabic
texts with facing English translations.]

2830 [NUWAYHIḌ, Jamāl Salīm]. *Abu Jmeel's daughter and
other stories: Arab folk tales from Palestine and Lebanon*
/ told by Jamal Sleem Nuweihed; tr. by members of her
family with Christopher Tingley. New York: Interlink
Books, 2002. 348pp.

Articles

2831 ALLIBERT, C. L'Ile des Femmes dans les récits arabes.
Études Océan Indien, 15 / 1992 (1993) pp.261-267.

2832 ATTAR, Samar & FISCHER, Gerhard. Promiscuidad,
emancipación, sumisión: el proceso educador y
establecimiento de un model de actuación femenino en la
historia marco de la 1001 Noches. *Anaquel de Estudios
Arabes,* 10 (1999) pp.9-27.

2833 BEN YAÏCHE, Hichem. La féminisation du monde: un
entretien avec Malek Chebel. *Hommes & Migrations,*
1210 (1997) pp.167-169. [Author of *La féminisation du
monde: essai sur Les Mille et une Nuits.*]

2834 BETTINI, L. Trois contes féminins du moyen Euphrate.
 *Dialectologia arabica: a collection of articles in honour
 of the sixtieth birthday of Professor Heikki Palva.* Helsinki:
 Finnish Oriental Society, 1995, (Studia Orientalia, 75),
 pp.25-40.

2835 BORG, Gert. Lust and carnal desire: obscenities attributed
 to Arab women. *Arabic and Middle Eastern Literatures,*
 3 ii (2000) pp.149-164. (Medieval Arabic literature).
 Also online at www.catchword.com

2836 CASTILLO CASTILLO, C. Una versión del `Relato de
 la mujer que hablaba según El Corán'. *Verse and the fair
 sex: studies in Arabic poetry and in the representation of
 women in Arabic literature. A collection of papers
 presented at the 15th Congress of the Union Européenne
 des Arabisants et Islamisants (Utrecht/Driebergen ...
 1990).* Ed. F.de Jong. Utrecht: Houtsma Stichting, 1993,
 pp.101-113.

2837 CHEIKH, Nadia Maria el. In search for the ideal spouse.
 Journal of the Economic and Social History of the Orient,
 45 ii (2002) pp.179-196. Also online at http://
 www.ingentaselect.com (Material related to marriage in
 two *adab* anthologies, namely the *'Uyūn al-akhbār* of Ibn
 Qutayba and *al-'Iqd al-farīd* of Ibn 'Abd Rabbihi.)

2838 CHEIKH, Nadia Maria el-. Women's history: a study of
 al-Tanūkhī. *Writing the feminine: women in Arab
 sources.* Ed. by Manuela Marín and Randi Deguilhem.
 London: Tauris, in association with The European Science
 Foundation, Strasbourg, France, 2002, (The Islamic
 Mediterranean, 1), pp.129-148.

2839 ELIAS, Jamal J. The *Hadīth* traditions of 'Ā'isha as
 prototypes of self-narrative. *Edebiyat,* N.S. 7 ii (1997)
 pp.215-233.

2840 ENDERWITZ, S. Wer ist Fauz? Zur Realität der Geliebten
 im Arabischen *Ġazal. Verse and the fair sex: studies in
 Arabic poetry and in the representation of women in Arabic
 literature. A collection of papers presented at the 15th
 Congress of the Union Européenne des Arabisants et
 Islamisants (Utrecht/Driebergen ... 1990).* Ed. F.de Jong.
 Utrecht: Houtsma Stichting, 1993, pp.56-65. (Geliebte
 von 'Abbās b.al-Aḥnaf.)

2841 ENNAIFAR, Elias. Zobéide, Charlus, Paquita ... Une
 interprétation d'un conte des *Mille et Une Nuits. IBLA,*
 62 / 184 (1999) pp.169-185. (Œuvres de Masoch, Sade,
 Balzac & Baudelaire.)

2842 ERYAN, Hany Muhammad el-. Las mujeres y el
 matrimonio en el *Kitāb al-'Iqd al-farīd* de Ibn 'Abd
 Rabbihi al-Andalusī. *Sharq al-Andalus,* 10-11, 1993-94,
 pp.313-323.

2843 GALMÉS DE FUENTES, Alvaro. La "Dama Sabiduría"
 en Ibn Ḥazm y en Dante. *Alifbâ,* 16 (1994) pp.41-47.

2844 GARCIA-CASADO, M. *Zaziya el-Hilalia* ou l'articulation
 d'une parole féminine. *Littérature & oralité au Maghreb:
 hommage à Mouloud Mammeri.* Paris: L'Harmattan, 1993,
 (Itinéraires & Contacts de Cultures, 15-16/1992),
 pp.113-120. (A travers le folklore des *Bani-Hilal* du sud
 Tunisien.)

2845 GARULO, T. Fidelidad e infidelidad femeninas: dos
 ejemplos paradigmáticos. *Verse and the fair sex: studies
 in Arabic poetry and in the representation of women in
 Arabic literature. A collection of papers presented at the
 15th Congress of the Union Européenne des Arabisants
 et Islamisants (Utrecht/Driebergen ... 1990).* Ed. F.de Jong.
 Utrecht: Houtsma Stichting, 1993, pp.114-138. (El caso
 de 'Ātika bint Zayd ... el caso de Nā'ila bint al-Farāfiṣa.)

2846 GARULO, Teresa. Women in medieval classical Arabic
 poetry. *Writing the feminine: women in Arab sources.*
 Ed. by Manuela Marín and Randi Deguilhem. London:
 Tauris, in association with The European Science
 Foundation, Strasbourg, France, 2002, (The Islamic
 Mediterranean, 1), pp.25-40.

2847 GNEMMI, A. Schéhérazade ou la source de miel. *Le
 baiser: premières leçons d'amour.* Dir. par Gérald Cahen.
 Paris: Editions Autrement, 1997, (Autrement: Collection
 Mutations, 169), pp.195-208.

2848 GOLDENBERG, M. La femme dans les Mille et une Nuits,
 de l'image à la réalité. *Cahier d'Études Maghrébines,*
 6-7 (1994) pp.275-276.

2849 GRUENDLER, Beatrice. Lightning and memory in poetic
 fragments from the Muslim West. Ḥafṣah bint al-Ḥājj (d.
 1191) and Sārah al-Ḥalabiyyah (d. c. 1300). *Crisis and
 memory in Islamic societies. Proceedings of the third
 Summer Academy of the Working Group Modernity and
 Islam held at the Orient Institute of the German Oriental
 Society in Beirut /* ed. Angelika Neuwirth and Andreas
 Pflitsch. Beirut: Orient-Institut der Deutschen
 Morgenländischen Gesellschaft; Würzburg: Ergon, 2001,
 (Beiruter Texte und Studien, 77), pp.435-452.
 [Al-Andalus & Morocco.]

2850 JUILLARD-BEAUDAN, C. Le triangle amoureux: le
 soufisme, la femme et l'amour. *Cahiers de l'Orient,* 50
 (1998) pp.131-138. (Littérature soufie.)

2851 KAHF, Mohja. Braiding the stories. Women's eloquence
 in the early Islamic era. *Windows of faith: Muslim women
 scholar-activists in North America.* Ed. G.Webb. Syracuse:
 Syracuse University Press, 2000, pp.147-171. (Women's
 compositions in the religio-historical corpus.)

2852 KRUK, R. Back to the boudoir: Arabic versions of the
 Sīrat al-amīr Ḥamza, warrior princesses, and the *Sīra's*
 literary unity. *Der muoz mir süezer worte jehen: Liber
 amicorum für Norbert Voorwinden.* Hrsg. L.Jongen u.
 S.Onderlinden. Amsterdam: Rodopi, 1997, (Amsterdamer
 Beiträge zur Älteren Germanistik, 48), pp.129-148.

2853 KRUK, R. The bold and the beautiful: women and 'fitna'
 in the 'Sīrat Dhāt al-Himma': the story of Nūrā. *Women
 in the medieval Islamic world: power, patronage, and
 piety.* Ed. G.R.G.Hambly. Basingstoke: Macmillan, 1998,
 (The New Middle Ages, 6), pp.99-116. (Arabian epic
 literature.)

2854 KRUK, Remke. Click of needles: polygamy as an issue
 in Arabic popular epic. *Writing the feminine: women in
 Arab sources.* Ed. by Manuela Marín and Randi
 Deguilhem. London: Tauris, in association with The
 European Science Foundation, Strasbourg, France, 2002,
 (The Islamic Mediterranean, 1), pp.3-23.

2855 LEEUWEN, Richard van. Traduire Shéhérazade.
 Translating Shahrazad. Tr. Demange, Odile.
 Transeuropéennes, 22 (2002) pp.89-99. [Parallel French
 & English text.]

2856 MAAOUIA, Abdallah. La femme et l'amour chez Ibn al
 Muqaffa. *Actes du colloque: L'homme, la femme et les
 relations amoureuses dans l'imaginaire arabo-musulman,
 Tunis ... 1992 / Ashghāl multaqá: Al-Rajul wa-'l-mar'a
 wa'l-ḥubb fī 'l-khayāl al-'Arabī al-Islāmī.* Tunis: Université
 des Lettres, des Arts et des Sciences Humaines, Tunis I,
 Centre d'Etudes et de Recherches Economiques et Sociales,
 Tunis, 1995, (Cahier du C.E.R.E.S. Série Psychologie, 8),
 pp.35-45.

2857 MACK, Beverly. "This will (not) be handled by the press:"
 problems - and their solution - in preparing camera-ready
 copy for *The collected works of Nana Asma'u, 1793-1864.
 History in Africa,* 25 (1998) pp.161-169.

2858 MALTI-DOUGLAS, Fedwa. Shahrazād feminist. The
 Thousand and One Nights *in Arabic literature and society.*
 Ed. R.G.Hovannisian & Georges Sabagh. Cambridge:
 Cambridge University Press, 1997, pp.40-55.

2859 MASPOCH BUENO, S. Retratos femeninos en poesía
 hebrea, árabe y castellana medieval. *Proyección histórica
 de España en sus tres culturas: Castilla y León, América
 y el Mediterráneo.* Vol. II: *Lengua y literatura española
 e hispanoamericana.* E.Lorenzo Sanz *(coord.).* Valladolid:
 Junta de Castilla y León, Consejería de Cultura y Turismo,
 1993, pp.461-473.

2860 MORAL, C. del. Poesía de mujer, poesía de hombre: la
 diferencia del género en la lírica andalusí. *Árabes, judías
 y cristianas: mujeres en la Europa medieval.* Ed. C.del
 Moral. Granada: Universidad de Granada, 1993,
 pp.173-193.

2861 MOTOYOSHI, Akiko. Sensibility and synaesthesia: Ibn
 al-Rūmī's singing slave-girl. *Journal of Arabic Literature,*
 32 i (2001) pp.1-29. [Incl. Arabic text.]

2862 NEUWIRTH, A. A quarrelling couple in court: Al-Ḥarīrī's
 presentation of an archetypal scenario bearing hidden
 political dimensions. *Fī miḥrab al-ma'rifah: Festschrift
 for Iḥsān 'Abbās.* Edited by Ibrāhīm as-Sa'āfīn. Beirut:
 Dar Sader & Dar al-Gharb al-Islami, 1997, pp.35-47.

2863 PINCKNEY STETKEVYCH, S. Sarah and the hyena: laughter, menstruation, and the genesis of a double entendre. *Mélanges de Science Religieuse,* 53 i (1996) pp.13-41. (The Arabic verb *ḍaḥikat/taḍḥaku* ... in two loci classici, one poetic, the other Qur'anic.)

2864 RABADÁN CARRASCOSA, M. La *jurayfiyya* o cuento fantástico: un medio de evasión para la mujer palestina. (Abstract: The *jurayfiyya*, or fantastic story: a means of evasion for Palestinian women.). *Estudios de Asia y Africa,* 30 i / 96 (1995) pp.7;123-137.

2865 RAMSAY, G. En arabisk förmoder. *Kvinnovetenskaplige Tidskrift,* 18 iii-iv (1997) pp.59-61. (Al-Khansā'.)

2866 REJEB, Souad. Le désir féminin dans les Mille et Une Nuit(s). *Actes du colloque: L'homme, la femme et les relations amoureuses dans l'imaginaire arabo-musulman, Tunis ... 1992 / Ashghāl multaqá: Al-Rajul wa-'l-mar'a wa'l-ḥubb fī 'l-khayāl al-'Arabī al-Islāmī.* Tunis: Université des Lettres, des Arts et des Sciences Humaines, Tunis I, Centre d'Etudes et de Recherches Economiques et Sociales, Tunis, 1995, (Cahier du C.E.R.E.S. Série Psychologie, 8), pp.15-24.

2867 ROBINSON, Cynthia. The lover, his lady, her lady, and a thirteenth-century Celestina: a recipe for love sickness from al-Andalus. *Islamic art and literature.* Oleg Grabar, Cynthia Robinson, eds. Princeton: Wiener, 2001, pp.79-115. [Illustrated MS of *Bayāḍ wa-Riyāḍ* in Vatican.]

2868 ROSENTHAL, F. Male and female: described and compared. *Homoeroticism in classical Arabic literature.* Ed. J.W.Wright & E.K.Rowson. New York: Columbia University Press, 1997, pp.24-54. (Two fifteenth-century monographs.)

2869 SAJDI, Dana al-. Trespassing the male domain: the *Qaṣīdah* of Laylā al-Akhyaliyyah. *Journal of Arabic Literature,* 31 ii (2000) pp.121-146. [Incl. Arabic text.]

2870 SALLIS, E. Sheherazade/Shahrazād: rereading the frame tale of the *1001 Nights. Arabic and Middle Eastern Literatures,* 1 ii (1998) pp.153-167.

2871 SHA'ABAN, Bouthaina. Arab women and literature: an overview. *Arab women: between defiance and restraint.* Ed. Suha Sabbagh. New York: Olive Branch Press, 1996, pp.235-237.

2872 SOBH, Mahmud. *Cuarteta de amor divino* de Rābi'a al-'Adawiyya. *Miscelánea de Estudios Arabes y Hebraicos: Sección Arabe-Islam,* 51 (2002) pp.395-404. (Primera mujer *ṣūfī* del Islam.) [Trans. into Spanish.]

2873 TALMON, Adi. Tawaddud - the story of a majlis. *The majlis: interreligious encounters in medieval Islam.* Ed. H.Lazarus-Yafeh, M.R.Cohen, S.Somekh, S.H.Griffith. Wiesbaden: Harrassowitz, 1999, (Studies in Arabic Language and Literature, 4), pp.120-127. [In Arabian Nights.]

2874 VASVARI, Louise O. "Hit the cat and tame the bride": shrew taming as wedding ritual, East to West. *American & British interactions, perceptions & images of North Africa.* Ed. Adel Manai. [Tunis: Tunisian Society for Anglo-Saxon Studies], 2000, (TSAS Innovation Series, 2000), pp.122-140. [In Arabic popular literature & Western literature.]

2875 VEGLISON ELÍAS DE MOLINS, J. La mujer madura en la literatura árabe: mitos y realidad. *Miscelánea de Estudios Árabes y Hebraicos: Sección Arabe-Islam,* 46 (1997) pp.329-358.

2876 VERMEULEN, U. 'Unaytara, la fille de 'Antar. *Proceedings of the 14th Congress of the Union Européenne des Arabisants et Islamisants. Budapest ... 1988.* Part 1. Ed. A.Fodor. Budapest: Eötvös Loránd University Chair for Arabic Studies & Csoma de Körös Society, Section of Islamic Studies, 1995, (The Arabist: Budapest Studies in Arabic, 13-14), pp.305-213.

2877 VIROLLE-SOUIBÈS, M. `Aïcha l'engeigneuse' ou le sens dessus dessous. *A la croisée des études libyco-berbères. Mélanges offerts à Paulette Galand-Pernet et Lionel Galand.* Ed. J.Drouin & A.Roth. Paris: Geuthner, 1993, (Comptes Rendus du Groupe Linguistique d'Etudes Chamito-Sémitiques, GLECS, Supplément 15), pp.377-390. [Moroccan Arabic folk-tale. Incl. French translation.]

2878 WALTHER, W. Märchenprinzessinnen in `Tausendundeiner Nacht'. *Verse and the fair sex: studies in Arabic poetry and in the representation of women in Arabic literature. A collection of papers presented at the 15th Congress of the Union Européenne des Arabisants et Islamisants (Utrecht/Driebergen ... 1990).* Ed. F.de Jong. Utrecht: Houtsma Stichting, 1993, pp.92-100.

2879 WIMMEN, H. 'Ammūriyyah as a female archetype: deconstruction of a mythical subtext from Abū Tammām to Jabrā Ibrāhīm Jabrā / 'Abd al-Raḥmān Munīf. *Myths, historical archetypes and symbolic figures in Arabic literature: towards a new hermeneutic approach. Proceedings of the International Symposium in Beirut, June 25th - June 30th, 1996.* Ed. A.Neuwirth, B.Embaló, S.Günther, Maher Jarrar. Beirut: Orient-Institut der Deutschen Morgenländischen Gesellschaft; Stuttgart: Steiner, 1999, (Beiruter Texte und Studien, 64), pp.573-582.

2880 YELLES-CHAOUCHE, Mourad. Les chants de l'escarpolette au Maghreb. *Journal of Mediterranean Studies,* 6 i (1996) pp.120-134. (L'un des répertoires féminins les plus importants du Maghreb.)

2881 La *jurayfiyya* o cuento fantástico: Los beduinos del valle del Naqa'; Ward Awrad Daqush. Tr. Rabadán Carrascosa, M. *Estudios de Asia y Africa,* 30 i / 96 (1995) pp.147-153. [Translated from Palestinian colloquial Arabic into Spanish.]

ARABIC - MODERN

Books

2882 [ABŪ ZAYD, Laylá]. *Return to childhood: the memoir of a modern Moroccan woman* / Leila Abouzeid. Tr. Taylor, H. L. [Austin:] Center for Middle Eastern Studies at the University of Texas at Austin, 1998. 94pp. [Tr. of *Rujū' ilá 'l-ṭufūla.*]

2883 ACCAD, Evelyne. *Des femmes, des hommes et la guerre: fiction et réalité au Proche-Orient.* Paris: Côté-Femmes, 1993. 234pp. [Tr. of *Sexuality and war,* New York 1990.]

2884 [AṬRASH, Laylá 'l-]. *A woman of five seasons* / Leila Al-Atrash. Tr. Halwani, N. & Tingley, Christopher. New York: Interlink Books, 2002. 170pp. [Novel. Tr. of *Imra'a li-l-fuṣūl al-khamsa.*]

2885 BISHR, Badrīya al-. *Le mercredi soir: femmes de Riyad; nouvelles.* Ed. Azhari, Nada al-. Tr. Gillon, Jean-Yves. Paris: L'Harmattan, 2001 (Ecritures Arabes, 169), 110pp. [Tr. of *Masā' al-Arba'a'.*]

2886 COOKE, M. *Women and the war story.* Berkeley: University of California Press, 1996. 367pp. [Arabic fiction.]

2887 FARSHAKH, Jurj. *Oum Farès: une mère dans le tourmente libanaise* / Georges Farchakh. Tr. Weber, M-C. Paris: Publisud, 1995. 294pp. [Tr. of *Khayt rafi' min al-dam.*]

2888 ḤABĪBĪ, Amīl. *Soraya fille de l'ogre: féerie* / Emile Habibi. Tr. Guillaume, J-P. [Paris:] Gallimard 1991, rp. 1996. 213pp.

2889 IDLIBĪ, Ulfat al-. *Sabriya: Damascus bitter sweet: a novel.* Tr. Clark, Peter. New York: Interlink Books, 1997. 186pp. [Tr. of *Dimashq yā basmat al-ḥuzn.*]

2890 KHALIFA, Sahar. *Memoires van een eigenzinnige vrouw: roman.* Tr. Poppinga, Djûke. Breda: De Geeus, 1993. 190pp. [Tr. of *Mudhakkirāt imra'a ghayr wāqi'īya.*]

2891 KHALĪFA, Saḥar. *Memoiren einer unrealistischen Frau.* Tr. Chammaa, Leila. Zürich: Unionsverlag, 1995. 183pp. [Tr. of *Mudhakkirāt imra'a ghayr wāqi'īya.*]

2892 KHARRĀṬ, Idwār al-. *Belles d'Alexandrie.* Tr. Barbulesco, L. Arles: Actes Sud, 1997. 215pp. [Tr. of *Yā banāt Iskandarīya.*]

2893 KLEINEIDAM, U. *Vier arabische Kurzgeschichten: kritische Untersuchungen zu frühen Werken von Gāda as-Sammān.* Frankfurt a. M. : Lang 1996 (Europäische Hochschulschriften. Reihe XXVII, Asiatische und Afrikanische Studien, 55), 288pp.

2894 MIṢBĀḤĪ, Ḥassūna al-. *Die rebellischen Töchter Scheherezades: arabische Schriftstellerinnen der Gegenwart* / Hassouna Mosbahi. Tr. Heller, E. Munich: Beck, 1997. 159pp.

2895 ODEH, Nadja. *Dichtung - Brücke zur Aussenwelt: Studien zur Autobiographie Fadwā Ṭūqāns.* Berlin: Schwarz, 1994, (Islamkundliche Untersuchungen, 178), 120pp.

2896 RIF'AT, Alīfa. *Die Mädchen von Burdain* / Alifa Rifaat. Tr. Karachouli, R. Zürich: Unionsverlag, 1995. 1148pp. [Tr. of *Sabāyā Burdayn*.]

2897 [SA'DĀWĪ, Nawāl al-]. *A daughter of Isis: the autobiography of Nawal El Saadawi.* Tr. Hetata, Sherif. London & New York: Zed, 1999. 294pp.

2898 SA'DĀWĪ, Nawāl al-. *Hamidas Geschichte: Erzählung* / Nawal El Saadawi. Tr. Enderwitz, S. Ungekürzte Ausg. 2. Aufl. Munich: Dt. Taschen-Verlag 1994. 131pp. [Tr. of *Ughnīyat al-aṭfāl al-dā'ira*.]

2899 SA'DĀWĪ, Nawāl al-. *La mujer que buscaba.* Tr. Devoto, A. Barcelona: Martinez Roca, 1998. 160pp. [Tr. of *Searching*.]

2900 SA'DĀW'I, Nawāl al-. *Memorias de la cárcel de mujeres.* Tr. Corniero, M. Madrid: Horas y Horas, 1995. 217pp. [Tr. of *Mudhakkirātī fi sijn al-nisā'*.]

2901 SA'DĀWĪ, Nawāl al-. *Vrouwengevangenis* / Nawal el Saadawi. Tr. Dehandschutter, S. & Lombaerts, L. Amsterdam: Muntinga, 1994, (Rainbow Pocketboeken, 166), 295pp. [Tr. of *Mudhakkirātī fi sijn al-nisā'*.]

2902 [SA'DĀWĪ, Nawāl al-]. *Walking through fire: a life of Nawal El Saadawi.* Tr. Hetata, Sherif. London: Zed, 2002. 251pp.

2903 [SALMĀWĪ, Muḥammad]. *La dernière danse de Salome: pièce en deux actes.* Tr. Latif Ghattas, Mona. Paris: L'Harmattan, 2001 (Théâtre des Cinq Continents, 92), 135pp. [Egyptian play.]

2904 SHAYKH, Ḥanān al-. *Donne nel deserto.* Tr. Pagani, S. Rome: Jouvence, 1994, (Narratori Arabi Contemporanei, 9), 303pp. [Tr. of *Misk al-ghazāl*.]

2905 SHAYKH, Ḥanān al-. *Femmes de sable et de myrrhe: roman* / Hanan el-Cheikh. Tr. Billacois, M. & Tahhan, B. Arles: Actes Sud; Brussels: Labor; Lausanne: L'Aire, 1994, (Babel, 137), 377pp. [Tr. of *Misk al-ghazāl*.]

2906 SHAYKH, Ḥanān al-. *La historia de Zahra.* Tr. Padilla, A. Barcelona: Ediciones del Bronce, 1999, (Etnicos del Bronce, 12), 238pp. [Tr. of *Ḥikāyat Zahra*.]

2907 SHAYKH, Ḥanān al-. *Mujeres de arena y mirra.* Tr. Todó, P. & Todó, L. M. Barcelona: Ediciones del Bronce, 1996, (Etnicos de Bronce, 3), 308pp. [Tr. of *Women of sand & myrrh*; original Arabic title *Misk al-ghazāl*.]

2908 SHAYKH, Ḥanān al-. *Sahras Geschichte: Roman aus dem Libanon* / Hanan al-Scheich. Tr. Theis, V. Basle: Lenos, 1993. 269pp. [Tr. of *Ḥikāyat Zahra*.]

2909 SHAYKH, Ḥanān al-. *Vrouwen tussen hemel en zand* / Hanaan as-Sjaikh. Tr. Poppinga, D. Breda: De Geus, 1994. 302pp. [Tr. of *Misk al-ghazāl*.]

2910 SULĀFA. *Una voz palestina.* Introducción, traducción y selección por I.Bejarano. Madrid: Letrumero, 1998, (Voz de Mujeres, 2), 108pp. [Poetry. Arabic text with Spanish translation. Arabic title: *Ṣawt Filasṭīnī*.]

2911 SZOSTAK, J. & TAUFIQ, Suleman. *Der wahre Schleier ist das Schweigen: arabische Autorinnen melden sich zu Wort.* Frankfurt a. M. : Fischer-Taschenbuch-Verlag 1995. 254pp.

2912 [ṬĀHIR, Bahā']. *De wraak van Safiya: roman* / Bahaa Taher. Tr. Leeuwen, Richard van. Amsterdam: Van Gennep, 2000. 125pp. [Novel. Tr. of *Khālatī Ṣafīya wa-'l-dayr*.]

2913 ('UTHMĀN, Laylá 'l-). *Carnet de femme* / Layla Al 'Othman. Edition bilingue. Traduction et présentation: O.Petit, W.Voisin. Paris: Publisud & UNESCO, 1997. 285pp. [Short stories in Arabic, with French translations.]

2914 'UTHMĀN, Laylá 'l-. *Zahra kommt ins Viertel: Erzählungen* / Laila al-Osman. Tr. Rahmer, A. & Forst, Nuha. Meerbusch: Ed. Orient, 1993, (Frauen aus dem Orient Erzählen, 6), 124pp.

2915 [WADĪ', Ṣalāḥ al-]. *Le marié. Candide au pays de la torture* / Salah el Ouadie. Tr. Drissi, Abdelhadi. Paris: Paris-Méditerranée, 2001. 123pp. [Novel tr. from Arabic.]

2916 ZAFZĀF, Muḥammad. *La mujer y la rosa.* Tr. Moina Rueda, B. & Louassini, Zouhir. Madrid: Agencia Española de Cooperación Internacional, 1997, (Ediciones Mundo Arabe e Islam: Autores Arabes Contemporáneos, 20), 127pp. [Tr. of *Al-mar'a wa-'l-warda*.]

2917 *Intersections: gender, nation, and community in Arab women's novels.* Ed. Lisa Suhair Majaj, Paula W.Sunderman, and Therese Saliba. Syracuse: Syracuse University Press, 2002. 287pp.

2918 *Le verbe dévoilé: petite anthologie de la poésie arabe au féminin.* Ed. Janabi, Abdul Kader el-. Paris: Paris-Méditerranée, 2001. 93pp. [Bilingual edition.]

2919 *Recueil de nouvelles de femmes de la Méditerranée.* Ed. Soula, Nadia. Tunis: CREDIF, 1995. 182pp.

2920 *The poetry of Arab women: a contemporary anthology.* Ed. Handal, Nathalie. New York: Interlink, 2001. 355pp.

2921 *Une voix bien à elles ... Un recueil de nouvelles par des femmes égyptiennes.* Choix de textes & introd. par Angèle Botros Samaan. Version française revue par Amal Farid. Cairo: Dar el Kuttub, 1997, (Prisme: La Série Littéraire, 3), 284pp.

2922 *Voices of change: short stories by Saudi Arabian women writers.* Ed. & tr. by Abubaker Bagader, A.M.Heinrichsdorff, D.S.Akers; additional translations by Abdul-Aziz al-Sebail. Boulder: Rienner, 1998. 171pp.

Articles

2923 RAMSAY, G. Kvinnorna har fattat sina pennor - utbildning och litteratur vid Piratkusten. *Kvinnovetenskaplige Tidskrift,* 18 iii-iv (1997) pp.15-22. [Women writers of short stories in UAE.]

2924 ABBAS, Adnan. Kobieta w poezji Badra Szakira as-Sajjaba. *Przeglad Orientalistyczny,* 173-174 (1995) pp.67-72.

2925 ABDEL-MALEK, Kamal. Iman Mersal: Egypt's postmodern poet. *Tradition, modernity, and postmodernity in Arabic literature. Essays in honor of Professor Issa J.Boullata.* Ed. Kamal Abdel-Malek & Wael Hallaq. Leiden: Brill, 2000, pp.411-414. [Trans. into English of poem *Crossing the threshold.*]

2926 [ABŪ 'ALĪ, Rasmī]. Comment mon ami Najeh Hassan s'acheta des chaussures; Mariage et mort de Joudeh n'a-qu'un-œil / Rasmi Abou Ali. Tr. Dujols, S. *Revue d'Etudes Palestiniennes,* 24 / 76 (2000) pp.26-30. [Two stories tr. from Arabic.]

2927 ABU GHAZALEH, Ilham. Gender in the poetry of the Intifada. *Palestinian women of Gaza and the West Bank.* Ed. Suha Sabbagh. Bloomington & Indianapolis: Indiana University Press, 1998, pp.91-113.

2928 ABU-HAIDAR, Farida. A voice from Iraq: the fiction of Alia Mamdouh. *Women: a Cultural Review,* 9 iii (1998) pp.305-311.

2929 [ABŪ 'L-NŪR, 'Ā'isha]. La rebelle / Aïcha Aboul-Nour. Tr. Gawdat, Guzine. *Une voix bien à elles ... Un recueil de nouvelles par des femmes égyptiennes.* Choix de textes & introd. par Angèle Botros Samaan. Cairo: Dar el Kuttub, 1997, (Prisme: La Série Littéraire, 3), pp.231-234.

2930 ABŪ SHĀW[I]R, Rashād. Pizza in memory of Mariam. Tr. Amin, Magda. *A land of stone and thyme: an anthology of Palestinian short stories.* Ed. Nur & Abdelwahab Elmessiri. London: Quartet, 1996, pp.85-92.

2931 AGHACY, Samira. Lebanese women's fiction: urban identity and the tyranny of the past. *International Journal of Middle East Studies,* 33 iv (2001) pp.503-523. Also online at http:// journals.cambridge.org

2932 ALEXANDRE-GARNER, Corinne. Alexandrie: "Une utopie qui s'écrirait au féminin". *Confluences Méditerranée*, 34 (2000) pp.173-185. [In novels of Durrell & Kharrat.]

2933 'ĀLIM, Rajā'. One thousand braids and a governess. *Voices of change: short stories by Saudi Arabian women writers*. Ed. & tr. Abubaker Bagader, A.M.Heinrichsdorff, D.S.Akers. Boulder: Rienner, 1998, pp.155-161.

2934 AMIREH, Amal. Framing Nawal el Saadawi: Arab feminism in a transnational world. *Intersections: gender, nation, and community in Arab women's novels*. Ed. Lisa Suhair Majaj, Paula W.Sunderman, and Therese Saliba. Syracuse: Syracuse University Press, 2002, pp.33-67. [Sa'dāwī is no longer addressing Arab women in her novels.]

2935 AMO, M. del. Escribir en femenino plural: las mujeres árabes y la literatura. *El imaginario, la referencia y la diferencia: siete estudios acerca de la mujer árabe*. M.del Amo (ed.). Granada: Departamento Estudios Semíticos, 1997, pp.13-31.

2936 AMO, M. del. Mujeres de papel (1): Hamida, la tradición se resquebraja. *Miscelánea de Estudios Árabes y Hebraicos: Sección Arabe-Islam*, 46 (1997) pp.17-28. (La novela de Naŷīb Maḥfūẓ.)

2937 AMO, M. del. Mujeres de papel (II): Zuhra, el trabajo y la cultura. *Miscelánea de Estudios Arabes y Hebraicos*: Sección *Arabe-Islam*, 48 (1999) pp.3-15. (Análisis de la novela *Mīrāmār* (1967) de Naŷīb Maḥfūẓ.)

2938 AMO, Mercedes del. Imágenes literarias de mujeres árabes. *Miscelánea de Estudios Arabes y Hebraicos: Sección Arabe-Islam*, 49 (2000) pp.31-43. (En la novela árabe contemporánea.)

2939 AMO, Mercedes del. La creación literaria de las mujeres magrebíes. *Miscelánea de Estudios Arabes y Hebraicos: Sección Arabe-Islam*, 50 (2001) pp.53-67. [Novels in French & in Arabic.]

2940 AMO, Mercedes del. La novela egipcia como reflejo de la situación de la mujer (1919-1952). *Homenaje al profesor José María Fórneas Besteiro*. Granada: Universidad de Granada, 1995, pp.53-64.

2941 AMYUNI, Mona Takieddine. A panorama of Lebanese women writers, 1975-1995. *Women and war in Lebanon*. Ed. Lamia Rustum Shehadeh. Gainesville: University Press of Florida, 1999, pp.89-111.

2942 AMYUNI, Mona Takieddine. Living on the edge: Sabah al-Kharrat Zwayn's poetic writings. *Journal of Arabic Literature*, 30 ii (1999) pp.171-192. [Lebanese writing in French & later in Arabic.]

2943 'AṬĪYA, Hanā'. Quand ma tante chante; Les deux dodues / Hana Ateyya. Tr. Gallois, S. *Peuples Méditerranéens*, 76 (1996) pp.43-51. [Short stories.]

2944 ['AṬĪYA, Hanā']. The women's room / Hana Atia. *Under the naked sky: short stories from the Arab world* / selected & trans. D.Johnson-Davies. Cairo: American University in Cairo Press, 2000, pp.182-184.

2945 'AWAJ, Zaynab al-. Nouara la folle / Zineb Laawadj. Tr. Bensalah, Amina. *Mediterraneans / Méditerranéennes*, 4 (1993) pp.136-145. [Arabic poem & French translation.]

2946 BAMIA, Aida A. Feminism in revolution: the case of Saḥar Khalīfa. *Tradition, modernity, and postmodernity in Arabic literature. Essays in honor of Professor Issa J.Boullata*. Ed. Kamal Abdel-Malek & Wael Hallaq. Leiden: Brill, 2000, pp.173-185.

2947 BAZEI, Saad al-. Lyrical interpretations of a mythic rape. *Alif*, 19 (1999) pp.113-130. [Yeats, Rilke & Abu-Risha on Leda & the swan.]

2948 BOOTH, Marilyn. Reflections on recent autobiographical writing in an Arab feminist vein. *Middle East Women's Studies Review*, 15 iv - 16 i (2001) pp.8-11.

2949 [BŪ JADRA, Rashīd]. *Nocturnes of an insomniac woman*, by Rachid Boujedra. Tr. Halool, Musa al-. *Arabic and Middle Eastern Literatures*, 1 ii (1998) pp.183-192. [Translated from the novel *Laylīyāt imra'a āriqa*.]

2950 BUTUROVIC, Amila. "Only women and writing can save us from death": erotic empowering in the poetry of Nizār Qabbānī (d.1998). *Tradition, modernity, and postmodernity in Arabic literature. Essays in honor of Professor Issa J.Boullata*. Ed. Kamal Abdel-Malek & Wael Hallaq. Leiden: Brill, 2000, pp.141-157.

2951 CANO LEDESMA, Aurora. Nāzik al-Malā'ika. Imágenes de una poetisa. *Homenaje al profesor José María Fórneas Besteiro*. Granada: Universidad de Granada, 1995, pp.99-109. [Iraqi academic, poet & translator.]

2952 CASSARINO, M. Sinestesie e visioni oniriche nei racconti d'una scrittrice tunisina contemporanea. *Studi Magrebini*, 22 / 1990 (1994) pp.125-136. ['Arūsīya al-Nālūtī.]

2953 CAUSA-STEINDLER, M. Une méconnue renommée Fadhila Chabbi, poétesse tunisienne. *IBLA*, 57 ii / 174 (1994) pp.252-273.

2954 COFFIN, N. Engendering resistance in the work of Ghassan Kanafani: *All that's left to you, Of men and guns*, and *Umm Sa'd*. *Arab Studies Journal / Majallat al-Dirāsāt al-'Arabīya*, 4 ii (1996) pp.98-118.

2955 COOKE, M. Femmes arabes, guerres arabes. (Abstract: Arab wars, Arab women.). Tr. Norris, A. *Peuples Méditerranéens*, 64-65 (1993) pp.25-48;324-325. [Analysis of modern literature.]

2956 COOKE, M. Mapping peace. *Women and war in Lebanon*. Ed. Lamia Rustum Shehadeh. Gainesville: University Press of Florida, 1999, pp.73-88. [Lebanese women writers.]

2957 COOKE, Miriam. A symposium on women writers in Damascus. *Middle East Women's Studies: the Review*, 11 iii (1996) pp.1-4.

2958 COOKE, Miriam. Humanist nationalism. *Social constructions of nationalism in the Middle East* / ed. Fatma Müge Göçek. Albany (USA): State University of New York Press, 2002, pp.125-140. (Lebanese war literature by women.)

2959 CORTÉS GARCÍA, M. Mito, mujer y tierra en un poeta iraquí contemporáneo: 'Alī Ya'fār al-'Allāq. *Boletín de la Asociación Española de Orientalistas*, 30 (1994) pp.93-103.

2960 COX, D. Autobiography and intertextuality: Rashīd Būjadra. *Writing the self: autobiographical writing in modern Arabic literature*. R.Ostle, E.de Moor & S.Wild (eds). London: Saqi, 1998, pp.229-240;323-324. [Būjadra's novel *Laylīyāt imra'a āriq*.]

2961 DAVIS TAÏEB, Hannah. The girl who found refuge in the people: the autobiography of Latifa Zayyat. *Journal of Arabic Literature*, 29 iii-iv (1998) pp.202-217.

2962 DEYOUNG, Terri. Love, death, and the ghost of al-Khansā': the modern female poetic voice in Fadwā Ṭūqān's elegies for her brother Ibrāhīm. *Tradition, modernity, and postmodernity in Arabic literature. Essays in honor of Professor Issa J.Boullata*. Ed. Kamal Abdel-Malek & Wael Hallaq. Leiden: Brill, 2000, pp.45-75.

2963 DIAB, Henry. "Du hittar mig alltid mellan raderna": Nizar Qabbani och kvinnan. *TfMS: Tidskrift för Mellanösternstudier*, 1999 ii (2000) pp.80-86.

2964 ENDERWITZ, S. Zeitgenössische arabische Frauenliteratur. *Berliner LeseZeichen*, 4 i-ii (1996) pp.30-39.

2965 FADEL, Munira Khalifa al-. The deterritorialization of the body in *Women of sand and myrrh*. *Gramma*, 5 (1997) pp.11-23. (Hanan al-Sheikh.)

2966 FAṬĀNĪ, Jamīla. Why shouldn't I be like her? *Voices of change: short stories by Saudi Arabian women writers*. Ed. & tr. Abubaker Bagader, A.M.Heinrichsdorff, D.S.Akers. Boulder: Rienner, 1998, pp.35-38.

2967 FAYAD, Mona. Strategic androgyny: passing as masculine in Barakat's *The stone of laughter*. *Intersections: gender, nation, and community in Arab women's novels*. Ed. Lisa Suhair Majaj, Paula W.Sunderman, and Therese Saliba. Syracuse: Syracuse University Press, 2002, pp.162-179.

2968 FONTAINE, J. Le centième livre littéraire féminin tunisien: `Silence' de Nefla Dahab. *IBLA*, 57 ii / 174 (1994) pp.275-285.

2969 FONTAINE, J. Le roman tunisien en 1998: des
 personnages misogynes. *IBLA*, 62 / 184 (1999)
 pp.205-209. (En arabe.)

2970 FONTAINE, Jean. 'Arûsiyya al-Nâlûtî: écrivaine
 tunisienne. *Maghreb Littéraire*, 1 i (1997) pp.55-70. [In
 Arabic.]

2971 FREITAG, U. Dying of enforced spinsterhood: Ḥaḍramawt
 through the eyes of 'Alī Aḥmad Bā Kathīr (1910-69).
 Welt des Islams, 37 i (1997) pp.1-27. [Play.]

2972 FU'ĀD, S[a]kīna. Celle qui viendra. Tr. Said, Aziza.
 *Une voix bien à elles ... Un recueil de nouvelles par des
 femmes égyptiennes.* Choix de textes & introd. par Angèle
 Botros Samaan. Cairo: Dar el Kuttub, 1997, (Prisme: La
 Série Littéraire, 3), pp.165-177.

2973 [GHĀMIDĪ, Nūra al-]. The dove is a woman / Nurah
 al-Ghamdi. *Voices of change: short stories by Saudi
 Arabian women writers.* Ed. & tr. Abubaker Bagader,
 A.M.Heinrichsdorff, D.S.Akers. Boulder: Rienner, 1998,
 pp.57-62.

2974 GHANDOUR, Sabah. Hanan al- Shaykh's *Hikayat Zahra*:
 a counter-narrative and a counter-history. *Intersections:
 gender, nation, and community in Arab women's novels.*
 Ed. Lisa Suhair Majaj, Paula W.Sunderman, and Therese
 Saliba. Syracuse: Syracuse University Press, 2002,
 pp.231-249.

2975 [GHĪṬĀNĪ, Jamāl al-]. Mystery woman. A short story /
 Gamal el-Ghitani. Tr. Starkey, Paul. *Banipal*, 13 (2002)
 pp.17-19. [Tr. of *Majhūla*.]

2976 GHUZZĪ, Muḥammad al-. Female; Quatrains for joy; The
 pen. Tr. Jayyusi, May & Heath-Stubbs, J. *The new
 African poetry: an anthology.* Ed. T.Ojaide, Tijan
 M.Sallah. Boulder: Rienner, 1999, pp.69-72.

2977 GÓMEZ GARCÍA, Luz. Cien años de poesía árabe escrita
 por mujeres. *Miscelánea de Estudios Árabes y Hebraicos:
 Sección Árabe-Islam*, 50 (2001) pp.133-167.

2978 GUTIÉRREZ DE TERÁN, I. Tres cuentos de autoras
 árabes contemporáneas. *Estudios de Asia y África*, 102
 / 32 i (1997) pp.163-181. (Salwa Naimi, Hanan al-Shayj,
 Salma Matar Sayf.) [Introd. with translations of three short
 stories.]

2979 [HĀDĪ, Maysalūn]. Her realm of the real / Mayselun Hadi.
 Tr. Mustafa, Shakir. *Banipal*, 14 (2002) pp.20-21.
 [Short story.]

2980 [ḤĀJJ, 'Unsī al-]. The messenger with her hair long to the
 springs / Ounsi el Hage. Tr. France, B. *Banipal*, 5 (1999)
 pp.3-8. [First part of long poem.]

2981 HAMMOND, Marlé. Subsuming the feminine other:
 gender and narration in Idwār al-Kharrāṭ's *Yā banāt
 Iskandariyya*. *Journal of Arabic Literature*, 31 i (2000)
 pp.38-58.

2982 HAMPARZOUMIAN, A. Dinero, sexo y amor se mezclan
 dolorosamente en la experiencia de Ḥamīda. *Al-Andalus
 - Magreb*, 4 / 1996 (1998) pp.257-280. (En la novela
 Zuqāq al-midaqq.)

2983 HARLOW, Barbara. Partitions and precedents: Sahar
 Khalifeh and Palestinian political geography.
 *Intersections: gender, nation, and community in Arab
 women's novels.* Ed. Lisa Suhair Majaj, Paula
 W.Sunderman, and Therese Saliba. Syracuse: Syracuse
 University Press, 2002, pp.113-131.

2984 HARTMAN, Michelle. Re-reading women in/to Naguib
 Mahfouz's *al-Liss wa'l-kilab (The thief and the dogs)*.
 Research in African Literatures, 28 iii (1997) pp.5-16.

2985 HATEM, Mervat [F.]. 'A'isha Taymur's tears and the
 critique of the modernist and the feminist discourses on
 nineteenth-century Egypt. *Remaking women: feminism
 and modernity in the Middle East.* Ed. Lila Abu-Lughod.
 Princeton: Princeton University Press, 1998, pp.73-87.
 (One of the leading women poets.)

2986 JAYYUSI, Salma Khadra. Modernist Arab women writers:
 a historical overview. *Intersections: gender, nation, and
 community in Arab women's novels.* Ed. Lisa Suhair Majaj,
 Paula W.Sunderman, and Therese Saliba. Syracuse:
 Syracuse University Press, 2002, pp.1-30.

2987 JUILLIARD BEAUDAN, C. Le champ du féminin dans
 la trilogie de Naguib Mahfouz: la vision de la femme en
 islam. *Cahiers de l'Orient*, 38 (1995) pp.169-180.

2988 KACHACHI, Inaam. Women in fear. *Under the naked
 sky: short stories from the Arab world* / selected & trans.
 D.Johnson-Davies. Cairo: American University in Cairo
 Press, 2000, pp.36-45.

2989 KAHF, Mohja. Politics and erotics in Nizar Kabbani's
 poetry: from the sultan's wife to the lady friend. *World
 Literature Today*, 74 i (2000) pp.44-52.

2990 KHARRĀṬ, Idwār al-. Girls of Alexandria. Tr. Liardet,
 F. *Mediterraneans / Méditerranéennes*, 8/9 (1996)
 pp.241-243.

2991 [KHAYRĪ, Wafīya]. Un homme et une femme / Waféya
 Khairy. Tr. Farid, Amal. *Une voix bien à elles ... Un
 recueil de nouvelles par des femmes égyptiennes.* Choix
 de textes & introd. par Angèle Botros Samaan. Cairo: Dar
 el Kuttub, 1997, (Prisme: La Série Littéraire, 3),
 pp.99-104.

2992 KHAYYĀṬ, Najāt. Had I been male. *Voices of change:
 short stories by Saudi Arabian women writers.* Ed. & tr.
 Abubaker Bagader, A.M.Heinrichsdorff, D.S.Akers.
 Boulder: Rienner, 1998, pp.19-22.

2993 KHOURY, Elias. Mahmoud Darwich: Rita et la poétique
 du couple. *Revue d'Etudes Palestiniennes*, 81 (2001)
 pp.58-69.

2994 KHOURY, R.G. Mayy Ziyāda (1886-1941), une grande
 citoyenne du monde ou la remarquable performance d'une
 femme arabe. *L'Orient au cœur: en l'honneur d'André
 Miquel.* Sous la responsabilité de Floréal Sanagustin. Paris:
 Maisonneuve & Larose, 2001, pp.141-161.

2995 KHOURY-GHATA, Vénus. Romans de femmes autour
 de la Méditerranée. *La Méditerranée des femmes.* Sous
 la dir. de Nabil el Haggar. Paris: L'Harmattan, 1998,
 pp.63-66. (Romancières arabes.)

2996 KLEMM, V. Saḥar Halīfas *Bāb as-sāḥa* - eine
 feministische Kritik der Intifada. *Welt des Islams*, 33 i
 (1993) pp.1-22.

2997 KOZMA, L. Remembrance of things past: Leila Abouzeid
 and Moroccan national history. *Social Politics*, 6 iii
 (1999) pp.388-406.

2998 [KŪNĪ, Ibrāhīm al-]. She and the dogs / Ibrahim el Kouni.
 Libyan stories: twelve short stories from Libya. Ed. Ahmed
 Fagih. London: Keegan [, sic] Paul International, 2000,
 pp.51-56.

2999 [KŪNĪ, Ibrāhīm al-]. She and the dogs / Ibrahim el Kouni.
 Libyan stories: twelve short stories from Libya. Ed. Ahmed
 Fagih. London: Keegan [*sic*] Paul International, 2000,
 pp.51-56.

3000 LAMRI, Soumia. Le message posthume.
 Islamochristiana / Dirāsāt Islāmīya Masīḥīya, 25 / 1999
 (2000) pp.17-21. (Ce témoignage posthume d'une jeune
 cancéreuse algérienne, morte à dix-sept ans, rassemble la
 lettre que lui écrivit son chirurgien et les trois poèmes
 qu'elle confia à son cahier d'écolière ... traduits de l'arabe.)

3001 LANE, Amanda. The modern Moroccan protagonist: a
 study of the works of Abouzeid, Boucetta, and Ben Jelloun.
 Maghreb Review, 21 iii-iv (1996) pp.267-271.

3002 LAOUEDJ, Zineb. Littérature féminine d'expression arabe
 en Algérie. *La Méditerranée des femmes.* Sous la dir. de
 Nabil el Haggar. Paris: L'Harmattan, 1998, pp.69-76.

3003 LÁZARO DURÁN, Maribel. La modernidad en femenino:
 Mayy Ziyāda desde la actualidad. *Miscelánea de Estudios
 Árabes y Hebraicos: Sección Árabe-Islam*, 51 (2002)
 pp.53-66. [Modern Arab media view.]

3004 MACHUT-MENDECKA, E. Postać kobiety w dramaturgii
 Raszszada Ruszdi ego. *Przegląd Orientalistyczny*,
 181-182 (1997) pp.98-103.

3005 MAIER, John. Literate women in three Moroccan writers.
 *The Arab-African and Islamic worlds: interdisciplinary
 studies.* Ed. by R.Kevin Lacey and Ralph M. Coury. New
 York: Lang, 2000, pp.259-278. [In Fatima Mernissi's
 autobiography & novels by Muḥammad Barrāda & Laylá
 Abū Zayd.]

3006 MANGANARO, Elise Salem. Lebanon mythologized or Lebanon deconstructed: two narratives of national consciousness. *Women and war in Lebanon.* Ed. Lamia Rustum Shehadeh. Gainesville: University Press of Florida, 1999, pp.112-128. [Fiction by Emily Nasrallah & Hanan al-Shaykh.]

3007 MANISTY, D. Negotiating the space between private and public: women's autobiographical writing in Egypt. *Writing the self: autobiographical writing in modern Arabic literature.* R.Ostle, E.de Moor & S.Wild (eds). London: Saqi, 1998, pp.272-282;328-329.

3008 MASLIYAH, Sadok. Zahawi: a Muslim pioneer of women's liberation. *Middle Eastern Studies,* 32 iii (1996) pp.161-171. (Modern Iraqi poet.)

3009 MAṬAR, Salīm. Woman of the flask. Excerpt from the novel. Tr. Clark, Peter. *Banipal,* 9 (2000) pp.45-50.

3010 MAZRUI, Alamin M. & ABALA, Judith I. Sex and patriarchy: gender relations in *Mawt al-rajul al-wahid 'ala al-ard (God dies by the Nile). Research in African Literatures,* 28 iii (1997) pp.17-32.

3011 MCKEE, E. The political agendas and textual strategies of Levantine women writers. *Feminism and Islam: legal and literary perspectives.* Ed. Mai Yamani. Reading: Ithaca, for the Centre of Islamic and Middle Eastern Law, School of Oriental and African Studies, University of London, 1996, pp.105-139.

3012 MCLARNEY, Ellen. Unlocking the female in Aḥlām Mustaghānamī. *Journal of Arabic Literature,* 33 i (2002) pp.24-44. Also online at http:// www.ingentaselect.com

3013 MELEK, Maysoon. The poet who helped shape my childhood. *Intimate selving in Arab families: gender, self, and identity.* Ed. Suad Joseph. Syracuse (USA): Syracuse University Press, 1999, pp.77-91;273. (Nazik al-Malaika.)

3014 MICHALAK-PIKULSKA, B. Su'ad al-Sabah - in the beginning was the female. *Folia Orientalia,* 34 (1998) pp.129-140. [Kuwaiti poet.]

3015 MONTORO MURILLO, R. Desarrollo de la narrativa femenina en Túnez. *El Magreb: coordenadas socioculturales.* C.Pérez Beltrán & C.Ruiz-Almodóvar (eds.). Granada: Grupo de Investigación Estudios Arabes Contemporáneos, Universidad de Granada, 1995, pp.299-323.

3016 MOORS, A. Natie, klasse en sekse: een antropologische visie op het werk van Saḥar Khalīfa. (Summar[y]: Nation, class and gender: an anthropological perspective on the work of Saḥar Khalīfa.). *De Arabische roman: identiteit en sociale werkelijkheid.* R.van Leeuwen, E.de Moor (red.). Bussum: Coutinho, 1994, (Publikaties van de Nederlandse Vereniging voor de Studie van het Midden-Oosten en de Islam (MOI): N. R. 13), pp.95-106;143.

3017 MORLING, A. Kvinderne i Nagib Mahfuzs romaner. *Semiramis,* 4 (1996) pp.49-90.

3018 MUFTĪ, Bashīr. Wardah's confessions: excerpt from a novel. Tr. Hilmy, Hassan. *Banipal,* 7 (2000) pp.68-69.

3019 MUHANNA, Abdullah al-. Ṣāliḥ Ğawdat (1912-1976) and woman's beauty reading in his poetry. *Studia Arabistyczne i Islamistyczne,* 8 (2000) pp.51-74.

3020 MUNAWWAR, Wafā'. The duties of a working mother. *Voices of change: short stories by Saudi Arabian women writers.* Ed. & tr. Abubaker Bagader, A.M.Heinrichsdorff, D.S.Akers. Boulder: Rienner, 1998, pp.43-46.

3021 MUTAWAKIL, Antelak M.al-. Self-liberation and national struggle in Yemeni women's early short stories. *Al-Masar,* 3 iii (2001) pp.13-28.

3022 MU[Z]AFFAR, Ma[yy]. A man and a woman; A woman; The message. Tr. Kawar, Samira. *Banipal,* 1 (1998) pp.23-23. [Poems.]

3023 NABIL, Oussama. Sarah d'al-Akkad entre les théories occidentales et l'optique égyptienne. *The proceedings of the International Conference: Comparative Literature in the Arab World, Centre for Comparative Linguistics and Literary Studies (CCLLS) ... Cairo University ... 1995. Qaḍāyā 'l-adab al-muqāran fī 'l-waṭan al-'Arabī.* Ed. Ahmed Etman. Cairo: Egyptian Society of Comparative Literature (ESCL), 1998, pp.183-208.

3024 NAJJĀR, Shahīra al-. Underfoot. Tr. Cobham, C. *Mediterraneans / Méditerranéennes,* 8/9 (1996) pp.314-318. [Short story.]

3025 NĀṢIRĪ, Buthayna al-. The short history of Samah. Tr. Tannoukhi, Nirvana. *Banipal,* 10/11 (2001) pp.111-112. [Short story tr. from Arabic.]

3026 NAṢR ALLĀH, [Imilī]. A house not her own. Tr. Khalil-Khouri, Thuraya. *Index on Censorship,* 29 v / 196 (2000) pp.175-179. [Short story.]

3027 NOWAIHI, Magda M.al-. Reenvisioning national community in Salwa Bakr's *Golden chariot. Intersections: gender, nation, and community in Arab women's novels.* Ed. Lisa Suhair Majaj, Paula W.Sunderman, and Therese Saliba. Syracuse: Syracuse University Press, 2002, pp.68-93.

3028 ODEH, Nadja. Coded emotions: the description of nature in Arab women's autobiographies. *Writing the self: autobiographical writing in modern Arabic literature.* R.Ostle, E.de Moor & S.Wild (eds). London: Saqi, 1998, pp.263-271;327-328.

3029 OFEISH, Sami A. Gender challenges to patriarchy: Wannus' *Tuqus al-isharat wa-l-tahawalat. Colors of enchantment: theater, dance, music, and the visual arts of the Middle East.* Ed. Sherifa Zuhur. Cairo: American University in Cairo Press, 2001, pp.142-150.

3030 OUYANG, Wen-Chin. Feminist discourse between art and ideology: four novels by Nawāl al-Sa'dāwī. *Al-'Arabiyya,* 30 (1997) pp.95-115.

3031 PIRONE, Bartolomeo. May Murr, testimonianze di multilinguismo e pluriculturalismo. *Frammenti, confluenze e prospettive mediterranee /* a cura di Rosalia Bivona e Giuseppina Igonetti. Naples: Arte Tipografica, 2001, (Lo Specchio del Mediterraneo, 1), pp.149-167. (Come altri scrittori libanesi ... May Murr fa bella mostra di opere composte in arabo e in francese.)

3032 PRIETO GONZÁLEZ, M. L. El amor y la imagen femenina en los relatos de 'Abd al-Raḥmān Maŷīd al-Rubay'ī. *Boletín de la Asociación Española de Orientalistas,* 30 (1994) pp.281-297.

3033 [QA'ĪD, Yūsuf al-]. The wretched girl and the miserable boy / Yousef al-Qa'eed. Tr. Kawar, Samira. *Banipal,* 2 (1998) pp.14-16. [Excerpt from novel.]

3034 [RAJAB, Muná]. Quand les femmes se revoltent / Mona Ragab. Tr. Loutfi, Salwa. *Une voix bien à elles ... Un recueil de nouvelles par des femmes égyptiennes.* Choix de textes & introd. par Angèle Botros Samaan. Cairo: Dar el Kuttub, 1997, (Prisme: La Série Littéraire, 3), pp.255-262.

3035 RENO, Samer M. An interview with Iraq's Lami'a Abbass Ammara. *Arab women: between defiance and restraint.* Ed. Suha Sabbagh. New York: Olive Branch Press, 1996, pp.238-243.

3036 RIF'AT, Alīfa. Alifa Rifaat's gentle conspiracy. *Eye to eye women: their words and worlds. Life in Africa, Asia, Latin America and the Caribbean as seen in photographs and in fiction by the region's top women writers.* (Ed. V.Baird). Oxford: New Internationalist, 1996, pp.24-26. (From *An incident in the Ghobashi household.*)

3037 RODED, Ruth. Gendered domesticity in the life of the Prophet: Tawfīq al-Ḥakīm's *Muḥammad. Journal of Semitic Studies,* 47 i (2002) pp.67-95. Also online at http:// www3.oup.co.uk/semitj (The outcome of a dialogue between the twentieth-century Egyptian playwright and classical Islamic texts.)

3038 SABBAGH, Suha. An interview with Sahar Khalifeh, feminist novelist. *Palestinian women of Gaza and the West Bank.* Ed. Suha Sabbagh. Bloomington & Indianapolis: Indiana University Press, 1998, pp.136-144.

3039 SABBAGH, Suha. An interview with Syria's Kamar Keilany. *Arab women: between defiance and restraint.* Ed. Suha Sabbagh. New York: Olive Branch Press, 1996, pp.244-249.

3040 SA'DĀWĪ, Nawāl al-. Mon expérience de création / Nawal Saadaoui. Tr. Barbulesco, L. *Qantara,* 10 (1994) pp.22-24.

3041 SA'DĀWĪ, Nawāl al-. Nawal el Saadawi on eternal love.
 Eye to eye women: their words and worlds. Life in Africa,
 Asia, Latin America and the Caribbean as seen in
 photographs and in fiction by the region's top women
 writers. (Ed. V.Baird). Oxford: New Internationalist, 1996,
 pp.20-20. (Translated from *Eternal love.*)

3042 SADDA, Hoda el. Women's writing in Egypt: reflections
 on Salwa Bakr. *Gendering the Middle East: emerging*
 perspectives. Ed. Deniz Kandiyoti. London: Tauris, 1996,
 pp.127-144.

3043 SAĪD, Khalida. Du concept de `littérature féminine`. Tr.
 Malas, Fayez. *Qantara,* 10 (1994) pp.32-33.

3044 SALAMA-RÉAU, Manal. La femme et le mariage.
 Cahiers de l'Orient, 63 (2001) pp.135-151. (La trilogie
 de Naguib Mahfouz.)

3045 SALIBA, Therese. A country beyond reach: Liana Badr's
 writings of the Palestinian diaspora. *Intersections:*
 gender, nation, and community in Arab women's novels.
 Ed. Lisa Suhair Majaj, Paula W.Sunderman, and Therese
 Saliba. Syracuse: Syracuse University Press, 2002,
 pp.132-161.

3046 SALIBA, Therese & KATTAN, Jeanne. Palestinian
 women and the politics of reception. *Going global: the*
 transnational reception of Third World women writers.
 Ed. Amal Amireh & Lisa Suhair Majaj. New York:
 Garland Publishing, 2000, pp.84-112. [Of women's
 writing.]

3047 SAMMĀN, Ghāda al-. Laila und der Wolf / Ghada
 Samman. Tr. Karachouli, R. *Arabische Erzählungen*
 der Gegenwart. Hrsg. E.Heller & Hassouna Mosbahi.
 Munich: Beck, 1997, pp.246-275.

3048 ṢAQR, Mahdī 'Īsá 'l-. Eine Frau, die auf dem Bürgersteig
 sitzt. Tr. Karachouli, R. *Arabische Erzählungen der*
 Gegenwart. Hrsg. E.Heller & Hassouna Mosbahi. Munich:
 Beck, 1997, pp.276-286.

3049 SELIM, Samah. Crossing borders: the construction of the
 feminine in the novels of Bahija Husayn. *Critique: Journal*
 for Critical Studies of the Middle East, 17 (2000)
 pp.31-47.

3050 SHAABAN, Bouthaina. Arab women novelists: creativity
 and rights. *Middle East Women's Studies Review,* 14 iv
 (2000) pp.1-6.

3051 SHA'ABAN, Bouthaina. The hidden history of Arab
 feminism. *Arab women: between defiance and restraint.*
 Ed. Suha Sabbagh. New York: Olive Branch Press, 1996,
 pp.250-253. [Women's literary journals 1892-1940.]

3052 SHAMLĀN, Sharīfa a[l]-. Zainab. *Voices of change:*
 short stories by Saudi Arabian women writers. Ed. & tr.
 Abubaker Bagader, A.M.Heinrichsdorff, D.S.Akers.
 Boulder: Rienner, 1998, pp.39-41.

3053 SHAYKH, Ḥanān al-. Die Nacht der Frauen / Hanan
 asch-Schaich. Tr. Karachouli, R. *Arabische Erzählungen*
 der Gegenwart. Hrsg. E.Heller & Hassouna Mosbahi.
 Munich: Beck, 1997, pp.287-296.

3054 SHAYKH, Ḥanān al-. The keeper of the virgins. Tr.
 Cobham, C. *Journal of Arabic Literature,* 27 iii (1996)
 pp.204-210. [Tr. of the short story *Ḥāris al-'adhārā',*
 1993.]

3055 СОКОЛОВА, И.Н. Первые арабские поэтессы,
 писательницы и журналистки. *Россия и Арабский Мир*
 / Russia and the Arab World / Rūsiyā wa-'l-'Ālam
 al-'Arabīya, 5 (1999) pp.119-125.

3056 SOKOLOVA, I. N. Suďby geroev v novellakh egipetskikh
 pisateleĭ Sukheĭr al'-Kalamavi i Mukhammada Abd
 al'-Khalima Abdallakha. (Summar[y]: Destinies of heros
 [sic] in the novels of Egyptian writers Suheir al-Kalamavi
 and Muhammad Abd al-Halim Abdallah.). *Vostok,* 1996
 i, pp.106-114;224.

3057 SONG, Kyung-Sook. The writing of Sahar Khalifah: from
 margin to centre. *JAMES: Annals of Japan Association*
 for Middle East Studies, 15 (2000) pp.1-25. (Feminist
 leader and a prominent writer in the West Bank.)

3058 STAUB, I. "Die USA sind gegen ein geeintes Arabien":
 Gespräch mit der ägyptischen Schriftstellerin und Ärztin
 Nawal as-Saadawi. *Der Arabische Almanach,* 1994,
 pp.16-20.

3059 SULLIVAN, Zohreh T. War, gender, and postcolonial
 writing. *War and its uses: conflict and creativity.* Ed.
 J.Kleist & B.A.Butterfield. New York: Lang, 1999,
 (Plattsburgh Studies in the Humanities, 6), pp.241-253.
 [Assia Djebar; Ṭayyib Ṣāliḥ; Salman Rushdie.]

3060 SUNDERMAN, P. W. Between two worlds: an interview
 with Hanan al-Shaykh. *Literary Review* (Madison), 40
 ii (1997) pp.297-308.

3061 TADIÉ, A. L'univers des romancières égyptiennes: thèmes
 et formes dans la littérature féminine. *Peuples*
 Méditerranéens, 77 (1996) pp.47-94. [Incl. theatre &
 poetry.]

3062 TAHTAH, Fatimah. El concepto de escritura femenina.
 Miscelánea de Estudios Árabes y Hebraicos: Sección
 Árabe-Islam, 47 (1998) pp.383-388. (Arabe, en general,
 y ... marroquí, en particular.)

3063 TĀMIR, Zakarīyā. The sleeping women. Tr. Abu-Deeb,
 Maya. *Banipal,* 1 (1998) pp.45-45. [Short story.]

3064 [ṬAYYIB, Ṭāriq al-]. Mad woman; Three-second fall /
 Tarek Eltayeb. Tr. Porteous, R. *Banipal,* 1 (1998)
 pp.46-48. [Short stories.]

3065 [UḤAYDIB, Laylá 'l-]. Women / Laila al-Ouhaydib. Tr.
 Collins, F. *Banipal,* 4 (1999) pp.59-59. [Story tr. from
 Arabic.]

3066 'UJAYLĪ, 'Abd al-Salām al-. La mère de Raki /
 Abdelssalam al'Ujaylî. Tr. Najmi, Abdelilah. *Qantara*
 (Paris), 19 (1996) pp.64-65. (Extraits.)

3067 ['UTAYBA, Māni' Sa'īd al-]. Karima: chapters from the
 novel / Mani'a Said al-Otaiba. Tr. Collins, F. *Banipal,*
 6 (1999) pp.55-59. [Tr. from Arabic.]

3068 'UTAYBĪ, Fāṭima al-. To celebrate being a woman.
 Voices of change: short stories by Saudi Arabian women
 writers. Ed. & tr. Abubaker Bagader, A.M.Heinrichsdorff,
 D.S.Akers. Boulder: Rienner, 1998, pp.53-56.

3069 ['UTHMĀN, I'tidāl]. La sultane / Etédal Osman. Tr.
 Sabry, Randa. *Une voix bien à elles ... Un recueil de*
 nouvelles par des femmes égyptiennes. Choix de textes &
 introd. par Angèle Botros Samaan. Cairo: Dar el Kuttub,
 1997, (Prisme: La Série Littéraire, 3), pp.187-200.

3070 WALTER, H. Die Rolle der Frau in den Werken der
 zeitgenössischen algerischen Schriftsteller Tahir Wattar
 (Algier) und Mohammed Dib (Paris). *Philosophy and*
 arts in the Islamic world. Proceedings of the Eighteenth
 Congress of the Union Européenne des Arabisants et
 Islamisants ... *Leuven ... 1996.* Ed. U.Vermeulen & D.De
 Smet. Leuven: Peeters, 1998, (Orientalia Lovaniensia
 Analecta, 87), pp.181-189.

3071 WALTHER, W. From women's problems to women as
 images in modern Iraqi poetry. *Welt des Islams,* 36 ii
 (1996) pp.219-241.

3072 WILD, S. Das schlechte Gewissen des Revolutionärs: ein
 Beitrag zur Interpretation von Ghassan Kanafanis
 Geschichtenzyklus *Umm Sa'd. Männer unter tödlicher*
 Sonne: Ghassan Kanafani's Werk heute. Hrsg. W.Fischer.
 Würzburg: Ergon, 1995, (Zwischen Orient und Okzident,
 4), pp.71-84.

3073 WIMMEN, H. 'Ammūriyyah as a female archetype:
 deconstruction of a mythical subtext from Abū Tammām
 to Jabrā Ibrāhīm Jabrā / 'Abd al-Raḥmān Munīf. *Myths,*
 historical archetypes and symbolic figures in Arabic
 literature: towards a new hermeneutic approach.
 Proceedings of the International Symposium in Beirut,
 June 25th - June 30th, 1996. Ed. A.Neuwirth, B.Embaló,
 S.Günther, Maher Jarrar. Beirut: Orient-Institut der
 Deutschen Morgenländischen Gesellschaft; Stuttgart:
 Steiner, 1999, (Beiruter Texte und Studien, 64),
 pp.573-582.

3074 WOLF, D. Gespräch mit Nawal el-Saadawi. *Du,* 1994
 vii-viii / 640, pp.70-72.

3075 YARED, Nazik Saba. Identity and conflict in the novels
 of contemporary Lebanese women novelists. *Edebiyât,*
 12 ii (2001) pp.215-228. Also online at www.tandf.co.uk/
 journals/online/0364-6505.htm

3076 Poesia araba femminile. Tr. Ricasoli, I. *Levante / Al-Mashriq (Rome),* 35 i (1993) pp.23-30. [Italian translations from Fadwá Ṭūqān, Amīna Saʿīd, Faḍīla Shābbī & Dhabīya Khamāʾis, with brief introduction.]

AZERI

Articles

3077 KIA, Mehrdad. Women, Islam and modernity in Akhundzade's plays and unpublished writings. *Middle Eastern Studies,* 34 iii (1998) pp.1-33.

BENGALI LITERATURE

Books

3078 NĀSARINA, Tasalimā. *Un retour,* suivi de *Scènes de mariage: récits / Taslima Nasreen.* Tr. Dutta Gupta, P. & Ray, Paul. Paris: Librairie Générale Française, 1997, (Le Livre de Poche, 14085), 220pp.

3079 *Briefe an Taslima Nasrin.* Freiburg i. B. : Kore 1994. 124pp. [From Muḥammad Shukrī, N.Gordimer, E.Jelinek, Salman Rushdie, P.Sollers, S.Sontag.]

3080 *Chère Taslima Nasreen /* Reporters sans Frontières. Paris: Stock, for Reporters sans Frontières, 1994. 92pp. [Letters addressed to Taslima Nasrin.]

3081 *Different perspectives: women writing in Bangladesh.* Ed. Firdous Azim, Niaz Zaman. Dhaka: Rachna & The University Press, 1998. 93pp.

Articles

3082 AMIN, Sonia. Rokeya's *Padmarag:* utopian alternative to the patriarchal family? *Dhaka University Studies,* 55 i (1998) pp.35-44. [Novel in Bengali.]

3083 AMIN, Sonia N. The changing world of Bengali Muslim women: the 'dreams' and efforts of Rokeya Sakhawat Hossein. *Understanding the Bengal Muslims: interpretative essays.* Ed. Rafiuddin Ahmed. Delhi: Oxford University Press, 2001, pp.139-152. (Pioneer feminist writer of Bengal.)

3084 BASU, Pūrabī. Radha will not cook today. Tr. Niaz Zaman & Ahmed, Shafi. *Selected short stories from Bangladesh.* Ed. Niaz Zaman. Dhaka: Rachna & The University Press, 1998, pp.182-187.

3085 BEGUM, Hasna. Man-woman relationship in contemporary fiction in Bangladesh. *Contemporary Bengali writing: Bangladesh period.* Ed. Khan Sarwar Murshid. Dhaka: University Press, 1996, pp.189-206.

3086 DUTTA, Kalyani. Rokeya Sakhawat Hosain's *Gyanphal* and *Muktiphal:* a critique of the iconography of the nation-as-mother. *Indian Journal of Gender Studies,* 7 ii (2000) pp.203-216.

3087 GHOSH, Bishnupriya. An affair to remember: scripted performances in the "Nasreen Affair". *Going global: the transnational reception of Third World women writers.* Ed. Amal Amireh & Lisa Suhair Majaj. New York: Garland Publishing, 2000, pp.39-83.

3088 GIUDICELLI, J. Quand Marianne vient du Bengale. *Esprit,* 208 (1995) pp.183-184. (Visite en France de ... Taslima Nasreen.)

3089 HARWAZINSKI, A. M. Der Fall Nasreen und das Symposion von Stavanger. *Neue Gesellschaft / Frankfurter Hefte,* 41 xi (1994) pp.1035-1038.

3090 [HOSENA, Selinā]. Motijan's daughters / Selina Hossain. Tr. Chaudhury, Sagar. *Selected short stories from Bangladesh.* Ed. Niaz Zaman. Dhaka: Rachna & The University Press, 1998, pp.153-165.

3091 KARIM, Rashid. Man-woman relationship in Bengali fiction. *Contemporary Bengali writing: Bangladesh period.* Ed. Khan Sarwar Murshid. Dhaka: University Press, 1996, pp.167-188.

3092 KHAN, Jalal Uddin. Reflections on the issue of Taslima Nasreen. *Asian Thought and Society,* 23 / 69 (1998) pp.238-243.

3093 MESBAH, Dilara. The ballad of Nihar Banu. Tr. Niaz Zaman & Sadat, Mirza Mamun. *Different perspectives: women writing in Bangladesh.* Ed. Firdous Azim, Niaz Zaman. Dhaka: Rachna & The University Press, 1998, pp.57-63. [Short story.]

3094 NĀSARINA, Tasalimā. Siberia in my soul. *Index on Censorship,* 25 ii (1996) pp.170-171. [Life in exile.]

3095 NĀSARINA, Tasalimā. The oppressor and the oppressed / Taslima Nasreen. *The dissident word. The Oxford Amnesty lectures /* Chris Miller, editor. New York: Basic Books, 1996, pp.115-130. (Compared to my feminist sisters in the West, I have written little about patriarchy, religion, man-woman relations, and the rights of women. Nevertheless, I have been marked out as an enemy of Islam and of my own country.)

3096 RAHMAN, A.R. Emergence of creativity among Muslim *bhadramahila. Muslim feminism and feminist movement: South Asia.* Vol. 3: *Bangladesh & Sri Lanka.* Ed. Abida Samiuddin, R.Khanam. Delhi: Global Vision Publishing House, 2002, pp.193-227. [Writing in Bengali.]

3097 SHAMSUL ALAM, S.M. Women in the era of modernity and Islamic fundamentalism: the case of Taslima Nasrin of Bangladesh. *Gender, politics, and Islam.* Ed. Therese Saliba, Carolyn Allen and Judith A.Howard. Chicago: University of Chicago Press, 2002, pp.201-234. [Originally published in *Signs,* 23 ii (1998).]

3098 SHAMSUL ALAM, S. M. Women in the era of modernity and Islamic fundamentalism: the case of Taslima Nasrin of Bangladesh. *Signs,* 23 ii (1998) pp.429-461.

3099 WRIGHT, Carolyne. Perils of free speech: the life and writings of Taslima Nasrin. *Contributions to Bengal studies: an interdisciplinary and international approach.* Ed. Enayetur Rahim, Henry Schwarz. Dhaka: Pustaka, 1998, pp.473-486.

3100 "They wanted to kill me". *Middle East Quarterly,* 7 iii (2000) pp.67-74. [Interview with Taslima Nasrin.]

BERBER

Books

3101 MEROLLA, D. *Gender and community in the Kabyle literary space: cultural strategies in the oral and in the written.* Leiden: Research School, CNWS, 1996, (CNWS Publications, 51), 283pp.

Articles

3102 ABROUS, Dahbia. Les joutes poétiques du henné: competition d'honneur et rapt symbolique. *Études et Documents Berbères,* 9 / 1992 (1993) pp.147-164.

3103 AMAHAN, Ali. L'écriture en *tašlḥyt* est-elle une stratégie des *zawaya? A la croisée des études libyco-berbères. Mélanges offerts à Paulette Galand-Pernet et Lionel Galand.* Ed. J.Drouin & A.Roth. Paris: Geuthner, 1993, (Comptes Rendus du Groupe Linguistique d'Etudes Chamito-Sémitiques, GLECS, Supplément 15), pp.437-449. [Incl. Berber text (facsim. of ms. in Arabic script and roman transliteration), with French translation, of *Traité des Femmes.*]

3104 KHATIR, Aboulkacem el-. Chants de mariage de la région de Tiznit (Sud marocain). *Awal,* 23 (2001) pp.159-163. [Texts in Berber with translations into French.]

3105 UMALU, Nouara. A yessetma. Ah! Mes sœurs. Texte berbère recueilli & trad. par Tassadit Yacine. *Awal,* 13 (1996) pp.124-125.

BOSNIAN

Books

3106 HAWKESWORTH, C. *Voices in the shadows: women and verbal art in Serbia and Bosnia.* Budapest: Central European University Press, 2000. 281pp.

3107 OBHODAŠ, Safeta. *Šeherezade u zemlji dugih zima: roman.* Wuppertal & Tuzla: Bosanska Rijec--Bosnisches Wort, 1999. 259pp.

3108 PELESIĆ-MUMINOVIĆ, Fatima. *Ime.* Ankara: MNVS, 1995, (Biblioteka Vehbija Hodžić, 3), 96pp. [Poems.]

Articles

3109 IDRIZOVIČ, Muris. Prve muslimanske književnice. (Summary: Three Moslem poetesses at the boundary between 19. and 20. century.). *Prilozi historiji Sarajeva: radovi sa znanstvenog simpozija* Pola milenija Sarajeva , *održanog 19. do 21. marta 1993. godine. Urednik: Dževad Juzbašić.* Sarajevo: Institut za Istoriju, Orijentalni Institut, 1997, pp.275-278. [Umihana Čuvidina (1795-1870), Nafija Sarajlić (1893-1970) & Šefika Nesterin-Bjelevac (b.1894).]

3110 SAMIC, Josna. La femme et la guerre en Bosnie (nouvelles). *La Méditerranée des femmes.* Sous la dir. de Nabil el Haggar. Paris: L'Harmattan, 1998, pp.79-94. (Temoignages romancés des femmes qui ont survécu à la séconde guerre mondiale, de même que de témoignages de celles qui ont subi les tortures dans la guerre présente.)

3111 ZAHIROVIĆ, Ajša. Pjesnikinje u književnoj tradiciji Sarajeva. (Summary: Poetesses in the literary tradition of Sarajevo.). *Prilozi historiji Sarajeva: radovi sa znanstvenog simpozija* Pola milenija Sarajeva , *održanog 19. do 21. marta 1993. godine. Urednik: Dževad Juzbašić.* Sarajevo: Institut za Istoriju, Orijentalni Institut, 1997, pp.315-318.

3112 ZAHIROVICH, Ajsha. I arrived; Let your daughters; Receive this fever of mine; I call you by the name of Sarajevo; Go this very morning. Tr. Soljan, I. *Gombak Review,* 3 i (1998) pp.36-40. [Bosnian poems.]

CHAGHATAY

Articles

3113 SZUPPE, M. The female intellectual milieu in Timurid and post-Timurid Herāt: Faxri Heravi's biography of poetesses, *Javāheral-'ajāyeb. Oriente Moderno,* 15 / 76 / 1996 ii (1997) pp.119-137. (Composing & writing ..., in some cases, in Chaghatay Turkish.)

COMORESE

Books

3114 HATUBOU, Salim. *Contes de ma grand-mère.* Paris: L'Harmattan, 1994. 110pp. (Contes Comoriens.)

DUTCH

Articles

3115 FAKHTEH, Nasser. Haar naam vas vrouw. *Is dit recht, mijn lief? Verhalen en gedichten over mensenrechten.* The Hague: Novib; Afferden: De Vijver; Brussels: NCOS, 1998, pp.17-40. [Short story written in Dutch.]

3116 SELIM, Nahed. De Paarse Prinses. *Buitenspiegels: verhalen over Nederland* / door Kader Abdolah [& others]. Amsterdam: Van Gennep; The Hague: Novib, 1998, pp.7-13. [Short story written in Dutch.]

ENGLISH

Books

3117 KHASHOGGI, Soheir. *Mirage.* New York: Forge, 1996. 351pp. [Novel by the sister of Adnan Khashoggi, banned in Saudi Arabia.]

3118 KONUK, Kader. *Identitäten im Prozeß: Literatur von Autorinnen aus und in der Türkei in deutscher, englischer und türkischer Sprache.* Essen: Blaue Eule, 2001. 210pp.

Articles

3119 AAL, Kareem. Breaking even; Fluidity of stone; Don't do violence to the details; Before the eagle landed. *Mizna,* 2 iii (2000) pp.28-29. [Poems by an Arab-American.]

3120 ABD. MANAF, Nor Faridah. Islamizing the "feminine, feminist and female" voices in three Malaysian short stories by Anglophone women writers. *Intellectual Discourse,* 8 ii (2000) pp.223-236. (Che Husja Azhari is a Malay Muslim while Lin & Pereira are both non-Malays & non-Muslims.)

3121 BARAKAT, Ibtisam. A morning with my mother. *Mizna,* 3 ii (2001) pp.[26]-[30].

3122 BARDOLPH, J. Brothers and sisters in Nuruddin Farah's two trilogies. *World Literature Today,* 72 iv (1998) pp.727-732.

3123 BARLAS, Fevziye Rahgozar. Princess of waltzes. *Critique and Vision / Naqd wa Ārmān,* 6 (1997) pp.6-18. [Short story in English.]

3124 BENZAHRA, Sidi Cherkawi. Death of a witch. *Mizna,* 2 ii (2000) pp.31-32. [Short story.]

3125 BOULLATA, Issa J. Search for Saleema. *Banipal,* 6 (1999) pp.68-70. [Short story in English set in Palestine.]

3126 DAYAL, Samir. Style is (not) the woman: Sara Suleri's *Meatless days. Between South Asians and postcoloniality: the lines.* Ed. D.Bahri & M.Vasudeva. Philadelphia: Temple University Press, 1996, pp.250-269. [Title of volume should probably read: *Between the lines: South Asians and postcoloniality.*]

3127 EZENWA-OHAETO. Shaking the veil: Islam, gender and feminist configurations in the Nigeria novels of Hauwa Ali and Zaynab Alkali. *Ufahamu,* 24 ii-iii (1996) pp.121-138.

3128 GUINDI, Yussef el. Stage directions for an extended conversation. *Mizna,* 3 iii (2001) pp.[6]-[9]. [Short story by an Egyptian-American on attitudes to clitoridectomy.]

3129 JALAL UDDIN KHAN. Poetry, critical theory, and the Princess. *Gombak Review,* 2 ii (1997) pp.177-181. [English poem about Princess Diana by Bangladeshi poet in Malaysia.]

3130 KAHF, Mohja. "The water of Hajar" and other poems. A performance of poetry and prose. *Muslim World,* 91 i-ii (2001) pp.31-44. [Written in English.]

3131 KAHF, Mohja. Hajar in America; Hijab scenes No 7. *Middle East Report,* 205 / 27 iv (1997) pp.39-39. [Poetry in English.]

3132 KAHF, Mohja. Thawra des odalisques at the Matisse rétrospective. *Jusoor / Jusūr,* 7-8 (1996) pp.383-388. [Poem written in English.]

3133 KAMRA, Sukeshi. Replacing the colonial gaze: gender as strategy in Salman Rushdie's fiction. *Between South Asians and postcoloniality: the lines.* Ed. D.Bahri & M.Vasudeva. Philadelphia: Temple University Press, 1996, pp.237-249. [Title of volume should probably read: *Between the lines: South Asians and postcoloniality.*]

3134 NAQI, Bushra. Pretty lass; Ideology. *Pakistani Literature,* [6] (2001) pp.187-188. [Poem written in English.]

3135 NGABOH-SMART, Francis. *Secrets* and a new civic consciousness. *Research in African Literatures,* 31 i (2000) pp.129-136. (Nuruddin Farah.) [Also online at http:// muse.jhu.edu/journals/ research_in_african_literatures]

3136 OKEREKE, G. E. Woman's quest for autonomy in Zaynab Alkali's *The stillborn*. *Ufahamu,* 24 ii-iii (1996) pp.97-120. [Set in Nigeria.]

3137 SARKER, Sonita. Larger than Bengal: feminism in Rokeya Sakhawat Hossain's *Sultana's dream* and global modernities. *Archiv Orientální,* 68 iii (2000) pp.441-456. (This light-hearted satire was the only one Hossain wrote in English.)

3138 SUKHNI, Wigdan al-. "She's just crazy". *Banipal,* 1 (1998) pp.55-56. [Short story in English.]

3139 YOUSSEF, Samir el-. Are you sure she doesn't live here? *Banipal,* 2 (1998) pp.20-21. [Short story written in English.]

FRENCH

Books

3140 ACHIR, Kerroum. *Nassima.* Paris: L'Harmattan, 1997, (Ecritures Arabes, 143), 282pp.

3141 ADNAN, Etel. *Sitt Marie Rose: a novel.* Tr. Kleege, G. 5th ed. Sausalito: Post-Apollo Press 1998. 105pp. [Novel set in Lebanese war.]

3142 ASSIMA, Fériel. *Une femme á Alger: chronique du désastre.* Paris: Arléa, 1995. 187pp.

3143 BELLEFQIH, Anissa. *Yasmina et le talisman.* Paris: L'Harmattan, 1999, (Ecritures Arabes, 155), 174pp. [Novel written in French.]

3144 BEN, Myriam. *Leïla: poème scénique en deux actes et un prologue*; suivi de, *Les enfants du mendiant.* Paris: L'Harmattan, 1998, (Théâtre des Cinq Continents, 42), 147pp.

3145 BOUCHEQIF, Nasser-Edine. *Ode pour la femme oubliée.* Paris: L'Harmattan, 2001 (Poètes des Cinq Continents, 299), 131pp.

3146 BOURAOUI, Nina. *Una vita di sguardi.* Tr. Melaouah, Yasmina. Milan: Feltrinelli, 1993. 119pp. [Tr. of *La voyeuse interdite*.]

3147 BOUSSOUF, Malika. *Vivre traquée.* Paris: Calmann-Lévy, 1995. 216pp. [Algeria.]

3148 BRAHIMI, Denise. *Maghrébines: portraits littéraires.* Paris: L'Harmattan/Awal, 1995. 181pp.

3149 CHARAF, Dounia. *Fatoum, la prostituée et le saint: roman.* Paris: L'Harmattan, 1998, (Collection Ecritures Arabes, 146), 186pp.

3150 CHAREF, Mehdi. *La maison d'Alexina: roman.* [Paris:] Mercure de France, 1999. 138pp.

3151 CHAULET-ACHOUR, Christiane. *Noûn: algériennes dans l'écriture.* Biarritz: Atlantica, 1998. 245pp.

3152 CLERC, J-M. *Assia Djebar: écrire, transgresser, résister.* Paris: L'Harmattan, 1997. 173pp.

3153 DEJEAN DE LA BÂTIE, Bernadette. *Les romans policiers de Driss Chraïbi: représentations du féminin et du masculin.* Paris: L'Harmattan, 2002. 229pp.

3154 DÉJEUX, J. *La littérature féminine de langue française au Maghreb.* Paris: Karthala, 1994. 256pp.

3155 DJEBAR, Assia. *Die Frauen von Algier.* Tr. Reinhardt, A.von. Zurich: Unionsverlag, 2000. 187pp. [Tr. of *Femmes d'Alger dans leur apartement: nouvelles*, Paris 1980. Novel in French.]

3156 DJEBAR, Assia. *Donne d'Algeri nei loro appartamenti.* Tr. Turano, G. Florence: Giunti, [2000]. 187pp. [Tr. of *Femmes d'Alger dans leur apartement: nouvelles*, Paris 1980. Novel in French. This translation previously published 1994 & 1998.]

3157 DJEBAR, Assia. *Fern von Medina.* Tr. Thill, H. Zürich: Unionsverlag, 1994. 395pp. [Tr. of *Loin de Médine: filles d'Ismaël: roman*, Paris, 1991.]

3158 DJEDAR, Assia. *Lejos de Medina: hijas de Ismael.* Tr. Martín Bermúdez, S. Madrid: Alianza, 1993, (Alianza Cuatro, 21), 272pp. [Tr. of *Loin de Médine*.]

3159 DJEBAR, Assia. *Loin de Médine: filles d'Ismaël: roman.* 2e éd. [Algiers:] ENAG, 1994; Paris: Libraire Générale Française, 1995, (Livre de Poche, 13672), 350pp.

3160 DJEBAR, Assia. *Lontano da Medina: figlie d'Ismaele.* Tr. Tresso, C. M. Florence: Giunti, 1993, (Astrea, 44), 356pp. [Tr. of *Loin de Médine*.]

3161 DJEMAÏ, Messaoud. *Le lapsus de Djedda Aïcha: et autre histoires à lire à haute voix.* Paris: L'Harmattan, 1993, (Ecritures Arabes, 94), 109pp.

3162 DONADEY, Anne. *Recasting postcolonialism: women writing between worlds.* Portsmouth: Heinemann, 2001. 178pp. (In-depth study of the works of major Francophone writers Assia Djebar and Leïla Sebbar.)

3163 FASSI FIHRI, Nouzha. *La baroudeuse: roman.* Casablanca: Eddif, 1997. 218pp. [Novel written in French.]

3164 GAFAÏTI, Hafid. *Les femmes dans le roman algérien: histoire, discours et texte.* Paris: L'Harmattan, 1996. 349pp.

3165 GHACHEM, Moncef. *Matin près de Lorand Gaspar.* Tunis: L'or du Temps Passage, 1998. 68pp. [Poetry & literary essays about his friendship with Lorand Gaspar.]

3166 GHALEM, Ali. *Die Frau für meinen Sohn: Roman aus Algerien.* Tr. Bucaille-Euler, A. & Thauer-Kalberlah, S. 2. Aufl. Basle: Lenos-Verlag 1994 (Lenos-Pocket, 22), 272pp. [Tr. of *Une femme pour mon fils*.]

3167 GHEZALI, Salima. *Les amants de Shahrazade.* La Tour d'Aigues: Aube 1999. 102pp. [Novel.]

3168 GHEZALI, Salima. *Los amantes de Sherezade.* Tr. [Pujol, Nuria]. Barcelona: Martínez Roca, [1999]. 138pp. [Tr. of *Les amants de Shahrazade*, novel.]

3169 KHERBICHE, Sabrina. *Nawel et Leila: roman.* Dakar: Présence Africaine, 1997. 85pp.

3170 MAROUANE, Leila. *La fille de la casbah: roman.* Paris: Julliard, 1996. 209pp.

3171 MAROUANE, Leila. *The abductor.* Tr. McNab, F. London: Quartet, 2000. 193pp. [Tr. of *Le ravisseur*. Novel.]

3172 MELLAH, Fawzi. *Elissa, la regina errante.* Catania: De Martinis, 1993. 223pp. [Tr. of *Elissa, la reine vagabonde*.]

3173 MISHRIKY, Salwa Elias. *Sans voix ou sans moi: Islam et islamisme.* New York: Lang, 2001 (Francophone Cultures and Literatures, 35), 316pp. [With ref. to the Algerian novel *Sans voix*, by Hafsa Zinai-Koudil, Paris 1997.]

3174 MOKEDDEM, Malika. *The forbidden woman. L'interdite.* Tr. Marcus, K. M. Lincoln (USA): University of Nebraska Press, 1998. 156pp. [Tr. of *L'interdite*.]

3175 MOURAD, Kenizé. *Selma, osmanská princezna.* Tr. Navrátilová, Danuše. Prague: Mladá Fronta, 1997. 547pp. [Tr. of *De la part de la princesse morte*, Paris 1987. Novel in French.]

3176 NESRINE, Fatiha. *La baie aux jeunes filles.* Paris: L'Harmattan, 2000 (Collection Ecritures Arabes, 160), 164pp.

3177 ORLANDO, V. *Nomadic voices of exile: feminine identity in francophone literature of the Maghreb.* Athens (USA): Ohio University Press, 1999. 254pp.

3178 ORMEROD, B. & VOLET, J-M. *Romancières africaines d'expression française: le sud du Sahara.* Paris: L'Harmattan, 1994. 159pp. [Incl. Muslims.]

3179 OUMASSINE, Damia. *L'arganier des femmes égarées: roman.* Casablanca: Fennec, 1998. 166pp.

3180 OUT EL KOULOUB. *Ramza.* Tr. Atiya, Nayra. Syracuse (USA): Syracuse University Press, 1994. 201pp.

3181 OUT EL KOULOUB. *Saidas Klage: Roman.* Tr. Büchel, A. Ungekürzte Taschenbuchausg. Munich: Piper 1998. 220pp. [Tr. of *Zanouba*.]

3182 SEBBAR, Leïla. *La jeune fille au balcon.* Paris: Seuil, 1996. 148pp.

3183 SEBTI, Fadéla. *Moi, Mireille lorsque j'étais Yasmina:*
 roman. Casablanca: Le Fennec, [1995]. 101pp.

3184 SEGARRA, M. *Leur pesant de poudre: romancières*
 francophones du Maghreb. Paris: L'Harmattan, 1997.
 237pp.

3185 SEGARRA, Marta. *Mujeres magrebíes: la voz y la mirada*
 en la literatura norteafricana. Barcelona: Icaria, 1998
 (Icaria Antrazyt, 129), 199pp. [Tr. of *Leur pesant de*
 poudre, Paris 1997. Francophone writers.]

3186 SIEBERT, R. *Andare ancora al cuore delle ferite: Renate*
 Siebert intervista Assia Djebar. Milano: La Tartaruga,
 1997. 238pp.

3187 STRINGER, S. *The Senegalese novel by women: through*
 their own eyes. Frankfurt a. M. : Lang 1996 (Francophone
 Cultures and Literatures, 7), 201pp.

3188 WINKELMANN, Esther. *Assia Djebar: Schreiben als*
 Gedächtnisarbeit. Bonn: Pahl-Rugenstein, 2000. 214pp.

3189 ZIANI, Rabia. *Le secret de Marie.* Paris: L'Harmattan,
 1995. 174pp.

3190 ZITOUNI, Ahmed. *La veuve et le pendu.* Levallois-Perret:
 Manya 1993. 201pp.

3191 *Intersections: gender, nation, and community in Arab*
 women's novels. Ed. Lisa Suhair Majaj, Paula
 W.Sunderman, and Therese Saliba. Syracuse: Syracuse
 University Press, 2002. 287pp.

3192 *La vie en rose...: nouvelles de femmes algériennes.* [Paris]:
 Marsa, 2001. 159pp.

3193 *Malika Mokeddem: envers et contre tout.* Sous la dir. de
 Yolande Aline Helm. Paris: L'Harmattan, 2000. 237pp.

Articles

3194 AAS-ROUXPARIS, Nicole. Interdiction et liberté dans
 L'interdite de Malika Mokeddem. *Malika Mokeddem:*
 envers et contre tout. Sous la dir. de Yolande Aline Helm.
 Paris: L'Harmattan, 2000, pp.157-173.

3195 ABDEL-JAOUAD, Hédi. "Too much in the sun": sons,
 mothers, and impossible alliances in Francophone
 Maghrebian writing. *Research in African Literatures,* 27
 iii (1996) pp.15-33.

3196 ABDESSEMED, Rabia. Le chauffeur de taxi. *La vie en*
 rose...: nouvelles de femmes algériennes. [Paris]: Marsa,
 2001, pp.93-101.

3197 ABDESSEMED, Rabia. Ma vie en suspens. *La vie en*
 rose...: nouvelles de femmes algériennes. [Paris]: Marsa,
 2001, pp.57-66.

3198 ABDESSEMED, Rabia. Mémoire de femmes: nouvelles.
 Algérie Littérature / Action, 17 (1998) pp.159-237.
 (Oeuvre intégrale inédite.)

3199 ABU-HAIDAR, Farida. Le chant morne d'une jeune fille
 cloîtrée: *La voyeuse interdite* de Nina Bouraoui. *Bulletin*
 of Francophone Africa, 3 (1993) pp.56-60.

3200 ABU-HAIDAR, Farida. Unmasking women: the female
 persona in Algerian fiction. *African francophone writing:*
 a critical introduction. Ed. Laïla Ibnlfassi & N.Hitchcott.
 Oxford: Berg, 1996, pp.69-81.

3201 ACCAD, Evelyne. Assia Djebar's contribution to Arab
 women's literature: rebellion, maturity. *World Literature*
 Today, 70 iv (1996) pp.801-812.

3202 ACHOUR, C. Weder Sultanin noch still: schreibende
 Frauen aus dem Maghreb. Tr. Fock, H. & Müller, Sabine.
 Zwischen Fundamentalismus und Moderne: Literatur aus
 dem Maghreb. Hrsg. H.Fock, M.Lüdke & D.Schmidt.
 Reinbek bei Hamburg: Rowohlt, 1994, (Literaturmagazin,
 33), pp.46-55.

3203 AHNOUCH, Fatima. Assia Djebar: the song of writing.
 Tr. Genova, P. A. *World Literature Today,* 70 iv (1996)
 pp.795-797.

3204 ALI-BENALI, Zineb. Dires de la folie: dires de la liberté.
 Discours de la folie dans la littérature des femmes en
 Algérie. *Bulletin of Francophone Africa,* 4 / 7 (1995)
 pp.9-20.

3205 ALI-BENALI, Zineb. Un espace selon son coeur (à propos
 de *L'incartade,* Laphomic, 1990 de Dina Mezerni).
 Espaces: actes des journées scientifiques du Département
 d'Espagnol de l'I.L.E. de Bouzaréah ... 1993. Algiers:
 Institut des Langues Etrangères, 1996, (*Langues et*
 Littératures, numéro spécial), pp.109-117. (Ecrit par
 une femme qui vit ailleurs ... publiée en Algérie.)

3206 AMMAR-KHODJA, Soumaya. `La femme est parole`.
 Bachir Hadj-Ali: poétique et politique. Sous la dir. de
 Naget Khadda. Paris: L'Harmattan, 1995, (Etudes
 Littéraires Maghrébines, 5), pp.45-48.

3207 AMO, Mercedes del. La creación literaria de las mujeres
 magrebíes. *Miscelánea de Estudios Arabes y Hebraicos:*
 Sección Arabe-Islam, 50 (2001) pp.53-67. [Novels in
 French & in Arabic.]

3208 AOUGBI, Rosa. La sorcière de la Haute Ville. *La vie*
 en rose...: nouvelles de femmes algériennes. [Paris]: Marsa,
 2001, pp.123-128.

3209 ARNHOLD, B. Dans les coulisses de la création: Fatima
 Gallaire répond aux questions. *Cahier d'Études*
 Maghrébines, 8-9, 1995-96, pp.269-276. [Algerian
 Francophone playwright.]

3210 ARNHOLD, B. L'émergence de femmes écrivains au
 Maghreb: Denise Brahimi ... répond aux questions.
 Cahier d'Études Maghrébines, 8-9, 1995-96, pp.245-251.

3211 ARNHOLD, B. L'exil et la fiction: Leïla Sebbar répond
 aux questions. *Cahier d'Études Maghrébines,* 8-9,
 1995-96, pp.239-244.

3212 ARNHOLD, B. Malika Mokeddem. *Cahier d'Études*
 Maghrébines, 8-9, 1995-96, pp.230-233. (Interview.)

3213 ARNHOLD, B. Spécificité de l'écriture féminine? Une
 interview avec Denise Brahimi à Cologne en mai 1993.
 Cahier d'Études Maghrébines, 8-9, 1995-96, pp.254-256.

3214 ASMA, Leïla. Intolérable intolérance. *La vie en rose...:*
 nouvelles de femmes algériennes. [Paris]: Marsa, 2001,
 pp.33-34.

3215 AYARI, Leila & BROSSEAU, M. In their *rightful* place:
 gender and place in three novels in Tunisian women
 writers. *Arab World Geographer. Le Géographe du*
 Monde Arabe, 1 ii (1998) pp.103-116. (French-language
 novels.)

3216 AZOUAOU, Rosa. L'attente. *La vie en rose...: nouvelles*
 de femmes algériennes. [Paris]: Marsa, 2001, pp.11-14.

3217 BACHOLLE, Michele. Ecrits sur le sable: le désert chez
 Malika Mokeddem. *Malika Mokeddem: envers et contre*
 tout. Sous la dir. de Yolande Aline Helm. Paris:
 L'Harmattan, 2000, pp.69-80.

3218 BAKA, Assia. Anouar. *La vie en rose...: nouvelles de*
 femmes algériennes. [Paris]: Marsa, 2001, pp.35-39.

3219 BAKOUCHE, Abdallah. Eloge de la grand-mère. *Algérie*
 Littérature / Action, 31-32 (1999) pp.286-288.
 (Nouvelle.)

3220 BEDRANE, Sabrinella. La vie en rose. *La vie en rose...:*
 nouvelles de femmes algériennes. [Paris]: Marsa, 2001,
 pp.5-10.

3221 BEN JELLOUN, Tahar. The girls of Tangier. Tr. Sellin,
 E. *Literary Review* (Madison), 41 ii (1998)
 pp.177-177. [Prose, translated from French.]

3222 BENSMAÏA, Réda. *La nouba des femmes du Mont*
 Chenoua: introduction to the cinematic fragment. Tr.
 Gage, J. C. *World Literature Today,* 70 iv (1996)
 pp.877-884. [Film by Assia Djebar.]

3223 BENZAKOUR CHAMI, Anissa. Percepción de la mujer
 occidental por los magrebíes. *Granada 1492-1992: del*
 reino de Granada al futuro del mundo mediterráneo.
 M.Barrios Aguilera & B.Vincent (eds.). Granada:
 Universidad de Granada, Diputación Provincial de
 Granada, 1995, (Biblioteca Chronica Nova de Estudios
 Históricos, 39), pp.393-405. [Incl. discussion of novels
 of Driss Chraïbi.]

3224 BERTÉ, Abdoulaye. La technique romanesque de Cheik Aliou Ndao dans *Un bouquet d'épines pour elle*. *Université Cheikh Anta Diop de Dakar, Annales de la Faculté des Lettres et Sciences Humaines*, 24 / 1994 (1995) pp.161-177.

3225 BEST, Victoria. Between the harem and the battlefield: domestic space in the work of Assia Djebar. *Signs*, 27 iii (2002) pp.873-879. Also online at http://www.journals.uchicago.edu

3226 BIVONA, Rosalia. Ombres, lumières, silences et miroirs brisés d'Algérie. *Femmes écrivains en Méditerranée*. Sous la dir. de Vassiliki Lalagianni. Paris: Publisud, 1999, pp.115-135. [Novels of Assia Djebar.]

3227 BOUABACI, Aïcha. L'écrivaine entre les maux des tabous et les mots de la raison. *Maghreb Littéraire*, 2 / 4 (1998) pp.123-135. [Her experience as Francophone Algerian writer.]

3228 BOUGHERARA-SOUIDI, Nassima. Littérature algérienne au féminin. *Cahier d'Études Maghrébines*, 8-9, 1995-96, pp.186-191.

3229 BRAHIMI, Denise. Assia Djebar: la femme et la langue. *Maghreb Littéraire*, 5 / 9 (2001) pp.39-47.

3230 BRAHIMI, Denise. Fatima Gallaire, une algérienne et le théâtre. *Bulletin of Francophone Africa*, 4 / 7 (1995) pp.67-76.

3231 BRAHIMI, Denise. La littérature des femmes maghrébines. *Cahier d'Études Maghrébines*, 8-9, 1995-96, pp.257-262.

3232 BRAHIMI, Denise. La sœur de Jugurtha. *Awal*, 13 (1996) pp.53-61. (Taos Amrouche ... réflexions consacrées à *Jacinthe noire*.)

3233 BRAHIMI, Denise. Portraits de mères dans la littérature maghrébine. *Awal*, 12 (1995) pp.29-37.

3234 BRAHIMI, Denise. Tahar Ben Jelloun: portrait de jeune fille marocaine? *La traversée du français dans les signes littéraires marocains. Actes du colloque international de l'Université York, Toronto ... 1994*. Textes réunis & publ. Yvette Bénayoun-Szmidt, Hédi Bouraoui, Najib Redouane. Toronto: La Source, 1996, pp.181-187.

3235 CHAREF, Mehdi. Alexina's house. Tr. Kirkup, J. *Banipal*, 6 (1999) pp.61-66. [Excerpt tr. from novel in French.]

3236 CHAREF, Mehdi. Alexina's house: continuing excerpt. Tr. Kirkup, J. *Banipal*, 7 (2000) pp.72-77.

3237 CHAULET-ACHOUR, C. Il était une fois ... des écrivaines. (Montage.). *Cahier d'Études Maghrébines*, 8-9, 1995-96, pp.224-229. (Hawa Djabali, Leïla Rezzoug, Malika Mokeddem.)

3238 CHAULET-ACHOUR, C. L'écriture et les femmes. *Cahier d'Études Maghrébines*, 8-9, 1995-96, pp.192-195.

3239 CHAULET-ACHOUR, C. Les "écrivaines" algériennes, 1993-1998: sur la voie d'une (re)connaissance. *Cahiers de l'Orient*, 51 (1998) pp.141-147.

3240 CHAULET-ACHOUR, Christiane & BERGER, Karima. "Dans un sens, dans l'autre, sans cesse". *Algérie Littérature / Action*, 22-23 (1998) pp.123-129. [Dialogue with Algerian Francophone author Karima Berger.]

3241 CHAULET-ACHOUR, Christiane & KERFA, Lalia. Portrait. *Malika Mokeddem: envers et contre tout*. Sous la dir. de Yolande Aline Helm. Paris: L'Harmattan, 2000, pp.21-37. [Of Malika Mokeddem.]

3242 CHAULET-ACHOUR, Christiane. Visages de femmes dans l'œuvre romanesque de Rabah Belamri. *Enracinement culturel et rôle des médiateurs au Maghreb: l'exemple de Rabah Belamri. Actes du colloque ... 1996*. Sous la dir. de Tassadit Yacine. Paris: Awal / L'Harmattan, 2000, pp.45-51.

3243 CHAULET-ACHOUR, Christianne. Le corps, la voix et le regard; la venue à l'écriture dans l'oeuvre de Malika Mokeddem. *Malika Mokeddem: envers et contre tout*. Sous la dir. de Yolande Aline Helm. Paris: L'Harmattan, 2000, pp.203-213.

3244 CHEVILLOT, Frédérique. Beurette suis et beurette ne veux pas toujours être: entretien d'été avec Tassadit Imache. *French Review*, 71 iv (1998) pp.632-644.

3245 CHIKHI, Beïda. Algériades: d'Assia Djebar à Nina Bouraoui. *Bulletin of Francophone Africa*, 5 / 9 (1996) pp.29-40.

3246 CHIKHI, Beïda. Histoire et stratégie fictionnelle dans les romans d'Assia Djebar. *Écrivains maghrébins & modernité textuelle*. Sous la dir. de Naget Khadda. Paris: L'Harmattan, 1994, (Etudes Littéraires Maghrébines, 3), pp.17-30.

3247 CROUZIÈRES-INGENTHRON, Armelle. Histoire de l'Algérie, destins de femmes: l'écriture du nomadisme dans *Les hommes qui marchent*. *Malika Mokeddem: envers et contre tout*. Sous la dir. de Yolande Aline Helm. Paris: L'Harmattan, 2000, pp.141-155.

3248 CURTI, L. Words, bodies, writing: feminist frontiers and global limits. *Communal Plural*, 6 ii (1998) pp.157-169. [Incl. Assia Djebar.]

3249 DECOURT, N. Pratiques de contes immigrés: quand des femmes entrent en littérature. *Littératures des immigrations. 1: Un espace littéraire émergent. Sous la dir. de C.Bonn*. Paris: L'Harmattan, 1995, (Etudes Littéraires Maghrébines, 7), pp.127-133. [Incl. Maghribi women in France.]

3250 DÉJEUX, J. L'étrangère dans la littérature maghrébine de langue française. *Hommes & Migrations*, 1167 (1993) pp.34-37.

3251 DHOUKAR, Hédi. Expressions algériennes: un entretien avec Christiane Achour. *Hommes & Migrations*, 1182 (1994) pp.42-44. (Femmes écrivains dans l'Algérie.)

3252 DIB, Mohammed. Assia Djebar, or Eve in her garden. Tr. Genova, P. A. *World Literature Today*, 70 iv (1996) pp.788-788.

3253 DJEBAR, Assia. Pourquoi j'écris. *Europas islamische Nachbarn: Studien zur Literatur und Geschichte des Maghreb*. Hrsg. E.Ruhe. Würzburg: Königshausen & Neumann, 1993, pp.9-24.

3254 DJEMAÏ, Abdelkader. La fille. *Maghreb Littéraire*, 5 / 9 (2001) pp.111-113. [Short story in French.]

3255 DONADEY, A. Cultural *métissage* and the play of identity in Leïla Sebbar's *Shérazade* trilogy. *Borders, exiles, diasporas*. Ed. E.Barkan & M-D.Shelton. Stanford: Stanford University Press, 1998, pp.257-273.

3256 EDDÉ, D. "J'avais déjà envie d'aventure, de quitter la maison, d'aller dans le désert ...". Un entretien d'Etel Adnan. *Revue d'Etudes Palestiniennes*, NS 15 / 67 (1998) pp.92-98. [Her childhood in Lebanon.]

3257 ELHANY MOURAD, Farida. Le métier d'écrivaine ... *Maghreb Littéraire*, 4 / 8 (2000) pp.97-116. [Moroccan writer.]

3258 ELIA, Nada. The fourth language: subaltern expression in Djebar's *Fantasia*. *Intersections: gender, nation, and community in Arab women's novels*. Ed. Lisa Suhair Majaj, Paula W.Sunderman, and Therese Saliba. Syracuse: Syracuse University Press, 2002, pp.183-199.

3259 FARDEHEB, Zohka. Algérie, mon amour, ma souffrance. *La vie en rose...: nouvelles de femmes algériennes*. [Paris]: Marsa, 2001, pp.47-56.

3260 FATHI, Rajae Berrada. L'initiative romanesque féminine entre la fiction et l'affranchissement. *Initiatives féminines / Mubādarāt nisā'īya*. Khadija Amiti ... [& others]. Casablanca: Le Fennec, 1999, pp.119-138. [Novels by Moroccan women writing in French.]

3261 FATIH, Zakaria. L'incorporation narrative de la féminité dans *Harrouda* de Tahar Ben Jelloun. *French Review*, 73 iv (2000) pp.690-698.

3262 FAULKNER, R. A. Assia Djebar, Frantz Fanon, women, veils, and land. *World Literature Today*, 70 iv (1996) pp.847-855.

3263 FONTAINE, J. L'écart dans la littérature féminine tunisienne. *Tunisie plurielle. Volume I. Actes du Colloque de l'Université York, Toronto, Canada*. Dir. Hédi Bouraoui. Tunis: L'Or du Temps, 1997, pp.233-248.

3264 FRICKEY, Pierrette. Temps, espace et mémoire dans
 l'oeuvre de Malika Mokeddem. *Malika Mokeddem:*
 envers et contre tout. Sous la dir. de Yolande Aline Helm.
 Paris: L'Harmattan, 2000, pp.117-129.

3265 GAFAITI, Hafid. L'autobiographie plurielle. Assia Djebar,
 les femmes et l'histoire. *Postcolonialisme &*
 autobiographie: Albert Memmi, Assia Djebar, Daniel
 Maximim. Alfred Hornung, Ernstpeter Ruhe, (eds).
 Amsterdam: Rodopi, 1998, (Studies in Comparative
 Literature, 20), pp.149-159. [Discussion, pp.187-190.]

3266 GAFAITI, Hafid. The blood of writing: Assia Djebar's
 unveiling of women and history. *World Literature Today,*
 70 iv (1996) pp.813-822.

3267 GALLAIRE, Fatima. Baï. *Une enfance algérienne, textes*
 inédits recueillis par Leïla Sebbar. Paris: Gallimard, 1997,
 pp.133-146.

3268 GALLAIRE, Fatima. Fatima Gallaire par elle-même.
 Cahier d'Études Maghrébines, 8-9, 1995-96, pp.263-266.
 [Algerian Francophone playwright.]

3269 GALLAIRE, Fatima. Seine Ehefrauen. Tr. Höhfeld, B.
 Cahier d'Études Maghrébines, 8-9, 1995-96, pp.267-268.
 [Tr. from the play *Co-épouses.*]

3270 GEESEY, P. Women's words: Assia Djebar's Loin de
 Médine. *The marabout and the muse: new approaches*
 to Islam in African literature. Ed. K.W.Harrow. Portsmouth
 (USA): Heinemann & London: Currey, 1996, pp.40-50.

3271 GHANDOUR, Sabah. Gender, postcolonial subject, and
 the Lebanese civil war in *Sitt Marie Rose. The*
 postcolonial crescent: Islam's impact on contemporary
 literature. Ed. J.C.Hawley. New York: Lang, 1998,
 pp.155-165.

3272 GRACKI, K. Writing violence and the violence of writing
 in Assia Djebar's Algerian quartet. *World Literature*
 Today, 70 iv (1996) pp.835-843.

3273 GROS, Isabelle. Malika Mokeddem: une enfance détruite
 et une écriture de l'espoir. *Malika Mokeddem: envers et*
 contre tout. Sous la dir. de Yolande Aline Helm. Paris:
 L'Harmattan, 2000, pp.175-183.

3274 GUÈYE, Médoune. La question du féminisme chez
 Mariama Bâ et Aminata Sow Fall. *French Review,* 72 ii
 (1998) pp.308-319.

3275 HABIBA, Meziane. La répresentation de la femme
 autochtone dans le Devoir de violence de Yambo
 Ouologuèm. *Expressions: Revue de l'Institut des Langues*
 Etrangères, Université de Constantine, 2 i (1993)
 pp.17-26.

3276 HAMIL, Mustapha. The poetics of love in Evelyne Accad's
 The excised. *Journal of North African Studies,* 4 i (1999)
 pp.78-86. [Francophone novel by Lebanese Christian
 about Arab women & their world.]

3277 HADDAWY, Diana. Sitt Marie Rose: a victim of
 estrangement. *Jusoor / Jusūr,* 7-8 (1996) pp.269-278.
 [Novel by Etel Adnan set in Lebanese war.]

3278 HAMMADOU, Ghania. La répudiée de la place du Zaïm.
 Algérie Littérature / Action, 18-19 (1998) pp.197-201.
 [Unpublished story.]

3279 HAMMADOU, Ghania. La répudiée de la Place du Zaïm.
 La vie en rose...: nouvelles de femmes algériennes. [Paris]:
 Marsa, 2001, pp.109-114.

3280 HAMMADOU, Ghania. Les voiles de mon enfance. *La*
 vie en rose...: nouvelles de femmes algériennes. [Paris]:
 Marsa, 2001, pp.83-92.

3281 HAMMADOU, Ghania. Réflexions d'une écrivaine.
 Malika Mokeddem: envers et contre tout. Sous la dir. de
 Yolande Aline Helm. Paris: L'Harmattan, 2000,
 pp.229-236.

3282 HAMOUTÈNE, Leila. Warda Bent el Kheil. *La vie en*
 rose...: nouvelles de femmes algériennes. [Paris]: Marsa,
 2001, pp.79-81.

3283 HAMOUTÈNE, Leïla. Warda Bent el Kheil. *Algérie*
 Littérature / Action, 26 (1998) pp.179-181. (Nouvelle.)

3284 HEILER, S. *Le miroir du silence* de Aïcha Bouabaci. Une
 poétique silencieuse, chantée et réfléchie. *Bulletin of*
 Francophone Africa, 5 / 9 (1996) pp.57-70.

3285 HELM, Yoland Aline. Entretien avec Malika Mokeddem.
 Malika Mokeddem: envers et contre tout. Sous la dir. de
 Yolande Aline Helm. Paris: L'Harmattan, 2000, pp.39-51.

3286 HELM, Yolande [Aline]. Malika Mokeddem: a new and
 resonant voice in francophone Algerian literature.
 Maghrebian mosaic: a literature in transition. Ed. by
 Mildred Mortimer. Boulder: Rienner, 2001, pp.195-211.

3287 HIPPOLYTE, Jean-Louis. Storytelling on the run in Leïla
 Sebbar's *Shérazade. Maghrebian mosaic: a literature in*
 transition. Ed. by Mildred Mortimer. Boulder: Rienner,
 2001, pp.289-304.

3288 HITCHCOTT, N. 'Confidently feminine'? Sexual role-play
 in the novels of Mariama Bâ. *African francophone*
 writing: a critical introduction. Ed. Laïla Ibnlfassi &
 N.Hitchcott. Oxford: Berg, 1996, pp.139-152.
 [Senegalese.]

3289 HITCHCOTT, Nicki. African "herstory": the feminist
 reader and the African autobiographical voice. *Research*
 in African Literatures, 28 ii (1997) pp.16-33. (Three
 texts - *Femme d'Afrique,* published by Aoua Kéita in 1975,
 Le baobab fou by Ken Bugul (1984), & *De Tilène au*
 plateau by Nafissatou Diallo (1975).)

3290 HOUARI, Leïla. Mimouna. Tr. Sellin, E. *Literary*
 Review (Madison), 41 ii (1998) pp.204-211. [Short story,
 translated from French.]

3291 IBNLFASSI, Laïla. L'appropriation de la voix féminine
 par les écrivains masculins marocains. *La traversée du*
 français dans les signes littéraires marocains. Actes du
 colloque international de l'Université York, Toronto ...
 1994. Textes réunis & publ. Yvette Bénayoun-Szmidt,
 Hédi Bouraoui, Najib Redouane. Toronto: La Source, 1996,
 pp.55-63.

3292 IBRAHIM-OUALI, Lila. Maïssa Bey: "des mots sous la
 cendre des jours": *Au commencement était la mer...* et
 Nouvelles d'Algérie. Esprit Créateur, 40 ii (2000)
 pp.75-85.

3293 INFANTE MORA, E. Concepto de género en las novelas
 de Tahar Ben Jelloun. *Awrāq,* 15 (1994) pp.11-27.

3294 IRELAND, Susan. Une écriture de l'apaisement dans *La*
 nuit de la lézarde. Malika Mokeddem: envers et contre
 tout. Sous la dir. de Yolande Aline Helm. Paris:
 L'Harmattan, 2000, pp.131-139.

3295 IRELAND, Susan. Voices of resistance in contemporary
 Algerian women's writing. *Maghrebian mosaic: a*
 literature in transition. Ed. by Mildred Mortimer. Boulder:
 Rienner, 2001, pp.171-193.

3296 IRLAM, Shaun. Mariama Bâ's *Une si longue lettre:* the
 vocation of memory and the space of writing. *Research*
 in African Literatures, 29 ii (1998) pp.76-93.

3297 JAGER, M. de. Translating Assia Djebar's *Femmes d'Alger*
 dans leur appartement: listening for the silence. *World*
 Literature Today, 70 iv (1996) pp.856-858.

3298 KADIR, Djelal. Assia Djebar: 1996 Neustadt International
 Prize for Literature. Of pencil points and petty tyrants.
 World Literature Today, 70 iv (1996) pp.777-777.

3299 KELLE, Michel. Mouloud Féraoun et Emmanuel Roblès.
 Algérie Littérature / Action, 31-32 (1999) pp.187-204.

3300 KELLEY, D. Assia Djebar: parallels and paradoxes.
 World Literature Today, 70 iv (1996) pp.844-846.

3301 KESTELOOT, L. Women's breakthrough in the African
 social novel. *African Environment,* 10 iii-iv / 39-40
 (1999) pp.17-30. [Incl. examples of Francophone Muslim
 writers.]

3302 KHADDA, Djawida. Impressions. *La vie en rose...:*
 nouvelles de femmes algériennes. [Paris]: Marsa, 2001,
 pp.41-46.

3303 KHADHAR, Hédia. Regards des femmes poètes de Tunisie
 (1956-2000). *Peuples Méditerranéens. Mediterranean*
 Peoples, 80 (1997) pp.177-186. (En langue française.)

3304 KHODJA, Soumya Ammar. Comme les doigts de la main. *La vie en rose...: nouvelles de femmes algériennes.* [Paris]: Marsa, 2001, pp.115-121.

3305 KHODJA, Soumya Ammar. For Assia Djebar: inspired by her book *L'amor, la fantasia.* Tr. Genova, P. A. *World Literature Today,* 70 iv (1996) pp.793-794.

3306 KLAW, Barbara. Mariama Bâ's *Une si longue lettre* and subverting a mythology of sex-based oppression. *Research in African Literatures,* 31 ii (2000) pp.132-150. Also online at www.nesli.ac.uk

3307 LABIDI, Zineb. Entretien avec Ahmed Zitouni. *Algérie Littérature / Action,* 27-28 (1999) pp.206-207.

3308 LABIDI, Zineb. Le ravisseur des mariées. *La vie en rose...: nouvelles de femmes algériennes.* [Paris]: Marsa, 2001, pp.15-19.

3309 LABIDI, Zineb. Le voile et le youyou. *La vie en rose...: nouvelles de femmes algériennes.* [Paris]: Marsa, 2001, pp.67-71.

3310 LANE, Amanda. The modern Moroccan protagonist: a study of the works of Abouzeid, Boucetta, and Ben Jelloun. *Maghreb Review,* 21 iii-iv (1996) pp.267-271.

3311 LANG, G. Jihad, ijtihad, and other dialogical wars in La mère du printemps, Le harem politique, and Loin de Médine. *The marabout and the muse: new approaches to Islam in African literature.* Ed. K.W.Harrow. Portsmouth (USA): Heinemann & London: Currey, 1996, pp.1-22. (Driss Chraïbi, Fatima Mernissi, & Assia Djebar.)

3312 LASSEL, Adriana. La solitude de Nora. *La vie en rose...: nouvelles de femmes algériennes.* [Paris]: Marsa, 2001, pp.129-132.

3313 LASSEL, Adriana. Le silence. *La vie en rose...: nouvelles de femmes algériennes.* [Paris]: Marsa, 2001, pp.25-28.

3314 LE BOUCHER, D(ominique). Expérience théâtrale au féminin. *Algérie Littérature / Action,* 29-30 (1999) pp.257-266. [Staging of a story by Maïssa Bey, by French women's group. Interview with Jocelyne Carmichael.]

3315 LE BOUCHER, Dominique. Les couleurs de la guerre. *Algérie Littérature / Action,* 33-34 (1999) pp.224-235. [Interview with Leïla Sebbar, author of *Soldats, Nouvelles,* Paris 1999.]

3316 LEE, S. Daughters of Hagar: daughters of Muhammad. *The marabout and the muse: new approaches to Islam in African literature.* Ed. K.W.Harrow. Portsmouth (USA): Heinemann & London: Currey, 1996, pp.51-61. (Assia Djebar.)

3317 LEE, Sonia. Hélé Béji's gaze. *Maghrebian mosaic: a literature in transition.* Ed. by Mildred Mortimer. Boulder: Rienner, 2001, pp.229-238. [Modern Tunisian authoress.]

3318 LEPROUST, K. Une série policière au féminin: Yasmina Khadra et le commissaire Llob. *Cahiers de l'Orient,* 51 (1998) pp.149-153. [Algerian novelist.]

3319 LINARES, M. Masculin/féminin dans *La mère du printemps* et *Naissance à l'aube* de Driss Chraïbi. *Homenatge a Amelia García-Valdecasas Jiménez* (vol.II). Ed. F.Carbó [& others]. Valencia: Facultat de Filologia, Universitat de València, 1995, (Quaderns de Filologia: Estudis Literaris, I), pp.503-507.

3320 LISO, E. Ecriture et mémoire dans les nouvelles de Fatima Gallaire: une lecture critique. *Bulletin of Francophone Africa,* 5 / 10 (1996) pp.52-59.

3321 LUNT, L. G. La quête de l'identité: la femme dans le roman tunisien contemporain. *IBLA,* 59 i / 177 (1996) pp.55-86.

3322 LUNT, L. G. Reclaiming the past: historical novels by contemporary women writers. *IBLA,* 62 / 184 (1999) pp.135-158. (A number of contemporary Tunisian women have chosen to write historical novels in French.)

3323 MADŒUF, J. Féminisme et orientalisme au miroir francophone d'Out-el-Kouloub (1892-1968). *Egypte / Monde Arabe,* 29 (1997) pp.101-114.

3324 MAJAJ, Lisa Suhair. Voice, representation, and resistance: Etel Adnan's *Sitt Marie Rose.* *Intersections: gender, nation, and community in Arab women's novels.* Ed. Lisa Suhair Majaj, Paula W.Sunderman, and Therese Saliba. Syracuse: Syracuse University Press, 2002, pp.200-230.

3325 MANGIA, A. M. Les rôles féminins dans les romans "beurs". *Littératures des immigrations.* 1: *Un espace littéraire émergent. Sous la dir. de C.Bonn.* Paris: L'Harmattan, 1995, (Etudes Littéraires Maghrébines, 7), pp.51-61.

3326 MCELANEY-JOHNSON, Ann. Epistolary friendship: *La prise de parole* in Mariama Bâ's *Une si longue lettre.* *Research in African Literatures,* 30 ii (1999) pp.111-121.

3327 MCILVANNEY, S. Female identity in process in Soraya Nini's *Ils disent que je suis une beurette.* *Modern & Contemporary France,* 6 iv (1998) pp.505-517.

3328 MCNEECE, Lucy Stone. La sirène des sables: le degré zéro de l'écriture chez Malika Mokeddem. *Malika Mokeddem: envers et contre tout. Sous la dir. de Yolande Aline Helm.* Paris: L'Harmattan, 2000, pp.53-67.

3329 MÉLIANI, Hamma. Les filles de Jelfen. *Algérie Littérature / Action,* 20-21 (1998) pp.245-283. (Théâtre.)

3330 MÉNAGER, S. D. Traces: Leïla Sebbar atteint au silence des rives. *Nottingham French Studies,* 34 ii (1995) pp.67-74.

3331 MÉNAGER, Serge. La 1ère personne plurielle des femmes écrivains marocaines des années 90. *Maghreb Littéraire,* 3 / 5 (1999) pp.17-32.

3332 MESSAÏLI, Saïda. Pardon. *La vie en rose...: nouvelles de femmes algériennes.* [Paris]: Marsa, 2001, pp.107-108.

3333 MEZGUELDI, Zohra. L'écriture comme construction d'une nouvelle image de soi: la littérature féminine de l'immigration maghrébine. *Initiatives féminines / Mubādarāt nisā'īya.* Khadija Amiti ... [& others]. Casablanca: Le Fennec, 1999, pp.139-153.

3334 MEZGUELDI, Zohra. La femme-terroir: représentation de la femme rurale dans l'œuvre de Mohamed Khaïr-Eddine. *Femmes rurales. / Nisā' qarawīyāt.* Collection dir. par Aïsha Belarbi. Casablanca: Editions Le Fennec, 1995, (Approches, 7), pp.143-158. [Moroccan Francophone author.]

3335 M'HENNI, Mansour. Elle. *Regards sur la littérature tunisienne.* A cura di Majid el Houssi, Mansour M'henni, S.Zoppi. Rome: Bulzoni, 1997, pp.234-234. [Poem in French.]

3336 MILLER, Mary-Kay F. My mothers / my selves: (re)reading a tradition of West African women's autobiography. *Research in African Literatures,* 28 ii (1997) pp.5-15. [Incl. writers from Senegal & Mali.]

3337 MOHAMMEDI-TABTI, Bouba. Trois œuvres féminines d'aujourd'hui: une réécriture du tragique? *Paysages littéraires algériens des années 90: témoigner d'une tragédie?* Sous la direction de C.Bonn & Farida Boualit. Paris & Montréal: L'Harmattan, 1999, (Etudes Littéraires Maghrébines, 14), pp.97-103.

3338 MOKEDDEM, Malika. De la lecture à l'écriture, des livres au livre, résistance ou survie? *Revue du Monde Musulman et de la Méditerranée,* 70, 1993-94, pp.53-55. [Algerian childhood.]

3339 MORTIMER, M. Reappropriating the gaze in Assia Djebar's fiction and film. *World Literature Today,* 70 iv (1996) pp.859-866.

3340 MORTIMER, Mildred. Assia Djebar's *Algerian quartet*: a study in fragmented autobiography. *Research in African Literatures,* 28 ii (1997) pp.102-117.

3341 MORTIMER, Mildred. Le désert intérieur et extérieur dans l'oeuvre romanesque de Malika Mokeddem. *Malika Mokeddem: envers et contre tout. Sous la dir. de Yolande Aline Helm.* Paris: L'Harmattan, 2000, pp.81-92.

3342 MORTIMER, Mildred. Reappropriating the gaze in Assia Djebar's fiction and film. *Maghrebian mosaic: a literature in transition.* Ed. by Mildred Mortimer. Boulder: Rienner, 2001, pp.213-228.

3343 NADIFI, Rajaa. Quand les femmes entreprennent d'écrire...
 sur les femmes. Initiatives féminines / Mubādarāt
 nisā'īya. Khadija Amiti ... [& others]. Casablanca: Le
 Fennec, 1999, pp.95-118. [Maghribi women writing in
 Arabic or in French, mainly as novelists, but also as
 sociologists.]

3344 NAUDIN, Marie. Malika Mokeddem: arabesques
 sahariennes. Malika Mokeddem: envers et contre tout.
 Sous la dir. de Yolande Aline Helm. Paris: L'Harmattan,
 2000, pp.93-104.

3345 NAUDIN, Marie. Tunisian women novelists and
 postmodern Tunis. Maghrebian mosaic: a literature in
 transition. Ed. by Mildred Mortimer. Boulder: Rienner,
 2001, pp.239-249.

3346 NELSON, Cynthia. Doria Shafik's French writing:
 hybridity in a feminist key. Alif, 20 (2000) pp.109-139.

3347 NELSON, Cynthia. Doria Shafik's French writing:
 hybridity in a feminist key. Alif, 20 (2000) pp.109-139.

3348 NOUIRI, Abdennour. Mériem ou la déchirure. Roman.
 Algérie Littérature / Action, 31-32 (1999) pp.5-183.

3349 ORLANDO, Valérie. Ecriture d'un autre lieu: la
 déterritorialisation des nouveaux rôles féminins dans
 L'interdite. Malika Mokeddem: envers et contre tout.
 Sous la dir. de Yolande Aline Helm. Paris: L'Harmattan,
 2000, pp.105-115.

3350 ORMEROD, Beverley & VOLET, Jean-Marie. Ecrits
 autobiographiques et engagement: le cas des Africaines
 d'expression française. French Review, 69 iii (1996)
 pp.426-444. [Incl. Aoua Kéita, Nafissatou Diallo, Amina
 Sow Mbaye & others.]

3351 PIEPRZAK, K. Assia Djebar: where wounding words are
 drowned. Banipal, 7 (2000) pp.70-71.

3352 RAHMOUNE, Ybdas. Arjouna. Algérie Littérature /
 Action, 20-21 (1998) pp.67-80. (Extrait d'un roman
 inédit.)

3353 RAÏSSI, Rachid. Enfantement à vif! (Nouvelle.). Algérie
 Littérature / Action, 33-34 (1999) pp.183-187.

3354 RASSIM, Ahmed. Chez l'épicier du coin; And
 Grandmother also says; Extracts from Drops of Shadow.
 Tr. Levin, G. Mediterraneans / Méditerranéennes, 8/9
 (1996) pp.142-147.

3355 REDOUANE, Najib. Abdelhak Serhane: annonciateur et
 dénonciateur du tragique féminin au Maroc. La traversée
 du français dans les signes littéraires marocains. Actes du
 colloque international de l'Université York, Toronto ...
 1994. Textes réunis & publ. Yvette Bénayoun-Szmidt,
 Hédi Bouraoui, Najib Redouane. Toronto: La Source, 1996,
 pp.219-236.

3356 REDOUANE, Najib. L'inscription du social dans les
 romans de Farida ElHany Mourad. Femmes écrivains
 en Méditerranée. Sous la dir. de Vassiliki Lalagianni. Paris:
 Publisud, 1999, pp.93-113. (Aanalyse de la société
 marocaine.)

3357 REDOUANE, Najib. La re-présentation de la femme dans
 l'oeuvre de Abdelhak Serhane. Bulletin of Francophone
 Africa, 3 / 5 (1994) pp.28-40.

3358 REDOUANE, N[a]jib. Trois voix féminines dans L'enfant
 endormi de Noufissa Sbaï. IBLA, 61 / 181 (1998)
 pp.11-25.

3359 REDOUANE, Najib. Zeida de nulle part de Leïla Houari:
 l'écriture de l'entre-deux. Arabic and Middle Eastern
 Literatures, 4 i (2001) pp.43-52. Also online at
 www.catchword.com

3360 RENAUDIN, Christine. "Guérir, dit-elle": le double
 pouvoir de la médecine et de l'écriture. Malika
 Mokeddem: envers et contre tout. Sous la dir. de Yolande
 Aline Helm. Paris: L'Harmattan, 2000, pp.215-228.

3361 REZZOUG, Leila. La carte d'identité. La vie en rose...:
 nouvelles de femmes algériennes. [Paris]: Marsa, 2001,
 pp.149-157.

3362 REZZOUG, Leïla. Grand-mère. La vie en rose...:
 nouvelles de femmes algériennes. [Paris]: Marsa, 2001,
 pp.133-144.

3363 RICE, Laura. The Maghreb of the mind in Mustapha Tlili,
 Brick Oussaïd, and Malika Mokeddem. Maghrebian
 mosaic: a literature in transition. Ed. by Mildred
 Mortimer. Boulder: Rienner, 2001, pp.119-149.

3364 ROSELLO, Mireille. Georgette! de Farida Belghoul:
 télévision et départenance. Esprit Créateur, 33 ii (1993)
 pp.35-46.

3365 ROTHE, A. Femme inconnue - pays inconnu? Nedjma de
 Kateb Yacine et Sobre héroes y tumbas d'Ernesto Sabato.
 Littérature maghrébine et littérature mondiale: Actes du
 colloque de Heidelberg ... 1993. C.Bonn, A.Rothe (ed.).
 Würzburg: Königshausen & Neumann, 1995, pp.101-116.

3366 RUHE, Doris. Scheherezades Botschaft. Sinnfülle und
 Sinnentzug in Assia Djebars Ombre sultane. Europas
 islamische Nachbarn. Studien zur Literatur und Geschichte
 des Maghreb. Band 2. hrsg. von Ernstpeter Ruhe.
 Würzburg: Königshausen & Neumann, 1995, pp.45-70.

3367 SAADI, Nourredine. Père de filles. Femmes et hommes
 au Maghreb et en immigration: la frontière des genres en
 question. Etudes sociologiques et anthropologiques. Sous
 la dir. de C.Lacoste-Dujardin & M.Virolle. Coord. Baya
 Boualem & Narjys El Alaoui. Paris: Publisud, 1998,
 pp.201-212. (Dans les textes des écrivains maghrébines.)

3368 SAFI-EDDINE, Khadija. A self of her own: the genesis
 of female identity in Mariama Bâ's So long a letter.
 Bouhout / Buḥūth, 7 (1997) pp.75-85.

3369 SAÏD, Amina. From strata of light. Tr. Kirkup, J.
 Banipal, 9 (2000) pp.60-60. [Poem in French.]

3370 SAÏD, Amina. Life and the land of dreams. Eye to eye
 women: their words and worlds. Life in Africa, Asia, Latin
 America and the Caribbean as seen in photographs and
 in fiction by the region's top women writers. (Ed. V.Baird).
 Oxford: New Internationalist, 1996, pp.78-78. [Poem
 translated from French.]

3371 SAÏD, Amina. Une femme; Soleil intense; Corps de
 femme; Odeur sèche des pins; Retenue par la dune;
 Aujourd'hui; Un jour je sais la page; Soleil à son lever;
 Sur les chemins de la vie; Quelqu'un en moi. Peuples
 Méditerranéens. Mediterranean Peoples, 80 (1997)
 pp.129-142. [Poems in French.]

3372 SA'ĪD, Amīna. On the tattered edges ...; My woman's
 transparence; The Africa of the statue; The vultures grow
 impatient. Tr. Sellin, E. The new African poetry: an
 anthology. Ed. T.Ojaide, Tijan M.Sallah. Boulder: Rienner,
 1999, pp.73-76. [Poems tr. from French.]

3373 SAÏKI, Salima. Le revenant. La vie en rose...: nouvelles
 de femmes algériennes. [Paris]: Marsa, 2001, pp.21-24.

3374 SCHAAD, I. Reise ins Innere des Geschlechts: das
 Weibliche und das Männliche in der Literatur von Assia
 Djebar und Tahar Ben Jelloun. Du, 1994 vii-viii / 640,
 pp.66-69.

3375 SCHATANEK, H. A propos de Loin de Médine de Assia
 Djebar. Cahier d'Études Maghrébines, 8-9, 1995-96,
 pp.198-200. [Interview.]

3376 SCHATANEK, H. Assia Djebar; l'émancipation de la
 femme par l'écriture. Cahier d'Études Maghrébines, 8-9,
 1995-96, pp.196-197.

3377 SEBBAR, Leïla. Entre-deux-langues. Ed. Heller, L.
 Cahier d'Études Maghrébines, 8-9, 1995-96, pp.236-238.

3378 SEBBAR, Leïla. La jeune fille avec des Pataugas. Die
 Kinder der Immigration. Les enfants de l'immigration.
 Hrsg. Ernstpeter Ruhe. Würzburg: Königshausen &
 Neumann, 1999, (Studien zur Literatur und Geschichte
 des Magreb, 4), pp.17-19. [Short story set in Algeria.]

3379 SEBBAR, Leïla. La moustiquaire. Une enfance
 d'ailleurs: 17 écrivains racontent. Textes inédits recueillis
 par N.Huston & Leïla Sebbar. Paris: Belfond, 1993,
 pp.241-253.

3380 SEBBAR, Leïla. Les mères du peuple de mon père, dans
 la langue de ma mère. Etre femme au Maghreb et en
 Méditerranée. Du mythe à la réalité. Sous la dir. de Andrée
 Dore-Audibert & Souad Khodja. Paris: Karthala, 1998,
 pp.159-165. (Les mères de mes livres.)

3381 SEBBAR, Leïla. Vous êtes belle. *La vie en rose...: nouvelles de femmes algériennes.* [Paris]: Marsa, 2001, pp.145-148.

3382 SEGARRA, M. El cuerpo y la palabra: la expresión del deseo femenino en la literatura africana francófona. *Studia Africana* (Barcelona), 9 (1998) pp.73-82. (Véronique Tadjo ... Assia Djebar.)

3383 SEGARRA, Marta. Paradoxe et ambiguïté dans *Le siècle des sauterelles. Malika Mokeddem: envers et contre tout.* Sous la dir. de Yolande Aline Helm. Paris: L'Harmattan, 2000, pp.185-202.

3384 SETTI, Selma. Corps à corps. *La vie en rose...: nouvelles de femmes algériennes.* [Paris]: Marsa, 2001, pp.73-78.

3385 SETTI, Selma. L'indescriptible mêlée. *La vie en rose...: nouvelles de femmes algériennes.* [Paris]: Marsa, 2001, pp.103-105.

3386 SHEPHERD, D. *Loin de Médine* d'Assia Djebar: quand les porteuses d'eau se font porteuses de feu. *Littérature et cinéma en Afrique francophone: Ousmane Sembène et Assia Djebar.* Sous la dir. de Sada Niang. Paris: L'Harmattan, 1996, pp.178-188.

3387 STORA, Benjamin. Women's writing between two Algerian wars. Tr. Mitsch, R.H. *Research in African Literatures,* 30 iii (1999) pp.78-94. [Francophone literature.]

3388 TAHON, Marie-Blanche. Les femmes et le religieux chez Fatima Mernissi. *La traversée du français dans les signes littéraires marocains. Actes du colloque international de l'Université York, Toronto ... 1994.* Textes réunis & publ. Yvette Bénayoun-Szmidt, Hédi Bouraoui, Najib Redouane. Toronto: La Source, 1996, pp.65-75.

3389 THÉRIAULT, Michel. Les rêves de Zahra dans *La nuit sacrée* de Tahar Ben Jelloun. *La traversée du français dans les signes littéraires marocains. Actes du colloque international de l'Université York, Toronto ... 1994.* Textes réunis & publ. Yvette Bénayoun-Szmidt, Hédi Bouraoui, Najib Redouane. Toronto: La Source, 1996, pp.189-199.

3390 TOUATI, Leïla. Trois drames brefs. *Algérie Littérature / Action,* 27-28 (1999) pp.173-180.

3391 TRAVERSAC, Behja. Une femme des Ouled Ghouini. *Algérie Littérature / Action,* 33-34 (1999) pp.219-223. (Nouvelle.)

3392 VALENSI, Lucette. The Scheherazade syndrome: literature and politics in postcolonial Algeria. *Algeria in others' languages.* Ed. by Anne-Emmanuelle Berger. Ithaca: Cornell University Press, 2002, pp.139-153. (Francophone Algerian literature.)

3393 WATSON, Julia. Unruly bodies: autoethnography and authorization in Nafissatou Diallo's *De Tilène au plateau (A Dakar childhood). Research in African Literatures,* 28 ii (1997) pp.34-56.

3394 WISE, Christopher. Qur'anic hermeneutics, Sufism, and *Le devoir de violence*: Yambo Ouologuem as Marabout novelist. *Yambo Ouologuem: postcolonial writer, Islamic militant /* ed. Christopher Wise. Boulder: Rienner, 1999, pp.175-195. [Previously published in *Religion and Literature,* 28 i (1996).]

3395 YAÇINE, Kateb. Hommage aux femmes. *Cahier d'Études Maghrébines,* 8-9, 1995-96, pp.70-71.

3396 YACINE, Kateb. Nedjma, the poem, the knife. Tr. Aresu, B. *Literary Review* (Madison), 41 ii (1998) pp.214-216. [Prose excerpt, translated from French.]

3397 ZAÏMA, Aïcha. Un mot à dire. *La vie en rose...: nouvelles de femmes algériennes.* [Paris]: Marsa, 2001, pp.29-31.

3398 ZIMRA, C. Not so far from Medina: Assia Djebar charts Islam's "Insupportable feminist revolution". *World Literature Today,* 70 iv (1996) pp.823-834.

3399 ZIMRA, Clarisse. Sounding off the absent body: intertextual resonances in "La femme qui pleure" and "La femme en morceaux". *Research in African Literatures,* 30 iii (1999) pp.108-124. (Djebarian *oeuvre.*)

3400 ZIREM, Hamza. Dis, est-ce que tu danses encore? *Algérie Littérature / Action,* 27-28 (1999) pp.148-151. [Short story in French.]

3401 ZOUARI, Faouzia. Taos Amrouche: la légende d'une femme. *Confluences Méditerranée,* 20, 1996-97, pp.145-155. [Algerian novelist.]

3402 Assia Djebar: Territoires des langues. *L'écrivain francophone à la croisée des langues: entretiens /* L.Gauvin. Paris: Karthala, 1997, pp.17-34.

3403 Private syntheses and multiple identities. *Banipal,* 2 (1998) pp.59-61. (Etel Adnan talks about her experiences, her work & attitudes to life.)

3404 Théâtr'elles à Montpellier. Ed. Carmichael, Jocelyne. *Etre femme au Maghreb et en Méditerranée. Du mythe à la réalité.* Sous la dir. de Andrée Dore-Audibert & Souad Khodja. Paris: Karthala, 1998, pp.167-186. [Five portraits of mothers from Francophone works by different Maghribi autors selected by Jocelyne Carmichael.]

3405 Un destino di esilio e di scrittura: intervista ad Assia Djebar. *Storia e Dossier,* 14 / 134 (1999) pp.25-33.

FULBE

Books

3406 ASMA'U, Nana. *Collected works of Nana Asma'u, daughter of Usman dan Fodiyo, (1793-1864)* [edited] by J.Boyd & B.B.Mack. East Lansing: Michigan State University Press, [1997], (African Historical Sources Series, 9). 753pp. [Works in Hausa, Fulfulde & Arabic.]

Articles

3407 BAUMGARDT, U. La représentation de l'autre. L'exemple du répertoire d'une conteuse peule de Garoua (Cameroun). (Abstract: Depicting the other: an example from the repertory of a Fulani story-teller from Garoua (Cameroon).). *Cahiers d'Études Africaines,* 34 i-iii / 133-135 (1994) pp.295-311;524-525.

3408 BOYD, J. & MACK, B. B. La poesía oral com a sistema educatiu: un estudi de cas del nord de Nigèria precolonial. *Studia Africana* (Barcelona), 6 (1995) pp.175-181. (Aquest estudi se centra en Nana Asma'u.)

3409 BOYD, J. & MACK, B. B. Women's Islamic literature in northern Nigeria: 150 years of tradition, 1820-1970. *The marabout and the muse: new approaches to Islam in African literature.* Ed. K.W.Harrow. Portsmouth (USA): Heinemann & London: Currey, 1996, pp.142-158.

3410 MACK, Beverly. "This will (not) be handled by the press:" problems - and their solution - in preparing camera-ready copy for *The collected works of Nana Asma'u, 1793-1864. History in Africa,* 25 (1998) pp.161-169.

GERMAN

Books

3411 DEMIRKAN, Renan. *Die Frau mit Bart.* Cologne: Kiepenheuer & Witsch, 1994. 107pp. [Novel in German.]

3412 KONUK, Kader. *Identitäten im Prozeß: Literatur von Autorinnen aus und in der Türkei in deutscher, englischer und türkischer Sprache.* Essen: Blaue Eule, 2001. 210pp.

3413 YEŞILADA, Karin. *Die geschundene Suleika.* Istanbul: Orient-Institut der Deutschen Morgenländischen Gesellschaft, 2000 (Pera-Blätter, 16), 31pp. (Das Eigenbild der Türkin in der deutschsprachigen Literatur türkischer Autorinnen.)

Articles

3414 MØRCK, Y. Migration, kvinder og skønlitteratur: spændingsfeltet mellem hjemvé og hjem. (Summary: Migration, women and fiction: the tension between homesickness and home.). *Kvinder, Køn & Forskning,* 7 iv (1998) pp.84-93. [Renan Demirkan & other Turkish writers.]

3415 ÖZTÜRK, Kadriye. Das Bild der türkischen Frau in
 Werken der türkischen Autorin Aysel Özakın. *The image
 of the Turk in Europe from the declaration of the Republic
 in 1923 to the 1990s: proceedings of the workshop held
 on 5-6 March 1999, CECES, Boğaziçi University.* Ed. by
 Nedret Kuran Burçoğlu. Istanbul: Isis, 2000, pp.221-232.

3416 TEKINAY, Alev. L'examen d'Allemand. Tr. Muhidine,
 Timour. *Paroles dévoilées: les femmes turques écrivent.
 Nouvelles choisies* par Nedim Gürsel. Paris:
 Arcantère/UNESCO, 1993, pp.243-259. [Translation of
 Die Deutschprüfung written in German.]

3417 WILDE-STOCKMEYER, M. Fremdheit für Frauen - nicht
 nur in der Fremde: literarische Texte türkischer
 Schriftstellerinnen. *Literatur fremder Kulturen: Türkei.*
 Hrsg. H.Scheuer. [Velber: Friedrich], 1993, pp.46-72.
 (Türkische und türkisch-deutsche Erzählungen.)

HAUSA

Books

3418 ASMA'U, Nana. *Collected works of Nana Asma'u,
 daughter of Usman dan Fodiyo, (1793-1864)* [edited] by
 J.Boyd & B.B.Mack. East Lansing: Michigan State
 University Press, [1997], (African Historical Sources
 Series, 9). 753pp. [Works in Hausa, Fulfulde & Arabic.]

Articles

3419 BIVINS, M. W. Daura and gender in the creation of a
 Hausa national epic. *African Languages and Cultures,*
 10 i (1997) pp.1-28.

3420 BOYD, J. & MACK, B. B. Women's Islamic literature in
 northern Nigeria: 150 years of tradition, 1820-1970. *The
 marabout and the muse: new approaches to Islam in
 African literature.* Ed. K.W.Harrow. Portsmouth (USA):
 Heinemann & London: Currey, 1996, pp.142-158.

3421 MACK, Beverly. "This will (not) be handled by the press:"
 problems - and their solution - in preparing camera-ready
 copy for *The collected works of Nana Asma'u, 1793-1864.
 History in Africa,* 25 (1998) pp.161-169.

JAVANESE

Articles

3422 FLORIDA, N. K. Sex wars: writing gender relations in
 nineteenth-century Java. *Fantasizing the feminine in
 Indonesia.* Ed. L.J.Sears. Durham (USA): Duke University
 Press, 1996, pp.207-224. (Suluk Lonthang, a rather wild
 Javano-Islamic mystic suluk (or Sufi song).)

MALAY & INDONESIAN

Books

3423 AVELING, H. *Shahnon Ahmad: Islam, power and gender.*
 Bangi: Penerbit Universiti Kebangsaan Malaysia, 2000.
 232pp.

3424 ZAINI-LAJOUBERT, M. *L'image de la femme dans les
 littératures modernes indonésienne et malaise.* Paris:
 Archipel, 1994, (Cahier d'Archipel, 24), 221pp.

Articles

3425 AJIDARMA, S. G. Clara. A short story. Tr. Bodden, M.
 H. *Indonesia,* 68 (1999) pp.157-163.

3426 ANDERSON, B. R. O'G. `Bullshit!' s/he said: the happy,
 modern, sexy, Indonesian married woman as transsexual.
 Fantasizing the feminine in Indonesia. Ed. L.J.Sears.
 Durham (USA): Duke University Press, 1996, pp.270-294.
 [A commentary on the novel Bidadari by Titie Said.]

3427 [BAHARUDDIN, Rosnah]. Rosnah Baharudin interviews
 Khadijah Hashim. Tr. Ishak, Solehah. *Malay Literature,*
 10 i-ii (1997) pp.11-20.

3428 BAHARUDDIN, Rosnah. *Senator Adila:* the corporate
 world through the looking glass. Tr. Bresson, Brigitte F.
 Malay Literature, 10 i-ii (1997) pp.1-10. [Novel in
 Malay by Khadijah Hashim.]

3429 BODDEN, M. H. Woman as nation in Mangunwijaya's
 Durga umayi. Indonesia, 62 (1996) pp.53-82.

3430 CAMPBELL, Christine. Is there a women's canon? *The
 canon in southeast Asian literatures: literatures of Burma,
 Cambodia, Indonesia, Laos, Malaysia, the Philippines,
 Thailand and Vietnam.* Ed. D.Smyth. Richmond: Curzon,
 2000, pp.88-98. [In Malay literature.]

3431 CAMPBELL, Christine. Women's lives through women's
 eyes: representations of women at work in the Malay novel.
 RIMA: Review of Indonesian and Malaysian Affairs, 31 ii
 (1997) pp.101-119.

3432 CAMPBELL, Christine. Women re-write themselves in
 Malay political novels in the post-independence period:
 Indonesian connection, Malaysian realisation. *Rethinking
 Malaysia.* Ed. Jomo K.S. Hong Kong: Asia 2000; Kuala
 Lumpur: Malaysian Social Science Association, 1999,
 (Malaysian Studies, 1), pp.246-266.

3433 DING CHOO MING. Raja Aisyah Sulaiman (c. 1870 -
 c. 1925), dernier écrivain de la noblesse du royaume de
 Riau-Lingga. Tr. Zaini-Lajoubert, M. *Archipel,* 47
 (1994) pp.39-45.

3434 FANE, B. Transgressing the boundaries of *bangsa:* an
 examination of *soesa* in Malay language *njiai* stories.
 RIMA: Review of Indonesian and Malaysian Affairs, 31 ii
 (1997) pp.47-61.

3435 GELMAN TAYLOR, J. Nyai Dasima: portrait of a mistress
 in literature and film. *Fantasizing the feminine in
 Indonesia.* Ed. L.J.Sears. Durham (USA): Duke University
 Press, 1996, pp.225-248. (Four versions of a story from
 Java ... the tale of Nyai Dasima.)

3436 HATLEY, B. Nation, "tradition," and constructions of the
 feminine in modern Indonesian literature. *Imagining
 Indonesia: cultural politics and political culture.* Ed. Jim
 Schiller & B.Martin-Schiller. Athens (USA): Ohio
 University Center for International Studies, 1997,
 (Monographs in International Studies: Southeast Asian
 Series, 97), pp.90-120.

3437 HATLEY, Barbara & BLACKBURN, Susan.
 Representations of women's roles in household and society
 in Indonesian women's writing of the 1930s. *Women and
 households in Indonesia. Cultural notions and social
 practices.* Ed. J.Koning, M.Nolten, J.Rodenburg & Ratna
 Saptari. Richmond: Curzon, 2000, (NIAS Studies in Asian
 Topics, 27), pp.45-67. (Two particular areas: the
 magazines produced by the numerous women's
 organizations ... & several examples of fiction published
 by women authors.)

3438 HOOKER, V. M. Women with a will? Writing female
 initiative in the Malay novel. *RIMA: Review of
 Indonesian and Malaysian Affairs,* 31 ii (1997)
 pp.63-100.

3439 LITTRUP, L. Pionerer i malaysisk kvindelitteratur.
 Humaniora: et Magasin om Humanistisk Forskning, 11 ii
 (1997) pp.27-30.

3440 PAUSACKER, Helen & COPPEL, Charles A. Lovesick:
 illness, romance and the portrayal of women in Low Malay
 literature from the Dutch East Indies. *RIMA: Review of
 Indonesian and Malaysian Affairs,* 35 i (2001) pp.43-77.

3441 SOERJO, T. A. The story of Nyai Ratna, or, how a faithful
 wife did wrong. A story that really happened in West Java.
 Tr. Riharti, E., Coté, J. & Soema, M. *RIMA: Review of
 Indonesian and Malaysian Affairs,* 32 i (1998) pp.45-95.

3442 WIERINGA, E. P. Female emancipation or literary
 convention? The theme of the woman who set out to free
 her husband in the Malay *Syair saudagar bodoh* (ca 1861)
 by Raja Kalzum. *RIMA: Review of Indonesian and
 Malaysian Affairs,* 31 ii (1997) pp.11-28.

3443 WIERINGA, E. P. Frauenemanzipation oder literarische
 Konvention? Zum Thema "die Frau, die auszog, ihren
 Mann zu erlösen" im malaiischen *Syair Saudagar Bodoh
 ([ca.]*1861) von der Dichterin Raja Kalzum. *Zeitschrift
 der Deutschen Morgenländischen Gesellschaft,* 147 i
 (1997) pp.195-211.

3444 ZAINI-LAJOUBERT, M. Le *Syair Cerita Siti Akbari* de Lie Kim Hok (1884), un avatar du *Syair Abdul Muluk* (1846). *Archipel,* 48 (1994) pp.103-124.

MALAYALAM

Articles

3445 ZUHARA, B. M. Educating Amina. Tr. Radhika, P. *Indian Literature,* 41 i / 183 (1998) pp.121-123. [Short story translated from Malayalam.]

MANDE/MALINKE

Articles

3446 CONRAD, D. C. Mooning armies and mothering heroes: female power in Mande epic tradition. *In search of Sunjata: the Mande oral epic as history, literature and performance.* Ed. R.A.Austen. Bloomington: Indiana University Press, 1999, pp.189-229.

3447 JANSEN, Jan. 'Sara', chanson fameuse de la littérature mandingue. *Etudes Maliennes,* 50 (1996) pp.37-42. [Incl. romanised text & French trans.]

PASHTO

Books

3448 MAJRŪḤ, Sayyid Bahā' al-Dīn. *Le suicide et le chant: poésie populaire des femmes pashtounes* / Sayed Bahodine Majrouh. Tr. du pashtou, adapté et présenté par A.Velter & l'auteur. Paris: Gallimard, 1994, (Connaisance de l'Orient, 65: Série Asie Centrale), 132pp.

Articles

3449 BANO, Zaitoon. Dilshad. Tr. Taizi, Sher Zaman. *So that you can know me: an anthology of Pakistani women writers.* Ed. Yasmin Hameed & Asif Aslam Farrukhi. Reading: Garnet & Unesco Publishing, 1997, pp.81-85. [Story tr. from Pashto.]

3450 BENAWA, Abdul Raouf. Native literature: poems on and about marriages. *Sabawoon / Sabāwūn,* 3 ii (1996) pp.3-4.

PERSIAN

Books

3451 AALAMI, Chahnaz. *Die Rolle der iranischen Frau in der persischen Literatur.* Saarbrücken: Nawid, 1993. 60+42pp. [In German & Persian. Persian title: *Naqs-i zān-i Īrānī dar adab-i Farsī* by Shahnāz A'lamī.]

3452 GHANDTCHI, Sandra. *Ein Bestseller aus der Islamischen Republik Iran: der Liebesroman Der Morgen nach dem Rausch (Bāmdād-i Humār) von Fattāna Ḥāg Sayyid Ğawādī (Parwīn).* Würzburg: Ergon, 2001 (Arbeitsmaterialen zum Orient, 5), 127pp.

3453 [JAWĀDĪ, Fattānah Ḥājj Sayyid]. *Der Morgen der Trunkenheit: Roman* / Fattaneh Haj Seyed Javadi. Aus dem Pers. von Susanne Baghestani. Frankfurt a.M. & Leipzig: Insel-Verlag, 2000. 415pp. [Tr. of *Bāmdād-i khimār.*]

3454 PĀRSĪPŪR, Shahrnūsh. *Women without men: a novella.* Tr. Talattof, Kamran & Sharlet, J. Syracuse (USA): Syracuse University Press, 1998. 131pp. [Tr. of *Zanān bidūn-i mardan.*]

3455 ROUHI, Leyla. *Mediation and love: a study of the medieval go-between in key Romance and Near-Eastern texts.* Leiden: Brill, 1999 (Brill's Studies in Intellectual History, 93), 311pp. [Ch. 3: The medieval Near-Eastern go-between, pp.135-203; Ch. 4: The medieval Spanish *alcahueta,* pp.204-285. Persian & Arabic literature & its influence in Spain.]

3456 SHĀMLŪ, Aḥmad. *Aïda dans le miroir* / Aḥmad Šāmlū. Tr. Abolgassemi, Parviz. Fuveau: RAC, 1994, (Collection de Poésie, 37), 41pp.

3457 [SHĪRĀZĪ, 'Alī]. *Farchunde, die Tochter des Landrats: persische Erzählungen* / Ali Schirasi. Oldenburg: Schardt, 1999. 93pp. [Tr. of *Farkhundah, dukhtar-i farmāndār.*]

3458 *A feast in the mirror. Stories by contemporary Iranian women* / tr. & ed. Mohammad Mehdi Khorrami, Shouleh Vatanabadi. Boulder: Rienner, 2000. 235pp.

3459 *In a voice of their own: a collection of stories by Iranian women written since the revolution of 1979.* Compiled and translated, with an introduction by F.Lewis & Farzin Yazdanfar. Costa Mesa: Mazda, 1996, (Bibliotheca Iranica: Persian Fiction in Translation series, 4), 153pp.

3460 *Mina mit dem blauen Kleid. Moderne Erzählungen iranischer Frauen. Eine Anthologie.* Hrsg. M.H.Allafi. Tr. Allafi, M.H. & others Frankfurt a.M.: Glaré, 1999 (Der Andere Orient, 11), 198pp.

Articles

3461 ABID, Jamila L. Parvīn E'teṣāmī - eine engagierte iranische Dichterin. *Spektrum Iran,* 13 iii (2000) pp.63-70.

3462 ALAVI, Bozorg. Forūğ Farrohzād. *Iran und Turfan: Beiträge Berliner Wissenschaftler, Werner Sundermann zum 60. Geburtstag gewidmet.* Hrsg. C.Reck & P.Zieme. Wiesbaden: Harrassowitz, 1995, (Iranica, 2), pp.23-33.

3463 ['ALAWĪ, Ṭāhirah]. Disappearance of an ordinary woman / Tahereh Alavi. *A feast in the mirror. Stories by contemporary Iranian women* / tr. & ed. Mohammad Mehdi Khorrami, Shouleh Vatanabadi. Boulder: Rienner, 2000, pp.101-107.

3464 [AQĀ'Ī, Farkhundah]. One woman, one love / Farkhondeh Aqai. *A feast in the mirror. Stories by contemporary Iranian women* / tr. & ed. Mohammad Mehdi Khorrami, Shouleh Vatanabadi. Boulder: Rienner, 2000, pp.153-161.

3465 [ARASṬŪYĪ, Shīwā]. I came to have tea with my daughter / Shiva Arastuyi. *A feast in the mirror. Stories by contemporary Iranian women* / tr. & ed. Mohammad Mehdi Khorrami, Shouleh Vatanabadi. Boulder: Rienner, 2000, pp.13-38.

3466 BIHBIHĀNĪ, Sīmīn, DĀWĀR, Mītrā & PĪRZĀD, Zūyā. Glimpses of daily life: short stories by Iranian women. Tr. Talattof, Kamran, Rahimieh, Nasrin & Kargar-Samani, M. *Iranian Studies,* 30 iii-iv (1997) pp.249-262.

3467 DAVIDSON, O. M. Women's lamentations as protest in the 'Shāhnāma'. *Women in the medieval Islamic world: power, patronage, and piety.* Ed. G.R.G.Hambly. Basingstoke: Macmillan, 1998, (The New Middle Ages, 6), pp.131-146.

3468 [FADAWĪ, Parvīn]. The bitter life of Shirin / Parvin Fadavi. *A feast in the mirror. Stories by contemporary Iranian women* / tr. & ed. Mohammad Mehdi Khorrami, Shouleh Vatanabadi. Boulder: Rienner, 2000, pp.219-228.

3469 HUNARMANDĪ, Ḥasan. The daughter of the sea; Colours; Epitaph. *Modern Persian poetry.* Ed., tr. & introd. Mahmud Kianush. Ware: Rockingham Press, 1996, pp.117-118.

3470 ĪRAJ MĪRZĀ, Jalāl al-Mamālik. Criticizing the veil. Tr. Karimi-Hakkak, Ahmad. *Qasida poetry in Islamic Asia and Africa.* Volume Two: *Eulogy's bounty, meaning's abundance: an anthology.* Ed. S.Sperl & C.Shackle. Consultant: N.Awde. Leiden: Brill, 1996, (Studies in Arabic Literature, XX), pp.192-195;439. [Persian text of qaṣīda, with facing English translation.]

3471 IRFANI, Suroosh. The Tree of paradise and the meaning of night: an odyssey of consciousness. *Islamic Culture,* 70 iii (1996) pp.15-34. (One of the most celebrated & controversial works of fiction published since the 1979 Revolution - Iranian feminist Shahrnush Parsipur's *Tooba & the meaning of night.*)

3472 KARACHI, Rouhanguiz. The role of women poets in the Persian poetry. *Saba: the Art Research & Studies Magazine,* 1 (1999) pp.88-94.

3473 LĀHUTĪ, Abū 'l-Qāsim. To the daughters of Iran. Tr.
 Karimi-Hakkak, Ahmad. *Qasida poetry in Islamic Asia
 and Africa*. Volume Two: *Eulogy's bounty, meaning's
 abundance: an anthology*. Ed. S.Sperl & C.Shackle.
 Consultant: N.Awde. Leiden: Brill, 1996, (Studies in
 Arabic Literature, XX), pp.196-199;439-4440. [Persian
 text of qaṣīda, with facing English translation.]

3474 LEWIS, Franklin & YAZDANFAR, Farzin. Iranian
 women, the short story and the revolution of 1979. *In a
 voice of their own: a collection of stories by Iranian women
 written since the revolution of 1979*. Compiled and
 translated, with an introduction by F.Lewis & Farzin
 Yazdanfar. Costa Mesa: Mazda, 1996, (Bibliotheca Iranica:
 Persian Fiction in Translation series, 4), pp.ix-xxxvii.

3475 MAZĀRI'Ī, Mihrnūsh. The old prostitute of the Ensenada
 Bar / Mehrnoosh Mazarei. Tr. Davaran, Ardavan.
 Literary Review (Madison), 40 i (1996) pp.127-129.
 [Short story.]

3476 MILANI, Farzaneh. The mediatory guile of the nanny in
 Persian romance. *Iranian Studies*, 32 ii / 1999 (2000)
 pp.181-201.

3477 MILANI, Farzaneh. The politics and poetics of sex
 segregation in Persian romances. *Discourse on gender
 / gendered discourse in the Middle East*. Ed. Boaz Shoshan.
 Westport: Praeger, 2000, pp.1-14;136-141.

3478 MILANI, Farzaneh. Voyeurs, nannies, winds, and gypsies
 in Persian literature. *Critique: Journal for Critical
 Studies of the Middle East*, 14 (1999) pp.107-123.

3479 MILLS, M. Whose best tricks? *Makr-i zan* as a topos in
 Persian oral literature. *Iranian Studies*, 32 ii / 1999 (2000)
 pp.261-270.

3480 MĪRZĀDAHGĪ, Shukūh. Setareh in the mist. Tr. Lewis,
 Franklin & Yazdanfar, Farzin). *In a voice of their own:
 a collection of stories by Iranian women written since the
 revolution of 1979*. Compiled and translated, with an
 introduction by F.Lewis & Farzin Yazdanfar. Costa Mesa:
 Mazda, 1996, (Bibliotheca Iranica: Persian Fiction in
 Translation series, 4), pp.103-110.

3481 NŪRĪZĀDAH, 'Alī Riḍā. Hassiba Boulmerka / Ali-Rezâ
 Nurizâdeh. *Modern Persian poetry*. Ed., tr. & introd.
 Mahmud Kianush. Ware: Rockingham Press, 1996,
 pp.205-206. [Algerian Olympic medalist.]

3482 PARSĪPŪR, Shahrnūsh. Mrs. Farrokhlagha Sadroldivan
 Golchehreh / Shahrnoosh Parsipour. Tr. Vafaei, Fahimeh.
 Literary Review (Madison), 40 i (1996) pp.67-74. [Short
 story.]

3483 PETERSEN, C. V. Simin Dâneshvar: Iransk
 prosalitteraturs første kvinde. *Semiramis*, 6 (1999)
 pp.125-140.

3484 RICHTER-BERNBURG, L. Plato of mind and Joseph of
 countenance: the notion of love and the ideal beloved in
 Kay Kā'ūs b.Iskandar's *Andarznāme*. *Oriens*, 36 (2001)
 pp.276-287.

3485 SHAYBĀNĪ, Manūchihr. Slave-girl. *Modern Persian
 poetry*. Ed., tr. & introd. Mahmud Kianush. Ware:
 Rockingham Press, 1996, pp.78-79.

3486 SPRACHMAN, P. The poetics of *ḥijāb* in the satire of Īraj
 Mīrzā. *Iran and Iranian studies: essays in honor of Iraj
 Afshar*. Ed. Kambiz Eslami. Princeton: Zagros, 1998,
 pp.341-357.

3487 STÜMPEL, I. Raum und (Frauen-)Realität in einem
 zeitgenössischen persischen Roman. *Asiatische Studien*,
 50 ii (1996) pp.445-462. (Šahrnūš Pārsīpūrs Roman
 Ṭūbā va ma'nā-i šab.)

3488 STÜMPEL, Isabel. Ṭāhira Qurrat al-'Ain. *Iran im 19.
 Jahrhundert und die Entstehung der Bahā'ī-Religion*.
 Herausgegeben von Johann Christoph Bürgel und Isabel
 Schayani. Hildesheim: Olms, 1998,
 (Religionswissenschaftliche Texte und Studien, 8),
 pp.127-143. (Die freiheitsliebende, iranische
 Nationaldichterin.)

3489 STÜMPEL[-HATAMI], I. Zeugin, Chronistin, Aufkärerin?
 Zum Selbstverständnis einer zeitgenössischen persischen
 Autorin. *Conscious voices: concepts of writing in the
 Middle East*. Proceedings of the Berne Symposium July
 1997. Ed. S.Guth, P.Furrer & J.C.Bürgel. Beirut:
 Orient-Institut der Deutschen Morgenländischen
 Gesellschaft; Stuttgart: Steiner, 1999, (Beiruter Texte und
 Studien, 72), pp.197-220. (Šahrnūš Pārsīpūr.)

3490 SZUPPE, M. The female intellectual milieu in Timurid
 and post-Timurid Herāt: Faxri Heravi's biography of
 poetesses, *Javāheral-'ajāyeb*. *Oriente Moderno*, 15 / 76
 / 1996 ii (1997) pp.119-137. (Composing & writing ...,
 in some cases, in Chaghatay Turkish.)

3491 ṬABĀṬABĀ'Ī, Nāhīd. Mina mit dem blauen Kleid. Tr.
 Allafi, M.H. *Mina mit dem blauen Kleid. Moderne
 Erzählungen iranischer Frauen. Eine Anthologie*. Hrsg.
 M.H.Allafi. Frankfurt a.M.: Glaré, 1999, (Der Andere
 Orient, 11), pp.24-39.

3492 TALATTOF, Kamran. Iranian women's literature: from
 pre-revolutionary social discourse to post-revolutionary
 feminism. *International Journal of Middle East Studies*,
 29 iv (1997) pp.5531-558.

3493 VANZAN, Anna. From the royal harem to post-modern
 Islamic society. Some considerations on women prose
 writers in Iran from Qajar times to the 1990s. *Women,
 religion and culture in Iran*. Ed. Sarah Ansari and Vanessa
 Martin. Richmond: Curzon, in association with The Royal
 Asiatic Society of Great Britain and Ireland, 2002,
 pp.88-98.

3494 [WAFĪ, Faribā]. My mother, behind the glass / Fariba Vafi.
 *A feast in the mirror. Stories by contemporary Iranian
 women* / tr. & ed. Mohammad Mehdi Khorrami, Shouleh
 Vatanabadi. Boulder: Rienner, 2000, pp.201-205.

3495 [YALFĀNĪ, Mihrī]. Samiras Einsamkeit / Mehri Yalfani.
 Tr. Jalali, Mohammad. *Mina mit dem blauen Kleid.
 Moderne Erzählungen iranischer Frauen. Eine Anthologie*.
 Hrsg. M.H.Allafi. Frankfurt a.M.: Glaré, 1999, (Der Andere
 Orient, 11), pp.141-149.

3496 ŻUK, Stanisław. Symbolism in the poetry of Forugh
 Farrokhzad. *Rocznik Orientalistyczny*, 55 ii (2003)
 pp.55-85.

RUSSIAN

Articles

3497 ABDIKARIMOV, Seilgazy. (Kazakhstan:) My wife's
 husband. Tr. Barthel, A. *World Literature Today*, 70 iii
 (1996) pp.559-566. [Story translated from Russian.]

SINDHI

Articles

3498 ABDULLAH, Begum Zeenat. Shannel. Tr. Saeed,
 Ahmed. *Pakistani Literature*, [6] (2001) pp.123-125.
 [Short story tr. from Sindhi.]

3499 DAWOOD, Attiya. The princess who followed a golden
 deer: a modern-day fairy tale. Tr. Farrukhi, Asif.
 Pakistan Journal of Women's Studies. Alam-e-Niswan, 4
 i (1997) pp.41-44.

SIRAIKI

Articles

3500 KALĀNCHVĪ, Mussarat. A heartless woman. Tr. Isar,
 Lubna. *Pakistani Literature*, [6] (2001) pp.109-111.
 [Short story tr. from Siraiki.]

SOMALI

Articles

3501 ADAN, Amina H. Women and worlds: the role of women
 in Somali oral literature. *Comparative Studies of South
 Asia, Africa and the Middle East*, 16 ii (1996) pp.81-92.

3502 DECLICH, F. Formas poéticas religiosas femeninas en un contexto rural somalí: el *Nabi-ammaan*. *Studia Africana* (Barcelona), 7 (1996) pp.123-145. (Himnos místicos.)

3503 DECLICH, F. Poesia religiosa femminile - *Nabi-ammaan*, nel contesto rurale della Somalia. *Africa* (Rome), 51 i (1996) pp.50-79.

3504 KAPTEIJNS, L. & ALI, Mariam Omar. *Sittaat*: Somali women's songs for the `Mothers of the believers`. *The marabout and the muse: new approaches to Islam in African literature*. Ed. K.W.Harrow. Portsmouth (USA): Heinemann & London: Currey, 1996, pp.124-141.

3505 KAPTEIJNS, L. Somali women's songs for the first ladies of early Islam. *ISIM Newsletter*, 3 (1999) pp.27-27.

SWAHILI

Books

3506 *Vamps and victims: women in modern Swahili literature.* Ed. Bertoncini-Zúbková, E. Cologne: Köppe, 1996. 314pp. [Anthology.]

Articles

3507 BERTONCINI-ZÚBKOVÁ, E. Image de la femme dans la littérature swahili. *Swahili Forum I / Afrikanistische Arbeitspapiere*, 37 (1994) pp.13-27.

3508 FAIR, Laura. Music, memory and meaning: the Kiswahili recordings of Siti Binti Saad. *Afrikanistische Arbeitspapiere*, 55 (1998) pp.1-16. (A famous *taarab* musician who performed in Zanzibar during the 1920s and 1930s.) [This volume is issued as *Swahili Forum* V.]

3509 KRÜGER, Marie. Negotiating gender identity and authority in the plays of Penina Muhando and Ari Katini Mwachofi. *Afrikanistische Arbeitspapiere*, 55 (1998) pp.53-71. (Contemporary Swahili women's writing.) [This volume is issued as *Swahili Forum* V.]

3510 MBELE, J. L. *Wimbo wa miti*: an example of Swahili women's poetry. *African Languages and Cultures*, 9 i (1996) pp.71-82. (Lamu, Kenya.)

3511 Anonymous (before 1900): In praise of a virtuous wife. Tr. Abdulaziz, M. H. *Qasida poetry in Islamic Asia and Africa*. Volume Two: *Eulogy's bounty, meaning's abundance: an anthology*. Ed. S.Sperl & C.Shackle. Consultant: N.Awde. Leiden: Brill, 1996, (Studies in Arabic Literature, XX), pp.332-337;465. [Swahili text of qaṣīda, with facing English translation.]

TAJIK

Articles

3512 BAHMANYOR. (Tajikistan:) The woman and the mirror. Tr. Sharma, Sunil. *World Literature Today*, 70 iii (1996) pp.587-588. [Story.]

3513 KŪHZOD, Ūrun. (Tajikistan:) Mother. Tr. Wilks, J. M. *World Literature Today*, 70 iii (1996) pp.583-586. [Story.]

TURKISH

Books

3514 CEYLAN, Selma. *Irrsinn der Ehre: die Ausreisserin 1-2-3.* Tr. Hennemuth, Ulrike & Meissner, Karin. Berlin: Hitit, 1998. 328pp. [Tr. of *Çıldırtan namus*, Istanbul 1998.]

3515 ZIELKE-NADKARNI, A. *Frauenfiguren in den Erzählungen türkischer Autorinnen: Identität und Handlungs(spiel)räume*. Pfaffenweiler: Centaurus, 1996, (Frauen in der Literaturgeschichte, 6), 130pp.

3516 *Paroles dévoilées: les femmes turques écrivent. Nouvelles choisies* par Nedim Gürsel. Paris: Arcantère/UNESCO, 1993. 278pp.

Articles

3517 ADIVAR, Halide Edip. L'enfant. Tr. Semizoğlu, Ali. *Paroles dévoilées: les femmes turques écrivent. Nouvelles choisies* par Nedim Gürsel. Paris: Arcantère/UNESCO, 1993, pp.23-32. [Translation of *Himmet çocuk*.]

3518 ANHEGGER, Robert & SCHUBERT, Gudrun. "Deutschland, du hast mir meine Frau gestohlen!" Das Bild der türkischen Frau im Spiegel der Gastarbeiterlieder. *Journal of Turkish Studies*, 26 i (2002) pp.21-35. (Der aşık.)

3519 ARAT, Yeşim. Der republikanische Feminismus in der Türkei aus feministischer Sicht. *Feminismus, Islam, Nation: Frauenbewegungen im Maghreb, in Zentralasien und in der Türkei*. (Hg.) Claudia Schöning-Kalender, Aylâ Neusel, Mechtild M.Jansen. Frankfurt a.M.: Campus, 1997, pp.185-196.

3520 ARAT, Yeşim. From emancipation to liberation: the changing role of women in Turkey's public realm. *Journal of International Affairs*, 54 i (2000) pp.107-123.

3521 ARIM, Meral & CULME-SEYMOUR, Angela. Mme Hatice Münevver Ayaşlı 1906-1999. *Journal of the Muhyiddin Ibn 'Arabi Society*, 27 (2000) pp.65-68.

3522 ATASÜ, Erendiz. Sous un ciel étranger. Tr. Jacotin, M. *Paroles dévoilées: les femmes turques écrivent. Nouvelles choisies* par Nedim Gürsel. Paris: Arcantère/UNESCO, 1993, pp.211-229. [Translation of *Yabancı bir göğün altında*.]

3523 BEKIROĞLU, Nazan. Female poets in Ottomans [*sic*]. *The great Ottoman-Turkish civilisation*. Vol. 4: *Culture and arts*. Editor-in-chief Kemal Çiçek. Ankara: Yeni Türkiye, 2000, pp.249-260.

3524 BERTRAM, C. Restructuring the house, restructuring the self: renegotiating the meanings of place in the Turkish short story. *Deconstructing images of "the Turkish woman"*. Ed. Zehra F.Arat. Basingstoke: Macmillan, 1998, pp.263-274.

3525 BURAK, Sevim. La maison incrustée de nacre. Tr. Muhidine, Timour. *Paroles dévoilées: les femmes turques écrivent. Nouvelles choisies* par Nedim Gürsel. Paris: Arcantère/UNESCO, 1993, pp.51-63. [Translation of *Sedef kakmalı ev.*]

3526 DINO, Guzine. Aux avant-postes de la littérature: femmes de la Turquie nouvelle. *Paroles dévoilées: les femmes turques écrivent. Nouvelles choisies* par Nedim Gürsel. Paris: Arcantère/UNESCO, 1993, pp.7-13.

3527 DURUEL, Nursel. Les cerfs, maman et l'Allemagne. Tr. Türkkan, Zühal. *Paroles dévoilées: les femmes turques écrivent. Nouvelles choisies* par Nedim Gürsel. Paris: Arcantère/UNESCO, 1993, pp.115-124. [Translation of *Annem, geyikler ve Almanya.*]

3528 ECEVIT, Bülent. Poems: The ageless woman of Pülümür; Tomorrow; Hand-in-hand we tended love. *Cultural horizons: a festschrift in honor of Talat S.Halman*. Ed. Jayne L.Warner / *Kültür ufukları: Talat S.Halman armağan kitabı. Hazırlayan Jayne L.Warner.* Syracuse (USA): Syracuse University Press; Istanbul: Yapı Kredi Yayınları, 2001, pp.407-409.

3529 ERBIL, Leyla. Le bateau. Tr. Dıno, Guzine. *Anka*, 18-19 (1993) pp.119-145. [Short story.]

3530 ERBIL, Leylâ. Le miroir. Tr. Muhidine, Timour. *Paroles dévoilées: les femmes turques écrivent. Nouvelles choisies* par Nedim Gürsel. Paris: Arcantère/UNESCO, 1993, pp.41-49. [Translation of *Ayna*.]

3531 ERVIN, E. The achievement of Adalet Ağaoğlu: an introduction. *An anthology of Turkish literature*. Ed. Kemal Silay. Bloomington: Indiana University, 1996, (Indiana University Turkish Studies & Turkish Ministry of Culture Joint series, XV), pp.552-558.

3532 ETENSEL ILDEM, Arzu. Adalet Ağaoğlu: une romancière témoin de son temps. *Femmes écrivains en Méditerranée*. Sous la dir. de Vassiliki Lalagianni. Paris: Publisud, 1999, pp.181-195.

3533 FINDLEY, C. V. La soumise, la subversive: Fatma Aliye,
 romancière et féministe. (Abstract: The subdued-subversive
 Fatma Aliye: a novelist and a feminist.). Turcica, 27
 (1995) pp.153-176;329.

3534 FINN, Robert P. Some female characters in Turkish fiction.
 Cultural horizons: a festschrift in honor of Talat S.Halman.
 Ed. Jayne L.Warner / Kültür ufukları: Talat S.Halman
 armağan kitabı. Hazırlayan Jayne L.Warner. Syracuse
 (USA): Syracuse University Press; Istanbul: Yapı Kredi
 Yayınları, 2001, pp.545-554.

3535 FURRER, P. Die Frau hat keinen Namen - oder doch?
 Feminismus und Islamismus am Beispiel zweier türkischer
 Romane. XXV. Deutscher Orientalistentag vom 8. bis
 13.4.1991 in München. Vorträge. Hrsg. C.Wunsch.
 Stuttgart: Steiner, 1994, (Zeitschrift der Deutschen
 Morgenländischen Gesellschaft, Supplement X),
 pp.228-236. (Kadının adı yok & Müslüman Kadının adı
 var.)

3536 FURRER, P. Propaganda in Geschichtenform -
 Erzählstrategien und Handlungsanweisungen in
 islamischen Frauenromanen aus der Türkei. Welt des
 Islams, 37 i (1997) pp.88-111.

3537 FURRER, Priska. Zwischen Didaktik und Ästhetik -
 islamistische Frauenromane in der Türkei. Die neue
 Muslimische Frau: Standpunkte & Analysen / hrsg. Barbara
 Pusch. Istanbul: Orient-Institut der Deutschen
 Morgenländischen Gesellschaft; Würzburg: Ergon, 2001,
 (Beiruter Texte und Studien, 85), pp.111-121.

3538 FÜRUZAN. Ah, mon bel Istanbul. Tr. Muhidine, Timour.
 Paroles dévoilées: les femmes turques écrivent. Nouvelles
 choisies par Nedim Gürsel. Paris: Arcantère/UNESCO,
 1993, pp.65-100. [Translation of Ah! güzel İstanbul.]

3539 GLASSEN, Erika. Töchter der Republik. Gazi Mustafa
 Kemal Paşa (Atatürk) im Gedächtnis einer intellektuellen
 Weiblichen Elite der ersten Republikgeneration nach
 Erinnerungsbüchern von Azra Erhat, Mina Urgan und
 Nermin Abadan-Unat. Journal of Turkish Studies, 26 i
 (2002) pp.241-264.

3540 GOKALP, Altan. L'identification d'une femme: Şahmerân,
 la reine des serpents, l'amante de Hâsib Karîm al-Dîn.
 Paroles, signes, mythes: mélanges offerts à Jamel Eddine
 Bencheikh. Ed. Floréal Sanagustin. Damascus: Institut
 Français d'Etudes Arabes de Damas, 2001, (P.I.F.D. 196),
 pp.417-437. [Anatolian folk literature.]

3541 GÜNEŞ-AYATA, Ayşe. The politics of implementing
 women's rights in Turkey. Globalizaton, gender, and
 religion: the politics of implementing women's rights in
 Catholic and Muslim contexts. Ed. Jane H.Bayes &
 Nayereh Tohidi. Basingstoke: Palgrave, 2001,
 pp.157-175. [Since 1923.]

3542 GÜNGÖR, Şeyma. Women who save their husbands from
 difficult situations in The Book of Dede Korkut. Kadın /
 Woman 2000, 2 ii (2001) pp.25-47.

3543 GÜRPINAR, Melisa. Trois femmes d'Istanbul. Tr. Gürsel,
 Nedim. Paroles dévoilées: les femmes turques écrivent.
 Nouvelles choisies par Nedim Gürsel. Paris:
 Arcantère/UNESCO, 1993, pp.125-131. [Translation of
 İstanbul'un gözleri mahmur.]

3544 KADRI, Yakup. Issız Köy ve dilsiz kız. Das verlassene
 Dorf und das stumme Mädchen. Modern Türk klasikler:
 öyküler. Moderne türkische Klassiker: Erzahlungen.
 Auswahl & Übersetzung von W.Riemann. Munich:
 Deutscher Taschenbuch Verlag, 1994, pp.60-71. [Parallel
 Turkish text & German translation.]

3545 KADIOĞLU, Ayşe. Die Leugnung des Geschlechts: die
 Türkische Frau als Objekt in grossen
 Gesellschaftsentwürfen. Tr. Nohl, Arnd-Michael. Die
 neue Muslimische Frau: Standpunkte & Analysen / hrsg.
 Barbara Pusch. Istanbul: Orient-Institut der Deutschen
 Morgenländischen Gesellschaft; Würzburg: Ergon, 2001,
 (Beiruter Texte und Studien, 85), pp.31-50.

3546 KARAKUŞ, Iris. Das Frauenbild in den Romanen Halide
 Edibs. Materialia Turcica, 18 (1997) pp.15-79.

3547 KÜR, Pinar. Les petits trajets. Tr. Durmaz, Süleyman.
 Paroles dévoilées: les femmes turques écrivent. Nouvelles
 choisies par Nedim Gürsel. Paris: Arcantère/UNESCO,
 1993, pp.169-193. [Translation of Kısa yol yolcusu.]

3548 KUTLU, Ayla. The graveyard of condemned women. Tr.
 Sürsal, Hilâl. Edebiyât, 12 ii (2001) pp.229-255. Also
 online at www.tandf.co.uk/journals/online/0364-6505.htm

3549 LEWIS, G. Heroines and others in the heroic age of the
 Turks. Women in the medieval Islamic world: power,
 patronage, and piety. Ed. G.R.G.Hambly. Basingstoke:
 Macmillan, 1998, (The New Middle Ages, 6),
 pp.147-160. (Reading the Book of Dede Korkut.)

3550 MARSCHKE, B. Die Schriftstellerin Fatma Aliye
 (1862-1936) - eine osmanische Modernistin? Zeitschrift
 für Türkeistudien, 10 ii (1997) pp.155-192.

3551 MERIÇ, Nezihe. Un air nostalgique. Tr. Muhidine,
 Timour. Paroles dévoilées: les femmes turques écrivent.
 Nouvelles choisies par Nedim Gürsel. Paris:
 Arcantère/UNESCO, 1993, pp.33-40. [Translation of
 Uzun hava.]

3552 OZBAY, Ferhunde. Gendered space: a new look at Turkish
 modernisation. Gender & History, 11 iii (1999)
 pp.555-568.

3553 ÖZKAN-KERESTECİOĞLU, İnci. Die Konstruktion der
 "neuen" Türkischen Frau und der internationale
 Frauenkongress (1935). Tr. Pusch, Barbara. Die neue
 Muslimische Frau: Standpunkte & Analysen / hrsg. Barbara
 Pusch. Istanbul: Orient-Institut der Deutschen
 Morgenländischen Gesellschaft; Würzburg: Ergon, 2001,
 (Beiruter Texte und Studien, 85), pp.17-30.

3554 ÖZLÜ, Tezer. La maison. Tr. Gürsel, Nedim. Paroles
 dévoilées: les femmes turques écrivent. Nouvelles choisies
 par Nedim Gürsel. Paris: Arcantère/UNESCO, 1993,
 pp.195-209. [Translation from Çocukluğun soğuk
 gecelri.]

3555 REINHARD, Ursula. The image of woman in Turkish
 ballad poetry and music. Music and gender. Ed.
 P.Moisala & B.Diamond. Urbana & Chicago: University
 of Illinois Press, 2000, pp.80-94.

3556 SAGASTER, B. Zum Bild der Europäerin: Stereotypen
 in der frühen osmanisch-türkischen Literatur. Berliner
 LeseZeichen, 4 i-ii (1996) pp.64-68.

3557 SARAÇGIL, Ayşe. Latife Tekin e la psicologia della
 povertà. Un ricordo che non si spegne: scritt i di docenti
 e collaboratori dell'Istituto Universitario Orientale di
 Napoli in memoria di Alessandro Bausani. Naples: Istituto
 Universitario Orientale, Dipartimento di Studi Asiatici,
 1995, 1996, (Series Minor, L), pp.437-464.

3558 SAULNIER, Mine G. La fille du cirque. Tr. Aysu, Ali.
 Paroles dévoilées: les femmes turques écrivent. Nouvelles
 choisies par Nedim Gürsel. Paris: Arcantère/UNESCO,
 1993, pp.231-241. [Translation of Sirk Kızı.]

3559 SEMIZOĞLU, Ali. La rhétorique de la misère (aspects du
 récit dans les romans de Latife Tekin). Anka, 18-19
 (1993) pp.29-39.

3560 SHAUL, E. Los donmes de Izmir. Aki Yerushalayim, 14
 / 48 (1993) pp.25-26. (1923-24: desendientes de los
 djudios ke ... se konvertieron al Islam, en el siglo 17.)

3561 SILAY, Kemal. Singing his words: Ottoman women poets
 and the power of patriarchy. Women in the Ottoman
 Empire: Middle Eastern women in the early modern era.
 Ed. M.C.Zilfi. Leiden: Brill, 1997, (The Ottoman Empire
 and its Heritage, 10), pp.197-213.

3562 SIRMAN, Nükhet. Gender construction and nationalist
 discourse: dethroning the father in the early Turkish novel.
 Gender and identity construction: women of Central Asia,
 the Caucasus and Turkey. Ed. Feride Acar & Ayşe
 Günes-Ayata. Leiden: Brill, 2000, (Social, Economic and
 Political Studies of the Middle East and Asia, 68),
 pp.162-176.

3563 SOYSAL, Sevgi. La guerre et la paix. Tr. Dino, Guzine.
 Paroles dévoilées: les femmes turques écrivent. Nouvelles
 choisies par Nedim Gürsel. Paris: Arcantère/UNESCO,
 1993, pp.101-113. [Translation of Savaş ve barış.]

3564 SOYSAL, Sevgi. Tante Rosa I love you. Tr. Schlyter, B.
 N. Dragomanen, 1 (1997) pp.40-45. [Short story,
 translated from Turkish into Swedish.]

3565 TEKELI, Şirin. Die erste und die zweite Welle der Frauenbewegung in der Türkei. *Feminismus, Islam, Nation: Frauenbewegungen im Maghreb, in Zentralasien und in der Türkei.* (Hg.) Claudia Schöning-Kalender, Aylâ Neusel, Mechtild M.Jansen. Frankfurt a.M.: Campus, 1997, pp.73-93.

3566 TEKIN, Latîfe. Un conte d'ordure. Tr. Semizoğlu, Ali. *Paroles dévoilées: les femmes turques écrivent. Nouvelles choisies* par Nedim Gürsel. Paris: Arcantère/UNESCO, 1993, pp.261-275. [Translation of *Bir çöp masalı.*]

3567 TEZCAN, Nuran. Lâmi'î's Ansichten über die Frauen und Frauenbilder aus einigen seiner Werke. *Journal of Turkish Studies,* 26 ii (2002) pp.295-310.

3568 TOMEK, Seljuk Fatima. Women as described in the *Dede Korkut* epic from medieval Turkic oral history. *Pakistan Journal of Women's Studies. Alam-e-Niswan,* 4 i (1997) pp.1-11.

3569 UYAR, Tomris. Des choses tièdes, molles et brunes. Tr. Dino, Guzine. *Paroles dévoilées: les femmes turques écrivent. Nouvelles choisies* par Nedim Gürsel. Paris: Arcantère/UNESCO, 1993, pp.143-155. [Translation of *Ilık, yumuşak ve kahverangi şeyler.*]

3570 WILDE-STOCKMEYER, M. Fremdheit für Frauen - nicht nur in der Fremde: literarische Texte türkischer Schriftstellerinnen. *Literatur fremder Kulturen: Türkei.* Hrsg. H.Scheuer. [Velber: Friedrich], 1993, pp.46-72. (Türkische und türkisch-deutsche Erzählungen.)

3571 YAŞIN, Neşe. Gender issue in poetry and Turkish Cypriot women's poetry. *Turkish Studies in Cyprus,* 2 (1996) pp.17-22.

URDU

Books

3572 *Parwaaz: a selection of Urdu short stories by women.* Tr. & with an introd. by Syeda S.Hameed & Sughra Mehdi. Ed. Hameed, Syeda S. & Mehdi, Sughra. Delhi: Kali for Women, 1996. 134pp.

Articles

3573 ABBAS, Azra. Woman or human being. *Engendering the nation-state.* Vol. 2. Ed. by Neelam Hussain, Samiya Mumtaz, Rubina Saigol. Lahore: Simorgh Women's Resource and Publication Centre, 1997, pp.43-57. (Alternative readings of some of the greats of Urdu literature, Saadat Hasan Manto, Bedi and Krishan Chandar ... from a feminist perspective.)

3574 ABBAS, Nuzhat. Conversing to/with shame: translation and gender in the Urdu ghazal. *Annual of Urdu Studies,* 14 (1999) pp.135-149.

3575 [AHMAD, Radīya Fāsih]. The inferno / Razia Fasih Ahmed. *Hoops of fire: fifty years of fiction by Pakistani women /* ed. Aamer Hussein. London: Saqi, 1999, pp.69-98. [Short story.]

3576 BARD, Amy. Value and vitality in a literary tradition: female poets and the Urdu *Marsiya. Annual of Urdu Studies,* 15 i (2000) pp.323-335. Also online at www.urdustudies.com

3577 BEDI, Rajinder Singh. Lajwanti. *India partitioned: the other face of freedom.* Volume 1. Ed. Mushirul Hasan. Rev. & enlarged ed. Delhi: Roli, 1997, pp.179-191. [Short story tr. from Urdu.]

3578 BREDI, Daniela. Fallen women: a comparison of Rusva and Manto. Tr. Memon, Anis. *Annual of Urdu Studies,* 16 i (2001) pp.109-127. Also online at www.urdustudies.com [Urdu novelists.]

3579 BREDI, Daniela. Muhammad Iqbāl sulla questione femminile. *Rivista degli Studi Orientali,* 73 i-iv / 1999 (2000) pp.53-68. [In nine Urdu poems, tr. into Italian.]

3580 CHUGHTĀ'Ī, 'Ismat. An excerpt from *Kaghazi hai pairahan* (The "Lihaf" trial). Tr. Naqvi, Tahira & Memon, Muhammad Umar. *Annual of Urdu Studies,* 15 ii (2000) pp.429-443. Also online at www.urdustudies.com (Charged with obscenity for my short story "Liḥāf" (quilt).)

3581 CHUGHTĀ'Ī, 'Ismat. Lihaf (The Quilt). Tr. Hameed, Syeda. *Women Living under Muslim Laws: Dossier,* 18 (1997) pp.10-17. Also online at www.wluml.org/english/ pubs [Lesbian short story, written in Urdu in 1941.]

3582 DRYLAND, E. Interview with Professor Sajida Zaidi, noted Indian poet, writer and intellectual. *Pakistan Journal of Women's Studies. Alam-e-Niswan,* 3 i (1996) pp.67-72.

3583 HINA, Zahida. Urdu literature and the patriarchal family. *Engendering the nation-state.* Vol. 2. Ed. by Neelam Hussain, Samiya Mumtaz, Rubina Saigol. Lahore: Simorgh Women's Resource and Publication Centre, 1997, pp.21-41. [Nearly two centuries of prose writing examined for attitudes to women's role in the family.]

3584 HUSSEIN, Aamer. Forcing silence to speak: Muhammadi Begum, *Mir'ātu'l-'Arūs,* and the Urdu novel. *Annual of Urdu Studies,* 11 (1996) pp.71-86.

3585 HYDER, Qurratulain. Four stories. *Journal of South Asian Literature,* 31-32 / 1996-1997 (1999) pp.129-181. (My Aunt Gracie; Dervish; Honor; My God, Veer, doesn't that lady in mauve look like Bette Davis?) [Tr. from Urdu.]

3586 IKRAM ULLAH Queen mother. Tr. Hassan, Faruq. *Pakistani Literature,* 5 i (2000) pp.51-59. [Story in Urdu.]

3587 KUMAR, Sukrita Paul. Surfacing from within: fallen women in Manto's fiction. *Annual of Urdu Studies,* 11 (1996) pp.155-162.

3588 KUMAR, Sukrita Paul. Surfacing from within: fallen women in Manto's fiction. *Life and works of Saadat Hasan Manto.* Ed. Alok Bhalla. Shimla: Indian Institute of Advanced Study, 1997, pp.103-112.

3589 LODHĪ, Farkhanda. Parbati. Tr. Rahman, Samina. *Hoops of fire: fifty years of fiction by Pakistani women /* ed. Aamer Hussein. London: Saqi, 1999, pp.123-144. [Short story.]

3590 MALIK, Jamal. The literary critique of Islamic popular religion in the guise of traditional mysticism, or the abused woman. *Embodying charisma: modernity, locality and the performance of emotion in Sufi cults.* Ed. P.Werbner & Helene Basu. London: Routledge, 1998, pp.187-208. (Especially evident in modern Urdu literature.)

3591 MANTO, Sa'adat Hasan. Ismat Chughtai. Tr. Asaduddin, M. *Annual of Urdu Studies,* 16 i (2001) pp.201-215. Also online at www.urdustudies.com [Short story tr. from Urdu.]

3592 MANZAR, Hasan. Kanha Devi and her family. *An epic unwritten: the Penguin book of Partition stories from Urdu* [selected & tr. by] Muhammad Umar Memon. Delhi: Penguin Books, 1998, pp.207-219.

3593 MASTOOR, Khadija. Farewell to the bride. Tr. Hashmi, Moneeza. *So that you can know me: an anthology of Pakistani women writers.* Ed. Yasmin Hameed & Asif Aslam Farrukhi. Reading: Garnet & Unesco Publishing, 1997, pp.33-38. [Story tr. from Urdu.]

3594 MINAULT, G. & KOMAL, B. Feminine voice in Urdu poetries, fictions and journals. *Muslim feminism and feminist movement: South Asia.* Vol. 1: *India.* Ed. Abida Samiuddin, R.Khanam. Delhi: Global Vision Publishing House, 2002, pp.165-208. [Female poets of the last three centuries & pre-Partition writers of journals.]

3595 NAHEED, Kishwar. Kishwar Naheed has a message for 'masters of countries with a cold climate'. *Eye to eye women: their words and worlds. Life in Africa, Asia, Latin America and the Caribbean as seen in photographs and in fiction by the region's top women writers.* (Ed. V.Baird). Oxford: New Internationalist, 1996, pp.82-82. [Urdu poem.]

3596 [NAHĪD, Kishwar]. Speechless princess; Relationships with no direction / Kishwar Naheed. Tr. Farrukhi, Asif. *Pakistani Literature,* 5 i (2000) pp.97-99. [Poems in Urdu.]

3597 NAIM, C.M. The earliest extant review of *Umra'o Jan Ada. Annual of Urdu Studies,* 15 i (2000) pp.287-291. Also online at www.urdustudies.com [1899, of novel by Ruswa.]

3598 NAQVI, Tahira. A note on Ismat Chughtai's nonfictional
 writings. *Annual of Urdu Studies,* 15 ii (2000)
 pp.405-408. Also online at www.urdustudies.com

3599 PATEL, Geeta. An uncivil woman: Ismat Chughtai (a
 review and an essay). *Annual of Urdu Studies,* 16 ii (2001)
 pp.345-355. Also online at www.urdustudies.com

3600 PETIEVICH, Carla. Gender politics and the Urdu ghazal:
 exploratory observations on *Rekhta* versus *Rekhtī*. *Indian
 Economic and Social History Review,* 38 iii (2001)
 pp.223-248.

3601 PETIEVICH, Carla. *Rekhti*: impersonating the feminine
 in Urdu poetry. *South Asia,* 24 Special issue (2001)
 pp.75-90.

3602 QĀSIMĪ, Aḥmad Nadīm. Countrywoman. Tr. Syed,
 Muzaffar Ali. *Fires in an autumn garden: short stories
 from Urdu and the regional languages of Pakistan.* Ed.
 Asif Farrukhi. Karachi: Oxford University Press, 1997,
 pp.80-86. [Short story tr. from Urdu.]

3603 SHAHĀB, Qudrat [A]llāh. Mother. Tr. Hasan, Khalid.
 Colours of loneliness. Edited by Muzaffar Iqbal. Karachi:
 Oxford University Press, 1999, pp.301-313. [Short story
 tr. from Urdu.]

3604 ZAHEER, Razia Sajjad. My lame aunt. *Parwaaz: a
 selection of Urdu short stories by women.* Tr. & with an
 introd. by Syeda S.Hameed & Sughra Mehdi. Delhi: Kali
 for Women, 1996, pp.59-65.

Maghrib (general)

Books

3605 BESSIS, S. & BELHASSEN, Souhayr. *Mujeres del
 Magreb: lo que esta en juego.* Madrid: Horas y Horas,
 1994. 225pp. [Tr. of *Femmes du Maghreb - l'enjeu,* Tunis
 1992.]

3606 CHARRAD, Mounira M. *States and women's rights: the
 making of postcolonial Tunisia, Algeria, and Morocco.*
 Berkeley: University of California Press, 2001. 341pp.
 Also online at http:// escholarship.cdlib.org/
 ucpressbooks.html

3607 CHELLIG, Nadia. *Jazay: princesse berbère.* [Algiers:]
 CNRPAH-CHIHAB, 1998, (Travaux du Centre National
 de Recherches Préhistoriques, Anthropologiques et
 Historiques), 170pp.

3608 DAOUD, Zakya. *Féminisme et politique au Maghreb:
 1930-1992.* Paris: Maisonneuve et Larose, 1993, 1994.
 373pp.

3609 LACOSTE-DUJARDIN, C. *Las madres contra las
 mujeres: patriarcado y maternidad en el mundo árabe.*
 Tr. Martorell, A. Madrid: Cátedra, 1993, (Feminismos,
 12), 283pp. [Translation of *Des mères contre les femmes:
 maternité et patriarcat au Maghreb,* 1985.]

3610 ZOMEÑO, Amalia. *Dote y matrimonio en Al-Andalus y
 el norte de África: estudio sobre la jurisprudencia islámica
 medieval.* Madrid: Consejo Superior de Investigaciones
 Científicas, 2000. 302pp.

3611 *Cent mesures et dispositions pour une codification
 maghrébine égalitaire du statut personnel et du droit de
 la famille* / Collectif 95 Maghreb Egalité. [Montpellier?:]
 Femmes sous Lois Musulmanes, 1996? 38pp.

3612 *Etre femme au Maghreb et en Méditerranée. Du mythe à la
 réalité.* Sous la dir. de Andrée Dore-Audibert & Souad
 Khodja. Paris: Karthala, 1998. 252pp.

3613 *Femmes, culture et société au Maghreb.* I: *Culture, femmes
 et famille.* Ed. Bourqia, Rahma, Charrad, Mounira &
 Gallagher, N. Casablanca: Afrique Orient, 1996. 183pp.

3614 *Femmes, culture et société au Maghreb.* II: *Femmes,
 pouvoir politique et développement.* Ed. Bourqia, Rahma,
 Charrad, Mounira. & Gallagher, N. Casablanca: Afrique
 Orient, 1996. 205pp.

3615 *Femmes et hommes au Maghreb et en immigration: la
 frontière des genres en question. Etudes sociologiques et
 anthropologiques.* Ed. Lacoste-Dujardin, C. & Virolle,
 M. Paris: Publisud, 1998. 229pp. [Almost entirely about
 Maghribi society.]

3616 *Histoire des femmes au Maghreb: culture matérielle et vie
 quotidienne.* Ed. Larguèche, Dalenda. Tunis: Centre de
 Publication Universitaire, 2000. 395pp. (Contributions
 de chercheurs maghrébins et européens présentées lors de
 rencontres organisées à Tunis en avril 1994 et octobre
 1996.)

3617 *Le leggi del diritto di famiglia negli stati arabi del
 Nord-Africa* / a cura di Roberta Aluffi Beck-Peccoz.
 Torino: Fondazione Giovanni Agnelli, 1997 (Dossier
 Mondo Islamico, 4), 226pp. [Translations of laws of
 Algeria, Egypt, Libya, Morocco & Tunisia.]

Articles

3618 AIXELÀ CABRÉ, Yolanda. Derechos y deberes de las
 mujeres del Magreb. Una aproximación comparativa en
 el campo legislativo. *Awrāq,* 19 (1998) pp.249-267.

3619 AMRI, Nelly. Les *Ṣāliḥāt* du Ve au IXe siècle / XIe-XVe
 siècle dans la mémoire maghrébine de la sainteté à travers
 quatre documents hagiographiques. *Al-Qanṭara: Revista
 de Estudios Arabes,* 21 ii (2000) pp.481-509.

3620 BEKKAR, Rabia. Statut social des femmes, accès à
 l'espace et à la parole publique. *Espaces publics, paroles
 publiques au Maghreb et au Machrek.* Sous la dir. de
 Hannah Davis Taïeb, Rabia Bekkar, J-C.David. Lyon:
 Maison de l'Orient Méditerranéen; Paris: L'Harmattan,
 1997, pp.83-90. (Au Maghreb.)

3621 BELHAMISSI, Moulay. Captifs musulmans et chrétiens
 XVI-XVIIIe s.: le cas des femmes et des enfants. *Actes
 du IIe Congrès International sur: Chrétiens et Musulmans
 à l'époque de la Renaissance. A'māl al-mu'tamar al-'ālamī
 al-thānī ḥawl al-Masīḥīyūn wa-'l-Muslimūn fī 'aṣr
 al-Nahḍa al-gharbīya.* Etudes réunies par Abdeljelil
 Temimi. Zaghouan: Fondation Temimi pour la Recherche
 Scientifique et l'Information, 1997, pp.53-63.

3622 BELHASSEN, Souhayr. La politique, une affaire
 d'hommes: situation des femmes dans le champ politique
 de trois pays du Maghreb (Maroc, Algérie, Tunisie).
 Bulletin of Francophone Africa, 5 / 9 (1996) pp.18-29.

3623 BEN ACHOUR-DEROUICHE, Sana. Etats non
 sécularisés, laïcité et droits des femmes. *Femmes de
 Méditerranée: religion, travail, politique.* Sous la dir. de
 Andrée Dore-Audibert et Sophie Bessis. Paris: Karthala,
 1995, pp.113-125. (Maghreb.)

3624 BERJAOUI, Khalid. Les droits de la femme et le statut
 personnel dans les systèmes juridiques des pays du
 Maghreb. *SGMOIK/SSMOCI Bulletin,* 6 (1998)
 pp.10-14.

3625 BESSIS, Sophie. Femmes et citoyennes: la question de
 l'égalité des sexes dans le Maghreb d'aujourd'hui.
 Democracia y derechos humanos en el mundo árabe.
 G.Martín Muñoz (ed.). Madrid: Agencia Española de
 Cooperación Internacional, 1993, pp.177-186.

3626 BOUCHERDAKH, Tahar. Sexualité et rapports dans le
 couple maghrébin. Revue critique. *Horizons Maghrébins,*
 25-26 (1994) pp.174-184.

3627 BOUDIAF, Akila. A propos de la citoyenneté des femmes
 et de l'égalité des droits au Maghreb. *Droits de
 citoyenneté des femmes au Maghreb: la condition
 socio-économique et juridique des femmes, le mouvement
 des femmes* / Belarbi Aïcha [& others]. Casablanca: Le
 Fennec, 1997, pp.21-62.

3628 BOURQIA, Rahma, CHARRAD, Mounira &
 GALLAGHER, N. Femmes au Maghreb: perspectives
 et questions. *Femmes, culture et société au Maghreb.* I:
 *Culture, femmes et famille. Sous la dir. de R.Bourqia,
 M.Charrad, N.Gallagher.* Casablanca: Afrique Orient,
 1996, pp.9-14.

3629 CHARRAD, Mounira. State and gender in the Maghrib.
 Arab women: between defiance and restraint. Ed. Suha
 Sabbagh. New York: Olive Branch Press, 1996,
 pp.211-220.

3630 CHARRAD, Mounira M. State and gender in the Maghrib.
 Women and power in the Middle East. Ed. Suad Joseph &
 Susan Slyomovics. Philadephia: University of Pennsylvania
 Press, 2001, pp.61-71;209-211.

3631 CHEBEL, Malek. Mères, sexualité et violence. *Etre
 femme au Maghreb et en Méditerranée. Du mythe à la
 réalité.* Sous la dir. de Andrée Dore-Audibert & Souad
 Khodja. Paris: Karthala, 1998, pp.49-59. (Au Maghreb.)

3632 CHOUTRI, Fadila. Des mères et leurs filles: de l'emprise
 à la fascination. *Femmes et hommes au Maghreb et en
 immigration: la frontière des genres en question. Etudes
 sociologiques et anthropologiques.* Sous la dir. de
 C.Lacoste-Dujardin & M.Virolle. Coord. Baya Boualem
 & Narjys El Alaoui. Paris: Publisud, 1998, pp.85-94.
 (Femmes maghrébines.)

3633 CLANCY-SMITH, Julia. A woman without her distaff:
 gender, work, and handicraft production in colonial North
 Africa. *Social history of women and gender in the
 modern Middle East* / ed. M.L.Meriwether, J.E.Tucker.
 Boulder: Westview, 1999, pp.25-62.

3634 CLANCY-SMITH, Julia. Envisioning knowledge:
 educating the Muslim woman in colonial North Africa,
 c.1850-1918. *Iran and beyond: essays in Middle Eastern
 history in honor of Nikki R.Keddie.* Ed. R.Matthee &
 B.Baron. Costa Mesa: Mazda, 2000, pp.99-118.

3635 CLANCY-SMITH, J. La femme arabe: women and
 sexuality in France's North African empire. *Women, the
 family, and divorce laws in Islamic history.* Ed. A.El
 Azhary Sonbol. Syracuse: Syracuse University Press, 1996,
 pp.52-63.

3636 DAOUD, Zakya. En marge de la Conférence mondiale
 des femmes de Pékin: la stratégie des féministes
 maghrébines. *Monde Arabe Maghreb Machrek,* 150
 (1995) pp.105-119.

3637 DAOUD, Zakya. Femmes, mouvements féministes et
 changement social au Maghreb. *Islam et changement
 social.* Publ. sous la dir. de Mondher Kilani, avec le
 concours de Ahmed Benani, Moncef Djaziri &
 H.Kilpatrick. Lausanne: Payot, 1998, pp.247-259.

3638 DAOUD, Zakya. Les Associations féministes maghrébines
 et la Conférence de Pékin. *Annuaire de l'Afrique du Nord,*
 34 / 1995 (1997) pp.899-904.

3639 DAVIS, S. S. Un potentiel limité: état, femmes
 maghrébines et développement. *Femmes, culture et
 société au Maghreb.* I: *Culture, femmes et famille. Sous
 la dir. de R.Bourqia, M.Charrad, N.Gallagher.* Casablanca:
 Afrique Orient, 1996, pp.183-199.

3640 DODI, C. Le donne maghrebine all'orizzonte del 2000.
 Africa e Mediterraneo, 14-15 (1995) pp.60-63.

3641 FAYAD, Mona. Cartographies of identity. Writing
 Maghribi women as postcolonial subjects. *Beyond
 colonialism and nationalism in the Maghrib: history,
 culture, and politics.* Ed. Ali Abdullatif Ahmida. New
 York & Basingstoke: Palgrave, 2000, pp.85-108.

3642 GRANDGUILLAUME, Gilbert. Les relations père-fils et
 père-fille au Maghreb. *Etre femme au Maghreb et en
 Méditerranée. Du mythe à la réalité.* Sous la dir. de Andrée
 Dore-Audibert & Souad Khodja. Paris: Karthala, 1998,
 pp.61-72.

3643 HAYEF, Imane. Le Collectif 95 Maghreb-Egalité.
 Transeuropéennes, 12-13 (1998) pp.127-129. (Dans le
 mouvement des femmes, le Collectif 95 Maghreb-Egalité
 en est un example.)

3644 HELLER-GOLDENBERG, L. Féminisme et fémininité
 au Maghreb ou le Maghreb à l'école des femmes. *Bulletin
 of Francophone Africa,* 5 / 9 (1996) pp.107-113.

3645 JANSEN, Willy. Sleeping in the womb: protracted
 pregnancies in the Maghreb. *Muslim World,* 90 i-ii (2000)
 pp.218-237.

3646 KETITI, Awatef & ENGELHARD, P. Women and the
 order of things in North Africa. *African Environment,*
 10 iii-iv / 39-40 (1999) pp.117-122.

3647 KHODJA, Souad. Rôle et statut de la mère dans la famille
 matrio-patriarchale. *Etre femme au Maghreb et en
 Méditerranée. Du mythe à la réalité.* Sous la dir. de Andrée
 Dore-Audibert & Souad Khodja. Paris: Karthala, 1998,
 pp.73-82. (Sociétés maghrébines.)

3648 LACOSTE-DUJARDIN, C. Mujeres beréberes: del rigor
 patriarcal a la innovación. *Vigia de Tierra,* 2-3 / 1996-7
 (1997) pp.71-83.

3649 LALAMI-FATÈS, Fériel. Codes de la famille et
 dynamique des luttes de femmes dans les pays du Maghreb.
 Bulletin of Francophone Africa, 5 / 9 (1996) pp.10-17.

3650 MARTÍN MUÑOZ, G. Mujer y vida políitica magrebí: un
 conflicto entre modernidad y tradición. *Explosión
 demográfica, empleo y trabajadores emigrantes en el
 mediterráneo occidental.* J.Montabes Pereira, B.López
 García & D.del Pino (eds.). Granada: Universidad de
 Granada, 1993, pp.85-105.

3651 MECHRI, Samira. The Western gaze in the Maghreb:
 veiling and unveiling tropes. *American & British
 interactions, perceptions & images of North Africa.*Ed.
 Adel Manai. [Tunis: Tunisian Society for Anglo-Saxon
 Studies], 2000, (TSAS Innovation Series, 2000), pp.76-87.

3652 MERINI, Rafika. A socio-literary perspective of women
 in the Maghreb: Morocco, Algeria, and Tunisia. *The
 Arab-African and Islamic worlds: interdisciplinary studies.*
 Ed. by R.Kevin Lacey and Ralph M. Coury. New York:
 Lang, 2000, pp.153-165.

3653 MERNISSI, Fatima. Femmes du Maghreb, partenaires
 incontournables de l'équilibre méditerranéen. *Les cultures
 du Maghreb.* Sous la dir. de M.Roque. Paris: L'Harmattan,
 1996, pp.123-131. (La part de la femme dans les
 stratégies démographiques et culturelles.)

3654 NADIFI, Rajaa. Quand les femmes entreprennent d'écrire...
 sur les femmes. *Initiatives féminines / Mubādarāt
 nisā'īya.* Khadija Amiti ... [& others]. Casablanca: Le
 Fennec, 1999, pp.95-118. [Maghribi women writing in
 Arabic or in French, mainly as novelists, but also as
 sociologists.]

3655 POWERS, David S. Women and divorce in the Islamic
 west: three cases. *Hawwa: Journal of Women in the
 Middle East and the Islamic world,* 1 i (2003) pp.29-45.
 Also online at http:// leporello.ingentaselect.com/
 vl=16277934/cl=41/nw=1/rpsv/cw/brill/15692078/(Lisbon,
 Ceuta, Bijāya.)

3656 REYSOO, F. Métaphores spatiales et sociales au Maghreb:
 pratiques corporelles des femmes arabo-musulmanes et
 berbères. *El imaginario, la referencia y la diferencia:
 siete estudios acerca de la mujer árabe.* M.del Amo (ed.).
 Granada: Departamento Estudios Semíticos, 1997,
 pp.127-141.

3657 SHATZMILLER, M. Women and wage labour in the
 medieval Islamic west: legal issues in an economic context.
 Journal of the Economic and Social History of the Orient,
 40 ii (1997) pp.174-206. (Mālikī legal sources from
 Muslim Spain & North Africa.)

3658 TOUALBI, Radia. Mère et fille à l'épreuve de la norme
 familiale. L'exemple maghrébin. *Etre femme au Maghreb
 et en Méditerranée. Du mythe à la réalité.* Sous la dir. de
 Andrée Dore-Audibert & Souad Khodja. Paris: Karthala,
 1998, pp.85-105.

3659 YELLES-CHAOUCHE, Mourad. Les chants de
 l'escarpolette au Maghreb. *Journal of Mediterranean
 Studies,* 6 i (1996) pp.120-134. (L'un des répertoires
 féminins les plus importants du Maghreb.)

3660 ZAMITI, Khalil. Guerre et paix entre les sexes. Explication
 par la misère et misère de l'explication. *Actes du
 colloque: L'homme, la femme et les relations amoureuses
 dans l'imaginaire arabo-musulman, Tunis ... 1992 /
 Ashghāl multaqá: Al-Rajul wa-'l-mar'a wa'l-ḥubb fī
 'l-khayāl al-'Arabī al-Islāmī.* Tunis: Université des Lettres,
 des Arts et des Sciences Humaines, Tunis I, Centre
 d'Etudes et de Recherches Economiques et Sociales, Tunis,
 1995, (Cahier du C.E.R.E.S. Série Psychologie, 8),
 pp.73-76. (Au Maghreb.)

3661 ZIAI, Fati. Personal status codes and women's rights in
 the Maghreb. *Muslim women and the politics of
 participation: implementing the Beijing platform.* Ed.
 Mahnaz Afkhami & E.Friedl. Syracuse (USA): Syracuse
 University Press, 1997, pp.72-82.

3662 (Rôles de la femme.). *Cahier d'Études Maghrébines,* 8-9,
 1995-96, pp.72-76.

3663 Femmes au travail. *Cahier d'Études Maghrébines,* 8-9,
 1995-96, pp.77-88. (Images et textes de femmes au
 travail.)

Malaysia

Books

3664 ARIFFIN, Rohana & others. *Shame, secrecy, and silence:
 study on rape in Penang.* Penang: Women's Crisis Centre,
 1997. 264pp.

3665 ARIFFIN, Rohana. *Women and trade unions in Peninsular
 Malaysia with special reference to MTUC and CUEPACS.*
 Pulau Pinang: Penerbit Universiti Sains Malaysia, 1997.
 264pp.

3666 CHANT, S. & MCILWAINE, C. *Three generations, two
 genders, one world: women and men in a changing
 century.* London: Zed (in association with the
 Commonwealth Secretariat), 1998. 237pp. (4. Malaysia,
 pp.67-84; 6. Pakistan, pp.109-134.]

3667 CHIN, C. B. N. *In service and servitude: foreign female
 domestic workers and the Malaysian "modernity" project.*
 New York: Columbia University Press, 1998. 299pp.
 [Indonesian & Philippine workers in Malaysia.]

3668 HASSAN, Sharifah Zaleha Syed & CEDERROTH, S.
 *Managing marital disputes in Malaysia: Islamic mediators
 and conflict resolution in the Syariah Courts.* Richmond:
 Curzon, 1997. 260pp.

3669 ISMA'IL, Sha'ban Muftah. *Women, economic growth &
 development in Malaysia.* Petaling Jaya: IBS Buku, 1997.
 143pp.

3670 MOHAMAD, Maznah. *Shifting interests and identities:
 the politics of gender, ethnicity and democratization in
 Malaysia.* Geneva: United Nations Research Institute for
 Social Development (UNRISD), [2001] (Gender Justice,
 Development and Rights: Substantiating Rights in a
 Disabling Environment), 35pp. Online at
 www.unrisd.org/enindex/research/genjus.htm

3671 NG, Cecilia. *Positioning women in Malaysia: class and
 gender in an industrializing state.* Basingstoke: Macmillan;
 New York: St. Martin's Press, 1999. 222pp.

3672 PASCARL-GILLESPIE, J. *Once I was a princess.*
 Edinburgh: Mainstream, 1999. 448pp. [First published
 Sydney 1995. Marriage to a Malay Prince.]

3673 PELETZ, M. G. *Reason and passion: representations of
 gender in a Malay society.* Berkeley: University of
 California Press, 1996. 402pp.

3674 SCHAFGANS, M. M. A. *Gender wage differences in
 Malaysia: parametric and semiparametric estimation.*
 London: Suntory and Toyota International Centres for
 Economics and Related Disciplines, 1997, (Discussion
 Paper, EM/97/325), 28pp.

3675 STIVENS, M. *Matriliny and modernity: sexual politics
 and social change in rural Malaysia.* St Leonards
 (Australia): Allen & Unwin, 1996. 316pp.

3676 TEASDALE, J. *Facing the bow: European women in
 colonial Malaya 1919-1945.* Nedlands: Centre for
 Migration & Development Studies, University of Western
 Australia, 1997. 262pp.

3677 *Muslim women and access to justice: historical, legal, and
 social experience in Malaysia.* Research findings and
 recommendations by the MUSWAL (Muslim Women and
 Law) Project. Penang: Women's Crisis Centre, 2000.
 115pp.

3678 *Women in Malaysia: breaking boundaries.* Ed. Omar,
 Roziah & Hamzah, Azizah. Kuala Lumpur: Utusan, 2003.
 305pp.

Articles

3679 ABAZA, Mona. Images on gender and Islam: the Middle
 East and Malaysia, affinities, borrowings and exchanges.
 Orient (Opladen/Leverkusen), 39 ii (1998) pp.271-284.

3680 ABAZA, Mona. Vorstellungen über Geschlecht und Islam
 - der Mittlere Osten und Malaysia: Übereinstimmungen,
 Entlehnungen und Wechselbeziehungen. *Der neue Islam
 der Frauen. Weibliche Lebenspraxis in der globalisierten
 Moderne: Fallstudien aus Afrika, Asien und Europa.*
 R.Klein-Hessling, S.Nökel, K.Werner (Hg.). Bielefeld:
 transcript Verlag, 1999, pp.277-296.

3681 ABDULLAH, Nor Aini & JAMALUDDIN, Siti Zaharah.
 Family law. *Survey of Malaysian Law,* 1994 (1996)
 pp.185-198.

3682 ABDULLAH, Nor Aini. Gender, concepts and legal
 provisions relevant to violence against women in Malaysia.
 Current legal problems in Malaysia. Ed. Mimi Kamariah
 Majid. Kuala Lumpur: University of Malaya Press, 1998,
 pp.173-198.

3683 ABU BAKAR, Noor Rahamah Hj. Working women and
 their families: a case study. *Asian Profile,* 24 ii (1996)
 pp.131-141. (Malaysia.)

3684 ACKERMAN, S. E. Rebellion and autonomy in
 industrializing Penang: the career history of a young Malay
 divorcee. *Southeast Asian Journal of Social Science,* 24
 i (1996) pp.52-63.

3685 AHANGAR, Muhammad Altaf Hussain. Effects of change
 of religion on marriage and maintenance obligation:
 judicial responses in Malaysia. *IIUM Law Journal,* 4 i-ii
 / 1994 (1996) pp.125-143.

3686 ARIFFIN, Jamilah, HORTON, S. & SEDLACEK, G.
 Women in the labour market in Malaysia. *Women and
 industrialization in Asia.* Ed. S.Horton. London: Routledge,
 1996, pp.207-243.

3687 ARIFIN, Rohana. Malaysian women in the modern era.
 Copenhagen Journal of Asian Studies, 12 (1997)
 pp.69-88.

3688 ARMSTRONG, J. Twenty years of domestic service: a
 Malaysian Chinese woman in change. *Southeast Asian
 Journal of Social Science,* 24 i (1996) pp.64-82.

3689 BLOUL, R. A. D. Gender and the globalization of Islamic
 discourses: a case study. *Southeast Asian identities:
 culture and the politics of representation in Indonesia,
 Malaysia, Singapore, and Thailand.* Ed. J.S.Kahn.
 Singapore: Institute of Southeast Asian Studies, 1998,
 pp.146-167. [Malaysia.]

3690 CHATTOPADHYAY, Arpita. Family migration and the
 economic status of women in Malaysia. *International
 Migration Review,* 31 ii (1997) pp.338-352.

3691 CHATTOPADHYAY, Arpita. Gender, migration, and
 career trajectories in Malaysia. *Demography,* 35 iii
 (1998) pp.335-344. [Errata for Table 5 printed in issue
 35 iv (1998), p.376.]

3692 CHEE HENG LENG & NG, C. Choon Sim. Economic
 restructuring in Malaysia: implications for women workers.
 *Searching for security: women's responses to economic
 transformations.* Ed. Isa Baud & I.Smyth. London:
 Routledge, 1997, pp.107-131.

3693 CHIN, C. B. N. Walls of silence and late twentieth century
 representations of the foreign female domestic worker: the
 case of Filipina and Indonesian female servants in
 Malaysia. *International Migration Review,* 31 ii (1997)
 pp.353-385.

3694 CHIN YOON FONG Filipina maids in Malaysia in the
 20th century. *Sejarah,* 4 (1996) pp.123-140.

3695 DAUD, Nuraihan Mat. Women's participation in scientific
 and technical fields in Malaysia. *Intellectual Discourse,*
 7 ii (1999) pp.197-214.

3696 DORAN, C. "A fine sphere for female usefulness":
 missionary women in the Straits settlements, 1815-45.
 *Journal of the Malaysian Branch of the Royal Asiatic
 Society,* 69 i / 270 (1996) pp.100-111. (Singapore,
 Melaka & Penang.)

3697 HEALEY, Lucy. Gender, "aliens", and the national imaginary in contemporary Malaysia. *Sojourn,* 15 ii (2000) pp.222-254. Also online at www.iseas.edu.sg

3698 HEALEY, Lucy. Gender, power and the ambiguities of resistance in a Malay community of peninsular Malaysia. *Women's Studies International Forum,* 22 i (1999) pp.49-61. Also online at http:// www.sciencedirect.com/ science/journal/02775395

3699 HOLDEN, Philip. Reinscribing Orientalism: gendering modernity in colonial Malaya. *Asian Journal of Social Science,* 29 ii (2001) pp.205-218. Also online at www.ingentaselect.com (The operations of Orientalism in the works of two British writers ... Joseph Conrad and Hugh Clifford.)

3700 ISMAIL, Rosnah & ABDUL RAHMAN, Wan Rafaei. Family psychosocial dynamics in the context of rapid economic and social change in Malaysia. *Empowerment,* 4 (1997) pp.53-70.

3701 JOBST, U. Frauen in Südostasien und ihre Rolle im nation-building Prozess: Das Beispiel Malaysia. *Nationalism and ethnicity in Southeast Asia. Proceedings of the Conference `Nationalism and Ethnicity in Southeast Asia` at Humboldt University Berlin ... 1993.* Ed. I.Wessel. Münster: Lit, 1994, (Berliner Asien-Afrika-Studien, 4/2), pp.309-320.

3702 KAMALUDDIN, Siti Fathilah. Abortion in urban Malaysia: women's experiences, narratives and reasonings. *Sarjana,* 14 (1997) pp.43-56.

3703 KAMALUDDIN, Siti Fathilah. Urban Malaysian women's experiences of abortion: some implications for policy. *Kajian Malaysia,* 16 i-ii (1998) pp.53-77.

3704 KAMARUDDIN, Zaleha, SANUSI, Mahmood & WAJIS, Nik Rahim Nik. Woman, rape and the law: comparative perspectives. *IIUM Law Journal,* 7 ii (1999) pp.141-174. (In the perspective of the Malaysian Penal Code.)

3705 KARIM, Wazir Jahan. The prayer room and the Japanese carp pond in the Malay house: new identities in gender, family and ageing. *RIMA: Review of Indonesian and Malaysian Affairs,* 31 ii (1997) pp.121-140.

3706 KAUR, Amarjit. Working on the global conveyor belt: women workers in industrialising Malaysia. *Asian Studies Review,* 24 ii (2000) pp.213-230.

3707 KONINCK, Rudolphe de & BERNARD, Stéphane. Les transformations récentes du monde rural malaisien: les enjeux et les défis. *Archipel,* 60 (2000) pp.217-234. (Le cas de la Malaysia.)

3708 KUSAGO, T. Individual aspiration or family survival: rural-urban female migration in Malaysia. *Asian and Pacific Migration Journal,* 7 iv (1998) pp.483-523.

3709 LADERMAN, C. C. Putting Malay women in their place. *Women of Southeast Asia.* P.Van Esterik, ed. 2nd rev. ed. [De Kalb:] Center for Southeast Asian Studies, Northern Illinois University (1996) pp.62-77.

3710 LIE, Merete. Two generations: life stories and social change in Malaysia. *Jounal of Gender Studies,* 9 i (2000) pp.27-43. [Women's lives.]

3711 MANDERSON, L. Colonial desires: sexuality, race, and gender in British Malaya. *Journal of the History of Sexuality,* 7 iii (1997) pp.372-388.

3712 MOHAMAD, Maznah. At the centre and the periphery: the contribution of women's movements to democratization. *Democracy in Malaysia: discourses and practices.* Ed. Francis Loh Kok Wah & Khoo Boo Teik. Richmond: Curzon, 2002, pp.216-240.

3713 MOHAMAD, Rashidah. Women's role in upland farming in Malaysia. *Women in upland agriculture in Asia: proceedings of a workshop held in Chiang Mai ... 1995.* Ed. C.E.van Santen, J.W.T.Bottema, D.R.Stoltz. Bogor: CGPRT Centre, 1996, (CGPRT, no. 33), pp.213-218.

3714 MORRIS, Barbara. The dynamics of governmental structure and the advancement of women: a comparison of Sri Lanka and Malaysia. *Journal of Asian and African Studies,* 34 iv (1999) pp.403-426.

3715 NAGATA, J. The `rebirth` of a modern Malay Muslim woman. *Southeast Asian Journal of Social Science,* 24 i (1996) pp.36-51.

3716 NARLI, Nilüfer. Malaysische Studentinnen und die islamistische *Dakwah*-Bewegung. Tr. Pusch, Barbara. *Die neue Muslimische Frau: Standpunkte & Analysen /* hrsg. Barbara Pusch. Istanbul: Orient-Institut der Deutschen Morgenländischen Gesellschaft; Würzburg: Ergon, 2001, (Beiruter Texte und Studien, 85), pp.261-275.

3717 (NG, Cecilia) & YONG, Carol. Information technology, gender and employment: a case study of the telecommunications industry in Malaysia. *Positioning women in Malaysia: class and gender in an industrializing state /* Cecilia Ng. Basingstoke: Macmillan; New York: St. Martin's Press, 1999, pp.142-166.

3718 (NG, Cecilia), HAMID, Siti Nor & ALI, Syed Husin. Rural development programmes, women's participation and organizations in Malaysia. *Positioning women in Malaysia: class and gender in an industrializing state /* Cecilia Ng. Basingstoke: Macmillan; New York: St. Martin's Press, 1999, pp.11-33.

3719 (NG, Cecilia) & MOHAMAD, Maznah. The management of technology, and women, in two electronics firms in Malaysia. *Positioning women in Malaysia: class and gender in an industrializing state /* Cecilia Ng. Basingstoke: Macmillan; New York: St. Martin's Press, 1999, pp.95-115.

3720 (NG, Cecilia) & CHEE HENG LENG Women in Malaysia: present struggles and future directions. *Positioning women in Malaysia: class and gender in an industrializing state /* Cecilia Ng. Basingstoke: Macmillan; New York: St. Martin's Press, 1999, pp.169-189.

3721 NOR, Latifah Mohd. An overview of gender earnings differentials in peninsular Malaysia. *IIUM Journal of Economics and Management,* 6 i (1998) pp.23-49.

3722 OMAR, Roziah. Women and health in the Seventh Malaysia Plan: strategies and approaches. *Sarjana,* 14 (1997) pp.121-140.

3723 PHANG HOOI ENG The economic role of the Chinese in Malaysia. *The Chinese in Malaysia.* Ed. Lee Kam Hing & Tan Chee Beng. Selangor: Oxford University Press, 2000, pp.94-122.

3724 POON, J. M. L. The Malay wedding. *Asian Thought and Society,* 23 / 69 (1998) pp.221-237.

3725 RAJ, Rita, CHEE HENG LENG, & SHUIB, Rashidah. Between modernization and patriarchal revivalism: reproductive negotiations among women in peninsular Malaysia. *Negotiating reproductive rights: women's perspectives across countries and cultures.* Ed. R.P.Petchesky & K.Judd. London: Zed, 1998, pp.108-144.

3726 RAMLI, Rashila. The unsettling partnership of women in development and Islamic ideology: engendering state-directed rural programmes. *Political economy of development in Malaysia.* Ed. B.N.Ghosh, Muhammad Syukri Salleh. Kuala Lumpur: Utusan Publications & Distributors, 1999, pp.144-176.

3727 STANDING, G. Cumulative disadvantage? Women industrial workers in Malaysia and the Philippines. *Patriarchy and economic development: women's positions at the end of the twentieth century.* Ed. V.M.Moghadam. Oxford: Clarendon, 1996, pp.269-302.

3728 STIVENS, M. Sex, gender and the making of the new Malay middle classes. *Gender and power in affluent Asia* /ed. Krishna Sen & M.Stivens. London: Routledge, 1998, pp.87-126.

3729 STRANGE, H. Tok Nyam: a mini-biography of a Malay great-grandmother. *Southeast Asian Journal of Social Science,* 24 i (1996) pp.18-35.

3730 TAN BENG HUI. Women organising for change: costing the Domestic Violence Act campaign in Malaysia (c.1985-1996). *Kajian Malaysia,* 17 i (1999) pp.48-69.

3731 TEH YIK KOON. The rape problem in Malaysia. *Manusia dan Masyarakat: Man and Society,* 10 (1997) pp.196-210.

3732 VIGNATO, Silvia. Le corps exclu: notes sur le sida en Malaysie. (Abstract: The body in exile: AIDS in Malaysia.). *Autrepart,* 12 (1999) pp.87-103;182.

3733 YUSOF, Yasmin A. Mohd, MAZLAN, Musaimah, IBRAHIM, Nunnawad, MAT JUSOH, Nor Azani, SIEW, S. Y. Y., MUNIANDI, L. & MANAN, W. A. Incidence of breast-feeding among Muslim women in Malaysia. *Journal of IMA,* 31 i (1999) pp.33-38.

3734 ZAKARIA, Abdul Hadi. The processing of status offenders in Malaysia: getting it done or getting it done right? *Manusia dan Masyarakat: Man and Society,* 10 (1997) pp.1-10. [Minors or females deemed to be in "moral danger".]

Mali

Books

3735 RONDEAU, C. *Les paysannes du Mali: espaces de liberté et changements.* Paris: Karthala, 1994. 362pp.

Articles

3736 ANDRO, Armelle & HERTRICH, Véronique. La demande contraceptive au Sahel: les attentes des hommes se rapprochent-elles de celles de leurs épouses? (Abstracts: Contraceptive demand in the Sahel: convergence of views between men and their wives; La demanda de anticonceptivos en el Sahel: ¿tienen hombres y mujeres expectativas similares?). *Population* (Paris), 56 v (2001) pp.721-772. [Burkina Faso, Mali, Ghana.]

3737 BERTRAND, Monique. Femmes et marchés fonciers urbains: mesures et déterminants d'une percée à Bamako, Mali. (Abstract: The involvement of women in urban property markets: measures and elements determining a breakthrough in Bamako, Mali.). *Autrepart,* 19 (2001) pp.29-48;197.

3738 BRUIJN, M. de. The hearthhold in pastoral Fulbe society, central Mali: social relations, milk and drought. *Africa: Journal of the International African Institute,* 67 iv (1997) pp.625-651.

3739 DE JORIO, R. Modelli divergenti e strategie individuali del matrimonio nel Mali contemporaneo. *Africa* (Rome), 51 iv (1996) pp.518-534.

3740 DIAKITE, Santoutou. Réflexions sur la scolarisation des filles au Mali. *Etudes Maliennes,* 48 (1995) pp.5-17.

3741 FIGUEIREDO, C. Identité et concitoyenneté: la réélaboration des relations entre hommes et femmes aux marges de la société Kel Adagh (Mali). *Touaregs et autres Sahariens entre plusieurs mondes: définitions et redéfinitions de soi et des autres* sous la direction de H.Claudot-Hawad, Aix-en-Provence: Institut de Recherches et d'Etudes sur le Monde Arabe et Musulman (1996) (Cahiers de l'IREMAM, 7-8), pp.113-134.

3742 GRIGSBY, William J. Women, descent, and tenure succession among the Bambara of West Africa: a changing landscape. *Human Organization,* 55 i (1996) pp.93-98.

3743 HERTRICH, V. Les réponses des hommes valent-elles celles des femmes? Une double collecte sur les questions génésiques et matrimoniales dans une population du Mali. ([Summaries:] Are men's and women's answers to be equally trusted? A dual data collection on maternity and fertility issues in a population in Mali; ¿Las respuestas de los hombres valen lo mismo que las de las mujeres? Una doble encuesta sobre cuestiones genésicas y matrimoniales en una población de Mali.). *Population (Paris),* 52 i (1997) pp.45-62.

3744 JESSEN, Jasmine Abel. La *la shwo cwo,* "la femme qui prend la grossesse": les accoucheuses traditionnelles dans la société senoufo du Mali. (Abstract: The *la shwo cwo,* the woman who takes care of the pregnancy: traditional midwives in Senoufo society, Mali.). *Transforming female identities: women's organizational forms in West Africa.* Ed. E.E.Rosander. Uppsala: Nordiska Afrikainstitutet, 1997, (Seminar Proceedings, 31), pp.107-119.

3745 LAMBERT, A. Les commerçantes maliennes du chemin de fer Dakar-Bamako. *Grands commerçants d'Afrique de l'Ouest: logiques et pratiques d'un groupe d'hommes d'affaires contemporains* / sous la direction de E.Grégoire et P.Labazée. Paris: Karthala & ORSTOM, 1993, pp.37-70.

3746 MCDOUGALL, E. A. A sense of self: the life of Fatma Barka. *Canadian Journal of African Studies. Revue Canadienne des Etudes Africaines,* 32 ii (1998) pp.295-315. [Slave in Mali, free woman in Morocco.]

3747 OPHEIM, M. Les filles et l'école au Mali. (Abstract: Girls' schooling in Mali.). *Nordic Journal of African Studies,* 9 iii (2000) pp.152-171.

3748 OPHEIM, Marianne. Les filles et l'école au Mali. (Abstract: Girls' schooling in Mali.). *Nordic Journal of African Studies,* 9 iii (2000) pp.152-171.

3749 SCHULZ, Dorothea E. Mesmerizing *missis,* nationalist musings: beauty pageants and the public controversy over 'Malian' womanhood. *Paideuma: Mitteilung zur Kulturkunde,* 46 (2000) pp.111-135.

3750 SCHULZ, Dorothea E. Women's associations, mass media, and morals in urban Mali. *ISIM Newsletter,* 6 (2000) pp.27-27.

3751 SIMARD, P. Assessing autonomy among Sahelian women: an analytical framework for women's production work. (Abstracts in translation: Comment aborder l'autonomie parmi les femmes sahéliennes: un cadre analytique pour le travail productif féminin; Avaliando a autonomia entre as mulheres de Sahel: um esquema analítico para a atividade de produção das mulheres; Valorando la autonomía entre mujeres sahelianas: un marco analítico para el trabajo productivo de mujeres.). *Development in Practice,* 8 ii (1998) pp.186-202;266;267-268;269. (Mali). Also online at www.catchword.co.uk/

3752 SIMARD, Paule & KONINCK, Maria de. Environment, living spaces, and health: compound-organisation practices in a Bamako squatter settlement, Mali. *Gender and Development,* 9 iii (2001) pp.28-39. Also online at http://www.ingentaselect.com (The compound is mainly a female living and working space.)

3753 SLOBIN, K. Repairing broken rules: care-seeking narratives for menstrual problems in rural Mali. *Medical Anthropology Quarterly,* 12 iii (1998) pp.363-383. [Muslim Dogon woman.]

3754 UCHUDI, Joseph Masudi. Covariates of child mortality in Mali: does the health-seeking behaviour of the mother matter? *Journal of Biosocial Science,* 33 i (2001) pp.33-54.

Mauritania

Books

3755 BLANC, François-Paul. *La filiation servile en Afrique du nord: jurisprudences marocaine et mauritanienne.* Perpignan: Presses Universitaires; Toulouse: Presses de l'Université des Sciences Sociales, 1999 (Revue Franco-Maghrébine de Droit, 7), 146pp. (Concubinage légal.)

3756 RUF, Urs Peter. *Ending slavery: hierarchy, dependency, and gender in central Mauritania.* Bielefeld: Transcript, 1999. 434pp.

3757 SIMARD, G. *Petites commerçantes de Mauritanie: voiles, perles et henné.* Paris: Karthala, 1996. 240pp.

3758 TAUZIN, A. *Le henné, art des femmes de Mauritanie.* Photographies de K.Ancellin-Saleck, Merzak Mehleb & Aline Tauzin. Paris: Ibis, [for] UNESCO, 1998. 62pp.

Articles

3759 CLEAVELAND, Timothy. Reproducing culture and society: women and the politics of gender, age, and social rank in Walāta. *Canadian Journal of African Studies. Revue Canadienne des Etudes Africaines,* 34 ii (2000) pp.189-217.

3760 FORTIER, Corinne. Le lait, le sperme, le dos. Et le sang? Représentations physiologiques de la filiation et de la parenté de lait en islam malékite et dans la société maure. (Abstract: Milk and sperm and back. And blood? Images of descent and fosterage in malekite islam and in Moorish society in Mauritania.). *Cahiers d'Etudes Africaines*, 41 i / 161 (2001) pp.97-138.

3761 FORTIER, Corinne. Le rituel de mariage dans la société maure: mise en scène des rapports sociaux de sexe. *Awal*, 23 (2001) pp.51-73.

3762 OULD AHMED SALEM, Zekeria. *Le prétexte de la berceuse: femmes, poésie populaire et subversion politique* en Mauritanie. *Annuaire de l'Afrique du Nord*, 34 / 1995 (1997) pp.771-789.

3763 OULD CHEIKH, Abdel Wedoud. Brotherhoods and gender relations in Mauritania. *ISIM Newsletter*, 8 (2001) pp.26-26.

3764 TAINE-CHEIKH, C. Du sexe au genre: le féminin dans le dialecte arabe de Mauritanie. (Résumé: From sex to gender: the feminine in the Arabic dialect of Mauritania.). *Matériaux Arabes et Sudarabiques. Nuṣūṣ wa-Abḥāth 'Arabīya wa-'Arabīya Janūbīya*, N.S. 5 (1993) pp.67-121.

Mediæval Islam see under countries & General: history & law

Morocco

Books

3765 ABOUMALEK, Mostafa. *Qui épouse qui? Le mariage en milieu urbain*. [Casablanca:] Afrique Orient, 1994. 246pp. [Morocco.]

3766 [ABŪ ZAYD, Laylá]. *Return to childhood: the memoir of a modern Moroccan woman* / Leila Abouzeid. Tr. Taylor, H. L. [Austin:] Center for Middle Eastern Studies at the University of Texas at Austin, 1998. 94pp. [Tr. of *Rujū' ilá 'l-ṭufūla*.]

3767 AIXELÀ CABRÉ, Yolanda. *Mujeres en Marruecos: un análisis desde el parentesco y el género*. Barcelona: Bella Terra, 2000. 317pp.

3768 ALAOUI, Cherifa. *Femmes et éducation: état des lieux*. Casablanca: Editions le Fennec, 1994, (Marocaines, Citoyennes de Demain), 142pp.

3769 ALAOUI, Fatima. *Parties de rien arrivées à zéro: la longue marche de la fondatrice du mouvement "Les Verts pour le Développement" de Marrakech à Pékin en passant par Mexico, Nairobi, Paris, Miami, Rio, Rome, Barcelone, Istanbul, afin de répondre à la seule question préoccupante de cette fin de siècle: "En Afrique somme-nous tous partis de rien pour arriver à zéro?"*. Rabat: Editions de l'Ère Nouvelle, 1996. 115pp.

3770 BAKER, Alison. *Voices of resistance: oral histories of Moroccan women*. Albany (USA): State University of New York Press, 1998. 341pp.

3771 BARKALLIL, Nadira, CHICHE, J., LEMRINI, Amina & NACIRI, Rabéa. *Femmes et éducation: blocages et impacts*. Casablanca: Editions le Fennec, 1994, (Marocaines, Citoyennes de Demain), 123pp.

3772 BENABDENBI DJERRARI, F[a]ttouma. *Marocaines & entreprise*. Casablanca: Fennec, 1995. 115pp.

3773 BENJELLOUN, Thérèse. *Femme, culture, entreprise au Maroc*. Casablanca: Wallada, [1993?]. 219pp.

3774 BLANC, François-Paul. *La filiation servile en Afrique du nord: jurisprudences marocaine et mauritanienne*. Perpignan: Presses Universitaires; Toulouse: Presses de l'Université des Sciences Sociales, 1999 (*Revue Franco-Maghrébine de Droit*, 7), 146pp. (Concubinage légal.)

3775 BOURQIA, Rahma. *Femmes et fécondité*. Casablanca: Afrique Orient, 1996. 135pp. [Morocco.]

3776 BOURQIA, Rahma. *Genre et emploi dans l'industrie textile marocaine*. Geneva: United Nations Research Institute for Social Development, 1999, (UNRISD Occasional Paper, 11), 41pp.

3777 BUITELAAR, M. *Ramadan: vasten en feesten in Marokko: hoe vrouwen Ramadan vieren*. Amsterdam: Muntinga, 1995, (Rainbow Pocketboeken, 206), 204pp. [Orig. published Amsterdam 1993 as *Vasten en feesten in Marokko*.]

3778 BUITELAAR, M. *Vasten en feesten in Marokko: hoe vrouwen ramadan vieren*. Amsterdam: Bulaaq, 1993. 155pp.

3779 CHEBEL, Malek. *El espíritu de serrallo*. Tr. Vivanco, J. Barcelona: Bellaterra, 1997. 239pp. (Estructuras y variaciones de la sexualidad magrebí.) [Tr. of *L'ésprit de sérail*, Paris 1988.]

3780 COMBE, Julie. *La condition de la femme marocaine*. Paris: L'Harmattan, 2001. 224pp.

3781 ENGELHARD, K. *Frauenförderung als entwicklungspolitische Aufgabe: eine entwicklungspolitische Analyse der Rolle der Frau in ausgewählten Wirtschaftszweigen Marokkos*. Saarbrücken: Verlag für Entwicklungspolitik Breitenbach, 1995, (Sozialwissenschaftliche Studien zu Internationalen Problemen, 192), 310pp.

3782 ENNAJI, Mohammed. *Serving the master: slavery and society in nineteenth-century Morocco*. Tr. Graebner, S. Basingstoke: Macmillan, 1999. 166pp. [Tr. of *Soldats, domestiques et concubines*, Paris 1994.]

3783 ENNAJI, Mohammed. *Soldados, sirvientes y concubinas: la esclavitud en Marruecos en el siglo XIX*. Tr. Torre, P. de la. Granada: Almed, 1999. 216pp. [Tr. of *Soldats, domestiques et concubines*, 1994.]

3784 ENNAJI, Mohammed. *Soldats, domestiques et concubines: l'esclavage au Maroc au XIXe siècle*. Paris: Balland, 1994. 220pp.

3785 FITOUSSI, Michele. *De gevangene: Malika Oufkir*. Tr. Wielink, Nini. Amsterdam: Arena, 1999. 320pp. [Tr. of *La prisonnière*, Paris 1999.]

3786 FITOUSSI, Michèle. *La prigioniera: dal palazzo reale alle carceri marocchine*. Tr. Dal Pra, Elena. Milan: Mondadori, 1999. 323pp. [Malika Oufkir. Tr. of *La prisonnière*, Paris 1999.]

3787 FITOUSSI, Michèle. *La prisonnière*. Tr. Schwartz, Ros. London: Doubleday, 2000. 293pp. [Malika Oufkir. English tr. of *La prisonnière*, Paris 1999.]

3788 FITOUSSI, Michèle. *La prisonnière: Malika Oufkir*. (Récit recueilli et présenté.). Paris: Grasset, 1999. 329pp.

3789 FITOUSSI, Michèle. *La prisonnière: Malika Oufkir*. [Récit recueilli et présenté.]. Paris: France Loisirs, 1999. 372pp.

3790 KAPCHAN, D. A. *Gender on the market: Moroccan women and the revoicing of tradition*. Philadelphia: University of Pennsylvania Press, 1996. 325pp.

3791 MEKNASSI, Rachid Filali. *Femmes et travail*. Casablanca: Le Fennec, 1994, (Marocaines Citoyennes de Demain), 119pp.

3792 MERNISSI, Fatima. *Chahrazad non è marocchina*. Tr. Scagliotti, S. Turin: Sonda, 1993. 187pp. [Tr. of *Chahrazad n'est pas marocaine*.]

3793 MERNISSI, Fatima. *Der Harem in uns: die Furcht vor dem anderen und die Sehnsucht der Frauen*. 2. Aufl. Tr. Link, M. Freiburg im B. : Herder 1994. 294pp. [Tr. of *Dreams of trespass: tales of a harem girlhood*, Reading (USA), 1994.]

3794 MERNISSI, Fatima. *Grænseløse drømme: mit liv i harem*. Tr. Warren, U. [Viby:] Centrum, 1994. 242pp. [Tr. of *Dreams of trespass: tales of a harem girlhood*, Reading, 1994.]

3795 MERNISSI, Fatima. *Het verboden dakterras: verhalen uit mijn jeugd in de harem: herinneringen*. Tr. Hengel, R. van. Breda: De Geus, 1994. 254pp. [Tr. of *Dreams of trespass*, Reading (USA), 1994.]

3796 MERNISSI, Fatima. *Het verboden dakterras: verhalen uit mijn jeugd in de harem: herinneringen.* Tr. Hengel, R. van. Breda: De Geus, 1996, (Geuzenpocket, 73), 314pp. [Tr. of *Dreams of trespass*, Reading (USA), 1994.]

3797 MERNISSI, Fatima. *Marruecos a través de sus mujeres.* Tr. Jiménez Morell, I. 5a ed. rev. y aum. Guadarrama: Ediciones del Oriente y del Mediterráneo, 2000 (Sociedades del Oriente y del Mediterráneo, 2), 214pp. [Tr. of *Le Maroc raconté par ses femmes.*]

3798 MERNISSI, Fatima & RICHETIN, C. *Rêves de femmes: contes d'une enfance au harem.* Casablanca: Editions Le Fennec, 1997. 319pp. [Tr. of *Dreams of trespass*, Reading (USA)1994.]

3799 MERNISSI, Fatima & RICHETIN, C. *Rêves de femmes: une enfance au harem.* Paris: Librairie Générale Francaise, 1998, (Le livre de Poche, 14513), 252pp. [Tr. of *Dreams of trespass*, Reading (USA) 1994.]

3800 MERNISSI, Fatima. *Rêves de femmes: une enfance au harem.* Paris: Albin Michel, 1996. 280pp. [Tr. of *Dreams of trespass*, Reading (USA)1994.]

3801 MERNISSI, Fatima. *Somnis de l'harem.* Tr. Udina, D. 3a ed. Barcelona: Columna, 2000 (Col-lecció Clàssica, 207), 220pp. [Tr. of *Dreams of trespass*, Reading (USA) 1994.]

3802 MERNISSI, Fatima. *Sueños en el umbral: memorias de una niña del harén.* Tr. Pérez, A. Barcelona: Muchnik, 1995. 292pp. [Tr. of *Dreams of trespass: tales of a harem girlhood*, Reading (USA), 1994.]

3803 MERNISSI, Fatima. *Vrouwen in Marokko aan het woord.* Tr. Mertens, I. Breda: De Geus, [1993], (Geuzenpocket, 8). 361pp. [Tr. of *Le Maroc raconté par ses femmes*, Rabat, 1984.]

3804 MORILLA AGUILAR, F. *Ritos nupciales del pueblo beréber.* Córdoba: Universidad de Córdoba, Servicio de Publicaciones, [1994], (Serie Monografías, 208). 111pp.

3805 NAAMANE-GUESSOUS, Soumaya. *Al di là del pudore.* Tr. Saladino, M. Palermo: La Luna, [1993]. 254pp. [Tr. of *Au-delà de toute pudeur*, Casablanca, 1988. Moroccan women.]

3806 NACIRI, Rabéa. *The women's movement and political discourse in Morocco.* Geneva: United Nations Research Institute for Social Development, 1998, (Occasional Paper, Fourth World Conference on Women, Beijing 1995, 8), 28pp.

3807 RAUSCH, Margaret. *Bodies, boundaries and spirit possession: Moroccan women and the revision of tradition.* Bielefeld: Transcript, 2000. 275pp.

3808 SADIQI, Fatima. *Women, gender and language in Morocco.* Leiden: Brill, 2003 (Women and Gender: the Middle East and the Islamic World, 1), 336pp.

3809 SEBTI, Fadéla. *Vivre musulmane au Maroc: guide des droits et obligations.* Casablanca: Le Fennec, 1997. 151pp.

3810 SILVA, Maria Cardeira da. *Um Islão prático: o quotidiano feminino em meio popular muçulmano.* Oeiras: Celta, 1999. 206pp. [Morocco.]

3811 *Droits de citoyenneté des femmes au Maghreb: la condition socio-économique et juridique des femmes, le mouvement des femmes* / Belarbi Aïcha [& others]. Casablanca: Le Fennec, 1997. 325pp. [Morocco & Tunisia.]

3812 *Femmes rurales.* Collection dir. par Aïsha Belarbi. Casablanca: Editions Le Fennec, 1995 (Approches, 7), (Approches, 7), 165+42pp. [Morocco. Arabic title: *Nisā' qarawīyāt.* Silsila bi-'ishrāf 'Ā'isha Bil'arbī.]

3813 *Initiatives féminines* / Khadija Amiti ... [& others]. Casablanca: Le Fennec, 1999. 171+69pp. [Morocco. Some articles in Arabic. Arabic title: *Mubādarāt nisā'īya.*]

3814 *La place de la femme dans la vie publique et dans la prise de décision: une étude comparative: le cas de l'Europe, du Canada, du Maroc et de la Palestine* / Institut International des Sciences Administratives. Paris: L'Harmattan, 1997. 141pp.

Articles

3815 AIGNESBERGER, E. La vida cotidiana de las mujeres en el Atlas. *Vigía de Tierra,* 2-3 / 1996-7 (1997) pp.115-127.

3816 AIT HAMZA, Mohamed. Les femmes d'émigrés dans les sociétés oasiennes (sud du Maroc). *Le Maroc et la Hollande: une approche comparative des grands intérêts communs.* Rabat: Université Mohammed V, Faculté des Lettres et des Sciences Humaines, 1995, (Colloques et Séminaires, 39), pp.159-169.

3817 AIXELÀ, Y. Voces de mujeres. La esfera laboral urbana en el Marruecos de finales del siglo XX. *Studia Africana: Publicació del Centre d'Estudis Africans,* 11 (2000) pp.39-59.

3818 ALAOUI, Cherifa. Obstacle à la scolarisation des filles en milieu rural. *Femmes et éducation: état des lieux.* [By] Cherifa Alaoui [& others]. Casablanca: Editions le Fennec, 1994, (Marocaines, Citoyennes de Demain), pp.85-96.

3819 ARNHOLD, B. Autour des drapés marocains de Clérambault. (Entretien [avec] Mounira Khémir.). *Cahier d'Études Maghrébines,* 8-9, 1995-96, pp.114-115.

3820 ARNHOLD, B. Fatima Mernissi. *Cahier d'Études Maghrébines,* 8-9, 1995-96, pp.135-139. [Interview, 1992.]

3821 ARNHOLD, B. Fatima Mernissi par elle-même. *Cahier d'Études Maghrébines,* 8-9, 1995-96, pp.140-148. [Interview, 1993.]

3822 ARNHOLD, B. L'émancipation par la prise de parole: enquête réalisée à l'Atelier d'Ecriture organisé par et pour les femmes maghrébines à Rabat en janvier 1993. *Cahier d'Études Maghrébines,* 8-9, 1995-96, pp.124-131.

3823 ARNHOLD, B. Latifa Bennani-Smirès. *Cahier d'Études Maghrébines,* 8-9, 1995-96, pp.150-152. [Interview with one of the two women members of the Moroccan parliament, 1993.]

3824 ARNHOLD, B. Nezha Sqalli. *Cahier d'Études Maghrébines,* 8-9, 1995-96, pp.154-157. [Interview with Moroccan pharmacist and politician, 1993.]

3825 ARNHOLD, B. Omar Azziman. *Cahier d'Études Maghrébines,* 8-9, 1995-96, pp.132-134. [Interview with Moroccan Minister of Human Rights, 1992-95, on role and status of Moroccan women.]

3826 AYAT, Fatima. Les pratiques corporelles de la femme marocaine entre tradition et modernité. *Horizons Maghrébins,* 25-26 (1994) pp.149-157.

3827 AZIZI, Souad. Le compensation matrimoniale dans le mariage traditionnel chleuh. *Awal,* 23 (2001) pp.101-114.

3828 BALDASSARE, Antonio. La hadra des femmes au Maroc. *La transe.* Sous la direction de Abdelhafid Chlyeh. Rabat: Marsam, 2000, pp.149-156.

3829 BARKALLIL, Nadira & NACIRI, Rabéa. Education et pratiques matrimoniales et familiales au Maroc. *Femmes et éducation: blocages et impacts.* [By] Nadira Barkallil [& others]. Casablanca: Editions le Fennec, 1994, (Marocaines, Citoyennes de Demain), pp.83-95.

3830 BARKALLIL, Nadira. Le Maroc et l'universalité du débat sur l'instruction des filles. *Femmes et éducation: état des lieux.* [By] Cherifa Alaoui [& others]. Casablanca: Editions le Fennec, 1994, (Marocaines, Citoyennes de Demain), pp.17-21.

3831 BEEK, Mariëtte van. Images of Lālla 'Awīsh: a holy woman from Marrakech. *Writing the feminine: women in Arab sources.* Ed. by Manuela Marín and Randi Deguilhem. London: Tauris, in association with The European Science Foundation, Strasbourg, France, 2002, (The Islamic Mediterranean, 1), pp.199-219.

3832 BELARBI, Aicha. Die organisierte Frauenbewegung in Marokko. Entstehung, Entwicklung und Perspektiven. *Feminismus, Islam, Nation: Frauenbewegungen im Maghreb, in Zentralasien und in der Türkei.* (Hg.) Claudia Schöning-Kalender, Aylâ Neusel, Mechtild M.Jansen. Frankfurt a.M.: Campus, 1997, pp.125-136.

3833 BELARBI, Aïcha. Femmes et société civile: réflexions sur le cas du Maroc. *Droits de citoyenneté des femmes au Maghreb: la condition socio-économique et juridique des femmes, le mouvement des femmes* / Belarbi Aïcha [& others]. Casablanca: Le Fennec, 1997, pp.249-272.

3834 BELARBI, Aïcha. Femmes rurales et technologie. *Femmes rurales. / Nisā' qarawīyāt.* Collection dir. par Aïsha Belarbi. Casablanca: Editions Le Fennec, 1995, (Approches, 7), pp.87-101.

3835 BELARBI, Aïcha. La quête et la conquête d'un espace de vie: contraintes et opportunités pour les femmes migrantes. *Initiatives féminines / Mubādarāt nisā'īya.* Khadija Amiti ... [& others]. Casablanca: Le Fennec, 1999, pp.63-75.

3836 BELRHITI, Amina. Satisfaction sexuelle onirique féminine. Présentation de cas marocains. *Actes du colloque: L'homme, la femme et les relations amoureuses dans l'imaginaire arabo-musulman, Tunis ... 1992 / Ashghāl multaqá: Al-Rajul wa-'l-mar'a wa-'l-ḥubb fī 'l-khayāl al-'Arabī al-Islāmī.* Tunis: Université des Lettres, des Arts et des Sciences Humaines, Tunis I, Centre d'Etudes et de Recherches Economiques et Sociales, Tunis, 1995, (Cahier du C.E.R.E.S. Série Psychologie, 8), pp.105-119.

3837 BENABDENBI DJERRARI, Fattouma. L'activité féminine: le cas du Maroc. *Droits de citoyenneté des femmes au Maghreb: la condition socio-économique et juridique des femmes, le mouvement des femmes* / Belarbi Aïcha [& others]. Casablanca: Le Fennec, 1997, pp.93-103.

3838 BENNANI, Farida. La condition de la femme au Maroc. *Droits de citoyenneté des femmes au Maghreb: la condition socio-économique et juridique des femmes, le mouvement des femmes* / Belarbi Aïcha [& others]. Casablanca: Le Fennec, 1997, pp.145-173. [Legal.]

3839 BENRADI, Malika. Ce que comprend la femme rurale de quelques dispositions du code du statut personnel. *Femmes rurales. / Nisā' qarawīyāt.* Collection dir. par Aïsha Belarbi. Casablanca: Editions Le Fennec, 1995, (Approches, 7), pp.127-141. (Le contrat de mariage et sa dissolution sont réglementés au Maroc par les livres I et II du code de statut personnel ou *Moudawana*.)

3840 BENRAHMOUNE-FASSI, Zineb. La collecte du bois et la déforestation. *Femmes rurales. / Nisā' qarawīyāt.* Collection dir. par Aïsha Belarbi. Casablanca: Editions Le Fennec, 1995, (Approches, 7), pp.73-85.

3841 BENZAKOUR-CHAMI, Anissa. Femmes et institutions. *Annuaire de l'Afrique du Nord,* 35 / 1996 (1998) pp.169-179. (La condition juridique de la femme marocaine.)

3842 BENZAKOUR-CHAMI, Anissa. Femmes et institutions. *Economies du Maghreb: l'impératif de Barcelone.* Sous la direction de Abdelkader Sid Ahmed, assisté de François Siino. Paris: CNRS, 1998, pp.169-179. (La condition juridique de la femme marocaine. Extrait de l'Annuaire de l'Afrique du Nord 1996.)

3843 BORAKI, Chemseddoha. Les contrebandières. *Initiatives féminines / Mubādarāt nisā'īya.* Khadija Amiti ... [& others]. Casablanca: Le Fennec, 1999, pp.77-93.

3844 BOUKHRIS, Fatima. Rituels du mariage dans la communauté berbère: symbolique d'une transmutation sociale. *Awal,* 23 (2001) pp.33-42. (Dans l'aire socioculturelle des Zemmour en particulier.)

3845 BOULIFA, Ammar ben Saïd. Le mariage chez les Imazir'en au Maroc. *Awal,* 13 (1996) pp.79-86. (Témoignage qui date de la fin du siècle dernier.)

3846 BOUMANS, L. Huwelijksvoorwaarden in het islamitisch huwelijksrecht van Marokko. *Recht van de Islam,* 12 (1995) pp.31-43.

3847 BOUMLIK, Habiba. Diverses manifestations de l'individualité: discours et pratiques. *Femmes et hommes au Maghreb et en immigration: la frontière des genres en question. Etudes sociologiques et anthropologiques.* Sous la dir. de C.Lacoste-Dujardin & M.Virolle. Coord. Baya Boualem & Narjys El Alaoui. Paris: Publisud, 1998, pp.143-149. (Fonctionnement d'une communauté maraboutique à Tafraoute - village berbère du sud du Maroc.)

3848 BOURQIA, Rahma. Espace social, femmes et environment: "les Beni Guil du Maroc oriental". *Femmes rurales. / Nisā' qarawīyāt.* Collection dir. par Aïsha Belarbi. Casablanca: Editions Le Fennec, 1995, (Approches, 7), pp.103-117.

3849 BOURQIA, Rahma. Femmes, savoir et université au Maroc: perspectives historiques et culturelles. *Les femmes et l'université en Méditerranée.* Sous la dir. de Nicky Le Feuvre, Monique Membrado & Annie Rieu. Toulouse: Presses Universitaires du Mirail, 1999, pp.179-11.

3850 BOURQIA, Rahma. Habitat, femmes et honneur: le cas de quelques quartiers populaires d'Oujda. *Femmes, culture et société au Maghreb.* I: *Culture, femmes et famille.* Sous la dir. de R.Bourqia, M.Charrad, N.Gallagher. Casablanca: Afrique Orient, 1996, pp.15-35.

3851 BOUSTA, Rachida Saïgh. Imaginaire matriarcal: une sainte au profil dantesque. *Bulletin of Francophone Africa,* 15-16 (2000) pp.65-76. [Lalla Aïcha Dghoughiyya of Marrakesh.]

3852 BOUTATA, Mohamed. A travail égal, formation inégale? La femme et la formation professionnelle: situation actuelle et perspectives. *Femmes et éducation: état des lieux.* [By] Cherifa Alaoui [& others]. Casablanca: Editions le Fennec, 1994, (Marocaines, Citoyennes de Demain), pp.97-139. [Morocco.]

3853 BROSSIER, E. & PESCHARD, S. Femmes berbères du Haut-Atlas marocain. (Abstract: Berber women of the Upper Atlas, Morocco.). *L'Ethnographie,* 90 ii / 116 (1994) pp.5;31-48.

3854 BUITELAAR, M. Public baths as private places. *Women and Islamization: contemporary dimensions of discourse on gender relations.* Ed. K.Ask & M.Tjomsland. Oxford: Berg, 1998, pp.103-123. (In Moroccan society.)

3855 CAIROLI, M.Laetitia. Factory as home and family: female workers in the Moroccan garment industry. *Human Organization,* 57 ii (1998) pp.181-189.

3856 CHAFAI, Leila. Las mujeres sujeto de marginación en Marruecos. *Anales de Historia Contemporánea,* 13 / 1997 (1998) pp.35-55.

3857 CHAFAI, Leila. Le mouvement des femmes: critiques et bilan. *Droits de citoyenneté des femmes au Maghreb: la condition socio-économique et juridique des femmes, le mouvement des femmes* / Belarbi Aïcha [& others]. Casablanca: Le Fennec, 1997, pp.307-325. (Maroc.)

3858 CHAMI, Anissa Benzakour. Femmes et dynamiques innovantes dans la société marocaine. *Initiatives féminines / Mubādarāt nisā'īya.* Khadija Amiti ... [& others]. Casablanca: Le Fennec, 1999, pp.13-29.

3859 CHARRAD, Mounira M. Becoming a citizen: lineage versus individual in Tunisia and Morocco. *Gender and citizenship in the Middle East.* Ed. Suad Joseph. Syracuse (USA): Syracuse University Press, 2000, pp.70-87. [Legal situation.]

3860 CHATTOU, Zoubir. Grossesse et accouchement: un champ symbolique. Cas de la société des Bni-Iznacen (Nord-Est Maroc). *Maghreb Review,* 18 iii-iv (1993) pp.166-173.

3861 CHEDATI, Brahim. Fille ou garçon - le même rendement. *Femmes et éducation: état des lieux.* [By] Cherifa Alaoui [& others]. Casablanca: Editions le Fennec, 1994, (Marocaines, Citoyennes de Demain), pp.67-83. [Education in Morocco.]

3862 CHERKAOUI, M., BAALI, A., HILALI, M.K., SEVIN, A., LARROUY, G., CROGNIER, E. & BOËTSC, G. Age au premier mariage, contraception et mortalité infantile: influence sur l'évolution de la fécondité d'une population berbère du Haut Atlas marocain (vallée d'Anougal). Age at first marriage, contraception and infant mortality: impact on the fertility trends within a Berber population of Morocco's High Atlas mountains (Anougal valley). *Bulletins et Mémoires de la Société d'Anthropologie de Paris,* 13 iii-iv / 2001 (2002) pp.207-220.

3863 CHICHE, J. Les femmes analphabètes: les dernières des derniers. *Femmes et éducation: blocages et impacts.* [By] Nadira Barkallil [& others]. Casablanca: Editions le Fennec, 1994, (Marocaines, Citoyennes de Demain), pp.17-53.

3864 CHIKHAOUI, Naïma. La femme rurale: une vie de travail. *Femmes rurales. / Nisā' qarawīyāt.* Collection dir. par Aïsha Belarbi. Casablanca: Editions Le Fennec, 1995, (Approches, 7), pp.61-72.

3865 CHIKHAOUI, Naïma. Un droit de regard sur les femmes prisonnières: essence d'une initiative. *Initiatives féminines / Mubādarāt nisā'īya.* Khadija Amiti ... [& others]. Casablanca: Le Fennec, 1999, pp.155-171.

3866 CHRISTIANSEN, Connie Carøe. Women's Islamic activism: between self-practices and social reform efforts. *Modernizing Islam: religion in the public sphere in the Middle East and Europe.* John L.Esposito, François Burgat, eds. London: Hurst, 2003, pp.145-165. [Morocco.]

3867 COLIN, J. *Al firâch* / le lit. Un concept juridique en Islam. (Abstract: *Al-firâch* / the bed: an Islamic legal concept.). *PJR - Praxis Juridique et Religion,* 10 i (1993) pp.56-72;123. (L'exemple de la Tunisie et du Maroc.)

3868 COLLINS, J. What motivates Moroccan women to emigrate to Spain? A novice researcher tells how she went about not getting the answer. *Middle East Women's Studies: the Review,* 12 iii (1997) pp.15-16.

3869 DACHMI, Abdesslam. L'adolescente: entre l'insertion sociale et la possession hystérique. *Insertion des jeunes et problèmes d'identité. Indimāj al-shabāb wa-qaḍāyā al-huwīya.* Coord. Abdesslam Dachmi, El Mostafa Haddiya. Rabat: Faculté des Lettres et des Sciences Humaines, 1996, (Série: Colloques et Séminaires, 54), pp.17-23. [Moroccan case study.]

3870 DACHMI, Abdesslam. Troubles du sommeil au féminin: observations des transactions précoces mères-filles au Maroc. *Enfance et développement. Actes de la Table Ronde organisée à Marrakech du 18 au 21 janvier 1996. Al-tifl wa-'l-tanmīya.* Coord. Abdesslam Dachmi. Rabat: Faculté des Lettres et des Sciences Humaines, 1997, (Série: Colloques et Séminaires, 67), pp.35-58.

3871 DAOUD, Zakya. (Maroc.) Le plan d'intégration de la femme. Une affaire révélatrice, un débat virtuel. *Annuaire de l'Afrique du Nord,* 38 / 1999 (2002) pp.245-257. [Political scenario.]

3872 DAOUD, Zakya. Luttes féminines au Maroc. *Awal,* 20 (1999) pp.89-94.

3873 DAVIS, Diana. Gender, indigenous knowledge, and pastoral resource use in Morocco. *Geographical Review,* 86 ii (1996) pp.284-288.

3874 DAVIS, Susan Schaefer. Changing gender relations in a Moroccan town. *Arab society: class, gender, power, and development.* Ed. N.S.Hopkins, Saad Eddin Ibrahim. Cairo: American University in Cairo Press, 1997, pp.209-225. [First published 1993.]

3875 DAVIS TAÏEB, Hannah. "Là où vont les femmes": notes sur les femmes, les cafés, et les Fast Food au Maroc. *Monde Arabe Contemporain: Cahiers de Recherche,* 4 (1995) pp.11-18.

3876 DIALMY, Abdessamad. Les rites obstétriques au Maroc. Un enjeu politique mérinide. (Summar[y]: Obstetrical rites in Morocco: a Merinide political wager.). *Annales: Histoire, Sciences Sociales,* 53 iii (1998) pp.481-504;751.

3877 DONADEY, Anne. Portrait of a Maghrebian feminist as a young girl: Fatima Mernissi's *Dreams of trespass.* *Edebiyât,* 11 i (2000) pp.85-103.

3878 DOUCHAÏNA, Rqia. La morphologie du verbe en Tagnawt. *Etudes et Documents Berbères,* 15-16 / 1998 (2000) pp.197-210. (Langage secret des femmes de la plaine de Tiznit ... dérivé du dialecte *tachelhit.*)

3879 ELFAKIR, Abdelhadi. Karima ou la résolution traditionnelle de l'Œdipe-fille au Maghreb. *Horizons Maghrébins,* 25-26 (1994) pp.165-173. [Psychotherapy case in Morocco.]

3880 ERRAZKI - VAN BEEK, M. Een vrouwenmuziekgroep uit Marrakech: de *'Anṭriyat. Sharqiyyât,* 7 i (1995) pp.28-56.

3881 FATHI, Rajae Berrada. L'initiative romanesque féminine entre la fiction et l'affranchissement. *Initiatives féminines / Mubādarāt nisā'īya.* Khadija Amiti ... [& others]. Casablanca: Le Fennec, 1999, pp.119-138. [Novels by Moroccan women writing in French.]

3882 FERRIE, Jean Noël. Point de vue anthropologique sur l'individualisme, les femmes et l'amour: boire du gin tonic et écouter Om Kalthoum. *Actes du colloque: L'homme, la femme et les relations amoureuses dans l'imaginaire arabo-musulman, Tunis ... 1992 / Ashghāl multaqá: Al-Rajul wa-'l-mar'a wa'l-ḥubb fī 'l-khayāl al-'Arabī al-Islāmī.* Tunis: Université des Lettres, des Arts et des Sciences Humaines, Tunis I, Centre d'Etudes et de Recherches Economiques et Sociales, Tunis, 1995, (Cahier du C.E.R.E.S. Série Psychologie, 8), pp.131-139. [One Moroccan girl's marriage choice.]

3883 FERRIÉ, Jean-Noël, BOËTSCH, Gilles & OUAFIK, Amina. "Vécu juridique", norme et sens de la justice: à propos de l'avortement au Maroc. (Summary: "Living with law", legal norm and sense of justice: about abortion in Morocco.). *Droit et Société,* 28 (1994) pp.677-690. (Du point de vue anthropologique.)

3884 FÓRNEAS BESTEIRO, J. M. La mujer magribí y sus `fuentes de información`: un capítulo de *Fī l-tufūla* de'A.al-Maŷīd b.Ŷellūn. *Al-Andalus,* 2 / 1994 (1996) pp.157-166.

3885 GARCIA-RAMON, M-D., ALBET-MAS, A., NOGUE-FONT, J. & RIUDOR-GORGAS, L. Voices from the margins: gendered images of 'otherness' in colonial Morocco. *Gender, Place and Culture,* 5 iii (1998) pp.229-240. Also online at www.catchword.co.uk

3886 GEERTDS, H. W. Variations sur le haïk. *Traces du Présent / Āthār al-Ḥāḍir,* 2-3 (1994) pp.70-75. [Drawings of draped women.]

3887 GÉLARD, Marie-Luce. L'inversion rituelle: ou quand les hommes se protègent des femmes chez les Aït Khebbach. *Awal,* 23 (2001) pp.43-49. [Morocco.]

3888 GHÉMIRES, Naïma. La femme rurale: caractéristiques socio-démographiques. *Femmes rurales. / Nisā' qarawīyāt.* Collection dir. par Aïsha Belarbi. Casablanca: Éditions Le Fennec, 1995, (Approches, 7), pp.45-60.

3889 GHEZZI, C. Emigration et condition de la femme autour de la Méditerranée. *Africa* (Rome), 49 iv (1994) pp.616-616. (Una tavola rotonda italo-marocchina.) [Discussion confined to Moroccan migration to Italy.]

3890 GÓMEZ CAMARERO, C. El movimiento femenino y feminista en Marruecos. *El Magreb: coordenadas socioculturales.* C.Pérez Beltrán & C.Ruiz-Almodóvar (eds.). Granada: Grupo de Investigación Estudios Arabes Contemporáneos, Universidad de Granada, 1995, pp.39-71.

3891 GRAY, Kenneth R. Women entrepreneurs in Morocco: a preliminary investigation. *Journal of North African Studies,* 6 iv (2001) pp.64-74.

3892 GRIFFITHS, C. Social development and women in Africa - the case of Morocco. *Journal of Gender Studies,* 5 i (1996) pp.63-79.

3893 HADRAOUI, Touria. `Les femmes aux Italiens`. *Confluences Méditerranée,* 14 (1995) pp.103-108. (La vie quotidienne d'un village marocain ... où pratiquement tous les hommes en âge de travailler ont émigré vers l'Italie.)

3894 HAJJARABI, Fatima. Femme et changement social: quelques remarques sur le cas du Rif central. *Femmes, culture et société au Maghreb.* I: *Culture, femmes et famille.* Sous la dir. de R.Bourqia, M.Charrad, N.Gallagher. Casablanca: Afrique Orient, 1996, pp.57-69.

3895 HAJJARABI, Fatima. Femmes, famille et changement social dans le Rif. *Le Maroc et la Hollande: une approche comparative des grands intérêts communs.* Rabat: Université Mohammed V, Faculté des Lettres et des Sciences Humaines, 1995, (Colloques et Séminaires, 39), pp.105-110.

3896 HAJJARABI, Fatima. Recherche sur les femmes rurales: essai de bilan. *Femmes rurales. / Nisā' qarawīyāt.* Collection dir. par Aïsha Belarbi. Casablanca: Editions Le Fennec, 1995, (Approches, 7), pp.13-23.

3897 HAKIM, Mohammed Ibn Azzuz. Mujeres tetuaníes famosas, de origen andalusí, caídas en el olvido. *"La política y los moriscos en la época de los Austria". Actas del encuentro.* Dir. Rodolfo Gil Grimau. Madrid: Consejería de Educación y Cultura, Comunidad de Madrid & La Fundación de Sur, 1999, pp.49-55.

3898 HARRAS, Mokhtar el. Feminité et masculinité dans la sociéte rurale marocaine: le cas d'Anjra. *Femmes, culture et société au Maghreb.* I: *Culture, femmes et famille.* Sous la dir. de R.Bourqia, M.Charrad, N.Gallagher. Casablanca: Afrique Orient, 1996, pp.37-56.

3899 HAYEUR, M. Contre-pouvoirs féminins au Maroc dans la famille et le religion. *Femmes et hommes au Maghreb et en immigration: la frontière des genres en question. Etudes sociologiques et anthropologiques.* Sous la dir. de C.Lacoste-Dujardin & M.Virolle. Coord. Baya Boualem & Narjys El Alaoui. Paris: Publisud, 1998, pp.127-141.

3900 HESSINI, Leila. Signification du voile au Maroc: tradition, protestation ou libération. *Femmes, culture et société au Maghreb.* I: *Culture, femmes et famille. Sous la dir. de R.Bourqia, M.Charrad, N.Gallagher.* Casablanca: Afrique Orient, 1996, pp.91-104.

3901 HEUVELS, M. Les effets de la migration au niveau de la femme et du ménage: une approche comparative de l'isolement dans la situation marocaine et néerlandaise. *Le Maroc et la Hollande: une approche comparative des grands intérêts communs.* Rabat: Université Mohammed V, Faculté des Lettres et des Sciences Humaines, 1995, (Colloques et Séminaires, 39), pp.171-176.

3902 IRBOUH, Hamid. French colonial art education and the Moroccan feminine milieu: a case study from Fez, 1927-30. *Maghreb Review,* 25 iii-iv (2000) pp.275-288.

3903 JORDENS-COTRAN, Leila. Huwelijksbevestiging in het Marokkaanse en Nederlandse recht. *Recht van de Islam,* 16 (1999) pp.83-131.

3904 KADMIRI, Bahia. Bilan de la scolarisation des filles. *Femmes et éducation: état des lieux.* [By] Cherifa Alaoui [& others]. Casablanca: Editions le Fennec, 1994, (Marocaines, Citoyennes de Demain), pp.23-67. (Maroc.)

3905 KAPCHAN, D. A. L'art oratoire des femmes marocaines sur la place du marché: tradition et transgression. Tr. Simonson, P. & Gibault, A. *Espaces publics, paroles publiques au Maghreb et au Machrek.* Sous la dir. de Hannah Davis Taïeb, Rabia Bekkar, J-C.David. Lyon: Maison de l'Orient Méditerranéen; Paris: L'Harmattan, 1997, pp.91-110.

3906 KAPCHAN, Deborah A. Hybrid genres, performed subjectivities: the revoicing of public oratory in the Moroccan marketplace. *Performing hybridity.* May Joseph, J.N.Fink, eds. Minneapolis: University of Minnesota Press, 1999, pp.207-228. (Women's performance of marketplace oratory in Beni Mellal, Morocco.)

3907 KHACHANI, Mohamed. L'entreprenariat féminin au Maroc: des repères. *Initiatives féminines / Mubādarāt nisā'īya.* Khadija Amiti ... [& others]. Casablanca: Le Fennec, 1999, pp.47-61.

3908 KHOLTI, Abdeljalil & LARAQUI, Chakib el Houssaine. La responsabilité en médicine du travail. *Revue Marocaine de Droit et d'Economie du Développement / Al-Majalla al-Maghribīya li-Qānūn wa-Iqtiṣād al-Tanmīya,* 32 (1994) pp.107-112. [Childbirth in Morocco.]

3909 KINGSMILL HART, U. Un parto en el Rif. Tr. Cabello, E. *Vigía de Tierra,* 1 (1995) pp.77-82. [Tr. of ch. 14 from *Behind the courtyard door: the daily life of tribeswomen in northern Morocco,* Ipswich (USA), 1994.]

3910 KOROSEC-SERFATY, P. Cotoiements, offenses et évitements: pratiques féminines juives des espaces publics au Maroc. *Espaces publics, paroles publiques au Maghreb et au Machrek.* Sous la dir. de Hannah Davis Taïeb, Rabia Bekkar, J-C.David. Lyon: Maison de l'Orient Méditerranéen; Paris: L'Harmattan, 1997, pp.111-118.

3911 KOZMA, L. Remembrance of things past: Leila Abouzeid and Moroccan national history. *Social Politics,* 6 iii (1999) pp.388-406.

3912 LEE BOWEN, D. Changing contraceptive mores in Morocco: population data, trends, gossip and rumours. *Journal of North African Studies,* 3 iv (1998) pp.68-90.

3913 LEMRINI, Amina. L'exclusion des femmes marocaines. *Femmes de Méditerranée: religion, travail, politique.* Sous la dir. de Andrée Dore-Audibert et Sophie Bessis. Paris: Karthala, 1995, pp.21-32.

3914 LEMRINI, Amina. L'image de la femme à travers le discours scolaire: elle cuisine, il lit. Tr. Chiche, J. *Femmes et éducation: blocages et impacts.* [By] Nadira Barkallil [& others]. Casablanca: Editions le Fennec, 1994, (Marocaines, Citoyennes de Demain), pp.55-81.

3915 LÓPEZ PLAZA, María Angeles. Les femmes sur la scène politique. *Confluences Méditerranée,* 31 (1999) pp.107-118. (Au Maroc.)

3916 MCDOUGALL, E. A. A sense of self: the life of Fatma Barka. *Canadian Journal of African Studies. Revue Canadienne des Etudes Africaines,* 32 ii (1998) pp.295-315. [Slave in Mali, free woman in Morocco.]

3917 MEDIANO, F. R. Una sociabilidad oblicua: mujeres en el Marruecos moderno. *Al-Qantara: Revista de Estudios Árabes,* 16 ii (1995) pp.385-402.

3918 MÉNAGER, Serge. Fatma Mernissi. Entretien. *Maghreb Littéraire,* 2 / 4 (1998) pp.97-119.

3919 MERNISSI, Fatima. Femmes, saints et sanctuaires au Maroc. *La religion par les femmes.* Sous la dir. de N.Auer Falk & R.M.Gross. Geneva: Labor et Fides, 1993, (Religions en Perspective, 6), pp.189-202. [Tr. of *Unspoken worlds,* 1989.]

3920 MERNISSI, Salima. El estatuto de la mujer en Marruecos. *El Islam jurídico y Europa: derecho, religión y política.* A.Borràs & Salima Mernissi (ed.). Barcelona: Icaria, 1998, (Antrazyt, 110), pp.103-121.

3921 MIADI, Zineb. Le statut de la femme marocaine au sein de l'institution familiale. *Droits de citoyenneté des femmes au Maghreb: la condition socio-économique et juridique des femmes, le mouvement des femmes /* Belarbi Aïcha [& others]. Casablanca: Le Fennec, 1997, pp.209-223. [Law.]

3922 MILLER, S. G. Gender and the poetics of emancipation: *The Alliance Israélite Universelle* in northern Morocco, 1890-1912. *Franco-Arab encounters: studies in memory of David C.Gordon.* Ed. L.C.Brown & M.S.Gordon. Beirut: American University of Beirut, 1996, pp.229-252.

3923 MOGA ROMERO, V. Peplos y jaiques. La condición femenina en el Rif colonial y la etnografía militar: una percepción. *Vigía de Tierra,* 2-3 / 1996-7 (1997) pp.153-169.

3924 MONKACHI, Mohamed. Femmes et religion entre le XVe et le XVIIe siècles. *Femmes et Islam. Al-Nisā' wa-'l-Islām.* Collection dirigée par Aïcha Belarbi. Casablanca: Le Fennec, 1998, pp.11-18. (Environnement socio-culturel et religieux qui a prévalu au Maroc.)

3925 MONKACHI, Mohamed. Lecture des mœurs de la femme rurale marocaine à travers les Nawazil de Ziyati: la région de Ghomara au XVIIe siècle. *Femmes rurales. / Nisā' qarawīyāt.* Collection dir. par Aïsha Belarbi. Casablanca: Éditions Le Fennec, 1995, (Approches, 7), pp.119-126.

3926 MORIN-BARDE, M. Coiffures, maquillages et tatouages. *Splendeurs du Maroc. Musée Royal de l'Afrique Centrale, Tervuren 1998.* Paris: Plume, 1998, pp.340-347.

3927 MOUHSSINE, Ouafae. Parler féminin et stigmatisation sociale au Maroc. *Peuples Méditerranéens. Mediterranean Peoples,* 79 (1997) pp.25-34.

3928 M'SALHA, Mohammed. Qu'en est-il aujourd'hui de la polygamie et de la répudiation en droit marocain? *Revue Internationale de Droit Comparé,* 53 i (2001) pp.171-182.

3929 NAAMANE-GUESSOUS, Soumaya. L'amour retenu. *Qantara* (Paris), 18 (1996) pp.42-45. (Dans la société marocaine.)

3930 NACIRI, Rabéa. Policy dialogue on women's industrial employment in Morocco. *UNRISD News,* 15, 1996-(1997) pp.7-8.

3931 NIELSEN, A.Sonne. Unge storby kvinder skaber nye
 praksisser: om kulturel kompleksitet i det moderne
 Marokko. *Jordens Folk*, 30 iii (1995) pp.113-117.

3932 OBERMEYER, Carla Makhlouf. Fertility norms and son
 preference in Morocco and Tunisia: does women's status
 matter? *Journal of Biosocial Science*, 28 i (1996)
 pp.57-72.

3933 OBERMEYER, Carla Makhlouf. Pluralism and
 pragmatism: knowledge and practice of birth in Morocco.
 Medical Anthropology Quarterly, 14 ii (2000)
 pp.180-201.

3934 OBERMEYER, Carla Makhlouf. Risk, uncertainty, and
 agency: culture and safe motherhood in Morocco. *Medical
 Anthropology*, 19 ii (2000) pp.173-201.

3935 OSSMAN, Susan. Se faire femme entre Le Caire et Paris.
 *Femmes et hommes au Maghreb et en immigration: la
 frontière des genres en question. Etudes sociologiques et
 anthropologiques.* Sous la dir. de C.Lacoste-Dujardin &
 M.Virolle. Coord. Baya Boualem & Narjys El Alaoui.
 Paris: Publisud, 1998, pp.77-84. (A partir de Casablanca,
 les pôles Paris & Le Caire émergent comme des points de
 référence.)

3936 PEYRON, M. La femme tamazight du Maroc central.
 *Femmes et hommes au Maghreb et en immigration: la
 frontière des genres en question. Etudes sociologiques et
 anthropologiques.* Sous la dir. de C.Lacoste-Dujardin &
 M.Virolle. Coord. Baya Boualem & Narjys El Alaoui.
 Paris: Publisud, 1998, pp.109-125.

3937 PEYRON, M. La mujer tamazight del Marruecos central.
 Vigía de Tierra, 2-3 / 1996-7 (1997) pp.139-151.

3938 PEYRON, Michael. Le mariage chez les Ayt Yafelman
 de l'Atlas marocain. *Etudes et Documents Berbères*, 17 /
 1999 (2002) pp.165-173.

3939 RADI, Ahmed. Culture and the construction of gender.
 Cultural studies, interdisciplinarity, and the university.
 Edited by Mohamed Dahbi, Mohamed Ezroura, Lahcen
 Haddad. Rabat: The Faculty of Letters and Human
 Sciences, 1996, (Publications of the Faculty of Letters and
 Human Sciences - Rabat. Series: Conferences and
 Colloquia, 60), pp.51-54. (Three texts: Freud's lecture
 "Femininity", Joseph Conrad's novel *Heart of Darkness*
 and comments made by a very young Moroccan boy (age
 five).)

3940 RAFFIN, Leila. The status of women in Morocco.
 Renaissance (Lahore), 10 ix (2000) pp.25-27.

3941 RAMÍREZ, A. El largo camino que lleva a España:
 secuencia de las migraciones femeninas marroquíes.
 Anales de Historia Contemporánea, 13 / 1997 (1998)
 pp.69-85.

3942 REYSOO, F. Ongehuwde moeders en onwettige kinderen
 in Marokko. *Sharqiyyât*, 10 ii (1998) pp.73-84.

3943 REYSOO, Fenneke. Gender, reproductive rights and health
 in Morocco: traps for unmarried mothers. *Development*,
 42 i (1999) pp.63-66. Also online at
 www.ingentaselect.com

3944 R'KHA, S. & BAALI, A. Migration des femmes et
 fécondité dans la ville de Marrakech (Maroc). Women
 migration and fertility in the city of Marrakech (Morocco).
 *Bulletins et Mémoires de la Société d'Anthropologie de
 Paris*, 13 iii-iv / 2001 (2002) pp.221-236.

3945 ROSANDER, E. E. Female linkage in Morocco and
 Senegal. *The third Nordic conference on Middle Eastern
 Studies: Ethnic encounter and culture change, Joensuu,
 Finland, 19-22 June 1995.* Proceedings archive. Bergen:
 University of Bergen, Centre for Middle Eastern and
 Islamic Studies, [for] Nordic Society for Middle Eastern
 Studies, 1996, Online at http:// www.hf.uib.no/smi/paj/
 default.html

3946 ROSANDER, E. E. Identité féminine musulmane, dans
 un village frontalier hispano-marocain. *Femmes, culture
 et société au Maghreb.* I: *Culture, femmes et famille. Sous
 la dir. de R.Bourqia, M.Charrad, N.Gallagher.* Casablanca:
 Afrique Orient, 1996, pp.105-125.

3947 ROSANDER, E. E. Women in groups in Africa: female
 associational patterns in Senegal and Morocco.
 *Organizing women: formal and informal women's groups
 in the Middle East.* Ed. D.Chatty & A.Rabo. Oxford: Berg,
 1997, pp.101-123.

3948 ROSEN, L. Marriage stories. *Recht van de Islam*, 17
 (2000) pp.1-14. [Moroccan matrimonial law & Moroccan
 citizens abroad.]

3949 RUGGERINI, M. G. & BARBALARGA, D. De l'analyse
 aux actions positives: un parcours de recherche. *Droits
 de citoyenneté des femmes au Maghreb: la condition
 socio-économique et juridique des femmes, le mouvement
 des femmes* / Belarbi Aïcha [& others]. Casablanca: Le
 Fennec, 1997, pp.9-20. (La femme en Tunisie & au
 Maroc.)

3950 RUGGERINI, M. G. Expérience et vécu au féminin entre
 tradition et modernité. *Droits de citoyenneté des femmes
 au Maghreb: la condition socio-économique et juridique
 des femmes, le mouvement des femmes* / Belarbi Aïcha [&
 others]. Casablanca: Le Fennec, 1997, pp.225-247.
 [Tunisia & Morocco.]

3951 SACRE, J. Haik de mots pour des femmes d'Essaouira.
 Traces du Présent / Āthār al-Ḥāḍir, 2-3 (1994) pp.76-77.

3952 SALIM, Zakia. L'entreprise féminine à Fès, une tradition.
 Initiatives féminines / Mubādarāt nisā'īya. Khadija Amiti
 ... [& others]. Casablanca: Le Fennec, 1999, pp.31-46.
 [1930s and 1940s.]

3953 SAMAMA, Yvonne. Les femmes et la représentation de
 l'espace: l'exemple de Télouet dans l'Atlas marocain.
 Awal, 13 (1996) pp.27-42.

3954 SAMAMA, Yvonne. Noces berbères à Telouet. *Awal*, 23
 (2001) pp.75-86.

3955 SBAÏ, Noufissa. Eternelles oubliées, les chanteuses
 publiques: "Les Chickhates". *Témoignage. Femmes
 rurales. / Nisā' qarawīyāt.* Collection dir. par Aïsha
 Belarbi. Casablanca: Éditions Le Fennec, 1995,
 (Approches, 7), pp.159-165.

3956 SEARIGHT, S. Le tatouage chez la femme berbère
 marocaine: Moyen Atlas et pays Zemmour. *Études et
 Documents Berbères*, 10 / 1993 (1994) pp.31-45.

3957 SERHANE, Abdelhak. Le sillon de la misogynie: le cas
 de Zhor. *Etre femme au Maghreb et en Méditerranée.
 Du mythe à la réalité.* Sous la dir. de Andrée
 Dore-Audibert & Souad Khodja. Paris: Karthala, 1998,
 pp.11-35. [Girl born in Morocco.]

3958 SILVA, M.C.da. O *suq* das vaidades: escolhas e
 performances femininas e aconstrução do *self* em
 Marrocos. *El imaginario, la referencia y la diferencia:
 siete estudios acerca de la mujer árabe.* M.del Amo (ed.).
 Granada: Departamento Estudios Semíticos, 1997,
 pp.33-57.

3959 SLYOMOVICS, S. "This time I choose when to leave":
 an interview with Fatna el Bouih. *Middle East Report*,
 218 / 31 i (2001) pp.42-43. [Moroccan political activist
 & sometime detainee.]

3960 SOUM-POUYALET, Fanny. De la femme à la *cheikha*,
 l'engrenage de la marginalité. *Awal*, 23 (2001)
 pp.115-129. (Chanteuses-danseuses populaires.)

3961 SOUM-POUYALET, Fanny. De la femme à la *cheikha*,
 l'engrenage de la marginalité. *Awal*, 23 (2001)
 pp.115-129. (Chanteuses-danseuses populaires.)

3962 STEINMANN, S. H. Gender, animal management, and
 environmental change in eastern Morocco. *Arab World
 Geographer. Le Géographe du Monde Arabe*, 1 ii (1998)
 pp.117-135.

3963 STEINMANN, S. H. Gender, pastoralism, and
 intensification: changing environmental resource use in
 Morocco. *Transformations of Middle Eastern natural
 environments: legacies and lessons.* J.Albert,
 M.Bernhardsson, R.Kenna, eds. New Haven: Yale
 University, 1998, (Yale School of Forestry and
 Environmental Studies, Bulletin Series, 103), pp.81-107.

3964 TAMIM, Mohamed. Le rôle de la femme dans le changement familial au Maroc: la famille du Haut-Atlas. *Familles turques et maghrébines aujourd'hui: évolution dans les espaces d'origine et d'immigration.* Sous la dir. de Nouzha Bensalah. Louvain-la-Neuve: Academia-Erasme; Paris: Masionneuve et Larose, 1994, pp.75-95.

3965 TAMOUH, Fatima Zahra. Trois "reines" marocaines. *Femmes, culture et société au Maghreb.* I: *Culture, femmes et famille. Sous la dir. de R.Bourqia, M.Charrad, N.Gallagher.* Casablanca: Afrique Orient, 1996, pp.69-82.

3966 TEMSAMANI, Touria Haji. Analyse socio-économique de la condition de la femme au Maroc. *Droits de citoyenneté des femmes au Maghreb: la condition socio-économique et juridique des femmes, le mouvement des femmes* / Belarbi Aïcha [& others]. Casablanca: Le Fennec, 1997, pp.77-92.

3967 TISSERON, S. Les drapés marocains de Gaëtan Gatian de Clérambault. *Cahier d'Études Maghrébines,* 8-9, 1995-96, pp.110-114. [Psychiatry.]

3968 VELDEN, Frans van der. Het Marokkaanse recht in Nederland. *Recht van de Islam,* 18 (2001) pp.117-129.

3969 VICENTE, Angeles & ZOMEÑO, Amalia. Dos ejemplos sobre la distribución del trabajo en el Marruecos rural: aproximación lingüística y etnográfica. *Estudios de Dialectología Norteafricana y Andalusí,* 2 (1997) pp.197-223.

3970 ZIRARI, Hayat. Des restes du sacrifice au désir d'enfanter: la *qaddīda. Annuaire de l'Afrique du Nord,* 33 / 1994 (1996) pp.145-157. (Au Maroc ... Un fête collective organisée par et pour les femmes, autour d'un couscous.)

3971 ZIRARI, Hayat. Des restes du sacrifice au désir d'enfanter: la *qaddīda. L'islam pluriel au Maghreb.* Sous la dir. de S.Ferchiou. Paris: CNRS, 1996, pp.145-157. [Previously published in *Annuaire de l'Afrique du Nord 1994,* 1996.] (Au Maroc ... Un fête collective organisée par et pour les femmes, autour d'un couscous.)

3972 ZIRARI, Najia. Le statut des femmes au Maroc: un éternel recommencement. *Confluences Méditerranée,* 33 (2000) pp.139-145.

3973 ZOMEÑO, A. *Kafā'a* in the Mālikī school: a *fatwā* from fifteenth-century Fez. *Islamic law: theory and practice.* Ed. R.Gleave & E.Kermeli. London: Tauris, 1997, pp.87-106.

3974 ZUIJDGEEST, N. "Marokkaanse vrouwen zijn wettelijk minderjarig": interview met Léon Buskens. *Soera,* 7 iii-iv (1999) pp.45-47.

3975 La situation de la femme au Maroc. *Cahier d'Études Maghrébines,* 8-9, 1995-96, pp.17-26.

Netherlands

Books

3976 BARTELS, K. & HAAIJER, I. *Vrouwenbesnijdenis en Somalische vrouwen in Nederland.* Utrecht: Stichting Pharos, 1995. 144pp.

3977 DESSING, Nathal M. *Rituals of birth, circumcision, marriage, and death among Muslims in the Netherlands.* Leuven: Peeters, 2001 (New Religious Identities in the Western world, 2), 211pp.

3978 DISTELBRINK, Marjolijn & TREES PELS, Annemarie Roode. *Een wil, maar nog geen weg: Marokkaanse vrouwen en hun relatie tot de arbeidsmarkt.* Rotterdam: ISEO, Intituut voor Sociologisch-Economisch Onderzoek, Erasmus Universiteit Rotterdam, 1995. 183pp.

3979 ELDERING, L. & BORM, J-A. *Alleenstaande Marokkaanse moeders.* Utrecht: Van Arkel, 1996. 149pp.

3980 LAKHO, Hameeda & RIJST, Magda van der. *Rejas occultas: de Pakistán a Holanda: el dia a dia de una pesadilla.* Tr. Arguilé, Marta. Barcelona: Mondadori, 2002. 237pp. [Pakistani immigrant in Netherlands. Tr. of *Verborgen tralies,* Amsterdam 2000.]

3981 LAKHO, Hameeda & RIJST, Magda van der. *Verborgen tralies.* Amsterdam: Arena; rp. [Vianen:] Areopagus, 2000. 220pp. [Pakistani immigrant in Netherlands.]

3982 YERDEN, Ibrahim. *Trouwen op z'n Turks: huwelijksprocedures van Turkse jongeren in Nederland en hun strijd om meer inspraak.* Ed. (Veenhoven, L.). Utrecht: Van Arkel, 1995. 128pp.

Articles

3983 BREMEN, C. van den. A modern interpretation of the headscarf. *ISIM Newsletter,* 4 (1999) pp.7-7. (A solution which combines Islamic precepts with Dutch regulations & expectations ... A headscarf safe for sports.)

3984 BROUWER, L. Good girls, bad girls: Moroccan and Turkish runaway girls in the Netherlands. *Muslim European youth: reproducing ethnicity, religion, culture.* Ed. S.Vertovec, A.Rogers. Aldershot: Ashgate, 1998, pp.145-166.

3985 BUITELAAR, M. Narratives on partner-choice. *ISIM Newsletter,* 4 (1999) pp.29-29. [Young men & women of Moroccan descent in the Netherlands.]

3986 CHOCHO, Esmé. De Eer. *Islam in een ontzuilde samenleving. Discussies over vrouwenemancipatie, kunst en onderwijs.* [By] Metin Alkan [& others]. Amsterdam: Koninklijk Instituut voor de Tropen, 1996, pp.15-25. [Young Moroccans in the Netherlands.]

3987 DOĞAN, Nihal. Les femmes turques dans la vie associative au Pays-Bas. *CEMOTI,* 21 (1996) pp.185-188.

3988 ECK, Clementine van. Honour killings among Turks in the Netherlands. *Journal of Turkish Studies,* 26 i (2002) pp.205-214.

3989 FOBLETS, M-C. Un droit pour ou par ses destinataires? Les complexités du rattachement juridique de l'alliance matrimoniale entre partenaires immigrés. *Familles-Islam-Europe: le droit confronté au changement.* Sous la direction de M-C.Foblets. Paris: L'Harmattan, 1996, pp.125-151. [Belgium & Netherlands.]

3990 GROOT, G. R. de & RUTTEN, S. Polygamie, naturalisatie, bigamie? *Recht van de Islam,* 13 (1996) pp.19-60. (In Nederland.)

3991 HEUVELS, M. Les effets de la migration au niveau de la femme et du ménage: une approche comparative de l'isolement dans la situation marocaine et néerlandaise. *Le Maroc et la Hollande: une approche comparative des grands intérêts communs.* Rabat: Université Mohammed V, Faculté des Lettres et des Sciences Humaines, 1995, (Colloques et Séminaires, 39), pp.171-176.

3992 LUTZ, H. Anstössige Kopftücher - Kopftuch-Debatten in den Niederlanden. *Der neue Islam der Frauen. Weibliche Lebenspraxis in der globalisierten Moderne: Fallstudien aus Afrika, Asien und Europa.* R.Klein-Hessling, S.Nökel, K.Werner (Hg.). Bielefeld: transcript Verlag, 1999, pp.35-61.

3993 MEULEMAN, Johan. Headscarves, homosexuals, and imams in the Netherlands. *ISIM Newsletter,* 8 (2001) pp.33-33.

3994 POST, C. S. De ambtenaar burgerzaken en islamitisch familierecht. *Recht van de Islam,* 14 (1997) pp.50-66. (Nederlandse Vereniging voor Burgerzaken.)

Niger

Books

3995 COOPER, B. M. *Marriage in Maradi: gender and culture in a Hausa society in Niger, 1900-1989.* Oxford: Currey; New Haven: Heinemann, 1997. 228pp.

3996 DJIBO, Hadiza. *La participation des femmes africaines à la vie politique: les exemples du Sénégal et du Niger.* Paris: L'Harmattan, 2001. 419pp.

3997 HAMANI, Abdou. *Les femmes et la politique au Niger.* Paris: L'Harmattan, 2001. 160pp.

Articles

3998 COOPER, B. M. Gender and religion in Hausaland: variations in Islamic practice in Niger and Nigeria. *Women in Muslim societies: diversity within unity.* Ed. H.L.Bodman, Nayereh Tohidi. Boulder: Rienner, 1998, pp.21-37.

3999 PETERSON, Sara Ann. Marriage structure and contraception in Niger. *Journal of Biosocial Science,* 31 i (1999) pp.93-104. Also online at www.journals.cup.org (Polygamous & monogamous marriages ... Ninety-eight per cent of the women in the study sample were Muslim.)

4000 POPENOE, R. Barbie and Ken in the Sahara: dolls, sex and gender among Moors in Niger. *Antropologiska Studier,* 58-59 (1997) pp.27-3.

4001 POPENOE, R. Islam and the body: female fattening among Arabs in Niger. *ISIM Newsletter,* 4 (1999) pp.5-5.

4002 RASMUSSEN, Susan J. Between ritual, theater and play: blacksmith praise at Tuareg marriage. *Journal of American Folklore,* 110 / 435 (1997) pp.3-27. (Dance ... accompanied by drumming, sung lyrics, and comic repartee.)

4003 RASMUSSEN, Susan J. From childbearers to culture-bearers: transition to postchildbearing among Tuareg women. *Medical Anthropology,* 19 i (2000) pp.91-116. [Niger.]

4004 RASMUSSEN, Susan J. Only women know trees: medicine women and the role of herbal healing in Tuareg culture. *Journal of Anthropological Research,* 54 ii (1998) pp.147-171. [Niger.]

4005 RASMUSSEN, Susan J. Parallel and divergent landscapes: cultural encounters in the ethnographic space of Tuareg medicine. *Medical Anthropology Quarterly,* 14 ii (2000) pp.242-270. [Niger.]

4006 RASMUSSEN, Susan J. Within the tent and at the crossroads: travel and gender identity among the Tuareg of Niger. *Ethos,* 26 ii (1998) pp.153-182.

4007 SPEIZER, I. S. & YATES, A. J. Polygyny and African couple research. *Population Research and Policy Review,* 17 vi (1998) pp.551-570. [Muslims in Niger.]

Nigeria

Books

4008 MACK, Beverly B. & BOYD, Jean. *One woman's jihad: Nana Asma'u: scholar and scribe.* Bloomington: Indiana University Press, 2000. 198pp.

4009 PLATTE, Editha. *Frauen in Amt und Würden: Handlungsspielräume muslimischer Frauen im ländlichen Nordostnigeria.* Frankfurt a.M.: Brandes & Apsel, 2000 (Wissen & Praxis, 96), 290pp.

4010 WERTHMANN, K. *Nachbarinnen: die Alltagswelt muslimischer Frauen in einer nigerianischen Grossstadt.* Frankfurt a. M. : Brandes & Apsel 1997 (Wissen und Praxis, 75), 255pp.

4011 *Islamic legacy for women's rights, health and concerns: workshop report, Kano, May 19-23, 1996; Ibadan, May 27-31, 1996* / Planned Parenthood Federation of Nigeria. Nigeria: Planned Parenthood Federation of Nigeria, 1996. 60pp.

Articles

4012 ABDULLAH, Hussaina. Multiple identities and multiple organizing strategies of female wage workers in Kano's manufacturing sector. (Résumé: Identités multiples et stratégies d'organisation multiples des ouvrières salariées dans le secteur industriel à Kano, Nigeria.). *Transforming female identities: women's organizational forms in West Africa.* Ed. E.E.Rosander. Uppsala: Nordiska Afrikainstitutet, 1997, (Seminar Proceedings, 31), pp.54-68. [Muslims & Christians.]

4013 ADAMU, Fatima L. A double-edged sword: challenging women's oppression within Muslim society in northern Nigeria. *Gender and Development,* 7 i (1999) pp.56-61. Also online at http:// www.ingentaselect.com

4014 ADERINTO, Adeyinka Abideen. Subordinated by culture: constraints of women in a rural Yoruba community, Nigeria. *Nordic Journal of African Studies,* 10 ii (2001) pp.176-187. [Christians, Muslims & traditional Yorubas.]

4015 BALOGUN, S.U. Enhancing female education in the northern state of Nigeria. *Journal of the Pakistan Historical Society,* 49 iii (2001) pp.21-26.

4016 BASTIAN, M. L. Female *"alhajis"* and entrepreneurial fashions: flexible identities in southeastern Nigerian clothing practice. *Clothing and difference: embodied identities in colonial and post-colonial Africa.* Ed. H.Hendrickson. Durham (USA): Duke University Press, 1996, pp.97-132.

4017 BELLO, M. V. Women organising under the structural adjustment programme. *Confronting state, capital and patriarchy: women organizing in the process of industrialization.* Ed. A.Chhachhi & R.Pittin. Basingstoke: Macmillan; New York: St. Martin's Press, in association with the Institute of Social Studies, 1996, pp.290-306. (Research in the urban & rural areas around Kano.)

4018 CALDWELL, John C., ORUBULOYE, I.O. & CALDWELL, Pat. Female genital mutilation: conditions of decline. *Population Research and Policy Review,* 19 iii (2000) pp.233-254. [Generally & among Christian & Muslim Yorubas in Nigeria.]

4019 COOPER, B. M. Gender and religion in Hausaland: variations in Islamic practice in Niger and Nigeria. *Women in Muslim societies: diversity within unity.* Ed. H.L.Bodman, Nayereh Tohidi. Boulder: Rienner, 1998, pp.21-37.

4020 DANGANA, Muhammad. The intellectual contribution of Nana Asma'u to women's education in nineteenth-century Nigeria. *Journal of Muslim Minority Affairs,* 19 ii (1999) pp.285-290.

4021 DINSLAGE, Sabine, LEGER, Rudolf & STORCH, Anne. Space and gender: cultural limitations of space in two communities of northeastern Nigeria. *Anthropos,* 95 i (2000) pp.121-127. [Islamized vs. local African community.]

4022 DÜKING, B. Status femminile e consuetudine islamica: l'istituzione della *kulle* nella Nigeria settentrionale. *Africa: Rivista Trimestrale di Studi e Documentazione dell'Istituto Italiano per l'Africa e l'Oriente,* 55 iii (2000) pp.338-362. [Hausas.]

4023 FEYISETAN, B. J. & AINSWORTH, M. Contraceptive use and the quality, price, and availability of family planning in Nigeria. *World Bank Economic Review,* 10 i (1996) pp.159-187. (In the working sample ... Over half the women (56 percent) are Muslim.)

4024 FEYISETAN, B. J., ASA, S. & EBIGOLA, J. A. Mothers' management of childhood diseases in Yorubaland: the influence of cultural beliefs. *Health Transition Review,* 7 i (1997) pp.221-234. [Incl. Muslims.]

4025 FEYISETAN, Bamikale J. Spousal communication and contraceptive use among the Yoruba of Nigeria. *Population Research and Policy Review,* 19 i (2000) pp.29-45. [Christians & Muslims.]

4026 HUTSON, Alaine S. The development of women's authority in the Kano Tijaniyya, 1894-1963. *Africa Today,* 46 iii-iv (1999) pp.43-63.

4027 HUTSON, Alaine S. Women, men, and patriarchal bargaining in an Islamic Sufi order: the Tijaniyya in Kano, Nigeria, 1937 to the present. *Gender & Society,* 15 v (2001) pp.734-753. Also online at http:// www.ingentaselect.com

4028 IBRAHIM, Bintu Adam. Kanuri women (Nigeria) and sustainable development: status and attitudes. *Population and Development Research Monograph Series,* 6 (1999) pp.345-380.

4029 IMAM, Ayesha, JODA, Asma'u & MEDAR-GOULD, S. Our debt to Hajara Usman. *African Environment*, 10 iii-iv / 39-40 (1999) pp.141-144. [Nigerian activist for women's rights & scholar.]

4030 IMAM, Yahya Oyewole. Muslim women in Nigerian politics. *Islamic Quarterly*, 41 i (1997) pp.69-76.

4031 ISIUGO-ABANIHE, U. C. Stability of marital unions and fertility in Nigeria. *Journal of Biosocial Science*, 30 i (1998) pp.33-41. [Incl. Muslims.]

4032 JUMARE, Ibrahim M. Women and land tenure in the Sokoto Sultanate of Nigeria. (Summary: Les femmes et le régime foncier dans le Sultanat de Sokoto au Nigéria.). *JAMES: Annals of Japan Association for Middle East Studies*, 13 (1998) pp.1-23.

4033 KASSAM, Margaret Hauwa. Some aspects of women's voices from Northern Nigeria. *African Languages and Cultures*, 9 ii (1996) pp.111-125.

4034 KLEINER-BOSSALLER, A. Zur Stellung der Frau in der Hausagesellschaft: ein brüchig gewordener Konsens. *Muslime in Nigeria: Religion und Gesellschaft im politischen Wandel seit den 50er Jahren*. Jamil M.Abun-Nasr (hrsg.). Münster: Lit, 1993, (Beiträge zur Afrikaforschung, 4), pp.83-126.

4035 MALAMI, Hussaini Usman. The unaccounted contribution of Nigerian women to the national economy. *Journal of Muslim Minority Affairs*, 16 ii (1996) pp.279-286. (In the Sokoto Caliphate.)

4036 NASIRU, W. O. A. The attitude of traditional *'ulamā'* to Muslim female education in Nigeria. *Muslim Education Quarterly*, 14 ii (1997) pp.69-79.

4037 NAST, H. J. Islam, gender, and slavery in West Africa circa 1500: a spatial archaeology of the Kano Palace, northern Nigeria. *Annals of the Association of American Geographers*, 86 i (1996) pp.44-77.

4038 O'BRIEN, Susan M. Spirit discipline: gender, Islam, and hierarchies of treatment in postcolonial northern Nigeria. *Interventions*, 3 ii (2001) pp.222-241. Also online at www.ingenta.com [Bori experiences among Hausa women.]

4039 OSAKUE, G. & MARTIN-HILBER, A. Women's sexuality and fertility in Nigeria: breaking the culture of silence. *Negotiating reproductive rights: women's perspectives across countries and cultures*. Ed. R.P.Petchesky & K.Judd. London: Zed, 1998, pp.180-216. [Incl. Muslims.]

4040 RAIN, D. The women of Kano: internalized stress and the conditions of reproduction, northern Nigeria. *GeoJournal*, 43 ii (1997) pp.175-187.

4041 RAJI, N.I. Mate selection, compatibility of couple and the place of women in family formation: a case study of Ilorin, Nigeria. *Islamic Culture*, 75 iii (2001) pp.105-125.

4042 RENNE, E. P. The meaning of contraceptive choice and restraint for Hausa women in a northern Nigerian town. *Anthropology & Medicine*, 4 ii (1997) pp.159-175.

4043 REYNOLDS, J. T. Islam, politics and women's rights. *Comparative Studies of South Asia, Africa and the Middle East*, 18 i (1998) pp.64-73. (In Nigeria's predominantly Muslim northern region.)

4044 SOETAN, Funmi. Entrepreneurship and Nigerian women - is there any meeting point? *Small Enterprise Development*, 8 i (1997) pp.41-46. [Inc. Muslim Hausa women.]

4045 TARFA, Sintiki. Why rural technologies fail to meet the needs of Nigerian women: evidence from Hausa women's groups in Kano state. *Women, globalization and fragmentation in the developing world*. Ed. Haleh Afshar & S.Barrientos. Basingstoke: Macmillan; New York: St. Martin's Press, 1999, pp.215-225.

4046 TOGUNDE, Oladimeji R. A social structural analysis of the effects of women's employment on fertility in urban Nigeria. *Journal of Developing Societies*, 15 ii (1999) pp.172-188. [Hausas, Igbos & Yorubas, incl. Muslims.]

4047 TOGUNDE, Oladimeji R. Determinants of women's employment in urban Nigeria: the impact of socio-cultural factors. *Journal of Asian and African Studies*, 34 iii (1999) pp.279-297. (Moslems are significantly less likely to be employed than Christians.)

4048 WERTHMANN, K. Die Frauen der *barracks*. Identitätsmanagement in einer nordnigerianischen Grossstadt. (Synopsis: Women of the barracks. Identity management in a northern Nigerian city.). *Sociologus*, 45 ii (1995) pp.167-182. (Altstadt von Kano.)

4049 WERTHMANN, Katja. "Seek for knowledge, even if it is in China!". Muslim women and secular education in northern Nigeria. *Africa, Islam and development: Islam and development in Africa - African Islam, African development*. Thomas Salter, Kenneth King (Eds). Edinburgh: Centre of African Studies, University of Edinburgh, 2000, pp.253-269.

4050 WILLIAMS, Pat. Religious fundamentalism and women's political behaviour in Nigeria. *Islamic Quarterly*, 42 i (1998) pp.68-82. [Among followers of African traditional religions, Christianity & Islam.]

4051 ZAKARIA, Yakubu. Entrepreneurs at home: secluded Muslim women and hidden economic activities in northern Nigeria. *Nordic Journal of African Studies*, 10 i (2001) pp.107-123.

Norway

Articles

4052 INGDAHL, N. En utilslørt feminist. *3.Verden-Magasinet X*, 4 iii (1995) pp.10-11. (Nada Merheb som er i ferd med å etablere seg en av de fremste ekspertene på kvinner og Islam i Norge.)

4053 INGDAHL, N. To muslimske ansikt. *3.Verden-Magasinet X*, 4 v (1995) pp.34-34. [Interviews with a Norwegian convert to Islam & a Pakistani woman long resident in Norway.]

4054 VANGEN, S., STOLTENBERG, C. & SCHEI, B. Ethnicity and use of obstetrical analgesia: do Pakistani women receive inadequate pain relief in labour? *Ethnicity & Health*, 1 ii (1996) pp.161-167. (In Norway.)

4055 WIKAN, U. Citizenship on trial: Nadia's case. *Dædalus*, 129 iv (2000) pp.55-76. [Norwegian-born Moroccan girl challenging her parents.]

Oman

Articles

4056 CHATTY, D. The burqa face cover: an aspect of dress in southeastern Arabia. *Languages of dress in the Middle East*. Ed. N.Lindisfarne-Tapper & B.Ingham. Richmond: Curzon, in association with the Centre of Near and Middle Eastern Studies, SOAS, 1997, pp.127-148.

4057 CHATTY, Dawn. Women working in Oman: individual choice and cultural constraints. *International Journal of Middle East Studies*, 32 ii (2000) pp.241-254.

4058 EICKELMAN, Christine. Fertility and social change in Oman: women's perspectives. *Arab society: class, gender, power, and development*. Ed. N.S.Hopkins, Saad Eddin Ibrahim. Cairo: American University in Cairo Press, 1997, pp.105-121. [First published 1993.]

4059 HEATH, C. Women, income and gender relations in rural Oman. *Change and development in the Gulf*. Ed. Abbas Abdelkarim. Basingstoke: Macmillan; New York: St. Martin's Press, 1999, pp.164-183.

4060 PERSSON, G. Jordemoder i Oman. *Samfund, sundhed og sygdom på den arabiske Halvø*. L.Erslev Andersen & M.R.Buhl (red.). Odense: Odense Universitetsforlag, 1995, (Odense University Publication in Contemporary Middle East Studies, 3), pp.145-147.

4061 QUTAMI, Yusuf. The effects of students' gender, self-efficacy and academic achievement on cognitive strategies for self-regulated learning. *Dirasat (Educational Sciences)*, 27 i (2000) pp.218-229. (At Sultan Qaboos University.)

4062 RIPHENBURG, C. J. Changing gender relations and the development process in Oman. *Islam, gender, & social change*. Ed. Y.Yazbeck Haddad & J.L.Esposito. New York: Oxford University Press, 1998, pp.144-168.

Ottoman & pre-Ottoman Turkey

Books

4063 AKŞIT, İlhan. *Mystère des Ottomans: le harem*. Tr. Grolier, Pierrette. Istanbul: Akşit, 2000. 180pp.

4064 AKŞIT, İlhan. *The mystery of the Ottoman harem*. Istanbul: Akşit, 2000. 180pp.

4065 FAROQHI, Suraiya. *Stories of Ottoman men and women: establishing status, establishing control*. Istanbul: Eren, 2002. 358pp. [Reprinted articles.]

4066 FREELY, John. *Inside the Seraglio: private lives of the Sultans in Istanbul*. London: Penguin, 2000. 360pp. [First published by Viking 1999.]

4067 GOODWIN, G. *The private world of Ottoman women*. London: Saqi, 1997. 261pp.

4068 GOST, R. *Der Harem*. Cologne: Du Mont, 1993. 248pp.

4069 JENNINGS, R. C. *Studies on Ottoman social history in the sixteenth and seventeenth centuries: women, zimmis and Sharia courts in Kayseri, Cyprus and Trabzon*. Istanbul: Isis Press, 1999, (Analecta Isisiana, 39), 728pp.

4070 *Women in the Ottoman Empire: Middle Eastern women in the early modern era*. Ed. Zilfi, M. C. Leiden: Brill, 1997, (The Ottoman Empire and its Heritage, 10), 333pp.

Articles

4071 ARTAN, Tülay. Periods and problems of Ottoman (women's) patronage on the Via Egnatia. *The Via Egnatia under Ottoman rule (1380-1699). Halcyon Days in Crete II: A symposium held in Rethymnon 9-11 January 1994*. Ed. E.Zachariadou. Rethymnon: Crete University Press, 1996, pp.19-43. [Properties and endowments of Ottoman princesses in the Balkans.]

4072 AYDIN, M.Akif. The codification of the Islamic-Ottoman family law and the decree of "Hukuk-ı Aile". *The great Ottoman-Turkish civilisation*. Vol. 3: *Philosophy, science and institutions. Editor-in-chief Kemal Çiçek*. Ankara: Yeni Türkiye, 2000, pp.705-713.

4073 BARZILAI-LUMBROSO, Ruth. Turkish men, Ottoman women: Turkish historians in the 1950s on Ottoman women. *Discourse on gender / gendered discourse in the Middle East*. Ed. Boaz Shoshan. Westport: Praeger, 2000, pp.15-28;141-145.

4074 BAŞBUĞU-YARAMAN, Aysegül. La femme turque dans son parcours emancipatoire de l'empire ottoman à la république. *CEMOTI*, 21 (1996) pp.15-31.

4075 BAŞCI, K. Pelin. Shadows in the missionary garden of roses: women of Turkey in American missionary texts. *Deconstructing images of "the Turkish woman"*. Ed. Zehra F.Arat. Basingstoke: Macmillan, 1998, pp.101-123.

4076 BRUMMETT, P. Dressing for revolution: mother, nation, citizen, and subversive in the Ottoman satirical press, 1908-1911. *Deconstructing images of "the Turkish woman"*. Ed. Zehra F.Arat. Basingstoke: Macmillan, 1998, pp.37-63.

4077 BRUMMETT, P. New woman and old nag: images of women in the Ottoman cartoon space. *Princeton Papers: Interdisciplinary Journal of Middle Eastern Studies*, 6 (1997) pp.13-57. (1908-1911.)

4078 DEMIRDIREK, Aynur. In pursuit of the Ottoman women's movement. Tr. Arat, Zehra F. *Deconstructing images of "the Turkish woman"*. Ed. Zehra F.Arat. Basingstoke: Macmillan, 1998, pp.65-81.

4079 FAROQHI, Suraiya. Crime, women, and wealth in the eighteenth-century Anatolian countryside. *Women in the Ottoman Empire: Middle Eastern women in the early modern era*. Ed. M.C.Zilfi. Leiden: Brill, 1997, (The Ottoman Empire and its Heritage, 10), pp.6-27.

4080 FAROQHI, Suraiya. From the slave market to Arafat: biographies of Bursa women in the late fifteenth century. *Turkish Studies Association Bulletin*, 24 i (2000) pp.3-20.

4081 FAROQHI, Suraiya. Von Sklavenmädchen zur Mekkapilgerin: Lebensläufe Bursaer Frauen im späten fünfzehnten Jahrhundert. *Das osmanische Reich in seinen Archivalien und Chroniken: Nejat Göyünç zu ehren*. Hrsg. K.Kreiser & C.K.Neumann. Istanbul: in Kommission bei F. Steiner Verlag Stuttgart, 1997, (Beiruter Texte und Studien, 65; Türkische Welten, 1), pp.7-29.

4082 FAROQHI, Suraiya. Women's work, poverty and the privileges of guildsmen. *Archiv Orientální*, 69 ii (2001) pp.155-164. [18th century Ottoman Empire.]

4083 FAY, Mary Ann. Ottoman women through the eyes of Mary Wortley Montagu. *Unfolding the Orient: travellers in Egypt and the Near East*. Ed. Paul & Janet Starkey. Reading: Ithaca, 2001, pp.157-167.

4084 FLEMING, K. E. Women as preservers of the past: Ziya Gökalp and women's reform. *Deconstructing images of "the Turkish woman"*. Ed. Zehra F.Arat. Basingstoke: Macmillan, 1998, pp.127-138.

4085 FRIERSON, Elizabeth Brown. Mirrors out, mirrors in: domestication and rejection of the foreign in late-Ottoman women's magazines (1875-1908). *Women, patronage, and self-representation in Islamic societies*. Ed. D.Fairchild Ruggles. Albany (USA): State University of New York Press, 2000, pp.177-204.

4086 GÖÇEK, Fatma Müge & BAER, M. D. Social boundaries of Ottoman women's experience in eighteenth-century Galata court records. *Women in the Ottoman Empire: Middle Eastern women in the early modern era*. Ed. M.C.Zilfi. Leiden: Brill, 1997, (The Ottoman Empire and its Heritage, 10), pp.48-65.

4087 GROZDANOVA, Elena. Das Los der Frauen nach den osmanischen "Registerbüchern der Beschwerden" vom 17. und 18. Jh. *Bulgarian Historical Review. Revue Bulgare d'Histoire*, 29 i-ii (2001) pp.52-68.

4088 GÜRTUNA, Sevgi. The clothing of Ottoman women. *The great Ottoman-Turkish civilisation*. Vol. 4: *Culture and arts. Editor-in-chief Kemal Çiçek*. Ankara: Yeni Türkiye, 2000, pp.78-92.

4089 HAERKÖTTER-UZUN, R. Öffentliche Diskussion in der Istanbuler Frauenpresse zu Beginn der Zweiten Konstitutionellen Periode am Beispiel *Maḥâsin*. *Presse und Öffentlichkeit im Nahen Osten*. Hrsg. C.Herzog, R.Motika, A.Pistor-Hatam. Heidelberg: Heidelberger Orientverlag, 1995, pp.83-91.

4090 HEFFERNAN, Teresa. Feminism against the East/West divide: Lady Mary's *Turkish Embassy letters*. *Eighteenth-Century Studies*, 33 ii (2000) pp.201-215.

4091 HOPWOOD, K. Byzantine princesses and lustful Turks. *Rape in antiquity*. Ed. S.Deacy & K.F.Pierce. London: Duckworth; Swansea: Classical Press of Wales, 1997, pp.231-242.

4092 IMBER, C. Women, marriage, and property: *mahr* in the *Behcetü'l-fetāvā* of Yenişehirli Abdullah. *Women in the Ottoman Empire: Middle Eastern women in the early modern era*. Ed. M.C.Zilfi. Leiden: Brill, 1997, (The Ottoman Empire and its Heritage, 10), pp.81-104.

4093 KARADENIZ, Feriha. Women in different classes of Ottoman society in the 16th and 17th centuries. *The great Ottoman-Turkish civilisation*. Vol. 2: *Economy and society. Editor-in-chief Kemal Çiçek*. Ankara: Yeni Türkiye, 2000, pp.702-706.

4094 KURT, Abdurrahman. Polygamy in the Ottoman society. *The great Ottoman-Turkish civilisation*. Vol. 2: *Economy and society. Editor-in-chief Kemal Çiçek*. Ankara: Yeni Türkiye, 2000, pp.686-695.

4095 LAPIDOT-FIRILLA, Anat. The memoirs of Halide Edib (1884-1964): the public persona and the personal narrative. *New Perspectives on Turkey,* 21 (1999) pp.61-77. (The first volume of memoirs.)

4096 LEWIS, Reina. On veiling, vision and voyage: cross-cultural dressing and narratives of identity. *Interventions,* 1 iv (1999) pp.500-520. (Turkey in the early years of the twentieth century.)

4097 MICKLEWRIGHT, Nancy. Public and private for Ottoman women of the nineteenth century. *Women, patronage, and self-representation in Islamic societies.* Ed. D.Fairchild Ruggles. Albany (USA): State University of New York Press, 2000, pp.155-176.

4098 ÖLÇER, Nazan & others. Le harem. *Topkapı à Versailles: trésors de la Cour ottomane* / Musée national des châteaux de Versailles et de Trianon, 4 mai - 15 août 1999. Paris: Editions de la Réunion des Musées Nationaux & Association Française d'Action Artistique, 1999, pp.208-218. [Incl. illustrated catalogue of tiles, glass window & eunuch.]

4099 OS, Nicole A.N.M.van. "A nation whose women are living in ignorance...": the foundation of the *Milli İnas Mektebi* in Nişantaşı. *International congress on learning and education in the Ottoman world, Istanbul, 12-15 April 1999.* Edited by Ali Çaksu. Istanbul: Research Centre for Islamic History, Art and Culture (IRCICA), 2001, (Studies and Sources on the Ottoman History Series, 6), pp.247-258. [1913.]

4100 OS, Nicole A.N.M.van. Ottoman women's organizations: sources of the past, sources for the future. *Islam and Christian-Muslim Relations,* 11 iii (2000) pp.369-383. Also online at www.catchword.com

4101 OS, Nicole van. "Müstehlik değil müstahsil", not consumers, but producers: Ottoman Muslim women and Milli iktisat. *The great Ottoman-Turkish civilisation.* Vol. 2: *Economy and society.* Editor-in-chief Kemal Çiçek. Ankara: Yeni Türkiye, 2000, pp.269-275.

4102 PEDANI [FABRIS], Maria Pia. Safiye's household and Venetian diplomacy. (Abstract: La famille de Safiye et la diplomatie vénitienne.). *Turcica,* 32 (2000) pp.9-32. (Albanian *haseki* of Murad III (1574-1595) & mother of Mehmed III.)

4103 PEIRCE, L. [P.]. "She is trouble ... and I will divorce her": orality, honor, and representation in the Ottoman court of 'Aintab. *Women in the medieval Islamic world: power, patronage, and piety.* Ed. G.R.G.Hambly. Basingstoke: Macmillan, 1998, (The New Middle Ages, 6), pp.269-300.

4104 PEIRCE, L. P. Le dilemme de Fatma: crime sexuel et culture juridique dans une cour ottomane au début des temps modernes. (Summar[y]: Fatma's dilemma: sexual crime and legal culture in an early modern Ottoman court.). *Annales: Histoire, Sciences Sociales,* 53 ii (1998) pp.291-319;450. (1541.)

4105 PEIRCE, L. P. Seniority, sexuality, and social order: the vocabulary of gender in early modern Ottoman society. *Women in the Ottoman Empire: Middle Eastern women in the early modern era.* Ed. M.C.Zilfi. Leiden: Brill, 1997, (The Ottoman Empire and its Heritage, 10), pp.169-196.

4106 PEIRCE, Leslie. Gender and sexual propriety in Ottoman royal women's patronage. *Women, patronage, and self-representation in Islamic societies.* Ed. D.Fairchild Ruggles. Albany (USA): State University of New York Press, 2000, pp.53-68.

4107 PROCHÁZKA-EISL, G. "Modern und trotzdem keusch": die ideale Partnerin im Spiegel osmanischer Heiratsanzeigen. *Wiener Zeitschrift für die Kunde des Morgenlandes,* 89 (1999) pp.187-205.

4108 REINDL-KIEL, H. A woman *timar* holder in Ankara province during the second half of the 16th century. *Journal of the Economic and Social History of the Orient,* 40 ii (1997) pp.207-238.

4109 RODED, Ruth M. Gendering Ottoman history. *The great Ottoman-Turkish civilisation.* Vol. 2: *Economy and society.* Editor-in-chief Kemal Çiçek. Ankara: Yeni Türkiye, 2000, pp.677 685.

4110 SCARCIA AMORETTI, B. Dames persanes de Constantinople. *Les Iraniens d'Istanbul.* Sous la dir. de T.Zarcone & F.Zarinebaf. Paris: Institut Français de Recherches en Iran & Institut Français d'Etudes Anatoliennes, 1993, (Bibliothèque Iranienne, 42; Varia Turcica, 24), pp.91-93. [From Italian Foreign Affairs Ministry archives of 1908.]

4111 SCHICK, İrvin Cemil. The women of Turkey as sexual personae: images from Western literature. *Deconstructing images of "the Turkish woman".* Ed. Zehra F.Arat. Basingstoke: Macmillan, 1998, pp.83-100.

4112 SENG, Y. J. Invisible women: residents of early sixteenth-century Istanbul. *Women in the medieval Islamic world: power, patronage, and piety.* Ed. G.R.G.Hambly. Basingstoke: Macmillan, 1998, (The New Middle Ages, 6), pp.241-268.

4113 SHAW, J. Gender and the 'nature' of religion: Lady Mary Wortley Montague's embassy letters and their place in Enlightenment philosophy of religion. *Bulletin of the John Rylands University Library of Manchester,* 80 iii (1998) pp.129-145.

4114 TUCKER, J. E. Revisiting reform: women and the Ottoman Law of Family Rights, 1917. *Arab Studies Journal / Majallat al-Dirāsāt al-'Arabīya,* 4 ii (1996) pp.4-17.

4115 VANZAN, A. In search of another identity: female Muslim-Christian conversions in the Mediterranean world. *Islam and Christian-Muslim Relations,* 7 iii (1996) pp.327-333. (Sixteenth to the eighteenth century ... The flow of converts was particularly abundant between the Republic of Venice and the Ottoman Empire.)

4116 WOLPER, Ethel Sara. Princess Safwat al-Dunyā wa al-Dīn and the production of Sufi buildings and hagiographies in pre-Ottoman Anatolia. *Women, patronage, and self-representation in Islamic societies.* Ed. D.Fairchild Ruggles. Albany (USA): State University of New York Press, 2000, pp.35-52.

4117 ZARINEBAF-SHAHR, Fariba. Ottoman women and the tradition of seeking justice in the eighteenth century. *Women in the Ottoman Empire: Middle Eastern women in the early modern era.* Ed. M.C.Zilfi. Leiden: Brill, 1997, (The Ottoman Empire and its Heritage, 10), pp.253-263.

4118 ZARINEBAF-SHAHR, Fariba. The wealth of Ottoman princesses during the Tulip age. *The great Ottoman-Turkish civilisation.* Vol. 2: *Economy and society.* Editor-in-chief Kemal Çiçek. Ankara: Yeni Türkiye, 2000, pp.696-701.

4119 ZARINEBAF-SHAHR, Fariba. Women, law, and imperial justice in Ottoman Istanbul in the late seventeenth century. *Women, the family, and divorce laws in Islamic history.* Ed. A.El Azhary Sonbol. Syracuse: Syracuse University Press, 1996, pp.81-95.

4120 ZARINEBAF-SHAHR, Fariba. Women and the public eye in eighteenth-century Istanbul. *Women in the medieval Islamic world: power, patronage, and piety.* Ed. G.R.G.Hambly. Basingstoke: Macmillan, 1998, (The New Middle Ages, 6), pp.301-324.

4121 ZILFI, M. C. "We don't get along": women and *hul* divorce in the eighteenth century. *Women in the Ottoman Empire: Middle Eastern women in the early modern era.* Ed. M.C.Zilfi. Leiden: Brill, 1997, (The Ottoman Empire and its Heritage, 10), pp.264-296. (Focusing on eighteenth-century Istanbul.)

4122 ZILFI, M. C. Women and society in the Tulip Era, 1718-1730. *Women, the family, and divorce laws in Islamic history.* Ed. A.El Azhary Sonbol. Syracuse: Syracuse University Press, 1996, pp.290-306.

4123 ZILFI, Madeline C. Ottoman slavery and female slaves in the early modern era. *The great Ottoman-Turkish civilisation.* Vol. 2: *Economy and society.* Editor-in-chief Kemal Çiçek. Ankara: Yeni Türkiye, 2000, pp.714-718.

4124 Kara Fatima at Constantinople. *International Journal of Kurdish Studies,* 15 i-ii (2001) pp.87-88. [Kara Fatima Hanoun, Kurdish ally of the Sultan. Reprinted from *The Illustrated London News,* 1854.]

4125 Le hammam. *Topkapı à Versailles: trésors de la Cour ottomane* / Musée national des châteaux de Versailles et de Trianon, 4 mai - 15 août 1999. Paris: Editions de la Réunion des Musées Nationaux & Association Française d'Action Artistique, 1999, pp.240-244. [Illustrated catalogue of painting, silver bowl, ivory mirror & comb, towels & wooden clogs.]

4126 Le quartier des odalisques. *Topkapı à Versailles: trésors de la Cour ottomane* / Musée national des châteaux de Versailles et de Trianon, 4 mai - 15 août 1999. Paris: Editions de la Réunion des Musées Nationaux & Association Française d'Action Artistique, 1999, pp.219-229. [Illustrated catalogue of paintings, jewellery & scarf.]

4127 Le quartier des sultanes. *Topkapı à Versailles: trésors de la Cour ottomane* / Musée national des châteaux de Versailles et de Trianon, 4 mai - 15 août 1999. Paris: Editions de la Réunion des Musées Nationaux & Association Française d'Action Artistique, 1999, pp.230-239. [Illustrated catalogue of music, woodwork, costume, metalwork, MSS, seals & purse.]

Pakistan (since 1947) see also South Asia (before Partition)

Books

4128 ADEEL, Umme Kalsoom & NAQVI, Hasan Mehdi. *Pakistani women in development: a statistical mirror.* Peshawar: Pakistan Academy for Rural Development, 1997. 404pp.

4129 AKHUND, Iqbal. *Trial and error: the advent and eclipse of Benazir Bhutto.* Karachi: Oxford University Press, 2000. 346pp.

4130 ALFF, C. *Die Lebens- und Arbeitsbedingungen von Frauen im ländlichen Punjab/Pakistan: eine empirische Fallstudie aus der Division Bahawalpur.* Berlin: Reimer, 1997, (Abhandlungen Anthropogeographie: Institut für GeographischeWissenschaften, Freie Universität Berlin, 56), 231pp.

4131 ALI, Shaheen Sardar. *Gender and human rights in Islam and international law: equal before Allah, unequal before man?* The Hague: Kluwer Law International, 2000. 358pp. (Example of Pakistan to demonstrate the divergence between theory & practice of Islamic law.)

4132 BREDI, Daniela. *Nazione, etnia, genere: le donne Muhāǧir di Karachi (Pakistan).* Rome: Istituto per l'Oriente "C.A.Nallino", 2000. 209pp.

4133 CHANT, S. & MCILWAINE, C. *Three generations, two genders, one world: women and men in a changing century.* London: Zed (in association with the Commonwealth Secretariat), 1998. 237pp. (4. Malaysia, pp.67-84; 6. Pakistan, pp.109-134.]

4134 CHITKARA, M. G. *Benazir: a profile.* Delhi: APH Publishing, 1996. 186pp.

4135 DEEN, Hanifa. *Broken bangles.* Sydney: Anchor, 1998; Delhi: Penguin Books, 1999. 324pp. [Women of Pakistan and Bangladesh.]

4136 DURRANI, Tehmina, HOFFER, W. & HOFFER, M. *Mein Herr und Gebieter: ich war die Begum des Löwen vom Punjab.* Tr. Dittmar-Kolb, H. Gütersloh: Bertelsmann-Club; Vienna: Buchgemeinscaft Donauland, 1994. 427pp. [Tr. of *My feudal lord*, London 1994. Married to Pakistani politician.]

4137 DURRANI, Tehmina, HOFFER, W. & HOFFER, M. M. *Mi señor feudal.* Tr. González Cófreces, J. A. Barcelona: Muchnik, 1994. 426pp. [Married to Pakistani politician. Tr. of *My feudal lord.*]

4138 DURRANI, Tehmina & CUNY, M-T. *Mon seigneur et maître: document.* Paris: Fixot, 1994. 411pp. [Tr. of *My feudal lord*, London 1994. Married to Pakistani politician.]

4139 ELSON, D. & EVERS, B. *Pakistan.* Rev. version. Manchester: Graduate School of Social Sciences, University of Manchester 1997 (Gender Aware Country Economic Reports: Working Paper 3), 51pp.

4140 GIUNCHI, E. *Radicalismo islamico e condizione femminile in Pakistan.* Turin: L'Harmattan Italia, 1999, (Metissage, 29), 153pp.

4141 GOURRET, L. *Benazir: l'envers du voile.* Paris: Denöel, 1997. 244pp.

4142 IKRAMULLAH, Shaista Suhrawardy. *From purdah to Parliament.* [Rev. ed]. Karachi: Oxford University Press 1998. 255pp. [Previously published London 1963.]

4143 NAZLI, Hina & HAMID, Shahnaz. *Concerns of food security, role of gender and intra-household dynamics in Pakistan.* Islamabad: Pakistan Institute of Development Economics, 1999, (Research Report, 175), 35pp.

4144 NIAZ-ANWAR, Unaiza. *Contemporary issues of Pakistani women: a psycho-social perspective.* Karachi: Pakistan Association of Women's Studies, Karachi University, 1997. 81pp.

4145 QAMBER, Rukhsana. *El alma en paz: la mujer pakistaní en la tradición y la actualidad.* 2ª ed. Barcelona: PPU, 2002. 177pp.

4146 ROUSSELOT, F. *Une femme au Pakistan: Nusrat Jamil.* [Paris:] Plon, 1999. 166pp.

4147 SALAM, Mariam. *Thy people.* Lahore: Sang-e-Meel Pablications, 1998. 190pp. [Memoirs of British convert in Pakistan.]

4148 SATHAR, Zeba A. & KAZI, Shahnaz. *Women's autonomy, livelihood & fertility: a study of rural Punjab.* Islamabad: Pakistan Institute of Development Economics, 1997. 100pp.

4149 SHAH, Fatima & HASAN, Raihana A. *Sunshine and shadows: the autobiography of Dr. Fatima Shah.* Tr., ed. & adapted as a tribute and a labour of love by her daughter, Raihana A.Hasan. Lahore: Ferozsons, 1999. 343pp. [Blind Pakistani woman's story.]

4150 SHAH, Nafisa. *Blood, tears and lives to live: women in the cross-fire, a study for HRCP.* Lahore: Human Rights Commission of Pakistan, 1998. 44pp. [Sindh.]

4151 SHAIKH, Muhammad Ali. *Benazir Bhutto: a political biography.* Karachi: Oriental Books Publishing House, 2000. 281pp.

4152 TINKER, A. G. *Improving women's health in Pakistan.* Washington: World Bank, 1998. 34pp.

4153 ZAIDI, S.Akbar. *The new development paradigm: papers on institutions, NGOs, gender and local government.* Oxford 1999, rp. [Karachi]: Oxford University Press, 2000 (Oxford Pakistan Paperbacks), 321pp. [Pakistan.]

4154 *Crime or custom? Violence against women in Pakistan.* New York: Human Rights Watch, 1999. 101pp.

4155 *Engendering the nation-state.* Vol. 1. Ed. by Neelam Hussain, Samiya Mumtaz, Rubina Saigol. Lahore: Simorgh, 1997. 266pp. [Mainly Pakistan.]

4156 *Engendering the nation-state.* Vol. 2. Ed. by Neelam Hussain, Samiya Mumtaz, Rubina Saigol. Lahore: Simorgh Women's Resource and Publication Centre, 1997. 158pp. [Conference papers, all dealing with Pakistani culture, or South Asian history.]

4157 *Family and gender in Pakistan: domestic organization in a Muslim society.* Ed. H.Donnan & F.Selier. Delhi: Hindustan Publishing Corporation, 1997. 249pp.

4158 *Leveling the playing field: giving girls an equal chance for basic education - three countries' efforts* / The World Bank. Washington: World Bank, 1996. 38pp. [Pakistan, Bangladesh, Malawi.]

4159 *Muslim feminism and feminist movement: South Asia.* Vol. 2: *Pakistan.* Ed. Abida Samiuddin, R.Khanam. Delhi: Global Vision Publishing House, 2002. 376pp.

4160 *Shaping women's lives: laws, practices & strategies in Pakistan.* Ed. Shaheed, Farida & others Lahore: Shirkat Gah, Women's Resource Centre, 1998. 492pp.

4161 *The gap between reproductive intentions and behavior: a study of Punjabi men and women.* Islamabad: Population Council, [1997]. 78pp. [Pakistan.]

4162 *Time to speak out: illegal abortion and women's health in Pakistan.* Lahore: Shirkat Gah / Women Living Under Muslim Laws, 1996. 34pp.

4163 *Women's law in legal education and practice in Pakistan: north south cooperation.* Ed. Rubya Mehdi & Farida Shaheed. Copenhagen: New Social Science Monograph, 1997. 303pp.

4164 *Women of Pakistan fifty years and beyond: diary 1998.* Islamabad: Uks-Research, Resource and Publication Centre on Women and Media, 1997. [34]pp.

4165 HAQUE, Riffat & BATOOL, Syeda Najeeba. *Climbing the ladder: a case study of the women's secondary education programme of Allama Iqbal Open University, Pakistan.* Geneva: International Bureau of Education, 1999, (Innodata Monographs, 4),

Articles

4166 ABDUL HAKIM Are status of women and contraceptive prevalence correlated in Pakistan? *Pakistan Development Review,* 39 iv (2000) pp.1057-1071. [Comments by Razzaque Rukhanuddin, pp.1072-1073.]

4167 ABDUL HAKIM & AZIZ, Azra. Socio-cultural, religious, and political aspects of the status of women in Pakistan. *Pakistan Development Review,* 37 iv (1998) pp.727-746.

4168 ABDUL WAHAB & AHMAD, Mahmud. Biosocial perspective of consanguineous marriages in rural and urban Swat, Pakistan. *Journal of Biosocial Science,* 28 iii (1996) pp.305-313.

4169 AHMED, Akbar S. Women and the household in Baluchistan and frontier society. *Family and gender in Pakistan: domestic organization in a Muslim society.* Ed. H.Donnan & F.Selier. Delhi: Hindustan Publishing Corporation, 1997, pp.64-87.

4170 AHMED, Durre Sameen. Changing faces of tradition. *Women's lifeworlds: women's narratives on shaping their realities /* ed. Edith Sizoo. London: Routledge, 1997, pp.39-53. [Pakistan.]

4171 AHMED, Shamima. The social construction of female leadership in South Asia: opportunities and constraints. *Asian Thought and Society,* 21 / 61-62 (1996) pp.55-66. (Bangladesh, India, & Pakistan.)

4172 AHSAM, A. Fundamentalist ideology and feminist resistance. *Muslim feminism and feminist movement: South Asia.* Vol. 2: *Pakistan.* Ed. Abida Samiuddin, R.Khanam. Delhi: Global Vision Publishing House, 2002, pp.53-70.

4173 AKHTAR, Sajjad. Do girls have a higher school drop-out rate than boys? A hazard rate analysis of evidence from a Third World city. *Urban Studies,* 33 i (1996) pp.49-62. (Karachi.)

4174 ALI, Karamat, ABDUL HAMID & KHAN, Naheed Zia. Female education in Pakistan: saga of insignificant visibles and significant invisibles. *Pakistan: the political economy of human resource development /* Karamat Ali [& others]. Lahore: Vanguard, 2001, pp.11-30.

4175 ALI, Karamat & ABDUL HAMID Major determinants of female child labour in urban Multan (Punjab-Pakistan). *Pakistan: the political economy of human resource development /* Karamat Ali [& others]. Lahore: Vanguard, 2001, pp.70-89.

4176 ALI, Karamat & ABDUL HAMID Problems of working women in the rural informal sector of Punjab (Pakistan). *Pakistan: the political economy of human resource development /* Karamat Ali [& others]. Lahore: Vanguard, 2001, pp.31-69.

4177 ALI, Khadija. Balancing budgets on women's backs: a case study of Pakistani urban working women. *Pakistan Economic and Social Review,* 38 i (2000) pp.87-127.

4178 ALI, Shaheen Sardar. A critical review of family laws in Pakistan: a women's perspective. *Women's law in legal education and practice in Pakistan: north south cooperation.* Ed. Rubya Mehdi & Farida Shaheed. Copenhagen: New Social Science Monograph, 1997, pp.198-223.

4179 ALI, Syed Mubashir. Gender and health care utilisation in Pakistan. *Pakistan Development Review,* 39 iii (2000) pp.213-234.

4180 ALI, Syed Mubashir & SULTAN, Mehboob. Socio-cultural constraints and women's decision-making power regarding reproductive behaviour. *Pakistan Development Review,* 38 iv (1999) pp.689-696. [In Pakistan.]

4181 ALVI, H. & RAUSE, S. Pakistani feminism and feminist movement. *Muslim feminism and feminist movement: South Asia.* Vol. 2: *Pakistan.* Ed. Abida Samiuddin, R.Khanam. Delhi: Global Vision Publishing House, 2002, pp.1-51. [Before and after Partition.]

4182 ARIF, G.M., NAJAM US SAQIB & ZAHID, G.M. Poverty, gender, and primary school enrolment in Pakistan. *Pakistan Development Review,* 38 iv (1999) pp.979-992. [Comments by Aliya H.Khan, pp.991-992.]

4183 ASEER, Sher Wali Khan. The marriage of daughters in Chitral. *Proceedings of the Second International HinduKush Cultural Conference.* Ed. Elena Bashir, Israr-ud-Din. Karachi: Oxford University Press, 1996, (Hindukush and Karakoram Studies, 1), pp.201-208.

4184 ASHRAF, Birjees & ASHRAF, Javed. Evidence on gender wage discrimination from the 1984-85 *HIES*: a note. *Pakistan Journal of Applied Economics,* 12 i (1996) pp.85-94. (Pakistan ... Household & Income Expenditure Surveys.)

4185 ASHRAF, Javed & ASHRAF, Birjees. Earnings in Karachi: does gender make a difference? *Pakistan Economic and Social Review,* 36 i (1998) pp.33-46.

4186 ASLAM SHAH, Nasreen. Urban slums: women's struggle for survival. *Pakistan Journal of Women's Studies: Alam-e-Niswan,* 4 ii (1997) pp.81-83. (Karachi.)

4187 BAHRI, Deepika. Telling tales: women and the trauma of Partition in Sidhwa's *Cracking India. Interventions,* 1 ii (1999) pp.217-234.

4188 BALCHIN, Cassandra & WARRAICH, Sohail Akbar. Untying the gordian knot: the theory and practice of divorce in Pakistan. *Women's law in legal education and practice in Pakistan: north south cooperation.* Ed. Rubya Mehdi & Farida Shaheed. Copenhagen: New Social Science Monograph, 1997, pp.260-275.

4189 BANO, Sabra. Women, class, and Islam in Karachi. *Family and gender in Pakistan: domestic organization in a Muslim society.* Ed. H.Donnan & F.Selier. Delhi: Hindustan Publishing Corporation, 1997, pp.189-207.

4190 BAQAI, Farah Gul. Begum Shaista Ikramullah: a woman who dared (1915-2000). *Pakistan Journal of History and Culture,* 21 ii (2000) pp.99-103. [Social & political activist in Delhi & Karachi.]

4191 BHATTI, Tasneem. Human rights status of rural women in Sindh: a report. *Pakistan Journal of Women's Studies: Alam-e-Niswan,* 4 ii (1997) pp.87-91.

4192 CARROLL, L. Qur'an 2:229: `A charter granted to the wife`? Judicial *khul'* in Pakistan. *Islamic Law and Society,* 3 i (1996) pp.91-126.

4193 CECCHERINI, Valérie. Rape and the Prophet: the women of Pakistan. *Index on Censorship,* 28 i / 186 (1999) pp.19-26. [*Zina* ordinance.]

4194 DAYAL, Samir. Style is (not) the woman: Sara Suleri's *Meatless days. Between South Asians and postcoloniality: the lines.* Ed. D.Bahri & M.Vasudeva. Philadelphia: Temple University Press, 1996, pp.250-269. [Title of volume should probably read: *Between the lines: South Asians and postcoloniality.*]

4195 DEDEBANT, Christèle. Conditions d'élaboration de la rhétorique féministe des ONG pakistanaises. *Revue des Mondes Musulmans et de la Méditerranée,* 85-86 (1999) pp.203-213.

4196 DEDEBANT, Christèle. Feminists in Pakistan. Rhetoric
 and models. *Crisis and memory in Islamic societies.*
 Proceedings of the third Summer Academy of the Working
 Group Modernity and Islam held at the Orient Institute of
 the German Oriental Society in Beirut / ed. Angelika
 Neuwirth and Andreas Pflitsch. Beirut: Orient-Institut der
 Deutschen Morgenländischen Gesellschaft; Würzburg:
 Ergon, 2001, (Beiruter Texte und Studien, 77),
 pp.389-402.

4197 DONNAN, Hastings. Return migration and female-headed
 households in rural Punjab. *Family and gender in*
 Pakistan: domestic organization in a Muslim society. Ed.
 H.Donnan & F.Selier. Delhi: Hindustan Publishing
 Corporation, 1997, pp.110-131.

4198 EWING, K. P. A *Majzub* and his mother: the place of
 sainthood in a family's emotional memory. *Embodying*
 charisma: modernity, locality and the performance of
 emotion in Sufi cults. Ed. P.Werbner & Helene Basu.
 London: Routledge, 1998, pp.160-183. [Pakistan.]

4199 FARIDI, A.R. Maulana 'Usmani's justification of women's
 rights in Islam. *Muslim feminism and feminist movement:*
 South Asia. Vol. 2: *Pakistan.* Ed. Abida Samiuddin,
 R.Khanam. Delhi: Global Vision Publishing House, 2002,
 pp.211-223. [Contemporary Pakistani Islamic scholar
 and jurist.]

4200 FAROOQI, Yasmin. Assessment, treatment and prevention
 of child abuse. *Pakistan Journal of Women's Studies.*
 Alam-e-Niswan, 3 i (1996) pp.79-86. [Case studies of 2
 girls in Pakistan.]

4201 FAROOQI, Yasmin N. Endurance of spousal aggression:
 helplessness or fear of social condemnation. *Pakistan*
 Journal of Women's Studies. Alam-e-Niswan, 5 i-ii (1998)
 pp.27-43. (Among the Pakistan married women.)

4202 FAROOQI, Yasmin N. Sexual harassment and
 post-traumatic stress disorder among female doctors on
 house-job. *Pakistan Journal of Women's Studies.*
 Alam-e-Niswan, 4 i (1997) pp.31-39. (Three different
 certified government hospitals in Lahore.)

4203 FATIMA, A.M. Class structure within the feminist
 movement: shifts and implications. *Muslim feminism*
 and feminist movement: South Asia. Vol. 2: *Pakistan.* Ed.
 Abida Samiuddin, R.Khanam. Delhi: Global Vision
 Publishing House, 2002, pp.71-81.

4204 FAZLI, Tahira Sadia. Housing credit programmes:
 collaterals requirements: a study from women's perspective.
 Pakistan Journal of Women's Studies: Alam-e-Niswan, 4
 ii (1997) pp.71-80. (Pakistan.)

4205 FENTZ, M. Kalasha kvindens røde perler. *Jordens Folk,*
 29 ii (1994) pp.73-79.

4206 FIKREE, Fariyal F., RIZVI, Narjis, JAMIL, Sarah &
 HUSAIN, Tayyiba. The emerging problem of induced
 abortions in squatter settlements of Karachi, Pakistan.
 Demography India, 25 i (1996) pp.119-130.

4207 GANGADHARAN, Lata & MAITRA, Pushkar. Does
 child mortality reflect gender bias? Evidence from
 Pakistan. *Indian Economic Review,* 35 ii (2000)
 pp.113-131.

4208 GARDEZI, Fauzia. Nationalism and state formation:
 women's struggles and Islamization in Pakistan.
 Engendering the nation-state. Vol. 1. Ed. by Neelam
 Hussain, Samiya Mumtaz, Rubina Saigol. Lahore:
 Simorgh, 1997, pp.79-110.

4209 GOHEER, Nabeel A. Poverty in Pakistan: increasing
 incidence, chronic gender preponderance, and the
 plausibility of Grameen-type intermediation. *Pakistan*
 Development Review, 38 iv (1999) pp.873-894.
 [Comments by Zafar Mueen Nasir, p.894.]

4210 HAERI, Shahla. Woman's body, nation's honor: rape in
 Pakistan. *Hermeneutics and honor: negotiating female*
 "public" space in Islamic/ate societies. Ed. Asma
 Afsaruddin. Cambridge (USA): Harvard University Press,
 for the Center for Middle Eastern Studies of Harvard
 University, 1999, (Harvard Middle Eastern monographs,
 32), pp.55-69.

4211 HALVERSON, S. J., AZIZ, Nahida & ALIBHOY, Karim.
 Strategies to involve women in water supply and sanitation.
 Sanitation and water for all. (Proceedings of the 24th
 WEDC Conference, Islamabad, Pakistan 1998.) Ed.
 J.Pickford. Loughborough: Water, Engineering and
 Development Centre, 1998, pp.233-236. (Pakistan.)

4212 HAQ, Farhat. Women, Islam and the state in Pakistan.
 Muslim World, 86 ii (1996) pp.158-175.

4213 HAQUE, Huma. Class, gender, violence and hegemonic
 discourse: a case study of rural Punjab. *Women's law in*
 legal education and practice in Pakistan: north south
 cooperation. Ed. Rubya Mehdi & Farida Shaheed.
 Copenhagen: New Social Science Monograph, 1997,
 pp.245-259. (Pakistan.)

4214 HAROON, Anis. Women's participation in the Muttahida
 Qaumi Movement. *Muslim feminism and feminist*
 movement: South Asia. Vol. 2: *Pakistan.* Ed. Abida
 Samiuddin, R.Khanam. Delhi: Global Vision Publishing
 House, 2002, pp.83-119.

4215 HASSAN, Riffat. Is Islam a help or hindrance to women's
 development? *Islam in the era of globalization: Muslim*
 attitudes towards modernity and identity. Ed. by Johan
 Meuleman. London: RoutledgeCurzon, 2002, pp.189-209.
 [How is it that in Pakistan, which professed its commitment
 to both Islam and modernity, manifestly unjust laws could
 be implemented, especially in relation to women?]

4216 HASSELL, Palvasha von. Asma Jahangir, lawyer and
 human rights activist from Pakistan. *Orient: Deutsche*
 Zeitschrift für Politik und Wirtschaft des Orients, 41 iv
 (2000) pp.546-554. (Kurzbiographien.)

4217 HAZARIKA, Gautam. Gender differences in children's
 nutrition and access to health care in Pakistan. *Journal of*
 Development Studies, 37 i (2000) pp.73-92.

4218 HEGLAND, M. E. A mixed blessing: the *Majales* - Shi'a
 women's rituals of mourning in northwest Pakistan.
 Mixed blessings: gender and religious fundamentalism
 cross culturally. Ed. J.Brink & J.Mencher. New York &
 London: Routledge, 1997, pp.179-196.

4219 HEGLAND, M. E. Flagellation and fundamentalism:
 (trans)forming meaning, identity, and gender through
 Pakistani women's rituals of mourning. *American*
 Ethnologist, 25 ii (1998) pp.240-266.

4220 HEGLAND, M. E. Gender and religion in the Middle East
 and South Asia: women's voices rising. *Social history*
 of women and gender in the modern Middle East / ed.
 M.L.Meriwether, J.E.Tucker. Boulder: Westview, 1999,
 pp.177-212. [Iran & Pakistan.]

4221 HEGLAND, M. E. Popular piety during Muharram: Shî'ah
 Muslim women and life cycle identity in Peshawar,
 Pakistan. *Bulletin of the Henry Martyn Institute of Islamic*
 Studies, 17 i (1998) pp.76-88.

4222 HEGLAND, M. E. The power paradox in Muslim women's
 Majales: north-west Pakistani mourning rituals as sites of
 contestation over religious politics, ethnicity, and gender.
 Signs, 23 ii (1998) pp.391-428.

4223 HEGLAND, Mary Elaine. The power paradox in Muslim
 women's *Majales*: north-west Pakistani mourning rituals
 as sites of contestation over religious politics, ethnicity,
 and gender. *Gender, politics, and Islam.* Ed. Therese
 Saliba, Carolyn Allen and Judith A.Howard. Chicago:
 University of Chicago Press, 2002, pp.95-132.
 [Originally published in *Signs,* 23 ii (1998).]

4224 HERBERS, H. Ernährungssicherung in Nord-Pakistan:
 der Beitrag der Frauen. (Summary: Securing food in
 northern Pakistan: the women's share.). *Geographische*
 Rundschau, 47 iv (1995) pp.234-239.

4225 HERBERS, Hiltrud. The changing position of women in
 northern Pakistan: from agricultural producers to off-farm
 employees. *Perspectives on history and change in the*
 Karakorum, Hindukush, and Himalaya. I.Stellrecht,
 M.Winiger (eds.). Cologne: Köppe, 1997, (Culture Area
 Karakorum Scientific Studies, 3), pp.417-430.

4226 HUSSAIN, Anusheh. The sexual exploitation and sexual abuse of children in Pakistan. *Women's law in legal education and practice in Pakistan: north south cooperation.* Ed. Rubya Mehdi & Farida Shaheed. Copenhagen: New Social Science Monograph, 1997, pp.233-244.

4227 HUSSAIN, Freda. Women education and national development. *Muslim feminism and feminist movement: South Asia.* Vol. 2: *Pakistan.* Ed. Abida Samiuddin, R.Khanam. Delhi: Global Vision Publishing House, 2002, pp.157-189.

4228 HUSSAIN, Neelam. The narrative appropriation of Saima: coercion and consent in Muslim Pakistan. *Engendering the nation-state.* Vol. 1. Ed. by Neelam Hussain, Samiya Mumtaz, Rubina Saigol. Lahore: Simorgh, 1997, pp.199-241. (Married against the wishes of her parents and paved the way for a contentious legal debate.)

4229 HUSSAIN, R. Community perceptions of reasons for preference for consanguineous marriages in Pakistan. *Journal of Biosocial Science,* 31 iv (1999) pp.449-461. Also online at www.journals.cup.org

4230 HUSSAIN, R. & BITTLES, A.H. Consanguineous marriage and differentials in age at marriage: contraceptive use and fertility in Pakistan. *Journal of Biosocial Science,* 31 i (1999) pp.121-138. Also online at www.journals.cup.org

4231 HUSSAIN, R. & BITTLES, A. H. The prevalence and demographic characteristics of consanguineous marriages in Pakistan. *Journal of Biosocial Science,* 30 ii (1998) pp.261-275.

4232 HYAT, Kamila. Images of the family in print media. *Engendering the nation-state.* Vol. 2. Ed. by Neelam Hussain, Samiya Mumtaz, Rubina Saigol. Lahore: Simorgh Women's Resource and Publication Centre, 1997, pp.65-71. [Women's roles presented in advertisements & newspaper articles in Pakistan.]

4233 ILAHI, Nadeem & GRIMARD, Franque. Public infrastructure and private costs: water supply and time allocation of women in rural Pakistan. *Economic Development and Cultural Change,* 49 i (2000) pp.45-75.

4234 ILYAS, Zareen. Women's Studies Library: a catalyst for social change. *Pakistan Journal of Women's Studies. Alam-e-Niswan,* 5 i-ii (1998) pp.111-114. (At the University of Karachi.)

4235 ISMAIL, Zafar H. Gender differentials in the cost of primary education: a study of Pakistan. *Pakistan Development Review,* 35 iv (1996) pp.835-849.

4236 J[A]HANGIR, Asma. Secularising Pakistan: injustice to women as witness. *Pakistan between secularism and Islam: ideology, issues & conflict.* Islamabad: Institute of Policy Studies, 1998, pp.263-273. [Women's evidence in law. Discussion, pp.289-306.]

4237 JAHANGIR, Asma. Women's rights are human rights: Pakistan's judicial system. *Old roads, new highways: fifty years of Pakistan.* Ed. V.Schofield. Karachi: Oxford University Press, 1997, pp.156-173.

4238 JAMAL, Khadija. Water and environmental sanitation projects - why women? *Sanitation and water for all. (Proceedings of the 24th WEDC Conference, Islamabad, Pakistan 1998.)* Ed. J.Pickford. Loughborough: Water, Engineering and Development Centre, 1998, pp.237-240. (Pakistan.)

4239 JAN, Tarik. Hudud laws: a safeguard against irresponsible sex. *Pakistan between secularism and Islam: ideology, issues & conflict.* Islamabad: Institute of Policy Studies, 1998, pp.331-346. [Discussion, pp.347-357.]

4240 JEJEEBHOY, Shireen J. & SATHAR, Zeba A. Women's autonomy in India and Pakistan: the influence of religion and region. (Abstracts: L'autonomie des femmes in Inde et au Pakistan: l'influence de la religion et de la région; Autonomía de la mujer en India y Pakistán: influencia de religión y región.). *Population and Development Review,* 27 iv (2001) pp.687-712;823;825. Also online at www.popcouncil.org/pdr [Muslims & Hindus in India, Muslims in Pakistan Panjab.]

4241 JIVAN, J. Country focus: women's situation in Pakistan. *Al-Mushir,* 41 iii (1999) pp.117-135.

4242 JOYIA, Muhammad Fiaz & KHALIQ, Parvez. Women's role in upland agricultural development in Pakistan. *Women in upland agriculture in Asia: proceedings of a workshop held in Chiang Mai ... 1995.* Ed. C.E.van Santen, J.W.T.Bottema, D.R.Stoltz. Bogor: CGPRT Centre, 1996, (CGPRT, no. 33), pp.241-249.

4243 KAMAL, Simi. Property ownership and control by rural women: effects of the interplay of formal and customary laws. *Pakistan Journal of Women's Studies. Alam-e-Niswan,* 4 i (1997) pp.25-29. (In rural areas of three provinces in Pakistan.)

4244 KAZI, Shahnaz. Gender inequalities and development in Pakistan. *Fifty years of Pakistan's economy: traditional topics and contemporary concerns.* Ed. Shahrukh Rafi Khan. Oxford: Oxford University Press, 1999, pp.376-414.

4245 KAZI, Shahnaz & SATHAR, Zeba A(yesa). The relative roles of gender and development in explaining fertility in rural Punjab. *Fertility transition in South Asia.* Ed. Zeba Ayesa Sathar and James E.Phillips. Oxford: Oxford University Press, 2001, pp.242-262. (Pakistan.)

4246 KHATTAK, Saba Gul. Gendered and violent: inscribing the military on the nation-state. *Engendering the nation-state.* Vol. 1. Ed. by Neelam Hussain, Samiya Mumtaz, Rubina Saigol. Lahore: Simorgh, 1997, pp.38-52. [Pakistan.]

4247 KHATTAK, Saba Gul. The repercussions of nuclearization on Pakistan women. *Development,* 42 ii (1999) pp.71-73. Also online at www.ingentaselect.com (Women are comparatively more disadvantaged than men.)

4248 LENTZ, Sabine. British officers, Kashmiri officials, adultery and "customary law". *Perspectives on history and change in the Karakorum, Hindukush, and Himalaya.* I.Stellrecht, M.Winiger (eds.). Cologne: Köppe, 1997, (Culture Area Karakorum Scientific Studies, 3), pp.401-415. [Gilgit Agency area 1908, & 1995.]

4249 MAHMOOD, Naushin & RINGHEIM, K. Factors affecting contraceptive use in Pakistan. *Pakistan Development Review,* 35 i (1996) pp.1-22.

4250 MAHMOOD, Naushin & DURR-E-NAYAB. Gender dimensions of demographic change in Pakistan. *Pakistan Development Review,* 37 iv (1998) pp.705-725. [Comments by Eshya Mujahid-Mukhtar, pp.722-725.]

4251 MATHUR, Deepa. Women in transition: a study in the context of Pakistan. *Contemporary Pakistan: trends and issues.* (Vol.I). Eds. Ramakant, S.N.Kaushik, Shashi Upadhyaya. Delhi: Kalinga, 2001, (South Asia Studies, 38), pp.77-89.

4252 MEHDI, Rubya. Introducing women's law as a part of legal education in Pakistan. *Women's law in legal education and practice in Pakistan: north south cooperation.* Ed. Rubya Mehdi & Farida Shaheed. Copenhagen: New Social Science Monograph, 1997, pp.24-46. (Legal situation of women in Pakistan.)

4253 MEHDI, Rubya. The offence of rape in the Islamic law of Pakistan. *Women Living under Muslim Laws: Dossier,* 18 (1997) pp.98-108. Also online at www.wluml.org/ english/pubs

4254 MILLS, M. A. Winds of change: women's traditional work and educational development in Pakora, Ishkoman Tehsil. *Proceedings of the Second International HinduKush Cultural Conference.* Ed. Elena Bashir, Israr-ud-Din. Karachi: Oxford University Press, 1996, (Hindukush and Karakoram Studies, 1), pp.417-426. [Ismaili households.]

4255 MINHAJ UL-HASAN, Syed. Marriage customs of the Pukhtoons: a case study of Hangu (NWFP), Pakistan. *Pakistan Journal of History and Culture,* 19 ii (1998) pp.85-97.

4256 MIRZA, Jasmin. Accommodating *purdah* to the workplace: gender relations in the office sector in Pakistan. *Pakistan Development Review,* 38 ii (1999) pp.187-206.

4257 MIRZA, Jasmin. Frauen im Bürosektor in Pakistan. *Die geschlechtsspezifische Einbettung der Ökonomie: empirische Untersuchungen über Entwicklungs- und Transformationsprozesse* / Gudrun Lachenmann, Petra Dannecker (Hrsg.). Münster: Lit, 2001, (Market, Culture and Society, 12), pp.269-293.

4258 MIRZA, Jasmin. The gendered organization of work and
 space in the office sector in Pakistan. *Internationales
 Asienforum,* 32 i-ii (2001) pp.7-25.

4259 MUMTAZ, Khawar. Bringing together the rights to
 livelihood and reproductive health. *Development,* 42 i
 (1999) pp.15-17. Also online at www.ingentaselect.com
 [Women in Pakistan.]

4260 MUMTAZ, Khawar & RAUF, Fauzia. Reproductive
 health and rights in the Baja Lines neighbourhood.
 Development, 42 i (1999) pp.54-58. Also online at
 www.ingentaselect.com (South of Lahore, Pakistan.)

4261 MUMTAZ, Khawar. The gender dimension in Sindh's
 ethnic conflict. *Internal conflicts in South Asia.* Ed.
 K.Rupesinghe & Khawar Mumtaz. Oslo: PRIO,
 International Peace Research Institute; London: Sage, 1996,
 pp.144-163.

4262 MUMTAZ, Soofia. Targeting women in micro-finance
 schemes: objectives and outcomes. *Pakistan Development
 Review,* 39 iv (2000) pp.877-890. [Pakistan.]

4263 NIAZ-ANWAR, Unaiza. Women and mental health -
 understanding women in distress. *Pakistan Journal of
 Women's Studies. Alam-e-Niswan,* 3 i (1996) pp.87-91.
 [Pakistan.]

4264 PARVEEN, Farhat & ALI, Karamat. Research in action:
 organising women factory workers in Pakistan.
 *Confronting state, capital and patriarchy: women
 organizing in the process of industrialization.* Ed.
 A.Chhachhi & R.Pittin. Basingstoke: Macmillan; New
 York: St. Martin's Press, in association with the Institute
 of Social Studies, 1996, pp.135-150.

4265 PERZ, Susan M. Women's interview responses regarding
 the situation of women in Pakistan. *Al-Mushir,* 42 iv
 (2000) pp.127-146.

4266 PONTIUS, A. A. No gender difference in spatial
 representation by schoolchildren in Northwest Pakistan.
 Journal of Cross-Cultural Psychology, 28 vi (1997)
 pp.779-786.

4267 QURAISHI, Asifa. Her honor. An Islamic critique of the
 rape laws of Pakistan from a woman-sensitive perspective.
 *Windows of faith: Muslim women scholar-activists in North
 America.* Ed. G.Webb. Syracuse: Syracuse University
 Press, 2000, pp.102-135.

4268 QURAISHI, Asifa. Her honour: an Islamic critique of the
 rape provisions in Pakistan's ordinance on *zina. Islamic
 Studies,* 38 iii (1999) pp.403-431.

4269 RAHMAN, Ghazala, NASIR, Surraiya J. & AZIZ,
 Shagufta. A profile of Pakistani female entrepreneurs.
 Pakistan Journal of Women's Studies. Alam-e-Niswan, 3
 i (1996) pp.1-11.

4270 RAI, Shirin. Crossing boundaries. *Jounal of Gender
 Studies,* 6 i (1997) pp.63-69. [Report on visit to Pakistan
 & current Pakistani law as discussed at Women's Law
 North-South Co-operation Seminar August, 1996.]

4271 RAUF, Fauzia. Environmental transformation and
 conflicts: women's perceptions from rural Punjab, Pakistan.
 Development, 41 iii (1998) pp.91-96.

4272 REHMAN, Javeed. Women's rights: the international law
 perspective with reference to Pakistan. *Women's law in
 legal education and practice in Pakistan: north south
 cooperation.* Ed. Rubya Mehdi & Farida Shaheed.
 Copenhagen: New Social Science Monograph, 1997,
 pp.106-128.

4273 REHMAN, Shakila A. Women in pregnancy: study of
 selected neglected risk factors. *Pakistan Journal of
 Women's Studies. Alam-e-Niswan,* 5 i-ii (1998) pp.73-86.
 (In two areas of Karachi city.)

4274 SADEQUE, Najma. The impact of technology on women's
 lives. *Engendering the nation-state.* Vol. 1. Ed. by
 Neelam Hussain, Samiya Mumtaz, Rubina Saigol. Lahore:
 Simorgh, 1997, pp.29-37. [Mainly Pakistan.]

4275 SAEED, Hilda. Gender and the discourse on health.
 Engendering the nation-state. Vol. 1. Ed. by Neelam
 Hussain, Samiya Mumtaz, Rubina Saigol. Lahore:
 Simorgh, 1997, pp.147-154. [Mainly Pakistan.]

4276 SAEED, Hilda & KHAN, Ayesha. Legalised cruelty:
 anti-women laws in Pakistan. *No paradise yet: the
 world's women face the new century.* Ed. Judith Mirsky
 and Marty Radlett. London: Panos/Zed, 2000,
 pp.119-136.

4277 SAIGOL, Rubina. The gendering of modernity: nineteenth
 century educational discourse. *Engendering the
 nation-state.* Vol. 1. Ed. by Neelam Hussain, Samiya
 Mumtaz, Rubina Saigol. Lahore: Simorgh, 1997,
 pp.155-186. [Reproduced in modern Pakistan state
 ideology.]

4278 SALAM, Mariam. The big wheel goes full circle.
 Pakistani Literature, [6] (2001) pp.195-199. [English
 wife's memoir of life in Pakistan.]

4279 SARDAR ALI, Shaheen. Is an adult Muslim woman *sui
 juris?* Some reflections on the concept of "consent in
 marriage" without a *wali* (with particular reference to the
 Saima Waheed case). *Yearbook of Islamic and Middle
 Eastern Law,* 3 / 1996 (1997) pp.156-174. (Lahore High
 Court.)

4280 SATHAR, Zeba A. & KAZI, Shahnaz. Pakistani couples:
 different productive and reproductive realities? *Pakistan
 Development Review,* 39 iv (2000) pp.891-910. [Panjab.
 Comments by Arshad Mahmood, pp.911-912.]

4281 SATHAR, Zeba A. & KIANI, M. Framurz. Some
 consequences of rising age at marriage in Pakistan.
 Pakistan Development Review, 37 iv (1998) pp.541-556.
 [Comments by Ghulam Yasin Soomro, pp.555-556.]
 Soomro,Ghulam Yasin

4282 SATHAR, Zeba A. Women's schooling and autonomy as
 factors in fertility change in Pakistan: some empirical
 evidence. *Girls' schooling, women's autonomy and
 fertility change in South Asia.* Ed. R.Jeffery & A.M.Basu.
 Delhi: Sage, in association with the Book Review Literary
 Trust, 1996, pp.133-149.

4283 SATHAR, Zeba Ayesha & KAZI, Shahnaz. Women's
 autonomy in the context of rural Pakistan. *Pakistan
 Development Review,* 39 ii (2000) pp.89-110.

4284 SERAJUDDIN, Alamgir Muhammad. The traditionalist
 and modernist response to the Muslim Family Laws
 Ordinance, 1961. *Contributions to Bengal studies: an
 interdisciplinary and international approach.* Ed. Enayetur
 Rahim, Henry Schwarz. Dhaka: Pustaka, 1998,
 pp.335-343. (A significant step in the social evolution
 of Bangladesh & Pakistan.)

4285 SHAH, Nafisa. A woman's sexual space: control and
 deviance. *Pakistan Journal of Women's Studies:
 Alam-e-Niswan,* 4 ii (1997) pp.31-40. (Ideas and material
 ... gathered ... from rural Sindh.)

4286 SHAH, Nafisa. Role of the community in honour killings
 in Sindh. *Engendering the nation-state.* Vol. 1. Ed. by
 Neelam Hussain, Samiya Mumtaz, Rubina Saigol. Lahore:
 Simorgh, 1997, pp.242-259.

4287 SHAH, Nasreen Aslam. Women in fisher(wo)men's village.
 Pakistan Journal of Women's Studies. Alam-e-Niswan, 4
 i (1997) pp.63-73. (In the outskirts of Karachi.)

4288 SHAHEED, Farida. The interface of culture, customs and
 law - implications for women and activism. *Women's
 law in legal education and practice in Pakistan: north
 south cooperation.* Ed. Rubya Mehdi & Farida Shaheed.
 Copenhagen: New Social Science Monograph, 1997,
 pp.47-62. (In the context of Pakistan.)

4289 SHAHEED, Farida. Women, state and power - the
 dynamics of variation and convergence across east and
 west. *Engendering the nation-state.* Vol. 1. Ed. by
 Neelam Hussain, Samiya Mumtaz, Rubina Saigol. Lahore:
 Simorgh, 1997, pp.53-78. (The contemporary women's
 movement in Pakistan.)

4290 SIDDIQUI, Rehana & SIDDIQUI, Rizwana. A
 decomposition of male-female earnings differentials.
 Pakistan Development Review, 37 iv (1998) pp.885-898.
 [Comments by M.Ramzan Akhtar, pp.897-898.]

4291 SIDDIQUI, Rehana, HAMID, Shahnaz & SIDDIQUI,
 Rizwana. Analysis of non-conventional indicators of
 gender relations: evidence from Pakistan. *Pakistan
 Development Review,* 39 iv (2000) pp.913-929.

4292 TARIQ, Pervaiz. Women convicts: offenders or victims? *Women's law in legal education and practice in Pakistan: north south cooperation.* Ed. Rubya Mehdi & Farida Shaheed. Copenhagen: New Social Science Monograph, 1997, pp.224-232. (In Pakistan.)

4293 WEISS, A.M. Gender relations and women empowerment. *Muslim feminism and feminist movement: South Asia.* Vol. 2: *Pakistan.* Ed. Abida Samiuddin, R.Khanam. Delhi: Global Vision Publishing House, 2002, pp.121-156.

4294 WEISS, A. M. The slow yet steady path to women's empowerment in Pakistan. *Islam, gender, & social change.* Ed. Y.Yazbeck Haddad & J.L.Esposito. New York: Oxford University Press, 1998, pp.124-143.

4295 WEISS, Anita A.M. The gendered division of space and access in working class areas of Lahore. *Contemporary South Asia,* 7 i (1998) pp.71-89.

4296 YASMEEN, Samina. Islamisation and democratisation in Pakistan: implications for women and religious minorities. *South Asia,* Special issue (1999) pp.183-195.

4297 YORK, Susan. Beyond the household: an exploration of private and public spheres in the Yasin Valley. *Family and gender in Pakistan: domestic organization in a Muslim society.* Ed. H.Donnan & F.Selier. Delhi: Hindustan Publishing Corporation, 1997, pp.208-233.

4298 YOUNG, Lindsay. Women's province: ethnicity and Hindu households in rural Sindh. *Family and gender in Pakistan: domestic organization in a Muslim society.* Ed. H.Donnan & F.Selier. Delhi: Hindustan Publishing Corporation, 1997, pp.88-109. (A disadvantaged & stigmatised minority since Partition.)

4299 ZAFAR, Fareeha. Education, gender and the power structure of the state. *Engendering the nation-state.* Vol. 1. Ed. by Neelam Hussain, Samiya Mumtaz, Rubina Saigol. Lahore: Simorgh, 1997, pp.187-198. [Pakistan.]

4300 ZAFAR, Muhammad Iqbal. Husband-wife roles as a correlate of contraceptive and fertility behaviour. *Pakistan Development Review,* 35 ii (1996) pp.145-170. (Pakistan.)

4301 ZAHID, Ghulam Mustafa. Mother's health-seeking behaviour and childhood mortality in Pakistan. *Pakistan Development Review,* 35 iv (1996) pp.719-731.

4302 ZIA, Shehla. Hudud laws: impact on women. *Pakistan between secularism and Islam: ideology, issues & conflict.* Islamabad: Institute of Policy Studies, 1998, pp.309-329. [Discussion, pp.347-357.]

Palestine & the Palestinians see also Israel

Books

4303 ARJONILLA, Sofía. *La mujer palestina en Gaza.* Madrid: Ediciones del Oriente y del Mediterráneo, 2001 (Colección Encuentros, 3), 155pp.

4304 'ASHRĀWĪ, Ḥanān. *Ich bin in Palästina geboren: ein persönlicher Bericht.* Tr. Sternheimer, M. Berlin: Siedler, 1995. 347pp. [Tr. of *This side of peace,* New York 1995.]

4305 EMMETT, A. *Our sisters' promised land: women, politics, and Israeli-Palestinian coexistence.* Ann Arbor: University of Michigan Press, 1996. 278pp.

4306 FARAH, Najwa Kawar. *A continent called Palestine: one woman's story.* London: Triangle SPCK, 1996. 136pp. [Autobiography, 1930s-80s.]

4307 FARHAT-NASER, Sumaya. *Thymian und Steine: eine palästinensische Lebensgeschichte.* Basle: Lenos-Verlag, 1995. 274pp.

4308 FARHAT-NASER, Sumaya. *Verwurzelt im Land der Olivenbäume: eine Palästinenserin im Streit für den Frieden.* Ed. Wilhelm, Dorothee. Basle: Lenos, 2002. 270pp.

4309 GORKIN, M. & OTHMAN, Rafiqa. *Three mothers, three daughters: Palestinian women's stories.* Berkeley: University of California Press, 1996. 234pp. Also online at http:// escholarship.cdlib.org/ucpressbooks.html

4310 GRÜNERT, A. *Der längste Weg heisst Frieden: die Frauen im ersten palastinensischen Parlament.* Munich: Deutscher Taschenbuch Verlag, 1998. 381pp.

4311 HAJ YAHIA, Muhammad M. *Wife-abuse and battering in the West Bank and Gaza: results of two national surveys.* Ramallah: Bisan Centre for Research and Development, 1999. 72pp.

4312 HAWA-TAWIL, Raymonda & FERRÉ, Christophe. *Palestine, mon histoire: récit.* Paris: Seuil, 2001. 247pp.

4313 KANAFANI, Fay Afaf. *Nadia, captive of hope: memoir of an Arab woman.* Armonk: Sharpe, 1998. 346pp. (Recounts experiences in Lebanon and Palestine from the close of World War I in 1918 to the Israeli invasion of Lebanon in 1982.)

4314 KAWAR, Amal. *Daughters of Palestine: leading women of the Palestinian national movment.* Albany (USA): State University of New York Press, 1996. 159pp.

4315 [NUWAYHIḌ, Jamāl Salīm]. *Abu Jmeel's daughter and other stories: Arab folk tales from Palestine and Lebanon* / told by Jamal Sleem Nuweihed; tr. by members of her family with Christopher Tingley. New York: Interlink Books, 2002. 348pp.

4316 RAWI, Rosina-Fawzia al-. *Gelber Himmel, rote Erde: Frauenleben in Palästina.* Vienna: Promedia, 1994. 151pp.

4317 RUBENBERG, Cheryl A. *Palestinian women: patriarchy and resistance in the West Bank.* Boulder: Rienner, 2001. 318pp.

4318 SALAH, Racha & BALBONT, L. *L'an prochain à Tiberiade: lettres d'une jeune Palestinienne du Liban.* Paris: Albin Michel, 1996. 250pp.

4319 SEBAG, G. *Enfant de Palestine: Soha Arafat.* Paris: Lafon, 1995. 234pp.

4320 SEBAG, G. *Soha Arafat: haar leven: dochter van het Palestijnse volk.* Baarn: De Kern, 1996. 234pp. [Tr. of *Enfant de Palestine: Soha Arafat,* Paris 1995.]

4321 SHAHID, Serene Husseini. *Jerusalem memories.* Ed. Makdisi, Jean Said. Beirut: Naufal, 1999. 278pp.

4322 SH'HADA, Nahda Y. *Gender and politics in Palestine: discourse analysis of the Palestinian Authority & Islamists.* The Hague: Institute of Social Studies, 1999 (Working Paper Series, 307), 88pp.

4323 SIGAUT, M. *Libres femmes de Palestine: l'invention d'un système de santé.* Paris: Ed. de l'Atelier, 1996. 174pp.

4324 TUCKER, J. E. *In the house of the law: gender and Islamic law in Ottoman Syria and Palestine.* Berkeley: University of California Press, 1998. 221pp.

4325 WELCHMAN, Lynn. *Beyond the code: Muslim family law and the shari'a judiciary in the Palestinian West Bank.* The Hague: Kluwer Law International, 2000. 444pp.

4326 WELCHMAN, Lynn. *Islamic family law: text and practice in Palestine.* Jerusalem: Women's Centre for Legal Aid and Counselling, 1999. 230pp.

4327 *Israël-Palestine: des femmes contre la guerre.* Textes rassemblés par Naama Farjoun. Tr. Guichard, Marc. Paris: Dagorno, 2001. 189pp. [Messages from the Internet.]

4328 *La place de la femme dans la vie publique et dans la prise de décision: une étude comparative: le cas de l'Europe, du Canada, du Maroc et de la Palestine* / Institut International des Sciences Administratives. Paris: L'Harmattan, 1997. 141pp.

4329 *Palestine/Israel directory: a guide to independent Palestinian and Israeli initiatives for human rights, women rights, social and economic justice, peace and cooperation; Palestinian and Israeli authorities and official institutions.* 4th rev. ed. Compiled by I.Jaradat Gassner, S.Katz, S.Nissen, Ziad Abbas Shamroukh. Jerusalem & Bethlehem: Alternative Information Center, 1996. 124pp.

4330 *Palestinian women of Gaza and the West Bank.* Ed.
Sabbagh, Suha. Bloomington & Indianapolis: Indiana
University Press, 1998. 262pp.

4331 *The evolution and development of democracy in Israel and
Palestine. Religious laws of personal status; freedom of
the press; confronting extremism; women's rights in
religious and democratic societies.* Jerusalem: IPCRI,
Israel/Palestine Center for Research and Information, 1998,
(Civil Society Publications), 153pp.

Articles

4332 ABDALLAH, S. L. Femmes dans les camps: rencontres
avec les femmes des camps palestiniens de Jordanie.
Revue d'Études Palestiniennes, N.S. 2 / 54 (1995)
pp.6-14.

4333 ABDALLAH, S. L. Les femmes palestiniennes continuent
leur combat. *Revue d'Études Palestiniennes,* NS 6 / 58
(1996) pp.67-74. [Discussions with Palestinian women
at Forum for Non-governmental Organisations associated
with Beijing Conference for Women.]

4334 ABDO, Nahla. Gender and politics under the Palestinian
Authority. *Journal of Palestine Studies,* 28 ii / 110 (1999)
pp.38-51.

4335 ABDO, Nahla. Women, war and peace: reflection from
the Intifada. *Women's Studies International Forum,* 25 v
(2002) pp.585-593. Also online at http://
www.sciencedirect.com/science/journal/02775395

4336 ABDULHADI, Rabab. The Palestinian women's
autonomous movement: emergence, dynamics, and
challenges. *Gender & Society,* 12 vi (1998) pp.649-673.

4337 AGMON, I. Muslim women in court according to the *sijill*
of late Ottoman Jaffa and Haifa: some methodological
notes. *Women, the family, and divorce laws in Islamic
history.* Ed. A.El Azhary Sonbol. Syracuse: Syracuse
University Press, 1996, pp.126-141.

4338 AGMON, I. Women, class, and gender: Muslim Jaffa and
Haifa at the turn of the 20th century. *International
Journal of Middle East Studies,* 30 iv (1998) pp.477-500.
(Four court cases.)

4339 AMAR, Netta & ARURI, Hanan. One Beijing - two
identities. *Palestine-Israel Journal,* 3 i (1996) pp.96-99.
(Israeli and Palestinian women at the 4th UN conference
and NGO Forum on Women, 1995.)

4340 AMERI, Anan. Conflict in peace: challenges confronting
the Palestinian women's movement. *Hermeneutics and
honor: negotiating female "public" space in Islamic/ate
societies.* Ed. Asma Afsaruddin. Cambridge (USA):
Harvard University Press, for the Center for Middle Eastern
Studies of Harvard University, 1999, (Harvard Middle
Eastern monographs, 32), pp.29-54.

4341 AQTUM, Musa T. al-. Biological characteristics of
smokers and nonsmokers among males and females in
Nablus area in the West Bank. *Al-Balqa',* 4 ii (1996)
pp.55-70.

4342 ASHRAWI, Hanan. Two short stories by a Palestinian
feminist. *Palestinian women of Gaza and the West Bank.*
Ed. Suha Sabbagh. Bloomington & Indianapolis: Indiana
University Press, 1998, pp.145-149.

4343 ATA, Abe W. Intermarriage in Palestine. *ISIM Newsletter,*
7 (2001) pp.33-33. [Christian-Muslim marriages.]

4344 ATRASH, Laila al-. A multiple identity. *Islamic Studies,*
40 iii-iv (2001) pp.655-660. [Jerusalem origins &
Palestinian childhood.]

4345 ATSHAN, Leila. Disability and gender at a cross-roads:
a Palestinian perspective. *Gender and disability: women's
experiences in the Middle East.* / Lina Abu-Habib. Oxford:
Oxfam, 1997, pp.53-59.

4346 BADR, Liyana. I returned to Jerusalem. *Islamic Studies,*
40 iii-iv (2001) pp.479-482.

4347 BARRAK, Anissa. Palestiniennes sur deux fronts: entretien
avec Mayada Bamieh Abbassi. *Confluences
Méditerranée,* 17 (1996) pp.109-115.

4348 BERGER GLUCK, S. Shifting sands, the
feminist-nationalist connection in the Palestinian
movement. *Feminist nationalism.* L.A.West. New York:
Routledge, 1997, pp.101-129. [Inside Palestine.]

4349 BERGER GLUCK, S. Where were the Palestinians?
Another view from Huairou. *AMEWS Newsletter,* 10 iv
(1996) pp.7-8. [Fourth World Conference on Women,
Beijing, September 1995.]

4350 BOTIVEAU, Bernard. L'islam dans la construction
nationale palestinienne: le débat sur le droit de la famille.
Annales de l'Autre Islam, 8 / 2001 (2002) pp.135-154.

4351 BOUKHARI, Houda. Invisible victims: working with
mothers of children with learning disabilities. *Gender
and disability: women's experiences in the Middle East.* /
Lina Abu-Habib. Oxford: Oxfam, 1997, pp.36-45.
[Lebanese & Palestinians in Beirut.]

4352 BREDESEN, I. S. Fire kvinner og en fred.
3.Verden-Magasinet X, 3 v (1994) pp.31-32. [Palestinian
women in Palestine.]

4353 CARRE, O. Interrogations sur le viol en contexte
musulman contemporain, notamment palestinien.
Maghreb Review, 22 iii-iv (1997) pp.221-236.
[Palestinian victim of both Israeli soldiers & PLO cadres.]

4354 CARRÉ, Olivier. Nationalisme palestinien et droit
musulman de la famille à propos de viols en état de guerre.
L'Orient au cœur: en l'honneur d'André Miquel. Sous la
responsabilité de Floréal Sanagustin. Paris: Maisonneuve
& Larose, 2001, pp.283-297.

4355 CHARLESWORTH, H. International human rights law:
prospects and problems for Palestinian women. *Human
rights: self-determination and political change in the
Occupied Palestinian Territories.* Ed. S.Bowen. The
Hague: Nijhoff, 1997, (International Studies in Human
Rights, 52), pp.79-91.

4356 CHAZAN, N. The role of women and female leadership
in the Intifada and the peace process. *The PLO and
Israel: from armed conflict to political solution,
1964-1994.* Ed. A.Sela & M.Ma'oz. Basingstoke:
Macmillan, 1997, pp.213-219.

4357 CHINKIN, C. The potential and pitfalls of the right to
self-determination for women. *Human rights:
self-determination and political change in the Occupied
Palestinian Territories.* Ed. S.Bowen. The Hague: Nijhoff,
1997, (International Studies in Human Rights, 52),
pp.93-117. [Palestinian women.]

4358 COHEN, Amnon. A tale of two women: a Jewish
endowment in 19th century Jerusalem. *Linguistic and
cultural studies on Arabic and Hebrew. Essays presented
to Professor Moshe Piamenta for his eightieth birthday.*
Ed. Judith Rosenhouse & Ami Elad-Bouskila. Wiesbaden:
Harrassowitz, 2001, pp.235-253. (An attempt of the new
Chief Rabbi to declare unlawful their newly acquired rights
was nullified by the Muslim *kadi.*)

4359 DOUMANI, Beshara [B.]. Endowing family: *Waqf,*
property devolution, and gender in greater Syria, 1800 to
1860. *Comparative Studies in Society and History,* 40 i
(1998) pp.3-41. (Extant Islamic court records ... Nablus
& Tripoli.)

4360 ENDERWITZ, Susanne. Palestinian autobiographies: a
source for women's history? *Writing the feminine: women
in Arab sources.* Ed. by Manuela Marín and Randi
Deguilhem. London: Tauris, in association with The
European Science Foundation, Strasbourg, France, 2002,
(The Islamic Mediterranean, 1), pp.49-72.

4361 FARHAT-NASER, Sumaya & SVIRSKY, Gila. Dialogue
in the war zone: Israeli and Palestinian women for peace.
Eye to eye: women practising development across cultures
/ ed. Susan Perry & Celeste Schenk. London: Zed, 2001,
pp.134-154.

4362 FLEISCHMANN, Ellen L. The emergence of the
Palestinian women's movement, 1929-39. *Journal of
Palestine Studies,* 29 iii / 115 (2000) pp.16-32.

4363 GHANEM, Hunaïda. De la prison à l'exclusion sociale.
Confluences Méditerranée, 17 (1996) pp.117-120.
(Femmes et guerres: Palestine.)

4364 GIACAMAN, R. Auf der Suche nach Strategien: die palästinensische Frauenbewegung in der neuen Ära. Tr. Strigl, H. ... *alles ändert sich die ganze Zeit: soziale Bewegung(en) im `Nahen Osten`.* Hrsg. J.Später, Freiburg i. B. : Informationszentrum Dritte Welt (1994) pp.201-205.

4365 GIACAMAN, R., JAD, Islah & JOHNSON, P. For the common good? Gender and social citizenship in Palestine. *Middle East Report,* 26 i / 198 (1996) pp.11-16.

4366 GIACAMAN, R. Für die soziale Integration der Frau: ein Gespräch über Frauen in Palästina, die Intifāda und den Stand der Unabhängigkeit. Tr. Sträter, F. *... alles ändert sich die ganze Zeit: soziale Bewegung(en) im `Nahen Osten`.* Hrsg. J.Später, Freiburg i. B. : Informationszentrum Dritte Welt (1994) pp.191-200.

4367 GIACAMAN, R. Le sexisme et les conditions de santé dans les territoires occupés. Tr. Sivan, A. B. *Revue d'Études Palestiniennes,* 51 (1994) pp.73-80.

4368 GIACAMAN, R. The women's movement on the West Bank. *Arab women: between defiance and restraint.* Ed. Suha Sabbagh. New York: Olive Branch Press, 1996, pp.127-133.

4369 GIACAMAN, Rita, JAD, Islah & JOHNSON, Penny. For the common good? Gender and social citizenship in Palestine. *Women and power in the Middle East.* Ed. Suad Joseph & Susan Slyomovics. Philadephia: University of Pennsylvania Press, 2001, pp.126-134;212-213.

4370 GIACAMAN, Rita & JOHNSON, Penny. Intifada Year Four: notes on the women's movement. *Palestinian women of Gaza and the West Bank.* Ed. Suha Sabbagh. Bloomington & Indianapolis: Indiana University Press, 1998, pp.216-230.

4371 GIACAMAN, Rita & JOHNSON, Penny. Searching for strategies: the Palestinian women's movement in the new era. *Women and power in the Middle East.* Ed. Suad Joseph & Susan Slyomovics. Philadephia: University of Pennsylvania Press, 2001, pp.150-158;214.

4372 GIBB, Camilla & ROTHENBERG, Celia. Believing women: Harari and Palestinian women at home and in the Canadian diaspora. *Journal of Muslim Minority Affairs,* 20 ii (2000) pp.243-259. Also online at www.catchword.com

4373 GLAVANIS-GRANTHAM, K. The women's movement, feminism and the national struggle in Palestine: unresolved contradictions. *Women and politics in the Third World.* Ed. Haleh Afshar. London: Routledge, 1996, pp.171-185. [Mainly *Intifada* years.]

4374 GOLAN, D. *Jerusalem Link*: des femmes pour la paix. *Confluences Méditerranée,* 17 (1996) pp.121-127.

4375 HAJ-YAHIA, Muhammad M. Beliefs about wife beating among Palestinian women: the influence of their patriarchal ideology. *Violence against Women,* 4 v (1998) pp.533-558.

4376 HALABI, Jehad Omar. The experience of managing diabetes in Palestinian women in refugee camps in Jordan. *Journal of IMA,* 31 iv (1999) pp.176-182.

4377 HALABI, Jehad Omar. The impact of diabetes on Palestinian women in refugee camps in Jordan. *Journal of IMA,* 31 i (1999) pp.24-32.

4378 HALASA, Malu. Divided in grief. *Index on Censorship,* 27 ii / 181 (1998) pp.66-70. [Widows of Israel & Palestine.]

4379 HAMMAMI, Rema & JOHNSON, Penny. Egalité avec différence: sexe et citoyenneté dans une Palestine en transition. Tr. Naoushi, Nisrine al- & Picaudou, Nadine. *Annales de l'Autre Islam,* 8 / 2001 (2002) pp.279-314.

4380 HAMMAMI, Rema & JOHNSON, Penny. Equality with a difference: gender and citizenship in transitional Palestine. *Social Politics,* 6 iii (1999) pp.314-343.

4381 HAMMAMI, Rema. From immodesty to collaboration: Hamas, the women's movement, and national identity in the Intifada. *Political Islam: essays from* Middle East Report. Ed. J.Beinin & J.Stork. London: Tauris, 1997, pp.194-210.

4382 HAMMAMI, Rema. Gender segmentation in the West Bank and Gaza Strip: explaining the absence of Palestinian women from the formal labor force. *The economics of women and work in the Middle East and North Africa.* Ed. E.Mine Cinar. Amsterdam: JAI, 2001, (Research in Middle East Economics, 4), pp.175-203.

4383 HAMMAMI, Rema. L'Intifada a-t-elle émancipé les femmes? Tr. Sivan, A. B. *Revue d'Études Palestiniennes,* 51 (1994) pp.59-65.

4384 HAMMER, Juliane. Prayer, *ḥijāb* and the *Intifāḍa*: the influence of the Islamic movement on Palestinian women. *Islam and Christian-Muslim Relations,* 11 iii (2000) pp.299-320. Also online at www.catchword.com (In the decade between 1986 & 1996.)

4385 HASSO, Frances S. Modernity and gender in Arab accounts of the 1948 and 1967 defeats. *International Journal of Middle East Studies,* 32 iv (2000) pp.491-510. [Accounts of why Palestinians left.]

4386 HASSO, Frances S. The "women's front": nationalism, feminism, and modernity in Palestine. *Gender & Society,* 12 iv (1998) pp.441-465.

4387 HILTERMANN, J. R. The women's movement during the Uprising. *Palestinian women of Gaza and the West Bank.* Ed. Suha Sabbagh. Bloomington & Indianapolis: Indiana University Press, 1998, pp.41-52.

4388 HOLT, Maria. Palestinian women, violence, and the peace process. *Development in Practice,* 13 ii-iii (2003) pp.208-216. Also online at http:// www.ingentaselect.com

4389 HOLT, Maria. Palestinian women and the contemporary Islamist movement. *Encounters* (Leicester), 3 i (1997) pp.64-75.

4390 HOLT, Maria. Palestinian women and the Intifada: an exploration of images and realities . *Women and politics in the Third World.* Ed. Haleh Afshar. London: Routledge, 1996, pp.186-203.

4391 IBRAHIM, Ibtisam. The status of Arab women in Israel. *Critique: Journal for Critical Studies of the Middle East,* 12 (1998) pp.107-120.

4392 JACOBY, Tami Amanda. Feminism, nationalism and difference: reflections on the Palestinian women's movement. *Women's Studies International Forum,* 22 v (1999) pp.511-523. Also online at www.sciencedirect.com/science/journal/02775395

4393 JAD, Islah. Des salons aux comités populaires: les femmes palestiniennes, 1919-1989. Tr. Sivan, A. B. *Revue d'Études Palestiniennes,* 51 (1994) pp.41-59.

4394 JAD, Islah. Les Palestiniennes face aux mouvements islamistes. *Confluences Méditerranée,* 27 (1998) pp.81-86.

4395 JAD, Islah. Patterns of relationships within the Palestinian family during the Intifada. Tr. Abu Hassabo, Magida. *Palestinian women of Gaza and the West Bank.* Ed. Suha Sabbagh. Bloomington & Indianapolis: Indiana University Press, 1998, pp.53-62.

4396 JAD, Islah, JOHNSON, Penny & GIACAMAN, Rita. Transit citizens: gender and citizenship under the Palestinian Authority. *Gender and citizenship in the Middle East.* Ed. Suad Joseph. Syracuse (USA): Syracuse University Press, 2000, pp.137-157.

4397 JAH, Islah. From salons to the popular committees: Palestinian women, 1919-89. *The Israel/Palestine question.* Ed. I.Pappé. London: Routledge, 1999, pp.249-268. [Originally published 1990.]

4398 JAMAL, Amal. Engendering state-building: the women's movement and gender-regime in Palestine. *Middle East Journal,* 55 ii (2001) pp.256-276.

4399 JARBAWI, Tafida. Le sexisme dans les manuels scolaires. Tr. Zabbal, F. *Revue d'Études Palestiniennes,* 51 (1994) pp.81-94. (Dans la société palestinienne.)

4400 JEAN-KLEIN, Iris. Mothercraft, statecraft, and subjectivity in the Palestinian intifada. *American Ethnologist,* 27 i (2000) pp.100-127.

4401 KAMAL, Zahira. The development of the Palestinian women's movement in the Occupied Territories: twenty years after the Israeli occupation. Tr. Khalidi, Ramla. *Palestinian women of Gaza and the West Bank.* Ed. Suha Sabbagh. Bloomington & Indianapolis: Indiana University Press, 1998, pp.78-88.

4402 KANAANA, Sharif. Women in the legends of the Intifada. *Palestinian women of Gaza and the West Bank.* Ed. Suha Sabbagh. Bloomington & Indianapolis: Indiana University Press, 1998, pp.114-135.

4403 KAWAR, Amal. Palestinian women's activism after Oslo. *Palestinian women of Gaza and the West Bank.* Ed. Suha Sabbagh. Bloomington & Indianapolis: Indiana University Press, 1998, pp.233-244.

4404 KHALĪF[A], Saḥar. Comments by five women activists: Siham Abdullah, Amal Kharisha Barghouthi, Rita Giacaman, May Mistakmel Nassar, Amal Wahdan. Tr. Bassiouni, Nagla el-. *Palestinian women of Gaza and the West Bank.* Ed. Suha Sabbagh. Bloomington & Indianapolis: Indiana University Press, 1998, pp.192-215.

4405 KRIESHE, Amal. No isolation any more. *Women's lifeworlds: women's narratives on shaping their realities* / ed. Edith Sizoo. London: Routledge, 1997, pp.102-110. [West Bank, Palestine.]

4406 KRÖHNERT-OTHMAN, S. Lebensführung und Zeitlichkeit in interkultureller Perspektive oder: Was liegt jenseits des Orientalismus? (Summar[y]: What lies beyond Orientalism? An intercultural perspective on life conduct and social time.). *Peripherie,* 20 / 77-78 (2000) pp.99-122;214-215. (Time perceptions & a moral economy among contemporary Palestinian women teachers.)

4407 KUTTAB, Eileen. Case studies from Palestine and Lebanon. Women studies [*sic*] program in Palestine: between criticism and new vision. *Arab regional women's studies workshop. Al-Nadwa al-iqlīmīya li-dirāsāt al-mar'a al-'Arabīya.* Ed. C.Nelson, Soraya Altorki. Cairo: American University in Cairo, 1998, (Cairo Papers in Social Science, 20 iii (1997)), pp.118-131. (Birzeit University.)

4408 KUTTAB, E. Libération des femmes, libération nationale. Tr. Zabbal, F. *Revue d'Études Palestiniennes,* 51 (1994) pp.67-72.

4409 KUTTAB, Eileen. The Women Studies Program in Palestine: between criticism and new vision. *Muslim women and the politics of participation: implementing theBeijing platform.* Ed. Mahnaz Afkhami & E.Friedl. Syracuse (USA): Syracuse University Press, 1997, pp.94-100. (Birzeit University.)

4410 LITTLE, Donald P. Documents related to the estates of a merchant and his wife in late fourteenth century Jerusalem. *Mamlūk Studies Review,* 2 (1998) pp.93-193. [Incl. Arabic text, English tr. & commentary, & photographs.]

4411 MAHMOUD, Fahmi M. S. Contraceptives used by Palestinian women in the past five decades. *Al-Balqa',* 5 i (1997) pp.85-104.

4412 MAKDISI, Jean Said. Teta, mother and I. *Intimate selving in Arab families: gender, self, and identity.* Ed. Suad Joseph. Syracuse (USA): Syracuse University Press, 1999, pp.25-52;271-272.

4413 MENDELSOHN ROOD, J. Government, law and family: Muḥammad Alī, marriage, and procreation in Syria, 1835. *Essays on Ottoman civilization: Proceedings of the XIIth Congress of the Comité International d'Études Pré-Ottomanes et Ottomanes, Praha 1996.* Prague: Academy of Sciences of the Czech Republic, Oriental Institute, 1998, (Archív Orientální: Supplementa, VIII), pp.317-330. (Jerusalem court archives.)

4414 MENICUCCI, G. Kulthum Auda, Palestinian ethnographer: gendering the Palestinian landscape. *The landscape of Palestine: equivocal poetry.* Ed. Ibrahim Abu-Lughod, R.Heacock, Khaled Nashef. Birzeit: Birzeit University Publications, 1999, pp.79-94. [Research carried out in 1928.]

4415 MENICUCCI, Garay. Kulthum Auda: the forgotten Palestinian ethnographer. *Auto/biography and the construction of identity and community in the Middle East.* Ed. by Mary Ann Fay. New York: Palgrave, 2002, pp.139-151.

4416 MITTELBERG, David & LEV-ARI, Lilach. Confidence in mathematics and its consequences: gender differences among Israeli Jewish and Arab youth. *Gender and Education,* 11 i (1999) pp.75-92. Also online at http://www.ingentaselect.com [Girls & boys.]

4417 MOHAN, R. Loving Palestine: nationalist action and feminist agency in Leila Khaled's subversive bodily acts. *Interventions,* 1 i (1998) pp.52-80.

4418 MOORS, Annelies. Embodying the nation: Maha Saca's post-intifada postcards. *Ethnic and Racial Studies,* 23 v (2000) pp.871-887. Also online at www.ingentaselect.com (Cultural politics of nationalism ... production and display of embroidered dresses.)

4419 MOORS, A. Gender relations and inheritance: person, power, and property in Palestine. *Gendering the Middle East: emerging perspectives.* Ed. Deniz Kandiyoti. London: Tauris, 1996, pp.69-84. [Jabal Nablus, Mandate period to 1980s.]

4420 MOORS, A. Over vrouwen en bezit: juridische documenten en mondelinge verhalen. *Recht van de Islam,* 14 (1997) pp.39-49. (Op de Westelijke Jordaanoever.)

4421 MORGAN, Robin. Women in the Intifada. *Palestinian women of Gaza and the West Bank.* Ed. Suha Sabbagh. Bloomington & Indianapolis: Indiana University Press, 1998, pp.153-170.

4422 MOTZKI, H. Child marriage in seventeenth-century Palestine. *Islamic legal interpretation: muftis and their fatwás.* Ed. Muhammad Khalid Masud, B.Messick, D.S.Powers. Cambridge: Harvard University Press, 1996, pp.129-140;347-349. [Discussion of a fatwa.]

4423 NA'ANA, Hamida. The cultural impact of the Left in Syria and Palestine: a personal view. *Cosmopolitanism, identity and authenticity in the Middle East.* Ed. Roel Meijer. Richmond: Curzon, 1999, pp.61-68.

4424 OLMSTEAD, J. Palestine Mandate: women's education and British and US policy. *Middle East Women's Studies Review,* 14 iv (2000) pp.13-13. (MESA panel review.)

4425 OLMSTEAD, J. Women "manufacture" economic spaces in Bethlehem. *World Development,* 24 xii (1996) pp.1829-1840.

4426 OLMSTEAD, Jennifer. Men's work / women's work: employment, wages and occupational segregation in Bethlehem. *The economics of women and work in the Middle East and North Africa.* Ed. E.Mine Cinar. Amsterdam: JAI, 2001, (Research in Middle East Economics, 4), pp.151-174.

4427 OLMSTEAD, Jennifer. Palestine Mandate: women's education and British and US policy. *Middle East Women's Studies Review,* 14 iv (2000) pp.13-13. (MESA panel review.)

4428 PETEET, J. Icons and militants: mothering in the danger zone. *Signs,* 23 i (1997) pp.103-129. [In camps in Lebanon, 1968-82.]

4429 PETEET, Julie. Gender and sexuality: belonging to the national and moral order. *Hermeneutics and honor: negotiating female "public" space in Islamic/ate societies.* Ed. Asma Afsaruddin. Cambridge (USA): Harvard University Press, for the Center for Middle Eastern Studies of Harvard University, 1999, (Harvard Middle Eastern monographs, 32), pp.70-88. [Palestinians in Lebanon 1968-1982, & in Palestine 1987-91.]

4430 PETEET, Julie. Mothering in the danger zone. *Gender, politics, and Islam.* Ed. Therese Saliba, Carolyn Allen and Judith A.Howard. Chicago: University of Chicago Press, 2002, pp.133-159. [In camps in Lebanon, 1968-82. Originally published in *Signs,* 23 i (1997).]

4431 PETEET, Julie. Nationalism and sexuality in Palestine. *Social constructions of nationalism in the Middle East* / ed. Fatma Müge Göçek. Albany (USA): State University of New York Press, 2002, pp.141-165. [PLO & Palestinian women in Lebanon 1968-82.]

4432 PETEET, Julie. Women and the Palestinian movement: no going back? *Women and power in the Middle East*. Ed. Suad Joseph & Susan Slyomovics. Philadephia: University of Pennsylvania Press, 2001, pp.135-149;213-214. (1968-82, Lebanon.)

4433 PLATT, Katherine. Places of experience and the experience of place. *The longing for home* / ed. Leroy S.Rouner. Notre Dame (USA): University of Notre Dame Press, 1996, (Boston University Studies in Philosophy and Religion, 17), pp.112-127. (Three examples .. the Eastern European Jewish stetl ... the childhood home places of women in rural Iran, & the Arab peasant villages of pre-1948 Palestine.)

4434 POUZOL, V. Femmes palestiniennes: un siècle d'engagement et de militantisme: perspectives de recherche. (Abstract: Palestinian women: a century of political and social involvement.). *Palestine, palestiniens: territoire national, espaces communautaires*. Sous la dir. de R.Bocco, B.Destremau, J.Hannoyer. Beirut: Centre d'Etudes et de Recherches sur le Moyen-Orient Contemporain, 1997, (Cahiers du CERMOC, 17), pp.339-350;404-405.

4435 POUZOL, V. Les associations de femmes palestiniennes en Jordanie: du militantisme à l'action caritative: (perspectives de recherche). Associations for women of Palestinian origin in Jordan: from militancy to charity: (a research agenda). *Jordanies*, 2 (1996) pp.114-118. [Parallel French & English text.]

4436 RABADÁN CARRASCOSA, M. La *jurayfiyya* o cuento fantástico: un medio de evasión para la mujer palestina. (Abstract: The *jurayfiyya*, or fantastic story: a means of evasion for Palestinian women.). *Estudios de Asia y Africa*, 30 i / 96 (1995) pp.7;123-137.

4437 ROSEN, R. Alone between the lines: reporting the death of Shifa el-Makussi. *Palestine-Israel Journal*, 5 iii-iv (1998) pp.143-152. [Murder of one Palestinian girl by another in detention in 1991.]

4438 ROTHENBURG, C. Understanding Ghada: the multiple meanings of an attempted stabbing. *Middle East Report*, 29 i / 210 (1999) pp.10-13. [Occupied West Bank, 1990.]

4439 RUGGI, S. Commodifying honor in female sexuality: honor killings in Palestine. *Middle East Report*, 206 / 28 i (1998) pp.12-15.

4440 SABBAGH, Suha. An interview with Dr. Eyad el-Sarraj: gender relations during the three psychodevelopmental phases under occupation. *Palestinian women of Gaza and the West Bank*. Ed. Suha Sabbagh. Bloomington & Indianapolis: Indiana University Press, 1998, pp.171-183.

4441 SABBAGH, Suha. Palestine's Hanan Mikhail Ashrawi: an interview. *Arab women: between defiance and restraint*. Ed. Suha Sabbagh. New York: Olive Branch Press, 1996, pp.21-25.

4442 SABBAGH, Suha. Palestinian women and institution building. *Arab women: between defiance and restraint*. Ed. Suha Sabbagh. New York: Olive Branch Press, 1996, pp.107-114.

4443 SABBAGH, Suha. The Declaration of Principles on Palestinian women's rights: an analysis. *Arab women: between defiance and restraint*. Ed. Suha Sabbagh. New York: Olive Branch Press, 1996, pp.115-120.

4444 SABBAGH, Suha. The Declaration of Principles on Palestinian women's rights: an analysis. *Palestinian women of Gaza and the West Bank*. Ed. Suha Sabbagh. Bloomington & Indianapolis: Indiana University Press, 1998, pp.245-254.

4445 SAKAKINI, Hala. Jerusalem and I: a personal record. *Islamic Studies*, 40 iii-iv (2001) pp.483-485.

4446 SAYIGH, R. Researching gender in a Palestinian camp: political, theoretical and methodological problems. *Gendering the Middle East: emerging perspectives*. Ed. Deniz Kandiyoti. London: Tauris, 1996, pp.145-167. (In Lebanon.)

4447 SAYIGH, Rosemary. Femmmes réfugiées, narratrices de l'histoire. Tr. Polo, A-L. *Revue d'Etudes Palestiniennes*, N.S 16 / 68 (1998) pp.30-42. [In Lebanon.]

4448 SAYIGH, Rosemary. Palestinian camp women as tellers of history. *Journal of Palestine Studies*, 27 ii / 106 (1998) pp.42-58. [In Lebanon.]

4449 SCHEINDLIN, D. Palestinian women's model parliament. *MERIA Journal*, 2 iii (1998) Online at http://www.biu.ac.il/SOC/besa/meria

4450 SCHEINDLIN, Dahlia. Palestinian women's model parliament. *Women Living under Muslim Laws: Dossier*, 22 (1999) pp.47-50. Also online at http://www.wluml.org/english/pubs

4451 SEGINER, Rachel & HALABI-KHEIR, Hoda. Adolescent passage to adulthood: future orientation in the context of culture, age and gender. *International Journal of Intercultural Relations*, 22 iii (1998) pp.309-328. (Israeli Druze ... & Jewish ... adolescents.)

4452 SEIKALY, May. "Women, collective memory and nationalism": a panel at MESA '96. *Middle East Women's Studies: the Review*, 12 i (1997) pp.9-11. [Palestine.]

4453 SHALHOUB-KEVORKIAN, Nadera. Reexamining femicide: breaking the silence and crossing "scientific" borders. *Signs*, 28 ii (2003) pp.581-608. Also online at http://www.journals.uchicago.edu/Signs/journal (Palestinian women.)

4454 SHALHOUB-KEVORKIAN, Nadera. Towards a cultural definition of rape: dilemmas in dealing with rape victims in Palestinian society. *Women's Studies International Forum*, 22 ii (1999) pp.157-173. Also online at http://www.sciencedirect.com/science/journal/02775395

4455 SHALHOUB-KEVORKIAN, Nadera. Wife abuse: a method of social control. *Israel Social Science Research*, 12 i (1997) pp.59-72. (In Palestinian society in East Jerusalem.)

4456 SHALHOUB-KEVORKIAN, Nadera & BAKER, Ahmad M. Wife abuse in Palestinian society: a social phenomenon or a social problem? *Arab Studies Quarterly*, 19 ii (1997) pp.41-55.

4457 SHARONI, S. Gender and the Israeli-Palestinian accord: feminist approaches to international politics. *Gendering the Middle East: emerging perspectives*. Ed. Deniz Kandiyoti. London: Tauris, 1996, pp.107-126.

4458 SHARONI, S. Gender in conflict: the Palestinian-Israeli conflict through feminist lenses. *Signs*, 24 ii (1999) pp.487-499. (Review essay.)

4459 SHERWELL, T. Palestinian costume, the Intifada and the gendering of nationalist discourse. *Journal of Gender Studies*, 5 iii (1996) pp.293-303.

4460 SIEGEL, Irene. The chaos of seeing: witnessing the Occupied Territories. *Middle East Women's Studies Review*, 17 iii-iv (2002-03) pp.1-9. Also online at http://www.amews.org/review/winter03.htm

4461 SINGER, A. Marriages and misdemeanors: a record of resm-i 'arūs vebād-i havā. *Princeton Papers: Interdisciplinary Journal of Middle Eastern Studies*, 4 (1996) pp.113-152. [16th-century Ottoman archives concerning villages near Jerusalem.]

4462 STRUM, P. West Bank women and the Intifada: revolution within the revolution. *Palestinian women of Gaza and the West Bank*. Ed. Suha Sabbagh. Bloomington & Indianapolis: Indiana University Press, 1998, pp.63-77.

4463 TADIÉ, Arlette. Une enfance à Gazza (1948-1958). *Revue d'Etudes Palestiniennes*, N.S. 25 / 77 (2000) pp.96-112.

4464 TALHAMI, Ghada. In Memorian Samiha Khalil (1923-1999). *Arab Studies Quarterly*, 21 ii (1999) pp.ii-iv. [Palestinian social activist.]

4465 TARAKI, Lisa. Palestine: from national liberation to feminism. *Middle East Policy*, 5 iii (1997) pp.173-176;187-189.

4466 TUCKER, J. E. The fullness of affection: mothering in the Islamic law of Ottoman Syria and Palestine. *Women in the Ottoman Empire: Middle Eastern women in the early modern era*. Ed. M.C.Zilfi. Leiden: Brill, 1997, (The Ottoman Empire and its Heritage, 10), pp.232-252.

4467 TZOREFF, Mira. Fadwa Tuqan's autobiography: restructuring a personal history into the Palestinian national narrative. *Discourse on gender / gendered discourse in the Middle East.* Ed. Boaz Shoshan. Westport: Praeger, 2000, pp.57-77;148-155.

4468 VELLOSO, A. Women, society and education in Palestine. *International Review of Education,* 42 v (1996) pp.524-530. [19th century to 1990s.]

4469 WA'RI, Na'ila 'l-. I lived in Jerusalem. *Islamic Studies,* 40 iii-iv (2001) pp.475-477. [Personal account of childhood home & return visit.]

4470 WÜRTH, A. The woman with two husbands. *Middle East Report,* 26 i / 198 (1996) pp.27-27. [Palestinian woman who married an Egyptian in Yemen while not fully divorced from Palestinian husband living in Saudi Arabia.]

4471 YOUNG, E. G. Palestinian women and health: a perspective from al-Hussein refugee camp, Amman, Jordan. *Arab Studies Journal / Majallat al-Dirāsāt al-'Arabīya,* 4 i (1996) pp.131-140.

4472 YOUNG, Elise G. The Global Women's History Project. *Middle East Women's Studies Review,* 14 ii (1999) pp.9-12;15. (Inaugural Conference: "Women from Northern Ireland and the Republic of Ireland and women from Israel and Palestine envisioning peace", Boston & Westfield, USA, 1999.)

4473 ZAKHARIA, Leila F. & TABARI, Samia. Health, work opportunities and attitudes: a review of Palestinian women's situation in Lebanon. *Journal of Refugee Studies,* 10 iii (1997) pp.411-429.

4474 ZALATIMO, D. An interview with Hanan Mikhail Ashrawi: the history of the women's movement. *Palestinian women of Gaza and the West Bank.* Ed. Suha Sabbagh. Bloomington & Indianapolis: Indiana University Press, 1998, pp.184-191.

4475 ZARU, Jean. Her jubilee - a chance to change. *Holy land, hollow jubilee. God, justice and the Palestinians /* ed. Naim Ateek and Michael Prior. London: Melisende, 1999, pp.252-257. (We Palestinian women live and work in a very traditional society.)

Philippines

Articles

4476 ANGELES, V. S. Philippine Muslim women: tradition and change. *Islam, gender, & social change.* Ed. Y.Yazbeck Haddad & J.L.Esposito. New York: Oxford University Press, 1998, pp.209-234.

4477 ANGELES, V. S. M. Women and revolution: Philipppine Muslim women's participation in the Moro National Liberation Front. *Muslim World,* 86 ii (1996) pp.130-147.

4478 FIANZA, M. L. Japanese ODA and Moro women in southern Philippines: a preliminary study. *Dansalan Quarterly,* 17 i-ii (1997) pp.5-33. (Official Development Assistance.)

Photography & documentary films

Books

4479 ALLOULA, Malek. *Haremsphantasien: aus dem Postkartenalbum der Kolonialzeit.* Tr. Egghart, S. Freiburg i. B. : Beck & Glückler 1994. 94pp. [Tr. of *Le harem colonial,* Paris 1981.]

4480 AMATYA, Sushma. *Our world.* Photo Mahmud. Dhaka: Map Photo Agency, 2000. [Photographs of women's lives in Bangladesh.]

4481 BROOKS, Geraldine. *Die Berber-Frauen: Kunst und Kultur in Nordafrika.* [Photographs by] Margaret Courtney-Clarke. Tr. Kluy, Alexander. Munich: Frederking und Thaler, 1997. 216pp. [Tr. of *Imazighen,* London 1996. Mainly pictures.]

4482 WILLIAMS, Gilda. *Shirin Neshat / Serpentine Gallery.* London: Serpentine Gallery, 2000. 16pp. [Illustrated guide to an exhibition of photographic art, mainly depicting Iranian women.]

4483 *Daughters of the Nile: photographs of Egyptian women's movements, 1900-1960.* Ed. Wassef, Hind & Wassef, Nadia. Cairo: American University in Cairo Press, 2001. 156+20pp. [English & Arabic. Arabic title: *Banāt al-Nīl : laqqtāt min ḥarakāt nisā'īya, 1900-1960.*]

Articles

4484 AFTAB, Tahera. Images of women at the end of the century. *Pakistan Journal of Women's Studies. Alam-e-Niswan,* 5 i-ii (1998) pp.61-71. (Women's lives in Pakistan.)

4485 CHAULET ACHOUR, Christiane. Portraits de femmes d'un pays en guerre. (Photographies et récits.). *Esprit Créateur,* 41 iv (2001) pp.101-112. (Algériennes.)

4486 CHHACHHI, Sheba. Finding face: images of women from the Kashmir valley. *Speaking peace: women's voices from Kashmir /* ed. Urvashi Butalia. Delhi: Kali for Women, 2002, pp.189-225. [Photographs.]

4487 FERRIÉ, J-N. & BOËTSCH, G. Contre Alloula: le `harem colonial` revisité. *Annuaire de l'Afrique du Nord,* 32 / 1993 (1995) pp.299-304. (Dénonciation ... de la carte postale coloniale représentant des Mauresques nues.)

4488 FERRIÉ, J-N. & BOËTSCH, G. Contre Alloula: le "harem colonial" revisité. *L'image dans le monde arabe.* Sous la dir. de G.Beaugé & J-F.Clément. Paris: CNRS, 1995, pp.299-304. (Dénonciation ... de la carte postale coloniale représentant des Mauresques nues.)

4489 GOLESTAN, Kaveh & RANJBAR, Nahid. Privacy behind bars. *Index on Censorship,* 26 vi (1997) pp.184-188. (Photographs ... taken inside the women's ward of Tehran's infamous Evin prison.)

4490 GOW, Greg. Viewing 'Mother Oromia'. *Communal Plural,* 9 ii (2001) pp.203-222. Also online at www.tandf.co.uk/journals [Survey of Oromo women's reactions to a postcard showing an Oromo woman feeding her baby with the caption 'Mother Oromia'.]

4491 KHÉMIR, Mounira. La femme orientale dans l'optique des premiers photographes. *Cahier d'Études Maghrébines,* 8-9, 1995-96, pp.116-118.

4492 LUCAS, A. Photographic images of women during the Indonesian revolution. *Indonesian independence fifty years on 1945-1995.* Ed. J.Drakard & J.Legge. Clayton (Australia): Monash Asia Institute, Monash University, 1996, (Annual Indonesia Lecture Series, 20), pp.47-72.

4493 MIR-HOSSEINI, Ziba. Negotiating the politics of gender in Iran: an ethnography of a documentary. *The new Iranian cinema: politics, representation and identity.* Ed. by Richard Tapper. London: Tauris, 2002, pp.167-199. [Problems author encountered when she wanted to shoot"Divorce Iranian Style" (1988), based on her book *Marriage on trial.*]

4494 MIR-HOSSEINI, Ziba. The making of *Divorce Iranian style. ISIM Newsletter,* 2 (1999) pp.17-17. (Documentary film.)

4495 MOORE, Lindsey. Frayed connections, fraught projections: the troubling work of Shirin Neshat. *Women: a Cultural Review,* 13 i (2002) pp.1-17. Also online at http://ninetta.ingentaselect.com (Iranian-American visual artist.)

4496 MOORS, Annelies. Embodying the nation: Maha Saca's post-intifada postcards. *Ethnic and Racial Studies,* 23 v (2000) pp.871-887. Also online at www.ingentaselect.com (Cultural politics of nationalism ... production and display of embroidered dresses.)

4497 RAHSEPAR, Jamshid. In search of the most intimate moments. *Tavoos / Ṭāwūs,* 2 (2000) pp.104-113. [Maryam Zandi's photographs of famous figures of Iranian literature, painting & cinema. Article in English & Persian.]

4498 SHEIKH, Reza. Shadafarin Ghadirian: Suspended in time. *Index on Censorship,* 29 ii / 193 (2000) pp.66-71. [Photographic portraits of Iranian women.]

4499 TOPÇUOĞLU, Nazif. Why do I take photographs of girls reading? Tr. Haydaroğlu, Mine. *4th Floor,* 6 (2002) pp.28-30. [Turkey.]

4500 WANGENHEIM, Annette von. Explosion der Stille. Ein Film über die Frauen im Jemen. *Jemen-Report,* 32 ii (2001) pp.33-34.

4501 ZAYA, O. Shirin Neshat y las mujeres de Allah. (Shirin Neshat and "Women of Allah".). *Atlántica Internacional,* 8 (1994) pp.28-34. [Photographic phantasies of Iranian women with guns; accompanying text in Spanish & English.]

4502 Lala Meredith-Vula: Bathers. *Index on Censorship,* 29 v / 196 (2000) pp.59-63. [Photographic studies of Roma women in an Ottoman bath-house in Albania.]

4503 Les femmes et leur vie au nord de l'Aurès: photographies d'Amir Rezzoug. *Annuaire de l'Afrique du Nord,* 30 / 1991 (1993) pp.313-328.

4504 Les femmes et leur vie dans le nord de l'Aurès: photographies d'Amir Rezzoug. *Etre marginal au Maghreb.* Textes réunis par Fanny Colonna avec Zakya Daoud. Paris: CNRS, 1993, pp.313-328.

Qatar

Articles

4505 METWALLY, M.M. Factors determining participation of Qatari women in the labour force: a discriminant analysis. *Asian Economic Review,* 44 ii (2002) pp.193-206.

Religion see under countries & General: religion

Russia & Russian Empire

Articles

4506 FATHI, Habiba. L'institution et le genre en Islam: l'expérience des musulmanes tatares de Russie. *Oriente Moderno,* 21 / 82 ii (2002) pp.379-413.

4507 KEFELI, A. Une note sur le rôle des femmes tatares converties au Christianisme dans la réislamisation de la moyenne-Volga, au milieu du XIXe siècle. *L'islam de Russie: conscience communautaire et autonomie politique chez les Tatars de la Volga et de l'Oural depuis le XVIIIe siècle.* Sous la dir. de S.A.Dudoignon, Dämir Is'haqov, Räfyq Möhämmätshin. Actes du colloque international de Qazan ... 1996. Paris: Maisonneuve & Larose, 1997, pp.65-71.

4508 RORLICH, Azade Ayşe. Intersecting discourses in the press of the Muslims of Crimea, Middle Volga & Caucasus: the woman question and the nation. *Gender and identity construction: women of Central Asia, the Caucasus and Turkey.* Ed. Feride Acar & Ayşe Günes-Ayata. Leiden: Brill, 2000, (Social, Economic and Political Studies of the Middle East and Asia, 68), pp.143-161. [Early 20th century.]

4509 СМИРНОВА, Е. Ю. Женские украшения сибирских татар конца XIX - первой трети XX века. *Материальная культура народов России.* Novosibirsk: Наука, 1995, (Культура Народов России, 1), pp.216-229.

Saudi Arabia

Books

4510 ALMUNAJJED, Mona. *Women in Saudi Arabia today.* Basingstoke: Macmillan, 1997. 153pp.

4511 DOUMATO, Eleanor Abdella. *Getting God's ear: women, Islam, and healing in Saudi Arabia and the Gulf.* New York: Columbia University Press, 2000. 312pp.

4512 SASSON, J. P. *Arabias døtre.* Tr. Aspaas, S. Oslo: Hjemmets Bokforlag, 1995. 243pp. [Tr. of *Princess Sultana's daughters.*]

4513 SASSON, J. *Desert Royal.* London: Doubleday, 1999. 224pp. [Princess's experiences & views of the oppression of Saudi women.]

4514 SASSON, J. P. *Ich, Prinzessin aus dem Hause Al Saud: ein Leben hinter tausend Schleiern.* Hameln: Niemeyer, 1994. 369pp. [Tr. of *Princess,* London 1992, based on the diaries of Suļtāna, a member of the Saudi royal family.]

4515 SASSON, J. P. *Ich, Prinzessin Sultana, und meine Töchter.* 2. Aufl. Munich: Bertelsmann, 1993. 286pp. [Tr. of *Princess Sultana's daughter.*]

4516 SASSON, J. P. *Princessen: en sann historie om livet bak sløret i Saudi Arabia.* Tr. Selmer, K. Oslo: Hjemmets Bokforlag, 1993. 260pp. [Tr. of *Princess,* London 1992, based on the diaries of Suļtāna, a member of the Saudi royal family.]

4517 ZINTGRAFF, D. & VUKOVIC, Emina Cevro. *En el harén.* Tr. Cabré, M. A. Barcelona: Mondadori, 1999. 219pp. [Saudi Arabia. Tr. of *Nell'harem,* 5 ed. Milan 1997.]

4518 ZINTGRAFF, D. & VUKOVIC, Emina Cevro. *Harem: une européenne raconte: j'ai vécu deux ans dans un palais des mille et une nuits.* Tr. Breuer, A. Lausanne: Favre, 1997. 208pp. [Tr. of *Nell'harem,* 5 ed. Milan 1997.]

4519 ZINTGRAFF, D. & VUKOVIC, Emina Cevro. *Nell'harem.* 5 ed. Milano: Sonzogno 1997. 235pp.

4520 ZINTGRAFF, Denise & VUKOVIC, Emina Cevro. *De vrouw uit duizend-en-een-nacht: mijn leven in een harem.* Tr. Laake, Marieke van. Amsterdam: Wereldbibliotheek, 1999. 203pp. [Saudi Arabia. Tr. of *Nell'harem,* 5a ed. Milan, 1997.]

Articles

4521 ALLAM, Hannah. Fifteen girls. *Mizna,* 4 i (2002) pp.5-6. (Saudi Arabia's religious police stopped schoolgirls from leaving a blazing building because they were not wearing correct Islamic dress ... 15 girls died.)

4522 ALTORKI, Soraya. Sisterhood and stewardship in sister-brother relations in Saudi Arabia. *The new Arab family / Al-Usra al-'Arabīya al-jadīda.* Ed. Nicholas S.Hopkins. Cairo: American University in Cairo Press, 2003, (Cairo Papers in Social Science, 24 i-ii / 2001), pp.180-200.

4523 ALTORKI, Soraya. The concept and practice of citizenship in Saudi Arabia. *Gender and citizenship in the Middle East.* Ed. Suad Joseph. Syracuse (USA): Syracuse University Press, 2000, pp.217-236.

4524 BRUCE, S. Eventyret begynder, når asfalten slutter - livet som jordemoder i Khamis Mushayt. *Samfund, sundhed og sygdom på det arabiske Halvø.* L.Erslev Andersen & M.R.Buhl (red.). Odense: Odense Universitetsforlag, 1995, (Odense University Publication in Contemporary Middle East Studies, 3), pp.140-144. [Midwife in Saudi Arabia.]

4525 DOUMATO, E. A. The Saudis and the Gulf war: gender, power and the revival of the religious right. *Change and development in the Gulf.* Ed. Abbas Abdelkarim. Basingstoke: Macmillan; New York: St. Martin's Press, 1999, pp.184-210. (The public invisibility of women becomes a visible sign of the monarch's piety.)

4526 DOUMATO, E. A. Women and work in Saudi Arabia: how flexible are Islamic margins? *Middle East Journal,* 53 iv (1999) pp.568-583.

4527 DOUMATO, Eleanor Abdella. Women in Saudi Arabia: between breadwinner and domestic icon? *Women and power in the Middle East.* Ed. Suad Joseph & Susan Slyomovics. Philadephia: University of Pennsylvania Press, 2001, pp.166-175;215-216.

4528 KHATEEB, Salwa Abdel Hameed al-. Muslim women's perception of equality: case study of Saudi women. *Mediterranean Quarterly,* 9 ii (1998) pp.110-131.

4529 ORABI, Hekmat M. al-. Attitude of Saudi women towards participating in the labor force. *Annals of the Faculty of Arts* (Ain Shams University) / *Ḥawlīyāt Kullīyat al-Ādāh (Jāmi'at 'Ayn Shams),* 27 i (1999) pp.21-40.

4530 SANABARY, Nagat el-. Women and the nursing profession in Saudi Arabia. *Arab women: between defiance and restraint.* Ed. Suha Sabbagh. New York: Olive Branch Press, 1996, pp.71-83.

4531 SHANDS, K. W. Under stjärnhimlen: på kvinnouniversitet i Saudiarabien. *Kvinnovetenskaplige Tidskrift,* 18 iii-iv (1997) pp.112-114.

4532 WYNN, Lisa. Contrats de mariage et droits de la femme en Arabie saudite. *Les frontières mouvantes du mariage et du divorce dans les communautés musulmanes.* Grabels: Women Living under Muslim Laws, 1996, (Programme Femmes et Loi dans le Monde Musulman: Dossier Spécial), pp.96-108. Also online at http://www.wluml.org/french/pubs/pdf/dossiers/sd/SD1.pdf

4533 YAMANI, Mai. Cross-cultural marriage within Islam: ideals and reality. *Cross-cultural marriage: identity and choice.* Ed. R.Breger & Rosanna Hill. Oxford: Berg, 1998, pp.153-169. (Example of a marriage between a Saudi Arabian woman & a Pakistani man, both Sunni Muslims.)

4534 YAMANI, Mai. Muslim women and human rights: the new generation in Saudi Arabia. *Democracy, the rule of law and Islam.* Ed. E.Cotran & Adel Omar Sherif. The Hague: Kluwer Law International, 1999, (CIMEL Book Series, 6), pp.477-488.

4535 YAMANI, Mai. Muslim women and human rights in Saudi Arabia: aspirations of a new generation. *The rule of law in the Middle East and the Islamic World: human rights and the judicial process.* Ed. by Eugene Cotran and Mai Yamani. London: Tauris, in association with the Centre of Islamic Studies and Middle Eastern Law, School of Oriental and African Studies, University of London, 2000, pp.137-143. [Law.]

4536 YAMANI, Mai. Some observations on women in Saudi Arabia. *Feminism and Islam: legal and literary perspectives.* Ed. Mai Yamani. Reading: Ithaca, for the Centre of Islamic and Middle Eastern Law, School of Oriental and African Studies, University of London, 1996, pp.263-281.

4537 YAMANI, Mai. The power behind the veil. *Index on Censorship,* 25 iv (1996) pp.80-83. (Saudi women's economic power.)

Senegal

Books

4538 DELAUNAY, V. *L'entrée en vie féconde: expression démographique des mutations socio-économiques d'un milieu rural sénégalais.* Paris: Centre Français sur la Population et le Développement, 1994, (Etudes du Ceped, 7), 326pp.

4539 DJIBO, Hadiza. *La participation des femmes africaines à la vie politique: les exemples du Sénégal et du Niger.* Paris: L'Harmattan, 2001. 419pp.

4540 LECARME-FRASSY, Mireille. *Marchandes dakaroises entre maison et marché: approche anthropologique.* Paris: L'Harmattan, 2000. 270pp.

4541 REINWALD, B. *Der Reichtum der Frauen: Leben und Arbeit der weiblichen Bevölkerung in Siin/Senegal unter dem Einfluss der französischen Kolonisation.* Münster: Lit, 1995, (Studien zur Afrikanischen Geschichte, 9), 417pp.

4542 RENAUD, M. L. *Women at the crossroads: a prostitute community's response to AIDS in urban Senegal.* Amsterdam: Gordon and Breach, 1997. 172pp.

4543 SARR, Fatou. *L'entrepreneuriat féminin au Sénégal: la transformation des rapports de pouvoirs.* Paris: L'Harmattan, 1999. 301pp.

Articles

4544 AMINATA, Sow Fall. Cultures and religions in Senegal. *Women Living under Muslim Laws: Dossier,* 17 (1997) Also online at www.wluml.org/english/pubs (Practices in the daily life of Christian and Muslim Senegalese.)

4545 ANTOINE, P., DJIRE, Mamadou & LAPLANTE, B. Les déterminants socio-économiques de la sortie du célibat à Dakar. (Abstracts: Socio-economic determinants of the age of marriage in Dakar; Los determinantes socio-económicos del fin de la soltería en Dakar.). *Population (Paris),* 50 i (1995) pp.94-117.

4546 AUBEL, Judi & others Strengthening grandmother networks to improve community nutrition: experience from Senegal. *Gender and Development,* 9 ii (2001) pp.62-73. Also online at http:// www.ingentaselect.com

4547 BECK, Linda J. Democratization and the hidden public: the impact of patronage networks on Senegalese women. *Comparative Politics,* 35 ii (2003) pp.147-169.

4548 BUGGENHAGEN, Beth Anne. Prophets and profits: gendered and generational visions of wealth and value in Senegalese Murid households. *Journal of Religon in Africa,* 31 iv (2001) pp.373-401.

4549 CREEVEY, L. Islam, women and the role of the state in Senegal. *Journal of Religion in Africa,* 26 iii (1996) pp.268-307.

4550 DIAW, Bamba. Teenager and maid in Senegal: cutting both ways. *African Environment,* 10 iii-iv / 39-40 (1999) pp.55-84.

4551 FALL, Rokhaya. Femmes et pouvoir dans les sociétés nord sénégambiennes. *Afrika Zamani,* N.S.2 / 1994 (1996) pp.69-79. (Hal Pulaar, Wolof et Serer.)

4552 FALL DIOP, N. C. La situation des femmes au Sénégal en milieu rural et dans la pêche artisanale: quelques éléments d'analyse. (Abstract: The situation of rural women engaged in smallscale fishing in Senegal: some elements of analysis.). *Transforming female identities: women's organizational forms in West Africa.* Ed. E.E.Rosander. Uppsala: Nordiska Afrikainstitutet, 1997, (Seminar Proceedings, 31), pp.96-106.

4553 HOVEN, E. van. Local tradition or Islamic precept? The notion of *zakāt* in Wuli (eastern Senegal). (Résumé: La notion de *zakāt* au Wuli (Sénégal).). *Cahiers d'Études Africaines,* 36 iv / 144 (1996) pp.703-722. (In the marriage ceremony.)

4554 JOURNET, O. Demain, les femmes? "Son fagot de bois a cassé la véranda de la maison". *Comprendre la Casamance: chronique d'une intégration contrastée.* Sous la coord. de F-G.Barbier-Wiesser. Paris: Karthala, 1994, pp.337-350.

4555 KALIS, Simone. De la culpabilité à la réparation: la responsabilité de la mère dans la pathologie de son enfant chez les Seereer Siin du Sénégal. *Anthropos,* 95 ii (2000) pp.363-370.

4556 KONATE, Dior. Sénégal: l'emprisonnement des femmes, de l'époque colonial à nos jours. *Revue Française d'Histoire d'Outre-Mer,* 86 ii / 324-325 (1999) pp.89-98.

4557 LOIMEIER, Roman. Cheikh Tidiane Sy und die Dā'irat al-Mustaršidīn wa-l-Mustašidāt in Senegal. *Die islamische Welt als Netzwerk. Möglichkeiten und Grenzen des Netzwerkansatzes im islamischen Kontext* / hrsg. Roman Loimeier. Würzburg: Ergon, 2000, (MISK: Mitteilungen zur Sozial- und Kulturgeschichte der Islamischen Welt, 9), pp.445-459.

4558 LULLI, F. Associazioni femminili, sistemi economici rotativi e identità urbane a Dakar. *Africa* (Rome), 53 iii (1998) pp.367-393.

4559 MBOUW, P. Les femmes, l'Islam et les associations religieuses au Sénégal: le dynamisme des femmes en milieu urbain. (Abstract: Women, Islam and the religious associations in Senegal: the dynamics of women in an urban setting.). *Transforming female identities: women's organizational forms in West Africa.* Ed. E.E.Rosander. Uppsala: Nordiska Afrikainstitutet, 1997, (Seminar Proceedings, 31), pp.148-159.

4560 M'BOW, Amadou Mahtar. La famille et le statut de la famille musulmane dans le droit moderne en Afrique de l'Ouest: le cas du Sénégal. *La crise des valeurs et le rôle de la famille dans l'évolution de la société contemporaine. Session de printemps 2001, Rabat 26-28 avril 2001. Azmat al-qiyam wa-dawr al-usra fī tqtawwur al-mujtama' al-mu'āṣir.* Rabat: Académie du Royaume du Maroc, 2001, pp.87-102.

4561 MELCHING, Molly. Abandoning female genital cutting in Africa. *Eye to eye: women practising development across cultures* / ed. Susan Perry & Celeste Schenk. london: Zed, 2001, pp.156-170. (In ... Senegal, 174 villages have made the unprecedented decision to end the harmful practice of female genital cutting (FGC) in their communities for ever.)

4562 PISON, Gilles, KODIO, Belco, GUYAVARCH, Emmanuelle & ETARD, Jean-François. La mortalité maternelle en milieu rurale au Sénégal. (Abstracts: Maternal mortality in rural Senegal; La mortalidad materna en el medio rural en Senegal.). *Population* (Paris), 55 vi (2000) pp.1003-1018.

4563 RABINE, Leslie W. Dressing up in Dakar. *Esprit Créateur,* 37 i (1997) pp.84-107. [Women's costumes in Senegal.]

4564 ROSANDER, E. E. Female linkage in Morocco and Senegal. *The third Nordic conference on Middle Eastern Studies: Ethnic encounter and culture change, Joensuu, Finland, 19-22 June 1995.* Proceedings archive. Bergen: University of Bergen, Centre for Middle Eastern and Islamic Studies, [for] Nordic Society for Middle Eastern Studies, 1996, Online at http:// www.hf.uib.no/smi/paj/default.html

4565 ROSANDER, E. E. Le *dahira* de Mam Diarra Bousso à Mbacké: analyse d'une association religieuse de femmes sénégalaises. (Abstract: The Mam Diarra Bousso Daira of Mbacké, Senegal: an analysis of a female religious association.). *Transforming female identities: women's organizational forms in West Africa.* Ed. E.E.Rosander. Uppsala: Nordiska Afrikainstitutet, 1997, (Seminar Proceedings, 31), pp.160-174. (Murid women.)

4566 ROSANDER, E. E. Women and Muridism in Senegal: the case of the Mam Diarra Bousso Daira in Mbacké. *Women and Islamization: contemporary dimensions of discourse on gender relations.* Ed. K.Ask & M.Tjomsland. Oxford: Berg, 1998, pp.147-175.

4567 ROSANDER, E. E. Women in groups in Africa: female associational patterns in Senegal and Morocco. *Organizing women: formal and informal women's groups in the Middle East.* Ed. D.Chatty & A.Rabo. Oxford: Berg, 1997, pp.101-123.

4568 SCHAFER, D. L. Shades of freedom: Anna Kingsley in Senegal, Florida and Haiti. *Slavery and Abolition,* 17 i (1996) pp.130-154. [Muslim Wolof enslaved in Senegal & transported to Americas.]

4569 SIMARD, P., TALL THIAM, Khadidiatou & DE KONINCK, M. Se créer une ville sur mesure: appropriation et aménagement de l'environnement urbain par des pileuses serer du quartier Médina (Dakar). *Géographie et Cultures,* 29 (1999) pp.59-77.

4570 SOW, Fatou. Famille et loi au Sénégal: permanences et changements. *Les frontières mouvantes du mariage et du divorce dans les communautés musulmanes.* Grabels: Women Living under Muslim Laws, 1996, (Programme Femmes et Loi dans le Monde Musulman: Dossier Spécial), pp.128-141. Also online at http:// www.wluml.org/french/pubs/pdf/dossiers/sd/SD1.pdf

4571 SOW, Papa. Ambiguïtés de l'accés à la terre au Sénégal: appropriation et exploitation de l'environnement rural par les "récolteuses de sel" du Lac Rose. *Studia Africana: Publicació del Centre d'Estudis Africans,* 11 (2000) pp.23-38.

4572 VALLI, Francesca. La Dā'irat al-mustaršidīn wa-l-mustaršidāt: un movimento social-religioso del Senegal contemporaneo. *Africa: Rivista Trimestrale di Studi e Documentazione dell'Istituto Italiano per l'Africa e l'Oriente,* 56 i (2001) pp.103-129.

4573 WEIL, P. M. Women's masks and the power of gender in Mande history. *African Arts,* 31 ii (1998) pp.28-37;88-91;95. (Senegambia ... non-Muslim Mandinka masks & ... Muslim Mande masks.)

4574 La prophétesse résistante: les chants d'Aliin Sitoé Diatta. *Comprendre la Casamance: chronique d'une intégration contrastée.* Sous la coord. de F-G.Barbier-Wiesser. Paris: Karthala, 1994, pp.457-460. [Colonial Casamance.]

Sierra Leone

Articles

4575 OJUKUTU-MACAULEY, S. Religion, gender, and education in northern Sierra Leone, 1896-1992. *Islam and trade in Sierra Leone.* Ed. Alusine Jalloh & D.E.Skinner. Trenton & Asmara: Africa World Press, 1997, pp.87-117. [Contrasting Muslims & Christians.]

Somalia

Books

4576 AMAN, *Somali woman.* Das Mädchen Aman: eine Nomadin erzählt. Aufgezeichnet von V.L.Barnes & J.Boddy. Hamburg: Hoffman & Campe, 1995. 382pp. [Tr. of *Aman: the story of a Somali girl,* London 1994.]

4577 DIRIE, Waris & MILLER, Cathleen. *Desert flower: the extraordinary journey of a desert nomad.* London: Virago, 1999. 238pp. [Somali woman's story. Previously published New York 1998.]

4578 DIRIE, Waris & MILLER, Cathleen. *Desert flower: the extraordinary journey of a desert nomad.* New York: Morrow, 1998. 228pp. [Somali woman's story.]

4579 DIRIE, Waris & MILLER, Cathleen. *Fiore del deserto: storia di una donna.* Milan: Mondolibri, 1999. 315pp. [Tr. of *Desert flower,* New York 1998. Somali woman's story.]

4580 DIRIE, Waris & MILLER, Cathleen. *Fiore del deserto: storia di una donna.* Milan: Garzanti, 2000. 314pp. [Tr. of *Desert flower,* New York 1998. Somali woman's story.]

4581 DIRIE, Waris & MILLER, Cathleen. *Fleur du désert: du désert de Somalie au monde des top-model, l'extraordinaire combat d'une femme hors du comun.* Tr. Deschamps, Josiane & Deschamps, Alain. Paris: Michel, 1998. 328pp. [Tr. of *Desert flower,* New York 1998. Somali woman's story.]

4582 DIRIE, Waris & MILLER, Cathleen. *Fleur du désert: du désert de Somalie au monde des top-model, l'extraordinaire combat d'une femme hors du comun.* Tr. Deschamps, Josiane & Deschamps, Alain. Paris: Ed. J'ai Lu, 2000. 279pp. [Tr. of *Desert flower,* New York 1998. Somali woman's story.]

4583 DIRIE, Waris & MILLER, Cathleen. *Flor del desierto.* Tr. Pages, Cristina. Barcelona: Planeta, 1999. 240pp. [Tr. of *Desert flower,* New York 1998. Somali woman's story.]

4584 DIRIE, Waris & MILLER, Cathleen. *Wüstenblume.* Tr. Jendricke, Bernhard. Munich: Schneekluth, 1998. 347pp. [Tr. of *Desert flower,* New York 1998. Somali woman's story.]

4585 HASSAN, Sirad Salad. *Sette gocce di sangue: due donne somale.* Palermo: Arcidonna, 1996 (La Luna, 34), 121pp.

4586 KAPTEIJNS, Lidwien & ALI, Maryan Omar. *Women's voices in a man's world: women and the pastoral tradition in Northern Somali orature, c. 1899-1980.* Portsmouth (USA): Heinemann, 1999. 224pp.

4587 UNALI, Lina. *Regina d'Africa: incanto dell'infanzia nomadica, infibulazione, matrimonio, guerra civile nelle boscaglie della Somalia.* Rome: Edizioni Associate, 1993, (Osservatorio Internazionale), 77pp.

Articles

4588 AHMED, Sadia. Islam and development: opportunities
and constraints for Somali women. *Gender and
Development,* 7 i (1999) pp.69-72. Also online at http://
www.ingentaselect.com

4589 DECLICH, F. Groups of mutual assistance: feminine and
masculine work among agriculturalists along the Juba
River. *Northeast African Studies,* N.S. 4 iii (1997)
pp.77-89.

4590 DECLICH, Francesca. Fostering ethnic reinvention: gender
impact of forced migration on Bantu Somali refugees in
Kenya. (Résumé: Invention de l'ethnicité et modification
des rapports de genre chez les réfugiés somali du Kénya.).
Cahiers d'Etudes Africaines, 40 / 157 (2000) pp.25-53.
[Much on conditions in Somalia.]

4591 GIGLI, M. Exogamie et endogamie dans un village de la
Somalie méridionale. *Anthropologie somalienne: actes
du IIe Colloque des Etudes Somaliennes (Besançon ...
1990).* Ed. Mohamed Mohamed Abdi. Besançon:
Université de Besançon; Paris: Belles Lettres, 1993,
(Centre de Recherches d'Histoire Ancienne: Annales
Littéraires, 123), pp.49-63.

4592 HAWK MERRYMAN, N. Women's welfare in the Jubba
valley: Somali socialism and after. *The struggle for land
in southern Somalia: the war behind the war.* Ed.
C.Besteman & L.V.Cassanelli. Boulder: Westview;
London: HAAN, 1996, pp.179-198.

4593 PELLION, O. Ségrégation et résistance à la ségrégation:
les formes de solidarité entre les femmes de Marerrey.
*Anthropologie somalienne: actes du IIe Colloque des
Etudes Somaliennes (Besançon ... 1990).* Ed. Mohamed
Mohamed Abdi. Besançon: Université de Besançon; Paris:
Belles Lettres, 1993, (Centre de Recherches d'Histoire
Ancienne: Annales Littéraires, 123), pp.21-32.

4594 SAMATAR, Abdi Ismail. Social transformation and
Islamic reinterpretation in northern Somalia: the women's
mosque in Gabiley. *Arab World Geographer. Le
Géographe du Monde Arabe,* 3 i (2000) pp.22-39.

4595 Aman recalls the day the games ended; Aman on how she
came into this world, as a nomad. *Eye to eye women:
their words and worlds. Life in Africa, Asia, Latin America
and the Caribbean as seen in photographs and in fiction
by the region's top women writers.* (Ed. V.Baird). Oxford:
New Internationalist, 1996, pp.50;86-88. [From *Aman:
the story of a Somali girl.*]

4596 Sharing stories: MAMA East African Women's Group:
Somalian women's stories. *Soundings,* 12 (1999)
pp.163-174. [Somali women in Britain retelling Somali
folklore.]

South Africa (general)

Books

4597 MAYAT, Zuleikha M. *A treasure trove of memories: a
reflection on the experiences of the peoples of
Potchefstroom.* Durban: Madiba, in association with the
Women's Cultural Group, 1996. 285pp.

Articles

4598 AHMED, Abdul Kayum. Developing a theology of
compassion: Muslim attitudes towards people living with
HIV/Aids in South Africa. *Annual Review of Islam in
South Africa,* 3 (2000) pp.22-26. Also online at
www.uct.ac.za/depts/religion/arisa3.htm

4599 DANGOR, Suleman. Historical perspective, current
literature and an opinion survey among Muslim women
in contemporary South Africa: a case study. *Journal of
Muslim Minority Affairs,* 21 i (2001) pp.109-129. Also
online at www.catchword.com

4600 HAFFAJEE, S., ESPREY, Y. & FRIDJHON, P. Gender,
religion, and religiosity: an exploration of attitudes towards
abortion among medical students. *Journal of the Islamic
Medical Association of South Africa. Majallat al-Jam'Tya
al-Ṭibbīya al-Islāmīya bi-Janūb Ifrīqiyā,* 6 i (2000)
pp.7-14. [In South Africa, incl. Muslims.]

4601 HOOSEN, S. A guideline to medical practitioners and
social workers on the psycho-social impact of domestic
violence on the women, family and community. *Journal
of the Islamic Medical Association of South Africa,* 8 ii
(2001) pp.35-40. [Muslim families in South Africa.]

4602 LEE, Rebekah. Conversion or continuum? The spread of
Islam among African women in Cape Town. *Social
Dynamics,* 27 ii (2001) pp.62-85. [Converts from
Christianity.]

4603 MOOSA, Ebrahim. Le conservatisme musulman en
Afrique du Sud. *Women Living under Muslim Laws:
Dossier,* 20 (1997) pp.36-48. Also online at http://
www.wluml.org/french/pubs/pdf/dossiers/dossier20/
D20fr.pdf

4604 MOOSA, Ebrahim. Muslim conservatism in South Africa.
Women Living under Muslim Laws: Dossier, 20 (1998)
Also online at http:// www.wluml.org/english/pubs

4605 RAUTENBACH, Christa. The recognition of Muslim
marriages in South Africa past, present and future. *Recht
van de Islam,* 17 (2000) pp.36-89. [Non-recognition of
polygamous marriages.]

South Asia (before Partition)

Books

4606 ALI, Azra Asghar. *The emergence of feminism among
Indian Muslim women, 1920-1947.* Karachi: Oxford
University Press, 2000. 291pp.

4607 AMIN, Sonia Nishat. *The world of Muslim women in
colonial Bengal, 1876-1939.* Leiden: Brill, 1996, (Social,
Economic and Political Studies of the Middle East, 55),
313pp.

4608 GUPTA, Charu. *Sexuality, obscenity, community: women,
Muslims, and the Hindu public in colonial India.* Delhi:
Permanent Black, 2001. 388pp.

4609 KHAN, Sharharyar M. *The begums of Bhopal: a history
of the princely state of Bhopal.* London: Tauris, 2000.
276pp.

4610 MENON, Ritu & BHASIN, Kamla. *Borders &
boundaries: women in India's Partition.* Delhi: Kahli for
Women; New Brunswick: Rutgers University Press, 1998.
274pp.

4611 SAIYID, Dushka. *Muslim women of the British Punjab:
from seclusion to politics.* Basingstoke: Macmillan, 1998.
145pp.

4612 ZAMAN, Umme Salma. *Muslim women and struggle for
independence.* Karachi: Kifāyat Akaydamī, 1997.
79+64pp. [Urdu & English. Urdu title: *Muslim khawātīn
awr jidd ū jahd-i āzādī.*]

4613 *Inventing boundaries: gender, politics and the Partition of
India.* Ed. Mushirul Hasan. Delhi: Oxford University Press,
2000. 393pp. [Previously published pamphlets, articles
& short stories.]

4614 *Muslim feminism and feminist movement: South Asia.* Vol.
1: *India.* Ed. Abida Samiuddin, R.Khanam. Delhi: Global
Vision Publishing House, 2002. 351pp. [Before and after
Partition.]

4615 MINAULT, G. *Secluded scholars: women's education
and Muslim social reform in colonial India.* Delhi: Oxford
University Press, 1998. 359pp.

Articles

4616 AHMAD, Nasim. Women's struggle for social political
and educational equality. *Muslim feminism and feminist
movement: South Asia.* Vol. 1: *India.* Ed. Abida
Samiuddin, R.Khanam. Delhi: Global Vision Publishing
House, 2002, pp.285-296.

4617 AHMED, Rahnuma. "Women's awakening": the construction of modern gender differences in Bengali Muslim society. *Journal of Social Studies*, 86 (1999) pp.1-27. [Late 19th & early 20th centuries.]

4618 AKHTARUZZAMAN, Md. Women in thirteenth century eastern Indian society. *Dhaka University Studies*, 55 i (1998) pp.17-21. (The status of women seems to have been one of those social aspects that became transformed after the establishment of Muslim rule in 1205 A.D.)

4619 ALI, Azra Asghar. Educational development of Muslim women in colonial India. *Journal of the Research Society of Pakistan*, 36 i (1999) pp.41-65.

4620 ALI, Azra Asghar. Indian Muslim women's suffrage campaign: personal dilemma and communal identity 1919-47. *Journal of the Pakistan Historical Society*, 47 ii (1999) pp.33-46.

4621 ALI, Azra Asghar. Muslim women and the beginning of health care culture in British India 1857-1947. *Pakistan Journal of Women's Studies. Alam-e-Niswan*, 4 i (1997) pp.13-24.

4622 ALI, Azra Asghar. Recovery of female voice through women's journals in Urdu in British India 1898-1947. *South Asia*, 21 ii (1998) pp.61-86.

4623 ALI, Azra Asghar. The emergence of reformist literature about Indian Muslim women in Urdu language (1857-1910). *Pakistan Journal of History and Culture*, 19 ii (1998) pp.27-41.

4624 ALI, Azra Asghar. The emergence of reformist literature in Urdu about Muslim women in colonial India, 1857-1910. *Pakistan Journal of Women's Studies. Alam-e-Niswan*, 5 i-ii (1998) pp.45-59.

4625 AMIN, Sonia N. The changing world of Bengali Muslim women: the 'dreams' and efforts of Rokeya Sakhawat Hossein. *Understanding the Bengal Muslims: interpretative essays*. Ed. Rafiuddin Ahmed. Delhi: Oxford University Press, 2001, pp.139-152. (Pioneer feminist writer of Bengal.)

4626 AMIN, Sonia Nishat. Women. *History of Bangladesh 1704-1971.* Volume 3: *Social and cultural history. Ed. Sirajul Islam, Assistant ed. Akmal Hussain.* 2nd ed. Dhaka: Asiatic Society of Bangladesh, 1997, pp.650-690. [18th-20th centuries.]

4627 ASLAM, Qais. Economic role of woman in Moghul society. *Government College Economic Journal*, 30 i-ii (1997) pp.59-66.

4628 AZIZ, Abdul. Islam and women rights movements in pre-independence India. *Muslim feminism and feminist movement: South Asia*. Vol. 1: *India*. Ed. Abida Samiuddin, R.Khanam. Delhi: Global Vision Publishing House, 2002, pp.7-46.

4629 AZIZ, Talat. Nawab Shah Jahan Begum of Bhopal: spokeswoman of Muslim women's education and social reformer. *Islam and the Modern Age*, 29 iii (1998) pp.257-264.

4630 BAHRI, Deepika. Telling tales: women and the trauma of Partition in Sidhwa's *Cracking India*. *Interventions*, 1 ii (1999) pp.217-234.

4631 BAQAI, Farah Gul. Begum Shaista Ikramullah: a woman who dared (1915-2000). *Pakistan Journal of History and Culture*, 21 ii (2000) pp.99-103. [Social & political activist in Delhi & Karachi.]

4632 BAQAI, Farah Gul. Ruttie Jinnah. *Pakistan Journal of History and Culture*, 17 ii (1996) pp.63-76. [Jinnah's Parsi wife.]

4633 BARNETT, R. B. Embattled begams: women as power brokers in early modern India. *Women in the medieval Islamic world: power, patronage, and piety.* Ed. G.R.G.Hambly. Basingstoke: Macmillan, 1998, (The New Middle Ages, 6), pp.521-536. (The Begams of Awadh (north India) are a case-study.)

4634 BILGRAMI, Fatima Z. Sir Syed's views on female education. *Journal of the Pakistan Historical Society*, 44 iii (1996) pp.243-257.

4635 BOKHARI, S.N. Legislations for women's right. *Muslim feminism and feminist movement: South Asia.* Vol. 2: *Pakistan.* Ed. Abida Samiuddin, R.Khanam. Delhi: Global Vision Publishing House, 2002, pp.191-209. [Before Partition.]

4636 BUTALIA, Urvashi. Community, state, and gender. Some reflections on the Partition of India. *Inventing boundaries: gender, politics and the Partition of India.* Ed. Mushirul Hasan. Delhi: Oxford University Press, 2000, pp.178-207. [Previously published in *Oxford Literary Review*, 16 i-ii, 1994. Attacks on Hindu & Muslim women.]

4637 CHANANA, K. Schooling of girls in pre-Partition Punjab. *Indian Journal of Gender Studies*, 4 ii (1997) pp.141-166. [Incl. Muslims.]

4638 CHATTERJEE, Shipra. The communalisation of female political identity. *Muslim feminism and feminist movement: South Asia.* Vol. 1: *India.* Ed. Abida Samiuddin, R.Khanam. Delhi: Global Vision Publishing House, 2002, pp.83-96. [1920s-40s.]

4639 DEUTSCH, K. A. *Marriage in Islam* by Begum Habibullah (1883-1975). *Indian Journal of Gender Studies*, 4 ii (1997) pp.269-273. [Speech published in *Leader of Allahabad*, 5 December 1929 on Muslim view regarding proposals to limit child marriage in South Asia.]

4640 FINDLY, Ellison Banks. Women's wealth and styles of giving: perspectives from Buddhist, Jain, and Mughal sites. *Women, patronage, and self-representation in Islamic societies.* Ed. D.Fairchild Ruggles. Albany (USA): State University of New York Press, 2000, pp.91-121.

4641 FISHER, M. H. Women and the feminine in the court and high culture of Awadh, 1722-1856. *Women in the medieval Islamic world: power, patronage, and piety.* Ed. G.R.G.Hambly. Basingstoke: Macmillan, 1998, (The New Middle Ages, 6), pp.489-519.

4642 GHADIALLY, R. The campaign for women's emancipation in Daudi Bohra sect of Indian Muslims: 1929-1945 . *Muslim feminism and feminist movement: South Asia.* Vol. 1: *India.* Ed. Abida Samiuddin, R.Khanam. Delhi: Global Vision Publishing House, 2002, pp.137-163.

4643 GHADIALLY, Rehana. Campagne pour l'émancipation des femmes dans une secte Ismaili Shia (Daudi Bohra) de musulmans indiens: 1925-1945. *Women Living under Muslim Laws: Dossier*, 14-15 (1996) pp.68-91. Also online at http:// www.wluml.org/french/pubs/pdf/dossiers/ dossier14-15/D14-15fr.pdf

4644 GHADIALLY, Rehana. The campaign for women's emancipation in an Ismaili Shia (Daudi Bohra) sect of Indian Muslims: 1925-1945. *Women Living under Muslim Laws: Dossier*, 14-15 (1996) pp.64-85. Also online at www.wluml.org/english/pubs

4645 GUHA, S. The nature of woman: medical ideas in colonial Bengal. *Indian Journal of Gender Studies*, 3 i (1996) pp.23-38. [Incl. attitudes to specifically Muslim customs.]

4646 GUPTA, Charu. Hindu women, Muslim men: cleavages in shared spaces of everyday life, United Provinces, c. 1890-1930. *Indian Economic and Social History Review*, 37 ii (2000) pp.121-149.

4647 HAMBLY, G. R. G. Armed women retainers in the zenanas of Indo-Muslim rulers: the case of Bībī Fāṭima. *Women in the medieval Islamic world: power, patronage, and piety.* Ed. G.R.G.Hambly. Basingstoke: Macmillan, 1998, (The New Middle Ages, 6), pp.429-467.

4648 HASSAN, Sakina. The reassessment of Muslim womanhood. *Muslim feminism and feminist movement: South Asia.* Vol. 1: *India.* Ed. Abida Samiuddin, R.Khanam. Delhi: Global Vision Publishing House, 2002, pp.297-306. [Early twentieth century South Asia.]

4649 HAYDEN, Robert M. Rape and rape avoidance in ethno-national conflicts: sexual violence in liminalized states. *American Anthropologist*, 102 i (2000) pp.27-41.

4650 JACKSON, P. Sulṭān Raḍiyya bint Iltutmish. *Women in the medieval Islamic world: power, patronage, and piety.* Ed. G.R.G.Hambly. Basingstoke: Macmillan, 1998, (The New Middle Ages, 6), pp.181-197. (Sulṭān of Delhi.)

4651 KHALIDI, Omar. Ottoman royal family in Hyderabad, Deccan, India. *Journal of the Pakistan Historical Society,* 46 iii (1998) pp.89-97. (The Niẓām's two sons married Turkish princesses.)

4652 KHALIDI, Omar. Ottoman royal family in Hyderabad, Deccan, India. *Hamdard Islamicus,* 21 iii (1998) pp.77-85. (The Niẓām's two sons married Turkish princesses.)

4653 KOZLOWSKI, G. C. Private lives and public piety: women and the practice of Islam in Mughal India. *Women in the medieval Islamic world: power, patronage, and piety.* Ed. G.R.G.Hambly. Basingstoke: Macmillan, 1998, (The New Middle Ages, 6), pp.469-488.

4654 LENTZ, Sabine. British officers, Kashmiri officials, adultery and "customary law". *Perspectives on history and change in the Karakorum, Hindukush, and Himalaya.* I.Stellrecht, M.Winiger (eds.). Cologne: Köppe, 1997, (Culture Area Karakorum Scientific Studies, 3), pp.401-415. [Gilgit Agency area 1908, & 1995.]

4655 MASUD, Muhammad Khalid. Apostasy and judicial separation in British India. *Islamic legal interpretation: muftis and their fatwas.* Ed. Muhammad Khalid Masud, B.Messick, D.S.Powers. Cambridge: Harvard University Press, 1996, pp.193-203;356. (Muslim women had no recourse other than apostasy when seeking judicial divorce.)

4656 MEHTA, Krishna. This happened in Kashmir. *Speaking peace: women's voices from Kashmir* / ed. Urvashi Butalia. Delhi: Kali for Women, 2002, pp.1-41. [Excerpts from book published 1954 & 1960 about events of 1947.]

4657 MENON, Ritu & BHASIN, Kamla. Oranges and apples. *India partitioned: the other face of freedom.* Volume 2. Ed. Mushirul Hasan. Rev. & enlarged ed. Delhi: Roli, 1997, pp.113-123. [From interview with Kamlabehn Patel about women's experiences at the time of Partition.]

4658 MINAULT, G. Women, legal reform, and Muslim identity. *Comparative Studies of South Asia, Africa and the Middle East,* 17 ii (1997) pp.1-10. [South Asia, late 19th - early 20th century.]

4659 MINAULT, G. Women, legal reform and Muslim identity. *Islam, communities and the nation: Muslim identities in South Asia and beyond.* Ed. Mushirul Hasan. Delhi: Manohar, 1998, pp.139-158. (South Asia, late 19th century.)

4660 MINAULT, G. Women's magazines in Urdu as sources for Muslim social history. *Indian Journal of Gender Studies,* 5 ii (1998) pp.201-214.

4661 MITRA, Sharmila. Socio-literary movements feminist leaders: Rokea Hossein and Sufia Kamal. *Muslim feminism and feminist movement: South Asia.* Vol. 3: *Bangladesh & Sri Lanka.* Ed. Abida Samiuddin, R.Khanam. Delhi: Global Vision Publishing House, 2002, pp.229-245.

4662 MUSHIRUL HASAN The myth of unity: colonial and national narratives. *Contesting the nation: religion, community, and the politics of democracy in India.* Ed. D.Ludden. Philadelphia: University of Pennsylvania Press, 1996, pp.185-208. [British view of Indian Muslims & growth of Muslim Indian nationalism.]

4663 ROUSE, Asma. Women's participation in the Pakistan movement. *Muslim feminism and feminist movement: South Asia.* Vol. 2: *Pakistan.* Ed. Abida Samiuddin, R.Khanam. Delhi: Global Vision Publishing House, 2002, pp.225-255.

4664 SAMIUDDIN, Abida. Muslim women's participation in the National Movement. *Muslim feminism and feminist movement: South Asia.* Vol. 1: *India.* Ed. Abida Samiuddin, R.Khanam. Delhi: Global Vision Publishing House, 2002, pp.47-82.

4665 SAMI-UD-DIN, Abida. Participation of Muslim women in the national movement. *Muslim women in India since Independence (feminine perspectives).* Ed. Haseena Hashia. Delhi: Institute of Objective Studies, 1998, pp.38-70.

4666 SHAH, Sayed Wiqar Ali. Women and politics in the North-West Frontier Province (1930-1947). *Pakistan Journal of History and Culture,* 19 i (1998) pp.67-80.

4667 SIDDIQI, Asiya. Ayesha's world: a butcher's family in nineteenth-century Bombay. *Comparative Studies in Society and History,* 43 i (2001) pp.101-129. Also online at http:// www.journals.cambridge.org

4668 SIDDIQUI, Mona. Law and the desire for social control: an insight into the Hanafi concept of *Kafa'a* with reference to the Fatawa 'Alamgiri (1664-1672). *Feminism and Islam: legal and literary perspectives.* Ed. Mai Yamani. Reading: Ithaca, for the Centre of Islamic and Middle Eastern Law, School of Oriental and African Studies, University of London, 1996, pp.49-68. (Compiled ... under the patronage of the Mughal emperor ... a book of *fiqh.*)

4669 SIDDIQUI, Mona. The concept of *wilaya* in Hanafi law: authority versus consent in *al-Fatawa al-'Alamgiri.* *Yearbook of Islamic and Middle Eastern Law,* 5 / 1998-1999 (2000) pp.171-185. (As a major issue in marriage.)

4670 SIKANDER, Yoginder. The role of women in Kashmiri Rishism. *Speaking peace: women's voices from Kashmir* / ed. Urvashi Butalia. Delhi: Kali for Women, 2002, pp.42-55. [14th-15th century Sufis.]

4671 SINGH, Brijraj. The enigma of Begum Samru: differing approaches to her life. *India International Centre Quarterly,* 24 iv (1997) pp.33-43.

4672 TAGORE, Rabindranath. The tale of a Muslim woman. *Image and representation: stories of Muslim lives in India* / ed. Mushirul Hasan and M.Asaduddin. Delhi: Oxford University Press, 2000, pp.48- 52. [Short story tr. from Bengali. First published 1941.]

4673 VANZAN, Anna. Medical education of Muslim women in turn-of-the-century India. The 9th chapter of the *Bihishtī zewar. Journal of the Pakistan Historical Society,* 48 i (2000) pp.3-8. (Written in Urdu by ... Mawlānā Ashraf 'Alī Thānawī ... a "mirror" for Muslim women published in the early 20th century.)

4674 WIGGINS, K. W. & MAHESHWARI, K. K. Begum Sumru and her coins. *Numismatic Digest,* 18 / 1994 (1996) pp.243-252.

4675 WILLMER, D. Women as participants in the Pakistan movement: modernization and the promise of a moral state. *Modern Asian Studies,* 30 iii (1996) pp.573-590.

4676 YASIN, Madhavi. Perspectives of social change in Kashmiri women (1900-1947). *5000 years of Kashmir.* Ed. with an introd. Balraj Puri. Delhi: Ajanta Publications, 1997, pp.87-98.

4677 ZAHID, Masood Akhtar. Empire and women: perspectives on literacy in 19th century Panjab. *Pakistan Journal of History and Culture,* 19 ii (1998) pp.57-72. [Incl. Muslims.]

4678 ZAHID, Masood Akhtar. Traditionalism and female literacy in late nineteenth century Punjab. *Journal of the Pakistan Historical Society,* 45 ii (1997) pp.203-213. [Incl. Muslims.]

4679 ZAMAN, Salma. Role of women in the struggle for freedom. *Journal of the Pakistan Historical Society,* 49 iv (2001) pp.63-80. [South Asia.]

Spain

MUSLIM & MEDIÆVAL SPAIN TO 1610

Books

4680 MARÍN, Manuela. *Mujeres en al-Andalus.* Madrid: Consejo Superior de Investigaciones Cientificas, 2000 (Estudios Onomástico-Biográficos de al-Andalus, 11), 783pp.

4681 MARTÍNEZ MARTÍNEZ, María. *Las mujeres en la organización de una sociedad de frontera: la etapa colonizadora-repobladora de Murcia, 1266-1272.* Murcia: Universidad de Murcia, 2000. 118pp.

4682 MIRRER, L. *Women, Jews, and Muslims in the texts of Reconquest Castile.* Ann Arbor: University of Michigan Press, 1996. 190pp.

4683 ZOMEÑO, Amalia. *Dote y matrimonio en Al-Andalus y el norte de África: estudio sobre la jurisprudencia islámica medieval.* Madrid: Consejo Superior de Investigaciones Científicas, 2000. 302pp.

4684 *Actes du VIIe Symposium International d'Etudes Morisques sur: Famille morisque: femmes et enfants. Familia morisca: mujeres y niños.* Etudes réunies et préfacées par Abdeljelil Temimi. Zaghouan: Fondation Temimi pour la Recherche Scientifique et l'Information, 1997. 345+92pp. [Arabic title: *A 'māl al-mu'tamar al-'ālamī al-sābi' li-l-dirāsāt al-Mūrīskīya - al-Andalusīya ḥawla: al-'ā'ila al- Mūrīskīya: al-nisā' wa-'l-aṭfāl.* Jam' wa-taqdīm 'Abd al-Jalīl al-Tamīmī.]

4685 *Árabes, judías y cristianas: mujeres en la Europa medieval.* Ed. Moral, C. del. Granada: Universidad de Granada, 1993. 246pp.

Articles

4686 ADANG, Camilla. Women's access to public space according to *al-Muḥallā bi-l-Āthār.* *Writing the feminine: women in Arab sources.* Ed. by Manuela Marín and Randi Deguilhem. London: Tauris, in association with The European Science Foundation, Strasbourg, France, 2002, (The Islamic Mediterranean, 1), pp.75-94. [By Ibn Ḥazm.]

4687 AGUILAR, Victoria & MARÍN, Manuela. Las mujeres en el espacio urbano de al-Andalus. *Casas y palacios de al-Andalus.* (Coord. J.Navarro Palazón). Barcelona: Lunwerg, 1995, pp.39-44.

4688 AGUILAR, Victoria. Mujeres y repertorios biográficos. *Estudios Onomástico-Biográficos de al-Andalus,* 8 (1997) pp.127-139.

4689 ALBARRACÍN NAVARRO, J. Nueve cartas moriscas de dote y arras de Vera (Almería) (1548-1551). *Actas del Congreso La frontera oriental nazarí como sujeto histórico (s.XIII-XVI), Lorca - Vera ... 1994.* Coord. P.Segura Artero. Almería: Instituto de Estudios Almerienses, Diputación de Almería, 1997, (Colección Actas, 29), pp.517-529.

4690 ARGENTE DEL CASTILLO OCAÑA, Carmen. La consideración de la mujer en una sociedad de frontera. *Homenaje al profesor José María Fórneas Besteiro.* Granada: Universidad de Granada, 1995, pp.669-686. (Reino de Jaén.)

4691 ARIÉ, R. Aperçus sur la femme dans l'Espagne musulmane. *Árabes, judías y cristianas: mujeres en la Europa medieval.* Ed. C.del Moral. Granada: Universidad de Granada, 1993, pp.137-160.

4692 AVILA, María Luisa. Women in Andalusi biographical sources. *Writing the feminine: women in Arab sources.* Ed. by Manuela Marín and Randi Deguilhem. London: Tauris, in association with The European Science Foundation, Strasbourg, France, 2002, (The Islamic Mediterranean, 1), pp.149-163.

4693 BIRRIEL SALCEDO, M. M. Notas sobre el matrimonio de los Moriscos granadinos (1563). *Mélanges Louis Cardaillac. Taḥīyat taqdīr al-Ustādh Luwī Kārdayāk: études* réunies et prefacées par Abdeljelil Temimi. Vol. 1. Zaghouan: Fondation Temimi pour la Recherche Scientifique et l'Information, 1995, pp.97-107.

4694 CARRASCO URGOITI, María Soledad. La figura de la cautiva en España (vida y literatura). *Europa e Islam tra i secoli XIV e XVI. Europe and Islam between 14th and 16th centuries.* A cura di Michele Bernardini, Clara Borrelli, Anna Cerbo, Encarnación Sánchez García. Naples: Istituto Universitario Orientale, 2002, (Collana "Matteo Ripa", XVIII), pp.883-907. [Moriscos, Muslim slaves in Spain & related situations.]

4695 CHAROUITI HASNAOUI, Milouda. La intervención de la mujer en la vida política granadina durante la primera mitad del siglo XV. *Estudios de frontera Alcalá la Real y el Arcipreste de Hita.* Coord. F.Toro Ceballos, J.Rodríguez Molina. Congreso internacional celebrado en Alcalá la Real ... 1995. Jaén: Diputación Provincial de Jaén, Area de Cultura, 1996, pp.323-334.

4696 GALLEGO, María Angeles. Approaches to the study of Muslim and Jewish women in medieval Iberian peninsula: The poetess Qasmuna bat Isma'il. (Resumen: Planteamientos metodológicos en el estudio de las mujeres musulmanas y judías en la Edad Media hispana: la poetisa Qasmuna bat Isma'il.). *Miscelánea de Estudios Arabes y Hebraicos: Sección Hebreo,* 48 (1999) pp.63-75.

4697 GÓMEZ URDÁÑEZ, Carmen. El morisco, la doncella y el fraile. Un cuadro de la práctica de la construcción en Zaragoza en 1605. *Artigrama,* 15 (2000) pp.313-343. (Proceso contra un morisco maestro de obras ... hecha para una doncella.)

4698 HASENFELD, Galia. Gender and struggle for identity: the Moriscas in sixteenth-century Castile. *Medieval Encounters,* 7 i (2001) pp.79-100.

4699 LACHIRI, Nadia. Andalusi proverbs on women. *Writing the feminine: women in Arab sources.* Ed. by Manuela Marín and Randi Deguilhem. London: Tauris, in association with The European Science Foundation, Strasbourg, France, 2002, (The Islamic Mediterranean, 1), pp.41-48.

4700 LACHIRI, Nadia. La mujer andalusí en los repertorios biográficos. *Miscelánea de Estudios Arabes y Hebraicos: Sección Arabe-Islam,* 51 (2002) pp.39-52.

4701 LACHIRI, Nadia. La vida cotidiana de las mujeres en Al-Andalus y su reflejo en las fuentes literarias. *Árabes, judías y cristianas: mujeres en la Europa medieval.* Ed. C.del Moral. Granada: Universidad de Granada, 1993, pp.103-121.

4702 LANDA, Robert. La situation de la femme dans la société morisque. *Actes du VIIe Symposium International d'Etudes Morisques sur: Famille morisque: femmes et enfants. Familia morisca: mujeres y niños / A 'māl al-mu'tamar al-'ālamī al-sābi' li-l-dirāsāt al-Mūrīskīya - al-Andalusīya ḥawla: al-'ā'ila al-Mūrīskīya: al-nisā' wa-'l-aṭfāl.* Etudes réunies et préfacées par Abdeljelil Temimi. Zaghouan: Fondation Temimi pour la Recherche Scientifique et l'Information, 1997, pp.176-185.

4703 LÓPEZ DE LA PLAZA, G. Las mártires voluntarias musulmanas de la Córdoba omeya. *Las mujeres en la historia de Andalucía. Actas del II Congreso de Historia de Andalucía, Córdoba, 1991.* Córdoba: Consejería de Cultura y Medio Ambiente de la Junta de Andalucía y Obra Social y Cultural Cajasur, 1994, pp.271-278. (Los mártires voluntarios ... nacidos normalmente de un matrimonio mixto musulmán/cristiana ... o educados por algún familiar cristiano.)

4704 LÓPEZ DE LA PLAZA, G. Las mujeres moriscas granadinas en el discurso político y religioso de la Castilla del siglo XVI (1492-1567). *En la España Medieval,* 16 (1993) pp.307-320.

4705 LÓPEZ DOMECH, Ramón. De nuevo sobre las dos mártires mozárabes Nunilo y Alodia. *Qurṭuba,* 5 (2000) pp.121-145.

4706 MAMI, Ridha. Algunos ritos de los Mudéjares del siglo XV: bodas, divorcios y circuncisión. *Actes du VIIe Symposium International d'Etudes Morisques sur: Famille morisque: femmes et enfants. Familia morisca: mujeres y niños / A 'māl al-mu'tamar al-'ālamī al-sābi' li-l-dirāsāt al-Mūrīskīya - al-Andalusīya ḥawla: al-'ā'ila al-Mūrīskīya: al-nisā' wa-'l-aṭfāl.* Etudes réunies et préfacées par Abdeljelil Temimi. Zaghouan: Fondation Temimi pour la Recherche Scientifique et l'Information, 1997, pp.218-223.

4707 MARÍN, M. Las mujeres en al-Andalus: fuentes e historiografía. *Árabes, judías y cristianas: mujeres en la Europa medieval.* Ed. C.del Moral. Granada: Universidad de Granada, 1993, pp.35-52.

4708 MARÍN, M. Parentesco simbólico y matrimonio entre los ulemas andalusíes. *Al-Qanṭara: Revista de Estudios Árabes,* 16 ii (1995) pp.335-356.

4709 MARÍN, Manuela. Retiro y ayuno: algunas prácticas religiosas de las mujeres andalusíes. *Al-Qanṭara: Revista de Estudios Arabes,* 21 ii (2000) pp.471-480.

4710 MARÍN, Manuela. Una vida de mujer: Subh. *Estudios Onomástico-Biográficos de al-Andalus,* 8 (1997) pp.425-445.

4711 MARTINEZ, François. Femmes et infants morisques: catégories selectives de l'expulsion. *Actes du VIIe Symposium International d'Etudes Morisques sur: Famille morisque: femmes et enfants. Familia morisca: mujeres y niños / A 'māl al-mu'tamar al- 'ālamī al-sābi' li-l-dirāsāt al-Mūrīskīya - al-Andalusīya ḥawla: al- 'ā'ila al-Mūrīskīya: al-nisā' wa-'l-aṭfāl. Etudes* réunies et préfacées par Abdeljelil Temimi. Zaghouan: Fondation Temimi pour la Recherche Scientifique et l'Information, 1997, pp.224-239.

4712 MARTÍNEZ ALBARRACÍN, Carmen Araceli. Juan Martínez Ruiz y la carta de dote y arras de una morisca. *VI Simposio Internacional de Mudejarismo, Teruel, 16-18 de septiembre de 1993. Actas.* [Zaragoza]: Centro de Estudios Mudéjares, Instituto de Estudios Turolenses, 1995, pp.833-844.

4713 MARTÍNEZ RUIZ, J. La onomástica de las moriscas de Baza (Granada), según documentos inéditos (siglo XVI). *L'expulsió dels moriscos: conseqüències en el món islàmic i el món cristià. 380è aniversari de l'expulsió dels moriscos: congrés internacional, Sant Carles de la Ràpita ... 1990.* Barcelona: Generalitat de Catalunya, 1994, pp.305-313.

4714 MARTÍNEZ RUIZ, J. Onomástica femenina en la Granada morisca (año 1565). *Proyeccion histórica de España en sus tres culturas: Castilla y León, América y el Mediterráneo.* Vol. III: *Arabe, hebreo e historia de la medicina.* E.Lorenzo Sanz (coord.). Valladolid: Junta de Castilla y León, Consejería de Cultura y Turismo, 1993, pp.131-142.

4715 MARTINEZ SAN PEDRO, Ma Desamparados. Algunos aspectos de la vida de las moriscas granadinas ante su matrimonio. *Actes du VIIe Symposium International d'Etudes Morisques sur: Famille morisque: femmes et enfants. Familia morisca: mujeres y niños / A 'māl al-mu'tamar al- 'ālamī al-sābi' li-l-dirāsāt al-Mūrīskīya - al-aNdalusīya ḥawla: al- 'ā'ila al-Mūrīskīya: al-nisā' wa-'l-aṭfāl. Etudes* réunies et préfacées par Abdeljelil Temimi. Zaghouan: Fondation Temimi pour la Recherche Scientifique et l'Information, 1997, pp.240-253.

4716 MORAL MOLINA, C. del. La mujer árabe en Andalucía durante la edad media: estado de la cuestión de los trabajos publicados hasta el momento. *Las mujeres en la historia de Andalucía. Actas del II Congreso de Historia de Andalucía, Córdoba, 1991.* Córdoba: Consejería de Cultura y Medio Ambiente de la Junta de Andalucía y Obra Social y Cultural Cajasur, 1994, pp.35-40.

4717 MOTOS GUIRAO, E. Aproximación a la mujer medieval a través de la arqueología. *Árabes, judías y cristianas: mujeres en la Europa medieval.* Ed. C.del Moral. Granada: Universidad de Granada, 1993, pp.91-102. [Evidence from mediæval Spain.]

4718 NIRENBERG, D. Religious and sexual boundaries in the medieval crown of Aragon. *Christians, Muslims, and Jews in medieval and early modern Spain: interaction and cultural change.* Ed. M.D.Meyerson & E.D.English. Notre Dame (USA): Notre Dame Press, 2000, (Notre Dame Conferences in Medieval Studies, VIII), pp.141-160. [Jewish or Muslim men charged with sexual relations with Christian women.]

4719 ORFALI, M. Influencia de las sociedades cristiana y musulmana en la condición de la mujer judía. *Árabes, judías y cristianas: mujeres en la Europa medieval.* Ed. C.del Moral. Granada: Universidad de Granada, 1993, pp.77-89. (La España cristiana y musulmana.)

4720 PERRY, Mary Elizabeth. Moriscas and the limits of assimilation. *Christians, Muslims, and Jews in medieval and early modern Spain: interaction and cultural change.* Ed. M.D.Meyerson & E.D.English. Notre Dame (USA): Notre Dame Press, 2000, (Notre Dame Conferences in Medieval Studies, VIII), pp.274-289.

4721 POWERS, David S. Women and divorce in the Islamic west: three cases. *Hawwa: Journal of Women in the Middle East and the Islamic world,* 1 i (2003) pp.29-45. Also online at http:// leporello.ingentaselect.com/ vl=16277934/cl=41/nw=1/rpsv/cw/brill/15692078/(Lisbon, Ceuta, Bijāya.)

4722 RIVERA, M-M. La construcción de lo femenino entre Musulmanes, Judíos y Cristianos (Al-Andalus y reinos cristianos, siglos XI-XIII). *Rapports entre Juifs, Chrétiens et Musulmans: eine Sammlung von Forschungsbeiträgen.* Hrsg. J.Irmscher. Amsterdam: Hakkert, 1995, pp.131-146.

4723 SEGURA GRAIÑO, F. Las mujeres en la frontera. *Estudios de frontera Alcalá la Real y el Arcipreste de Hita.* Coord. F.Toro Ceballos, J.Rodríguez Molina. Congreso internacional celebrado en Alcalá la Real ... 1995. Jaén: Diputación Provincial de Jaén, Area de Cultura, 1996, pp.633-644. (Dos siglos del Reino de Granada.)

4724 SERRANO-NIZA, D. El adorno femenino en Al-Andalus: fuentes lexicográficas para su estudio. *Boletín de la Asociación Española de Orientalistas,* 30 (1994) pp.229-238.

4725 SHATZMILLER, M. Women and wage labour in the medieval Islamic west: legal issues in an economic context. *Journal of the Economic and Social History of the Orient,* 40 ii (1997) pp.174-206. (Mālikī legal sources from Muslim Spain & North Africa.)

4726 TLILI-SELLAOUTI, Rachida. L'image de la femme morisque dans l'inconscient des occidentaux aux 17ème-18ème siècles. *Actes du VIIe Symposium International d'Etudes Morisques sur: Famille morisque: femmes et enfants. Familia morisca: mujeres y niños / A 'māl al-mu'tamar al- 'ālamī al-sābi' li-l-dirāsāt al-Mūrīskīya - al-Andalusīya ḥawla: al- 'ā'ila al-Mūrīskīya: al-nisā' wa-'l-aṭfāl. Etudes* réunies et préfacées par Abdeljelil Temimi. Zaghouan: Fondation Temimi pour la Recherche Scientifique et l'Information, 1997, pp.288-304.

4727 URBANEJA ORTIZ, Catalina. La mujer morisca. *Jábega,* 77 (1997) pp.32-47.

4728 VALENCIA RODRÍGUEZ, R. La mujer y el espacio público de las ciudades andalusíes. *Saber y vivir: mujer, antigüedad y medievo.* M.I.Calero Secall y R.Francia Somalo (coord.). Málaga: Universidad de Málaga, [1996], pp.113-125.

4729 ZOMEÑO, Amalia. Abandoned wives and their possibilities for divorce in al-Andalus: the evidence of the *Wathā'iq* works. *Writing the feminine: women in Arab sources.* Ed. by Manuela Marín and Randi Deguilhem. London: Tauris, in association with The European Science Foundation, Strasbourg, France, 2002, (The Islamic Mediterranean, 1), pp.111-126.

4730 ZOMEÑO, Amalia. Donaciones matrimoniales y transmisión de propriedades inmuebles: estudio del contenido de la *siyāqa* y la *niḥla* en al-Andalus. *L'urbanisme dans l'Occident musulman au Moyen Âge: aspects juridiques. Actes recueillis et préparés* par Patrice Cressier, Maribel Fierro et Jean-Pierre Van Staëvel. Madrid: Casa de Velázquez, Consejo Superior de Investigaciones Científicas, 2000, pp.75-99.

MODERN SPAIN

Books

4731 ARIÑO GIMÉNEZ, Pilar. *Mujeres inmigrantes marroquíes en la Comunidad de Madrid: identidad y problemática de integración.* [Madrid]: Fundación Humanismo y Democracia, 1998. 266pp.

4732 RAMÍREZ, A. *Migraciones, género e Islam: mujeres marroquíes en España.* Madrid: Agencia Espanola de Cooperación Internacional, 1998. 380pp.

Articles

4733 BOUILLET, C. Soigner la folie de l'autre: Salima-Casablanca-Barcelona. *Revue Européenne des Migrations Internationales,* 13 iii (1997) pp.267-273. [Psychiatric treatment of young Moroccan immigrant in Barcelona.]

4734 CEBRIÁN ABELLÁN, A. & AURELIO, C. A. Género y actividad laboral magrebí. De las dificultades receptoras a la relegación laboral. *Anales de Historia Contemporánea,* 13 / 1997 (1998) pp.107-125. (Inmigración femenina magrebí.)

4735 DIETZ, Gunther. Discrimination of Muslim women in Spain. *Multi-level discrimination of Muslim women in Europe.* Jochen Blaschke (ed.). Berlin: Parabolis, 2000, pp.341- 520.

4736 GÓMEZ CAMARERO, C. Aproximación a la inmigración femenina magrebí en España. *Miscelánea de Estudios Árabes y Hebraicos: Sección Arabe-Islam,* 44 (1995) pp.25-37.

4737 GÓMEZ FAYRÉN, J. Mujer e integración social del inmigrante magrebí: un reto para el año 2000 en la región de Murcia. *Anales de Historia Contemporánea,* 13 / 1997 (1998) pp.165-187.

4738 GREGORIO GIL, C. Mujeres inmigrantes marroquíes en la CAM. *Inmigración magrebí en España: el retorno de los moriscos.* Madrid: MAPFRE, 1993, (Colección El Magreb, 8), pp.385-393. (Comunidad Autónoma de Madrid.)

4739 HOLGADO FERNÁNDEZ, I. La mujer inmigrante marroquí en Barcelona. *Vigía de Tierra,* 2-3 / 1996-7 (1997) pp.171-179.

4740 MOLINA MELIÁ, A. La regulación del matrimonio. *Acuerdos del Estado español con los judíos, musulmanes y protestantes.* By J.Bonet [& others]. Salamanca: Universidad Pontificia de Salamanca, 1994, (Bibliotheca Salmanticensis: Estudios, 162), pp.159-188. [Incl. Muslims.]

4741 RAMÍREZ, A. El largo camino que lleva a España: secuencia de las migraciones femeninas marroquíes. *Anales de Historia Contemporánea,* 13 / 1997 (1998) pp.69-85.

4742 RAMÍREZ, A. Huríes sin paraíso: la emigración feminina marroquí a España. *Awrāq,* 14 (1993) pp.165-198.

4743 ROSANDER, E. E. Translocal Islam: Murid women in Senegal and Spain. *Religion and politics in Africa and the Islamic world: report from the 1997 conference of the University of Copenhagen ... 1997.* Ed. N.Kastfelt & J.Tvillinggaard. Copenhagen: North/South Priority Research Area, 1997, pp.243-262.

4744 ROSANDER, Eva Evers. Money, marriage and religion: Senegalese women traders in Tenerife, Spain. *Africa, Islam and development: Islam and development in Africa - African Islam, African development.* Thomas Salter, Kenneth King (Eds). Edinburgh: Centre of African Studies, University of Edinburgh, 2000, pp.167-191.

4745 SERRANO MARTÍNEZ, J. M. La actividad laboral de las mujeres magrebíes inmigrantes en la región de Murcia. Empleo en el servicio doméstico? *Anales de Historia Contemporánea,* 13 / 1997 (1998) pp.141-164.

4746 VILAR, J. B. IV Jornadas de inmigración magrebí: la mujer inmigrante en la Región de Murcia (Murcia, 8-9 Abril 1997). *Awrāq,* 28 (1997) pp.289-293.

4747 VILAR, J. B. La mujer magrebí en la región de Murcia. *Anales de Historia Contemporánea,* 13 / 1997 (1998) pp.11-14.

Sri Lanka

Books

4748 *Muslim feminism and feminist movement: South Asia.* Vol. 3: *Bangladesh & Sri Lanka.* Ed. Abida Samiuddin, R.Khanam. Delhi: Global Vision Publishing House, 2002. 360pp.

Articles

4749 ASAD, M.N.M.Kamil. History of Muslim women's education in Sri Lanka. *Journal of the Pakistan Historical Society,* 49 iii (2001) pp.15-19.

4750 DE MUNCK, V. C. Love and marriage in a Sri Lankan Muslim community: toward a reevaluation of Dravidian marriage practices. *American Ethnologist,* 23 iv (1996) pp.698-716.

4751 MATHALI, S. Abitha. Literacy amonst Muslim women of Sri Lanka - issues for research: a report of Muslim Women's Association, Sri Lanka. *Pakistan Journal of Women's Studies. Alam-e-Niswan,* 5 i-ii (1998) pp.95-99.

4752 MUTHALIF, Sithie Abitha. Migration of Muslim women to West Asia: impact on the economic and family relations among Muslim households in Sri Lanka. *Pakistan Journal of Women's Studies: Alam-e-Niswan,* 4 ii (1997) pp.41-47.

4753 NUHUMAN, M.A. & SENADHIRA, S. Ethnic identity, religious fundamentalism and Muslim feminism in Sri Lanka. *Muslim feminism and feminist movement: South Asia.* Vol. 3: *Bangladesh & Sri Lanka.* Ed. Abida Samiuddin, R.Khanam. Delhi: Global Vision Publishing House, 2002, pp.285-314.

4754 NUHUMAN, M.A. Ethnic identity, religious fundamentalism and Muslim women in Sri Lanka. *Women Living under Muslim Laws: Dossier,* 21 (1998) pp.89-111. Also online at http:// www.wluml.org/english/pubs

4755 SCHRIJVERS, J. Internal refugees in Sri Lanka: the interplay of ethnicity and gender. *European Journal of Development Research,* 9 ii (1997) pp.62-82. [Incl. Muslims.]

4756 SCHRIJVERS, Joke. 'We were like coconut and flour in the pittu'; Tamil-Muslim violence, gender and ethnic relations in eastern Sri Lanka. *Nēthrā,* 2 iii (1998) pp.10-39.

4757 SPENCER, J. Fatima and the enchanted toffees: an essay on contingency, narrative and therapy. (Fatima et les caramels enchantés: un essai sur la contingence, la narration et la thérapie: résumé.). *Journal of the Royal Anthropological Institute,* 3 iv (1997) pp.693-710. (The demonic possession of a young Muslim woman in Sri Lanka.)

4758 WIJAYATILAKE, Kamalini. Les droits de la femme dans la famille: l'expérience sri lankaise. *Les frontières mouvantes du mariage et du divorce dans les communautés musulmanes.* Grabels: Women Living under Muslim Laws, 1996, (Programme Femmes et Loi dans le Monde Musulman: Dossier Spécial), pp.142-150. [With particular ref. to Muslims.] Also online at http:// www.wluml.org/french/pubs/pdf/dossiers/sd/SD1.pdf

Sudan

Books

4759 ALI, Mohamed H.Fadlalla. *Das islamische Ehe- und Kinderschaftsrecht im Sudan: mit Hinweisen zu den Lehren der Islamischen Rechtsschulen, der anwendbaren Familienrechtsvorschriften für Nichtmuslime im Sudan und im deutschen Familienrecht.* Frankfurt a.M.: Lang, 2001 (Internationalrechtliche Studien, 17), 272pp.

4760 GRAWERT, E. *Making a living in rural Sudan: production of women, labour migration of men, and policies for peasants' needs.* Basingstoke: Macmillan, 1998. 239pp.

4761 HALE, S. *Gender politics in Sudan: Islamism, socialism, and the state.* Boulder: Westview, 1996. 294pp.

4762 HICKS, Esther K. *Infibulation: female mutilation in Islamic northeastern Africa.* 2nd ed., rev. and expanded. New Brunswick: Transaction, 1996. 319pp. [Sudan, Ethiopia, Eritrea, Jibuti, Somalia. First published 1993.]

4763 JOK, Jok Madut. *Militarization, gender and reproductive health in South Sudan.* Lewiston: Edwin Mellen Press, 1998. 339pp.

Articles

4764 ABDEL HALIM, Asma. Attack with a friendly weapon. *What women do in war time: gender and conflict in Africa.* Ed. M.Turshen, C.Twagiramariya. London: Zed, 1998, pp.85-100. [Sudan.]

4765 ABDEL MAGID, A[hmed] M. & BADRI, Amna M. The
 attitudes of a sector of male health providers towards
 female circumcision (FC) in the Sudan. *Ahfad Journal
 / Majallat al-Aḥfād,* 16 i (1999) pp.3-22.

4766 ABDEL MAGID, Ahmed [M.] & OMRAN, Muna. The
 uncircumcised female is an ideal state of circumcision - a
 case study from Sudan. *Ahfad Journal / Majallat
 al-Aḥfād,* 16 ii (1999) pp.2-15.

4767 ABDEL MAGIED, Ahmed M. Re-circumcision: the hidden
 devil of female genital mutilation (FGM) in Sudan - case
 study on the perception and attitudes of Sudanese men.
 Ahfad Journal / Majallat al-Aḥfād, 17 ii (2000) pp.3-14.

4768 ABDEL MAGIED, Ahmed M. Re-circumcision: the hidden
 devil of female genital mutilation - case study on the
 perception, attitudes and practices of Sudanese women.
 Ahfad Journal / Majallat al-Aḥfād, 17 i (2000) pp.22-32.

4769 ABDEL MAGIED, Ahmed. Some FGM terminology
 between the negative and positive impacts - with special
 reference to Sudan. *Ahfad Journal / Majallat al-Aḥfād,*
 15 ii (1998) pp.4-13. (Female genital Mutilation (FGM).)

4770 ABUSHARAF, Rogaia Mustafa. Migration with a feminine
 face: breaking the cultural mold. *Arab Studies Quarterly,*
 23 ii (2001) pp.61-85. [Sudanese women migrating alone
 to North America.]

4771 AHMAD, Eman A/Rahman & AHMED, Sara A/Mageed.
 The extent of secondary school girls knowledge of the
 Sudanese women's movement, from its inception until
 1999. *Ahfad Journal / Majallat al-Aḥfād,* 17 i (2000)
 pp.45-46. (Research note.)

4772 ALI, Nada Mustafa M. The invisible economy, survival,
 and empowerment: five cases from Atbara, Sudan.
 Middle Eastern women and the invisible economy. Ed.
 R.A.Lobban. Gainesville: University Press of Florida,
 1998, pp.96-109.

4773 ALKONTI, Fatima. Determinants of maternal health care
 in Northern Sudan. *CDC 27th Annual Seminar on
 population issues in the Middle East, Africa and Asia.*
 Cairo: Cairo Demographic Center, 1998, (Research
 Monograph Series, 27; CDC Annual Seminar, 1997),
 pp.392-422.

4774 ALMAAZ, Ikhlas Yousif Rizig & ELAMIN, Zahra
 Mohammed. Female university girl student empowerment
 indicators. *Ahfad Journal / Majallat al-Aḥfād,* 17 i (2000)
 pp.48-50. (Research note.)

4775 AMIN, Nafisa Ahmed al. A history of Sudanese women
 organizations and the strive [*sic*] for liberation and
 empowerment. *Ahfad Journal / Majallat al-Aḥfād,* 18 i
 (2001) pp.2-23.

4776 BADRI, Amna E. Educating African women for change.
 Ahfad Journal / Majallat al-Aḥfād, 18 i (2001) pp.24-34.
 (History of Ahfad University for Women.)

4777 BADRI, Dina. A strategy for organizational change in the
 administration of the mother and child health / family
 planning / eradication of harmful traditional practices,
 Ahfad Reproductive Health Centre. *Ahfad Journal /
 Majallat al-Aḥfād,* 15 i (1998) pp.4-14. (Omdurman.)

4778 BEDRI, Nafisa M. Where is health in family sciences?
 Ahfad Journal, 13 i (1996) pp.32-37. (Concept of the
 Family Sciences at Ahfad University for Women.)

4779 BELL, H. Midwifery training and female circumcision in
 the inter-war Anglo-Egyptian Sudan. *Journal of African
 History,* 39 ii (1998) pp.293-312.

4780 BERNAL, V. Islam, transnational culture, and modernity
 in rural Sudan. *Gendered encounters: challenging
 cultural boundaries and social hierarchies in Africa.*
 M.Grosz-Ngaté & Omari H.Kokole, eds. London:
 Routledge, 1997, pp.131-151.

4781 DECKER, D. F. Females and the state in Mahdist
 Kordofan. *Kordofan invaded: peripheral incorporation
 and social transformation in Islamic Africa.* Ed. E.Stiansen
 & M.Kevane. Leiden: Brill, 1998, (Social, Economic and
 Political Studies of the Middle East and Asia, 63),
 pp.86-100.

4782 DELMET, C. Endogamie et réciprocité dans les systèmes
 matrimoniaux soudanais. *Epouser au plus proche:
 inceste, prohibitions et stratégies matrimoniales autour
 de la Méditerranée.* Sous la dir. de P.Bonte. Paris: Editions
 de l'Ecole des Hautes Etudes en Sciences Sociales, 1994,
 pp.399-417. (Chez les Arabes soudanais.)

4783 ELDAHAB, Amna M. Swar. Contraceptive use and
 fertility of women in urban Sudan. *Ahfad Journal,* 13 ii
 (1996) pp.12-30.

4784 ELTYIEB, Eiman Elzubair. NGOs and income generating
 activities for women. *Population and Development
 Research Monograph Series,* 6 (1999) pp.381-419.
 (Sudan.)

4785 GRAWERT, E. "Einer soll fortziehen ...". Wie Frauen in
 Kutum (Westsudan) durch Flexibilität und Mehrarbeit die
 Migrationsfolgen auffangen. *Wandern oder bleiben?
 Veränderungen der Lebenssituation von Frauen im Sahel
 durch die Arbeitsmigration der Männer.* E.Grawert (Hrsg.)
 unter mitarbeit von G.Rübcke & R.Hamel. Münster: Lit,
 1994, (Bremer Afrika-Studien, 8), pp.97-115.

4786 GRAWERT, E. Arbeitsmigration von Männern und
 ländliche Frauenarbeit: Optionen der Ernährungssicherung
 im Sudan. *Wuqûf,* 7-8, 1992- (1993) pp.535-546.

4787 GRUENBAUM, E. The cultural debate over female
 circumcision: the Sudanese are arguing this one out for
 themselves. *Medical Anthropology Quarterly,* 10 iv
 (1996) pp.455-475.

4788 GRUENBAUM, Ellen. Sudanese women and the Islamist
 state. *Women and power in the Middle East.* Ed. Suad
 Joseph & Susan Slyomovics. Philadephia: University of
 Pennsylvania Press, 2001, pp.115-125;212.

4789 HALE, S. 'The new Muslim woman:` Sudan's National
 Islamic Front and the invention of identity. *Muslim
 World,* 86 ii (1996) pp.176-199.

4790 HALE, S. The women of Sudan's National Islamic Front.
 Political Islam: essays from Middle East Report. Ed.
 J.Beinin & J.Stork. London: Tauris, 1997, pp.234-249.

4791 HALE, Sondra. Gender politics and Islamization in Sudan.
 Women Living under Muslim Laws: Dossier, 18 (1997)
 pp.51-80. Also online at www.wluml.org/english/pubs

4792 HALE, Sondra. Ideology and identity: Islamism, gender,
 and the state in the Sudan. *Mixed blessings: gender and
 religious fundamentalism cross culturally.* Ed. J.Brink &
 J.Mencher. New York & London: Routledge, 1997,
 pp.117-142.

4793 HALE, Sondra. The Islamic state and gendered citizenship
 in Sudan. *Gender and citizenship in the Middle East.* Ed.
 Suad Joseph. Syracuse (USA): Syracuse University Press,
 2000, pp.88-104.

4794 HASAN, Idris Salim al- & MCHUGH, N. Sitt Naṣra bint
 'Adlān: a Sudanese noblewoman in history and tradition.
 *Women in the medieval Islamic world: power, patronage,
 and piety.* Ed. G.R.G.Hambly. Basingstoke: Macmillan,
 1998, (The New Middle Ages, 6), pp.537-549.

4795 IBRAHIM, Fatima Ahmed. Sudanese women's union:
 strategies for emancipation and the counter movement.
 Ufahamu, 24 i-iii (1996) pp.3-20. [Since 1956.]

4796 ISMAIL, E. Frauenbewegung und Islam im Sudan.
 Wuqûf, 7-8, 1992- (1993) pp.523-534.

4797 JUAN, Joselin, GERMANO, Sidonia & JUAWN, Sara.
 Sexual violence among displaced women and girl child.
 Ahfad Journal / Majallat al-Aḥfād, 17 ii (2000) pp.50-52.
 (Research note. Khartoum State.)

4798 KHALAFALLA, Limya Abdelgaffar. Towards gender
 sensitive policies in Sudan: a study on Sudan national
 comprehensive strategy. *Ahfad Journal / Majallat
 al-Aḥfād,* 18 i (2001) pp.60-62. (Research note.)

4799 KIBREAB, Gaim. Resistance, displacement, and identity:
 the case of Eritrean refugees in Sudan. *Canadian Journal
 of African Studies. Revue Canadienne des Etudes
 Africaines,* 34 ii (2000) pp.249-296.

4800 KLEIN-HESSLING, R. & SAMMANI, Birgit el-. "Die Mädchen wollen keinen Bauern heiraten. Ein Migrant ist besser." Ein sudanesisches Dorf am Tropf der Golfstaaten: 'Anbeled'. *Wandern oder bleiben? Veränderungen der Lebenssituation von Frauen im Sahel durch die Arbeitsmigration der Männer.* E.Grawert (Hrsg.) unter mitarbeit von G.Rübcke & R.Hamel. Münster: Lit, 1994, (Bremer Afrika-Studien, 8), pp.24-45. (In der nordsudanesischen Provinz Ash-Shimaliya.)

4801 KLEIN-HESSLING, R. Wo endet die Trauer? Soziale Praktiken im Diskurs über islamische Identität im Nordsudan. *Der neue Islam der Frauen. Weibliche Lebenspraxis in der globalisierten Moderne: Fallstudien aus Afrika, Asien und Europa.* R.Klein-Hessling, S.Nökel, K.Werner (Hg.). Bielefeld: transcript Verlag, 1999, pp.229-248.

4802 MAHGOUB, Rihab Kamal K(h)a(l)ifa. Critical analysis of the curriculum development of the Rural Women Training Programme at Ahfad University for women. *Ahfad Journal / Majallat al-Aḥfād,* 14 ii (1997) pp.26-34. (Omdurman.)

4803 MAHMOUD, Fatima Babiker. The gender impact of war, environmental disruption and displacement. *Ecology, politics and violent conflict.* Ed. Mohamed Suliman. London: Zed, (in association with) Institute for African Alternatives & Development and Peace Foundation, 1999, pp.45-58. [Sudan.]

4804 MANSOUR, Duria, ELABASS, Mahasin A. & ABDELMAGEED, Ahmed. The role of Sudanese women in the field of science and technology: obstacles and future prospects. *Ahfad Journal,* 13 i (1996) pp.38-46.

4805 MANSOUR, Durria, MOHAMMED, Rehab & RAHAMA, Amel. Women gender specific role in relation to schistosomiasis transmission in Halfa el Gadida (Sudan). *Ahfad Journal / Majallat al-Aḥfād,* 15 ii (1998) pp.14-26.

4806 MARCHESINI REGGIANI, A. Nell'Islam contro le discriminazioni: intervista a Fathima Ahmed Ibrahim. *Africa e Mediterraneo,* 14-15 (1995) pp.64-65. (Le donne del Sudan.)

4807 MICHAEL, B. J. Baggara women as market strategists. *Middle Eastern women and the invisible economy.* Ed. R.A.Lobban. Gainesville: University Press of Florida, 1998, pp.60-73.

4808 MICHAEL, Barbara. Female heads of patriarchal households: the Baggara. *Journal of Comparative Family Studies,* 28 ii (1997) pp.x;xiv;170-182.

4809 NAGEEB, Salma. Der Markt: weibliche Aneignung öffentlicher Räume. *Die geschlechtsspezifische Einbettung der Ökonomie: empirische Untersuchungen über Entwicklungs- und Transformationsprozesse* / Gudrun Lachenmann, Petra Dannecker (Hrsg.). Münster: Lit, 2001, (Market, Culture and Society, 12), pp.183-199. (Sudan.)

4810 OBID, Nahla Ali Mohd el & MOHAMED, Nada Faroug Osman. The southern women as perceived in the mind of the northern man, and the marital relationship between them. *Ahfad Journal / Majallat al-Aḥfād,* 17 i (2000) pp.46-48. (Research note.)

4811 OSMAN, Abdal Monium Khidir. Challenges for integrating gender into poverty alleviation programmes: lessons from Sudan. *Gender and Development,* 10 iii (2002) pp.22-30. Also online at http://www.ingentaselect.com

4812 OTOR, Samuel C.J. & PANDEY, Arvind. Adolescent transition to coitus and premarital childbearing in Sudan: a biosocial context. *Journal of Biosocial Science,* 31 iii (1999) pp.361-374. Also online at www.journals.cup.org (This survey was exclusively conducted in the Muslim north.)

4813 PANTULIANO, S. Inurbamento e trasformazioni culturali: il caso delle donne Kababish a Omdurman (Sudan). *La città ineguale: pratiche culturali e organizzazione della marginalità in Africa e America Latina.* A cura di R.Cattedra e M.Memoli. Milan: Unicopli, 1995, (Studi e Ricerche sul Territorio, 49), pp.189-204.

4814 PANTULIANO, S. Strategie matrimoniali, produttività femminile e processi di urbanizzazione tra i Kababish del Sudan. *Africa* (Rome), 49 iii (1994) pp.393-411.

4815 PITAMBER, Sunita. Accessing financial resources and entrepreneurial motivations amongst the female informal sector micro-entrepreneurs in Sudan. *Ahfad Journal / Majallat al-Aḥfād,* 17 i (2000) pp.4-21.

4816 RAHAMA, Amna Ahmed. Gender role in crisis situation: the case of famine in 1984/85, Kordofan, Sudan. *Ahfad Journal / Majallat al-Aḥfād,* 14 ii (1997) pp.4-15.

4817 RHEINGANS, F. "Frauen übernehmen Männerarbeit - und die Männer schicken das Geld". Migration bei den Nyimang-Nuba (Sudan). *Wandern oder bleiben? Veränderungen der Lebenssituation von Frauen im Sahel durch die Arbeitsmigration der Männer.* E.Grawert (Hrsg.) unter mitarbeit von G.Rübcke & R.Hamel. Münster: Lit, 1994, (Bremer Afrika-Studien, 8), pp.81-96.

4818 RICKS, Irelene P. Islamic crusades in North Africa and their impact on female human capital development in Egypt and Sudan. *Mediterranean Quarterly,* 10 i (1999) pp.116-131.

4819 ROLLS, M.J. The development of entrepreneurial abilities: the experience of women in rural Kordofan - Sudan. *Ahfad Journal / Majallat al-Aḥfād,* 14 ii (1997) pp.16-25.

4820 SAEED, Khadiga Elsayed. The impact of male out-migration on women's role and status in Sudan. *Ahfad Journal / Majallat al-Aḥfād,* 18 i (2001) pp.62-63. (Research note.)

4821 SAFWAT, Safia Mohamed. Advocating Islamic rights. *Women's lifeworlds: women's narratives on shaping their realities* / ed. Edith Sizoo. London: Routledge, 1997, pp.111-119. [Sudan.]

4822 SALIH, Osama A. School of Family Sciences: three decades of achievement. *Ahfad Journal,* 13 i (1996) pp.4-12. (The first School inaugurated at Ahfad University for Women.)

4823 SHARKEY, H. J. Two Sudanese midwives. *Sudanic Africa,* 9 / 1998 (1999) pp.19-38. [Documents from 1931, 1955.]

4824 TANON, Hoyam Hussein. The awareness of female university students towards Child Rights Convention: case study Ahfad University for Women. *Ahfad Journal / Majallat al-Aḥfād,* 17 ii (2000) pp.47-48. (Research note.)

4825 TOENSING, C. The Shaykh and the saviors: conceptions of gender in two approaches to girls' education in the northern Sudan, 1907-1921. *Arab Studies Journal / Majallat al-Dirāsāt al-'Arabīya,* 4 i (1996) pp.55-69.

4826 TOM, Abdullahi Osman el-. Female circumcision and ethnic identification in Sudan with special reference to the Berti of Darfur. *GeoJournal,* 46 ii (1998) pp.163-170.

4827 Legal aid, new laws & violence against women in Sudan. *Women Living under Muslim Laws: Dossier,* 18 (1997) pp.81-90. Also online at www.wluml.org/english/pubs

Sweden

Books

4828 AKPINAR, Aylin. *Male's honour and female's shame: gender and ethnic identity construction among Turkish divorcées in the migration context.* Uppsala: Dept. of Sociology, 1998. 172pp.

4829 BERG, M. *Seldas andra bröllop: berättelser om hur det är: turkiska andragenerationsinvandrare, identitet, etnicitet, modernitet, etnologi.* Göteborg:Etnologiska Föreningen i Västsverige, [1994]. 305pp.

4830 GUSTAFSSON, K. *Profetens döttrar: muslimska kvinnor i Sverige.* Stockholm: Brevskolan, 1993. 107pp.

Articles

4831 CRETSER, G. A. Cross-national marriage in Sweden: immigration and assimilation 1971-1993. *Journal of Comparative Family Studies,* 30 iii (1999) pp.v;ix-x;363-380. [Incl. Muslims from Middle East.]

4832 LEOPOLD, Angela. Livstycket: working with immigrant women in a Stockholm suburb. *Soundings*, 8 (1998) pp.146-163. [Incl. Turks, Iraqis, Iranians, Lebanese, Somalis, & Syrians.]

4833 MOJAB, Shahrzad & HASSANPOUR, Amir. The politics and culture of "honour killing": the murder of Fadime Şahindal. *Pakistan Jounal of Women's Studies: Alam-e-Niswan*, 9 i (2002) pp.57-77. [Daughter of Kurdish imigrants in Sweden.]

4834 SPETS, U. Vykort till världen: Mozhgan Afrakute. *Kvinnovetenskaplige Tidskrift*, 18 iii-iv (1997) pp.88-90. [Iranian biologist in Sweden & Iran.]

Switzerland

Books

4835 ABU-SAHLIEH, Sami A. Aldeeb. *Mariages mixtes entre Suisses et étrangers musulmans: enjeux de normes légales conflictuelles* / Sami Aldeeb. Lausanne: Institut Suisse de Droit Comparé, 1996. 24pp.

4836 SANCAR-FLÜCKIGER, A. *Ethnische Grenzen - politische Wirksamkeit: Formen kollektiver Auseinandersetzung von Zwangsmigrantinnen aus der Türkei im schweizerischen Exil.* Bern: Lang, 1995, (Europäische Hochschulschriften: Reihe 1, Volkskunde, Ethnologie, B275), 330pp.

Articles

4837 BLEISCH BOUZAR, Petra. Christlich-muslimische Ehen - islamisches Recht und dessen Interpretation in der Schweiz. *Muslime und schweizerische Rechtsordnung. Les musulmans et l'ordre juridique suisse.* René Pahud de Mortanges, Erwin Tanner (Hrsg./éd.). Freiburg (Switzerland): Universitätsverlag Freiburg, 2002, (Freiburger Veröffentlichungen zum Religionsrecht, 13), pp.375-401.

4838 EPINEY, Astrid, MOSTERS, Robert & GROSS, Dominique. Islamiches Kopftuch und religiöse neutralität an der öffentlichen Schule. *Muslime und schweizerische Rechtsordnung. Les musulmans et l'ordre juridique suisse.* René Pahud de Mortanges, Erwin Tanner (Hrsg./éd.). Freiburg (Switzerland): Universitätsverlag Freiburg, 2002, (Freiburger Veröffentlichungen zum Religionsrecht, 13), pp.129-165.

4839 HEINIGER, Marcel. Muslime und Musliminnen in der Schweiz - eine statistischer Überblick. *Muslime und schweizerische Rechtsordnung. Les musulmans et l'ordre juridique suisse.* René Pahud de Mortanges, Erwin Tanner (Hrsg./éd.). Freiburg (Switzerland): Universitätsverlag Freiburg, 2002, (Freiburger Veröffentlichungen zum Religionsrecht, 13), pp.3-10.

Syria

Books

4840 CHATILA, Khaled. *Le mariage chez les Musulmanes en Syrie: étude de sociologie.* Paris: Libr. Orientaliste Paul Geuthner, 1998. 303pp. [Reprod. of 1934 ed.]

4841 DEONNA, L. *Syrians: a travelogue (1992-1994).* Tr. Snow, C. Pueblo: Passeggiata, 1996. 110pp. [Tr. of *Syriens, syriennes.*]

4842 DEONNA, L. *Syriens, syriennes (1992-1994).* Carouge-Genève: Zoé 1995. 122pp.

4843 PFAFFENBACH, C. *Frauen in Qalamun/Syrien: Auswirkungen sozioökonomischer und politischer Transformationen auf die alltagliche Lebenswelt und die raumlichen Handlungsmuster der Frauen in einer ländlichen Region.* Erlangen: Palm & Enke, 1994, (Erlanger Geographische Arbeiten: Sonderband, 21), 261pp.

4844 TARAZI, Bourane. *Damas dans la tourmente.* Beyrouth: Editions Al Massar, 1998. 286pp. [Syrian childhood.]

4845 TUCKER, J. E. *In the house of the law: gender and Islamic law in Ottoman Syria and Palestine.* Berkeley: University of California Press, 1998. 221pp.

Articles

4846 AZHARI, Taef Kamal el-. Dayfa Khātūn, Ayyubid queen of Aleppo 634-640 A.H./1236-1242 A.D. *JAMES: Annals of Japan Asociation for Middle East Studies,* 15 (2000) pp.27-55.

4847 BARAZANGI, Nimat Hafez. Self-identity as a form of democratization: the Syrian experience. *Democratization and women's grassroots movements.* Ed. Jill M. Bystydzienski & Joti Sekhon. Bloomington: Indiana University Press, 1999, pp.129-149. [Women.]

4848 BÖTTCHER, A. L'élite féminine kurde de la Kaftâriyya, une confrérie naqshbandî damascène. *Annales de l'Autre Islam,* 5 (1998) pp.125-139.

4849 BÖTTCHER, Annabelle. Portraits of Kurdish women in contemporary Sufism. *Women of a non-state nation: the Kurds.* Ed. Shahrzad Mojab. Costa Mesa: Mazda, 2001, (Kurdish Studies Series, 3), pp.195-208. (Damascus.)

4850 DAHER, Jamil. Gender in linguistic variation: the variable (q) in Damascus Arabic. *Perspectives on Arabic linguistics XI. Papers from the eleventh annual symposium on Arabic linguistics.* Ed. Elabbas Benmamoun, Mushira Eid, Niloofar Haeri. Amsterdam: Benjamins, 1998, (Amsterdam Studies in the Theory and History of Linguistic Science: Series IV, Current Issues in Linguistic Theory, 167), pp.183-206.

4851 DEGUILHEM, R. Naissance et mort du waqf damascain de Ḥafiza Hānūm al-Mūrahlī (1880-1950). *Le waqf dans l'espace islamique: outil de pouvoir socio-politique. Al-Waqf fī 'l- 'ālam al-islāmī: adāt sulṭa ijtimā 'īya.* Organisé & présenté R.Deguilhem. Damascus: Institut Français de Damas, 1995, (Publications de l'Institut Français de Damas, 154), pp.203-225.

4852 ESTABLET, Colette & PASCUAL, Jean-Paul. A propos du *sadāq* ou *mahr* dans une région arabe de l'empire ottoman à l'aube du XVIIIe siècle. *Droit et Cultures,* 142 (2001) pp.211-229. [Damascus documents.]

4853 ESTABLET, Colette & PASCUAL, Jean-Paul. Women in Damascene families around 1700. *Journal of the Economic and Social History of the Orient,* 45 iii (2002) pp.301-319. Also online at http://www.ingentaselect.com (449 inventories of deceased Damascenes.)

4854 HAJO, Siamend. Kurdinnen in Syrien. *AMI: Anti-Militarismus Information,* 26 i (1996) pp.11-16.

4855 HILL, Fiona. The gender of tradition: Syrian women and the feminist agenda. *Remaking the Middle East.* Ed. P.J.White & W.S.Logan. Oxford: Berg, 1997, pp.129-151.

4856 KABOUR, M. C. A mulher siria através da historia. *NAO: Revista de la Cultura del Mediterráneo,* 58 (1996) pp.91-94.

4857 LIE, Suzanne Stiver & VOGT, Kari. Islamization in Syria: gender, education and ideology. *Journal of South Asian and Middle Eastern Studies,* 26 ii (2003) pp.22-41.

4858 LONGUENESSE, E. Femmes médecins en pays arabe: l'exemple de la Syrie. (Summary: Female doctors in Islamic countries: Syria as a test case.). *Sociologie, Santé,* 9 (1993) pp.132-152.

4859 LONGUENESSE, E. Lycéennes en treillis et fonctionnaires voilées. *Damas: miroir brisée d'un Orient arabe.* Dir. A-M.Bianquis, E.Picard. Paris: Eds. Autrement, 1993, pp.207-218.

4860 MERIWETHER, M. L. The rights of children and the responsibilities of women: women as *Wasis* in Ottoman Aleppo, 1770-1840. *Women, the family, and divorce laws in Islamic history.* Ed. A.El Azhary Sonbol. Syracuse: Syracuse University Press, 1996, pp.219-235.

4861 MERIWETHER, M. L. Women and *Waqf* revisited: the case of Aleppo, 1770-1840. *Women in the Ottoman Empire: Middle Eastern women in the early modern era.* Ed. M.C.Zilfi. Leiden: Brill, 1997, (The Ottoman Empire and its Heritage, 10), pp.128-152.

4862 NA'ANA, Hamida. The cultural impact of the Left in Syria and Palestine: a personal view. *Cosmopolitanism, identity and authenticity in the Middle East.* Ed. Roel Meijer. Richmond: Curzon, 1999, pp.61-68.

4863 PELLITTERI, A. Immagine donna in *Ḥawādith Dimashq al-yawmiyya (1741-1762)* di Aḥmad al-Budayrī al-Ḥallāq. *Verse and the fair sex: studies in Arabic poetry and in the representation of women in Arabic literature. A collection of papers presented at the 15th Congress of the Union Européenne des Arabisants et Islamisants (Utrecht/Driebergen ... 1990).* Ed. F.de Jong. Utrecht: Houtsma Stichting, 1993, pp.153-170.

4864 PFAFFENBACH, C. ...und die Frauen bleiben zu Hause: Arbeitsmobilität von Männern und die Veränderung von Frauenrollen in einer ländlichen Region Syriens. (Summary: Spatial mobility of men and the changing status of women in rural Syria.). *Geographische Rundschau,* 47 iv (1995) pp.240-244.

4865 POUZET, L. Vision populaire de la femme en Syrie aux VIe et VIIe / XIIe et XIIIe siècles. *Proceedings of the 14th Congress of the Union Européenne des Arabisants et Islamisants. Budapest ... 1988.* Part 1. Ed. A.Fodor. Budapest: Eötvös Loránd University Chair for Arabic Studies & Csoma de Körös Society, Section of Islamic Studies, 1995, (*The Arabist: Budapest Studies in Arabic,* 13-14), pp.295-304.

4866 QATTAN, Najwa al-. Textual differentiation in the Damascus *Sijill:* religious discrimination or politics of gender? *Women, the family, and divorce laws in Islamic history.* Ed. A.El Azhary Sonbol. Syracuse: Syracuse University Press, 1996, pp.191-201.

4867 SCHEHERAZADE My sister Isabelle. *Intimate selving in Arab families: gender, self, and identity.* Ed. Suad Joseph. Syracuse (USA): Syracuse University Press, 1999, pp.92-105. (I was born ... in a Christian conservative family in Aleppo.)

4868 SEMERDJIAN, Elyse. Sinful professions: illegal occupations of women in Ottoman Aleppo, Syria. *Hawwa: Journal of Women in the Middle East and the Islamic world,* 1 i (2003) pp.60-85. Also online at http:// leporello.ingentaselect.com/vl=16277934/cl=41/nw=1/ rpsv/cw/brill/15692078/

4869 SHAABAN, Bouthaina. Persisting contradictions: Muslim women in Syria. *Women in Muslim societies: diversity within unity.* Ed. H.L.Bodman, Nayereh Tohidi. Boulder: Rienner, 1998, pp.101-117.

4870 SHA'ABAN, Bouthaina. The status of women in Syria. *Arab women: between defiance and restraint.* Ed. Suha Sabbagh. New York: Olive Branch Press, 1996, pp.54-61.

4871 STRUBBE, B. A ray of light in Atlanta. *Aramco World,* 47 vi (1996) pp.28-29. (Syria ... Ghada Shouaa, the country's first Olympic gold medallist.)

4872 TUCKER, J. E. The fullness of affection: mothering in the Islamic law of Ottoman Syria and Palestine. *Women in the Ottoman Empire: Middle Eastern women in the early modern era.* Ed. M.C.Zilfi. Leiden: Brill, 1997, (The Ottoman Empire and its Heritage, 10), pp.232-252.

Tajikistan

Articles

4873 HARRIS, Colette. Health education for women as a liberatory process? An example from Tajikistan. *Women, globalization and fragmentation in the developing world.* Ed. Haleh Afshar & S.Barrientos. Basingstoke: Macmillan; New York: St. Martin's Press, 1999, pp.131-149.

4874 [HARRIS, Colette]. Karomat Isaeva's tale, as told to Colette Harris. *Soundings,* 8 (1998) pp.67-82. [Tajik woman 1925-1997.]

4875 HARRIS, Colette. The changing identity of women in Tajikistan in the post-Soviet period. *Gender and identity construction: women of Central Asia, the Caucasus and Turkey.* Ed. Feride Acar & Ayşe Günes-Ayata. Leiden: Brill, 2000, (Social, Economic and Political Studies of the Middle East and Asia, 68), pp.205-228.

4876 HARRIS, Colette. Women and the construction of the Tajik nation state. *Lettre d'Asie Centrale,* 7 (1998) pp.6-8.

4877 KANJI, Nazneen. Trading and trade-offs: women's livelihoods in Gorno-Badakhshan, Tajikistan. *Development in Practice,* 12 ii (2002) pp.138-152. Also online at http:// www.ingentaselect.com

4878 KUV(V)ATOVA, A.(A.). The role of women's NGOs in peace building process and creating of civil society in Tajikistan. *Тачрибаи таърихии сулҳи Точикистон. Исторический опыт миротворчества в Таджикистане. Historical experience of peace of Tajikistan.* Dushanbe: Вазорати Фарҳанги Чумҳурии Точикистон, 2001, pp.280-284.

4879 КУВВАТОВА, А.А. Роль женских неправительственных организаций в процессе укрепления мира и построении гражданского общества в Таджикистане. *Тачрибаи таърихии сулҳи Точикистон. Исторический опыт миротворчества в Таджикистане. Historical experience of peace of Tajikistan.* Dushanbe: Вазорати Фарҳанги Чумҳурии Точикистон, 2001, pp.183-188.

4880 SHARIPOVA, Muborak & TADJBAKHSH, Shahrbanou. Babel: widows of Tajikistan. *Index on Censorship,* 27 ii / 181 (1998) pp.163-168.

4881 TADJBAKHSH, Shahrbanou. Between Lenin and Allah: women and ideology in Tajikistan. *Women in Muslim societies: diversity within unity.* Ed. H.L.Bodman, Nayereh Tohidi. Boulder: Rienner, 1998, pp.163-185.

4882 ПУЛАТОВА, Ш. Вклад женщин становление мира в Таджикистане. (Contribution of women in keeping peace in Tajikistan [summary].). *Тачрибаи таърихии сулҳи Точикистон. Исторический опыт миротворчества в Таджикистане. Historical experience of peace of Tajikistan.* Dushanbe: Вазорати Фарҳанги Чумҳурии Точикистон, 2001, pp.212-214;304.

4883 Dreimal Todesstrafe - Frauenbild und Mord in Zentralasien (Usbekistan, Tadschikistan). Tr. Warning, G. *Hannoversche Studien über den Mittleren Osten,* 22 (1998) pp.181-184.

Tanzania (mainland)

Articles

4884 NAGAR, Richa. I'd rather be rude than ruled: gender, place and communal politics among South Asian communities in Dar es Salaam. *Women's Studies International Forum,* 23 v (2000) pp.571-585. Also online at http:// www.sciencedirect.com/science/journal/02775395 [Shi'i women, Hindu women and Hindu women married to Shi'i men.]

4885 NAGAR, Richa. Religion, race, and the debate over *mut'a* in Dar es Salaam. *Feminist Studies,* 26 i (2000) pp.661-690. (Among the Khoja Shia Ithna Asheri Muslims.)

Trinidad

Books

4886 KASSIM, Halim Sa'adia. *Locating women in the growth of Islamic educational institutions in Trinidad, 1917-1960.* [Schoelcher]: Université des Antilles et de la Guyane, Groupe de Recherche AIP-CARDH, 1997 (Paper presented at the 29th Annual Conference of the Association of Caribbean Historians, 1997), 29pp.

Tunisia

Books

4887 ACCAD, E. *Wounding words: a woman's journal in Tunisia.* Tr. Hahn, C. T. Oxford: Heinemann Educational, 1996. 183pp.

4888 BAKALTI, Souad. *La femme tunisienne au temps de la colonisation 1881-1956.* Paris: L'Harmattan, 1996. 307pp.

4889 BARSKA, A. *Status kobiety w tunezyjskim systemie obyczajowo-obrzędowym.* Opole: Wyższa Szkoła Pedagogiczna im. Powstańców Śląskich, 1994, (Studia i Monografie, 214), 131pp. [Summary in French.]

4890 BCHIR, Badra. *L'enjeu du féminisme indépendant en Tunisie: modèles et pratique.* Tunis: Centre d'Etudes et de Recherches Economiques et Sociales, 1993, (Cahier du CERES: Série Sociologique, 21), 194pp.

4891 [BEN MILED, Emna]. *Les tunisiennes ont-elles une histoire?* [Tunis:] E. Ben Miled, [1998]. 293pp.

4892 BEN SAID CHERNI, Zeineb. *Les dérapages de l'histoire chez T.el Haddad: les travailleurs, Dieu et la femme.* Tunis: Editions A. ben Abdallah, [1993?]. 171pp.

4893 BLILI TEMIME, Leïla. *Histoire de familles: mariages, répudiations et vie quotidienne à Tunis, 1875-1930.* Tunis: Script, 1999. 278pp.

4894 DENIEUIL, Pierre-Noël. *Les femmes entrepreneurs en Tunisie: paroles et portraits.* [Tunis]: Centre de Recherches, d'Etudes, de Documentation et d'Information sur la Femme, 2001. 179pp.

4895 DŁUŻEWSKA, A. *Kobieta w Tunezji.* Warsaw: Dialog, 1998. 151pp.

4896 GHANMI, Azza. *Le mouvement féministe tunisien: témoignage sur l'autonomie et la pluralité du mouvement des femmes (1979-1989).* Tunis: Chama, 1993. 157pp.

4897 ḤADDAD, al-Ṭāhir. *Pensées de Tahar Haddad.* Présentation et trad. de Hédi Balegh. [Tunis?: n. p.] 1993. 128pp. [1933.]

4898 HADDAD, Radhia. *Parole de femme.* Tunis: Elyssa, [1995]. 253pp. [Feminists in Tunisia.]

4899 HEJAIEJ, Monia. *Behind closed doors: women's oral narratives in Tunis.* London: Quartet, 1996. 269pp.

4900 HOLMES-EBER, Paula. *Daughters of Tunis: women, family, and networks in a Muslim city.* Boulder: Westview Press, 2002. 166pp.

4901 JRAD, Neïla. *Mémoire de l'oubli: réflexion critique sur les expériences féministes des années quatre-vingt.* Tunis: Cérès, 1996. 217pp. (En Tunisie.)

4902 LAMARI, Moktar & SCHÜRINGS, Hildegard. *Forces féminines et dynamiques rurales en Tunisie: contributions socio-économiques et espoirs des jeunes filles du monde rural.* Paris: L'Harmattan, 1999. 255pp.

4903 MAHFOUDH-DRAOUI, Dorra. *Paysannes de Marnissa: le difficile accès à la modernité.* [Tunis?:] Chama 1993. 134pp.

4904 MARZOUKI, Ilhem. *Le mouvement des femmes en Tunisie au XXème siècle: féminisme et politique.* Paris: Maisonneuve et Larose, pour CERES, 1993. 310pp.

4905 RAIBALDI, Louise. *Prostitution féminine au Maghreb oriental: rituels religieux et droit positif tunisien.* Villeneuve d'Ascq: Presses Universitaires du Septentrion, 2000 (Thèse à la Carte), 255pp.

4906 WALETZKI, Stephanie. *Ehe und Ehescheidung in Tunesien: zur Stellung der Frau in Recht und Gesellschaft.* Berlin: Schwarz, 2001 (Islamkundliche Untersuchungen, 241), 412pp.

4907 WEBER, Anne Françoise. *Staatsfeminismus und autonome Frauenbewegung in Tunesien.* Hamburg: Deutsches Orient-Institut, 2001. 122pp.

4908 *Budget-temps des ménages ruraux et travail invisible des femmes rurales en Tunisie.* Tunis: Centre de Recherches, d'Etudes, de Documentation et d'Information sur la Femme, 2000. 192pp.

4909 *Femmes & ville.* Tunis: Centre de Recherches, d'Etudes, de Documentation et d'Information sur la Femme, 2000. 143pp.

4910 *Femmes du bout des doigts: les gisements du savoir-faire féminin en Tunisie.* [Tunis:] CREDIF, Centre de Recherches, d'Etudes, de Documentation et d'Information sur la Femme, [1995]. 93pp. [In French and Arabic.]

4911 *Femmes et hommes en Tunisie: en chiffres.* [Tunis]: Centre de Recherches, d'Etudes, de Documentation et d'Information sur la Tunisie, Observatoire de la Condition de la Femme en Tunisie, 2002. 104pp.

4912 *Femmes rurales de Tunisie: activités productives et actions de promotion.* Tunisie: CREDIF, 1996. 159+[39]pp.

4913 *Noces tissées, noces brodées: costumes et parures féminins de Tunisie.* Paris: Musée National des Arts d'Afrique et d'Océanie, 1995. 140pp. [Exhibition catalogue.]

4914 *Répertoire de competences féminines en Tunisie.* Ed. Knani, Radhia. Tunis: Credif, for Ministère aux Affaires de la Femme et de la Famille, 1993. 333pp. [Directory of women professionals.]

Articles

4915 ACCAD, Evelyne & BEN ABA, Amel. Femmes de Tunisie. *Peuples Méditerranéens. Mediterranean Peoples,* 80 (1997) pp.167-176.

4916 BEN HASSINE, Oum Kalthoum. Femmes en sciences: obstacles, défis et enjeux. *Revue Tunisienne de Sciences Sociales / Al-Majalla al-Tūnisīya li-l-ʿUlūm al-Ijtimāʿīya,* 36 / 118 (1999) pp.11-26. (En Tunisie.)

4917 BEN REJEB, R. Grossesse hors mariage et maternité provisoire. À propos du vécu psychologique de vingt mères célibataires. *IBLA,* 56 i / 171 (1993) pp.65-72. (Dans la Tunisie actuelle.)

4918 BEN SALEM, Lilia. Approches féministes et nouvelles problématiques dans le domaine du travail: le cas de la Tunisie. *Les femmes et l'université en Méditerranée.* Sous la dir. de Nicky Le Feuvre, Monique Membrado & Annie Rieu. Toulouse: Presses Universitaires du Mirail, 1999, pp.297-307.

4919 BERRY-CHIKAOUI, I. The invisible economy at the edges of the medina of Tunis. *Middle Eastern women and the invisible economy.* Ed. R.A.Lobban. Gainesville: University Press of Florida, 1998, pp.215-230.

4920 BOISSEVAIN-SOUID, Katia. Saïda Manoubiya, son culte aujourd'hui, quelles spécificités? *IBLA: Revue de l'Institut des Belles Lettres Arabes,* 63 ii / 186 (2000) pp.137-164. (A Tunis, une femme sainte du XIIIe siècle.)

4921 BOUCHRARA, Traki Zannad. La femme et la vie politique en Tunisie trente-sept ans après l'Indépendance nationale. *Cahier d'Études Maghrébines,* 8-9, 1995-96, pp.13-15.

4922 BRAND, Laurie A. Arab women and political liberalization: challenges and opportunities. *Democracy and its limits: lessons from Asia, Latin America, and the Middle East.* Howard Handelman & Mark Tessler, eds. Notre Dame: University of Notre Dame Press, 1999, pp.242-261. [Case studies of Jordan & Tunisia.]

4923 CHAKER, Samira Kria. Travail rémunéré des femmes et changement structurel de la société. *Tunisie plurielle.* Volume I. *Actes du Colloque de l'Université York, Toronto, Canada. Dir. Hédi Bouraoui.* Tunis: L'Or du Temps, 1997, pp.269-277. (En Tunisie.)

4924 CHAMARI, Alya Chérif. Le droit de citoyenneté des femmes au Maghreb: le cas de la Tunisie. *Droits de citoyenneté des femmes au Maghreb: la condition socio-économique et juridique des femmes, le mouvement des femmes* / Belarbi Aïcha [& others]. Casablanca: Le Fennec, 1997, pp.175-189. [In law.]

4925 CHAOUACHI, Saida. Le statut juridique de la femme en Tunisie. *Droits de citoyenneté des femmes au Maghreb: la condition socio-économique et juridique des femmes, le mouvement des femmes* / Belarbi Aïcha [& others]. Casablanca: Le Fennec, 1997, pp.191-207.

4926 CHARRAD, M. M. Cultural diversity within Islam: veils and laws in Tunisia. *Women in Muslim societies: diversity within unity.* Ed. H.L.Bodman, Nayereh Tohidi. Boulder: Rienner, 1998, pp.63-79.

4927 CHARRAD, Mounira M. Becoming a citizen: lineage versus individual in Tunisia and Morocco. *Gender and citizenship in the Middle East.* Ed. Suad Joseph. Syracuse (USA): Syracuse University Press, 2000, pp.70-87. [Legal situation.]

4928 CHATER, Souad. Décolonisation et discours féministe en Tunisie (1930-1956). *Maghreb Review*, 19 i-ii (1994) pp.61-73.

4929 CHATER, Souad. Femmes tunisiennes: les nouvelles frontières. *Awal*, 20 (1999) pp.95-112.

4930 CHATER, Souad. Les mutations de la condition de la femme tunisienne (1956-1994). *Cahiers de la Méditerranée*, 49 (1994) pp.37-60.

4931 CHEKIR, Hafidha. Les actions positives au profit de femmes dans le domaine économique et social. *Droits de citoyenneté des femmes au Maghreb: la condition socio-économique et juridique des femmes, le mouvement des femmes* / Belarbi Aïcha [& others]. Casablanca: Le Fennec, 1997, pp.63-75. (Tunisie.)

4932 CHEKIR, Hafidha. Women, the law, and the family in Tunisia. *Gender and Development*, 4 ii (1996) pp.43-46.

4933 COLIN, J. *Al firâch* / le lit. Un concept juridique en Islam. (Abstract: *Al-firâch* / the bed: an Islamic legal concept.). *PJR - Praxis Juridique et Religion*, 10 i (1993) pp.56-72;123. (L'exemple de la Tunisie et du Maroc.)

4934 CURTISS, R. H. Women's rights: an affair of state for Tunisia. *Arab women: between defiance and restraint*. Ed. Suha Sabbagh. New York: Olive Branch Press, 1996, pp.33-37. [Focuses on Nebiha Gueddana, Head of Department of Family Planning.]

4935 DAOUD, Zakya. Les femmes tunisiennes: gains juridiques et statut économique et social. (Résumé: Tunisian women: legal progress and economic and social status.). *Monde Arabe Maghreb-Machrek*, 145 (1994) pp.27-48;141.

4936 DERSCH, D. & OEVERMANN, U. Methodisches Verstehen fremder Kulturräume: Bäuerinnen im Wandlungsprozess in Tunesien. (Summar[y]: Systematic understanding of foreign culture areas - peasant women in the transition process in Tunisia.). *Peripherie*, 14 / 53 (1994) pp.26-53;110-111.

4937 DHAOUADI, Mahmoud. Un essai de théorisation sur le penchant vers l'accent parisien chez la femme tunisienne. *International Journal of the Sociology of Language*, 122 (1996) pp.107-125.

4938 DŁUŻEWSKA, A. Małżeństwo w Tunezji. (Résumé: Lc mariage en Tunisie.). *Afryka Azja Ameryka Łacińska*, 74 (1997) pp.7-21.

4939 DŁUŻEWSKA, Anna. Les activités extérieures des femmes de Gabès et d'Oudref (Tunisie). *Africana Bulletin*, 48 (2000) pp.139-160.

4940 DWYER, Kevin. Organizing for the rights of women: Tunisian voices. *Arab society: class, gender, power, and development*. Ed. N.S.Hopkins, Saad Eddin Ibrahim. Cairo: American University in Cairo Press, 1997, pp.479-495. [First published 1991.]

4941 FARRO, A. L. Les organisations et les actions des femmes: une expérience d'intervention sociologique en Tunisie. *Droits de citoyenneté des femmes au Maghreb: la condition socio-économique et juridique des femmes, le mouvement des femmes* / Belarbi Aïcha [& others]. Casablanca: Le Fennec, 1997, pp.273-306.

4942 FERCHIOU, S. "Invisible" work, work at home: the condition of Tunisian women. *Middle Eastern women and the invisible economy*. Ed. R.A.Lobban. Gainesville: University Press of Florida, 1998, pp.187-197.

4943 FERCHIOU, S. La possession, forme de marginalité féminine. *Annuaire de l'Afrique du Nord*, 30 / 1991 (1993) pp.191-200. (Au Maghreb, et en particulier en Tunisie.)

4944 FERCHIOU, Sophie. Féministe d'état en Tunisie: idéologie dominante et résistance féminine. *Femmes, culture et société au Maghreb. I: Culture, femmes et famille*. Sous la dir. de R.Bourqia, M.Charrad, N.Gallagher. Casablanca: Afrique Orient, 1996, pp.119-140.

4945 FERCHIOU, Sophie. Femmes tunisiennes entre "féminisme d'Etat" et résistance. *Femmes de Méditerranée: religion, travail, politique*. Sous la dir. de Andrée Dore-Audibert et Sophie Bessis. Paris: Karthala, 1995, pp.181-192.

4946 FERCHIOU, Sophie. La possession, forme de marginalité féminine. *Etre marginal au Maghreb*. Textes réunis par Fanny Colonna avec Zakya Daoud. Paris: CNRS, 1993, pp.191-200. (Au Maghreb, et en particulier en Tunisie.)

4947 GHOUL, Yahya el-. L'école dans la ville. L'école française de filles de Nabeul (1889-1956): instruction, nationalités, et nationalisme. *Revue d'Histoire Maghrébine / Al-Majalla al-Tārīkhīya al-Maghāribīya*, 27 / 97-98 (2000) pp.63-85.

4948 GILL, H. Cultural and linguistic dilemmas of middle-class women in post-colonial Tunisia. *European Legacy*, 1 i (1996) pp.114-120.

4949 HÉLIN, E. Les femmes magistrats en Tunisie: implantation professionnelle et intégration sociale. (Abstract: The women in the magistracy in Tunisia; Zusammenfassung: Die Frauen als Richter in Tunisien: Berufliche Einbürgerung und soziale Integration.). *Droit et Cultures*, 30 (1995) pp.91-105;153;156.

4950 HOLMES-EBER, P. Migration, urbanization, and women's kin networks in Tunis. *Journal of Comparative Family Studies*, 28 ii (1997) pp.vii;xi;54-72.

4951 JERAD, Nabiha. La condition de la femme en Tunisie entre altérité et aliénation. *Tunisie plurielle*. Volume I. *Actes du Colloque de l'Université York, Toronto, Canada*. Dir. Hédi Bouraoui. Tunis: L'Or du Temps, 1997, pp.279-290.

4952 KAMMERER-GROTHAUS, H. Frauen in Tunesien - gestern und heute. *Cahier d'Études Maghrébines*, 8-9, 1995-96, pp.90-104.

4953 KELLY, Patricia. Trouver des points communs: valeurs islamiques et égalité entre les sexes dans la loi amendée sur le statut personnel en Tunisie. *Les frontières mouvantes du mariage et du divorce dans les communautés musulmanes*. Grabels: Women Living under Muslim Laws, 1996, (Programme Femmes et Loi dans le Monde Musulman: Dossier Spécial), pp.70-95. Also online at http:// www.wluml.org/french/pubs/pdf/dossiers/sd/ SD1.pdf

4954 KERROU, Mohamed & M'HALLA, Moncef. La prostitution dans la médina de Tunis au XIXe et XXe siècles. *Annuaire de l'Afrique du Nord*, 30 / 1991 (1993) pp.201-221. [1856-1930s.]

4955 KERROU, Mohamed & M'HALLA, Moncef. La prostitution dans la médina de Tunis au XIXe et XXe siècles. *Etre marginal au Maghreb*. Textes réunis par Fanny Colonna avec Zakya Daoud. Paris: CNRS, 1993, pp.201-221. [1856-1930s.]

4956 KHAÏAT, Leyla. Femmes tunisiennes chefs d'entreprise. *Cahiers de l'Orient*, 46 (1997) pp.75-80.

4957 LABIDI, Lilia. Discours féministe et fait islamiste en Tunisie. *Confluences Méditerranée*, 27 (1998) pp.69-80.

4958 LABIDI, Lilia. From sexual submission to voluntary commitment: the transformation of family ties in contemporary Tunisia. *The new Arab family / Al-Usra al- 'Arabīya al-jadīda*. Ed. Nicholas S.Hopkins. Cairo: American University in Cairo Press, 2003, (Cairo Papers in Social Science, 24 i-ii / 2001), pp.117-139.

4959 LARGUECHE, D. Confined, battered, and repudiated women in Tunis since the eighteenth century. *Women, the family, and divorce laws in Islamic history*. Ed. A.El Azhary Sonbol. Syracuse: Syracuse University Press, 1996, pp.259-276.

4960 LARGUECHE, Dalenda. Dar joued ou l'oubli dans la mémoire. *Annuaire de l'Afrique du Nord*, 30 / 1991 (1993) pp.177-190. (Espace de réclusion de la femme désobéissante et rebelle.) [Tunis.]

4961 LARGUECHE, Dalenda. Dar joued ou l'oubli dans la mémoire. *Etre marginal au Maghreb*. Textes réunis par Fanny Colonna avec Zakya Daoud. Paris: CNRS, 1993, pp.177-190. (Espace de réclusion de la femme désobéissante et rebelle.) [Tunis.]

4962 LAROUSSI-ZAHAR, Souad. Criminalité féminine et mutations sociales dans la société tunisienne. *Cahiers de la Méditerranée*, 49 (1994) pp.169-187.

4963 LOBBAN, R. A. Women in the invisible economy in
 Tunis. *Middle Eastern women and the invisible economy.*
 Ed. R.A.Lobban. Gainesville: University Press of Florida,
 1998, pp.198-214.

4964 MAAOUIA, Abdallah. Enquete sur les facteurs
 psycho-sociaux de la criminalité féminine. *Revue
 Tunisienne de Sciences Sociales / Al-Majalla al-Tūnisīya
 li-l-'Ulūm al-Ijtimāʻīya,* 36 / 118 (1999) pp.109-120.
 [Case study from Tunisia.]

4965 MAAOUIA, Abdallah. Etude sur la criminalité féminine:
 approche bibliographique. *Revue Tunisienne de Sciences
 Sociales / Al-Majalla al-Tūnisīya li-l-'Ulūm al-Ijtimāʻīya,*
 36 / 118 (1999) pp.95-108. (Criminalité tunisienne.)

4966 MAHFOUDH, Dorra. La participation des femmes
 tunisiennes à la vie économique et à la vie publique.
 *Droits de citoyenneté des femmes au Maghreb: la condition
 socio-économique et juridique des femmes, le mouvement
 des femmes* / Belarbi Aïcha [& others]. Casablanca: Le
 Fennec, 1997, pp.105-123.

4967 MAHMOUD, Muhammad. Women and Islamism: the
 case of Rashid al-Ghannushi of Tunisia. *Islamic
 fundamentalism.* Ed. Abdel Salam Sidahmed,
 Anoushiravan Ehteshami. Boulder: Westview, 1996,
 pp.249-265.

4968 MEDIMEGH DARGOUTH, Aziza. La femme tunisienne:
 pilier et enjeu de la démocratie et du développement.
 Femmes, culture et société au Maghreb. I: *Culture, femmes
 et famille. Sous la dir. de R.Bourqia, M.Charrad,
 N.Gallagher.* Casablanca: Afrique Orient, 1996,
 pp.97-117.

4969 MIZOURI, Laroussi. Mariage mixte, religion,
 jurisprudence: cas de la Tunisie. *Revue d'histoire
 Maghrébine / Al-Majalla al-Tārīkhīya al-Maghāribīya,*
 25 / 91-92 (1998) pp.349-359.

4970 MURPHY, E. C. Women in Tunisia: a survey of
 achievements and challenges. *Journal of North African
 Studies,* 1 ii (1996) pp.138-156.

4971 OBERMEYER, Carla Makhlouf. Fertility norms and son
 preference in Morocco and Tunisia: does women's status
 matter? *Journal of Biosocial Science,* 28 i (1996)
 pp.57-72.

4972 RASMUSSEN, A. M. Kvindelige forsørgere i Tunesien.
 Mellemøst-Information, 14 iii (1997) pp.8-10.

4973 RICHEZ, J. Transformations des logements et rôle des
 femmes à Mahdia. *Bulletin de la Société Languedocienne
 de Géographie,* 28 / 117 i-ii (1994) pp.29-53.

4974 RUGGERINI, M. G. & BARBALARGA, D. De l'analyse
 aux actions positives: un parcours de recherche. *Droits
 de citoyenneté des femmes au Maghreb: la condition
 socio-économique et juridique des femmes, le mouvement
 des femmes* / Belarbi Aïcha [& others]. Casablanca: Le
 Fennec, 1997, pp.9-20. (La femme en Tunisie & au
 Maroc.)

4975 RUGGERINI, M. G. Expérience et vécu au féminin entre
 tradition et modernité. *Droits de citoyenneté des femmes
 au Maghreb: la condition socio-économique et juridique
 des femmes, le mouvement des femmes* / Belarbi Aïcha [&
 others]. Casablanca: Le Fennec, 1997, pp.225-247.
 [Tunisia & Morocco.]

4976 SAAD, Mounira. La perpetuité des pratiques cultuelles,
 le cas de Saïda Manoubiya. *IBLA,* 64 /188 (2001)
 pp.185-200. (Une affiliation essentiellement féminine.)

4977 SCHÜRINGS, H. Mädchen und Frauen fordern ein Recht
 auf Ausbildung: Berufsbildung im ländlichen Raum in
 Tunesien. *Wuqūf,* 10-11 / 1995-96 (1997) pp.403-423.

4978 SINGER, H-R. Ein arabischer Text aus dem alten Tunis.
 Festschrift Ewald Wagner zum 65. Geburtstag. Hrsg.
 W.Heinrichs & G.Schoeler. *Band I: Semitische Studien
 unter besonderer Berücksichtigung der Südsemitistik.*
 Beirut: Deutsche Morgenländische Gesellschaft; Stuttgart:
 Steiner, 1994, (Beiruter Texte und Studien, 54),
 pp.275-284. (Brautkleidung in Tunis.) [Transliterated
 colloquial Arabic text & German translation.]

4979 SMIDTH, H. På (henna-) besøg hos Salma og Achour.
 Diwan: Tidsskrift for Arabisk Kultur, 2 i (1995) pp.2-5.
 [In Tunisia.]

4980 TEBAÏ, Alia. Le Maghreb: le front aux vitres. *Qantara*
 (Paris), 18 (1996) pp.49-51. [Tunisian women.]

4981 TEMIMI, Abdeljelil. Deux documents inédits sur les
 marginaux morisques: femmes, enfants et handicapés à
 Zaghouan au milieu du XIXe siècle. *Revue d'Histoire
 Maghrébine / Al-Majalla al-Tārīkhīya al-Maghāribīya,*
 24 / 87-88 (1997) pp.463-465.

4982 TEMIMI, Abdeljelil. Deux documents inédits sur les
 marginaux morisques: femmes, enfants et handicapés à
 Zaghouan au milieu du XIXe siècle. *Actes du VIIe
 Symposium International d'Etudes Morisques sur: Famille
 morisque: femmes et enfants. Familia morisca: mujeres y
 niños / A'māl al-mu'tamar al-ʻālamī al-sābiʻ li-l-dirāsāt
 al-Mūrīskīya - al-Andalusīya ḥawla: al-'āʼila al-Mūrīskīya:
 al-nisāʼ wa-'l-aṭfāl. Etudes réunies et préfacées par
 Abdeljelil Temimi.* Zaghouan: Fondation Temimi pour la
 Recherche Scientifique et l'Information, 1997,
 pp.285-287.

4983 TJOMSLAND, M. Kvinner i Tunisia: frihet eller likevekt?
 3.Verden-Magasinet X, 4 v (1995) pp.28-29.

4984 TRIKI, Souâd. Les femmes dans la sphère duale de
 l'économie. *Droits de citoyenneté des femmes au
 Maghreb: la condition socio-économique et juridique des
 femmes, le mouvement des femmes* / Belarbi Aïcha [&
 others]. Casablanca: Le Fennec, 1997, pp.119-143.
 (Tunisie.)

4985 TURKI, Mohamed. Le mariage morisque en Tunisie tel
 qu'il est encore pratiqué actuellement. *Actes du VIIe
 Symposium International d'Etudes Morisques sur: Famille
 morisque: femmes et enfants. Familia morisca: mujeres y
 niños / A'māl al-mu'tamar al-ʻālamī al-sābiʻ li-l-dirāsāt
 al-Mūrīskīya - al-Andalusīya ḥawla: al-'āʼila al-Mūrīskīya:
 al-nisāʼ wa-'l-aṭfāl. Etudes réunies et préfacées par
 Abdeljelil Temimi.* Zaghouan: Fondation Temimi pour la
 Recherche Scientifique et l'Information, 1997,
 pp.305-309.

4986 TURKI, Rim. Le tabou de la maternité célibataire dans les
 sociétés arabo-musulmanes (exemple de la Tunisie.). *La
 Méditerranée des femmes. Sous la dir. de Nabil el Haggar.*
 Paris: L'Harmattan, 1998, pp.133-155.

4987 WALTERS, K. Gender, identity, and the political economy
 of language: Anglophone wives in Tunisia. *Language
 in Society,* 25 iv (1996) pp.515-555.

4988 WALTZ, S. Politique et sens de l'efficacité parmi les
 femmes tunisiennes. *Femmes, culture et société au
 Maghreb.* I: *Culture, femmes et famille. Sous la dir. de
 R.Bourqia, M.Charrad, N.Gallagher.* Casablanca: Afrique
 Orient, 1996, pp.141-159.

4989 ZOUARI-BOUATTOUR, Salma. Femme et emploi en
 Tunisie. *Femmes, culture et société au Maghreb.* I:
 *Culture, femmes et famille. Sous la dir. de R.Bourqia,
 M.Charrad, N.Gallagher.* Casablanca: Afrique Orient,
 1996, pp.161-181.

Turkey (since 1922)

Books

4990 ARAT, Yeşim. *Political Islam in Turkey and women's
 organizations.* Istanbul: Türkiye Ekonomik ve Sosyal
 Etütler Vakfi, 1999 (TESEV Yayınları, 8), 103pp.

4991 ARIN, Canan. *The legal status of women in Turkey.*
 Istanbul: Women for Women's Human Rights, 1996,
 (Women for Women's Human Rights Report, 1), 42pp.

4992 DUMAN, Seyyare. *Schweigen: zum kommunikativen
 Handeln türkischer Frauen in Familie und Gruppe.*
 Münster: Waxmann, 1999 (Mehrsprachigkeit, 2),
 252+22pp.

4993 GÖLE, Nilüfer. *Musulmanas y modernas: velo y
 civilización en Turquía.* Tr. Rodríguez, P. Madrid: Talasa,
 [1993?], (Hablan las Mujeres, 11). 192pp. [Tr. of *Modern
 mahrem,* Istanbul 1992.]

4994 GÖLE, Nilüfer. *Musulmanes et modernes: voile et
 civilisation en Turquie.* Tr. Riegel, J. Paris: La
 Découverte, 1993. 167pp. [Tr. of *Modern mahrem,*
 Istanbul, 1992.]

4995 GÖLE, Nilüfer. *Republik und Schleier: die muslimische Frau in der Moderne.* Berlin: Babel-Verlag Hund und van Uffelen, 1995. 200pp. [Tr. of *Modern mahrem,* Istanbul, 1992.]

4996 GÖLE, Nilüfer. *The forbidden modern: civilization and veiling.* Ann Arbor: University of Michigan Press, 1996. 173pp. [Turkey.]

4997 GRISSMANN, Carla. *Dinner of herbs.* London: Arcadia, 2001. 170pp. [Anatolian village in the 1960s; much on the lives of women.]

4998 HAHLEN, R. *Türkisches Ehegatten- und Geschiedenenunterhaltsrecht.* Frankfurt a. M. : Lang 1996 (Europäische Hochschulschriften: Reihe II, Rechtswissenschaft, 1813), 145pp.

4999 ILKKARACAN, Pinar. *A brief overview of women's movement(s) in Turkey (and the influence of political discourses).* Istanbul: Women for Women's Human Rights, 1996, (Women for Women's Human Rights Report, 2), 31pp.

5000 KÖKSAL, Mehmet. *Das Verlöbnis und seine Auflösung im deutschen und türkischen Recht unter besonderer Berücksichtigung der Rechtsstellung der Eltern: eine Untersuchung im Spannungsfeld von Rechtswirklichkeit und Gesetzesrecht.* Konstanz: Hartung-Gorre, 1995, (Konstanzer Schriften zur Rechtswissenschaft, 89), 160pp.

5001 ÖZDALGA, E. *The veiling issue: official secularism and popular Islam in modern Turkey.* Richmond: Curzon, 1998, (NIAS Reports, 13), 105pp.

5002 OZYEGIN, Gul. *Untidy gender: domestic service in Turkey.* Philadelphia: Temple University Press, 2001. 276pp.

5003 RICCO, C. di. *Riti nuziali in Turchia.* Naples: Istituto Universitario Orientale, 1993, (Dipartimento di Studi Asiatici: Series Minor, 43), 213pp.

5004 SAKARANAHO, Tuula. *Complex other: a rhetorical approach to women, Islam, and ideologies in Turkey.* Helsinki University of Helsinki: 1998 (Comparative Religion, 3), 255pp.

5005 SAKTANBER, Ayşe. *Living Islam: women, religion and the politicization of culture in Turkey.* London: Tauris, 2002. 277pp.

5006 STEINHILBER, B. *Grenzüberschreitungen: Remigration und Biographie - Frauen kehren zurück in die Türkei.* Frankfurt a. M. : IKO-Verlag für Interkulturelle Kommunikation 1994. 524pp.

5007 STRASSER, S. *Die Unreinheit ist fruchtbar: Grenzüberschreitungen in einem türkischen Dorf am Schwarzen Meer.* Vienna: Wiener Frauenverlag, 1995, (Reihe Frauenforschung, 25), 270pp.

5008 TÜRKELI, Nalan. *Une femme des gecekondu: journal.* Tr. Delahaye, Oya. Paris: Ed. du Toit, 2000. 181pp. [Incl. "Entretien avec Oya Delahaye & Evelyne Ragot.]

5009 WEDEL, Heidi. *Lokale Politik und Geschlechterrollen: Stadtmigrantinnen in türkischen Metropolen.* Hamburg: Deutsches Orient-Institut, 1999. 317pp.

5010 YESILYURT GÜNDÜZ, Zuhal. *Die Demokratisierung ist weiblich...: die Frauenbewegung und ihr Beitrag zur Demokratisierung der Türkei.* Osnabrück: Der Andere Verlag, 2003. 125pp.

5011 ZANA, Leyla. *Ecrits de prison.* Textes traduits du kurde et du turc par Kendal Nezan. Paris: Des Femmes, 1995. 114pp.

5012 *Deconstructing images of "the Turkish woman".* Ed. Arat, Zehra F. Basingstoke: Macmillan, 1998. 342pp.

5013 *Fertility trends, women's status, and reproductive expectations in Turkey: results of further analysis of the 1993 Turkish demographic and health survey.* Ankara: Hacettepe University, Institute of Population Studies;Calverton: Macro International, Demographic and Health Surveys, [1997]. 127pp.

5014 *Turquie, les mille visages: politique, religion, femmes, immigration.* Ed. Rigoni, Isabelle. Paris: Syllepse, 2000. 278pp. [Conference, Paris 1999.]

Articles

5015 ABADAN-UNAT, Nermin. A biography: an adamant defender of 'deep ecology' and ecofeminism: Günseli Tamkoç (1921-1998). *Kadın / Woman 2000,* 2 ii (2001) pp.1-9.

5016 ABADAN-UNAT, Nermin. Die türkische Frau in der Politik - gestern und heute. *Zeitschrift für Türkeistudien,* 7 i (1994) pp.27-42.

5017 ACAR, Feride & AYATA, Ayşe. Discipline, success and stability: the reproduction of gender and class in Turkish secondary education. *Fragments of culture: the everday of modern Turkey.* Ed. by Deniz Kandiyoti & Ayşe Saktanber. London: Tauris, 2002, pp.90-111.

5018 AÇIKALIN, Işıl. An investigation on linguistic gender differences in the classroom. *Turkic Languages,* 5 ii (2001) pp.226-233. (At Anadolu University.)

5019 ALANKUŞ-KURAL, Sevda & ÇAVDAR, Ayşe. Eine Frau, zwei (patria(r)chalische) Darstellungen. Tr. Sagaster, Börte & Nurtsch, Ceyda. *Die neue Muslimische Frau: Standpunkte & Analysen* / hrsg. Barbara Pusch. Istanbul: Orient-Institut der Deutschen Morgenländischen Gesellschaft; Würzburg: Ergon, 2001, (Beiruter Texte und Studien, 85), pp.167-190. [Turkey.]

5020 ARAAT, Yesim. A woman prime minister in Turkey: did it matter? *Women & Politics,* 19 iv (1998) pp.1-22. (Tansu Çiller.)

5021 ARAT, Yeşim. A feminist mirror in Turkey: portraits of two activists in the 1980s. *Princeton Papers: Interdisciplinary Journal of Middle Eastern Studies,* 5 / 1996 (1997) pp.113-132.

5022 ARAT, Yeşim. A feminist mirror in Turkey: portraits of two activists in the 1980s. *Challenges to democracy in the Middle East.* [By] W.Harris, A.Baram, Ahmad Ashraf, H.Lowry, Yeşim Arat. Princeton: Wiener, 1997, pp.113-132.

5023 ARAT, Yeşim. Democracy and women in Turkey: in defense of liberalism. *Social Politics,* 6 iii (1999) pp.370-387.

5024 ARAT, Yeşim. Der republikanische Feminismus in der Türkei aus feministischer Sicht. *Feminismus, Islam, Nation: Frauenbewegungen im Maghreb, in Zentralasien und in der Türkei.* (Hg.) Claudia Schöning-Kalender, Aylâ Neusel, Mechtild M.Jansen. Frankfurt a.M.: Campus, 1997, pp.185-196.

5025 ARAT, Yeşim. Feminist institutions and democratic aspirations: the case of the Purple Roof Women's Shelter Foundation. *Deconstructing images of "the Turkish woman".* Ed. Zehra F.Arat. Basingstoke: Macmillan, 1998, pp.295-309.

5026 ARAT, Yeşim. From emancipation to liberation: the changing role of women in Turkey's public realm. *Journal of International Affairs,* 54 i (2000) pp.107-123.

5027 ARAT, Yeşim. Gender and citizenship: considerations on the Turkish experience. *Women and power in the Middle East.* Ed. Suad Joseph & Susan Slyomovics. Philadephia: University of Pennsylvania Press, 2001, pp.159-165;214-215.

5028 ARAT, Yeşim. Gender and citizenship in Turkey. *Gender and citizenship in the Middle East.* Ed. Suad Joseph. Syracuse (USA): Syracuse University Press, 2000, pp.275-286.

5029 ARAT, Yeşim. One ban and many headscarves: Islamist women and democracy in Turkey. *Hagar,* 2 i (2001) pp.47-60.

5030 ARAT, Yeşim. On gender and citizenship in Turkey. *Middle East Report,* 26 i / 198 (1996) pp.28-31.

5031 ARAT, Yeşim. The project of modernity and women in Turkey. *Rethinking modernity and national identity in Turkey.* Ed. Sibel Bozdoğan & Reşat Kasaba. Seattle: University of Washington Press, 1997, pp.95-112.

5032 ARAT, Zehra F. Educating the daughters of the Republic. *Deconstructing images of "the Turkish woman".* Ed. Zehra F.Arat. Basingstoke: Macmillan, 1998, pp.157-180.

5033 ARAT, Zehra F. Politics of representation and identity. *Deconstructing images of "the Turkish woman"*. Ed. Zehra F.Arat. Basingstoke: Macmillan, 1998, pp.1-34. [Turkish women.]

5034 ARAT, Zehra F. Representations of Turkish women. *ISIM Newsletter*, 7 (2001) pp.34-34.

5035 ARAT, Zehra F.Kabasakal. Where to look for the truth: memory and interpretation in assessing the impact of Turkish women's education. *Women's Studies International Forum*, 26 i (2003) pp.57-68. Also online at http:// www.sciencedirect.com/science/journal/02775395

5036 ARIM, Meral & CULME-SEYMOUR, Angela. Mme Hatice Münevver Ayaşlı 1906-1999. *Journal of the Muhyiddin Ibn 'Arabi Society*, 27 (2000) pp.65-68.

5037 ARIN, Canan. Femicide in the name of honor in Turkey. *Violence against Women*, 7 vii (2001) pp.821-825. Also online at http:// www.ingenta.com/journals/browse/sage/ j322

5038 ARIN, Canan. Le statut juridique des femmes en Turquie. *Les frontières mouvantes du mariage et du divorce dans les communautés musulmanes*. Grabels: Women Living under Muslim Laws, 1996, (Programme Femmes et Loi dans le Monde Musulman: Dossier Spécial), pp.37-49. Also online at http:// www.wluml.org/french/pubs/pdf/ dossiers/sd/SD1.pdf

5039 ASLAN, Canan. The legacy of a European-oriented transformation: gender relations in contemporary Turkey. *European Legacy*, 1 iii (1996) pp.981-987.

5040 BALIM-HARDING, Çiğdem. Representations of Turkish women: objects of social engineering projects or individuals? *Bulletin of the John Rylands University Library of Manchester*, 80 iii (1998) pp.107-127.

5041 BELLÉR-HANN, Ildikó. Informal associations among women in north-east Turkey. *Turkish families in transition*. Ed. G.Rasuly-Paleczek. Frankfurt a.M.: Lang, 1996, pp.114-138.

5042 BELLÉR-HANN, Ildikó. Women, work and procreation beliefs in two Muslim communities. *Conceiving persons: ethnographies of procreation, fertility and growth* / P.Loizos and P.Heady. London: Athlone Press, 1999, (London School of Economics Monographs on Social Anthropology, 68), pp.113-137. (Lazi villagers in northeast Turkey; Uighurs in Xinjiang.)

5043 BENTON, C. Women and Islamists in Turkey. *Muslim World*, 86 ii (1996) pp.106-129.

5044 BERIK, Günseli & BILGINSOY, Cihan. Type of work matters: women's labor force participation and the child sex ratio in Turkey. *World Development*, 28 v (2000) pp.861-878.

5045 BERKTAY, Fatmagül. Grenzen der Identitätspolitik und islamistische Frauenidentität. Tr. Prochazka-Eisl, Gisela. *Die neue Muslimische Frau: Standpunkte & Analysen* / hrsg. Barbara Pusch. Istanbul: Orient-Institut der Deutschen Morgenländischen Gesellschaft; Würzburg: Ergon, 2001, (Beiruter Texte und Studien, 85), pp.67-87. [Turkey.]

5046 CAJOLY, M-G. Militantisme islamiste et féminin à Istanbul: des femmes en quête d'une troisième voie. *CEMOTI*, 25 (1998) pp.229-253.

5047 CAJOLY, M-G. Une modernité sous le voile? Les voix féminines du Parti Refah. *Annales de l'Autre Islam*, 6 (1999) pp.27-42.

5048 ÇAKIR, Serpil. Chronologie: le mouvement des femmes en Turquie. *CEMOTI*, 21 (1996) pp.201-205.

5049 CHANDEL, Bhuvan. Professor İoanna Kucuradi on justice & human rights. *Journal of Turkish Studies*, 25 (2001) pp.61-65. [Turkish philosopher.]

5050 ÇINAR, E.Mine & ANBARCI, Nejat. Working women and power within two-income Turkish households. *The economics of women and work in the Middle East and North Africa*. Ed. E.Mine Cinar. Amsterdam: JAI, 2001, (Research in Middle East Economics, 4), pp.289-310.

5051 ÇINAR, E. Mine. Unskilled urban migrant women and disguised employment: home-working women in Istanbul, Turkey. *The political economy of the Middle East*. Vol. 1: *Economic development*. Ed. T.Niblock & R.Wilson. Cheltenham: Elgar, 1999, pp.210-221. [Previously published *World Development*, 22 iii (1994), pp.369-380.]

5052 CINDOGLU, Dilek & SIRKECI, Ibrahim. Variables that explain variation in prenatal care in Turkey; social class, education and ethnicity re-visited. *Journal of Biosocial Science*, 33 ii (2001) pp.261-270.

5053 CINDOGLU, Dilek. Virginity tests and artificial virginity in modern Turkish medicine. *Women's Studies International Forum*, 20 ii (1997) pp.253-261.

5054 ÇINAR, E. Mine. Substitution between unskilled females, males and apprentices in small scale textile firms. *ODTÜ Gelişme Dergisi. METU Studies in Development*, 23 iii (1996) pp.329-340. (Survey data on ... Istanbul.)

5055 DAVAZ-MARDIN, Asli. The Women's Library in Istanbul. *Gender & History*, 12 ii (2000) pp.448-466. (Established in December 1989). Also online at www.nesli.ac.uk

5056 DAY, L. H. & IÇDUYGU, Ahmet. The consequences of international migration for the status of women: a Turkish study. ([Abstracts:] Etude turque sur l'impacte de la migration internationale sur la condition féminine; Las consecuencias de la migración internacional para la condición de las mujeres: un estudio turco.). *International Migration*, 35 iii (1997) pp.337-371.

5057 DAYIOĞLU, Meltem. Labor market participation of women in Turkey. *Gender and identity construction: women of Central Asia, the Caucasus and Turkey*. Ed. Feride Acar & Ayşe Günes-Ayata. Leiden: Brill, 2000, (Social, Economic and Political Studies of the Middle East and Asia, 68), pp.44-73.

5058 DEVRIM-BOUVARD, Nukte. Turkish women and the Welfare Party: an interview with Şirin Tekeli. *Middle East Report*, 26 ii / 199 (1996) pp.28-29.

5059 DIETRICH, A. Deutsche Frauen in der Türkei: Arbeitsmigrantinnen, Heiratsmigrantinnen, Emigrantinnen. *Zeitschrift für Türkeistudien*, 9 i (1996) pp.99-112.

5060 DRAGONA-MONACHOU, Myrto. Ioanna Kuçuradi, glimpses at her views of ethics and human rights. *Journal of Turkish Studies*, 25 (2001) pp.97-106. [Turkish philosopher.]

5061 DURAKBAŞA, Ayşe & CINDOĞLU, Dilek. Encounters at the counter: gender and the shopping experience. *Fragments of culture: the everday of modern Turkey*. Ed. by Deniz Kandiyoti & Ayşe Saktanber. London: Tauris, 2002, pp.73-89.

5062 DURAKBAŞA, Ayşe. Kemalism as identity politics in Turkey. *Deconstructing images of "the Turkish woman"*. Ed. Zehra F.Arat. Basingstoke: Macmillan, 1998, pp.139-155.

5063 ERASLAN, Sibel. Das politische Abenteuer islamistischer Frauen in der Türkei. Tr. Pusch, Barbara. *Die neue Muslimische Frau: Standpunkte & Analysen* / hrsg. Barbara Pusch. Istanbul: Orient-Institut der Deutschen Morgenländischen Gesellschaft; Würzburg: Ergon, 2001, (Beiruter Texte und Studien, 85), pp.51-66.

5064 ERAYDIN, Ayda & ERENDIL, Asuman. The role of female labour in industrial restructuring: new production processes and labour market relations in the Istanbul clothing industry. *Gender, Place and Culture*, 6 iii (1999) pp.259-272. Also online at www.catchword.co.uk

5065 ERGINSOY, Güliz. Global encounters and gender hierarchies in the community of 'Garipçe'. *New Perspectives on Turkey*, 18 (1998) pp.131-146.

5066 ERHAN, Selahattin. The GAP (South-East Anatolia Project) and women in irrigation. *International Journal of Water Resources Development*, 14 iv (1998) pp.439-449. Also online at www.catchword.co.uk

5067 ERMAN, Tahire, KALAYCIOĞLU, Sibel &
 RITTERSBERGER-TILIÇ, Helga. Money-earning
 activies and empowerment experiences of rural migrant
 women in the city: the case of Turkey. *Women's Studies
 International Forum*, 25 iv (2002) pp.395-410. Also
 online at http:// www.sciencedirect.com/science/journal/
 02775395

5068 ERMAN, Tahire. The impact of migration on Turkish rural
 women: four emergent patterns. *Gender & Society*, 12 ii
 (1998) pp.146-167.

5069 ERMAN, Tahire. The meaning of city living for rural
 migrant women and their role in migration: the case of
 Turkey. *Women's Studies International Forum*, 20 ii
 (1997) pp.263-273.

5070 ERMAN, Tahire. Women and the housing environment:
 the experences of Turkish migrant women in squatter
 (gecekondu) and apartment housing. *EB: Environment
 and Behavior*, 28 vi (1996) pp.764-798. (Ankara.)

5071 ESIM, Simel. Sisters' keepers: economic organizing among
 informally employed women in Turkey. *An international
 feminist challenge to theory*. Ed. V.Demos [&] M.T.Segal.
 Kidlington: JAI, 2001, (Advances in Gender Research, 5),
 pp.163-178.

5072 ESIM, Simel. Why women earn less? Gender-based factors
 affecting the earnings of self-employed women in Turkey.
 *The economics of women and work in the Middle East and
 North Africa*. Ed. E.Mine Cinar. Amsterdam: JAI, 2001,
 (Research in Middle East Economics, 4), pp.205-223.

5073 ESIM, Simel & CINDOGLU, Dilek. Women's
 organizations in 1990s Turkey: predicaments and
 prospects. *Middle Eastern Studies*, 35 i (1999)
 pp.178-188.

5074 EŞIM, Simel. Solidarity in isolation: urban informal sector
 women's economic organizations in Turkey. *Middle
 Eastern Studies*, 36 i (2000) pp.140-152.

5075 GLASSEN, Erika. Töchter der Republik. Gazi Mustafa
 Kemal Paşa (Atatürk) im Gedächtnis einer intellektuellen
 Weiblichen Elite der ersten Republikgeneration nach
 Erinnerungsbüchern von Azra Erhat, Mina Urgan und
 Nermin Abadan-Unat. *Journal of Turkish Studies*, 26 i
 (2002) pp.241-264.

5076 GÖÇEK, Fatma Müge. To veil or not to veil: the contested
 location of gender in contemporary Turkey. *Interventions*,
 1 iv (1999) pp.521-535.

5077 GOKALP, Altan. `Mariage de parents`: entre l'échange
 généralisé et le mariage parallèle: le cas de la Turquie.
 *Epouser au plus proche: inceste, prohibitions et stratégies
 matrimoniales autour de la Méditerranée*. Sous la dir. de
 P.Bonte. Paris: Editions de l'Ecole des Hautes Etudes en
 Sciences Sociales, 1994, pp.439-452.

5078 GÖLE, Nilüfer. Islamisme et féminisme en Turquie.
 Confluences Méditerranée, 27 (1998) pp.87-93.

5079 GREENING, Anna. The Women's Library in Istanbul: the
 international context. *Gender & History*, 12 ii (2000)
 pp.467-471. Also online at www.nesli.ac.uk

5080 GÜL, Songül Sallan & GÜL, Hüseyin. Equal opportunity
 for women in government employment: the cases of the
 United States and Turkey. *Turkish Public Administration
 Annual*, 22-23, 1996- (1997) pp.119-140.

5081 GÜLÇUBUK, Bülent, GÜN, Sema & YILDIRAK,
 Nurettin. Badania obszarów wiejskich południowej
 Anatolii. Udział kobiet w produkcji rolnej. *Afryka Azja
 Ameryka Łacińska*, 75 (1999) pp.53-55.

5082 GÜLÇÜR, Leyla & İLKKARACAN, Pinar. The "Natasha"
 experience: migrant sex workers from the former Soviet
 Union and eastern Europe in Turkey. *Women's Studies
 International Forum*, 25 iv (2002) pp.411-421. Also
 online at http:// www.sciencedirect.com/science/journal/
 02775395

5083 GÜLENDAM, Ramazan. The development of a feminist
 discourse and feminist writing in Turkey: 1970-1990.
 Kadın / Woman 2000, 2 i (2001) pp.93-116.

5084 GÜNEŞ-AYATA, Ayşe. Solidarity in urban Turkish
 family. *Turkish families in transition*. Ed.
 G.Rasuly-Paleczek, Frankfurt a. M. : Lang (1996)
 pp.98-113.

5085 GÜNEŞ-AYATA, Ayşe. The politics of implementing
 women's rights in Turkey. *Globalizaton, gender, and
 religion: the politics of implementing women's rights in
 Catholic and Muslim contexts*. Ed. Jane H.Bayes &
 Nayereh Tohidi. Basingstoke: Palgrave, 2001,
 pp.157-175. [Since 1923.]

5086 GÜNEŞ-AYATA, Ayşe. Woman as identity-makers [*sic*]:
 the case of urban Alevi in Turkey. *Zeitschrift für
 Türkeistudien*, 13 i (2000) pp.57-68.

5087 GÜNGÖR, Ayadım Deniz. The gender gap in Turkish
 education - a regional appproach. *ODTÜ Gelişme Dergisi.
 METU Studies in Development*, 28 iii-iv / 2001 (2002)
 pp.339-360.

5088 GÜNLÜK-SENESEN, Gülay & ÖZAR, Semsa.
 Gender-based occupational segregation in the Turkish
 banking sector. *The economics of women and work in
 the Middle East and North Africa*. Ed. E.Mine Cinar.
 Amsterdam: JAI, 2001, (Research in Middle East
 Economics, 4), pp.247-267.

5089 HAYASI, Tooru. Gender differences in modern Turkish
 discourse. *International Journal of the Sociology of
 Language*, 129 (1998) pp.117-126.

5090 IBRAKHIMOVA, Guyltchekhra. Socio-economic and
 demographic characteristics affecting contraceptive use in
 Turkey 1993. *CDC 27th Annual Seminar on population
 issues in the Middle East, Africa and Asia*. Cairo: Cairo
 Demographic Center, 1998, (Research Monograph Series,
 27; CDC Annual Seminar, 1997), pp.215-237.

5091 İÇDUYGU, Ahmet. Correlates of timing of induced
 abortion in Turkey. *Demography India*, 25 i (1996)
 pp.131-146.

5092 ILCAN, Suzan M. Fragmentary encounters in a moral
 world: household power relations and gender politics.
 Ethnology, 35 i (1996) pp.33-49. (Rural Turkey.)

5093 ILKKARACAN, Pinar & [OTHERS] Exploring the
 context of women's sexuality in eastern Turkey. *Women
 Living under Muslim Laws: Dossier*, 22 (1999)
 pp.100-113. Also online at http:// www.wluml.org/
 english/pubs

5094 ILKKARACAN, Pinar & BERKTAY, Ayse. Women in
 Turkey finally gain full equality in the family: the new
 Civil Code in Turkey. *Middle East Women's Studies
 Review*, 17 i-ii (2002) pp.19-22.

5095 ILYASOĞLU, Aynur. Le rôle des femmes musulmanes
 en Turquie: identité et image de soi. *CEMOTI*, 21 (1996)
 pp.43-52.

5096 İLYASOĞLU, Aynur. Islamist women in Turkey: their
 identity and self-image. *Deconstructing images of "the
 Turkish woman"*. Ed. Zehra F.Arat. Basingstoke:
 Macmillan, 1998, pp.241-261.

5097 İMAMOĞLU, E.Olcay. Changing gender roles and marital
 satisfaction in Turkey. *Gender and identity construction:
 women of Central Asia, the Caucasus and Turkey*. Ed.
 Feride Acar & Ayşe Günes-Ayata. Leiden: Brill, 2000,
 (Social, Economic and Political Studies of the Middle East
 and Asia, 68), pp.101-116.

5098 İNCIRLIOĞLU, Emine Onaran. Images of village women
 in Turkey: models and anomalies. *Deconstructing images
 of "the Turkish woman"*. Ed. Zehra F.Arat. Basingstoke:
 Macmillan, 1998, pp.199-223.

5099 İNCIRLIOĞLU, Emine Onaran. Village women in central
 Anatolia: reality, models, anomalies. *ISIM Newsletter*, 6
 (2000) pp.9-9.

5100 İPŞIROĞLU, Zehra. Die Stellung der Frau und der
 Mädchens in der türkischen Kinder- und Jugendliteratur
 (KJL). *Diyalog*, 1994 i, pp.119-124.

5101 KABASAKAL, Hayat. A profile of top women managers
 in Turkey. *Deconstructing images of "the Turkish
 woman"*. Ed. Zehra F.Arat. Basingstoke: Macmillan, 1998,
 pp.225-239.

5102 KADIOĞLU, Ayşe. Die Leugnung des Geschlechts: die
 Türkische Frau als Objekt in grossen
 Gesellschaftsentwürfen. Tr. Nohl, Arnd-Michael. *Die
 neue Muslimische Frau: Standpunkte & Analysen* / hrsg.
 Barbara Pusch. Istanbul: Orient-Institut der Deutschen
 Morgenländischen Gesellschaft; Würzburg: Ergon, 2001,
 (Beiruter Texte und Studien, 85), pp.31-50.

5103 KADIOĞLU, Ayşe. Migration experiences of Turkish
 women: notes from a researcher's diary. ([Abstracts:]
 L'émigration telle que vécue par les femmes turques: notes
 du journal d'un chercheur; Experiencias migratorias de
 mujeres turcas: notas del diario de un investigador.).
 International Migration, 35 iv (1997) pp.537-557.

5104 KANDIYOTI, Deniz. Gendering the modern: on missing
 dimensions in the study of Turkish modernity. *Rethinking
 modernity and national identity in Turkey.* Ed. Sibel
 Bozdoğan & Reşat Kasaba. Seattle: University of
 Washington Press, 1997, pp.113-132.

5105 KANDIYOTI, Deniz. Pink card blues: trouble and strife
 at the crossroads of gender. *Fragments of culture: the
 everday of modern Turkey.* Ed. by Deniz Kandiyoti & Ayşe
 Saktanber. London: Tauris, 2002, pp.277-293. (An
 ethnography of male-to-female transsexuals in Istanbul
 who inhabit a world of entertainers and prostitutes.)

5106 KANDIYOTI, Deniz. Some awkward questions on women
 and modernity in Turkey. *Remaking women: feminism
 and modernity in the Middle East.* Ed. Lila Abu-Lughod.
 Princeton: Princeton University Press, 1998, pp.270-287.

5107 KESKIN, Burcak. Political participation patterns of
 Turkish women. *MERIA Journal,* 1997 iv, Online at
 www.biu.ac.il/SOC/besa/meria.html

5108 KILIÇ, Deniz & UNCU, Gaye. Rapport nationale sur la
 Turquie. *Women Living under Muslim Laws: Dossier,* 20
 (1997) pp.142-145. Also online at http://
 www.wluml.org/french/pubs/pdf/dossiers/dossier20/
 D20fr.pdf (Les lesbiennes.)

5109 KILIÇ, Deniz & UNCU, Gaye. Turkey country report.
 Women Living under Muslim Laws: Dossier, 20 (1998)
 Also online at http:// www.wluml.org/english/pubs
 [Position of lesbians.]

5110 KIRCA, Süheyla. Turkish women's magazines: the popular
 meets the political. *Women's Studies International Forum,*
 24 iii-iv (2001) pp.457-468. Also online at
 ww.sciencedirect.com/science/journal/02775395

5111 KOC, Ismet. Determinants of contraceptive use and method
 choice in Turkey. *Journal of Biosocial Science,* 32 iii
 (2000) pp.329-3422. Also online at
 www.journals.cup.org

5112 KRAUSE-DRESBACH, G. Besuchsmuster und
 Besuchsstruktur - Bemerkungen zu sozialen Welt einer
 jung verheirateten Frau. *Familie und Alltagskultur:
 Facetten urbanen Lebens in der Türkei.* Hrsg.
 W.Schiffauer, Frankfurt a. M. : Institut für
 Kulturanthropologie und Europäische Ethnologie (1993)
 (Kulturanthropologie-Notizen, 41), pp.238-266.

5113 KIRCA, Süheyla. *Kim* and *kadınca*: bridging the gap
 between feminism and women's magazines. *New
 Perspectives on Turkey,* 22 (2000) pp.61-84. (Two
 women's magazines published in Turkey .. to define the
 1990s woman.)

5114 KIRCA, Süheyla. Von Hexen und Hochglanzschönheiten:
 Frauenzeitschriften in der Türkei. Tr. Vorhoff, K.
 Istanbuler Almanach, 1 (1997) pp.61-63.

5115 KIRPINAR, İ. & others. First-case postpartum psychoses
 in eastern Turkey: a clinical case and follow-up study.
 Acta Psychiatrica Scandinavica, 100 iii (1999)
 pp.199-204.

5116 MANIKOWSKI, M. No documents, no history: Kadın
 Eserleri Kütüphanesi ve Bilgi Merkezi Vakfı: die Stiftung
 Frauenbibliothek und -informationszentrum. *Istanbuler
 Almanach,* 2 (1998) pp.70-72. (Istanbul.)

5117 MEYER, J. H. Çiller's scandals. *Middle East Quarterly,*
 4 iii (1997) pp.27-31.

5118 MÖCKER, C. & BRAUNS, J. Der doppelte Blick:
 internationale Solidaritätsarbeit mit Antimilitaristinnen in
 der Türkci. *AMI: Anti-Militarismus Information,* 25 xii
 (1995) pp.90-96.

5119 MORAY, Meryem. Frauen und Politik: die aktuelle
 Entwicklung der Lage der Frauen in der Türkei. Tr.
 Yarar-Zarif, Ferah. *Zeitschrift für Türkeistudien,* 6 i
 (1993) pp.5-34.

5120 MOUHIDINE, Timour. Quelques reflexions sur
 Beyoğlu'nda fuhuş (La prostitution à Beyoğlu).
 Observatoire Urbain d'Istanbul: Lettre d'Information, 6
 (1994) pp.15-16. [History of prostitution in Istanbul,
 prompted by G.Scognamillo, *Beyoğlu'nda fuhuş,* Istanbul
 1994.]

5121 MÜFTÜLER-BAC, Meltem. Turkish women's
 predicament. *Women's Studies International Forum,* 22
 iii (1999) pp.303-315. Also online at http://
 www.sciencedirect.com/science/journal/02775395

5122 NARLI, Nilüfer. Women and Islam: female participation
 in the Islamicist movement in Turkey. *Turkish Review
 of Middle East Studies,* 9, 1996/97, pp.97-109.

5123 NAVARO-YAS[H]IN, Y. The historical construction of
 local culture: gender and identity in the politics of
 secularism versus Islam. *Istanbul: between the global
 and the local.* Ed. Çağlar Keyder. Lanham: Rowman &
 Littlefield, 1999, pp.59-73.

5124 NECEF, Mehmet Ümit. Islamiske modeshows. *Midtøsten
 Forum,* 10 i-ii (1996) pp.36-39. [Tyrkiske kvinder og
 modeshows.]

5125 NECEF, Mehmet Ümit. Kvinder, modernitetens symbol
 i Tyrkiet. *Mellemøst-Information,* 10 vi (1993) pp.1-4.

5126 NEUSEL, Aylâ. Aufstand im Haus der Frauen: die Neue
 Frauenbewegung in der Türkei. *... alles ändert sich die
 ganze Zeit: soziale Bewegung(en) im 'Nahen Osten'.* Hrsg.
 J.Später, Freiburg i. B. : Informationszentrum Dritte Welt
 (1994) pp.135-144.

5127 NEYZI, Leyla. Gülümser's story: life history narratives,
 memory and belonging in Turkey. *New Perspectives on
 Turkey,* 20 (1999) pp.1-26. (Gülümser Kalık, a ... woman
 from Tunceli, now living in Istanbul ... The Turkish
 modernity project.)

5128 NORTON, J. Faith and fashion in Turkey. *Languages
 of dress in the Middle East.* Ed. N.Lindisfarne-Tapper &
 B.Ingham. Richmond: Curzon, in association with the
 Centre of Near and Middle Eastern Studies, SOAS, 1997,
 pp.149-177.

5129 OKTEN, Aysenur. Post-Fordist work, political Islam and
 women in urban Turkey. *The economics of women and
 work in the Middle East and North Africa.* Ed. E.Mine
 Cinar. Amsterdam: JAI, 2001, (Research in Middle East
 Economics, 4), pp.269-288. ("Post-Fordist" organization
 of production.)

5130 ÖZAR, Şemsa & GÜNLÜK-ŞENESEN, Gülay.
 Determinants of female (non-)participation in the urban
 labour force in Turkey. *ODTÜ Gelişme Dergisi. METU
 Studies in Development,* 25 ii (1998) pp.311-328.

5131 OZBAY, Ferhunde. Gendered space: a new look at Turkish
 modernisation. *Gender & History,* 11 iii (1999)
 pp.555-568.

5132 ÖZBAY, Ferhunde. Les femmes dans les années 1990:
 education, santé et emploi. *CEMOTI,* 21 (1996)
 pp.53-76. (En Turquie.)

5133 ÖZDALGA, E. Civil society and its enemies: reflections
 on a debate in the light of recent developments within the
 Islamic student movement in Turkey. *Civil society,
 democracy and the Muslim world. Papers read at a
 conference held at the Swedish Research Institute in
 Istanbul ...1996.* Ed. E.Özdalga & S.Persson. Istanbul:
 Swedish Research Institute, 1997, (Swedish Research
 Institute in Istanbul: Transactions, 7), pp.73-84.
 (Head-covering & Islamic identity.)

5134 ÖZKAN-KERESTECIOĞLU, İnci. Die Konstruktion der "neuen" Türkischen Frau und der internationale Frauenkongress (1935). Tr. Pusch, Barbara. *Die neue Muslimische Frau: Standpunkte & Analysen* / hrsg. Barbara Pusch. Istanbul: Orient-Institut der Deutschen Morgenländischen Gesellschaft; Würzburg: Ergon, 2001, (Beiruter Texte und Studien, 85), pp.17-30.

5135 OZLER, Sule. Export orientation and female share of employment: evidence from Turkey. *World Development,* 28 vii (2000) pp.1239-1248.

5136 ÖZTÜRKMEN, Arzu. A short history of *Kadınca* magazine and its feminism. *Deconstructing images of "the Turkish woman".* Ed. Zehra F.Arat. Basingstoke: Macmillan, 1998, pp.275-293.

5137 ÖZYEĞIN, Gül. The doorkeeper, the maid and the tenant: troubling encounters in the Turkish urban landscape. *Fragments of culture: the everday of modern Turkey.* Ed. by Deniz Kandiyoti & Ayşe Saktanber. London: Tauris, 2002, pp.43-72.

5138 ÖZYER, Nuran. Das Bild des türkischen maedchens [*sic*] in der deutschen Kinder- og Jugendliteratur. *Dil Dergisi,* 12 (1993) pp.5-18.

5139 ÖZYÜREK, Esra G. "Feeling tells better than language": emotional expression and gender hierarchy in the sermons of Fethullah Gülen Hocaefendi. *New Perspectives on Turkey,* 16 (1997) pp.41-51.

5140 PARLA, Ayse. The "honor" of the state: virginity examinations in Turkey. *Feminist Studies,* 27 i (2001) pp.65-88.

5141 PELIN, Serap [Ş]ahino[ğ]lu. The question of virginity testing in Turkey. *Bioethics,* 13 iii-iv (1999) pp.256-261. Also online at http:// www.blackwell-synergy.com

5142 PLOQUIN, J-C. Leyla Zana: une `détermination d'acier` pour la cause kurde. *Confluences Méditerranée,* 17 (1996) pp.159-164. (Femmes et guerres: Turquie.)

5143 PUSCH, B. Das Zentrum für Frauenforschung der Universität Istanbul: İstanbul Üniversitesi Kadın Araştırma ve Uygulama Merkezi. *Istanbuler Almanach,* 3 (1999) pp.90-90.

5144 PUSCH, B. Frauenpower in der proislamischen Presse. *Istanbuler Almanach,* 2 (1998) pp.67-69. (In der Türkei.)

5145 PUSCH, B. Schleierhafter Protest? Zur Kopftuchdebatte in der Türkei. *Der neue Islam der Frauen. Weibliche Lebenspraxis in der globalisierten Moderne: Fallstudien aus Afrika, Asien und Europa.* R.Klein-Hessling, S.Nökel, K.Werner (Hg.). Bielefeld: transcript Verlag, 1999, pp.147-174.

5146 PUSCH, B. Verschleierte Berufung? Zur beruflichen Situation proislamischer Journalistinnen in der Türkei. *Zeitschrift für Türkeistudien,* 11 ii (1998) pp.213-231.

5147 PUSCH, Barbara. Stepping into the public sphere: the rise of Islamist and religious-conservative women's non-governmental organizations. *Civil society in the grip of nationalism: studies on political culture in contemporary Turkey.* Ed. S.Yerasimos, G.Seufert, K.Vorhoff. Istanbul: Orient-Institut der Deutschen Morgenländischen Gesellschaft & Institut Français d'Etudes Anatoliennes, 2000, pp.475-505. [Turkey.]

5148 PUSCH, Barbara. Türkische Kopftuchpolitiken: Einstellungen von "Kopftuchstudentinnen" und Akademischem Personal im Vergleich. *Die neue Muslimische Frau: Standpunkte & Analysen* / hrsg. Barbara Pusch. Istanbul; Orient-Institut der Deutschen Morgenländischen Gesellschaft; Würzburg: Ergon, 2001, (Beiruter Texte und Studien, 85), pp.137-166.

5149 RAMAZANOĞLU, Yıldız. Islamistische und feministische Frauen am Scheideweg. Tr. Yalcın, Sevda & Pusch, Barbara. *Die neue Muslimische Frau: Standpunkte & Analysen* / hrsg. Barbara Pusch. Istanbul: Orient-Institut der Deutschen Morgenländischen Gesellschaft; Würzburg: Ergon, 2001, (Beiruter Texte und Studien, 85), pp.89-110. [Turkey.]

5150 RAUDVERE, C. Female dervishes in contemporary Istanbul: between tradition and modernity. *Women and Islamization: contemporary dimensions of discourse on gender relations.* Ed. K.Ask & M.Tjomsland. Oxford: Berg, 1998, pp.125-145.

5151 RAUDVERE, C. Urban visions and religious communities: access and visibility. *Alevi identity: cultural, religious and social perspectives. Papers read at a conference held at the Swedish Research Institute in Istanbul, November ... 1996.* Ed. T.Olsson, E.Özdalga & C.Raudvere. Istanbul: Swedish Research Institute in Istanbul, 1998, (Swedish Research Institute in Istanbul Transactions, 8), pp.185-197. (Islamism in Turkey has become a public drama.)

5152 RAUDVERE, Catharina. Space, place and visibility: Islamistic women in Turkey. *ISIM Newsletter,* 7 (2001) pp.30-30.

5153 REINART, Ustun. Ambition for all seasons: Tansu Ciller. *MERIA Journal,* 3 i (1999) Online at www.biu.ac.il/SOC/besa/meria

5154 REINART, Ustun. Freedom under wraps: Islamic garb on Turkish campuses. *MERIA Journal,* 2 iii (1998) Online at http:// www.biu.ac.il/SOC/besa/meria

5155 RITTERSBERGER-TILIÇ, Helga & KALAYCIOĞLU, Sibel. Legitimating and re-production of domestic violence in Turkish families. *Zeitschrift für Türkeistudien,* 12 i (1999) pp.225-240.

5156 RUMPF, Christian. Das merkwürdige Ende der Strafbarkeit des Ehebruchs - zu einem Urteil des türkischen Verfassungsgerichts. *Zeitschrift für Türkeistudien,* 12 i (1999) pp.119-124.

5157 SAKTANBER, Ayşe. Women, Islamism and politics in Turkey: a critical perspective. *Middle East Policy,* 5 iii (1997) pp.170-173;187-189.

5158 SARIÖNDER, Refika. Frauen und Re-Islamisierung in der Türkei und in Indonesien - ein Vergleich. *Der neue Islam der Frauen. Weibliche Lebenspraxis in der globalisierten Moderne: Fallstudien aus Afrika, Asien und Europa.* R.Klein-Hessling, S.Nökel, K.Werner (Hg.). Bielefeld: transcript Verlag, 1999, pp.175-199.

5159 SCHEIFELE, Sigrid. Sinnlichkeit und Emanzipation. Überlegungen zur Attraktivität islamistischer Gruppen für Frauen. *Feminismus, Islam, Nation: Frauenbewegungen im Maghreb, in Zentralasien und in der Türkei.* (Hg.) Claudia Schöning-Kalender, Aylâ Neusel, Mechtild M.Jansen. Frankfurt a.M.: Campus, 1997, pp.273-293. [Especially Turkey.]

5160 SECOR, Anna J. The veil and urban space in Istanbul: women's dress, mobility and Islamic knowledge. *Gender, Place and Culture,* 9 i (2002) pp.5-22. Also online at http:// www.ingentaselect.com

5161 SEUGERT, G. Türkei: Leyla Zana - eine Kurdin im Parlament. *Zum Beispiel Kurden.* Red. A.Metzger. Göttingen: Lamuv Verlag, 1996, pp.63-66.

5162 SEV'ER, Aysan & YURDAKUL, Gökçeçiçek. Culture of honor, culture of change: a feminist analysis of honor killings in rural Turkey. *Violence against Women,* 7 ix (2001) pp.964-998. Also online at http:// www.ingenta.com/journals/browse/sage/j322

5163 SHANKLAND, D. Changing gender relations among Alevi and Sunni in Turkey. *Turkish families in transition.* Ed. G.Rasuly-Paleczek. Frankfurt a. M.: Lang, 1996, pp.83-97.

5164 ŞISMAN, Nazife. Wie nehmen moderne Frauen in der Türkei islamistische Frauen wahr? Tr. Ergün, Nazire & Mutlu, Şebnem. *Die neue Muslimische Frau: Standpunkte & Analysen* / hrsg. Barbara Pusch. Istanbul: Orient-Institut der Deutschen Morgenländischen Gesellschaft; Würzburg: Ergon, 2001, (Beiruter Texte und Studien, 85), pp.191-210.

5165 STIRLING, P. & İNCIRLIOĞLU, Emine Onaran. Choosing spouses: villagers, migrants, kinship and time. *Turkish families in transition.* Ed. G.Rasuly-Paleczek, Frankfurt a. M. : Lang (1996) pp.61-82.

5166 TEKELI, Sirin. Les femmes, vecteur de la modernisation.
 Tr. Yerasimos, S. *Les Turcs: Orient et Occident, Islam
 et laïcité.* Ed. S.Yerasimos. Paris: Autrement, 1994, (Série
 Monde HS, 7), pp.138-152.

5167 TEKELI, Şirin. Die erste und die zweite Welle der
 Frauenbewegung in der Türkei. *Feminismus, Islam,
 Nation: Frauenbewegungen im Maghreb, in Zentralasien
 und in der Türkei.* (Hg.) Claudia Schöning-Kalender, Aylâ
 Neusel, Mechtild M.Jansen. Frankfurt a.M.: Campus, 1997,
 pp.73-93.

5168 TEKELI, Şirin. Les femmes républicaines et la place de
 la femme turque dans la société d'aujourd'hui: statut
 juridique et politique. *CEMOTI,* 21 (1996) pp.33-41.

5169 TEPE, Harun. Approaches in ethics and Kuçuradi's ethics
 of value. *Journal of Turkish Studies,* 25 (2001)
 pp.289-297. [Turkish philosopher.]

5170 TETIŞKEN, Hülya. Kuçuradi and ethics. *Journal of
 Turkish Studies,* 25 (2001) pp.327-332. [Turkish
 philosopher.]

5171 TIMMERMANS, Chris. Jeunes filles de Turquie: vie
 familiale et instruction scolaire. *Familles turques et
 maghrébines aujourd'hui: évolution dans les espaces
 d'origine et d'immigration.* Sous la dir. de Nouzha
 Bensalah. Louvain-la-Neuve: Academia-Erasme; Paris:
 Masionneuve et Larose, 1994, pp.175-187.

5172 TOKTAŞ, Şule. Engendered emotions: gender awareness
 of Turkish women mirrored through regrets in the course
 of life. *Women's Studies International Forum,* 25 iv (2002)
 pp.423-431. Also online at http://
 www.sciencedirect.com/science/journal/02775395

5173 TOPÇUOĞLU, Nazif. Why do I take photographs of girls
 reading? Tr. Haydaroğlu, Mine. *4th Floor,* 6 (2002)
 pp.28-30. [Turkey.]

5174 TUFAN-TANRIÖVER, Hülya. Représentation des femmes
 dans la presse islamique: la page féminine du quotidien
 Zaman. Annales de l'Autre Islam, 6 (1999) pp.155-167.
 [Turkey.]

5175 ÜŞÜR, Serpil. Drei Identitätsmodelle für Frauen und ihre
 jeweiligen Konzepte des öffentlichen und privaten Raumes
 in der Türkei. *Feminismus, Islam, Nation:
 Frauenbewegungen im Maghreb, in Zentralasien und in
 der Türkei.* (Hg.) Claudia Schöning-Kalender, Aylâ Neusel,
 Mechtild M.Jansen. Frankfurt a.M.: Campus, 1997,
 pp.295-304.

5176 VANER, Semih. Table ronde (I): La femme au fil de
 l'histoire en Turquie. *CEMOTI,* 21 (1996) pp.79-85.

5177 WEDEL, H. Binnenmigration und ethnische Identität -
 Kurdinnen in türkischen Metropolen. (Zusammenfassung:
 Internal migration and ethnic identity - Kurdish women in
 Turkish metropolises.). *Orient* (Opladen), 37 iii (1996)
 pp.437-452;553-554.

5178 WEDEL, H. Kemalistische identitätspolitik und die
 Kurdinnen in der Türkei. *SGMOIK/SSMOCI Bulletin,* 7
 (1998) pp.8-11.

5179 WEDEL, Heidi. Informelle Netzwerke und politische
 Partizipation von Frauen in informellen Siedlungen in
 Istanbul. *Die islamische Welt als Netzwerk.
 Möglichkeiten und Grenzen des Netzwerkansatzes im
 islamischen Kontext* / hrsg. Roman Loimeier. Würzburg:
 Ergon, 2000, (MISK: Mitteilungen zur Sozial- und
 Kulturgeschichte der Islamischen Welt, 9), pp.383-398.

5180 WEDEL, H. Kurdinnen in türkischen Metropolen:
 Migration, Flucht und politische partizipation. *Ethnizität,
 Nationalismus, Religion und Politik in Kurdistan.* C.Borck,
 E.Savelsberg, S.Hajo (Hrsg.). Münster: Lit, 1997,
 (Kurdologie, 1), pp.155-84.

5181 WEDEL, Heidi. Kurdish migrant women in Istanbul:
 community and resources for local political participation
 of a marginalized social group. *Women of a non-state
 nation: the Kurds.* Ed. Shahrzad Mojab. Costa Mesa:
 Mazda, 2001, (Kurdish Studies Series, 3), pp.115-134.

5182 WEYLAND, P. Gendered lives in global spaces. *Space,
 culture and power: new identities in globalizing cities.* Ed.
 Ayşe Öncü & P.Weyland. London: Zed, 1997, pp.82-97.
 [Filipina domestic labour in Istanbul.]

5183 WHITE, J. B. Islamic chic. *Istanbul: between the global
 and the local.* Ed. Çağlar Keyder. Lanham: Rowman &
 Littlefield, 1999, pp.77-91.

5184 WILPERT, C. Table ronde (II): L'organisation familiale
 et la place de la femme dans la société. *CEMOTI,* 21
 (1996) pp.87-89. (En Turquie.)

5185 WOLBERT, B. The reception day - a key to migrant's
 reintegration. *Turkish families in transition.* Ed.
 G.Rasuly-Paleczek, Frankfurt a. M. : Lang (1996)
 pp.186-215.

5186 YILMAZ, İhsan. Legal pluralism in Turkey: persistence
 of Muslim laws. *International Journal of Turkish Studies,*
 7 i-ii (2001) pp.110-124. [Marriage laws.]

5187 [ZANA, Leyla]. Lettre de Leyla Zana au premier ministre
 turc. Tr. Ravenel, Bernard. *Confluences Méditerranée,*
 34 (2000) pp.127-129. (Députée kurde de Turquie
 condamnée en 1994.)

5188 ZEYTINOGLU, Isik Urla & others Factors affecting
 managers' careers in Turkey. *The economics of women
 and work in the Middle East and North Africa.* Ed. E.Mine
 Cinar. Amsterdam: JAI, 2001, (Research in Middle East
 Economics, 4), pp.225-245.

5189 ZEYTINOĞLU, Işık Urla. Constructed images as
 employment restrictions: determinants of female labor in
 Turkey. *Deconstructing images of "the Turkish woman".*
 Ed. Zehra F.Arat. Basingstoke: Macmillan, 1998,
 pp.183-197.

5190 ZEYTINOĞLU, Işık, ÖZMEN, Ömür Timurcanday,
 KATRINLI, Alev Ergenç, KABASAKAL, Hayat &
 ARBAK, Yasemin. Migrant women in waged domestic
 work in Turkey. *Middle East Report,* 29 ii / 211 (1999)
 pp.42;45.

5191 The struggle for religious freedoms in Turkey. An interview
 with Merve Safa Kavakci. *Middle East Affairs Journal,*
 6 iii-iv (2000) pp.99-107.

Turkmens & Turkmenistan

Books

5192 BLACKWELL, Carole. *Tradition and society in
 Turkmenistan: gender, oral culture and song.* Richmond:
 Curzon, 2000. 203pp.

Articles

5193 BAŞTUĞ, Sharon & HORTAÇSU, Nuran. The price of
 value: kinship, marriage and meta-narratives of gender in
 Turkmenistan. *Gender and identity construction: women
 of Central Asia, the Caucasus and Turkey.* Ed. Feride Acar
 & Ayşe Günes-Ayata. Leiden: Brill, 2000, (Social,
 Economic and Political Studies of the Middle East and
 Asia, 68), pp.117-140.

5194 PINNER, R. The Turkmen wedding. *Halı,* 100 (1998)
 pp.104-107;117. (Description of rituals, with illustrations
 of carpets & weavings.)

5195 SEIWERT, I. & MÜLLER, Christine. *Tschyrpy und kurte:*
 zwei turkmenische Frauengewänder in der Sammlung des
 Museums für Völkerkunde zu Leipzig. *Jahrbuch des
 Museums für Völkerkunde zu Leipzig,* 40 (1994)
 pp.136-154. + frontispiece & plates VII-XII.

Uganda

Articles

5196 SEMAFUMU, Sanyu. Freedom of choice or Pandora's
 box? Legal pluralism and the regulation of cross-cultural
 marriages in Uganda. *Cross-cultural marriage: identity
 and choice.* Ed. R.Breger & Rosanna Hill. Oxford: Berg,
 1998, pp.113-128. [Incl. Muslims.]

United Arab Emirates

Books

5197 HOLTON, P. *Wüstensand und Sternenzelt: eine Frau aus dem Westen entdeckt die arabische Welt.* Tr. Gottwald, J. Munich: Knaur, 1994, (Knaur, 60211), 452pp. [Tr. of *Mother without a mask,* London 1991. In UAE.]

Articles

5198 ABOU-SALEH, M. T. & GHUBASH, R. The prevalence of early postpartum psychiatric morbidity in Dubai: a transcultural perspective. *Acta Psychiatrica Scandinavica,* 95 v (1997) pp.428-432.

5199 ABU-HILAL, Maher M. & AAL-HUSSAIN, Abdul-Qader A. Dimensionality and hierarchy of the SDQ in a non-Western milieu: a test of self-concept invariance across gender. *Journal of Cross-Cultural Psychology,* 28 v (1997) pp.535-553. [Self-description questionnaire for Arab boys & girls in Al-Ain, UAE.]

5200 ALI, Fawzia al-. Television programs for women in the United Arab Emirates and the city of Milwaukee, U.S.A. *DOMES: Digest of Middle East Studies,* 7 iii (1998) pp.37-50.

5201 DAWODU, Adekunle & others Biosocial factors affecting vitamin D status of women of childbearng age in the United Arab Emirates. *Journal of Biosocial Science,* 30 iv (1998) pp.431-437. Also online at www.journals.cup.org (Limited skin exposure to sunlight appears to be an important determinant of vitamin D status.)

5202 GAZALI, L. I. al-, BENER, A., ABDULRAZZAQ, Y. M., MICALLEF, R., KHAYYAT, A. I. al- & GABER, T. Consanguineous marriages in the United Arab Emirates. *Journal of Biosocial Science,* 29 iv (1997) pp.491-497.

5203 HAMADI, Hassan Ahmed Ali al-. Diyyah of woman according to Islamic fiqh and the judiciary in the United Arab Emirates. *Contemporary Jurisprudence Research Journal / Majallat al-Buḥūth al-Fiqhīya al-Muʿāṣira,* 38 (1998) pp.43-60.

5204 MOOKERJI, Sati. Subjugated to what extent? Women in the workplace today in the United Arab Emirates. *ISIM Newsletter,* 1 (1998) pp.17-17.

5205 RAMSAY, G. Kvinnorna har fattat sina pennor - utbildning och litteratur vid Piratkusten. *Kvinnovetenskaplige Tidskrift,* 18 iii-iv (1997) pp.15-22. [Women writers of short stories in UAE.]

5206 RASMUSSEN, A. M. Kvinderne i Dubai. *Mellemøst-Information,* 14 v (1997) pp.4-7.

5207 REBELLO, P. Politics of fashion in Dubai. *ISIM Newsletter,* 1 (1998) pp.18-18.

5208 SAYEGH, Fatima al-. Women and economic changes in the Arab Gulf: the case of the United Arab Emirates. *DOMES: Digest of Middle East Studies,* 10 ii (2001) pp.17-39.

5209 SWADI, Harith, BENER, Abdulbari & DARMAKI, Fatima al. Dieting among Arab girls. *Arab Journal of Psychiatry. Al-Majalla al-ʿArabīya li-l-Ṭibb al-Nafsī,* 11 i (2000) pp.25-35. (In the UAE.)

United States of America

Books

5210 AHMED, Leila. *A border passage: from Cairo to America - a woman's journey.* New York: Farrar, Straus & Giroux, 1999. 307pp.

5211 BANNER, L. W. *Finding Fran: history and memory in the lives of two women.* New York: Columbia University Press, 1998. 243pp. [Noura Durkee, American convert to Islam.]

5212 HAMMAD, Suheir. *Drops of this story.* New York: Writers and Readers Pub., 1996. 93pp. [Autobiographical anecdotes of a Palestinian-American.]

5213 KASSINDJA, Fauziya & MILLER BASHIR, Layli. *Do they hear you when you cry.* New York: Delacorte, 1998. 518pp. [Muslim refugee from Togo in USA.]

5214 KASSINDJA, Fauziya & MILLER BASHIR, Layli. *Niemand sieht dich: wenn du wenst.* Tr. Wasel, Ulrike & Timmermann, Klaus. Munich: Blessing, 1998. 507pp. [Tr. of *Do they hear you when you cry,* New York1998. Muslim refugee from Togo in USA.]

5215 SHAKIR, Evelyn. *Bint Arab: Arab and Arab American women in the United States.* Westport: Praeger, 1997. 226pp.

5216 TATE, Sonsyrea. *Little X: growing up in the Nation of Islam.* [San Francisco:]HarperSanFrancisco, 1997. 230pp.

5217 *Family and gender among American Muslims: issues facing Middle Eastern immigrants and their descendants.* Ed. Aswad, Barbara C. & Bilgé, Barbara. Philadelphia (USA): Temple University Press, 1996. 327pp.

5218 *Windows of faith: Muslim women scholar-activists in North America.* Ed. G.Webb. Syracuse: Syracuse University Press, 2000. 295pp.

Articles

5219 ABRAHAM, Margaret. Sexual abuse in South Asian immigrant marriages. *Violence against Women,* 5 vi (1999) pp.591-618. Also online at http:// www.ingenta.com/ journals/browse/sage/j322 (In the United States.)

5220 ABRAHAM, Margaret. Speaking the unspeakable: marital violence against South Asian immigrant women in the United States. *Indian Journal of Gender Studies,* 5 ii (1998) pp.215-241. [Incl. Muslims.]

5221 ABUGIDEIRI, Hibba. The renewed woman of American Islam: shifting lenses toward 'gender *jihad*'? *Muslim World,* 91 i-ii (2001) pp.1-18.

5222 ABUSHARAF, Rogaia Mustafa. Migration with a feminine face: breaking the cultural mold. *Arab Studies Quarterly,* 23 ii (2001) pp.61-85. [Sudanese women migrating alone to North America.]

5223 AHMED, Nilufer, KAUFMAN, G. & NAIM, Shamim. South Asian families in the United States: Pakistani, Bangladeshi, and Indian Muslims. *Family and gender among American Muslims: issues facing Middle Eastern immigrants and their descendants.* Ed. Barbara C.Aswad & Barbara Bilgé. Philadelphia (USA): Temple University Press, 1996, pp.155-172.

5224 ALTOMARE, Kareema. A partial list of organizations for Muslim women's rights, advocacy, and higher Islamic education in the United States. *Windows of faith: Muslim women scholar-activists in North America.* Ed. G.Webb. Syracuse: Syracuse University Press, 2000, pp.249-257.

5225 AMMAR, Nawal H. Simplistic stereotyping and complex reality of Arab-American immigrant identity: consequences and future strategies in policing wife battery. *Islam and Christian-Muslim Relations,* 11 i (2000) pp.51-70. Also online at http:// www.catchword.com

5226 ANWAY, Carol L. American women choosing Islam. *Muslims on the Americanization path?* Ed. Y.Yazbeck Haddad, J.L.Esposito. New York: Oxford University Press, 2000, pp.145-160. [First published in 1998 by University of South Florida.]

5227 ASCOLY, Nina. A woman's place is in the Nation: analyzing the discourse of the `Nation of Islam'. *Women Living under Muslim Laws: Dossier,* 20 (1998) Also online at http:// www.wluml.org/english/pubs

5228 ASCOLY, Nina. La place de la femme dans la Nation: analyse du discours de la "Nation de l'Islam". *Women Living under Muslim Laws: Dossier,* 20 (1997) pp.103-137. Also online at http://www.wluml.org/french/ pubs/pdf/dossiers/dossier20/D20fr.pdf

5229 BARAZANGI, Nimat Hafez. Muslim women's Islamic
 higher learning as a human right: the action plan. *Muslim
 women and the politics of participation: implementing the
 Beijing platform*. Ed. Mahnaz Afkhami & E.Friedl.
 Syracuse (USA): Syracuse University Press, 1997,
 pp.43-57.

5230 BARAZANGI, Nimat Hafez. Muslim women's Islamic
 higher learning as a human right: theory and practice.
 *Windows of faith: Muslim women scholar-activists in North
 America*. Ed. G.Webb. Syracuse: Syracuse University
 Press, 2000, pp.22-47. (North American Muslim
 women.)

5231 BILGÉ, Barbara. Turkish-American patterns of
 intermarriage. *Family and gender among American
 Muslims: issues facing Middle Eastern immigrants and
 their descendants*. Ed. Barbara C.Aswad & Barbara Bilgé.
 Philadelphia (USA): Temple University Press, 1996,
 pp.59-106.

5232 BING-CANAR, J. & ZERKEL, Mary. Reading the media
 and myself: experiences in critical media literacy with
 young Arab-American women. *Signs*, 23 iii (1998)
 pp.735-743. (Video project on Chicago's Arab-American
 community.)

5233 CAINKAR, Louise. Immigrant Palestinian women evaluate
 their lives. *Family and gender among American Muslims:
 issues facing Middle Eastern immigrants and their
 descendants*. Ed. Barbara C.Aswad & Barbara Bilgé.
 Philadelphia (USA): Temple University Press, 1996,
 pp.41-58.

5234 DALLALFAR, Arlene. Iranian women as immigrant
 entrepreneurs. *Gender & Society*, 8 iv (1994)
 pp.541-561. [USA.]

5235 DALLALFAR, Arlene. The Iranian ethnic economy in
 Los Angeles: gender and entrepreneurship. *Family and
 gender among American Muslims: issues facing Middle
 Eastern immigrants and their descendants*. Ed. Barbara
 C.Aswad & Barbara Bilgé. Philadelphia (USA): Temple
 University Press, 1996, pp.107-128.

5236 DALY, M.Catherine. The 'Paarda' expression of Hejaab
 among Afghan women in a non-Muslim community.
 Religion, dress and the body. [Ed.] Linda B.Arthur.
 Oxford: Berg, 1999, pp.147-161. [In USA.]

5237 DISUQI, Rasha al-. The evolving quest for American
 women's political rights and the role of Muslim women.
 Middle East Affairs Journal, 6 iii-iv (2000) pp.61-75.
 (American Muslims.)

5238 EBAUGH, H.R. & SALTZMANN CHAFETZ, J.
 Structural adaptations in immigrant congregations.
 Sociology of Religion, 61 ii (2000) pp.135-153. [In USA,
 incl. Muslims.]

5239 EISENLOHR, C. J. Adolescent Arab girls in an American
 high school. *Family and gender among American
 Muslims: issues facing Middle Eastern immigrants and
 their descendants*. Ed. Barbara C.Aswad & Barbara Bilgé.
 Philadelphia (USA): Temple University Press, 1996,
 pp.250-270.

5240 HADDAD, Y. Y[azbeck] & SMITH, J. I. Islamic values
 among American Muslims. *Family and gender among
 American Muslims: issues facing Middle Eastern
 immigrants and their descendants*. Ed. Barbara C.Aswad
 & Barbara Bilgé. Philadelphia (USA): Temple University
 Press, 1996, pp.19-40.

5241 HANASSAB, Shideh & TIDWELL, Romeria.
 Intramarriage and intermarriage: young Iranians in Los
 Angeles. *International Journal of Intercultural Relations*,
 22 iv (1998) pp.395-408. (Young Muslim Iranians &
 young Jewish Iranians.)

5242 HANASSAB, Shideh. Sexuality, dating, and double
 standards: young Iranian immigrants in Los Angeles.
 Iranian Studies, 31 i (1998) pp.65-75.

5243 HASSOUNEH-PHILLIPS, Dena Saadat. "Marriage is half
 of faith and the rest is fear Allah": marriage and spousal
 abuse among American Muslims. *Violence against
 Women*, 7 viii (2001) pp.927-946. Also online at http://
 www.ingenta.com/journals/browse/sage/j322

5244 HATEM, Mervat F. How the Gulf War changed the
 AAUG's discourse on Arab nationalism and gender politics.
 Middle East Journal, 55 ii (2001) pp.277-296.

5245 HEGLAND, M. [E.]. Learning feminist pedagogy with
 students and Iranian-American grandparents. *Middle
 East Women's Studies Review*, 13 iv - 14 i (1999) pp.1-2.

5246 HOWELL, Kubrah Razawi. American Imams speak out
 on the subject of women: a cross-cultural survey. *Islam
 in America*, 2 iv (1996) pp.28-30.

5247 KAUFMAN, G. & NAIM, Shamim. An international
 family: a case study from South Asia. *Family and gender
 among American Muslims: issues facing Middle Eastern
 immigrants and their descendants*. Ed. Barbara C.Aswad
 & Barbara Bilgé. Philadelphia (USA): Temple University
 Press, 1996, pp.173-178. [Now in USA & elsewhere.]

5248 KHAN, Surina. The All-American queer Pakistani girl:
 the dilemma of being between cultures. *Women Living
 under Muslim Laws: Dossier*, 18 (1997) pp.7-9. Also
 online at www.wluml.org/english/pubs

5249 MAHDI, Ali Akbar. Perceptions of gender roles among
 female Iranian immigrants in the United States. *Women,
 religion and culture in Iran*. Ed. Sarah Ansari and Vanessa
 Martin. Richmond: Curzon, in association with The Royal
 Asiatic Society of Great Britain and Ireland, 2002,
 pp.189-214.

5250 MAHDI, Ali Akbar. Trading places: changes in gender
 roles within the Iranian immigrant family. *Critique:
 Journal for Critical Studies of the Middle East*, 15 (1999)
 pp.51-75. [In USA.]

5251 MCCLOUD, Aminah Beverly. The scholar and the *fatwa*:
 legal issues facing African American and immigrant
 Muslim communities in the United States. *Windows of
 faith: Muslim women scholar-activists in North America*.
 Ed. G.Webb. Syracuse: Syracuse University Press, 2000,
 pp.136-144. [Especially female Muslim scholars.]

5252 MOORE, Kathleen. The *Hijab* and religious liberty:
 anti-discrimination law and Muslim women in the United
 States. *Muslims on the Americanization path?* Ed.
 Y.Yazbeck Haddad, J.L.Esposito. New York: Oxford
 University Press, 2000, pp.105-127. [First published in
 1998 by University of South Florida.]

5253 MOUSSETTE, Kris Ann Balser. Female genital mutilation
 and refugee status in the United States - a step in the right
 direction. *Boston College International and Comparative
 law Review*, 19 ii (1996) pp.353-395. [African women's
 experiences.]

5254 READ, Jen'nan Ghazal & BARTKOWSKI, John P. To
 veil or not to veil? A case study among Muslim women in
 Austin, Texas. *Gender & Society*, 14 iii (2000)
 pp.395-417. Also online at http:// www.ingentaselect.com

5255 SHAKIR, Evelyn. Lebanese women: the Beirut-New York
 connection. *A community of many worlds: Arab
 Americans in New York City*. Ed. by Kathleen Benson and
 Philip M.Kayal. New York: Museum of the City of New
 York / Syracuse University Press, 2002, pp.213-225.
 [Interviews with five Christians and one Muslim.]

5256 SWANSON, J. C. Ethnicity, marriage, and role conflict:
 the dilemma of a second-generation Arab-American.
 *Family and gender among American Muslims: issues
 facing Middle Eastern immigrants and their descendants*.
 Ed. Barbara C.Aswad & Barbara Bilgé. Philadelphia
 (USA): Temple University Press, 1996, pp.241-249.

5257 WALBRIDGE, L. S. Five immigrants. *Family and
 gender among American Muslims: issues facing Middle
 Eastern immigrants and their descendants*. Ed. Barbara
 C.Aswad & Barbara Bilgé. Philadelphia (USA): Temple
 University Press, 1996, pp.301-317.

5258 WALBRIDGE, L. S. Sex and the single Shi'ite: *mut'a*
 marriage in an American Lebanese Shi'ite community.
 *Family and gender among American Muslims: issues
 facing Middle Eastern immigrants and their descendants*.
 Ed. Barbara C.Aswad & Barbara Bilgé. Philadelphia
 (USA): Temple University Press, 1996, pp.143-154.

5259 WALBRIDGE, Linda S. Sex and the single Shi'ite: *mut'a*
 marriage in an American Lebanese Shi'ite community.
 Women Living under Muslim Laws: Dossier, 18 (1997)
 pp.18-30. Also online at www.wluml.org/english/pubs

Uzbekistan

Books

5260 KRÄMER, Annette. *Geistliche Autorität und islamische Gesellschaft im Wandel: Studien über Frauenälteste (otin und xalfa) im unabhängigen Usbekistan.* Berlin: Schwarz, 2002 (Islamkundliche Untersuchungen, 246), 462pp.

Articles

5261 ALIMOVA, Dilarom & AZIMOVA, Nodira. Women's position in Uzbekistan before and after independence. *Gender and identity construction: women of Central Asia, the Caucasus and Turkey.* Ed. Feride Acar & Ayşe Güneş-Ayata. Leiden: Brill, 2000, (Social, Economic and Political Studies of the Middle East and Asia, 68), pp.293-304.

5262 BARBIERI, M., BLUM, A., DOLKIGH, E. & ERGASHEV, A. Nuptiality, fertility, use of contraception, and family policies in Uzbekistan. *Population Studies,* 50 i (1996) pp.69-88.

5263 FATHI, Habiba. Le pouvoir des *otin,* institutrices coraniques, dans l'Ouzbékistan indépendant. *Cahiers d'Asie Centrale,* 5-6 (1998) pp.313-333.

5264 GHAVAMSHAHIDI, Zohreh. Die Entstehung des Nationalstaates und die Geschlechterideologie in Usbekistan. *Feminismus, Islam, Nation: Frauenbewegungen im Maghreb, in Zentralasien und in der Türkei.* (Hg.) Claudia Schöning-Kalender, Aylâ Neusel, Mechtild M.Jansen. Frankfurt a.M.: Campus, 1997, pp.139-165.

5265 HEUER, B. "Nationaler Aufbruch" in Uzbekistan - Perspektiven für Frauen. *Osteuropa,* 47 ii (1997) pp.173-190.

5266 KAMP, Marianne. Pilgrimage and performance: Uzbek women and the imagining of Uzbekistan in the 1920s. *International Journal of Middle East Studies,* 34 ii (2002) pp.263-278. Also online at http:// journals.cambridge.org (The pilgrimage of modern education.)

5267 KANDIYOTI, Deniz. Women and social policy. *Social policy and economic transformation in Uzbekistan.* Ed. K.Griffin. Geneva: International Labour Office, 1996, pp.129-148.

5268 KRÄMER, Annette. Crisis and memory in Central Asian Islam. The Uzbek example of the 'otin' and 'xalfa' in a changing environment. *Crisis and memory in Islamic societies. Proceedings of the third Summer Academy of the Working Group Modernity and Islam held at the Orient Institute of the German Oriental Society in Beirut /* ed. Angelika Neuwirth and Andreas Pflitsch. Beirut: Orient-Institut der Deutschen Morgenländischen Gesellschaft; Würzburg: Ergon, 2001, (Beiruter Texte und Studien, 77), pp.365-387.

5269 ÖZATAŞ, Aslı. The role of women in the making of the new Uzbek identity. *Eurasian Studies,* 3 iii (1996) pp.102-109.

5270 PIRNAZAROVA, Flora. Islamisierung der Frauen und Neubelebung des kulturellen Erbes. Einige Anmerkungen zur aktuellen Situation in Usbekistan. *Feminismus, Islam, Nation: Frauenbewegungen im Maghreb, in Zentralasien und in der Türkei.* (Hg.) Claudia Schöning-Kalender, Aylâ Neusel, Mechtild M.Jansen. Frankfurt a.M.: Campus, 1997, pp.263-267.

5271 SAKTANBER, Ayşe & ÖZATAŞ-BAYKAL, Aslı. Homeland within homeland: women and the formation of Uzbek national identity. *Gender and identity construction: women of Central Asia, the Caucasus and Turkey.* Ed. Feride Acar & Ayşe Güneş-Ayata. Leiden: Brill, 2000, (Social, Economic and Political Studies of the Middle East and Asia, 68), pp.229-248.

5272 [SAVEL'EVA, T. K.]. The role of education in formation and development of language competence of women in Uzbekistan under conditions of polyethnicity / T.Savelieva. *Contemporary Central Asia,* 1 i (1997) pp.44-62.

5273 TOKHTAKHODJAEVA, M. Traditional stereotypes and women's problems in post-Soviet Uzbekistan: a survey of the mass media. *Women Living under Muslim Laws: Dossier,* 22 (1999) pp.32-43. Also online at http:// www.wluml.org/english/pubs

5274 VALIEVA, Barno. Frauen in Usbekistan. Notizen zur Wiederentdeckung islamischer Tradition. *Feminismus, Islam, Nation: Frauenbewegungen im Maghreb, in Zentralasien und in der Türkei.* (Hg.) Claudia Schöning-Kalender, Aylâ Neusel, Mechtild M.Jansen. Frankfurt a.M.: Campus, 1997, pp.269-272.

5275 YURKOVA, Irina. Die Gestaltung von Handlungsräumen von Frauen: Selbstbeschäftigung in der post-sowjetischen Wirtschaft in Usbekistan. *Die geschlechtsspezifische Einbettung der Ökonomie: empirische Untersuchungen über Entwicklungs- und Transformationsprozesse /* Gudrun Lachenmann, Petra Dannecker (Hrsg.). Münster: Lit, 2001, (Market, Culture and Society, 12), pp.347-368.

5276 Dreimal Todesstrafe - Frauenbild und Mord in Zentralasien (Usbekistan, Tadschikistan). Tr. Warning, G. *Hannoversche Studien über den Mittleren Osten,* 22 (1998) pp.181-184.

West Africa (general)

Books

5277 PELEIKIS, A. *Migration and gender in a global village: Lebanese women at home and in West-Africa: a lecture ... June 12, 1996.* Beirut: Orient-Institut der Deutschen Morgenländischen Gesellschaft, 1997, (Beyrouth Zokak el-Blat(t), 6), 28pp.

Articles

5278 CISSÉ, B. P. International law sources applicable to female genital mutilation: a guide to adjudicators of refugee claims based on a fear of female genital mutilation. *Columbia Journal of Transnational Law,* 35 ii (1997) pp.429-451. [Describing practices in Horn of Africa & West Africa.]

5279 PERINBAM, B.Marie. The salt-gold alchemy in the eighteenth and nineteenth century Mande world: if men are its salt, women are its gold. *History in Africa,* 23 (1996) pp.257-278. [Anthropological & cosmological aspects of commodities of long-distance trade.]

5280 REVEYRAND-COULON, O. Les énoncés féminins de l'islam. *Religion et modernité politique en Afrique noire: Dieu pour tous et chacun pour soi.* Sous la dir. de J-F.Bayart. Paris: Karthala, 1993, pp.53-100. [West Africa.]

5281 SAMB, Babacar. Monde arabo-islamique et l'Afrique de l'Ouest: coopération culturo-religieuse informelle ou coopération culturelle institutionnelle? *La civilisation islamique en Afrique de l'Ouest. Communications du Symposium International ... 1996, Dakar, Sénégal.* Ed. Samba Dieng. Istanbul: Organisation de la Conférence Islamique, Centre de Recherches sur l'Histoire, l'Art et la Culture Islamiques (IRCICA), 1999, (Série d'Histoire des Nations Musulmanes, 4), pp.377-386.

5282 WILSON FALL, W. The upward mobility of wives: gender, class and ethnicity. *African Philosophy,* 12 ii (1999) pp.175-196. (Fulbe.)

Western Sahara

Books

5283 JULIANO, D. *La causa saharaui y las mujeres: "siempre hemos sido muy libres".* Barcelona: Icaria, 1998, (Más Madera, 16), 110pp.

5284 PERREGAUX, C. *Frauen der Wüste.* Hamburg: Verlag Libertare Assoziation, [1995], (Nosotras, 1). 157pp. [Tr. of *Femmes sahraouies, femmes du désert,* Paris 1990.]

5285 PERREGAUX, C. *Gulili: mujeres del desierto saharaui.* Tr. Zulaika, R. Tafalla: Txalaparta, 1993. 153pp. [Translation of *Femmes sahraouies, femmes du désert,* Paris, 1990.]

Articles

5286 BAD, Kheira Boulahi. Valoración sobre el proceso emancipativo de las mujeres saharauis. *Studia Africana: Publicació del Centre d'Estudis Africans,* 11 (2000) pp.7-12.

5287 CARATINI, S. Le rôle de la femme au Sahara occidental. (Abstract: The social role of the woman in the Western Sahara.). *La Pensée,* 308 (1996) pp.115-124;173.

Western arts & literatures

Books

5288 COCO, C. *Harem: il sogno esotico degli occidentali.* Venice: Arsenale, 1997. 191pp. [Mostly illustrations.]

5289 COCO, C. *Harem: l'Orient amoureux.* Tr. Morgenthaler, R. Paris: Menges, 1997. 191pp. [Tr. of *Harem: il sogno esotico degli occidentali,* Venice,1997. Mostly illustrations.]

5290 COCO, C. *Harem: Sinnbild orientalische Erotik.* Tr. Podehl-Fenu, C. Stuttgart: Belser Verlag, 1997. 191pp. [Tr. of *Harem: il sogno esotico degli occidentali,* Venice,1997. Mostly illustrations.]

5291 COCO, C. *Secrets of the Harem.* New York: Vendome Press, 1997. 191pp. [Tr. of *Harem: il sogno esotico degli occidentali,* Venice,1997. Mostly illustrations.]

5292 DELPLATO, Joan. *Multiple wives, multiple pleasures: representing the harem, 1800-1875.* Madison: Fairleigh Dickinson University Press, 2002. 283pp.

5293 KAHF, Mohja. *Western representations of the Muslim woman: from termagant to odalisque.* Austin: University of Texas Press, 1999. 207pp.

5294 LEWIS, Reina. *Gendering Orientalism: race, femininity and representation.* London: Routledge, 1996. 267pp.

5295 MERNISSI, Fatema. *Scheherazade goes West: different cultures, different harems.* New York: Washington Square Press, 2001. 228pp.

5296 PINN, I. & WEHNER, M. *EuroPhantasien: die islamische Frau aus westlicher Sicht.* Duisburg: DISS, 1995. 257pp.

5297 YEAZELL, Ruth Bernard. *Harems of the mind: passages of Western art and literature.* New Haven: Yale University Press, 2000. 314pp.

5298 YEAZELL, Ruth Bernard. *Harems of the mind: passages of Western art and literature.* New Haven: Yale University Press, 2000. 314pp.

Articles

5299 ALEXANDRE-GARNER, Corinne. Alexandrie: "Une utopie qui s'écrirait au féminin". *Confluences Méditerranée,* 34 (2000) pp.173-185. [In novels of Durrell & Kharrat.]

5300 BEN DRISS, Hager. History via the unconscious in Miriam Cooke's *Hayati, my life. Middle East Women's Studies Review,* 17 i-ii (2002) pp.9-12.

5301 BENITEZ-ROCA, Sylvie. Aspects de la femme morisque dans cristianos y moriscos d'Estébanez Calderón (1838). *Actes du VIIe Symposium International d'Etudes Morisques sur: Famille morisque: femmes et enfants. Familia morisca: mujeres y niños / A 'māl al-mu'tamar al-'ālamī al-sābi' li-l-dirāsāt al-Mūrīskīya - al-Andalusīya ḥawla: al-'ā'ila al-Mūrīskīya: al-nisā' wa-'l-aṭfāl. Etudes* réunies et préfacées par Abdeljelil Temimi. Zaghouan: Fondation Temimi pour la Recherche Scientifique et l'Information, 1997, pp.24-32.

5302 B(ENJAMIN), R(oger) & others Painting catalogue: classic Orientalism; The expanding East; The ancient East; The Gérôme paradigm; Neo-romantics and naturalists; Impressionists and plein-airists; Symbolists and decorators; Avant-garde and colonial art. *Orientalism: Delacroix to Klee.* R.Benjamin, curator & ed. Sydney: Art Gallery of New South Wales, 1997, pp.54-187.

5303 BOËTSCH, Gilles & SAVARESE, Eric. Le corps de l'Africaine: érotisation et inversion. (Abstract: The African woman's body: eroticism and inversion.). *Cahiers d'Etudes Africaines,* 39 / 153 (1999) pp.123-144. (Comparant les images de deux "types" de femmes indigènes - femme noire & femme mauresque.)

5304 BONEBAKKER, S. A. & SCOTT, A. Santa Nefissa. *Quaderni di Studi Arabi,* 16 / 1998 (1999) pp.125-141. (Sayyida Nafīsa ... in sixteenth century Italian poetry and prose.)

5305 CARRIER, J-L. Voile, femmes voilées en Orient et voyageurs occidentaux (XVè - XVIIIè siècles.). *Horizons Maghrébins,* 25-26 (1994) pp.121-127.

5306 CERUTI BURGIO, Anna. La "Schiava turca" e "La Madonna dal collo lungo" del Parmigianino e la poesia di Andrea Baiardi. *Il Carrobbio,* 25 (1999) pp.35-41.

5307 DE BIASI, P-M. Les tentations de l'Orient: la culte de la femme orientale dans le *Voyage en Egypte* de Gustave Flaubert. *Literature and its cults: an anthropological approach / approche anthropologique: la littérature et ses cultes.* Ed. P.Dávidházi & J.Karafiáth. Budapest: Argumentum, 1994, pp.97-110.

5308 DEPREZ, Christine. La rencontre et la communication entre voyageuses et femmes autochtones dans les récits de voyage en Orient au féminin. *Femmes écrivains en Méditerranée.* Sous la dir. de Vassiliki Lalagianni. Paris: Publisud, 1999, pp.9-26.

5309 DJEBAR, Assia. "Algériennes, le regard qui recule ...". *Europas islamische Nachbarn. Studien zur Literatur und Geschichte des Maghreb.* Band 2. hrsg. von Ernstpeter Ruhe. Würzburg: Königshausen & Neumann, 1995, pp.11-16. (Les peintres.)

5310 DOBIE, M. Montesquieu's political fictions: Oriental despotism and the respresentation of the feminine. *Transactions of the Ninth International Congress on the Enlightenment, Münster ... 1995.* Vol. III. Oxford: Voltaire Foundation, 1996, (Studies on Voltaire and the Eighteenth Century, 348), pp.1336-1339.

5311 EVANS, Peter W. From Maria Montez to Jasmine: Hollywood's oriental odalisques. *"New" exoticisms: changing patterns in the construction of otherness.* Ed. I.Santaolalla. Amsterdam: Rodopi, 2000, (Postmodern Studies, 29), pp.157-165.

5312 GALLETTI, Mirella. Western images of women's role in Kurdish society. *Women of a non-state nation: the Kurds.* Ed. Shahrzad Mojab. Costa Mesa: Mazda, 2001, (Kurdish Studies Series, 3), pp.209-225. [Travel accounts & political reports.]

5313 HOLDEN, Philip. Reinscribing Orientalism: gendering modernity in colonial Malaya. *Asian Journal of Social Science,* 29 ii (2001) pp.205-218. Also online at www.ingentaselect.com (The operations of Orientalism in the works of two British writers ... Joseph Conrad and Hugh Clifford.)

5314 JUILLIARD-BEAUDAN, C. La Circassie: l'imaginaire en action. *Cahiers de l'Orient,* 42 (1996) pp.123-135. (La répresentation picturale de la Circassienne.)

5315 KLEDAL, A. R. Mor Danmark mellem haremskvinder og danske bønder: om dansk orientalisme og dannelsen af national identitet i 1800-tallets romantiske billedkunst. *TfMS: Tidskrift för Mellanösternstudier,* 1999 ii (2000) pp.7-15.

5316 LOUNIS, Aziza. *Confidences d'une fille de la nuit*: histoire d'une quête à travers *"le continent de la passion". Maroc: littérature et peinture coloniales (1912-1956). Actes du colloque ... 26-27-29 octobre 1994.* Rabat: Université Mohammed V, Faculté des Lettres et des Sciences Humaines, 1996, (Colloques et Séminaires, 52), pp.135-142. (François Bonjean.)

5317 MATAR, Nabil I. The representation of Muslim women in Renaissance England. *Muslim World,* 86 i (1996) pp.50-61. (The Turkish model.)

5318 MONOD-FONTAINE, I. Le paradoxe de l'odalisque. *Le Maroc de Matisse: exposition présentée à l'Institut du Monde Arabe ... 1999 ... 2000.* Paris: Institut du Monde Arabe / Gallimard, 1999, pp.111-153. [Incl. catalogue entries for paintings.]

5319 MUNKHOLM, P. Karen Blixen og islam. *Bogens Verden,* 82 iv (2000) pp.29-32.

5320 NIEDERLE, H. A. Der "hässliche" Orientale" in der Bekenntnisliteratur von leidgeprüften Frauen (z.B. Betty Mahmoudy). *Wir und die Anderen: Islam, Literatur und Migration.* W.Dostal, H.A.Niederle, K.R.Wernhart (Hg.). Vienna: WUV Universitätsverlag, 1999, (Wiener Beiträge zur Ethnologie und Anthropologie, 9), pp.191-198.

5321 ÖZYER, Nuran. Das Bild des türkischen maedchens [*sic*] in der deutschen Kinder- og Jugendliteratur. *Dil Dergisi,* 12 (1993) pp.5-18.

5322 RIBEIRO, R. J. Le sérail dans les *Lettres persanes* de Montesquieu. *Transactions of the Ninth International Congress on the Enlightenment, Münster ... 1995.* Vol. III. Oxford: Voltaire Foundation, 1996, (Studies on Voltaire and the Eighteenth Century, 348), pp.1333-1336.

5323 RODGERS, Terence. Restless desire: Rider Haggard, Orientalism and the New Woman. *Women: a Cultural Review,* 10 i (1999) pp.35-46. [*Ayesha*, etc.]

5324 ṢADRZĀDEH, Māndānā. Le statut de la femme musulmane dans les *Lettres persanes.* *Luqmān,* 16 ii / 32 (2000) pp.73-92.

5325 SALLAM, Mona Hamed. The different attitudes toward women in the East and the West in the late 19th century and the early 20th century, a comparative study with special emphasis on Hilton Hill's novel "His Egyptian wife". *The proceedings of the International Conference: Comparative Literature in the Arab World, Centre for Comparative Linguistics and Literary Studies (CCLLS) ... Cairo University ... 1995. Qaḍāyā al-adab al-muqāran fī 'l-waṭan al-'Arabī.* Ed. Ahmed Etman. Cairo: Egyptian Society of Comparative Literature (ESCL), 1998, pp.209-216.

5326 SCHICK, İrvin Cemil. The women of Turkey as sexual personae: images from Western literature. *Deconstructing images of "the Turkish woman".* Ed. Zehra F.Arat. Basingstoke: Macmillan, 1998, pp.83-100.

5327 VASVARI, Louise O. "Hit the cat and tame the bride": shrew taming as wedding ritual, East to West. *American & British interactions, perceptions & images of North Africa.*Ed. Adel Manai. [Tunis: Tunisian Society for Anglo-Saxon Studies], 2000, (TSAS Innovation Series, 2000), pp.122-140. [In Arabic popular literature & Western literature.]

Yemen

Books

5328 ALI, Miriam & WAIN, J. *Hinter dem Schleier aus Angst und Tränen: eine Mutter kämpft um ihre Töchter, die in den Jemen verkauft wurden.* Tr. Lindner, H. Munich: Heyne, 1996. 379pp. [Tr. of *Without mercy,* London 1995. Mother of British girls married in Yemen.]

5329 ALI, Miriam & WAIN, J. *Sin compasión: la lucha de una mujer contra la esclavitud actual.* Tr. Riva, C. M. Barcelona: Planeta / Seix Barral, 1995. 318pp. [Tr. of *Without mercy,* London, 1995. Mother of British girls married in Yemen.]

5330 GLANDER, A. *Inheritance in Islam: women's inheritance in Sana'a (Republic of Yemen): law, religion, and reality.* Frankfurt a. M. : Lang, Europäischer Verlag der Wissenschaften 1998 (Europäische Hochschulschriften. Reihe XXVII, Asiatische und afrikanische Studien, 69), 141pp.

5331 HOECK, E. *Ich sah den Jemen ohne Schleier: als Ärztin zwischen Orient und Okzident.* 2. Aufl. Berlin: Frieling 1999. 223pp.

5332 MUHSEN, Zana & CROFTS, A. *Csak még egyszer lássam az anyámat: rabszolgaságom története.* Tr. Losonci, G. Budapest: M. Kvklub & Geomédia, 1996. 192pp. [Tr. of *Sold.* British-born Yemeni girls in arranged marriages in Yemen.]

5333 MUHSEN, Zana & CROFTS, A. *Såld.* Ny utg. Tr. Leijer, D. Stockholm: Bonnierförlag & MånPocket, 1994. 204pp. [Tr. of *Sold.* British-born Yemeni girls in arranged marriages in Yemen.]

5334 MUHSEN, Zana & CROFTS, A. *Solgt.* 2. udgave. Tr. Skovlund, B. Copenhagen: Vintern 1993, rp. Ruds-Vedby: Vega, 1995. 218pp. [Tr. of *Sold.* British-born Yemeni girls in arranged marriages in Yemen.]

5335 MUHSEN, Zana & CROFTS, A. *Sprzedane!* Tr. Rostworowska, M. Katowice: Od Nowa, 1994. 280pp. [Tr. of *Sold,* 1991. British-born Yemeni girls in arranged marriages in Yemen.]

5336 MUHSEN, Zana & CROFTS, A. *Vendidas.* Tr. Riva, C. M. Barcelona: Planeta-Seix Barral, 1993. 277pp. [Tr. of *Sold.* British-born Yemeni girls in arranged marriages in Yemen.]

5337 MUHSEN, Zana & CROFTS, A. *Vendues!* Paris: Fixot, 1993. 334pp. [Tr. of *Sold.* British-born Yemeni girls in arranged marriages in Yemen.]

5338 SCHÖNIG, Hanne. *Schminken, Düfte und Räucherwerk der Jemenitinnen: Lexikon der Substanzen, Utensilien und Techniken.* Würzburg: Ergon Verlag, 2002 (Beiruter Texte und Studien, 91), 415pp.

5339 WÜRTH, Anna. *Aš-Šarī'a fī Bāb al-Yaman: Recht, Richter und Rechtspraxis an der familienrechtlichen Kammer des Gerichts Süd-Sanaa (Republik Jemen) 1983-1995.* Berlin: Duncker & Humblot, 2000 (Soziologische Schriften, 69), 284pp.

5340 *Hinter dem Schleier: drei bewegende Lebensgeschichten.* 3. Aufl. Munich: Heyne, 1997. 543pp. [Autobiographies of Zana Muhsen (in Yemen), Fadhma Aïth Mansour Amrouche & Djura (Kabyle Algerian women).]

Articles

5341 ANDERSEN, L.Erslev. Moderne kvinder i Yemen. *Mellemøst-Information,* 10 x (1993) pp.7-10.

5342 BADRAN, Margot. Unifying women: feminist pasts and presents in Yemen. *Gender & History,* 10 iii (1998) pp.498-518.

5343 BA OBEID, Mohammad Awadh. Gewalt gegen Frauen in der Republik Jemen. *Jemen-Report,* 31 ii (2000) pp.24-25.

5344 BOXBERGER, L. From two states to one: women's lives in the transformation of Yemen. *Women in Muslim societies: diversity within unity.* Ed. H.L.Bodman, Nayereh Tohidi. Boulder: Rienner, 1998, pp.119-133.

5345 BRIXEL, P. Jemenitische Frauendelegation in Deutschland. *Jemen-Report,* 30 ii (1999) pp.42-42.

5346 BRUCK, G. vom. Being worthy of protection: the dialectics of gender attributes in Yemen. (Abstracts: Mériter protection: la dialectique des attributs du genre au Yemen / Schutzwürdig: die Dialektik der Geschlechtereigenschaften in Jemen / Digno/a de proteccion: la dialectica sobre los atributos de genero en Yemen). *Social Anthropology,* 4 ii (1996) pp.145-162;211-212.

5347 BRUCK, G. vom. Elusive bodies: the politics of aesthetics among Yemeni elite women. *Signs,* 23 i (1997) pp.175-214.

5348 BRUCK, Gabriele vom. Elusive bodies: the politics of aesthetics among Yemeni elite women. *Gender, politics, and Islam.* Ed. Therese Saliba, Carolyn Allen and Judith A.Howard. Chicago: University of Chicago Press, 2002, pp.161-200. [Originally published in *Signs,* 23 i (1997).]

5349 BRUCK, Gabriele vom. Le nom comme signe corporel: l'exemple des femmes de la noblesse yéménite. (Summar[y]: Names as bodily signs.). *Annales: Histoire, Sciences Sociales,* 56 ii (2001) pp.283-311;555.

5350 CARAPICO, S. Gender and status inequalities in Yemen: honour, economics, and politics. *Patriarchy and economic development: women's positions at the end of the twentieth century.* Ed. V.M.Moghadam. Oxford: Clarendon, 1996, pp.80-98.

5351 CARAPICO, S. Women and public participation in Yemen. *Arab women: between defiance and restraint.* Ed. Suha Sabbagh. New York: Olive Branch Press, 1996, pp.62-64.

5352 CARAPICO, Sheila & WUERTH, Anna. Passports and passages: tests of Yemeni women's citizenship rights. *Gender and citizenship in the Middle East.* Ed. Suad Joseph. Syracuse (USA): Syracuse University Press, 2000, pp.265-271.

5353 CARAPICO, Sheila. The dialectics of fashion: gender and politics in Yemen. *Women and power in the Middle East.* Ed. Suad Joseph & Susan Slyomovics. Philadephia: University of Pennsylvania Press, 2001, pp.183-190;216.

5354 CLARK, J. A. Women and Islamic activism in Yemen. *Yemen Update,* 39 (1997) pp.13-15.

5355 CLARK, Janine. "This is the bride": on polygamy in Yemen. *Middle East Report,* 204 / 27 iii (1997) pp.32-32.

5356 CLARK, Janine Astrid & SCHWEDLER, Jillian. Who opened the window? Women's activism in Islamist parties. *Comparative Politics,* 35 iii (2003) pp.293-312. (Jordan and Yemen between 1995 and 1998.)

5357 DAFTARY, Farhad. Sayyida Ḥurra: the Ismāʿīlī Ṣulayḥid Queen of Yemen. *Women in the medieval Islamic world: power, patronage, and piety.* Ed. G.R.G.Hambly. Basingstoke: Macmillan, 1998, (The New Middle Ages, 6), pp.117-130.

5358 DAHLGREN, Susanne. Kvinnor som hot mot samhället. Diskussioner om "kvinnan" i Aden före och efter Jemens enande. *TfMS: Tidskrift för Mellanösternstudier,* 1998 i, pp.4-22.

5359 DAHLGREN, Susanne. Women's lib, the southern way: reflections from the past decades. *Yemen Update,* 43 (2001) pp.23-25. (South Yemen.) Also online at www.aiys.org/webdate/yu43.html

5360 DIAMOND, J. Marie Stopes International in Yemen. *British-Yemeni Society Journal,* 6 (1998) pp.18-20. Also online at http:// www.al-bab.com/bys/journal.htm

5361 ELIE, Serge D. The representation of gender in the ethnographic discourse on Yemen: a case for paradigmatic fossilization? *Middle East Women's Studies Review,* 17 i-ii (2002) pp.13-18.

5362 FREITAG, U. & SCHÖNIG, H. Wise men control wasteful women: documents on 'customs and traditions' in the Kathīrī State Archive, Say'ūn. *New Arabian Studies,* 5 (2000) pp.67-96.

5363 GRÄF, B. Neue Mode, oder: warum tragen Frauen in Zingibar Gesichtsschleier. *Jemen-Report,* 29 i-ii (1998) pp.12-13.

5364 GREVEN, Dorothea. Willkommen Freund! Grossverpflegung auf Jemenitisch. *Jemen-Report,* 33 i (2002) pp.9-11. (Hamidah's Funduq in Shibam.)

5365 KELLER, U. Die arrangierte Heirat in Sana'a. *Jemen-Report,* 27 i (1996) pp.4-7.

5366 LOEB, L. D. Gender, marriage, and social conflict in Habban. *Sephardi and Middle Eastern Jewries: history and culture in the modern era.* Ed. H.E.Goldberg. Bloomington & Indianapolis: Indiana University Press, 1996, pp.259-276.

5367 MASHRAFI, Hamad Rashid al-. Determinants of fertility and contraceptive use in the Republic of Yemen. *CDC 27th Annual Seminar on population issues in the Middle East, Africa and Asia.* Cairo: Cairo Demographic Center, 1998, (Research Monograph Series, 27; CDC Annual Seminar, 1997), pp.172-192.

5368 MEHLS, Hartmut. Aus Träumen geboren. Die Selbsthilfe von blinden Frauen im Jemen. *Jemen-Report,* 32 ii (2001) pp.12-15.

5369 MUHSEN, Zana. Noch einmal meine Mutter sehen. Tr. Morawetz, Silvia. *Hinter dem Schleier: drei bewegende Lebensgeschichten.* 3. Aufl. Munich: Heyne, 1997, pp.7-214. [Tr. of *Sold,* by Zana Muhsen & Andrew Crofts, London 1991. British girl in Yemen.]

5370 NAÏM-SANBAR, Samia. Contribution à l'étude de l'accent yéménite: le parler des femmes de l'ancienne génération. *Zeitschrift für Arabische Linguistik,* 27 (1994) pp.67-89.

5371 RAMADAN, Suad. Facing the backlash: one woman's experience in Yemen. *Gender and disability: women's experiences in the Middle East.* / Lina Abu-Habib. Oxford: Oxfam, 1997, pp.60-66.

5372 SCHÖNIG, H. Traditionelle Schönheitsmittel der Jemenitinnen: die Körperbemalung (naqš) mit Galltinte (hiḍāb). *Jemen-Report,* 26 i (1995) pp.22-24.

5373 SCHÖNIG, H. Traditionelle Schönheitsmittel der Jemenitinnen (2): Hennaöl (qaṭr al-ḥinnā'). *Jemen-Report,* 26 ii (1995) pp.9-11.

5374 SCHÖNIG, H. Yemeni women's traditional cosmetics (Part 1). *Yemen Update,* 38 (1996) pp.10-15.

5375 SCHUMACHER, Barbara. Gespräche mit jemenitischen Frauen. *Jemen-Report,* 32 i (2001) pp.29-33.

5376 SHIVTIEL, A. Women in Arabic proverbs from Yemen. *New Arabian Studies,* 3 (1996) pp.164-175.

5377 SOBHI, Saeed Hasson. Women's rights in Yemen today. *Yearbook of Islamic and Middle Eastern Law,* 6 / 1999-2000 (2001) pp.76-86.

5378 TRABOULSI, Samer. The queen was actually a man: Arwā bint Aḥmad and the politics of religion. *Arabica,* 50 i (2003) pp.96-108. Also online at http:// www.ingentaselect.com (Arwā bint Aḥmad (d.532/1137) ruled in Yemen for fifty-five years.)

5379 WALTERS, D. M. Invisible survivors: women and diversity in the transitional economy of Yemen. *Middle Eastern women and the invisible economy.* Ed. R.A.Lobban. Gainesville: University Press of Florida, 1998, pp.74-95.

5380 WANGENHEIM, Annette von. Explosion der Stille. Ein Film über die Frauen im Jemen. *Jemen-Report,* 32 ii (2001) pp.33-34.

5381 WILLEMSEN, Tineke M. & LENNING, Alkeline van. Women's studies project in the Yemen: experiences from the counterpart's viewpoint. *Women's Studies International Forum,* 25 v (2002) pp.515-527. Also online at http:// www.sciencedirect.com/science/journal/02775395

5382 WÜRTH, A. The woman with two husbands. *Middle East Report,* 26 i / 198 (1996) pp.27-27. [Palestinian woman who married an Egyptian in Yemen while not fully divorced from Palestinian husband living in Saudi Arabia.]

Zanzibar

Books

5383 RUETE, E. *Leben im Sultanspalast: Memoiren aus dem 19. Jahrhundert.* Hrsg. & mit einem Nachwort versehen von A.Nippa. Frankfurt a. M. 1989, rp. [Bodenheim:] Philo-Verl. 1998. 288pp. [Rev. ed of *Memoiren einer arabischen Prinzessin,* 1886.]

Articles

5384 FAIR, L. Dressing up: clothing, class and gender in post-abolition Zanzibar. *Journal of African History,* 39 i (1998) pp.63-94.

5385 HANAK, Irmi. Language, gender and the law: divorce in the context of Muslim family law in Zanzibar. *African Languages and Cultures,* 9 i (1996) pp.27-42.

5386 NISULA, Tapio. "The woman in the body": spirits and spouses in Zanzibar Town. *Shifting ground and cultured bodies: postcolonial gender relations in Africa and India.* Ed. Karen Armstrong. Lanham: University Press of America, 1999, pp.67-102.

5387 YAHYA-OTHMAN, Saida. If the cap fits: Kanga names
 and women's voice in Swahili society. *Swahili Forum
 IV / Afrikanistische Arbeitspapiere,* 51 (1997)
 pp.135-149. [Kangas with inscriptions (kanga names)
 are worn by Muslim women in Zanzibar.]

Indices to the Bibliography

Name Index to the Bibliography

Including all persons mentioned: authors, editors, translators, reviewers and personal subjects. References are to item serial numbers.

Subject Index to the Bibliography

References are to serial numbers of entries.

Indices to the Encyclopedia

Introduction to the Indices

The indices to this first volume of the Encyclopedia of Women and Islamic Cultures on Methodologies, Paradigms, and Sources is composed of two parts: Name Index and Subject Index. In the name index the personal names of (historical) figures are included, plus the names of countries, places, dynasties, schools, and organizations. It should be noted that the name index does not contain references to the names of authors; these are included in the bibliography of each article.

The subject index contains references to technical terms.

The entries in both indices are listed alphabetically following the Roman alphabet. In case of generic terms, sub-entries are listed. Cross-references are given. For the entries that appear most frequently, the English terms as well as the transliteration from the original language is given.

The compilation of the indices was undertaken by Dr Marloes Janson.

Name Index to the Encyclopedia

Subject Index to the Encyclopedia